Acclaim for

DANIEL J. BOORSTIN'S

THE

CREATORS

BOOKS BY DANIEL J. BOORSTIN

The Creators

*

The Discoverers

*

The Americans: The Colonial Experience
The Americans: The National Experience
The Americans: The Democratic Experience

*

The Mysterious Science of the Law
The Lost World of Thomas Jefferson
The Genius of American Politics
America and the Image of Europe
The Image: A Guide to Pseudo-Events in America
The Decline of Radicalism
The Sociology of the Absurd
Democracy and Its Discontents
The Republic of Technology
The Exploring Spirit
The Republic of Letters
Hidden History

*

The Landmark History of the American People (with Ruth F. Boorstin)
A History of the United States (with Brooks M. Kelley)

THE CREATORS

THE CREATORS

DANIEL J. BOORSTIN

And, as imagination bodies forth
The forms of things unknown, the poet's pen
Turns them to shapes, and gives to airy nothing
A local habitation and a name.

—SHAKESPEARE, *A Midsummer Night's Dream*, V, 1

VINTAGE BOOKS
A DIVISION OF RANDOM HOUSE, INC.
NEW YORK

FIRST VINTAGE BOOKS EDITION, OCTOBER 1993

The photographs on pages 37, 73, 147, 201, 265, 379, 511, and 555 are from the Bettmann Archive and the photograph on page 641 is from the National Portrait Gallery in London.

Library of Congress Cataloging-in-Publication Data
Boorstin, Daniel J. (Daniel Joseph), 1914–
The creators: a history of heroes of the imagination / Daniel J. Boorstin.—1st Vintage Books ed.
p. cm.
Originally published: New York: Random House, c1992.
Companion volume to: The discoverers. 1983.
Includes bibliographical references and index.
ISBN 0-679-74375-8 (pbk.)
1. Civilization—History. 2. Arts—History. 3. Creation.
I. Title.
[CB69.B65 1993]
909—dc20 93-15502
CIP

Book design by Bernard Klein

Manufactured in the United States of America
10 9 8 7 6 5 4 3 2 1

FOR RUTH

To me there is no past or future in art.
If a work of art cannot live always in
the present it must not be considered at
all. The art of the Greeks, of the Egyptians,
of the great painters who lived in other times,
is not an art of the past, perhaps it is more
alive today than it ever was.

— PABLO PICASSO (1923)

In art, we are the first to be heirs of all
the earth. . . . Accidents impair and Time
transforms, but it is we who choose.

— ANDRÉ MALRAUX (1950)

CONTENTS

PART XII: THE WILDERNESS WITHIN

A Personal Note to the Reader

AFTER *The Discoverers,* a tale of man's search to know the world and himself, I was more than ever convinced that the pursuit of knowledge is only one path to human fulfillment. This companion book, also a view from the literate West, is a saga of Heroes of the Imagination. While *The Discoverers* told of the conquest of illusions—the illusions of knowledge—this will be a story of visions (and illusions) newly created. For this is a story of how creators in all the arts have enlarged, embellished, fantasized, and filigreed our experience. While ancient science has only a historical interest, and Galen and Ptolemy live only for the scholar, the ancient arts are living treasures for all of us.

These creators, makers of the new, can never become obsolete, for in the arts there is no correct answer. The story of discoverers could be told in simple chronological order, since the latest science replaces what went before. But the arts are another story—a story of infinite addition. We must find order in the random flexings of the imagination. Here I have chosen creators who appeal to me, who have brought something new into the arts. But each of us alone must experience how the new adds to the old and how the old enriches the new, how Picasso enhances Leonardo and how Homer illuminates Joyce.

PROLOGUE

THE
RIDDLE
OF
CREATION

It has been said that the highest praise of God consists in the denial of Him by the atheist, who finds creation so perfect that he can dispense with a creator.

—MARCEL PROUST (1921)

PART ONE

WORLDS
WITHOUT
BEGINNING

If God created the world, where was he before creation? . . .
How could God have made the world without any raw mate-
rial? . . .
If he is ever perfect and complete, how could the will to create
have arisen in him?

—JAIN SACRED TEXT (NINTH CENTURY)

1

The Dazzled Vision of the Hindus

THE Hindus have left an eloquent history of their efforts to answer the riddle of Creation. The Vedas, sacred hymns in archaic Sanskrit from about 1500 to 900 B.C., do not depict a benevolent Creator, but record a man's awe before the Creation as singers of the Vedas chant the radiance of this world. Their objects of worship were *devas* (cognate with Latin *deus,* god) derived from the old Sanskrit *div,* meaning brightness. Gods were the shining ones. The luminosity of their world impressed the Hindus from the beginning. Not the fitting-together-ness, not the hierarchy of beings or the order of nature, but the blinding splendor, the Light of the World. How the world once came into being or how it might end seemed irrelevant before the brightness of the visible world.

The Vedic hymns leave us a geology of names and myths and legends, untroubled by the mysteries of origin and destiny. Over all shines a radiant fire illuminating the Hindu vision. The fire-god was everywhere—how many was he? Sacrificial fire was a messenger carrying the consumed oblation upward to the gods. Benares, the pilgrim's destination, was the City of Light. The god Agni (meaning fire, related to Latin *ignis*) was said to be "the priest of the gods and the god of the priests." In the heavens he was the sun, in the atmosphere he was lightning, and on earth fire.

> O Agni, illuminator of darkness, day by day we approach you
> with holy thought bringing homage to you.
> Presiding at ritual functions, the brightly shining custodian
> of the cosmic order. . . .

The god who makes fire and light makes all seeing possible. What sanctifies the worshiper is no act of conversion, no change of spirit, but the simple act of seeing, the Hindi word *darśan*. A Hindu goes to a temple not to "worship," but rather "for *darśan,*" to see the image of the deity. Each of the cities sacred to each of the thousands of gods offers its own special *darśan*: Benares (Varanasi) for the *darśan* of Lord Visvanath, the high Himalayas for the *darśan* of Vishnu, or a nearby hilltop for the *darśan* of a local god. In the life of the sacred city of Benares the quest for seeing embodies much that is distinctive to the religions of Hindus. The Hindu is dazzled by a vision of the holy, not merely holy people but places like the Himalayan peaks where the gods live, or the Ganges which flows from Heaven to Earth, or countless inconspicuous sites where gods or goddesses

or unsung heroes showed their divine mettle. The Hindu pilgrims trek hundreds of miles just for another *darśan.*

So too the people of India attach a special value to the sight, the *darśan,* of a saintly person or a great leader. When Mahatma Gandhi crossed India by train, thousands collected along the tracks, gathering at his stopping places for an instant's glimpse of the Mahatma through a train window. They were "taking his *darśan.*" According to the Hindus, the deity or a holy spirit or place or image "gives *darśan*" and the people "take *darśan,*" for which there seems no counterpart in any Western religion.

Darśan is a two-way flow of vision. While the devotee sees the god, so too the god sees the devotee, and the two make contact through their eyes. In building a new temple, even before images of the gods are made, the gods are beseeched to turn a kindly eye on all who come to see them. And when the images of the gods are made, their eyes are the last part completed. Then when the image is consecrated its eyes are finally opened with a golden needle or the touch of a paintbrush. Sometimes large enamel eyes are inserted in the eye sockets. The bulbous or saucer eyes that make Indian paintings of gods seem bizarre to us are clues to the dominance of vision in the Hindu's relation to his gods. Many gods, like Siva and Ganesa, have a third eye in the center of their forehead. Brahma, the Thousand-Eyes, regularly has four heads, to look in all directions at once, and sometimes he has leopard-spot eyes all over his body.

For the Hindu, seeing became a form of touching. The Brahmanas, the sacred priestly texts attached to the Vedas, say "The eye is the truth. If two persons come disputing with each other . . . we should believe him who said 'I have seen it,' not him who has said 'I have heard it.' " This intimacy of visual contact explains too why Hindus forbade certain meetings of the eyes in public, not only between lovers but even between husband and wife.

While "seeing" brought sanctity and satisfaction to the Hindu, Western religions of Judaism, Christianity, and Islam found their way through the Word. "In the beginning was the Word, and the Word was with God, and the Word was God." "The Word was made flesh, and dwelt among us . . . full of grace and truth." Western religious traditions were wary of the seen, of the image, and the Protestant Reformation built a theology on this suspicion of all images.

Western religions begin with a notion that One—One God, One Book, One Son, One Church, One Nation under God—is better than many. The Hindu, dazzled by the wondrous variety of the creation, could not see it that way. For so multiplex a world, the *more* gods the better! How could any one god account for so varied a creation? And why not another alternative between monotheism and polytheism? The Oxford Orientalist Max Müller (1823–1900) who introduced the West to the Rig-Veda had to invent a word for the Hindu attitude. Kathenotheism, the worship of one god at a time,

described the Hindu way of being awed by the wonders of the Creation. An Olympian democracy allowed the devotee to focus his *darśan* on one particular god at each moment. But that god was not supreme over all others. In this tolerant, ever-growing community of gods and goddesses, each divinity was willing to take a turn receiving the *darśan* of the faithful. None of the nasty envy of the Greek gods whose festering pride and jealousy motivated the Homeric epics! And how unlike the sovereign Creator-God of the Hebrews and Christians and Muslims. "For I the Lord thy God am a jealous God." But Vishnu, Siva, and Devi is each momentarily seen as creator, sustainer, and supreme power, each surrounded by a galaxy of lesser gods. The Western worshiper is baffled in his quest for a hierarchy among them. The dazzled vision sees no hierarchy but the mystery expressed in every growing thing. As the Upanishads, commentaries on the Vedas, sang (c.400 B.C.):

"Fetch me a fruit of the banyan tree."
"Here is one, sir."
"Break it."
"I have broken it, sir."
"What do you see?"
"Very tiny seeds, sir."
"Break one."
"I have broken it, sir."
"Now what do you see?"
"Nothing, sir."
"My son," the father said, "what you do not perceive is the essence, and in that essence the mighty banyan tree exists. Believe me, my son, in that essence is the self of all that is. That is the True, that is the Self. And you are that Self, Svertaketu!"

(Translated by A. L. Basham)

It is hardly surprising that the awestruck Hindus never came up with a single grand Creator-God.

Trying all sorts of answers to the riddle of Creation the Rig-Veda offered myths of beginnings. The manifold universe, one story went, was produced from a primeval sacrifice. A primeval man, Prajapati, the Lord of Beings, who existed even before the founding of the universe, was sacrificed. How he came into being, why or to whom he was sacrificed is not clear. The gods themselves appear to have been his children. The "Hymn of the Primeval Man" tells us how the universe emerged:

When they divided the Man
 into how many parts did they divide him?
What was his mouth, what were his arms,
 what were his thighs and his feet called?

The brahman was his mouth,
of his arms was made the warrior,
His thighs became the vaiśya,
of his feet the śudra was born.

The moon arose from his mind,
from his eye was born the sun,
from his mouth Indra and Agni,
from his breath the wind was born.

From his navel came the air,
from his head there came the sky,
from his feet the earth, the four quarters from his ear,
thus they fashioned the worlds.

With Sacrifice the gods sacrificed to Sacrifice—
these were the first of the sacred laws.
These mighty beings reached the sky,
where are the eternal spirits, the gods.
(Translated by A. L. Basham)

Sacrifice thus repeats the essential mystery of creation in cycles of re-creation, and priests create the world anew. Without this regular sacrifice might not the original chaos return?

While the Hindus sought and found the solace of myth in their countless communities of gods and goddesses, they never allowed themselves the comfort of dogma. How many were the gods? Who ruled among them? What did they know of their own creation and the first creation if there was one? Despite all this wondrous wealth of myth and poetry, the Brahman poets in the Rig-Veda sang courageous doubt. So went their "Hymn of Creation":

But, after all, who knows, and who can say
whence it all came, and how creation happened?
The gods themselves are later than creation,
so who knows truly whence it has arisen?

Whence all creation had its origin,
he, whether he fashioned it or whether he did not,
he, who surveys it all from highest heaven,
he knows—or maybe even he does not know.
(Translated by A. L. Basham)

And there is no deeper division between West and East than that marked by this reluctance of Hindu sages to answer the luminosity of the creation with simple dogmas and definitions. Western philosophers, after the Greeks, committed themselves to the "law of the excluded middle"—Socrates must be either mortal or not-mortal—but Hindus saw many more

possibilities. One Hindu sect, the Jains, declared there were always not only two possibilities but seven, which gave them their Doctrines of Maybe, wrapping both the darkness and the dazzling brilliance of creation in a twilight of doubt.

For the Hindu the creation was not a bringing into being of the wonder of the world. Rather it was a dismemberment, a disintegration of the original Oneness. For him the Creation seemed not the expression of a rational, benevolent Maker in wondrous new forms but a fragmenting of the unity of nature into countless limited forms. The Hindu saw the creation of our world as "the self-limitation of the transcendent." For the Hindu our very notion of creation was reversed. Instead of transforming nothing into everything, the Hindu creation broke into countless imperfect fragments what was already there. The Hindu reached back for the Oneness that was there in the beginning and he aimed to reintegrate nature. The cycles of birth and death have perpetuated that disintegrating force of creation. *Samsara,* the transmigration of the soul from one life to another, perpetuated the separateness of the individual. As the distinctions of caste survived, each generation paid the price of the misdeeds of earlier lives. The object for all was to "get off the wheel," to escape the cycle, and merge finally into the original One.

The numerous sects of Hindus found their several ways to answer the riddle of creation. The Jains, as their ninth-century poet sang, found the forces of nature good enough:

No single being had the skill to make this world—
For how can an immaterial god create that which is material?
How could God have made the world without any raw material?
If you say he made this first, and then the world, you are faced with an endless regression.
If you declare that this raw material arose naturally you fall into another fallacy,
For the whole universe might thus have been its own creator, and have arisen equally naturally.
If God created the world by an act of his own will, without any raw material,
Then it is just his will and nothing else—and who will believe this silly stuff?
If he is ever perfect and complete, how could the will to create have arisen in him?

While the aim of the Christian faithful would be "eternal Life," the aim of the Hindu was to be uncreated. Yoga, or "union," was the disciplined effort to reverse creation and return to the perfect Oneness from which the world had been fragmented.

2

The Indifference of Confucius

IN some parts of the world even the most profound thinking people have not been worried by the mystery of creation. Everyday concerns have consumed their thought and focused their philosophy. They have paid little attention to the puzzles of origin and destiny. Nor have they been troubled by the possibility of other worlds before or after this one. Are they the worse for it? Their indifference to the mysteries of creation has saved their energy for the work of this world. But it has been a symptom, too, of a suspicion of change, a reluctance to imagine the new.

"We do not yet know how to serve man," Confucius (c.551–479 B.C.) warned, "how can we know about serving the spirits?" When asked "What about death," he retorted, "We don't know yet about life, how can we know about death?" Is it any wonder that the Chinese have left us a thin stock of creation myths? The lone creation myth that has survived in Chinese lore appears to have been a late borrowing from Sumeria or the Rig-Veda.

Among the great creators, the great spokesmen of ethical ideals, none is more miraculous than Confucius himself. He claimed no divine source for his teachings, nor any inspiration not open to everyone. Unlike Moses, the Buddha, Jesus, or Mohammed, he proclaimed no Commandments. Just as Hinduism is a name for the religions of India, so Confucianism is a name for the traditional beliefs of the Chinese family. Their "religious" rituals or sacrifices were presided over not by a professional priest but by the head of the family and state sacrifices were led by the head of the state. Confucius insisted that he was only reviving ancient teachings.

Confucius was never crucified, never martyred. He never led a people out of a wilderness nor commanded forces in battle. He left little mark on the life of his time and aroused few disciples in his day. Pursuing the career of an ambitious reform-minded bureaucrat, he ended his life in frustration. It is easy to see him as an ancient Don Quixote. But his lifelong unsuccessful tilting against the evils of the chaotic Chinese states of his day somehow

awakened his people, and eventually commanded two thousand years of Chinese culture.

Born into the impoverished nobility, Confucius was left an orphan at an early age. Educated only in the traditional aristocratic pursuits of archery and music, he began in a low clerical position overseeing the pasture of oxen and sheep. As he slowly climbed in the public service of his native state of Lu he acquired a reputation for learning. He was said to have memorized the whole *Book of Poetry,* the classic anthology of three hundred poems. He began preaching reform of the oppressive taxes of his time. He urged no new system of government but a new kind of leader, a "superior person" who would aim to benefit the people.

By the time he was fifty-three, in 498 B.C., Confucius' disciples were active in the government of the Chi family who had seized the government of Lu. But in Lu, plagued by insurrection, Confucius saw little hope for his reforms. He left for greener fields. Trying his powers of persuasion, for the next dozen years he wandered from state to state. But he was no politician, and everywhere he failed.

Confucius was only one of a new class of vagrant scholars who exploited the political chaos of their time, using ancient learning to cover their ambitions. Most were more adept at palace intrigue than at palace wisdom. A scholar who found his native state ruled by an upstart alien usurper offered his wisdom to any neighboring prince who would listen. These uprooted scholars became a new Machiavellian class. But Confucius carried no Machiavellian message. To every prince, Confucius preached his cliché sermon: Govern for the benefit of the people, reduce taxes, recruit "superior men" of any origin.

After his frustrating years of vagrancy, he returned to his old sinecure in his native Lu. There among his early disciples he spent the last years of his life. Nowhere had he attained high office or achieved reforms. Still, he had never lost the reverence of his small band of students. Legend reported that when Confucius died in 479 his disciples spent three whole years and Tzu-kung, his leading disciple, spent another three years mourning at his grave. "From the birth of mankind until now," declared Tzu-kung, "there has never been the equal of Confucius."

While Confucius failed as a politician, as a teacher he was a spectacular success. His simple, open-ended maxims speak to us today. He offered no dogma but a way of learning that remained congenial to John Dewey and our most experimental modern American philosophers. In China before Confucius there seem to have been no schools except those to teach archery. Historians credit Confucius with the first effort to organize an educational program to train young men for roles in government. His classic question asked, "What has one who is not able to govern himself to do with governing others?"

His Socratic method never ended in dogmatic conclusions. When he found his disciple Tzu-kung arrogantly critical of students, "The Master said, 'Obviously Tzu-kung has become quite perfect himself, to have time to spare for this; I do not have this much leisure.' " Wisdom was "when you know a thing, to recognize that you know it, and when you do not know a thing, to recognize that you do not know it." "The mistakes of a gentleman may be compared to the eclipses of the sun or the moon. When he makes a mistake, all men see it; when he corrects it, all men look up to him." Truth was always to be pursued but never possessed. "Study as if you were following someone you could not overtake, and were afraid of losing." "When walking in a party of three, I always have teachers. I can select the good qualities of the one for imitation, and the bad ones of the other and correct them in myself." (*Analects,* VII:21)

Confucius never pretended to have a divine message of which he was the chosen vehicle. People's problems could be solved not by supernatural forces but only by their own and their ancestors' experience. And "Heaven" was Confucius' name for the natural cosmic order that matched the ethical sense in every man. He would not appeal to any ruling Being up there. He was naturally suspicious of prayer. When he was near death, his earnest disciples asked permission to pray for him. But Confucius objected, "My kind of praying was done long ago"—not in words but in deeds. The example of all the great ancestors should govern a virtuous man. The "will of Heaven" was discovered not through theology but in "the collective experience of the ancestors," another name for history. In Confucius' world each man had to find the path for himself.

Still, there is no way of thought so experimental, and no philosopher so tentative that his suggestions cannot be frozen into a dogma by self-seeking disciples. Confucius was no exception. In the West his simple messages survived in fragmentary, easily remembered maxims. The practical wisdom of Confucius has become so proverbial that the "sayings" of Confucius are found in daily newspapers to whose readers Confucius is a mystery. Alexander Pope described this popular Western Confucius in his *Temple of Fame* (1714):

> Superior and alone, Confucius stood
> Who taught that useful science,—to be good.

The teachings of Confucius have come down to us through his *Analects* (Conversations), in twenty chapters and 497 verses, a miscellany of aphorisms, maxims, and episodes. Probably compiled by the disciples of Confucius' disciples, it is not known by that name before the Han dynasty (202 B.C.–A.D. 220). A version compiled near the end of the Han dynasty dis-

placed the earlier ones, and about A.D. 175 the text was carved on stone tablets. Fragments of those stones have survived, and innumerable editions have since appeared. The *Analects* were one of four Confucian texts given authoritative new editions in 1190 by the Neo-Confucian philosopher Chu Hsi. Along with the *Book of Mencius,* the *Great Learning,* and the *Doctrine of the Mean,* it was one of the Four Books, the Chinese Classics that until 1905 were the subject of the Chinese civil service examinations. The *Analects* offered Confucius' basic notions, including the idea of benevolence (*jen*) as the leading quality of the superior man, the mean (*chung yung*) or moderation in all things, the will of Heaven (*T'ien*) or the harmony of nature, filial piety or propriety (*li*), and the "rectification of names" (*cheng ming*), or recognizing the nature of things by giving them their right names.

As the centuries passed, the fragmentary teachings of Confucius were petrified into "Confucianism." The very word, which would have horrified Confucius, seems to have been invented about 1862 by European Christians and fit their simplistic view of the "religions" of the non-Christian world. Under the Han Empire the teachings of the Master were shaped into an ideology, and became state dogma. Over the next centuries, countless "schools" rose and fell, shaping Chinese culture for the twenty-five hundred years after Confucius.

But the Confucian emphasis on the family, morals, and the role of the good ruler did not satisfy the popular need for the explanation of man and his place in the universe. Another school grew out of the effort to account for the mystery of the world, the spontaneity of man, and the wondrous variety of nature. This came to be known as Taoism—after Tao or "the way"—drawing on folk currents and building on the writings of a mysterious master, Lao-tzu (c.604–531 B.C.). An antidote—and a complement—to the rigid moralism of the later Confucians and their state religion, Taoism became both an elevated philosophy and a popular religion. Developing over the years, its doctrines encouraged a sense of freedom in thinkers and artists, and eventually Taoist ideas were incorporated into Confucianism. While the Taoists were interested in man's relation to the cosmos and to nature, their subtle philosophy had no place for a Creator. As we read in the work attributed to Lao-tzu:

> There is a thing confusedly formed,
> Born before heaven and earth.
> Silent and void
> It stands alone and does not change
> Goes round and does not weary,
> It is capable of being the mother of the world.
> I know not its name
> So I style it "the way."

.
Man models himself on earth,
Earth on heaven,
Heaven on the way,
And the way on that which is naturally so.
(Translated by D. C. Lau)

With their belief in "oneness" and "nonbeing" the Taoist poetic imagination was more interested in the unity of experience than in any conceivable power of a Creator to make the new. As Chuang-tzu (flourished fourth century B.C.), the great follower of Lao-tzu, recalled:

Once I dreamt that I was a butterfly, fluttering here and there; in all ways a butterfly. I enjoyed my freedom as a butterfly, not knowing that I was Chou. Suddenly I awoke and was surprised to be myself again. Now, how can I tell whether I was a man who dreamt that he was a butterfly, or whether I am a butterfly who dreams that she is a man? . . . This is called the interfusion of things.

This feeling for the unity of the world's processes gave the Taoist Chuang-tzu a stoic power to face his personal afflictions. A friend who came to console him on the death of his beloved wife of many years found Chuang-tzu not grieving or weeping but placidly seated on a mat singing and beating time on a basin. Reproached for his callous behavior, Chuang-tzu replied:

When she died, how could I help being affected? But as I think the matter over, I realize that originally she had no life; and not only no life, she had no form; not only no form, she had no material force (*ch'i*). In the limbo of existence and non-existence, there was transformation and the material force was evolved. The material force was transformed to be form, form was transformed to become life, and now birth has transformed to become death. This is like the rotation of the four seasons, spring, summer, fall, and winter. Now she lies asleep in the great house [the universe]. For me to go about weeping and wailing would be to show my ignorance of destiny. Therefore I desist.

At the point of death, he rejected the burial plans of his disciples for an elaborate outer coffin. Without such protection, they said, his corpse might be torn apart by birds of prey. His response was another morbid reminder of the unity of nature, of the oneness of the Tao. "Above the ground," he said, "it's the crows and the kites who will eat me; below the ground it's the worms and the ants. What prejudice is this, that you wish to take from the one to give to the other?" This subservience to nature was repugnant to the moralistic Confucians.

It is not surprising that the later Taoists could not be troubled by the

mystery of creation from nothing (*ex nihilo*). For, although constantly referring to a state of "non-being," they said, there was no such thing as "nothing"; the void of chaos in the beginning was packed with the material force of *ch'i*. "What came into existence before there were things?" asked Kuo Hsiang (died 312), in his commentary on the book by Chuang-tzu. "If I say yin and yang came first, then since yin and yang are themselves, what came before them? . . . There must be another thing, and so on *ad infinitum*. We must understand that things are what they are spontaneously and not caused by something else." "But let us ask whether there is a Creator or not. If not, how can he create things? If there is he is incapable of materializing all the forms. Therefore, before we can talk about creation, we must understand the fact that all forms materialize by themselves. Hence everything creates itself without the direction of any Creator. Since things create themselves, they are unconditioned. This is the norm of the universe." Nothing like the days of Creation in the Book of Genesis, this was an endless continuous process all stages of which are always present. There was no Creator, exhausted by making the world once and for all, and so no need to interrupt the process by a Day of Rest.

Taoism developed on two levels: a philosophy of spontaneity and naturalism and a folk religion that sought the (quite unnatural) means of immortality in its own rituals and techniques. These included a diet that did not feed the "three worms"—disease, old age, and death—but nourished the body. Yet there were links between these levels. Breath control gave a hint of immortality and nourished a mysterious "embryonic body" within. And sexual discipline that avoided ejaculation preserved the semen to mix with breath and nourish the body and the brain. Taoist alchemy, too, sought an elixir of immortality, while meditation gave visions of the countless spirits in the body and in the universe.

If the West justified man's creative powers by the godlike sharing of the powers of an original Creator, the Chinese sought to act in harmony with the order of nature. After Confucius, a technique of "correlative thinking" found correspondences between human conduct and the whole cosmos well expressed in the classic statement of Tung Chung-shu (c.179–104? B.C.):

> The vital forces of Heaven and earth join to form a unity, divide to become the yin and yang, separate into the four seasons, and range themselves into the five agents. . . . In the order of their succession they give birth to one another, while in a different order they overcome each other. Therefore in ruling, if one violates this order, there will be chaos, but if one follows it, all will be well governed.

Each of the five agents was related to one of the five traditional departments of the Chou government of his time. For example, wood was the agent of the minister of agriculture, while metal was the agent of the minister of the interior. If the minister of agriculture was corrupt, played partisan politics and forced worthy men to retire, "teaching the people wild and prodigal ways," then peasants would neglect the work of the fields "amusing themselves with gambling, cock-fighting, dog racing, and horsemanship; old and young will be without respect, great and small will trespass upon each other; thieves and brigands will arise . . . then the minister of the interior is ordered to punish the leaders of the rebellion and set things right. Therefore we say metal overcomes wood." And similarly fire was the agent of the minister of war, water the agent of the minister of justice, and earth the agent of the minister of works.

The meaning of the five agents in daily experience was explained in the book the *Tso Chuan* in the early Han era:

> Men follow the laws revealed in the celestial signs, living in accord with the nature of terrestrial things. Heaven and earth give rise to the Si *Ch'i* [yin and yang, wind and rain, dark and light], and from these are born the Five Elements [Metal, Wood, Water, Fire, and Earth]. Out of man's use of these come the Five Flavors [sour, salty, acrid, bitter, sweet], the Five Colors [green, yellow, scarlet, white, black], and the Five Modes [in music]. But when these are indulged to excess, confusion arises and in the end man loses sight of his original nature.

So the pervasive five agents held all the world, all nature, and all society together.

Confucius himself, so far as we know, was not much interested in cosmogony, metaphysics, or the origins of the universe. And his successors turned neither to creating gods nor to one Creator-God. Instead they described creation as a process of natural forces. A key idea was their notion of the yin and the yang, which expressed their belief in the shaping, creative power of natural forces at work everywhere. It remains a constant reminder of the this-worldly emphasis of Chinese thought. The Chinese would not seek refuge in the frolics, passions, and intrigues of gods and goddesses. An eloquent Taoist statement of yin-yang comes from Huai-nan Tzu's synthesis (c.122 B.C.): Creation without a Creator, a mystic parable for gentlemen-rulers in all times and places.

> Before heaven and earth had taken form all was vague and amorphous. Therefore it was called the Great Beginning. The Great Beginning produced emptiness and emptiness produced the universe. The universe produced material-force which had limits. That which was clear and light drifted up to become heaven, while that which was heavy and turbid solidified to become earth. It was very easy for

the pure, fine material to come together but extremely difficult for the heavy, turbid material to solidify. Therefore heaven was completed first and earth assumed shape after. The combined essences of heaven and earth became the yin and yang, the concentrated essences of the yin and yang became the four seasons. And the scattered essences of the four seasons became the myriad creatures of the world. After a long time the hot force of the accumulated yang produced fire and the essence of the fire force became the sun; the water force became the moon. The essence of the excess force of the sun and moon became the stars and planets. Heaven received the sun, moon, and stars while earth received water and soil. . . .

When heaven and earth were joined in emptiness and all was unwrought simplicity, then without having been created, things came into being. This was the Great Oneness. All things issued from this oneness but all became different, being divided into the various species of fish, birds, and beasts. . . . But he who can return to that from which he was born and become as though formless is called a "true man." The true man is he who has never become separated from the Great Oneness.

The origin of this simple division of natural forces is hidden in antiquity.

The yin and the yang reached out across Asia to Japan, Vietnam, and Korea, where the yin-yang symbol was adopted for the national flag. This Huai-nan Tzu version of the yin-yang works of creation prefaced the *Nihon shoki* (720), the oldest official Japanese history. Astrology, astronomy, medicine, government, and the arts elaborate the yin-yang distinction and notions that were supposed to follow from it.

In time the Taoist ways of thinking about man and nature were assimilated into the renewed Confucian theorizing by the great synthesizer Chu Hsi (1130–1200):

In the beginning of the universe there was only material-force consisting of yin and yang. This force moved and circulated, turning this way and that. As this movement gained speed, a mass of sediment was pushed together and, since there was no outlet for this, it consolidated to form the earth in the center of the universe. . . .

Further Question: Can the universe be destroyed?

Answer: It is indestructible. But in time man will lose all moral principles and everything will be thrown together in a chaos. Man and things will all die out, and then there will be a new beginning.

Further Question: How was the first man created?

Answer: Through the transformation of material-force. When the essence of yin and yang and the five agents are united, man's corporeal form is established. This is what the Buddhists call production by transformation. There are many such productions today, such as lice.

Question: With reference to the mind of Heaven and earth and the principle of Heaven and earth, Principle is moral principle. Is mind the will of a master?

Answer: The mind is the will of a master, it is true, but what is called "master" is precisely principle itself. It is not true that outside of the mind there is principle, or that outside of principle there is mind.

The way of thought that brought together Confucian morality and Taoist sympathy with nature saw time as a series of cycles, without beginning or end. And, as Chu Hsi suggests, Buddhism, too, would be transformed as it entered this Confucian world. Yet, somehow the Chinese also saw history as lineal in its smaller dimensions. Unwilling to fix a time for the beginning of the world or of their nation, they marked their sixty-year cyclical calendar with the years of the reigning monarch, to date human events precisely in historical time.

Just as yin and yang explained regularity and balance in nature, so the five agents were a key to the cycles of history. Wood produced fire; fire produced earth; earth produced metal; metal produced water, and so on and on. Still it was possible instead to rearrange the agents by which one element overcame another. This resulted in a different order, since fire was "overcome" by water, water by earth, earth by wood, and wood by metal. Every dynasty had to be associated with one of the five elements, and to be legitimate had to appear at the predestined point for its "element" in the cyclical series. Dynasties, usually after the fact, claimed their right to seize the throne to preserve the proper order of agents.

Thus the Chinese emperor Wang Mang (33 B.C.–A.D. 23; ruled A.D. 2–23), commonly known as the Usurper, justified his coup, which ended the Early Han dynasty, by the fact that he was a descendant of the Yellow Emperor, whose agent was Earth. So he was qualified to fill the place in the cyclical series which required another dynasty of the agent earth. Apparent irregularities in the series were explained away by conveniently inserting into the calendar an "intercalary" reign—a kind of leap year—of the fluid agent water. For centuries, debates over dynastic legitimacy were translated into the language of the five elements.

Eternal harmony, with everything properly proceeding from its procreating *ch'i* of material forces, made novelty seem alien. The idea of the creation of something *ex nihilo* (from nothing) had no place in a universe of the yin and yang and the five elements, always in order, always in proper series. Unlike the Western world of a surprising Creation, of man at war with nature, the world of Confucius transformed by Taoist and Buddhist currents saw man at home among transformations, procreations, and re-creations.

A vivid symptom of this contrast between West and East is the difference between two ways of thinking about man's place in the landscape. Land-

scape painting is a late arrival in Western art. Ancient writers tell us of Greek murals that were landscapes, including some scenes from the *Odyssey*. Roman villas were decorated with idealized landscapes, and we can still see some in Pompeii. The frescoes (c.1338) of Ambrogio Lorenzetti (c.1300?–1348) in the Palazzo Publico in Siena are the earliest surviving Western paintings showing us a scene painted direct from nature. A series called *Good and Bad Government*, they reveal the emphasis of the West, for here it is the human figure of statesman or lover, hunter or soldier, saint or savior that dominates. Leonardo's familiar *Mona Lisa* (c.1503–1505) offers the landscape as a background. Albrecht Altdorfer (1480–1538) in the early sixteenth century begins experimenting with landscapes of the Danube. The outdoor settings for the Brueghels' paintings in the seventeenth century are not raw nature but a countryside where man plays, carouses, and hunts, and where the Blind lead the Blind. Not until the Dutch and Flemish painters of the seventeenth century—Rembrandt, Jacob van Ruisdael, Meindert Hobbema—does landscape become a subject all its own. Finally in the nineteenth century landscape becomes the painters' grand laboratory.

But in China, by the fourth century the landscape had already become an endlessly fertile subject. There nature is no mere setting for the human drama. In the earliest Western depictions of landscape, the viewer stands outside looking at the spectacle of man's work, his battles, his follies, or his worship. Man is the foreground. But the Chinese landscape was a scene of harmony and rhythmic life, where man fits inconspicuously, even obscurely.

In the Chinese landscapes we must seek out man. When we do find him he is a speck, whether a fisherman, a hermit, or a sage in contemplation. Even "empty" space is not the vacuum that the West so abhorred but an untapped resource of the universal *ch'i,* one with mountains and streams, as they said, "because there is a principle of organization connecting all things." A philosopher of the Yuan era, T'ang Hou (flourished 1320–1330), observed the incorporation of man in nature and nature in man:

> Landscape painting is the essence of the shaping powers of Nature. Thus through the vicissitudes of yin and yang—weather, time, and climate—the charm of inexhaustible transformation is unfailingly visible. If you yourself do not possess that grand wavelike vastness of mountain and valley within your heart and mind, you will be unable to capture it with ease in your painting.

3

The Silence of the Buddha

THE Buddha had no answer to the riddle of creation. Much of his appeal to millions around the world for twenty-five hundred years came from his commonsense refusal to try to answer unanswerable questions. "Is the universe eternal or not eternal, or both?" "Is the universe infinite in space or not infinite, or both or neither?" The Buddha listed these among the fourteen questions to which he allowed no reply.

"Have I ever said to you," the Buddha asked, "come, be my disciple and I will reveal to you the beginning of things?" "Sir, you have not." "Or, have you ever said to me I will become your pupil for you will reveal to me the beginning of things?" "Sir, I have not." His only object, the Buddha reminded his disciple, was "the thorough destruction of ill for the doer thereof." "If then," the Buddha went on, "it matters not to that object whether the beginning of things be revealed . . . what use would it be to have the beginning of things revealed?"

This hardheaded approach may surprise us in the West, where we commonly think of Buddhism as a mystic way of thought. But a wholesome reticence entered the mainstream of Buddhism, and came to be called the Silence of the Buddha. Confucius, too, had his own list of things "about which the master never spoke"—"weird things, physical exploits, disorders, and spirits." Inquiry for its own sake, merely to know more, philosophy on the Greek model, had no place either in the Buddhist tradition. Greek philosophers, beginning with Thales, were men of speculative temperament. What is the world made of? What are the elements and the processes by which the world is transformed? Greek philosophy and science were born together, of the passion to know.

The Buddha's aim was not to know the world or to improve it but to escape its suffering. His whole concern was salvation. It is not easy for us in the West to understand or even name this Buddhist concern. To say that the Buddhists had a "philosophy" would be misleading. Not only did the

Buddha remain silent when asked about the first creation. He despised "speculations about the creation of the land or sea" as "low conversation," which was like tales of kings, of robbers, of ministers of state, talk about women and about heroes, gossip at street corners, and ghost stories. He urged disciples to follow his example and not fritter away their energy on such trifles.

He offered an original, if slightly malicious, explanation of how the idea of a single Creator had ever got started. He said it began as only a rumor, invented by the conceit of a well-known figure inherited from the prolific Hindu mythology. The culprit was none other than Brahma, of wondrous and various genealogy. Originally associated with the primeval Prajapati, whom we have met, Brahma was said to have been born from a golden egg. Some credited him with creating the earth, others said that he had sprung from a lotus that issued from the protector-god Vishnu's navel. In the Buddha's lifetime Hindus still worshiped Brahma as a creator god.

The Lord Buddha explained how, at one stage in the endless cycles of the universe, this character had cast himself in the role of Creator:

> Now there comes a time when this world begins to evolve, and then the World of Brahma appears, but it is empty. And some being, whether because his allotted span is past or because his merit is exhausted, quits his body in the world of Radiance and is born in the empty World of Brahma, where he dwells for a long, long time. Now, because he has been so long alone he begins to feel dissatisfaction and longing, and wishes that other beings might come and live with him. And indeed soon other beings quit their bodies in the World of Radiance and come to keep him company in the World of Brahma.
>
> Then the being who was first born there thinks: "I am Brahma, the mighty Brahma, the Conqueror, the Unconquered, the All-seeing, the Lord, the Maker, the Creator, the Supreme Chief, the Disposer, the Controller, the Father of all that is or is to be. I have created all these beings, for I merely wished that they might be and they have come here!" And the other beings . . . think the same, because he was born first and they later. And the being who was born first lived longer and was more handsome and powerful than the others. . . .
>
> That is how your traditional doctrine comes about that the beginning of things was the work of the god Brahma.

Following the Buddha, the Buddhist scriptures repeatedly boasted their freedom from such silly personal conceits as belief in a Creator.

The indifference of the Buddha to the tantalizing questions of creation had a source in the experience of the Gautama Buddha himself. His career was quite the opposite of that which led Confucius to his own kind of indifference. Confucius was uninterested in the origin of the world because it had

no current bearing on the reformation of man or of government. The Buddha was interested in escaping the world and so aimed to make life on earth irrelevant. Both men were teachers. While Confucius offered maxims for the politician, the Buddha's life was raw material for legends, folklore, and fairy tales.

The obscure Confucius was frustrated in his unsuccessful search for the power to reform society. The Gautama Buddha (561?–483? B.C.) willfully abandoned power and glory. Confucius lived among sordid intrigues of bedroom and palace. The Buddha's life was overcast with sublime mysteries.

Prince Siddhartha, later to be the Gautama Buddha, was born in Kapila-vastu in northeastern India on the border of present-day Nepal. A prince of the Kingdom of the Bakyas, he was raised in fabled Oriental luxury. The legend of his life reveals the archetype of the Buddha, the essence of Buddhism, which grew over the centuries after his death. But the early Buddhists, like the Hindu Brahmins, believed that religious knowledge was too sacred to be written down. For four centuries after his death, facts and legends about the Buddha, his dialogues and sayings were preserved only in the memories of monks. The surviving accounts of his life are the accumulated product of disciples over generations.

This composite character is revealed in the very name of the Buddha. For *buddha* (past participle of Sanskrit *buddh,* to awaken or to know) is not a personal name but a term of praise, like messiah or christ (the anointed one). The proper name of the founder was Gautama. In his time he was known as Sakyamuni, the Sage from the tribe of the Sakyas. Unlike the founder of Christianity or of Islam, the Gautama Buddha was not thought to be unique. He represented a kind of person who recurred, but only rarely, over the aeons. The Gautama Buddha was not the first nor would he be the last. He was another in an endless series of Enlightened Ones. For us the historical Sakyamuni is lost in the historic Buddha.

He had not appeared on earth first as Gautama. For his perfect enlightenment could not have been attained in only one life. It must have been the result of his repeated earlier efforts in numerous incarnations. Only then had he become a Bodhisattva, a Bodhi-being in the person of the Prince Siddhartha. The explanation in the Buddhist scriptures of how this came about directs us to the Buddhist view of history. And their endless cycles of time also help us understand why the mystery of creation did not trouble them.

> Someone is called a Bodhisattva if he is certain to become a Buddha, a "Buddha" being a man who has first enlightened himself and will thereafter enlighten others. . . . This change from an ordinary being to a Bodhi-being takes place when

his mind has reached the stage when it can no longer turn back on enlightenment. Also he has by then gained five advantages; he is no more reborn in the states of woe, but always among gods and man; he is never again born in poor or low-class families; he is always male, and never a woman; he is always well-built, and free from physical defects; he can remember his past lives, and no more forgets them again.

(Translated by Edward Conze)

This full enlightenment was reached gradually, during three "incalculable aeons." "In the first incalculable aeon he does not yet know whether he will become a Buddha or not; in the second he knows he will be a Buddha, but does not dare to say so openly; in the third he knows for certain that one day he will be a Buddha, and fearlessly proclaims that fact to the world." With charming inconsistency, the same Buddhists who admired the Lord Buddha for his commonsense refusal to answer the fourteen unanswerable questions could not resist a temptation to calculate the "incalculable." Some figured it as a vast number increased by multiples, others by squares. One of the more precise scholars offered a number designated by 1 followed by 352 septillions of kilometers of zeros, allowing that one zero occupies a length of 0.001 meter.

In the endless cycles of the World, in each Great Period, or Kalpa, there were four Ages, comparable to the four ages of the Greeks and the Hindus. Each Great Period began with an Age of Destruction by fire, wind, and water, followed by a gradual re-formation and re-population of the world. In none of these did a Creator appear nor were His works required. The Great Periods were not all the same. In some no Buddha would appear and these are called "void." In others one or many Buddhas might appear. In each cycle of recovery the primordial water slowly receded and a solid world of dry land emerged. Where the sacred tree of the Buddha would be, a lotus appeared. There were as many lotuses as there would be Buddhas in the Period.

During each Great Period, life carried on by transmigration (*samsara*) of souls from one creature to another. Schools of Buddhism disagreed on points of doctrine, but they agreed that there was no beginning to the process of transmigrations. And there would surely be no end. Since there were an infinite number of souls, how could there ever be a time when they all would have attained Nirvana?

Attaining Nirvana was, of course, everyone's hope. For the transmigrations of a soul finally dissolved the self, and so ended the suffering that came with all existence. The arrival of the Gautama Buddha on earth as Prince Siddhartha about 561 B.C. was just another stage in the countless processes of his reincarnation. And his previous lives provided some of the most

appealing passages in the Buddhist scriptures. They chronicle how his soul had stored up merit toward his reward of ever-higher incarnations and final fulfillment in Buddhahood and Nirvana.

The tale of the hungry tigress told how Gautama, in an earlier incarnation as Prince Mahasattva, had gone walking in the jungle. There he encountered a weary tigress who a few days before had been delivered of seven cubs. Since she could find no meat or warm blood to feed them, they were all about to die of hunger. Mahasattva thought, "Now the time has come for me to sacrifice myself! For a long time I have served this putrid body and given it bed and clothes, food and drink, and conveyances of all kinds. . . . How much better to leave this ungrateful body of one's own accord and in good time! It cannot subsist for ever, because it is like urine which must come out. To-day I will use it for a sublime deed. Then it will act for me as a boat which helps me to cross the ocean of birth and death." With those words the prince threw himself down in front of the tigress. But she was too weak to move. Mahasattva, being "a merciful man," had carried no sword. So he cut his throat with a sharp piece of bamboo and fell near the tigress, who soon ate all his flesh and blood, leaving only bones. "It was I," the Buddha explained to his disciple, "who at that time and on that occasion was that Prince Mahasattva."

Finally, as Prince Siddhartha, he had been born again into a life of luxury. For the young prince the King provided three palaces, one for winter, one for summer, and one for the rainy season. During the rainy season the prince was entertained by beautiful dancing girl–musicians, as his father did not want him to be tempted to leave the palace. Shuddhodana had reason to take special measures to keep his son Gautama at his princely station. For Gautama's birth, Buddhist scriptures reported, had been most unusual. When the birth approached, Queen Maya accompanied the King to Lumbini, "a delightful grove, with trees of every kind, like the grove of Citraratha in Indra's Paradise."

> He came out of his mother's side, without causing her pain or injury. His birth was as miraculous as that of . . . heroes of old who were born respectively from the thigh, from the hand, the head, or the armpit. . . . He did not enter the world in the usual manner, and he appeared like one descending from the sky. . . . With the bearing of a lion he surveyed the four quarters, and spoke these words full of meaning for the future: "For enlightenment I was born, for the good of all that lives. This is the last time that I have been born into this world of becoming."
>
> (Translated by Edward Conze)

Seven Brahmin priests predicted that if the boy stayed at home he would eventually become a universal monarch, but if he left home he would become a Buddha.

He was married off at the age of sixteen to his cousin Yashodhara, "chaste and outstanding for her beauty, modesty, and good breeding, a true Goddess of Fortune in the shape of a woman." And in due time Yashodhara bore him a son. "It must be remembered that all the Bodhisattvas, those beings of quite incomparable spirit, must first of all know the taste of the pleasures which the senses can give. Only then, after a son has been born to them, do they depart to the forest."

On his pleasure excursions the young Gautama was awakened to human suffering. The gods dismayed him by images of old age and of disease. Finally they showed him a corpse. And at the sight of death his heart was again filled with dismay. "This is the end," he exclaimed, "which has been fixed for all, and yet the world forgets its fears and takes no heed! . . . Turn back the chariot! This is no time or place for pleasure excursions. How could an intelligent person pay no heed at a time of disaster, when he knows of his impending destruction."

Now, at the age of twenty-nine, Prince Siddhartha (not yet a Buddha) began his experimental search for truth, which meant a way out of the sufferings of the world. For himself and all mankind he sought escape from Creation. When, why, and how suffering had first been brought into being was not his concern. Would it not be enough to show the way out of the suffering that plagued mankind every day?

After the vision of the corpse, the gods sent a vision of a religious mendicant to remind Gautama of his mission to deliver mankind. In the long past this apparition had seen other Buddhas. Now he exhorted Gautama to follow in their path. "O Bull among men, I am a recluse who, terrified by birth and death, have adopted a homeless life to win salvation! Since all that lives is to extinction doomed, salvation from this world is what I wish and so I search for that most blessed state in which extinction is unknown." With these words the being rose like a bird into the sky. Gautama, amazed and elated, was now fully convinced of his mission of salvation. "Then and there," Buddhist scriptures report, "he intuitively perceived the Dharma [the ultimate reality; The Way], and made plans to leave his palace for the homeless life."

In the middle of the night, before setting out "to win the deathless state," Gautama took a parting look at his beautiful wife and his infant son asleep in their palace bedchamber. He did not awaken them for fear they might dissuade him from his flight. Gautama's next years of relentless search for Enlightenment and Salvation rivaled the range of William James's *Varieties of Religious Experience.* Baffling episodes of mysticism and satanism were interrupted by blinding flashes of common sense.

For a while he sat at the feet of renowned sages, learning their systems for escaping selfhood by entering "the sphere of neither-perception-nor-

non-perception" through the ecstasy of mystic trances. They still did not lead him to Enlightenment.

Then he turned to a monkish life of self-denial. He starved himself until his buttocks were like a buffalo's hoof, his ribs like the rafters of a dilapidated shed, the pupils of his eyes sunk deep in their sockets "as water appears shining at the bottom of a deep well," and the skin of his belly cleaved to his backbone. We see the emaciated Gautama in the unforgettable Greco-Gandhara sculpture of the second century. "This is not the Dharma which leads to dispassion, to enlightenment, to emancipation," he concluded, ". . . Inward calm cannot be maintained unless physical strength is constantly and intelligently replenished."

When his five companion ascetics abandoned him, he returned to a normal diet, his body became fully rounded again and "he gained the strength to win enlightenment." When he walked toward the roots of a sacred fig tree (now called the *bodhi* tree, *Ficus religiosa*) intent on his high purpose, Kala, "a high-ranking serpent, who was as strong as a King elephant," was awakened by "the incomparable sound of his footsteps" and saluted Gautama, who seated himself cross-legged in the most immovable of postures and said he would not arise until he had received Enlightenment. "Then the denizens of the heavens felt exceedingly joyous, the herd of beasts, as well as the birds, made no noise at all, and even the trees ceased to rustle when struck by the wind."

Now he suffered his final trial, the siege of the satanic Mara, Lord of Passions. Mara's demonic army, including his three sons (Flurry, Gaiety, and Sullen Pride) and three daughters (Discontent, Delight, and Thirst), attacked the impassive Gautama. He speedily dispersed Mara's hordes, who fled in panic. The great seer, "free from the dust of passion, victorious over darkness' gloom," using his skill at meditation entered a deep trance. In the first watch of the night (6:00 P.M. to 10:00 P.M.) he recalled all his own former lives, the thousands of births he had been through. "Surely," he concluded, "this world is unprotected and helpless, and like a wheel it turns round and round." He saw that the world of samsara, of birth and death, was "as unsubstantial as the pith of a plantain tree." In the second watch (10:00 P.M. to 2:00 A.M.) he attained "the perfectly pure heavenly eye" and saw that the rebirth of beings depended on the merit of their deeds, but "he found nothing substantial in the world of becoming, just as no core of heartwood is found in a plantain tree when its layers are peeled off one by one." In the third watch (2:00 A.M. to 6:00 A.M.) he saw the real nature of the world, how greed, delusion, and ignorance produced evil and prevented getting off the wheel of rebirth.

The climax of his trance was Enlightenment, the state of all-knowledge. "From the summit of the world downwards he could detect no self any-

where. Like the fire, when its fuel is burnt up, he became tranquil." "The earth swayed like a woman drunken with wine . . . and the mighty drums of thunder resounded through the air. Pleasant breezes blew softly, rain fell from a cloudless sky, flowers and fruits dropped from the trees out of season—in an effort to show reverence for him."

Gautama now at the age of thirty-five had become a Buddha. He arose and found the five ascetic monks who had abandoned him. To them he preached the middle way to Enlightenment, which became the essential doctrine of Buddhism: the Holy Eightfold Path—right views, right intentions, right speech, right conduct, right livelihood, right effort, right mindfulness, and right concentration, and the Four Holy Truths. These Truths were: first, that all existence—birth, decay, sickness, and death—is suffering; second, that all suffering and rebirth are caused by man's selfish craving; third, that Nirvana, freedom from suffering, comes from the cessation of all craving; and fourth, that the stopping of all ill and craving comes only from following the Holy Eightfold Path. These steps to the extinction of self were the way of the Buddha, the way of Enlightenment.

Is it any wonder that the Buddha dismissed those who asked when and how the world was created? That he aimed at them "the unbearable repartee" of silence? What soul en route to Buddhahood would waste energy on the mystery of creation? The Buddha aimed at Un-Creation. The Creator, if there was one, was plainly not beneficent. The Buddha charitably had not conjured up such a Master Maker of Suffering, who had imposed a life sentence on all creatures. If there was a Creator, it was he who had created the need for the extinction of the self, the need to escape rebirth, the need to struggle toward Nirvana. The Lord of the Buddhists was the Master of Extinction. And no model for man the creator.

The Homeric Scriptures of the Greeks

THE Greeks' spirit of inquiry grew with the centuries. But their sacred epic had little to say about Beginnings. Instead it was a saga of human adventure and human gods. Homer's two testaments, the *Iliad* and the *Odyssey*, remain the first and greatest epics of Western civilization. Still, who Homer

was, how Homer worked, and how the stories were perpetuated have baffled scholarly detectives for three thousand years. And the making of the Homeric saga remains a parable of the mystery of creation.

Plato (427?–347 B.C.), a mythmaker of proven talent, complained that while Homer was "the greatest of poets and the first of tragedy writers" it was unfortunate that he had become "the educator of Hellas" and the guide "for the ordering of human things." He was troubled that the *Iliad* and the *Odyssey* offered no set of moral commandments or divine ordinances but only epics of a long-past heroic age. Homer sang in the *Iliad* of four days in the ten-year war of the Greeks against the Trojans and in the *Odyssey* recalled the adventures of one Greek on his way home. From about 1200 B.C. and for seven hundred years until Plato's time these two epics were the basis of Greek religion and morals, the chief source of history, and even of practical information on geography, metallurgy, navigation, and shipbuilding. Still more remarkable, for two and a half millennia after Plato, the Homeric epics as primordial works of the imagination reigned over the Western world of letters. The core of humanistic scholarship, the songs of Homer resound without interruption above the changing dogmas of politics, religion, and science. The prophetic Greeks called him "the poet."

Homer's survival is a stark contrast to the fate of the Greeks' other creations. The Acropolis lies in ruins, and there is probably not one complete freestanding statue surviving from the Great Age. We cannot hear Greek music. Their literary legacy, which has dominated Western culture, survives only in fragments. While we know the names of at least 150 ancient Greek writers of tragedy, what remain for us are mere samples. Of all the 92 plays of Euripides whose names survive we have only a fifth (18 or 19), of the 82 of Aeschylus less than a tenth (7), and of Sophocles' 122, a fifteenth (7). Would the power of the ancient Greeks have been greater or less if the bulk of their work had come to us? Of the works of Agathon, the most eminent follower of the three famous tragedians at whose house Plato set his *Symposium,* we have only fragments. Yet Agathon was reputed to be the great innovator, the first to write a tragedy on his own imaginary subject and the first to divide a play into acts. For us he is hardly more than a literary rumor.

In the lottery of time, Homer's two great epics managed to survive. Why? How? Homer's chances of survival were multiplied by his perennial popularity in all sorts of climates. His works were copied again and again, somehow undimmed by centuries of changing styles. There were some happy coincidences, such as the dry climate of Egypt that happened to provide natural museum conditions for preserving fragile manuscripts. And Alexander the Great's conquest of Egypt (332 B.C.) set the scene for Greek rulers to found the greatest of all ancient libraries at Alexandria. In the

literal sense, in Egypt Homer survived the test of time. Of the Egyptian papyri that have lasted into our century, about half are copies of the *Iliad* or the *Odyssey,* or commentaries on them. In the Hellenistic Age, after the death of Alexander the Great, educated Greeks continued to learn Homer by heart, much as, later, the people in the West would know their Bible, or as Muslims memorized their Koran.

Even after the rise of Christianity, the *Iliad* and the *Odyssey* remained the very model of the heroic epic, outshining Christian classics. English critics who disagreed about everything else were all Homer's acolytes. Alexander Pope preached:

> Be Homer's works your study and delight;
> Read them by day, and meditate by night.

And the romantic John Keats, "On First Looking into Chapman's Homer" discovered the world:

> Then felt I like some watcher of the skies
> When a new planet swims into his ken;
> Or like stout Cortez when with eagle eyes
> He stared at the Pacific—and all his men
> Looked at each other with a wild surmise—
> Silent, upon a peak in Darien.

Even the solemn Walter Bagehot from the heart of industrial England declared that "a man who has not read Homer is like a man who has not seen the ocean. There is a great object of which he has no idea." Today the best American poets still test themselves as translators of Homer.

The *Iliad* and the *Odyssey* took form centuries before the invention of the Greek alphabet. We still know very little about the language that the prehistoric migrants brought into Greece, and from which the language of Homer grew. Only after World War II, and its advanced science of cryptography, was the earliest Greek writing deciphered by the precocious English architect Michael Ventris (1922–1956). As a boy his twin passions were the classics and cryptography. At fourteen he heard Sir Arthur Evans describe a mystifying pictographic script he had uncovered on the clay tablets at Knossos, which he called Linear B. At the age of eighteen the determined young Ventris put his clues together in a paper for the *American Journal of Archaeology.* When Ventris returned from the war in 1949, he applied the latest statistical techniques to the growing data of archaeology from mainland Greece. He made his dramatic announcement on BBC radio in 1952. The mysterious Linear B, he revealed, was an archaic form of the classical

Greek language. (Its undeciphered predecessor Linear A still awaits an-
other Michael Ventris.) It was a syllabic script of some ninety signs in which
the ancient language of Mycenae had been written from about 1500 B.C.
Then, about 1200 B.C., in a rare example of lost technology, writing disap-
peared from the Greek mainland. Five hundred years passed before lan-
guage was again written. Finally, around 700 B.C. the Greeks adapted the
Phoenician alphabet into a phonetic way of writing their own language. It
was during this interregnum of the spoken word, when there still was no
way of writing Greek, that the Homeric epics came into being.

The Homeric epics, then, were inevitably an *oral* creation. They were
recollections of bards in an era when there was no writing. How, without
writing, were works of such length and complexity first put together? And
then perpetuated? (A skilled Serbian bard who was recently engaged to sing
a poem as long as the *Odyssey*, took two weeks, performing two hours
morning and afternoon, to complete his tale.) In our literate age when
printed matter is cheap, it is more difficult than ever to imagine how the
Iliad and the *Odyssey* were created.

Still, in the last half century we have learned more about the creation of
these long oral epics than was learned by Homeric scholars in the preceding
thousand years. We owe this to a bold young American scholar, Milman
Parry (1902–1935), who was inspired to go to the mountains of Yugoslavia,
where illiterate bards still sang heroic epics to illiterate audiences. There he
hoped to recapture the oral age. There he hoped to relive, as classical
scholars before him had not, the tasks and talents of Homeric bards and the
hopes and delights of their audiences. And there indeed he witnessed spec-
tacular bardic feats. Contrary to modern assumptions, the bards do not
recite lines that they have memorized. Instead, they compose anew before
each audience, putting together their tale with poetic embellishments as
they go along.

The bards, Parry found, were but skillful improvisers from a limited and
familiar stock. Drawing on a repertoire of traditional themes—the promise
of Zeus, the anger of Achilles, the ransoming of Hector's body, the beauty
of Helen and her kidnapping by Paris—they composed their song anew for
each occasion. The episodes were held together by familiar phrases, which
they used again and again, recognized by the audience as the proper idiom
of song. In phrases like "rosy-fingered Dawn," "owl-eyed Athena," "city-
sacking Achilles," "sea-girt Ithaca," which the modern reader tolerates as
literary cliché, Parry found clues to the composition of oral epics. Stock
phrases, ready-made to fit the meter of a Homeric line, gave the bard
breathing space to choose the next episodes. To describe Achilles in the
Iliad, there are at least thirty-six different formula-epithets. The one to be
used depends on the space in the line and the needs of the meter. In the first

twenty-five lines of the *Iliad* there are twenty-five such formulas or pieces of them. A full third of both the *Iliad* and the *Odyssey* is composed of lines repeated elsewhere in the same poem.

The bard was singing to an audience. These listeners who could not read could not leaf pages to see how the story ended, nor look backward or forward to count the repetitious formulas. What they heard gave them both the joy of recognition and the pleasure of suspense. No wonder Homer expressed his doubts that mere Memory could be the mother of the Muses. Odysseus praised the "inspired" bard Demodokos and when Odysseus returned to Ithaca and was tempted to kill Phemius who had sung to the Suitors, the bard begged:

> You will be sorry in time to come if you kill the singer of songs. I sing to the gods and to human people, and I am taught by myself, but the god has inspired in me the song-ways of every kind. I am such a one as can sing before you as to a god.

No mere reciter of a fixed text, the self-taught Homeric bard was inspired by the gods and by the audience. While an actor in our literate age is circumscribed by the written word, the oral bard was far freer to respond to his audience. Each performance was spontaneous and unique, not only in *how* it was sung, but even in what was sung. We cannot find a literary original for an oral poem. Yet the different surviving versions have an uncanny similarity, as if copied from a divine original!

It is no wonder, then, that Homer remains a mystery. Who was Homer? This so-called Homeric Question has provoked some of the bloodiest professorial battles. Speculation about Homer has itself spawned fantasies of epic proportions. Homer himself became a myth.

The ancient Greeks had no doubt that Homer was a real person. Before the Great Age, until about 450 B.C., they put his birthplace on the little island of Chios, off the western coast of Asia Minor, where his epics were being sung by people who called themselves *Homeridae,* descendants of Homer. Herodotus (fifth century B.C.), the knowledgeable nephew of a practicing bard, said that Homer had lived four hundred years earlier and named him as the author of the two great epics. By the early fifth century B.C., Homer had already become so myth-heroic that several different towns, including Athens, claimed to be his birthplace. But how did his works reach mainland Greece, and how did they first acquire a fixed literary form like that which survives? No satisfactory answer has been agreed on for any of these questions. Greek patriots like to believe that the *Iliad* and the *Odyssey* were a spontaneous, divinely inspired emanation from the Greek people. If Homer, the perfect poet, was descended from Orpheus, then excrescences and imperfections must be later corruptions.

. . .

Fixed texts of the *Iliad* and the *Odyssey* seem to have appeared with the return of writing in the fifth century B.C. The rise of a small literate class brought the new pastime of people reading privately to themselves. And this brought a trade in manuscripts as the oral epics were written down. One scholarly tradition credits the first fixed written texts for the *Iliad* and the *Odyssey* to the decrees of Solon, who in the sixth century B.C. ordered regular recitations of the works of Homer. Most historians claim that it was the Athenian tyrant Pisistratus who decreed a written text for Homer.

The written text provided both an object of idolatry and a convenient target for academic critics. Plato's attack on the baleful influence of Homer testified to his uninterrupted influence. Aristotle declared that "the structure of the two Homeric poems is as perfect and the action in them is as nearly as possible one action," as can be, and his authority prevailed. The light of Homer shone undimmed throughout the Christian "almost Greek-less" Middle Ages. Then Homer became the leading figure in the classical revival of the Renaissance. Boccaccio, Petrarch, and Lorenzo Valla all were acolytes. The first printed edition of Homer, in 1488, confirmed his reign as prototype of poetry and epic.

Poets have tested themselves by translating Homer into the idiom of their time. Alexander Pope (1688–1744) opened his admired version of the *Iliad* in 1720:

> The wrath of Peleus' son, the direful spring
> Of all the Grecian woes, O goddess, sing!
> That wrath which hurl'd to Pluto's gloomy reign
> The souls of mighty chiefs untimely slain;
> Whose limbs unbury'd on the naked shore
> Devouring dogs and hungry vultures tore.
> Since great Achilles and Atrides strove,
> Such was the sov'reign doom, and such the will of Jove.
> Declare, O Muse! in what ill-fated hour
> Sprung the fierce strife, from what offended power?

Which, for Robert Fagles in 1990 became:

> Rage—Goddess, sing the rage of Peleus' son Achilles,
> murderous, doomed, that cost the Achaeans countless losses,
> hurling down to the House of Death so many sturdy souls,
> great fighters' souls, but made their bodies carrion,
> feasts for the dogs and birds,
> and the will of Zeus was moving toward its end.
> Begin, Muse, when the two first broke and clashed,
> Agamemnon lord of men and brilliant Achilles.

The progress of modern Western thought entertains us with a kaleido-scope of opinions, "facts," and fantasies about Homer. In the running battle between "the Ancients," and "the Moderns," Homer was ex officio com-mander of the Ancient forces. A scholar could make a reputation by a new strategy or slogan. The French Abbe d'Aubignac (1604–1676) berated "illit-erate" Homer for bad taste and immorality, then erased him as a person who never existed. The works, he said, were pieced together by some crude editor. In the next century the English scholar Richard Bentley (1662–1742) pitied "poor Homer" as "a primitive provincial who wrote a sequel of songs and rhapsodies, to be sung by himself for small earnings and good cheer at festivals and other days of merriment; the *Ilias* he made for the men, and the *Odysseis* for the other sex."

The rising social sciences produced a whole new library of Homeric speculation. Perhaps, after all, there really was nothing supernatural about Homer, and his works were simply a product of his age. The burgeoning ideas of biological evolution that Erasmus Darwin (1731–1802), Charles's versatile grandfather, prophetically expressed in his *Zoonomia* (1794–1796) had a Homeric counterpart. A German professor Friedrich A. Wolf (1759–1824), a friend of Goethe and Wilhelm von Humboldt, in his *Prolegomena to Homer* (1795) showed how the Homeric epics had emerged from the processes of social evolution. First composed orally about 950 B.C., in an age without writing, he explained that they were repeated and modified by four centuries of bards. After being written, they continued to evolve in response to changing ideas. Although there probably was a Homer, the unity of the epics emerged only over the centuries. Wolf gives a hint of the fashionable new optimism before the products of evolution as he dissolved Homer into the elusive processes of history.

After Wolf, the Homeric mystery was compounded and illuminated by comparative literature, philology, sociology, archaeology, and anthropol-ogy. Had the *Iliad* and the *Odyssey* been pieced together, like the German *Nibelungenlied,* or the Finnish national epic, the *Kalevala,* from many separate original "lays"? If this was how it had happened, then their glow-ing epic unity was more miraculous than ever. Or did the *élan vital* that Henri Bergson saw in biological evolution also create new artistic species?

Still some faithful remained. Heinrich Schliemann, inspired by Homer, believed that the *Iliad* was literal history. Digging at Hissarlik, Homer's Troy, he used the facts of archaeology and the relics that he unearthed to prove that myth and history were somehow one. Were the Homeric myths themselves a kind of history?

The new halo with which Schliemann crowned Homer invited academic fury. The leading German classicist, Professor Ulrich von Wilamowitz-Moellendorff (1848–1931), found the author of the *Odyssey* "a not very gifted

patch-worker" (*ein gering begabter Flickpoet*). But oddly enough, the new science of comparative religion restored Homer's epics to the canon of sacred documents. Combining Wolf's evolutionary arguments with the "higher criticism" of recent biblical scholars, the English master translator Gilbert Murray (1866–1957), showed that, like the Old Testament, the *Iliad* and the *Odyssey* accreted by tradition. Of course Murray did not solve the Homeric riddle, but he put Homer's works securely among the highest mysteries of Creation. Were the gods jealous of this Homeric mystery? Was there a curse like that on violators of the pharaoh's tombs? The two bold scholars who did most to tear the veil of mystery from Homer, Milman Parry (1902–1935) and Michael Ventris (1922–1956), both came to an early, untimely end.

Homer's world of gods and goddesses bypassed the perplexing questions of the first Creation of the earth and of man. In the *Iliad* and the *Odyssey* we see man and the gods fully matured. If Homer ever was troubled about how or why the world came into being, he does not share his concern with us. The full-grown gods' loves and hates provide the motive power, the sources of defeat or victory, success or catastrophe in the *Iliad* and the *Odyssey*. Achilles, whose wrath is the theme of the *Iliad,* is the son of Peleus, who is the grandson of Zeus, and of the Nereid Thetis whom the gods had given in marriage to Peleus. Never are the gods absent from the story as we watch Aphrodite, protectress of Helen, and Apollo, the protector of all Troy, struggle vainly against "the plan of Zeus." The *Odyssey,* too, glows with the divine, the miraculous, and the preternatural. Under the watchful eyes of Zeus, we see Odysseus' seduction by the goddess Calypso, his encounter with the Lotus Eaters, the Cyclopes, Circe, and finally his voyage to Hades. The Greeks every day saw men and women aided or frustrated by the whims or purposes of the gods. This they found more urgent and more interesting than speculation over how and why it all began.

So, too, by showing their gods and goddesses as immortal men and women with all the human passions, fears, and hopes, they made men and women the more godlike. The hybrid nature of man would remain a dominant theme in Judaism and Christianity. The Greeks shaped their gods in man's image. They made man their point of departure, and for them the problems of Creation were only afterthoughts. But Judaism and Christianity would turn the question around, and start from God. By making man in God's image, they committed themselves to facing the Mystery of Creation, with endless consequences.

The Greeks replaced cosmology with genealogy, leaving us an ample and explicit account of the births and families of the gods. It was Hesiod (c.750–675 B.C.), another epic bard, whose *Theogony* (Birth of the Gods)

became the canon. We can follow Hesiod in the lively translations by Apostolos N. Athanassakis. Less shadowy than Homer, Hesiod was a most un-Homeric gloomy figure. His father emigrated from Asia Minor to Boeotia in central Greece. One day, he recalled, there appeared to him the Helikonian Muses:

> "Listen, you country bumpkins, you swag-bellied yahoos,
> we know how to tell many lies that pass for truth,
> and we know, when we wish, to tell the truth itself."
> So spoke Zeus' daughters, masters of word-craft,
> and from a laurel in full bloom they plucked a branch,
> and gave it to me as a staff, and then breathed into me
> divine song, that I might spread the fame of past and future,
> and commanded me to hymn the race of the deathless gods,
> but always begin and end my song with them.

As the Muses commanded, Hesiod produced a poetic genealogy of the gods.

Hesiod also produced mundane poems of moralism and everyday life. His lazy brother Perses, with lies and bribes, had tried to steal Hesiod's share of their father's estate. One happy result of this family quarrel was Hesiod's *Works and Days*. In this long poem (828 hexameters) Hesiod lectures his brother (and his whole corrupt age), with reminders of how Prometheus was punished for his theft of fire. Incidentally, Hesiod provided some of our earliest details of the rigors, pleasures, and temptations of archaic Greece, its peasant ways and the perils of its seafaring. And he sings of the decline of humankind from the earliest Golden Generation who "lived as if they were gods, their hearts free from all sorrow, by themselves, and without hard work or pain; no miserable old age came their way. . . . All goods were theirs." Then the foolish Silver Age, followed by the Bronze Age of strength and strife.

> And I wish that I were not any part
> of the fifth generation
> of men, but had died before it came
> or had been born afterward.
> For here now is the age of iron. . . .
> when guest is no longer at one with host,
> nor companion to companion
> when your brother is no longer your friend,
> as he was in the old days.

In his *Theogony*, Hesiod, going back to the very beginning, provides a gory and sexually explicit chronicle of the births of the gods. Every act of

Creation was an episode of divine loves and hates. "It was Homer and Hesiod," Herodotus writes, "who composed a 'theogony' for the Greeks, and who first gave the gods distinctive titles, and defined their forms and functions." Hesiod did not invent the gods but he gave them genealogical respectability. Unlike what we read in Genesis, Hesiod shows us not the Act of Creation but countless acts of procreation.

> Chaos was born first and after her came Gaia
> the broad-breasted, the firm seat of all
> the immortals who hold the peaks of snowy Olympos,
> and the misty Tartaros in the depths of broad-pathed earth
> and Eros, the fairest of the deathless gods;
> he unstrings the limbs and subdues both mind
> and sensible thought in the breasts of all gods and all men.
> Chaos gave birth to Erebos and black Night;
> then Erebos mated with Night and made her pregnant
> and she in turn gave birth to Ether and Day.

As the gods multiply, their lives become more violent and their glory more complicated. The first generation of Titans were the Cyclopes with their "single round eye that leered from their foreheads, and inventive skill and strength and power" and other "brazen sons," each with "a hundred invincible arms" and fifty heads. One of these Titans, Kronos, castrated his father Ouranos as he lay with his mother, Gaia. From the flowing blood of Ouranos came the Furies, the Giants, and the Nymphs of the Ash Trees. Out of Ouranos' genitals cast in the water arose the beautiful Aphrodite. All these were the beginnings of new procreations in unending generations. When Kronos coupled with his sister Rheis, also a child of Ouranos and Gaia, the greatest of their offspring was Zeus, who ever thereafter ruled gods and men from Olympus. The rest of *Theogony* is a saga of Zeus, who uses the thunder and lightning that the Cyclopes gave him and enlists the hundred-handed, fifty-headed monsters to defeat the rebellious Titans.

> When Zeus drove the Titans out of the sky
> giant Gaia bore her youngest child, Typhoeus;
> goaded by Aphrodite, she lay in love with Tartaros.
> The arms of Typhoeus were made for deeds of might,
> his legs never wearied, and on his shoulders were
> a hundred snake heads, such as fierce dragons have,
> and from them licking black tongues darted forth.

From such couplings came the vast progeny of gods, even the Muses themselves.

PART TWO

A CREATOR-
GOD

What was God doing before He created the World?
Martin Luther replied, "He sat under a birch tree cutting rods
for those who ask nosey questions."

The Intimate God of Moses

THE idea of an original Creation by a single all-powerful Creator comes to the West through Moses, the greatest of the Hebrew prophets. It was Moses, too, who announced the paradoxical, mysterious nature of the Creator. Bards and philosophers, priests and princes around the world had found countless reasons to turn away from the riddle of Creation. But this Hebrew prophet, born in Egypt of obscure immigrant parents of a servant class, allowed himself to be named the ambassador plenipotentiary of the Creator. And he brought epoch-making answers to crucial questions.

There was a historical Moses, as even skeptical scholars agree. Recent archaeology puts the Exodus from Egypt at about 1290 B.C., and suggests that Moses was born sometime in the thirteenth century B.C. It is not easy to separate history from legend, but we have evidence that he was a talented priest and politician, a persuasive moralist and lawgiver. Some say that he may have been an Egyptian by birth. "Moses" (the Hebrew "Moshe"), derived from the Egyptian *moser,* simply means "is born" (as in the Pharaoh Thutmose, "The God Thoth is born"). Perhaps his full name was longer, appending the name of a god. The name "Mose" was also in use. The associations of the word *mashah* (to draw out) in Hebrew suggests that Moses' name may have referred to the fact that as an infant he was "drawn out" of the Nile, or perhaps that he drew the Israelites forth from Egypt and from the flood.

"Hebrew" (from Egyptian *Habiru*) was the name for a class of serving people who had been in Egypt for many generations. One of the pharaohs must have feared them and enslaved them. By Moses' time, it seems, the Pharaoh had ordered the death of every newborn Hebrew male. The Bible reports how Moses survived:

> And there went a man of the house of Levi, and took to wife a daughter of Levi. And the woman conceived, and bare a son; and when she saw him that he was a goodly child, she hid him three months. And when she could not longer hide him, she took for him an ark of bulrushes, and daubed it with slime and with pitch, and put the child therein; and she laid it in the flags by the river's brink. And his sister stood afar off, to wit what would be done to him.
> And the daughter of Pharaoh came down to wash herself at the river; and her maidens walked along by the river's side; and when she saw the ark among the flags, she sent her maid to fetch it. And when she had opened it, she saw the child; and, behold, the babe wept. And she had compassion on him, and said, This is

one of the Hebrews' children. Then said his sister to Pharaoh's daughter, shall I go and call to thee a nurse of the Hebrew women, that she may nurse the child for thee? And Pharaoh's daughter said unto her, Take this child away, and nurse it for me, and I will give thee thy wages. And the woman took the child, and nursed it. And the child grew, and she brought him unto Pharaoh's daughter, and he became her son. And she called his name Moses; and she said, "Because I drew him out of the water."

During his years at the Pharaoh's court (probably of Ramses II) not detailed in the Bible (Exodus 2:1–10), Moses must have had an opportunity to learn how a kingdom was governed and how an army was commanded. At this time the Pharaoh ruled a vast empire, including Canaan (Palestine) and some of Syria.

Probably knowing that he was born a Hebrew, Moses felt righteous anger at the oppression of his people. "And he spied an Egyptian smiting an Hebrew, one of his brethren. And he looked this way and that way, and when he saw that there was no man, he slew the Egyptian, and hid him in the sand." The next day when he returned to the Hebrew workers, he found two of them fighting. He reprimanded the worker in the wrong, "Wherefore smitest thou thy fellow?" The guilty worker retorted, "Who made thee a prince and a judge over us? Intendest thou to kill me, as thou killedst the Egyptian?" Moses was alarmed that his own crime had been discovered, for he knew the Pharaoh would seek to slay him.

With grim appropriateness, Moses began his career as prophet of Judaism and founder of the community of Israel in the role of a refugee. He fled to the land of Midian, in northwest Arabia, east of the Gulf of Aqaba. There, a fugitive from the Pharaoh's justice, he began a new life. Until then we know nothing extraordinary about Moses except the circumstances of his rescue in the bulrushes. If he had stayed on in Egypt and had not committed murder he might have had a successful career in the Pharaoh's service.

In Midian, when he sat down to rest by a well, he had the good luck to meet the seven daughters of Jethro, a shepherd priest (Exodus 2:15ff.), who had come to water their flock. When some unfriendly shepherds tried to drive them away, Moses stood up for them and watered their flock. When the daughters returned home their father asked why they had returned so soon. Jethro invited Moses to come live with them, and offered his daughter Zipporah to be Moses' wife. She bore a son whom Moses, recalling his refugee status, named Gershom (by folk etymology from "stranger"), "for he said, I have been a stranger in a strange land" (Exodus 2:16–25). Meanwhile, as the sufferings of the children of Israel in Egypt became intolerable, they cried to their God to help them escape.

Then, with no further biblical explanation, came the event that changed

Moses' life. He was tending his father-in-law's flock in a remote "backside of the desert," where he came to "Mt. Horeb"—probably the place later called Mount Sinai.

> And the angel of the Lord appeared unto him in a flame of fire out of the midst of a bush: and he looked, and behold, the bush burned with fire, and the bush was not consumed. And Moses said, I will now turn aside, and see this great sight, why the bush is not burnt. And when the Lord saw that he turned aside to see, God called unto him out of the midst of the bush, and said, Moses, Moses. And he said, Here am I. And he said, Draw not nigh hither; put off thy shoes from off thy feet, for the place whereon thou standest is holy ground. Moreover he said, I am the God of thy father, the God of Abraham, the God of Isaac, and the God of Jacob. And Moses hid his face; for he was afraid to look upon God. (Exodus 3:2–6)

Rationalists suggest that what Moses saw may have been the brilliant blossoms of one of the mimosa families, the desert acacia (*Loranthus acacia*).

Moses' first encounter with his Creator-God already revealed the divine paradox of Creation. Historians of religion call this Moses' "theophany," their name for a visible appearance of God or a god to a man. But Moses had not dared to look upon his Creator. The contradictory characteristics of this Creator-God appeared at once. For while the God was not to be seen or even to be named, He entered intimately into every man's life and treated man as a kind of equal.

Responding to the cries from the children of Israel, God directed Moses to go to Pharaoh "that thou mayest bring forth my people the children of Israel out of Egypt." Moses at first demurred. Who am I, an inept stammerer, he said, to take on this momentous task? When the children of Israel would ask the name of this God who had sent him, what was he to say? "And God said unto Moses, I AM THAT I AM: and he said, Thus shalt thou say unto the children of Israel, I AM hath sent me unto you . . . The Lord God of your fathers, the God of Abraham, the God of Isaac, and the God of Jacob . . . this is my name for ever, and this is my memorial unto all generations" (Exodus 3:14–15). The precise meaning of the Hebrew "I am that I am"—usually transliterated as "Yahweh"—has been the subject of endless speculation.

Until then, it seems, the God of the Fathers had been known as "El Shaddai" (God of the Mountain or Almighty God) or "El 'Elyon" (God Most High). In the future the God of Moses would be Yahweh. A widely accepted explanation is that Yahweh comes from the Hebrew verb "to be." As the causative form it means "to bring into being." The name derived from it would mean "He who brings into being," or the Creator. The

magical uses of names, the power that knowing a name gives over the person named, and the fear of uttering the name of the Potentate—all these ideas are familiar enough to anthropologists. But for Moses, biblical scholar Martin Buber observes, Yahweh was not so much a name as a "dark, mysterious cry," an elemental invocation of the Creator. To Moses' diffidence, God had replied, "Certainly I will be with thee."

The awe before this Creator-God, and the reluctance to utter or embody Him in a name remained strong in the Jewish tradition. The laity, to avoid irreverence, were still not to pronounce God's name. Only priests at the benediction, and later only the High Priest, were allowed to utter the "unutterable" name. And the High Priest should whisper lest his fellow priests hear the name. The torture-death suffered by a famous rabbi (Hanina ben Teradion) during the persecutions of Hadrian was explained as God's punishment for his sacrilege in having pronounced the holy name. Medieval Jewish philosophers still referred to "the proper, the great, the wonderful, the hidden, the excellent name, the written-but-not-read name." Synonyms, abbreviations, and even deliberate mispronunciations were among the devices used to avoid the irreverence of naming the unnamable. A favorite epithet, with heavy theological and polemical overtones, was "He-who-spake-and-the-world-came-into-being."

The belief that God existed but that His qualities could not be described became the basis of a whole new theology. In this way Philo of Alexandria (late first century B.C. to first century A.D.) would combine philosophy and theology in the style of Plato, foreshadowing Christian thought. At the same time Philo declared that the love which God had planted in man would help man become godlike. The great Unnamable had made men resemble Him.

Here was a path leading man to think himself a potential creator. Man would himself then be no mere object or victim or instrument of gods but part of the processes of creation. This was the paradox of the God of Moses. The God who would not reveal his name, and on whom Moses dared not look, promised Moses, "Certainly I will be with thee" (Exodus 3:12). The hint that man might himself possess Creator-like qualities appeared in a new intimacy between God and man. As the Bible explained in Genesis, the First Book of Moses, "God created man in his own image, in the image of God created he him" (Genesis 1:27).

The perpetual "covenant" between a Creator-God and a Man-in-God's-Image was an extraordinary idea. In religions and mythologies where the gods had been made in man's image, it was not surprising that Zeus or Juno, or Poseidon or Aphrodite should be angered at their human rivals. But this God of the Unutterable Name actually entered into an agreement, a cove-

nant, establishing mutual obligations with his God-like human creations. The Bible offers numerous examples of "covenants," solemn agreements between individuals or peoples. One of the most memorable was that between Jonathan and David (1 Samuel 18:3). God covenanted with Noah (Genesis 9:13) and with Abraham (Genesis 18–21; 17:4–14). And it was when "God remembered his covenant with Abraham, with Isaac, and with Jacob" and the sufferings of their descendants in Egypt that He commissioned Moses, at the burning bush, to lead out the children of Israel (Exodus 2 and 3). The covenant negotiated through Moses—that He would be their God taking them to their promised land, and they would take Him for their God above all others—dominated the Five Books of Moses (the Pentateuch). The word "testament" itself is an archaic synonym for "covenant." Some versions still distinguish the two divisions of Scripture as the Books of the Old Covenant (The Old Testament) and the Books of the New Covenant (The New Testament). God's ambassador, Moses, sealing the covenant with the children of Israel, brought into being the community of Israel. In this way Moses himself became a creator. Some students of religious history are tempted then to call Judaism by the name of "Mosaism."

For man's awareness of his capacity to create, the Covenant was a landmark. It declared that a people become a community through their belief in a Creator and His Creation. They confirmed their creative powers through their kinship, their sharing qualities of God, their intimate and voluntary relationship to a Creator-God.

In biblical times, there were many ways of sealing a covenant. One was to dismember and sacrifice a lamb or some other animal. Eating the sacrifice would symbolize a bond of union between the covenanters, just as the dismemberment of the sacrificial victim symbolized the fate of a faithless covenanter. Circumcision was the biblical symbol of sealing the covenant between God and the children of Israel. The removal of the foreskin of male members of the community is an ancient custom with varied forms around the world. It appears to have been common among the primitive Semites. As the use of a "sharpened stone" (probably a flint knife) by Moses' wife, Zipporah, in the circumcision of their son suggests, it may even have preceded the age of metals (Exodus 4:25). In the Books of Moses, the ceremony on the organ of procreation affirmed the covenant between Yahweh and the children of Israel, past, present, and future.

In earlier times circumcision was performed (as in much of the world today) at puberty or perhaps (as in some Muslim communities) just before marriage. But, God told Abraham (Genesis 17:7–13), "a token of the covenant betwixt you and me" was the rite of circumcision (Genesis 17:11). "And he that is eight days old shall be circumcised among you, every man child

in your generation . . . and my covenant shall be in your flesh for an everlasting covenant" (Genesis 17:12–13). The covenant with God, first sealed when the male child received his name and his identity in the community, affirmed every man's godlike qualities, his share in the processes of creation.

Between God and the children of Israel, another symbol of man's relation to his Creator was the Sabbath, which had precedents in the Babylonian Sabbath and their seven-day week. But for the Hebrews the Sabbath, like circumcision, became a sign of the Covenant. The Commandment to keep the Sabbath and its meaning came through Moses.

> And the Lord spake unto Moses, saying . . . Verily my sabbaths ye shall keep: for it is a sign between me and you throughout your generations; that ye may know that I am the Lord that doth sanctify you. . . . Ye shall keep the sabbath therefore. . . . Six days may work be done; but in the seventh is the sabbath of rest, holy to the Lord. . . . Wherefore the children of Israel shall keep the sabbath, to observe the sabbath throughout their generations, for a perpetual covenant. It is a sign between me and the children of Israel for ever; for in six days the Lord made heaven and earth, and on the seventh day he rested, and was refreshed. [Exodus 31:12–17]

These were the words that the Lord spoke to Moses and then affixed on the "two tables of testimony, tables of stone, written with the finger of God" (Exodus 31:18).

The ideas of a Creator-God, of the Covenant, and of man's godlike qualities were woven into a single texture of belief. In a popular table-hymn for the Sabbath by the Spanish-Jewish philosopher Abraham Ibn Ezra (c.1050–1164), "I keep the Sabbath, God keeps me: it is an eternal sign between Him and me." Biblical scholars suspect that the Hebrews did not observe the Sabbath until Moses brought God's Commandment to them. And it was Moses who made the idea of Sabbath inseparable from the Covenant between God and man, and from the belief in a Creator-God. As Martin Buber puts it, the Sabbath enjoined by Moses affirmed "the God who 'makes' heaven and earth and in addition man, in order that man may 'make' his own share in the creation."

In the Jewish tradition, the Sabbath began at sundown on Friday and lasted till sundown on Saturday, in the pattern of the biblical days. "And the evening and the morning were the sixth day" (Genesis 1:3). During the Babylonian exile and in later generations, the Sabbath became a binding custom, sustaining the community sense of the Jews even when they were dispersed, far from Temple or synagogue. For the Sabbath observance was moved into the home, and the covenant with the God of Moses was cele-

brated in every family. The differing attitudes toward observance of the Sabbath have become a touchstone of the different sects of Judaism, and have divided the community of modern Israel. At times the commandment to rest on the Sabbath was interpreted so strictly that Jews refused to take up arms to defend themselves on that day. And they became an easy target for enemies who knew their customs. Those in the Jewish community who refused such a suicidal interpretation of the Sabbath insisted that "the Sabbath was made for Man, not Man for the Sabbath."

Through the five Books of Moses (the Pentateuch) Moses led Western man's effort to understand the Creation and find a human share in its processes. The Bible reports that Moses "wrote all the words of the Lord" (Exodus 24:4), but some modern biblical scholars credit Moses with recording only a fifth of the text. This would still include crucial parts—the Ten Commandments, the Covenant, and its interpretations.

Moses' heroic role in our story of creators was as prophet of the single Creator-God. The Mosaic God probably contained some Egyptian elements, including perhaps the belief in a single creator as well as elements of the word and idea of Yahweh. There were also relics of the earliest Hebrew beliefs—the special contractual relationship between this God and his people, the revealing of the god in storms and mountains, and the idea of the God of the Fathers. But by insisting on a single Creator-God, Moses was himself a kind of creator. A messenger of the new. "To believe in 'One God,' " Josiah Royce observes, "means, in general, to abandon, often with contempt or aversion, many clear beliefs, fears, and customs relating to the 'many gods,' or to the other powers, whose place or dignity the 'one God' tends henceforth to take and to retain." Historically it cannot be shown that monotheism always comes after polytheism. And there is little foundation for the self-serving belief, popular in Britain in the nineteenth century, that monotheism is everywhere the product of human progress.

Belief in one God plainly makes it easier to imagine a Creator. If there are no divine competitors, the Creation can more readily be conceived as a single rational product. At the same time, if there is one all-beneficent Creator-God, it is harder to explain the origin of evil, which in polytheism is the work of special gods. The one God who has created the universe surely has not abandoned His creation. Then history, no longer a vector of divine wills or whims, expresses the divine will. As the one God appears in place of all others, religions of one God tend to be intolerant. This jealous God inspires awe before His holiness, before the mystery of the Creator and the Creation. He also is personal, not as a vague all-pervasive entity but as a person who can be addressed. Then man's role in history becomes more obvious and more conspicuous.

Yet the believer in one God is not always strictly a monotheist. The First

Commandment, "Thou shalt have none other gods before me," is consistent with the existence of competing gods who should not be equally honored (Deuteronomy 5:7). It even suggests a hierarchy of gods. Moses preferred his one God, the God of Israel, to all others. And this could be monolatry, the worship of the one God. But to deny the claim of other gods to be worshiped did not necessarily deny their existence. There are many variants of monotheism. The monotheism of Israel, stemming from Moses, affirms a single Creator and righteous ruler of the world. This later becomes the ethical monotheism of the Hebrew prophets. Greek philosophers espoused a kind of monotheism in their belief that God was somehow immanent in the world. When Aristotle was asked whether God was related to the world as the "order" is to the army, or as the "general" is to the army, he answered that God was both, "although rather the general." Some even see Hinduism, too, as a bizarre kind of monotheism with all the Hindu gods being aspects of a single universal entity (the only reality), while the world itself is unreal.

The special character of Mosaic monotheism began in limitation. God's unique relation to His "chosen people," the children of Israel, whom He led forth from bondage in Egypt, made Him real and personal. And it was this Covenant between Yahweh and His people that sealed man's godlike qualities, man's capacity to imitate God as a creator. Even as the Jews affirmed the unity and uniqueness of their God, the special relation of God to Israel long remained. "I am the Lord, your Holy One, the creator of Israel, your King" (Isaiah 43:15). But, they believed, the God of Israel will one day become the universal God, when all people accept the God of Israel for their own. "And the Lord shall be king over all the earth: in that day shall there be one Lord, and his name one" (Zechariah 14:9). Israel's exclusive possession of the one God was only a step toward that God's universal dominion.

While the Hindus never ceased to be dazzled by the Creation and its wonders, for the Jews it was not so much the creativity of Yahweh as His justice that kept them in awe. "Torah," the Hebrew word that became a synonym for the Five Books of Moses, which recounted the story of Creation, means "law." God's grand gift to Israel, transmitted through Moses, was the Torah, including the Ten Commandments, which were the law by which they lived. This was the law that sealed the Covenant, the relation between Yahweh and His people, and man's potential as a creator.

The elaboration of Jewish learning, which became the Talmud in the early centuries of the Christian era, was largely the exposition of the traditions and distinctions of the law by which Jews were expected to live. The tradition remained that God had not ceased His creative activity when the world had been made. Or, as a modern commentator observes, God kept

on talking after His Book had gone to press. At this very moment He is creating the events of our time. While schools and synagogues debated the fine points of the Law, there continued an awed reticence before the Work of Creation. Rabbis cautioned against public debate of the mystery of Creation, which was to be discussed only privately and to a single listener. It was permitted to expound what, as Genesis explained, took place on the six days of Creation, and what is within the expanse of heaven. But what was before the first day of Creation or what is above, beneath, before, or behind, was not to be publicly discussed. "With what is too much for thee do not concern thyself," warned Sirach (second century B.C.), "for thou hast been shown more than thou art capable of." Still, the Jews, almost alone among believers, could joke about their God. Since they could converse (and covenant) with Him, why not joke with Him too?

The Birth of Theology

THE struggle of Western man toward belief in his creative powers was, oddly enough, a struggle against the seductive charms of the Greek philosophers. They made their epic cycles irresistible. The eloquent images of Plato's *Timaeus,* telling how the world had been compounded of the pure eternal ideas and the impure material substances, were not soon forgotten. But these proverbially creative people never ascribed to man the creative powers that their own civilization revealed. They could not envisage a Creator who brought a world into being *ex nihilo,* nor could they imagine man escaping from the cycles of re-creation. Or, perhaps, like the Chinese after their exposure to these ideas through contact with Islam and Nestorian Christianity in the seventh and eighth centuries, they did not find the ideas appealing, considered them, and turned away. Still, their efforts would not be lost. The astonishing beauties of Greek philosophies, and even their over-simplified versions of the world's processes, would be way stations (and sometimes targets) toward answering the riddle of creation.

The man who pointed the way from the plausible symmetries of Greek philosophy was Philo of Alexandria (c.25 B.C. to A.D. c.50). A devotee of the God of Moses, he was himself both an admirer of and a refugee from the elegant explicit world of Plato. Often called the first Christian philoso-

pher, Philo was a Jew. Which of course is not surprising, since the Christian Messiah was also a Jew. In his efforts to confirm the truths and widen the foundations of the Mosaic religion, Philo transformed Greek philosophy and Mosaic revelation into a vernacular for Christian theology.

The opportunity for the work of Philo came from his desire to interpret the Books of Moses for the Jews and Gentiles of Alexandria, then the melting pot of Mediterranean culture. The conquests of Alexander the Great (356–323 B.C.) had spread Greek culture around the Mediterranean and far eastward to the shores of the Indus River in northern India. After occupying Egypt, Alexander founded his namesake city (332 B.C.), which would be a living legacy, a nursery of the dazzling afterlife of Greek culture. When Alexander's domain was divided at his death, Egypt was taken over by one of his self-made Macedonian generals, Ptolemy I (305?–283), called Ptolemy Soter (Savior), who founded the Greek dynasty that was to rule Egypt for more than two centuries. Just as his predecessors had been called pharaohs (from the Egyptian "great house"), so his successors called themselves Ptolemies. The dynasty would not come to an end until the death of the romantic and ruthless Cleopatra (69–30 B.C.), the seventh Ptolemy. The real-life Cleopatra used all her wiles to keep the fading dynasty alive. After a brief period as Caesar's mistress in Rome (46–44 B.C.), she returned to Egypt and murdered her brother, with whom Caesar had made her share the throne, but failed to win back Caesar. She did infatuate Antony, whom she married in 36 B.C., and then enticed into a futile campaign for an independent Egyptian monarchy. After these hopes were smashed at the decisive naval battle of Actium (31 B.C.) Antony committed suicide. She undertook a last personal campaign of seduction on the young Octavian (Augustus: 63 B.C.–A.D. 14). When that failed, she gave up. To avoid being exhibited in Octavian's Roman triumph, she too committed suicide (probably by poison, though legend preferred an asp).

At Alexandria the high renaissance of Greek culture came in the reign (265–246 B.C.). of the ambitious Ptolemy II (309–246 B.C.). Son of the founder of the dynasty, he was nicknamed Philadelphus (lover of his sister) because, following the custom of the pharaohs, and to consolidate his power, he married his sister. His Greek subjects were scandalized, but Alexandrian poets were extravagant in his praise. A wily and aggressive monarch, he expanded his father's realm up the Nile, along the Red Sea, and into northern Arabia. He used the wealth from his conquests to make Alexandria the cultural center of the Mediterranean, whose lights brightened European culture during the following centuries. A wonderfully cosmopolitanized "Hellenistic culture" flourished there. "Other cities," a Hellenistic scholar boasted, "are but the cities of the country around them; Alexandria is the city of the world."

Alexander the Great, according to legend, had imagined a great library

in his namesake city. The Ptolemies made his vision a reality, when their royal library became the first ample repository of the West's literary inheritance. As emissaries of an alien language, they aimed to prove the Greek claim to the respect of the conquered people. And they succeeded better than they had intended. For they made it possible for the Greek currents eventually to be mingled and lost in the widening stream of Christianity. The library of Alexandria was intended to be a kind of "deposit" library. By the early fourth century B.C. the written word had become the main vehicle of Mediterranean culture. This library would preserve a reliable text of every work in Greek and a representative collection in other languages.

To accomplish this the Ptolemies used the authority of their office. Ships anchoring in Alexandria harbor, Galen reported, were required to hand over their books to a library official so that a copy could be made for the collections. Special rapid-copying shops did this work, and such books were labeled "From the ships." The collection was miscellaneous, cosmopolitan, unorthodox, and comprehensive. It included the philosophers of all schools, along with cookbooks, books of magic, natural history, drama, and poetry. Perhaps never before or since has the whole literary culture of a vast and cultivated region of the world been so conveniently displayed. Of course, there were no *printed* books, and probably not yet anything like a "codex" or volume of stitched sheets. Their books were in the form of foot-wide scrolls, each of which unrolled was about twenty feet long. Each roll would contain only about sixty pages of a modern book. Many were written on both sides. At its height the Alexandria library probably contained some half-million such scrolls.

Ptolemy II enlarged the library, adding a museum and research center. Here was the seedbed of the ancient Greek Renaissance, which came to be known as Hellenistic culture. Plato and Aristotle were revived and elaborated in new schools. Mathematicians Eratosthenes and Euclid, the physicist Archimedes, the poet Theocritus, and the philosophers Zeno and Epicurus nourished a new circle of culture around the Mediterranean.

The grandest consequence of the project was a translation of the Hebrew Bible into Greek, which from its beginning was enshrouded in legend and folklore. Ptolemy brought together seventy-two Jewish scholars, and reportedly asked each of them individually to translate the whole Hebrew Bible. The astonishing result, according to Jewish legend, was that the seventy-two versions were identical. Jews may have spread this legend to persuade Gentiles of the divine inspiration of the original, but the Jewish community became a victim of its own advertising. According to tradition, the translators had been sent to Alexandria at Ptolemy's request by Eleazar, then the chief priest in Jerusalem. This Greek version, called the Septuagint (from Latin *Septuaginta,* seventy; abbreviated LXX), became the Bible of

the early Christian Church, in which the Messianic prophesies of the coming of Christ were to be found. When the Jews saw that this text could be used to defeat their missionary purposes, the Jews themselves ceased using the text.

Meanwhile the Greek Septuagint became the Old Testament of the Christian Church as it expanded around the Mediterranean in the Age of Jesus and the Church Fathers. This was the Old Testament that Saint Paul knew, although he seems also to have known and used the Hebrew. From the Septuagint, not from the Hebrew original, translations were made into Old Latin, Coptic, Armenian, Arabic, and other languages, and it has remained the authoritative Old Testament for the Greek Church. In the first Christian centuries Jews around the Mediterranean fasted on the anniversary of the day in the time of Ptolemy II when the Books of Moses were first written in Greek. On that day, they said, darkness came over the world for three days. And they believed it was a dark day for their missionary hopes.

But no one can doubt that the seventy-two anonymous translations of the Septuagint, by re-creating the Books of Moses in Greek, had unwittingly opened wide avenues to an uncertain future. Perhaps, some scholars now suspect, the translation was made not for Ptolemy's library but for the use of the Jews of Alexandria, who were no longer at home in Hebrew. One of the brilliant and productive members of this community who gave the Books of Moses a new life was our Philo of Alexandria (Philo Judaeus). Outwardly Philo lived the privileged life of a wealthy Alexandrian but inwardly he nurtured a self-conscious Jewish soul. In the society but not wholly of it, he spent his life in search of latent meanings. Following Moses, he was one of a long line—through Maimonides (1135–1204), Spinoza (1632–1677), Felix Mendelssohn (1809–1847), to Marx, Freud, and Einstein among others—who brought the insights of the outsider. He would be a very model and prototype of countless Jewish creators in the next two millennia.

Born to a Jewish family only recently moved from Palestine to Alexandria, Philo tasted the delights of patrician society. At the time of Jesus, Alexandria, not Rome or Athens, was the cultural center and philosophical resource of the Roman Empire. Here Platonism was transformed into Neoplatonism, and here grew the generations of late-flowering Greek science that would become the canon of medieval Europe. Philo's family were the Rothschilds of their age. And his brothers bore conspicuously Gentile names. Alexander was one of the richest men of the city, and of the ancient Mediterranean world. When Herod Agrippa, king of Judaea, needed money, Alexander lent him the enormous sum of two hundred thousand drachmas, perhaps because Alexander admired Agrippa's wife. As chief tax collector he was reputed to have provided the gold and silver for covering the grand gates of the temple in Jerusalem. He had influence in Rome, too,

as an old friend of Emperor Claudius and steward for the emperor's mother. Another of Philo's brothers, Tiberius Alexander, abandoned Judaism, became Roman procurator in Palestine, and then Nero's prefect of Egypt, where, during a riot, he was said to have commanded a massacre of Jews.

Philo himself recorded his enjoyment of Alexandria's parties, its theater (he reported the enthusiasm of the audience for a now-lost play of Euripides), and its concerts. An aficionado of sports, he distinguished between the boxers who were really skillful and those who were simply tough enough to take the punishment. He saw chariot races where the excited spectators were killed when they ran onto the racecourse. And he reported complacently those banquets where he managed to leave without being stupefied by food or drink. A local celebrity, he was so well known for his style of life that people were puzzled that his wife, unlike other socialites, did not wear the fashionable heavy gold jewelry. According to gossips, she explained, "The virtue of the husband is sufficient ornament for the wife."

He made himself spokesman and champion of several hundred thousand members of the Jewish community of Alexandria. They needed him. Although Roman rulers were indifferent to arcane doctrines of religion, they insisted on an outward show of loyalty and had no patience with people who disturbed the peace. Citizens of the empire, of whatever religion, were expected to sacrifice to the Roman gods and worship the emperor as a god. For a turbulent century (166–63 B.C.) the Maccabees in Palestine had led the Jews' struggle for independence, and Palestine remained unruly. The Jews threatened to revolt rather than allow a statue of Caligula to be set up for worship in the Temple.

The wealth and influence of Jews in Alexandria fed envy and anti-Semitism, and nourished wild rumor of their disloyalty. Philo wrote a series of tracts attacking Flaccus, a Roman governor of Egypt, and even Caligula himself for their persecution of the Jews. He argued that rulers prospered only so long as they protected the Chosen People of God. And he showed how divine retribution (with the help of Caligula) had forced the persecuting Flaccus into exile. After a pogrom in Alexandria (A.D. c.39–40), Philo led a delegation to Rome for the purpose of asking Caligula to restore the rights that Alexandrian Jews had long enjoyed under the Ptolemies, and he himself recorded his audience with the emperor. Just as Philo was about to answer the malicious charges of Apion, the vocal anti-Semite, he was stopped by the emperor. Still, Philo said, God was on their side, and would punish Caligula soon enough. The Praetorian Guard murdered Caligula the very next year.

Philo might have been described as a nonobservant Orthodox Jew. Despite his assimilated way of life, he professed to believe in all the traditional rituals. His faith and his passion for orthodoxy were at the heart of his

being. But his education was thoroughly Hellenistic. Greek was the language of instruction for him, like other cultivated citizens of Alexandria. Education in his mind was so identified with Greek that he even assumed that Moses must have had a Greek tutor. His own "general education" in one of the Greek "gymnasiums" would have included, among the "liberal" arts, arithmetic, geometry, astronomy, music, grammar, rhetoric, and logic (all of which he puts into his own account of Moses' education). Greek literature and philosophy were the core. While he never learned Hebrew, he must have felt that he did not need to, for the Bible was now available in a divinely inspired translation, the Septuagint. Greek literature was an inexhaustible treasure. He believed, too, that the Greeks had copied their truths from Moses.

In fact, Philo was a star pupil of both Moses and Plato. His great feat was to allow them to speak to each other. For Philo, philosophy was a way of preparing to search for the highest truth. And philosophy was only the "handmaiden" of theology, which depended not on unaided reason, but on divine revelation and inspired prophets. He strengthened the case for theology by making Greek philosophy a way station toward understanding man's role in the Creation. If the Greeks were creators of philosophy for the West, so Philo and the Church Fathers who came after him, all creatures of the Hellenistic world, were founders of theology as the study of God and the effort to give a consistent statement to a religious faith. Theology developed with the rise of Christianity. For reasons we have already seen, there was not the same need or opportunity for theology in the great Eastern faiths of Hindus, Confucians, or Buddhists. Of course they found their own paths to study the nature of reality, of humanity, and of society. But the Creator-God of Jews and Christians invited speculation. And He was a point of departure for countless notions, theories, and dogmas about the nature of man, the governance of the world, salvation, and the First and Last Times.

Theology, a Western creation nurtured in Hellenistic Alexandria, was both a producer and a by-product of Christianity. Plato, and Aristotle after him, talked about God and the gods. But for Plato it was not a respectable subject, since he identified theology with myth, which could only mislead men from rational pursuits. So he expelled poets—those who made myths plausible and appealing—from his ideal Republic. Ironically the weakness of this antiseptic rationalism would be revealed in the works of Plato himself, whose myths persuaded the generations who would not follow his reasons.

As a technique for finding meaning in sacred Scripture and sacred lore, theology was born in Allegory. From the Greek meaning "other" and

"speak out" (*allos—agoreuein;* literally, speaking otherwise than one seems to speak), Allegory describes a way of saying something more, and quite different, from what appears on the surface. Wyclif (1382) later explained Allegory as that which is "said by ghostly [spiritual] understanding." Philo gave the Books of Moses spiritual meanings that stirred the imagination and reinforced the faith of later centuries. Enriched by Allegory, the Scriptures became infinitely adaptable to the needs of future generations. *On Allegory,* Philo's greatest work, in eighteen surviving titles (besides some nine titles that have been lost) is an extended, meandering, imaginative exploration of the biblical text, finding levels of meaning deep below the surface.

On the Creation, the Septuagint reads "and God finished on the sixth day His works." But, Philo wrote, "It is quite foolish to think that the world was created in six days or in a space of time at all." (The Septuagint said six, while the Hebrew had said, "on the seventh day.") "Six," according to Philo, meant "not a quantity of days, but a perfect number," which showed that the world had been made according to a plan. This also showed that Philo had become a disciple of Pythagoras. Influenced by Plato, Philo offered his own allegorical version of the Creation in Genesis. On the first day God created the whole intelligible world of ideas. But while Plato had treated the essential primordial ideas as "eternal" and "uncreated," according to Philo God Himself had created the ideas, which were seven (a favorite Pythagorean symbolic number). First (following Plato) was the idea of the "receptacle" into which all the other ideas would fit, then the idea of the four elements, the idea of the celestial bodies, and the idea of mind and soul. Then God created concrete copies of the receptacle and the four elemental ideas, which became the four elements.

During the next days God fulfilled the creative possibilities—on the second day the heavens; on the third day the lands, the seas, trees, and plants; on the fourth day the sun and moon and stars; and on the fifth day fishes and birds. Then on the sixth day He created land animals and *the mind* of the ideal man (Genesis 1:27). "So God created man in his own image, in the image of God created he him; male and female created he them," and finally *the embodied man* (Genesis 2:7). "And the Lord God formed man of the dust of the ground, and breathed into his nostrils the breath of life; and man became a living soul."

Besides making philosophic sense of the scriptural passages, Philo finds hidden meanings in commonplace scriptural events. What of the Garden of Eden? Was it not a garden, Philo reminds us, that surely did *not* need cultivating? Yet Adam was put there to cultivate it. Why? "The first man," he explained, "should be as it were a sort of pattern and law to all workmen in future of everything that ought to be done by them." And why "coats of skins" for Adam and Eve? (Genesis 3:21) To show the virtue of frugal-

ity—that "the garment made of skins, if one comes to a correct judgment, deserves to be looked upon as a more noble possession than a purple robe embroidered with various colors." Abraham's marriage to Sarah and to Hagar was meant to show that philosophy was sterile without the inspiration of theology. Here Philo adapted a current allegory of the Odyssey in which Penelope's suitors, who had only the rudiments of education, were successful with her handmaidens but could rise no higher. The Egyptian whom Moses smote and hid in the sand of course had a higher meaning. The slain Egyptian stood for two false doctrines of the Epicureans: "the doctrine that pleasure is the prime and greatest good, and the doctrine that atoms are the elementary principles of the universe."

Philo's way of reading Scripture was original and powerful in his time. Before him, the Stoic philosophers had found ways of reading the poets to confirm the philosophers. But for Philo the "other reading," the Allegory, was the real significance of the revealed text. Still, the power of the "other meaning" does not necessarily void the literal truth of the plain meaning. Even after his elaborate Allegory of the six days of Creation he declares that the biblical words themselves are "considered with strict truth." As a believing Jew he warns against making Allegory an excuse for not observing the rituals prescribed in the Pentateuch.

Allegory was needed because of the gulf between Creator and creatures. And it was a clue to the mysteries of Creation. The plain surface message in the Sacred Scriptures had been scaled to man's understanding. Allegory, elaborated and developed by Philo, became more than a technique of scriptural exegesis. It founded a new discipline, theology, that, as we have seen, explored a new penumbra between man and his Creator. Passages in the Pentateuch and the Prophets had given hints of a Messiah. In Philo's day, rabbis were speculating on when the Days of the Messiah would come, what were the preconditions, and how long the Days of the Messiah would last. The growing power of Rome suggested the realistic need to postpone fulfillment of these hopes into the indefinite future.

Philo's Allegories opened countless new possibilities. His Logos brought an appealing vehicle between Creator and creature. Arcane in its beginning, in its Christian transformations the Logos would be one of the most potent ideas in history, touching intimately the lives of the West. *Logos,* a familiar word in Greek philosophy, meant "word," "reason," or "plan." A name for the deepest mysteries, it suggested what man might know and how much he could not know about the processes of Creation. Countless volumes by philosophers and theologians have not exhausted its subtleties.

Early Greek philosophers used the idea of Logos to describe the orderly processes in nature. Eastern religions had similar terms for nature or god or the cosmic plan. Plato's *Timaeus* described a process of creation in which

the world was fashioned from eternal models. Philo went on to encompass the archetypal forms in his idea of God. Logos is his name for them. Ideas are God's thoughts, created by God, yet one with God from eternity. His God, then, is not a mere Platonic artisan creating after eternal models but the original Creator of the models. The Logos, or the divine plan and reason and word, is one with God. Here Philo signaled another liberation from patterns and eternal archetypes. The Logos, the link and the affiliation between God and his cosmos, was God's instrument of creation, somehow visible to his creature, man.

Even Philo himself, the Master of Allegory, could not have imagined the theological creations elaborated from his Logos. Neoplatonism, Gnosticism, and lesser sects in Alexandria and elsewhere found their own meanings and new clues. Christian elaboration of the idea of Logos, which Philo's work began, would suggest the indefinable dimensions of man's creative powers. According to Philo, the Logos is somehow a "second God," the first-begotten Son of the uncreated Father, the pattern of the Creation, the model of human reason, and "the man of God." The Logos, model of the human mind, is "the heavenly Adam." The Logos is God's viceroy, mediating between Creator and creatures, and manna for the creature. Yet God appeared through the Logos in the burning bush, and in Moses himself.

In the Old Testament *Logos,* the word of God, was a name for divine revelation, sometimes also meaning wisdom or reason. Sometimes, too, it is personified (Proverbs 8) to mean not what is spoken but the speaker. But in the Gospel according to Saint John, the Word, or Logos, carries a new meaning:

> In the beginning was the Word, and the Word was with God, and the Word was God. The same was in the beginning with God. All things were made by him; and without him was not any thing made that was made. In him was life; and the life was the light of men. . . . And the Word was made flesh, and dwelt among us, (and we beheld his glory, the glory as of the only begotten of the Father,) full of grace and truth. [John I:1–14]

In this latest of the Gospels (generally dated between A.D. 70 and 105) Christian theologians hear the accents of Philo. He reverberates also in the style of Paul's writings and in the Epistle to the Hebrews.

Others imitate Philo's style of Allegory to make Bible stories into theological principles. It was through the Logos, Saint John explains, that men were created, that man shared the qualities of God, that man could apprehend the truth of God. The Logos was the water of life, the bread of life, the door of the fold, the Good Shepherd, the Resurrection and the Life, the Way, the Truth, the Life, and the way to Eternal Life. Philo had provided

the vernacular in which the Christian message reached the Hellenistic world. Incidentally he supplied the central concept in which Christianity restated the story of Creation, the relation of Creator to creature, and the role of the Christ in history. By making Moses into a philosopher, he marked off a new arena for philosophical speculation, and added revelation to the Greek resources. Theology became something quite different from mythology. No realm of poetic fantasy, theology would be a new cartography of the paths between the Creator and his creatures.

At the same time Philo opened a new way of thinking about novelty in history. The foundations of Christian thought would be the Gospels—Good News. When Philo showed Holy Scripture to be an "inspired cryptogram," he made the Good News more plausible. We can know, Philo declared, *that* God is, but we cannot know *what* He is. So, too, man, with his godlike power of creation, could not know what he might create, nor where the novelties of history might lead him.

7

The Innovative God of Saint Augustine

CHRISTIANITY, turning our eyes to the future, played a leading role in the discovery of our power to create. The ancient Greeks, adept at poetic and philosophic speculation about the past, seldom speculated about the future. And the typical Greek thinker has been called a "backward-looking animal." The dominant figure in this modern Christian story, after Jesus and Saint Paul, was Saint Augustine. He would help us to Janus-Vision.

We have seen how Hesiod's myth of a Golden Age, popularized by poets and dramatists, had depicted the decline of practically everything. His Paradise Lost was a tale of man's fall from the primitive Age of Innocence down into the present Age of Iron. Empedocles' cycles of creation, destruction, and re-creation also made progress inconceivable.

To Plato, too, nothing new seemed possible. Confined by his theory of forms, the only progress he could imagine was to come closer to the ideal models that had existed from eternity. And Aristotle in his own way denied the possibility of the new. His preexisting "appropriate forms" prescribed the limits within which any institution like the city-state could develop.

Greek hopes for mankind, imprisoned in the mold of their idealism, prevented their imagining that man's power to create might be infinite.

The Greeks saw the advance of civilization bringing new ills. Their sour parable of technological progress was the familiar myth of Prometheus. Punished for affronting the gods by stealing fire for men's use, Prometheus was chained to a rock so an eagle could feed on his liver, which grew back each night. According to Lucretius, necessity had led men to invent, and then inventions spawned frivolous needs that equipped and encouraged them to slaughter one another in war. Strabo (63 B.C.?–A.D. 24?) complained that cultivated Greeks had brought decadence to innocent barbarians. According to the geographer-historian Trogus, the Scythians had learned more from nature than the Greeks had learned from all their philosophers.

With meager historical records, the Greeks naturally credited the great inventions to gods or ancient heroes. The benefactors of mankind, they thought, must have been superhuman. But Euhemerus of Messene (c.300 B.C.), in an ingenious travel fantasy, debunked the gods as mere idealized fabrications based on heroes who had really lived. His theory—"Euhemerism"—attracted Roman skeptics, menaced pagan faith, and appealed to pious Christians.

Then Christian writers themselves opened the ways. The very idea of Gospels (Good News) was new. Early Christian writers attacked the idea of cycles. The Church Fathers reminded people that every day they were witnessing changes and not a mere repetition of earlier events. Origen (185?–254) of Alexandria dismissed the absurd notion that "in another Athens another Socrates will be born who will marry another Xanthippe and will be accused by another Anytus and another Meletus." "In your clothing, your food, your habits, your feelings, finally even in your language," Tertullian (160?–230?) told the citizens of Carthage, "you have repudiated your ancestors. You are always praising antiquity, but you renew your life from day to day." "If you look at the world as a whole, you cannot doubt that it has grown progressively more cultivated and populated. Every territory is now accessible, every territory explored, every territory opened to commerce." The full Christian armory was targeted on the repetitive view of history.

But it was one thing to ridicule a simplistic dogma, quite another to create something in its place. This would be the grand achievement of Saint Augustine. He would offer an all-encompassing view of man's place in the unfolding drama of time, which made plausible man's own creative powers in a novelty-laden future.

Augustine came to his faith in mid-life, and his enduring writings were inspired by the traumas of his time. Born of middle-class parents in 354 in

Tagaste, a small town on the coast of Algeria, he showed such promise in school that his family sent him to study in Carthage hoping to qualify him for government service. His father was a pagan, but his mother was a devout Christian, who yearned to see Augustine converted to her faith. Teaching rhetoric in Carthage, Augustine became unhappy with his rowdy students and their irregular fees and went to Rome. There Symmachus, the influential leader of the pagan party, was charmed by Augustine's eloquence and good nature. Symmachus became his patron and secured his appointment as professor of rhetoric in Milan, then the residence of the Western Roman Emperor. When the thirty-year-old Augustine arrived in Milan in 384, where Symmachus was the prefect, his career prospects were bright. As professor of rhetoric he delivered the regular eulogies of the emperor and the consuls of the year, and so had the opportunity to ingratiate himself with men in power. He was the closest thing to a minister of propaganda for the imperial court.

The young Augustine's tasks at court were clear enough and challenging. But he was torn by inner uncertainties. His travail during these crucial years Augustine would record in his *Confessions,* which William James in the twentieth century still found the most eloquent and vivid account of the troubles of the "divided soul." Although Augustine never was at home in Greek, he was captivated by classical philosophy and inspired by reading Cicero to turn away from rhetoric. "An exhortation to philosophy . . . altered my affections. . . . Every vain hope at once became worthless to me; and I longed with an incredibly burning desire for an immortality of wisdom." At the same time his mother, Monica (332?–387; later canonized), a woman of simple Christian faith, harassed him with her pleas for his instant conversion.

In his impatient quest, Augustine had earlier joined the Manichaeans, who had much to attract a young man of twenty. Appealing to "reason" against faith or authority, they offered their own simple dualist dogma. The conflict between the Kingdom of Light and the Kingdom of Darkness, they said, solved the riddle of Creation, the origins of evil, and all other knotty problems. A secret society, with much of the appeal of the Communist Party in the troubled capitalist society of the 1930s, and with cells all over the Roman world, the Manichaeans enjoyed the aura of "the happy few." Emphasizing self-knowledge, they divided their members into the Elect, who followed a rigorous discipline of fasts and rites and would speedily enter paradise at death, and the Hearers, who supported the Elect and would enter paradise only after reincarnation. Their founder, a Persian sage Mani (or Manes, 216?–276?) claimed to be God's final prophet. Since the Manichaeans included Jesus among their prophets, Christians treated them as a heresy, while the Manichaeans called themselves the purest of all faiths.

They became a religion of their own, the more feared and abominated by both respectable pagan Romans and orthodox Catholics because they had foreign ties and their numbers were never publicly known. Historians have called them the Bolsheviks of the fourth century. For nine years before coming to Milan, Augustine had been a Hearer. But now the Manichaeans' easy certainties no longer satisfied him.

And there were other considerations. His pious mother, still pressing him to convert, was arranging his marriage to a Catholic heiress. The emperor whom he served was a Christian, and Bishop Ambrose of Milan was militantly orthodox. Soon after his arrival in the city Augustine became a catechumen, a person seeking instruction in the Church. He recorded in his *Confessions* how he was overwhelmed by Ambrose the charismatic preacher, who revealed the Hebrew origins of Greek philosophy, destroyed the Manichaean materialist dogma of light and darkness, and opened new ways of thinking about the future. "So I was confounded and converted." Simplicianus, whom he had asked to instruct him as he had instructed Ambrose, baptized Augustine on Easter Eve, 387. His mother, extravagantly pleased, said she was now ready to die.

Abandoning a worldly career, Augustine returned in 391 to his native Tagaste. "I was looking for a place to set up a monastery, to live with my 'brethren.' I had given up all hope in this world. What I could have been, I wished not to be; nor did I seek to be what I am now. For I chose to be humble in the house of my God rather than to live in the tents of sinners." The small Catholic congregation of neighboring Hippo needed an assistant for their aging Bishop Valerius. The hostile Manichaeans were numerous and the bishop of the heretical Donatists forbade local bakers to bake bread for the Catholics. The Orthodox needed a native voice, for Valerius was a Greek, not at home in Latin, and ignorant of the community's rural Punic dialect. One day when Augustine stopped casually to pray in the basilica, the others there turned suddenly to him, pushed him to the apse, and forcibly ordained him as their priest. The astonished Augustine felt himself "condemned" by his God, who thus had "laughed him to scorn."

For the rest of his life Augustine remained in Hippo, which he would make famous in the annals of Christendom. When Valerius died, Augustine became bishop of Hippo. "I feared the office of a bishop to such an extent," he recalled, "that, as soon as my reputation came to matter among 'servants of God,' I would not go to any place where I knew there was no bishop. I was on my guard against this: I did what I could to seek salvation in a humble position rather than be in danger in high office. But . . . a slave may not contradict his Lord. I came to this city to see a friend, whom I thought I might gain for God, that he might live with us in the monastery. I felt secure, for the place already had a bishop. I was grabbed. I was made a

priest . . . and from there, I became your bishop." The position of bishop made daily demands on Augustine as administrator, judge, teacher, and preacher.

Still, during these years in Hippo, Augustine's literary output, with the aid of his staff of stenographers, was phenomenal. Four hundred sermons and two hundred letters (some amounting to treatises on great issues) have survived—also books on Christian Doctrine (c.397–428), on the Trinity (c.400–416) and countless other theological topics.

Augustine's two masterworks expounding human destiny in two contrasting dimensions are very much alive today. His *Confessions* (c. 400), a saga of his inward life, and its successors and imitators over the centuries, would allow the world to share the spiritual travail and posturings of the most restless men and women. In this tradition of the internal Odyssey, Rousseau a millennium and a half later would stir poets, novelists, dramatists, and revolutionaries. The *City of God* (413–426), Augustine's scheme of universal history, as we shall see, helped man off the "wheel" of again-and-again, toward a new view of the Creator. Providing a vocabulary for Christian thinking in the West for centuries, his work was occasioned by the trauma of his own lifetime.

At midnight on August 24, 410, as the gates of Rome were opened, and the city was awakened by Gothic battle trumpets sounding their victory, Alaric and his hordes poured in. "Eleven hundred and sixty-three years after the foundation of Rome, the Imperial City, which had subdued and civilized so considerable a part of mankind," Gibbon records, "was delivered to the licentious fury of the tribes of Germany and Scythia." Rome had fallen!

For the people of that age this event, which for us is only another episode in the long barbarian invasions, was apocalyptic. "When the brightest light on the whole earth was extinguished," wrote Saint Jerome, who heard the news in Bethlehem, "when the Roman empire was deprived of its head and when, to speak more correctly, the whole world perished in one city, then 'I was dumb with silence, I held my peace, even from good, and my sorrow was stirred.' " "Who would believe," he asked "that Rome, built up by the conquest of the whole world, has collapsed, that the mother of nations has also become their tomb?"

There is no modern counterpart for that catastrophe, for no modern city has the mystique of Rome. Following Virgil's prophecy in the *Aeneid* that Romans would have "dominion without end," Rome had been known as the Eternal City. Obeying Jesus' exhortation to "render unto Caesar the things which are Caesar's" and Saint Paul's warning that "the powers that be are ordained of God," good Christians saw no sacrilege in submitting to the secular authority of Rome. Some had actually seen the hand of Provi-

dence in the rise of the Roman Empire. Augustus (27 B.C.–A.D. 14) and Jesus were contemporaries, and the rising empire seemed a bulwark of the faith. So Tertullian (160?–230?) justified Christian prayers for the health of Roman emperors. "For we know that only the continued existence of the Roman Empire retarded the mighty power which threatens the whole earth, and postpones the very end of this world with its menace of horrible afflictions." When the Romans tired of civil war, Ambrose recalled, they conferred the imperium on Augustus Caesar, "thus bringing to an end their intestine strife. But this also made it possible for the Apostles to travel throughout the whole world as the Lord Jesus had bidden them: 'Go forth and teach all nations,' " "Let the Church march on!" intoned Augustine, "The Way is open; our road has been built for us by the emperor."

For the strong pagan party the Fall of the City seemed proof that Christianity was destroying Rome. But Bishop Augustine in Hippo made it the point of departure for his Christian view of history. Now in his mid-fifties, having spent much of his life attacking heresies, he "did not wish to be accused of having merely contradicted the doctrine of others, without stating my own." The thirteen years (413–426) he spent on his *City of God* created a new kind of defense of the new religion.

First he aimed to correct rumors about what really happened when Alaric entered Rome. A sign of divine Providence was Alaric's respect for the treasure of the Church and the persons of Christians. When one of his men discovered the hiding place of the consecrated gold and silver vessels of Saint Peter, Alaric ordered their return to the church in the Vatican. Alaric was reported as saying that he waged war against the Romans but not against the Apostles. And, because of the Christians, Rome—unlike Sodom—was not totally destroyed. The first chapter of *The City of God* observed that "all their headlong fury curbed itself, and all their desire of conquest was conquered . . . this ought they to ascribe to these Christian times, to give God thanks for it, and to have true recourse by this means unto God's name. . . ."

Even if the barbarians had not shown such mercy, their entry into Rome would not have been an argument against Christianity. "The truth is that the human race has always deserved ill at God's hand . . . ," as Tertullian observed, "the very same God is angry now, as he always was, long before Christians were so much as spoken of." The first half of *The City of God* sang this familiar exonerating litany of the catastrophes before Jesus Christ. To support his case against the pagans, Augustine would commission his disciple Orosius to catalog the misfortunes that came before there was a Christianity. Not lacking material, Orosius produced his *Seven Books of Histories against the Pagans*, which a thousand years later could still be distinguished by Petrarch as the classic summary of "the evils of the world."

Having disposed of the gross libels on the role of Christianity in history, Augustine went on to create his own philosophy of history, which would dominate Western thought for the next millennium. And he provided the most potent weapon against historical pessimism and the classic cycles. His ideas would show an uncanny power to be transformed into a modern idea of progress.

Awed by man's ingenuity, Augustine exclaimed:

> . . . man's invention has brought forth so many and such rare sciences and arts (partly necessary, partly voluntary) that the excellency of his capacity makes the rare goodness of his creation apparent, even then when he goes about things that are either superfluous or pernicious, and shows from what an excellent gift he has those inventions and practices of his. What varieties has man found out in buildings, attires, husbandry, navigation, sculpture, and painting! What perfection has he shown in the shows of theatres, in taming, killing, and catching wild beasts! What millions of inventions has he against others, and for himself in poisons, arms, engines, stratagems, and such like! What thousands of medicines for the health, of meat for the palate, of means and figures to persuade, of eloquent phrases to delight, of verses for pleasure, of musical inventions and instruments! How excellent inventions are geography, arithmetic, astrology, and the rest! How large is the capacity of man, if we should dwell upon particulars! Lastly, how cunningly and with what exquisite wit have the philosophers and heretics defended their very errors—it is strange to imagine!
>
> (Bk. XXII, Ch. XXIV, translated by John Healey)

Yet all these remarkables, he warned, were no proper measure of the advance of mankind, no promise of endless progress on earth. They only revealed "the nature of man's soul in general as man is mortal, without any reference to the way of truth whereby he comes to the life eternal."

Augustine did offer a promise of novelty and uniqueness in human experience. The coming of Jesus Christ, he declared, had disposed of the cyclical view once and for all. Redesigning the shape of history from the wheel to the line, Augustine gave man's life direction. The familiar words of Ecclesiastes (I, 9, 10)—"there is no new thing under the sun, nor any thing whereof one may say, behold this is new: it hath been already in the time that was before us"—only described the recurrence of "successive generations, the sun's motions, the torrents' falls, or else generally all transitory creatures . . . trees and beasts." "Far be it from the true faith that by these words of Solomon we should believe are meant these cycles by which . . . the same revolutions of time and of temporal things are repeated. . . . God forbid, I say, that we should swallow such nonsense! Christ died, once and for all, for our sins." Christianity took man off the wheel, "which, if reason could not refute, faith could afford to laugh at." The Christian God

opened the vistas of infinity, "whereas His wisdom being simply and uni-
formly manifold can comprehend all incomprehensibility by his incompre-
hensible comprehension." Now history was revealed not as an "eternal
return" but as an eternal movement, to fulfill the promise announced by the
coming of Christ.

Classical thinkers had, one way or another, put the motive force of
history outside the individual man. For Plato and Aristotle, we have seen,
history reproduced eternal ideas or fulfilled preexisting natural forms. In
the early Roman Empire the power of Fortune attained the dignity of a cult.
Others assigned the decisive role to Chance or the Fates. But for Christians,
in Ambrose's phrase, the material world offered "not gods but gifts," a
catalog of opportunities for mankind. Euripides had accused bold inventors
or grand discoverers of "imagining themselves wiser than the gods." When
the ancients deified benefactors into Promethean deities, they were refusing
to see the creative powers in man himself. Man's destiny, no longer whole-
sale, had become retail. The crucial questions now concerned the individual
soul.

The City of God offered its own way of measuring man's fulfillment.
Symmachus and his pagan party in Rome had defended the old religion by
its proven usefulness and challenged Christianity as a novelty unproven by
its uses. But Augustine's test rose above the visibly useful.

All mankind he divided into two "cities"—two vast communities that
encompass the whole earth of past, present, and future. "That which ani-
mates secular society (*civitas terrena;* the earthly city) is the love of self to
the point of contempt for God; that which animates divine society (*civitas
caelestis;* the heavenly city) is the love of God to the point of contempt for
self. The one prides itself on itself; the pride of the other is in the Lord; the
one seeks for glory from man, the other counts its consciousness of God as
its greatest glory."

The earthly city, Augustine the realist explained, was a world of conflict.
"By devoting themselves to the things of this world, the Romans did not
go without their reward" in victories, "deadly or at any rate deathly." Yet
victory did not go to the virtuous. "God grants earthly kingdoms both to
the good and to the evil, yet not haphazard . . . nor yet by fortune, but in
accordance with the order of times and seasons, an order which, though
hidden from us, is fully known to Him. . . . Felicity, however, He does not
grant except to the good." "The greatness of the Roman empire is not
therefore to be ascribed either to chance or fate. Human empires are con-
stituted by the providence of God." The foundation of the earthly city was
laid "by a murderer of his own brother, whom he slew through envy, and
who was a pilgrim upon earth of the heavenly city." Just as Cain slew Abel,
so Romulus murdered his brother Remus. "The strife therefore of Romulus

and Remus shows the division of the earthly city itself; and that of Cain and Abel shows the opposition of the city of men and the city of God."

Augustine's story begins with the Creation and will end with the Last Judgment. Every event is unique, and every soul follows its own destiny, to survive in Hell or in Heaven. History mysteriously marshals citizens of the City of God toward their reward of eternal life. "And I, John," said he, "saw that holy city, New Jerusalem, coming down from God out of heaven, prepared as a bride adorned for her husband. . . . And he that sat upon the throne said, Behold, I make all things new." No one could know when fulfillment would come, for History was a continuous unfolding of man's mysterious capacities—for creation, for love of God, for joining the Eternal City. The climactic event for the world was the coming of Christ. But the climactic event for each man still lay in the promise of history, which had transported the classical Golden Age from the remote past into the remote but certain future. In a historic coup d'état men had seized the powers of their Creator.

8

The Uncreated Koran

THE contrast between the Hebrew and Christian views of the Creator and the Muslim view appears wherever we look—in the creeds, the traditions, and the visions of Islam. This, as much as anything else, makes it hard for us in the West to feel at home with Islam. For Islam found the very notion of Creation unappealing. The first, decisive, yet unfamiliar evidence is the Muslim view of Holy Scripture. The Muslim counterpart to Jesus is not Mohammed. Christians believe in the Incarnation, the taking on of human form by Jesus, conceived as the Son of God. But Muslims believe in Inlibration, the embodiment of God in a Book. That book is the Koran. The reverence and mystery that Christians feel toward Jesus the Christ is what Muslims feel toward their Book.

Few notions are more difficult for a Westerner to grasp than the dogma of the *un*created Koran, which became a pillar of Muslim faith. Passages in the Koran itself suggest that the book had existed from eternity. But the dogma was firmly established only after it survived the attacks of reformers.

Some decades passed after the death of Mohammed in 632 before Muslims produced a school of theological speculation, a first abortive effort at a "reformation" in Islam. The Mu'tazilites (or the Separators, who refused to commit themselves to any one of the contenders for the caliphate) followed the Greek philosophers. Proposing reason as a confirmation and a test of Islam, they used the philosophers' techniques to prove God's justice and explain away the existence of evil. An eloquent critic Ash-Sharrastani (died 1153) later summarized the Mu'tazilite argument that the Koran (along with speech itself) must have been created:

> If it [the Koran] were eternal there would be two eternals. . . . What makes the eternity of speech impossible is that if the speech which is command and prohibition were eternal God would have had to lay commands on Himself. . . . The words "Take off thy shoes," [Koran, Surah XX, 12] addressed to Moses when he did not exist. . . . is speech with the non-existent, and how can a non-entity be addressed? Therefore all commands and narrations in the Koran must be speech originated at the time the person addressed was spoken to. Therefore the speech is in time.

The Mu'tazilites even risked questioning the literal truth of the Koranic texts, which said that God possessed hands and eyes.

What most angered the orthodox was this suggestion that the Koran had actually been created in time. But behind this heterodoxy was the Mu'tazilites' sincere hope of vindicating the power and unity of Allah. In the dogma of the *un*created Koran the Mu'tazilites saw a nest of perils for Muslim theology. If the Koran had not been created by God, how then had it come into being? Did that suggest—horror of horrors!—that there was some other power capable of such a luminous product? And would not that impugn the axiomatic unity and omnipotence of Allah?

The struggle over whether the Koran was uncreated and existed from eternity or whether it was created at a particular time by God and hence not eternal was no arcane quibble. This explosive question would not be left to theologians. It became a crisis in Islam. Men suffered torture and death for asserting that the Koran was or was not created.

It was during the brilliant and turbulent reign (724–743) of Caliph Hisham of Damascus, the tenth of the great Umayyad caliphs in the East, that the dangerous notion of the *created* Koran was first seriously proposed. In some ways Hisham himself was experimental. As he pushed his conquest out from Syria, defeating the Khazars and conquering Georgia, he tried to make his Arab troops part of the local communities. Pointing his ambitions eastward, he presided over the first Arabic translations of Iranian literature, and welcomed the foreign motifs from Persian architecture and decoration.

He recruited talent wherever he could find it, even enlisting the Christian theologian John of Damascus as his financial officer.

Hisham braved strange and powerful enemies across the Middle East, ingeniously enlisting them in his empire of the faithful. But he was a scrupulous guardian of the faith. In the cosmopolitan atmosphere of his reign we begin to hear suggestions that the Koran was created. John of Damascus reported that this novel idea was considered "a contemptible abomination." Caliph Hisham had Ja'd b. Dirham, the rebellious teacher of the suspect doctrine, put to death. After the fall of the Umayyad dynasty, the very name of Umayyad became anathema. The Umayyad tombs were violated. The corpse of Caliph Hisham himself was exhumed and publicly scourged.

With the rise of the Abbasid dynasty, the Muslim community was split. The authority of the new caliphate, never recognized in Spain nor in Morocco, reached westward only as far as Algiers. The traditional popular view of the uncreated Koran continued to be officially protected. When the famous Harun al-Rashid (786–809), fifth Abbasid caliph, heard one of the learned men of his realm (Bishr al-Marisi) say that the Koran was created, he threatened to "kill him in such a way as he had never yet killed anyone." The unfortunate rebel went into hiding for twenty years, until Harun al-Rashid had died.

It was in the Golden Age of the caliphate, in the reign of Al-Mamun (813–833), Mamun the Great, that the House of Islam became newly receptive to the creative novelties of the outside world of unbelievers. Then, too, the dogma of the created Koran was newly tolerated. For a few years it actually became the official doctrine.

Under Mamun the Great, culture flourished as never before in the closed community of Islam. He opened windows to the world, especially to the West. In his new capital of Baghdad, Mamun set up his House of Wisdom, or more precisely a House of Knowledge. There he collected scholars, seeking out from remote capitals like Constantinople great works of the "foreign" sciences, and he brought translators to put works from Greek, Syriac, Persian, and Sanskrit into Arabic. Now Believers could read works of Aristotle, Galen, Ptolemy, Hippocrates, and Euclid in their own language. Mamun had an observatory built by the great astronomer-astrologer Al-Farghani, who wrote treatises on Ptolemaic astronomy, on the mathematical theory of the astrolabe, and made a new estimate of the circumference of the earth. The great Al-Khwarizmi wrote a treatise on algebra, introduced Hindu numerals (later misnamed "Arabic"), and surveyed Greek and Hindu science. Never before and probably never since, was the community of Islam so receptive to creativity and novelty wherever found.

It is not surprising, then, that Mamun the Great welcomed the suggestion

that the Koran itself offered another proof of the creativity of Allah. In 827 he publicly adopted and proclaimed the doctrine of the Mu'tazilites that the Koran was created.

Mamun the Great attached such importance to this dogma that he instructed his governors to query judges and scholars and enforce belief in the dogma of the created Koran. This became his test of orthodoxy. With threats of torture he made some Muslim martyrs among those who refused. The most famous of these, Ahmad Ibn Hanbal (780–855), had been a scholar from his boyhood in Baghdad. He traveled about the holy cities, studied with famous Muslim scholars in Mecca, Medina, Syria, Mesopotamia, Kufa, and Basra, and returned to settle in Baghdad, where he became the very model of everyday orthodoxy. He offered many more than the required number of prayers daily, and recited the whole Koran once every seven days. People called his life a continuous fast. He refused to budge from his traditional faith that the Koran was Allah's *un*created word. When chains and prison would not persuade him, in 834 Mamun's successor Caliph Mutasim had him scourged in the palace. As the angry crowd outside were about to attack the palace the caliph stopped the punishment. Soon thereafter Ibn Hanbal was freed.

Popular feeling for the tradition of the *un*created Koran was so strong that no later caliph dared insist on the contrary dogma. In 848 Caliph Al-Mutawakkil proclaimed that no one should be required to subscribe to the doctrine of the created Koran. The name of Hanbal became sacred and thousands attended his funeral. His compilation of forty thousand traditions related to the sunnah (the words and deeds) of the Prophet survived as an authority for Muslim law and sciences. His disciples, the Hanbalites, became one of the main schools of Muslim law. The caliphs had learned that the believing masses would not give up their faith in the uncreatedness of the Koran, which remained orthodox Muslim dogma.

Over the centuries again and again this position has been officially fortified. Mullahs gave this mysterious dignity of uncreatedness even to the everyday utterance of the words of the Koran by the faithful. "Agreement has established," orthodox mullahs affirmed, "that what is between the two covers is the word of God, and what we read and write is the very speech of God. Therefore the words and letters are themselves the speech of God. Since the speech of god is uncreate, the words must be eternal uncreate." So Islam rests firmly on Inlibration.

The more we read of the Koran and the Muslim God, the more natural it seems that Islam exempted their Holy Script from the world of creation. For the Muslim God, though a kind of Creator, had a character quite different from the God of the Hebrews and the Christians. As we have seen,

Muslims allowed that the Bible was originally a sacred scripture. In several places, the Koran, too, mentions the six days of Creation. But in the Koran the role of the Creator is transformed. The familiar words of Genesis record that God spent six days on the Creation. "And on the seventh day God ended his work which he had made; and he rested on the seventh day from all his work which he had made. And God blessed the seventh day, and sanctified it: because that in it he had rested from all his work which God created and made" (Genesis 2:2 and 3).

In the Koran God never rests, for he can never be tired.

> We created the heavens
> And the earth and all
> Between them in Six Days
> Nor did any sense
> Of weariness touch Us.
>
> (Surah L, 38)

It is no wonder that the Koranic God was not wearied. For He created not by making but by ordering, not by work but by command. The creation of anything occurs when He decrees it into being.

> To Him is due
> The primal origin
> Of the heavens and the earth:
> When He decreeth a matter,
> He saith to it: "Be,"
> And it is.
>
> (Surah II, 117)

Again and again the Koran describes God's fiat.

There are some similar expressions in Genesis of God creating by fiat. "And God said, Let there be light: and there was light" (Genesis 1:3). But there is a vast difference in emphasis between the acts of Creation in the Bible and in the Koran. And between the character of the Hebrew-Christian God the Maker, and the Muslim God of Fiat. In the Bible, the Creation in the first chapter of Genesis is a historic event, prologue to all the rest of history chronicled in the Book. In the Koran the six "days" of Creation are not the beginning of a story but "signs" of God's omnipotence and his claim on our obedience. Everything about us today, how man is benefited by animals, how the sun and moon and stars shine, how the winds blow and change, how the rain falls to nourish the crops, how ships move, and how mountains remain in place—all these command our obedience and our awe of God.

The Muslim Creator-God is notable not only, nor even mainly, for His work in the Beginning, but as an orderer, a commander, of life and death in our present. The Judeo-Christian God is awesome for the uniqueness of His work in the Beginning. Then He may intervene by divine providence. But the Muslim God awes us by the continuity, the omnipresence, the immediacy, the inscrutable arbitrariness of his decrees.

> It is He Who gives Life
> And Death; and when He
> Decides upon an affair,
> He says to it, "Be,"
> And it is.
> (Surah XL, 68)

After the six days of God's ukases, the six days of fiat, the God of the Koran, having no reason to rest, simply mounted the Throne of authority. From there he continued to rule by decree over life and death and every earthly act.

The relation of the Muslim God to his creature man, then, is quite unbiblical. The uniqueness of the biblical Creator-God was in his powers of making; the uniqueness of man and woman too would be in their power to imitate their God and after their fashion to exercise the power of creation. After God created the species in the Beginning, he blessed them to be fruitful and multiply; He made them so that each procreated after its kind (Genesis 1:22). This spectacle of Creation shaped and limited Western man's thinking.

In the Koran, God's fiat recurs in the conception and gestation of every human being, in every repetitive phenomenon of nature. Again and again God gives his order, "Be," and it is, for each stage in man's growth. Every such decree of re-creation provides an additional "sign" of God's power and authority.

Why did God create man? The God of the Bible would judge man by his fulfillment of his godlike image. Not so in Islam.

> "I have only created
> Jinns and men, that
> They may serve Me.
> I created the Jinn and humankind only that they might worship Me."
> (Surah LI, 56)

Since Allah would judge men only by their attitude toward Him, Muslims do not like to be called Mohammedans. This is a kind of sacrilege, implying that any man, even the Prophet himself, could claim the submission due to

God alone. The People of the Koran prefer to call themselves Muslims, from "Islam," the Arabic word for submission or obedience. The Koran repeatedly reminds us that Allah's creatures are also his "servants" or "slaves." What clearer warning against reaching for the new? For a believing Muslim, to create is a rash and dangerous act.

BOOK ONE

CREATOR MAN

The artist's whole business is to make something out of nothing.

—PAUL VALÉRY (C.1930)

Mystified by the power to create, it is no wonder that man should imagine the artist to be godlike. In the West, belief in a Creator-God was a way of confessing that the power to make the new was beyond human explanation. By deifying the Creator, the West somehow encouraged and endorsed the new. Of course man's power to create did not depend on a theory, and the human need to create has transcended the powers of explanation. Peoples of ancient Egypt, Greece, and Rome who did not know a Creator-God, who made something from nothing, still created works unexcelled of their kind. And peoples of the East who saw a cosmos of cycles created works of rare beauty in all the arts. Across the world, the urge to create needed no express reason and conquered all obstacles.

Still the West, whose unusual hospitality to the new was rooted in many causes and many mysteries, found added incentive in the vision of a Creator-God and a creator man. Creators in the West found their own ways to make a legacy, our heritage of the arts. In this book I describe the who, when, where, and what. But the *why* has never ceased to be a mystery.

Man's power to make the new was the power to outlive himself in his creations. He found the materials of immortality in the stone around him or the artificial stone that he could make. He flexed his muscles of creativity in structures whose purpose would remain a mystery, and in temples of community. He dared to make images of himself and of the life around him. He made his words into worlds, to relive his past and reshape his future.

PART THREE

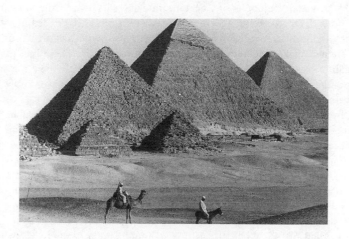

THE POWER
OF
STONE

Lend me the stone strength of the past
and I will lend you
The wings of the future, for I have them.

—ROBINSON JEFFERS (1924)

The Mystery of Megaliths

FROM the valleys of the Indus and the Nile to the Orkney Isles, the coasts of Brittany and the jungles of Yucatán, time offers its own verdict on man's creations. Everywhere men have protested and resisted. Upended fifty-ton stones, alone or in rows or in circles, bear witness to man's effort to outlive his life and make something that would endure forever. These first grand megalith creations long outlasted their creators. But with their message comes the mystery of their creation, reminding us that men never know the powers of what they have created.

Of the many puzzling megaliths, the enormous works of primeval architecture scattered around northwestern Europe, the most impressive and the most famous is Stonehenge. On an undulating plain near the cathedral city of Salisbury in southern England are the remains of two concentric circles of large stones, enclosing rows of smaller stones. In the early Middle Ages this pile was christened "Stonehenge" from the Old English for "hanging stones."

Stonehenge "stands as lonely in history," said Henry James, "as it does on the great plain." When archaeologists found similar remains elsewhere around the Atlantic fringe of Europe, they tried to give Stonehenge its proper place in history. Most other megaliths were single stones or groups of stones called menhirs (from Breton or Welsh "long stone") set upright. But Stonehenge was a large open-air structure of stones symmetrically arranged. Some had been shaped to lie on the uprights. The tops of some showed a projecting piece, a tenon, to fit into the mortise hole of the stone that rested on it.

The individual menhirs were single feats of primitive engineering. Stonehenge was something more—a work of primeval architecture. Archaeologists who made timetables from remains in Mesopotamia, Egypt, and the Aegean, dated Stonehenge near the dawn of European history. They would not believe that Stonehenge could be the work of "barbarians" who had neither metal nor writing. Stonehenge, they said, must have been a distant offshoot from the centers of Western civilization in the Mediterranean. "Megalithic missionaries," they said, must have brought the advanced Mediterranean technology across Europe. These migrants supposedly were not "fresh contingents of Neolithic farmers" but "a spiritual aristocracy." The peculiarities of their sepulchral architecture suggested at least three groups of such missionaries in Great Britain. This appealing vision con-

firmed the fertility of the revered sources of Western culture in the eastern Mediterranean and at the same time affirmed the incompetence of mere "barbarians." Without the inspired know-how of Egypt and Mycenae behind them, who could have created such grand structures in those remote centuries?

But this self-serving vision proved an illusion, a parable of the dangers of seeming too wise about man's powers of creation. An unpredicted new twentieth-century technique for dating man's past creations dissolved the tempting vision of prehistoric missionaries crossing Europe to instruct Neolithic barbarians in the architecture of megaliths. It was a surprising byproduct of World War II research for the atomic bomb. In 1945 an ingenious atomic physicist, Willard Frank Libby (b. 1908), and his students at the University of Chicago suggested that measuring the presence of a rare isotope of carbon (carbon-14) might help date archaeological remains. This form of carbon is always found in the atmosphere in microscopic quantities and it disintegrates at a fixed rate. When organic objects cease to grow, they cannot assimilate carbon. Thus, by comparing the amount of carbon-14 in the object with that in the atmosphere today, it might be possible to fix the approximate date when a fossilized organism died or when a tree was cut. This provided a better method than any before for dating objects up to fifty thousand years in age. When checked by another technique, "dendrochronology" (the use of very old trees to measure antiquity), it appeared that Libby's assumptions about the amount of carbon-14 in the atmosphere in the distant past were not quite correct. Tests on the rings of trees several thousand years old revealed that the radiocarbon level before 1000 B.C. had deviated from the present level and was higher than now. This changed the yardstick for measuring antiquity and meant that specimens were even older than suggested by Libby's examples based on constant carbon-14 production in the atmosphere.

When applied to Stonehenge and the associated organic remains, these new techniques carried a startling message. They pushed the date for the construction of Stonehenge back to about 2000 B.C., long before the Cyclopean stone walls of Mycenae. Stonehenge, one of the most impressive, now became one of the earliest works of European architecture, the work of "mere barbarians," people who had neither metal nor writing. It meant that other megalithic monuments could have dated from that early age. The enduring monuments of primeval architecture, then, were no longer witnesses to the outreaching power of Mycenae. Instead they revealed man's irrepressible creative powers everywhere and democratized the history of man the creator. For now it appeared that the great prehistoric works were not dispersed from a single source. From this too we learn not to underestimate man's powers to create. If we see the *what* we must not always expect

to know the *why* or the *how*. Archaeologists did not see how these prehistoric Britons could have moved fifty-ton megaliths. Still Stonehenge must have been the precocious work of remote antiquity.

The practice of careful burial, to which the primeval megalithic monuments bear witness, also reveals early man trying to create, to outlast the brief span of his life. This sense of time, the awareness that countless others have come before and that others will follow in endless generations, distinguishes man from other animals. With this discovery of the meaning of death—that man's own life is limited—the life of architecture begins. And so begins man the creator's effort to conquer time.

Megalithic tombs were built in well-defined styles. There were "passage" graves in which a central stone-built chamber is approached through a long narrow passage, all covered by a circular mound of earth. And there were chamber tombs, or "gallery" graves where the burial chamber is entered directly. Besides, there were long corridors built of megaliths (*allée couverte*), and rows of standing stones, or single standing menhirs. All were symptoms of man's yearning for immortality, his calculated effort by creating to rescue his person from the ravages of time.

Millennia later, when we study these remains we prove the success of those earliest architects. But their success was ambiguous and megaliths became vehicles of myth. It was said that Saint Patrick, in the fifth century, came upon a passage grave some 120 feet in length. According to a sacred text of the saint's life, the people said, "We do not believe this affair, that there was a man of this length." To which Saint Patrick replied, "If you wish you shall see him." He touched his crozier to a stone near the head of the grave, made the sign of the cross, and said, "Open, O Lord, the grave." The earth opened, the stones separated, and the buried giant arose. "Blessed be you, O holy man," said the giant weeping, "for you have raised me even for one hour from many pains. I will walk with you." "We cannot allow you to walk with us," the people exclaimed, "for men cannot look upon your face for fear of you. But believe in the God of Heaven and accept the baptism of the Lord, and you shall return to the place in which you were. And tell us of whom you are." The giant explained that he had been swineherd to the king and was slain by enemy warriors just one hundred years before on that very day. "And he was baptized and confessed God, and he fell silent, and was placed once more in his grave."

The ancient barrow graves attracted a fantastic variety of inhabitants. *Beowulf,* the Old English epic (c. eighth century), reported a dragon who lived in a chambered barrow guarding a rich treasure. Geoffrey of Monmouth (d.1155), one of the most popular (and most inventive) historians of the

Middle Ages, celebrated Stonehenge. His *Historia regum Britanniae* (1135–1139) told how Brutus, great-grandson of Aeneas, and his followers had settled Britain and exterminated the native giants. Later, the Jute invaders Hengist and Horsa conquered the land by treacherously cutting the throats of the four hundred and sixty native British princes whom they then buried on the Salisbury plain.

Geoffrey's story climaxed in the glorious conquests of King Arthur, aided by his resourceful court magician Merlin. One day when Merlin and King Arthur visited the grim Salisbury plain, Merlin proposed a grand memorial like the Dance of the Giants, a structure of enormous stones in Ireland. And why not bring those very same stones across the water to make a monumental circle in this place and "here shall they stand for ever"? When the king laughed, Merlin replied, "Laugh not so lightly . . . in these stones is a mystery." Ancient giants, he explained, had brought the great stones "from the furthest ends of Africa" and they had a certain "virtue of witchcraft." Geoffrey recounted how Merlin used his magic to transport and reerect the Dance of the Giants on Salisbury plain, where they became Stonehenge, which never lost Merlin's magic.

When King James I visited Stonehenge in 1620 he ordered the famous architect and set designer Inigo Jones (1573–1652) to draw a plan of the monument and explain how it had been built. Jones concluded that "Stonehenge was no work of the Druids, or of the ancient Britons; the learning of the Druids consisting more in contemplation than practice, and the ancient Britons accounting it their chiefest glory to be wholly ignorant in whatever Arts." Stonehenge then must have been the work of the Romans, for they alone had the required technology.

Forty years later, John Aubrey (1626–1697), who lived near Stonehenge, reviewed the monument for King Charles II (reigned 1660–85). He explored the site and so became known as England's first archaeologist. The ring of cavities he discovered came to be called Aubrey Holes. In them, supposedly, other stones had once been placed. Dating the structure long before Roman or Saxon times, Aubrey suggested:

> That the Druids being the most eminent Priests, or Order of Priests, among the Britaines; 'tis odds, but that these ancient monuments . . . were Temples of the Priests of the most eminent Order, viz. Druids, and . . . are as ancient as those times. This Inquiry, I must confess, is a gropeing in the Dark . . . although I have brought it from an utter darkness to a thin mist, and have gone further in this Essay than any one before me . . .

Besides the Druids there were plenty of other contenders—including the "Cerngick giants," who may have built Stonehenge as a "triumphal tropical temple." John Dryden (1631–1700) himself applauded such speculation:

. . . you may well give
To Men new vigour, who make Stones to live.
Through you, the Danes (their short Dominion Lost)
A longer conquest that the Saxons boast.
Stone-Heng, once thought a Temple, you have found
A Throne, where Kings, our Earthly Gods, were crown'd. . . .

Druids, imaginary and real, would never cease to haunt Stonehenge. They seem to have won the battle of the legends. Julius Caesar's vivid description of Druid rituals and human sacrifices in his *Gallic Wars* was embellished by Pliny. But there really were Druids, a priestly class among the ancient Celts. Their name came from their word for tree, probably the oak, in the forests where they performed their rituals. The real Druids were already familiar in Gaul and may have come to Britain with the Celts in about the fifth century B.C. Emperor Tiberius suppressed their rituals in Britain in the first century but nostalgia for the Druids survived.

Their most persuasive champion was a friend of Sir Isaac Newton who was a man of science, a Cambridge-trained physician and Fellow of the Royal Society, Dr. William Stukeley (1687–1765). His popular book, *Stonehenge, a temple restored to the British Druids* (1740), sought to "make our moderns ashamed, to wink in the sun-shine of learning and religion," and sang a paean to the Druids' wondrous "patriarchal" powers, which he traced back to Abraham. But he did make some useful observations. Measuring the distances between the positions for stones he came up with a "druid cubit" (20.8 inches), their unit of length, and sketched the site in detail so "if it ever happen, that this noble work should be destroyed: the spot of it may be found by these views."

Stukeley's awe of the learned Druids led him to the fertile suggestion that the axis of Stonehenge aimed precisely at the point of midsummer sunrise. He found that "the principle line of the whole work" was directed to that point in "the northeast, where abouts the sun rises, when the days are longest." Later research revealed that the stones were also oriented toward the cycles of the moon. The celestial wanderings of the moon, which shift in periods of 18.6 years, are much more complicated than those of the sun. The four Station Stones appeared to be lined upon the two extremes of the midsummer moonrise. Now archaeologists agree that Stonehenge was indeed some kind of observatory, subtly oriented to the motions of the sun and the moon.

For pious medieval Christians megaliths were a menace. From Nantes (658), in a part of France where many megaliths survived, a Church decree commanded "Bishops and their servants to dig up and remove and hide to places where they cannot be found, those stones which in remote and woody

places are still worshipped and where vows are still made." Charlemagne, King Alfred, and Canute all issued edicts against the idolatry of megaliths. But gradually it appeared that these monuments of pagan magic could be made to serve Christian piety. Megaliths which could not be moved or hidden or destroyed could readily be Christianized. An incised crucifix or a small stone cross affixed to the top of a menhir did the job. The great stones of the megalithic tombs were incorporated into chapels and churches and Christian tombs seen today in France, Spain, and Portugal.

As fear of pagan magic dwindled, megaliths became landscape fantasies, "follies," and grottoes, adding delight to country estates. Imitation Stonehenges and mock-megaliths were ordered by wealthy gentlemen to enliven country walks for their weekend visitors. In the 1820s a public-spirited gentleman of Yorkshire, William Danby (1752–1833), instead of giving handouts to the local unemployed, paid each a shilling a day to help him build the impressive Druids' temple that still survives. When Field Marshal Henry Seymour Conway (1721–1795) who commanded British troops in the last years of the American war, left his post as governor of Jersey, the grateful inhabitants offered him as a going-away present a megalithic monument discovered on the island in 1785. His gratitude was tempered when he discovered that he would have to pay for transporting the enormous stones across the water to his house outside Henley. But that he did and the prehistoric megaliths still lend their magic to a hill overlooking the Thames.

Castles of Eternity

OF the Seven Wonders of the World, famous in antiquity, only the oldest, the Pyramids, has survived. The ancient Egyptians have won their battle against time. We wonder that monuments elsewhere outlast the centuries, but the Egyptian world seems changeless. The perpetual sun and the annual rhythm of the rising Nile declare continuity of life as vivid to us as it was to the ancient Egyptians. Their message from 2700 B.C. still comes in the Pyramids. Why could not man himself be changeless, and go on living forever? They built cities of the dead for people who would never die. Where we see the lifeless dead, ancient Egyptians saw endless life. "O King N thou art not gone dead," reads the Pyramid text, "Thou art gone alive."

Eternal life needed an eternal dwelling. The earliest Egyptians built houses of reeds. And by the period of the Pyramids, their houses were built of sun-dried brick, which also have gone with the wind. But now we see those Egyptians as great stone builders. Their indestructible dwellings for the dead became castles of eternity.

While the words of their optimism, their belief in life everlasting, remain arcane and elude us, their stones still publish their faith in the equality of the dead with the living. Egyptian tomb paintings make their daily life more vivid than that of any other ancient people. We see them eating and drinking, irrigating their fields, cultivating and harvesting, hunting and fishing; we see them dancing and sculpting and building. We see their children playing four thousand years ago. Sepulchral stele ask prayers for the deceased from all passersby. "O ye who live and exist, who love life and hate death. . . ."

Abhorrence of death somehow did not lead them to fear the dead or worship ancestors. Tomb robbery could hardly have been so prevalent in all periods if the Egyptians had been haunted by fear of the dead. Excavators almost never find an unrobbed tomb. The Egyptian way was not to fear death but to deny it. They insisted on the similarity of the needs of "men, gods, and dead." Like the living prince's royal "house of the living," the temple was "the god's castle," and the tomb was everyman's castle. There the owner lived on and his possessions were stored.

Because the dead had reason to fear the living, the jewel-adorned mummies were hidden in deep tomb shafts. Inscribed on the walls of the chamber and the sides of the sarcophogus were spells against intruders. Even the hieroglyphs of men and animals drawn to protect and serve the deceased might be threatening. To make these harmless, the ambivalent tomb artists of the Old Kingdom sometimes would take off legs or bodies, or even chop them in half. To feed the tenants of these hidden apartments, tomb architects of the Age of the Pyramids built over the burial shaft another structure, a mastaba, with a false door leading to a life-sized statue of the deceased to receive the food offerings. To ensure a continuous supply of food after death, noblemen set aside land as an endowment for priests to feed them. The better-furnished tombs of the Second Dynasty even contained washbasins and privies.

The relations of the dead to the living were sometimes too intimate for comfort. Since the invisible spirit "comes in darkness and enters slinking in," the malicious dead could do their mischief undetected. But the loving dead could continue to help. Ancient Egyptians wrote letters to deceased parents asking their support and their protection. To the unfriendly dead they wrote letters begging them to go away. In a touching letter from the Twentieth Dynasty, a distressed widower recalls how faithful he had been

during his life and begs his dead wife to stop her mischievous tricks. "I did not give thee pain through anything that I did. Nor didst thou find me flouting thee by behaving like a peasant and entering into a strange house. . . . I did the thing that a man in my position usually does as regards thy ointment, thy provisions and thy clothes, and I did not dispose of them elsewhere on the pretext that 'the woman is away.' " In her last illness he had employed a master physician, on her death had mourned for eight months, had limited his food and drink, and then for three years remained celibate. Why, since her death, had she inflicted all sorts of evil on him? He begged the gods to judge between them. A letter like this would be inscribed on an earthenware dish with a food offering. After nostalgic recollection of good times together came the grievance or the request for aid. Death, it seems, had not extinguished the deceased, but had only increased the distance between the writer and the addressee.

In the Old Kingdom, the most ancient period of historic Egypt, only the Pharaoh seems to have enjoyed eternal life. But passing centuries brought "the democratization of the hereafter." Magical pyramid texts on the coffins of nobles helped them become deified into eternal life. In the "Western" regions of the afterlife there was little distinction between pharaohs and nobles. Eventually this opportunity for eternal life reached down the social scale to anyone—even artisans, peasants, and servants—who could afford the necessary ritual and magic. But before then, since servants were the property of their masters, they somehow, through their masters, enjoyed a vicarious immortality.

Naturally enough, to prepare for continuing life, the ancient Egyptians tried to preserve the living form. Techniques for protecting the body from decay improved to provide nobles and commoners as well as pharaohs with the body for an eternal life. Mummification, beginning as a science, increasingly became an art. After removing the brain of the deceased, the intestines were taken out and put in four alabaster vases. The heart, believed to be the seat of the intellect, was separated, wrapped, and reinserted in the body. The empty abdomen was stuffed with linen, sawdust and aromatic spices. Seventy days of soaking in natron (hydrated sodium carbonate) prevented the rest of the body from decaying. The natron-dried body was wrapped in rolls of linen steeped in gum. There were sixteen such layers on the mummy of Tutankhamon. Between the layers they inserted small stone charms, fetishes, and papyrus scraps with magic texts.

Early efforts aimed only to prevent decay. But gradually the priestly embalmers became cosmeticians. They used resinous pastes to flesh out the corpse, inserted artificial eyes, and added metal sheaths to hold fingers in place. Though the body was no longer so skillfully preserved, now it was wrapped in garish painted linen rolls. The deteriorating art of the embalmer

after the Twenty-first Dynasty symbolized the decay of ancient Egyptian civilization.

But the mystique of the mummy survived and its medicinal powers became proverbial. In the Middle Ages "mummy," the powder made (really or reputedly) from ground-up mummies, was a staple of European apothecary shops. "These dead bodies," the English traveler Hakluyt complained in 1599, "are the Mummie which the Phisitians and Apothecaries doe against our willes make us to swallow." Originally the world "mummy" did not refer to the dead body, but came from the Arabic *mumiyah,* meaning bitumen or tar, and was based on the misconception that the black appearance of mummies came from their having been dipped in pitch.

What the mummy did for the Pharaoh's body, the pyramid and its surrounding stone temples created for his house. Both showed ancient Egyptian optimism, faith that they could conquer time. How and why their unexcelled techniques for building in stone were so quickly perfected still puzzles historians. Only about a century elapsed between the first notable Egyptian structures of stone and the triumphant masonry of the Great Pyramid. How did they quarry huge blocks of limestone, transport them for miles, then raise, place, and fit them with a jeweler's precision? All without the aid of a capstan, a pulley, or even a wheeled vehicle!

Modern engineers find mathematics their indispensable tool. Yet the mathematics of the ancient Egyptians, compared with that of other ancient peoples, was crude. Egyptian arithmetic in the Age of the Pyramids was based wholly on a knowledge of the "two times" table and we can wonder whether in the modern sense it should even be called mathematics. Multiplication and division were cast in the form of addition. They multiplied a number by duplicating it the required times, and then added the sums, and their system of division was similar. Oddly enough, this "dyadic" principle would be used again in the twentieth-century computer, but for most of history it was a dead end. Their rudimentary system of "unit-fractions" left them no way of expressing complex fractions.

Still, the Great Pyramid (the Pyramid of Cheops), covering 13.1 acres with six and a quarter million tons of stone, whose casing blocks averaged two and a half tons each, showed a micrometric accuracy of design. The squareness of its north and south sides had a margin of error of only 0.09 percent, and of the east and west sides only 0.03 percent. The vast dressed-rock pavement on which this enormous mass was resting, when surveyed from opposite corners deviated from a true plane by only 0.004 percent. And there is no evidence that their techniques or designs were borrowed from abroad.

The oldest surviving architectural structure of stone masonry, the Step

Pyramid of Zoser, appeared suddenly in the Third Dynasty of the Old Kingdom (c. 2700 B.C.). The refinement of its masonry casing is already remarkable. Imhotep, the man reputed to be the architect, their pioneer tactician in the battle against time, was deified as Founding Father of Egyptian culture. Celebrated as chief minister, astrologer, and magician to the great Third Dynasty pharaoh Zoser (c.2686–c.2613 B.C.), he became the patron of writing. Scribes would pour a libation to him from their writing jar before beginning work. His proverbs were repeated for centuries, and he became the mythical founder of Egyptian medicine. Two thousand years after his death he was still remembered and given fully divine status. Ailing devotees prayed at temples built to him in Memphis and on the island of Philae in the Nile, where they went hoping that Imhotep would reveal cures in their dreams. The Greeks adapted him as their god of medicine, whom they called Asklepios.

At Saqqara, overlooking the ancient capital of Memphis south of modern Cairo, we can still see Imhotep's solid claim to fame. His Step Pyramid, the world's oldest surviving creation of hewn stone, is a birthplace of the architectonic spirit. What we see today is a rectangular stone structure of six steps, at the base measuring 597 yards from north to south and 304 yards from east to west, reaching a height of 200 feet. Excavations suggest that it was larger when it was first completed. Before the weathering of centuries and the removal of fragments to build other buildings, it must have contained 850,000 tons of stone and was part of a vast complex of walls and temples. The surrounding buildings, so far as we know, were also without precedent. When cased with freshly hewn white Tura limestone rising above the tawny sands they were a dazzling spectacle.

The Step Pyramid was man's first skyscraper. Even in ancient Egypt, where it would soon be overtowered by taller, grander monuments, it never ceased to inspire awe, recorded in graffiti by pilgrims in the age of Rameses II, fifteen hundred years later. A monument to the newly discovered creative powers of man the architect, it was a monument, too, to man the organizer and to the power of community. Zoser's pyramid, as we shall see, was one of the earliest signs of the constructive power of the state.

Still, the uses of the pyramid are obscure. Part of a funerary monument complex, the Step Pyramid was probably intended to be Zoser's tomb. Perhaps the buildings surrounding the Pyramid were stone replicas of the royal palace in Memphis, to serve the Pharaoh's needs in his later life.

The time between the building of this first large structure known to history and the triumphs of the Great Pyramid of Cheops was a little more than a century. We are not accustomed to think of the Egyptians as paragons of progress, but few great advances in human technique have been so sudden and so spectacular. A new technology of creation! Not until the

modern skyscraper in the mid-nineteenth century, four thousand years later, was there another comparable leap in man's ability to make his structures rise above the earth. Then the technology of the skyscraper, too, as we shall see, arrived with a comparable speed.

The new art and technology of hewn-stone building was suddenly revealed in gargantuan scale, with a wonderful new-rounded perfection of craft. The Step Pyramid was a work of small-block masonry. Its stones, about nine inches square, were small enough to be managed by hand without mechanical devices. Within another half-century at the so-called temple of the Sphinx, Egyptians were handling boulders of thirty tons. The increase in scale was matched by improvements of technique.

Zoser's successor Sekhemkhet built a step pyramid, but it disintegrated. The first "true" pyramid, with a square base and flat sides sloping to a point at the summit, appears to have been the pyramid of Meidum (about thirty miles south of Memphis) built by Huni, the last king of the Third Dynasty. This disintegrated pyramid of Meidum revealed a step-pyramid core of several stages cased with six thick coatings of local Tura limestone. Additional fillings and facings of stone produced a geometrically true pyramid. Only at the bottom do traces of this shape remain, disintegrated above by gravity, by weather, and by the pilfering of stone for use elsewhere. The limestone casing, poised inward at an angle of 75 degrees, was not bonded together, but depended entirely on its angle of incline for solidity.

The pyramid at Meidum was not the last unsuccessful effort to build a durable perfect pyramid. The problems of the first architect-engineers in stone remain vividly portrayed in the so-called Bent Pyramid, twenty-eight miles north of Meidum, built by King Seneferu (c.2650 B.C.) of the Fourth Dynasty. On a square ground plan measuring 620 feet at the base, the smooth mountain of stone rises at first at an angle of 54 degrees and 31 minutes for about half its height, then, abruptly and symmetrically, the angle decreases to 43 degrees and 21 minutes until the top of the pyramid is reached at 303 feet (101 meters). Various explanations have been offered for the change to a less steep angle of construction. It is most likely that, in mid-project, the builders decided to avoid another catastrophe like the collapse of the pyramid at Meidum, and so left us a bizarre monument to architectural discretion.

We see another evidence of that discretion at Dahshur within sight of the Bent Pyramid and a short distance to the north. This so-called Red Pyramid, which takes its color from the underlying blocks of local limestone now exposed, was the earliest tomb known to have been completed as a true pyramid. It seems flat compared with the later pyramids of the Giza group. And so it is, for the collapse at Meidum had revealed the perils of the steeper angle at the first stage of the Bent Pyramid. The builders cautiously inclined

this pyramid at an angle (43 degrees and 36 minutes) almost the same as that of the upper half of the Bent Pyramid. Their caution was justified, for their basic structure has withstood the millennia. But the gentle slope made it an easy quarry for stone robbers. Piece by piece over the centuries they removed the original covering of dressed white limestone, which once gave it a dazzling finished elegance, leaving it now with a distinctive color never intended by the architects.

Where else can we see, within less than a hundred miles, in full scale, so comprehensive an open-air museum of one of the great ages of architecture? These two monuments at Dahshur, the Bent Pyramid and the Red Pyramid, show a transition from the small-stone masonry of the Step Pyramid and Meidum to the magnificent megaliths of the Great Pyramid at Giza. The pyramid builders had now learned how to increase stability by laying the stones of the inner limestone base at a slope, and in other ways, too. Still to come was the gargantuan scale of Giza—the megalithic blocks (two and a half tons to fifteen tons), and the bold steep angle of about 52 degrees. Future pyramids with their still-steeper gradient survived because of improvements in structural design.

The climax of this first great age of architecture still rises above the desert near Cairo at Giza, on the west bank of the Nile. There three grand stone monuments of perfect pyramid design reveal our legacy from Pharaohs Cheops (Khufu), Khaf-Re, and Man-kau-Re, all of the Fourth Dynasty (c.2650–2500 B.C.). Of these, the Great Pyramid of Cheops, commonly dignified as the Great Pyramid (rising to some 482 feet), is the oldest, the largest, and the best built. The exact quantity of hewn stone inside remains one of its many secrets. Its outer structure of huge limestone blocks rests on an inner core of rocks. Without dismantling the pyramid we cannot know the size of that core. What we do know allows us to estimate that it contained about 2,300,000 hewn stone blocks with an average weight of two and a half tons. This gargantuan mass and its desert site frustrate any effort to compare the architectural power of the Great Pyramid with anything else in the world. The 13.1 acres covered by its base would be room enough for the cathedrals of Florence, Milan, and St. Peter at Rome, with space to spare for Westminster Abbey and London's St. Paul's.

Two thousand years after their construction, the tourist-historian Herodotus (c.425 B.C.) visited the Pyramids and put together his unforgettable concoction of fact, myth, and fantasy, explaining how and why they were built. The Egyptians, he said, were the first people "to broach the opinion that the soul of man is immortal." The Great Pyramid, according to Herodotus, was the work of the forced labor of a hundred thousand men, relieved every three months by a fresh lot. By ten years' oppression Cheops

produced the sixty-foot-wide causeway of polished stone covered with carvings of animals to convey the stones the five-eighth mile from the Nile to the building site. On a sort of island, Cheops built fantastic underground chambers. Twenty years of oppression produced the Great Pyramid itself, "the stones of which it is composed are none of them less than thirty feet in length." Herodotus imagined a machine for hoisting the stones. Awed by the vast numbers employed, he noted "an inscription in Egyptian characters on the pyramid which records the quantity of radishes, onions, and garlic consumed by the labourers who constructed it; and I perfectly well remember that the interpreter who read the writing to me said that the money expended in this way was 1600 talents of silver . . . then . . . what a vast sum must have been spent on the iron tools . . . and on the feeding and clothing of the labourers."

Cheops plunged his country into "all manner of wickedness" to finance his project. When he needed more treasure, Herodotus recounts, he sent his daughter to the public brothels to sell her favors. But she, too, wanted to leave a memorial pyramid. To accumulate her "hope chest" she required each man to make her a present of a stone "towards the works which she contemplated." The monument to her charms (which Herodotus saw, and so can we) was a good deal smaller than the Great Pyramid. Measuring one hundred and fifty feet along each side, it is the midmost of the three small pyramids in front of the Great Pyramid.

We still know little about the ancient Egyptian technology for handling the large blocks of stone. There is no evidence that they had anything like the capstan (familiar on shipboard for hoisting the anchor) or the pulley. Perhaps they had no kind of lifting tackle. For moving blocks they must have depended on sleds, rollers, and levers. They did leave us pictures of temporary brick and earth embankments constructed to provide ramps up which they dragged stones to their desired height. Of course these would have added substantially to the task of construction. A pyramid provided natural support for such an embankment, which may help explain the appeal of this shape for their high-rise monuments.

Uninhibited by evidence, awed visitors have enjoyed making up their own accounts of how and why pyramids were built. Some said the pyramids were granaries. Medieval Arab legends told of an ancient king who foresaw the Great Flood and built pyramids to store the secrets of astronomy, geometry, physics, and technology. The traveler Ibn Batuta (1304–1377) reported that Hermes Trismegistos (the Greek name for the Egyptian god Thoth) "having ascertained from the appearance of the stars that the deluge would take place, built the pyramids to contain books of science and knowledge and other matters worth preserving from oblivion and ruin." This belief in a hidden relation between the Great Pyramid and the truths of science and religion never died.

But why did ancient Egyptians create their monuments in the shape of pyramids? The word "pyramid," purely Greek in origin, gives us no clue. A similar word in Greek means "wheaten cake," and perhaps the Greeks thought that from a distance the pyramids looked like cakes resting on the desert. "Obelisk," another Greek word of architectural interest, had a comparable flippant origin because it was the Greek word for "little spit" or "skewer." We know that the ancient Egyptians called a tomb a Castle of Eternity. In the Egyptian language their word for pyramid may have meant "place of ascension." This would square with the fact that the earliest such structures were step pyramids, and such step cores were found within later pyramids.

For ascent to the heavens, a step pyramid served as well and perhaps more conveniently than the smooth-surfaced later true pyramids, whose construction was vastly more difficult and labor-consuming. Building a true pyramid required a single long high embankment or a series of low ramps. What spiritual, magical, and aesthetic benefits were great enough to justify so heavy an additional cost?

To the ancient Egyptians, any mound—mastaba, step pyramid, or true pyramid—could be a symbol of life. It was on a primeval mound emerging from the waters of chaos (like the mounds that emerged annually from the Nile when its water receded) that Atum the god of creation first appeared to create the universe. Any mound might have magic power to promote continuing life for the entombed deceased. But why the smooth, the "true," pyramid?

We do have some clues. The Age of the Pyramids saw the rise of the Heliopolitan priesthood, a thriving cult of the sun. When the sun rose on the Valley of the Nile, what its rays first touched was the tip of the Pyramid long before it reached the humbler dwellings below. How natural, then, that the king, the likeness of the sun-god Re, should live perpetually in a dwelling like the primeval hill! And in the very material of the first solid substance, the Benben, which was a stone. Just as in this life, so in the hereafter, the king must survive to protect his people. And what better image than a true pyramid, spreading symmetrically from a heavenward point, like the rays of the sun shining down on the earth?

The king, according to the pyramid texts, mounts to the heavens on the rays of the sun. May not the true pyramid have represented these rays on which the king could ascend? If so, then the design of the true pyramid would have been every bit as practical for the ever-living pharaoh as the steps of the Step Pyramid. To ease the king's ascent and for accompanying the sun-god Re in daily journeys around the earth, they sometimes provided the king with a wooden boat, like that found near the Great Pyramid in its chamber lined with Tura limestone. In the Fourth Dynasty, the Age of the Pyramids, the Pharaoh was the circumnavigating heavenly companion and

the earthly image of the sun-god Re. Gradually the pharaohs incorporated the name of the sun-god into their own.

The meanings and benefits of the Pyramids were not all other-worldly. They would also be monuments of community, of the awesome power of the state. Centuries of travelers' tales, of legends and the fantasies of Haggadah illustrators have created the misleading stereotype of a tyrannical Pharaoh with gangs of sweating slaves driven by heartless overseers. While we idealize the pious craftsmen and humble laborers who built Amiens, Mont-St.-Michel, and Chartres over centuries, and we extol a society that could put so much of its capital into enduring monuments of faith, we have not been generous to the pyramid builders.

The advance of Egyptology has helped us see similarities in the monument builders of all ages. Many ancient Egyptian images survive to show laborers moving heavy stones and shaping sculpture, and foremen directing the work. We do not see whips or any other evidence of forced labor. Egyptologists now are agreed that the pyramids were not the work of slaves. Perhaps, they suggest, ancient Egyptians, like other people since, were proud of their grand public works. Firm in their shared loyalties and religious faith, might they not have been proud too, to join in works of community? During the months of inundation of the Nile, peasants who were unable to work at their crops could come to a pyramid site, always near the river. At this time every year the water transport of people and building materials was easiest. Meanwhile, in the off-season, small groups of workers would be quarrying the building stone.

At least seventy thousand workers at a time must have been engaged during the three months of inundation in the Age of the Pyramids. In the absence of other evidence and before the age of firearms, it is hard to imagine how such a crew could have been forcibly drawn from distant villages and brutally kept at work over many decades. Increasing evidence suggests that the pyramids were built by voluntary labor. In Old Kingdom Egypt there appear to have been few slaves except for some prisoners of war. If the pyramids overwhelm and dazzle us as great public works, might they not also have impressed the people who built them? Might they not have been proud of their part in so great a work? We have some clues in the tally marks that we can still read on the casing stones. Some inscriptions—"Boat Gang" or "Craftsmen Crew"—mark special tasks, while others—"How vigorous is Snofru" or "The White Crown of Khufu"—mark the reign when the work was done. And others—"Vigorous Gang," "Enduring Gang," or "Sound Gang"—declare the workers' pride. Can we not imagine that pyramid builders, returning each season to their villages, boasted to their amazed fellow villagers of the scale and grandeur of the work in which they had a small part?

The pyramids are the only great public works we know from the Fourth Dynasty. They appear to have transformed Egypt from a country of scattered villages into a strong centralized nation. How spectacular a first demonstration of what an organized state could accomplish! What unprecedented supplies of food, what mass transport, shelter, and sanitation! The power of the state was now revealed. While the primeval state created the pyramids, the pyramids themselves helped create the state in a focus of communal effort, of common faith in the living sun-god. The enormous task over many years must have brought into being a numerous bureaucracy, which could be enlisted for other purposes. In the Age of the Pyramids the word "pharaoh" itself meant "great house," not the person of the ruler but the place where the divine ruler dwelled. Pyramid builders, affirming their faith and their community, were making an eternal dwelling place for their ruler. After the Fourth Dynasty we witness the speedy decline of the central state. Nobles who had once built their tombs around the great pyramid of the Pharaoh now built them out in the provinces where they lived and ruled. And this, too, marked the decline of pyramid building and the deterioration of the quality of stone monuments.

We begin to see how crude it is to ask whether the pyramids were a "useful" creation. For they were grand public works, creatures and creators of community. Perhaps sensing this, when the founders of the United States sought, for the new nation's Great Seal, a fitting symbol of America's hopeful unknown future, they chose an unfinished pyramid (still found on the dollar bill, Series of 1935). A modern physicist, Kurt Mendelssohn, has helped us put the Fourth Dynasty pyramid building in a modern perspective:

> There is only one project in the world today which, as far as one can see, offers the possibility of being large enough and useless enough to qualify eventually for the new pyramid. And that is the exploration of outer space. . . . In the end, the results of space exploration are likely to be as ephemeral as the pharaoh accompanying the sun. The effort—will be gigantic. No other incentive will be provided than the satisfaction of man to make a name for himself by building a tower that reaches unto planetary space. Five thousand years ago the Egyptians, for an equally vague reason, accepted a monstrous sacrifice of sweat and toil. . . .

May not future generations puzzle over why late-twentieth-century man, at astronomical cost, went shooting off into outer space?

However inscrutable their motives, in their aim to conquer time the ancient Egyptians succeeded. They still carry the plain message of man's power as communal creator. In 1215, according to the Arab chronicler Abd al Latif, Caliph Malek al Azis Othman was offended by these monuments of idolatry. As a work of piety he assembled a large crew to destroy one

of the smaller pyramids, the pyramid of Menkaure at Giza. After eight months' labor, his crew had made so little impression that he gave up. The mark of that hopeless effort is still visible in a small scar on the north slope of that pyramid. Since then, only the exploits of tomb robbers and the frolics of boisterous tourists tossing stones down from the summits have marred the pyramids' simple grandeur.

11

Temples of Community

NOT a single building of the Periclean Age of Greek architecture remains as intact as the Great Pyramid. Yet the ancient Greeks won their battle with time in their own way. Their structures survive only as fragments, in ruins or in copies, but the forms that they created, unlike the Egyptians', surround us every day in our homes and public buildings, in our mantelpieces, in our windows and doorways. While the ancient Egyptians survive in their indestructible original works, the ancient Greeks survive through styles and motifs. Their survival resides in their persuasive power to command imitation and reincarnation.

Greek architecture has been called a kind of abstract sculpture. And perhaps no other form of art so separates the product from its original use. We admire the buildings on the Athenian Acropolis, even if we do not understand their function, and would not share the purpose for which they were built. If abstract art appeals by its form and not by its meaning, this surely must be the appeal of the ancient Greek architecture that survives.

It abstracts, too, by using stone to take the place of wood. The distinctive features of classic Greek architecture—the column and architrave (post and lintel)—are a translation of primitive wooden forms. The earliest columns in Greek temples appear to have been made of wood. The stone column, which was to become a hallmark of Greek architecture and of the whole classical tradition, in the beginning may have been fashioned after Egyptian or other Middle Eastern Mediterranean models. Only after the seventh century B.C. were Greek columns made of stone. Other surviving features of the Doric and Ionic orders betray their original wooden form. One of the more obvious is the shape of the triglyph, which alternates with the metopes

in the frieze, plainly derived from wooden beam ends. The reasons to substitute stone for wood were not all aesthetic, for the invention and widespread use of roofing tiles in the seventh century B.C. put a weight on the columns that wood could not support.

Greece is "a marble peninsula," where coarser limestone too is plentiful. One variety of limestone found on the plains of Argos was easily split into irregular blocks for the distinctive "polygonal" masonry of terrace and fortification walls. Another variety found in the west and north of the Peloponnese had a rough surface and many cavities, providing a base for the finishing plaster. This less attractive marble was a common material for public buildings. But the Parthenon and other fifth-century monuments on the Acropolis were of Pentelic marble hewn from the quarries on Mount Pentelicus, ten miles northeast of Athens. Pentelic marble differs from other Greek marbles by its slight tincture of iron, which, exposed to the weather, gives the golden patina we admire on the Parthenon. The white marble used by ancient Greek sculptors and architects, the Parian marble from Paros, an island of the Cyclades in the Aegean, lacks the iron tincture, has larger transparent crystals, and remains white over the centuries. Special qualities of Pentelic marble help explain the elegance of the Parthenon and its companions of the Great Age, as it takes a sharp edge and a polished surface for close-fitting joints and subtle optical refinements.

The emergence of a homogeneous Greek architecture remains very much a mystery. There was a Greek architecture long before there was a Greek nation. The landscape of the Greek peninsula was fragmented by small mountain ranges, split by the Gulf of Corinth, and not united by any Nile. Communications were primitive and people were divided by dialects, for in the classic age of Greek architecture there was not yet a standard Greek language. Yet by the fifth century B.C. there had emerged a Doric style all over the peninsula. The rectangular stone temple was surrounded by columns, each topped by its echinus and abacus, and all enclosed by an architrave with a plain lintel, surmounted by a frieze of triglyphs and metopes, and roofed by a gently inclined pediment. An Ionic style from Ionia—Asia Minor and adjacent islands—became a kind of dialect variant in the language of architecture, with minor variations of proportion and detail.

Since temples were all houses for the same gods, built to suit the same tenants, perhaps it is not surprising that they should have had a common style. Men were always diffident about their ability to provide dwellings worthy of their gods. "But will God indeed dwell on earth?" King Solomon asked at the Temple of Jerusalem, "Behold the heaven and heaven of heavens cannot contain thee; how much less this house that I have builded" (I Kings 8:27). Once a satisfying traditional form had been established, was

it not only good sense to follow it? The fact that the Doric and the Ionic temples were so true to type across the fragmented landscape may have helped Plato to develop his theory of ideas. Perhaps there really was a transcendent ideal of beauty in architecture. And of that ideal perhaps all the temples, whether in Olympia, in Paestum, or in Athens, were only copies.

The Greek temples, like the pyramids of Egypt, were creations of community. First, of the large unspoken community of communities across Greece that somehow enforced their single type and common style. This widespread aesthetic community enfolded many small face-to-face communities, each an independent city-state, or polis.

The Greek *polis* was as distinctive as the Greek temple. Commonly translated as "city-state," it was really neither a city nor a state. And when we quote Aristotle to say that "Man is a political animal" we are misquoting. What he really said was that Man is by nature a polis-dwelling animal. The polis was a self-sufficient community just large enough and just small enough. Self-sufficiency, needed for independence, also provided opportunities for full human development. This meant that the city-state (or polis) could be neither wholly urban nor wholly rural, for it needed both countryside and city. In each polis there could be only one town. Otherwise citizens could not know firsthand one another's needs. That town, the center of government, was usually walled, containing an agora or marketplace and a citadel or acropolis (originally the "polis").

The polis, strictly speaking, consisted not of the territory but of the citizens. And it took its name not from the place where they lived but from its citizens. Thus Athens was named after the Athenians (devotees of the goddess Athena) and not vice versa. Mid-fifth-century Athens still kept relics of its tribal origins, for example in a law that restricted citizenship to the legitimate children of two parents of citizen stock. This whole "citizen" minority participated in the government, which, from *their* point of view, was a democracy. For they all were members of the governing Assembly and all had a chance to be in the Council, a kind of executive committee controlling finances. Members of the Council were chosen by lot and could be reelected only once.

During the Age of Pericles (c.460–429 B.C.) there were several hundred such Greek poleis so varied that a general history of them is not possible. But their common virtues are recognizable and have been eloquently celebrated. Only participation in such a polis-community, as Aristotle noted, could make a man fully human. Virtues of the polis came, too, from the fact that it was not too large. Federalism as a way of joining communities into a single vast nation was alien to the ancient Greeks. They did experiment with

leagues and confederations for specific purposes, but their political philosophers did not even include federalism in their taxonomy of governments. A government so extensive that all citizens could not consult with one another seemed inconsistent with the good life, which was the purpose of the organized community. A state composed of too many people might be self-sufficient, but, Aristotle insisted, "it will not be a true polis, because it can hardly have a true constitution. Who can be the general of a mass so excessively large? Who can be herald, except Stentor?"

The largest polis in the Great Age of ancient Greece was Athens, whose population probably did not exceed 250,000. Corinth then had less than 100,000, and Thebes, Argos, Corcyra, and Acragas perhaps counted 50,000 each, many numbered 5,000, and hundreds of poleis had even less. With so many poleis sprinkled across the fragmented mountain-cut landscape, no one of them could have reached far out to the countryside. Athens, the most extensive, covered an area somewhat less than that of the state of Rhode Island (about one thousand square miles).

The classic temples of their Great Age were creations of these communities, and public in every sense of the word. In a special Greek sense, too, for the Greeks spent their days out of doors. Their temples, unlike churches, were not primarily places of worship but houses for gods. They were designed not to contain crowds of the faithful, but to be looked at by an admiring populace from the outside.

Each temple, the pride of a polis, had been "designed by a committee." In mid-fifth century B.C., when the greatest temples were being built, the decision to build one would be made by the polis' Assembly and/or the Council who would set the budget, authorize the expenditure, and appoint a building commission. In a religious center like Delphi or Eleusis the temple overseers would make the decisions and the money would be dispensed by a finance board. The commissioners who supervised the work from design to completion were not experts or architects but simply citizens active in commerce, politics, or the professions.

They seem not to have drawn plans or elevations as a modern architect would. These Greeks of the classic age left us on their vases countless samples of their skill and imagination as draftsmen, but scholars have not found a single architectural drawing. Apparently they did not need them. In the beginning the Greek word *architekton* meant master carpenter, and by the sixth century, when stone had displaced wood for important temples, the dominant figure was the stonemason. The conventional design of a Greek temple was so firmly established that only variations of detail could be expected, and these could be settled on the spot, while the building was going up.

This uniformity distinguishes Greek architecture from the creations of

other great ages of building. The layman can notice conspicuous differences between the Gothic cathedrals of Rheims, Amiens, Chartres, and Notre-Dame de Paris, though all were designed within a few decades of one another. Among Greek temples of the Great Age there are of course differences of scale. But only the eye of a specialist can find the differences of design between Greek Doric temples of the same epoch, even those so far apart as the Temple of Poseidon at Paestum in southern Italy and the restored Temple of Zeus at Olympia on the Greek Peloponnese.

The Parthenon on the Acropolis of Athens, paragon of classical Greek architecture, hardly differs in plan or design from the familiar model. The only notable departure was the addition of a second chamber within, behind the main sanctuary, which still did not alter the impression from the outside.

What distinguished the Parthenon, then, was no novelty of conception, no additional "feature" or product of some clever architect's imagination, but rather the refinements of the work. These were only "niceties" of Doric design, but centuries of admirers have noted their subtle charm. Some of these "subtleties" may not have been planned or intended. They may have been consequences or accidents of the fact that the Parthenon was built on foundations of a smaller temple and that some of the columns were being reused.

Perhaps the curvature of the column shafts was intended to correct an optical illusion. Columns with perfectly straight sides when seen against the light will seem thinner in the middle, which, of course, gives an impression of flimsy support. Greek stonemasons prevented this by making the columns bulge out slightly halfway up. This entasis, which in the sixth century was greater than that needed merely to correct the optical illusion, gave the columns an elastic appearance and so counteracted the tendency of the eye to reach indefinitely upward. Fifteen hundred years later, the upward reach would be an object of the Gothic builders. But the Greek column's gentle curve induced the eye to travel up and down along the shaft. Stonemasons seem to have taken account of this problem by making the more conspicuous columns at the corners thicker than the rest.

Such "refinements" increase our delight in the familiar form but do not call attention to themselves. The aim was not to make the temple original or impress us with the boldness of the architect. Even the greatest Greek sculptors, potters, painters, and architects were not individualists. Greek art at its greatest was "canonical," governed by rules and "orders" on which the artist only made refinements. And these refinements distinguished the masterpiece. But originality too was subdued into slight curves on standard forms. If, to us, "artist" conjures up visions of the Left Bank or bohemia, rebels against society's conventional standards, among the classic Greeks

it was quite otherwise. Their rebel was not found among artists but among philosophers—he was not a Phidias but a Socrates.

Rivalry among scores of poleis kept them building, writing, singing. The Greek city-states in their heyday lived a story of endless wars. No one could dominate all the rest, and efforts to form a United City-States of Greece never succeeded. Their great prose epic, Thucydides' *History of the Peloponnesian War,* was a chronicle of competition between Athens and Sparta, with loosely affiliated, dubiously reliable allies. It was a grand parable of turbulent centuries that still somehow produced the glory that was Greece. While other eras would call up their Alexanders and Caesars, Elizabeths or Napoleons as patrons and catalysts of culture, ancient Greece left a legacy of communities in competition revealing the transcendence of culture over politics.

Before the fourth century B.C., architecture in Greece was primarily the art of building temples, products of community spirit and community rivalry. There is no apt modern counterpart of such civic loyalty, except perhaps the nineteenth-century American rivalry among young Western cities in building hotels and railroad stations. The residential and community center of the Greek city-state was anything but an aesthetic delight. The contrast between the random disorderliness of their city streets and the "canonical" symmetry of the Doric or Ionic "order" of their temples was striking. Since the threat of invaders was ever present, the objection to a geometric city plan was quite practical, because the confusion of streets, as Aristotle observed, bewildered and delayed invaders.

The pioneer city planner Hippodamus of Miletus (born c.500 B.C.) remains a shadowy figure, like others to whom the Greeks attributed heroic roles. Aristotle, unfriendly to Hippodamus' abstract approach, discounted him as a man of "long hair" and unworkable theories, "the first man without practical experience of politics" who dared to devise an ideal constitution. Anticipating John Stuart Mill, he appears to have argued that the law in his ideal state of only ten thousand citizens should do no more than protect citizens against one another. The whole business of his utopian government would be to prevent or punish insult, injury to person or property, and murder—leaving each individual to find for himself the good life. Still Hippodamus did not hesitate to box city dwellers into his own geometric gridiron scheme, a stark contrast to the higgledy-piggledy streets of Greek cities in his time. His native Miletus, in western Anatolia, at the mouth of the Meander River, had been the Greek cultural capital in the East. After it had been leveled by the Persians in 494 B.C., Hippodamus proposed that the city be rebuilt with streets on his grid plan. The Athenians in the mid-fifth century B.C. had him plan their port of Piraeus. He probably

helped plan the Greek colony of Thurii in southern Italy (c.443 B.C.), and
also Rhodes. The appealing grid town plan came to be called Hippodamian.

But the leading Greek city-states had not been planned. They had simply
grown. Houses of the classic period, unimpressive from the outside, were
not expected to add to the beauty of the city. Private residences were
squeezed into areas not occupied by the agora, the temples, the theater,
gymnasia or other places for community functions. In the second century
A.D. Pausanias, at Delphi along the Sacred Way up to the Temple of Apollo,
described the remains of the monumental clutter that had been built in the
fifth century B.C. He saw relics of a gilded statue of the courtesan Phryne
erected by her lover Praxiteles next to two statues of Apollo, one from the
Persian wars, another to commemorate a victory over Athens, then the
statue of an ox memorializing a victory over the Persians, more statues of
Apollo, and so on up the hill.

Ancient Greek cities commonly began around a public square, or agora,
surrounded by market stalls wherever there was space. The open agora in
its day became a symbol of the free exchange of goods and ideas. "I have
never yet been afraid of any men," Cyrus the conquering king of Persia
sneered, "who have set a place in the middle of their city, where they could
come together to cheat each other and tell one another lies under oath." In
the later, Hellenistic age of empires, when planned cities were more com-
mon, the agora would be closed off on all four sides, a sign that people were
no longer so free to gather. For Aristotle the plan of a city expressed its form
of government. While "a level plain suits the character of democracy," a
single high citadel (or acropolis) suited monarchies or oligarchies, and an
aristocracy called for "a number of different strong places."

The Acropolis, the citadel and still the symbol of classic Athens, was
enclosed by a wall and served as the central fortress as early as the thirteenth
century B.C. Never the center of commerce or of government, it became the
focus of the polis' religion and civic ceremony. By the early sixth century
B.C. the Acropolis was the site of at least two grand limestone temples, with
smaller temples or treasuries. A new marble temple and a great new en-
tranceway were being built when the invading Persians occupied and lev-
eled Athens in 480 B.C. Then, when the citizens began rebuilding they
started on the Agora as their symbol of a revived democratic spirit, and
neglected the Acropolis. But Pericles led them back to the Acropolis, and
his restoration would remain for millennia the visible reminder of the glory
that was Greece and the uncanny power of the polis. The Acropolis revealed
the possibilities of "urban renewal."

Many buildings of the Periclean Age that glorified the Acropolis were
built on foundations of earlier buildings with reused stones cut for earlier
purposes. The Parthenon, an expanded version of an already partially com-

pleted temple, was not a monument to any one architect. It was finally the product of a battle of improvisation between an eminent general, Cimon (507?–499 B.C.) and an ambitious politician, Pericles.

Rebuilding the Acropolis, as Plutarch (A.D. 46?–120?) recalled, was a shrewd politician's design for public works. Recovering from the Persian invasion, after rebuilding the city's defenses and restoring the Agora, Pericles offered his grand exercise in civic glory and popular gratification.

> . . . it being his desire and design that the undisciplined mechanic multitude that stayed at home should not go without their share of public salaries, and yet should not have them given them for sitting still and doing nothing, to that end he thought fit to bring in among them . . . these vast projects of buildings and designs of works . . . and just occasion of receiving the benefit and having their share of the public moneys. . . . Thus, to say all in a word, the occasions and services of these public works distributed plenty through every age and condition.
>
> (Translated by John Dryden and others)

The "architects" for the great temples on the Acropolis, as we have seen, did not play the role of architects in our time. Not clearly distinguished from the engineers, contractors, or master workmen, they were charged only to redo conventional plans. Although an official architect had a greater share of honor, he might not be paid much more than a skilled workman. When the architect and the building commission had agreed on the design, a herald in the marketplace invited bids for parts of the work. The architect was expected to draw up specifications for each part and contracts were awarded to the lowest bidders, each backed by a guarantor. Since there is no sign of profit for the guarantors, they probably were performing a civic service. The accounts for the building of the Erectheum, for example, show citizens working alongside "metics" (non-Athenians) and slaves, all with much the same pay.

The cost of a public building was met by appropriations from the treasury or through public subscription. The Parthenon (exclusive of the colossal gold-and-ivory statue of Athena) is estimated to have cost some five hundred talents at a time when the whole annual internal revenue of Athens was about four hundred talents. The classic Greeks seem to have made a fetish of keeping the public informed of the progress and cost of public works. Instructions to contractors and workers were probably posted on wooden bulletin boards. For the whole citizenry, and for future generations, a permanent record was carved on stones set up as public monuments. Surviving fragments of these tablets remain our richest source of information about classic Greek building practice. They include requests for tenders by contractors, specifications for materials and workmanship, the length of

the working day, the fines for overruns, and, of course, procedures for the resulting lawsuits. Citizens were no less eager then than now to know what became of "the taxpayers' money."

The names of a few Greek architects became legendary, but none reached the divine status of an Imhotep nor even became a celebrity in his own time. As community enterprises, the great temples were deeply entangled in city politics—none more so than the Acropolis, and especially the Parthenon. In the Age of Pericles Athens's city-state allies, who had contributed money to a war chest, were scandalized at the grandeur of Athens's public buildings, constructed at the allies' expense. The astute Pericles, as Plutarch recalled, had removed the common treasure of the Athenian allies from the isle of Delos and put it in Athenian custody, offering "their fairest excuse . . . namely, that they took it away for fear the barbarians would seize it, and on purpose to secure it in a safe place." Pericles then made that security doubly safe by transferring the investment from the treasury into the rebuilding of the Acropolis. "Greece cannot but resent it as an insufferable affront," the allies complained, "and consider herself to be tyrannized over openly, when she sees the treasure, which was contributed by her upon a necessity for the war, wantonly lavished out by us upon our city, to gild her all over, and to adorn and set her figures and temples, which cost a world of money." Even as the people of Athens enjoyed their remunerative employment on the public works the Parthenon became a center of public controversy when Pericles decided to increase its size and cost substantially. The story recently untangled by scholars is worthy of twentieth-century machine politics.

A politician selecting an "architect" for a public building in Pericles' day would have had a much wider choice than that of a modern mayor or city commission. When the city of Tokyo in 1986 decided to erect a great municipal center (to be the largest building in Japan), it announced a competition and appointed a panel of leading architects as judges. Tange's winning plan was chosen not only for its functional appeal but also for its splendor and originality. But choosing an "architect" for the Parthenon was nothing like that, for what they wanted was a supervisor of construction and a master of detail, someone who could keep workers supplied with schedules of measurements, and sometimes even with full-scale patterns for their carving. He was expected finally to see all the pieces hoisted and fitted according to the familiar requirements of the order (Doric or Ionic) in which the structure was to be built.

Callicrates had been chosen by the celebrated Athenian general Cimon, then a virtual dictator, to be master builder of the first Parthenon. He was well along in the work when Cimon lost the favor of the Athenian people.

In a democratic revulsion led by Pericles, Cimon was prosecuted for allegedly having accepted a bribe, was stripped of his powers and ostracized in 461. Pericles, aiming to undo, or at least to redo, the work of his hated enemy, removed Callicrates from the job and replaced him with his own man, Ictinus. Callicrates did not receive any major assignments for some time, and none within the city. Meanwhile Pericles substantially revised the plans for the Parthenon. The earlier design (six by sixteen columns), he argued, had been too long for its width and so it was replaced by a relatively broader building (eight by seventeen columns). The new dimensions, covering an area more than a third greater than its predecessor's, increased the cost correspondingly. But it offered a more appropriate setting for the huge statue of the town's patron goddess, Athena. Incidentally, it also extended the years of employment on public works, with obvious political benefits for Pericles and his supporters.

The fame and the credit for building the Parthenon came not to its "architects" but mainly to Pericles, with incidental notice to Phidias as Pericles' supervisor for all the reconstruction on the Acropolis. A century later Demosthenes (385?–322 B.C.) looked back with nostalgia on that admirably anonymous public spirit.

> The edifices which their administrations have given us, their decorations of our temples and the offerings deposited by them, are so numerous and so magnificent, that all the efforts of posterity cannot exceed them. Then, in private life, so exemplary was their moderation, their adherence to the ancient manners so scrupulously exact, that, if any of you ever discovered the house of Aristides or Miltiades, or any of the illustrious men of those times, he must know that it was not distinguished by the least extraordinary splendour.

He might have added that no statue was erected to Miltiades after the Battle of Marathon, nor to Themistocles after the Battle of Salamis. In those days even the tyrants did not dare build monuments to themselves.

Since the canons of classic Greek architecture allowed variety only in the scale of the building or in decorative detail, the supervising architects were also sometimes known as sculptors. But sculptors and stonemasons were hardly distinguished from one another, for they worked in the same medium and used the same tools. Both proceeded by similar stages, first roughing out the sculptural block or masonry column and then gradually cutting, dressing, and smoothing the stone once it was in place. To minimize the danger of accidental damage, the finishing was left until after the moving and hoisting had all been done. Finally tinted wax was worked into the pores of the marble to give the desired color to sculptured parts like hair, eyes, lips, costumes, triglyph, moldings, and metopes.

Sculptors and architect builders both followed fixed rules of proportion. Just as the architect had his canons for the parts and proportions of the Doric or Ionic order, so too the sculptor had prescribed for him the anatomical proportions of each figure in integers easy to remember. The sculptor Polyclitus (fifth century B.C.), as we shall see, so perfectly embodied the simple proportions in his *Doryphorus,* a young athlete holding a spear, that the work itself came to be known as "the canon." The *Doryphorus* became a model for sculptors just as the Parthenon was a model for architects. Vitruvius was struck by the mathematical precision of canons of the sculptors of the Great Age.

> For Nature has so constituted the human body that the face. . . . from the bottom of the chin to the lower edge of the nostrils is a third of its height; from the nostrils to the median termination of the eyebrows the length of the nose is another third; and from this point to the springing of the hair, the forehead extends for yet another third part. . . . The rest of the bodily members have also their measured ratios, such as the ancient painters and master sculptors employed for their attainment of boundless fame.
>
> (Translated by Rhys Carpenter)

Phidias (born c.490 B.C.), skilled as a sculptor, owed his prominence to Pericles, who chose him to supervise all the building on the Acropolis. Still, we cannot surely identify Phidias' own work on the Parthenon, except for the statue of Athena that the Parthenon housed. When Pericles no longer controlled Athens, Phidias became a target for Pericles' enemies. First, as Plutarch recounts, they accused him of stealing the gold supplied for the Athena Parthenos. "There was nothing of theft or cheat proved against him; for Phidias, from the very first beginning, by the advice of Pericles, had so wrought and wrapt the gold that was used in the work about the statue, that they might take it all off, and make out the just weight of it, which Pericles at that time bade the accusers do." When they failed in this, they charged him instead with impiety, "especially that where he represents the fight of the Amazons upon the goddess's shield, he had introduced a likeness of himself as a bald old man holding up a great stone with both hands, and had put in a very fine representation of Pericles fighting with an Amazon." Plutarch tells us that "Phidias then was carried away to prison, and there died of a disease; but as some say, of poison, administered by the enemies of Pericles, to raise a slander or a suspicion at least, as though he had procured it."

The architect builders put up their canonical temples all across the mainland and the Peloponnese, producing the remarkable uniformity of classic Greek architecture. After leaving the Parthenon, Callicrates found a half-

dozen other assignments outside Athens, building temples at Sunion, in Acharnai, at Rhamnus, and on Delos. Ictinus, too, followed his completion of the Parthenon by work on the temple of Demeter and Persephone at Eleusis, and the temple of Apollo at Bassai. Perhaps Phidias did not die in jail, for there is evidence that after the date of his trial he was working on an enormous ivory-and-gold statue of Zeus for the temple at Olympia. Despite the battles between the poleis and the intestine conflicts of politicians, all the gods still dwelled in houses of strict Doric or Ionic order.

12

Orders for Survival

THE most un-Greek thing we can do, philosophers tell us, is to imitate the Greeks. Yet the great works of Greek art that invited imitation did not inspire creation. The legacy of Greek architecture was "classic" forms and their arrangement in "orders." This was appropriate too, for, as we have seen, their architecture followed a few well-known traditional models. The last will and testament of Greek architecture was written not by a Greek but by a Roman, four centuries after the building of the Parthenon. The author was Vitruvius, a Roman military engineer and architect of the Age of Augustus in the first century B.C. We know so little about him that even his name is in doubt. Vitruvius was only his first name.

Though not an eminent man of letters, he writes self-consciously about himself. Unlike other architects, he says, he could not appeal to clients by his good looks. He probably served as engineer-architect on Julius Caesar's far-flung expeditions in the Maritime Alps, in Spain, and in Africa. And after Caesar's assassination in 44 B.C., he seems to have served Octavian, to whom he dedicates his *Ten Books of Architecture (De Architectura)*.

This work, in which he "disclosed all the principles of the art" (about three hundred printed pages in English translation), had an uncanny power over later centuries. But Vitruvius's name as architect was definitely associated with only one building, the basilica and shrine in honor of Augustus at Fano in Umbria. While most of the architectural monuments of his age disappeared, Vitruvius survived in his words. Since none of his illustrations remained, he exerted his influence as the prime exponent of classical

architecture through his verbal instructions, observations, and word pictures of the model orders for Western architecture. Later editors had to supply or to invent their own illustrations, and they did.

The accidents of history conspired to make Vitruvius's work the West's primer of architecture for a millennium and a half, with a fertile and vigorous afterlife. Did it survive because it was important in its time? Or is it important because it happened to survive? Classical scholars condescend to his style and try in translation to preserve the "crudities" of his language. But for the modern lay reader it is one of the few seminal works of technical literature that can be read for entertainment.

Reading Vitruvius today, we are not surprised that he remained the messenger of classical architecture. He helps us understand, too, why and how the Romans made architecture their master art. For Rome was a civilization of organization and mastery, and architecture was Vitruvius's name for the arts of shaping and organizing the whole man-made environment. "In architecture," observed Nietzsche, "the pride of man, his triumph over gravitation, his will to power, assume a visible form. Architecture is a sort of oratory of power." And it was never more so than in ancient Rome. Cicero, Vitruvius's contemporary, classed architecture with medicine and teaching, and Vitruvius called architecture a great profession. But in his time, even in Rome, it was not yet organized as a separate profession. The master builder, the environment-shaping artist, was not distinguished from the engineer, the planner, or the interior designer. Nothing that concerned space or time was alien to him.

The architect's work, according to Vitruvius, was the most comprehensive and most liberal of the arts, "for it is by his judgment that all work done by the other parts is put to test." A man of natural ability and quick learning, the architect must "be educated, skillful with the pencil, instructed in geometry, know much history, have followed the philosophers with attention, understand music, have some knowledge of medicine, know the opinions of the jurists, and be acquainted with astronomy and the theory of the heavens." His treatise covers, in turn: town planning and the siting of cities; the primordial substances (and building materials); the principles of temple building, symmetry, and the classic orders; public buildings, theaters, baths, and gymnasia; domestic buildings; stucco, fresco, pavement, and coloring; water, its collecting, supply; acqueducts and wells; geometry, astronomy, the measuring of time by sundials and water clocks; machines for hoisting, moving, and measuring; military machines and defenses.

The architect could not properly site the streets of a city unless he knew the directions of the prevailing winds to avoid their blowing through the alleys. "Then let the directions of your streets and alleys be laid down on the lines of division between the quarters of two winds." Since there were

"only eight" winds, houses could be sited to avoid their worst bluster. History had to explain the familiar elements of classic architecture:

> For instance, suppose him to set up the marble statues of women in long robes, called Caryatides, to take the place of columns, with the mutules and coronas placed directly above their heads, he will give the following explanation to his questioners. Caryae, a state in Peloponnesus, sided with the Persian enemies against Greece; later the Greeks, having gloriously won their freedom by victory in the war, made common cause and declared war against the people of Caryae. They took the town, killed the men, abandoned the State to desolation, and carried off their wives into slavery, without permitting them, however, to lay aside the long robes and other marks of their rank as married women, so that they might be obliged not only to march in the triumph but to appear forever after as a type of slavery, burdened with the weight of their shame and so making atonement for their State. Hence, the architects of the time designed for public buildings the statues of these women, placed so as to carry a load, in order that the sin and the punishment of the people of Caryae might be known and handed down even to posterity.
>
> (Translated by Morris Hicky Morgan)

And so, too, a knowledge of botany and medicine would help the architect understand when to cut the timber for his buildings.

> Timber should be felled between early Autumn and the time when Pavonius begins to blow. For in Spring all trees become pregnant, and they are all employing their natural vigour in the production of leaves and of the fruits that return every year. The requirements of that season render them empty and swollen, and so they are weak and feeble because of their looseness of texture. This is also the case with women who have conceived. Their bodies are not considered perfectly healthy until the child is born; hence, pregnant slaves, when offered for sale, are not warranted sound, because the fetus as it grows within the body takes to itself as nourishment all the best qualities of the mother's food, and so the stronger it becomes as the full time for birth approaches, the less compact it allows that the body be from which it is produced. After the birth of the child, what was heretofore taken to promote the growth of another creature is now set free by the delivery of the newborn, and the channels being now empty and open, the body will take it in by lapping up its juices, and thus becomes compact and returns to the natural strength which it had before.
>
> (Translated by Morris Hicky Morgan)

For the modern historian Vitruvius provides a treasury of ancient Roman ways. But to centuries of builders he delivered the Greek commandments for designing and constructing the three orders—Doric, Ionian, Corinthian. For Vitruvius these genera had the distinctiveness of the kinds of creatures in the organic world. And his rules for the orders, though drawn from the

actual proportions of classic Greek buildings, he claimed to be "founded in the analogy of nature." The beauty of the Greek temples, he insisted, was not the product of any architect's imagination. Rather, it embodied the symmetry and proportion found in all nature, and especially in the human body.

Vitruvius then ingeniously showed that the human body provided the elements of architectural symmetry—the circle and the square. The figure he described came to be known as Vitruvian Man, and cast a spell over the visual imagination of many centuries—from Leonardo da Vinci to William Blake. The dimensions of the human body, by defining both circle and square, provided the elements of all other symmetry. "For if a man be placed flat on his back, with his hands and feet extended, and a pair of compasses centered at his navel, the fingers and toes of his two hands and feet will touch the circumference of a circle described therefrom." And so, too, may the figure of the perfect square be defined. "For if we measure the distance from the soles of the feet to the top of the head, and then apply that measure to the outstretched arms, the breadth will be found to be the same as the height, as in the case of plane surfaces which are perfectly square."

It was not surprising, then, "that the ancients had good reason for their rule, that in perfect buildings the different members must be in exact symmetrical relations to the whole scheme." He reminds us that *all* units of measurement were simple applications to the whole material world of the natural proportions of man—the "finger," the "palm," the "foot," and the "cubit" (the length of the arm from the tip of the middle finger to the elbow). And, whether we chose, like Plato, to say that the "perfect number" was ten (the number of the fingers of the hand), or with others to say that it was six (a man's foot being one sixth of his height), Vitruvius noted that we still followed the symmetry of nature.

For the architecture of temples, the buildings of greatest dignity and authority, there were only three original orders. The subtle natural symmetry of each had an aura of divinity. "The Doric was the first to arise, and in early times. For Dorus, the son of Hellen and the nymph Phthia, was king of Achaea and all the Peloponnesus, and he built a fane, a temple to Pannonian Apollo which chanced to be of this order, in the precinct of Juno at Argolis, a very ancient city, and subsequently others of the same order in the other cities of Achaea, although the rules of symmetry were not yet in existence." For their model they turned to man himself.

Wishing to set up columns in that temple, but not having rules for their symmetry, and being in search of some way by which they could render them fit

to bear a load and also of a satisfactory beauty of appearance, they measured the imprint of a man's foot and compared this with his height. On finding that, in a man, the foot was one sixth of the height, they applied the same principle to the column, and reared the shaft, including the capital, to a height six times its thickness at its base. Thus the Doric column, as used in buildings, began to exhibit the proportions, strength, and beauty of the body of a man.

(Translated by Morris Hicky Morgan)

Later, when they wanted to build a temple not to the male god Apollo but to the graceful Diana, "they translated these footprints into terms characteristic of the slenderness of women, and thus first made a column the thickness of which was only one eighth of its height, so that it might have a taller look." In the capital they put volutes, "hanging down at the right and left like curly ringlets," and ornamented in front with festoons of fruit in place of hair. The flutes on the columns they brought down all the way, falling like the folds of the robes worn by matrons. And this became the second order, the Ionic.

The third order, the Corinthian, was "an imitation of the slenderness of a maiden," which invited its own prettier effects by adornment. He recounts that when a maid of Corinth died, her mourning nurse put on top of her tomb a basket with a few things that the girl had cherished and covered the basket with a roof tile. The basket happened to cover the root of an acanthus plant. When spring came the acanthus sprouted, and as the roof tile prevented stalks from growing up in the middle the leaves curved out into volutes at the edges. When the sculptor Callimachus passed by he was inspired to make the sprouting acanthus leaves his model for a "Corinthian" capital. This set the style and helped define the other proportions for a whole Corinthian order with its own proper maidenly symmetry.

Vitruvius specified in mathematical detail the ornaments and the proportions of all parts of each of these three original orders. These specifications went beyond the gross dimensions, beyond the relation of width to length, to a minute prescription for the placing of columns and their fluting, and other subtleties. All the architectural members above the capital had to be inclined toward the front by a twelfth part of their own height, for otherwise they would not seem perpendicular. The column could not be uniform in thickness from top to bottom, "on account of the different heights to which the eye has to climb. For the eye is always in search of beauty, and if we do not gratify its desire for pleasure by a proportionate enlargement in these measures, and thus make compensation for ocular deception, a clumsy and awkward appearance will be presented to the beholder." Vitruvius's calculations showed how to make precisely the right bulge for "an agreeable and appropriate effect."

Whatever Vitruvius may have been in his own time—military engineer, man of letters, practitioner and teacher of a new liberal art of architecture—for later centuries he became the legislator of the arts. He defined, declared, and decreed *the* orders of architecture. With a legislator's overconfidence he claimed that he had "disclosed all the principles [*rationes*] of the art [*disciplinae*]." He proved effective in ways he might have predicted. While he guided, he also narrowed the imagination of architects for generations. The creators who might have been inspired by the classical Greek experience he imprisoned into archetypes. But he actually succeeded in his quixotic purpose of quantifying an art into a science. And he did make it teachable.

Vitruvius's eyes were fixed so obsessively on the surviving beauties of the past that he did not notice the revolutionary architectural achievements of his own time. He stood at the threshold of one of the great innovative ages of Western architecture, but all he professed to see was decadence. His book reeks with condescension toward "the new taste that has caused bad judges of poor art to prevail over true artistic excellence." He refers to concrete only as a material useful for making polished floors. And he gives no hint that this new kind of "artificial stone" ingeniously combined with ancient brick by the unexcelled skills of Roman engineering would create grand new forms. But this humble fluid concrete was already beginning to raise grandiose space-encompassing buildings without precedent and would liberate architects from Vitruvius's orders.

The power of his sacred text for architects was not fully realized until a thousand years had passed. His alone among ancient architectural treatises has survived. Fifty-five manuscripts have appeared, the oldest written in the ninth century at Jarrow in Northumberland, copied from others brought there from Italy in the seventh century. Still, his influence on building during the Middle Ages was meager. Like other seminal books, Vitruvius's leaped the centuries. Then the great Renaissance architects, beginning with Alberti (1404–1472), who wrote his own ten books "On Building," (*De Re Aedificatoria*), faithfully patterned their treatises on his. Bramante, Ghiberti, Michelangelo, Vignola, and Palladio all acknowledged Vitruvius as their master in the art and made his ten books their gospel.

In the very act of codifying the "liberal" profession of architect, Vitruvius stultified the architect's work. His orders became the order of architecture, propriety became the standard of beauty, and the great Greek creations cast a long dark shadow.

Vitruvius's lifetime, between the death of Julius Caesar (44 B.C.) and the death of Augustus (A.D. 14), embraced some of the most productive decades in the long history of architecture. In Rome during that Augustan Age more than 125 important buildings were constructed or restored. While Vitruvius

pleaded for beauty, decorum, and authority (*auctoritas*) in the works of his time, he wrote little about their brilliant Roman embodiments. A whole new cycle of creation was in progress with new materials and new forms, far outside the classic Greek canons. But the great Roman mentor of architects was not a friend of Roman architecture. How were the Romans liberated from ancient canons to make their own?

13

Artificial Stone: A Roman Revolution

"THE ancient Romans," Voltaire complained, "built their greatest masterpieces of architecture, the amphitheatre, for wild beasts to fight in." In this "enlightened" verdict on Roman architecture critics and historians have joined for the last thousand years. Vision of the ancient Roman creations had long been clouded by Vitruvius's idealizing of ancient Greece. The arts of Rome, like Roman civilization as a whole, have had a bad press. The title of Edward Gibbon's classic *Decline and Fall of the Roman Empire* has dominated literary imagination. Awed by the grand spectacle of so great a civilization disintegrating, we have thought too little about its rise and the creations that made it great. Western pundits have applauded Rome's decline. "I know not why any one but a school-boy," Dr. Johnson decreed, "should whine over the Commonwealth of Rome, which grew great only by the misery of the rest of mankind." "The barbarians who broke up the Roman empire," Ralph Waldo Emerson agreed, "did not arrive a day too soon." Still, Roman creations are among the most remarkable works of mankind. And their architecture remains their most original and most enduring contribution to the arts of the West.

It is not so surprising that architects schooled in Vitruvius and the beauties of classic Greece have been slow to recognize the greatness of Roman architecture. For the beauties of classic Greece were revealed in the elegance of polished marble and survive with a charming patina. But the decisive new Roman material was concrete, which in modern times has borne the stigma of the commonplace. Concrete is the everyday substance of our sidewalks, driveways, and roads, of dams, bridges, and office buildings. How could it have been the raw material of a revolution in architecture and the shaper of new beauties?

The accidents of geology provided the Romans with a new basis for their concrete and their architecture. Mud, adobe, and mortar had of course been used for millennia. But the Romans added a new mineral to their concrete, pozzolana (Latin *pulvis puteolanus*). This volcanic earth they first found in thick strata at Pozzuoli (Latin *Puteoli*), a seaport near Naples, not far from Lake Avernus, the legendary mouth of hell. The discovery that pozzolana-enriched concrete would harden in contact with water had been made when the people in Pozzuoli mixed this local volcanic sand with lime for buildings on the water's edge. Pozzolana was imported to Rome for bridges, wharves, and jetties until the same volcanic sand was found in large quantities in the nearby Alban Hills. By Augustus' time pozzolana was used in all concrete for buildings. "This substance," Vitruvius explained, "when mixed with lime and rubble, not only lends strength to buildings of other kinds, but even when piers of it are constructed in the sea, they set hard under water." Concrete made of pozzolana resisted fire as well as water, and would preserve Roman monuments through centuries.

We have been misled, too, by the legendary boast of Augustus (63 B.C.–A.D. 14) that he "found Rome a city of bricks and left it a city of marble." In fact the Romans found architecture a realm of marble, and would remake it in concrete. But in the time of Augustus, marble, used in Roman buildings mainly in slabs for facing or in decorative fragments for mosaics or pavements, was a material more cosmetic than structural. Like stucco, it covered a solid core of brick and concrete, which made their grand and distinctive buildings possible.

Builders were so convinced of the unique qualities of their crucial new element, pozzolana, that, in the heyday of their high imperial age, they routinely incorporated it in the concrete for buildings, great or small. Bricks, one of the most ancient and familiar building materials, when added in the concrete gave character, novelty, and grandeur to their works. Walls of brick required less labor than stonework of the same quality, and could be made of local clay where there was no stone. Bricks, besides being wonderfully durable, protected against heat and weather. More than three thousand years before Augustus, the city of the biblical Abraham, Ur of the Chaldees, had been built of sun-dried brick and kiln-dried brick. The Tower of Babel was probably built of brick, as was Nebuchadnezzar's city of Babylon. In the great age of Roman architecture, bricks embedded in concrete helped hold together grand new shapes.

Roman bricks themselves record a saga of foresight and organization. Sun-dried bricks, Vitruvius explained, should be made only in spring or autumn and, to allow full and uniform drying, should be made at least two years in advance. The best bricks, like those at Utica, had been left to dry for five years. Under the Empire, when bricks were visible on the outside

of buildings they were no longer the structural material. They were only a protective skin covering a structure of concrete. Roman bricks were made in several shapes and sizes. Often the bricks were cut into triangles which had their hypotenuse laid out and their apex inserted in a core of concrete. The commonest, which were about one and a half inches thick and two feet square, we would call large tiles, for they were thinner than our common bricks.

As the decades passed, bricks became smaller and took new shapes, while the thickness of the mortar and its strength increased. During the first three centuries of the Empire, a proportion of the bricks in each brickyard were stamped as they were made, and so became historical documents, witnesses to the Roman sense of order and of history. Stamped bricks commonly carried the name of the owner of the estate where they were made, the name of the brickmaster, and sometimes too the names of consuls in office. In familiar Latin abbreviations they carried a message like this: "Brick from the estates of His Excellency, C. Fulvis Plautianus, Prefect of the Praetorian Guard, Consul for the second time, from the Terentian Brickyard, made by L. Aelius Phidelis." In their time these stamps probably were meant to serve for inventory or for taxation, but now they help us date Roman monuments and trace the development of their architecture. Brickmaking was eminently respectable, for senators not usually allowed to be in trade could be in the brickmaking business which was classed as a kind of agriculture.

The dated bricks help us follow the Roman revolution in architecture, which Gibbon himself overlooked. Concrete, the drab and humble raw material of the Roman revolution, seems to have been beneath the dignity of his rotund eloquence. Nor does he celebrate the soaring, enveloping new shapes. Of course Vitruvius, though an opinionated conservative, dared not omit from his architects' guide a full discussion of the materials (including brick and concrete) in common use.

The shapes developed by the Romans—arches, vaults, and domes—have become so familiar and so essential to our architecture that we find it hard to believe they ever had to be created. The earlier architecture of the ancient West had been an architecture of mass. Dominated by posts, roofs, and walls, it displayed columns and architraves. Then the architect's problem was to arrange masonry or bricks to support a platform or a roof. There were variations only in the size, weight, and shape of the masses, the materials of the walls, the number and disposition of the columns. The great works of Greek temple architecture, as we have seen, were made to be viewed from the outside, not to be experienced from within. The inner chamber, the cella, was reserved for the priest alone. The Greek buildings were "trabeated" (from Latin *trabs,* beam). Such structures were domi-

nated by the vertical and the horizontal, by right angles and rectangles that confined the architectural imagination.

Even the few apparent ancient exceptions, like the pyramids, were masses for external viewing. In one of the grand revisions of the creative imagination, the Romans would change all this. They built an architecture of interiors, of vast enclosed spaces. And this was a new kind of space—within arches, vaults, and domes, in omnipresent dominating curves, where walls became ceilings, and ceilings reached up to the heavens. The artificial world, the world of interiors that architects would make for man, was transformed into a new curvesomeness. The classic Greeks had gathered out in the open air. Roman architecture brought people indoors to share their public and exchange their private concerns. Their spectacular new domed and vaulted shapes would dignify and glorify religious faiths, political hopes, and law-making efforts across the West—from Hagia Sophia to St. Mark's in Venice, St. Peter's in Rome, St. Paul's in London, the Capitol in Washington, D.C., and in American state capitals.

This grand Roman innovation in architecture would be accomplished in two centuries as the essential ingredient, concrete, was perfected gradually by trial and error. Vitruvius tried to explain the chemistry, but the improvements were not based on chemical theory. The remarkable qualities of perfected concrete in the Age of Hadrian, the Age of the Pantheon, would be attained by further trial and error in improving the proportions of lime and pozzolana and other ingredients in the mortar.

The techniques of laying concrete were also improved. In the beginning, each horizontal course was allowed to dry before the successor was applied. The result was an unsightly horizontal line of cleavage between layers. Then an improved slower-drying mixture allowed the successive layers to fuse into a single mass, and before the death of Hadrian in A.D. 137 pozzolana-enriched concrete had become a monumental building material in its own right.

The Roman Empire had brought cities into being and created a far-flung urban culture with common needs. And the new architectural creations arose from the needs of these Roman cities. While the glory of classic Greek architecture was in its temples to gods and civic deities, the grandeur of Roman architecture began in the public baths. How and why Romans acquired their mania for public baths remains a mystery. But its signs were everywhere.

Some of the earliest were the grand Stabian baths of the second century B.C. at Pompeii, with elegant arches and a soaring conical dome topped by a central opening that anticipated one of the most appealing features of the Pantheon three centuries later. Grand public bath buildings sanitized and enriched urban life all across the Roman provinces. Besides the *balneum,*

or private bath, found in the town houses and country villas of wealthy Romans, there were the *thermae,* or public baths. Some historians count these among "the fairest creations of the Roman Empire." During the second century B.C. they multiplied at a great rate in Rome. It became common for a public-spirited citizen to make a gift of a public bath building to his neighborhood. Others were built commercially by contractors who hoped to make a profit from admission fees. Agrippa's census (33 B.C.) counted 170 such establishments in Rome, and a century later Pliny the Elder (23–79) had to give up counting. Soon there were nearly a thousand. When Pliny the Younger arrived for a brief stay at his country villa near Ostia, and did not want to fuel his own furnaces, he found "a great convenience" in the three public baths in the neighboring village.

The essentials of a public bath were quite the same everywhere—a changing room, a sweating room heated by hot-air passages under the floor or in the walls, a large vaulted hall gently heated with intermediate temperatures, an unheated frigidarium partly open to the sky with a cold plunge, and a rotunda heated by circulating vapor, open at the top to admit sunlight at noon and in the afternoon. In addition, there were swimming pools. Nearby areas provided for strolling, for conversation, for sunning, for exercise, for various kinds of handball, hoop-rolling, and wrestling. Attached were concert halls, libraries, and gardens. The baths at their best were public art museums and museums of contemporary art. To them we owe the preservation of some of our best copies of Greek sculpture and our great treasures of Roman sculpture. The Farnese Bull, the Hercules, and the Belvedere Torso survived in the remains of the baths of Caracalla and the famous Laocoön group was found in the baths of Trajan.

This was emphatically public architecture, aiming to make every human function sociable. The latrine in the earliest Stabian baths at Pompeii was an open room with seats around the edges so the occupants could enjoy one another's company. In the remains of the Hadrianic baths at the distant Roman colony of Lepcis Magna we can still see the marble seats around three sides of a spacious open room, with the fourth side occupied by a statue in a niche. The social latrine became standard in public baths. If bathing could be a pleasurable social occasion, why not defecating?

In later envious centuries in the West, especially among other peoples like the British who were far from matching the Romans in plumbing, the baths became a symbol of Roman decadence. In Roman times, too, baths were the butt of moralists and bluenoses. In the early republic, it was still thought improper for Cato the Censor (234–149 B.C.) to take a bath in the presence of his son. Under the early Empire there was an increasing tolerance of nudity and the mixing of the sexes and no formal prohibition of mixed bathing. But for the women who objected there were special baths or

separate designated times. Eventually popular outcry against scandalous behavior in the baths led Hadrian to issue a decree separating the sexes. Throughout the Empire baths were enormously popular, accessible to all free Romans at a nominal fee.

Not only the sexual promiscuity but other excesses aroused Roman concern. Besides the procurers of both sexes under the porticoes there were aggressive vendors of food and drink. Some Romans, it seemed, enjoyed the hot baths mainly "to raise a thirst" or stimulate their appetite. "You will soon pay for it, my friend," Juvenal (60–140?) warned, "if you take off your clothes, and with distended stomach carry your peacock into the bath undigested!" It was tempting to spend most of the day in the baths. The emperor Commodus (161–192), who imagined himself to be the god Hercules, took as many as eight baths a day, and exhibited his prowess in gladiatorial contests until his outraged advisers had him strangled by a champion wrestler. Efforts to prevent such excesses led to regulated hours of opening and closing.

To this conspicuous Roman institution, Edward Gibbon gives less than a paragraph of his seven volumes, casually reminding us that they "had been constructed in every part of the city, with Imperial magnificence." Though frequently satirized by Juvenal and others, the Roman baths left no literary, graphic, or sculptural art of their own. We have no script for the daily drama of the bath. The institution where Romans acted out much of their daily lives remained formless, unrecorded, and anonymous. Like the hotels and department stores of nineteenth-century America, they were Palaces of the Public, promoting, along with personal cleanliness, wholesome athletic activity, conversation, and the enjoyment of literature and the arts. So, too, they promoted urban pride and reincarnated the Greek ideal for which Juvenal pleaded—"a healthy mind in a healthy body" (*mens sana in corpore sano*). Like the great clocks in medieval town halls, they too were tokens of community. Nor were the Roman bathers mere spectators. This pioneer public amenity invited them to participate in a secular and sensuous synagogue.

The public baths have left us some of our most impressive Roman ruins. A fragment of the remains of the Baths of Caracalla which altogether once covered twenty-seven acres has become a delightful opera house for open-air performances. The thirty-two acres of the ruins of the Baths of Diocletian now house the National Roman Museum, the Church of Saint Mary of the Angels, the Oratory of Saint Bernard, and a surrounding piazza. In their time the baths amazed visitors to the Imperial city.

The community bath, an enclosed structure to keep the water and the people warm, exploited the special qualities of the pozzolana-enriched Roman concrete to resist humidity and to shape interior space. The Roman

architects also used their new materials for other civic functions that brought people together indoors. After the baths, basilicas were the most common and most characteristic Roman public buildings. A "basilica" (from the Greek for king) was a covered hall whose "royal" dignity came from its large size and the public and legal activities that it sheltered. In Roman times a basilica, usually attached to or near the forum, also housed markets, trials, and judicial hearings, public meetings, and covered promenades.

The basilica expressed, too, the same novel Roman interest in interiors. For basilicas throughout their history were usually simple and barnlike in their exterior. Decoration was on the inside. Their later form and their suitability for the Christian liturgy came from their widespread earlier use as a courtroom. In the first century B.C. the basilica commonly provided a raised platform at one end for the judge. With the coming of Christianity the raised end was enclosed by an apse, a semicircular half-domed extension of the wall, which made the whole design especially convenient for the Christian service. The earliest known basilica, the Basilica Porcia, was built by Cato the Elder in 184 B.C. as an addition to the Roman forum, and many others followed in Rome and elsewhere. The only building we can confidently ascribe to Vitruvius's own design is the Basilica at Fano (c.27 B.C.) which survives only in his description. These earliest basilicas, like Vitruvius's, were square or rectangular, and usually roofed by timbers. In due course they, too, would be laboratories for the Roman revolution in architecture.

The great incentive came in an unexpected way on the night of July 18, A.D. 64. The fire that broke out in Rome on that night, in Gibbon's words, "raged beyond the memory or example of former ages" and ravaged the city for nine days. Of the fourteen regions of the city three were leveled to the ground, and seven were devastated. The cause of the fire was never finally determined. This was the tenth year of the reign of Nero (37–68; reigned 54–68), who had well earned the suspicion and contempt of all Romans by murdering his mother and his wife, by extorting from the rich and oppressing the poor. He had forced his successful generals to suicide, and randomly tortured and executed any who excited his suspicion. He scandalized the Senate and soiled the imperial dignity by his buffoonery in the theater and public ostentation of his meager talents as singer and poet. By the year 64 the hatred of all classes of Romans naturally fueled the rumor that he had set the fire himself. It was suggested that he had destroyed the center of Rome so he could rebuild it all into a vast palace of his own and then rename the city after himself.

"To divert a suspicion which the power of despotism was unable to

suppress," Gibbon recounts, "the emperor resolved to substitute in his own place some fictitious criminals." He made many martyrs, for his victims were the unlucky adherents of the despised new sect called Christians. "Some were nailed on crosses;" reports Tacitus, "others sewn up in the skins of wild beasts, and exposed to the fury of dogs; others again, smeared over with combustible materials, were used as torches to illuminate the darkness of the night. The gardens of Nero were destined for the melancholy spectacle, which was accompanied with a horse race, and honoured with the presence of the emperor, who mingled with the populace in the dress of and attitude of a charioteer." The new sect had prophesied a second coming of Christ, with a worldwide conflagration. Nero loved classic Greek themes. In his legendary fiddling, he may have been using the Fire of Rome to accompany his own song to the lyre on the burning of Troy.

The fire's conspicuous historic consequences can be explained only if we grasp the contradictory character of Nero himself. He suffered a repressed and insecure childhood, for when his father died he was raised under the terrifying menaces of his uncle, the deranged emperor Caligula, until Caligula was murdered and succeeded by Claudius. Nero was then brought up by his mother, the impetuous and domineering Agrippina the Younger. She used the wiles of incest and murder to secure for him the imperial throne in place of Claudius's own son and rightful heir. Agrippina steered the resentful Nero into and out of marriages of convenience until finally she herself was murdered (A.D. 59) by Nero's hired assassins.

Yet Nero must have had hidden strengths of character. For despite this erratic childhood, when he became the first boy emperor of Rome in A.D. 54 at the age of seventeen, he opened his reign with five generous and constructive years. He tried to reform the circus entertainments by forbidding contests that would cause bloodshed, he banned capital punishment, and even set up procedures for slaves to bring legal proceedings against cruel masters. Claudius, his predecessor, had put forty senators to death, but the young Nero in these first years tolerated those who plotted against him, pardoned the writers of satiric epigrams, and even found ways to make the Senate more independent. Nero's clemency speedily became proverbial. Romans repeated his words when he signed his first death warrant, "Why did they teach me how to write?" After his first speech to the Senate he was acclaimed the herald of a Golden Age. If Nero had died in A.D. 59 when he was only twenty-two, he might have been celebrated as a noble precocious statesman.

What so suddenly happened to the man? A diabolical transformation occurred in the next three years, when he secured the murder of his demented mother, and then of his wife, so he could marry the wife of a senator. The surprising continuous thread in his life was an obsession with the arts.

Even if he did not actually fiddle while Rome burned, the legend carried the truth that Nero was a man of consuming artistic passion. He even imagined giving up his throne to be a full-time poet and musician so that "they would adore in me what I am." And he believed he could use his art to bring his enemies to tears and repentance. This obsession lasted through his brief life, and, on June 9, 68, just as he was about to commit suicide at the age of thirty-one, he was reputed to exclaim, "What an artist dies in me!"

Nero's artistic aspirations were more than a madman's dream. The Great Fire of 64 gave him an opportunity that, as even hostile historians report, he seized with creative energy and imagination. The chance to rebuild Rome had not been offered since Rome was burned by the Gauls in 390 B.C. After that earlier fire, as Tacitus chronicled, the capital was rebuilt "indiscriminately and piecemeal." This time it would be different. By Nero's orders, Rome would be rebuilt "in measured lines of streets, with broad thoroughfares, buildings of restricted height, and open spaces, while porticoes were added as a protection to the front of the apartment-blocks (*insulae*). These porticoes Nero offered to erect at his own expense, and also to hand over the building sites, clear of rubbish, to the owners." He organized garbage removal by requiring that ships which carried grain up the Tiber must carry refuse downstream to be dumped in the Ostian marshes. He improved the water supply, required fire walls between buildings, and directed all householders to keep in the open their appliances for extinguishing fires. Tacitus (only ten years old at the time of the Great Fire) was Nero's bitter critic, but he gave grudging credit to the mad emperor. "These reforms, welcomed for their utility, were also beneficial to the appearance of the new capital. Still, there were those who held that the old form had been the more salubrious, as the narrow streets and high-built houses were not so easily penetrated by the rays of the sun; while now the broad expanses, with no protecting shadows, glowed under a more oppressive heat."

Nero's aesthetic megalomania had subtle and far-reaching effects on Western architecture. For the Great Fire hastened the liberation from the architecture of mass, of parallels and right angles, which was the legacy of Greece into the architecture of curves, of vaults and domes. Nero's new building code, specifying that future structures be more fireproof by avoiding timbers or beams (*sine trabibus*), implied the new architecture of concrete and its sinuous shapes for interiors. Large indoor spaces would now be enclosed not by flat ceilings but by rounded vaults of the newly improved artificial stone. The Fire of 64 thus cleared the way for what Suetonius called "the new form for the buildings of the city." This was not the first nor the last example of man's endless capacity to make catastrophe the catalyst of creativity.

. . .

Nero seized the incendiary opportunity to create for himself a grand palace. Much of the Rome that would not be reconstructed according to his new building code was reserved for his personal palace. If completed it would have covered some 125 acres, about one third of the city. The Golden House (*Domus Aurea*) it came to be called, because its façade was covered with gold. And there were symbolic reasons for the name. The Augustan Age, which Nero hoped to equal or excel, had been called Golden (*aurea aetas, aurea saecula, aurei dies*). After the fire, the name was an ironic reminder that Nero's reign at its beginning had been predicted to be Golden. As Suetonius (c.69–post 122?) describes Nero's Golden House, it was impossible to exaggerate its magnificence:

> Its vestibule was large enough to contain a colossal statue of the Emperor a hundred and twenty feet high; and it was so extensive that it had a triple portico a mile long. There was a pond, too, like a sea, surrounded with buildings to represent cities, besides tracts of country, varied by tilled fields, vineyards, pastures and woods, with great numbers of wild and domestic animals. In the rest of the palace all parts were overlaid with gold and adorned with gems and mother-of-pearl. There were dining rooms with fretted ceilings of ivory, whose panels could turn and shower down flowers, and were fitted with pipes for sprinkling the guests with perfumes. The main banquet hall was circular and constantly revolved day and night, like the heavens. He had baths supplied with sea water and sulphur water. When the palace was finished in this manner and he dedicated it, he deigned to say nothing more than that he was at last beginning to be housed like a human being.
>
> (Translated by William L. MacDonald)

The Golden House was not just a complex of buildings, but a vast pleasure park, for in that age *domus* (like the later Italian *villa*) meant a whole establishment—a palace, gardens, ponds, and fields. Nero's Golden House, like Xanadu's imaginary Pleasure Dome, was set in a delightful rural landscape (*rus in urbe*), which he had transported into the very heart of Rome. Much is still to be learned from future archaeological excavations. But we already know that Suetonius gave us only a hint of the palatial fantasies. There was good reason for wiseacres in the Forum to warn: "All Rome is being made into a villa! Flee to Veii [an old Etruscan stronghold twelve miles north]—until the villa spreads to Veii."

Nero's Golden House broke "the tyranny of the right angle." Even the great courtyard in the center of the façade splayed out its flanks to make three sides of an irregular hexagon. The grounds of the Golden House, as we have seen, abounded in fantasy. The idea of a rural villa in the heart of Rome was itself fantastic. An artificial lake, on the low ground where the

Colosseum would later stand, was surrounded by villages in the varieties of Greek classic architecture—a bizarre encyclopedic museum of the long Roman tradition of country villas.

Embedded in the center of the east wing, his octagonal hall with its circular canopy of concrete marked a new departure in architecture. It used man-made stone—Roman-improved concrete—to make almost any kind of shape. Here the vaults that had served the practical purposes of baths and of basilicas converged. The straight walls of an octagon merged into the smooth curves of a dome, creating a salon with a circular opening in the center. Fountains cascading down the rear completed the fluid spectacle. Interest now focused on the interior to create a new sense of closure. Light streaming down from the center and filtering between the columns that elevated the dome made this interior world newly autonomous. The elements of the Roman revolution in architecture were all there. Concrete-domed space now offered men interior heavens of their own creation and the domed interior, as we shall see, became a man-made New World.

The emperors who succeeded Nero were eager to relieve themselves of the odium of the expropriation that had provided the land for the palace, and they displaced Nero's palace by monuments to their own generosity. Aided by the Roman fires of 80 and 104, they erased the traces of Nero's megalomania. The low ground that Nero had made into an artificial lake to improve the vista from his palace became the site of the Colosseum (Flavian Amphitheater) for free public entertainment. On top of what had been the domestic wing of the Golden House, Trajan built grand public baths, where all could enter without charge. Under Domitian, Nero's porticoes around the Forum became an elegant shopping center. Only seventy years after its construction, all that remained of Nero's prodigious Golden House was the lonely 120-foot gilded statue of Nero. Legend reported that, after Nero, each emperor put the image of his head in place of Nero's. Unfortunately, the powerful early popes did not follow this example, but simply destroyed the statue.

The secular emphasis of the Roman architecture was signaled in the very names they gave to their grandest works. The Greeks knew their monumental buildings by the names of the gods whom they honored—the Parthenon (after *Parthenos,* the virgin goddess, Athena), or the Temple of Olympian Zeus. But Romans knew their architectural monuments by the names of the emperors who had them built—Nero's Domus Aurea, the Flavian Amphitheater (the Colosseum), Hadrian's Pantheon, the Baths of Caracalla. Roman architects never attained the celebrity of architects in later ages and received little credit for their most famous Roman buildings. The principal architect of Nero's Golden House was probably Severus, but we know little

about him or the team of specialists he supervised, despite the radical novelty of the building he helped shape.

Romans had forgotten where the Golden House had stood when, in the fifteenth century, they dug under Trajan's Baths and came upon rooms that had been part of Nero's domestic wing. They could not explain these underground rooms painted in the Pompeiian style, and assumed that they were originally decorated grottoes. Later, Raphael, who had an intense interest in ancient Roman remains, had himself lowered down on ropes to study the "grottoes." Raphael imitated the style of the "grotto" walls, in which fantastic forms of people and animals were intermingled with flowers, garlands, and arabesques into a symmetrical design, when he painted the Vatican loggias. This was called *grottesche*—in the style of the grottoes. "Grotesk," William Aglionby's English treatise on painting explained in 1686, "is properly the Painting that is found under Ground in the Ruines of Rome." After Raphael (1483–1520), the word became popular for distorted, exaggerated, or humorous forms in painting or sculpture. And so today Nero's bizarre ambitions survive secretly in our everyday language.

If Nero's buildings were soon torn down, their example lived on. Twenty-five years after the Golden House, Domitian's palace, benefiting from still further improvements in the quality of concrete, followed the Neronian example with domes and curves enlivening even the domestic wing. In another twenty-five years, the newly liberated architecture flowered in Hadrian's villa, a curvesome world where people took for granted their gently shaping interiors.

14

Dome of the World

BY a lucky accident of history, the best-preserved monument of ancient Rome, the Pantheon, is the triumph of the Roman revolution in architecture. That triumph survives, too, within our daily sight—in churches and mosques and synagogues, in urban chapels and country seats, in the political capitals of monarchies, dictatorships, and democracies. The dome of Hadrian's Pantheon lives on across the West, proclaiming the triumph of art over politics. Peoples who never knew the Roman Empire, nor ever were

governed by Roman law, could not resist the grandeur of Roman architecture. The dome of the Pantheon has been imitated to exalt the God of the Hebrews, the Savior of Christians, the Allah of Muslims, and the Sovereignty of the People.

This versatility of the Pantheon style is no wonder, for it was a "canopied void." A symbol of man's ability to make space his own, Hadrian's dome provided a man-made emptiness for every religion and every nation to fill in its own way. Here we see at the same time a plain symbol of man's power, of the emptiness of that power and man's impatience to fill that void with something of his creation.

When we visit the Pantheon today in Rome we find it hard to think of it as a triumph of prosaic and prudent organization. On the Campus Martius we see a vast domed cylinder fronted by a columned and pedimented porch in the familiar Greek style. As we pass through the porch, however, and enter the empty circular hall which *is* the Pantheon, we are overawed by its simple rotundity. This man-made world has as its own sky a coffered dome with its own light, through a large (twenty-seven feet in diameter) circular opening (or oculus) at the top. After the familiar solidity of the stone columns and flat ceilings of the entrance we are suddenly struck by the comprehensive openness of the interior. As the focused sun streams through the oculus, the building becomes a vast orrery, recording in the movement of sunlight the revolutions of the earth.

This triumph of what was most distinctly Roman in architecture was the creation of one of the most passionate Roman devotees of Greece, Hadrian (born 76; emperor 117–138). He actually did for the Greeks what they could never do for themselves when he formed a single Greek federation with headquarters in Athens. And he gave equal representation to all the Greek cities. He codified the Athenians' laws, and completed their Temple of Olympian Zeus. Having rebuilt the shrines of Delphi, he was personally initiated into the mysteries at Eleusis. He assumed the title Olympius proclaiming a Grecophile Roman emperor who admired beauty everywhere.

The Golden House of Nero, the Pantheon of Hadrian, the Hagia Sophia of Justinian, the Abbé Suger's St.-Denis, and more recently the Versailles of Louis XIV—all celebrate their inspirer and organizer rather than the technicians and professionals who designed and built them. The epoch-marking buildings have commonly fulfilled the vision of amateurs. These eponyms had the power and the will to do what expert builders and traditional craftsmen dared not.

Architecture, precisely because it is so collaborative, has opened opportunities for the amateur to try new stratagems, outrageous and expensive novelties. For centuries, only princes and popes and Maecenases could commission paintings and sculpture, could command marches, sonatas, and

symphonies to be composed, could hire eulogies, epics, lyrics, and threnodies. But the designs themselves were the works of the artists. Pope Paul III could order Michelangelo to decorate the Sistine Chapel but could not design it. Architecture was different. Since the fulfillment required vast resources and the labor of many men, the sovereign could play the architect and create the design.

In the reign of Trajan, who preceded Hadrian, Apollodorus of Damascus (c.20–c.130?) was the emperor's minister of works and chief engineer, designer of Trajan's forum, concert hall, and baths, and of several triumphal arches. Trajan's famous bridge across the Danube, which Apollodorus built, was the emperor's proof that the Empire would not be bounded by a mere river. Here Trajan showed "that there might be no obstacle to his going against the barbarians beyond it." The bridge itself became a symbol of the difference between the prudent Hadrian and his expansive predecessors. Hadrian destroyed the Danube bridge, fearing that it might help the barbarians to invade the Empire.

But in architecture Hadrian had the arrogance of the amateur. His own pretensions as an architect made the celebrated Apollodorus an irritant. Hadrian's envy of the great architect-engineer of his age produced the legend that Hadrian banished and then executed Apollodorus. Historic encounters between Apollodorus and Hadrian were still being reported by Dio Cassius a century later. Once when Emperor Trajan was consulting Apollodorus, Hadrian interrupted with some comment. At the time, it seems, Hadrian had been making architectural drawings of his own. Then Apollodorus impatiently retorted to Hadrian, "Be off, and draw your pumpkins. You don't understand any of these matters." Hadrian could never forget the slight. Yet as emperor he still sought the eminent professional's counsel. When Hadrian sent Apollodorus his own design for the Temple of Venus and Rome, he formally asked the architect's opinion. Bluntly Apollodorus replied that the temple should have been built on higher ground to make it stand out more conspicuously on the Sacred Way. Within the temple itself, Apollodorus added, the statues had been made too tall for the height of the cella. "For now, if the goddesses wish to get up and go out, they will be unable to do so." Hadrian was understandably vexed, not only to be criticized so freely, but especially because the mistakes by this time could not be corrected.

If Hadrian was no expert architect, he was an enthusiastic and tireless builder, a model of the cultivated ruler. The roster of Roman emperors lists megalomaniacs, paranoiacs, matricides, and wife murderers. But the list could dazzle us also with the philosophical, poetic, and architectural talents of Roman emperors who sought immortality in the arts. Of these none excelled Hadrian. "His nature," the uncharitable Dio Cassius (155?–post

230) wrote, "was such that he was jealous not only of the living but also of the dead." And, we might add even of the unborn, whom he was determined to impress.

Born in Rome in 76, Hadrian was only nine when his father died, and he was put in the care of his father's cousin, the future emperor Trajan. In Trajan's childless household, Hadrian was the emperor's favorite; he married Trajan's grandniece, and became the heir apparent. By the unusually early age of thirty, even while still fighting alongside Trajan in distant Dacia, he was made praetor. After the whimsical oscillations of court favor, Trajan formally adopted Hadrian as his successor just before his death in 117.

As emperor, Hadrian aimed to consolidate rather than extend the Empire. He traveled all across the Roman world from Britain to Palestine enforcing discipline and fortifying borders. In an age when absence from Rome was an invitation to rebellion by ambitious rivals, Hadrian showed self-confidence by his extended travels. Ruthless execution of his enemies, which he regularly blamed on others, helped him hold power for more than twenty years.

Monuments of Hadrian's ambitions, whims, enthusiasms, and prejudices were spread across the Empire. In northern Britain his great stone wall from Wallsend-on-Tyne to Bowness-on-Solway held the frontier against the barbarians. On one of his travels in Asia Minor he fell in love with a handsome youth named Antinoüs (born c.110) and made him his companion. When Antinoüs drowned in the Nile in 130 there were rumors that he had sacrificed himself for some mysterious purpose. To assuage the emperor's grief, cults of Antinoüs sprang up across the Empire, and statues of Antinoüs became familiar. A city in Egypt was christened Antinoöpolis.

In the early 130s Hadrian had ordered a ban on circumcision, probably because of his horror of physical mutilation. He had made castration a crime equal to murder. But he ignored the sacred significance of circumcision for the Jews. In 134, protesting Hadrian's prohibition of their ritual, the Jews of Judaea, led by Bar Kokhba, rose in revolt. Then Hadrian's officers dissolved Judaea, which became Syria Palaestina under a consular legate and two Roman legions. In this way Hadrian made the Jews a "homeless" people, and created the Jewish Diaspora.

"The explorer of everything interesting" (*omnium curiositatum explorator*) was Tertullian's (160?–230?) praise of Hadrian. He showed his administrative talents in codifying the praetor's edicts to make the laws more certain, and in humanizing the treatment of slaves. Hadrian's creative spirit was best expressed in architecture. The remains of his villa at Tivoli sixteen miles northeast of Rome still charm the tourist. The original country palace, stretching a full mile, displayed his experimental fantasy. There, on the

shores of artificial lakes and on gently rolling hills groups of buildings celebrated Hadrian's travels in the styles of famous cities he had visited with replicas of the best he had seen. The versatile charms of the Roman baths complemented ample guest quarters, libraries, terraces, shops, museums, casinos, meeting rooms, and endless garden walks. There were three theaters, a stadium, an academy, and some large buildings whose functions we still cannot fathom. Here was a country version of Nero's Golden House.

Tivoli's historic significance is less in its grandeur than in its wonderfully relaxed way of shaping the relics of the right-angled Greek masses into curves and vaults and domes. The emperor's circular island retreat, the Teatro Marittimo, enclosed concave and convex chambers. Tivoli displayed every conceivable form of arch and undulation. There were temples to assorted gods, including one to the Greek-Egyptian god Serapis. The vestibule of the Piazza d'Oro was covered by a curious pumpkin vault, of the design that had excited Apollodorus' ridicule. The new architecture of interiors revealed itself too in the outward shapes. The exterior of the Piazza d'Oro expressed the curved interior, which was the heart of the building. The architecture of mass was being displaced by an architecture of space, no longer piling and hewing stone for the outside viewer, but creating a novel world within.

Hadrian's Pantheon in the heart of Rome, like Nero's renewal of the city, was another example of how catastrophe sparks creativity. For, like the Parthenon, it was not the first public building on its site. There Marcus Agrippa (64?-17? B.C.), friend of Augustus, had built an earlier Pantheon, which was destroyed by the fire of 80. Rebuilt by Domitian, it was again destroyed by fire in 110. This gave Hadrian his opportunity.

In his new Pantheon, Hadrian would exploit all the possibilities of concrete with bold design and engineering technology. Astonishingly his building still stands for us to see. It stands because, having been consecrated as a church, it was cared for through the ages. But it must be experienced from within. It was perhaps the first great ancient monument designed as an interior. In its dazzling burnished void we are overwhelmed by the challenging circular emptiness of a rotunda 150 feet (43.3 meters) across and of precisely the same height. The natural light pouring through a circular open skylight reminds us that the natural world is still out there. Eight piers mark semicircular chambers serving as niches. But our eyes are carried upward to the coffered dome.

Modern architects are awed by the ingenuity that used an intricate scheme of concrete brick-reinforced arches to overarch so vast an opening and for eighteen hundred years bore the concrete dome's enormous weight. What made this possible was artificial stone shaped to order in the very

place where it would be used. This first required a forest of timbers, beams, and struts to provide the hemispherical dome of wood on which the concrete could be poured. Concrete comprised nine tenths of the whole building. Brick only gave body and strength to the concrete and carried down the thrust of the weight. Marble facings and mosaic fragments were just veneer.

Concrete, too, was at the very foundation where it provided a solid deep ring on which the whole rested. For the rotunda walls concrete had been poured into trenches of a thin brick shell. As each layer dried, another brick shell was provided to make a trench for more concrete. And so it went until the terrace level from which the dome curved inward. At this point the timbers provided a wooden dome on which to pour the concrete. And negative wooden molds had been prepared to impress the shapes of the receding coffers.

The Romans had mastered some surprising subtleties with their rough raw material. Their concrete always included an "aggregate" of broken rocks. While these fragments, heavier than the matrix of lime and pozzolana and sand, increased the mass of the concrete and its supporting capacity, they also increased the weight. The higher up one went in the structure, the less need there was to support weight and the more desirable that the material itself should have less weight. A close study of the concrete used in the rising levels of the Pantheon shows an astonishing subtle variation. The weight of aggregate used in the concrete decreases in regular layers upward in the building. The heaviest chunks of aggregate are in the foundations, and then they become lighter in the lower walls. The aggregate in the concrete of the topmost part of the dome is fragments of pumice, one of the lightest of volcanic rocks.

The idea of an intricate wooden frame large and strong enough to support the concrete cast for the Pantheon dome staggered the medieval imagination. So they created a plausible legendary alternative. Was it not possible instead that Hadrian's engineers had heaped up inside the rising Pantheon walls an enormous rounded mound of earth on which the cement dome could be cast? Of course this posed a new problem of how to clear the earth from the finished cylinder once the cement had dried. For this too they conjectured a solution. The shrewd Hadrian, they suggested, had the foresight to seed the earth with pieces of gold as the mound was built, and so left an automatic incentive for workers clearing the mound when the concrete vault had hardened in place.

To be an architect in concrete required creative organization and timing far beyond those needed for building in cut stone. For stones could be cut to size in advance, set aside, and then fitted as needed. But precisely because concrete was formless it was more demanding, taking shape only as it was

put in place. At some stages one layer of concrete had to be fully dried
before another was put on, at other points the layers were to be merged. At
still others, like the top horizontal circles of the dome, the concrete had to
be still tacky to take the rings of tiles around the oculus. The disciplined
gangs of labor in Rome were put to good use. Scores of workmen were timed
to arrive at the point where the mortar had dried, while others were climb-
ing up and down ramps to deliver the concrete and the supporting bricks.
Some manipulated cranes, and still others clambered up the inner wooden
scaffolding, ready to fit facings of marble or trims of bronze.

Once the forest of timbers was removed, the visitor felt himself in a
man-made cosmos. When the sun, "the eye of Zeus," streamed through the
oculus at the crest of the dome the whole building became a planetarium.
Some called the effect of this heavenly light in the man-made cosmos an
"epiphany"—a sudden manifestation of an otherworldly being. "Pantheon"
meant temple of all the gods (*templum deorum omnium*). "Perhaps it has
this name," the historian Dio Cassius (155?–post 230) observed a century
later, "because it received among the images which decorated it the statues
of many gods, including Mars and Venus; but my own opinion of the name
is that because of its dome the Pantheon resembles the heavens." Religious
and imperial symbolism combined, for the Roman dominions were as exten-
sive as the heavens, which were both the habitat of the gods and "the canopy
of empire." Only a temple of all the gods could celebrate a state that
encompassed the world, and Romans called their Pantheon the temple of
the world.

It still carried this message a millennium later. Stendhal found it the very
embodiment of the sublime. Shelley, while confessing his "propensity to
admire," reported his impressions on March 23, 1819:

> The effect of the Pantheon is totally the reverse of that of St. Peter's. Though
> not a fourth part of the size, it is, as it were, the visible image of the universe;
> in the perfection of its proportions, as when you regard the unmeasured dome
> of heaven, the idea of magnitude is swallowed up and lost. It is open to the sky,
> and its wide dome is lighted by the ever-changing illumination of the air. The
> clouds of noon fly over it, and at night the keen stars are seen through the azure
> darkness, hanging immoveably, or driving after the driving moon among the
> clouds. We visited it by moonlight. . . .

While the Pantheon remains wondrously intact in its domed perfection, it
has suffered minor pillages. The Pantheon we see today is not all that
Hadrian dedicated in 128. The building was originally fronted by an exten-
sive rectangular columned forecourt as long as the Pantheon itself. Some

modern visitors have been disturbed by the present angular pedimented porch. But a circular building needed a clear signal of its entrance. This the Grecophile Hadrian supplied by a conventional form that might have satisfied Vitruvius, and may even have been built to his textbook specifications. But after this obeisance to tradition, Hadrian made his own radical advance. The first Pantheon, by Agrippa (c.25 B.C.), had been noted for its caryatids in the familiar Greek orders. Hadrian moved on to the dome. And the same subtle relations between the square, the circle, and the human figure, which Vitruvius had explained, were embodied in the Pantheon rotunda. It was these Vitruvian proportions that Leonardo da Vinci would celebrate. The dome rises from a wall above the paving exactly equal to its own height. In the vertical section the rotunda is half a circle inscribed in the upper half of a square. And the radius of the dome appears to be the same as the interior height of the cylinder.

The preservation of the Pantheon, despite the anti-pagan enthusiasms of the early Middle Ages, was itself a miracle. It was luckily still standing in 608, when Emperor Phocas in Constantinople allowed Pope Boniface IV to consecrate it as a church "after the pagan filth was removed . . . so that the commemoration of the saints would take place henceforth where not gods but demons were formerly worshipped." For the five intervening centuries, while the surrounding buildings fell into ruin, the Pantheon had survived. Its metal fittings tempted robbers. The Byzantine emperor Constans II visited Rome long enough to take away its gilded bronze roof tiles, of which he was promptly robbed by Arab pirates off Sicily. The popes tried to improve the structure by adding towers to the front. The belligerent and profligate Pope Urban VIII (1568–1644; pope, 1632–1644) of the aristocratic Barberini family of Florence, the ally of Richelieu—and who first supported, then condemned, Galileo—was an architectural enthusiast. Patron of Bernini, he adored the Pantheon. In 1632 he inscribed on the back of the porch, "Pantheon, the most celebrated edifice in the whole world" (*Pantheon aedificium toto terrarum orbe celeberrium*). Then he proceeded to strip off the bronze from the roof beams of the Pantheon porch for one of his own projects. "What was not done by the barbarians," the Roman wits quipped, "was done by the Barberinis" (*Quod non fecerunt barberi, fecerunt Barberini*). The Pantheon metal appears to have been used to cast eighty cannon to be emplaced on the Castel Sant' Angelo, the colossal circular stone mausoleum that Hadrian had built for himself. Urban VIII argued that it was better to use the metal to defend the Holy See than simply to keep rain off the Pantheon porch. Still somehow the Pantheon has managed to retain its original bronze doors.

Despite minor desecrations, the Pantheon has remained the grand symbol of a new age in architecture. Until the twentieth century it was reputed

to be the largest dome ever built (141 feet in diameter). While Hadrian left a bold mark on the architecture of Rome and the West, he was curiously reluctant to leave his name. Having rebuilt Agrippa's Pantheon, instead of inscribing his own name, he misled historians by restoring Agrippa's original inscription, "Marcus Agrippa, son of Lucius, three times consul, built this" (M. AGRIPPA. L.F. COS. TERTIUM fecit). But the dated bricks leave no doubt that the Pantheon was built between 118 and 128, under Hadrian. Probably it was less modesty than willfulness that made him refuse to sign the greatest architectural monument of the age. No wonder the ancients found him a baffling character—"niggardly and generous, deceitful and straightforward, cruel and merciful, and always in all things changeable." In 1520 the artist Raphael (1483–1520) chose to be buried there. In the nineteenth century, it became the tomb of the first two kings of the new Italian nation.

One of the versatile Hadrian's most memorable creations was the plaintive verse he wrote on his deathbed:

> Animula vagula blandula,
> Hospes comesque corporis,
> Quae nunc abibis in loca
> Pallidula rigida nudula,
> Nec ut soles dabis iocos. *Ad animam suam*
> (Little soul, wandering gentle guest and companion of the
> body, into what places will you now go, pale, stiff, and
> naked, no longer sporting as you did!)

And Hadrian did create a grand resting place for his body. His mausoleum, employed as the core of the Castel Sant' Angelo, begun in 135, three years before his death, remains even more conspicuous and more familiar to the tourist than the Pantheon. Mausoleums were usually round, and this too was a rotunda, a vast stone drum faced with marble and surrounded by statues. On top in the middle was a roof garden in the Babylonian style. He made it rotund to imitate the tomb of his idol Augustus, but far exceeded it in magnificence. This was also a final monument to the departed architecture of mass, for it had no significant interior, only a burial chamber. It would provide the setting for the tragic last act of Puccini's *Tosca*. And the future of Western public architecture lay in the fertile afterlife of the Pantheon.

15

The Great Church

CHRISTIANITY created its own reasons for transforming architecture. In the Greek and Roman cults, which Christianity would displace, the temple was the dwelling of the god. Athena's statue was housed in the cella, the inmost chamber of the Parthenon, to which only the priests had access. The public offered devotions on an altar outside, and in games, horse races, or musical contests, climaxing every year in a festive Panathenaean procession. In Christianity the temple became a church, a place of indoor assembly. It took its name from the Greek word for assembly, *ekklesia* (from which derives "ecclesiastical"), which could mean either the building or the community gathered within.

The Christian church followed the tradition of the Jewish synagogue, which also was an assembly hall. "Synagogue," for the Jews' ancient gathering place, a place of worship and study, came from the Greek word "to bring together" (*synagein*). But in the long run church architecture would owe less to the synagogue than to Roman public buildings. The Roman basilica, as we have seen, with its large rectangular interior, designed for baths or law courts, was well suited for Christian assembly, prayer, and liturgy. The apse at one end, with its raised platform where the judges sat, was easily adapted for the altar on which all could see the priest perform the Mass. The needs of Christian liturgy were not well served by the classic Greek architecture of post and beam, of masses ornamented to impress the viewer on the outside. Still, some early Christian churches (such as San Paolo in Rome) were of post-and-beam construction with trussed wood roofs. Christian churches needed large *interior* spaces. And they would be served, too, by heaven-shaped ceilings, arches, and domes emphasizing the common upreach of the praying congregants to another world. But vaults and domes did not appear in Western churches before the sixth century.

The dome, which Roman concrete had made possible, gave a new grandeur to the aspiring interior. Still, the diameter of even so grand a dome as

the Pantheon was not ample enough for the thousands of Christian worshipers expected to assemble for pomp and prayer, nor was it suited for the Christian liturgy. There had to be another idea. But the Pantheon had left an indelible mark on architecture. And for eighteen hundred years the Pantheon motif, a high domed rotunda behind a templelike entrance, would reappear across the West, and outlive changing styles—Renaissance, baroque, rococo, modern. A domed rotunda of stone was built by Roman legionnaires in remote Scotland, a Pantheon-like mausoleum for Diocletian arose at Split in Yugoslavia, and the first Church of the Holy Sepulcher in Jerusalem was said to be on a similar plan. Countless early Christian churches still remind us of the Pantheon. The greatest Renaissance architects modeled their work on this building that they called Santa Maria Rotonda, "Round Saint Mary." The Pantheon was reincarnated again and again and in delightful variants by Palladio and his disciples and imitators on the English countryside. No architectural design after classic Greece had so widespread, so versatile, and so enduring a power.

In his long reign Emperor Justinian (483–565; reigned 527–565) made the Mediterranean once again a Roman lake, and celebrated the climax of ancient Roman Christianity. He restored the fabric of empire across Africa, Spain, and Italy with his phenomenal generals Belisarius and Narses, and rebuilt the Eastern capital at Constantinople. His lasting monument was the Great Church.

But in the cultural panorama of the West, Justinian, the emperor of grand Christian hopes, has received less than his due. Byzantium survives only in our peripheral vision. Which is unfortunate, because Byzantium's very location on the eastern edges of the Roman Empire was a Fertile Verge where Roman ways met the novel and exotic. Justinian's enduring work bridged time and space, this world and the next, the sacred and the secular. His career revealed the social mobility in the Eastern Empire of this period and showed that, with enough luck, the career was open to talents, even onto the imperial throne. Born Petrus Sabbatius to an obscure peasant family in a village in what became Yugoslavia, he was lucky in his uncle, the able and ambitious Justin, who had gone to Constantinople and risen in the army of the emperor. Young Petrus Sabbatius (later known as Justinian) must have been about eight when his uncle sent for him and catapulted him into the high life of the capital. Justin himself had little education, and was said to need a wooden stencil to sign his name. But he provided his nephew with a solid education in Greek and Latin, and had him trained for a military career. When the aging Justin (452–527) became emperor in 518 he made Justinian his chief counselor, then his co-emperor in 527, a few months before his death. And when Justinian became emperor in his own right, he had the grandiose hope to reunify the Empire and give a new unity to Christendom.

Much of what Justinian created came from his orderly, organizing mind and his ambitious, if volatile, imagination. Inspired by the power of ideas, he fancied himself a theologian, but his great talent was as a lawmaker. When he became emperor in 527, the institutions of Roman law were a disordered inheritance. To codify and clarify Roman law and make it teachable he found a talented lawyer, Tribonian (died 545), who shared his passion for legal order and possessed the necessary technical knowledge and experience. Six years' labor by Tribonian and the sixteen lawyers on his commission produced the most influential secular codification in history. Justinian hoped "with the help of Almighty God . . . to cut short the prolixity of lawsuits by pruning the multitude of enactments." Justinian's *Code* (Codex, 529) provided a definitive selection of imperial enactments, and copies were sent to all the provinces.

In addition, the prodigious *Digest* (533) had the utopian purpose of permanently reducing the number of legal opinions. The commission had examined two thousand books by reputable lawyers, and reduced them to one twentieth their bulk by selecting only items of enduring value. Their new elementary textbook, the *Institutes,* had the force of law. And the emperor optimistically forbade commentaries. Greek was the language of most citizens of Constantinople, but the commission's product was in Latin, Justinian's native language. The *Corpus Juris Civilis,* as the whole codifying work came to be called, had no effective competition in the West for thirteen hundred years, and the Roman Empire survived in Justinian's Byzantine legal incarnation.

As we shall see, this inheritance might not have become ours had Justinian never married the bewitching demimondaine, Theodora, one of three daughters of a bear keeper in the Hippodrome in Constantinople. The child Theodora began as a stagehand for her elder sister, who, according to Procopius, "was already one of the most popular harlots of the day. . . . As soon as she was old enough and fully developed, she joined the women on the stage and promptly became a courtesan, of the type our ancestors called 'the dregs of the army.' " Her sexual energy became a byword. "Often she would go to a bring-your-own-food dinner-party with ten young men or more, all at the peak of their physical powers and with fornication as their chief object in life, and would lie with all her fellow-diners in turn the whole night long: when she had reduced them all to a state of exhaustion she would go to their menials, as many as thirty on occasions, and copulate with every one of them; but not even so could she satisfy her lust." Who would have predicted that she would become an emperor's faithful wife, a passionate Christian theologian, and the most powerful empress in the history of the Roman Empire?

Suddenly and unaccountably, Theodora abandoned her lascivious ways, settled in a modest house near the palace, and earned her living by spinning

wool. Attracted by Theodora's beauty, wit, intelligence, and youth, Justinian determined to marry her, and persuaded his uncle, Emperor Justin, to raise Theodora to the rank of patrician. Roman law still forbade any senator to marry an actress, and his straitlaced aunt, Empress Euphemia, would not tolerate a harlot in the palace. But when Euphemia died, Justinian was free to marry Theodora in 525, which he did. He then had her crowned Augusta, which gave her some title to divinity, and for the rest of her life she shared the imperial power.

Since there were no political parties in Constantinople, frustrated political passions were expressed in the sports arena. The Hippodrome of Constantinople—about two thousand by six hundred feet—which became the model of modern circuses, had been completed by Constantine in 330, and was the largest of the ancient world. The Hippodrome took its name from the fact that it was designed for horse racing, but it was also a place for entertaining the populace with the death struggles of men and beasts. When Justinian came to the throne in 527, the passions of the Blues and the Greens in the Hippodrome were running high. Justinian identified with the Blues, who years before had befriended Theodora and her sisters when their bear-keeper father had died. Rival toughs of both parties united against Justinian's reforms under the name of Nika (Victory). Assembled in the Hippodrome, they demanded that Justinian dismiss his ministers, and Justinian hastily agreed.

The irresolute Justinian prepared to flee. But the iron-willed Theodora persuaded him to stay and turn his general Belisarius on the mob in the Hippodrome. Some thirty thousand were massacred, but not before much of Constantinople was burned to the ground. Justinian and Theodora remained in power, which made possible their monuments for posterity.

Once again catastrophe was a catalyst to creativity. Like the burning of Rome five centuries before, which gave Nero his opportunity, the Nika holocaust of Constantinople in 532 gave Justinian his invitation.

The church that Constantine had built on the foundations of a pagan temple in 325 had been destroyed by fire in 415 and again rebuilt, only to be demolished by the Nika. "So the whole church at the time lay a charred mass of ruins," Procopius explained. "But the emperor Justinian built not long afterwards a church so finely shaped that if anyone had enquired of the Christians before the burning if it would be their wish that the church should be destroyed and one like this should take its place, showing them some sort of model of the building we now see, it seems to me that they would have prayed that they might see their church destroyed forthwith, in order that the building might be converted into its present form."

While the emperor gathered artisans from the whole world, God provided architects close at hand: "Anthemius of Tralles, the most learned man

in the skilled craft which is known as the art of building" in all living memory and associated with him Isidorus, a Milesian. Plans were prepared in less than six weeks, and on February 23, 532, only thirty-nine days after the Great Fire, work began on Justinian's Great Church.

Anthemius (died before 558), from a cultivated family near Izmir in western Asia Minor, was the last of the great architects of the Roman Empire. With a cosmopolitan education in Alexandria, he was a man of many talents. He earned fame in the Middle Ages for his works of mathematics and geometry on the properties of cones and parabolas. He was said to have been the first to show that an ellipse could be drawn by a string looped around two fixed points. Fascinated by the properties of mirrors, he produced a work on this subject still used in the eighteenth century. He also was a practical joker. When he lost a lawsuit in Constantinople to a certain Zeno, he secretly installed a steam-driven device in Zeno's cellar to make the building shake, and so forced Zeno to abandon his house for fear of an earthquake. When Anthemius was brought before Justinian, the emperor simply said that his own imperial powers could not compete against Zeus' thunder or Poseidon's earthquakes.

Master builders, who worked by rule of thumb, were not hard to find in Constantinople. Since Constantine's time churches there had mostly followed the traditional basilica design, a rectangular hall with a pitched or vaulted roof. Such a roof also covered the round or hexagonal churches over the tombs of martyrs. Master builders were adept at these simple structures. But an architecture interfusing shapes and spaces would demand Anthemius's sophisticated mathematics of cones and parabolas and ellipses.

It is not easy to define the precise role of Justinian in creating the Great Church. The grand concept was almost certainly his. Architecture, as we have seen, gave the amateur, if he was a sovereign, a unique opportunity to be a creator. And awe of the emperor automatically gave him credit for all the great works of architecture built in his reign. Since it was a king's duty to accommodate his people by grand public works, monuments of antiquity bear the fame and usually, too, the name, of ruling kings. "To watch over the whole Roman Empire, and so far as was possible, to remake it," was how Procopius described Justinian's mission. Perhaps at Justinian's command, or at least with his encouragement, Procopius wrote *Buildings*, a whole book describing the emperor's architectural works "so that it may not come to pass in the future that those who see them refuse, by reason of their great number and magnitude, to believe that they are in truth the works of one man."

The grandest of Justinian's buildings survives for us to see. The Great Church, as it came to be called, known in Greek as Hagia Sophia—Church

of the Holy Wisdom—combined as never before the novel features of the revolutionary Roman architecture, and on a scale never before thought possible. To place a Dome of the World over the largest basilica ever made would require the utmost expertise of the geometer-mathematician-engineer. The result would be a mystifying new feeling of interior space, and of the relation between this world and the next.

The need for this new grandeur was not so much theological as ecclesiastical. For the worship of the early Christians a simple hall (or even a cave or catacomb) had served. But by the fourth century, when Christianity was in the care of a Roman emperor, the Church began to mimic the ceremony and the splendor of the state. The simple barnlike interior of the basilica would not do. What was needed was a domed basilica, but this raised new architectural problems. In the Pantheon, a dome over a rotunda, the rotunda walls had provided an unbroken uniform support. But how place a dome over a square? How preserve the rotund elegance and yet keep the whole open for assembly?

Here was a problem in both solid geometry and engineering. One solution was pendentives, spherical triangular pieces of vaulting reaching up from each corner of the supporting structure to hold up the base of the dome. The first large dome to be so supported was this dome of Justinian's Great Church of the Holy Wisdom, a monument to Anthemius's mastery of geometry as much as to his engineering skill. Another less elegant device was the squinch, a corner filler of diagonal masonry that transformed the square, step by step into a round shape to support the dome. Some of these squinches would be added to Hagia Sophia in later years. The "secret" of how to balance a dome over a square was the great contribution of Byzantium to architecture. It was a symbol, too, of Byzantine efforts to borrow the panoply of this world to embellish the next. Procopius described the product:

> So the church has become a spectacle of marvellous beauty, overwhelming to those who see it, but to those who know it by hearsay altogether incredible. . . . Yet it seems not to rest upon solid masonry but to cover the space with its golden dome suspended from Heaven. . . . though they turn their attention to every side, and look with contracted brows upon every detail, observers are still unable to understand the skillful craftsmanships, but they always depart from there overwhelmed by the sight. . . . It was by many skilful devices that the Emperor Justinian and the master-builder Anthemius and Isidorus secured the stability of the church, hanging, as it does, in mid-air.
>
> (Translated by H. R. Dewing)

Incidentally, the dome atop a basilica at its central point would suggest a cruciform plan for both the Roman cross and the Greek cross in future churches.

The Great Church, after the Pantheon, is the largest dome surviving from antiquity and the largest vaulting space of any building before modern times. The present dome rises to 184 feet in a building 252 feet long and 234 feet wide. Some of its construction problems came from the fact that the art of casting concrete, which produced the Pantheon, had by Justinian's time been lost or neglected, making it harder to provide a rigid structure to carry down the enormous thrusts. The main structural materials were cut stone and marble, baked brick, wrought iron, and lead. Stone was used on the piers and other points of greatest stress; bricks served for walls, arches, and vaults. The joints of the stone were held together by iron clamps and dowels, rods, and bars. To prevent future fires, Justinian had forbidden any use of wood. The stone courses were held together, not by lime or asphalt but by lead poured in the interstices.

Since money was no object, Justinian used his imperial powers to bring materials from everywhere. In his verse epic Paul the Silentiary, of Justinian's court, sang of marbles of every color and texture—black with white streaks from the Bosporus, green from Carystus or Sparta in Greece, polychrome from Phrygia, silver-flecked porphyry from Egypt, red-and-white veined from the Taurus Mountains in Asia Minor, yellow from Libya, with an effect like meadows of fantastic flowers. Justinian, according to Procopius, had "gathered together all skilled workmen from the whole earth." A hundred foremen, each with a hundred under him, made ten thousand in all. "And fifty foremen with their folk built up the right half of the church and fifty likewise the left, so that through their emulation and zeal the structure was speedily raised."

Their spectacular creation was a vast interior of tantalizing complexity. The wide nave extending east and west was terminated at each end by hemicycles crowned by semidomes, while each semidome was flanked by two semicircular exedras (alcoves) carrying still smaller semidomes. Over all rose the central dome, which gained the impression of self-suspension from the ring of forty-two arched windows side by side around the points where it rose from the base on the basilica. The dome seemed not to rest on stone but to be suspended by a golden chain from heaven, which made the building "marvellous in its grace, but by reason of the seeming insecurity of its composition altogether terrifying." Not only was it miraculous to set a dome so gracefully over a rectangle, but the dome seemed to rest on a ring of light—something the Romans themselves never achieved.

The interior seemed "not illuminated from without by the sun, but . . . the radiance comes into being within," glistening from the spectrum of the world's marbles and the scintillating mosaics. Miscellaneous objects of gold, silver, and brass filled countless niches. The two aisles were separated from the nave by colonnades with gilded capitals. From the rim of the dome brass chains suspended, holding oil lamps of silver with flickering wicks.

The gold-plated silver iconostasis, the screen separating the sanctuary, depicted Christ, the Virgin Mary, and the Apostles, and the gates were ornamented with the monogram of Justinian and Theodora. Paul the Silentiary was dazzled by the red curtains around the altar showing Christ in "a garment shimmering with gold, like the rays of the rosy-fingered dawn, which flashes down to the divine knees, and a chiton, a deep red from the Tyrian shell dye."

As a place of worship could the Great Church ever be excelled? "And whenever anyone enters this church to pray," Procopius reported, "he understands at once that it is not by any human power or skill, but by the influence of God, that this work has been so finely turned. . . . And this does not happen only to one who sees the church for the first time, but . . . on each successive occasion, as though the sight were new each time." From the first moment when he entered the completed building Justinian felt this exhilaration.

On December 27, 537, the interior was cleansed of scaffolding and finally visible in its whole glittering glory. To dedicate the Great Church Justinian emerged from his palace in state in a four-horse chariot. He oversaw the sacrifice of a thousand oxen, six thousand sheep, six hundred stags, one thousand swine, and ten thousand birds and fowl, and gave thirty thousand bushels of meal to the poor and needy. "Thereupon the Emperor Justinian continued on his way with the Cross and the Patriarch; but within the Royal Gates [at the entrance to the nave] he let fall the hand of the Patriarch and hastened on alone into the ambo, and, extending his arms toward heaven, he cried, 'Glory to God, Who has deemed me worthy of fulfilling such a work. O Solomon, I have surpassed thee!' "

To build the Great Church in five years, ten months, and four days was a feat. But later events suggested that the dome may have been erected in undue haste. Perhaps the bold design was more a monument to Anthemius's geometric speculations than to his architectural experience. Uncharitable historians say he proved to be a mere amateur. The dome built by Anthemius exerted a dangerous, outward thrust. Within twenty years, in August 553 and December 557, earthquakes cracked the dome, and on May 7, 558, a large piece of the dome and the adjacent half-dome and the eastern arch collapsed. Luckily the rest of the structure remained. Justinian ordered the dome to be speedily rebuilt. And so it was, by Isidorus the Younger, nephew of the Isidorus who had helped Anthemius. It is this second dome, higher and more stable, that has survived. Isidorus should probably take credit for another first in architectural creation. To support this second dome he built "true" pendentives, independent members with a different curve from the dome that they supported. And he supplied

additional support with a new course of heavy masonry outside at the base of the dome.

The building suffered and survived millennial ravages of nature and of man. Earthquakes in 989 and 1344 left cracks and collapsed some of the arches and half-domes, which were duly repaired. When Constantinople fell to the Crusaders in 1204, they stripped the gold and silver treasures. The changing winds of Christian orthodoxy also took their toll. The Iconoclasts who condemned religious images and icon worship were championed by Emperor Leo III in 726. Icon worshipers were persecuted and Hagia Sophia was piously redecorated to cover up the diabolic images.

The Great Church also lived an eventful modern afterlife. First it became the unpredicted symbol of the conquest of Christianity by Islam. After one of the decisive battles of history, Sultan Mohammed II, undaunted by the defensive chain across the Golden Horn, hauled his fleet overland from the Bosporus. Constantinople fell on May 29, 1453. The Muslim conqueror entered the city, Gibbon recounts, "attended by his viziers, bashaws, and guards, each of whom . . . was robust as Hercules, dexterous as Apollo, and equal in battle to any ten of the race of ordinary mortals. . . . By his command the metropolis of the Eastern church was transformed into a mosque; the rich and portable instruments of superstition had been removed; the crosses were thrown down; and the walls, which were covered with images and mosaics, were washed and purified and restored to a state of naked simplicity." As a consequence, "the dome of St. Sophia itself, the earthly heaven, the second firmament, the vehicle of the cherubim, the throne of the glory of God, was despoiled of the oblations of ages; and the gold and silver, the pearls and jewels, the vases and sacerdotal ornaments, were most wickedly converted to the service of mankind." Minarets and a great chandelier were added and, in place of the scintillating mosaics, chaste calligraphic disks of Arabic letters extolled Allah and the Koran.

For five hundred years the Great Church remained a mosque and never since has it seen Christian worship. In 1921 the Byzantine Institute of America was permitted to begin uncovering and cleaning the mosaics. Then in 1935 Kemal Ataturk (1881–1938), first president of the Turkish Republic, made the Great Church, the Great Mosque, into a museum. And so it became a grand symbol of the power of stone, the transcendence of art over politics and also, perhaps, over religion.

16

A Road Not Taken:
The Japanese Triumph of Wood

WESTERN belief in a Creator-God and creator man has carried with it belief that nature is to be mastered. But the Japanese, for example, who did not have a Creator-God or a myth of beginnings like ours in the West, found another path and have made nature their ally. Their world, like Hesiod's, is a product of procreation. The male and female deities, Izanagi and Izanami, stood on the Floating Bridge of Heaven and thrust down the Heavenly Jeweled Spear into the ocean below. Brine dripping from the spear coagulated into an island on which they lay together. Then Izanami gave birth to the islands of Japan along with the deities of nature—mountains, rivers, trees, and crops.

Their reverent, friendly, and intimate Japanese feelings toward nature have been expressed in an attitude to mountains very different from ours in the West. Japanese country folk have viewed mountain peaks and even smoking volcanoes as collaborating spirits. Hunters revered the mountain *kami,* whom farmers saw protecting them and supplying the water to make their rice grow. It is in the mountains, says Shinto myth, that the purified ancestral spirits dwell after thirty-three or fifty years of waiting in the nearby cemetery. Eventually these ancestral mountain spirits themselves became helpful *kami,* coming down to the rice paddies in spring and returning to their high habitats in the fall.

Cults of the mountain *kami* as early as the Nara period (710–794) nourished the supernatural powers by mountain asceticism and bred belief in mountain magic. The flourishing cult of Mount Fuji (now with more than thirteen hundred shrines) made its majestic volcanic cone the nation's symbol. An ancient folktale reports the contest between Japan's three sacred mountains.

In ancient times Yatsu-ga-take [Mount Haku] was higher than Mt. Fuji. Once the female deity of Fuji [Asama-sama] and the male deity of Yatsu-ga-take

[Gongen-sama] had a contest to see which was higher. They asked the Buddha Amida to decide which was loftier. It was a difficult task. Amida ran a water pipe from the summit of Yatsu-ga-take to the summit of Fuji-san and poured water in the pipe. The water flowed to Fuji-san, so Amida decided that Fuji-san was defeated.

Although Fuji-san was a woman, she was too proud to recognize her defeat. She beat the summit of Yatsu-ga-take with a big stick. So his head was split into eight parts, and that is why Yatsu-ga-take (Eight Peaks) now has eight peaks.

Loyal pilgrims to Mount Fuji, who wanted to see their favorite mountain win, used to leave their sandals at the top to raise its height.

The European fear of mountains delayed the climbing of Mont Blanc, western Europe's highest mountain, till 1786. But there is no period of recorded history when the Japanese were not climbing Mount Fuji. Its symmetrical cone was one of the oldest subjects of their art and poetry. The ascent of Mount Fuji with its ten stations early became a ritual, and the circuit of the crater's rocky peaks carried a high ceremonial meaning of Japanese affinity with nature.

Surprisingly, this feeling has not been shaken by frequent earthquakes. Every year nearly 10 percent of the energy released in the world by earthquakes is concentrated around Japan. In the last century Japan has suffered twenty-three destructive earthquakes. The most disastrous, in 1923, left one hundred thousand dead. Still, the myth of Shinto—the indigenous Japanese religion with its cultic devotion to the deities of nature and its veneration of the emperor as a descendant of the sun goddess—managed even to make earthquakes a token of good cheer. In the very beginning, we are told, when the sun goddess, sister of Susanowo, came out of her cave and brightened the earth, the eight million dancing deities of nature were so delighted that they shook the earth with their shouts of joy, as they still do from time to time.

The omnipresent expression of the traditional Japanese relation to nature is the Shinto belief in *kami.* The Japanese term *kami,* of uncertain origin, is not properly defined by any familiar Western term. According to Motoori Norinaga (1730–1801), the prophet of Shinto in the Edo period, *kami* are found in "such objects as birds, beasts, trees, plants, seas, mountains and so forth. In ancient usage, anything whatsoever which was outside the ordinary, which possessed superior power, or which was awe-inspiring was called kami." Their omnipresence and the need to worship them attest an overarching reverence—equally for the bud of the flower, for the veins and wrinkles on the tiny stone, for the snowcapped Mount Fuji, for a chrysanthemum bush, for a giant cypress, or for ideas like growth or creation. Ancient Shinto, awed by the specificity and uniqueness of all natural objects, gave each its own *kami,* and dared not homogenize the blowing wind and the immobile mountain into any single pallid abstraction.

"So God created man in his own image . . . male and female created he them. . . . and God said unto them, Be fruitful, and multiply, and replenish the earth, and subdue it: and have dominion over the fish of the sea, and over the fowl of the air, and over every living thing that moveth upon the earth." And God made plants for man's sustenance. In Christian theology the "natural" man is evil, because he has not been redeemed from his original sin.

Nothing could be more different from the traditional Japanese view. In the mythology of the *Nihon Shoki,* men and women are the brothers and sisters of all objects in nature. Man has no "dominion" over nature, because he is part of it. He cannot be the master of other creatures, for all are members of the same family. The *kami* are man's collaborators. So landscape painting, which comes only late and slowly in Western art, is an ancient form in Japan, as we have seen that it was in China. There man is an inseparable aspect of the landscape, as the landscape is part of man.

While Western architects would battle the elements, the Japanese, admiring their power, have sought ways to exploit their charms. Western architects used stone to resist the ravages of time, but the Japanese would win by submitting. Conquest by surrender has been familiar in Japanese life. Some say that is the weapon of Japanese women. It is the way of judo (derived from a Chinese word meaning "gentle way"), a sport that aims "to turn an opponent's force to one's own advantage rather than to oppose it directly." By contrast with the belligerence of Western boxing and wrestling, judo promotes an attitude of confidence and calm readiness. The great works of early Western architecture—Stonehenge, the Pyramids, the Parthenon, the Pantheon, Hagia Sophia—were created to defy the climate, the seasons, and the generations. But Japanese architecture became time's collaborator. The Western concern was for survival, the Japanese concern was for renewal. Nature was composed of myriad *kami*, self-renewing forces. Shinto celebrated the reviving seasons, whose omnipresent symbols were flowers and trees.

This Japanese way was revealed in traditional Japanese architecture by the dominance of wood (as in China and Korea), when much of the rest of the world chose the way of stone. Even today the oldest surviving buildings in Japan are made of wood. A facile explanation is that wooden structures were less vulnerable to earthquakes. But history has shown that wooden structures are easy victims of earthquake in addition to being far more vulnerable to fire, typhoon, and hurricane. Where stone was used in the castles of Nagoya and Osaka, apparently in response to European firearms, it survived earthquakes better than wood.

The interior construction of ancient Japanese tombs showed advanced techniques of stone construction (found also in China and Korea), which

have survived in some castle walls and stone bridges. And there are impressive examples of early Japanese stone sculpture. But there is not a single surviving ancient Japanese building of stone. The precocious development of Japanese metallurgy may help us understand their early uses of wood. Stone can be fashioned with stone, as it must have been to shape the mortise-and-tenon stone joints of Stonehenge. Woodworking, fashioning and fitting timbers for large buildings, required tools of iron. And with such tools, however primitive, wood construction was much easier than construction in stone. Other modern civilizations emerged during a Bronze Age before they had iron woodworking tools. Western cultures understandably began their architecture in stone and brick and then stayed with these materials. But even in the primitive Yayoi era (300 B.C.–A.D. 300), when Japanese architecture was born, they had plenty of the iron tools that made the crafting of wood feasible.

In Japan, too, the terrain, the climate, and the rainfall produced flourishing forests. The large stands of the blessed cypress (Japanese "hinoki," *Chamaecyparis obtusa*) proved a happy coincidence. Carpenters' tools of those early times did not include a crosscut saw or the familiar modern plane, and cypress, with its grain running straight along the length of the timber, was suited to these limitations of their tool-chest. From the very beginning the appealing soft texture of cypress and its fragrance encouraged the Japanese to enjoy the unadorned surface. Probably, too, the influence of China, where wood architecture was highly developed, had an effect.

There are of course some advantages to wooden buildings, which we in the West forget. As Edward S. Morse (1838–1925), the pioneer Western student of Japanese culture, explained in 1885, before the epidemic of Westernization:

> . . . the Japanese house . . . answers admirably the purposes for which it was intended. A fire-proof building is certainly beyond the means of a majority of these people, as indeed it is with us; and not being able to build such a dwelling, they have from necessity gone to the other extreme, and built a house whose very structure enables it to be rapidly demolished in the path of a conflagration. Mats, screen-partitions, and even the board ceilings can be quickly packed up and carried away. The roof is rapidly denuded of its tiles and boards, and the skeleton framework left makes but slow fuel for the flames. The efforts of the firemen in checking the progress of a conflagration consist mainly in tearing down these adjustable structures; and in this connection it may be interesting to record the curious fact that oftentimes at a fire the streams are turned, not upon the flames, but upon the men engaged in tearing down the building!

Wood, being an organic material, even after it is cut from the growing tree responds to the weather. The architects of the splendid Shosoin, the imperial treasure repository at Nara, took account of this. The triangular cypress

logs stacked horizontally gave a smooth surface on the interior and a corrugated surface on the outside. In wet weather the logs expand to seal the building, but when it is hot and dry they shrink and create ventilating cracks so the air can circulate within.

The classic examples of Japanese traditional architecture are found at Ise, the most famous Shinto shrine on the south coast of Honshu. Here, better than anywhere else, we witness the distinctive Japanese conquest of time by the arts of renewal. Here, too, we can see how Japanese architecture has been shaped by the special qualities of wood, and how wood has carried the creations of Japanese architects on their own kind of voyage through time. Stone by its survival and its crumbling has often carried messages never intended. But few relics of wood survive the centuries. Those we inherited intact from Egypt were sealed in the bowels of stone tombs and pyramids. Wooden ruins inspire us with a desire to clear them away. They are the makings not of romantic landscapes but of fire hazards and slums. What landscape architect ever decorated a garden with a dilapidated structure of wood? Where are the Piranesis of wooden ruins?

What the wooden shrines at Ise offer us are not architectural relics. These are not the remains of the past. They are not even "monuments" as the Parthenon on the Acropolis, the Temple at Paestum, the Colosseum in Rome are monuments. Though the visitors to Ise match the numbers of tourists who throng the Acropolis in Athens or the Forum in Rome, most come not as tourists. To Ise they can still come for a living experience, to worship at these shrines as their ancestors did when the shrines were first built centuries ago.

Ironic twists of history, and even acts of plunder and of war, have preserved stone relics. If Lord Elgin had not removed (1801–1803) sculptures and architectural fragments from the Parthenon on the Acropolis in Athens and transformed them into the "Elgin Marbles," museum models of classic art, none might ever have survived. But there was a price to pay, for his first shipment was lost at sea and only the second found a home in the British Museum, where we can see them today.

Western visitors to pre-Westernized Japan were struck by the absence of those architectural stone monuments so characteristic of European countries. But the classic examples of traditional Japanese architecture, the shrines at Ise, are not really monuments either. Not mere reminders of the past, they are rather its revivals. For the Ise shrines are always new, or at least never more than twenty years old. The Inner Shrine (Naiku) and the Outer Shrine (Geku) are both rebuilt on nearby land from the ground up every twenty years. This ceremony of reconstruction has been repeated since about A.D. 690 for the Naiku shrine to the supreme goddess Amaterasu-Omikami and also for the Geku shrine to the goddess of

foodstuffs, clothing, and other necessities of life, Toyouke-no-Omikami. It has remained a continuous rhythmic feature of Japanese life over these centuries. During the civil wars of the fifteenth and sixteenth centuries the ceremonial reconstruction was sometimes neglected. After the seventeenth century the cycle for a while became twenty-one years. When the fifty-ninth renewal, scheduled for 1949, was postponed as a consequence of war, special ceremonies were held at Ise praying for forgiveness for the delay. The postponed renewal was accomplished in October 1953. The next, the sixtieth renewal, was completed after ten years of preparation in October 1973, with food, ritual, and traditional dance.

In the West we have revered the past by costly works of architectural restoration. We patch up falling columns and prop up failing buttresses. In Venice we struggle to prevent the sinking of palaces and churches of earlier centuries. All in our stony struggle for survival. For three years scaffolding and derricks overshadowed the west front of our national capitol to restore the stone façade. The restoration of the Statue of Liberty in New York Harbor, which took years and cost millions, became a flamboyant expression of national pride and international goodwill.

Ise is another story, not of restoration but of renewal. There every effort ensures that the renewed structure will be as elegant as the one replaced. First the new site is purified by priestly ceremonies. Selection of the hinoki from a special forest begins ten years in advance. These sixteen thousand cypress timbers, chosen with accompanying prayers, are hauled on wagons drawn by local residents in ceremonial white robes. After the timber-hauling pageant the neighboring townsfolk are privileged to strew white pebbles on the inner precincts of the two main shrines that the dedication will make off-limits.

Acquiescence to the forces of nature is revealed in countless ways. Each shrine's supporting columns, much thicker than needed to hold up the structure, are the shape and thickness of the live tree. Stuck in the ground as they once grew, they respond to the moisture of the earth. The finished shrine displays the variegated beauty of the hinoki's natural texture—not the dead uniformity of a painted surface but the nuanced grain of natural growth.

It is not surprising that the skills and the standards of the ancient Japanese carpenter-joiner have survived these fifteen hundred years. For each generation has had the opportunity and the need to match the work of the first builders. In the Ise tradition, the Japanese do not waste their energies repairing the great works of the past. Instead, they do the same work over and over again themselves. They build their Chartres anew in each generation. "Herein alone," Edward S. Morse observed, "the Japanese carpenter has an immense advantage over the American, for his trade, as well as other

trades, have been perpetuated through generations of families. The little children have been brought up amidst the odor of fragrant shavings. . . ."

The Japanese carpenters' tools, it seems, were at first made from prototype iron implements brought in ancient times (c.300 B.C.–A.D. 300) from the Asian mainland. Though refined over the centuries, these still show their early origins. They are designed for the Asian stroke—sawing and planing toward the body, rather than, as in the West, away from the body. Japanese wooden structures used few nails, for they were carpenter-joined. Love of the unadorned wood surface produced a variety of tools for different woods and different finishes that astonished Western observers who wondered if the perfect swallow-tail joints at the corners of door and window frames could have been the product of magic. By 1943, before hand-operated power tools were widely used, the customary tool-chest of a Japanese carpenter included 179 items. His nine chisels had cutting edges that increased by increments of 3 millimeters (0.12 in.). The Japanese carpenter lavished on the frames of shrines and houses a micrometric elegance that Westerners have reserved for their most elegant cabinets. Their shrines and houses of wood became their prized furniture. And almost their only furniture!

Respect for the uniqueness of each piece of wood is assured when lumber for these structures is not sold in random pieces. To provide timbers that match one another in grain and color, the segments of cut logs are tied back together in the positions they filled in the living trunk. How different from the stock of a Western lumberyard! The very word "lumber" (which in English first referred to miscellaneous stored items) betrays the difference. For the Japanese carpenter every timber has its claim to a continuing life.

In countless little ways the Ise shrines are still intimately tied to nature and the seasons. The cakes and sake for the renewal celebrations are made from rice ceremonially transplanted in the same seven-acre rice paddies that have been used for two thousand years. This field is irrigated with the clean waters of the river Isuzu, and fertilized not by night soil but only by dried sardines and soy bean patties. In late April trees are cut for the new hoes to be used in sowing the seed. In late June young men and women, wearing white garments tucked in with red cords, transplant the seedlings to the tune of sacred drum and flute music, and join in a procession to the nearby shrine of the deity who owns the paddy, where they dance and pray for the harvest.

Classical Shinto buildings do not dominate the surrounding nature but fit in. They are nonmonumental in every sense of the word. Made of wood and not of stone, they do not defy the elements. And they do not rise above the surrounding trees. Unlike Gothic cathedrals or Greek temples, they are

not structures complete in themselves that could be set in cities or on mountaintops. Japanese shrines do not overwhelm or aspire. The buildings at Ise acquiesce in the landscape and become part of it, renewable as the seasons.

In their "modest" scale they differ too from the sacred buildings of other great world religions. Hindus, Buddhists, Jews, Christians, and Muslims have built their temples, synagogues, churches, and mosques in grand dimensions. In Japan, if you see a work of sacred architecture from before the Meiji era that rises on a monumental scale, it is apt to be a Buddhist or Chinese import. Grand pagodas like those at Yakushiji were probably transformations of the Indian stupa. Even on these imported forms the Japanese medium of wood leaves its special mark. While the oldest *stone* pagodas in Japan come only from the twelfth century, much older pagodas there that date back to the eighth century (730) were made of wood. Buddhism, to house enormous statues of the seated or reclining Buddha, imported an alien taste for the colossal. What is thought to be the largest wooden building under a single roof is the Daibutsuden, the Hall of the Great Buddha of Todaiji at Nara. First built in 751, it has been several times destroyed by fire and rebuilt, once in the twelfth century and again in the early eighteenth century. But all the while classical Shinto architects have obstinately preserved the human scale.

The great works of Western architecture live in our mind's eye in hefty Greek columns, in the overwhelming domes of the Pantheon and St. Peter's, in the national capitols, and of course in Gothic spires. In the last century, too, we have declared our architectural war on nature in the very name of our skyscraper. "An instinctive taste," Samuel Taylor Coleridge wrote, "teaches men to build their churches in flat countries with spire steeples, which, as they cannot be referred to any other object, point as with silent finger to the sky and stars." This Western taste that Coleridge noted infected Japan only in the last century, an import from the West.

Even when Western architecture was not dramatized by a spire, it has commonly emphasized the vertical. During the European Renaissance, which gave ancient Greek and Roman motifs their modern vitality, the featured decorative element was the wall. A cornice sometimes revealed where the roof had been. But the roof itself, except when made into a dome or spire, disappeared from the approaching spectator's view. And since the dominance of steel and concrete and glass, modern Western architecture has remained an architecture of walls, façades, and invisible roofs.

Japanese classical architecture has offered a delightful contrast. The most expressive element is the roof, and the emphasis is on the horizontal. The small scale of the traditional buildings makes it possible for the approaching pedestrian to envision the whole roof, including the ridge, even as he begins

to enter. The beauty of the building is most conspicuously the beauty of the roof, with its curves and sweeps and sculptural modeling. The styles of Shinto architecture, then, are distinguished by their roofs, and the hierarchy of Japanese buildings is fixed not by their height but by their roof design.

By contrast to the cornerstone laying, the customary dedication of a Western building, in Japan it is the placing of the decorative and symbolic ridgepole that dedicates the whole. This ceremony calls for divine protection, gives thanks for having completed the most difficult part of the work, and prays for safety and durability. Not only symbolically but functionally the Japanese roof holds the building together. The ridge, with its heavy timbers at right angles, emphasizes the horizontal, and the weight of the roof keeps the whole structure in place. The heavier the roof, Japanese carpenters have said, the more stable the structure. In earthquakes that are not too severe, this design has advantages. A building not resting on deep foundations but on columns at ground level, and held together by the roof, may bounce and sway without collapsing.

The Japanese concern for the form of the roof, both inside and out, discouraged the use of one of the most common structural features of Western architecture, and still further emphasized the horizontal. The familiar truss, a most un-Japanese device, is made of straight pieces to form a series of rigid triangles. It dates from Western pre-history and has had a long and useful career. Timber trusses, like those used by the ancient Greeks for roofing, were common in the Middle Ages and the Renaissance. The ancient Greeks also knew the arch, but found its shape so unappealing that they used it mainly for sewers. So the Japanese, who knew well enough the engineering principle of the truss, must have found that its crossed emphasis and its explicit rigidity violated their vision of simple elegance and flexibility for a sacred building. The truss was not widely used by the Japanese until their architecture was Westernized.

The stable wetland-farming communities of the world of Shinto offered a horizontal perspective on the universe. The Shinto divinities came not from the heavens but from beyond the horizon. The primary form of Shinto worship was not prayers sent upward to the heavens but food grown in the surrounding lands and offered on altars at the human level. While the inspiring vistas from a Greek temple are upward to the open sky, and the Gothic cathedral silhouettes its gargoyles and spires against the sky, the classical Japanese building offered a view from or through the building out to the surrounding landscape.

Apart from the roof, the most interesting feature of a classic Japanese building is its horizontal plan. For interest and variety Western architects achieved their modular arrangements in the vertical, in the differing heights and diverse decoration of a building's stories. But the Japanese architects

achieved this in the horizontal. The famous Ninomaru Palace of Nijo Castle in Kyoto, built for shoguns who came to visit the capital, became a model that we can still see. There an appealing asymmetric arrangement of squares and rectangles attached at corners and edges unfolds as we move through the building or along its exterior. We enjoy a spectrum of visual surprises, far more suspenseful than what is offered by the vertical stacking of stories that can be encompassed at a glance outside a Western building. Incidentally, this same scheme multiplies the corner rooms with their broad horizontal vistas. The tatami (a straw floor mat about six by three feet), which became the standard Japanese measure of floor area, reinforced the geometric design and further emphasized the horizontal.

The horizontal view, bringing together indoors and outdoors, minimizes the boundaries in between. The mingling of inner and outer space, achieved in the modern West only laboriously and expensively by the use of glass, comes naively in classic Japanese architecture. The approaching visitor can see through the building to the garden on the other side. And the occupant seated before the opened or half-opened fusuma and shoji (movable paper screens) encompasses the house-scape and landscape in a single sweep of the eye.

The Japanese house, never complete in itself, was part of the landscape, and the garden was one with the house. When transplanted into the city, the Japanese house still called for its own miniaturized piece of landscape. The forest was sampled indoors by bonsai, the art of dwarfing trees. The classic Japanese garden had little in common with the Mughal gardens of India, the fountained landscapes of Rome, or the geometrical vistas of Versailles. Nor with the familiar informal Western gardens of colorfully patterned flowers in bloom. The Japanese garden was designed for all seasons, acquiescing in their changes and making the most of them.

The great ancient capitals of the West—Athens with her Acropolis, Rome with her seven hills—used the profile against the sky for buildings on undulating terrain. The Parthenon or a Capitoline temple punctuated the high points. But, like Nara before it, Kyoto (Heian-kyo), on the Chinese model, was laid out as a flat rectangle (three and a half miles north to south, three miles east to west) divided by a great north–south highway, and was subdivided by parallel avenues into checkerboard units. This city-model of clarity was surrounded by mysterious mist-covered mountains on the horizon. The "borrowed view" in garden design was a way to incorporate distant forested hills, the horizontal view, into the design for the house and garden.

Shinto, even when overlaid with Buddhist and Chinese elements, as in Ryoanji and other famous Zen temples, still speaks affinity with nature, reaching outward, not upward. The Japanese garden adds a whole new

dimension to our Western view. It is not merely a product but a microcosm of nature. Mountains, oceans, islands, and waterfalls are all there in small horizontal compass. The *kami* can be as easily revered in a rock garden as on a mountainside. Rocks, a prominent foil to the fragility of growing trees and shrubs and mosses, affirm the unchanging. They are not an architect's effort to defy the forces of time and nature, but another way of acquiescing. The Japanese garden renews what dies or goes dormant, and reveres what survives.

In all these ways the Japanese declared a truce with the menaces of nature and of passing time. However belligerent were Shinto's political teachings, for man's relation to nature Shinto offered conquest by surrender. Their pact with nature was written in timbers of hinoki. Uncompromising Western architects in stone again and again boasted that though their lives might be short, their works would be eternal. The Japanese architects in wood could not be so deceived. At Ise they could see that if the life of art is short, life and the creators of art are eternal.

PART FOUR

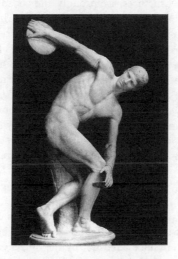

THE MAGIC
OF
IMAGES

It is the great scope of the sculptor to heighten nature into
heroic beauty; i.e., in plain English, to surpass his model.

—BYRON (1821)

17

The Awe of Images

MAN'S earliest grand structures rise proudly and conspicuously, megaliths on the Salisbury plains, pyramids on the deserts of Giza, zigurrats on the Mesopotamian flats. But his earliest images of living creatures lie hidden in the dark cave recesses of Altamira, Lascaux, and Les Trois Frères. While man boasted defiance of time and the elements in his arts of architecture, he seemed reticent, hesitant, and even fearful to imitate the Creator with images. The image of a moving animal, stag or bull or bison, had some of the awesome mystery of life itself. His surviving creations show that Palaeolithic (Stone Age) man had a delightful and energetic power as image maker. We do not know precisely *why* he made these earliest surviving fixed images. We brashly assume that he must have had a reason. But *where* he made them tells us something.

Deep in the circuitous stalactite-blocked, waterlogged caves, the most impressive of these first wall drawings, paintings, and carvings were not discovered until the late nineteenth century. Palaeolithic men secreted their handiwork from the weather and from the passersby. The spectacular works of prehistoric man were uncovered not by the diligence of scholars or the courage of explorers but by the restless nosiness of boys and dogs.

A nobleman hunting on his estate in Santander Province in northern Spain in 1868 lost his dog pursuing a fox in the bushes. He heard barking as if from a great distance, and going in search he found the narrow opening into which his dog had fallen. Squeezing down, he entered the caves of Altamira, which were destined to revise our view of man the artist, and even our notion of the history of art. But it took some time for their meanings to be discovered.

Seven years later a local landowner, Marcelino de Sautuola, began exploring the caves. His interest piqued by the impressive collection of prehistoric stone implements, engraved bones, and statuettes he had seen at the Paris Exposition, he began digging in the Altamira caves and found traces of ancient human occupancy. One day in the summer of 1879, his little daughter Maria, who was with him, wandered off to one of the low-ceilinged chambers, into which light was filtering. In excitement she came back and exclaimed the "Eureka!" of prehistoric art: "*¡Papá, mira toros pintados!*" (Look at the painted bulls!). Crouching, he followed her into the low chamber and shone his lamp on the uneven rock of the ceiling. There he was astonished by vivid paintings of one great bison, then another and another.

He recognized a long-extinct animal known to have lived in that region in Palaeolithic times. The style was similar to that of numerous small sculptures of reindeer antlers and engravings on stone found in the Palaeolithic caves in France. De Sautuola jumped to the conclusion that these paintings too were the work of Palaeolithic man. Though an amateur, he published his argument to a world of doubting scholars.

On de Sautuola's side was the fact that some of the paintings were covered with a stalagmitic layer, and that the existence of the cave had been unknown to the neighborhood until 1868. But the experts, led by Émile Cartailhac, professor of prehistory at Toulouse and the dean of French archaeology, declared the paintings to be fakes. The Altamira caves showed no paintings of reindeers, which was surprising if these were really made in the so-called Reindeer Age, the last phase of the Old Stone Age. They saw none of the calcite which would have been deposited over the thousands of years, and paint in the cracks of the walls suggested the use of a brush—another anachronism. And where was the smoke from the torches of prehistoric times? They firmly concluded that the paintings had been made after de Sautuola's first discovery of the cave in 1875. Skeptics even accused him of hiring a French artist friend to paint the Altamira ceiling. By the time of his death in 1888 de Sautuola was still not vindicated. The Altamira paintings remained in disrepute.

Then, providentially, a series of spectacular discoveries across western and southwestern Europe brought fame to Altamira and credibility to Palaeolithic artists. In 1872 a French cave explorer, Émile Rivière (1835–1922), in Menton on the French Riviera had made the sensational find of a Palaeolithic human skeleton with ornamented headdress, thus providing evidence of burial rites much earlier than ever before imagined. He was summoned in 1895 to view a newly discovered cave, the Grotte de la Mouthe in the Dordogne. This cave, like that at Altamira, was found by accident, when a local farmer clearing a rock shelter for a toolshed broke through its wall. Boys of the neighborhood crawled a hundred yards into the cave, where they reported pictures of animals engraved on the walls and ceiling. On his arrival Rivière confirmed these pictures to be the work of prehistoric artists and found a decorated stone lamp that those artists could have used.

In 1901, more caves were discovered in the Dordogne, at Combarelles and Font-de-Gaume, revealing a fantastic array of drawings, paintings, and engravings which also now began to be credited to Palaeolithic man. In 1902 the Association Française pour l'Avancement des Sciences convened a meeting in the Dordogne to view the paintings. With academic solemnity they decreed these to be Palaeolithic.

The eminent Professor Cartailhac now took the young abbé Henri Breuil with him for another look at Altamira. In their enthusiasm they stayed

there a month while Breuil laboriously copied the paintings. As rain fell in torrents outside, Breuil in the shallow caves lay on his back on straw-filled sacks with only candles for light. Though as a child he had enjoyed drawing butterflies, Breuil had no training as an artist. It is lucky for us that he was so talented and that he dared make his scrupulous drawings while the discovery was fresh. Breuil's drawings are in many respects more accurate and more vivid than later color photographs. The irregular rock surface can distort the photographed image and makes engravings hard to decipher. Breuil's admirable copies in color vividly shaped our visions of Palaeolithic art.

Now Professor Cartailhac made his apologies not only to Palaeolithic man but to the maligned Marquis de Sautuola, long dead. "Mea Culpa d'un Sceptique" was the title of his article on Altamira (1902). He confessed himself "party to a mistake of twenty years' standing, to an injustice which must be frankly admitted and put right." Within these twenty years the learned world had completely revised its view of prehistoric man's creative powers. Once Altamira was confirmed, the additional evidence of those powers appeared overwhelming. In 1912, fantastic sculptures of bison were found by three boys exploring the Volp River where it went underground between Enterre and le Tuc d'Audoubert in the Pyrenean foothills. There the spectacular drawings of Les Trois Frères caves in 1916 included the famous "sorcerer," a man mysteriously cloaked in reindeer skin and wearing antlers.

In 1940 at Lascaux in the Dordogne during the grim days of the Nazi occupation there was an uncanny reenactment of Altamira. Boys in the neighborhood had been alerted to possible cave discoveries in the limestone hills. Their former schoolmaster, who had become an archaeologist, had seen that they were equipped with flashlights. When the lead boy's dog disappeared, the boy followed down a narrow descent into the circuitous passages of a long cave. There the boy's flashlight revealed a spectacular procession of painted animals on the white limestone walls. An endless parade of horses, stags, bisons, and wild cattle. Four colossal bulls triple life-size collided on the dome of the ceiling. On one side stags appeared to be swimming across a lake; on the other side was a line of shaggy ponies. And then, too, wild goats, enormous humpbacked cattle, and a two-horned rhinoceros. Among them was the first Palaeolithic action picture, a man falling before the charge of a wounded bison. The boys had happened on a climactic exhibit of Palaeolithic art excelling anything found before. The boys swore one another to secrecy and placed a twenty-four-hour guard at the entrance to keep their find safe from souvenir hunters.

They reported to their schoolmaster, who came quickly and risked a squeeze down the stalactite-encrusted entrance into the lengthy corridors.

Convinced that these Lascaux caves were no figment of adolescent imagination, he telegraphed Breuil, who arrived in haste. After study, Breuil certified Lascaux as one of the Six Giants of Palaeolithic cave art and spent two months recording the finds. Who can say how many more Altamiras and Lascaux still lie waiting for nosy hunting dogs, alert five-year-old girls or adventurous teenage boys?

This improbable drama of man the creator, set in the dark caverns of western Europe, is the product of some happy coincidences. Lascaux and these best works of Upper Palaeolithic art we can now date, not to the 40,000 B.C. of Abbé Breuil but to about 15,000 B.C. In the six decades after 1879 there was a Grand Opening of the Artworks of Palaeolithic Man that had lain unnoticed for millennia, and historians then stormed the citadel of prehistoric art speedily and serendipitously. To plumb the secrets of prehistoric cities was an arduous, incremental business of sifting sand, dusting artifacts, and collecting shards. Grand ancient structures, long since disappeared, leave only the traces of their foundations. The shape of Palaeolithic man's dwelling-places can only be guessed. But the beauties of his pictures lie fully revealed once we have found and broken into the halls of stalagmitic caves, which seem to have been sealed for our sakes. While the beauties of Greek sculpture of their Great Age can be seen now only dimly reflected in accidental fragments or in inferior Roman copies, the paintings of Palaeolithic man fifteen millennia earlier still glowed in their aboriginal splendor for twentieth-century scholars.

Lucky for us, too, that these Palaeolithic caves were not opened much earlier or piecemeal over the centuries. The surprising revelation of what man could create even before he could write, and before he was civilized, came accidentally within a few recent decades. If these caves had been opened gradually, they might never have survived in the bulk that impresses us with Palaeolithic man the creator. The ominous experience of Lascaux showed man's capacity to disintegrate speedily the inheritance of millennia. Opened in 1940, it was so overrun by tourists and fungus that it had to be closed to the public in 1964. The New England Puritans had explained the Indians' presence in America as God's way of preserving the continent uncorrupted until their purified version of Christianity could take over. By what providence were the works of prehistoric man preserved until the discovery of prehistory itself provided an era into which they could be placed?

Most remarkable was the burst of creative energy that had brought forth these paintings in the first place, a flowering of visual art among the Palaeolithic hunting peoples. Because it happened in prehistory, we are inclined to charge it to the "normal" development of cultures, and so rob it of its

mystery and surprise. We are told to see here a predictable stage of cultural anthropology. Or was it an unaccountable efflorescence of Man the Creator—none the less unaccountable because the artists remain anonymous? Discovery of Altamira was momentous for our grasp of the history of the arts, showing us that man's creations do not necessarily improve with his tools, or with the passage of time.

Homo sapiens may be nearly half a million years old. But not until recent geologic time, the Upper Palaeolithic epoch just before ours, did man make figures of living beings that have survived. Before then he seems to have worked at the decorative arts, shaping his tools and axes to give them a more pleasing form. But now finally in the works left to us in three great centers—the caves of the Dordogne, the central French Pyrenees, and the Cantabrian mountains of northwest Spain—man dares and succeeds in making images of the animals among whom he lives and from whom he makes his living. Why so suddenly, after so many hundreds of thousands of years, did man begin being a graphic artist? Perhaps the abundance of game in southwestern Europe in late Pleistocene times was an encouragement. Perhaps well-fed hunters now had the leisure to try their skill and imagination on the walls of their secure caves.

Palaeolithic man of course carried the model of the human body everywhere he went. Man was the only omnipresent living figure in man's presence. And yet the Palaeolithic cave artists painted and drew animals. Almost never did they draw a man or a woman. Their art is emphatically "zoomorphic," depicting the wild animals from which man took his meat. He must have felt a community with the animals he hunted, with whom his own life was bound. Here, in the very act of trying to "represent"—to re-present—his quarry, the fearful powers all around him, he was awakened to another power in him, his power to create. Here in the secret passages of deep limestone caves, in the womb of the earth, he felt safe while he created. Was any of man's other discoveries more shocking or mysterious?

We can mark stages toward this momentous self-discovery. The first notable step toward man's self-awareness may have been his formal recognition of death, as shown by his acts of careful burial. So he saw the uniqueness of each creature and he saw himself as an object. The practice of ornamenting the body, which seems so natural to us, came late. None of the numerous Neanderthal burials has provided a single bead or other bodily ornament. Not until about forty thousand years ago did man begin to decorate himself. Artificial mirrors appear only much later, but prehistoric man could have used his reflection in water as his first mirror. Whoever first ornamented himself was the first artist.

The discovery of his power to paint vivid images, attested on the walls of his Neolithic cave dwellings, was a historic leap in man's self-awareness.

Now man could be awed not only by the moving, menacing mammoths, humpbacked bison, reindeer, and wild pig. He had the power to awe himself by his own creations and his newly discovered powers as creator. The works of the artists of Altamira remain alive though we do not know and may never know their purposes. They remind us of the iridescence of art and the transcendence of the work of art over its maker.

18

Human Hieroglyphs

THE ancient Egyptians found their own way to create an immortal image. For three thousand years their sculpture showed less change than modern European sculpture in a decade. And their pharaohs of the Third Dynasty (2980–2900 B.C.) still appear to the layman's eye virtually in the same style as their pharaohs of the Twenty-sixth Dynasty (663–525 B.C.). These monuments and statues of unexcelled elegance were not the expression of individual artists but mementos of eternal god-kings. Tomb and temple reliefs and paintings perpetuated the changeless rhythm of daily life.

Their Pharaoh was not a mere agent of the god, he was the god. Crowning a Pharaoh was not like the Roman Senate deifying a dead emperor. It was "not an apotheosis but an epiphany," not the making of a god but the revealing of the god. The unchanging god.

And anyone could "read" a sacred statue. Tomb and temple art did for the illiterate ancient Egyptian what the carvings on Gothic cathedrals would do for the medieval Christian. *Hieroglyph* (sacred carving), the name the Greeks gave to this writing, was just right. At first their hieroglyphs were pictures carved in stone. Then all Egyptian sculpture became a kind of three-dimensional hieroglyph.

The original Egyptian "picture writing" remained a mystery long after their ancient alphabetic writings had been deciphered. Historians insisted on oversimplifying. Possibly excepting Pythagoras, few if any of the Greeks understood the nature of Egyptian hieroglyphs. The irresistible temptation was to imagine they were intended to communicate what they showed in pictures. The Greeks characteristically assumed that hieroglyphs carried myth and allegory. In them Plotinus (A.D. 205?–270), the prophet of Neoplatonism, found hints of his own arcane philosophy.

The first clues to the discovery that hieroglyphs were phonetic symbols were detected by a phenomenal German polymath Athanasius Kircher (1602–1680). As a young man of thirty, summoned by Pope Urban VIII and Cardinal Barberini, he taught mathematics at the College of Rome, and then spent his last forty-six years as a restless explorer of every known science. He found ways to direct the light of the sun and moon onto a novel planetarium, and became an expert on catoptrics (the science of light reflected by mirrors). He experimented with phosphorescent substances, suggested the affinity of magnetism and light-rays, and sought ways to transmute iron into copper. He tried determining longitude by the declination of a magnetic needle. He was credited with inventing the first magic lantern. Fascinated by hieroglyphs, he, too, was misguided by the Renaissance assumption that they must have deep symbolic meaning. But when he imagined they might also be phonetic symbols, his study of the Coptic language led him to the correct suspicion that hieroglyphs were an earlier form of the Coptic. Two centuries later, in 1822 the mystery of hieroglyphs was finally solved by the Frenchman Jean-François Champollion (1790–1832), using Coptic and Greek to decipher the hieroglyphs on the Rosetta Stone. A few famous proper names—Ptolemy and Cleopatra and Rameses, each royally enclosed in a cartouche—gave him his crucial clues.

It had taken millennia to discover that hieroglyphs were the phonetic symbols of a dead spoken language. But statuary hieroglyphs, the sculptures and reliefs, were direct and visual. And they proved to be the true "picture writing" of the ancient "figure-writers." A statue of Zoser or Rameses II needed no Rosetta stone!

The "hieroglyphic" style, which gave Egyptian art its character and its durability, was never better described than by the pioneer French Egyptologist Gaston Maspero (1846–1916), who became director general of excavations and antiquities for the Egyptian government, discovered the first great cache of mummies, excavated Saqqarah, and valiantly worked to prevent the looting of Egypt's antiquities. He was awed by the simplicity of the ancient Egyptians' technique:

> Their conventional system differed materially from our own. Man or beast, the subject was never anything but a profile relieved against a flat background. Their object, therefore, was to select forms which presented a characteristic outline capable of being reproduced in pure line upon a plane surface. . . . The calm strength of the lion in repose, the stealthy and sleepy tread of the leopard, the grimace of the ape, the slender grace of the gazelle and the antelope, have never been better expressed than in Egypt. But it was not so easy to project man—the whole man—upon a plane surface without some departure from nature. A man cannot be satisfactorily reproduced by means of mere lines, and a profile outline necessarily excludes too much of his person.
>
> (Translated by Amelia Edwards)

Yet, as it turned out, some of their most unforgettable creations were human figures.

The arts of Egypt, where the Greeks believed that all civilization had begun, seemed especially significant. Herodotus (fifth century B.C.) credited the Egyptians with discovering the solar year and making the calendar. They "first brought into use the names of the twelve gods, which the Greeks adopted from them; and first erected altars, images, and temples to the gods; and also first engraved upon stone the figures of animals." By about 3200 B.C., when King Narmer, classically recorded on a famous slate palette, unified the "two Egypts" into one ruled by a divine king, the shape of Egyptian art for the next millennia was already revealed. The spoken words of ancient Egyptians were gone with the wind, but their visual images survived with the impassive features of their eternal god and the repetitive contours of their daily lives. This was possible because their visual arts did not try to say too much. Their conventional style, conforming to its own rigid canon, became an institution to be preserved with their religion.

We think of the ancient Egyptians as pyramid builders from the unique mark they left on the desert landscape. We should think of them too as image makers, for no other people in Western culture has given so crucial a role to its images, and none has nourished so continuous and homogeneous a style. Egyptian sculpture, like the pyramids themselves, was collaborative. Quarrying the stone from a cliff face with a soft copper chisel aided by wetted wooden wedges expanded in the sun required the skill and patience of many people working together. Cutting the stone expertly where it was found could save laborious transportation, and reduce the sculptors' work when it reached its destination. Then the sculptors' task was only one in a series. Next came the cutters of hieroglyphs, followed by metalworkers to insert the eyes, and painters for coloring. Artist-craftsmen worked in teams.

Awed by the beauty of their work, we must try to remember that their creation in their eyes had an urgent practical use. Its main function was changelessness. Their conventional images were to form what the stone was to substance. Stone images would perpetuate the living form for the eternal life served by the pyramids.

The continuity of Egyptian life was punctuated by the struggle of vigorous pharaohs to unite Upper (Southern) and Lower (Northern, Delta) Egypt. And invaders carried innovations. By bringing the horse-drawn chariot and the composite bow, about 1680 B.C. the Hyksos hastened the pace of life. The most famous of their ancient innovators was the fabled Akhenaton (1375–1358 B.C.), who established a new cult of the sun-god and briefly refreshed the forms of art.

But since Egyptian geography made life seem repetitive, their artists'

divinely appointed task of creation was to reflect this in flawless enduring images. The king's primary obligation, as Amenhotep III said, was "to make the country flourish as in primeval times by means of the designs of 'Maat' [the divine right order]." For them the movement of time, mirror of a divine archetype, was not a progress but a rhythm.

The Nile, the current of Egyptian life, dramatized that rhythm. Egypt, as Herodotus noted, was the gift of the Nile, lands made fertile by annual inundations. Egyptians were those who drank Nile water. The reliable Nile showed its own cycle of birth and death, and Egyptians gloried in the symmetry of their world. If there was a Nile below, there must also be a Nile above. Rain was their "Nile in the sky." The Pharaoh was keeper of this eternal order. If regularity ruled the world, unique events were unreal or insignificant. And if the unique had no meaning, what meaning could there be in history? Since their past was never remote, theirs was a timeless world. Since the same event occurred again and again, their texts could describe the whole past as if it were recent.

In other societies, the king, being only the agent of the gods, could be more or less effective, generous or wrathful, but not in the Egyptian realm of god-kings. The Pharaoh's face and gesture were not features for a character portrait but the impassive image of a regular universe. Living embodiment of the unchanging God, the Pharaoh could not conceivably be arbitrary or whimsical. The Egyptian chronicles did not announce that a new king now rules, but rather that another king has "ascended" the timeless throne. Their indifference to the unique frustrates the modern historian. When King Pepi II (Sixth Dynasty, c.2566–2476 B.C.) commanded carved reliefs to record his unprecedented ninety-year reign, the sculptors depicting his victory over the Libyans listed names of the defeated chiefs beside their images. But these are the very same names listed in the victory reliefs of King Sahure two hundred years before! When Rameses III named his conquests in Asia, he simply copied the list of his predecessor, Rameses II, who in turn had copied the list of Tuthmosis III. So the repetition of the timeless went on.

It is not surprising, then, that the triumph of Egyptian art was the portrait statue in stone, a perfect embodiment of a static view of life. This meant, too, that Egyptian sculpture could not be the product of fancy, imagination, or originality. Nor should any work be identified with particular sculptors. Their enduring truth was the harmony between man and the eternal order, embodied in their king. The Egyptian word for "great house"—Pharaoh—by the Eighteenth Dynasty came to mean the king himself, the container of divinity. And since Egyptian sculpture was itself a religious institution, the continuity of their religion required a timeless sculptural style.

Their pyramids, "castles of eternity," we have seen, were grand symbols of the ancient Egyptian obsession with eternal life. The mummy and its substitutes would provide a permanent body for the spirit of the deceased. Just as the pyramid builders were not mere engineers, Egyptian sculptors were not mere decorators. Their task was to ensure the prosperous afterlife of the tomb's occupant. Their sculptures were backups for the mummy. If the mummy should decay or be damaged or stolen, the deceased man's *Ka,* his vital force, would need this other habitation. A portrait statue inscribed with the deceased's name and animated by an "opening of the mouth" ceremony could serve in place of the mummy. Housed in a sculptured likeness, the deceased man's *Ka* would live on forever. Egyptians at the tomb felt close to their departed. When meals were offered at the tomb on feast days the deceased was assumed to be present.

We see efforts to be doubly sure that the *Ka* would not lack its body, in the numerous "reserve heads" found in some tombs. In case their mummified bodies were destroyed, limestone portraits of the family of King Cheops (Fourth Dynasty, c. 2640 B.C.) were put in the burial chamber. These appear to reproduce the plaster masks that were modeled over the linen mummy-wrappings.

The portrait statue in the tomb was no mere memorial, but was designed to be the person himself. Nor was it intended originally to be an object of visual delight for visitors. For in the early Dynastic tombs these portrait statues were hidden away in the *serdab,* a sealed statue chamber. Funerary statues were made "not to be admired but to be immured." They expressed a feeling stronger than agoraphobia, a "claustrophilia," revealed in the pyramid itself, in the swaddled corpse in a nest of coffins inside an ornate sarcophogus, and also in the curious "block" sculptures. In these figures, legs and arms were kept confined in a solid stone cube, with only the head, the side of the arms and the toes protruding. The shape itself expressed secure confinement and solidity.

Still, to serve its practical purpose the funerary statue had to be a clearly recognizable portrait of the deceased. Otherwise the vagrant *Ka* might not find its proper habitat. In the temple to a god-king, too, the portrait had to be recognizable. But it could not depict casual or commonplace activities. By contrast the grave stele of classical Greece might show the deceased at a meal or playing a game. The changeless majesty of the Pharaoh link between the human and the divine could not even hint at the abrasions, the irritations, or joys of this temporary life below.

In the Old Kingdom the deceased king became the god Osiris. Then gradually all deceased Egyptians could become Osiris too, and the tombs and funerary statues of private persons increased. The sculptor's difficult assignment was to show the subject's individuality without any time-bound

character or personality. The stable figure, hands at side, could not show movement, and Egyptian sculptors focused on the most immobile part of the body, the head.

By the time of the New Kingdom (1580–1350 B.C.), the forms of Egyptian sculpture in the round did show some variety. Funerary statues were no longer secreted in the *serdab*. They were multiplied, were sometimes colossal parts of the architecture, or they might be small statues included in the coffin. Except for the period of Akhenaton's celebrated monotheistic sally (1373–1357 B.C.) the sculptural style was little changed. When Akhenaton moved his capital from Thebes to Amarna, a modernist "Amarna Interlude," emphasizing the shared regency between the Pharaoh and the heavenly king Aten and liberating from old rituals, briefly left its mark in a few uniquely stylish figures. But this interlude soon ended. Egyptian religion dominated sculptural art, and ancient Egyptian sculpture never became secular.

The art of portraiture very early created its own rigid conventions. Craftsmanship became the enemy of imagination. The Egyptians' "canon," an archetype for the sculptured human figure, may be the most durable pattern in the history of art. In a number of unfinished tombs we find the marks of the "grid" that guided the sculptor at his work. It was long supposed that these were only a device commonly used by artists—the *mise aux carreaux*—for enlarging any small sketch. Then it was noticed that the squares always intersected bodies in the same places. These proved to be the units of the canon of Egyptian sculpture. A standing figure comprised eighteen rows of squares (not counting a nineteenth row for the hair above the forehead). The smallest unit, the width of the fist, measured the side of a square. From wrist to elbow was three squares, from sole of the foot to top of the knee was six squares, to the base of the buttock nine squares, to the elbow of the hanging arm twelve squares. to the armpit fourteen and a half squares, to the shoulder sixteen squares. The seated figure from sole to top measured fourteen squares. This same scheme was also applied to painting and relief. These precise proportions were followed for some twenty-two hundred years, longer than the whole Christian era, from the Third Dynasty (2980–2900 B.C.) to the Twenty-sixth Dynasty (663–525 B.C.). Even the Twenty-sixth Dynasty brought simply a revision in the measuring units.

The Egyptian artists never developed perspective. The mere appearance of an object to the eye, varying with the position and movement of the viewer, did not interest them. Of course, perspective requires that we depict the apparent diminution of the object as it approaches the vanishing point. And this may require foreshortening. But the ancient Egyptians focused on actual unchanging physical dimensions.

The Egyptian canon not only prescribed the location and proportion of every bodily detail, but the way of depicting the body. On a flat surface the head must be presented in profile, but the eyes frontally. Statues in the round were designed to be viewed only from the front. This unbending canon inhibited the artist's imagination, but it also accounted for the high standard and unmistakable style of Egyptian sculpture over millennia. The canon was both the price and the prison of the sculptor's high art.

The Pharaoh had to be depicted in a timeless posture. If standing, he had both feet firmly on the ground, arms down by his side. Or if seated, he was in the hieratic posture he took during his public appearance. The body of a ruler, the living god Horus, was always youthful. Though variations in style could indicate the reign when a statue was made, it only suggested the features of some particular Pharaoh. In the New Kingdom, to ensure a uniform image, the Pharaoh's chief sculptor would make a master portrait. Copies taken from the work of the few artists allowed to view the Pharaoh in person would be reproduced by casting to serve the whole kingdom.

The rigidity of tradition and the power of archetypes were tested in Akhenaton's Amarna Interlude. In the New Kingdom in that revolutionary phase of Akhenaton's monotheism the visual arts briefly showed signs of a new naturalism. But Egyptian artists still did not formulate laws of perspective. The frontal view continued to dominate.

Egyptian sculpture thus remained three-dimensional hieroglyphs communicating some features of the subject but not depicting their actual appearance. Just as an alphabet prescribes the form of words, so the sculptor's canon prescribed the forms of images. Continuity of style was inevitable, and continuity brought anonymity. Identifying the "artist" of a funerary statue is like seeking the carver of a particular gargoyle on Notre-Dame. When we find the names of artists inscribed in Egyptian tombs, these prove not to be the artists' signatures. Instead they only list an artist's name in his master's household to ensure his service in the hereafter. The draftsman of sculpture was called a "figure writer." In a surprising reversal of the usual chronology of the arts, their pictorial sketches appear to be derived from the cursive writing, which in turn had derived from the pictorial hieroglyphs. So the design of reliefs, painting, and sculpture in the round eventually came from writing, rather than vice versa! Identifying the other arts with writing kept them, too, rigidly conventional, shaped not by artists' fancy but by traditional forms.

Just as Egyptian society idealized changelessness, so Egyptian sculptors aimed at an abstraction suggested by what was seen. They succeeded so well so early that they felt little need to "perfect" their style. And the precocity of Egyptian art was its curse. Unlike the ancient Greeks, they did not keep experimenting to make figures more human. As we have seen, they became

expert at embalming, with special techniques for eviscerating the body and separately preserving its internal parts. But during ritual preparation of the body, dissection for mere knowledge seemed sacrilege. Adept with medicines—Homer called them "a race of druggists"—they also knew how to set broken bones, and were famed dentists and obstetricians. But their meager knowledge of human anatomy did not increase, nor did their created works become more true to nature.

The higher a person's status, the more rigid and unvaried were the portraits, and very early the Pharaoh became a stereotype. Officials of lower rank, whom the people were used to seeing in the flesh, were sometimes portrayed with distinctive face and either slender or paunchy body. For these figures, too, there were rules. Scribes were to be shown in a priestly posture, whether striding or seated, with papyrus scroll and writing material. Statues of working people, caught in characteristic attitudes, were unmistakably farming, herding cattle, fishing, building boats, playing music, performing acrobatic feats, or dancing.

Figures transposed from three dimensions to two in sculptured relief or painting were still governed by a well-known canon, which was obstinately objective. Without regard to perspective they combined different points of view to display a body's solid shape and dimensions. The result was a style that has been easily caricatured.

In painting and relief the horse or the gazelle was best caught in full profile with a single undulating line. But the human trunk had to be grasped in a three-quarters or frontal view to show the body's bulk, the shape of the shoulders and the arms. They presented the human head in profile but with a full-face eye and on a full-face bust. This cluster of disjointed points of view came to be called the paratactic style by analogy to the practice in grammar of placing phrases together without a connective. ("I came, I saw, I conquered.") Commonly Egyptian artists in the same picture showed both a frontal view of some parts and a profile of other parts. The principles of perspective, had the Egyptians known them, would have provided a single coherent point of view. But they were not interested in mere "points of view" that changed with the viewer. To them, perspective might have seemed only a trick for concealing real shapes and sizes.

Their concrete literal-mindedness appeared, too, when they wanted to show quantities. What clearer way to tell that a hundred prisoners and ten princes were taken in a battle than to paint just that many of them in neat rows where they could be counted? Paintings in a nobleman's tomb, too, were inventories, a plain orderly survey of all his main possessions, his wives and children, cattle, cornfields and fruit trees, so these could be taken along to the next world. Colors, too, were prescribed—green (color of resurrection) for the body of the god Osiris, blue for the sky-god (Amon-Ra), yellow

(color of gold) for other gods. Red, the color of evil, for the tales about wicked gods, sometimes in the Old Kingdom was deprived of its evil powers by a black line through every red hieroglyph. White depicted hope and pleasure.

This hieroglyphic art flourished in the tomb and temple paintings of the Old Kingdom where we witness the herding of cattle, the harvesting of grain and grapes, girls playing the "vine" game or dancing with castanets, boys playing tug-of-war, men hunting and trapping birds. Expressionless faces and conventional postures convey unambiguous messages. Avoiding a crude straining for naturalism, the Egyptian artists reward us with the clarity and elegance of calligraphy. They were "figure writers," undistracted by time or place. The same religion that required realism in their art saved them from trying to make their images more natural.

What they lacked in naturalism they made up in gigantism. No other people was so obsessed by colossi, or so successful with the colossal image. Shape and form and color were prescribed in an almost alphabetic way. And if they could not make it better, they could make it bigger. Since in their tomb and temple relief the larger figures showed the more powerful people, the largest statues would be the most potent. Like messages in large type, Egyptian colossi were headline-hieroglyphs, and because they were abstractions, Egyptian statues had a boundless capacity for enlargement. A gigantic statue in naturalistic style seems bizarre or ridiculous, but an enlarged Pharaoh in conventional style is all the more impressive. Colossi were hieroglyphs of power.

The Great Sphinx at Giza became a symbol of the grandeur and the mystery of ancient Egypt. Cut directly from the solid rock on the site where stone was quarried for the pyramid of Cheops, the Great Sphinx rises 66 feet above the sand, is 13 feet wide at the front and stretches 240 feet from haunch to forepaw. The forelegs (projecting fifty feet from the breast) were added by masonry. When built, the Sphinx was probably plastered and painted. In the reign of Pharaoh Khafre (c.2550 B.C.), it was once part of a vast temple complex. While the lion's body made it an effective guardian of this sacred place, the human head (originally adorned by a royal beard and headdress and a symbolic cobra) was probably intended to represent the Pharaoh. Later, in the New Kingdom, it came to represent the sun-god.

In ancient times the Great Sphinx was so familiar a symbol of Egypt that Herodotus' omission of it from the surviving account of his travels is taken for evidence that our text of his work is incomplete. The Great Sphinx has become increasingly cryptic with the centuries, blanketed with sand, worn by wind and storm, mutilated and pillaged. An Arab doctor from Baghdad, Abdel Latif, noted about 1200 that "its mouth bears the mark of grace and

beauty. . . . it smiles in a gracious manner." But medieval Muslim icono-
clasts chipped away the Sphinx's nose. Mark Twain, including the Sphinx
along with the Pyramids in his hurried tour of Egypt in *Innocents Abroad,*
told how a member of his party tried to hammer off a souvenir from the
Sphinx's face. More recently the Sphinx has suffered severely from reckless
"restoration."

The immensity of the figure fascinated generations of artists. An English
artist, William Brockedon, in 1846 noted (taking ten inches as the normal
length of a man's head) that the bulk of the Sphinx was "nearly 40,000 times
greater than its original." The Sphinx made vivid Napoleon's invocation at
Giza, "Soldiers, forty centuries look down upon you." And he set his party
to measuring it for Vivant Denon's *Description de l'Égypte.* One of the
miracles in the history of art is that the Great Sphinx avoided the fate of
Cleopatra's Needle and other movable objects in the millennial pillage of
Egyptian antiquities. Sheer mass has kept the Sphinx and other colossi in
place for us.

Egyptian colossi therefore have played an especially conspicuous role in
the afterlife of ancient Egyptian art. They have often outlived the buildings
to which they were attached. The so-called Colossi of Memnon on the
floodplain near the Valley of the Kings, though much damaged, still attract
tourists by their gigantism and their mystery. They were seventy feet high,
each cut from a single stone. Originally built for the vast mortuary temple
of Amenhotep III (1411–1375 B.C.) of the Eighteenth Dynasty, they were
intended to guard the gates of his temple. Ancient Greek travelers named
the northern statue "Memnon" in honor of a Trojan war hero. It became
famous in classical literature as "the singing Memnon" because at sunrise
it would emit strange sounds. Some tourists heard human voices, others
thought they heard harp strings. The skeptical Greek geographer Strabo (63
B.C.?–A.D. 24) suspected a machine installed by the temple priests. When
Hadrian and his wife, Sabina, arrived in A.D. 130, the singing Memnon
remained silent on their first morning. But it spoke up the next day and
inspired their court poetess to compose a paean to both Memnon and the
emperor. Emperor Septimius Severus in A.D. 202 was not so fortunate.
When the statue repeatedly refused to speak to him, he tried to conciliate
it by repairing its cracks. Never again was the statue heard to sing. The
cracks have multiplied since, but no song has come back with them. On the
Nile floodplains these two battered colossi remain, three-dimensional hiero-
glyphs of the grandeur of Egypt of the pharaohs.

The hypnotic colossal style survives spectacularly in the works of the
energetic Rameses II, who reigned for sixty-seven years (1292–1225 B.C.),
had his image reproduced all over Egypt, and carved his name on every
available monument. Of his many vast building projects, at Karnak, Luxor,

Thebes, Memphis, and elsewhere, the most distinctive was his grotto temple at Abu Simbel. Determined to erase the memory of Akhenaton and other hated predecessors, he had his men dismantle their monuments as quarries for his own. But the great temple at Abu Simbel needed no imported materials because it extended two hundred feet into a sandstone monolith. The temple façade faces the rising sun. At the entrance are four gigantic statues of the seated sun-god Rameses II. The entering rays magically illuminate a frieze of sacred baboons and eight thirty-two-foot-high statues of the Pharaoh as the god Osiris. The entrance statues of the enthroned Rameses, carved from the pink sandstone cliff, are almost as big as the Colossi of Memnon. Each is sixty-seven feet high and weighs twelve hundred tons. At the feet of the Pharaoh, reaching halfway up to his knees, are figures of his favorite wife, the beautiful Nefertari, his mother and several sons and daughter. The Pharaoh's lips alone are three feet wide. Centuries ago, one of the heads was broken off. The faces of the remaining three are barely distinguishable from one another. All are impassive, with a divine dignity, all wearing the double crown of the "two Egypts," the royal headdress and beard.

After the Aswan High Dam was built in the 1960s the rising waters threatened to submerge both this main temple and a smaller one nearby. For an unprecedented feat of preservation, UNESCO funds were collected from fifty countries. International crews of engineers supervised cutting the façade into blocks by handsaw, to avoid the machine vibrations that might have cracked the brittle sandstone. From 1964 to 1966 the whole structure was dug away, and then reconstructed two hundred feet above the river, with a new cliff-cave to accommodate the interior. The visitor to Abu Simbel now witnesses something more than the dignity and grandeur of the Egypt of the pharaohs, a spectacle that would have surprised and delighted the ambitious Rameses. The awe of the whole world three thousand years later, his colossi have found a new dimension of the afterlife.

19

The Athletic Ideal

INSPIRED by models from Egypt, the ancient Greeks imagined that all civilization had originated there. And in mid-seventh century B.C., they began visiting the country. An ambitious regent of the conquering Assyrian king Ashurbanipal (663), Psamtik I (664–610 B.C.; reigned 663–609 B.C.) enlisted Greek mercenaries in his successful Egyptian rebellion and founded a new dynasty. Then he allowed the Greeks to settle in the Nile Delta, where they flourished in trade and shipping. In Egypt they were awed by the stone temples and colossal statues. Though their homeland was rich in marble, only after sea traffic began to flow between Egypt and Greece did the Greeks make their first life-size marble statues. These seventh-century *kouroi* (youth), which became the prototype of the classic male nude, are almost indistinguishable in stance and posture from the work of the Egyptians. The figures stand rigid, arms stretched down against the body, fists clenched, head faced forward, left leg slightly advanced. Designed to be viewed frontally, they were symmetric, each half of head and trunk the mirror image of the other. The figures that had survived almost unchanged for Egyptian millennia would become the starting point of a dynamic Greek art that would delight the following millennia.

The dynamism of Greek sculpture sprang from the Greek way of life, especially from their life in the open air. They celebrated the undraped active body in the lively competitive spirit of the city-state. The Greeks have been called the only truly athletic people of antiquity. To see how classical Greek sculpture came to be created, we must try to understand the meaning of athletics to them in the three centuries when they were making the models for Western visual arts (c.700–c.400 B.C.).

We inherit our very different attitude toward athletics from the Roman Empire when athletic activities had become "games," *ludi,* entertainments (from *ludere,* to play) to gratify the Roman crowd. The Colosseum (Flavian Amphitheater, dedicated A.D. 80) itself bore witness that Roman athletics

had become spectator sports. Technology has brought our Colosseum into our living rooms, and for us, too, athletics have become "sports" (from "disport," to divert or amuse).

For the ancient Greeks athletics had another meaning. Their word for athlete came from a root meaning a "contest." The adjective from it meant "struggling" and later came to mean "miserable" or "wretched." An athlete, Pindar said, was one "who delights in the toil and the cost." "Deeds of no risk are honorless whether done among men or among hollow ships." Beginning as each city's "national" festival, then as a ritual of peaceful competition among cities, athletic contests flourished with the city-states. The intensity of athletic competition was a barometer of civic loyalties. The first Olympic festival-contests between the communities were held in 776 B.C. and then every four years until A.D. 393.

The Greeks did not go in for team sports. Only individuals competed and all honor went to the victor, whose reward at the Olympic competition was a crown of wild olive. The special virtue of the athlete, according to Pindar, was *aidos*—respect for the gods and fellowmen. The proper athlete was no bully, but neither was he "a good sport" or "a good loser." A defeated athlete never congratulated the victor. Since it was a disgrace to be defeated, the Spartans, it was said, forbade their citizens to engage in intercity boxing or the risky pankration, where they were unlikely to win. Losers, Pindar tells us, returned to their mothers in shame, "by back ways they slink away, sore smitten by misfortune."

Athletic contests arose in ritual. Homer devotes the twenty-third book of the *Iliad* to the funeral games for Patroclus. At such games the deceased was commemorated by mementos given as prizes. The Olympic games, Pindar tells us, began in the ritual celebrating Hercules' victory over Augeas when he cleansed the stables by deflecting the river Alpheus. At Olympia, a sacred place, the games honored Olympian Zeus. The games began as only a one-day ceremony, then in 472 B.C. extended to five days, ending with sacrifices and a banquet honoring the victors. The tie to religion helps explain the remarkable continuity of Greek athletics. The later Olympic games follow the rules described by Homer. Finally the Christian emperor Theodosius I abolished them in A.D. 393 because they were pagan relics.

Even before there was a Greek nation, the Olympic festival brought Greeks together in a Panhellenic celebration. Only freeborn Greeks could compete. Numerous other festivals grew up—at Delphi, Delos, Corinth, and Nemea—modeled on the Olympic, but with local embellishments. At Nemea the wild-olive-wreath prize was displaced by a crown of parsley.

Music and poetry celebrated the gods and the winners. The first national festival at Delphi was a musical contest. Pindar (518–438 B.C.), one of the

greatest Greek lyric poets, wrote his famous cycles of odes to athletic victors. He praised the winner in 476 B.C. of the boys' boxing competition:

> Know now, son of Archestratos,
> Hagesidamos, because of your boxing
>
> I shall sing a sweet song
> To be a jewel in your crown of golden olive . . .

Festival games were symbols of peace, but Greece was seldom at peace. War in those days was not weapon against weapon, but man against man, and a citizen had to be prepared to defend his city. "No citizen has any right to be an amateur in the matter of physical training," urged Socrates, as Xenophon recalled. "It is part of his profession as a citizen to keep himself in good condition, ready to serve his state at a moment's notice. The instinct of self-preservation demands it likewise: for how helpless is the state of the ill-trained youth in war or in danger! Finally, what a disgrace it is for a man to grow old without ever seeing the beauty and the strength of which his body is capable!"

Every athlete was in training for defense. Since the ravines that split the Greek countryside demanded long jumps for the chase, the long jump became a regular athletic event. But there was no high jump. The Greek athletic long jumper had to hold weights, from four to eight pounds, testing his ability to carry a weapon. The race in armor was another regular event. It was sometimes called the hoplite race after the class of citizens who could not afford horses but still could equip themselves with full personal armor. After the eighth century B.C. the rise of hoplite warfare—the massed phalanx of armed citizens in close formation—made the strength of each citizen crucial to holding the line. At first each contestant wore a helmet and carried a shield, but later had only a shield.

The discus throw may have begun as a test of ability to throw stones in battle. In the *Iliad,* when Ajax and Hector had thrown their spears, they picked up stones and fought on. Some ancient critics objected that, instead of the discus throw, it would be better to train men to throw "stones that fill the hand." In the javelin throw, as on the battlefield, to add distance and accuracy a thong was looped around a finger to give the javelin a spinning motion. The pankration made unarmed combat into a game. Eight of Pindar's Odes celebrate victors in this most dangerous and most popular of their regular athletic events. It combined wrestling and boxing, allowed kicking and strangling, but biting and gouging were forbidden. One popular opening was to break your opponent's finger. It was common to twist feet out of sockets and not unknown to kill an opponent by strangling. The

umpires sometimes placed the olive crown on the dead body of a valiant loser.

Cities rewarded their representatives handsomely. Competitors in the great festivals were apt to be men of wealth who could afford the time to train and could pay their own way to the contests. Still, "amateur" citizen-athletes expected to be paid for the glory they brought to their hometown. Solon, the great Athenian legislator (c.590 B.C.), enacted a limit on victory grants—five hundred drachmas for the Olympics, one hundred drachmas (the year's earnings of a workingman) for the others. Fringe benefits included free meals, front seats at festivals, and exemption from taxes. The winner was honored by a hymn of victory and celebrated in odes by the great lyric poets.

The custom of erecting statues of the victors would prove fertile for the arts in the West. In the earliest times a city might erect a statue of the victorious athlete both at the scene of his victory and back home. The victor himself might offer a little votive statue in gratitude. By the sixth century it had become a custom to allow the victor to erect a life-size statue of himself. In 408, when Eubatus, a runner from Cyrene, came to compete at the Olympics, an oracle had already promised him success, so he arrived there with his own victory statue. An attractive as well as a self-confident man, he aroused the passions of the famous courtesan Lais, who tried to seduce him. He resisted her advances but brought home her portrait. When his wife saw the portrait of Lais, she was so impressed by his fidelity that she erected another statue of him in Cyrene.

During the Panhellenic athletic festivals, thousands of victory statues were fashioned and erected at festival sites and the hometowns of the athletes. But of the life-size bronze victory figures only a few, like the charioteer from Delphi, remain.

The statues of the great athletes were supposed to cure illness. One of the most popular cults surrounded Theogenes, the famous boxer from Thasos, an island in the north Aegean, whose athletic victories in mid-fifth century B.C. numbered more than thirteen hundred. Other athletes were so intimidated by Theogenes' reputation as a heavyweight winner that sometimes they refused to confront him. And then the umpires conceded to him what the Greeks called a victory "without dust" (*akoniti*). Exploiting his name (Theogenes, "god-born"), he claimed that he was not simply the son of a priest but himself a son of a god, and so a demigod. In a rebellion supported by Theogenes in 465 B.C. Thasos revolted from the Delian League, and rejoined Athens only after a siege.

But at his death Theogenes left a legacy of hatred. One night when an enemy crept out to flog his statue in the marketplace, the statue fell and

killed him. Under a primitive principle of law (perpetuated in England as the law of deodand) an object that causes death is itself guilty and must be punished. This guilty statue of Theogenes was taken out to sea and dumped overboard. The next season the Thasos crops failed, bringing an unprecedented famine. When the city fathers consulted the oracle at Delphi, they were advised to recall their political exiles. Still the famine continued. The Delphic oracle next suggested they try reviving the memory of Theogenes. They fished up Theogenes' statue from the sea bottom, replaced it on its original base and so ended the famine. This time the Thasians bound down the statue with chains. Five centuries after Theogenes' death the boxer's statue was still famous for its cures. On his travels Pausanias noted Theogenes cult statues across Greece, and even among the barbarians. The people of Thasos made a good thing of their athletic demigod. If anyone offered less than one obol to Theogenes' memory, they proclaimed, "it will lie on his conscience" and not accomplish the desired effect.

Concerned citizens, including Euripides, Plato, and Diogenes, warned against idolizing athletes. The sixth-century philosopher Xenophanes (born 576 B.C.) of Colophon, in Asia Minor, was troubled by the extravagant honors to a winning athlete in his home city. "Yet is he not so worthy as I, and my wisdom is better than the strength of men and horses. Nay this is a foolish custom nor is it right to honour strength more than excellent wisdom." A century later Euripides was more vivid. "Of all the countless evils throughout Hellas none is worse than the race of athletes. . . . Slaves of their belly and their jaw they know not how to live well. . . . In youth they strut about in splendour, the idols of the city, but when bitter old age comes upon them they are cast aside like worn-out cloaks." He asked, "Who ever helped his fatherland by winning a crown for wrestling, or for speed of foot, or hurling the diskos or striking a good blow on the jaw?" And, in the rising Roman Empire, Galen (A.D. c.130–c.200) himself was eloquent in his disgust:

> In the blessings of the mind athletes have no share. Beneath their mass of flesh and blood their souls are stifled as in a sea of mud. Nor do they enjoy the best blessings even of the body. Neglecting the old rule of health which prescribes moderation in all things they spend their lives in over-exercising, in over-eating, and over-sleeping like pigs. Hence they seldom live to old age and if they do they are crippled and liable to all sorts of diseases. They have not health nor have they beauty. Even those who are naturally well proportioned become fat and bloated: their faces are often shapeless and unsightly owing to the wounds received in boxing and pankration.
>
> (Translated by E. Norman Gardiner)

Life in the open air in athletic Greece would change the sculptural image they inherited from claustrophilic Egypt. While the Egyptian figures wore

a brief skirt, now the Greek *kouroi* were nude. Some are slimmer than others, perhaps reflecting the physical types in different parts of Greece. Still, with only minor variations, they all follow the canon of proportions revealed on the grids found on Egyptian figures. Complete or in part, more than two hundred of these authentic *kouros* statues survive.

The *kouroi* were the Greek sculptor's "laboratory." And naturalism, like the nude, was to be a contribution of Greek sculpture to Western art. The nude, as Kenneth Clark reminds us, is an art form invented by the Greeks in the fifth century B.C. They believed that unashamed nudity and their willingness to appear nude in the Games distinguished them from the barbarians. This had not always been so. In the funeral games for Patroclus, Homer recounts that when Euryalus wrapped his hands in cowhide thongs he put on his boxing trunks. Thucydides (471?–400? B.C.), too, observed that the earliest Greeks, like the barbarians of his own time, "even in the Olympic contests . . . wore belts across their middles; and it is but a few years since that the practice ceased."

When and why the Greek athletes first took off their shorts was a source of irreverent legend. Perhaps the new fashion was set when Orsippus of Megara, at the Olympics in 720 B.C., lost his shorts in the middle of his race. He won anyway, and others followed his example of nudity. Others recalled that, at one of the festival races at Athens, the leading runner's shorts slipped down and tripped him before he could reach the finish line. To prevent such accidents in the future, an edict required contestants to be naked. King Agesilaus of Sparta (444–360 B.C.) who organized the defense against the Persians, though notorious for his own poor physique, once exhibited Persian prisoners of war naked to encourage his own men—by contrasting the flabby Persians with the trim and bronzed Spartans.

The first nudes were only male, the *kouroi.* By the fifth century there were a few female nudes, but these did not become common till later centuries, and even then with some inhibition. Male gods were usually portrayed nude, while female goddesses were usually draped, with the conspicuous exception of Aphrodite. From time to time women had their athletic contests. Inscriptions do survive for statues of three women victors at Delphi, but they probably did not compete against men. Among statues of victors at Olympia, Pausanias (second century A.D.) did not find even one of a woman. He described the girls' games at the Temple of Hera, sister and consort of Zeus, queen of heaven and protectress of marriage.

Once every four years the women of the Committee of Sixteen weave a robe for the statue of Hera, and they also arrange the Heraean festival. This consists of races for unmarried girls. They are not all of the same age; the youngest run first, then those of the second age group and finally the oldest girls. This is how they compete: their hair hangs loose, and they wear a tunic reaching to a little

above the knee, with the right shoulder bare as far as the breast. Like the men, they have the Olympic stadium reserved to them for these Games, but the stade is shortened for their races by about a sixth. To the victors they give olive wreaths and a share of the beef sacrificed to Hera, and they are allowed to erect statues of themselves with inscriptions. . . . As with the Olympic festival, they trace back these girls' Games to antiquity.

This girls' costume was the familiar dress of the goddess Artemis (or Diana) as huntress.

At Sparta, freer than Athens in such matters, by the fifth and fourth centuries B.C. women, in training to be fit mothers of Spartan soldiers, were competing naked before men. "Gymnastic," the Greek word for athletics, meant literally "exercises performed naked." During the most popular events, wrestling and pankration, it would have been hard to keep a decent cover. In Sparta, though not elsewhere, women did wrestle, but there is no record of women boxers anywhere in Greece. Salacious rumors reported girls wrestling with boys on the island of Chios in the third century A.D. Plato in his *Laws* required physical training for women. He rejected wrestling and pankration but favored racing and fencing provided girls over thirteen wore "appropriate dress." At Olympia women were not admitted as spectators to men's athletic meets. Pausanias records that any woman caught at the games would be thrown from the cliffs of Mount Typaeum. Pericles declared in his funeral speech that the greatest glory of a woman was to not be talked about by men, whether in praise or blame. It seems that women's races were organized only for "virgins," and marriage (usually at about eighteen) ended a woman's athletic career.

While athletic contests displayed ample models of the mature male body, there was not the same opportunity to observe the female body. Praxiteles (born c.390 B.C.) was called the "inventor" of the female nude for his Aphrodite of Cnidus (c.370 B.C., known only through copies), of legendary beauty. Before him the male ideal had shaped sculptors' figures of the female. When Zeuxis (c.400 B.C.) set about painting a Helen for the Temple of Hera, for models he asked the people of Kroton to show him their most beautiful virgins. Instead they took him to the gymnasium, showed him the boys exercising there, and said he could surely imagine the beauty of their sisters. Earlier sculptors and painters seem not to have worked from models in a studio but from watching athletes at exercise. Not to be put off, Zeuxis insisted on a proper female model. The public council came to his aid. "He did not believe he could find in one body all the things he looked for in beauty," Cicero later recounted, and so selected five maidens.

The Egyptian contrast can remind us that naturalistic art was not inevitable. But art that aimed to copy nature would dominate Rome, the Renais-

sance, and modern Western Europe. In the tradition of Myron, Phidias, and Praxiteles, it expressed a new attitude, too, toward the artist himself. Still, as we shall see, copying "nature" was not the same as copying the distinctive features of one individual. The artist's signature began to appear on works of sculpture. No longer a mere craftsman trying to do better what others had already done, he was in a competitive personal quest. The beauty of the natural living body was his unattainable ideal. Even before the subjects of Greek nudes were distinguished and their models identified, the artists began to be individualized.

The Greeks of course had to imagine an "inventor" of the art of sculpture, and they called him Daedalus. The legendary craftsman (c.690 B.C.) had been born in Athens, but was plagued by a nephew who invented the saw and the potter's wheel and threatened to excel him in skill. The jealous Daedalus threw him down to his death from the Acropolis, and was forced to leave the city. In Crete Daedalus's ingenuity made him famous. To confine the Minotaur, he devised the Labyrinth, and then, to prevent his leaving Crete, King Minos used the Labyrinth to imprison Daedalus and his son Icarus. To escape, Daedalus made wings with wax and feathers that carried him all the way to Sicily, and so he became the first man to fly. But, in the familiar story, when Icarus flew too close to the sun, the wax on his wings melted, and he drowned in the part of the Aegean that came to be called the Icarian Sea. After his escape, Daedalus continued his miraculous craftsmanship, becoming the inventor of sculpture.

There probably was a sculptor named Daedalus (c.650 B.C.) who came from Crete. Wooden cult images, Pausanias reported, had been called *daedala* ("wonders of craftsmanship"), and the real Daedalus may have fashioned these into recognizable human forms. "Being the first to give them open eyes, and parted legs, and outstretched arms," Diodorus Siculus, the Greek historian of the first century B.C., recounted, "he justly won the admiration of men; for before his time statues were made with closed eyes and hands hanging down and cleaving to their sides." Other archaic sculptors, disciples of Daedalus, came to be known as the Daedalids, who were said to be the first sculptors in marble.

The progress toward a freer, more natural portrayal of the human body was unmistakable. But it was not matched by comparable progress in knowledge of human anatomy. The classic Greeks did not consider the study of anatomy a proper end in itself. They knew the human body from the outside, from gymnasiums and athletic festivals, but did not dissect. From the sixth century, the postures of *kouroi* became more natural and more accurate anatomically in an ever more vital portrayal of the living body in movement. And across this mountain-fractured land the development again was remarkably uniform. It is much easier to date the figures than to localize them. Sculptors, like architects, were much in demand

across Greece, and signatures from all over intermingle, transcending politics in the community of art.

The dominant Panhellenic theme is increasing naturalism. Comparing the *kouroi* from decade to decade shows the head becoming more rounded, arms more subtly shaped, buttocks acquiring their characteristic slight hollow, and legs more accurately curving. The ear ceases to be schematized on one plane, and instead is scrupulously modeled into its lobe, its tragus, and antitragus. Unfortunately the noses are usually missing today, but eyes gradually reveal the roundness of the eyeball, the recess at the inner corner, and finally the lachrymal caruncle, a small fleshy excrescence. A comparable increasing precision appears in the modeling of hair, mouth, collarbone, chest, abdomen, shoulder blades, and feet.

The whole figure becomes more alive as stance becomes relaxed and the rigid symmetry of posture disappears. The heel is lifted, the arms raised, the head turned. Besides the familiar *kouroi,* there appear sculptured monuments in varied shapes and sizes. Designed to fit into pediments, metopes, and friezes of buildings are figures reclining and moving, striding, flying, running, falling. Greek sculpture in the great age must have been still more varied than what we can see today. Their favored sculptural material was bronze. In the early seventh century solid casting had been displaced by hollow casting. Bronze freed the sculptor to uplift limbs and tempted him to new postures. But in late antiquity, when marble statues were burned in lime-kilns, bronze statues were melted for their metal, leaving our picture of ancient sculpture sketchy and accidental.

The quest of Greek sculptors reached a spectacular climax in the fifth century B.C., when the stiff Egyptian figure had been miraculously transformed. A new artistic freedom had come with the exhilarating Greek defeat of the Persians at Marathon (490 B.C.) and Salamis (480 B.C.). In philosophy, too, we see a new sense of flux and a search for ways of describing change. Heraclitus (flourished c.500 B.C.) was opposing Thales' single imperishable substance with his notion of endless flux. Pythagoras saw flux in the transmigration of souls, and he envisaged rhythm and proportion everywhere. Parmenides and Zeno found new ways to separate Being from Becoming. The new interest in mechanics suggested a new internal relation among parts of the body in motion.

Nudes now included females. A new subtlety came even into the rendering of drapery, which became a hallmark of Greek sculpture in the Great Age. The body took freer gestures and motions, illustrated in the familiar discus thrower of Myron (flourished c.460–440 B.C.). This was the age of Phidias (500 B.C.), who sculpted three statues of Athena for the Acropolis, supervised the frieze of the Parthenon, and made the colossal ivory-and-gold Zeus at Olympia. From Praxiteles in the next century (born at Athens,

c.390 B.C.) we luckily have one surviving original, the celebrated Hermes with the infant Dionysus (found at Olympia, 1877).

Athletic victory statues were ideal types. While sculptors might distinguish between the physique of a runner and that of a boxer, they still would not portray the features of a particular victor. Interested in man in general, they did not leave us individualized portraits of the memorable figures. When gods were revered in ideal human form the same physical type represented man and gods equally. Athenians, fearing a "cult of personality," ostracized (487–417 B.C.) individuals who threatened to become tyrants, even if they had only found ways to include their likeness in a public monument. Among the reasons for Phidias's exile, we have seen, was the accusation that he had portrayed himself on the shield of Athena on the Acropolis.

The mask, the hallmark of the Greek theater, expressed the classic preference for ideal types and the fear of personal uniqueness. Except for a few early experiments, masks plainly representing the features of specific individuals do not appear until the Great Age of Greek sculpture is past.

Still, the Greeks found one sculptor whose work expressed their ideal. Polyclitus was said to be "the only man who has embodied art itself in a work of art." A "sculptor's sculptor," he became the undisputed legislator for his art. While Vitruvius's "orders" of classic architecture were only Roman afterthoughts about Greek works in earlier centuries, Polyclitus was himself a great Greek sculptor and his "canon" was a product of Greek sculpture's Great Age, the mid-fifth century B.C. It was as if Vitruvius had designed and built the Parthenon, and then written the specifications in a treatise on architecture.

Polyclitus's bronze figure of a nude male athlete, the *Doryphoros,* or Spear Bearer, came to be called the "canon" (the measure). In the Roman centuries this became the best-known, most influential Greek statue, with the power of a legendary archetype.

Polyclitus came from Argos, the rival of Sparta in the Peloponnesus. Pupil of the great Ageladas, who was the teacher of both Myron and Phidias, he became the leading sculptor of the Age of Pericles, a prolific sculptor of athletic victors, and the paragon of the classic style. He won a famous competition against Phidias and others for the statue of an Amazon at Ephesus. His spectacular gold-and-ivory statue of the goddess Hera for her temple at Argos was praised by Strabo as even more beautiful, although slightly smaller, than Phidias's Olympian Zeus.

His *Doryphoros* survives only in Roman copies and copies of copies. And we have only a few phrases from Polyclitus's definitive treatise on sculpture, also called the "canon," which provided conundrums for archaeologists to

match the mysteries of classical beauty. Was his statue shaped to conform to the principles of his treatise or was his treatise written about the statue? We cannot know. But belief in his rules for making a beautiful statue persisted. Pliny the Elder (A.D. 23–79), the versatile Roman encyclopedist, four centuries after Polyclitus still credited him with "perfecting" the science of sculpture in metal, just as Phidias "had opened up its possibilities." "Polyclitus . . . made a statue which artists call the 'Canon' and from which they derive the basic forms of their art, as if from some kind of law." Polyclitus's often repeated axiom was that "perfection arises through many numbers." Even if a sculptor deviated only slightly in each of his measures, he warned, in the end these could add up to a large error.

The canon, too, could protect the sculptor from the fickle public taste. A cautionary tale, still repeated seven centuries after Polyclitus's death, explained:

> Polyclitus made two statues at the same time, one which would be pleasing to the crowd and the other according to the principles of his art. In accordance with the opinion of each person who came into his workshop, he altered something and changed its form, submitting to the advice of each. Then he put both statues on display. The one was marvelled at by everyone, and the other was laughed at. Thereupon Polyclitus said, "But the one which you find fault with, you made yourselves; while the one which you marvel at, I made."

The unmistakable Greek classic style may be a product of its mathematically prescribed proportions.

The ancient Greeks had long associated measure with beauty. "Measure and commensurability," wrote Plato in the *Philebus,* "are everywhere identifiable with beauty and excellence." This notion, the heart of Polyclitus's canon, Aristotle himself traced back to Pythagoras's discovery that "the qualities of numbers exist in a musical scale [*harmonia*], in the heavens, and in many other things." If the sounds of an octave could be expressed in harmonious proportions, why not also the harmony of the whole universe? The surviving fragments of Polyclitus's treatise, finding sculptural beauty in numbers, add his bit to the Pythagorean tradition. When Vitruvius, centuries later, expounded his own famous system of proportions, we have seen that his *symmetria* for the architectural orders plainly drew on a sculptural canon.

That Polyclitus probably worked by his own canon we know from repeated complaints that his statues were too much alike, "almost all composed after the same pattern." Lysippus (flourished 328 B.C.), the greatest sculptor of the Age of Alexander the Great, became famous for his slenderized variations from Polyclitus's canon. A native of Sikyon, near Poly-

clitus's birthplace, Lysippus was reputed to have made some fifteen hundred statues, more than any other artist of his time. Still none of his original works has survived. His many portraits of Alexander the Great, beginning when Alexander was only a boy, were said to record the development of both a great artist and a great subject.

Creating a statue to resemble a particular person was a new idea for the Greeks and had to be introduced as a kind of "style." Pliny credits Lysistratus, the brother of Lysippus with "inventing" realistic portraiture. "He was the first person who modelled a likeness in plaster of a human being from a living face, and established the method of pouring wax into this plaster mould and then making final corrections in the wax cast. . . . It was this man who introduced the method of making realistic likenesses. Before him they sought to make statues as beautiful as possible."

20

For Family, Empire—and History

THE Romans sought something different. No longer fixing their eyes on Plato's "perfect truth as a perpetual standard of reference, to be contemplated with the minutest care," they granted the individual in all his warts and wrinkles a claim to sculptural immortality. Roman artists aimed to make that person survive in bronze or marble, "thereby not allowing human appearances to be forgotten nor the dust of ages to prevail against men." To celebrate the individual was the distinctive aim of Roman sculpture. And celebrate in every sense of the word—to make public, to honor, and to preserve. "Is there anyone," Polybius (205–125 B.C.) asked, "who would not be edified by seeing these portraits of men who were renowned for their excellence and by having them all present as if they were living and breathing? Is there any sight which would be more ennobling than this?"

The "ennobling" custom that propelled their art of portrait sculpture began in the Roman funeral. After the procession to the Forum for the eulogy and after the burial rites, the family returned to put a portrait of the deceased in the most prominent part of the house. "The portrait is a mask," Polybius explained, "which is wrought with the utmost attention being paid to preserving a likeness in regard to both its shape and its contour. Display-

ing these portraits at public sacrifices, they honor them in a spirit of emula-
tion, and when a prominent member of the family dies, they carry them in
the funeral procession, putting them on those who seem most like [the
deceased] in size and build. . . . One could not easily find a sight finer than
this for a young man who was in love with fame and goodness." These
imagines, as the Romans called them, made of wax and painted, were
fastened on busts and kept in small wooden shrines in the inner walls of the
atrium. There could be no mistake about who was the person portrayed, for
under each shrine was inscribed that person's name, merits, and achieve-
ments. These images in the atrium wall were connected with one another
by colored lines, displaying in sculpture the family's genealogical chart for
all who entered the house. On festival days the shrines were opened and the
busts crowned with bay leaves. At family funerals, to recall eminent ances-
tors, people put on these masks and walked in procession before the body.

The right to parade these images was a privilege of noble families. Begin-
ning in the Republic, the custom actually helped create a Roman "nobility."
The name for a member of this new class, *nobilis,* originally meant cele-
brated, renowned, or well-known (from Latin *noscere,* to know). Members
of this "noble" class came to be "known" by name and facial features
because their family masks had been carried through the streets. So Roman
portraits were creators as well as creatures of nobility.

Recognizable likenesses of individual people were not unknown before
the days of the Roman Republic. In Old Kingdom Egyptian tombs the
figure of the deceased had to be recognizable so the *Ka* could find its proper
habitation. But the Egyptian tomb statue was not a memorial. It was a
substitute for the person, to provide an eternal body in case the mummy
was destroyed. Art historians debate whether the first drawn and sculpted
human figures were of individuals or of types or symbols. Some "primitive"
figures appear to be caricatures of individuals. Unlike Greek statues, the
Egyptian tomb statues were not intended for public display. In ancient
Mesopotamia and Egypt the public statues in the fifth and sixth centuries
B.C. appear to represent types.

In the early fifth century B.C., when some Greeks began to try to individu-
alize figures, their love of the ideal type expressed in the canons of Polyclitus
proved overwhelming. Even as they made their athletic nudes more and
more "natural" and perfected the ideal proportions, they still did not make
them more individual. When the Romans made copies of the full-size
figures of the nude body, they commonly copied them as busts or herms
(pillars topped by busts or heads). The Romans liked to adorn their houses,
gardens, and public places with portraits of the great figures of Greek
history, philosophy, and poetry. Of Demosthenes alone more than forty
different representations survive. They are identified as Demosthenes not by

facial features but by the name inscribed. The individualized figure of the tyrannicide, Aristogeiton, erected in 477 or 476 B.C. is a rare, perhaps unique example. We have little reason to believe that the Roman portraits used to commemorate famous Greeks really resembled their subjects.

But by the fourth century B.C. Greek portraits do become individualized. It was these Greek artists who would teach Romans the art of portraiture and so help them achieve their distinctively Roman art. By that time the Greek portraits that purport to show us Herodotus, Thucydides, Plato, and Socrates have individualizing features. Were these mere fantasies of the sculptors? When the Athenian statesman Lycurgus (c.390–c.325 B.C.) rebuilt the theater of Dionysus (c.340–330 B.C.), he erected portrait bronzes of Aeschylus, Sophocles, and Euripides, all of whom had been dead for at least seventy years. Although these likenesses could hardly have been shaped by anyone who had known the men, they showed that a taste for individualized sculpture was developing. Masks worn by actors in the theater were now supposed to resemble the people who were personified.

After the decline of the city-state, Greek sculptors had produced another great age in the Hellenistic flowering. Instead of pursuing the athletic ideal, they made realistic portrait heads of unique individuals. The era began appropriately with a now-famous, persuasively individual bust of Aristotle (died 322), followed by portraits of Demosthenes (died 322 B.C.; statue dedicated 280 B.C.) and Epicurus (died 270 B.C.). These were only a sample, for they left us "portraits" too of Zeno, Diogenes, Aesop, and the familiar blind Homer. The Greeks in this Hellenistic age were actually perfecting a new genre of realistic fiction. Sculptors offered their imagined unique individuals in an art that would flourish among the Romans.

The many portraits of Alexander the Great (356–323 B.C.) betray this new kind of realism. While they show his development during his short life, they portray him as the fictionalized hero. The Hellenistic era that followed his death left countless portraits of other rulers, many on coins.

The contrast between the Greek and the Roman spirit was dramatized in the sculptural creations of the Roman Republic. It was the contrast between Greek idealism, the search for the perfect, and Roman verism, which focused on the world's miscellany. The abstract beauty of myth was displaced by personality and politics. On the Parthenon the victory of the Greeks over the Persians was depicted not directly in the historic battles but obliquely in battles of Giants, Gods, and Amazons. Greek sculptors, even when they reached for portraiture, simply depicted eminent lawgivers, philosophers, and poets.

The Roman demand for portraits that had begun in the funeral customs of noble families reached down to include ordinary citizens, women, and

children. It became as common for a Roman man of affairs to commission portraits of his family as it would be for the seventeenth-century Dutch burghers. The portraits that Romans copied from the Greeks were mostly busts and herms, but portraits of their own men and women were often whole life-size figures, fully clothed in toga, military regalia, or domestic garment. Through these we can write a history of Roman costume, style, and coiffure. We can date the portraits of women by their hairdo—from the simple parted design with central roll of the Augustan Age to the high honeycomb and coils of the Flavians and Antonines.

Under the Roman Republic, sculpture still served family ritual—now by ruthlessly depicting wrinkles and warts and creases. Because of the funeral function of portraits, old age naturally became a common subject. But when Gaius Julius Caesar Octavianus (63 B.C.–A.D. 14) was given the title "Augustus" (exalted, sacred) in 27 B.C. and became the object of worship, his portrait had to be apotheosized. As sculpture became the vehicle of politics and the visual symbol of empire, sculptors were posed a new dual problem. They had to offer recognizable reproducible likenesses of this Augustus, to unite imperial loyalties behind this particular man. Yet the figures had to be sufficiently idealized to serve a religious ritual function, raising him above human rank. An ideal figure by the canons of Polyclitus or anybody else would not do. Nor would an unflattering portrait of the idiosyncratic individual. So, with the reign of the imperial divine Augustus there emerged a new "classicism." While the Greeks had given their gods an ideal human form, the Romans strived to make their rulers godlike.

As portraits of Augustus and the imperial family spread out to the provinces, Greek sculptors and their Roman disciples made an enduring public record of Roman history. The need to advertise each emperor, and the miscellaneous succession of emperors, invigorated art with a new political purpose, originating in the distinctive Roman classicism of the reign of Augustus (31 B.C.–A.D. 14).

In portraits of Augustus, his aquiline nose and the characteristic divided locks of hair above his forehead are easily recognized. But he has the body of a god, in classic Greek proportions. He is always in the prime of life, never old or aging. The most famous of his surviving portraits (the Augustus of Prima Porta, Livia's Villa; now in the Vatican) shows him wearing ornate Roman armor, right hand raised to address the army, left hand holding a staff or lance. His imperial ventures are recorded in relief on his armor. Another type of Augustus depicts him draped and veiled performing sacrifices as pontifex maximus. Still another is a simple royal head. The other patricians, too, live on in only mildly idealized portraits. This is a period of unforgettable faces. One Roman nobleman is so concerned for his family status that he displays in each hand the bust of an ancestor.

Politicians used portrait sculpture for extravagant self-advertising. Cicero himself so indicted Verres (73–71 B.C.), the rapacious governor of Sicily:

> There was an arch set up by him [Verres] in the forum of Syracuse, upon which stood a nude figure of his son and also a statue of Verres himself on horseback looking out over the province which he has denuded. In addition there were statues of him in every location, a fact which seemed to demonstrate that he was able to set up in Syracuse just about as many statues as he took away. In Rome too we see on the base of statues to him in large letters: "Given by the federation of Sicily."

Augustan portraits were only a beginning. Likenesses of succeeding Roman emperors followed without exception: the vigorous Tiberius, the uncouth Claudius, the flabby Nero, the majestic Hadrian (reigned 117–138), the reflective Marcus Aurelius (reigned 161–180), the sinister Caracalla (reigned 211–217). For us the sculptors have made the history of the Empire more vividly personal than any other era of antiquity.

Though the glories and tragedies of Augustan Rome were military, its preeminent sculptural monument advertised peace. After a long series of far-flung battles climaxing in the Battle of Actium against Antony and Cleopatra in 31 B.C., Augustus had pacified Gaul and Spain. Then the Altar of Augustan Peace (*Ara Pacis*) was decreed by the Senate in 13 B.C. and dedicated in 9 B.C. on the Campus Martius. This Altar of Peace, which luckily we can see substantially reconstructed in Rome today, was a Roman foil for the Parthenon. The Athenians had glorified their patron goddess with ideal figures in the Panathenaic procession. But the *Ara Pacis* celebrated Emperor Augustus himself, and portrayed him followed by the members of his family, the officers of the government, the priests, and a sample of the Romans who were there to dedicate the site on July 4, 13 B.C. The frieze on the walled enclosure (thirty-eight by thirty-four feet) surrounding the altar depicts in realistic detail the actual dedicatory procession. The imperial children are looking bored in their little togas. One tugs at the garment of the adult in front of him as his older brother looks on reproachfully. This pictorial archive removes any uncertainty that the emperor himself and the highest dignitaries were really there.

Still, the sculptors of the *Ara Pacis* had not forgotten the Greek tradition to which they owed their arts. An allegorical panel of Mother Earth—or perhaps Italia—in the Greek manner provides a rotund symbol of fertility, flanked by two personified winds, all localized in a pastoral landscape of the kind Virgil (70–19 B.C.) was romanticizing in his Eclogues. The historical event is validated and sanctified by the legendary prototype as we see

Aeneas, the founder of Rome, sacrificing on his arrival at his promised land. To confirm Augustus as the second founder of Rome, another panel shows Romulus and Remus. On the processional panels and smaller friezes ordinary Romans are casually conversing. The sculptures become a journalistic report framed in the pastoral and patriotic tradition.

Roman sculptors remained faithful servants of historical journalism, bringing alive for us the struggles and triumphs of their Empire. Historical arches, in a technique rivaling modern photojournalism, depicted the world-shaking events as Romans wanted to see them. The monuments themselves remind us of the wondrous continuity of the Empire and its works. Although the emperor Titus (A.D. 79–81) had a short reign, a series of catastrophes and good fortunes made him a large figure in Roman history. He worked energetically to repair the destruction caused by the eruption of Vesuvius in 79. And then the fire that devastated Rome in A.D. 80 gave him another grand opportunity for reconstruction. He had the glory of finishing the Colosseum, which his father, Vespasian (A.D. 70–79), had begun, to replace the amphitheater destroyed in the fire of Nero's time, and he hastily built magnificent public baths. Titus's opening festivities, according to Suetonius, were "of the utmost magnificence and lavishness." He staged a mock naval battle by flooding an old amphitheater built by Augustus near the Tiber, along with spectacular gladiatorial combats and a show with five thousand animals.

Titus's capture and sacking of Jerusalem in A.D. 70–71, when he was his father's commander, was commemorated in the so-called Arch of Titus, built in A.D. 81 by his younger brother and successor Domitian (reigned A.D. 81–96, last of the Flavians). This sensational display of Roman imperial jingoism depicts on one side the spoils of the Jewish Temple of Jerusalem (including conspicuously the sacred seven-branched candelabrum) carried in procession, and on the other the heroic emperor driving his chariot past the lances of his soldiers, accompanied by Victory. Titus had brought back to Rome from Jerusalem another trophy, lovely Berenice, the daughter of the Jewish king Herod Agrippa I. He never married her, and when Romans objected to the liaison of a son of their emperor with a Jewess, Titus dismissed her—(in Suetonius's phrase) *invitus, invitam,* the unwilling dismissing the unwilling. Their unhappy separation survived as the theme of Racine's tragedy *Berenice* (1670). Among Roman emperors Titus also had the distinction of dying a natural death, whereafter he was promptly deified by the Roman Senate.

Titus's successor Domitian became famous for his passion to be celebrated in sculpture. He especially enjoyed seeing himself depicted as Hercules. "He permitted no statues to be set up in his honor," Suetonius

reported, "unless they were of gold and silver and were of a certified weight. He also built so many arcades and arches, complete with the insignias of triumphs, throughout all the regions of the city that on one of them someone added the following inscription in Greek: '*Arci.*' " This was a pun: on the Latin *arcus* for arch, and the Greek *arkei,* "It is enough."

If statues could perpetuate memory, destroying them could erase memory. So the Romans developed the institution of *Damnatio memoriae.* It grew out of the penalties in the primeval XII Tables for the ancient Roman crime of treason. In addition to execution and confiscation of property the *praenomen* (first name) of the condemned could not be perpetuated in his family, images of him were to be destroyed, and his name was to be erased from all inscriptions. The only way the accused could escape these indignities was by committing suicide before the charge was formally lodged. *Damnatio memoriae* became a favorite weapon of retribution by the Senate, to be wielded by nervous upstarts against their predecessors. The Senate used it against Nero during his lifetime, and it was enacted posthumously against the ruthless Domitian. As a consequence the statues of Domitian were defaced or destroyed. The only statue of Domitian that survived, according to Procopius, was the one his wife set up after his death. In order to provide the sculptors a model for this statue she had to piece together the emperor's body, which had been dismembered by his murderers.

The Roman passion for creating and preserving the historical record in sculpture left us a grand and bizarre monument. Trajan's Column is perhaps the most complete visual record of any military event in antiquity. It has few rivals before photography. Though erected (A.D. 106–113) in the heart of Rome, its images are curiously inaccessible. Dedicated in Trajan's Forum in 113, it commemorated his victories over the Dacians, as the ancient inhabitants of Romania were called. The Column, 125 feet high, was also intended to provide a lookout for admirers of Trajan's public buildings, his forum and the nearby markets that had been cut into the slope of the Quirinal Hill. The interior contained a spiral staircase, with loopholes to admit light. Relief sculptures carved on the outside told the story of Trajan's two campaigns against the Dacians (101–102 and 105–106) in archival detail. This was, of course, a record for the ages, but no one has figured out how it could have been examined by contemporaries. It is just possible that the upper figures could have been observed from the tops of a surrounding two-story arcade.

A spiral band of carved Parian marble three feet wide winds up the Column. If it could be unwound it would stretch to 656 feet in length, considerably longer than the whole frieze of the Parthenon. A spectator trying to trace the story up the twenty-three spirals will be dizzied by circumambulating. As the spiral reaches upward the viewer on the ground

cannot discern the figures. The designer was probably Apollodorus of Damascus, who had planned Trajan's Forum and his basilica. And he did what he could to help the straining spectator at ground level. The carving was kept shallow so shadows would not obscure figures below. To make the men and animals clear from a distance he exaggerated their size in relation to the landscape in a kind of inverted perspective. He had the figures painted in bright colors, and attached metal for the weapons and the ornaments and harness of the horses. This was the same Apollodorus who, some years later, offended Hadrian by his sarcasm about Hadrian's "pumpkin" design and was banished and perhaps executed as a result.

In cinematic fashion (the technique of a silent wordless film, for there were no inscriptions) the scenes dissolve one into another. This was novel both in scale and in style, for the early Assyrian battle reliefs give us nothing so grand or so vivid. Here the star, the emperor Trajan, appears in one scene after another, having changed his costume to suit the action. Altogether there are about twenty-five hundred figures in 150 episodes moving upward from left to right. The narrative is divided in half, with a figure of Victory to mark the truce between the first and second Dacian campaigns. The Column scarcely depicts the melee of battle but, like Caesar's *Gallic Wars,* offers an orderly chronological résumé of the social, geographic, technical, logistic, and human aspects of this war. No stage in the planning, the preparations, or the supply is omitted—from the emperor addressing the army, through the sacrifices offered for victory, the building of pontoon bridges and engines of warfare, the crossing of mountains, the capturing and interrogating of prisoners, the removal of booty, and finally the suicide of the Dacian chief Decebalus while being pursued by Roman cavalry. Dramatic counterpoint shows the delight of soldiers at receiving a prize from Trajan juxtaposed with the torture of Roman prisoners by Dacian women, and then the decent treatment of Dacian prisoners in a Roman camp, rounded off in the last scene by herds grazing in an idyllic landscape. Seldom before or since has there been so comprehensive and circumstantial a visual record of war by contemporaries. Yet this costly and dazzling historical record, in scrupulous and elegant detail, was mostly invisible to contemporaries! As it is to us on the ground today, Trajan's Column was History for History's sake.

The Column had its own lives and afterlives. Its role as a lookout was displaced by its function as a war memorial, to become at last a historical record. Originally supposed to be topped by an eagle, it was finally surmounted by a statue of Trajan, whose ashes, with those of his spouse, were buried beneath. Trajan's statue was mysteriously removed in the Middle Ages to be replaced in 1588 by the present statue of Saint Peter.

21

The Healing Image

CHRISTIANITY began as an enemy of images. Inspired by their Hebrew inheritance, the Fathers of the Church were haunted by the fear of idolatry. The Second Commandment had condemned images. Again and again the Old Testament forbade the worship of foreign gods or the making of images to represent the God of Israel. The words of the Book of Exodus (20:4–6) went much further:

> Thou shalt not make unto thee any graven image, or any likeness of any thing that is in the heaven above, or that is in the earth beneath, or that is in the water under the earth;
>
> Thou shalt not bow down thyself to them, nor serve them: for I the Lord thy God am a jealous God, visiting the iniquity of the fathers upon the children unto the third and fourth generation of them that hate me;
>
> And shewing mercy unto thousands of them that love me, and keep my commandments.

The Greek words for "idolatry" originated in the New Testament and in Christian literature in the first centuries. Paul elevated "idolatry" into a sin and listed it among those to be shunned by Christians.

When Rome fell to the barbarian hordes of Alaric on August 24, 410, Christians were accused of inciting the malice of the gods who had long protected the city, and whose images they had destroyed. But Saint Augustine's *City of God* (413–426) attacked the idolatry of the Romans and even tried to enlist the authority of enlightened pagans against images. The great sin, according to Augustine, was worshiping the creature in place of the Creator. Since idols became vehicles for demons, "worshipers of idols are worshipers of demons."

Except for a brief relapse under Julian the Apostate (331–363; emperor, 361–63), the early Christian emperors all attacked the worship of idols. Emperor Theodosius the Great (346?–395; reigned 376–95) closed the pagan

temples in 391, forbade idolatry as the horrendous crime of lèse-majesté, and encouraged the destruction of idols. His energetic piety reached out to the Empire's far provinces, as Edward Gibbon recounts with eloquent nostalgia:

> Many of these temples were the most splendid and beautiful monuments of Grecian architecture: and the emperor himself was interested not to deface the splendour of his own cities or to diminish the value of his own possessions. Those stately edifices might be suffered to remain as so many lasting trophies of the victory of Christ. . . . But as long as they subsisted, the Pagans fondly cherished the secret hope that an auspicious revolution, a second Julian, might again restore the altars of the gods; and the earnestness with which they addressed their unavailing prayers to the throne increased the zeal of the Christian reformers to extirpate, without mercy, the roots of superstition.

The power of images had been recognized by Saint Augustine (354–430) himself when he denounced their demonic capacity. Still, practical men of piety could not deny that images could inspire and sustain Christian faith. "Lest what is reverenced and adored be painted on the walls," they at first dared show their Lord only obliquely, as a lamb or a shepherd, or in a bodiless hand reaching from above. But to provide ancient satisfactions for worshipers in the new faith somehow there had to be Christian images, too. And by the sixth century the Christian fear of images had much abated. Theologians had come to the rescue, showing that images were useful, or even necessary, vehicles of divinity.

Christians were reminded that Saint Paul had called Christ the Image of God (2 Corinthians 4:3; Colossians 1:15). Saint Basil (330?–379?) explained that "the honor rendered to the image passes to the prototype." Just as Christ the Son of God "as an image is absolutely without difference, as generated he preserves the same essence as the Father." Just as "an Emperor's image is the Emperor" and does not cause two emperors to exist, so it was with Christ, the supreme emperor. While the emperor's image made of wood, wax, and colors was "a corruptible image, an imitation of something corruptible," Christ's image was "the splendor of the glory" of God.

Still, a Christianity without images was clearly conceived by the revered Fathers of the Church. The Iconoclastic Movement of the eighth century shows how deep were the aniconic currents. Why was this outburst so late in coming, and why did it end so suddenly? These events in Constantinople and the Eastern Empire punctuate with a giant question mark the whole history of Christian art.

The champion of the battle against images was the Byzantine emperor Leo III (680?–741; emperor, 717–41), ambitious and energetic founder of the

so-called Isaurian (or Syrian) Dynasty. He seized the throne from Theodosius III by enlisting the aid of besieging Arab armies on the pretext that he would subdue the Eastern Roman Empire for them. Then, much to the Arabs' chagrin, his first achievement as emperor was to organize the defense of Constantinople against them. He drove off Caliph Suleiman in 717 and broke the siege of the city. Leo then turned his organizing energies to the reform of his Eastern Empire. He suppressed mutinies, established discipline in the army, imposed taxes to support his vast defensive military operations, enacted an agrarian code to protect small farmers, and reorganized the whole provincial bureaucracy. His most durable reform was to "humanize" and Christianize Justinian's *Corpus Juris* in his own brief *Ecloga Legum* (726) by changing the law of marriage and property, and substituting amputation and mutilation for some death penalties.

Reforming Christianity, for Emperor Leo III, meant destroying religious images and opposing all who tolerated them. The sources of his purifying passion are obscure. Enemies accused Leo of infection by Muslim dogma when he was a boy in northern Syria. Or we may, in wider perspective, see him as a champion in the historic battle between the Greco-Roman classical tradition and the mysticism and monotheism of the Eastern provinces. In that battle of "Athens against Jerusalem" Leo III spoke for Jerusalem. There was a political element, too, in the Byzantine attitude toward images, for the worship of the emperor's image had not been interrupted by the progress of Christianity. The image of the emperor continued to do duty for the emperor himself in courtrooms, theaters, and public assemblies to the far reaches of his Empire. Juxtaposing the image of Christ suggested the emperor's heavenly authority. In the late seventh century Emperor Justinian II revolutionized Byzantine coinage by putting on one side of his coins the image of Christ and on the other the image of himself as "Servus Christi."

Cults of images grew in the centuries just before Leo III, and by the sixth century they had developed a full-scale theological defense that helped icons survive savage persecution and the onslaught of saints and theologians. After Emperor Justinian I (483–565; reigned 527–65), Christian images played a magic role in the chronicles of pilgrims. Cures and miracles multiplied from sacred images in Christian households. Gregory of Tours told how Christ Himself appeared to demand that he be decently covered in the painting of His crucifixion at Narbonne. Even the candles lit before images would perform miracles and cure illnesses. One patient, as a seventh-century life of Saint Theodore of Sykeon recounted, was cured by dewdrops that fell from an icon of Christ, and another was healed by a mysterious sweetness, sweeter than honey, tasted in the mouth when praying before an image of Christ.

Stories multiplied of the use of images as palladia, or magic shields, to

defend cities against attack, and of their "apotropaic" powers to ward off evil. Images became household furnishings, a general "prophylaxis," for those who could afford them. Constantinople resisted the Avars in 626, an eyewitness recorded, when the patriarch had images of the Virgin and Child painted on the city gates. Miraculous Christ images were commonly paraded around the city to protect it against fire or enemy attack.

As the vogue of image worship grew in the late sixth and seventh centuries the legends grew of images not made by human hands that brought their message direct from God to the viewer. In the town of Izalos the picture showing a miracle performed by the relics of Saint Stephen appeared so speedily after the event that it must have been the work of an angel. Other images were miraculous mechanical impressions of a holy original, such as the face of Christ made by pressing a piece of cloth against His face, or impressions of His arms on the Column of the Flagellation. Such images were common enough to acquire a name of their own—*acheiropoietoi* ("not made by hand")—which suggested that such an image somehow perpetuated the Incarnation.

Until the late fourth century, images had been justified mainly as educational tools, "the books of the unlearned." Then, by the late sixth and seventh centuries they became holy in themselves, with a mysterious affinity to whatever they represented. No longer mere channels of knowledge about sacred things, they became sanctified elements in the experience of the holy. These images, Dionysius the Areopagite (A.D. c.500) explained, were "the multiplicity of visual symbols, through which we are led up hierarchically and according to our capacity to the unified deification, to God and divine virtue . . . through visible images to contemplation of the divine." By the seventh century apologists for images no longer argued on the basis of the needs of illiterate beholders and instead described "the establishment of a timeless and cosmic relationship between the image and its prototype."

Arguments from analogy became more sophisticated. From the axiom in Genesis (1:27) that "God created man in his own image, in the image of God created he him" they moved on to a divine sanction and divine quality in all images. They enlisted the subtle Neoplatonic dogma of a divine essence that appeared in a descending series of reflections, and so eventually in religious images. If the God-made image of man is divine, then may not a man-made image of God also have an odor of divinity? In worshiping images of saints, may we not be glorifying the "house of the Holy Ghost"? Perhaps the artist—no longer the "deceiver" whom the early Church Fathers condemned—was simply continuing the divine acts of creation. If in Christ God became man and so capable of visual representation, did not all pictures teach the doctrine of Incarnation? Was not the distinction between the image and its prototype just another kind of idolatry?

We cannot be surprised that these subtleties troubled the pious and powerful emperor Leo III. A self-made man who had built his reputation by intrigue and military command, Leo III held strong views in theology that he enforced with imperial authority. He forcibly baptized heretics and Jews. His practical interests made him a bitter opponent of the tax-free monasteries that were attracting thousands of able-bodied men into the cloisters. In 726 he opened his Iconoclastic campaign with a flourish—by destroying the mosaic image of Christ over the gate of his own palace. He replaced it with a cross. But the widespread political and economic consequences of his Iconoclasm would be more than he had bargained for. As his campaign against sacred images spread, so too did rebellions of outraged worshipers, such as that in the Cyclades islands in the very next year (727). Monks organized against him. Pope Gregory II (715–31), who had been a prop of the Eastern Empire but could not tolerate this emperor's authority in the religious sphere, resisted the destruction of religious images in the Byzantine-held areas of Italy. Leo retaliated in 731 by seizing for his imperial treasury the papal taxes (some three and a half hundred-weights of gold annually) on the churches in Calabria and Sicily. The consequences shook Europe, for Pope Gregory II and his successor Gregory III (731–41), turned away from the Byzantine emperor to ally themselves with the Frankish kings.

Until that dramatic iconoclastic act in his own palace Leo III seems to have shared the common faith in images. This change of heart was a surprise, for at Constantinople in 718 he himself had used a miraculous icon of the Virgin to help him hold off the Arab invaders. But his close relations with the Saracens (the nomadic desert peoples between Syria and Arabia) may give us a clue to his violent revulsion against the idolatry of images. His youth in upper Syria had brought him a knowledge of Arabic, in which he seems to have been fluent.

A plausible legend reminds us of the close spiritual affinity of Christian emperors with their Muslim-Arab enemies on the battlefield. This story in the records of the Council of Nicaea in 787, which ordered the worship of images, made the Umayyad caliph Yazid II (reigned 720–24) the first enforcer of Iconoclasm in the Christian churches. The gullible caliph, gravely ill, was approached by a Jewish "magician and fortuneteller, an instrument of soul-destroying demons, a bitter enemy of the Church of God," who promised him a healthy and prosperous thirty-year reign if he would only destroy every representational painting or image in all the Christian churches. The caliph, accepting the diabolical bargain, "destroyed the holy icons and all other representations in every province under his rule, and, because of the Jewish magician, thus ruthlessly robbed the churches of God under his sway of all ornaments, before the evil came into this land. As the God-loving Christians fled, lest they should have to

overthrow the holy images with their own hands, the emirs who were sent
for this purpose pressed into their service abominable Jews and wretched
Arabs; and thus they burned the venerable icons, and either smeared or
scraped the ecclesiastical buildings." This experiment in iconoclasm did not
fulfil the Jewish magician's promise. Caliph Yazid was assassinated in 724,
only two and a half years after his Iconoclastic edict, and his son ordered
the magician put to death for false prophecy. When Emperor Leo III
launched his own battle against images in 726, his energetic aide was
reported to have the same name as the evil Jewish magician. And a disas-
trous volcanic eruption seemed to show God's displeasure at the spreading
idolatry.

Leo's arguments against images revealed a Jewish, and perhaps also a
Muslim, influence. To Leo III and his advisers Mosaic law seemed com-
mand enough. Still, he waited four years after his symbolic act of 726, and
in 730 he issued his edict against all sacred images. At the same time he
removed the patriarch of Constantinople, who had been an image wor-
shiper. The party of images, who would prevail and so would write the
history, libeled Leo as a burner of books and universities. But the truth
seems to be that education improved in his reign. The full fury of theological
passion was released by Leo's Iconoclast son and heir, the able Constantine
V (718–775; reigned 741–75). The image worshipers' nickname for him—
Copronymus ("called from dung")—has stuck in the history books. Despite
the libels of the iconodules (image worshipers), neither Leo nor his son was
an enemy of music or the arts. They were secular in their preferences, but
no more ascetic than the caliphs.

Yet theological and political passions were inseparable. When Constantine
V at the age of twenty-one came to the throne in 741, he was challenged by
his much older brother-in-law Artavasdos, who seized Constantinople as a
restorer of sacred images. It took Constantine two years to recapture the
capital, and the rebels inflamed Constantine's Iconoclasm. Leo III's acts
against the image worshipers had been moderate and sporadic, but Constan-
tine became fanatic. His troubles were soon compounded by a disastrous
epidemic (745–47) of the bubonic plague. And when there were not enough
left alive to bury the dead, Constantine had to repopulate his empire with
two hundred thousand migrants from Bulgaria. In his relentless persecution
of the "iconodules" he stigmatized the former patriarch as a "wood-
worshiper." In 764–65 he required all subjects to take an oath renouncing
images, and he enforced their wholesale destruction. He banned the adora-
tion of relics, forbade the worship of the Mother Mary, and the title of Saint.

To validate his iconoclasm, Constantine summoned a church council in
754 to proclaim that no religious image of any kind would be permitted.

Since Christ had both a human and a divine nature, the council argued, any image of Christ must either be attempting the impossible (depicting the infinite divine nature in finite human forms) or committing a heresy (by showing His human nature alone and so destroying the unity of Christ's person). But these Iconoclasts had entered the thicket of theology. Entangled in the arcane definitions of Christology, Constantine V, the political autocrat, was no match for the subtle monastic mind. And the long victory lay with the iconodules, the worshipers of images, who provided ever more ingenious compromises between idolatry and Christianity. To the argument that no one has seen God the iconodules retorted: But Christ has come to us in the flesh. The efforts to impose Iconoclasm by force failed, and the victory of images was accomplished by the power of ideas.

When Leo III used the Laws of Moses to forbid religious images, his opponents quickly confuted him with the simple fact that those laws had been revealed long before the divine Incarnation. The coming of Christ, God in human shape, had changed everything. Now the human form was no longer an invitation to idolatry but an avenue to God. By recalling the visible forms of Christ, His Holy Mother, the Apostles and the Saints, worshipers were lifted toward the Highest Truth. This was only their first and most elementary response to the Iconoclasts.

Religious images found their subtle historic champion in a most improbable place. Saint John of Damascus (c.675–c.750) was born into a wealthy Greek-speaking Damascus family known as the Mansour (Victorious or Redeemed). As son of the high official of the Muslim caliph charged with financial administration of the Christian community, he succeeded to his father's job. For obscure reasons, about 700 he retired to the monastery of Saint Sabbas, near Jerusalem, where he stayed till his death, exerting vast influence on the life of the Church, its theology, its liturgy, its art and music. Though canonized by both the Latin and the Greek churches, John of Damascus has never attained the celebrity among lay believers to which his versatile achievements entitle him. He wrote the hymnology of the Eastern Orthodox Church and is credited with inventing the musical pattern of eight tones used in the Byzantine liturgy. His *Font of Wisdom* became the standard textbook of the Greek Church and a revered source for Thomas Aquinas, refuting the main heresies and expounding the two natures of Christ. And it was his polemical tracts (726–30) that most persuasively defended the need for images in Christianity. Failing to use sacred images, John explained, was actually denying God's Incarnation in Christ. He led the way, as Jaroslav Pelikan has shown, in Christian theology's historic transformation of images from idols into icons.

Against the crude dogmatism of the Iconoclasts, John of Damascus defined an image as "a mirror and a figurative type, appropriate to the

dullness of our body." And he followed the Neoplatonists in treating images as a way of using the senses to rise above the senses, to the eternal world of divine essences. God's Incarnation in Christ was itself a recognition of the weakness of the flesh, of man's need for images. The Christian image of Christ, of Mary, or of the Saints was "a triumph, a manifestation, and a monument in commemoration of a victory." When anyone viewed a sacred image, he participated in the victory of Christ over the demons. "I have often seen those with a sense of longing," John of Damascus recalled, "who, having caught sight of the garment of their beloved, embrace the garment as though it were the beloved person himself." Christian worship of icons showed similar affection for the image that was really addressed to Christ Himself. The Christian use of icons was not pagan but simply human.

On the troublesome question of the dual nature of Christ, John again took the offensive. Pictures of the visible Christ could not exist independently of Him any more than a shadow could exist without the form that casts the shadow. Against the Iconoclast argument that an image had to be made of the same substance as the original, he insisted that the image was not "consubstantial" with its original. It was, rather an imitation (or *mimesis*) in the Platonic sense, only a shadow. "Christ," John of Damascus concluded, "is venerated not *in* the image but *with* the image."

Constantine V, unmoved by these arguments, tried to enforce his Iconoclast position with his imperial authority. The so-called Seventh Ecumenical Council of Hieria in 754, which corralled 338 bishops to do the emperor's bidding, formally anathematized John of Damascus, as it proclaimed an iconoclastic crusade. Priests were executed on mere suspicion of being image worshipers, and the Constantinople mob joined with a lynching. Constantine expelled monks and nuns and seized monastic properties, with results favorable to the army and to the economy.

The power of the Iconoclasts was short-lived. When Constantine VI (771–797; reigned 780–97) came to the throne as a child of nine, he was dominated by his power-mad mother, Irene. Using the religious issue to consolidate her power, in 787 she convened the Second Council of Nicaea, which reversed Constantine V's Council of 754 and glorified John of Damascus. Some 350 Greek bishops and two representatives of the pope resoundingly affirmed the worship of images whose veneration, they said, was "transferred to their prototypes." The worship of images, they concluded, was not only permitted, it was commanded both by tradition and by theology. The passage in the Book of Deuteronomy that forbade images was followed immediately by a curse on anyone who "dishonors his father or mother" or removes his father's "landmarks," in which icons must be included. Since the invisible God had become human and visible in Christ, and the human nature of Christ had been transformed by the Incarnation,

the worship of icons was needed to affirm the true meaning of Christ. So the council affirmed a new Christian epistemology in which the senses were sanctified.

What might have been the future of Western art if the Iconoclasts had prevailed and spread their orthodoxy through the Church of Rome? How different might Western Christendom have been without the collaboration of painters and sculptors! All the great historic religions, except Judaism and Islam, have enlisted the image makers—painters and sculptors. Even during their brief decades of power, the Iconoclasts did affect the arts of Byzantium. When Christian artists were forced into secular channels, they, like the Muslims, turned to geometric and floral motifs, and produced a brief but brilliant classical revival.

Because John of Damascus and his theological cohorts prevailed with their theological subtlety and commonsense psychology, the Christian Church remained free to enlist the representational arts. Western artists would benefit from the patronage, the inspiration, and the enthusiasm of faithful Christians. Whether the West in the long run could have been as rich in art had the artists been forced into secular channels, we will never know. The examples of Islam and of militantly secular totalitarian states in the twentieth century remind us of how much might have been lost. The triumph of John of Damascus produced more than a treasury of beautiful objects. For during worship, as Patriarch Nicephorus of Constantinople (806–15) explained, icons could convey "theological knowledge" of a divine reality that transcended all being. "They are expressive of the silence of God, exhibiting in themselves the ineffability of a mystery that transcends being. Without ceasing and without silence, they praise the goodness of God, in that venerable and thrice-illumined melody of theology."

In the Christian East, sacred images played a distinctive role in this melody. The religious art of the medieval West would be mainly didactic or decorative. But in Byzantium images became icons, vital elements in devotion and architecture. Every image of Christ became somehow a confession of faith in the Incarnation. So important did images become that the historic return of icons to the churches was, and still is, commemorated by one of the main feasts of the Eastern Church. This is the Feast of Orthodoxy on the first Sunday of Lent, "the Sunday of Orthodoxy." Empress Theodora managed finally to end the controversy in 843 after the death of her iconoclastic husband, Emperor Theophilus. Ironically, political and theological turmoil forced her to end her days in a convent in 858. The hymn for the Sunday of Orthodoxy speaks to the Virgin Mary:

From you, O Mother of God, the indescribable Word of the Father was incarned and accepted to be described. He restored the obscured image of God in man,

uniting it to Divine beauty. So that we, now, use both images and words in confessing our salvation.

Western Christianity was not destined to suffer another iconoclastic trauma till the Reformation of the sixteenth century.

But even after the defeat of the Iconoclasts, representational art was never quite liberated in the East. It became the art of the icon, which survived for centuries in Byzantium, Russia, and in between. The incorporation of images into theology gave the art of the icon the rigidity of theology. In Byzantium the icons did not merely represent the Incarnation, they somehow expressed it and were part of its history. There, when architects and artists returned with enthusiasm to sacred images, they never ceased to be haunted by suspicions of "graven images." Sculpture in the round was not tolerated, and even sculpture in relief was rare. A new Eastern visual liturgy developed, a holy scripture of images, keyed to the liturgical feasts, and placed in a canonical order. Icons produced iconography, a new element in Byzantine Church architecture.

The iconostasis, a solid screen of wood, stone, or metal to separate the sanctuary from the nave in the Eastern Christian churches, became the prescribed way of displaying icons. The top row on the iconostasis showed the biblical prophets; the second row, the events and miracles in the life of Christ on earth; the third row, the deesis, a central icon of Christ enthroned in the center, with icons of the Mother and Child (the Incarnation) on the left and Christ the Pantocrator (Christ in majesty) on the right. The bottom row commonly showed icons of special local interest. Only minor variations appeared over the centuries, with an additional row of icons sometimes added above or below. The familiar order survived into the nineteenth century, easing the grasp of the illiterate viewer on the Great Truths of the Church in any church that he happened to enter. The survival of the icon bore witness to the changeless life and unchanging faith of a mass of Eastern believers. It became, too, symbolically a part of the screen that shielded the mystery of the Eucharist from the worshiper.

Few sacred images survived the onslaughts of the Iconoclasts. After their defeat, brilliant artists expert in paint and mosaic were still wary of deviating from the expected image. Even the greatest of icon painters in the fifteenth century, Andrei Rublev, shows little of the freedom of his great Christian contemporaries in the West. A surprising homogeneity of design and restraint pervades the icons over many centuries and over a vast continent. When art became one with theology the artist-creator became an acolyte of the archetype, fearing to offer his private vision.

22

"Satan's Handiwork"

WHILE Christian theology was enlisted to give artists a divinely appointed task, in Islam religion remained the inhibitor of the arts. "The angels," said the Prophet Mohammed, "will not enter a house in which there is a picture or a dog." Those most severely punished on the Day of Judgment—along with the murderer of a prophet and the seducer from true knowledge—will be "the maker of images or pictures." Since the Koran did not explicitly forbid images, the notorious Muslim hostility to images came from the Traditions (Hadiths) of the Prophet.

Pious Muslims had long since made the destruction of images a religious duty. Many a Muslim Savonarola salved his conscience and lit his way to heaven with his own "bonfire of the vanities." When the Umayyad caliph Uman ibn Abd al-Aziz (717–20) found a picture in his bathroom he had it rubbed out and sought out the painter "to have him well beaten." Sultan Firuz Shan Tughluk (c.1308–1388; reigned 1351–88) left his mark in Muslim history not only by building his own capital city, Firuzabad, and by constructing mosques, hospitals, baths, bridges, and the Jumna Canal, but by mutilating and destroying innumerable works of art. His autobiography boasted that he had erased all pictures from the doors or walls of his palaces and "under the divine guidance and favor" had even removed the figured ornaments from saddles and bridles, from goblets and cups, dishes and ewers, from tents, curtains, and chairs. Sometimes pious Muslims economized efforts by merely scratching or smearing the faces of images they happened on.

Yet Islam, unlike Christianity, was ill organized to mount a doctrinal crusade against images. The unstinting commitment to the Koran, to be supplemented only by the Traditions of the Prophet, discouraged any elaborate doctrine of the arts. There was no priestly hierarchy to proclaim an authorized dogma, nor were there illustrated versions of the Koran. The Christian attitudes for and against images, as we have seen, can be traced

to Councils of the Church or revered Church Fathers. The Koran, itself a vehicle of the beauty and eloquence of Arabic, helped diffuse that language, played a role comparable to that of the Homeric epics or the Judeo-Christian Bible, and provided an increasing resource for a rich literature. Calligraphy—the art of writing—glorified the Koran with unexcelled flamboyance and elegance.

But the Muslim passion against images was a spontaneous by-product of Muslim history and society. Although there was never any specifically religious art in Islam, the Muslim-Arab world proved fertile of other kinds of art. The story of the arts in Islam dramatizes the struggle of Islam to establish its uniqueness, reveals its problems in a world of Unbelievers, and exposes its hopeless struggle to affirm God the Creator by denying Man the Creator.

The scriptural basis for iconoclasm, as we have seen, was Moses' Second Commandment. The personal influence of the many Jewish converts to Islam reinforced this traditional Semitic fear of human representation in sculpture and painting. Then there was the earnestness of the Prophet and his disciples to distinguish their faith from the pagan religions that it displaced. The idols in the Kaabah in Mecca in pre-Islamic times were the special target of their fears. Yet in the earlier Arab world there had been no developed tradition of figural art which they would have to deny. So there was no need for a Muslim iconoclasm. Islam, by affirming the "stark monotheism" of a God who had a monopoly on creation, abhorred the temptations to compete with God by man's pretended acts of creation.

At the Day of Judgment when God calls upon the painter to breathe life into the forms he has made, the painter's mockery of God's acts of "creation" is exposed. Then he is sentenced to the worst punishments of hell. The artist by pretending to be a creator has denied the uniqueness of God and commits blasphemy with every stroke of his brush. According to the Koran, God alone is the "fashioner" (*musawwir*).

> He is God, the Creator
> The Evolver,
> The Bestower of Forms
> (Or Colors).
> (Surah LIX, 24)

Muslim man (and surely Muslim woman!) was not made in God's image, but was only an image made by the unique Image Maker.

The career of the arts in Islam produced a grand irony that would have dismayed or outraged the Prophet. For Muslim history proved the power-

lessness of Allah to monopolize the powers of creation, and confirmed the irrepressible human need to create, which was eventually recognized, encouraged, and rewarded by the Heroes of Islam themselves. The mosque, the building and the institution, made claims peculiar to Islam, and was shaped accordingly. But there was no distinctively Muslim tradition of religious painting, and no religious sculpture of living figures. In Christian countries the flourishing of painting and sculpture is a measure of the vitality and reach of Christian faith. In Islam, on the contrary, the flourishing of representational art measures the willingness of Muslim leaders to defy the tenets of their faith. Muslim painting, which has charmed the non-Muslim world and commands extravagant prices from modern collectors, remains a monument to artists undaunted by threats of hellfire and damnation.

Some say that the "orthodox" Muslim leaders' disregard of the religious prohibition against representing living figures is no more remarkable than the proverbial violation of their own religious tenets by Jews and Christians and the "faithful" of other faiths. Nor, they say, was it more flagrant than prominent Muslims' defiance of the prohibition of wine, of music, of gaming, of the building of stately tombs, or the making of eunuchs. The celebrated caliph Harun al-Rashid (786–809), the conquering hero of *The Arabian Nights,* was a habitual drinker, though usually discreetly and in private. Musicians, singers, dancing girls, and eunuchs were familiar features of Muslim courts. But paintings themselves became part of the record of history, and despite all efforts to conceal or erase the sins of the painter, they would survive to our own time. The works of Muslim artists and of others inspired by Islam had the delicious taste of forbidden fruit.

At first leaders of Islam who dared violate their religious tradition with representational art tried to keep their vices private. Of the works of early Muslim artists only random fragments have been discovered. At the height of the empire of the Caliphate (from Arab "caliph" for "successor") in the two centuries after the Prophet's death, the caliphs and their agents were already defying the prohibition. The very first caliphs, the Umayyads (661–750), were flagrant in disobedience. For their palaces they commissioned frescoes of lions, dogs, and butting rams, and on pilgrimages to Mecca would decorate their tents with similar figures brocaded in gold. Their successors, the Abbasid caliphs (750–1258) cultivated a reputation for strict piety, but their violations were even more conspicuous. Mansur (712?–775; reigned 754–75), who built a new capital at Baghdad and founded a splendid city there, adorned the top of the dome of his palace with the figure of a knight on horseback, who served as a weather vane and also pointed his lance in the direction from which to expect the rebel army to attack. Caliph Amin (809–13) fashioned his pleasure boats for parties on the Tigris in the

shapes of lions, eagles, and dolphins. Others showed more respect for popular prejudice by keeping their art indoors. In his Baghdad palace Caliph Muqtadir (908–932) built a work of legendary grandeur—a tree of gold and silver, with eighteen branches carrying precious stones shaped like fruit, and gold and silver birds that sang when moved by the wind. At each end of the decorative pool were the opposed figures of fifteen horsemen in elegant silks tilting their swords and lances.

By the eleventh century the Fatimid caliphs were shameless in their extravagance, vividly reported later by the Muslim historian Maqrizi (1364–1442). A ceremonial tent commissioned by Yazuri, minister of Caliph Mustansir (1035–1094), and decorated with the images of all the world's animals, occupied 150 workmen for nine years. This same art-loving vizier became legendary for encouraging competition among his artists.

> Now Yazuri had introduced al-Qasir and Ibn Aziz into his assembly . . . they each designed a picture of a dancing-girl in niches also painted, opposite one another. . . . Al-Quasir painted a dancing-girl in a white dress in a niche that was coloured black, as though she were going into the painted niche, and Ibn Aziz painted a dancing-girl in a red dress in a niche that was colored yellow, as though she were coming out of the niche. And Yazuri expressed approval of this and bestowed robes of honour on both of them and gave them much gold.

By about 1200 imaginary competitions between artists had become a favorite subject for poets. The Persian poet Nizami (c.1140–c.1202) depicted an ancient competition at the court of Alexander the Great. One spring day while Alexander was entertaining the emperor of China, the wine-filled monarchs debated the talents of East and West. After comparing the different attainments in magic and singing and lute playing, they mounted a competition to compare the skills of their painters. And so (in Thomas W. Arnold's translation):

> At length, it was agreed, as test of skill
> To hang a curtain from a lofty dome,
> In such a manner that on either half
> Two painters should essay their skill, unseen . . .
> Until, their task complete, they drew aside
> The curtain that concealed each masterpiece;
> But,—strange to see! no difference was found
> Between the two, in colour or in form. . . .

Alexander ordered the curtain hung once again between the paintings. Now the Westerner's painting still glowed, while the other's faded and disappeared. When the curtain was drawn up again the Chinese's mirror-picture reappeared.

For when the painters started on their task,
And hid themselves behind the curtain's screen,
The Rumi showed his skill by painting forms,—
The Chini worked at naught save polishing.
Of form and colour which the other took.
The judges, weighing well each rival's skill
Gave credit for the insight each had shown:
In painting, none the Rumi could excel;
The Chini was supreme in polishing.

Wherever Islam spread, its rulers brought a love of pictorial art. They left a rich legacy in Spain, where the elegant marble lions in the courtyard of the Alhambra, near Granada, still proclaim the victory of man's impulse to create.

Although statues of living persons were rare in medieval Islam, life-histories appeared early in Arabic-Muslim literature out of efforts to confirm the sources of Traditions of the Prophet. And history was mainly exegesis of the Prophet and of lives of the faithful. Figure painting remained a secular courtly art, a silent witness to the separation into two cultures. One was the culture of the folk with its primitive fear of images, and the other the luxurious culture of the caliphs who had the power, the wealth, and the imagination to defy ancient taboo. The earliest works of pictorial art in Islam were relics of the sybaritic Umayyad caliphs, who became bywords for their contempt of the strict commandments of the Prophet. Still the power of tradition and theologians remained strong enough to keep figure painting out of Muslim religious buildings.

The Mongols surging west were reckless in their destructive passions. In 1220, when Genghis Khan and his Mongols sacked Bukhara, cultural center of Islam, they shredded the manuscripts of the Koran to make litter for their horses stabled in the Great Mosque. And in 1258, when Hulagu, his grandson, captured Baghdad, which had been the treasure city of the Abbasid caliphs for five centuries, he murdered the last of the Abbasid caliphs, massacred eight hundred thousand of its inhabitants, and allowed his Mongols to plunder the city for a week.

And with the decline of the caliphate, the Mongols and Turks who conquered or were conquered by Islam diluted the traditions with their own tastes. By the fifteenth century, Muslim theologians had yielded to the facts of life, to their rulers' passions for ornament and the beauties of representational art. Now some of the revered sayings of the Prophet were dismissed. The Mongol and Turkish rulers consummated their blasphemy by claiming distinction for themselves as painters. The great founder of Moghul India, Babur (1483–1530), of the line of Tamerlane who claimed descent from Genghis Khan, admired and patronized painters. By the sixteenth century

the shahs of Persia, too, were expecting to be praised by their chroniclers as "delicate painters with a fine brush."

The supreme defiance of the traditional Muslim taboo came with a luxuriant art depicting the Prophet Himself. The Mongol invasions created a "Timurid" art (after Tamerlane (1336?–1405)), bringing together Persian and Chinese techniques in the art of manuscript illumination. A brilliant surviving work from fifteenth-century Herat, the art center of far-eastern Persia, was the *Miraj Nameh,* or *Night Journey of the Prophet.* The manuscript, translated into eastern Turkish and elegantly calligraphed, was acquired by Louis XIV's ambassador to Constantinople and survives in mint condition in the Bibliothèque Nationale in Paris. In its sixty-one gilded illustrations we follow the miraculous ascension of the Prophet Mohammed on his graceful steed, Buraq, which had the head of a beautiful woman. Led by the angel Gabriel from the "Sacred Mosque" at Mecca to the "Far-off Mosque" in Jerusalem, he ascends from there through all six of the lower Heavens up to the Seventh Heaven, and finally to ecstatic contemplation of the Divine Essence at the Throne of God. En route the Prophet witnesses the torture of those who violated the commandments of their faith by such crimes as drinking wine, fornicating, speaking evil of Muslims (and making images like these?). Their tongues are cut out by red demons, only to grow back so they can be torn out again. The clear faces and figures of Mohammed and other biblical and Koranic characters are adorned by a flame-halo.

As great painters, including many from abroad, appeared in Islam, theologians had no difficulty making their work seem holy. Poets reminded the faithful that the visual arts, too, were inspired by God. The Persian mystic Jalal ad-Din Rumi (1207–1273), founder of the Whirling Dervish order, defended the painting of ugly as well as beautiful creatures to teach how evil too can come from God. An official Persian historian of the early sixteenth century, Khwandamir, revised the traditional Muslim view of painting in his praise of Master Behzad (c.1455–c.1536; active 1480–1536) whose brilliance as an illuminator and painter of miniatures created a newly exalted role for the painter. After Behzad proved that painting could be sublime, Muslims finally dared view God as "the Eternal Painter." Even the artists who could not breathe life into their figures were now said to be emulating God, praising Him by their efforts. Snatched from the depths of hell, the painter was elevated to a heavenly role. So the official sixteenth-century Persian historian Khwandamir (died 1535) explained:

Since it was the perfect decree of the incomparable Painter and the all-embracing wish of the Creator—"Be and it was"—to bring into existence the forms of the

variegated workshop, the Portrait-painter of eternal grace has painted with the pen of (His) everlasting clemency the human form in the most beautiful fashion in accordance with the verse "And He has fashioned you and has made your forms most beautiful."

(Translated by Thomas W. Arnold)

Now painters were dignified along with calligraphers as among "the most distinguished sons of Adam." The Moghul emperor Akbar (1556–1605) even argued that only by trying to reproduce living beings, as the painter did, could man become fully aware of the disparity between insignificant man and the all-creating God. In Islam, art, like everything else, came to be covered by the pall of theology. There was no Muslim aesthetic nor, despite the grandeur of their artists' works, any suggestion that art and beauty were their own reason for being.

The Muslim world never ceased to be haunted by Allah's monopoly on creation. And the popular fear of images never died. When the militant sultan Mahmud II of Turkey (1785–1839; reigned 1808–30) had his portrait put up in the barracks in Constantinople, there was an uprising against this unclean act, which incited the carnage of four thousand bodies thrown into the sea.

Muslim rulers of Turkey, unlike their Christian contemporaries in the West who were flaunting their extravagant patronage of artistic splendor, still took pains to conceal their sponsorship of the arts. Muhammed II, one of the first of these Ottoman patrons of art, brought Gentile Bellini (1429?–1507) to Constantinople (1479–80), where he painted one of the best surviving portraits of the sultan. But this was not public knowledge, and somehow the sultans managed to preserve their pious reputations as enemies of pictorial art. Few sovereigns have left a more vivid pictorial record than Suleiman the Magnificent (1495?–1566; reigned 1520–66), alive today in a portrait by Titian and another by his own Nigari. The illuminated manuscripts that he commissioned for the historical record are unexcelled in their details of battles, sieges, and military splendor. Suleiman too managed to keep his reputation for piety.

The later Moghul emperors in India, including Akbar the Great (1556–1605), have acquired a unique vividness among rulers East or West by their bountiful patronage of portrait, landscape, and military painters, and their scrupulous insistence on colorful detail. Still, when collections of portraits of the Ottoman sultans were published in recent times, they were concealed from any but the sultans' closest confidants. One bold official of Sultan Mustafa III (reigned 1757–73) dared commission some picturesque views of Constantinople, and engaged a painter (camouflaged as a physician) to visit him and paint his portrait. But when presented with the finished portrait,

he feared "it may even some day expose me to disparaging judgments in the minds of my family, even in those of my own children," and so he gave back the painting to the artist under a pledge of secrecy.

When photography appeared in the nineteenth century, it offered a new challenge to the mullahs' theological acrobatics. Muslims wishing to be photographed remembered the Hadiths against pictorial representation. They were glad to be told that since photographs were made by God Himself through the agency of His Sun they were not under the ban of the paintings by presumptuous human artists. Yet in much of the Muslim world, photographs remained under the Prophet's ban. A Muslim photographer in Delphi, who had spent many years successfully photographing people in groups, in an onrush of conscience finally destroyed all his plates. But, ironically, when he attempted the blameless photography of inanimate buildings, he failed because he had no understanding of the laws of perspective.

Muslims who were tempted to create images that would outlast the span of life granted them by their Creator were inhibited again and again by their overweening dogma of God's uniqueness. "Everything is perishing," they quoted the Koran, "except the Face of God." By refusing to make images of living beings, they would acquiesce in God's uniqueness and man's impotence. Like the Japanese at Ise, in their own way they refused to battle time and became its ally, leaving permanence to God alone.

PART FIVE

THE
IMMORTAL
WORD

Once a word has been allowed to escape, it cannot be recalled.

—HORACE (FIRST CENTURY B.C.)

Some books are undeservedly forgotten; none are undeservedly remembered.

—W. H. AUDEN (1962)

Dionysus the Twice-Born

BY creating in words patterns of experience, man found some escape from his brief and changeful years. And among the most durable and charming of Greek creations were their myths of the gods. Quite appropriately, Dionysus, Greek god of drama, dance, and music, the most insecure of the Olympians, was twice-born. The jealous goddess Hera, Zeus' consort, maliciously persuaded her rival lover Semele, a mortal woman, to demand that Zeus appear to her in his true celestial form. The dazzling sight killed her and prematurely brought out of her womb Zeus' child whom she was carrying. Zeus sewed this fetus into his thigh, and in full time the infant Dionysus emerged again. Unique among the gods, he was born of mortal woman. A latecomer on Olympus, he never ceased to be a stranger there, but had a fertile life on earth. Worship of Dionysus spread across Greece into the Roman Empire. God of mystery and of contradictions, Dionysus was both the reassurer of the familiar return of spring and the opener of strange vistas.

The Great Dionysia in March and April sang elated hopes for renewal.

I give thee hail, Kronion, Lord of all that is wet and gleaming. . . .
To us also leap for full jars, and leap for fleecy flocks, and for fields of fruit,
 and for hives to bring increase. . . .
Leap for our Cities, and leap for our sea-borne ships, and leap for our young
 citizens and for goodly Themis.

(Translated by Jane Harrison)

Dionysus was, as Plutarch described him, god of "the whole wet element"—of fertilizing moisture, of rain and dew, of wine, of lifeblood, of male semen, and of the juicy sap of plants. A god of the welcome return, he replenished jars with grain and oil, conceived and nourished the young of sheep and goat and cow. And Dionysus' other name was Bacchus. The fruit of his vine was the lubricant and stimulant of dance and song, of unworldly and otherworldly delights. In this form of Bacchus he was worshiped in winter darkness. The Rural Dionysia in December and early January, repeated at the annual Lenaea (festival of Dionysus) in Athens in January and February, displayed a large phallus, with chants, dances, and comic revelry.

The Anthesteria in February and March, the season of flowers, Thucydi-

des tells us, was the most ancient celebration of Dionysus. On the first day, the jars of wine sealed since the autumn harvest were opened for libations at the god's sanctuary. On the second day, the Day of the Jugs (Choes), each contestant was given a full jug of wine to drink, competing to see who could empty his first. A procession into the city from the sea accompanied Dionysus holding a vine alongside two satyrs playing flutes. After the parade of garland bearers and flute players and the sacrifice of a bull came a symbolic marriage, a "hierogamy" of the god himself to the queen of the city. On the last day special prayers were offered and special gruel offered for the returning dead. The rejoicing suddenly became ominous. For Dionysus was god of both Death and Life, and the dread dead were the source of life. "It is from the dead that food, growth and seeds come to us." Lifeless winter and resurrecting spring were twin necessities of life. The vegetation-god had to die in order to be reborn. The last days of Dionysus' festivals were evil, when the powers of the underworld returned.

Dionysus himself was a messenger from that underworld. When he grew to manhood he had descended to Hades to rescue his mother, Semele. He brought her up, and so raised her to Olympus. In due course she acquired her own cult, which Pindar saluted:

> Among the Olympians she lives who died
> In the thunderbolt's crash,
> Long-haired Semele; Pallas
> Loves her for ever, and father Zeus, and exceedingly
> Her ivy-crowned boy loves her.
> (Translated by Maurice Bowra)

Dionysus, then, was both the god of fertility and the god of death. Heraclitus said that "Hades and Dionysus are one and the same."

The nuns of Dionysus were maenads (or *mainades*), from *mania* (madness), named after the wild ecstasy of their worship. At Delphi, the center of their cult, the Pythia gave her oracular answers in the sanctum where beside the golden statue of Apollo was the tomb of Dionysus. These maenads, officially appointed delegates from their cities to the festival of Dionysus, celebrated the god in sacral dances. Led up the hill above Delphi by a young priest who played the role of the god, they set a style for wine-hazed orgies (*orgia*), the frenetic dances to drum and pipe that titillated the Greeks and later enticed the Romans.

These drunken devotees of Dionysus, filled with their god (*entheos:* from which "enthusiasm"), felt no pain or fatigue, for they possessed the powers of the god himself. And they enjoyed one another to the rhythm of drum and pipe. At the climax of their mad dances the maenads with their bare

hands would tear apart some little animal that they had nourished at their breast. Then, as Euripides observed, they would enjoy "the banquet of raw flesh." On some occasions, it was said, they tore apart "a tender child as if it were a fawn." On midwinter nights they would dance from Delphi up to the very top of Parnassus (eight thousand feet above sea level). On one occasion, Plutarch recounted, the maenads rescued from a snowstorm were brought back with their clothes frozen stiff. The cult of Dionysus reached Italy by the second century B.C., when the Roman Senate had to issue a decree forbidding their Bacchanalian rites.

Dionysus, in the familiar role of the persecuted god, was ingenious in devising punishments for unbelievers. Thebes, home of his mother, Semele, by the fifth century B.C. had become the center of the Dionysiac cult. There Semele's three sisters, daughters of King Cadmus of dragon's teeth fame, all denied Dionysus' divinity. When Pentheus, the son of one of them, succeeded to Cadmus' throne, he forbade the worship of Dionysus. The god bewitched Pentheus into dressing up as one of the maenads and enticed him up the mountain to spy on their orgies. When the maenads saw him they tore him to pieces. Pentheus' mother, Agave, proudly returned to Thebes with his severed head, which she imagined to be that of a lion.

"The fair song of Dionysus" at his festivals, the "dithyramb," was the womb from which Greek drama came. Perhaps dithyramb refers to Dionysus' birth "through two doors," or it may suggest the "triumph" of the god (from thriambos, Latin *triumphus*), or perhaps identifies him as lord of the "tomb." It may even have been a ritual name for Dionysus himself. "I know how to lead the fair song of Lord Dionysus, the dithyramb," boasted Archilochus of Paros in the seventh century B.C., "when my wits are fused with wine." When Archilochus, a poet of legendary eloquence, was denied the hand in marriage of his beloved Neobule by her father, he avenged himself by writing such mordant satire that father and daughter both hanged themselves.

At first simply a song of Dionysus led by the wine-misted god himself, the dithyramb became a fixed choral creation with a definite form. The talented poet and musician Arion (625–585 B.C.) according to Herodotus was "the first to invent the dithyrambic measure, to give it its name, and to recite in it at Corinth." Once on his return from a successful recital tour to Sicily, the sailors decided to seize his treasure and throw him overboard. Arion persuaded them to let him sing one last song with his lyre, which charmed a dolphin to come alongside. The dolphin then carried him safely to Corinth even before the ship. When the sailors arrived there pretending that they had left Arion behind, they were punished, while Arion's lyre and the friendly dolphin achieved immortality as constellations.

Arion, it was said, made the dithyramb a formal, stationary song, which

he taught choirs to perform. The Dionysia at Corinth was celebrated in circular dances to the music of reed flutes by choruses of fifty men and boys around the altar of Dionysus.

In the sixth century B.C. the dithyramb itself became a rich source of literary legend. Lasos of Hermione (548 B.C.), who was said to have brought the dithyramb from Corinth to Athens, there initiated the competition in making dithyrambs. His principal competitor was Simonides of Ceos (c.556–468? B.C.), "inventor" of the arts of memory, and reputedly the first poet to accept money to write eulogies. According to Aristophanes, the repeated competition for the honors between Lasos and Simonides became so tiresome that Lasos finally gave up with an "I do not care!" So the most successful ancient dithyrambist, Simonides, won fifty-six prize bulls and countless dedicatory tripods.

Simonides' nephew, Bacchylides (c.505–c.450 B.C.), also prospered by writing odes to the winners of athletic contests, encomiums (honoring the hosts at the *komos,* the revels at the end of a banquet), and dithyrambs for the Dionysian festivals. Pindar (528–442 B.C.), better known for his odes to the Olympic victors, also wrote dithyrambs for the spring festival at Athens. Athens erected a statue to him in reward for his dithyrambic praise:

Shining and violet-crowned and sung, bulwark of Greece, famous Athens, city
of the gods.
Where the sons of the Athenians laid down the shining foundations of freedom.
Listen, War-Cry, daughter of War, prelude of spears, to whom men are
sacrificed in the holy sacrifice of death for their city.

(Translated by Arthur Pickard-Cambridge)

"Circular chorus" was another name for the dithyramb at Athens, where it was danced and sung by fifty men or boys around the altar in the orchestra. So it was distinguished from the rectangular dramatic chorus of the later drama.

At Athens the contest of dithyrambic choruses was not among individuals but among tribes. Each chorus was drawn from one of the ten tribes, five offering choruses of men, and five of boys. The expense of producing a festival dithyramb was first undertaken by a wealthy citizen, the *choregus.* The cost was much greater than for the later performances of tragedy and comedy. In the years of Athens's decline, when no one citizen could afford to pay for this honor, it was shared by several, then finally undertaken by the state. During the Great Age the citizen-sponsors competed for the services of the best poets and musicians. The victorious tribe was rewarded with a tripod dedicated to Dionysus. The winning poet was awarded a bull, second prize was an amphora of wine, and third prize was a goat. The

winning *choregus* also was rewarded. Simonides boasted of the many times his head had been covered with ribbons and roses, when he was carried home in a festal chariot.

The dithyramb, after about 450 B.C., gradually disintegrated. As the words became less important, the music dominated and these latter-day bursts of bombast made "dithyrambic" a synonym for wild and vehement rhetoric. The dithyramb finally became secular music, like the nineteenth-century European oratorio but with the popular appeal of modern calypso.

In ancient Greece, where poets sang, music and poetry were never quite separate. When the dithyramb lost its rhythmic symmetry, strophe (when the chorus moved in one direction) against antistrophe (when the chorus moved in the other direction), solo songs were added. Literary form was smothered by the sounds of music. The new looseness of the dithyramb offended critics. As the flute acquired modulation and a wider range some complained of the undue influence of the flute player. Plato himself was troubled by the audience's passion for novelty, which would prove a catalyst for creativity. "With the ancients," Dionysius of Halicarnassus (died 7 B.C.) reported nostalgically in his *Antiquities,* "even the dithyramb was orderly." By the fourth century B.C. the traditional forms had dissolved, and the dithyramb lost its featured place in Athenian festivals. But its fertile by-products would glorify Greece long after dithyramb had become a strange archaic word.

24

The Birth of the Spectator: From Ritual to Drama

Songs to Dionysus would bring back spring. Every dithyrambic tie to the past insured the future. Ritual was insurance against spring frost, but in every man there was a maenad, dissatisfied with stale rhythm. Everyone was twice-born, torn between wish for the familiar return and hope for the intoxicating new.

In drama man found ways to create unique events for delight, reflection, and dismay, and so make experience outlast the actor. But the idea of drama did not come quickly or easily. The role of *spectator,* the person who stood outside the action, was not obvious, for the shared communal experience

was overwhelming. The chorus came before the solo. In ancient Greece, from the seventh century B.C. we see the slow stages by which man discovered that he need not always be a participant. In a new kind of immortality man could now outlive his time, relive earlier times, foreshadow later times by witnessing actors on a stage.

While drama would be a fertile vehicle of creations, the idea of drama itself was no man's conscious creation. It was a by-product of man's worship, of his twice-born ambivalent nature. And Greek drama would provide elegant archetypes in which to recast experience to relive it at will. When the Athenian could sit in the Theater of Dionysus and watch the reenacted struggles and quarrels of Agamemnon, time past had become time present, and could be projected at will into time future. The dramatist had created new dimensions of experience. To achieve this demanded courageous acts of imagination. The watching citizens must imagine themselves elsewhere. And the actors must successfully pretend to be other people.

This was the momentous advance from ritual to drama. For the history of this achievement, the surviving literature of Greek drama is woefully incomplete and accidental. We have seen how few of the works of their great dramatists have survived. But the ancient Greek theaters indelibly marked the landscape, leaving us a more ample record of the places than of the words and music uttered there.

The birth of the spectator in ancient Greece is the story of the festivals of Dionysus, of how and where they were celebrated. The first Dionysian festivals were a general community activity that moved about and required no permanent building. Not separated from other daily concerns, they were celebrated first in an "orchestra" (Greek for "dancing place") in the agora (marketplace), where everyone took part. These outdoor celebrations were open to the sky. In Athens they were later moved from the agora to the southern slope of the Acropolis, where too the nucleus was an "orchestra," a circular dancing place around the altar of the god. The dithyrambs sung and danced there came to be known as "circular" dances for a "circular" chorus. And the altar would remain long after the festival had taken on a new dramatic form. In the beginning, it seems, all present participated in the festival. Since there was no raised platform for the chorus, all stood on the same level. Near the orchestra was the temple of the god, conveniently placed so the holy image could be taken out on festival days for the god to witness his celebration. Except for the god there were no "spectators."

In festive song and dance, any separation of citizens was invidious. Since the whole community reaped the benefits of the spring-insuring rituals, all should join. But when ritual became drama, a new separation marked the community as a new dimension was added to experience. Now some "acted" while others watched. Citizens became witnesses, with a new set

of sentiments. The communal focus ceased to be merely an orchestra or dancing place and became instead a theater (from *theatron,* "seeing place"). To create drama, the spectator had to be separated from the actor. We do not know precisely when the spectator was born. But we can see the architecture that would give the Greek spectator his vantage point and multiply him in the next centuries. The hilly landscape helped by making it possible for citizens seated in rows to see the drama below. Poets celebrating the isles of Greece have not often enough extolled the hills of Greece, which also nurtured the culture that was the Greek glory.

By the early fifth century there seem to have been wooden seats for spectators, perhaps in the agora and probably also in the Theater of Dionysus on the side of the Acropolis. The collapse of these wooden seats was said to be the occasion for providing a proper "theater" designed to seat a large audience safely in an auditorium for the convenient viewing of performances. At first circular tiers of seats were cut into the side of a hill and later made of stone or marble. Remains of such an auditorium of the fourth-century B.C. that would seat fifteen thousand spectators are visible on the slope of the Acropolis of Athens. In the Great Age of Greek drama, other features were added. The orchestra probably remained as it was, with the central altar intact. Behind it, in full view of the seated audience appeared the *skene* (perhaps from Greek for "tent") in which actors could change masks and costumes. The *skene* became a movable wooden structure to represent a palace or a temple.

In the drama poets, playwrights, and actors found a laboratory for their imagination. And for all spectators it was a way of escaping their time and place. Drama conquered time for the new community of spectators.

When the Athenian citizens were moving up from the level orchestra into their stone seats on the hillside, separating themselves from the dancing participants, a similar separation was taking place in the circular chorus below. Slowly, one after another, to the number of three, "actors" moved out of the chorus, making possible a schematic reenactment of deeds from the past. Until then what went on in the orchestra was a *telling* danced and sung by the chorus, in which the whole community somehow took part.

The primitive orchestra, like the farmers' threshing floor of hardened ground used in Greece today, was a village dancing place. It was naturally circular for dancing around some sacred thing—a maypole, an image, or an altar of the god. There the whole community of worshipers were dancing the same dance, chanting the same chorus. To dance was to join the community, to cease to dance was a kind of death. When all were in the action, a spectator place, a "theater" or seeing place, was not needed, for the dance was everyone's ritual. And the Greek word for ritual was *dromenon,* "a thing done." The rites of spring, the *dromenon* of the Dithyramb, the Spring

Festival, as Jane Harrison has explained, were "a re-presentation or a pre-presentation, a re-doing or a pre-doing" of the hoped-for results. The "doing" of the ritual was communal, and its purpose was quite practical, for without the return of Spring, there would be no crops, no newborn cattle. The Rites of Spring, the invocation and propitiation of Dionysus, were the invitation and reassurance.

In Greek the word *drama,* like the word for ritual, also meant "thing done." But now there were "actors" (doing the doing) and "spectators" (seeing the doing). The dithyramb was the whole community jointly addressing the god. Now a *drama,* the doing of actors down there in the orchestra, was for the benefit of spectators. One part of the community was addressing another part. A few were acting for the many. The religious overtones of Greek drama, resounding with its dithyrambic origins, would never be lost. When not only the god but a human community of spectators was there, the performance could be judged for its own sake. No longer merely a familiar ritual for the return of the familiar, the performance was a work of art, a creation, offering a new kind of uniqueness.

After the seventh century B.C. when the dithyramb failed a few times to bring abundant crops, perhaps it lost some of its magical appeal. Perhaps the rhythms of the circular chorus became stale and perfunctory. It was about the time of the emergence of drama from ritual in the late sixth century B.C. that Pisistratus organized the works of Homer into their classic form and decreed that the whole *Iliad* and *Odyssey* be recited at the annual Panathenaea festival. For drama, too, heroic themes had irresistible appeal. It is hardly surprising that, after the centuries of singing and dancing to the *telling* and *retelling* of heroic ancient tales, someone had the idea of *doing* or *redoing* those long-sung deeds. Thespis, said Aristotle, was the true inventor of Attic tragedy, the prototype of Greek drama. A poet from Icarus' home district in Attica, he was the first to introduce an "actor" into the chorus. What a small beginning! The thespian prototype was nothing but a single person whose role Thespis invented as answerer standing apart from the chorus. The Greek name for this actor, who pretended to be someone he was not, was Hypocrites. Two millennia later the Greek word became the root for the English word "hypocrite," used by both Wyclif and Chaucer for any dissembler.

In the beginning the role of this first actor was only to respond to the chorus and its leader, providing a spoken dialogue between the songs of the chorus. The subject of this dialogue was a heroic saga of the kind Homer had made familiar. The chorus continued to sing its lyric songs, but the presence of a dramatized figure from the story offered the chorus a newly dramatic role. Thespis's modest innovation did not destroy the liturgy but

was beginning to transform what had been a festival to please a god into a performance for the delight of spectators.

In 534 B.C., at the first recorded performance of Greek tragedy in its primitive form, Thespis won the prize. And he took another step toward an art of impersonation when he experimented with the mask. According to tradition, Thespis disguised his face when acting by covering it with white lead, and then hung flowers over his face. Later he tried plain linen masks, which his disciples varied for dramatic effect. They saw how masks could serve a new practical purpose before the fifteen thousand spectators on the hillside, to make the character of the wearer plain.

Since there were never more than three actors in a performance of classic Greek tragedy, masks helped them play many parts. Eventually there were thirty different types of masks, distinguishing the young and the old, the amiable, the irascible, or the heroic. Pallor displayed suffering. The masks of women's characters suggested an old servant, a young virgin, an experienced courtesan. A snub-nose marked a person of low birth. The needs of the spectator at a distance would govern.

After Thespis, the new art of Greek tragedy speedily unfolded. Seldom in the West has the genesis of an art form been so clearly visible or so sharply focused. The great creators of Greek tragedy were the Athenian trinity—Aeschylus (525–c.456 B.C.), Sophocles (496?–406 B.C.), and Euripides (485–406 B.C.). In the pitifully small sample of their works that has survived, we can see the new art come into being. The Greek tragedian was expected, even required, to be prolific. To be performed at an annual Dionysiac festival he had to produce not just one play but a tetralogy of three tragedies and a light satyr piece. Altogether the tetralogy might add up to six thousand verses (compared with about eight thousand verses in Shakespeare's *Hamlet*). To win his two dozen victories, Sophocles had to be wondrously fertile and able to produce on demand.

In the arts, as in social drinking, athletics, and other cultural activities, the Greeks loved competition. They enjoyed contests at their festivals, made their festivals into contests, and delighted in praise and prizes to the winners. Epitaphs of poets, musicians, and tragedians note their prizes. Contests for a prize in dithyramb at the Dionysia did not cease until the late fourth century B.C., when the private patrons (*choregoi*) were displaced by annually elected sponsors (*agonothetes*) supported by public funds. With the rise of drama as a recognized form, interest focused on the contests among the tragedians. The panel of ten judges, one from each of the ten tribes, swore to give an impartial verdict. Spectators sometimes became violent to protest an unpopular award. The winner was proclaimed by the herald and honored with a crown of ivy.

The many victories won by Aeschylus and Sophocles suggest that the

custom encouraged the great creators. Each won the prize for more than half his plays. Euripides, a bolder and more irreverent innovator, had less success with the judges. In the age before best-seller lists and published box-office receipts the prizes show the tragedians' popular appeal. In the annual competitions at Athens for the best tragedy, Aeschylus won first prize thirteen times, Sophocles won twenty times, once defeating Aeschylus, and once being defeated by Euripides. The poets crowned by posterity were applauded by their first spectators.

Before the death of Euripides in 406 B.C. Greek tragedy had acquired a form that makes it almost recognizable as drama to modern eyes. But costuming and staging were conventional, physical action was restrained, and violence occurred only offstage. There were three actors, action, suspense, climax and denouement. In the fifty years that separated the first performance of Aeschylus from the death of Euripides, the ancient Dionysian festival was transformed and the dramatic legacy of classic Greece had taken shape.

The lives of the great trinity of Greek tragedians, when there was no Left Bank or bohemia, reveal how closely the fortunes of the arts were tied to the fortunes of the community. They show us the poet as the public man. Both Aeschylus and Sophocles took on conspicuous civic commissions. Aeschylus fought at Marathon (490) when he was thirty-five, and again at Artemisium and at Salamis. Pindar and Sophocles were his disciples. And Sophocles' first offering at the Dionysiac festival of 468 B.C. actually won the prize over his master, for the panel of judges had been packed with Aeschylus' political enemies.

Sophocles' long life spanned the Great Age of Athenian power. He served as a treasurer for the tribute money from the subject states, was elected one of Athens's ten generals, and mounted expeditions to discipline the allies. At the age of eighty-three, in 413, after the defeat of Athenian forces in Sicily, Sophocles served on the commission to reorganize the government. A man of wealth, noted for his elegant style of life, he was a model of the Athenian public man of letters. Like Aeschylus, he still saw a cosmos where man could take solace in rhythms enforced by gods.

The legends of Euripides report him as a diluter of the old religion, losing faith in these divine rhythms. No religious patriot, he was scholarly, withdrawn, and morose, and, like Socrates later, he was reputed to have been prosecuted for blasphemy. The Trinity of Tragedians had acquired a canonical status in the 330s, when Lycurgus erected bronze statues of the three in the Theater of Dionysus below the Acropolis.

Although each added new elements to the novel art, all three were confined by the traditional forms. Centuries would pass before Athenians would let their dramatic imagination play freely with their heroic past. They

still dared only marginal changes of the Dionysian dithyramb. "The number of actors," Aristotle tells us, "was first increased to two by Aeschylus, who curtailed the business of the chorus, and made the dialogue, or spoken portion, take the leading part in the play." With only two spokesmen (now beginning to be called actors) and a chorus, the opportunities for what we think of as drama were still limited. But Aeschylus' own tragic concept was fulfilled with the two actors. He did not see drama as a conflict (*agon,* or contest) between actors but saw a solitary hero—an Agamemnon, an Orestes, an Eteocles, a Prometheus—facing his own destiny, wrestling with his soul. And Aeschylus' second actor made it possible for the plot to move. The performance, unlike that of Thespis, was no longer only a hero's statement with choral background. When the second actor, like the ghost of Darius in *The Persians,* came in with news, the situation could change. This second character could establish the innocence of the hero, provide a new range of moral choices, and so add suspense and surprise.

"A third actor and scenery were due to Sophocles," according to Aristotle. With his third actor Sophocles too made a new kind of tragedy. Now the hero could be judged against a more complex web of circumstances. Sophocles' chorus, no longer merely liturgical, takes part in the plot. In place of epic narrative or a lyric song, we hear dialogues among all three actors. Persuaded by this innovation, Aeschylus himself adopted a third actor for his *Oresteia.* Sophocles' stage begins to be set for a more realistic showing of a man and his problems.

Euripides further widens the dramatic range, changes the saga to suit his purpose, and begins to humanize his hero. His prologue no longer merely opens the action but tells the story before the action. And he finally resolves his dramatic problem by the *deus ex machina,* a god lowered onto the stage with a crane and pulley to intervene in the action. Euripides, Aristotle tells us, marked the final development of the literary form of Greek tragedy.

The trinity commanded the attention, the passions, and the admiration of their whole community. The most prized in his own time was Aeschylus, long revered as the founder of Greek tragedy. Sophocles was worshiped as a hero. Knowing his Euripides, Plutarch noted, was an infallible test of the true Athenian. By reciting Euripides, Athenian prisoners at Syracuse won their liberty. Once a suspicious ship was allowed entry to an Athenian port only after passengers showed their familiarity with Euripides. Legend had it that Athens was saved when conquering Spartan generals, about to level the city, were restrained by a chorus from Euripides' *Electra.*

Greek tragedy remained remarkably close to its origins. The subjects, the heroes, and the moral choices continued to be confined by religious tradition, and liberation from that ancient archetype of the dithyramb was long and slow. The stage, masks, and costumes stayed on as ties to the Dionysian

festivals. The spectator of Greek tragedy was not to be shocked or amused by unique and novel characters. And the tragedian with his chorus and three actors aimed to reinforce in the *doing* what had so long been known only in the telling.

Most Greek tragic dramas elaborated the Homeric legends whose messages from dim antiquity thus became vividly contemporary. In the ocean of time all men swam together. "Time will reveal everything," said Euripides, "it is a babbler, and speaks even when not asked." The secrets of the future were no more obscure than the secrets of the past, and the great poets brought them together.

Stage costumes reinforced the rhythmic, ritual familiarity of the events recounted. By Aeschylus' time there was a conventional stage costume for tragedy, which remained a tie to the ancient rituals even into Roman times. The basic garment for the tragic stage was a *chiton,* a loose garment made from a rectangular piece of linen or wool, similar to that in daily use. Women wore it draped, to reach from neck to ankle, on men it reached the knees. This simple chiton for daily wear, familiar on the caryatids of the Erechtheum, was sleeveless, kept in place at the shoulders by brooches and at the waist by a belt that bloused the excess material into a pouch. But the stage costume for tragedy, unlike the daily chiton, was elaborate and costly, paid for by wealthy citizens who vied with one another in elegance and extravagance. The Greek word *cothurnus* for the actor's heavy wooden-soled boots became a synonym for the mannered lofty style, the elevated grandeur, of the tragic drama.

The poets thus helped the spectator, a person at a distance, rediscover the heroes of myth and saga. But how slowly they dared create new themes and characters! Only forty lines survive of the bold young poet Agathon (born c.445–c.400 B.C.) who, as Aristotle noted, wrote a tragedy "in which both incidents and names are of the poet's invention." Plato immortalized Agathon by placing his *Symposium* at Agathon's house in 416 on the occasion of that young poet's first victory in competition, and the legendary Agathon was reputed to be the only poet worthy of succession to the great trinity. Centuries passed before others dared follow his lead.

25

The Mirror of Comedy

DIONYSUS the twice-born became the foster father of two opposed spirits as the dithyramb that celebrated him divided into Tragedy and Comedy. In the last days of Athenian glory both Tragedy and Comedy, as Aristotle said, attained their "natural" forms. But both still revealed their archaic skeleton, and Dionysus never ceased to reign.

By mid-fifth century B.C., Tragedy and Comedy each had staked out different realms. Tragedy recaptured the ancient and the remote, gods and heroes. The spectator could see an enlarged version of himself struggling with grand issues of time and destiny. "All human happiness or misery," Aristotle observed in his *Poetics,* "takes the form of action; the end for which we live is a certain kind of action . . . therefore . . . the first essential, the life and soul, so to speak, of Tragedy is the Plot; and . . . characters come second." Tragedy was a vision of events at a great distance in time (usually too in space) from the spectator.

Comedy held up a mirror to the present. If Tragedy conjured up the unseen, Comedy rescued the familiar from the cliché. Comedy intensified daily experience, dramatizing the garrulous old man, the boastful soldier, the vain courtesan, the rude conceited youth, who all were so commonplace that they had ceased to be interesting. But Comedy made them laughable.

Tragedy, then, tended to depict men as better than they were. But Comedy, Aristotle explained, showed "an imitation of men worse than the average; worse, however, not as regards any and every sort of fault, but only as regards one particular kind, the Ridiculous, which is a species of the Ugly. . . . the mask, for instance, that excites laughter, is something ugly and distorted without causing pain." This meant that Comedy required a courage not found in all poets. Aristophanes (c.450–c.357 B.C.), the Greek writer of Comedy who became companion in fame to the great Trinity of Tragedians, was as eminent for his courage as for his eloquence, wit, and fantasy. Eleven of his plays have survived, but perhaps three times that many have been lost.

In ancient Greece, the writer of drama had a monopoly on media of public criticism. Drama was already the most democratic of the arts. The Old Comedy exploited the opportunity of a traditional festival Day of Misrule, when nothing was sacred. Behind the veil of religion and liturgy and in front of the assembled community, the comic poet could condemn the tyrant, satirize arcane philosophers, question male dominance, mock sexual morality, and make the gods objects of fun. If his messages were amusing enough, and embellished and enlivened by dance and music, in ancient Athens (population of some thirty-five thousand) he could instantly reach an audience of fifteen thousand. While the tragedian had to offer a tetralogy of three tragic plays and a light satyr piece in order to compete at the annual festival, the competition in comedy required only a single play.

Aristophanes eagerly seized the poet's opportunity. Like other comic poets, he was transforming the folk art of village comedians into a self-conscious art form—and so created a mirror of comedy that would inspire generations of dramatists to speak in the voice of social critics. The stirring times of Aristophanes' adult life spanned the whole quarter-century of the Peloponnesian War (431–404 B.C.). This testing time for Athenians and their empire would be a proving time for the arts of comedy. Experiments in colonizing, in enlisting and subduing allies, brought the exhilarations of victory and the frustrations of defeat, and revealed the perils of both democracy and tyranny. Aristophanes seems to have been raised in the peaceful countryside on the island of Aegina. When he first came to Athens as a youth he saw a fevered city permanently at war. While his jibes had all the topical relevance of a modern political cartoonist they have not become obsolete.

From the beginning, his irreverence toward the great and the powerful was awesome. In his early twenties, with his first comedy he won second prize at the Great Dionysia of 427. Surviving in fragments, *The Daitales* (*The Banqueters*), about the eternal battle of the generations, shows a know-it-all city-educated son returning home to his rustic father. His father despairs that while he has not learned his Homer, has neglected athletics, and cannot even sing a traditional song, he has become a connoisseur of wines and perfumes, and learned the tricks of the money changers. "No pity," the father insists, "shall deter me from washing this salt fish with all the dirt I know is in it."

At the very next year's Great Dionysia (426) Aristophanes plunged into the risky realms of current politics. And he dared defy Cleon, whom Thucydides called "the most violent man at Athens and by far the most powerful," with his *Babylonians,* a sharp attack on the war and on Athens's brutal contempt for its allies. Silently casting Cleon in the Persian tyrant's role, he showed a chorus of branded Babylonian slaves, forcibly working in a mill. So Aristophanes asserted "freedom of the drama," millennia before the

freedom of the press. This brought on his prosecution by Cleon for calling Athens the "tyrant-City," and so compounding his sin of pacifism with slander and treason.

The young Aristophanes kept up his pacifist barrage, even while the war-fevered community remained subservient to Cleon, whose frown, it was said, made people vomit with fear. At the Dionysian winter festival (425 B.C.) Aristophanes won first prize for another bitter antiwar comedy, *The Acharnians,* which appeared under a pseudonym, for reasons that Aristophanes himself explains (in Gilbert Murray's brilliantly modernized translation):

> And how Cleon made me pay,
> I've not forgotten, for my last year's play:
> Dragged me before the Council, brought his spies
> To slander me, gargled his throat with lies,
> Niagara'd me and slooshed me, til—almost—
> In so much sewage I gave up the ghost.

The plot of *The Acharnians* centers on Dicaeopolis, Aristophanes' model of the good citizen who hates war but cannot persuade the politicians to make peace. Finally he negotiates a treaty of peace privately for himself and his family.

Relentless against tyrants, Aristophanes plunges on. *The Knights,* at the next winter Dionysian Festival (424), savaged Cleon by name and was awarded first prize. In Aristophanes' rollicking travesty the central character is Demos, the Athenian people whose household is disrupted by a newly purchased slave, Cleon, who has groveled into the master's favor. When an oracle reveals that Cleon will be succeeded in favor by an Agoracritus, a sausage seller, a chorus addresses Cleon: "You devour the public funds that all should share in; you treat the treasury officials like the fruit of the fig tree, squeezing them to find which are still green or more or less ripe."

But the public still dreads Cleon. To avoid angering him by a truthful portrait, those who make masks for the theater go on strike. "His eye is everywhere," Demosthenes complains, "And what a stride! He has one leg on Pylos and the other in the Assembly; his arse gapes over the land of the Chaonians, his hands are with the Aetolians and his mind with the Clopidians." Speaking for all later demagogues Cleon explains, "I only stole in the interest of the City!" "I may shout indifferently for right or for wrong, but I keep you fed by it!" The sausage seller, now the savior of Athens, condemns Cleon to an appropriate punishment. "It will not be over-terrible. I condemn him to follow my old trade; posted near the gates, he must sell sausages of asses' and dogs' meat; perpetually drunk, he will exchange foul

language with prostitutes and will drink nothing but the dirty water from the baths."

When the tyrant Dionysius I of Syracuse wanted to know all about Athens, Plato sent him the plays of Aristophanes. He could not have done better, for nothing escaped Aristophanes' eye. In *The Wasps,* which won first prize at the Lenaean Festival of 422, he makes fun of the Athenian legal system, which had transformed juries into a system of public welfare. When the city gave three obols each day for serving on a jury, shiftless citizens were reluctant to bring trials to an end.

The Sophists were the inviting target of *The Clouds.* Aristophanes makes Socrates the comic villain of this piece, though in real life Socrates was the Sophists' outspoken enemy. A stupid farmer trying to dispose of his creditors, hears that Socrates' "Thinkery" teaches people how to make the Worse Cause appear the Better. When the lessons of the Thinkery become too complicated for him he puts his son under Socrates' tutelage. There, according to the Thinkery's impeccable logic, the son is taught that he must beat his father.

> Tell me, is it not right, that in turn I should beat you for your good, since it is for a man's own best interest to be beaten? What! must your body be free of blows, and not mine? am I not free-born too? the children are to weep and the fathers go free? You will tell me, that according to the law, it is the lot of children to be beaten. But I reply that the old men are children twice over and that it is far more fitting to chastise them than the young, for there is less excuse for their faults.

At the Great Dionysia of 423 the play received only the third and lowest prize, but Aristophanes still considered it his best.

Some of Aristophanes' most appealing themes concern the power (and the powerlessness) of women. Later generations always seem to understand his *Lysistrata,* offered at the Lenaean Festival of 411, a desperate moment for Athens. The expedition to Sicily in 413 had ended in disaster—ships, army, and the best young men all lost. The war was in its twentieth year, and with no peace in sight. Was there not some way, Lysistrata asked, to enlist lust in the cause of peace? If the men in charge could not find a way, why not the women? "What sensible thing are we women capable of doing? We do nothing but sit around with our paint and lipsticks and transparent gowns and all the rest of it."

For his ingenious peace mission Aristophanes creates the strong but not unfeminine Lysistrata (Dismisser of Armies), who leads the women of Athens in a sex strike. They will refuse their husbands the pleasures of the

marriage bed, then seize the Acropolis and the treasure in the Parthenon. Finally the women win by persistence and self-control, and the comedy ends in a festal scene of Spartans and Athenians with their wives. "Such a merry banquet I've never seen before!" an Athenian exclaims, "The Spartans were simply charming. After the drink is in, why, we're all wise men, every one of us."

Preserving the sexual without the ritual ingredient has made *Lysistrata* seem indecent. But Dionysiac comedy was a phallic festival. In Aristophanes' time, actors in the Old Comedy regularly wore a monstrous phallus hanging out of their costume.

Still Aristophanes never let his social conscience stifle his fantasy, nor let his comic mission keep him grounded. The Great Dionysia in the spring of 414 was another bitter time for Athens. Less than two years before, the Athenians had committed one of the most shameful excesses of their long war when the inhabitants of the neutral island of Melos refused to surrender in 416—all the adult men were massacred and the women and children enslaved. Thucydides gave twenty-two chapters to this savage episode. For other reasons, too, this was an ominous season. On the night before the fleet set out for Sicily the city suffered a horrendous sacrilege when the sacred herms had their noses and phalluses broken off. The consequences of the sacrilege appeared soon enough when disaster befell the expedition to Sicily.

It was in this spring of 414, at the Great Dionysia, that Aristophanes offered *The Birds.* All who would build vast empires yet avoid war must simply grow wings, set up their empire in the sky, and surround it with walls. From this strategic location the Birds could dominate mankind by threatening to devastate the crops. From their Cloud-cuckoo-land they could also dominate the gods by intercepting the steam from the sacrifices on which the gods depended for nourishment. To suit the avid bird-watcher, Aristophanes displays a colorful variety—the aggressive hoopoe, the mellifluous nightingale, the graceful flamingo, and the less celebrated cormorant, halcyon, widgeon, jay, sedge-bird, finch, kestrel, cuckoo, falcon, and miscellaneous doves, among others. They still govern mankind by the omens in their flights read by professional augurs. And needless to say, the Birds win their battle against the starving and humiliated gods. As a prize, the leader of the Birds gets Zeus' daughter Basileia (Sovereignty) for his wife, which lets Aristophanes end the play in the customary festive wedding.

Aristophanes' most popular play for later generations, *The Frogs,* appears to have been his most successful too in his own time, winning first prize at the Great Dionysia (405), and replayed by popular demand the very next day. Imagine fifteen thousand Athenians showing wild enthusiasm for a play that compared the literary merits of two dead tragedians! *The Frogs*

vividly reveals the grand role of drama in Athens's community life. Their literature was certainly not, in Woodrow Wilson's phrase, "mere literature." In 405, when *The Frogs* was produced in the Theater of Dionysus, Aeschylus was fifty years dead, Euripides and Sophocles gone only a year before. "I want a poet," Dionysus in the play complains, "for most be dead; only the false live on." A bevy of mediocrities offer themselves, "All writing tragedies by tens of thousands, And miles verboser than Euripides." For Dionysus they are (in Gilbert Murray's translation):

> Leaves without fruit; trills in the empty air,
> And starling chatter, mutilating art!
> Give them one chance and that's the end of them,
> One weak assault on an unprotected Muse.
> Search as you will, you'll find no poet now
> With grit in him, to wake word of power.

He descends to Hades, where all the great tragedians had gone, to find Euripides and bring him back to earth. As Charon ferries him across the Styx, the frogs, from whom the play takes its name, chant their famous chorus—

> Brekekekex co-ax.
>
> Co-ax, co-ax, co-ax,
> Brekekekex co-ax?
> Our song we can double
> Without the least trouble:
> Brekekekex co-ax.

Dionysus arrives in Hades just in time to witness a competition between Aeschylus and Euripides for the Throne of Tragedy, and the right to sit beside Pluto. Finally, when Pluto asks Dionysus to choose between them he prefers Aeschylus simply because he likes him more, and brings him back up to Earth, as the Chorus sings,

> Send good thoughts with him, too, for the aid of a travailing nation,
> So shall we rest at the last, and forget our long desolation,
> War and the clashing of wrongs.

26

The Arts of Prose and Persuasion

"IN most of our abilities, we differ not at all from the animals"; Isocrates observed about 374 B.C., "we are in fact behind many in swiftness and strength and other resources. But because there is born in us the power to persuade each other and to show ourselves whatever we wish, we not only have escaped from living as brutes, but also by coming together have founded cities and set up laws and invented arts, and speech has helped us attain practically all of the things we have devised." It was writing, of course, that made it possible for the powers of persuasion to reach across the years.

Poetry, which usually meant metrical language or "verse," bore conspicuous signs of the intention to be remembered. But prose, the language of everyday trivia, bore no such signs. It required an effort of imagination to see how the flow of daily words could become the substance of lasting art.

The first literary work in prose was history. And we call Herodotus (c.480–c.425 B.C.) the Father of History because his is the earliest surviving work in Greek prose that aimed to give literary form to an extended narrative of the past. The Greek *historie* means "inquiry" or the search for truth. Herodotus might also perhaps be called the Father of Prose, for until his time verse was still the normal vehicle for narratives of great events and heroes of the past. The chroniclers and philosophers like Heraclitus (c. 540–c. 470 B.C.) had already tried to give literary form to their prose and to sharpen the precision and accuracy of their language. But the surviving fragments of Heraclitus' work lack the clarity and elegance of later prose. In fact, ancients called him "the obscure one," and not until the dialogues of Plato (428–347 B.C.) did philosophic prose take polished literary form.

Although he writes in prose, Herodotus is still in the Homeric tradition celebrating great men and wondrous deeds. His accounts of the local customs of Egyptians and others broadened the Greeks' views of themselves. His successor Thucydides was in the same tradition, but professed to be

more scrupulous in separating rumor and romance from fact. Herodotus, lacking documents, reported speeches as he thought they ought to have been said under the circumstances. And Thucydides also explained, "My habit has been to make the speakers say what was in my opinion demanded of them by the various occasions, of course adhering as closely as possible to the general sense of what they really said." Apologizing for the lack of "romance" in his history, his purpose was "not an essay which is to win the applause of the moment, but as a possession for all time." Herodotus and Thucydides proved that prose could be an appealing, effective, and durable literary medium. And they set a standard of literary art that survived. But history, unlike music and gymnastics, did not become a new field of study for the Athenian educational program of paideia.

Still, Herodotus did signal the appearance of a new literary art of prose to which the future belonged. Politics in the West was not to be a chronicle of lonely Solomons keeping their own counsel. Rather it was to be a history of councils, of senates, parlements and parliaments—of men trying to persuade one another, their fellow governors, and the people whom they governed. In politics there was neither time nor opportunity for epics elaborating messages into verse. Prose, the language of everyday life, would be the vehicle of persuasion. And the new art of rhetoric would provide the techniques, define the standards, and shape the style of the message. What was required was not merely rules for judging a polished literary work but skill in using the common discourse. Even as public expectations grew, despots needed the arts of persuasion to mollify and satisfy their subjects. Rhetoric, which Aristotle himself defined as the arts of persuasion, became a necessary if often unacknowledged skill of the government classes. The arts of prose became essential to the arts of governing.

We know much more about the creation of this new art of prose and its handmaiden rhetoric than we do of the origins of the art of poetry. Prose was associated with the earliest hesitant moves toward democracy. And we see it allied, too, with opposition to Plato's pursuit of absolutes. The rise of prose as an art and of rhetoric as a discipline is plainly connected both with wider public participation in government and with appeal to expediency rather than to truth as the guide of political life. The classic antithesis between rhetoric (the concern for the appropriate) and philosophy (the pursuit of truth) was dramatized by Plato in two of his Dialogues, the *Phaedrus* and the *Gorgias*. Ever since Plato's time the arts of persuasion have been associated with popular institutions, with the pursuit of compromise and the acceptance of relative and temporary solutions instead of the pursuit of Truth, of the utopian and the ideal.

Gorgias (483–376 B.C.), born in Leontini, near Syracuse, the oldest Greek settlement in Sicily, is reputed to be the first ancient Greek to create an art

of prose style. His arrival as an ambassador from his hometown seeking Athenian aid in 427 B.C. marks the beginning of rhetoric in Athens. He was one of the most prominent and influential of the Sophists. These practical philosophers were a thriving symbol of the Greek quest for links between thought and action, between the pursuit of truth and the arts of persuasion. For us, "sophist" describes a person given to clever but specious reasoning. But originally a Sophist (from the Greek *sophia*, wisdom; or from *sophizesthai*, making a profession of being clever) was simply a wise man skilled in some special way. In the fifth century B.C., the Great Age of classic Greece, a Sophist was a teacher who traveled about giving instructions in successful living. The Sophists were paid for their services, and some, like Gorgias, did very well for themselves. Plato (in his *Protagoras, Phaedrus,* and *Gorgias*) and others who were unsympathetic to their pragmatic approach to life treat them as an errant school of philosophy or, rather, of antiphilosophy. But they were a varied lot who simply shared a suspicion of absolutes and ultimates, of the pursuit of Truth and Virtue, of which Plato was the brilliant exponent. They were more interested in what they called successful living, in the accommodations of community, than in the Platonic Ideas.

By ancient repute, Protagoras (c.485–c.410 B.C.) was the first Sophist. A friend of Pericles, he prospered and attained wealth and eminence by his fees from teaching. When Athens founded a colony at Thurii in 444, he was given the task of drawing up its laws. He professed to teach *arete* (honor or nobility), which some said was simply the technique of successful living. He is best remembered for his motto "Man is the measure of all things." He and his fellow Sophists were impressed that different nations had different rules even about sacred matters like marriage and burial. They concluded that most morals were conventional. Therefore, they preached, since morals were relative and successful living was the important thing, all men should defer to the morals of their community. This also implied that all knowledge was relative and no science could be universal. So Protagoras ridiculed the philosophic speculations of Socrates and Plato about what was the "real" world. Nevertheless Protagoras himself did write a book, *On the Gods,* which questioned the gods' existence. His books were publicly burned, and he was expelled from Athens.

But paradox plagued the Sophists and others who claimed that they could improve society by improving its techniques of persuasion. It seems that Protagoras had instructed a young man in rhetoric, with the understanding that he should be paid his tuition fees only if the young man won his first lawsuit. Unfortunately the ungrateful young man's first lawsuit was the one that Protagoras had to bring to recover his fees.

Gorgias, pioneer Sophist of another breed, focused less on philosophy than on oratory, and made the art of rhetoric his key to successful living.

In cities newly experimenting with democratic institutions, it seemed that success depended on the ability to influence people. When the spoken word was the only medium that reached the whole community, rhetoric aimed to train pupils to defend any cause or its opposite. Platonic philosophers naturally ridiculed this as only the technique of "making the worse seem the better cause." Like Dale Carnegie, Gorgias and his fellow Sophist teachers of rhetoric promised to teach their pupils how to influence people. They taught the arts of persuasion but not the techniques of discovering virtue. To show the superior importance of the powers of persuasion, Gorgias once told how his brother, a physician, saw that his patient needed a particular operation. But the patient would not agree to the operation until Gorgias used his rhetorical powers.

Distrusting the philosophers' pompous distinctions between the phenomenal world of everyday life and their own "real" world of Ideas, Gorgias countered with his satirical treatise "On That Which Is Not, or on Nature." His three mock-philosophic propositions disposed of the private world of the philosophers. He said he had proven that nothing exists, that even if something existed no one could have knowledge of it, and finally, in the unlikely event that somebody did know, there was no way he could communicate it to others. But Gorgias was famous also for having his very own prose style. According to Diodorus Siculus, a Greek historian in the first century B.C., he was "the first to make use of figures of speech which were far-fetched and distinguished by artificiality: antithesis, isocolon, parison, homoeoteleuton, and others which then, because of the novelty of the devices, were thought worthy of praise, but now seem labored and ridiculous when used to excess." His extravagant figures of speech came to be called the "Gorgianic figures," symptoms of the strenuous effort to create an art of literary prose.

As a Sophist, Gorgias built his style and his system of rhetoric on the concept of "the opportune" (*to kairon*). The master of the art of rhetoric, Gorgias said, had the ability to defend any cause, and the worse the cause the better the test of the orator's skill. In his *Encomium of Helen* he showed the flamboyant style that would influence his successor Isocrates as well as Thucydides. He had chosen this subject, he explained, because it was the orator's duty not only to praise the praiseworthy but to defend the maligned. And who was more in need of such defense than Helen of Troy? She should not be blamed for abandoning her husband Menelaus and yielding to the handsome Paris, for she must have been the innocent victim of fate, the will of the gods. Or if not, she must have been overcome by force or by words or by the irresistible power of love. These exhausted the possibilities, and Gorgias, like a defense lawyer in a courtroom, showed that in every conceivable circumstance Helen was blameless.

In another rhetorical exercise Gorgias came to the rescue of a Greek hero whose honor, like Helen's, needed rehabilitating. The melodramatic career of the much maligned Palamedes, who joined the expedition against Troy, had already been put on the stage by Aeschylus and Sophocles, and according to Gorgias, too, he was really a victim. His enemy the wily Ulysses had forged a letter from Priam offering Palamedes gold to betray the Greeks and then planted the gold in Palamedes' tent. As a result the innocent Palamedes was stoned to death. So went Gorgias's story. Gorgias, with tight lawyerly logic, argued that Palamedes could not have betrayed the Greeks, and even if he could have he would not have wanted to. Students learned these speeches to become familiar with the Gorgianic style and method of argument. If Gorgias could make Helen and Palamedes look good, what might not the arts of rhetoric accomplish for the lesser villains whom his pupils would defend in the Athenian courts? Unfortunately for Gorgias's reputation, his style survives in Plato's elegant parody in Agathon's speech in the *Symposium*.

The rise of prose as a literary art was destined to have a deep influence on Western literature and education. The ancient prophet of humanism Isocrates (436–338 B.C.), in the shadow of Plato, his eloquent opponent, has received less than his due. His style "survives" in his speeches for Helen and Palamedes. But Plato's dazzling portrayal of Ideas and Absolutes has left us impatient with the prosaic arts of persuasion, the techniques of community that Isocrates practiced, taught, and defended. Yet the arts of rhetoric, the improvement of the arts of persuasion, would become the basis of humanistic education in the West for the next millennia.

While Plato and his Academy aimed to produce philosophers, Isocrates and his schools looked for the statesmen needed in his turbulent age. The ninety-seven years of Isocrates' life stretched from the decline of the Periclean empire to the rise of the empire of Philip of Macedon. In 430 B.C. when, for the first time in many years, Pericles was not reelected to the board of ten generals, he lost the power base from which he had led Athens. His death in 429 B.C. and the collapse of the old empire left Athens in political limbo. Isocrates then grew up in the trying years of the Peloponnesian War (431–404 B.C.), a time of plague in which two of Pericles' sons died and the population was decimated, a time of broken peace treaties and bitter naval defeats. Athens's domestic disorders ended in the seizure of power by the Thirty Tyrants, and their removal by a fragile democracy.

Isocrates, son of a prosperous flute manufacturer who lost his fortune during the war, early acquired a passion for the idea of a unified, outreaching Greece. He vainly hoped that problems of poverty at home could be solved by resettling needy Greeks in a conquered Persian empire. Wanting

a profession, Isocrates became a Sophist, paid to teach the arts of successful living. This did not commit him to any school of philosophy but only to a practical approach to all problems—in conspicuous contrast to Plato and others at his Academy who hoped to discover the True and the Good. Isocrates lacked the voice and the physique to be an effective speaker himself, but for fifty-five years he taught oratory. He began by writing law-court speeches for others to deliver. The law of Athens required that every litigant, plaintiff or defendant, in court had to speak for himself. And there was no prosecuting attorney. But nothing prevented a citizen from hiring an expert speech writer (a "logographer"). Greeks, being like Americans a litigious lot, needed both teachers of oratory and writers of law-court speeches. But speakers in the courtroom like modern politicians were not eager to acknowledge their ghostwriters. Legal speech-writing was well paid and engaged the best oratorical talent, including Demosthenes himself.

After ten years as a speech writer, about 393 B.C. Isocrates opened his own school of rhetoric. He would have preferred to call it a school for statesmen. Some biographers see his new career as a kind of conversion, based on Isocrates' belief that rhetoric, the art of oratory, was the best preparation for statesmen. In 353 he summed up his philosophy of rhetoric:

> The greatest statesmen of this and earlier generations studied and practised oratory—Solon, who was called one of the Seven Sophists, Themistocles, Pericles. . . . Athens honours with a yearly sacrifice the Goddess Persuasion. . . .
>
> My own view of philosophy is a simple one. It is impossible to attain absolute knowledge of what we ought or ought not to do; but the wise man is he who can make a successful guess as a general rule, and philosophers are those who study to attain this practical wisdom. There is not, and never has been, a science which could impart justice and virtue to those who are not by nature inclined towards these qualities; but a man who is desirous of speaking or writing well, and of persuading others, will incidentally become more just and virtuous, for it is character that tells more than anything.

While Isocrates' school, unlike Plato's Academy, was not an elite sect, it was open only to those who could pay in advance the fee of a thousand drachmas for the three- or four-year course. Finally his school had taught almost a hundred pupils, but not more than nine at a time. From these fees and from the gifts of wealthy and successful pupils, Isocrates became one of the twelve hundred richest men in Athens. He was called on to perform a "liturgy," a public service of the wealthiest citizens, who were to provide a chorus for one of the dramatic contests, to recruit and train one of the ten teams for the torch race, to underwrite one of the embassies to one of the Panhellenic festivals, or to host a banquet at one of the festivals. An extraordinary liturgy in wartime required the citizen to equip a warship.

But a wealthy citizen might try to escape this burden by an ingenious institution called *antidosis* (exchange of property). He would challenge a citizen who he thought was wealthier than himself either to undertake the liturgy service or to exchange properties with him. When the liturgy assigned to Isocrates required him to fit out a warship at his own expense, he challenged it with an antidosis lawsuit. When he lost, he seized the occasion to demonstrate his rhetorical skills. He cast himself as a misunderstood Socrates on imaginary charges, and expounded the personal philosophy that we have quoted.

Isocrates' school produced Athens's generals, statesmen, and men of letters. And his models survive in the main forms of rhetoric: judicial (law-court speeches), deliberative (political speeches), and epideictic (ceremonial speeches praising or blaming: funeral or festive orations). He polished these tirelessly for publication in written form. One of his best-known speeches, his *Panegyric,* was said to have taken him nearly fifteen years to compose. Even when the occasion for his speech is fictitious, he adds dramatic detail by referring to the running out of water in the water clock, as if the oration really were being spoken. Rhetoric, "the artificer of persuasion," had become self-conscious. "In good style it is necessary for vowels not to fall in adjacent positions," his handbook advised, "for this would create a halting effect, nor is it right to end one word and begin the next with the same syllable. . . . Let the flow of words not be entirely prosaic, which would be dry, but mixed with every rhythm." And for prose he established his own iambic and trochaic rhythms.

With the new artifices of rhetoric and the arts of literary prose Isocrates defined a Greek humanism, a culture of language, of the spoken and written word. "The people we call Greeks," he said, "are those who have the same culture as ours, not the same blood." That culture was mainly the achievement of Athens, which he, like Thucydides, saw as "the school of Greece." It was the Greek word cast in its new art of prose that had a new power to enforce Hellenic unity. "True words, words in conformity with law and justice, are images of a good and trustworthy soul," and would create a still wider community. Western culture, the education that civilized the West, would be based on this faith in the immortal word.

Before the end of Isocrates' long life, there appeared two monumental champions of the arts of prose who would far overshadow the pioneers. The first was Aristotle (384–322 B.C.), unexcelled organizer, classifier, and codifier of knowledge, "Nature's Secretary." Aristotle's rhetoric, the product of years of reflection and revision, would have a domineering influence for centuries. What Vitruvius would do for classical architecture Aristotle did for the classical "modes of persuasion." Surveying the numerous text-

books, he regretted that the subject had been narrowed by too much attention to law-court rhetoric and too little to political rhetoric, where larger issues were debated, and to the arts of persuasion in daily life. Rhetoric, he said, was not a science, for it had no special subject matter. But the arts of persuasion, he insisted, were needed by everybody. In our time they go by the names of Public Relations and Advertising.

The arts of persuasion by prose had been elaborated in Athens within a single century. Aristotle himself was convincing evidence of the overweening power of the spoken word in classical Athens. And of the Athenian powers of creative self-consciousness. Prose was now a distinctive art, and Aristotle describes its powers with his usual common sense. While the sciences aimed at the certainty of Truth, rhetoric aimed only at the probable, to which men could be persuaded. Aristotle notes the three main forces of persuasion—the character of the speaker, the emotions of the audience, and the powers of logic (real or apparent). Like Isocrates he classifies the forms of oratory (political, forensic, and epideictic) according to when they were used, and he describes the best prose style for each.

Aristotle's readable treatise on rhetoric reminds us that success as prose stylists rescued Plato and Aristotle and philosophy itself for Western humanistic education. The great philosophers from Heraclitus to William James and Henri Bergson and Alfred North Whitehead were masters of prose. Their prose styles are almost as recognizable as their philosophic message. So they encompassed philosophy into the arts, making it everyone's delight. Aristotle covered all literature in two works. His *Poetics* dealt with poetry in all its forms: tragedy, epic poetry, and comedy. His *Rhetoric* dealt with prose and "the faculty of observing in any given case the available means of persuasion." Both shaped Western thinking for fifteen hundred years.

To Aristotle's theories, Demosthenes (382–322 B.C.) provided real-life models for every form of public persuasion. What for Isocrates had been an art sharpening moral sensibilities became for Demosthenes a political weapon. The word "Philippic," which we inherit from Demosthenes' diatribes against King Philip of Macedon, expressed the dominant spirit of his oratory—the posture of attack. Son of a wealthy sword maker who died leaving a large inheritance when Demosthenes was only seven, he was put in the charge of guardians who embezzled his estate. When he was old enough to know what had been done to him, he spent years suing his guardians. He sought instruction in public speaking and might have taken Isocrates' course if it had not been too expensive.

During this fruitless personal litigation Demosthenes made a living writing courtroom speeches for others. Legends clustered around his physical

weaknesses. It was said that he was not strong enough to join in the usual Greek course of gymnastic education, and that a speech defect (making him unable to pronounce the letter p) forced him into practicing for endless hours. It was said that he tried to remedy his defect by speaking with pebbles in his mouth or by running and then reciting verses while he was breathless. An eloquent champion of Athenian independence, he relentlessly opposed Philip of Macedon in his series of *Philippics.* But his masterpiece, revered by rhetoricians as perhaps "the greatest speech of the greatest orator of antiquity," had a curious history. After the defeat of the Athenians at Chaeronea (338 B.C.), his friend Ctesiphon persuaded the Council to pass a resolution honoring Demosthenes with a golden crown for his steadfast independence and patriotism. His lifelong enemy Aeschines countered with a personal attack on Ctesiphon, charging that the resolution was illegal and that Demosthenes himself and his intransigence were the real cause of Athens's misfortunes.

In 330, when the case finally came to trial, Demosthenes defended himself against charges of indecision, bribe taking, and cowardice. His confrontation with Aeschines was the Great Rhetorical Exhibit of antiquity—judged by a public jury of at least five hundred citizens, with a large audience of idlers and curiosity seekers. In this, his most famous speech, "On the Crown," Demosthenes defended the foreign policy he had unsuccessfully espoused for twenty years. Demosthenes won the jury's vote by a vast majority, which forced the disgraced Aeschines into exile. And his speech became *the* rhetorical classic. Cicero wrote a prologue to it, and translated it into Latin, to be memorized by Roman schoolboys. Queen Elizabeth I, herself a master of the spoken word, took lessons from Demosthenes set by her teacher Roger Ascham.

But this champion of Athenian democracy was destined to die as the victim of the fickle populace. The fugitive treasurer of Alexander the Great, seeking asylum in Athens, brought a huge sum to bribe the Athenians to rebel against Alexander. When deposited in the Acropolis, half of it mysteriously disappeared. Demosthenes, one of the commissioners in charge, was accused, and was tried at his own request. Convicted, he was condemned to pay fifty talents. He retired into exile but was soon recalled. After the defeat of the Athenians near Crannon, in Thessaly, in 322 B.C. he left the city again. He was condemned to death. Pursued by the Macedonian king Antipater, he took sanctuary in the temple of Neptune in Calauria. There, as Plutarch relates, he dreamed that he was acting in a tragedy. On awaking, he enacted the end of the tragedy by taking poison. The people of Athens erected his statue in brass, inscribed on the base:

> Had you for Greece been strong, as wise you were,
> The Macedonian had not conquered her.

Statesman and orator would be one as education became the culture of the immortal word.

BOOK TWO

RE-CREATING THE WORLD

To live, to err, to fall, to triumph, to create life out of life.

—JAMES JOYCE (1915)

Man, like his God, could make something from nothing, or from the most unlikely materials. From the past he created consolation, words he made into music, and light he fashioned into an architecture. Death he imagined into an adventure. Every earthly experience, every disaster, human weakness, vice, or folly became raw material for the composite Human Comedy, with insights into the familiar and epics of the unfamiliar. Plagues became incentives to witty tales. Pilgrimages offered a panorama. Personal illusions formed a modern literature. Spectators reappeared to watch a nation's tragedy and comedy and grandeur onstage. The afterlife became a drama of human choice. The fall and rise of empires became sagas of epic historians. And the modern city—its money, its loves and hates, its commerce and its hinterland—was an infinite resource. Responsive readers inspired and directed the attentive writer. The music of words and instruments created new communities. Time itself was captured and confined in the painted moment and light made into a creative ally. New World architects punctuated the heavens with their skyline.

PART SIX

OTHERWORLDLY
ELEMENTS

*It is only through symbols of beauty that our poor spirits can
raise themselves from things temporal to things eternal.*

—ABBÉ SUGER (TWELFTH CENTURY)

The Consoling Past

A ROMAN senator, in prison awaiting execution for treason, created a vehicle for ancient culture throughout the Middle Ages and a consoling classic to the troubled centuries. The unlucky leisure that occasioned this work had been enforced on Boethius by the illiterate but enlightened King Theodoric of the Ostrogoths, whom he had served. Now in 523, the victim of a suspicious king and jealous courtiers, he languished in a cell in the tower of Pavia near Milan. For years he had been preparing himself for this feat of prison literature.

Boethius (480?–524?) was born into a noble Roman family that had converted to Christianity long before his time. When his father, Roman consul in 487, died, the boy was raised by an influential guardian, whose daughter he married and so rose speedily in the Roman civil service. Knowledge of Greek was no longer common among the Roman upper classes, but Boethius somehow learned the language. His legendary mastery of Greek produced the myth that he had studied for eighteen years in Athens. The precocious Boethius improved Theodoric's relations with barbarian kings. He directed the building of a water clock and sundial for the king of the Burgundians, and chose a harp player for the Frankish court of Clovis. By 510, when only thirty, he was raised to the consulship, a dozen years later he saw his young sons as the two consuls, and in the very next year he rose as *magister officiorum* to become King Theodoric's intimate counselor.

Meanwhile Boethius had somehow found time to build an encyclopedic library—partly of his own writing, partly translated from the Greek. He invented the name *quadrivium* (at first *quadruvium*) for a program of education. These four "mathematical" disciplines (arithmetic, music, geometry, and astronomy) were the way to knowledge of the numerical "essences," which the Neoplatonists called the only real objects of knowledge. Boethius wrote a treatise on each of the mathematical disciplines. His *Arithmetic* and *Music* (the first known work of musical theory in the Christian West) survived to become standard texts in the Middle Ages. So, for the Latin reader, the learned of medieval Europe, Boethius saved "the first elements of the arts and sciences of Greece." By analogy to the *quadrivium* for the mathematical disciplines the Middle Ages would produce the *trivium* for the verbal disciplines (grammar, rhetoric, and logic). *Quadrivium* and *trivium* together comprised the Seven Liberal Arts. Boethius

also provided basic texts for the study of Aristotelian logic in the Middle Ages. In his four theological tracts on the nature of God and the person of Christ he provided the model of medieval scholasticism, the prototype for Saint Thomas Aquinas, and so merited the title of the First Scholastic. "Theology," which we have seen had been pursued at least since Philo in the first century, Boethius now used to describe philosophic inquiry into the nature of God. And he gave it the rigorous Aristotelian character that seven centuries later would bear fruit in Aquinas's *Summa Theologica* (c.1265–93).

The learned Cassidorus, Theodoric's secretary of state, acclaimed the twenty-five-year-old Boethius. "In your translations, Pythagoras the musician, Ptolemy the astronomer, Nicomachus the arithmetician, Euclid the geometer are read by Italians, while Plato the theologian and Aristotle the logician dispute in Roman voice; and you have given back the mechanician Archimedes in Latin to the Sicilians." As a young man, Boethius announced his lifetime project to "instruct the manners of our State with the arts of Greek wisdom."

It was Boethius's fatal fall from royal favor, in the very model of an Aristotelian tragic hero, that made him creator of the solacing classic of later centuries. Personal disaster, the isolation of prison, and separation from his books would stir a new vision all his own. And he managed to translate and transform the subtleties of Plato and Aristotle into a popular philosophy. Boethius's personal tragedy was a symptom of the uncertainties of the age, the rivalries between the Eastern and the Western empires. Theodoric the Great was at first spectacularly successful in fostering a productive coexistence between the Goths and the Romans. Declaring all (including his Gothic tribesmen) subject to the Roman law, he insisted on tolerance of the orthodox Catholics and safety for the defenseless Jews. But the healing of the schism between the Churches of East and West fed Theodoric's fears that his Italian subjects would renounce his rule in favor of the Eastern Orthodox emperor. When the Roman senator Albinus was accused of writing treasonous letters to the emperor Justin, Boethius impulsively protested, "The senate and myself are all guilty of the same crime. If we are innocent, Albinus is equally entitled to the protection of the laws." The uneasy Theodoric, taking this to be a confession of guilt, had it confirmed by a forged letter from Boethius to the Eastern emperor and arrested Boethius on suspicion of high treason.

The imprisonment that provided his unwelcome sabbatical from official duties forced Boethius to concentrate on questions of fate and destiny. And his enduring work, *The Consolation of Philosophy,* was the creation of these last two miserable years of Boethius's life. Gibbon, always hostile to metaphysics, found it "a golden volume . . . which claims incomparable merit

from the barbarism of the times and the situation of the author." In his prison cell and without his library, Boethius had to depend on his well-cultivated memory, the prime resource of scholars in the days before the printing press. If Boethius had been surrounded by his books he could hardly have written so concise or so popular a work. After the Latin Bible, his was perhaps the most widely read book of the European Middle Ages.

At first Boethius's little one-hundred-page volume with its alternate brief passages of prose and verse has the look of a mere collection of writings by others. But all is really Boethius's creation, an anthology of his own poignant classical memories. *Nam in omni adversitate fortunae infelicissimum genus est infortunii, fuisse felicem* (For in every ill-turn of fortune the most unhappy sort of misfortune is to have been happy). In these few pages his vast reading in ancient philosophers had been refined, embellished, and simplified. The goddess Philosophy, Boethius's interlocutor, leads us in dramatic dialogue from self-pity through "the gentler remedy" (understanding the whims of Fortune) to "the stronger remedy" (discounting the earthly goods which depend on Fortune). Man's sin is mere forgetfulness, the clouded memory of the soul. For, as Plato explained, before birth every soul is pure, committed to the Good. Philosophy restores that memory. But how can evil exist in a world where God is Good and history is governed by God's Providence? The everyday errancy of Fate does not disrupt the divine scheme of God, the "still point of the turning world." The closer we come to that central point, retreating from the rotating changefulness of the world, the freer we too will be. Love holds us all together and helps each of us recover the memory of our pristine soul.

But if everything is foreordained by God, how can we be free to choose? Philosophy, the consoling goddess, distinguishes God's way of knowing from man's, which comes down to their different relation to time. The mind of the eternal God "embraces the whole of everlasting life in one simultaneous present." "Whatever lives in time exists in the present and progresses from the past to the future, and there is nothing set in time which can embrace simultaneously the whole extent of its life: it is in the position of not yet possessing tomorrow when it has already lost yesterday. In this life of today you do not live more fully than in that fleeting and transitory moment." This explains why God's foreknowledge does not deny man's moral responsibility. *The Consolation of Philosophy* is prison literature. And the pious prisoner must somehow "justify the ways of God to Man." He cannot escape the problem of theodicy, of how a benevolent God could tolerate evil. This would also trouble other prison authors, Sir Thomas More writing his *Dialogue of Comfort agaynst Trybulacion* (1534) and John Bunyan at his *Pilgrim's Progress* (1676).

For the generations who could not read Greek and had lost contact with

the wisdom of the ancients the form and style of Boethius's *Consolation* gave help. Though closely reasoned, its brief chapters alternating prose and verse encouraged the casual reader. The dialogue between the optimistic Mistress Philosophy and the disconsolate prisoner carries along the troubled layman.

The book that was destined to be the classic of the Christian Middle Ages was not clearly the work of a Christian, although few of its notions are un-Christian. Boethius would have us "offer up humble prayers" to a personal God, "a judge who sees all things," but he offers no distinctly Christian doctrine, nor does he quote the Bible. He lived up to the promise of his title, "The Consolation of *Philosophy,*" by helping every lonely prisoner reach God through his own reason.

Impatient with theology, Gibbon admired Boethius, for "the sage who could artfully combine in the same work the various riches of philosophy, poetry, and eloquence, must already have possessed the intrepid calmness which he affected to seek. Suspense, the worst of evils, was at length determined by the ministers of death. . . . A strong cord was fastened round the head of Boethius and forcibly tightened, till his eyes almost started from their sockets; and some mercy may be discovered in the milder torture of beating him with clubs till he expired. But his genius survived to diffuse a ray of knowledge over the darkest ages of the Latin world. . . ."

Later generations paid homage to Boethius, and his work enjoyed a rich and varied afterlife. Master translator Boethius would eventually himself benefit from the most eminent and adept translators. King Alfred the Great (849–899) did a free version of the *Consolation* into Anglo-Saxon with his own explanatory comments, and he made Boethius one of his golden four of "the books most necessary for all men to know." In the next century a Swiss Benedictine at the monastery of St. Gall put the book into Old High German. Someone translated it into Provençal. Jean de Meung, the thirteenth-century author of the second part of *Le Roman de la Rose,* put the whole *Consolation* into French. This was probably the version that attracted Chaucer to translate the *Consolation* into English prose and to embroider Boethius's philosophy into the poetry of "The Knight's Tale" and *Troilus and Criseyde.* Dante placed Boethius among the twelve lights in the heaven of the Sun:

> That joy who strips the world's hypocrisies
> Bare to whoever heeds his cogent phrases:

Chaucer's was only the first of many efforts at "Englishing" the *Consolation.* The most famous and most remarkable was that by Queen Elizabeth I

(1533–1603). In 1593, desolate at the news that the Protestant leader Henry of Navarre (1553–1610) had forsaken the Protestant cause and taken up the Catholic faith at St.-Denis, she tried to allay her "great grief" by reading the Bible and the Holy Fathers and by frequent conferences with the archbishop. Then she solaced herself daily by translating Boethius, and shamed sluggish scholars by finishing one page every half hour. She wrote the verses in her own hand, but dictated the prose to her secretary, and completed the whole *Consolation* in something between twenty-four and twenty-seven hours. Scholars agree that she managed to retain the dignity of the Latin original with a certain "ragged splendour."

28

The Music of the Word

BOETHIUS'S textbook on music (c.505), along with his *Consolation of Philosophy,* solaced generations with the harmony of the universe. Drawing on Pythagoras, Plato, and Nicomachus—whom he had translated and with whom he would be depicted in medieval drawings—he helped the great Greeks provide the mathematical basis for musical theory in the West.

And he perpetuated their grandiose concept of music. Boethius explained that "music is associated not only with speculation but with morality as well. . . . The soul of the universe was joined together according to musical concord." Studying the universal concord, the *musicus* was a cosmologist. His relation to the composer or singer or player of music was like that of the architect to the bricklayer. Or, as Guido of Arezzo put it (c.1000), "he who makes and composes music is defined as a beast because he does not understand." Boethius's treatise spared no detail of the Greek theories and concluded with Ptolemy's own theory of the divisions of the tetrachord. Despite or because of its technicality, Boethius's work survived in 137 manuscripts, becoming one of the first musical works to go into print (Venice, 1491–92).

Christianity, conquering European culture in the Middle Ages, inherited this heavy baggage of musical theory. The "music of the spheres," a pagan notion, still appealed, and the Pythagorean belief in numbers satisfied the need for symbols. Was it not exhilarating that the seven notes of the scale

expressed the pitches produced by the revolving of the seven planetary spheres? And that the number 7 also had a special meaning for man, since his earthly body was symbolized by the number 4 and his soul by 3. This *Homo quadratus,* the properly proportioned man, was described by the architect Villard de Honnecourt and depicted in a famous diagram by Leonardo da Vinci. Greek theories of monophonic music cast thinking about music in this appealing mold of Pythagorean numbers.

The Christian churches needed liturgy, which meant thinking of music not as numbers but as sound. The music of the word would be a way station from cosmology. Saint Paul had exhorted the faithful to sing and make melody in "psalms and hymns and spiritual songs." The first record of Christian worship had been the hymn sung at the institution of the Lord's Supper (Mark 14:26).

When the early churches first admitted music, they recalled classic warnings against the wrong sort of music. In his *Confessions* Saint Augustine described the perils. While the Church songs moved him to tears at his conversion, he was "moved not with the singing, but with the thing sung":

> I then acknowledge the great good use of this institution. . . . that so by the delight taken in at the ears, the weaker minds be roused up into some feeling of devotion. And yet again, so oft as it befalls me to be moved with the voice rather than with the ditty, I confess myself to have grievously offended: at which time I wish rather not to have heard the music.
>
> (Translated by William Watts)

He recalled how in Milan the music of his mentor Saint Ambrose had affected him. "How did I weep, in Thy Hymns and Canticles. . . . voices flowed into mine ears, and the Truth distilled into my heart, whence the affections of my devotion overflowed, and tears ran down, and happy was I therein."

Ambrose, the defender of the faith against the Arian heresies from Alexandria, had embellished the Milanese services on the Oriental model by prescribing music for the church festivals and introducing the antiphonal singing of the Psalms. So he created the Christian hymn. At least four of the hymns he wrote still survive and he became the legendary author of many more. The singing of hymns then became part of the Rule of Benedict for the canonical hours. The famous Te Deum, the Ambrosian Hymn of Praise, was said to have been composed responsively and spontaneously at the baptism of Augustine. When Ambrose began singing "Te Deum Laudamus," Augustine replied, "Te Dominum confitemur," and Ambrose continued with the words that became the hymn. In his cathedral in Milan, Bishop Ambrose introduced metrical hymns that were widely imitated

across the West, and his four-line stanzas of iambic dimeter came to be known as Ambrosiani.

The liturgy of the Catholic services, the Music of the Word, would become the main vehicle of the art of music in the West during the next centuries. Ambrose's own form of the chant would retain its character and remain a Milanese liturgy into modern times. Saint Augustine's treatise focused on how rhythm and meter were applied to "long and short noises, including syllables, spoken or sung."

The Gregorian chant, fertile creation of the medieval church, would be the enduring monument in the West of monophonic music—that is, music that consists of a single line or melody without any accompaniment as part of the work. This first Christian music would bear the name of Saint Gregory the Great (c.540–604; pope, 590–604), who deserves to be known as its compiler and promoter. The Christianizing of music, however, limited the independence of music, along with that of poetry, philosophy, and architecture.

Gregory himself was both the symbol and the agent of the new Europe-wide power of the Church and especially of the papacy. In the struggles between the Eastern and Western Roman empires and between Roman and barbarian, of which Boethius had been a victim, Gregory would play a leading role. Born in Rome in 540, only sixteen years after the death of Boethius, Gregory came of a wealthy family that had already produced other popes. He received a good classical education, was at home in Latin but did not know Greek. After the Lombard invasions he became *praefectus urbis,* chief administrator of Rome at the age of thirty-two.

When Gregory gave up the government of the turbulent city, he retreated to the peace and piety of the monastery. He made his own home on the Coelian hill into a Benedictine monastery of St. Andrew, and he gave away his large landed inheritance to establish a half-dozen other monasteries. In 579 Pelagius II sent him as papal nuncio to Constantinople, where for seven years he sought reinforcements against the barbarian Lombards. Soon after he returned to Rome, the plague carried away the pope. And in 590, according to the custom of the time, the Senate, clergy, and people of Rome chose him pope by acclamation. The unwilling Gregory still had to be confirmed by the emperor in Constantinople, to whom his name was sent. Committed to the monastic life, Gregory wrote to Emperor Maurice begging him not to confirm the election, but the letter was intercepted. Gregory fled the city but was captured after three days and had the papacy imposed on him. Still complaining of "the lowly height of external advancement," and pleading to remain a monk, he finally "undertook the burden of the dignity with a sick heart," and was "so stricken with sorrow that he could scarcely speak."

Never was reluctant power exercised more effectively. Gregory became the architect of the medieval papacy, the people's pope, and purifier of the Church. He seized the opportunity of the Lombard invasions and the impotence of the Byzantine exarch in Ravenna to extend the Church's power over thought, culture, and morals. An effective administrator, he gave the Church a coherence that survived through the Middle Ages. The Napoleon of the papacy, master of Machiavellian politics, he used the turbulence of the Byzantine empire, the struggles between the Eastern and Western churches, and the influx of barbarian tribes to make the papacy supreme in Western Christendom. In 596 he sent forty monks to England with the Augustine (died 604) known as Apostle to the English, who became the first archbishop of Canterbury. Borrowing from the earlier Augustine, Gregory conferred on himself the title Servant of God's Servants, and was canonized by popular acclaim. In the eighth century he was named one of the doctors of the Church, the last of the Latin fathers.

Just as the most enduring of the versatile Napoleon's achievements was not his empire but the Napoleonic Code, so the most enduring achievement of Gregory the Great would be the Gregorian chant. And just as Napoleon was not the author of his code, so Gregory did not compose the Gregorian chants. He did write a vast work on Job and on other books of the Bible, and issued a widely used Pastoral Rule. But, as he cautioned Augustine of Canterbury, he was wary of an imposed uniformity. His concern was unity in Christian faith, and his musical scheme for the Roman service laid a foundation for the music of the West. Out of the Gregorian chant, a renaissance of the monophonic music inherited from the ancients, Western polyphony would grow.

Christianity had set the stage for Gregory's leadership and the creation of this wonderfully fertile Music of the Word. The fear of graven images (Exodus 20:4,5) at first had excluded the pictorial arts from the churches, for the faithful remembered the wrath of Saint Paul on seeing statues in the Greek temples. "Forasmuch then as we are the offspring of God, we ought not to think that the Godhead is like unto gold, or silver, or stone, graven by art and man's device" (Acts:17:16–17, 23–24, 29). But music was part of the Christian service from the beginning. Since the first Christians were Jews, they naturally borrowed and adapted the music of the Hebrew divine service. That service featured singing the Psalms of David in either responses or antiphony. New Christian congregations made psalm singing a part of their service that would survive in the Gregorian chants. But since the ancient Hebrews had no musical notation, their melodies for recitation were preserved only by memory. Their accents for cantillation became the "neumes," the original notation for medieval Christian music. So the early

Church music combined the inheritances of Jewish temple music with ancient Greek musical theory.

"Hymns," songs of praise of God, had often been mentioned in the Bible. Jesus and his companions had sung a hymn before going to Gethsemane. Bishop Ambrose of Milan was credited with introducing hymns into the service. At first these were new Latin poems, such as "Deus creator omnium," which lived on as religious folk song. But the Council of Laodicea (A.D. 363), which established the canon of the Scriptures, decreed that in the Church service only the words of the Bible should be admitted. As a result, although Saint Augustine himself and others wrote Ambrosian hymns, these were not introduced in the divine service until the twelfth century. Centuries later the Reformation churches of France and Switzerland would purify their service, too, by excluding anything but the Bible.

The psalmody of the Christian churches naturally adapted the Jewish styles of antiphony (the dialogue of a double chorus) or responsorial (the response of a chorus to a solo singer). Augustine had tried to justify the wordless alleluia singing of the Jewish service because "one who is jubilant does not utter words but sounds of joy without words . . . a joy so excessive that he cannot find words for it." Still, the tradition that prevailed was the singing of psalms. The fear of "wordless" music, the "lascivious" music against which Plato had warned and which had once misled Augustine himself, was so great that the early Church forbade instruments.

The human voice was something else. "Song awakens the soul to a glowing longing for what the song contains;" urged a fourth-century author, "song soothes the lusts of the flesh; it banishes wicked thoughts, aroused by invisible foes; it acts like dew to the soul, making it fertile for accomplishing good acts; it makes the pious warrior noble and strong in suffering terrible pain; it is a healing ointment for the wounds suffered in the battle of life . . . for 'the Word of God' if sung in emotion has the power to expel demons." And Thomas Aquinas explained, "Instrumental music as well as singing is mentioned in the Old Testament, but the Church has accepted only singing on account of its ethical value: instruments were rejected because they have a bodily shape and keep the mind too busy, induce it even to carnal pleasure. Therefore their use is unwise, and consequently the Church refrains from musical instruments in order that by the praise of God the congregation may be distracted from concern with bodily matters."

When Gregory set about reforming the Church, he made music one of his targets. Wary of wordless music, he set about establishing a uniform liturgy to inspire the faithful and unite them in the Word. Suspicious of secular learning, he saw music only as a devotional art. When he found the clergy wasting time cultivating their singing voices, he condemned in his

decree of 595 the "singing deacons" "who enrage God, while they delight the people with their accents." To leave the higher clergy free to administer the sacraments, to visit the sick and distribute alms, he ordered deacons to sing only the Gospel. The musical part of the services would be performed by the lower clergy. To supply professional singers he fostered the Roman Schola Cantorum. By the ninth century there was a uniform body of chant in the Western Church, for which Gregory was given credit and which bore his name.

The chastening of Church music would produce some surprising consequences in the next centuries. While Gregory's aim was not aesthetic, the chanted liturgy offered fantastic opportunities for creation and variation. These would be richly explored in the Mass, the sacred daily reenactment of the Last Supper and in the Divine Office, which consisted of eight daily prayer services for assigned hours of the day. Every day of the ecclesiastical year acquired its own Mass and Office, which varied according to two cycles, one celebrating the fixed feasts (Proper of the Saints) and another celebrating the movable feasts (Proper of the Time). And if there was a conflict between two designated festivals, a table indicated which took precedence. The chants repeated every day were set to many different melodies. For example, some 267 settings have been found for the Agnus Dei.

Then textual and musical accretions called "tropes" offered opportunity for personal or even whimsical embellishment of the Mass. While textual tropes served as a gloss interpreting the ancient text, musical tropes elaborated the music. But the reforming Council of Trent (1545–63) would cut out the tropes, which had long delighted the faithful.

We would make a great mistake, then, to think of the Gregorian chant (plainsong or plainchant) as monotonous or simply repetitive. More than eleven thousand tunes or texts of medieval chants survive in manuscript form, "graduals" for the Mass, and antiphonaries for the Office, along with notated missals and breviaries. While the Gregorian chants are monophonic music with a single melodic line, their words invited countless variations. Parts of the liturgy became chants in which each syllable was pronounced to a single musical note. Others became "neumatic" chants, with clusters of notes in series, sometimes as many as a dozen accompanying a single syllable. And then the subtly florid "melismatic" chants would set a single vowel to two hundred or more notes.

The misnamed "plainsong" has thus mystified students of music for a millennium. While the Gregorian chant in its afterlife has flourished as the authentic music of the Roman Church, its original character still remains in doubt. Not until the twentieth century did the Gregorian chant come

back into its own. The old melodies had been mutilated into a monotonous plainchant to facilitate organ accompaniment. In 1889 the scholarly Benedictine monks of Solesmes in France undertook to rediscover the medieval practice. Their product was numerous volumes of "Gregorian chants" in a free-flowing nonrhythmic style. By 1903 they had recaptured the Gregorian chant to the satisfaction of Pope Pius X, himself a scholar of musical history, who established their versions of the Gregorian melodies by his encyclical *motu proprio.* But the rhythms still remain a puzzle. Pius X's purified Gregorian chant banned the "theatrical style" of recitation, forbade the use of instruments, replaced women by boys in the church choir, and restricted the use of the organ. A Vatican Edition provided an authorized corpus of plainchant, which would prevail in the modern Catholic world. Even a Pius X lacked the power to dam up musical creations, as he gave bishops some latitude to vary the music of the liturgy within his guidelines.

While music was preserved through the liturgy, and the Church had a near monopoly of literacy, the Church of course had no monopoly on music in the Middle Ages. By the twelfth and thirteenth centuries in southern France the troubadours, composers who performed their own works, were producing a rich music to accompany their singing of the first vernacular lyric poetry in a European tongue, in the Provençal language. Eleanor of Aquitaine brought this art to the north, where the trouvères flourished. About twenty-five hundred troubadour poems and many more of the trouvère songs survive, some with their music. These monophonic songs, though sung by men of all classes, were part of the ritual of courtly love. Their counterparts in Germany were the minnesinger (from *minne,* Middle Dutch for love) of the twelfth and thirteenth centuries whose work was perpetuated by the meistersinger (members of city singing guilds) after the fourteenth century. Chivalry and courtly love produced thousands of love lyrics, which are echoed by Wagner in *Tannhäuser, Lohengrin, Tristan and Isolde,* and *Parsifal.*

For the Church, music remained a devotional art, and for centuries Church music remained an empire of the Word. Since it made no sense to recite different words simultaneously, Church music remained monophony. This "single-voice" music was a counterpart of Romanesque architecture, the architecture of the basilica, of simple clear lines. And in Gregorian chant, a music of unison, one voice without the resonance of instrumental accompaniment followed the line of the Word.

But the future of Western music lay in polyphony. Without a music of many voices, many simultaneous parts, Bach, Beethoven, or Chopin would have been inconceivable. How did Western music come to this basic revolutionary idea, which we commonly know as harmony? It seems to have emerged

somehow out of the Gregorian chant, and the infant idea must have been nourished by the wealth of Gregorian melody. Perhaps polyphony came naturally when different singers sang the same words simultaneously, each at the level at which he was most at ease. Which would make the origins of polyphony, "many-voiced music," another example of the Vanguard Word.

The birth of polyphony was recorded in the Carolingian renaissance, about 900, in a book called *Musica enchiriadis* (Handbook of Music), perhaps by Hucbald (840?–930?), a Benedictine monk of northern France. But the polyphony it describes already in use is not yet free composition. Instead a melody is taken from the repertoire of Gregorian chant to which another melody is added. The Gregorian plainchant melody, the cantus firmus, or "fixed song," would thus remain the basis of the new polyphony for three hundred years. At first it was made polyphonic by having a second singer repeat the melody at the lower fifth or fourth. Others could join by repeating either of these parts at the octave.

"Organum" was the name for this primitive polyphony. Perhaps it came from the Greek, describing the interval for the second voice because the second "voice" was being played on the organ. When Pope John XXII in 1332 forbade polyphony in the Church, he still allowed this simple form called "parallel organum." *Musica enchiriadis* had already described "converging organum," in which two singers of parallel organum started and ended in unison. When free organum appeared in the late eleventh century the intervals between the voices varied. Sometimes the parts moved in contrary directions, with the cantus firmus going down, the other voice up. Sometimes the parts crossed, putting the Gregorian melody above or below the other part. Here was an appealing new freedom for musical ingenuity, still not abandoning the basic Gregorian melody of the Word.

When the dreaded millennial year, 1000, had come and gone without the end of the world, Western Christians took heart. More than 160 organa have survived from the eleventh century. And the twelfth century saw the elaboration of polyphonic music in the monastery of St.-Martial at Limoges, in southern France. This St.-Martial style, "melismatic organum," filigreed the additional part with groups of notes set against a single note of the Gregorian melody. Then the singer of the cantus firmus would have to sustain his note until the other singer had completed his group of notes, sometimes as many as twenty. Having to hold his single note, he became known (from the Latin *tenere,* to hold) as the tenor, the singer of long-held notes. He was also "holding" the Gregorian melody. Enticing variations were opened when the cantus firmus could move from the upper position to the lower, with the upper part developing its own melodies. Though at first improvised, the added voice began to follow rules of its own.

Even before the first Gothic church was built, we have seen the music of

the Word beginning to show a playful Gothic spirit. In polyphony, simultaneous voices were traveling different melodic paths. Like the Gothic architecture, this would first come in northern France. In the richly varied motet of the thirteenth century, it developed at the singing school of Notre-Dame in Paris. Church leaders remained suspicious of polyphony in any form, "disorganized music" corrupting the simple Gregorian line with a lascivious secular spirit. But the Gothic spirit, on the way to rebuilding Western music in melodies of unheard complexity, was destined to rebuild the churches of Christendom.

29

An Architecture of Light

FROM the ancient Greeks came an architecture of outdoor monuments. From the Romans came an architecture of interior spaces. In the late Middle Ages in western Europe there appeared the first new style in a thousand years. Its special element would be light. Those who first saw it in the early twelfth century at St.-Denis, outside Paris, simply called it modern architecture (*opus modernum*). Then Vasari and other architects of the Renaissance in Italy who were disciples of Vitruvius christened it Gothic after the local workmen who were not Romans and to denote modern in the worst sense. "Gothic" had become a term of contempt for the barbarians who, centuries before, had invaded western Europe and destroyed the great monuments of the Roman Empire. In the great age of Gothic art no one thought of himself as Gothic.

Still the name has stuck indelibly for the arts of western and northern Europe from the twelfth to the sixteenth century. And now it paradoxically reminds us of a creative liberating spirit. But it obscures the dramatic uses that the new style made of its special element, light. "Gothic" conjures up images of gloomy darkness that would make it the name for a literature of forbidding mystery. To understand the uniqueness of the architecture that broke the European mold and opened a new era in Western architecture we must see what its creators thought and made of light. And why and how they chose this elusive unsubstantial element for their architecture.

What could be more obvious than that light is the source of all visual

beauty? Dionysius the Areopagite, whom Saint Paul himself had converted, and who was the founder of the church of St.-Denis, had elaborated this obvious fact into a principle of theology. In his *Celestial Hierarchy* Dionysius had described God as absolute light and light as the creative force in the universe. And Dante would put him at the summit of his "Paradiso" because in that book Dionysius had shown the way of rising to God. Theologians called this the anagogic (upward-leading) approach. The beauties of a church, then, should be mere aids "from the material to the immaterial," transparencies between us and God the "Father of the lights" and Christ "the first radiance" revealing the Father to the world.

The Gothic architecture of light would leave its mark on modern public architecture of the West—on our palaces and parliaments and universities. We can trace the first great work in the architecture of light to the shaping imagination of the French statesman-architect Suger (1081?–1151), abbot of St.-Denis. He would embody the "upward-leading" theology of Dionysius in a building. And he would reveal the opportunities in the Church for men of splendid talents to rise from humble station to shine across Western Christendom.

Born to a peasant family near Paris, at the age of ten Suger was deposited by his parents as an oblate, to be dedicated to the monastic life, in the nearby monastery of St.-Denis. In due course he became a monk, then was elected the abbot in 1122. The abbey remained his home until he died in 1151. He seems to have thought of the king of France as his father and he frequently called the abbey of St.-Denis his mother. He gloried in his lowly origins, "I, the beggar, whom the strong hand of the Lord has lifted up from the dunghill." The adopted child of St.-Denis, he felt that as he belonged to the Church, so the Church belonged to him. This helps explain, too, his unabashed taste for the gorgeous and the ornate in his church in an age of militant ascetics. His noticeably short stature, like that of Erasmus, Mozart, and Napoleon, was said to reinforce his ambition. As a friend noted in Suger's epitaph:

> Small of body and family, constrained by twofold smallness,
> He refused, in his smallness, to be a small man.

Luckily, his classmate at the school of St.-Denis was Louis Capet, who became King Louis VI. Suger remained this king's confidant, and his patriotic devotion to the French monarchy was warmed by personal affection.

Saint Denis had brought Christianity to France in the third century and become the first bishop of Paris. Reputedly martyred, he was buried in the place that later became the suburb of Paris named after him. Charlemagne attended the dedication of a new church there in 775, and as Saint Denis

became recognized as the patron saint of the French monarchy, the abbey acquired the profitable privilege of holding fairs under the saint's protecting name. On a legendary journey to the Holy Land, Charlemagne had acquired the sacred relics that were finally deposited at St.-Denis. By the eleventh century the Benedictine monastery there was preeminent in France and perhaps in all Europe.

Meanwhile the Capetian dynasty, founded in 987 by the ambitious Hugh Capet (940–996), laid the basis of the modern French monarchy with institutions that lasted until 1789. Hugh the Great was buried in the abbey church and it remained the burial place of French monarchs, the sanctuary of the monarchy. Only three French kings—Philip I, Louis VII, and Louis XI—would be buried elsewhere. The abbey church became a symbol of divine sanction for French kings, and of continuing royal support for the Church. After it became a "royal" abbey, it was exempt from feudal dues and subject only to the king.

But grand traditions of crown and scepter could not themselves create a new style in architecture. This required an inspired builder. Fortunately for the arts in the West the talented Abbot Suger was such a person and the church to which he was called needed to be rebuilt and expanded. Lucky for us too that, in an age of bitter theological controversy, Suger steered a prudent middle course between the mystic and the rationalist. These diverging paths remain vividly defined for us by his two famous contemporaries Saint Bernard of Clairvaux (1090–1153) and Peter Abelard (1079–1142). For Saint Bernard, fervent mystic and "purifier" of monasteries, known as the Thaumaturgus of the West, a church bedizened by gold and silver and stained glass was a Synagogue of Satan. The clergy, he said, should be models of charity and simplicity, avoiding the path of "scandalous curiosity." Which was the very direction of Bernard's archenemy, Abelard, prophet of rationalism and a founder of scholastic theology. Yet Abelard's path would also lead him to St.-Denis, where he attracted scores of students, among them Héloïse. The love affair of Abelard and Héloïse produced a son, after whose arrival they secretly married. Her outraged protector wreaked revenge by hiring ruffians to castrate Abelard. After this public humiliation, Abelard retired to the Benedictine monastery of St.-Denis, where he compiled his book entitled *Yes and No* (*Sic et Non*). Following his risky maxim "By doubting we come to questioning, and by questioning we learn truth," he answered the 158 key questions in Christian theology.

Abelard's next work, *Theologia,* on the doctrine of the Trinity, was burned as heretical, for he rashly debunked the most sacred tradition of the abbey. He sought to prove that, contrary to common belief, the patron saint of the abbey and of all France was not the biblical Denis of Athens (or Dionysius the Areopagite) who had been converted by Saint Paul. The

monks of St.-Denis were so outraged that Suger, newly elected abbot of St.-Denis, gave Abelard the unusual permission to leave the abbey—on condition that he not become a monk of any other house.

Even as a young man in his twenties Suger had impressed his superiors at St.-Denis with his practical talents. His abbot and his friend King Louis VI sent him on sensitive diplomatic missions. Then in 1122 he was elected to succeed the abbot, whose lax administration was under attack. Suger boasted that he had reformed the life of the abbey "peacefully, without scandal and disorder among the brothers, although they were not accustomed to it." He set the example of moderation by eating meat only when he was ill, by drinking wine always diluted with water, and by choosing food that was "neither too coarse nor too refined."

But when Suger turned his thoughts to the disintegrating building of the abbey church he was anything but moderate. Must not the House of God, he asked, be an "image of heaven"? He demanded that "golden vessels, precious stones, and whatever is most valued among all created things, be laid out, with continual reverence and full devotion, for the reception of the blood of Christ." The Great Cross in St.-Denis could never have enough gems and pearls. Suger then rose from the beauty of beauty to the beauty of light, without which there was no beauty. He was captivated by the aspiring theology of Dionysius, the reputed founder of St.-Denis, who described God as absolute light, and light as the creative force in the universe.

We must see what Suger created not from the perspective of our late-twentieth-century glass-walled, light-drenched architecture, but from Suger's twelfth-century solid-walled, heavy-columned, barrel-vaulted Romanesque. While Suger's Gothic did not flood church interiors with daylight, it produced unique and melodramatic new lighting effects.

St.-Denis offered Suger his providential opportunity. In 1124, only two years after he became abbot, the abbey attained a new symbolic eminence. King Louis VI, threatened by invasion from the Holy Roman Emperor Henry V and King Henry I of England, had hastened to St.-Denis to invoke his patron saint. There he received the banner of St.-Denis, the "oriflame" in the shape of orange points of flame, which became the royal standard. By feudal custom this made the king the vassal of the abbot, who represented the saint and incidentally made the abbey, in Louis's own words, "the capital of the realm." Louis deposited there the crown of his father, Philip I, which he said had rightfully belonged to the saint. Thenceforth St.-Denis would remain the tomb of French kings, the traditional depository of the crown of France, and the abbot was empowered to consecrate future kings. Incidentally, Louis granted the abbey the right to hold a new

fair in honor of Saint Denis, which became one of the most lucrative in the Middle Ages.

Pilgrim hordes flocked to St.-Denis. "The distress of the women," Suger reported, "was so great and so intolerable that you could see the horror how they, squeezed in by the mass of strong men as in a winepress, exhibited bloodless faces as in imagined death; how they cried out horribly as though in labour; how several of them, miserably trodden under foot [but then] lifted by the pious assistance of men above the heads of the crowd, marched forward as though upon a pavement." Suger made his abbey a royal archive and wrote a life of Louis VI. Best of all, he left us his own history of the planning, construction, and consecration of the rebuilt abbey church of St.-Denis, which has earned him a pioneer's place in the history of historical writing.

The royal proclamation making St.-Denis the religious capital announced the auspicious moment for rebuilding and enlarging the church. Suger began a fund-raising campaign in no way inferior to the efforts of our times. Only one quarter of the renovation funds would come from the abbey's regular revenues. The rest Suger gathered from the increased profits of properties he had improved, from the revenues of fairs, and from donors who had been promised the personal intercession of Saint Denis if they made a handsome gift. Incidentally, donors might receive the title *frankus S. Dionysii,* once suggested as the origin of the name France. The campaign went on for thirteen years before the work was begun. When Louis VII succeeded his father in 1137, Suger was no longer close to the royal administration, and so had the leisure for writing history and rebuilding the abbey church.

In Suger's day, luckily for the future of the arts in Europe, the Ile-de-France—a region in north-central France that had long been the political center—had no special architectural style of its own. Planning a grand new church, Suger had to start from scratch. Not being an architect, he had the further advantage of freedom from professional inhibitions or conventional rules. His two imagined "models," Hagia Sophia in Constantinople and the biblical Temple of Solomon in Jerusalem, he had never seen. Happily, with the free vision of the amateur and the miraculous collaboration of God, Suger could embody the upward-leading theology of his patron saint in his new church of St.-Denis. And at the same time he created the hallmarks of the Gothic—ribbed vaults, which supported the vaulted roof without heavy supporting walls, three portals of richly carved decoration and a rose window at the west, ambulatories and chapels radiant with the light of stained-glass windows, and the structure of the chevet (ambulatory, chancel, and chapels) supported on points of masonry rather than on solid walls. The worshiper within sensed only a skeletal structure dramatized by stained-glass light.

To accomplish this purpose the church would be rebuilt in three stages by a plan that evolved in Suger's mind gradually, in response to the resources. He first imagined importing columns from Rome "through the Mediterranean, thence through the English Sea and the tortuous windings of the River Seine." But this proved unnecessary. "Through a gift of God a new quarry, yielding very strong stone, was discovered such as in quality and quantity had never been found in these regions. There arrived a skillful crowd of masons, stonecutters, sculptors and other workmen, so that—thus and otherwise—Divinity relieved us of our fears."

The west or entrance end, begun in 1137 and completed in 1140, lengthening the old nave by 40 percent, was built of stone from the miraculous quarry. It was a symbol of royal authority, just as the eastern end announced the authority of the clergy. There a striking new feature, a rose window of stained glass, was placed over the middle of three richly carved stone portals. Crenellations atop the façade emphasized St.-Denis as the embattled protector of the monarchy. The three entrance arches, which for Suger represented the Trinity, also recalled the Arch of Constantine in Rome, through which the triumphant emperor passed in purification on the way to be received as a divinity.

Before completing the towers of the west façade, Suger abruptly turned to the choir at the east end, leaving the connecting nave till later. In 1140 he began the most original, intricate and audacious part of his plan, the first truly Gothic structure. The choir was completed in only three years and three months. The Norman and Romanesque styles had been marked by massive piers and columns, heavy walls, rounded arches, barrel vaults and a few windows, with sharply defined interior space. That was an architecture of rotundity, solidity, and containment, for the fortress-church, the Church militant. The new luminous skeleton of stone proclaimed a Church no longer on the defensive, but reaching prayerfully up to God and triumphantly to the world in an architecture of light. The simple engineering device that Suger introduced in his choir and that made this possible was the ribbed-vault. With slender ribs of stone to support the vault, the walls could be opened into more and larger windows. Suger used these ribs to separate the nine adjoining chapels lit by sixteen stained-glass windows, beaming many-colored light to be reflected on the polished mosaic floor and on the dazzling altar of gold and gems. "The entire sanctuary," Suger boasted, "is thus pervaded by a wonderful and continuous light entering through the most sacred windows."

It is no wonder that awed pilgrims and worshipers called these French works (*opere francigena*) the modern architecture (*opus modernum*). Suger's west entrance—the narthex, with its sharply defined forms—arches of stone sculpture, rose window and crenellations, was only a prologue to the fully Gothic choir where a slender frame of stone invited polychrome

light. Suger's choir above contrasted to the solid walls, groined vaults, and enclosed spaces of the Romanesque crypt below.

The two ends of the reconstructed church were to be connected by a nave, which Suger included in his plan but never completed. The legend that Christ had personally hallowed the original walls made Suger reluctant to demolish them for rebuilding. He had first decorated the walls of the nave with murals that found no place in the new Gothic architecture of transparent walls. This third stage of rebuilding, to be finished after Suger's death, would carry the ribbed vaults and luminous walls of the choir into the body of the church. The nave of Notre-Dame in Paris shows what he probably had in mind.

God helped again when the huge wooden beams needed to tie the structure together could not be found. Suger led the search into the woods. "By the ninth hour or sooner we had, through the thickets, the depths of the forests and the dense, thorny tangles, marked down twelve timbers (for so many were necessary) to the astonishment of all, especially those on the spot . . . to the praise and glory of our Lord Jesus, Who protecting them from the hands of plunderers, had reserved them for Himself and the Holy Martyrs as He wished to do." A terrifying storm during construction destroyed the best houses and stone towers in the neighborhood, but "was unable to damage these isolated and newly made arches tottering in mid-air, because it was repulsed by the power of God." All who worked at the building, Suger explained, would rise above earthly theology and be glorified by reaching toward a vision of the harmony of God. The builders would themselves be "edified." Dazzled by his success in fulfilling Dionysius' hopes Suger described his feelings when finally he gazed on the main altar.

> When—out of my delight in the beauty of the house of God—the loveliness of the many-colored stones has called me away from external cares, and worthy meditation has induced me to reflect, transferring that which is material to that which is immaterial, on the diversity of the sacred virtues; then it seems to me that I see myself dwelling, as it were, in some strange region of the universe which neither exists entirely in the slime of the earth nor entirely in the purity of Heaven; and that, by the grace of God, I can be transported from this inferior to that higher world in an anagogical manner.
>
> (Translated by Erwin Panofsky)

At the consecration of the church and dedication of the choir on June 14, 1144, King Louis VII led a procession of the relics in the presence of Eleanor of Aquitaine, five archbishops, and the nobles of the realm. So they reenacted the legendary first consecration of the Church when Christ himself had led a celestial hierarchy of saints and angels. The ceremony now sealed

the bond between the king and Saint-Denis, and peace between King Louis VII and his feudal vassals.

Over Suger's futile objections, Bernard persuaded Louis as a penance to undertake a Crusade to the Holy Land. Going off on this disastrous Second Crusade the king left his crown and the royal administration in the hands of Suger. During the king's absence the versatile abbot reformed the government and the system of taxation, suppressed civil war, and so became (in Louis VII's phrase) Père de la Patrie. When the beaten and humiliated king returned, sadly estranged from his wife, Eleanor, Suger resisted temptation and gave back the crown. By the time of his death in 1151 the indefatigable Suger embodied the long and glorious Capetian kingship in St.-Denis, which became the archetype of the French cathedrals brilliantly visible later in Paris, Chartres, Reims, and Amiens.

The light coming through stained-glass windows became a hallmark of the Gothic in later medieval churches. Here, too, Suger was a pioneer. The stained-glass windows for which St.-Denis was to be the prototype preceded by nearly a century the great technical advances of the glassmaker's craft, which would produce thinner flatter sheets and a wider range of colors. But these advances would tempt stained-glass artists to compete with painters, and so lose the primitive vigor seen in the St.-Denis windows. Happily, the glass of the early twelfth century had just the crudities to give it a varying textural interest of its own. Just as in architecture, there was yet no local style of stained glass in the Ile-de-France. Along with the bronze founders, jewelers, and enamel workers from the valleys of the Rhine and the Meuse, the masons and stone carvers from northern and southwestern France, and the mosaicists from Italy, whom he had come to know in his diplomatic travels, Suger collected "many masters" of stained glass from many regions. His international workshop produced lighting effects that outshone the occasional small windows of Carolingian and Romanesque buildings. And for the first time the windows of St.-Denis used a series of medallions to tell a story. These narrative windows illuminated the life of Moses, told allegories from the Epistles of Saint Paul, and depicted the Tree of Jesse (including a figure of Suger prostrate before the Virgin).

"The dull mind rises to truth through that which is material," Suger had inscribed on bronzed doors of the west entrance. "And, in seeing this light, is resurrected from its former subversion." In the next century a French bishop, Gulielmus Durandus of Mende (1237?–1296), in his *Rationale Divinorum Officiorum,* expounded the unique function of stained glass in this architecture of light. "The glass windows in a church are Holy Scriptures which expel the wind and the rain, that is all things hurtful, but transmit the light of the true Sun, that is God into the hearts of the faithful."

That light somehow never reached the revolutionary mobs from Paris who arrived at St.-Denis in October 1793. Following their command to "destroy pitilessly" this monument of royal power, they set about pillaging the work of Suger. A French painter, Hubert Robert (1733–1808), romanticized their sabotage in *La violation des caveaux de Saint-Denis.* After the building had fallen into neglect, desecrated by birds of passage and pouring rain, what glittering stained-glass windows were left became a special target for the "preservers" of antiquities. Now it would be hard to say whether St.-Denis suffered more from the enemies or from the admirers of the Gothic. Windows that had survived the Huguenots and the Revolution were mostly destroyed by the industrious Alexandre Lenoir (1762–1839) in 1799, the self-appointed savior of French art who removed from St.-Denis 140 panels of the original stained glass ostensibly for his Musée des Monuments Français in Paris. Only thirty-one were replaced. The rest were either smashed in oxcart transit to Paris or sold by him to foreign collectors.

Ironically, Lenoir's work of "preservation" did much to inspire Chateaubriand's glorification of Christianity in *Le Génie du Christianisme* (1802) and nourished the Romantic movement, which led to the classic misrepresentation of the Gothic spirit. Just as Piranesi had transformed the fragments of the classic into dark romantic imaginings, so Chateaubriand inverted Suger's Gothic into the opposite of the upward-leading theology of light.

> . . . the shadows of the sanctuary, the dark aisles, the secret passages, the low doors, all of this evokes in a Gothic church the labyrinths of the forests; it all makes us conscious of religious awe, the mysteries, and the divinity. . . . The Christian architect, not satisfied with building forests, wanted, as it were, to imitate their murmurs, and by the help of the organ and suspended bronze he has associated with the Gothic temple the noise of the winds and the thunder that rolls through the depths of the forest.
>
> (Translated by Paul Frankl)

Goethe, who called architecture "frozen music," took up Chateaubriand's lead and found his own Gothic tones in the German forests. And the great figures of French literature joined the litany. Victor Hugo (1802–1885), in his *Hunchback of Notre-Dame,* made the disfigured Gothic church his architectural Quasimodo. And the historian Jules Michelet (1798–1874) saw Nature as the progenitor of the Gothic.

30

Adventures in Death

IT is no accident that a lifelong refugee from his native city should have created an epic of everyman's exile from life to death. The year 1300, which the energetic Pope Boniface VIII had designated as the first centenary Holy Year of Jubilee for the Roman Catholic Church, was one of ill omen for the thirty-one-year-old Dante (1265–1321). In that year he had been elected to the highest office in the Republic of Florence. "All my woes and all my misfortunes," Dante observed, "had their origin in my unlucky election." A victim in the cross fire between pope and emperor, he was exiled in 1302 on trumped-up charges of corruption in office, conspiracy against the pope, and treason to the Republic of Florence. Warned that if he returned he would be burned at the stake, he never again in the remaining two decades of his life dared set foot in his beloved Florence.

Dante's quick but unlucky rise was due to his conspicuous talents, his energy in public office, and his good connections. He was born in 1265 into a prosaic commercial family, the Alighieri (Dante, his given name, was a contraction of Durante). His father carried on the family moneylending business and raised Dante comfortably in Florence's expanding economy. An only son, Dante suffered the death of his mother before he was twelve. When his father remarried, he was raised in his father's second family. He came to know the Latin classics and Aquinas, but never learned Greek. In Florence's cosmopolitan literary community, he was lucky in having as his mentor Brunetto Latini (1212?–1294?), a leader in the Guelf (or papal) party, who had brought back from Paris an enthusiasm for literature. Brunetto sponsored the talented boy Dante, who later acknowledged this man who taught him "how man becomes eternal" through the written word.

Dante's personal disaster arose from the entry into Florence in 1301 of Charles of Valois, brother of the king of France, under the pretext of keeping the peace between the embroiled factions of the Guelf party. Dante himself had gone to Rome to negotiate Pope Boniface VIII's support for

the city's independence. When Dante's mission failed, on his return to Florence he was arrested. His bitter exile was described in the prophecy of his ancestor Cacciaguida whom he meets in the "Paradiso." "You shall leave everything beloved most dearly; and this is the arrow which the bow of exile shoots first. You shall come to know how salt is the taste of another's bread, and how hard the path to descend and mount by another man's stairs . . . it will be for your fair fame to have made you a party by yourself." An outcast from his native city, he easily imagined the medieval Christian's exile into life after death, a place of eternal rewards and punishment. Dante himself would suffer a double exile—from his beloved city and from his beloved lady.

Bizarre to the modern eye, courtly love was a fertile institution of the late Middle Ages, although hardly an inspiration for lovers today. The relation of a courtly lover to his lady resembled that of a feudal vassal to his lord. The sentiment appears first in the troubadours in southern France at the end of the eleventh century. The lover of whom they sang was supinely obedient to his lady, addressing her not as "my lady" but as *midons* (Provençal for "my lord"), and he did his lady's bidding, however trivial or perilous. Medieval courtly love was always for another man's wife. It is not surprising that sexual love in those days was an extramarital experience, for marriage in the courtly classes was a cold-blooded transaction, cementing an alliance or securing a dowry.

Medieval authors had exploited their classic inheritance. The popular *Ars Amatoria* of the Roman poet Ovid (43 B.C.–A.D. 17) told how to conquer women of easy virtue and also instructed women on seducing men. It was axiomatic for Ovid that love could not exist between husband and wife. "Ovid Misunderstood" (in C. S. Lewis's phrase) was concocted with the cult of the Virgin Mary, and spiced with Arabic medical and mystical elements. By Dante's day, the lore and institutions of courtly love were well established. The lady who would be his "judge," his Beatrice, was the lady of courtly love.

Courtly love, like the medieval afterlife, put lovers on this earth in another kind of exile. Dante's poetic combining of courtly love with love of God, neither of which could be consummated in this life, merited Yeats's praise of him as "the chief imagination of Christendom." And Dante's "medieval synthesis" summed up the loves that dominated his times. His *Divine Comedy* would describe the life in death that dramatized the Christian's hopes and his *Vita nuova* would depict the new life that came from unfulfilled earthly love.

According to Dante, the experience that gave him a "new life" came when he was only nine, in the spring of 1274. Then, at his first glimpse of the nine-year-old Beatrice, "The glorious lady of my mind first appeared to

mine eyes . . . clothed in most noble hue, a subdued and modest crimson, cinctured and adorned after the fashion that was becoming to her most tender age." His pulse quickened and he trembled as he recalled Homer's words, "She seemed not the daughter of a mortal man but of God." Nine years passed before he saw her again, when she and he were both eighteen, and he had the good luck to see her among other ladies, "clothed in hue of purest white." It was at the ninth hour of that day that she "gave me a salutation of such virtue, that methought I beheld the uttermost bounds of blessedness." From then he never ceased to think and dream of her, but he was careful to keep this love a secret. When he saw her in a group he would fix his gaze on another lady who stood between them, so no one could detect his passion.

This Beatrice probably was a real person, Beatrice Portinari, daughter of a Florentine banker. In 1287 she married Simone de' Bardi, scion of a more powerful banking family. Dante appears never to have had physical contact with her.

Meanwhile, at the age of twelve, Dante was betrothed by his family to Gemma Donati, a suitable person of Guelf noble stock. After twelve years of engagement, about 1298, his family arranged the marriage. It was said they did this at the time to solace him, still mourning over the death of Beatrice eight years before. And, of course, to provide an Alighieri heir.

The miseries of this match are described by Dante's admirer Boccaccio. "Dante formerly had been used to spend his time over his precious studies whenever he was inclined, and would converse with kings and princes, dispute with philosophers, and frequent the company of poets, the burden of whose griefs he would share, and thus solace his own. Now, whenever it pleased his new mistress, he must at her bidding quit this distinguished company, and bear with the talk of women, and to avoid a worse vexation must not only assent to their opinions, but against his inclination must even approve them. . . . He who had been used to laugh or to weep, to sing or to sigh, according as pleasing or painful thoughts prompted him, now must not dare, or, should he venture, must account to his mistress for every emotion, nay, even for every little sigh. Oh! what unspeakable weariness to have to live day by day, and at last to grow old and die, in the company of such a suspicious being!" They had four children, but Dante does not even mention his wife in his writings. At his exile from Florence Dante would leave Gemma behind and never see her again.

The death of his ethereal Beatrice, a mere glimpse of whom had given him a new life, had left him disconsolate. He sought the consolations of philosophy in Boethius, Cicero, Saint Augustine, Aristotle, and Saint Thomas Aquinas, and immersed himself for thirty months in "the schools of the religious and the disputations of the philosophers." The public decla-

ration of his sacred love of Beatrice in *La vita nuova* about 1293 came only after she was safely in another world. This book, which has about the same length and form as Boethius's, might have been called "The Consolation of Love." But what attenuated love!

Alternating passages of thirty-one poems in the new *dolce stil nuovo* with prose commentary carry Dante's recollections from the first words written in his book of memory—at the age of nine his glimpse of "the glorious lady of my mind" (*la gloriosa donna della mia mente*)—to the death of Beatrice "the gentle lady, who for her worth was placed by the most high Lord in the heaven of peace, where Mary is." In between, the prose commentary describes Dante's struggle to express and repress signs of his love. He writes his poems in Italian and not in Latin, he explains, "because he desired to make his words intelligible to a lady who had difficulty in understanding Latin verses." To keep his sacred love secret, he feigned love for other women, his "screens of love," though the insincere "trifles in verse" that he wrote for them some thought "beyond the bounds of courtesy." He designs his sonnet to Beatrice as if it were for someone else. Finally,

> . . . there appeared to me a wondrous vision, wherein I beheld things that made me determine to speak no more of this blessed one until such time as I could treat of her more worthily. And to attain this I study all I may, even as she truly knoweth. So that if it be the pleasure of him by whom all things live, that my life persevere for some few years, I hope to write of her what hath never been written of any woman.
>
> (Translated by Thomas Okey)

So even before his exile Dante prophesied the grand sequel to the "Legend of Beatrice Sanctified."

Fifteen years later he fulfilled his promise with the *Divine Comedy*. This, like *La vita nuova,* would be autobiographical, following the progress of Dante's soul. But it was broader, more dramatic, more didactic. Dante explained why he called it a "comedy," in his letter to Can Grande della Scala of Verona (1291–1329), patron of the arts and his protector, dedicating to him the *Paradiso:*

> The aim of the work is to remove those living in this life from a state of misery and to guide them to a state of happiness. . . . The title of the book is "Here beginneth the Comedy of Dante Alighieri, a Florentine by birth, but not by character." And for the comprehension of this it must be understood that . . . comedy is a certain kind of poetical narrative which differs from all others. It differs from tragedy in its subject matter,—in its way, that tragedy in its beginning is admirable and quiet, in its ending or catastrophe foul and horrible. . . . Comedy, on the other hand, begins with adverse circumstances, but its theme has a happy

termination. . . . Likewise they differ in their style of language, for tragedy is lofty
and sublime, comedy lowly and humble. . . . From this it is evident why the
present work is called a comedy. For if we consider the theme, in its beginning
it is horrible and foul, because it is Hell; in its ending fortunate, desirable, and
joyful, because it is Paradise; and if we consider the style of language, the style
is lowly and humble, because it is the vulgar tongue, in which even housewives
hold converse.

<div align="right">(Translated by C. S. Latham)</div>

The adjective "divine" was no part of Dante's original title, and the word
perhaps was first used by others to describe the "divine" Dante himself. The
Venice printed edition of 1555 christened it the "Divine Comedy."

Dante summed up his universal theme, "The subject of the whole work,
then, taken merely in the literal sense is 'the state of the soul after death
straightforwardly affirmed'. . . . But if, indeed, the work is taken allegori-
cally [which he urges], its subject is: 'Man, as by good or ill deserts, in the
exercise of his free choice, he becomes liable to rewarding or punishing
Justice.' " And so the work recounts adventures in death.

Begun when Dante was about forty-three, the *Comedy* was written in
exile. And the theme of exile remains in the foreground. With Virgil for his
guide, Dante boasts of his parallel to the *Aeneid*, which also was a tale of
exile. Just as Virgil himself had adopted the wandering theme from Homer's
Odyssey, the *Comedy* is an odyssey of Dante's soul. In the grand tradition
of epic and allegory Dante becomes the peer-companion of Virgil. In his
chaotic time of warring cities, he seeks to fulfill Virgil's promise of a single
Italian nation—in the Italian language and with the world-unifying mission
of Rome.

The *Divine Comedy* is not a mere cosmology of the Middle Ages but the
story of a man confronted with its consequences. It is the journey of a
person, not a survey of theology. From the familiar first line—"Nel mezzo
del cammin di nostra vita"—Dante puts himself in the story. It is "halfway"
in the journey, because Dante is now midpoint in man's appointed span of
years. And the fear and sufferings of all the figures remain vivid. The ancient
greats—Homer, Horace, Ovid, and Lucas—are excluded from Heaven only
because they could not know Jesus Christ. As Virgil explains (in John
Ciardi's translation):

> For such defects are we lost, though spared the fire
> and suffering Hell in one affliction only:
> that without hope we live on in desire.
> <div align="right">(Inferno: IV, 40ff.)</div>

When we compare Aeneas's brief hectic voyage to the underworld
(*Aeneid*, Book VI) with Dante's odyssey through Inferno, Purgatorio, and

Paradiso, we see how Christian theology had refined, vivified, and elaborated thinking about good and evil, rewards and punishments. Virgil's netherworld was a realm of confusion and disorder, of miscellaneous retribution. But Dante's afterlife is beautifully and subtly symmetrical, rich in numerical and symbolic significance. Dante, someone has said, is "Saint Thomas Aquinas set to music." The whole *Comedy* is dominated by the symbolic trinity—from the three books, or *cantiche* (Inferno, Purgatorio, and Paradiso), to the terza rima (three lines rhyming, aba, bcb, etc.). Each *cantica* has thirty-three cantos, so the three parts together come to ninety-nine cantos, which, with the introductory canto total one hundred. While three was the number of the Holy Trinity, one hundred was ten times ten, the numerical symbol of perfection. After the Limbo of the virtuous unbaptized, the Inferno was divided into nine lowering circles where the damned were grouped under the three capital vices (incontinence, violence, and fraud). Francesca suffering in the second circle of the Inferno recounts the occasion of her sinful love with Paolo:

> On a day for an alliance we read the rhyme
> of Lancelot, how love had mastered him.
> We were alone with innocence and dim time.
>
> Pause after pause that high old story drew
> our eyes together while we blushed and paled;
> but it was one soft passage overthrew
>
> our caution and our hearts. For when we read
> how her fond smile was kissed by such a lover,
> he who is one with me alive and dead
>
> breathed on my lips the tremor of his kiss.
> That book, and he who wrote it, was a pander.
> That day we read no further.
> (Inferno: V, lines 124ff.)

Of course Satan was at the bottom.

While Hell is a pit, Purgatory, on an island at the antipodes of Jerusalem, is a mountain that questing souls can climb up. As Dante reaches up out of Purgatory, his guide, Virgil, suddenly disappears, but Beatrice comes, with a reproach:

> "Dante, do not weep yet, though Virgil goes.
> Do not weep yet for soon another wound
> shall make you weep far hotter tears than those!"
> (Purgatory, Canto XXX, lines 55ff.)

"Look at me well. I am she. I am Beatrice.
How dared you make your way to this high mountain?
Did you not know that here man lives in bliss?"

I lowered my head and looked down at the stream.
But when I saw myself reflected there,
I fixed my eyes upon the grass for shame.
I shrank as a wayward child in his distress
shrinks from his mother's sternness, for the taste
of love grown wrathful is a bitterness.

(Purgatory, Canto XXX, lines 73ff.)

The way up is divided into the seven deadly sins. Just as in Hell, the graver sins are at the bottom, and at the very top is the Earthly Paradise. Then Paradise consists of heavenly spheres. The seven planetary heavens starting from the Earth are the heavens of the Moon, Mercury, Venus, the Sun, Mars, Jupiter, and Saturn. These are surrounded outside by two stellar heavens—the Heaven of the Fixed Stars, and of the Primum Mobile. Beyond is the Empyrean, and finally God. Even the perfections of Paradise thus have clear division, and the planetary heavens (corresponding to the seven deadly sins) are staged around the seven cardinal virtues. They range from the secular and the active toward the highest contemplative. Each of the three *cantiche* ends with the word "stars" (*stelle*).

And the Paradise ends with Saint Bernard's prayer for Dante, urging the Virgin to intercede to give him at least a moment's direct vision of God:

"Virgin Mother, daughter of thy son;
humble beyond all creatures and more exalted;
predestined turning point of God's intention;
thy merit so ennobled human nature
that its divine Creator did not scorn
to make Himself the creature of His creature. . . .

Now comes this man who from the final pit
of the universe up to this height has seen,
one by one, the three lives of the spirit.
He prays to thee in fervent supplication
for grace and strength, that he may raise his eyes
to the all-healing final revelation. . . ."

(Paradise, XXXIII, lines 1ff.)

The Virgin lifts her eyes upward and so does Dante. Now in a flash he perceives the Divine Essence that conquers speech and memory—"the Light in which everything the will has ever sought is gathered . . . and . . . every quest made perfect."

We can taste the beauty of Dante's Italian:

All' alta fantasia qui manco possa;
ma gia volgeva il mio disio e 'l velle,
si come rota ch' igualmente e mossa,
l'Amor che move il sole e l'altre stelle.

High fantasy lost power and here broke off;
Yet, as a wheel moves smoothly, free from jars,
My will and my desire were turned by love,
The love that moves the sun and other stars.
(Paradise, XXXIII, lines 142ff.; translated by Dorothy L. Sayers)

Dante's feat of prosody has daunted even the ablest translators. His work on the *Comedy* from 1308 to 1321 "had made him lean for many years." To translate fifteen thousand lines in tightly rhymed terza rima requires that many triple rhymes. John Ciardi concluded that the English language, unlike Italian, had no such rhyming resources and so settled for something less. Still the English reader should not be frightened by the language barrier. English translations in prose and verse—by Longfellow, Charles Eliot Norton, Dorothy L. Sayers, John Ciardi, and others—can be read with the same pleasure and suspense that attend the reading of the *Odyssey* or the *Aeneid*. The adventure story in verse takes the reader along, from the picturesque, malodorous, and horrendous to the glamorous, fragrant, and delightful. The searing heats of Hell and the dazzling lights of Paradise are as much a part of the story as the allegorical scholar's meaning. Dante wrote in the vernacular "to be of more general use . . . for he knew that if he had written metrically in Latin as the other poets of past times had done, he would only have done service to men of letters."

It is remarkable that he could produce so coherent a structure in years of wandering. After the decree of exile in 1302, Dante went to Forli and Verona in 1303, then he was taken in by Bologna until 1306, when all the Florentine exiles were expelled. As a refugee he moved on to Sarzana, then to Lucca and Casentino with other stops in Tuscany, before returning to Verona, which he left in 1318 for his last honored years in Ravenna. There scholars and poets became his disciples. After the "Inferno" and "Purgatorio" became public, Dante's reputation spread. But when he was invited to Bologna to receive the poet's laurel, he declined an honor that he said he would accept only from his native city. Dante's patron, Guido Novello da Polenta, lord of Ravenna, sent him with an embassy to the doge of Venice to settle a dispute over the death of some Venetian sailors. When the unfriendly Venetians refused them permission to return to Ravenna by sea, they had to return overland along the malaria-infested coast. The malaria contracted on the way proved fatal to Dante, who died in Ravenna in 1321 at the age of fifty-six.

At Dante's death, the last thirteen cantos of the "Paradiso" were nowhere to be found. Virgil had never completed the *Aeneid.* In this too had Dante followed his guide? Despairing admirers finally asked his sons Jacopo and Piero, both "rhymers," to complete their father's work. But, as Boccaccio reports, a lucky miracle made this unnecessary. One night, in the ninth month after Dante's death, while Jacopo di Dante was asleep

> . . . his father had appeared to him, clothed in the purest white, and his face resplendent with an extraordinary light. . . . Jacopo asked him if he lived, and . . . Dante replied: "Yes, but in the true life, not our life." Then Jacopo asked him if he had completed his work before passing into the true life, and . . . what had become of that part of it which was missing. . . . To this Dante seemed to answer: "Yes, I finished it."

> (Translated by F. J. Bunbury)

Then Dante, still in the vision, took Jacopo by the hand, led him to the room where Dante had been sleeping, touched one of the walls, and said, "What you have sought for so much is here." The next morning before dawn Jacopo went to the designated room and there in a hidden recess found the thirteen missing cantos "all mouldy from the dampness of the walls, and had they remained there longer, in a little while they would have crumbled away."

Had Dante never written the *Comedy* he would still have been a creator of modern literature. Early in his years of exile he wrote another work in Italian, the unfinished *Convivio,* a mini-encyclopedia of philosophy for the layman. And if Dante had never written works in Italian, he would still be a major figure in medieval thought for his Latin treatises. *De vulgari eloquentia* (1304–5) summarized the biblical account of the origin of language, and admitted the superiority of Latin but defended Italian as a new literary language that all could understand. In *De monarchia* he described the divine plan for the Roman Empire. The emperor, like the pope, had received his mandate direct from God. Dante, torn between the claims of this world and the next, was the unhappy ambassador—in Latin praising the Italian vernacular, and in Italian marking the paths into the otherworld.

Death, which did not defeat his works and became the arena for his *Divine Comedy,* played tricks on Dante's bodily remains. Too late, the people of Florence tried to bring back their exiled hero. Again and again they tried to persuade the people of Ravenna to yield Dante's bones to Florence. In 1515 one of their own, the Medici pope Leo X, received a petition from the Florentine Academy with a promise from Michelangelo to make an appropriate tomb in Florence. Leo X authorized a mission from Florence to Ravenna to accomplish their hopes. But "the much wished-for

translation of Dante's remains did not take place," the envoys reported to
Leo X, "inasmuch as the two delegates of the Academy who were sent for
the purpose found Dante neither in soul nor in body; and it is supposed that,
as in his lifetime he journeyed in soul and in body through Hell, Purgatory,
and Paradise, so in death he must have been received, body and soul into
one of those realms."

Still, the reason for the pope's disappointment remained secret. In 1782,
when Dante's tomb in Ravenna was to be renovated, the opening of the
coffin again revealed no remains. But no one betrayed the secret of the
empty tomb. It was still a secret in 1865, on the six hundredth anniversary
of Dante's birth, when Florentines repeated their effort. Now the officials
of Ravenna replied that since the creation of a unified Italy, the Florentine
Dante was no longer in "exile." The tomb was to be opened and the remains
to be identified during the anniversary celebration. Just then a workman
breaking through a wall in the Braccioforte Chapel adjoining Dante's tomb
happened on a secreted wooden coffin. Inscriptions on this coffin and expert
examination of the skeleton it contained identified these as the remains of
Dante. It was decided to open the original tomb in public. An eyewitness
on that day, June 7, 1865, reported the suspense. Would a second skeleton
be found there? The original tomb was publicly shown to be empty. The
rediscovered skeleton was then assembled and displayed on white velvet
under glass to receive the homage of all Italians. Dante's bones were once
again entombed in the city that had given him his last living refuge.

PART SEVEN

THE HUMAN COMEDY: A COMPOSITE WORK

It takes two to speak the truth—one to speak, and another to listen.

—HENRY DAVID THOREAU (1849)

Nothing has really happened until it's been described.

—VIRGINIA WOOLF

Escaping the Plague

Was there escape from the cataloged virtues and vices of Dante's afterlife? Could there be stories without a moral, of human adventure and misadventure? The horrors of the plague provided Boccaccio with the incentive and the opportunity. But for the writer there was no easy refuge from stereotypes of classic lore and medieval legend with their themes of love and battle, of cowardice, deception, and courage. It was only a natural catastrophe that provided Giovanni Boccaccio (1313–1375) the frame for a human comedy in the modern spirit.

Boccaccio's early life followed the fortunes of his father. Born in Florence in 1313, an illegitimate son, he seems still to have been received amiably into his father's household. His stepmother, a relative of Dante's Beatrice, may have been the "reliable source" for his life of Dante. After a good education in Latin and accounting, at fourteen he was sent by his father to the Bardi firm's branch office in Naples to learn the banking business. Six unhappy years there as an apprentice banker were followed by another six years learning canon law at the university. When the kings of Naples needed a full line of credit to finance their defense of the papal cause, the young banker was welcome at court. There "lusty young lords and cavaliers" attended "the bravest and most honorable ladies, shining in glittering gold and adorned with their precious and most rare jewels." These Neapolitan delights stayed with him all the rest of his life, drawing him back to the scenes of his youth.

One glittering lady in particular, known under the pseudonym of Fiammetta, would play a leading role in Boccaccio's life and work. At their first meeting, "the shining eyes of the fair lady, all sparkling, looked into my eyes with a piercing light . . . which, passing through my eyes, struck my heart so deeply with the beauty of that fair lady, that it resumed its earlier trembling which still endures." Boccaccio never married, but he did father five children by unidentified mistresses.

When his father's firm went bankrupt about 1340, Boccaccio returned to Florence, where he would remain a Neapolitan in exile. "Of my being in Florence against my will I shall tell you nothing," he wrote back to his boon companion in Naples, "for it would have to be set forth not in ink but in tears." And he signed himself, "Fortune's enemy."

Boccaccio's early works were a product of Naples's fertile literary life. When he returned to Tuscany at the age of twenty-seven, he had already

written poetry and prose on conventional themes of myth and chivalry. In terza rima he recounted a contest between Diana and Venus, and the pursuit by young lovers. *Il Filostrato,* the story of Troilus and Criseida, was a long epic of the love of two friends for the same woman that would provide a basis for Chaucer's poem and Shakespeare's play. And from *Teseide,* set in Athens in the time of Prince Theseus, Chaucer fashioned his *Knight's Tale.*

In Florence, without the patronage of his father or the diversions of a brilliant court, Boccaccio found it hard to feel at home. After a trip to Ravenna seeking employment or benefaction, he returned to Florence in the spring of 1348 at the horrendous climax of the Black Death. Now, in place of the Greek gods and goddesses, nymphs and shepherds, knights and ladies of his earlier works, Boccaccio created his own version of the Human Comedy. And his tales of daily life would survey the succulent sensualism of medieval life.

Seeing the ravages of the Black Death, Petrarch envied "happy posterity who will not experience such abysmal woe, and will look on our testimony as fable!" A Carthusian monk, after attending the burial of his prior and all thirty-four others in his monastery, with only his dog for a companion went searching for a refuge. "No bells tolled and nobody wept no matter what his loss," a Sienese chronicler reported, "because almost everyone expected death . . . people said and believed, 'This is the end of the world.' " We know now that the cause of the Black Death is a plague bacillus that thrives in the stomach of a particular flea that lives in the fur of the black rat. The "bubonic" form infects the bloodstream, causing buboes, or swellings of the lymph glands, and internal hemorrhages, while the more lethal and more communicable pneumonic form enters the respiratory system.

In the fourteenth century, when neither cause nor remedy was known, the plague was a melodramatic reminder of how a whimsical Fortune ruled mankind. All the more so because Europe had been relatively free of the most lethal epidemic diseases since about the eighth century. The Jews, of course, were among the first to be blamed, and across Germany, the Flagellants led thousands of Jews to slaughter. The plague had arrived in Europe in October 1347, at the Sicilian port of Messina on Genoese ships coming from the Black Sea. Within three years it would cut down a third of the population of Europe.

In the winter of 1348, when the plague reached Florence, the flower of late medieval Europe, the city was already reeling from civil disorders. Two of its most important banks, including Boccaccio's father's firm, had failed. Boccaccio was understandably exaggerating when he reported "that more than 100,000 human beings lost their lives within the walls of Florence, what with the ravages attendant on the plague and the barbarity of the survivors

toward the sick." We now know that at least half of Florence's 100,000 population died in that plague year. People would retire apparently well and die of the disease before they awoke. Seldom did an afflicted person survive more than five days. The usual course was much shorter. A doctor, it was said, might catch the disease at the patient's bedside and die before he could leave the room. The chronicler of Florence, Giovanni Villani (1280?–1348) ended his life in the middle of a sentence—punctuated by the Black Death.

Luckily for us, Boccaccio was there and survived to write the *Decameron* between 1348 and 1352. His eyewitness account of the plague became the "Introduction to the First Day." "To take pity on people in distress is a human quality which every man and woman should possess," Boccaccio begins, while asking the reader's sympathy for his own frustration in love. To all who have been kind to him he offers this book and "where it seems to be most needed"—to women.

> And who will deny that such encouragement, however small, should much rather be offered to the charming ladies than to the men? For the ladies, out of fear or shame, conceal the flames of passion within their fragile breasts, and a hidden love is far more potent than one which is worn on the sleeve, as everyone knows who has had experience of these matters. Moreover they are forced to follow the whims, fancies and dictates of their fathers, mothers, brothers, and husbands, so that they spend most of their time cooped up within the narrow confines of their rooms, where they sit in apparent idleness, reflecting on various matters, which cannot possibly always be pleasant to contemplate.
>
> (Translated by G. H. McWilliam)

He promises "to provide succour or diversion for the ladies, but only for those who are in love, since the others can make do with their needles, their reels and their spindles. I shall narrate a hundred stories or fables or parables or histories or whatever you choose to call them." These were to be recited in ten days by seven ladies and three young men who had fled the plague.

In the "Introduction to the First Day" he apologizes for the "unpleasantness" of what he must now describe, the "deadly pestilence" of 1348. "And were it not for the fact that I am one of many people who saw it with their own eyes, I would scarcely dare to believe it." He recounts the terrifying spread of the disease, the futile efforts to avoid infection, the callousness of frightened Florentines. "In the face of so much affliction and misery, all respect for the laws of God and man had virtually broken down and been extinguished in our city." Women lost their modesty, men lost their inhibitions. Natural feelings were smothered and "more often than not bereavement was the signal for laughter and witticisms and general jollification." One Tuesday morning at the height of the plague seven young ladies are

praying in the deserted church of Santa Maria Novella. Then in come three young men (none less than twenty-five years of age) "in whom neither the horrors of the time nor the loss of friends or relatives nor concern for their own safety, have dampened the flames of love." One of the ladies, Pampinea, proposes that the young men join them just outside Florence in a country estate for the duration of the plague—"shunning at all costs the lewd practices of our fellow citizens and feasting and merrymaking as best we may without in any way overstepping the bounds of what is reasonable." Then, "in a spirit of chaste and brotherly affection," accompanied by one or two maids and three manservants, they all take up residence in a palace with a spacious garden two miles outside the city.

To entertain themselves for the next two weeks they agree that every day one of them will reign as king or queen, will announce a theme for the storytelling, and call on each to tell a story. The sovereign for the day names the king or queen for the next day, and so it will go until each of the ten has reigned and they have told one hundred tales. Just as Dante's *Divine Comedy,* which Boccaccio much admired, has one hundred cantos, so Boccaccio offers his hundred tales. A deeper parallel has been suggested. Perhaps plague-stricken Florence was Boccaccio's Hell, the storytelling palace and gardens embellished by pastoral peace and lyric and dance were his Paradise, and the tales themselves were his Purgatory.

But Boccaccio was a refugee from Dante. Unlike the *Divine Comedy,* which is ranged in orderly levels of Hell, Purgatory, and Paradise, Boccaccio's Human Comedy reveals the bewildering miscellany of human experience. The topics for the *Decameron* days are conspicuously earthy and heterogeneous. Boccaccio not only does not preach but does not even reveal a sense of sin. Unlike Dante, he does not take responsibility for the truth of the stories told. Instead he assigns this responsibility to the tellers of the tales, whose varying credibility adds spice, ambiguity, and nuance.

So Boccaccio creates a human panorama of love, courage, cowardice, wit, wisdom, deceit, and folly, seen through the eyes of the ten young people. The themes of the Days all somehow touch on the mysteries of Fortune. On Day I and Day IX, each may choose any theme. But the other days have their special themes: (II) on people who, after misfortunes, attain an unexpected state of happiness; (III) on those who attain their desires (or recover what was lost) through their ingenuity; (IV) about those whose loves have an unhappy ending; (V) who suffer misfortune but finally attain happiness; or (VI) who, by a clever gambit have managed to escape loss or danger; (VII) the tricks wives have played on their husbands; (VIII) men or women on their lovers, or by men on men; on a final day (X) about those who have acted generously or courageously.

This catalog of human experience does not commit tellers or listeners to any philosophy or theology. Boccaccio's world shows no cardinal virtues or deadly sins. A third of the stories take place in Florence, and more than three quarters are set in Italy. But the rest come from across the world, from England to China, from antiquity to Boccaccio's day, where most occur. The actors include peasants and workers along with the familiar knights and squires, pilgrims, and abbots of the troubadours. Women play leading roles.

The *Decameron* with good reason has been called "the epic of the merchant class." Instead of celebrating the canonical medieval virtues, the stories tell us how much can be accomplished by a quick wit, a ready tongue, shrewdness, and foresight in the marketplace. What all men and women share is their struggle to defeat ill fortune and exploit good fortune while satisfying their sexual desires. Boccaccio has escaped from Dante's allegory into the everyday world of love and lust, wit and deception, stinginess and generosity. If he does not teach the art of living virtuously, he does teach the "art of living well."

Boccaccio confessed that few of the stories were entirely his own invention. He appropriated the elements of his tales from Spain, France, Provence, and the Near East, from folklore, myth, and legend. Surprisingly, even his "eyewitness" account of the plague was adapted from the chronicle of an eighth-century Italian Benedictine monk, Paulus Diaconus. But he had the modern talent for renewal, for making twice-told tales seem new.

The very concept of a human comedy, a secular sampling of man's everyday experiences on earth, had to be created by Boccaccio. In a favorite tale, the very first on Day I, we taste the flavor of the *Decameron* as we follow the surprising career of a notary, Cepperello of Prato, who delighted in lying and cheating. "He would take particular pleasure, and a great amount of trouble in stirring up enmity, discord and bad blood between friends, relatives and anybody else; and the more calamities ensued, the greater would be his rapture. . . . Of women he was as fond as dogs are fond of a good stout stick. . . . He would rob and pilfer as conscientiously as if he were a saintly man making an offering." He was hired to go to Burgundy to use his guile to collect unpaid bills. But in the midst of business he suddenly fell ill, and his death seemed imminent.

The two Florentine brothers with whom he was lodging feared the consequences for them if this wicked blasphemer died on their premises. How could they get rid of their unwelcome lodger—alive or dead? Cepperello, overhearing their concerns, asked them to summon a holy friar for his confession. The naive friar listened dutifully to Cepperello's sanctimony. His excesses of kindness and generosity revealed him as an uncanonized saint. For example, he even confessed to the sin of boasting of his virginity.

He confessed to his "gluttony" when, after long periods of fasting or prayer, "he had drunk water as pleasurably and avidly as any great bibber of wine." The greatest sin of his life, he finally recalled, was that as a child he had once rudely cursed his mother. When Cepperello died, the priest arranged a service "of great pomp and ceremony" in the monastery. Thereafter the townspeople celebrated the purity of his life, "called him, and call him still Saint Ciappelletto. Moreover it is claimed that through him God has wrought many miracles, and that He continues to work them on behalf of whoever commends himself devoutly to this particular saint."

Perhaps Cepperello's career was not unique among the saints. The next two stories, which happen to concern Jews, both show a liberated modern irreverence. The Jew Abraham is the object of his Christian friend Johannot's charitable hopes that he will be converted. Against his Christian friend's advice, the Jew travels to Rome to size up the religion at its headquarters. On his return he reports that in Rome he had found the Church dignitaries to be "gluttons, winebibbers, and drunkards without exception, and that next to their lust they would rather attend to their bellies than to anything else, as though they were a pack of animals. . . . He saw that they were such a collection of rapacious money-grubbers that they were as ready to buy and sell human, that is to say, Christian blood, as they were to trade for profit in any kind of divine object." But the friend hears that the trip had firmly convinced the Jew to become a Christian. How could this be? Abraham explains. The highest dignitaries of the Church, he said, seemed to be using all their efforts to destroy the Christian religion at its headquarters. "But since it is evident to me that their attempts are unavailing, and that your religion continues to grow in popularity, and become more splendid and illustrious, I can only conclude that, being a more holy and genuine religion than any of the others, it deservedly has the Holy Ghost as its foundation and support."

There is not a saint or a scholar among the *Decameron* tales. While their commonest theme is love, they could also provide footnotes of sadism and masochism. Yet, whatever their tales, the visible conduct of the ten nubile young people is conspicuously proper.

The tale of the love of Ghismunda and Guiscardo is a favorite of all the "stories about the sorrows of others." Tancredi, prince of Salerno, dotes on his daughter and cannot bear to give her away in marriage. She falls in love with Guiscardo, one of her father's valets of humble birth, sends him letters, and has secret rendezvous with him in a nearby cave. Tancredi determines to put an end to their affair and he kills Guiscardo. Then, to "console" his daughter, Tancredi sends her a handsome goblet of gold in which he has put Guiscardo's heart. When she sees what is in the goblet, she determines to pour poison in the goblet and drink it so she and her beloved may be

finally reunited. But before the fatal draft she addresses her obdurate father: "It is clear, Tancredi, that you are made of flesh and blood and that you have fathered a daughter made of flesh and blood, not one of stone or of iron. . . . I was deceived by you. Will you say . . . that I consorted with a man of low condition? Poverty does not diminish anyone's ability, it only diminishes his wealth! Many kings and great rulers were once poor, and many of those who plow the land and watch the sheep were once very rich, and they still are."

One of the most popular stories on the day devoted to people attaining their desires was how the innocent maiden Alibech was taught by the monk Rustico to put the Devil back into Hell. To prepare her for the lesson, he stripped himself naked and instructed her to do the same, when she asked:

"Rustico, what is that thing I see sticking out in front of you and which I do not have?"

"Oh, my child," replied Rustico, "that is the Devil, about which I told you. Now you can see him for yourself. He is inflicting such pain in me that I can hardly bear it."

"Praise be to God!" said the girl. "I am better off than you are, for I do not have such a Devil."

"That is very true," Rustico replied, "but you do have something else which I do not have, and you have it in place of this."

"Oh?" answered Alibech. "What is it?"

"You have a Hell," said Rustico, "and I firmly believe that God has sent you here for the salvation of my soul. Since this Devil gives me such pain, you could be the one to take pity on me by allowing me to put him back into Hell. You would be giving me great comfort, and you will render a great service to God by making Him happy, which is what you say was your purpose in coming here."

"Oh, father," replied the girl in good faith, "since I have Hell, let us do as you wish and as soon as possible."

"May God bless you, my child," Rustico said. "Let us go then and put it back, so that he will at last leave me in peace."

And after saying this, he led the girl over to one of the beds and showed her what position to take in order to incarcerate that cursed Devil. The young girl, who had never before put a single Devil into Hell, felt a slight pain the first time, and because of this she said to Rustico:

"This Devil must certainly be an evil thing and truly God's enemy, father, for he not only hurts others, but he even hurts Hell when put back into it."

"My child," Rustico said, "it will not always be like that." And to prove that it would not be, they put him back in Hell seven times before getting out of bed; in fact, after the seventh time the Devil found it impossible to rear his arrogant head, and he was content to be at peace for a while.

(Translated by Mark Musa and Peter Bondanella)

Boccaccio was only forty when he completed the *Decameron* and provided the classic prototypes of the modern short story. *Novella*—a little new

thing—was the name given to Boccaccio's tales. They differed from anecdotes, which came from anybody's lips in the marketplace, by being contrived into "the artful pattern of a plot." Each of these hundred "new little things," was a hint and an inspiration for others who one day would make a large new thing, not a "novella," but a "novel."

After completing the *Decameron,* about 1353, Boccaccio lived on for more than twenty years. Then he retreated from the turbulent currents of everyday life to the conventional themes of his youth. The person responsible for this retreat was the lodestar of Renaissance humanism, the Italian poet Francesco Petrarch (1304–1374). Born nine years before Boccaccio, Petrarch was acclaimed as the greatest scholar of his age. Son of a lawyer in Arezzo, he was taken to Avignon by his father, who hoped for employment in the exiled papacy. Under pressure from his father he studied law at Montpellier but was luckily liberated to sate "an unquenchable thirst for literature." After taking minor religious orders, Petrarch enjoyed halcyon years in the household of Cardinal Colonna in Avignon. There, at the age of twenty-three he met the legendary Laura, to whom he would write his *Canzoniere,* the series of poems in her praise that established his place in Italian literature.

A celebrity for his pursuit of Latin classics, Petrarch searched monastic libraries, actually discovering a rich cache of Cicero's letters at Verona. His models were not the medieval scholastics but Cicero, Virgil, and Saint Augustine. Like many another celebrity, Petrarch luxuriated in public adulation while professing to yearn for solitude, and he even wrote a treatise on the virtues of the solitary life. In 1340, perhaps at his instigation, both Paris and Rome invited him to be crowned as their poet laureate. Of course he chose Rome, was crowned on the Capitoline Hill on April 8, 1341, and then deposited his laurels at the tomb of Saint Peter. His Laura died of the Black Death on April 6, 1348, the twenty-first anniversary of their first meeting. Everywhere on his diplomatic travels and from his retreat in Vaucluse he celebrated the Latin classics and their relevance to the Christian tradition.

Boccaccio's meeting with Petrarch in Florence in 1350 marked a reverse in the direction of his work from the human comedy and the broad humanism of the ancients to the textual humanism of medieval scholars. Even before the *Decameron* his writing had been in Italian. Afterward he wrote mostly in Latin. He had prepared himself for discipleship by writing a Latin biography of Petrarch. But Petrarch was condescending to the *Decameron,* which he never claimed to have read fully. Finally, in 1373, charitably noting that he had enjoyed "a hasty perusal," Petrarch explained that it was "a very big volume, written in prose and intended for the masses." The "some-

times too free" tone of the book, he told Boccaccio, might be condoned because of "your age at the time and in view of the public to which the book is addressed."

Boccaccio, under Petrarch's spell, acquired the enthusiasm of a born-again Christian humanist, a devotee of classical scholarship. Though neither he nor Petrarch could read Greek, they enjoyed reverently viewing Greek manuscripts of Homer and Plato. Boccaccio had a hand in creating at the University of Florence the first professorship of Greek in Western Europe, then brought its first incumbent, Leontius Pilatus, to live in his house. The appointment lasted only two years, for the Florentines had hoped the professor would instruct them in "commercial" Greek for their business. It was only through Pilatus's crude Latin translations that Boccaccio and Petrarch came to know Homer.

A frightening visit that Boccaccio received in 1362 confirmed his repentance for the *Decameron*. A holy man who came to his house brought word of the prophetic deathbed vision of a Carthusian monk, the Blessed Petroni. Jesus told Petroni that both Petrarch and Boccaccio would soon die and be eternally damned if they did not promptly turn away from profane studies like poetry and literature, and focus their thoughts instead on the world to come. The terrified Boccaccio wrote to Petrarch announcing his determination to heed the saintly warning. He would give up literature, burn his own writings, and sell his library to Petrarch. But the complacent Petrarch reminded Boccaccio that death, the common lot of man, was not to be dreaded. "Be reasonable," he wrote, "I know of many who have attained the highest saintliness without literary culture; I don't know of any who were excluded from sanctity by culture. . . . All good men have the same goal, but there are numberless ways thither, and much variety for the pilgrim . . . the way of knowledge is certainly more glorious, illumined and lofty. Give me an example of a saint who arose from the mass of the unlettered, and I will match him with a greater saint of the other sort." Still, if Boccaccio was determined to give up scholarship, Petrarch would consider buying his library for a fair price from an itemized list. He invited Boccaccio to come live with him "for our few remaining days, as I have always hoped and as indeed you once promised," so they could share their libraries. Boccaccio never took up this invitation.

Under the influence of Petrarch, Boccaccio wrote ponderous Latin works. His encyclopedia of classical mythology, *Genealogies of the Pagan Gods,* which he continued to enlarge for the last twenty-five years of his life, remained the standard work for four centuries. And his early biographers extolled this book while ignoring the *Decameron.* Boccaccio's last work of fiction, the curious misogynist *Corbaccio* (The Evil Crow) (1355) expressed in Italian prose his unhappy flight from the world of the *Decameron.*

Never having found the patron he sought, Boccaccio's last years in Florence were beset by poverty. His Tuscan friends gave him employment by sending him as ambassador to Avignon and Rome. He made a meager living as a copyist, transcribing his own works for others. Finally, in October 1373, the Commune of Florence engaged him for a hundred florins to read aloud and comment on Dante's *Divine Comedy* in the Church of San Stefano de Badia. He gave sixty such lecture-readings before his pains of gout and scabies and his obesity—and learned objections to his efforts to "vulgarize" Dante—put a stop to the series. The death of his mentor Petrarch in July 1374 added to his miseries, which Petrarch himself had generously tried to assuage by willing Boccaccio a valuable fur coat for cold nights in his study. Boccaccio died on December 21, 1375. In his last words in the epitaph he wrote for himself he affirmed that "he cherished the nourishing Muses."

Like other classics of vernacular literature, the *Decameron* was widely read before academic critics dignified it by their attention. It was disseminated not through monastic scriptoria and university libraries but by Italian merchants who took copies with them across Europe. Not for the first or last time, authors were far ahead of scholars. Even after the book had delighted generations of readers, for centuries the translators insisted on remaining anonymous. It was a half-millennium before a translator of the *Decameron* into English dared sign his name to the work.

Even these anonymous early English translators proceeded with extreme caution. "Whenever met with any thing that seemed immodest or loose," one explained in his preface, he had studied "so to manage the Expression, and conceal the Matter, that the fair Sex may read it without blushing." Despite all these precautions, two and a half centuries passed before any apparently complete translation, perhaps by John Florio, appeared—in 1620. Modern English translations still kept certain troublesome passages (like the story of the innocent Alibech) decently veiled in the original Italian. Those who tried to fumigate Boccaccio served modern readers with a short list of the most interesting stories.

Joys of Pilgrimage

THE pilgrim metaphor permeated Christian literature. It was embodied in drama, ritual, and travel adventure. What the tourist is in our twentieth-century West, the pilgrim was in the European Middle Ages. But while the modern tourist wanders in search of the interesting, the unexpected, and the titillating, the medieval pilgrim journeyed toward a certain end. His travel bore the stamp of orthodoxy. Like Jesus Himself, every follower of Jesus was a "pilgrim" (derived from the Latin *peregrinus* for stranger or foreigner) in this life, awaiting the eternal life to come.

By Chaucer's time pilgrimage had become a flourishing institution. Across Europe Christians dramatized their faith by voyage to a sacred place. Jerusalem was, of course, the preferred destination, but Rome was a close second. The Jubilee Year, first so named by the bold and enterprising Pope Boniface VIII, in 1300 offered special indulgences to the pilgrims who came to Rome. The cult of saints and relics from the eleventh to the fourteenth centuries multiplied pilgrim destinations, certified by miracles performed by the saints. On the Continent, after Rome the favored destination was Santiago de Compostela in northwestern Spain. In England it was Canterbury, where innkeepers prospered from the crowds who came to share the sanctity of the life and death of Saint Thomas Becket.

> And specially, from every shires ende
> Of Engelond, to Caunterbury they wende,
> The holy blisful martir for to seke,
> That hem hath holpen, whan that they were seke . . .
> Of sondry folk, by aventure y-falle
> In felawshipe, and pilgrims were they alle . . .

When such places and their relics worked miracles, Aquinas explained, they were vehicles of the power of God. Some pilgrims went for penance.

A heinous crime, like that of the noble Frotmund who killed his father, was punished in 850 by perpetual pilgrimage. Such pilgrims traveling from shrine to shrine were condemned to a life in fetters that ended only when a saint miraculously broke their chains as a sign of forgiveness. Only after Frotmund had visited seven shrines were his chains finally broken in the little town of Redon in northwestern France. The powers of Saint Peter's shrine in Rome were advertised by an impressive exhibit of broken fetters hanging from the altar. An unfulfilled vow to make a pilgrimage might bring divine punishment. When the English knight who had his broken arm healed by Saint James failed to make his promised visit to the saint's shrine at Reading, the saint broke his other arm.

Pope Urban II at the end of the eleventh century developed the "indulgence," a formal remittance of punishment for sins by visiting certain shrines. Pilgrims, like widows and orphans, had the legal status of a *miserabilis persona,* which gave them special protection en route to fulfill their vows. The crowds of pilgrims benefited innkeepers and merchants, while they enriched the churches. When Henry VIII dissolved the Canterbury Cathedral priory, he hauled away twenty-six cartfuls of jewels and precious metals, the gifts of grateful pilgrims.

Pilgrim shrines, too, like modern tourist centers, had their ups and downs. The appeal of the tomb of Saint Thomas at Canterbury, popular in the twelfth century, declined with rumors in the next century that the saint had lost his power to work miracles.

Pilgrimage had its own ritual. A pilgrim was blessed by a priest at the outset, took a special oath, carried a staff, and wore a distinctive garment, with a bag for provisions hanging at his side. When he returned home his hat bore the badge of the shrine he had visited. Like modern tourists, pilgrims organized in groups and engaged experienced guides to find the way and lead them to hospitable inns. Illustrated pilgrim Baedekers with maps noted sights along the way and warned of risks to health and purse.

> "Now let us ryde, and herkneth what I seye
> And with that word we ride forth our weye."

To make his journey count for penance the pilgrim was expected to suffer. In addition to suffering the usual trials of medieval travel, the more devout would walk barefoot, while fasting and constantly praying. But as the institution became popular it became more pleasant, less a penance than a travel holiday. Pilgrims who joined the tours from Venice to Muslim Jerusalem went to see the exotic, buy souvenirs, and then write their own journals. Sir John Mandeville (who, if there was such a person, must have been a contemporary of Chaucer) wrote the most popular travel book of the age,

describing fountains of youth and monstrous animals, ostensibly to guide
pilgrims to the Holy Land.

Dubious miracles increased with the competition for pilgrims. The Rood
of Boxley, a life-size figure of Christ on the Cross that actually shed tears,
rolled its eyes, and foamed at the mouth, was finally discovered to contain
"certain engines and old wires with old rotten sticks in the back."

After that Tuesday evening, December 29, 1170, when four knights of
Henry II splashed the blood and brains of Archbishop Thomas Becket on
the cathedral pavement, pilgrims traveled to the shrine of his martyrdom.
From all over England they came and even from abroad. Their route from
Southampton through Winchester to Canterbury is still called the Pilgrims'
Way. Some went to fulfill a vow made when they had recovered from illness
or escaped disaster, some simply for penance, others to annoy the king by
honoring his ancestral enemy. But kings came too. The barefoot Henry II,
in haircloth and woolen shirt, hastened to Canterbury on July 12, 1174, to
avoid excommunication. But many had no better reason than the modern
tourist.

By Chaucer's day (1340?–1400) pilgrimage had become a pleasurable,
emphatically secular, and delightfully sociable adventure.

> Whan that Aprile with his showres soote
> The droughte of March hath perced to the roote,
> And bathed every veine in swich licour,
> Of which vertu engendred is the flowr . . .
> And small fowles maken melodye
> That sleepen al the night with open ye—
> So priketh hem Nature in hir corages—
> Thanne longen folk to goon on pilgrimages. . . .

Rare among medieval institutions, it brought together on speaking terms
men and women of all ranks and conditions. Kings and peasants, doctors
and patients, lawyers and clients, were not just in one another's presence,
as they might have been in church. On a long journey together they relieved
boredom by learning about one another with conversation and tale-telling.
The pilgrims tried other sorts of entertainment, not always decorous or
edifying. A priest in Chaucer's time, William Thorpe, preached against that
passion "to seek and visit the bones or images . . . of this saint or that."
"Runners thus madly hither and thither into pilgrimage borrow hereto
other men's goods (yea and sometimes they steal men's goods hereto), and
they pay them never again." The pardoner himself warns:

> A lecherous thing is wyn, and dronkenesse
> Is ful of stryving and of wrecchednesse,

O dronke man, disfigured is thy face,
Sour is thy breeth, foul artow to embrace

Organizers of these pleasure trips, Thorpe noted, "will ordain beforehand to have with them both men and women that can well sing wanton songs; and some other pilgrims will have with them bagpipes: so that every town they come through, what with the noise of their singing, and with the sound of their piping, and with the jangling of their Canterbury bells, and with the barking out of dogs after them, they make more noise than if the king came there away, with all his clarions and many other minstrels." And pilgrims were tempted to become "great janglers, tale-tellers, and liars."

The pilgrimage proved to be an admirable vehicle for Chaucer's rich contribution to the human comedy. His worldly-wise career had gathered a colorful store of personal experience. If he could only persuade all in the pilgrim party to speak for themselves and entertain one another, the varied bouquet of tales could not fail to entertain all readers. And incidentally create a warm encyclopedic narrative of England in his time. Chaucer's tales revealed the tellers, and even his animal fables acquired human dimension. Chantecleer, his favorite wife, and the fox would tell us more than the Nun's Priest who recounted the fable intended. Chaucer's lively wit and unforgettable poetry gave to twice-told tales a new life.

Yet for Chaucer, unlike Boccaccio, literature was only an avocation. And he wrote the first great poem in the English language in the interstices of a busy public life. In an age of plagues, volatile politics, and civil disorder, he managed to keep the goodwill and patronage of three kings—Edward III, Richard II, and Henry IV. From all of them he received substantial favors, remunerative posts at home, and distinguished missions abroad. His official positions were the outline of his biography.

Geoffrey Chaucer, born into a prosperous London family about 1340, did start with advantages. His father, a successful wholesale wine merchant, could send him to a good London school for the rudiments of Latin and science. He knew French (the language of his father's business and of the court), and he may have done his translation of Boethius into English from Jean de Meung's French. In 1357 Chaucer's family secured for him a desirable place as page in the household of Elizabeth, countess of Ulster, wife of Lionel, the second son of Edward III. There he, like other sons and daughters of rising merchants and professionals, received a courtly education and the opportunity to make useful "contacts." The personable Chaucer took full advantage of his opportunities. Traveling widely in the retinue of the countess, he saw the country and met people of influence.

Courts like that of the countess were entertained by literature read aloud.

Unlike Latin classics, these works were not designed for the scholar in his study. For group entertainment they had to be written in the vernacular. English in place of French was beginning to come into its own as the literary language at court. It carried an aura of patriotism, too, while the Hundred Years' War against France was in full flood. The apprentice courtiers—pages and young ladies—were expected to participate by singing and versifying. There was a lot to know about the ways of the court, which Chaucer was learning despite his mercantile origins. In his early long verse works about the noble classes he embroidered the familiar themes of chivalry and courtly love.

When Edward III crossed the Channel in 1359 to enforce his claim on the throne of France, young Chaucer joined in the siege of Reims. And when Chaucer was captured by the French, the king ransomed him for the considerable sum of sixteen pounds, then enlisted him as a trusted messenger during peace negotiations. Chaucer married well, to a knight's daughter who received a lifetime annuity for her service to the queen, and whose position at court would help him. He himself soon received an annuity from the king, who continued to keep him busy. After a diplomatic mission to Spain in 1366, royal assignments took him to Flanders and France. In Italy, if he did not meet Boccaccio, he at least became acquainted with Boccaccio's work, and he acquired manuscripts of Petrarch's works and of Dante's *Divine Comedy*. For miscellaneous services the king favored him with a grant for life of a daily pitcher of wine.

In 1374, when Chaucer was appointed to the remunerative position of controller of the customs for the Port of London, he and his wife received a convenient rent-free house on London Wall above Aldgate. The duties of this job required daily attendance at the office to keep records in his own hand. By now his numerous salaries, annuities, and fringe benefits had made him a wealthy man. When Edward III died in 1377, Chaucer's friend and patron John of Gaunt had the boy king Richard II confirm Chaucer's posts and benefits, and graciously commute the daily wine to a life annuity. Still more favors, including the peculiarly medieval wardships, forfeitures, and grants, piled up.

Chaucer must have filled his posts creditably, for he continued to be reappointed. As clerk of the works at Westminster, the Tower of London, and other royal estates he supervised the construction and maintenance of public buildings, and carried large sums of payroll money. In 1390, the year before he gave up the job, he was robbed and beaten up three times within four days. After appointment as justice of the peace in 1385, he became knight of the shire attending Parliament for Kent.

Consummate tact was required for a public person to survive the troubled times of the Peasants' Revolt of 1381 and the tense years that followed. He

was embarrassed as defendant in a legal action for rape, but his accuser finally released him. Still, he managed somehow to stay in royal favor, in an age when the good opinion of one king might bring a death warrant from his successor. When the exiled Henry IV returned to England and was crowned in 1399, he too confirmed Chaucer's grants and benefits and even added another handsome annuity. The political tribulations of Chaucer's lifetime were the raw material for Shakespeare's tragedy of Richard II and his Henry IV. Chaucer died in London in 1400, and was buried in Westminster Abbey, where few commoners before him had been so honored.

During these busy troubled times Chaucer produced the first great body of English poetry. But the works of his early years bear the mark of his courtly education and tell us little of the life of his time. In the tradition of the popular French *Roman de la Rose,* which Chaucer himself undertook to translate, he wrote four long dream-vision poems. His first, *The Book of the Duchess,* was an elegy to Blanche, duchess of Lancaster, John of Gaunt's first wife, who had died in the plague of 1369. After his discovery of Dante, Petrarch, and Boccaccio, Chaucer wrote three more long poems in heroic couplets, all as dream-visions. *The House of Fame* recounts what happened to Aeneas after the fall of Troy. *The Parliament of Fowls* reveals the poet's vision of the Court of Nature on Saint Valentine's Day "when every fowl cometh there to choose his mate" and the competition of three male eagles for a single beautiful female. It is best known for its opening lines:

> The lyf so short, the craft so long to lerne,
> Th' assay so hard, so sharp the conquering,
> The dredful joye, that alwey slit so yerne,
> Al this mene I by love, that my feling
> Astonyeth with his wonderful worching
> So sore y-wis, that when I on him thinke,
> Nat wot I wel wher that I wake or winke.

> The life so short, the craft so long to learn
> The attempt so hard, the victory so keen,
> The fearful joy, so arduous to earn,
> So quick to face—by all these things I mean
> Love, for his wonders in this worldly scene
> Confound so that when I think of him
> I scarcely know whether I sink or swim.
> (Modernized by Theodore Morrison)

In *The Legend of Good Women* the poet, as penance, tells "a glorious legend" of good women and the evil men who betrayed them.

Troilus and Cressida, Chaucer's longest poem, of some eight thousand

lines, completed about 1385, still rewards us with its passion, eloquence, and suspense. Set in the age of the Trojan War, the story is borrowed and whole lines are translated from Boccaccio. The romance of Troilus and Cressida was not found in the *Iliad*, which anyway Chaucer knew only secondhand. Five books in rime royal tell the love of Troilus, son of Priam, king of Troy, for Cressida, daughter of a Trojan soothsayer Calchas, who foresees the fall of Troy. Troilus and Cressida consummate their love with the scheming of Cressida's uncle, Pandarus. When Calchas takes refuge in the camp of the besieging Greeks, he persuades them to take Cressida into their camp in an exchange of prisoners. Cressida promises the desolate Troilus that she will return after ten days. But, once in the Greek camp, she abandons Troilus and yields to the Greek Diomede. She does not return to Troy on the appointed tenth day, and Troilus is convinced of her faithlessness when on armor taken from Diomede he sees the brooch he had given her as a token of their love. Troilus fails to kill Diomede in battle, but is himself killed by Achilles. The poem ends in the Boethian spirit, with Troilus looking down from above on the folly and transience of earthly love.

Chaucer's *Canterbury Tales,* written in the last decade of his life, marks a surprising new vision, a work that would outshine all his others. What led Chaucer the poet to turn from polite literary conventions to cast the people of his time in a human comedy of his own creation? To us it seems odd that this should need explaining. We take it for granted that our literature should deal with everybody. But the medieval world of letters in a learned language known to few had long diverged from everyday experience. Chaucer turned to that experience for the materials of a new contemporary epic, his contribution to the human comedy. His productive literary years after about 1380 were especially turbulent for England. The Peasants' Revolt of 1381 burned manors, murdered landlords, lawyers, and officials, and brought one hundred thousand marchers to London. They entered through Aldgate, over which Chaucer had his official lodgings. They burned the Savoy, the palace of Chaucer's friend and patron John of Gaunt. Chaucer survived these events, though some of his friends did not. But the sanguine Chaucer somehow never wrote these disasters into his copious poems.

In the busy years between about 1386 and 1399 when Chaucer was writing *The Canterbury Tales* he had found a scheme that lent itself to writing piecemeal, and so could be produced in the intervals of his public duties. To offer many narrators in a frame was not new. Boccaccio had used a similar scheme in his *Decameron,* which Chaucer may have known. About the same time Chaucer's English friend the "moral Gower" to whom he dedicated *Troilus and Cressida* was writing his *Confessio amantis,* a bouquet of stories told by the same narrator. But Chaucer deftly used the

pilgrimage to widen all the dimensions—the kind of people who told the tales, the actors in the tales, and the audience—into a saga of his time.

Now, Chaucer said, he would write "some comedy," which, in the language of his day, meant a narrative poem with an agreeable ending. The term probably came from the Italian, where, as we have heard Dante explain, a comedy was in a style "lax and unpretending . . . written in the vulgar tongue, in which women and children speak." *The Canterbury Tales* was not meant for reading aloud to a polite circle. The turmoil of the years when Chaucer began this work had made the court a less agreeable audience. Chaucer's "comedy" would be about ordinary people and for ordinary people. Just as the *Divine Comedy* adds interest by Dante's reaction to what he sees, so we come to know the pilgrims by what they tell and how they reacted to what they heard.

Chaucer then created his own popular "court" of thirty-one pilgrims en route from London to Canterbury. This motley company was not random but wonderfully representative. Pilgrims from nearly all ranks of English life meet at the Tabard Inn (which really existed at the time) just across the Thames from London (nowadays this neighborhood would be called a red-light district). Harry Bailly (the real name of Tabard's innkeeper in Chaucer's day) offers to come along as their guide. Others in the party have also been identified as Chaucer's contemporaries. "To shorten the way" Bailly suggests that they entertain one another "at no cost." Each will tell two tales on the way to Canterbury, and two on the way back. The prize for the best story will be a dinner at the Tabard. By a show of hands, all agree to the plan and to let Bailly preside as judge.

Chaucer is plainly reaching out. His pilgrims do not include the classes with whom he has been consorting, the junior members of the royal family, and the upper nobility. Nor at the other end of the social scale does he include serfs or farm workers. All the rest are represented—from the gentry (the Knight and his son) through church women and men of the upper classes (a Prioress and a Monk), clergy of the lower ranks (Nuns, Nun's Priest, Friar, and Parson), hirelings of the church (Summoner, Pardoner), the professions (the Clerk, the Man of Law, and the Doctor of Physic), the petty officials and employees (Summoner, Bailiff, Manciple), middle-class persons of property (Franklin, Wife of Bath, Merchant), craftsmen and guildsmen (Carpenter, Weaver, Dyer, Tapestry-maker, Haberdasher, Miller), and the lower orders (Yeoman, Cook, Shipman, Plowman). Even the omissions help make the company a persuasive sample of real life.

Yet Chaucer's pilgrims are not merely "representative." Each has a distinctive face and figure, stature and gesture, with his very own variety of impatience and enthusiasm. We hear the Prioress "intoning through her nose the words divine," the Friar "a gay dog and a merry." We see the

Merchant's "forked beard and beaver hat," the Franklin's beard "as white as daisy petals" and his ruddy face, the Reeve "slender and choleric," the pockmarked Summoner so pimpled that he scared away children.

While most of Chaucer's pilgrims are men, some of the most effective storytellers, like the oft-married Wife of Bath, are women. She says with relish that her fifth husband finally complied:

> "myn owene trewe wyf,
> Do as thee lust the terme of al thy lyf,
> Keep thyn honour, and keep eek myn estaat"—
> After that day we hadden never debaat.

Perhaps the predominantly male character of Chaucer's audience left him freer in his choice of tales. Themes borrowed or stolen from antiquity, from Petrarch, Dante, or Boccaccio, are intermixed with elaborated folk-tales, animal fables, embroidered superstitions, and familiar tragedies to express the hopes and fears in the imaginations of his contemporaries. There are many theories of the proper order of the tales. Only twenty-four tales were told on the way to Canterbury. The return journey was never chronicled, so we do not know who would have won the prize dinner. The short dramatic interludes that link the stories entertain us with the reactions of the pilgrims to one another. Chaucer himself is always there, with self-disparaging comments, a slightly obtuse and puzzled witness to the human condition. We readers are invited to form our own conclusions.

> For seint Paul seith, that all that writen is,
> To our doctryne it is y-write, y-wis,
> Taketh the fruyt, and lat the chaf be stille.

Chaucer bears witness to the unconventional, and perhaps disreputable, character of his work. For he finally adds his own "Retraction," which recalls the apology that ended Boccaccio's *Decameron.* "As they stand," wrote Boccaccio, "these tales, like all other things, may be harmful or useful depending on who the listener is." Chaucer straightforwardly asks Christ's forgiveness for all his listed writings that "concern worldly vanities, which I renounce in my retractions." He excludes only his translation of Boethius. But he still strangely insists, "All that is written is written for our doctrine." Was this retraction an epitaph, a deathbed confession—or a plea for immortality?

While *The Canterbury Tales* create a new version of the human comedy, though incomplete and unfinished, they sample the forms of medieval narrative. They offer us a one-man renaissance, a medieval anthology trans-

lated by the modern spirit. We hear a romance retold in "The Squire's Tale of the Tartar King" and his daughter who is given a ring that lets her understand the language of birds. Then, the bawdy "Miller's Tale" gives us a taste of the fabliau, coarse and comic. An Oxford student, Nicholas, and a parish priest's assistant, Absolon, are both in love with Alison, the handsome young wife of an aged uxorious carpenter. They scheme to sleep with Alison by convincing the husband that a second Great Flood is about to destroy the world. Nicholas manages to win her for a night for himself. That night his jealous rival, begging a kiss, climbs up to the bedroom window. She offers him her rump, which Absolon kisses. When he comes back for another, Nicholas offers his rump, which the clever Absolon kisses with a hot iron. Nicholas's screams alarm the unsuspecting carpenter who has prepared for the flood by suspending himself in a makeshift boat from the ceiling. Thinking the flood has come, the carpenter cuts the rope of his boat and crashes to the floor in a dead swoon.

Arthurian themes appear in "The Wife of Bath's Tale." First she catalogs the evils of celibacy while giving an account of her five marriages. She then tells of a knight who will escape the death penalty for rape if within a year he can discover what it is that women most desire. He meets an old witch who promises him the answer if he will marry her, which he does. She gives him the answer, which saves his life. Chaucer's flavor survives in Theodore Morrison's modernized English.

> "My liege and lady, most of all," says he,
> "Women desire to have the sovereignty
> And sit in rule and government above
> Their husbands, and to have their way in love. . . ."

The witch then poses him another difficult question.

> "Choose now, which of two courses you will try:
> To have me old and ugly till I die
> But evermore your true and humble wife,
> Never displeasing you in all my life,
> Or will you have me rather young and fair
> And take your chances on who may repair
> Either to your house on account of me
> Or to some other place it well may be.
> Now make your choice, whichever you prefer."

Since the knight has learned his lesson well, he yields her the sovereignty in answering this question too. She rewards him by becoming exquisitely beautiful and also promising to be faithful.

> And so they lived in full joy to the end.
> And now to all us women may Christ send
> Submissive husbands, full of youth in bed,
> And grace to outlive all the men we wed.

Then there are short narratives each pointing a moral. The Canon Yeoman cautions against alchemy and other rogueries. The Clerk extols virtues, embroidering the tale of Griselda that Petrarch had translated into Latin from the *Decameron*. When the poor peasant girl Griselda becomes the wife of the Marquis Walter she vows perfect obedience to her husband. He tests her first by taking away their infant children and pretending that he has had them killed. She responds only with the docile request that they be decently buried where animals will not dig up their little bodies. When he says he will dismiss her so he can take a noble wife, she obediently cleans the house for her successor. Still uncomplaining, she returns to her parents' humble cottage. Finally the marquis reveals that she has passed the test. He brings her back as his wife revealing that he was only testing her steadfastness.

> This tale is written, not that it were good
> For wives to follow such humility,
> For that could not be borne, although they would;
> But that each man, whatever his station be,
> Should stand as steadfast in adversity
> As did Griselda. . . .
> For since to mortal man a wife could show
> Griselda's patience, how much more we ought
> To take all that God sends us here below
> With good grace. . . .

One of Chaucer's more picturesque creations is the unctuous swindler, the Pardoner, who makes his living by selling pardons for all sorts of sins. His tale begins with a ringing sermon against gluttony, drunkenness, and other evils that he illustrates by his tale of three drunken gamblers. In a time of plague they go out together to kill Death, who has killed their friend. Told that they will find Death under a tree, they go there and find a hoard of gold. But they also find Death when each plots to secure more than his share of the find. Two of them kill the third whom they have sent to get food and drink. Then they drink the wine which had been brought by their slain comrade, but which he had poisoned to secure the treasure for himself. And the Pardoner concludes:

> O sin accursed above all cursedness,
> O treacherous murder, O foul wickedness,

> O gambling lustfulness and gluttony,
> Traducer of Christ's name by blasphemy. . . .
> And now, good men, your sins may God forgive
> And keep you specially from avarice!
> My holy pardon will avail in this,
> For it can heal each one of you that brings
> His pennies, silver brooches, spoons or rings.
> Your wives, come offer up your cloth or wool!
> I write your names herein my roll, just so.
> Into the bliss of heaven you shall go!

Despite his Retraction, Chaucer never returned to less worldly writing. In 1391 he wrote a *Treatise on the Astrolabe* for "my little son Lewis . . . of the tender age of ten year." Based on a Latin translation of a work in Arabic, it survives as the oldest known work in English on a complex scientific instrument, witness to Chaucer the enthusiastic and versatile amateur.

It remains a mystery how Chaucer's works circulated, to whom, and in how many copies. He allowed parts of the unfinished work to circulate among friends. Fifty-five complete manuscripts have survived. We must wonder, too, that when monasteries were the scriptoria, Chaucer's novel and entertaining, worldly but unedifying work had the power to make itself known. Before printing there was no way of making a reliable estimate of the number of copies of a work that circulated.

Chaucer's works enjoyed a rich and varied afterlife. He had become a byword and a popular English author long before he appeared in print. He was widely imitated, and by the fifteenth century a whole school of Scottish writers came to be known as the Chaucerians. He was a good believing Catholic, but because of his gibes at monks and pardoners English Protestants treated him as their forerunner. Though he was long praised for his naiveté, his defenders say that a naive collector of customs would have been "a paradoxical monster." *The Canterbury Tales* attracted illustrators and became a favorite text for pioneering printers, from William Caxton (c.1422–1491) to William Morris and beyond.

Centuries passed before Chaucer's stature as a poet was rediscovered. He was condescended to as "rough Chaucer," for his verses seemed not to scan. Then another literary amateur, a versatile Clerk of the House of Commons, Thomas Tyrwhitt (1730–1786) discovered that the final *e*'s in words had actually been pronounced in Chaucer's day. So he made Chaucer's verses scan. Since then English writers have acclaimed his poetry for its sweetness and charming flow as much as for its broad humanity.

Writers most unlike Chaucer have claimed his lineage. Edmund Spenser (according to Dryden) declared "that the soul of Chaucer was transfused

into his body, and that he was begotten by him two hundred years after his decease." The mystic William Blake noted a wider reincarnation. "Chaucer's characters," he wrote, "live age after age. Every age is a Canterbury Pilgrimage; we all pass on, each sustaining one of these characters; nor can a child be born who is not one of these characters of Chaucer."

33

"In the Land of Booze and Bibbers"

"MOST illustrious Drinkers and you, most precious Syphilitics," Rabelais greeted his readers in 1534, "for it is to you, not to others, that my writings are dedicated." So he introduced the first great comic epic of Western literature, a long digressive adventure in dipsomania. Just then it was not surprising that his paean to the absurd should be a tale of drink, for in the summer of 1532 France had suffered the worst drought in living memory. As Rabelais recalled, men were seen "lolling out their tongues like greyhounds that have run for six hours; many threw themselves into wells; others crept into a cow's belly to be in the shade. . . . It was hard work to keep the holy water in the churches from being exhausted. But they so organized it, by the advice of My Lords the Cardinals and the Holy Father, that no one dared to take more than one dip."

Like many a best-selling author, Rabelais followed closely in the path marked by another recent best-seller. That summer of 1532 had seen the publication of the sensationally successful book *Les Grandes et inestimables cronicques du grant et énorme géant Gargantua,* a fanciful tale of a family of giants whom Merlin had created for King Arthur. Rabelais noted that "the printers have sold more copies of that work in two months than they have Bibles in nine years." He may have had something to do with writing or revising the *Cronicques de Gargantua,* but this did not prevent him from writing his very own tale of giants. His pretended sequel is the book that many call the first modern novel. Speedily written, as the work of Alcofribas Nasier (anagram for François Rabelais), it was printed in October and sold briskly that November at the Lyons fair.

Pantagruel, the All-Thirsty One, was already familiar in the French mystery plays as the demon of thirst who went around sprinkling salt into

people's throats. Learned physicians like Rabelais had made it a name for the irritation of the throat that induced thirst. But Rabelais would depart shamelessly and exuberantly from the proprieties of medicine and the Arthurian legend. He felt justified because Aristotle, still the highest authority on almost everything, had observed that of all living creatures only man was endowed with laughter. And at the outset of Book One of *Gargantua* he announced his theme:

> It teaches little, except how to laugh:
> The best of arguments; the rest is chaff,
> Viewing the grief that threatens your brief span
> For smiles, not tears, make the better autograph,
> Because to laugh is natural to man.
> (Translated by Samuel Putnam)

But there is no straight road to the absurd or the comic.

The surprising path that François Rabelais (c.1490–1553) created for himself was through medicine and the thickets of pedantry. Born to the family of a prosperous French lawyer in Touraine in central France, by 1521 he was a Franciscan monk, writing Greek verses to Guillaume Budé (1468–1540), a friend of Erasmus, founder of the Collège de France, inspirer of revived interest in Greek literature. In 1523, when the Sorbonne banned the study of that "heretical language," Rabelais's Franciscan superiors seized his Greek books. When these were finally returned he transferred to a more hospitable Benedictine monastery. By 1528 Rabelais—without permission from his superiors—had taken off his monk's robes and gone to Paris to study medicine. There he fathered two of his illegitimate children by an unidentified widow. Studying at the Faculty of Medicine of Montpellier he received his doctor's degree in medicine (1537), and though it was forbidden by the Sorbonne, he actually dissected the corpse of a hanged criminal. Modern admirers have credited him with such medical "discoveries" as the uterine origin of hysteria in women and novel treatments for syphilis.

Medicine was still a humanistic science, based on the ancient Greek texts of Hippocrates and Galen, which students read only in translation. At Montpellier, Rabelais had impressed his fellows and alarmed his professors by his own translations of the sacred Greek medical texts because a student who could read these texts—and the New Testament—in the original might be tempted to draw his own conclusions. He never ceased to champion the "humanistic" approach to medicine, seeking progress through the better reading of ancient texts.

In Rabelais's erudite imagination, drink would attain elaborate proportions. It was on a drought-cursed Friday, Rabelais recounts, that Panta-

gruel was born. "His father named him as he did; for *Panta* in Greek is equivalent to all, and *Gruel* in the Hagarene language means thirsty, the inference being that at the hour of the child's birth, the world was all athirst. Moreover his father in a mood of prophecy foresaw that his son would one day be the Ruler of the Thirsty Ones." This volume never abandons the leitmotif of drink. When Pantagruel grows up and assumes his throne, his great battle is against the invading Thirsty-People (Dipsodes).

Pantagruel was an instant sellout. Two printings were quickly disposed of, and it was immediately pirated. The next year he wrote a parody of popular almanacs, which he called *Pantagrueline Prognostications*. Meanwhile the authorities at the city hospital of Lyons appointed him their principal physician with a stipend of forty French pounds a year.

From the popular *Cronicques de Gargantua,* Rabelais had borrowed the device of listing the giants' precise measurements, the texture and dimensions of their clothing, their food and drink, their urinations and defecations. Rabelais's astonishing talent for exaggeration expanded everything into a primeval free-flowing narrative—the birth, education, and adventures of the intrepid young Pantagruel, son of Gargantua and his wife, Badebec, daughter of the king of Utopia. We follow his education in Paris, his meeting with his boon companion Panurge, the learned debates at the Sorbonne, and Pantagruel's victorious military excursion to defend Utopia against the invading Thirsty-ones, including too a trip to the netherworld.

Rabelais then exploited the popularity of his own Pantagruel by spinning off his own Book One on Gargantua, Pantagruel's father. For these ribald ventures Lyons had the advantage of remoteness from the vigilant eye of the Sorbonne. When the gibes of *Pantagruel* against the Sorbonnists came to their notice in October 1533, they labeled the work obscene but still did not impose the faculty's formal act of suppression. When King Francis I came to Lyons for the marriage of his second son to Catherine de' Medici, Rabelais met the energetic young Jean du Bellay, bishop of Paris, who would become his great patron. To relieve his pain from sciatica, du Bellay took along Dr. Rabelais on his trip to Rome. There Rabelais sought, unsuccessfully, to secure the pope's absolution for having given up his monastic robes and for changing from the Franciscans to the Benedictines without proper authority.

He must have been a prodigious worker. Despite his travels and his enlarged hospital duties, soon after his return to Lyons in 1534 he published the substantial Book One of his great comic novel. *La Vie inestimable du grand Gargantua, père de Pantagruel* was again signed Maistre Alcofribas (Nasier). While *Pantagruel* had spun out the fantasy of an amiable giant growing up and going forth to battle in Utopia, this tale of his father, *Gargantua,* plunged into troublesome issues of education, politics, warfare,

and the Church. Although Rabelais remained a Catholic all his life, he sometimes came perilously close to the Protestant positions. The controversial Erasmus (1466?–1536) he called his spiritual "father and mother."

These were turbulent times, fertile of both discovery and creation. When Rabelais was a boy, Columbus was making his first voyages to America. He had just become a Franciscan novice when Martin Luther posted his 95 theses on the door of Palast Church in Wittenberg and was putting the Bible into German. This was the birthtime, too, of modern nations and of the French language under Francis I. In neighboring Italy Rabelais saw the recent works of Leonardo, Michelangelo, Raphael, and Titian.

Learned men across Europe were finally reading their classics in the original Greek. In such an age it still took courage to expose the absurdity of the learned. What might have been Rabelais's fate was dramatized in the tragedy of his friend Étienne Dolet (1509–1546), "the first martyr of the Renaissance." Dolet had set up a maverick printing press in Lyons, and after Rabelais's own expurgated edition of *Gargantua* and *Pantagruel,* which softened his strictures against the Sorbonne, Dolet brought out his "new edition" of Rabelais, reproducing all Rabelais's original indiscretions. The Sorbonne banned both editions. Dolet urged his countrymen to write in French, their mother tongue, rather than in Latin, "so that foreigners won't call us barbarians." His courage left many in doubt whether he was an atheist or merely a Protestant, but the Sorbonne was not interested in fine distinctions. They condemned Dolet for the heresy of denying the immortality of the soul. On his way to be burned alive at the stake, he punned, "Non dolet ipse Dolet, sed pro ratione dolet." (Dolet does not suffer for himself, but he suffers for the sake of reason).

Rabelais was fortunate in his patrons—Abbot Geoffroy d'Estissac of the Benedictine monastery that he first joined in refuge from the Franciscans; Cardinal Jean du Bellay, who took him along on trips to Rome; and then Jean's elder brother Guillaume Seigneur de Langey, who supported him for several years in Turin. With their aid he finally did secure the pope's absolution for abandoning the monastic garb and changing orders. In the vacillating orthodoxies of the age, Rabelais himself played an ambiguous role between compassion for Evangelicals and Protestants and conformity to the latest Roman dogma. But he somehow retained the support of Francis I. In 1551 Jean du Bellay secured for him paid positions as curate of two churches and in accordance with the customs that he lampooned, he never lived in either place, but "farmed out" these benefices and spent his own last years in Paris.

While Rabelais made every institution and article of faith the target of his extravagant imagination, his most enduring fantasies were oblique in their

comic attack. The narrative flow of his *Gargantua,* Book One of his ro-
mance (written and published after *Pantagruel,* which he called Book Two),
is straightforward. He begins conventionally enough, with the birth and
youth of Gargantua, his education at home and in Paris, where Gargantua
experiences both an old-fashioned scholastic education by Tubal Holofernes
and an enlightened humanistic education by Ponocrates. The Cake Ped-
dlers' War shows how petty quarrels lead to mayhem and murder.

There was more to come, but only after a long interval. It was not until
1546, twelve years after *Gargantua,* that Rabelais's Book Three appeared.
But it was his first two volumes, the *Gargantua* (1534) and the *Pantagruel*
(1532), that would become classics of Western literature. These provided a
single novel of romance in the style of those that in the next century would
disorder the imagination of Don Quixote and incite Cervantes's own anti-
romance.

There is more in the marrow of these books, Rabelais explained, than
readers might expect. "Following the dog's example, you will have to be
wise in sniffing, smelling, and estimating these fine and meaty books, swift-
ness in the chase and boldness in the attack are what is called for; after
which, by careful reading and frequent meditation, you should break the
bone and suck the substantific marrow . . . in the certain hope that you will
be rendered prudent and valorous by such a reading." The title pages of
both volumes bore the anagram Maistre Alcofribas (Nasier), "Abstractor
of Quintessence."

But footnotes are seldom required for Gargantua's young life. "This
infant did not, as soon as he was born, begin to cry 'Mie, mie' like other
children; but in a loud voice, he bawled 'Give me a drink! a drink! a drink!'
as though he were inviting the whole world to have a drink with him, and
so lustily that he was heard through the land of Booze and Bibbers."
Gargantua's codpiece, the flap in the front of his trousers, took sixteen and
a quarter ells of cloth "in the form of a buttress, securely and jovially
fastened with a pair of pretty gold buckles" and two enameled hooks each
enchased with a huge emerald the size of an orange. "For (as Orpheus says,
lib. De Lapidibus, and Pliny, *lib. ult.*) this stone has an erective virtue and
one very comforting to the natural member. The bulge of the codpiece was
nearly six feet long."

Gargantua so impresses his father, Grandgousier, when, as a boy, he
invents an ingenious Rump-Wiper that Grandgousier gives the boy a proper
education and one day has him made a Doctor of Jovial Science. When
Gargantua arrives in Paris to be educated at the university, he finds the
people "so stupid, such ninnies, and so foolish by nature that a juggler, a
pardon-peddler, or relict-seller, a mule with bells, or a fiddler in the middle
of a public square will gather a bigger crowd than a good evangelic preacher
ever could." To escape the gaping crowd Gargantua takes refuge in the

towers of Notre-Dame. From there he proclaims in a loud voice, "I suppose these rascals expect me to pay my own welcome and *proficiat,* do they? That's fair enough. I'm going to give them a vintage *par rys*—of a kind to make you laugh." Then he unbuttons his handsome codpiece and "he drenched them with such a bitter deluge of urine that he thereby drowned two-hundred-sixty-thousand-four-hundred-eighteen, not counting the women and little children. A certain number escaped this doughty pisser by lightness of foot; and these, when they had reached a point above the University, sweating, coughing, spitting, and out of breath, all began cursing and swearing, some in wrath while others were laughing fit to burst. . . ." These people, "done for from laughing," decided to name their city Paris (from *par rys,* "laughing"). "Up to that time it had been called Leutitia, as Strabo tells us, *lib. iii,* that is to say, *White* in Greek, on account of the white rumps of the ladies there." Attracted by the melodious bells in the towers of Notre-Dame, Gargantua takes them as jingle bells for the neck of the mare he is sending back to his father loaded with Brie cheese and fresh herring.

In Paris he suffers the scholastic discipline of the great doctor, Tubal Holofernes, who, after five years and three months, teaches him to recite his letters backward and to write the Gothic script so he can copy numerous books, "for the art of printing was not yet practised." Then he spends more than ten years and eleven months on the standard Latin grammar "with the commentaries of Bang-breeze, Scallywag, Claptrap, Gualehaul, John the Calf, Copper-coin, Flowery-tongue, and a number of others," which he recited in reverse order to prove to his mother that grammar was no science at all. His next tutor, Ponocrates, follows the humanistic mode of education, introduces him to learned men of lively minds, directs his interests to nature, while inducting him into the mathematical sciences, geometry, astronomy, and music and encouraging him to hunt and swim to keep fit—so that now he does not lose a single hour of the day. Meanwhile Gargantua has learned to play 217 different games (all listed), some of Rabelais's own invention.

In a sudden change of scene we are plunged into the Cake Peddlers' War. As the cake peddlers of Lerne pass along the highway they are approached by shepherds who simply want to buy their cakes. But the cake peddlers turn on them, calling them "scum of the earth, toothless bastards, red-headed rogues, chippy-chasers, filthy wretches of the kind that dung in the bed, big lubbers, sneaky curs, lazy hounds, pretty boys, pot-bellies, wind-jammers, good-for-nothings, clodhoppers, bad customers, greedy beggars, blowhards, mamma's darlings, monkey-faces, loafers, bums, big boobs, scoundrels, simpletons, silly jokers, dudes, teeth-chattering gramps, dirty cowherds, and dung-dripping shepherds" who ought to be satisfied with coarse lumpy bread and big round loaves.

This occasions a grand melee, out of which grows a murderous war. The

episode caricatures the interminable quarrel of Rabelais's own lawyer father with neighbors over the fishing rights in a stream. Here Rabelais introduces one of his most attractive inventions, the good-natured monk Frère Jean, whose deeds of valor defend the local shepherds against the aggressive King Picrochole of the Cake Peddlers. Gargantua finally rewards Frère Jean by building him a new kind of monastery (or anti-monastery), the proverbial Abbey of Thélème, ruled by the motto "Do what you will." Inhabited only by handsome men and women richly "dressed according to their own fancy," it becomes an epicure's utopia. Members of the order speak a half-dozen languages, play musical instruments, and write verses to one another—the girls by the age of ten, the boys by twelve.

Pantagruel's adventures in Book Two, written sometime before Book One, are disjointed and delightfully random. Pantagruel's youth, like that of his father, is filled by noble deeds. In Paris for his education he meets his lifelong companion Panurge. Gargantua pleads for Renaissance learning in a letter to his son. And Pantagruel shrewdly settles a legal quibble between Lord Kissarse and Monsieur Suckpoop by theological hairsplitting debated in sign-language. Then Pantagruel and Panurge are off to the war in Utopia, which was being laid waste by the Dipsodes. When their friend Epistemon is decapitated, Panurge holds the head against his codpiece, "to keep it warm, as well as to keep it out of the draught." Then with fifteen or sixteen stitches he reattaches Epistemon's head. "Epistemon was healed, and very cleverly, too, except that he was hoarse for more than three weeks afterward, and had a hacking cough, which he could only get rid of by drinking a lot." Meanwhile, Epistemon has been dead long enough to have some wonderful adventures in hell and the Elysian Fields. There Alexander the Great earns a miserable living patching old shoes, and Xerxes hawks mustard. "All the Knights of the Round Table were poor day-laborers, plying an oar on the rivers Cocytus, Phlegethon, Styx, Acheron, and Lethe. . . . But for each fare, all they get is a punch in the nose, and at night, a little piece of moldy bread." Needless to say, Pantagruel and Panurge win the war.

When we read Rabelais in translation, we are grasping for his wit through a veil. Rabelais's book was an act of faith in a language he was beginning to make literary. Chateaubriand would say that Rabelais "created French literature." His respected medical works he had written in Latin, but he chose to write his novel in French. Spoken literature and the arts of memory were still only partly displaced by the printed word. Francis I, Rabelais himself reported, had Rabelais's book read aloud to him. Not till 1539 did French become the language of the law courts. Calvin translated his own *Institutes of the Christian Religion* from Latin into French in 1541. When Joachim du Bellay wrote the manifesto of the new French literature, his

Defence and Illustration of the French Language (1549), Rabelais was one of the few French men of learning who had dared write books in the language of the marketplace.

Luxuriating in the vulgar tongue, Rabelais makes his book a showcase for its fresh eloquence. Exploiting the exclamations, hyperboles, and obscenities of the marketplace, he never uses one word when twenty would possibly come to mind. Even through English translations like those of J. M. Cohen and Samuel Putnam, we can still see Rabelais wallowing in the vernacular. Now that printing presses reached an ever-widening market of the newly literate, the French language offered the novel incentives of money and celebrity. *Gargantua and Pantagruel* displays the ebullience of a language newly liberated from the academy, and Rabelais himself is drunk on words. We can imagine that he might have swallowed a French dictionary—if one had been available at the time. But Robert Estienne's pioneer Latin-French dictionary did not appear until 1538.

In 1546, twelve years after *Gargantua,* when Rabelais produced his Third Book, orthodoxy had become more fervent. Only the year before, Waldensian heretics had been massacred in southeastern France, and in Paris that same year Rabelais's friend Dolet was burned at the stake for heresy. This Third Book, a sequel to the narrative of Pantagruel, is the first to bear Rabelais's name as author and "doctor of medicine." It is more serious than its predecessors, in a Rabelaisian way. Dedicated to a friend of literature, Margaret Queen of Navarre, sister of Francis I, it rambles around "The Woman Question" (*La Querelle des Femmes*), then widely agitated by learned men. Panurge, deciding to marry, consults with theologians, philosophers, lawyers, doctors, and miscellaneous divines and diviners. Rabelais precipitately brings Gargantua all the way back from the afterlife to harangue his son Pantagruel on the importance of parental consent to marriage. But the pope had held that parental consent was not required because the sacrament of marriage performed by a priest was enough to join the parties in the eyes of God. Still, Rabelais, along with Erasmus, the Evangelicals, and the Protestants, found the need for parental consent in the Old Testament and feared the pope's monopoly over a realm that God had assigned to father and mother. For aristocrats and propertied people in those days marriage was more a political and commercial than an amorous alliance. Fortune-hunters or romantics could and often did abscond with well-endowed daughters to the ruin of the family estates. Yet the collusion of a priest (as in Romeo's case, with unfortunate consequences) did not prevent noble families from using the law of rape against a suitor who married without parental consent. While Rabelais lets us share Panurge's

pains of indecision, we hear on all sides that cuckoldry is the only certainty in marriage.

When Pantagruel asks Panurge when he is going to get out of debt, Panurge shrewdly replies:

> I'm a creator, you say, and of what? Why, look at all those nice, charming little creditors! For creditors are indeed—and I'll stick to it through hell-fire—nice and charming creatures. . . .
>
> Don't you think I feel good, when, every morning, I see around me those same creditors, and all of them so humble, so ready to serve me, and so full of bowings and scrapings? And when I note how, upon my showing a little better face to one than to the others, the old bastard thinks he's going to have his settlement first. . . . These are my office-seekers, my hangers-on, my bowers, my greeters, my constant petitioners.
>
> <div align="right">(Translated by Samuel Putnam)</div>

With his genius for seeing the other side, Rabelais reports Judge Bridlegoose's simple procedure for deciding law cases by casting dice. The only trouble is that with advancing age the judge cannot make out the score on the dice. But why, if he can no longer read, does he still require parties to submit so many documents? First, for the sake of formality "without which whatever is done is of no value," and also because preparing and handling the papers provides "a dignified and salutary form of exercise." Finally, the slow procedure allows a wholesome interval of time before the case is decided. "If judgement were given when the case was raw, unripe, and in its early stages, there would be a danger of the same trouble as physicians say follows on the lancing of an abcess before it is ripe, or the purging of some harmful humour from the body before it has fully matured. . . . Furthermore, Nature instructs us to pick and eat fruit when they are ripe . . . likewise to marry our daughters when they are nubile."

Rabelais's Third Book, written as a sequel to *Pantagruel,* had received the royal privilege, but neither this nor his dedication had saved it from suppression by the Sorbonne. They found no explicit heresy, but still his irreverent puns on "soul" and "ars-oul" irritated them. Now he explains, in his dedication of the Fourth Book to Cardinal Odet de Chatillon, that "the slanders of certain cannibals, misanthropes, and agelasts" had tried his patience and almost decided him "not to write another iota." It may have seemed to his credit that he was attacked by Calvin in 1550. His new patron, the cardinal, renewed the royal privilege for all his works.

This Fourth Book (1548; enlarged, 1552), the longest and the least incoherent of all, delightfully embroiders the tales of the search for a Northwest Passage then fascinating Western Europe. Rabelais may have known Jacques Cartier (1491–1557), explorer of Canada and "discoverer" of the St.

Lawrence River, from whom he borrowed the outline of Pantagruel's voyage, still an adventure in dipsomania. On this journey to the Oracle of the Divine Bottle, the Holy Bacbuc (from Hebrew for bottle), we rediscover Pantagruelism, "a certain gaiety of spirit pickled in disdain of fortuitous things." On the high seas, on strange islands, and in exotic ports he meets Windmill-Swallowers, Spouting Whales, Ruachs (who live on wind), Serpentine Chitterlings, Popefigs, Papimaniacs, Gastrolators, and Rodilardus the large cat whom he took for a Devil. The land was so frigid that even words were frozen:

"Here, here," exclaimed Pantagruel, "here are some that are not yet thawed." Then he threw on the deck before us whole handfuls of frozen words, which looked like crystallized sweets of different colours. We saw some words gules, or gay quips, some vert, some azure, some sable, and some or. When we warmed them a little between our hands they melted like snow, and we actually heard them, though we did not understand them, for they were in a barbarous language. There was one exception, however, a fairly big one. This, when Friar John picked it up, made a noise like a chestnut that had been thrown on the embers without being pricked. It was an explosion and made us all start with fear. "That," said Friar John, "was a cannon shot in its day."

Panurge asked Pantagruel to give him some more. But Pantagruel answered that only lovers give their words.

(Translated by J. M. Cohen)

The so-called Fifth Book, which was not printed until 1562, nine years after Rabelais's death, is not generally accepted as the work of Rabelais. But it does have some authentic Rabelaisian turns, like the Furred Cats, who cause all the world's evils. The oracle Bacbuc now firmly revises Aristotle: "Not laughing, but drinking is the proper role of man." The shibboleth "Drink!" takes on new meaning when she explains that when a certain Jewish captain of old was leading his people across the desert "he received manna out of the skies, which to their imagination tasted exactly as food had tasted in the past. Similarly here, as you drink of this miraculous liquor you will detect the taste of whatever wine you may imagine." It was an age when each Renaissance scholar, blessed by new thirsts for ancient liquor, was finding something to his own taste.

Just as Rabelais's Fourth Book appeared, the French king Henry II was in his most anti-Roman mood, issuing new edicts against papistical abuses. And Rabelais was called a pliant royal propagandist for his gibes at Popejiggers and Papimaniacs. Unfortunately in April of that very year when King Henry II made up his differences with the pope, ridicule of Rome was suddenly not only unstylish but life-risking. The magistrate who sniffed the shift in royal doctrine and banned Rabelais's book on March 1, 1552, was

none other than an old friend and the ally of his youth, fellow pioneer of humanism, André Tiraqueau (1480–1558). Rabelais must have found it hard to whet his thirst for laughter. We know nothing for sure about how Rabelais's life ended in 1553. There were stories of his death in prison, and various reports of his last words. The most appealing were noted by his inventive English translator Pierre Motteux (c.1663–1718). "I am going to seek a grand perhaps; draw the curtain, the farce is played."

<p style="text-align:center">34</p>

Adventures in Madness

CERVANTES'S *Don Quixote,* sometimes called the first modern novel, was born as a kind of anti-novel. Beginning as the tale of an "ingenious gentleman of La Mancha" whose mind had been unbalanced by reading too many books of chivalry, Don Quixote soon became a nickname for anyone inspired by lofty but unrealizable ideals. The self-educated son of an impoverished apothecary-surgeon, Miguel de Cervantes (1547–1616) would embroider the disparity between illusion and reality. With personal experience more of "reverses than of verses" he sought in words a reward that he had earned but never received in the world. An expert on poverty, Cervantes cheerily concluded that "the best sauce in the world is hunger, and as the poor are never without it, they always eat with relish." One of seven children, he was born in 1547 in Alcalá de Henares, a small town then the site of one of Spain's great universities. His father, an itinerant, impecunious *médico cirujano* (apothecary and paramedic), was imprisoned for debt at least once before he moved his family to Madrid, still only a large village (it became Philip II's capital in 1561). Miguel's father, Roderigo, had tried unsuccessfully to avoid imprisonment on the grounds of his family's status as *hidalgos.* We know little else of Cervantes's first twenty-one years. He probably never attended a university, but loved to read anything he could find. In the household of a Spanish cardinal in Rome he came to know Italian life and letters.

All his adult life Cervantes bore the mark of his courage in the quixotic effort of his age—to defend the faith against the Turkish-Muslim hordes. Christian forces, split every which way by theological quibbles and dynastic

rivalries, somehow managed for a time to unite against the menace. At Lepanto, at the western end of the Gulf of Corinth on October 5, 1571, the Christian allies, 208 galleys, and numerous smaller vessels with thirty thousand men fought a four-hour battle against the inferior Ottoman fleet. By nightfall the allies had won a decisive victory. Cervantes later recalled that "there were fifteen thousand Christians, all at the oar in the Turkish fleet, who regained their longed-for liberty that day."

At that Battle of Lepanto when the signal to fire was given, the young Cervantes was lying below with a fever. But he demanded to be taken on deck to command his perilous post. As Cervantes himself reported:

> In the naval battle of Lepanto he lost his left hand as a result of a harquebus shot, a wound which, however unsightly it may appear, he looks upon as beautiful, for the reason that it was received on the most memorable and sublime occasion that past ages have known or those to come may hope to know; for he was fighting beneath the victorious banner of the sons of that thunderbolt of war, Charles V of blessed memory.

(Translated by Samuel Putnam)

He never ceased to be proud of the two gunshot wounds in his chest and the loss of the use of his left arm and hand, which he said was "to the greater glory of the right."

After convalescing a few months, by April 1572 he was serving again on Spanish ships. But the quarreling allies soon abandoned hope of crushing the resurgent Ottoman navy, and Cervantes, eager for action and promotion, made his way back to Spain. Since he did not yet have the ten years' service normal for promotion to captain, he sought promotion directly from the king, with impressive letters of recommendation. The letters did not secure his promotion but would cost him dearly in Turkish captivity.

As his ill-starred galley *El Sol* approached France it was attacked by a Turkish flotilla of pirates and taken to Algiers to be held for ransom. Cervantes's prized letters of recommendation made him seem an especially valuable hostage. His five and a half years as a slave in Algiers, he said, "taught him patience in adversity."

His captors' impression that he was a person of high station who could command the highest ransom was, of course, false. But it led them to keep him under heavy security, and "tempted by the bait of covetousness . . . they looked after my health with somewhat more care." In the spring of 1576 the restless twenty-eight-year-old Cervantes failed in his first effort at escape. He and some fellow Christians, seeking to reach Oran, were abandoned by their guide and returned to Algiers to be punished as fugitives. Cervantes was put in heavy chains, but his high price discouraged terminal punishment.

The next summer Cervantes's family sent three hundred crowns for ransom, which the pirates took for his brother Roderigo, while they awaited a higher price for Miguel. Cervantes himself organized a plan to hide in the cave outside Algiers awaiting a Spanish frigate along the coast. Betrayed by a Spaniard, he was hauled before the pasha of Algiers, and threatened with death and torture. When Cervantes insisted that he alone had contrived the whole affair, the pasha was so impressed with Cervantes's courage that he bought the valiant Cervantes from his Algerian owners. Within five months the restless Cervantes had got a message through to the commander of the Spanish garrison in Oran, with instructions on how to help the captives. The unlucky Moor who carried these messages was impaled and Cervantes was sentenced to two thousand blows, but he once again eluded punishment.

By the fall of 1579 Cervantes had been in captivity for four years. He secretly engaged a Valencia merchant residing in Algiers to buy a frigate to rescue him and sixty other captives. Again a fellow Spaniard, Dr. Juan Blanco de Paz, a Dominican monk at Salamanca, betrayed the plot. With his hands tied behind and a halter around his neck for his imminent execution, Cervantes again claimed that he alone was responsible and demanded all the punishment for himself. His "gallant effrontery" once more carried the day. The pirates' covetousness and the pasha's admiration for his courage spared his life. The treacherous Dominican was rewarded by a single gold *escudo* and a pot of Algerian butter (which some considered more a punishment than a reward).

Finally in the spring of 1580 two monks arrived from Spain with ransom money contributed by Cervantes's family and friends. Finding that it was not quite the five hundred gold crowns demanded, Cervantes's local admirers, Spanish merchants in Algiers, made up the required sum. Returning to Madrid in late 1580, the thirty-three-year-old Miguel de Cervantes already had a heavy investment in a military career. With no other way to make a living, he was acutely conscious that for his ransom "the entire property of his parents, as well as the dowries of his two sisters, now left in poverty, had been sacrificed." He found sporadic employment in the campaign in Portugal and as the king's messenger to Oran. But his valorous services to the king were not properly rewarded.

In 1584 he married the daughter of a respectable family, eighteen years his junior, in a village near Madrid. She brought him a small farm, a vineyard, chickens and beehives, and furnished a household with silver and alabaster images of the Virgin. This brief interlude was the most comfortable period of his life.

Of respectable occupations in Spain at this time, literary production was probably the most unregulated. Madrid, becoming the headquarters of an

aggressive world empire, offered the liveliest opportunities. Ignatius Loyola had founded the Society of Jesus (1540) only a few years before. This was Spain's Golden Age when the newly flourishing Castilian language was becoming a national vernacular. The classic chivalric romance, *Amadis de Gaula* (1508) had lately appeared. Poetry was a hobby for lawyers, doctors, priests—and why not for soldiers too? The printing press had not yet displaced the written word. Following the medieval custom of circulating manuscripts, many who would not have dared write for the press wrote for friends. When Cervantes had left for military service the Madrid theater was four planks laid across benches with a blanket for backdrop, and plays were loosely connected scenes with vaudeville interludes. But when he returned from captivity, there were permanent theater structures, and plays were plotted into clearly separated acts. Playwrights were beginning to make money.

In this informal literary life of Madrid, Cervantes, though not a university man, somehow made his way. He wrote dedicatory poems for other people's books on all sorts of subjects. He tried the theater. Later Cervantes would claim credit for a new three-act format for plays, and for staging moral characters who revealed their inner thoughts. Of the thirty plays he wrote in these years only two have survived. But his desperate efforts to earn a living from the stage did not succeed. On the Madrid literary scene he had to compete with "the Spanish phoenix," the prolific and versatile Lope de Vega (1562–1635), whom Cervantes himself called "nature's prodigy." After three decades the best Cervantes could boast of his plays was that they "were recited without offering of cucumbers or other missiles, and ran their career without hisses, shouts, or uproar."

Cervantes's self-discovery took time. His first extended literary work off the stage was *La Galatea* (1585), in the familiar escapist genre of the day. A diffuse pastoral romance, it recounted the loves of shepherds and shepherdesses on the idyllic countryside. But it must have suited some public taste, for Cervantes sold the publishing rights for a substantial sum, and it was widely appreciated abroad. An unschooled soldier at thirty-three had suddenly produced a work of fashionable literary elegance.

Before Cervantes found his literary vocation, he had to serve another disastrous tour in the School of Hard Knocks. The "Invincible Armada," Spain's ill-starred naval force in one of the decisive battles of modern history, was the product of a national effort in which Cervantes would have a small unlucky role. As commissary assigned to requisition wheat and oil, he recklessly enforced his authority against the Dean and Chapter of Seville. They promptly responded with his excommunication, and 1588 proved a bad year all around. Cervantes's surviving literary efforts of that time were a preliminary sonnet to a treatise on a kidney disease and two odes (one of

prophecy, the other of condolence) on the Armada. A soft-hearted and erratic bookkeeper, he was not well suited to the exacting task of purchasing agent. After the defeat of the Armada he petitioned the king for a position in America. What he received was high commendation, and reduction in pay from twelve reales a day to ten.

Cervantes's punishment for loyal government service was not yet complete. In 1592, charged with unauthorized seizure of barley and wheat, irregularities in his accounts, and a huge deficit that he could not explain, he tried to meet his financial emergency by a six-play contract. With a Seville theatrical manager, Cervantes signed a money-back guarantee. If the plays were not among the best ever staged in Spain, he would not have to be paid. Even before he could fulfill this contract he was jailed. Troubles accumulated. After release from prison he was conned out of his savings by an absconding Seville banker. Then he was remanded to jail for another three months for failing to obey the court's order that he fully settle his garbled accounts. A decade later government officials were still harassing the forty-four-year-old veteran of battles and bureaucracy.

The next years (1600–1604), when Cervantes must have been writing his great work, are a mystery. We do not know where he was or even how he earned his living. His chivalrous ventures had been rewarded only by a maimed left arm, a loss of reputation, terms in prison, poverty, and destitution. His life so far was a disillusioning experience for which the popular romances of chivalry were no antidote. The Spanish emperor Charles V had them read to him during his siestas. But Saint Theresa listed addiction to these romances among the sins of her youth. A law of 1553 prohibited the printing and sale of any such books in the Indies, and the Cortes was considering a law to have them burned.

Cervantes claimed that his *Don Quixote* was designed to kill off these romances of chivalry. Incidentally he created a prototype of the novel, the most popular form of modern literature. Cervantes had already experimented in still another literary form, also a progenitor of modern fiction. In his Prologue to *Two Exemplary Novels* (not published until 1613, but probably written at least ten years earlier), Cervantes boasts that he is "the first to have written novels [short stories] in the Castilian tongue . . . these are my own, neither imitated nor stolen. My mind conceived them, my pen brought them forth, and they have grown in the arms of the printing press." He meant these tales to be morally "exemplary." "If I believed that the reading of these Novels would in any way arouse an evil thought or desire, I would sooner cut off the hand that wrote them than see them published. At my age one does not trifle with the life to come." Quite a pledge from a man of sixty-six who had already lost the use of his left hand!

The "exemplary novel" which many think his best, "The Man of Glass,"

recounts the strange malady that a brilliant student caught from drinking a poisonous love potion. "The unhappy man imagined that he was entirely made of glass, and under this delusion, when anyone came near him, he used to utter piteous cries . . . that he should not approach him, because he would break him, for he was not really and truly as other men, but was all of glass from head to foot." His fellow townsmen valued him for his ideas and insights. "Glass," the student explained, "is a subtle and delicate material: the soul acts through it with more promptitude and efficiency than through the body, which is heavy and earthy." He understood the world differently from those made of flesh and blood. Enticed by his "glassy" state of mind, the people of Salamanca believed the student could answer all their questions and of course he was harmless, for he dared not risk any act of violence. As he wandered about town he uttered penetrating witticisms on the charlatanry that he saw everywhere—bad poets, perverse judges, crooked lawyers, murderous physicians, and swindling merchants. He saw through them all. This madness lasts for two years. After the student was cured by a clever monk, he tried to resume his custom of preaching in the public square, where people had once hung on his every word. But now that he was sane, no one was interested. He was nothing more than a brilliant law graduate of Salamanca.

It is possible that *Don Quixote* was conceived when Cervantes was lying in the Royal Prison of Seville in 1597. The publisher did not have high hopes when the first part of Cervantes's masterpiece was published in Madrid in January 1605, for he bothered to secure the official privilege only for Castile. The book was an immediate popular success. When King Philip III, looking out from his palace, saw a student in gales of laughter over a book, he was reported to have said, "He must be mad—or he's reading *Don Quixote.*" The book would be a commercial success, too, at least for the publishers, who now had the license extended to Aragon and Portugal. Pirated editions were issued at once, and the book soon appeared in Brussels and Milan, and an English translation came out in 1612. Cervantes had sold all his rights to the first publisher in Madrid and so had little to profit from his success.

Don Quixote, a pretended knight-errant, would have an enduring appeal matched by no real one. This "ingenious gentleman of La Mancha" in south-central Spain had stocked his library with romances of chivalry, which addled his brain and nourished his illusion that he must himself become a knight-errant. Outfitted with a suit of rusty armor and a decrepit horse, Rosinante, he enlisted for his squire a local peasant, Sancho Panza, to whom he promised the governorship of an island. Traveling the countryside to right the wrongs of the world, he defended the honor of his lady love, Dulcinea del Toboso, from a nearby village. She, however, was unaware of

his devotion. His imagination transformed rustic inns, roguish innkeepers, rude goatherds, and flocks of sheep into an enchanted landscape of moated castles, gallant knights, and their supporting troops. Windmills became enemies against which he had to battle. Whether falling awkwardly off his knightly nag or being cudgeled by peasants and innkeepers, Don Quixote remained indomitable. "Bear in mind, Sancho, that one man is no more than another, unless he does more than another. All these tempests that fall upon us are signs that fair weather is coming shortly, and that things will go well with us, for it is impossible for good or evil to last forever. Hence it follows that the evil having lasted long, the good must be now nigh at hand. . . ." After their saddlebags were stolen, Sancho recommended that Don Quixote, like ancient knights-errant, live off the herbs of the field. To which the knight replied:

"For all that, I would rather have just now a quarter of bread, or a loaf and a couple of sardines than all the herbs described by Dioscorides, even with Doctor Laguna's notes. Nevertheless, Sancho the Good, mount your beast and come along with me, for God, who provides for all things, will not fail us—more especially when we are so active in his service as we are—since he fails not the midges of the air, nor the grubs of the earth nor the tadpoles of the water, and is so merciful that he maketh his sun to rise on the evil and on the good, and sendeth rain on the just and on the unjust."

"Your worship would have made a better preacher than knight-errant," said Sancho.

(Translated by Rudolph Schevill after John Ormsby)

The meandering narrative, interrupted by ballads and interludes, finally leaves the reader in the air, ready for a second part.

But, like Rabelais before him, Cervantes needed the incentive of an impostor. In ten years Cervantes had reached the fifty-ninth chapter of his Part Two when he discovered that someone had already published a spurious Second Part, licensed on July 4, 1614. Riding on Cervantes's reputation, this fake Part Two was about to preempt the market.

The impostor prefaced his work by brutally ridiculing Cervantes himself. Better this sequel, he boasted, than another work from an author who cackled, whose tongue wagged more freely than the one hand he had left, whose books written in a dungeon bore the brand of the convict and the ill temper of the jailbird. This insolent plagiarist has never been identified, but in the marketplace he appears to have profited from his haste. And Cervantes responded in haste, which would mar his last fifteen chapters.

This second part, like the first, when it finally emerged from the censor's bureaucracy, sold well, was translated into French, and was soon being bound and marketed together with Part One. As Cervantes testified and

prophesied, already in that early age of literacy Part One had been a spectacular seller. The student, Sanson, who shared Don Quixote's illusion, boasts:

> "that there are more than twelve thousand volumes of the said history in print this very day, . . . and I am persuaded there will not be a country or language in which there will not be a translation of it. . . . There are those . . . who have read the history and say they would have been glad if the author had left out some of the countless cudgelings that were inflicted on Señor Don Quixote in various encounters."
>
> "That's where the truth of the history comes in," said Sancho.
>
> (Translated by Rudolph Schevill after John Ormsby)

Part Two continues the familiar roles of the two leading characters, and describes the enchantment and disenchantment of the peerless Dulcinea. The leading characters have somehow changed places—Quixote has become a Sancho, Sancho a Quixote. We hear Don Quixote advising Sancho how to govern his "island." "Eat neither garlic nor onions that your breath may not betray your rustic origin. Walk slowly and speak with deliberation, but not in such a manner as to give the impression that you are listening to yourself; for all affectation is bad."

The work ends with the frustrating return of Don Quixote's sanity. When the Knight of the White Moon unhorses Don Quixote in a chivalric encounter, Don Quixote begs, "Drive home your lance, O knight, and take my life since you already have deprived me of my honor." The Knight of the White Moon refuses, but asks that "the great Don Quixote" retire to his own village for a year. The downcast Don Quixote agrees. Sancho, brokenhearted, "feared that Rosinante was maimed for life, his master's bones permanently dislocated—it would have been a bit of luck if his madness also had been jolted out of him." And so it had. On leaving Barcelona, the site of this encounter, Don Quixote looked back. "Here," he said, "was Troy; here my luck and not my cowardice robbed me of the glory I had won; here it was that fortune practiced upon me her whims and caprices; here my exploits were dimmed; and here, finally, my star set never to rise again." As they approach their village Sancho falls on his knees.

"Open your eyes, O beloved homeland," he cried (as translated by Samuel Putnam), "and behold your son, Sancho Panza, returning to you. If he does not come back very rich, he comes well flogged. Open your arms and receive also your other son, Don Quixote, who returns vanquished by the arm of another but a victor over himself and this, so I have been told is the greatest victory that could be desired. . . ." The ingenious knightly gentleman does not long survive the pastoral life. With Don Quixote's sanity and

disillusion comes also his sickness. "I have good news for you, kind sire," said Don Quixote. . . . "I am no longer Don Quixote de la Mancha but Alonso Quijano, whose mode of life won for him the name of 'Good.' " At the point of death, he turned to Sancho. "Forgive me, my friend," he said, "for having caused you to appear as mad as I by leading you to fall into the same error, that of believing that there are still knights-errant in the world." "Ah, master," cried Sancho through his tears, "don't die, your Grace, but take my advice and go on living for many years to come; for the greatest madness that a man can be guilty of in this life is to die without good reason, without anyone's killing him, slain only by the hands of melancholy."

Luckily or shrewdly Cervantes had created a new form, which other authors could elaborate and embellish—a maquette for versions of the human comedy. Not only had he created a novel, he had created the Western novel. Which gave him a role among creators of our modern world comparable to that of Copernicus in the world of discoverers. But while Copernicus shifted our focus outward from the earth to the sun, Cervantes shifted our focus from the outer world inward to man. And just as the physicist Dalton would reveal many more kinds of matter than had been imagined, so Cervantes pointed literati inward to unsuspected and unexamined varieties of people. While the gatherers of statistics were finding new uniformities among groups of people, Cervantes pioneered in revealing the variety of the individual, leading the effort of modern literature to translate all experience into the novel.

The creator was moving into new territory. The novel would reach out even as it reached in. It would democratize both the audience and the subject of literary art. By "re-creating life out of life," the novel would discover modern man to himself. What statistics and social science were to accomplish for the public experience, the art of the novel did for the private.

Since the epic sang the deeds of legendary heroes, it is not surprising that there are only about a half-dozen great epic poems in Western literature. We like to hear our epics repeated—reassurances of our shared reverence for courage, piety, love, and heroism. A new epic, then, is a kind of contradiction in terms, for the epic ties us to the deep past and nourishes us from tradition. Similarly, Cervantes's target, the medieval chivalric romance, which had developed in twelfth-century France and spread across Europe, was highly conventional. It, too, was first written in the more easily remembered verse, and only later in prose. "Romance" first meant a work in French, derived from Latin, the language of Rome. On the European continent the word for novel, too, would be *roman,* derived from the language in which the romance had first been narrated. Romances were not chroni-

cles of pitched battles, like those between Greeks and Trojans, but told of legendary knights devoted to Jesus Christ and their lady loves, in tournaments and the halls of castles, with a full complement of dragons and monsters, all under the spell of magicians.

Romances, too, appealed by retelling: "The Matter of Britain" (Celtic subjects, e.g., King Arthur and his court), "The Matter of Rome" (e.g., the Trojan War or Alexander), "The Matter of France" (e.g., Charlemagne's court), and "The Matter of England" (e.g., King Horn and Guy of Warwick). A pastiche of pagan myth, Christian lore, and feudal custom, like the American Western they flourished on fulfilled expectations. The listener (more often than the reader, in the days before printing) awaited the glorious moment of Hector, Lancelot, or Galahad, and was eager to see the devil-born Merlin captured and wicked Modred get his comeuppance.

The "novel," from Italian *novella* (little new thing), though a modern successor to the epic and the romance, would not attract by its reciting of the traditional and the familiar. Instead, it aimed at surprise, suspense, and the unexpected. The novelist would play God on the landscape of his creation. "For me alone," Cervantes protested against the impostor who wrote a spurious Part Two, "Don Quixote was born and I for him; it was for him to act, for me to write, and we two are one."

Cervantes made his hero no recognizable epic figure, nor a man of wealth or high station, but only an ingenious fifty-year-old gentleman of modest means who had living with him "a housekeeper in her forties, a niece who was not yet twenty, and a lad of the field and marketplace who saddled his horse for him and wielded the pruning-knife." By afflicting his middle-class hero with the illusion that the conventions of the familiar romance were real, he opened the window to a daily life not seen in epic or romance. Now the reader shared another person's encounter between his inner feelings and the world out there. The novelist thus became the reader's guide into another person. "The author of our history," Don Quixote observes when he is told that his life story is already being circulated in books, "must be some sage enchanter for to such, nothing that they choose to write about is hidden." Perhaps Cervantes was the better equipped to provide his maquette for the modern novel because he was not especially reflective or deeply learned or philosophical. He was in love with the colors and moments and movements of life. And his familiarity with the Spanish landscape was indispensable.

Cervantes's Prologue declared his concern "for what that venerable Legislator, the Public, will say." "Let it be your aim," he agreed, "that, by reading your story, the melancholy may be moved to laughter and the cheerful man made merrier still; let the simple not be bored, but may the clever admire your originality; let the grave ones not despise you, but let

the prudent praise you." Cervantes's "Bible of humanity" (in Sainte-Beuve's phrase) would have a wondrous afterlife. He has never been better applauded than by his admirer and translator, Tobias Smollett:

> In a word, Cervantes, whether considered as a writer or a man, will be found worthy of universal approbation and esteem; as we cannot help applauding that fortitude and courage which no difficulty could disturb, and no danger dismay; while we admire that delightful stream of humour and invention, which flowed so plenteous and so pure, surmounting all the mounds of malice and adversity.

Four days before his death, and after he had received extreme unction, Cervantes uttered a gallant farewell, "with one foot already in the stirrup, and with the agony of death upon me." He died on April 23, 1616, on the same day with Shakespeare. He left no will, and his grave in the Trinitarian Convent in Madrid is not marked. "Cervantes, a patient gentleman who wrote a book," Ortega y Gasset warns us, "has been seated in the Elysian Fields for three centuries now, where he casts melancholy glances about him as he waits for a descendant to be born who shall be capable of understanding him."

35

The Spectator Reborn

IT was for a new audience in a newly flourishing art form that Shakespeare produced his version of the human comedy. Now again a writer could reach his whole community with a sustained work of literary art. The drama born in ancient Greece as we have seen was a community art. Begun as ritual with the whole community dancing in the "orchestra" together, it became a spectacle in which some citizens participated only as spectators. But in the European Middle Ages the literary arts became either immured in monastic libraries or elaborated for the entertainment of courtly audiences. The troubadours (from *trobar,* to find or invent), who flourished in Provence into the thirteenth century singing the langue d'oc vernacular, were expected to entertain the noble ladies. While supposed to "invent," in fact they only elaborated conventional tales of kings and queens, shepherds and shepherdesses, of adulterous and unrequited love. The folk music and folk-

lore, which no one could inhibit, remained a world apart from writers and readers.

The Renaissance city and the city theaters somehow furnished a community of spectators like that which had inspired and acclaimed the great Greek dramatists. Now the spectator was reborn. "Citizens"—inhabitants of the city—became a full-spectrum theater audience. This community became the opportunity and the inspiration for Shakespeare too, whose great works were written to be acted, not to be read.

The theater had risen in London during Shakespeare's youth. The suddenness with which the new pastime had appeared raised the alarm of the learned and the pious. Like television in our time, theater acquired its frightening popularity within a half century. Playwrights and actors had been amateurs and the first players made their living by touring their troupes around the country. When they came to London they acted in the bear-baiting rings or in the courtyards of inns. But in 1576, when Shakespeare was a twelve-year-old schoolboy in Stratford, James Burbage built the first theater in London, and within forty years there were at least five others. The Globe, the Rose, the Swan, the Red Bull, the Fortune, and Blackfriars, specially designed for their purpose, were attracting Londoners of both sexes and all classes to an appealing and time-consuming new kind of professional entertainment. Travelers from the Continent were surprised at this feature of London life.

"By the daily and disorderly exercise of a number of players and playing houses erected within this City," the lord mayor of London wrote to the archbishop of Canterbury in 1592, "the youth thereof is greatly corrupted and their manners infected with many evils and ungodly qualities by reason of the wanton and prophane devices represented on the stages by the said players, the apprentices and servants withdrawn from their works." It was no wonder that in 1596 the Privy Council assented to an order "to thrust those Players out of the Citty and to pull downe the Dicing houses." Playhouses were forced out to the suburbs, beyond the city walls, to the north and west, or, like the Globe, southward to the other side of the Thames.

When many buildings had been specially constructed for presenting plays, audiences had to be attracted. Paying from a penny to a half a crown for admission, they filled the daily performances. An Englishman visiting a playhouse in Venice in 1611 found "the house very beggarly and base in comparison of our stately playhouses in England; neither can their actors compare with us for apparel, shews and music."

The building that James Burbage appropriately christened the Theatre still had the large round open-air arena of the baiting pit, now paved and with drains to carry off rainwater. Surrounding the arena were three super-

imposed rows of galleries. The spectators numbered altogether about three
thousand. Most paid a penny to stand in the yard, others paid twopence or
more for a seat in the galleries or boxes. The players, no longer crowded
onto an improvised booth on stage, now enjoyed a large permanent stage
with changing rooms behind, and a gallery above for a lord's room and
musicians. The roofed changing rooms supported a "hut" on its fourth story
to hold suspension gear so angels or other players could fly down to the
stage. An open-air arena on this plan was called a "public" theater. The
alternative, the "private" theater, with a usual capacity of about seven
hundred, was an indoor structure like the great halls of the Inns of Court
and the Oxford and Cambridge colleges, adapted from the Tudor domestic
hall. A low stage protruded into the room where benches accommodated
the spectators. In the larger of these "private" playhouses there were three
galleries around the sides and the end. Spectators would be seated in the
pit, in galleries, or in boxes, and paid sixpence or more. Until about 1606,
only private playhouses were found within the City of London, and public
playhouses only in the suburbs.

Playhouses were open to all who had the price of admission. But while
public theaters attracted everyone, and drew mainly from the lower classes,
the private theaters with higher admission prices appealed to the better
educated. Publishers of plays tried to give their printed dramas a sophis-
ticated tone by indicating on the title page that the work had been prepared
for a "private" theater. The theater had its origins in performances at court,
as the continuing control by the Master of the Revels indicated, but the
audiences at the new theaters were anything but courtly. A sharp observer
in 1579 reported:

> In our assemblies at plays in London, you shall see such heaving, and shoving,
> such itching and shouldering to sit by women . . . that it is a right comedy to
> mark their behaviour, to watch their conceits. . . . Not that any filthiness in deed
> is committed within the compass of that ground, as was done in Rome, but that
> every wanton and his paramour, every man and his mistress, every John and his
> Joan, every knave and his queen, are there first acquainted and cheapen the
> merchandise in that place, which they pay for elsewhere as they can agree.

The frequent changes of program encouraged Londoners to come back to
the same theater again and again. As Shakespeare observed in the opening
chorus of *Henry V:*

> O! for a Muse of fire, that would ascend
> The brightest heaven of invention;
> A kingdom for a stage, princes to act
> And monarchs to behold the swelling scene.

> But pardon, gentles all,
> The flat unraised spirits that hath dar'd
> On this unworthy scaffold to bring forth
> So great an object: can this cockpit hold
> The vasty fields of France? or may we cram
> Within this wooden O the very casques
> That did affright the air at Agincourt?

In two weeks during the 1596 season a Londoner could have seen eleven performances of ten different plays at one playhouse, and on no day would he have had to see a repeat performance of the day before.

The burgeoning city theaters no longer provided profitable employment for amateurs. Playwriting had quickly become a growth industry and a profession. Of the twelve hundred plays offered in London theaters in the half century after 1590, some nine hundred were the work of about fifty professional playwrights.

Into this world came the young William Shakespeare (1564–1616) from Stratford-on-Avon. Son of a prominent and prosperous alderman, he seems to have had a solid elementary education at the grammar school, but he had not gone to the university. At the age of eighteen he married Anne Hathaway, twenty-six, of a substantial family in the neighborhood. They had a daughter and then twins, a boy and a girl. By 1592 he was acting in London, and was well enough known to invite the often-quoted sarcasm of Robert Greene, a prominent rival playwright. "There is an upstart crow, beautified with our feathers, that with his *Tygers heart wrapt in a Players hide* supposes he is as well able to bombast out a blank verse as the best of you, and, being an absolute Johannes Fac totum, is in his own conceit the only Shake-scene in a country." The first publication of this jack-of-all trades (fac totum) "upstart crow," William Shakespeare, was *Venus and Adonis* (1593), in the courtly mythological tradition, and dedicated to the Earl of Southampton.

> Call it not love, for Love to heaven is fled,
> Since sweating Lust on earth usurp'd his name;
> Under whose simple semblance he hath fed
> Upon fresh beauty, blotting it with blame;
> > Which the hot tyrant stains and soon bereaves,
> > As caterpillars do the tender leaves.
>
> Love comforteth like sunshine after rain,
> But Lust's effect is tempest after sun;
> Love's gentle spring doth always fresh remain,
> Lust's winter comes ere summer half be done.
> Love surfeits not, Lust like a glutton dies;
> Love is all truth, Lust full of forged lies.

He followed it the next year with his "graver labour," *The Rape of Lucrece,* another long poem dedicated to the earl. His best poetry, outside the plays, would be found in his 154 sonnets, published in 1609 and dedicated to a cryptic "Mr. W. H." But Shakespeare was most committed to the newly flourishing entertainment art. Despite his not entirely respectable occupation he became a gentleman in 1596, when the College of Heralds finally granted his father a coat of arms.

We know little else about Shakespeare's private life during these twenty years when he wrote the great body of drama and poetry against which all later creators of English literature would be measured. He prospered, and very soon, at his new occupation in London. By 1597 he was well enough off to buy the Great House of New Place, the second largest dwelling in Stratford. It was three stories high with five gables, on a city lot sixty by seventy feet. Within the next few years he also purchased a 137-acre tract near town for £230 cash, and invested the considerable sum of £440 in the lease of tithes. In 1613 he bought for speculation the Blackfriars Gate-House property in London. His remunerative loans and continuing litigation proved him a man of substance. Shakespeare became for a time the most popular playwright of the London stage. Prudent investments and his good reputation would enable him to leave his heirs a solid estate.

When the First Folio of Shakespeare's thirty-six plays was published in 1623, seven years after his death, eighteen plays appeared in print for the first time. Printing a play was a way of squeezing some profit from a playwright's work when it could not be acted because of the plague or when the stage version had failed. Players' companies guarded successful scripts against competitors. In 1598, when Sir Thomas Bodley began building the collection for the great Oxford library that still bears his name, he persuaded the Stationers' Company in London, which had a monopoly of English printing, to agree to send his library in perpetuity a copy of every book. But he cautioned his librarian in Oxford against collecting the "many idle books and riff-raffs . . . almanacs, plays, and proclamations," of which he would have "none, but such as are singular." Of plays, he explained, "hardly one in forty" was worth keeping.

Printing the texts of plays was a way of giving the theater and the new profession of playwright an aura of respectability. In 1616, when Ben Jonson, Shakespeare's rival, published a folio of his *Workes* it was the first time the collected plays of an English author had been published. The First Folio of Shakespeare in 1623 was only the second. Jonson was ridiculed for dignifying his plays as if they were serious literary "Workes." Plays printed before 1616 appeared in the unbound form common for almanacs and joke books. To print plays in a large handsomely bound folio as was done with

collections of sermons or ancient classics claimed a new longevity for the playwright's work.

Shakespeare's contemporary public were not readers but listeners. While our age of omnipresent print, and of photographic and electronic images, relies on the eye, Elizabethans were experienced and long-suffering listeners. Once in 1584, when Laurence Chaderton, Master of Emmanuel College, Cambridge, the town's preacher for a half century, had preached for only two hours the disappointed congregation cried out, "For God's sake, sir, go on! we beg you, go on!" He and others urged that listening was more profitable than reading. The spoken word brought "the zeale of the speaker, the attention of the hearer, the promise of God to the ordinary preaching of His Word . . . and many other things which are not to be hoped for by reading the written sermons." Those who lived by the spoken word made every sermon a performance. Reading the classic sermons of Shakespeare's contemporary John Donne (1573–1631), we miss the histrionic talent that kept his audiences on edge for hours.

Shakespeare could prosper only by pleasing these audiences. As Dr. Samuel Johnson would note on the opening of the Drury Lane Theater in 1747, "we that live to please must please to live." Shakespeare's posthumous fame proved a surprising coincidence of the vulgar taste of his time with the sophisticated taste of following centuries. For Shakespeare the claims of immortality were not pressing. It was more urgent to please contemporary London playgoers. Beginning in London as the actor who annoyed Robert Greene in 1592, he appeared as a "principal comedian" in Ben Jonson's *Every Man in His Humour* in 1598, and a "principal tragedian" in Jonson's *Sejanus* in 1603, and he continued to act until he retired to Stratford in 1611.

His acting talent also gave him an advantage in selling his plays. An Elizabethan playwright usually wrote a play to the order of a playing company, then read it to the actors for their approval. If his work was approved he was paid six pounds and his role was over. Some playwrights, like George Chapman, did not even go to see their plays performed. But Shakespeare, we are told, paid close attention to the production. By 1594 he was an acting member of the Lord Chamberlain's Company, which had its problems. In 1597 a seditious comedy, *The Isle of Dogs,* by Thomas Nashe and Ben Jonson led the Privy Council to shut all playhouses. Jonson and two of the actors were sent to prison. In 1598, when the theaters reopened, Shakespeare enjoyed a great success with *Henry IV,* Part One, introducing Falstaff. The company also did well with Jonson's *Every Man in His Humour,* in which Shakespeare acted.

When the company lost their lease at the Theatre they pooled the actors' resources to build a new theater across the Thames south of London. With

timbers from Burbage's dismantled historic Theatre they erected the new Globe Playhouse in July 1599. Taking the motto *Totus mundus agit histrionem* (A whole world of players), the Lord Chamberlain's Company flourished with its rich repertory by Shakespeare, Jonson, and others, despite increasing competition from new theaters and the boys' companies. Shakespeare himself held an investor's share and as an actor was entitled to another portion of the company's receipts, adding up to about 10 percent. His share fluctuated over the years. For the first time these actors had financed the building of their own theater. And the greatest English dramatist acquired a substantial stake in the popularity of his work in his own day. The public was becoming a patron.

On his accession, King James designated the former Lord Chamberlain's Company as the King's Company. Letters patent (May 19, 1603) expressly authorized nine of its members (including William Shakespeare and Richard Burbage) "freely to use and exercise the art and faculty of playing Comedies, Tragedies, Histories, Interludes, Morals, Pastorals, stage plays . . . as well for the recreation of our loving subjects as for our solace and pleasure." The company acted before the court six times during the next Christmas holidays.

Shakespeare continued to write and act for the King's Company at the Globe and in the Blackfriars, their "private" playhouse during winter. The Age of Shakespeare at the Globe had a dramatic end on June 19, 1613. During a gala performance there of Shakespeare's *Henry VIII* "with many extraordinary circumstances of pomp and majesty," the cannon discharged from the thatched roof to announce the entry of the king set fire to the thatch. "Where being thought at first but an idle smoke, and their eyes more attentive to the show, it kindled inwardly, and ran round like a train, consuming within an hour the whole house to the very ground. This was the fatal period of that virtuous fabric; wherein yet nothing did perish but wood and straw, and a few forsaken cloaks; only one man had his breeches set on fire, that would perhaps have broiled him, if he had not by the benefit of a provident wit put it out with bottle ale." By the following spring the prosperous members of the King's Company, including Shakespeare, had paid for having the Globe "new builded in a far fairer manner than before." But Shakespeare, who now owned a fourteenth share in the enterprise, had retired to Stratford. Within his twenty-year London career he had produced the poems and plays that made him the idol of English literature. The English-speaking community in all future centuries would be united by familiarity with "the Bible and Shakespeare."

Shakespeare had arrived at a crucial moment for a creator's collaboration with the city audience. The city theater, as we have seen, had just now

provided new incentives and opportunities to reach out to a listening public hungry for entertainment. The reborn spectator offered the literary man a new chance for feedback, which meant a new stimulus and a new resource for creators. In the soliloquy itself, a newly developed literary convention, the actor shared his private thoughts with the audience. We hear the hesitating Hamlet blame himself:

> O! that this too solid flesh would melt,
> Thaw and resolve itself into a dew;
> Or that the Everlasting had not fix'd
> His canon 'gainst self-slaughter! O God! O God!
> How weary, stale, flat, and unprofitable
> Seem to me all the uses of this world.
> Fie on it! O fie! 'tis an unweeded garden
> That grows to seed; things rank and gross in nature
> Possess it merely. . . .
>
> (I, ii)

The sense of nationhood, inspired by a vigorous virgin queen and by a generation of world explorers, challenged by a formidable Spanish rival, was enriched by a national vernacular recently conscious of itself. As John of Gaunt boasts in *Richard II:*

> This royal throne of kings, this scepter'd isle,
> This earth of majesty, this seat of Mars,
> This other Eden, demi-paradise,
> This fortress built by Nature for herself
> Against infection and the hand of war,
> This happy breed of men, this little world,
> This precious stone set in the silver sea,
> Which serves it in the office of a wall,
> Or as a moat defensive to a house,
> Against the envy of less happier lands,
> This blessed plot, this earth, this realm, this England. . . .
>
> (II, i)

By reaching recklessly out to imaginary creations of other times and places the Elizabethan stage violated the traditional canons of Aristotle's *Poetics,* which still insisted on the duty of all artists to imitate nature. "Art imitates nature as well as it can," observed Dante, "as a pupil follows his master, thus it is a sort of grandchild of God." These Aristotelian unities of time, place, and action would make the unreality of the stage less disturbing. And a play *read,* it was said, "hath not half the pleasure of a Play *Acted:* for . . . it wants the pleasure of Graceful Action."

Sir Philip Sidney expressed the liberated Elizabethan spirit in his *Apologie for Poetrie* (1580; published, 1595):

> Only the poet, disdaining to be tied to any such subjection, lifted up with the vigor of his invention, doth grow in effect another nature, in making things either better than nature bringeth forth, or, quite anew, forms such as never were in nature. . . . Nature never set forth the earth in so rich tapestry as divers poets have done. . . . Her world is brazen, the poets only deliver a golden.

And he translated the plain biblical theology into literature: man the creator fulfilling the image of his Creator. "Neither let it be deemed too saucy a comparison to balance the highest point of man's with the efficacy of nature; but rather give right honor to the heavenly Maker of that maker, who, having made man to his own likeness, set him beyond and over all the works of that second nature: which is nothing he showeth so much as in poetry."

The dramatist, no longer to be blamed for "deceiving" his audience by misrepresenting nature, should be applauded, for "that which they do, is not done to *Circumvent,* but to *Represent,* not to *Deceive* others, but to make others *Conceive.* " In the next century John Dryden would actually defend the dramatist's mission as a welcome kind of "deception." Sidney's *Apologie for Poetrie* had been a prophetic defense of the poet's power to reach *in,* to carry the listener into the playground of his personal imagination. For the poet mere imitation (*mimesis*) was not enough. Writing before any of Shakespeare's plays had appeared, while still defending the Aristotelian unities, he deplored the poor products on the London stage.

We do not know that Shakespeare ever read Sidney. But Sidney's declaration of independence from the imprisoning archetype of nature spoke for Shakespeare, too, and opened a world for the adventuring word. This new stage, this new scene of collaborative conception and deception, Shakespeare peopled beyond even Sidney's imagining. The poet and his audience would journey inward to bizarre new worlds where creation somehow preceded conception. The spectator was no longer a mere victim but a full collaborator, without whom the poets' work was unfulfilled. The vast new world within, a new "nature" of the poets' own creation, stretched infinitely in all directions.

With prodigious energy Shakespeare used all the conventions of his age in this joint exploring-creating expedition. He started with light comedy, *The Comedy of Errors, The Taming of the Shrew, Love's Labour's Lost,* and the tragedy of *Romeo and Juliet.* He explored the recent history of the Wars of the Roses in the three parts of *Henry VI.* He depicted the tragedies of earlier English history in *Richard II* and *Richard III,* in the adventures of *Henry IV* and *Henry V.* He mined the grandeur, romance, and tragedy of

ancient Rome in *Julius Caesar, Antony and Cleopatra,* and *Coriolanus.* He elaborated comedies from the Italian—*The Merchant of Venice* and *Much Ado about Nothing*—and invented the fantasy of *A Midsummer Night's Dream.* He reshaped fragments of history and folklore into triumphant tragedies—*Hamlet, Othello, King Lear,* and *Macbeth.*

The limits imposed by Elizabethan society Shakespeare somehow made into his opportunity. For the dramatist still dared not comment explicitly on the politics or mores of his own age. Not until the theater would be freed from the whims of the Master of the Revels and the Privy Council could there be serious dramas of contemporary life on the London stage. Ironically, Hamlet and Lear and Macbeth would remain alive for alien centuries, precisely because Shakespeare's inhibitions saved him from recounting topical problems in familiar settings. He would reach out to us, and take us inward with him to enjoy the Human Comedy in exotic costumes and on remote scenes, equally enticing to the Elizabethan theatergoer and to us.

While we can never solve the mystery of Shakespeare, we do know enough about him and his work to dispose of some easy generalizations. For example, the temptation bred on the Left Banks of the world to identify the creator's genius with instability, or even with madness. Shakespeare's life makes us pause at Proust's self-serving declaration that "everything great comes from neurotics. They alone have . . . composed our masterpieces." Shakespeare's contemporaries seemed agreed on his good-natured equanimity. It is hard to believe he was bland. But Charles Lamb and others have found it "impossible to conceive a mad Shakespeare." Did he have "the sanity of true genius"? Among quarrelsome competing playwrights, he avoided the acrimony that drew his rival Ben Jonson into a murderous duel with a fellow actor and sent him to prison for a seditious play. Called the amiable "English Terence," he was widely praised for "no railing but a reigning wit." Still, during Shakespeare's lifetime, Ben Jonson exceeded him in reputation and it was Jonson, not Shakespeare, whom the king appointed poet laureate with a substantial pension in 1616.

Had Shakespeare not enjoyed the affection of his fellow actors his plays might not have survived. About three fourths of the prolific output of playwrights in his lifetime has disappeared. But Shakespeare's fellow actors, as a token of friendship to him, did us the great service of preserving the texts of his plays when they arranged publication of the First Folio in 1623. What other playwright of that age was so well served by his fellows? The First Folio Shakespeare, the compilers explained, was published not for profit but "only to keep the memory of so worthy a friend and fellow alive as was our Shakespeare." In his Ode addressed "to the Memory of My Beloved Master William Shakespeare," Jonson's praise for the "Sweet Swan

of Avon," expressed a general view. Shakespeare's professional life, in a turbulent age, was conspicuously placid. Except for the "dark lady of the sonnets," we know of no unrequited loves, no Beatrice or Fiammetta! Still, amiable legends circulated which had the ring of truth and the appeal of Shakespearean wit, and which idolatrous biographers would have trouble explaining away. One was a stage-door anecdote noted for March 13, 1601, in the diary of a London student:

Upon a time when [Richard] Burbidge played Richard III there was a citizen grew so far in liking with him that, before she went from the play, she appointed him to come that night unto her by the name of Richard the Third. Shakespeare, overhearing their conclusion, went before, was entertained and at his game ere Burbidge came. Then, message being brought that Richard the Third was at the door, Shakespeare caused return to be made that William the Conqueror was before Richard the Third.

Shakespeare's proverbial fluency was praised by his fellow actors in their preface to the Folio. "His mind and hand went together, and what he thought, he uttered with the easiness that we have scarce received from him a blot in his papers." But Jonson, a laborious writer who left only a fraction of Shakespeare's output, years later still nursed resentment that the players should have "mentioned it as an honor to Shakespeare, that in his writing . . . he never blotted out a line. My answer hath been, 'Would he had blotted a thousand!' "

Unlike other great creators of the human comedy, Shakespeare never left his home country. Even in England he traveled little, and had no public life outside his profession. He had a meager formal education, "small Latin and less Greek," and showed no learned idiosyncrasy in his reading habits. His best resource was probably in the classic curriculum of the Elizabethan grammar school he attended, reinforced by the reading habits of any literate Elizabethan. Like Boccaccio and Chaucer before them, the writers of Shakespeare's age did not aim at "originality." They were accustomed to borrow, embellish, elaborate, and revise Homer, Ovid, Cicero, Virgil, Plutarch, among others, and the abundant classical myths and legends. None of Shakespeare's plays told a thoroughly original story. As an actor, Shakespeare made his living and stocked his memory with works of other playwrights. He seems to have been well read too in contemporary English authors. The narrow scope and traditions of his elementary education focused his imagination. He felt no uneasiness at drawing on these others and on his own earlier works, or simply translating into blank verse Holinshed's *Chronicles* or North's *Plutarch*. His *Julius Caesar, Coriolanus,* and *Antony and Cleopatra* showed a faithfulness to their Plutarchean source

that might worry later pursuers of originality. When Ben Jonson ridiculed Shakespeare's lack of classical learning, one of Shakespeare's champions retorted "That if Mr. Shakespeare had not read the Ancients, he had likewise not stollen any thing from 'em; (A Fault the other made no Conscience of)."

The better-documented Ben Jonson provided a perfect foil for our Shakespeare. The robust and irritable Jonson, insecure stepson of a bricklayer, was proud of his learning, and of the sponsorship of the pedantic William Camden. In his plays he took up and developed the popular psychology of "humours." With explicit theories he professed to do his best to follow the classical rules and apologized, as in *Sejanus,* when he violated them. His most durable play, *Volpone,* applied the simplistic theory that each character should express a dominant humour. While Shakespeare, too, briefly experimented with this theory (in *Timon of Athens*), his achievement was to liberate the theater from such conventions and formulas. Jonson explained in the Prologue to *Every Man in His Humour,*

> Though need make many poets, and some such
> As art and nature have not bettered much;
> Yet ours, for want, hath not so loved the stage,
> As he dare serve th' ill customs of the age. . . .
> One such, today, as others plays should be;
> Where neither chorus wafts you o'er the seas,
> Nor creaking throne comes down the boys to please . . .
> But deeds and language such as men do use,
> And persons such as Comedy would choose,
> When she would show an image of the times,
> And sport with human follies, not with crimes. . . .

Shakespeare's characteristic response was an *Antony and Cleopatra,* which violated all classical rules and offered thirty-two changes of scene across the remote and ancient world.

Nothing was more remarkable about Shakespeare than his afterlife. Within a half century after his death, in 1668, John Dryden intoned the paean of posterity.

> . . . he was the man who of all Modern and perhaps Ancient Poets, had the largest and most comprehensive Soul. All the Images of Nature were still present to him, and he drew them not laboriously, but luckily: when he describes any thing, you more than see it, you feel it too. Those who accuse him to have wanted learning, give him the greater commendation: he was naturally learned; he needed not the spectacles of Books to read Nature: he looked inwards, and found her there.

"I am proud," Coleridge boasted in 1811, "that I was the first in time who publicly demonstrated . . . that the supposed irregularities and extravagances of Shakespeare were the mere dreams of a pedantry that arraigned the eagle because it had not the dimensions of the swan." And he saw that "on the Continent the works of Shakespeare are honoured in a double way; by the admiration of Italy and Germany, and by the contempt of the French."

For the cult of Shakespeare, which has had its ups and downs but never died, George Bernard Shaw in 1901 invented the word "bardolatry." The cult flourished too in Tocqueville's America, this land of the equality of conditions, where frontier wits made burlesques of Shakespeare a staple for raw communities. "The literary inspiration of Great Britain darts its beams into the depths of the forests of the New World," Tocqueville noted in 1839. "There is hardly a pioneer's hut which does not contain a few odd volumes of Shakespeare. I remember reading the feudal drama of Henry V for the first time in a log cabin."

36

The Freedom to Choose

MILTON'S *Paradise Lost* would do for his age, and perhaps for modern times, what Dante's *Divine Comedy* had done for the Middle Ages. The writings and life of John Milton (1608–1674) were as redolent of the challenges, promises, and frustrations of the modern Christian West as were Dante's of the certitudes of medieval Christendom. Milton saw a world of wider, more varied alternatives. His special contribution to the composite human comedy was to create poetry and prose of the pains, rewards, and vagaries of man's adventures in choice—"to assert eternal Providence and justify the ways of God to man." And he could not have created a motif more expressive of the nation whose struggle for law and the citizen's right to choose reached a climax in his time.

Milton's fortunate circumstances gave him the opportunity for self-education, without which his creations in poetry and prose would have been impossible. Born in London into a family of comfortable means, he had a father who loved learning and composed music. "My father destined me in

early childhood for the study of literature," Milton recalled, "for which I had so keen an appetite that from my twelfth year scarcely ever did I leave my studies for my bed before the hour of midnight." At St. Paul's School he learned Latin, Greek, and Hebrew, which his father supplemented by tutors in other languages at home. Milton's phenomenal talent for languages would enrich his own writing from the best authors of ancient and modern European literature. "When I had thus become proficient in various languages and had tasted by no means superficially the sweetness of philosophy, he sent me to Cambridge." From his father he inherited, too, an obstinate Protestant disposition. His grandfather had been a firm Roman Catholic, and when Milton's father turned Protestant he had been disinherited. Milton himself never ceased to write of his own father with tenderness and gratitude for having inspired his epic vocation.

At Cambridge, Milton worked hard but found it "disgusting to be constantly subjected to the threats of a rough tutor and to other indignities which my spirit cannot endure." After a quarrel with a tutor who actually whipped him he was sent down from Christ's College. He enjoyed this brief literary "exile," and even after returning to college he most enjoyed the "literary retirement" of the Long Vacations. Receiving his bachelor's and master's degree, he spent six years with his family at their house in Hammersmith, a London suburb, and then at the quiet village of Horton, on his own course of reading to repair the pedantries of Cambridge. His younger brother, Christopher, had just become a law student at the Inner Temple, but his father saved him from that fate. "For you did not, father, order me to go where the broad way lies, where opportunities for gain are easier and the golden hope of accumulating money shines steadily. Nor did you force me to study law and the ill-guarded legal principles of the nation." Instead, "I devoted myself entirely to the study of Greek and Latin writers, completely at leisure," with occasional trips to the city "to purchase books or to become acquainted with some new discovery in mathematics or music."

If Milton had a premonition that he would be totally blind for the last twenty-three years of his life, he could not have better used his first thirty years, acquiring the languages and harvesting the literatures of Western Europe in his prodigious memory. But this voracious, round-the-clock reading from the age of twelve, he later said, was "the first cause of injury to my eyes." On his grand tour he met the learned elite of France and Italy, who were impressed by his facility in their languages. They found his poems in Latin and Italian remarkably good work for an Englishman.

His notable experience was meeting two famous victims of tyranny. In Paris he had "ardently desired to meet" Hugo Grotius (1583–1645), the great Dutch humanist and founder of the modern science of international law. In his homeland Grotius had been sentenced to life imprisonment for his

political views and for taking the wrong side in a Calvinist dispute over free will. After a sensational escape from prison in a box of books, Grotius had found refuge in Paris as Queen Christina's ambassador. In Florence Milton sought out, "found and visited the famous Galileo grown old, a prisoner to the Inquisition for thinking in astronomy otherwise than the Franciscan and Dominican licensers thought."

Returning to England in July 1639, a newly self-conscious Englishman, he imagined fulfilling his literary destiny by an epic poem about the legendary King Arthur. But King Arthur, too, had become politically controversial. For King James I (reigned, 1603–25), by claiming descent from King Arthur, had tried to legitimize himself as the fulfillment of an ancient prophecy. Milton would have to find his epic theme elsewhere.

Even before leaving England he would have merited a place in a select anthology of English poetry. He had already written *Comus* (1634) and the elegy "Lycidas" (1637), some of his best short poems, sonnets, and the lyrics "L'Allegro" and "Il Penseroso," with their counterpoint themes. In "L'Allegro," the haunting lines call out:

> Hence, Loathèd Melancholy,
> Of Cerberus and blackest Midnight born,
> In Stygian cave forlorn
> Mongst horrid shapes, and shrieks, and sights unholy
> Find out some uncouth cell
> Where brooding darkness spreads his jealous wings
> And the light raven sings

"Il Penseroso" gloomily admonishes:

> Hence, vain deluding Joys
> The brood of Folly without father bred
> How little you bested
> Or fill the fixed mind with all your toys

His tribute to Shakespeare had been included in the Second Folio of Shakespeare's works (1632). But for the next twenty years (1640–60) he would spend his literary energies on prose.

The polemic arising out of Milton's own unlucky marriage first brought him public notice. His pamphlet on divorce, too, was in substance a plea for the freedom to choose. His early Latin elegies and sonnets at Cambridge had idealized the love of man and woman, and he boasted that he had successfully resisted the sexual seductions of Paris. But he proved inept at living out his ideal. In 1642, still unmarried at thirty-three, he met Mary Powell,

the seventeen-year-old daughter of a royalist Oxfordshire businessman to whom Milton's father had lent a substantial sum. Milton instantly fell in love. The senior Powell not only paid the twelve pounds of interest due on the loan but also a dowry of one thousand pounds, and offered his daughter too. Married after only a month's acquaintance, Milton took his young bride back to his modest house in London and the quiet life of a private tutor.

For young Mary it was a shocking change from her family's large country house near convivial Oxford. She could not bear hearing the pupils whipped for disobeying, and, a stranger to the world of books, Mary felt bored and homesick. In mid-August the new bride left to "visit" her parents. Meanwhile the brewing Civil War had embittered her hasty marriage by violent antagonism between the ardent royalist Powells and the passionate Parliamentarian John Milton. Three years passed before Mary was persuaded to return to her husband.

Though staggered by the desertion of his idealized bride of a month, Milton never wrote about these personal feelings. Instead he published his first pamphlet—*The Doctrine and Discipline of Divorce: restored to the good of both sexes, from the bondage of Canon Law, and other mistakes, to Christian freedom, guided by the rule of Charity.* English law at the time admitted adultery as the only ground for divorce. Milton might have covered his own case by urging the addition of desertion as a legal cause. Instead he took off from the grand proposition "That Man is the occasion of his own miseries, in most of those evils which he imputes to God's inflicting." Without a spiritual compatibility, "instead of being one flesh, they will be rather two carcasses unnaturally chained together." Milton addressed Parliament to make incompatibility a cause for divorce. Of course, he admitted, liberty of divorce could be abused in England as it had been by the ancient Jews. But always "honest liberty" is "the greatest foe to dishonest license." Indissoluble marriage had become "the Papists' Sacrament and unfit marriage the Protestants' Idol." A marriage contrary to the desire of the partners was only bondage. Milton's crusade would continue into the twentieth century, when the witty English lawyer A. P. Herbert attacked this "Holy Deadlock" (1934), which another wit defined as "Monagony—the state of being married to one person."

Milton's little tract on divorce sold twelve hundred copies within six months and brought him notoriety as author of a lewd book. Despite the large sale, few would confess to reading it, which led Milton to introduce the second edition with a motto from Proverbs (18:13), "He that answereth a matter before he heareth it, it is folly and shame unto him."

While the Mary Powell debacle left its mark on Milton, it never soured him on marriage. She died a few days after the birth of their daughter in

1652. In 1656 Milton married Katherine Woodcock, who also died in child-birth two years later. His third marriage in 1663, when he was fifty-five, to the attractive twenty-four-year-old Elizabeth Minshull of "a peaceful and agreeable humour," proved idyllic.

But Milton's relation to his daughters was a misery. The eldest, Anne, crippled and with a speech defect, never learned to write her own name. Instead of sending her sisters Mary and Deborah to school, Milton hired private tutors. For reasons of his own he taught them to pronounce Latin, French, Italian, Spanish, Greek, and Hebrew. Though they never understood these languages, in their teens they could pronounce the words well enough to read aloud to their father. Mary so detested her father that when she heard the news of his impending third marriage she regretted it was not news of his death. Milton's notorious quip—"One tongue is enough for a woman"—was his way of shrugging off his daughters' pains. While he was daily exploiting the unhappy obedience of his daughters, he was at the same time writing his tragedy "of man's first disobedience."

Since Milton's thesis on the liberty of divorce has become commonplace, his little book has ceased to be read. But twentieth-century totalitarianism has made his eloquent fifty-page pamphlet, *Areopagitica* (1644), on freedom of the press newly relevant.

The vulgar reaction to his English-language book on divorce made Milton wish he had written it in Latin, and he gave Greek titles to his next pamphlets. The meaning of *Areopagitica* would be clear enough to the readers he wanted to reach. Named after Areopagus, the hill near the Acropolis where the governing council of ancient Athens met, it was cast as an oration. "Speech of Mr. John Milton for the Liberty of Unlicensed Printing to the Parliament of England," it recalled the successful plea of Isocrates to reform the system of government. Milton pleaded for reform in England to liberate the book.

> For books are not absolutely dead things, but . . . do preserve as in a vial the purest efficacy and extraction of that living intellect that bred them. I know they are as lively, and as vigorously productive, as those fabulous Dragon's teeth; and being sown up and down, may chance to spring up armed men. And yet on the other hand unless wariness be used, as good almost kill a Man as kill a good Book; who kills a Man kills a reasonable creature, God's Image; but he who destroys a good Book, kills reason itself, kills the Image of God, as it were in the eye. Many a man lives a burden to the Earth; but a good Book is the precious life-blood of a master-spirit, embalmed and treasured up on purpose to a life beyond life.

Licensing had been used by popes and the hated Inquisition, while Moses, Daniel, Saint Paul, and the Church Fathers had preached the free pursuit

of learning. "Prove all things, hold fast to that which is good." "Promiscuous" reading was actually necessary for the discovery of virtue. "As therefore the state of man now is, what wisdom can there be to choose, what continence to forbear, without the knowledge of evil? He that can apprehend and consider vice with all her baits and seeming pleasure, and yet abstain, and yet distinguish, and yet prefer that which is truly better, he is the true warfaring Christian." Without that freedom there could be no increase of knowledge. Since, as Francis Bacon noted, "authorized books are but the language of the times," the censor's task is "to let pass nothing but what is vulgarly received already."

Despite Milton's eloquence the licensing act was not repealed. But the issue remained alive and Milton's plea became an endless refrain. Jefferson made Milton one of his heroes and always put the *Areopagitica* on his reading list for young disciples. Mirabeau echoed it in his pamphlet on freedom of the press in 1788.

Milton's next classic tract appealed for the freedom of people to choose their rulers. Prepared during the trial of King Charles I, it was published only two weeks after the king's execution on January 30, 1649. "The Tenure of Kings and Magistrates, proving That it is Lawful, and hath been held so through all ages, for any, who have the power, to call to account a tyrant, or wicked King, and after due conviction, to depose, and to put him to death; if the ordinary magistrate have neglected, or denied to do so." Forceful but not strikingly original, he compounded ancient and modern political theorists with the Bible and prophets of the Reformation. In a calm, reasoned, and scriptural defense of the regicides, he addressed a first and second *Defence of the English People* to readers on the Continent. These works all lived on in the arsenal of free government.

While Milton saw himself as champion of "the freedom to choose," Cromwell's Council of State saw him as spokesman of their new republican orthodoxy. In 1649 they rewarded him for services rendered and engaged him as their secretary for foreign tongues. Milton's first commission was to reply to the sentimental and vastly popular *Eikon Basilike,* which purported to be King Charles I's own record of his inward thoughts during his last suffering days and hours. That book, speeding through sixty editions in a year, threatened the survival of the new government founded on the beheading of the king. Milton's lengthy *Eikonoklastes* attacked the sanctimonious king. For this Milton was rewarded with new lodgings and an apartment in Whitehall with the government's inner circle.

Milton's personal limitations appeared in his scheme *Of Education* (1644), one of the last manifestos of Renaissance humanism. Leaving the pupil little freedom of choice, he proposed to train gentlemen to be scholar-leaders and "to perform justly, skillfully and magnanimously all the offices

both private and public of peace and war." After the Greek and Latin classics came Italian "easily learnt at any odd hour" supplemented by Hebrew, Chaldean, and Syriac. His plan for the years from twelve to twenty-one did not include the university. But it did include fencing, "the solemn and divine harmonies of Musick," and regular walks in the country. "The end then of learning is to repair the ruins of our first parents by regaining to know God aright, and out of that knowledge to love him, to imitate him, to be like him." Unfortunately, when Milton applied his "system" to educating his two nephews, the result was not impressive.

"Ever in my great Taskmaster's eye," Milton remained the defender of liberty until the very last moment, and at great risk. After the death of Oliver Cromwell in 1658, England fell into anarchy amid clamor to restore the monarchy. By 1660 the restoration of the executed king's son, Charles II, seemed inevitable. And only a month before the Parliament's invitation to Charles II to return to the throne, Milton published a revised edition of his *Ready and Easy Way to Establish a Free Commonwealth and the Excellence thereof, with the Inconvenience and Dangers of Readmitting Kingship in this Nation.* This might have been his own death warrant, for the Restoration would surely bring revenge against all Commonwealth men. The bodies of Cromwell, of John Bradshaw, the judge who pronounced sentence on Charles I, and Henry Ireton who had signed the execution warrant were disinterred and hanged at Tyburn. The Commonwealth leader Henry Vane was executed for treason, and in a paroxysm of royalist enthusiasm, the Parliament condemned thirty-two persons to death, and twenty-seven to lesser punishments. What would be Milton's fate?

Milton went into hiding, but was found and confined in the Bedford county jail. Another inmate, twenty years younger than Milton, was John Bunyan, the unschooled son of a tinker, imprisoned for preaching without a license. Bunyan would remain there for twelve years because he would not agree to stop preaching. During this time Bunyan wrote his autobiographical *Grace Abounding* and eight other books. Milton, rescued by his friends, and more fortunate or more compromising, was soon released. Parliament granted him an official pardon for all his past offenses. But Milton's books were to be burned by the hangman, and all further sale or publication of them was prohibited.

By 1651 Milton was totally blind from the affliction that had been creeping on him since his youth. And his affliction helped save him from punishment by the royalist Parliament. Now his pious enemies were willing to "leave him under the rod of correction, wherewith God hath evidenced His particular judgment by striking him blind."

The Restoration proved a blessing for English literature. It gave Milton, only forty-two and in full talent, the opportunity to fulfill the epic ambition

that he had been nursing since his grand tour. If the great issues of the constitution and of toleration had not been settled, if the caldron of vituperation had not stopped boiling while Milton was mature and productive, he might have spent himself in more pamphleteering polemics. But the Restoration removed Milton from the arena into which he had descended with such enthusiasm.

Long before the Restoration, Milton had suspected that his blindness might have been the divine punishment for his libertine and heterodox beliefs. Some of the "ancientest and wisest" poets and philosophers also had been blind. Yet he could not find the sin that would justify this punishment. "I call upon Thee, my God, who knowest my inmost mind and all my thoughts, to witness that. . . . I am conscious of nothing, or of no deed, either recent or remote, whose wickedness could justly occasion or invite upon me this supreme misfortune."

"Not blindness," Milton said, "but the inability to endure blindness is a source of misery." As he concludes his reflective sonnet "When I consider how my light is spent":

> . . . God doth not need
> Either man's work or his own gifts; who best
> Bear his mild yoke, they serve him best.
> His state is kingly; thousands at his bidding speed,
> And post o'er land and ocean without rest;
> They also serve who only stand and wait.

Not even "this supreme misfortune" would deprive him of his freedom to create as he chose. For blindness too would nourish inwardness and inspiration. Having suffered without clear reason, he had a personal incentive to "assert Eternal Providence, And justify the ways of God to men." He organized his life into a productive routine. Rising at four o'clock most of the year, and five o'clock in winter, he had a man read the Hebrew Bible to him for about a half hour. Then he contemplated. At seven his amanuensis returned for dictation. If the reader was late, Milton would complain, "I wanted to be milked." All morning would be spent in dictating or being read to. After dinner at noon he walked, sometimes for three or four hours, depending on the weather. He always had a garden. If he could not go out he exercised in a swing, which he kept in motion by a rope attached to a pulley. For recreation he played on his organ or the bass viol. Evenings he liked to listen to "some choice poets" for refreshment, and "to store his fancy against morning." If there were visitors he would talk with them in his study between six and eight, then went downstairs to supper. Before retiring, usually at about nine o'clock, he smoked his pipe and drank a glass of water.

To compose a long epic like *Paradise Lost* when he could not write it down himself required, besides everything else, a prodigious memory. Milton's powers of memory, he often noted, put him in the tradition of Homer and the other blind poets and seers of antiquity. He compared himself with mythological figures like Tiresias, to whom Zeus gave long life and the powers of prophecy after Hera had struck him blind for seeing Athena bathing.

When his reader-amanuensis was not there Milton still managed somehow. Children of friends or aged friends themselves were eager to hear Milton's wisdom in response to their reading. He might be irritated at the reader's inability to pronounce Italian to his taste, but he seemed grateful, and sometimes even jovial. Dictating, he sat relaxed in his easy chair with one leg flung over the arm. From his pregnant memory he would dictate "many, perhaps forty lines as it were in one breath, and then reduce them to half the number." In winter he frequently composed lying in bed.

Now Milton was free to focus his talents inward to compose his life's epic ambition. The vernacular, "the language of housewives," which Dante had felt it necessary to defend for his epic, now was quite natural for a patriotic Englishman. Dante had painfully disciplined himself with terza rima. But in English literature, by Milton's day, Shakespeare and other dramatists had shown the liberating powers of blank verse. Milton would enjoy this freedom too. Since "blank verse" (lines of iambic pentameter that are unrhymed and hence called "blank") is close to the natural rhythms of English speech, it is easily adapted to all moods and all levels of discourse.

Dante, we have seen, had explained that his *Comedy* was so called because it inevitably had a happy ending—in the movement upward from Hell, through Purgatory, to the empyrean Paradise. And Dante chronicled an unambiguous universe of sharp distinctions, of levels of virtue and vice, where the dramatic spectacle was not the choices but the consequences of vice or virtue. Milton's *Paradise Lost* was surely not a comedy. He described tragedy "as it was anciently composed . . . the gravest, moralest, and most profitable of all other poems," and found his great examples in Aeschylus, Sophocles, and Euripides. Though *Paradise Lost* was not designed for the stage, it still could be called tragedy, revealing "Tears such as angels weep." The drama and suspense came from momentous choices by God, by Satan, by Eve, by Christ Himself—and, of course, by Adam. In his opening lines Milton explained that the loss of Paradise was the consequence of the wrong choice made by the first man, which he made the theme of his epic:

> Of man's first disobedience, and the fruit
> Of that forbidden tree whose mortal taste

> Brought death into the world, and all our woe,
> With loss of Eden, till one greater Man
> Restore us, and regain the blissful seat,
> Sing, Heavenly Muse. . . .

Western Europe, transformed in three and a half centuries by the Renaissance and the Protestant Reformation, had moved from a culture of consequences to a culture of choices. "Many there be that complain of divine Providence for suffering Adam to transgress. Foolish tongues! when God gave him reason, he gave him freedom to choose, for reason is but choosing; he had been else a mere artificial Adam. . . ." Milton would ring changes on this reminder of both God's gift and the price man had to pay.

After returning from his Grand Tour, Milton had sought forms for his epic and first seems to have thought of drama. He began composing *Paradise Lost* about 1655 and finished it about 1665. The first edition was published in 1667 in ten books. These were grim years for Londoners. The frightful plague, which had arrived early in 1665, by September had carried away more than twenty-six thousand victims. To avoid the plague, Milton moved out of town, but came back early in 1666. The Great Fire of London, which began to burn on the morning of September 2, after three days and nights had destroyed two-thirds of the city, including eighty churches, eleven thousand houses, and famous public buildings like St. Paul's Cathedral. Six months later parts of the city were still smoldering. The book trade of course suffered heavily.

Milton took the manuscript of *Paradise Lost* to the Simmons family, whose buildings had luckily escaped the fire and who had published for him before. They offered him an advance of five pounds with another five pounds to be paid when a first edition of fifteen hundred was sold, and for possible second and third printings of thirteen hundred copies, Milton was to receive an additional five pounds each. No edition was to be more than fifteen hundred copies. All future rights were assigned to the Simmonses. At most, with a spectacular sale of six thousand copies, Milton would net twenty pounds. At three shillings a copy, within two years the first printing was sold out. The book was registered and licensed, but some title pages bore only his initials instead of his name.

We have a hint of sales resistance in the fourteen pages added in a few months by the publisher. Along with errata and prose summaries of each of the ten books came Milton's defiant attack on rime as "no necessary adjunct or true ornament of poem or good verse (in longer works especially), but the invention of a barbarous age to set off wretched matter and lame metre." Blank verse did not aim to excel in the jingling sound of like endings, a fault avoided by the learned ancients both in their poetry and

oratory. "This neglect, then, of rime so little is to be taken for a defect, though it may seem so perhaps to vulgar readers, that it rather is to be esteemed an example set, the first in English, of ancient liberty recovered to heroic poem from the troublesome modern bondage of riming." Even Milton's prosody became a manifesto for liberty!

With no excessive modesty, Milton explained the superiority of his epic over both Homer and Virgil:

> Not less but more heroic than the wrath
> Of stern Achilles on his foe pursued
> Thrice fugitive about Troy wall; or rage
> Of Turnus for Lavinia disespoused,
> Or Neptune's ire or Juno's, that so long
> Perplexed the Greek and Cytherea's son
> (Bk IX, lines 14ff.)

The brief and cryptic Creation story in the Bible Milton elaborated into a long heroic poem focused on the decisions by the leading characters. How will Satan, Beelzebub and the rebellious angels avenge their defeat by God? Should they make war or find revenge through this new creature in a newly created world? When God sees that Satan will corrupt man, what will God do? But since man fell not by predestination but by Satan's seduction and man's own free will, how can man be saved? Will God accept a Savior's ransom? When we see the drama in Eden we wonder whether Adam and Eve will eat the forbidden fruit. Will the angel Raphael persuade Adam to obey? After the Son of God drives out the Satanic hosts, can man resist the seducer? Will the Maker give Adam a companion? And can she resist Satan, newly incarnated in the Serpent? Will Adam still obey, or will he share her sin to share her life? Will Adam and Eve have to leave Paradise? How will the Son of God save them? Expelled from the Garden, can they find "a paradise within"? Satan himself, whom many see as the hero of the work, on being thrust out of Heaven, makes his classic declaration of man's Freedom to Choose:

> Hail, horrors, hail
> Infernal world, and thou profoundest hell
> Receive thy new possessor, one who brings
> A mind not to be chang'd by place or time.
> The mind is its own place, and in itself
> Can make a heav'n of hell, a hell of heav'n.
> (Bk. I, lines 250ff.)

Dante makes us spectators of the final rewards and punishments. But Milton's epic of heroic choices shows us man tested, blessed, and cursed by

the gift of knowledge. God too reminds man that he lives a life of choice; and that his Fall is at his own will. For God would have no satisfaction in a blind obedience.

> Freely they stood who stood, and fell who fell . . .
> What pleasure I, from such obedience
> Paid when Will and Reason (Reason also is Choice),
> Useless and vain, of freedom both despoiled . . .
> They trespass, authors to themselves in all,
> Both what they judge and what they choose; for so
> I formed them free, and free they must remain
> Till they enthrall themselves . . .
> Self-tempted, self-depraved . . .
>
> (Bk. III, lines 102ff.)

And, though he lose Paradise he must face the tests of this world:

> The world was all before them, where to choose
> Their place of rest, and Providence their guide.
> They hand in hand with wandering steps and slow,
> Through Eden took their solitary way.
>
> (Bk. XII, lines 646ff.)

The world into which Milton led his readers was surely not for him a "place of rest." In June 1665 young Thomas Ellwood, his student helper, a faithful Quaker who had been imprisoned for his faith, had helped Milton and his family find refuge from the London plague. When Ellwood came to see him in August at Chalfont St. Giles about twenty-three miles outside London, Milton handed him a bulky manuscript to take home for his critical opinion. Returning the manuscript, Ellwood discussed the poem "modestly but freely," apparently without extravagant praise. "Thou hast said much here of paradise lost, but what has thou to say of paradise found?" Milton responded with *Paradise Regained* (1671), telling in blank verse the story of Christ in the wilderness. Though tempted by Satan, Christ, unlike Adam and Eve, never succumbed, and so paradise would be regained by Christ's strength, giving mankind a second chance.

Milton's long tragic poem *Samson Agonistes* (Samson the Champion; 1671), published with *Paradise Regained,* may have been written much earlier, even before Milton went blind. Now it had a plain autobiographical significance. A tragedy in the classic Greek form, it was never intended for staging. Milton still boasted that he had observed in it the Aristotelian unities, for the whole drama begins and ends "according to ancient rule and best example, within the space of twenty-four hours." Milton retells the

story from the Book of Judges, focusing on the last pitiable days of the
blinded Samson, who refuses to pardon the "manifest serpent" Delila.
Summoned to amuse the unsuspecting Philistines by his feats of strength,
he pulls down the pillars of their idolatrous temple, destroying them all
together with himself. Milton helps us follow Samson's inward progress
from blind despair to strength as God's champion:

> All these indignities, for such they are
> From thine, these evils I deserve and more,
> Acknowledge them from God inflicted on me
> Justly, yet despair not of his final pardon
> Whose ear is ever open, and his eye
> Gracious to readmit the suppliant;
> In confidence whereof I once again
> Defy thee to the trial of mortal fight,
> By combat to decide whose god is God,
> Thine or whom I with Israel's sons adore.
> (lines 1168ff.)

As Samson had been "Eyeless in Gaza at the mill with slaves," so Milton
found himself in London after the Restoration. After that, could Milton
have joined his Chorus, "calm of mind, all passion spent"?

Milton himself never sought the easy solace of a dogma someone else had
defined. He never became a professing member of any sect, never regularly
attended any particular church, nor observed any sectarian rites at home.
He lived out his belief that, since every man had divine guidance, each must
choose his faith for himself. Dr. Johnson would not forgive him for it.

Few poets have had a more checkered afterlife. Joseph Addison, in his
prosaic *Spectator* first hailed Milton's *Paradise Lost* "looked upon, by the
best Judges, as the greatest Production, or at least the noblest Work of
Genius, in our Language." The Romantic rebels, Blake and Shelley, de-
lighted to see themselves in his Satan. T. S. Eliot attacked Milton as one
whose sensuousness, dulled by blindness, had been "withered by book-
learning," and who wrote English "like a dead language." But few ever did
more to make that language live.

Sagas of Ancient Empire

THE saga of empire was added to the human comedy in 1776 with the first volume of Edward Gibbon's classic *Decline and Fall of the Roman Empire*. It was a time for thinking about empires. After a Seven Years' War Britain had secured Canada from France and Florida from Spain. Conquests in India had created a British Asian empire of unprecedented reach and power. Meanwhile, Britain's imperial wars had given North American colonists the opportunity and the desire to govern themselves. And in this seminal year Thomas Jefferson's American Declaration of Independence showed "a decent respect to the opinions of mankind" by explaining how and why future empires would decline. Gibbon (1737–1794) had had a safe gentlemanly taste of the wars for empire by serving at home defense under his father as captain in the Hampshire militia. As a member of the House of Commons, he witnessed the debates and supported Lord North's policies that would lose the American colonies.

In that Age of William Pitt, John Wilkes, and Edmund Burke, and the great debates over empire, we can be grateful that Gibbon was not a more political person. We might then have inherited a file of dreary state papers instead of the most read and most readable work of a modern historian. Luckily, too, Gibbon was entranced by the people who made history. If he had been more vulnerable to the glittering abstractions of his age he might have become an English Montesquieu, writing for scholars of political thought. If he had sought historical laws or cycles or found some single cause, he might have been bedside reading no more than Vico or Marx.

But Gibbon became the ultimate humanist historian, whose story is dominated by vivid but inscrutable persons. He begins with "The Age of the Antonines," in the first century and draws his narrative to a close with the coronation of Petrarch as poet laureate of Rome, the tribune Rienzi's short-lived efforts to restore the freedom and government of Rome, the return of the popes to Rome from the Babylonian captivity in Avignon and

their efforts to establish dominion over the nobles, and the conquest of Constantinople by "the great destroyer" Mohammed II in 1453.

Finally Gibbon humanized his own work as he recalled the night of June 27, 1787, between eleven and twelve when he wrote the last lines of the last page in the summerhouse of his garden in Lausanne. "I will not dissemble the first emotions of joy on recovery of my freedom, and, perhaps, the establishment of my fame. But my pride was soon humbled, and a sober melancholy was spread over my mind, by the idea that I had taken an everlasting leave of an old and agreeable companion."

A Ulysses on a voyage of his own devising, he somehow resisted the siren simplicities of his age, as he also avoided the deadly channels of respectable scholar-antiquarians. His focus on the human is heroic as he went the way of an amateur. Very early he conceived his love of his subject, and his comfortable station afforded him the leisure and the library. With no need for gainful employment he enjoyed a vagrant independence. Without wife or children, he remained a loner. Nor did he spend his energies consulting other scholars or traveling in search of manuscripts. Instead he relied heavily on his own books and his powers of reflection.

Born in 1737 at Putney in Surrey to a wealthy father who could afford to be a member of Parliament, he later reflected on his good luck. "My lot might have been that of a slave, a savage, or a peasant; nor can I reflect without pleasure on the bounty of Nature, which cast my birth in a free and civilized country, in an age of science and philosophy, in a family of honourable rank, and decently endowed with the gifts of fortune." The eldest of seven children, and the only one who survived infancy, he had no convivial family life. A sickly child, he withdrew into books. Neglected by his mother, who died when he was nine, he was nurtured by a bookish aunt who became "the true mother of my mind as well as of my health." As a boy he was charmed by ancient times and faraway places, especially by Pope's *Homer* and *The Arabian Nights,* "two books which will always please by the moving pictures of human manners and specious miracles." After his two years at Westminster School ill health required that he be instructed by private tutors. Various ailments sent him to physicians at Bath, and his father took him visiting country houses where he explored their antiquarian libraries. Already, he recalled, he "aspired to the character of an historian." "Instead of repining at my long and frequent confinement to the chamber or the couch, I secretly rejoiced in those infirmities, which delivered me from the exercises of the school and the society of my equals. As often as I was tolerably exempt from danger and pain, reading, free desultory reading, was the employment and the comfort of my solitary hours. My indiscriminate appetite subsided by degrees in the historic line. . . ."

Before his fifteenth birthday, when his father entered him as a student

at Magdalen College, he had read voraciously all the English books he could find on ancient history. "I arrived at Oxford with a stock of erudition that might have puzzled a doctor, and a degree of ignorance of which a school-boy would have been ashamed." His fourteen months there were "the most idle and unprofitable of my whole life." Founded in a barbarous age, the schools of Oxford, "steeped in port and prejudice," were "still tainted with the vices of their origin." Reading theology on his own at the age of sixteen, he led himself into the Roman Catholic Church, and to his father's horror was received into the Church by a priest in London in 1753.

Hastily seeking a cure for the boy's "spiritual malady," his father succeeded far better than he knew. What he devised as a punishing exile provided the educational base for the historian's great work. On the advice of a friend, Gibbon's father sent him to live with a Calvinist minister, Daniel Pavilliard, in Lausanne in Switzerland. And Gibbon recalled that without "my childhood revolt against the religion of my country," his life would have been quite different. "I should have grown to manhood ignorant of the life and language of Europe; and my knowledge of the world would have been confined to an English cloister. . . . One . . . serious and irreparable mischief was derived from the success of my Swiss education; I had ceased to be an Englishman. At the flexible period of youth, from the age of sixteen to twenty-one, my opinions, habits and sentiments were cast in a foreign mould; the faint and distant remembrance of England was almost obliterated; my native language was grown less familiar." Pavilliard proved the patient tutor, who helped him become bilingual in French, a master of Latin, and competent in Greek. By translating passages from Latin into French, then back into Latin, Gibbon could check his understanding of the original. In his leisure, too, he was "reviewing the Latin Classics under the four divisions of 1 Historians, 2 Poets, 3 Orators, and 4 Philosophers in a chronological series from the days of Plautus and Sallust to the decline of the language and Empire of Rome." He developed a special admiration for Cicero's character and style. Following "the precept and model of Mr. Locke," he kept notes on his sources, writing a critical essay on each of them. A great inspiration was hearing Voltaire declaim his own writings on the stage, and sharing "the wit and philosophy" of his table. Meanwhile he was diligently reading theology, and by Christmas 1754, to his father's relief, had led himself back into the Protestant communion.

In 1757, when he was just twenty, Gibbon fell in love with Susanne Curchod, whose "personal attractions . . . were embellished by the virtues and talents of the mind." The brilliant daughter of a penniless Protestant minister, she was not his father's idea of a suitable match. "On my return to England I soon discovered that my father would not hear of this strange alliance, and that without his consent I was myself destitute and helpless.

After a painful struggle I yielded to my fate: I sighed as a lover, I obeyed as a son: my wound was insensibly healed by time, absence, and the habits of a new life." He seems never again to have thought of marriage. What might have become of Gibbon if, instead of listening to his father, he had shared his life with the charming Suzanne? And perhaps have made a literary or political career on the Continent? Suzanne went on to marry the brilliant Jacques Necker, Louis XVI's minister of finance, and established one of the celebrated salons of modern Paris. *Their* daughter was the prolific author and saloniste Madame de Staël.

Years later, in his *Memoirs*, Gibbon still ascribed the "fruits" of his education "to the fortunate banishment which placed me at Lausanne." And his journal suggests what he meant by education. "In the three first months of this year [1758] I read Ovid's *Metamorphoses,* finished the conic sections with M. de Traytorrens, and went as far as the infinite series; I likewise read Sir Isaac Newton's *Chronology* [*of Ancient Kingdoms Amended* (1728)], and wrote my critical observations upon it." Back in England with the two things he loved most, his books and his leisure, he continued his wide reading for another five years.

But Gibbon was provoked when the French "degraded" their Academy of Inscriptions, the guardian of Greek and Latin culture, to the lowest rank among their three royal societies. His response, his first work, an *Essai sur l'étude de la littérature,* written in French and published in London in 1761, was "suggested by a refinement of vanity, the desire of justifying and praising my favourite pursuit." And it was prophetic of his lifework. "I was ambitious of proving by my own example, as well as by my precepts, that all the faculties of the mind may be exercised and displayed by the study of ancient literature." Again "like a pious son" he had yielded to his father's urging to publish this "proof of some literary talent." The family hoped it would help secure him a diplomatic appointment "as a gentleman or a secretary" to attend the scheduled peace congress of Augsburg. That congress never met. But Gibbon was not unduly discouraged that this loss of his "literary maidenhood" was received with cold indifference, was little read and speedily forgotten. He toyed with topics for an ambitious work of history. He considered a history of the liberty of the Swiss, but its materials were "locked in the obscurity of an old barbarous German dialect." Or a history of the Republic of Florence under the Medicis. "On this splendid subject I shall most probably fix; but *when* or *where,* or *how* will it be executed?"

Still searching for his subject, when England's war with France ended in 1763, he returned to the Continent on a belated grand tour. In Paris he met Diderot and d'Alembert, then revisited Lausanne, climbed in the Italian Alps, and toured the "tame and tiresome uniformity" of Turin, Milan, and

Genoa—toward "the great object of our pilgrimage," Rome. "I can neither forget nor express the strong emotions," he wrote twenty-five years later, "which agitated my mind as I first approached and entered the eternal city. After a sleepless night, I trod, with a lofty step, the ruins of the Forum; each memorable spot where Romulus *stood,* or Tully spoke, or Caesar fell, was at once present to my eye; and several days of intoxication were lost or enjoyed before I could descend to a minute and cool investigation." Inspiration for his lifework would not come from "cool investigation" but from lone intimate experience. "It was at Rome, on the 15th of October, 1764, as I sat musing amidst the ruins of the Capitol, while the barefooted friars were singing vespers in the Temple of Jupiter, that the idea of writing the decline and fall of the city first started to my mind." The motive could hardly have been more personal—concern not for the grand epochs of history but for the people and the story behind the poignant ruins where he sat. Characteristically, his "original plan was circumscribed to the decay of the city rather than of the empire."

But Gibbon did not plunge at once into his masterwork. The years after his return to England were intellectually vagrant, preoccupied with the declining health of his father. After his father's death in 1770 Gibbon came into his own, financially and intellectually. He set himself up in a house in Bentinck Street in London, with six servants, a parrot, and a Pomeranian. Though he had found "filial obedience" "natural and easy," he now enjoyed "the gay prospect of futurity."

> No sooner had I settled in my house and library, than I undertook the composition of the first volume of my *History.* At the outset all was dark and doubtful; even the title of the work, the true era of the Decline and Fall of the Empire, the limits of the introduction, the division of the chapters, and the order of the narrative; and I was often tempted to cast away the labour of seven years. The style of an author should be the image of his mind, but the choice and command of language is the fruit of exercise. Many experiments were made before I could hit the middle tone between a dull chronicle and a rhetorical declamation: three times did I compose the first chapter, and twice the second and third, before I was tolerably satisfied with their effect. In the remainder of the way I advanced with a more equal and easy pace. . . .

His fluency increased as he went on, and so did his self-confidence. But he remained concerned lest readers should doubt his spontaneity and independence. In his memoirs he insisted that for at least five of his six volumes his "first rough manuscript, without any intermediate copy, has been sent to the press. . . . Not a sheet has been seen by any human eye, excepting those of the author and the printer: the faults and merits are exclusively my own."

By 1775 he had been admitted to Dr. Johnson's select dining circle, which

included the painter Sir Joshua Reynolds and the actor David Garrick, with both of whom he became friendly. But for James Boswell, who found him "ugly, affected, disgusting," Gibbon "poisoned" the Literary Club.

Gibbon deserves more credit than he has received for his heroic resistance to the seductions of an age with a genius for oversimplification. Coleridge unwittingly reminds us of Gibbon's achievement when he blames him for failing to make "a single philosophical attempt . . . to fathom the ultimate causes of the decline or fall of that empire." When Gibbon declared that "the subject of history is Man," he was not mouthing a cliché but affirming his faith in the inscrutable being who is only partly intelligible to himself. His *Decline and Fall of the Roman Empire* was above all else a human comedy. And emphatically not what Montesquieu, Voltaire, and others meant when they said that history was "philosophy teaching by examples." Gibbon had a wholesome distrust of abstractions. His history did not consist of generalizations that the facts could illustrate but was the very texture of experience. That the greatest of modern historians had no "philosophy of history" was a secret of his greatness and his longevity.

Still, he did not always firmly resist. And in the final Chapters XV and XVI of his first volume he did yield to the simplifying temptation. These chapters on "The Progress of the Christian Religion," and "The Conduct of the Government towards the Christians" were his most controversial, attracting the greatest interest and exciting the most outspoken hostility. He listed "Five Causes of the Growth of Christianity": Zeal of the Jews, the Doctrine of the Immortality of the Soul among the Philosophers, Miraculous (but Contested) Powers of the Christian Church, Virtues of the First Christians, and the Christians Active in the Government of the Church. He offended by giving no place to the divinity of Christ or divine inspiration, and he outraged the pious by doubting the authenticity of the miracles and mischievously asking when the Church's miraculous powers had ceased. His "Causes" listed the human elements in the story.

The publisher had originally planned to print only five hundred copies of this first volume but doubled the number when he read the manuscript. Though attacked by some for its impious account of Christianity, the book was widely acclaimed by literary England. Gibbon enjoyed the approval by the "public" to whom he had committed his seven years' work. "I had likewise flattered myself, that an age of light and liberty would receive, without scandal, an inquiry into the human causes of the progress and establishment of Christianity." The first printing was exhausted in a few days, and soon Gibbon was flattered by being pirated in Dublin. He luxuriated in the praise and printed at length in his *Memoirs* the letter from David Hume in Edinburgh saying that had he not known Gibbon personally "such a performance by an Englishman in our age would have given

me some surprise." Joining "all the men of letters" in admiration he urged Gibbon to continue the work.

Two years passed before Gibbon began his second volume. The second and third appeared together in 1781. These bring the story through the age of Constantine, Julian the Apostate's effort to revive the pagan faith and virtues of the old Rome, the barbarian invasions, the fall of Rome in 410, and the intermixing of Roman and barbarian cultures. The third volume concludes with "General Observations on the Fall of the Roman Empire in the West."

> . . . the decline of Rome was the natural and inevitable effect of immoderate greatness. Prosperity ripened the principle of decay; the causes of destruction multiplied with the extent of conquest; and, as soon as time or accident had removed the artificial supports, the stupendous fabric yielded to the pressure of its own weight. The story of its ruin is simple and obvious; and, instead of inquiring why the Roman empire was destroyed, we should rather be surprised that it had subsisted so long.

Gibbon felt the transience of power in 1782, when Lord North's government fell and he lost his remunerative commission on the Board of Trade. He speculated briefly on seeking another government post, but decided instead to return to his beloved Lausanne, where no political concerns would trouble him. Though for eight years he had not exchanged letters with his Lausanne friend, Georges Deyverdun, he now wrote suggesting they set up a household together. "My reason becomes clear, my courage grows strong," he wrote Deyverdun from London in June 1783, "and I am already walking on the terrace, laughing with you about all these cobweb threads that seemed to be iron chains." Despite his friend's warnings that he would be bored, he found Lausanne an intellectual Mecca, especially in summer. An English visitor soon described him as "the *grand monarque* of literature at Lausanne." He could not have chosen a better place for his work. Deyverdun was an agreeable and stimulating companion, and he did not lack intellectual visitors.

Had Gibbon been a less passionate historian he might have considered his work complete with three volumes and the end of the Western Empire. But he carried on, and made the next three volumes a work all its own, starting with Byzantium's counterpart to the Age of the Antonines, then following through the vicissitudes of emperors and empresses, the rise of Roman law, the menace of the barbarians of the desert, and the fall of Constantinople in 1453. He had begun Volume Four before leaving England, and the next five years of leisure among friends brought him through Volumes Five and Six, which he completed in June 1787. He took the

manuscript of all three volumes to England, where they were published on his fifty-first birthday, May 8, 1788. Again he basked in the favors of literary Britain and a prosperous sale of his books.

In these later volumes Gibbon resists the temptation to dogma. Just as he treats the decline of the Western Empire, volume by volume, as a series of human dramas, in the final three volumes he casts the height and decline of the Eastern Empire as later acts of the same drama. When, in the final chapter of the final volume, he looks back on fifteen centuries, he does not take his stance in the scholar's library. He reminds us that "It was among the ruins of the Capitol that I first conceived the idea of a work which has amused and exercised near twenty years of my life," and now again from the Capitoline Hill he surveys the ruins of Rome, relics of his story. With the learned Poggius in 1430, he views "from that commanding spot the wide and various prospect of desolation." "The place and the object gave ample scope for moralising on the vicissitudes of fortune, which spares neither man nor the proudest of his works, which buries empire and cities in a common grave; and it was agreed that in proportion to her former greatness the fall of Rome was the more awful and deplorable." And when finally "after a diligent inquiry," he discerns "four principal causes of the ruin of Rome, which continued to operate in a period of more than a thousand years," what he gives us are not what the modern social scientist could call "causes." Instead he simply reminds us of the chapters and episodes of his human comedy: "I. The injuries of time and nature. II. The hostile attacks of the barbarians and Christians. III. The use and abuse of the materials. And, IV. The domestic quarrels of the Romans."

In Gibbon's lifetime the world of science was newly liberated from the medieval demand for meaning. By abjuring any "philosophy of history" or the rational simplicities of his age, he too was freed to recover impartially all the elusive human atoms of history. In the Royal Society in London and other "invisible colleges," scientists, virtuosi, and amateurs were expanding their world with tiny increments of knowledge. There were a few theoretic dazzlers like Sir Isaac Newton. But the most important shift in attitude toward knowledge was from an interest in the cosmos, in universal order and salvation, to an interest in facts. Now it seemed possible for every man to become his own scientist, and perhaps also his own historian. The telescope, the "flea glass" (or microscope), the thermometer, and scores of other measuring devices were transforming experience into experiment. The incremental approach to the physical world, spawning a wonderful new-grown wilderness of facts and contraptions, was also Gibbon's approach to the world of human nature. The new scientific quest for meaning was only beginning to transform the social world into a modern cosmos of new

dogmatic simplicities. Gibbon still gives us incremental history on a grand scale.

While human nature for Gibbon is anything but unintelligible, it tempts him precisely because it is only partly explicable. His explanations of rise and fall, of prosperity and decline, are lists and alternatives. What he recounts is "the triumph of barbarism *and* religion." His balanced style was well designed for ambiguity and equivocation. An appealing example is his description of the younger Emperor Gordian (192–238):

> His manners were less pure, but his character was equally amiable with that of his father. Twenty-two acknowledged concubines, and a library of sixty-two thousand volumes, attested the variety of his inclinations; and from the productions which he left behind him, it appears that both the one and the other were designed for use rather than for ostentation.

His footnote adds, "By each of his concubines the younger Gordian left three or four children. His literary productions, though less numerous, were by no means contemptible." The quirks and quibbles of theologians, the rivalries, crimes, and monstrosities of Eastern monarchs, their wives and mistresses and sons and daughters, are both "amusing and instructive." Can anything be trivia that can illuminate this, "the greatest, perhaps, and the most awful scene in the history of mankind"?

The landscape becomes the setting for parables of human nature. When earthquakes shook the eastern Mediterranean on July 21, 365, "their affrighted imagination enlarged the real extent of a momentary evil . . . and their fearful vanity was disposed to confront the symptoms of a declining empire and a sinking world." Which they explained as the retribution of a just Deity. "Without presuming to discuss the truth or propriety of these lofty speculations, the historian may content himself with the observation, which seems to be justified by experience, that man has much more to fear from the passions of his fellow-creatures than from the convulsions of the elements."

Human habits, utterances, exclamations, and emotions are not mere raw materials for distilling "forces" and "movements" but the very essence of history. The more vividly we see, the better we know our subject. Inevitably, then, we must doubt our capacity to grasp the whole story. Advancing into his final three volumes, Gibbon ceases to speak only for himself, and enlists us as "we." Classic sagas had been grand and impersonal, but Gibbon makes his intimate, precisely because he does not speak the obsolescing parables of science or social science. Nor is he confined by the etiquette of chronology. Although his story extends from the Age of the Antonines (A.D. c.98) to the fall of Constantinople in 1453, he gives more space to the

first few centuries than to the whole last millennium. "My Roman decay," he calls it. Somehow he is entranced by the melodramatic and melancholy scenes of decay. These had first inspired his work, attracted him to the decline and fall of the Western Roman Empire and to its equal, the declining Empire of the East. It is not surprising that he is not attracted by the thriving Western civilization that would rise out of the ruins of Rome. His pleasures of melancholy are the very sentiments that produced Shelley's "Ozymandias," and that nourished the Romantic movement. These still make his history of a great empire intimate, as we join him in sighing for the departed grandeur. Just as Piranesi (1720–1778) was transforming the classic into the romantic by what he made of the Roman ruins, so Gibbon was working a comparable magic with his saga of a disintegrated empire.

38

New-World Epics

GIBBON created his sagas of ancient empire from familiar material. He had the writings of the Antonines themselves, of Procopius, Tacitus, and the Church Fathers. But Prescott and Parkman, historians of empires falling and rising in the New World, were traveling there in unfamiliar territory. They had to create their dramas from the rawest of raw material. They had to discover the landscape, conceive new heroes, and mark their own paths through time. The story of how they made their histories was itself a kind of epic.

The easy life of Edward Gibbon, troubled only by obedience to his father and the eclipse of Lord North, was not the lot of these historians of rising empires in America. William Hickling Prescott (1796–1859) and Francis Parkman (1823–1893) each showed a single-minded courage with few precedents in the annals of literature. While it was the familiar spectacle of decay and decline that inspired Gibbon's view of Empire, Parkman and Prescott were captured by the unchronicled drama of a New World.

William Hickling Prescott was the son of a wealthy Boston judge from a historic New England family. On the walls of his library at 55 Beacon Street he displayed the crossed swords of his grandfather William Prescott, who was in command at Bunker Hill, and his wife's grandfather, who

captained the British sloop that cannonaded Boston during the battle. He was sent of course to Harvard, where he had an undistinguished record. One day in his junior year when students in the Commons were bombarding one another with scraps of food, he turned as his name was called out and a crust of bread hit him in his open left eye. He never saw with the eye again, and within two years an inflammation impaired the vision of his right eye. For long periods he could not read at all, at other times he could read for only a few minutes, and never more than an hour or two a day.

Prescott was intended to take up his "natural inheritance" and follow the law. But five months as a law clerk in his father's office squinting his one good eye at antique reports and documents in Gothic type were enough to convince him that he must find some other vocation. Meanwhile the strain of these months and his recurrent attacks of rheumatism persuaded his family to send him to recuperate in his grandfather's house in the Azores. From there he traveled around Europe, not for historical inspiration but to find a cure for his several ailments. Returning to Boston, he was persuaded that he would have to live with his infirmities and find a career to go with them. Friends believed that his affable outgoing personality would qualify him for business, in which his family had been successful. Or he could have afforded to remain a gentleman of leisure, but somehow he was determined, whatever the difficulties, to pursue a career in letters.

He had already begun finding ways to deal with his impaired vision. His family income helped him do his reading, as he "resolved to make the ear, if possible, do the work of the eye." At first his wife, whom he married in 1820, read to him. Then Prescott relied on a hired secretary, whose crude pronunciation of Spanish, French, or Italian he still managed to understand. "As the reader proceeded," he explained, "I dictated copious notes; and when these had swelled to a considerable amount they were read to me repeatedly, till I had mastered their contents sufficiently for the purpose of composition. The same notes furnished an easy means of reference to sustain the text." He liked to have at least a glimpse of the books himself. The difficulties of reading Gothic type may have led him away from a German subject.

Finding the labor of writing a severe trial to his eye, in London he had bought his first noctograph. This device for the blind was a framework of parallel wires that folded down on a sheet of carbon paper. Using the wires to guide his fingers, he wrote with an ivory stylus, which left an impression below. So he did not need to know when the ink in his pen was exhausted, and he avoided running the lines into one another. "The characters thus formed made a near approach to hieroglyphics; but my secretary became expert in the art of deciphering, and a fair copy—with a liberal allowance for unavoidable blunders—was transcribed for the use of the printer." Still,

he warned his readers not to give him "undeserved credit" for having surmounted the incalculable obstacles that lie in the path of the blind man. His friend George Ticknor (1791–1871) had also abandoned the practice of law for a career in letters. At twenty-six, the brilliant Ticknor, as professor of French, Spanish, and belles lettres, was trying to broaden the antique Harvard curriculum, and was writing his landmark *History of Spanish Literature*. American interest in Spain had been awakened by the works of Washington Irving, who had been a diplomatic attaché in Madrid, and whose romanticized *Christopher Columbus* (1828) was vastly popular. The Peninsular War (1808–14) and the exploits of Bolívar in the Latin American wars for independence had kept Spain in the news. Spanish scholars had been editing their archives, but no epic history had been written from them.

Prescott's fellow Bostonians, to whom he was only a half-blind gentleman of leisure, were astonished in 1837 at the publication of his three-volume *History of the Reign of Ferdinand and Isabella the Catholic*. Though he had spent ten years at work in his darkened study, he had to be persuaded to send his manuscript to the publisher. His father insisted that "the man who writes a book which he is afraid to publish is a coward." The first printing sold out in five weeks, and the work was acclaimed on both sides of the Atlantic. Prescott then decided to turn to the American scene for his saga of the Spanish conquest. When he heard that Irving was already at work on the conquest of Mexico, Prescott offered to abandon the subject. But Irving generously deferred to the newcomer.

For his writing on the Spanish conquest Prescott had all the help that his patrician position and his wealth could provide. To supplement his personal library of five thousand volumes he enlisted a Harvard classmate, then minister to Spain, to secure copies of manuscripts and to find learned assistants in the archives. The copied manuscripts arrived in Boston by the thousands. To fix them in his mind Prescott had some read to him a dozen times. For a friend of his youth, Fanny Erskine, who had married the Spanish minister to Mexico, Prescott bought a daguerreotype camera. And from Mexico she sent pictures and descriptions of the historic scenes.

Three years of labor produced the three volumes of his *Conquest of Mexico* in 1843. Without stopping to take breath, he turned to the companion *History of the Conquest of Peru,* which appeared in three volumes in 1847.

Prescott's polished histories were a product of his miraculous memory. During his morning horseback rides to Jamaica Plain he would compose in his mind whole chapters at a time. "My way has been lately to go over a large mass in my mind—over and over—till ready to throw it on paper— *then* an effort rather of memory than of creation."

Despite his prodigious industry Prescott considered himself indolent. To keep his writing on schedule he made playful bets with himself or his secretary. On one occasion he promised his favorite reader-secretary, James English, the sum of one thousand dollars if he did not finish his next stint of pages on time. "39 pages in 15 days," he boasted in Boston as he was writing about Cortés's advance in Mexico, "not bad for the giddy town where I have been spinning about in dances and dinners, *plus quam suf.*"

Though Prescott has been called the nation's first "scientific historian" for his use of manuscript sources, he would live on as a creator of literature. "The Conquest of Mexico" Prescott called "the greatest miracle in an age of miracles. . . . It is, without doubt, the most poetic subject ever offered to the pen of the historian."

> The natural development of the story . . . is precisely what would be prescribed by the severest rules of art. The conquest of the country is the great end always in view of the reader. From the first landing of the Spaniards on the soil, their subsequent adventures, their battles and negotiations, their ruinous retreat, their rally and final siege, all tend to this grand result till the long series of events is closed by the downfall of the capital. . . . It is a magnificent epic, in which the unity of interest is complete.

And one of his greatest feats as a "scientific" historian, was to depict the scenes of his drama so vividly without ever having been there—for he never visited Spain, Mexico, or Peru.

The enduring interest in Prescott's *Conquest of Mexico* comes less from his engaging survey of Aztec civilization than from his genius for the epic. Hernando Cortés, "his enlightened spirit and his comprehensive and versatile genius," dominates the book in a bitter-end contest with his noble antagonist the "barbarian" emperor Montezuma. The better we know the wealth and weaknesses of the Aztec emperor the more poignant is his downfall. The grandeur and elegance of the Aztec monuments offer ironic contrast to the horrors of cannibal savagery. Prescott awes us by this unlikely combination of "refinement" with "the extreme of barbarism." The saga of the "knight-errant" Cortés follows his triumphal march to Mexico City, his residence there, receiving the allegiance and treasure of Montezuma, his expulsion by the fury of the Mexicans, his retreat, his triumphal return and siege, overcoming famine and conspiracy in his own camp, and achieving the final surrender of Mexico. Cortés's heroic career is rounded out by his defeat of enemies' intrigues in Spain, and his royal confirmation as supreme commander.

Prescott captures the suspense of the living experience, and never better than in his classic account of the *Noche Triste*. On that "melancholy night"

of July 1, 1520, Cortés's forces retreating from Mexico City were slaughtered by a surprise attack.

> The night was cloudy and a drizzling rain, which fell without intermission, added to the obscurity. The great square before the palace was deserted, as, indeed, it had been since the fall of Montezuma. Steadily, and as noiselessly as possible, the Spaniards held their way along the great street of Tlocopan, which so lately had resounded to the tumult of battle. All was now hushed in silence; and they were only reminded of the past by the occasional presence of some solitary corpse, or a dark heap of the slain, which too plainly told where the strife had been hottest. . . . they easily fancied that they discerned the shadowy forms of their foe lurking in ambush, and ready to spring on them. But it was only fancy; and the city slept undisturbed even by the prolonged echoes of the tramp of the horses, and the hoarse rumbling of the artillery and baggage trains. . . . They might well have congratulated themselves on having thus escaped the dangers of an assault in the city itself, and that a brief time would place them in comparative safety on the opposite shore. —But the Mexicans were not asleep.

He concludes his history with a ruthless but charitable portrait of his hero. "Cortés was not a vulgar conqueror. He did not conquer from the mere ambition of conquest. If he destroyed the ancient capital of the Aztecs, it was to build up a more magnificent capital on its ruins. If he desolated the land, and broke up its existing institutions, he employed the short period of his administration in digesting schemes for introducing there a more improved culture and a higher civilization." And Cortés was not cruel, "at least, not cruel as compared with most of those who followed his iron trade. . . . He allowed no outrage on his unresisting foes. This may seem small praise, but it is an exception to the usual conduct of his countrymen in their conquests, and it is something to be in advance of one's time."

Finally, Prescott notes and explains Cortés's "bigotry, the failing of the age, for, surely it should be termed only a failing. When we see the hand, red with the blood of the wretched native, raised to invoke the blessing of Heaven on the cause which it maintains, we experience something like a sensation of disgust at the act, and a doubt of its sincerity. But this is unjust. We should throw ourselves back (it cannot be too often repeated) into the age; the age of the Crusades. For every Spanish cavalier, however sordid and selfish might be his private motives, felt himself to be the soldier of the Cross. . . . Whoever has read the correspondence of Cortes, or, still more has attended to the circumstances of his career will hardly doubt that he would have been among the first to lay down his life for the Faith." And Prescott ends by humanizing Cortés, with the aid of his companion-in-arms, Bernal Díaz, who recounts how "when very angry, the veins in his throat and forehead would swell, but he uttered no reproaches against either officer

or soldier," how he loved cards and dice, would take a nap after his meals under a tree, even in stormy weather. Cortés never became rich from his conquests. "It was perhaps intended that he should receive his recompense in a better world."

There is a strange symmetry in the lives and works of the two pioneers of a literature of American history, William Hickling Prescott and his successor Francis Parkman. It is almost as if a dissatisfied editor had chosen to revise the life of Prescott for another emphasis in the next generation. Both labored under disabilities that made their works deeds of heroism. But while Prescott had his blindness thrust on him by a crust of bread in his eye, Parkman at eighteen was energetically creating his own disabilities. And he was bolder than Prescott in his choice of subject. Spain, Prescott's point of departure, was an eminently respectable area for historical literature, proven by Washington Irving's popular *Columbus* (1828), his *Conquest of Granada* (1829), and his *Alhambra* (1832). Europe seemed the proper base for serious American historians. Even George Bancroft's immensely popular three-volume *History of the Colonization of the United States* had followed that convention. And Prescott, too, followed the fortunes of Spain in the New World.

Parkman made a bold and risky thrust. As an eighteen-year-old sophomore, also at Harvard College, his literary ambitions "crystallized into a plan of writing the story of what was then known as the 'Old French War,' that is, the war that ended in the conquest of Canada. . . . My theme fascinated me, and I was haunted with wilderness images day and night." Soon he "enlarged the plan to include the whole course of the American conflict between France and England, or, in other words, the history of the American forest." Boston friends who heard his plan were dismayed that a man of Parkman's talents and resources should choose a subject so peripheral to the mainstream of European history, a tale whose actors were red savages and crude colonists.

Parkman had been attracted by his love of the forest, an unconventional enthusiasm for a New England Brahmin. His grandfather was one of the richest Boston merchants, his father the minister of the New North Church. And his mother was descended from the Reverend John Cotton, the Patriarch of New England, who had defended the magistrates against troublemakers like Roger Williams. The sickly but hyperactive Frank was sent at the age of eight to live with his maternal grandfather, Nathaniel Hall, in neighboring Medford on the ancestral estate that bordered six thousand acres of wild woodland. "I walked twice a day to a school of high but undeserved reputation, in the town of Medford. Here I learned very little, and spent the intervals of schooling more profitably in collecting eggs,

insects, and reptiles, trapping squirrels and woodchucks, and making persistent though rarely fortunate attempts to kill birds with arrows." This first taste of the domesticated wilderness stirred his interest in the wilder wilderness, its inhabitants and their ways. After four years his father brought him back to Boston to the Chauncy Hall School to prepare for the Harvard entrance examinations.

He inevitably entered Harvard, "the center of the intellectual aristocracy of our country," in the class of 1844. There he studied Latin, Greek, mathematics, natural and ancient history, and a modern language. Longfellow was lecturing on French and Spanish literature. The pioneer professor of history, Jared Sparks, was teaching a new university subject, the American Revolution. Parkman received highest honors in History.

Since college "athletics" did not exist—Harvard had not yet put its first boat on the Charles, baseball and football were still decades in the future, and there was no proper gymnasium—students had to find their exercise off campus. By the time his successor historian of the West, Theodore Roosevelt, came to Harvard, athletics would be well established. The undergraduate Parkman eagerly returned to the wilderness paths that he had come to love as a boy. At Harvard he would study early by candlelight so he could be outdoors when the sun was up. In the summer of his sophomore year, he took off from Albany with a friend, visited the battlefields of the French and Indian Wars around Lake George and Lake Champlain, crossed Vermont and New Hampshire into Canada, and then returned to Cambridge via Mount Katahdin in Maine. At eighteen he was already keeping a journal of his adventures, of sleeping outdoors and living off the country. He later attributed his painful harvest of physical ailments, disabling headaches, insomnia, and blindness, to one strenuous undergraduate excursion when he spent three days and nights in the woods in the rain without shelter after his spruce-bark canoe had fallen apart.

The avalanche of his ills, as his biographers explain, seems to have come from his relentless determination to make his easy Boston life into a struggle. Wealth and social position had smoothed his path to a literary career. But he seems to have enjoyed making his simplest literary task a battle against obstacles. Even in Harvard's primitive gymnasium, which offered nothing but gymnastics, he overstrained himself. He idealized struggle, the heroic, the dangerous, and the masculine, which helps explain his passionate opposition to woman suffrage. If a struggle did not offer itself, he somehow managed to create one. His tendency toward depression, headaches, and weak eyesight appears to have run in his family. But he built up his ills to dramatize his life. His letters expand on his heart trouble, depression, headaches, semiblindness, insomnia, water on the knee, rheumatism, and arthritis. He had "so thoroughly studied his own case" that the famous

Dr. S. Weir Mitchell had no help to offer. Somehow the one ailment Parkman never imagined for himself was hypochondria. The shadow of Prescott was always with him. Both had impaired eyesight. But Parkman thought his own worsening disability outdid Prescott's. "Prescott could see a little—confound him and he could even look over his proofs, but I am no better off than an owl in the sunlight."

By his senior year at Harvard, Parkman's family, alarmed at his ailments, hoped to cure him by sending him on a European grand tour. At Rome he saw the pope, and managed to spend a brief tour in a monastery of the Passionist monks, "the strictest of the orders of monks—wear haircloth next the skin—lash their backs with 'disciplines' made of little iron chains, and mortify the flesh in various other similar ways." The medal they had given him, to bring on a vision of the Virgin, had not worked in their kind efforts to convert him. Later when he came to know the Sioux he said he preferred them to the monks. Still, the Rome experience, and visits to the church of the Benedictines in Messina, gave this son of a Congregational minister "new ideas of the Catholic Church. Not exactly, for I reverenced it before as the religion of brave and great men—but now I honor it for itself. They are mistaken who sneer at its ceremonies as a mere mechanical farce; they have a powerful and salutary effect on the mind."

Returning home, after Harvard College he went on to the Law School. After receiving his law degree in 1846, he was invited by his cousin Quincy A. Shaw on a strenuous hunting expedition to the Far West. Despite his ailments, Parkman eagerly accepted. This would be the crucial experience of his life, his baptism into the culture of the American Indian and his first encounter with frontiersmen, soldiers, and emigrants. All these would figure in his *Oregon Trail,* the first classic of the American West, of American frontiersmen on their way. The Shaw party went by steamboat and horseback from St. Louis to Fort Laramie, Wyoming, where they found an encampment of Sioux. There Parkman and his guide left the party and joined the Sioux, sharing their food, their life, and their buffalo hunts for some weeks. So he learned the Indian ways of a tribe similar to the Iroquois, about whom he would be writing, and that was still in the "unspoiled" condition in which Champlain and La Salle would have met the Iroquois.

Parkman returned in even worse health than when he had left. His eyesight had suffered from the glaring sun of the high plains and he was so weakened by dysentery contracted from the Sioux diet that he had barely been able to keep his seat in the saddle on the rocky buffalo hunts. In Boston, like Prescott, he dictated *The Oregon Trail* as his sisters or Quincy Shaw read him his notes. After serial publication in 1847, it appeared as a book in 1849, and has never ceased to appeal. During the next two years he tried to

recover his health, but then relentlessly returned to the projected twenty-year plan for his history of France and England in North America. In 1850 he married Catherine Bigelow of an old New England family. Both she and their son died in 1858, plunging him into a deep depression. Four years would pass before he could return to his writing.

Meanwhile, in 1851 he had published *The Conspiracy of Pontiac,* the first volume of his large plan. He described his problems in writing. "The difficulties were threefold: an extreme weakness of sight, disabling him even from writing his name except with eyes closed; a condition of the brain prohibiting fixed attention except at occasional and brief intervals; and an exhaustion and total derangement of the nervous system producing of necessity a mood of mind most unfavorable to effort." For writing he relied on a noctograph similar to Prescott's except that instead of carbonated paper he used "a blacklead crayon" with which he could write "not unlegibly with closed eyes." To avoid strain on him his readers dared not read to him much more than a half hour at a time, and days passed when he could not listen at all. For the first six months his composition averaged about six lines a day. Then his health improved and he could compose "while pacing in the twilight of a large garret, the only exercise which the sensitive condition of his sight permitted him on an unclouded day while the sun was above the horizon." In two and a half years, the book was completed.

He had chosen to write the *Pontiac* first though it was the last in chronological order of his series. Perhaps he feared he might not live to produce the earlier volumes. Pontiac's conspiracy, the final great explosion of Indian power in the conflict between British and French for North America, provided a climactic conclusion "affording better opportunities than any other portion of American history for portraying forest life and the Indian Character, and I have never seen reason to change this opinion." His mentor, Professor Jared Sparks, congratulated him on "a striking picture of the influence of war, and religious bigotry, upon savage and semi-barbarous minds," but missed "a word or two of indignation now and then." Parkman had paid for having the book set in type, and it was published but sold only slowly.

When Parkman returned to writing in 1862, he picked up his large plan and doggedly turned out the seven volumes of his historic drama beginning with *Pioneers of France in the New World* (1865) and concluding with *Montcalm and Wolfe* (1884) and *A Half-Century of Conflict* (1892). As his readers increased, so did his fame. His production, prodigious under any circumstances, was miraculous with his handicaps. Ailments multiplied with age. When arthritis and water on the knee made it hard for him to walk, he pursued horticulture from a wheelchair in his three-acre garden

at Jamaica Pond. He developed his own varieties of lilies, rhododendrons, and apples. After writing his *Book of Roses* (1866) and numerous articles, he was appointed professor of horticulture at Harvard.

In the tradition of Gibbon and Prescott, Parkman's achievement was seeing the human and the personal in the great movements of history. The rise of a profession of American history brought criticism for his not being interested enough in the Westward Movement, which became a professional icon, an original species of historical thinking. But Parkman would not let his story become the victim of demography, sociology, or professional jargon. He too was an atomic historian, focusing on the ultimate human unit. With few exceptions, the titles of his works featured the heroic figures—the Pioneers of France, the Jesuits, La Salle, Count Frontenac, Montcalm, and Wolfe. Never professionally "trained" as a historian, he never lost the enthusiasm of the amateur. And he wrote before the rise of academic history would make readability suspect. Just as Gibbon had been engaged by the spectacle of Roman grandeur in decline, and Prescott by a new Spanish empire in creation, Parkman was entranced by the wilderness struggles of France and England in North America in the making of a new freer world. If Parkman did not show enough indignation to satisfy Jared Sparks, or enough "philosophy" to satisfy the Congregational apostle Theodore Parker, he dramatized a grand conflict between the ideals of Absolutism, Rome and France on one side and those of Liberty, Protestantism, and England on the other—acted out on the novel scene of the American wilderness. And he showed charity, sympathy, and tolerance for all those in the battle.

His masterpiece, *Montcalm and Wolfe* (two volumes, 1884), described the decisive battle in the struggle for Canada. "In making Canada a citadel of a state religion . . . the clerical monitors of the Crown robbed their country of a trans-Atlantic empire. New France could not grow with a priest on guard at the gate to let in none but such as pleased him. . . . France built its best colony on a principle of exclusion and failed; England reversed the system and succeeded." Henry Adams said this book put Parkman "in the front rank of living English historians" in an age when history flourished. Parkman explained that he had studied the subject "as much from life and in the open air as the library table." On his continentwide wilderness battleground, Parkman luxuriated in accounts of his heroes sacrificing their lives. So he depicted the martyrdom of Father Jogues and the death of La Salle "in the vigor of his manhood at the age of forty-three."

The Battle for Quebec on the Plains of Abraham in 1759 gave Parkman the opportunity to depict the death in battle of two heroes. In his last hours the English commander Wolfe, after being felled by three shots, mustered strength to cut off the enemies' retreat. " 'Now God be praised, I will die

in peace!' And in a few moments his gallant soul had fled." On the other side, "In the night of humiliation," when the French forces had abandoned Quebec,

> Montcalm was breathing his last within its walls. When he was brought wounded from the field, he was placed in the house of the Surgeon Arnoux . . . whose younger brother, also a surgeon, examined the wound and pronounced it mortal. "I am glad of it," Montcalm said quietly; and then asked how long he had to live. "Twelve hours, more or less," was the reply. "So much the better," he returned. "I am happy that I shall not live to see the surrender of Quebec." He is reported to have said that since he had lost the battle it consoled him to have been defeated by so brave an enemy. . . .

A restless admirer of the heroic, Parkman had celebrated it in his own career.

Supported most of his life by his family inheritance, he lived simply. But he welcomed his two-thousand-dollar-a-year salary as Harvard's new professor of horticulture. He never taught history or lectured for money. The royalties from his books never helped much, since he spent the profits from one volume to copy documents for the next.

But he basked in the admiration of connoisseurs. Henry James, "fascinated from the first page to the last" by *Montcalm and Wolfe,* found it "a truly noble book." Theodore Roosevelt dedicated his *Winning of the West* to Parkman, who had provided "models for all historical treatment of the founding of new communities and the growth of the frontier here in the wilderness," and compared him with Gibbon. It was lucky that the talents of an American Gibbon were engaged in chronicling the rise of Jefferson's Empire for Liberty while the drama was still visible. As John Fiske prophesied, "The book which depicts at once the social life of the Stone Age and the victory of the English political ideal over the ideal which France inherited from imperial Rome, is a book for all mankind and for all time."

39

A Mosaic of Novels

As historians added their visions of the past to the human comedy, novelists created wide-angle mirrors for their readers and their times. The rapid improvement in the technology of printing in the nineteenth century made the book a popular vehicle for a new reading public, as hungry for an imaginary drama as for piquant rumors and the latest news. Now authors, with the aid of publishers and sales figures, received speedy feedback. They could know quickly what their readers liked, and were increasingly tempted to give them whatever they wanted. The author-creator himself became the audience of his audience.

Unlike great literary creations of earlier centuries—of Dante, Rabelais, Cervantes, and Milton—the novelists' new versions of the human comedy would not be monolithic. The emphatically secular world of the vernacular, of everybody's here-and-now, had to be created and re-created piecemeal. And the reading public's human comedy would always be unfinished. "Nothing in the world exists in a single block," wrote Balzac. "Everything is a mosaic. The history of the past may be told in chronological sequence, but you cannot apply the same method to the moving present."

The idea of a comprehensive human comedy came to Honoré de Balzac almost as an afterthought. Some might even call it a marketing notion. In 1841, when the great bulk of his novels had already been written, he signed a contract with a group of French publishers to publish all his works under the title *La Comédie humaine*. Before then he had grouped together novels and stories under inclusive titles, such as "Scenes of Private Life," "Scenes of Paris Life," "Scenes of Provincial Life." His first notion was to call his complete works "Études sociales." But a recollection of Dante, whose Comedy later generations called Divine, suggested to Balzac around 1839 that he distinguish his kind of Comedy by calling it Human. He succeeded in borrowing a Dantesque dignity for his earthly world.

Balzac's title proved appropriate for his many-sided saga of the people

of his time. As a frustrated playwright who saw his work in "scenes," he also may have intended the theatrical analogy. But while Shakespeare's plays could be parsed into Histories, Comedies, and Tragedies, Balzac's novels did not fit the familiar dramatic categories. Calling himself the Secretary of Society, he thought all his works were a kind of history. While his broad sense of the ridiculous provided what for ancient Greece was the raw material of comedy, his overarching sense of fate and dominant circumstance made all his novels a form of tragedy. Now that literature had become popular, the scholars' neat categories would no longer do. The novel revealed the confusions of daily experience.

Balzac himself was a prodigy. In his short fifty-one years (1799–1850) he wrote ninety-two novels, scores of short stories, and a half-dozen plays. Believing that "all excesses are brothers," he showed that Paris "has only two rhythms: self-interest or vanity." Balzac's own life was dominated by contradictory passions, for love and for fame, for mystic unity and for the chaos of everyday facts. No one more effectively depicted the destructive power of "money, the only god we now believe in," yet no one was more hungry for money than Balzac. A willing victim of the mystic Mesmer and other cloudy dogmas, he was still an enthusiastic student of *things*. "I have learned more from Balzac," wrote Friedrich Engels, "than from all the professional historians, economists, and statisticians put together." But for Henry James he was the gold-plated "towering idol" from whom he had "learned more of the lessons of the engaging mystery of fiction than from anyone else." In tune with his declaration that "in every life there is only one true love," Balzac repeatedly professed eternal love to the woman he was addressing at the moment. But he kept in reserve his bedroom or banknote passion for secret favorites. Next to love, what he professed to love most was fame through the generations. Yet he schemed for the baubles of celebrity and social precedence. His life was a perfect Balzac novel.

He had a talent for making every experience a point of departure for another novel, and few people he knew escaped becoming figures in his novels. "I have undertaken the history of a whole society. I have often described my plan in this one sentence: 'A generation is a drama with four or five thousand outstanding characters.' That drama is my book." He did not quite come up to that number, but there are about two thousand characters in the novels and stories that make up his human comedy.

Balzac's own uneventful life, on a narrow stage, might have seemed meager material for fiction. Oscar Wilde insisted that "Balzac is no more a realist than Holbein was. He created life, he did not copy it." Born in Tours, a provincial capital in north-central France, to a civil-servant father, from his earliest years he savored a family obsessed with money and status. His father, Bernard-François, had married Laure, the much younger

daughter of a substantial family of cloth merchants, and had received a valuable farm as dowry. The Balzacs tried to acquire social status by adding the unmerited aristocratic "de" to their family name, and in other ways. His eccentric father read widely in Rabelais, Rousseau, and Sterne, and was obsessed with his health. He said he hoped to live to be a hundred and fifty and invested in longevity through the Tontine, a financial scheme by which those who contributed received dividends during their lifetime and the accumulated capital was finally awarded to the last survivor. To protect his investment, Bernard-François drank little wine but lots of milk, swallowed the sap of trees, chewed bark, and retired early after frugal meals.

Fifteen months after Bernard-François's marriage, Laure gave birth to a son whom she fed at her own breast but who died after twenty-three days. When her second child, Honoré, was born on May 20, 1799, she sent him away to a wet nurse. This was not unusual in the middle classes at the time, but he never forgave her for it. "Who can say how much physical or moral harm was done me by my mother's coldness? Was I no more than the child of marital duty, my birth a matter of chance . . . ? Put out to nurse in the country, neglected by my family for three years, when I was brought home I counted for so little that people were sorry for me." At the age of four he was sent off to the Collège de Vendôme, run by the Oratorian Brothers.

Shockingly liberal by the standards of the time, the school defied military conventions by calling boys to class with a bell instead of a drum. Other schools had edifying books read aloud during meals to prevent vagrant thoughts, but the Oratorians actually allowed conversation. Yet, "for the sake of good conduct and discipline, and to preserve the progress made during the year," the school allowed no holidays. Pupils were punished by striking their knuckles with a leather rod or by imprisonment in an improvised dungeon, six feet by six feet, beneath the stairs in each dormitory. During his six years at the school, Honoré's mother came to visit him only twice. As an adult Balzac discovered that he had been so promptly sent away to school because his mother was about to bear the illegitimate child of a young officer from a neighboring town. Hoping to stop gossip, or in a show of bravado, Madame Balzac actually persuaded the officer to act as the child's godfather. This half-brother, Henri, became their mother's favorite, much to the irritation of Honoré and his sister, Laure, who called themselves "the children of conjugal duty."

At the fall of Napoleon in 1814, the family moved to Paris. For the next two years Honoré was again shipped off to board while he concluded his studies at the Lycée Charlemagne, without distinction. At his family's urging he studied law at the Sorbonne and apprenticed as a clerk in a law office. More to his interest were the courses by Guizot and Cousin. The lectures he heard at the Museum of Natural History also left a permanent

mark. Geoffroy Saint-Hilaire (1772–1844), the naturalist turned philosopher, expounded the "unity of composition" of all creatures against Georges Cuvier (1769–1832), the founder of comparative anatomy, who saw variety within four types of structure. For all his life Balzac never quite made up his mind between a mystic unity and the infinitude of facts.

Despite family pressure he never found the lawyers' ways of thought congenial, and his whimsies made him a menace in the staid chambers. "Monsieur Balzac is requested not to come today," the head clerk once wrote him, "because there is a great deal of work to be done." Honoré passed the law examinations, but was still determined not to be a lawyer. He had already formed his ambition to be a writer. His mother agreed to give Honoré a chance to prove his writing talent, and out of the father's modest pension the family would stake him for two years at fifteen hundred francs a year in a spartan attic room in Paris. To fend off the neighbors' sneers for indulging their son in so erratic a career, they pretended that he had gone away to live with a cousin. Meanwhile Honoré must not be seen in Paris, and must go out only after dark.

During this trial period he wrote an unsuccessful tragedy, *Cromwell* (1819), and numerous other items that he later called "literary hogwash." Friends counseled that Balzac was plainly not suited for literature, and he feared that they might find him a job. Then he would become "a clerk, a machine, a riding-school hack doing its thirty turns a day and eating, drinking and sleeping at fixed hours. I shall be like everyone else. And that's what they call living, that life at the grindstone, doing the same thing over and over again. . . . I have not yet smelt the flowers of life and I'm in the only season when they blossom. . . . I'm hungry and nothing is offered to appease my appetite. What do I want? . . . I want ortolans; for I have only two passions, love and fame, and nothing has happened to satisfy either, and never will."

Despite the fortunes Balzac eventually earned from his writing, he would never be self-supporting. His appetite for luxuries was insatiable, never limited by his income. Instead of spending his meager garret allowance "sensibly on rent and laundry and food," "the first thing you did," his sister, Laure, scolded, "was to buy a mirror in a gilt frame and a picture for your room." A congenital bankrupt and an obsessive shopper, he was a genius at finding ways to be extravagant.

For the next years his writing frenzy would be occasionally interrupted by an assortment of spectacularly unsuccessful business enterprises. These included a project for cheap pocket editions of French classics, a plunge into worthless railroad stock, an untested new printing process called Fontereotype, an effort to corner the pineapple market, and a get-rich-quick scheme to exploit the heaps of slag from ancient Roman silver mines in Sardinia.

· · ·

Balzac's love life, too, was full of extravagant hopes and unfulfilled expectations. His first grand passion was Mme. Laure de Berny, a friend of his mother, whom he met in 1822, when she was still married to an older man who was blind and had left her to manage the family estate. The mother of nine children, of whom seven survived, she engaged Balzac to tutor the five who remained at home. Although forty-five, and older than his mother, she became his first tutor in the ways of love. She appealed to the young man of twenty-three both for herself, still warm and attractive, and for the imagined world from which she came—the court of Louis XVI at Versailles, where her mother had been a lady of the bedchamber. Over the next years Mme. de Berny, his Dilecta (Chosen one), remained his mistress, companion, counselor, and editor. When she died in 1836 he was deeply shaken.

By 1832 he had already become friendly with Eveline Hanska, an attractive Polish countess married to the Ukrainian owner of vast estates. She was to be his other grand passion. After her adoring fan letters to which he responded warmly, they arranged a rendezvous in Neuchâtel in Switzerland, where she brought her husband. Balzac reported to his sister, Laure:

> God, but the Val de Travers is beautiful and the Lac de Bienne is ravishing. This is where we sent the husband to order luncheon. But we were exposed to view. So, in the shadow of a great oak tree we exchanged our first quick kiss of love. Then, since her husband is getting on for sixty, I swore to wait and she to keep her hand and heart to me. Was it not delicious to have dragged a husband, who looks to me like a tower, all the way from the Ukraine and travel six hundred leagues to meet his wife's lover who had only to come a hundred and fifty, the monster!

> (Translated by V. S. Pritchett)

His passion for his Eve was reinforced by frequent later rendezvous in the Ukraine, Paris, and elsewhere. They did finally marry in March 1850, just five months before his death, when Balzac was half blind and desperately ill.

Overlapping and in between Balzac's meetings with these two women were many transient passions. His tastes were ample but not indiscriminate. His closest lifelong friends were his sister, Laure, and Mme. Zulma Carraud, wife of the director of studies at Saint-Cyr, who saw the genius in him, and offered the solace of her household whenever needed. English women, he said, interested him for their whiter skin and their national reticence. There was his liaison with the "Contessa" Frances Lovell, Mme. de Visconti, who finally yielded on the enormous white divan that he had designed especially for her, and the stunning Jane Digby, Lady Ellenborough. He was

tantalized by the Marquise (later Duchess) de Castries who, he said, "let it appear that there was the most noble of harlots concealed within her . . . that she would become the most ravishing of mistresses by the act of removing her corset"—which she never did, at least not for him.

He seemed always alert for new people, men or women, to put in his novels. And though women were playing a smaller role than men in French public life, he explored the many roles they did play. With no firsthand experience of high politics, high finance, or military command, with scant knowledge even of the landscape of his country, and little acquaintance with peasants, farmers, or workers, he still found enough scenes and characters for his own kind of panorama. As the workshop for his human comedy he set up an elegantly furnished apartment in the Rue Cassini that he hoped would be refuge from his creditors. Attached to the scabbard on a plaster statuette of his idol Napoleon a paper read, "What he did not achieve by the sword I shall achieve by the pen. Honoré de Balzac." He never lacked for grandiose metaphors. As "the Secretary of Society," he aimed "to compete with the Civil Register." "You can't imagine what La Comédie humaine is! To compare literature with architecture, it's more immense than the Cathedral of Bourges."

But when could he garner the experience needed for his fourteen or sixteen hours a day writing at his desk? His routine was regular and relentless, as he described it in March 1833:

> I go to bed at six or seven in the evening, like the chickens; I'm waked at one o'clock in the morning, and I work until eight; at eight I sleep again for an hour and a half; then I take a little something, a cup of black coffee, and go back into my harness until four; I receive guests, I take a bath, and I go out, and after dinner I go to bed. I'll have to lead this life for some months, not to let myself be snowed under by my debts.
>
> (Translated by Samuel Rogers)

He followed this schedule with occasional interruptions, terminated only by his fatal illness. Driven by "the terrible demon of work, seeking words out of the silence, ideas out of the night," he dressed for his work as if for a ritual—in his famous white monkish robe, with a belt of Venetian gold, from which hung a paper knife, scissors, and a gold penknife, and wearing Moroccan slippers. We like to imagine that he felt the joy of creation, to match his pride in the product. But he never ceased to resent the pressure to produce. "To be for ever creating!" he complained. "Even God only created for six days!"

He continually blamed the pressure on his need for money. After the failure of his play *Quinola* in 1842 he declared, "I'm going to do what I've

been doing for the past fifteen years, to bury myself in the depths of work and creation, which has the advantage that its pangs cause you to forget other sufferings. I have to earn 13,000 francs by my pen during the next month." His lawyer insisted that he sell Les Jardies, the property outside Paris on the route to Versailles, which he had dreamed of fitting out as a retreat for himself and his beloved Eve Hanska. Balzac's fancy had transformed it into something unprecedented in France, a profitable pineapple plantation under glass, and he could not bear parting with this imagined Eden.

To hide from his creditors he changed residences and lodged under assumed names. Though he was not generously paid by the publishers, who were always pressing him for more, he still could have lived comfortably on his fifteen thousand francs a year from his books, if he had not suffered from chronic extravagance. Bills survive for his order of fifty-eight pairs of gloves at one time, with comparable bills from his fashionable tailor and his jeweler. Notorious for his jeweled walking sticks, he had a penchant for statues of Napoleon, and he embellished his red-leather-upholstered study and his books with the coat of arms of his putative ancestors. In 1828 his friend and publisher, Henri Latouche, wrote him in dismay:

> You haven't changed at all. You pick out the rue Cassini to live in and you are never there. . . . Your heart clings to carpets, mahogany chests, sumptuously bound books, superfluous clothes and copper engravings. You chase through the whole of Paris in search of candelabra that will never shed their light on you, and yet you haven't even got a few sous in your pockets that would enable you to visit a sick friend. Selling yourself to a carpet-maker for two years! You deserve to be put in Charenton lunatic asylum.
>
> (Translated by V. S. Pritchett)

Balzac's lifelong and finally futile campaign to be elected one of the "immortals" of the Académie Française seemed as much motivated by a passion for money as for prestige. After 1836 he declared that he would get in even if he had to batter down the Académie's doors with cannon fire. The prize was an annual salary of two thousand francs plus another six thousand for serving on the Dictionary Committee, and probably a life peerage.

Would Balzac have written, and what might he have written, if he had not been driven to pay for his extravagances? When the prospects of sharing Eve Hanska's (or someone else's) fortune seemed to take off the financial pressure, or when illness or travel interfered with his purchases, he did write less. We must, then, be grateful for the prodigal tastes that moved him to create. And for the sanguine disposition that made him believe he could somehow keep ahead of his creditors. Despite Balzac's sour view of human

nature and his surgical accounts of the mercenary strain in mankind, he had
an optimism about his own talent and the immortality of his work. This
Baudelaire (1821–1867) noted in Balzac and other writers of genius. "How-
ever great may be the sorrows that overtake them, however discouraging
the human spectacle, their healthy temperaments always in the end prevail,
and perhaps something better, which is a deep natural wisdom."

In the arts and letters, Balzac's Paris was a stage for giants. He knew
Delacroix (1798–1863), one of whose paintings (*Girl with the Perroquet*)
probably inspired his novel *La Fille aux yeux d'or*. He was a close friend
of Gautier (1811–1872), a friend and rival of Victor Hugo (1802–1885) and of
Eugène Sue (1804–1857), a confidant of George Sand (1804–1876), a target
of Sainte-Beuve (1804–1869), and an acquaintance of Rossini (1792–1868).
Despite his herculean work schedule he wallowed in Parisian salon life,
staying active in the arena of literary abuse and sycophancy.

It was an age, too, of volatile and oscillating political fortunes—from the
ancien régime of Louis XVI, through the Revolution of 1789, the Terror of
1793–94, the Directory (1795–99), the Consulate (1799–1804), the Napole-
onic Empire (1804–14), the Restoration Monarchy of Louis XVIII (1814–30),
the July Monarchy of Louis Philippe (1830–48), the Revolution of 1848 and
the Second Republic (1848–52) to follow. It was an age of volatile Paris mobs
and ephemeral monarchs, and of stirring slogans—an hourglass political
world that was periodically turned upside down. Today's patriot was to-
morrow's traitor. People went to the café to read the partisan press but
avoided incriminating themselves as subscribers.

Balzac was a fairly consistent royalist and Catholic, anything but a
reformer or a politician. When he ran for the National Assembly in April
1848 he received 20 votes, while in Paris alone his opponent Lamartine
received 159,800. A few days before the election he had published his
personal manifesto. "Between 1789 and 1848 France, or Paris if you prefer,
has changed its constitution every fifteen years. Is it not time, for the honour
of our country, to devise and institute a form, an empire, a durable system
of rule, so that our prosperity, our commerce, and our arts, which are the
lifeblood of our commerce, credit and our renown, in short, all the fortunes
of France, may not be periodically imperilled?" But he had no prescription.
"We have *liberty* to die of hunger, *equality* in misery, the *fraternity* of the
street-corner."

To his vehicle, the novel, he gave a new classic shape, creating the novel
of ideas. While he experimented with many forms, he wrote most of his
novels as narratives in the third person. But he wrote others in the first
person "to give the greatest intensity of life" to his characters. He wrote one
long novel in the form of letters. And in another he gathered the story in

fragments from three people. *Droll Stories* (*Contes drolatiques*, 1832–37) showed his grandiose literary ambitions by echoing Boccaccio and Rabelais.

His era had been dominated by wholesale issues—*Ancien Régime* vs. the Republic, the Rights of Man vs. the Legitimacy of Monarchs, Bourbon vs. Orléans—and by conventions, constitutions, emperors, and demagogues. A refugee from public controversy, Balzac provided a new kind of secret history. Many literate Frenchmen must have felt they had exhausted their concern for the state and society. Within a few decades they had seen the extravagant court of Louis XVI, the horrors of the guillotine, the glories of Napoleon, the surgings of the Paris mobs, the rivalries of ancient dynasties, the failed promises of legislation. Was this not the time for a modern Procopius to privatize history? To seek asylum in the lives, the hopes, the mysteries of individual men and women?

So he made the novel into his modern kind of history, more amorphous and miscellaneous than the respected classic forms, more elusive and more intimate. "The historian of manners," he noted, "obeys harsher laws than those that bind the historian of facts. He must make everything seem plausible, even the truth; whereas in the domain of history properly so called, the impossible is justified by the fact that it occurred." The novelists' version was "in the depiction of the causes that beget the facts, in the mysteries of the human heart whose impulses are neglected by the historians." Balzac's Human Comedy was a grand mosaic of his epoch, with many themes but no plot. Each hero is moved by some dominant passion—for money, love, or social position. Relentlessly contemporary and comprehensive, he still drew only the classes of Frenchmen he knew. He did not write about peasants or workers, but wrote about authors, artists, journalists, businessmen, speculators, charlatans, ne'er-do-wells, landowners, merchants, and the women whom they loved and who loved them. In Stefan Zweig's phrase, he was "a literary Linnaeus."

Balzac's youthful "literary hogwash" written before 1829 was unsigned. The first novel published under his name, and the earliest work to be incorporated in *La Comédie humaine* was *Les Chouans* (1829), about royalist guerrillas in western France in 1799. He was already irritating publishers by endless proof corrections, which ran up printing costs. "What the devil has got into you," his publisher Latouche exclaimed. "Forget about the black mark under your mistress's left tit, it's only a beauty spot." *Les Chouans* was praised by reviewers but did not sell. His next book, *La Physiologie du marriage,* published later that year, a surefire attention-getter, set him on the road to fame, or at least notoriety. In it "a young bachelor" revealed the knowledge of women he had acquired in thirty years of unmarried life. Insisting that "marriage is not born of Nature," Balzac realistically separated romantic love from the biological drive to reproduce.

Marriage, he explained, was an ongoing civil (or domestic) war in which, as in other wars, superior force and guile made the winner. The book was especially popular with women, whose grievances it exposed.

At thirty-four years of age he had already published two dozen novels and numerous tales under his own name, and had sketched his large scheme. "Salute me," he exclaimed to his sister, Laure, and her husband when he visited them in 1833, "I am on the way to becoming a genius!" By 1838, he predicted, "the three sections of this vast work will be, if not entirely complete, at least super-imposed so that the reader will be able to judge it as a whole." In a letter to Eve Hanska in 1834 he outlined his ambitious project.

The *Études de moeurs* will be a complete picture of society from which nothing has been omitted, no situation in life, no physiognomy or character of man or woman, no way of living, no calling, no social level, no part of France, nor any aspect of childhood, old age, middle age, politics, justice or war. . . . In the *Études philosophiques* I shall show the *why* of sentiments, the *what* of life; what is the structure, what are the conditions outside which neither society nor man can exist; after having surveyed it in order to describe it, I shall survey it in order to judge it. Also, in the *Études de moeurs* there will be *individuals* treated as *types,* and in the *Études philosophiques* there will be *types* depicted as *individuals.* Thus I shall have brought all aspects to life, the type by individualizing it, the individual by typifying him. If twenty-four volumes are needed for the *Études de moeurs,* only fifteen will be needed for the *Études philosophiques* and only nine for the *Études analytiques.* Thus Man, Society and Mankind will be described, judged and analyzed without repetitions in a work which will be like a western Thousand and One Nights.

(Translated by Norman Denny)

From anyone else, such a program would have seemed pretentious. But Balzac would justify his publisher Latouche's description of him as "that volcano of novels who can turn out one in six weeks."

It was essential to this grandiose concept that the whole work never be completed. Their coherence would come from documentary truth. Following the prescription of Balzac's country doctor, "We proceed from ourselves to men, never from men to ourselves." With his "prodigious taste for detail," he would capture the personal nature of experience. "The author firmly believes that details alone will henceforth determine the merit of works improperly called *romans* [novels, or romances]." This sometimes overwrought detail, along with the dominant, usually unappealing, passions of his characters, repels many American readers nowadays.

To give historical coherence to his whole comedy, Balzac pioneered the multinovel saga. Keeping characters alive from novel to novel, he allowed

them to age, develop, or disintegrate. Although Old Goriot died, his ambitious daughter, Mme. de Nucingen, and her husband lived on in many novels. He referred readers to earlier novels—"See *Le Père Goriot*"—in which the same character had appeared. After a dormant period, characters would reemerge to remind us they are still alive. Over the twenty-five years of his writing they created their own problems as they aged.

Few, even among Balzac admirers, have read the bulk of his ninety-odd novels. But his passion for accurate history and his grand scheme make any of them a window into his *Comédie humaine.* Despite the complexity of his plan Balzac insisted, "I love simple subjects." In the English-speaking world his most popular novels would include *Eugénie Grandet,* "A Scene from Provincial Life" (1833), the tale of an enterprising small-town miser, the mayor of Saumur, and the struggle between two families for the hand and fortune of his heiress. We follow his profitable speculations in securities appreciated by the Restoration, and witness his daughter's unhappy widowhood. "The pale cold glitter of gold was destined to take the place of all warmth and colour in her innocent and blameless life, and lead a woman who was all feeling to look on any show of affection with mistrust. . . . Such is the story of this woman, who is in the world but not of the world, who, made to be a magnificent wife and mother, has no husband, children, or family." The theme of *Le Père Goriot,* "A Scene from Private Life" (1835), set in Paris, Balzac summarized in his notebook. "A worthy man—middle-class boarding house—600 francs income—stripped himself to the bone for his two daughters, who each have 50,000 a year—dies like a dog." As we follow the frustration of Old Goriot we meet his two daughters, the cynical ex-convict Vautrin who aims to corrupt the young Rastignac from the provinces, the warm-hearted medical student Bianchon, and other boarders. All these figures reappear in later segments of *La Comédie humaine.*

La Peau de chagrin (The Wild Ass's Skin; 1831), one of the Philosophical Studies, opens our window on Balzac's mysticism, the improbable complement to his passion for the concrete. This other Balzac is the enthusiast for mesmerism, cosmic unity, and the "life force." In this odd novel he elaborated a simple item in his notebook, "The discovery of a skin representing life. An oriental fable." The young Raphael, about to commit suicide by jumping into the Seine, wanders into an antique shop. There the mysterious dealer offers him the magic skin of a wild ass. The Sanskrit inscription on the skin promises its owner, "Express a desire and thy desire shall be fulfilled. But let thy wishes be measured against thy life. Here it lies. Every wish will diminish me and diminish thy days." The dealer who sells him the skin has lived to be a hundred because he has never expressed a desire. Raphael accepts the bargain and we follow his wishes to the fatal end. He has taken the counsel of Rastignac: "Dissipation, my dear fellow, is a way

of life. When a man spends his time squandering his fortune, he's very often on to a good thing: he is investing his capital in friends, pleasures, protectors and acquaintances."

In *The Rise and Fall of César Birotteau* (1837), one of his "Scenes from Parisian Life," the charlatan hero prospers by selling a "cephalic oil" supposed to make hair grow. Haunted by the specter of bankruptcy (as Balzac himself had been), he is "killed by the idea of financial probity as by a pistol-shot." And one of his most copious and vivid novels, *Lost Illusions* (1837, 1839, 1843), depicts the vices, foibles, and charms of the Paris *beau monde* through the struggles of an aspiring young poet from the provinces. He has no money but becomes the protégé of an influential patroness. He discovers that in the literary world, too, only money counts. Abandoned by his patroness, he turns to journalism, trying to make his way in the corrupt scandalmongering press, but when he finally returns to his home in the provinces he finds it no less corrupt than Paris.

Balzac's Human Comedy for the reading public was never quite separate from the world he was re-creating. Just before he lost consciousness in August 1850, Balzac is reported to have recalled the skillful doctor whom he had created in *Le Père Goriot,* and he said, "Only Bianchon can save me."

40

In Love with the Public

EVEN if Dickens had not been a great event in English literature, he would be a great event in English history. For, as G. K. Chesterton reminds us, "the man led a mob. He did what no English Statesman, perhaps, has really done; he called out the people." Dickens's career was a grand literary love affair with the English public, not just the reading public but the whole listening public.

A great love affair needs two willing partners, as there surely were here. Charles Dickens and the people of early Victorian England were made for each other. This happy coincidence explains much of the appeal and also the limits of Dickens's work. Seldom has an author been so cherished by his readers or an audience so beloved by an author. Dickens himself boasted

of "that particular relation (personally affectionate like no other man's) which subsists between me and the public." Perhaps this was because he was "a brilliant listener," and "allowed no man to be a bore."

Dickens's childhood prepared him to speak about the common life. If Balzac's family worried over their claim to add a "de" to their name, and disciplined him at the Oratorian Brothers' best school, Dickens suffered the working-class discipline of a boot-blacking factory, the shame of a father in debtor's prison, and the hunger of a six-shilling weekly wage. While Balzac shared the mercenary ambitions of middle-class France and the intrigues of Paris salons, Dickens was trying to stay alive and to make a living. They produced two versions of the human comedy as different as the France and England of their time. Balzac's France was turbulent, with memories of the guillotine and recurrent surging Paris mobs, with a new "constitution" every fifteen years, with upstart and defunct titles, ephemeral monarchies, royalist and democratic ideologies, and resounding street slogans. Balzac's beau ideal was Napoleon and in his own fashion Balzac had determined to conquer the world. Money and the salon were his refuge from war and politics. Without a family or children, Balzac had a dozen mistresses.

Dickens's England was another story. The slender young queen Victoria came to the throne in 1837, the year when Dickens first achieved fame with "Pickwick Triumphant." It was an age of empire, an age of complacency and reform. The Reform Bills of 1832 and 1867 would disintegrate the rotten boroughs, and respond to the agitation of Workingmen's Associations, Chartists, and others. The contradictions of the era were expressed in the Crimean War. On the other side of Europe, in "The Charge of the Light Brigade," at Balaklava and Inkerman, gallant British troops recklessly disregarded casualties. But the scandalous disregard of the health of the troops sparked the saintly heroism of Florence Nightingale (1820–1910).

It was an age of public brutality and unctuous religiosity, of private insensitivity and sentimentality, an age of cruel prisons, unbending factory discipline, and illiterate workers. Yet all these ills, it was believed, could be cured by better orphanages, humane prisons, Factory Acts, improved Poor Laws, repealed Combination Laws—generally by heeding the voice of the people spoken through a widening suffrage. The ills of this society, unlike Balzac's, would be cured not by revolution but by muscular Christianity and strong-willed morality.

The trials of Dickens's childhood would put his own optimism to the test, and would figure disproportionately in his works. In Balzac's human comedy children are only pawns in the game of inheritance, but in Dickens's they play leading roles. The childhood fortunes and misfortunes of Oliver Twist, David Copperfield, and Tiny Tim engage us as much as those of any

of his adult heroes. Little Nell of *The Old Curiosity Shop* never ceased to be the author's favorite, and Dickens wept whenever he gave public readings of her death. Unique among the great novels, his human comedy is enlivened by young men and women who were not yet rocked by adult passions.

Born in Portsmouth in 1812 to John Dickens, a paymaster in the Navy, Charles Dickens, at the age of five, moved with his family to London. John Dickens, the son of a domestic servant, had married the pretty daughter, one of ten children, of another Navy paymaster. Before they moved to London, John Dickens's father-in-law had embezzled £5,000 of Navy funds, was convicted, and fled the country, which destroyed John Dickens's hopes for financial help. A devoted family man, he did not gamble and drank only moderately. But he was generous, and loved to entertain, always hoping (like Mr. Micawber) that something would turn up. John Dickens could never live within his income, and throughout his life Charles Dickens had the burden of trying to keep his father out of debtor's prison.

When Charles was only twelve, his father, "as kindhearted and generous a man as ever lived," was committed to Marshalsea Debtor's Prison. There Dickens recalled:

> My father was waiting for me in the lodge, and we went up to his room . . . and cried very much. And he told me, I remember, to take warning by the Marshalsea, and to observe that if a man had twenty pounds a year, and spent nineteen pounds nineteen shillings and sixpence, he would be happy; but that a shilling spent the other way would make him wretched. I see the fire we sat before now; with two bricks inside the rusted grate, to prevent its burning too many coals. Some other debtor shared the room with him, who came in by and by; and as the dinner was a joint-stock repast, I was sent up to "Captain Porter" in the room overhead, with Mr. Dickens' compliments, and I was his son, and could he, Captain P., lend me a knife and fork?

Mrs. Dickens had imprudently rented a large house to be a school where she might repair the family fortunes, but no pupils ever came. Meanwhile, to save money, they took Charles out of school. "What would I have given, if I had had anything to give, to have been sent back to any other school, to have been taught something anywhere!"

When a friend, manager of a boot-blacking factory in the Strand, offered Charles a job at six shillings a week, "in an evil hour for me" the family leaped at it. "It is wonderful to me how I could have been so easily cast away at such an age. . . . My father and mother were quite satisfied. They could hardly have been more so, if I had been twenty years of age, distinguished at a grammar-school, and going to Cambridge." The searing experience of the job he recalled in Dickensian detail.

My work was to cover the pots of paste-blacking: first with a piece of oil-paper, and then with a piece of blue paper; to tie them round with a string; and then to clip the paper close and neat all round, until it looked as smart as a pot of ointment from an apothecary's shop. When a certain number of grosses of pots had attained this pitch of perfection, I was to paste on each a printed label; and then go on again with more pots. Two or three other boys were kept at similar duty downstairs on similar wages.

The manager did the only thing he could to increase Charles's humiliation, by requiring the boys to work before an open window to attract customers along the Strand.

A curious twist of Victorian humanitarianism allowed the families of Marshalsea prisoners to live with them and come and go to the prison. Charles's mother lived in the prison, while Charles and his sister Fanny spent Sundays there. When John Dickens was released, Mrs. Dickens would have been happy to keep Charles making his six shillings a week at the blacking warehouse. But John Dickens disagreed, and sent Charles as a day pupil to the respectable Wellington House Academy. It was ruled by a sadistic headmaster who seemed to enjoy hitting the palms of offenders' hands with "a bloated mahogany ruler," or "viciously drawing a pair of pantaloons tight with one of his large hands and caning the wearer with the other." Dickens did passably, and even won a Latin prize though he had never taken Latin. But when his struggling parents, already evicted from their house for failure to pay their rent, were burdened with another baby, they could no longer pay the fees, and Charles, just fifteen, was taken out of school. Hired as office boy in a firm of solicitors, he saw his salary soon rise from ten shillings to fifteen shillings a week. He found the work repetitious—registering wills, serving processes, filing documents—but he amused himself by observing the pompous idiosyncrasies of lawyers and clients.

Meanwhile, John Dickens, who had been charitably retired from the Navy with a small pension, at the age of forty-one had learned shorthand and joined the Parliamentary reporting staff of the *British Press*. Charles himself while at school had sent that paper some "penny-a-line" notices of local items. Following his father's example, he now determined to become a journalist. This meant mastering shorthand, and even in this tiresome exercise he found drama. "The changes that were wrung upon dots, which in such a position meant such a thing, and in such another position something else entirely different; the wonderful vagaries that were played by circles; the unaccountable consequences that resulted from marks like flies' legs; the tremendous effect of a curve in the wrong place; not only troubled my waking hours, but reappeared before me in my sleep." Although not yet

seventeen he obtained a job as court reporter in the Consistory Court of the Bishop of London, where he acquired a treasury of jargon, obfuscation, and legal muddles for any number of novels. At eighteen he secured a reader's ticket at the British Museum and he read fervently in his spare hours. With his remarkable shorthand skill, he went on, by the age of twenty, to report on Parliament for his uncle Barrow's new paper. His sight of the travesties of the law had already made him a reformer when he witnessed the Parliamentary battle over the Reform Bill of 1832. He widened his view of London life as a reporter for the Liberal *Morning Chronicle* and helped them win some news beats against *The Times.*

Meanwhile the slight Maria Beadnell, who came of a minor banking family above his station, infatuated him by her harp playing, her coy ringlets, and teasing ways. But her family had already promised her to a more appropriate young man, whom she married, and Dickens was left with a frustration from which he would never really recover. Three years later he met a quite different figure, Catherine Hogarth, the full-bosomed daughter of a successful journalist. The Hogarths saw promise in the young Charles, applauded the match, and he married Kate in 1836. She bore him ten children (nine of whom survived), and with his growing fame, their convivial family life became quite public. But she was moody, inept at conversation, and over the years the sociable Charles found her far from an ideal companion for his celebrity.

That celebrity came upon him like a whirlwind at the age of twenty-five. It is still not easy to explain. Dickens's first notable publication, in February 1836, was *Sketches by Boz,* a collection of his pieces from magazines and newspapers, under the appropriate subtitle "Illustrative of Everyday Life and Everyday People." The book was widely and favorably reviewed, and the author, likened by critics to Washington Irving or Victor Hugo, was praised for his "power of producing tears as well as laughter." But when the first number of the scheduled monthly installments of *Pickwick Papers* appeared later that year, it was received without enthusiasm. The publisher Chapman and Hall had printed only 400 copies of the first installment. Hoping to increase the sale in the provinces, they sent out 1,500 copies of the next four numbers "on sale or return." Of these an average of 1,450 copies were returned. After the first number had appeared, the popular caricaturist Robert Seymour, who was illustrating the series, became despondent over young Dickens's wholesale revision of Seymour's original plan. At Dickens's demand that he redo an illustration, Seymour committed suicide.

With these unhappy events, the publisher Chapman and Hall could easily have dropped the project. But the enthusiastic Dickens persuaded them to find another illustrator whom he would choose and supervise. Luckily, as

it proved, the celebrated George Cruikshank was not available, and they found the sketches submitted by the eager young William Makepeace Thackeray (1811–1863) quite unsuitable. Instead they gave the commission to the precocious but relatively unknown Hablot Knight Browne (1815–1882), who would become famous as "Phiz," the illustrator of novels by Dickens and others. By the end of July 1836, when Sam Weller had appeared in the *Pickwick Papers,* the sales exploded to forty thousand copies for each number. Dickens wrote his publisher, "Pickwick Triumphant!"

The popularity of *Pickwick* was a literary phenomenon without precedent—in the youth of the author, in the suddenness and durability of the acclaim—and has found few successors. "Here was a series of sketches," Dickens's intimate friend and biographer John Forster observed in amazement, "without the pretence to such interest as attends a well-constructed story; put forth in a form apparently ephemeral as its purpose; having none that seemed higher than to exhibit some studies of cockney manners with help from a comic artist; and after four or five parts had appeared, without newspaper notice or puffing . . . it sprang into a popularity that each part carried higher and higher, until people at this time talked of nothing else, tradesmen recommended their goods by using its name, and its sale, outstripping that of all the most famous books of the century, had reached an almost fabulous number." Carlyle reported a clergyman who heard a deathly-ill parishioner exclaim, "Well, thank God, Pickwick will be out in ten days anyway!"

Forster likened Dickens's popularity to the slavery of men of letters in ancient times. "He had unwittingly sold himself into a quasi-bondage, and had to purchase his liberty at a heavy cost, after considerable suffering." But Dickens's bondage, like Balzac's, was self-created. He remained in the thick of things, editing magazines, organizing good causes, reporting for newspapers, while he wrote his novels piecemeal. Like *Pickwick,* his next novel, *Nicholas Nickleby* (1838–39), was written in twenty monthly parts. Then *The Old Curiosity Shop* (1849–41) and *Barnaby Rudge* (1841) were written in shorter weekly installments. Novel writing for Dickens was the closest thing to journalism because it was periodical writing. This was a commitment not only to the publisher, for whom the work was contracted, but to the public, whose expectant response could suggest or even dictate the direction of the story. Nearly all Dickens's novels were written in this way.

With the "serial novel" Dickens was innovating. While nowadays the normal form for a novel is a single volume, it was not so in Dickens's day. In the eighteenth century a novel might come to five volumes. Later, in the times of Jane Austen (1775–1817) and Sir Walter Scott (1771–1832), three volumes had become standard. When the price was half a guinea (10s. 6d.) a volume, most people could not afford to buy the book. But each install-

ment of the *Pickwick Papers* published by Chapman and Hall was only thirty-two pages of print. In green paper covers, with two illustrations and some pages of advertisement, three or four chapters were offered to readers on the last day of the month for one shilling.

Unlike Balzac, Dickens was a daytime writer. In his early years he wrote fluently, sometimes for the whole day, and made few revisions. But by midcareer he was normally writing only from nine until two. His erasures and interlineations and revisions increased. The serial calendar normally controlled the pace of his writing. Each number had to reach a point of rest, yet keep the reader breathless for the next number. The serial novelist, needing to keep only one jump ahead of his readers, could not follow Trollope's prescription that "an artist should keep in his hand the power of fitting the beginning of his work to the end." When Dickens published the first number of a novel, he rarely had more than four or five numbers written. And when he reached the middle he might still be only one number ahead. Committed by contract to write more than one serial at a time, Dickens was often under pressure. For example, he was writing numbers of *Oliver Twist* before he had completed the *Pickwick* series, and was already writing the opening numbers of *Nicholas Nickleby* before he had ended *Oliver Twist*.

The progress of a serial novel would inevitably reflect the personal misfortunes of the novelist. When Mary Hogarth, Dickens's sister-in-law, to whom he was deeply devoted, died on May 7, 1837, and sent him into a depression, the result was that there were no June numbers of either *Pickwick* or *Oliver Twist*. And when Dickens died on June 9, 1870, he had already written enough of *Edwin Drood* to provide serial publication of three posthumous numbers.

The periodical way of writing also tied the author and the content of the novel intimately to the daily life of his time. Dickens himself explained in his original Preface to *Nicholas Nickleby* (1839), "Other writers submit their sentiments to their readers, with the reserve and circumspection of him who has had time to prepare for a public appearance. . . . But the periodical essayist commits to his readers the feelings of the day, in the language which those feelings have prompted." The reader who was impatient to spend his shilling for the latest green-covered chapters at the end of every month had been conjured up by the serial novelist. Here was a wider, more instantaneous audience, "more delicately responsive" to the author. And the author too could be continuously and instantly responsive to the audience. Just as Shakespeare could take the measure of his audience by the box-office receipts at the Globe or the heard response of spectators to individual scenes, so Dickens could do the same with each part of a novel. Dickens described the price paid by the serial novelist as "periodical paragraph disease."

Loving his audiences, Dickens responded promptly to their signals. *Martin Chuzzlewit* (1843–44) Dickens himself called "in a hundred points immeasurably the best" he had yet written. But in its first four serial numbers it did not sell well—only some 20,000 for each number compared with the 50,000 for *Pickwick* and *Nicholas Nickleby,* and 100,000 for *The Old Curiosity Shop.* Dickens conferred with his publishers Chapman and Hall and his intimate John Forster on what could be done. Forster suggested that the public had become so accustomed to weekly installments of his more recent novels that they did not like to wait a whole month for the next installment of *Chuzzlewit.*

Instead of making *Chuzzlewit* a weekly serial, Dickens found another way to heighten interest. He would have Chuzzlewit "go to America." And so he announced at the end of the fifth number. A sound commercial reason was that only the year before, in 1842, Dickens's *American Notes* had been a roaring popular success in England. America, Dickens said, had failed to live up to "the republic of my imagination." In the United States he had been lionized by readers, and formed warm personal friendships with Longfellow and others, but he was vilified by the press. Slavery in America, which Dickens loudly opposed, they said was none of his business. His plea for an American copyright law to protect authors from pirating they called purely mercenary, a motive that Americans found suspect in foreigners. In 1843, he believed, British readers would eagerly buy anything that Dickens had to say about America, especially if it was unfavorable. His American mail continued to bring scurrilous letters and contemptuous articles. "I have a strong spice of the Devil in me," he explained, "and when I am assailed, as I think falsely or unjustly, my red hot anger carries me through it bravely." He would use the next numbers of *Chuzzlewit,* still unwritten, to embroider the most offensive points of his *American Notes* and get even with his American assailants. But English readers were only mildly pleased, and increased their purchase of the next numbers of *Chuzzlewit* by a scant three thousand. The predictable American reaction was explosive. "Martin has made them all stark raving mad across the water," Dickens reported to Forster with glee. Carlyle also seemed pleased to note that "All Yankee-Doodle-dum" had exploded "like one universal soda bottle." In the long run Dickens's instinct for the public taste was confirmed. In the next century, *Martin Chuzzlewit* would rival *Pickwick, Oliver Twist, David Copperfield,* and *A Christmas Carol* in popularity.

Dickens, while a man of enthusiasm and compassion, unlike Balzac, was not a man of passion. Emphatically a democrat, he remained a special kind of Victorian populist. "My faith in the people governing," he summed up in 1869, "is, on the whole, infinitesimal; my faith in the People governed is,

on the whole, illimitable." Experience as a Parliamentary reporter had not increased his confidence in representative assemblies. He had suffered the House of Commons "like a man," and in the House of Lords "yielded to no weakness but slumber." He boasted having seen many elections without "ever having been impelled (no matter which party won) to damage my hat by throwing it up in the air in triumph." What he saw of the Congress in Washington did nothing to change his views. Never had he "been moved to tears of joyful pride at the sight of any legislative body."

Still, he never lost faith in the power of "the People," through legislation, to push reform. He spoke, wrote, and contributed time and money for every major reform movement during his lifetime. He opposed capital punishment and promoted laws for the reform of prisons, for the improvement and diffusion of education, for better hospitals and improved urban sanitation, for safer factories and shorter working hours, for humane treatment of orphans, the insane, the deaf, and the blind, for widows, and debtors. He sometimes sounded like an anarchist, the enemy of all institutions, but he spent himself for legal reforms with the conviction of a committed socialist.

Dickens's friends admired his good nature and especially his ability to "laugh at the majesty of his own absurdities." As George Bernard Shaw observed, the England of Thackeray and Trollope is long gone, "But Dickens's England, the England of Barnacle and Stiltstalking and Hamlet's aunt, invaded and overwhelmed by Merdle and Veneering and Fledgeby, with Mr. Gradgrind theorizing and Mr. Bounderby bullying in the provinces, is revealing itself in every day's news, as the real England we live in." The comic in Dickens, his feeling for the theater and the music hall, prevented him from becoming a solemn preacher. His dramatic sense cast the world's ills, its triumphs and tragedies, in story form, and his polemics were effective precisely because they were not arguments.

One of the mysteries of Dickens's prodigious achievement is how he secured the raw materials for stories that covered the whole of English working-class and middle-class life. He made the most of every moment of his limited experience, such as the few months of his father's imprisonment in Marshalsea. He did live on the Continent for months at a time, but this was mainly to write, not to gather material. Still he managed to squeeze those experiences too, finding the clue for *The Chimes* in his hapless time in Genoa. Before he was twenty-five he had briefly shared the hungry life of London's destitute working-class children, had felt the miseries of sadistic school discipline, had witnessed the foibles of the legal profession and the absurdities of law courts, had endured the rhetoric of both houses of Parliament, had followed the London theater, and had a short energetic career as a newsman.

While Balzac sought his fortune in harebrained projects for pineapple

plantations or Sardinian silver mines, Dickens experimented only with ways to reach people with the word. The most strenuous of these experiments was the *Daily News* (1846), which he helped found to promote his programs of reform, and to dispute the primacy of the powerful *Times* (circulation about twenty-five thousand). His paper settled into a meager circulation of about four thousand and Dickens remained editor for only seventeen issues. More successful was his aptly titled *Household Words* (1850–59), a weekly miscellany, selling for twopence, which aimed to be "as amusing as possible, but all distinctly and boldly going to what . . . ought to be the spirit of the people and the time." Every problem of the day, from illiteracy to sewage disposal and inhuman jails became a target in its pages. The first number sold one hundred thousand copies and it flourished for nearly a decade (1850–59). *All the Year Round* (1859–88), its successor, was still more successful. Each number offered a serial by a famous author, advertised in advance, beginning with the opening installment of *A Tale of Two Cities.*

In 1858, when Dickens had first thought of a novel about the French Revolution, he sought research advice from his friend Thomas Carlyle (1795–1881), whose *French Revolution* (1837) had been widely acclaimed. From the London Library, Carlyle, who had been one of its founders, sent Dickens two cartloads of books. In other ways, too, this was a hard time for Dickens, whose troubled marriage of two decades was finally coming apart. Seeking a title for his revolutionary novel, he first thought of *One of These Days.* "What do you think of *this* name for my story—*Buried Alive?*" he asked Forster, "Does it seem too grim? Or *The Thread of Gold?* Or *The Doctor of Beauvais?*" At the last minute he came up with a better idea, along with a more effective way to reach his expectant public:

> I have got exactly the name for the story that is wanted, exactly what will fit the opening to a T. *A Tale of Two Cities.* Also . . . I have struck out a rather original and bold idea. That is, at the end of each month to publish the monthly part in the green cover, with two illustrations at the old shilling. This will give *All the Year Round* always the interest and precedence of a fresh weekly portion during the month; and will give me my old standing with my old public, and the advantage (very necessary in this story) of having numbers of people who read it in no smaller portions than a monthly part.

Again Dickens had shrewdly judged his public. Within ten years each number of *All the Year Round* was selling three hundred thousand copies.

Whenever Dickens discovered a public enthusiasm, he responded. His first long Christmas story, *A Christmas Carol* (1843), proved a spectacular success, selling six thousand copies on the day of publication. Even the jaundiced Lord Jeffrey (1773–1850) congratulated him for having "done

more good by this little publication, fostered more kind feelings, and prompted more positive acts of beneficence, than can be traced to all the pulpits and confessionals in Christendom since Christmas 1842." Thackeray proclaimed it "a national benefit, and to every man or woman who reads it a personal kindness." Naturally, Dickens decided to make it the first of an annual Christmas serial. He followed it with *The Chimes, The Cricket on the Hearth, The Battle of Life,* and *The Haunted Man*—all profitable, but none quite up to the first number. Few of Dickens's other writings had involved him so personally as *A Christmas Carol.* He had "wept and laughed, and wept again, and excited himself in a most extraordinary manner in the composition; and thinking whereof he walked about the black streets of London fifteen and twenty miles many a night when all other folks had gone to bed."

Had he thought of it he too might have called the body of his novels *The Human Comedy.* But Dickens was not one for abstractions. He thought not of "humanity" but of "the People." They were the scene that he surveyed, and his novels ran the gamut of popular concerns. In the midst of writing the serials of *Bleak House,* his tale of the absurdities of the Court of Chancery, he went to Birmingham to plead the cause of public education. In what might have been his own literary manifesto he attacked "the coxcombical idea of writing down to the popular intelligence." "From the shame of the purchased dedication, from the scurrilous and dirty work of Grub Street, from the dependent seat on sufferance at My Lord Duke's table today, and from the sponging-house or Marshalsea tomorrow . . . the people have set literature free."

For Dickens, freeing literature meant freeing the author from servility to patrons or fellow literati in order to champion popular causes. He was not always successful, as when, hoping to redeem his son Charles from the perils of Torydom, he wrote his *Child's History of England.* But the sufferings of the destitute children of London, the schemes of pettifogging lawyers, the frustrated hopes of hardworking clerks, the criminals of passion and greed, all these he surveyed in *David Copperfield, A Christmas Carol, Oliver Twist, Nicholas Nickleby, Bleak House, Hard Times, Little Dorrit,* and *The Old Curiosity Shop.* Their legacy was not a philosophy of life but a cast of unforgettable characters: Mr. Micawber, Scrooge, Fagin, Little Nell, and countless others. Bagehot properly described him as "a special correspondent for posterity."

His own life, too, dramatized the conventional values of his time. In conspicuous contrast to Balzac, he was, at least publicly, the loyal husband and playful father. His wife Kate's activities during their early married life were continually restricted by what he delicately called "an anti-Malthusian

state." His constant need for money was not due to extravagance, though he lived well and entertained generously, but to the improvidence of his father, the demands of other family members, and the need to support his nine surviving children. His emotional frustrations came from idealizing his wife's sister, Mary Hogarth, who had lived with his family and whose death was a bitter blow, and from nostalgia for his "first love," Maria Beadnell. Still, when he met Maria years later he found her fat and dull.

Dickens was widely praised for "his deep reverence for the household gods." His romps with his children were noted and applauded. But his unhappiness with his wife and his cruelty to her had to be hushed up. His separation from Kate in 1858 became a scandal that would hardly have roused a whisper in a Balzacian salon. The rumored cause was his intimate relation with a pretty young actress, Ellen Ternan, opposite whom Dickens himself had played a passionate role in a benefit performance of an arctic melodrama, *The Frozen Deep.* Despite Victorian reticence he had to justify himself to his audience, and he made matters worse by a notice headed "Personal" on the front page of *Household Words* on June 12, 1858.

> I most solemnly declare, then—and this I do both in my own name and in my wife's name—that all the lately whispered rumors touching the trouble at which I have glanced, are abominably false. And that whosoever repeats one of them after this denial, will lie as wilfully and as foully as it is possible for any false witness to lie, before Heaven and earth.

Not until 1939 were his daughter Katey's revelations of Dickens's family life finally published. "Nothing," declared Katey, "could surpass the misery and unhappiness of our home." Yet Dickens's relations with Ellen Ternan remained veiled in hypocrisy or reverence.

Whatever the changing fortunes of Dickens's marital love, he never ceased courting his one constant love, the public. The warm response of his readers was revealed at his death in 1870. From America, where people had reason to feel otherwise, Longfellow noted that "this whole country is stricken with grief." Paris mourned "at the thought of all we—his family— have just lost in Charles Dickens." Carlyle declared that his death had "eclipsed . . . the harmless gaiety of nations." And he was buried in Westminster Abbey.

But Dickens was never satisfied with the indirect relation to his beloved public through the printed word. He wanted to see their faces, hear their laughter, share their tears. His hunger for the living audience increased with time, abridged his writing career, and hastened his death. As a child he had delighted in the London Christmas pantomimes; at school he had enjoyed staging plays in toy theaters. By the time he was sixteen he was frequenting

the London theaters with his fellow law clerks. When he had just begun his career as a Parliamentary reporter, he wrote to the manager at the Lyceum Theater requesting an audition. He boasted "a strong perception of character and oddity, and a natural power of reproducing what he saw."

He never lost his fascination with the theater. His favorite form of philanthropy was to stage benefit performances with well-known actors or literary figures, and himself as an actor and director. His roles included Sir Epicure Mammon in *The Alchemist,* Bobedil in *Every Man in His Humour,* Shallow in *The Merry Wives of Windsor,* the Ghost of Gaffer Thumb in *Tom Thumb,* and many others in plays no longer remembered. On his American trip he persuaded the withdrawn Kate to act a comic part, and he was surprised at how "devilish well" she did it. It was during a performance of the lurid *Frozen Deep* at Manchester in 1857 that he first played the role of Ellen Ternan's lover, which he replayed painfully offstage in the years to come.

It took very little to turn Dickens's interest in acting into the obsession that conquered his last years. When he returned to London from Italy in 1845, he read his sequel to *A Christmas Carol,* called *The Chimes,* to ten friends at a dinner given by Forster on the night of December 3. It was a smashing, in retrospect we might say a disastrous, success. Subtitled "A Goblin Story," *The Chimes* is the sentimental tale of a messenger, Trotty Veck, down on his luck, who has visions of the evils of London life and the misfortunes of his daughter. The famous Shakespearean actor William Macready (1793–1873) had been at the reading, as Dickens observed. "If you had seen Macready last night, undisguisedly sobbing, and crying on the sofa as I read, you would have felt, as I did, what a thing it is to have power."

Dickens's taste for power over an audience, not just as one actor in a stage play, but as the lone reader of his own words, became a fatal addiction. The public readings from his own work were profitable. Under different managers he eventually offered 423 paid public readings, for which he received a total of some £45,000, an average of more than £100 per reading. This would amount to nearly half the £93,000, which was the whole value of his estate at his death. At the Christmas season, 1853, his first public reading from his own books at a benefit in the Birmingham Town Hall to an audience of two thousand was successful beyond all his hopes. On December 27, when he read *A Christmas Carol* (of course unaided by any public address system) he kept listeners electrified for three hours. Then on December 29 he read *The Cricket on the Hearth.* A second reading of the *Carol* on December 30 attracted twenty-five hundred working people at reduced prices. "They lost nothing, misinterpreted nothing, followed everything closely, laughed and cried. . . . I felt as if we were all bodily going up into the clouds together."

Dickens seized the multiplying opportunities to embrace his audience in

public. On his second trip to America, in Boston in December 1867, when he read *A Christmas Carol* and the trial scene from *Pickwick,* Dickens reported, "Success last night beyond description or exaggeration, the whole city is quite frantic about it today, and it is impossible that prospects could be more brilliant." John Greenleaf Whittier confirmed that "Those marvellous characters of his come forth . . . as if their original creator had breathed new life into them. . . . you must beg, borrow, or steal a ticket to hear him. Another such star-shower is not to be expected in one's lifetime."

After his London series Dickens made strenuous reading tours across England, to Ireland and Scotland. He improved his technique, too, cutting the *Christmas Carol* from the three hours of his first reading down to two. In Paris, where his Christmas story of the year had sold nearly two hundred thousand copies, he reached his beloved public across the language barrier. "The Reading so stuns and oversets the Parisians," Dickens reported of his reading for charity at the British embassy in January 1863, "that I shall have to do it again. Blazes of Triumph! . . . They are so extraordinarily quick to understand a face and gesture, going together . . . that people who don't understand English, positively understand the Readings!"

The trials of the reading circuit were often painful. On April 10, 1866, when Dickens did his first reading of "Doctor Marigold," adapted from his last Christmas story (which had sold more than two hundred and fifty thousand copies), he had already rehearsed it two hundred times. Then Dickens read to overflow crowds from St. James Hall, London, to Liverpool, Manchester, Glasgow, Edinburgh, Aberdeen, ending at Portsmouth in late May. On this tour Dickens suffered the custody and cuisine of a manager whom Mark Twain (who followed Dickens's example in his own profitable lecture tours) knew as "a gladsome gorilla." Far from carrying him "into the clouds," Dickens's obsessive public readings were carrying him to his grave. He never allowed the pains of a sore throat or the tortures of his swollen foot in the years after 1867 to delay or cancel a reading. Once, when it was rumored that his gout would force him to cancel a tour, he insisted that he was suffering from nothing but "periodical paragraph disease," and had "not had so much as a headache for twenty years."

Appropriately, he took leave of his beloved public not in cold type but in their warm presence. In January 1870, suffering from gout and exhaustion, repeatedly warned by his doctor that his readings would be his death, he began a suicidal series of twelve readings a week. His pulse had risen dangerously, during intermissions he had to be laid on a sofa, and sometimes ten minutes would pass before he could speak a sentence. When he bungled with Pickswick, Picnic, and Peckwicks, before he could manage "Pickwick," this too seemed to amuse him. His hand was swelling painfully. But he completed his engagement on March 15, 1870, again reading *A*

Christmas Carol and the trial from *Pickwick.* In the enthusiastic audience of two thousand, his granddaughter Mekitty, who had never heard him before, was frightened at "the dreadful moment when he cried." With tears streaming down his cheeks, as he limped off the stage he declared, "From these garish lights I now vanish forevermore, with a heartfelt, grateful, respectful, affectionate farewell."

PART EIGHT

FROM CRAFTSMAN TO ARTIST

The lyf so short, the craft so long to lerne,
Th'assay so hard, so sharp the conquering.

—GEOFFREY CHAUCER (C.1380)

Archetypes Brought to Life

THE first Western artist to bring painted Christian archetypes to life was also the first to be brought to life by his admirers. Giotto di Bondone (1267?–1337) was a legend in his own time. A young man of twenty-four when Giotto died, Boccaccio featured him in a story in the *Decameron*. "Giotto was a man of such genius that there was nothing in Nature . . . that he could not paint with his stylus, pen, or brush, making it so much like its original in Nature that it seemed more like the original than a reproduction. Many times, in fact, while looking at paintings by this man, the observer's visual sense was known to err, taking what was painted to be the very thing itself." In his "Purgatory," Dante, Giotto's contemporary, meets those suffering from the endemic sin of artists:

> O gifted men, vainglorious for first place,
> how short a time the laurel crown stays green
> unless the age that follows lacks all grace!
>
> Once Cimabue thought to hold the field
> in painting, and now Giotto has the cry
> so that the other's fame, grown dim, must yield.
> (Translated by John Ciardi)

It is not surprising that Dante's praise for Giotto was so grudging. He must have envied the artist newcomer who had been acclaimed in the native Florence from which Dante had been so early and so unjustly exiled.

Giotto's phenomenal native talent was still celebrated in the sixteenth century by Vasari, the biographer of Renaissance artists. One day in the late thirteenth century, he reports, as Cimabue (1240–1302), the master painter of Florence, passed on the road to nearby Vespignano, he was surprised to find a young shepherd "portraying a sheep from nature on a flat and polished slab, with a stone slightly pointed, without having learnt any method of doing this from others, but only from nature." This was the boy Giotto. Not one to hesitate, "Cimabue, standing fast all in a marvel, asked him if he wished to go to live with him. The child answered that, his father consenting, he would go willingly." When Giotto's father "lovingly" consented, the boy accompanied Cimabue to Florence, and "in a short time, assisted by nature and taught by Cimabue, the child not only equaled the manner of his master, but became so good an imitator of nature that he

banished completely that rude Greek manner and revived the modern and good art of painting, in producing the portraying well from nature of living people, which had not been used for more than two hundred years."

A young immigrant to the city, Giotto throughout his life prospered from the good opinion and the profitable commissions of the rich and famous. And one of his first important commissions was the chapel for the family of the notorious Paduan usurer Scrovegni, whom Dante consigned to the burning sands of the seventh level of Hell. On that chapel Giotto spent two years and there left some of his best work. We know of no occasion when Giotto refused to profit by embellishing his own adopted city or any others that could pay his price. The nostalgic Dante stood for old-village virtues, while Giotto prospered with the growing commercial metropolis. Himself reputed to be a usurer, Giotto hired out looms to weavers and sued debtors if they did not repay him promptly and with interest. He served the Bardi and Peruzzi, powerful bankers of Florence, moneylenders to the pope and the king of England; he worked for the Visconti of Milan and embraced the patronage of Robert of Anjou, king of Naples.

Giotto's confidence in his talent was proverbial. When Pope Boniface VIII wanted some pictures painted for St. Peter's, Vasari recounts, he sent a courtier to Florence "to see what sort of man was Giotto." Since artists in Siena had already supplied samples of their work, the courtier asked Giotto for "some little drawing, to the end that he might send it to His Holiness."

> Giotto, who was most courteous, took a paper, and on that, with a brush dipped in red, holding his arm fast against his side in order to make a compass, with a turn of the hand he made a circle, so true in proportion and circumference that to behold it was a marvel. This done, he smiled and said to the courtier: "Here is your drawing." He, thinking he was being derided, said: "Am I to have no other drawing but this?" " 'Tis enough and to spare," answered Giotto, "send it, together with the others, and you will see if it will be recognized." The envoy, seeing that he could get nothing else, left him very ill-satisfied and doubting that he had been fooled.
>
> (Translated by Gaston du C. de Vere)

Giotto's *tour de talent* won the pope's commission and "there was born from it the proverb that is still wont to be said to men of gross wits: Thou art rounder than Giotto's circle!" Called to Rome, Giotto painted five scenes from the life of Christ for the apse of St. Peter's and the chief panel in the sacristy. The pope was so well pleased that he gave Giotto six hundred ducats of gold, "besides granting him so many favours that they were talked of throughout all Italy."

While the facts of Giotto's life are overcast with legend, there is no doubt

of his role as a creator of modern painting. He transformed schematic religious symbols into warm living figures and so showed the way for creating human figures that transcended religion. The art of painting in the West followed his pioneer efforts to humanize the lore of Christianity, to make religion real. The image of nature would come later. But Christianity provided the first arena and the drama where Western artists brought the visible world to life.

In Florence Giotto applied his talents to the familiar Christian stories, but he did not allow himself to be imprisoned in the familiar ways of treating them. The novelty of his way of painting at once attracted disciples. Among them was Cennino Cennini (c.1370–c.1440), whose influential *Craftsman's Handbook* (*Libro dell'arte*, 1437), one of the first treatises on art to discuss the proportions of man, defined the new tradition of Giotto. Now, at last, he declared, painting "justly deserves to be enthroned next to theory, and to be crowned with poetry." For "an occupation known as painting . . . calls for imagination, and skill of hand, in order to discover things not seen, hiding themselves under the shadow of natural objects, and to fix them with the hand, presenting to plain sight what does not actually exist." It was Giotto who "changed the profession of painting from Greek [Byzantine] back into Latin [Roman], and brought it up to date; and he had more finished craftsmanship than anyone has had since."

A century after his death Giotto was already recognized as a one-man Renaissance. With the rise of Christianity and the persecution of idolatry by the Iconoclasts, Lorenzo Ghiberti (1378–1455) recounts (c.1450): "all the statues and pictures of such nobility, antiquity and perfection were destroyed and broken to pieces. . . . the most severe penalty was ordered for anyone who made any statue or picture. Thus ended the art of sculpture and painting and all the teaching that had been done about it. . . . Art was ended and the temples remained white for about six hundred years." Then, Ghiberti notes, Cimabue made feeble efforts to revive painting in his Byzantine ("Greek") style. But it was left to Giotto, whom Cimabue himself had discovered on the Florentine countryside, to "introduce the new art," abandon the "crude" Byzantine manner, and attract disciples "as gifted as the ancient Greeks."

> Giotto saw in art what others had not attained. He brought the natural art and refinement with it, not departing from the proportions. He was extremely skillful in all the arts and was the inventor and discoverer of many methods which had been buried for about six hundred years. When nature wishes to grant anything she does so without avarice. He was prolific in all methods, in fresco on walls, in oil, and on panels. . . .
>
> (Translated by Elizabeth Gilmore Holt)

Bold in his manner, he was comfortingly familiar in his matter. He painted only Christian subjects, but impressed his viewers by saying something new in an old vocabulary. Even the casual student can sense this in the grandeur, bulk, and depth of his *Virgin in Majesty* (the Ognissanti Madonna; c.1310), still among the first paintings to greet the visitor to the Uffizi in Florence. With Gothic liberation he refreshed the central figures of Christian iconography.

Giotto's undisputed triumph of Christian-lore-brought-to-life was his grand series of frescoes (1303–8) in the nave of the Scrovegni Arena Chapel in the Church of the Annunziata in Padua. In front of this chapel every year the life of the Virgin Mary was dramatized in miracle plays. On the walls of the small bare church, Giotto dramatized his story in three tiers of narrative frescoes. Underneath he painted a monochrome band of personified Virtues and Vices. Among the virtues are Prudence, Fortitude, Temperance, Justice, Hope, Faith, Charity, and among the vices are Envy, Despair, Wrath, Injustice, Inconstancy, Folly, Infidelity or Idolatry. All figures have a statuesque human bulk and roundness, with limbs revealed under naturally flowing garments. Each shows the medieval emblem and the familiar gesture of its subject. But they have a bodily reality that had not been known in Western painting for centuries, on distinctive landscapes of rocks, hills, and valleys with real sheep and goats and pigs, and identifiable trees and flowers and weeds. *The Adoration of the Magi* is saved from cliché by three distinctive kings with a unique camel in a mystic rocky landscape. If we want to understand what the Christ story meant and why it survived into the age of naturalist art, we cannot do better than review the Arena Chapel.

The principles of perspective were not to be rediscovered for another century, and the knowledge of anatomy was not to be modernized for more than a century. Still, Giotto found his own way to depict space and the roundness of the human body. An empirical artist without a theory of his own, he introduced the art of modern painting; the science was still to come.

The stature of the works insistently attributed to him is a measure of his originality and his influence. Vivid frescoes of biblical stories and the legend of Saint Francis in the Church of San Francesco in Assisi bear the mark of Giotto's "modern" style—the realism, human warmth, variety of expression, and telling details of landscape. What scholars now call "the Assisi Problem" arises from the variety of styles in these frescoes. Cimabue himself may have painted some of them. The role of Giotto there has been overshadowed by the uncertain date of his birth, which might have made him too young for this important commission. But across northern Italy, in Santa Maria Novella in Florence, in Rimini and Padua, crucifixes revealed the power of Giotto and his disciples to humanize the stereotype. Giotto's fame as an artist was recognized by his fellow citizens of Florence in 1334, when

they named him *capomaestro,* or surveyor, of their cathedral and architect
to the city. He showed the versatility expected of artists of his age when,
a few months later, he began building the bell tower beside the cathedral,
which was finished only after his death.

<p style="text-align:center">42</p>

Roman Afterlives

WHAT Giotto did for the human body and the Christian story, only a
century later another Florentine would do for architecture. Filippo Brunel-
leschi (1377–1446) found his archetypes in the monuments of ancient Rome.
In 1401, luckily for Western architecture, the twenty-four-year-old Filippo
did not win the competition to make the bronze reliefs for the doors of the
Baptistery of San Giovanni in Florence. The judges announced a tie be-
tween him and Lorenzo Ghiberti (1378–1455) and urged the two to collabo-
rate. When Brunelleschi refused to work except on his own terms, the
commission went to Ghiberti, and Brunelleschi left Florence in pique. "So
he went to Rome where at the time one could see beautiful works in public
places," his contemporary biographer Antonio Manetti (1423–1491) re-
ported. He would give a brilliant new afterlife to the Roman arts of building.

A Florentine background more different from that of Giotto would be
hard to imagine. Brunelleschi's father, of a respectable old family, pros-
pered by supplying the army of the city. Apprenticed as a goldsmith,
Brunelleschi soon showed remarkable talent. Despite his youth, he received
a commission to sculpt a wooden crucifix for the church of Santa Maria
Novella, and his advice was sought on public buildings. If he had won the
commission for the Baptistery doors, he might have remained only a pros-
perous sculptor in Florence and Western architecture might not have borne
his mark.

His friend Donatello (1389?–1466), who would play for sculpture the
pioneer role that Giotto played for painting, accompanied him, and, accord-
ing to Manetti, "together they made rough drawings of almost all the
buildings in Rome and in many places beyond the walls, with measurements
of the widths and heights as far as they were able to ascertain by estimation,
and also the lengths, etc. In many places they had excavations made in order

to see the junctures of the membering of the buildings and their type—whether square, polygonal, completely round, oval, or whatever . . . they estimated the heights . . . of the entablatures and roofs from the foundations. They drew the elevations on strips of parchment graphs with numbers and symbols which Filippo alone understood." The puzzled Romans called them "treasure hunters," for they could imagine no other motive for all the digging and measuring.

Brunelleschi had no difficulty finding the treasure he was seeking, which was the dignity and elegance of the ancient Roman buildings. "He found a number of differences among the beautiful and rich elements of the buildings—in the masonry, as well as in the types of columns, bases, capitals, architraves, friezes, cornices, and pediments, and differences between the masses of the temples and the diameters of the columns; by means of close observation he clearly recognized the characteristics of each type: Ionic, Doric, Tuscan, Corinthian, and Attic. As may still be seen in his buildings today, he used most of them at the time and place he considered best."

Giotto, Brunelleschi, and their fellows pioneered the Renaissance re-creation on which we have built modern times. Celebrated as "inventors and discoverers of many methods that had been buried for about six hundred years," they also unwittingly conjured up a "Middle Ages" between two ages of classic excellence. Without them it might have been unnecessary to imagine the cultural hiatus that has plagued us ever since.

From Rome Brunelleschi brought back to Florence the vocabulary and the grandeur of the Roman style with some of the secrets of Roman building technology, and gave them new life. Just as Dante had translated Christian mythology from Latin into the Italian vernacular, and as Giotto had translated painting from the Byzantine ("Greek") into the Latin (Roman), Brunelleschi revived a Tuscan order in architecture. He aimed to prove that "the years between" were not a gulf but only an interruption, as he adapted the grandiose Roman forms to Florentine buildings on a smaller scale with a new grace and light elegance.

What is called the first true Renaissance building, and the first in Brunelleschi's own style, is the Foundling Hospital (1419–24) in Florence, built by his own guild of silk merchants and goldsmiths. The façade of the loggia shows how far he has come from the Gothic, how much he has depended on the classical motifs, and how boldly he has adapted them. A light series of rounded arches is supported by slim columns with a dominant horizontal element above, covering a vault of small domed bays in a square plan. The interior of his chapel for the Chapter House attached to Santa Croce and built for the Pazzi banking family (c.1430) also uses columns, pilasters, and arches for a Pompeian grace. Blank white walls subdivided by gray pilasters

are quite unlike the high windows, carved pillars, and infiltering light of the Gothic. The classical orders lend a touch of elegance to a modest interior. He also uses his Roman vocabulary for grander buildings like the basilical churches of San Lorenzo (c.1419) and of Santo Spirito (c.1434) in the shape of a Latin cross, or the church of Santa Maria degli Angeli, a central-domed octagon.

Brunelleschi learned more than a style and a set of motifs from the ancient Romans. His triumph as a re-creator would be posthumous and worldwide, for the archetypes of Roman architecture, its columns, domes, and architraves, would be revived in new combinations in buildings on every continent, and celebrated in America in countless county court-houses and post offices, on the façades of ambitious community builders, in Monticello and on Capitol Hill. In his own time he created a unique monument of architecture that was as eloquent of Renaissance Florence as the Pantheon was of Hadrian's Rome or Hagia Sophia of Byzantium. Using Roman techniques and a bold engineering imagination he built the dome of the cathedral of Florence, which dominates the skyline and still charms twentieth-century visitors.

The citizens of Florence had begun their cathedral back in 1296, a century before Brunelleschi made his first trip to Rome. In 1334 Giotto had been honored by the commission to design the bell tower, but work on the main structure had proceeded slowly. By the early fifteenth century the nave was completed and work began on the great octagon at the east (altar) end. As the walls of the complex octagon rose, overseers of the works found them-selves confronted with a vast opening 138.5 feet across, which had to be covered by a dome. They had no choice. But how to do it? How their urban rivals—Pisa, Siena, Milan, Padua—might have enjoyed the spectacle of an ambitious city that could not even roof its own cathedral! But successive supervising architects had evaded the problem by focusing on every other part of the work. By about 1413 the walls of the octagon drum at the east end had risen to their full 180 feet and the challenge had to be faced.

Brunelleschi had been eagerly anticipating the assignment. By 1417 he had already been paid for some drawings and had made a wooden model of his design. In 1418 the overseers of the works finally announced a public compe-tition. The other leading competitor was Ghiberti, Brunelleschi's bête noire. The tactless judges trying to bring these two together, as they had vainly tried once before, gave the supervisory assignment of building the dome to them jointly, with a master stonemason working under them. Construction was begun on August 7, 1420, and completed all the way up to the base of the lantern on August 1, 1436. A Brunelleschi-Ghiberti team was designed for trouble. Brunelleschi, who had never forgotten losing to Ghiberti the commission for the bronze Baptistery doors, would leave a series of invec-

tive sonnets as his literary legacy. During work on the dome Brunelleschi seized every opportunity to show up his rival's incompetence. He would even pretend to be ill at crucial moments so Ghiberti would have to face the most difficult problems alone. Luckily Ghiberti was dismissed in 1425 and completion of the work was left to Brunelleschi.

The problem, engineering and aesthetic, was of unprecedented difficulty. How Brunelleschi solved it was still a mystery to Vasari, who wrote his biography a century later (1550). Vasari reported that the baffled citizens of Florence, desperate for a way to dome their cathedral, recalled the ancient Roman expedient. Perhaps they, like the builders of the Pantheon, should fill the structure with earth to support the dome as it was being built. And by sprinkling coins randomly in the dirt they too would give the children of the town an incentive for clearing the earth away.

Brunelleschi's ingenuity saved them from this and other harebrained schemes. He amply earned his fame by his original plan and by the machines he devised for carrying on the work. The large size of the opening, its height aboveground, and the advanced stage of the building when Brunelleschi was enlisted for the job all added to the normal difficulties of constructing a dome. The method of building a dome or arch usual at the time was first to construct a wooden framework (called the centering) to support the bricks or stones as they were put in place. When the wedge-shaped keystone was inserted in the center, the wooden centering could be removed. The stones would then be held together by the force of gravity, and the dome or arch would remain stable by a constant downward thrust. But the size of such a dome was plainly limited by the length and strength of the timbers for the centering. And no trees could be found to make the centering for an opening of 138.5 feet. Even if such trees could be found, the expanse was so broad that the weight of the timbers themselves would break the centering even before being loaded with the stone covering.

In 1418 the octagon stone drum on which the dome would rest had already been built. Its eight symmetrical sides of slim vertical walls were penetrated by circular windows carrying out the design of the nave. They would collapse if subjected to a sideward thrust from a dome above. Intended only to support the dome, these sides were not capable of bearing any but a vertical thrust. So a Gothic solution, a dome exerting an outward thrust supported by flying buttresses like those of Notre-Dame in Paris, seemed out of the question. Also, flying buttresses would violate the cathedral's exterior design, even if the structure had provided a place on which to rest them, which it did not. On the other hand, the dead weight of a solid concrete dome like that of the Pantheon would have crushed the fragile walls of the octagon drum on which it rested. Thus it was impossible for Brunelleschi to gratify his taste for things Roman.

Force of circumstances drove the reluctant Brunelleschi back to a pointed

dome in the Gothic spirit. Seeing the octagon drum on which to place his dome, with only its eight strong corner supports and thin walls in between, Brunelleschi would build on these limitations. Since the usual centering was impossible he had to find another way to support the stone structure as it was being built. By designing his dome of two shells, an inner and an outer, he would reduce the weight of each shell, and yet increase the grandeur of the outer shell. He would make a pointed dome supported in sections, with each of the eight sides of the octagon held up by major stone ribs at the angles. There would be two minor ribs within each stone section, and horizontal arches would connect the major and minor ribs. By 1425 Brunelleschi had raised the dome to the point where it curved sharply inward, and then the lack of centering posed what seemed an insuperable problem.

Now he had to take advantage of the freedom that he had secured from the building committee to make changes in materials and methods as the work required. To make up for the lack of centering, his dome was built in horizontal courses on the sectional supports. Each course was bonded to the one below to carry its own weight and also support the next ring above it. When Brunelleschi reached the perilous inward curve of the dome, he had to change his materials. Since the stone he was using might be too heavy for the uncentered structure, he took a leaf from the ancient Romans, substituting brick for stone, and laying the bricks in the herringbone pattern he had seen in Rome. Separate brickwork was laid for the inner and the outer domes as the work proceeded, reducing the thickness of each as the dome went up. The result was a cellular system, with an increasing space between the layers till the space between the layers became six feet at the crown. For this unusual work, Brunelleschi had to invent new cranes and derricks for lifting the stone and bricks. To avoid wasting the workmen's time in descending for meals, he provided a high canteen at their workplace on the dome.

Brunelleschi's close and strenuous study of the ancient archetypes had borne fruit. When all eight sections and the horizontal brick courses binding them were in place, this left an open eye at the top like that in the Pantheon. The eye of the Pantheon dome, a solid structure of artificial stone (concrete) could be left open to the sky. But the ribs of Brunelleschi's dome tended to pull back at the top and open the ring. There had to be a heavy decorative "stopper" to press down on the ribs and hold them together at the top. This explains the surprisingly large size of the existing lantern. In 1436, when the need was apparent, a competition was held for the stopper design, which Brunelleschi naturally won with his model for a functional lantern of classical elegance. His octagonal turret of tall arched windows would tie the eight ribs of the dome to the corners of the lantern by ingenious classical flying buttresses. Each graceful buttress was topped by an inverted curled classical

bracket (console), terminating the reluctantly Gothic dome with an unmistakable tribute to Roman antiquity. The pinnacle was an undulating conical turret surmounted by a crucifix on an imperial orb. What more succinct symbol that the Renaissance, in Émile Mâle's aphorism, was "Antiquity ennobled by the Christian faith"!

Construction of the lantern began in 1446, only a few months before Brunelleschi's death. His design was carried out by his friend and disciple Michelozzo (1396–1472) and still dominates the Florentine townscape with a monument to a great re-creator.

There were countless other ways of re-creation, of giving new life to archetypes. Giotto found his own way by breathing humanity into the Madonna, Christ on the Cross, the biblical story, and the tales of the saints. Brunelleschi drew on the ancient Romans to reshape the buildings of his Florence. Leon Battista Alberti (1404–1472), the prototype of the "universal man" of the Renaissance, achieved his fame by giving a new afterlife to Vitruvius. The illegitimate son of a wealthy merchant banker family that had been exiled from Florence by their rivals, Alberti was born in Genoa, where his father was managing the family interests. As a child he lived with his family in Venice until he was sent to a boarding school in Padua, where he had a solid classical Latin education. A precocious Latin stylist, at twenty Alberti wrote a comedy that the experts mistook and published for an authentic Roman work. At his father's death, relatives swindled him out of his inheritance and left him a penniless student in Bologna. By 1428, when his family's exile had been revoked, he went to Florence, where he used his versatile talents to widen the Florentine revival. A papal dispensation allowed him despite his illegitimacy to take holy orders, which provided him with a steady living. He held two Tuscan benefices in absentia while he was still living in Rome and entered the papal civil service, but he was a most unsanctimonious cleric.

Pope Eugenius IV introduced Alberti to the Florentine galaxy of Donatello, Ghiberti, and Brunelleschi who stretched his interests to include all the arts and sciences. On returning to Rome in 1447 he became architectural adviser to Pope Nicholas V (1447–1455) on urban renewal and the restoration of churches. Yet he remained in close touch with his friends in Florence, where his literary interests were a perfect complement to the engineering concerns of Brunelleschi. In contrast to the practical Brunelleschi, who discovered how the Romans had fitted their stone corners and laid their bricks, Alberti's passion was for the mathematics in which his father had trained him. He never ceased to be interested in the rational order of things: the ratios of the dimensions of columns and architraves, the "order" in the Italian language which he dignified with its first grammar, the "sci-

ence" of cryptography where he provided the first known frequency tables and cipher wheel, or the design for a great city.

Alberti, like Brunelleschi, embellished the palazzi of his time with columns, pediments, and cornices from ancient temples and forums. Following the style of the Colosseum, his classic work for the merchant princes was the three-story Palazzo Rucellai (1446–1451) in Florence, where he gave a fortresslike stone palazzo a classical elegance with pilasters of the Roman orders. The Christian church in his time, a high central nave with lower aisles on either side, posed an aesthetic problem for the façade. The Arch of Constantine in Rome with its three arches offered Alberti a solution that he seized for the Tempio Malatestiano in Rimini (c.1446) and the Sant' Andrea in Mantua (1470).

Alberti's interests in architecture grew along with his passion for Roman antiquities. In Ferrara, as a guest of the Estes, he built a miniature triumphal arch to hold the statue of Leonello's father. When Leonello urged him to rationalize architecture by "purifying" the text of Vitruvius, Alberti took up the project with enthusiasm. At the papal court in 1443, he studied the Roman remains and then advised the ambitious Pope Nicholas V on reconstructing St. Peter's and the Vatican Palace. Alberti's Roman interests led him to try to refloat the ancient galleys on Lake Nemi, about which he wrote a treatise.

Talent and experience now superbly qualified Alberti to provide a bible for Renaissance architects with his revival of Vitruvius, whose *Ten Books of Architecture* had never been forgotten but was not available. Then about 1415 Poggio Bracciolini (1380–1459), the tireless searcher for classical texts, luckily turned up a manuscript of Vitruvius, which Alberti would be the first to use. And following Vitruvius, Alberti wrote his own *Ten Books* in Latin, and called it *De re aedificatoria* (On Building), destined to be the standard architectural handbook for centuries to come. To preserve the Roman flavor, Alberti called his churches "temples," where people worshiped "the gods," by which, of course, he meant God, Christ, and the saints. Completed and dedicated to Pope Nicholas V in 1452, it was published in print by his brother Bernardo in Florence in 1485, thirteen years after his death.

Widely translated, Alberti's book lived on as a modern guide to recreating the classical architecture that Vitruvius had canonized. Alberti gave new coherence to the five classical orders, surveyed materials and designs for walls, bridges, castles, and waterworks and for houses appropriate to different social classes, and finally offered a city plan. With Pythagorean orthodoxy he explained the relation of architectural proportions to the musical harmonies, and insisted that beauty was not a matter of personal taste but was governed by mathematics and reason. Beauty had to

be distinguished from mere ornament, of which oddly enough he made the column his example. So he showed how far he had come from the ancients.

Vitruvius had an inexhaustible capacity for afterlives. About 1530 an eccentric wealthy scholar, Count Gian Giorgio Trissino (1479–1550), in Vicenza in northern Italy undertook to rebuild his own villa in the classical style. A fanatical follower of Vitruvius, in this villa he would house a kind of monastic academy for disciples who were to study mathematics, music, and philosophy on a Vitruvian plan. Among the stonemasons working on his villa was the talented young Andrea di Pietro della Gondola, whom he adopted as a disciple and christened Palladio after Pallas Athena. This Palladio (1508–1580) did not disappoint his godfather—he became an apostle of purism in the rebirth of classical architecture. He provided the standard guidebook to the antiquities of Rome (*Le antichità di Roma,* 1554), and reconstructed Roman buildings for the plates in a new Venetian edition of Vitruvius (1556). Then in 1570 Palladio published his own *Four Books of Architecture,* taking "Vitruvius for my master and guide," following the Pythagorean harmonies updated to the musical intervals in use in Palladio's day. Palladio's classical re-creations would shape the architecture of Inigo Jones in England and Georgian architecture on the American side. Here the "Palladian" became not only a style but a cult, of which Thomas Jefferson was a devoted disciple.

43

The Mysteries of Light: From a Walk to a Window

BRUNELLESCHI'S elegant conquest of space by his dome for the cathedral of Florence gave new life to the ancients' ways of building. At the same time, Giotto and his fellow painters were seeking another way of conquering space, by translating the three-dimensional world onto the two dimensions of their frescoes or panels. They too would give a new vividness to the glories of their God. While the architect dealt in wood and stone, the painter's resource was an elusive, even mysterious, phenomenon. At the Creation, God said "Let there be Light," and the ways of light remained a clue to how God spread his Grace. We have seen that light provided a clue and a symbol for the "upward-leading" theology and the Gothic Archi-

tecture of Light of Suger at St.-Denis. The Franciscan Roger Bacon (1220–c.1292) had told in his encyclopedic treatise about 1260 "how the ineffable beauty of the divine wisdom would shine and infinite benefit . . . overflow" if "placed before our eyes . . . defined by geometrical forms . . . far better than mere philosophy could express it." In this modern quest for the geometry of light Brunelleschi and Alberti would play heroic roles. And their technique of capturing space would dominate Western painting for centuries.

The principles of linear perspective were their *re*discovery. The ancient Greeks used foreshortening in their vases of the fifth century B.C., and Hellenistic painters created illusions of depth. Vitruvius himself defined scenography as "the shading of the front and the retreating sides, and the correspondence of all lines to the vanishing point, which is the center of a circle." Agatharchus of Samos (fifth century B.C.), who painted a "scene" for a tragedy of Aeschylus about the time of the Peloponnesian War (and was then enlisted by Alcibiades to decorate his house), wrote a basic book on perspective. Followed by Democritus and Anaxagoras, he "showed how, given a center in a definite place, the lines should naturally correspond with due regard to the point of sight and the divergence of the visual rays, so that by this deception a faithful representation of the appearance of buildings might be given in painted scenery, and so that, though all is drawn on a vertical flat façade, some parts may seem to be withdrawing into the background, and others to be standing out in front." Although in practice the ancients never mastered quite precisely the geometrically derived perspective of Brunelleschi and Alberti, late Hellenistic and Roman wall paintings from Pompeii and from a house on the Palatine show that they had mastered an illusionist technique and that it survived.

But somehow the mastery of perspective and the idea of a vanishing point disappeared in the Middle Ages in a rare example of the loss of a well-developed technique. Dominated as we are by graphic vistas in perspective, we hardly remember the philosophers' arguments against this "perspective" way of seeing the world. Plato, who had his own way of looking at everything, objected to the very same "deception" of the senses that Vitruvius had praised as a way of giving a "faithful representation of the appearance of buildings in painted scenery." If two objects or two persons were really the same size, Plato argued, the honest artist should make them so in his picture, and not depict one smaller than the other simply because it was seen at a greater distance. Deploring this reckless "innovative" spirit of the perspective painters, he praised Egyptian art for not using perspective. In Egypt, he noted, "no painter or artist is allowed to innovate . . . or to leave the traditional forms and invent new ones." The result was that the traditional ways had survived unchanged for "ten thousand years . . . and no

exaggeration—their ancient paintings and sculptures are not a whit better or worse than the works of today." Plotinus, too, praised the absolute honesty of Egyptian art, in which all objects were shown in their true proportions, not foreshortened to match the illusion of distance.

The reasons for the medieval loss of perspective are obscure, but their rediscovery is well documented and vivid. It was the work of no man of theory but of the practical and inventive Brunelleschi. His friendly first biographer Antonio Manetti (1423–1491), writing only a few years after Brunelleschi's death, praised him as "either the re-discoverer or the inventor" of "what painters today call perspective, because it is part of that science which aims at setting down well and rationally the differences of size that men see in far and near objects, such as buildings, plains, mountains, and landscapes of all kinds and which assigns to figures and other things the right size that corresponds to the distance at which they are shown." Manetti credited him with rules that artists had used ever since.

For his epochal experiment Brunelleschi used only a small wooden panel about fourteen inches square and a flat mirror of the same size. On the panel he had painted in perspective a picture of the baptistery that stood on the piazza opposite the cathedral of Florence, as seen from just inside the central door of the cathedral. The part representing the sky he covered with burnished silver to reflect the passing clouds. Into the painting Brunelleschi cut a small hole directly opposite the position of his eyes as he had stood inside the cathedral portal. The hole was small as a lentil on the painted side, but opened wider in the back so he could put his eye against it and look through.

The flat mirror that he needed for his experience—exactly the size of the painted panel—would only recently have become available. Elegant ladies in the Middle Ages carried on their belts portable round mirrors in ornamented cases of ivory and silver, and the mirror (*speculum*) was a favorite medieval metaphor. But only in the early thirteenth century was the technology developed for putting on glass a backing of silver or lead, which finally made possible large flat mirrors. Venetian glassmakers prospered by marketing these in the early fourteenth century.

Dante himself was fascinated by the divine geometry of light observed in mirrors. When he reached the Ninth Sphere of Paradise (the *Primum Mobile*), he turned from Beatrice to behold God as a nondimensional point of light ringed by nine glowing spheres of the angel hierarchy (in John Ciardi's translation):

> Just as man before a glass can see
> a torch that burns behind him, and know it is there
> before he has seen or thought of it directly;

> And turns to see if what the glass has shown
> is really there; and finds, as closely matched
> as words to music, the fact to its reflection,
> Just so, as I recall, did I first stare
> into the heaven of those precious eyes
> in which to trap me, Love had set his snare. . . .

In Purgatory, dazzled by reflected sunlight, he noted God's symmetry:

> When a ray strikes glass or water, its reflection
> leaps upward from the surface once again
> at the same angle but opposite direction
> From which it strikes, and in an equal space
> spreads equally from a plumb-line to mid-point,
> as trial and theory show to be the case.
> Just so, it seemed to me, reflected light
> struck me from up ahead, so dazzlingly
> I had to shut my eyes to spare my sight.

It was this mirror magic that centuries later would enchant the halls of Versailles.

With his small painted panel and his mirror Brunelleschi performed his epochal perspective experiment in the piazza of Florence on a day in 1425. Under the portal of the cathedral and facing the baptistery he held the unpainted side of the panel close against his face and peered through the hole. With his other hand he held the mirror at arm's length facing inward toward the painting. "When one looked at it thus," Manetti reported, "the burnished silver . . . , the perspective of the piazza, and the fixing of the point of vision made the scene absolutely real. I have had the painting in my hand and have seen it many times in those days, so I can testify to it." Brunelleschi's "point of vision" was the perspective "vanishing point." He inspired others to design their paintings around a vanishing point, but Manetti insisted that none was Brunelleschi's equal. Uccello (1397–1475), fascinated by the technique of perspective, enlisted the aid of the mathematical Toscanelli and applied it with great skill in the battle scene of *The Battle of San Romano* (now in the National Gallery in London), in the *Flood* in Santa Maria Novella in Florence, and numerous sketches. He was so engrossed by it that it was said he went on drawing perspective sketches and would not stop even for meals. Responding to his wife's call, Uccello would exclaim, "What a sweet thing perspective is!" The joys of perspective did not wear off. Later Renaissance painters luxuriated in its delights.

Giotto and others before had found their own personal ways of capturing space. But now Brunelleschi had opened a public geometry of perspective.

Luckily his younger friend Leon Battista Alberti was the perfect comple-
ment to his mentor's practical genius. What would have come of Brunelles-
chi's experiment if there had not been close at hand a mathematically
sophisticated artist with literary talent?

Luckily, too, Alberti was a man of broad culture, with a good classical
education and knowledgeable in the long tradition of Western works on
optics. The subject of light and how it reached the eye had fascinated
scientists and philosophers, ancient and modern—which makes the medie-
val loss of the techniques of perspective all the more remarkable. Among
its ancient exponents, besides Vitruvius (c.25 B.C.), were Euclid (c.300 B.C.),
whose pioneer *Optica* aimed to define the rectilinear visual rays; Ptolemy,
whose *Optica* (A.D. c.140) had applied Euclid's insights to the laws of
refraction, and whose *Geography* had projected the spherical form of the
earth onto a two-dimensional map of the world; Galen (A.D. c.175), whose
misleading physiology of the eye governed centuries; and, perhaps most
important, the great Arab scientist Alhazen (A.D. c.1000), whose treatise
offered a persuasive mechanistic theory of sight. More recently, Roger
Bacon's *Opus Majus* (c.1260) had provided an able compendium. An enter-
prising archbishop of Canterbury, John Pecham (c.1230–1292) had then
composed his popular *Perspective Communis* (A.D. c.1270) which reconciled
the ideas of his predecessors and would govern European optics through the
Renaissance. What remained to be done was to focus all this miscellaneous
learning on the needs of the artist.

This is precisely what Alberti's *Della Pittura* (1436), dedicated to Brunelles-
chi, aimed to do. By defining the divine mathematics of perspective, he
established the painter's profession in the universe of humanist learning.
Now art too would no longer be concerned with mere opinions, but with
certezze (truths). The guidance that his Vitruvius would give to architects,
this work now gave to painters. It was no simple revision of ancient texts,
nor a mere recipe book, but the first work we know that relates the artist's
task to the laws of optics, and so raise the painter above the artisan. Now
the practitioner of a liberal art, the painter became an artist.

The treatise of the thirty-five-year-old Alberti transformed the painter's
vision as well as his craft. From a decorative surface on which objects were
displayed the painting now became a pictorial space containing objects. As
Alberti explained how objects in the picture should be diminished in direct
proportion to their distance from the viewer, his "artificial perspective"
created a three-dimensional space on a two-dimensional surface. Painting
for Alberti and followers became a science of space.

Earlier painters had begun with the furniture, Alberti began with the
room. His perspective geometry declared the independence of space:

First of all, on the surface on which I am going to paint, I draw a rectangle of whatever size I want, which I regard as an open window through which the subject to be painted is seen; and I decide how large I wish the human figures in the painting to be. . . . Then I establish a point in the rectangle wherever I wish, and [as] it occupies the space where the centric ray strikes, I shall call this the centric [or vanishing] point. The suitable position for this centric point is no higher from the base line than the height of the man to be represented in the painting will seem to be on the same plane. Having placed the centric point, I draw lines from it to each of the divisions of the base line. These lines show me how successive transverse quantities visually change to an almost infinite distance.

(Translated by Cecil Grayson)

Alberti conceived his picture as the cross section of a visual pyramid. Its apex was in the eye and its base in the objects depicted, with its space extending through successive planes to the vanishing point, where all the planes (orthogonals) converged. A horizontal line through the vanishing (centric) point defined the horizon. As an aid he set up and looked through a *velo,* or reticulated net, which Dürer and others later used to help them grasp the artificial perspective. This mathematically homogeneous space gave a new unity and coherence to any painting.

Though these devices may seem obscure to the modern layman, they were plain enough to Alberti's painter-contemporaries. They increasingly followed this prescription for defining the space that their painting encompassed. Just as Suger's architecture at St.-Denis revealed the divine mystery of light to the faithful through the transparent walls, so Alberti's perspective geometry of light-filled space revealed the divine symmetry of the visible world. The laws of optics, as the ascetic archbishop of Florence, Saint Antonio (1446–59) explained, showed God's way of diffusing his grace (*lux gratiae*) through the universe. The science of perspective, by making painters into philosophers, had created an eighth liberal art. And as the interpreter of the divine order in the visible universe the artist acquired the dignity of the scientist. Toscanelli (1397–1482), the versatile Florentine cosmographer whose maps guided Columbus and whose sun dial adorned the cupola of the cathedral of Florence, called Brunelleschi "a new Saint Paul." Exhilarated by the mathematics of space and light, Alberti himself thought the painter had become "almost another god"—a Narcissus seeing his own beauty reflected in nature.

The young Masaccio (1401–1428) was already startling the Florentine worshipers by his perspective illusion of a chapel seen through the wall of Santa Maria Novella. And Alberti's mathematics stirred interest and enthusiasm for perspective. The unexcelled elegance and color of Domenico Veneziano's disciple Piero della Francesca (c.1420–1492) tempt us to forget

his epochal contribution to the marriage of science and art. Late in life, Piero seems to have abandoned painting to write his own *De prospectiva pingendi* (*On Perspective in Painting*, c.1474–82). Advancing Alberti's techniques, he aimed to demonstrate the sovereign geometry of nature. The many aspects of nature, he wrote, were best grasped by the eye if they were expressed in simple geometrical forms. It is not surprising that twentieth-century cubists hailed him as their prophet. Centuries before them, he had anticipated Cézanne's prescription that "within nature all forms are based on the cylinder, the sphere, the cone." Yet Cézanne himself would pioneer a revision and a flattening of the painter's pictorial space.

When Alberti casually described the surface on which the artist painted as "an open window through which I view that which will be painted there," he proclaimed a new power of the modern painter to capture space and impose a personal point of view in the space he created. But he also confessed a limitation when he insisted that the perspective was from only one point of view. Is there more "realism" in the modern perspective view than in the "naive" paintings of an earlier era? Or only a departure from the walk to the window?

Earlier paintings like the well-known fresco in the Loggia del Bigallo in Florence (c. 1350) showed the buildings of the city as a person walking about would have seen or felt them. None was shown smaller because it was at a greater distance. These pre-perspective views gave a tactile sense of the huddled-together jumble of the buildings of a medieval city. This sense was lost in the homogeneous space of a perspective view. A walker's view was more intimate. But Alberti and his followers produced a powerful persistence of the vision of an artist looking through his window. The artist's "artificial perspective" would dominate Western art into the twentieth century. It had given a power to substitute the unique view of an artist's self for the varied sensations of pedestrians in the landscape, and so too an uncanny power to substitute art for experience.

44

Sovereign of the Visible World

ALBERTI'S perspective offered only the frame—"an open window through which I view that which will be painted there." By filling that space the artist became sovereign over the whole visible world. In a story in his notebooks Leonardo da Vinci (1452–1519) defends with relish the artist's sovereignty. It seems that King Matthias of Hungary (1443–1490) received two gifts on his birthday. A poet brought a book of verses composed for the occasion and a painter gave him a portrait of his beloved. The king quickly closed the book and turned to the picture. "O King," the indignant poet exclaimed, "read, but read, and you will learn matter of far weightier substance than a mute picture." To which the king retorted, "It does not satisfy the mind of the listener or beholder like the proportions of the beautiful forms that compose the divine beauties of this face here before me, which being all joined together and reacting simultaneously give me so much pleasure with their divine proportion." And he asked, "Which is the nearer to the actual man: the name of the man or the image of the man?" "Painting extending as it does to the works of God is nobler than poetry which only deals with fabricated stories about the deeds of men."

Painting, then, was rightfully one of the liberal arts because "she deals not only with the works of nature but extends over an infinite number of things which nature never created." "The eye . . . the window of the soul, is the principal means by which the central sense can most completely and abundantly appreciate the infinite works of nature; and the ear is the second, which acquires dignity by hearing of the things the eye has seen." Great painters feast their eyes on nature, but after the Roman Empire painters only imitated other painters until, Leonardo explained, Giotto the Florentine, "not content with imitating the works of Cimabue his master—being born in the mountains and in the solitude inhabited only by goats and such beasts, and being guided by nature to his art, began by drawing on the rocks the movements of the goats of which he was keeper."

"Knowing how to see" (*Saper vedere*) became the object of Leonardo's life, a name for his art and his science.

> He who loses his sight loses his view of the universe, and is like one interred alive who can still move about and breathe in his grave. Do you not see that the eye encompasses the beauty of the whole world? It is the master of astronomy, it assists and directs all the arts of man. It sends men forth to all the corners of the earth. It reigns over the various departments of mathematics, and all its sciences are the most infallible. It has measured the distance and the size of the stars; has discovered the elements and the nature thereof; and from the courses of the constellations it has enabled us to predict things to come. It has created architecture and perspective, and lastly, the divine art of painting. O, thou most excellent of all God's creations! What hymns can do justice to thy nobility; what peoples, what tongues, sufficiently describe thine achievements?

Leonardo created his Empire of the Eye with the advantages of a rural Tuscan boyhood, a lucky apprenticeship, and a freedom from bookish prejudices. The illegitimate son of a prosperous Florentine notary, Leonardo was born on his father's estate at Vinci in the countryside near Florence. His mother, Caterina, was probably a peasant. Leonardo's father had children only by his wives of his third and fourth marriages. Meanwhile Leonardo was raised in his father's house as if he had been legitimate. When a neighbor asked him to paint a dragon on a shield, Vasari recounts, he "carried into a room of his own lizards great and small, crickets, serpents, butterflies, grass-hoppers, bats" all of which he compounded into "a great ugly creature." The young Leonardo bought caged birds in the marketplace, so he could take them home and set them free. A memory of his childhood in his notebook (the starting point of Freud's speculations about him) was how "as I lay in my cradle a kite came down to me and opened my mouth with its tail, and struck me many times with its tail between my lips. This seems to be my fate."

When Leonardo moved into town with his father, his education was meager and conventional—learning to read and write Tuscan Italian and acquiring the elements of arithmetic. If his father had been of a higher station or Leonardo had shown academic promise, he might have been sent to the University of Florence to be filled with Latin book learning, and prepared for a learned profession. Instead, apprenticed in the workshop of Andrea del Verrocchio (1435–1488), a famous painter and sculptor, he spent twelve years securing the practical education for which his temperament had fitted him. To Verrocchio's studio came great artists of the day—Botticelli, Perugino, and Pollaiuolo. After Leonardo was admitted to the painters' guild in 1472 he stayed on in the workshop.

When the master assigned young Leonardo to paint the angel in Ver-

rocchio's *Baptism of Christ, Madonna and Child,* the apprentice did it so well, according to Vasari, that "Andrea would never again touch colours, being most indignant that a boy should know more of the art than he did." A similar legend had been told of Cimabue and his pupil Giotto, and would be told of Francia and Raphael (1483–1520). It was also told of Picasso and his teacher-father. "He is a poor pupil," Leonardo later wrote in his notebook, "who does not surpass his master." By 1477, Leonardo, at the age of twenty-five, with his own studio was supporting himself by commissions. Was Verrocchio, as some say, to be Leonardo's John the Baptist? Was not Leonardo himself one of Verrocchio's masterpieces?

Leonardo's combination of limited book learning and long workshop training helps account for his lifelong distrust of bookish knowledge and scholastic commentators. He felt at home among craftsmen and engineers. In 1482, when Leonardo was thirty, Lorenzo de Medici (the Magnificent) sent him to Ludovico Sforza, duke of Milan, to present a silver lyre in the shape of a horse's head, on which Leonardo was an adept performer. There in Milan Leonardo remained for eighteen years, from age thirty to forty-eight. It is not clear why Lorenzo, a jealous patron and shrewd judge of talent, made no effort to bring him back. Perhaps Leonardo himself, the scientist-artist-engineer, preferred the enterprising spirit of Sforza's Milan to the Neoplatonic miasma of the Medici circle in Florence. These years in Milan were among his most productive—as a painter and as a designer of court festivals and noble weddings—yet he made the time to pursue his interests in anatomy, biology, mathematics, physics, and mechanics. His anatomical studies, Leonardo himself boasted, had led him during his life to dissect some thirty corpses. He enjoyed the stirring companionship of savants and filled his notebooks with subjects for treatises he would never write, while offering plans to the Sforzas for fantastic weapons, grand schemes of military architecture and hydraulic engineering.

When the French captured Milan in 1499 the duke was exiled and Leonardo left. After stopping briefly at Mantua for a portrait commission and at Venice to plan the city's defense against the Turks, he returned to Florence. His six years there were interrupted by a tour in the service of Cesare, the prototypical Borgia (c.1475–1507), who was commanding the army of his father, Pope Alexander VI, to reconquer the papal states of Romagna and the Marches. The city of Florence enlisted Leonardo as engineer in their war against Pisa and commissioned him to paint a grand mural for the Palazzo della Signoria while he pursued his scientific experiments.

Recalled to Milan in 1506 by its new overlord, the king of France, Leonardo spent the next seven years there on architecture, sculptural projects, engineering, anatomy, and scientific illustration, doing only a little

painting. When the French were driven from Milan in 1513, he was invited to Rome and given a studio in the Belvedere of the Vatican by his Florentine patron Giuliano de' Medici, brother of the new pope, Leo X. The papal commissions Leonardo hoped for never came, but he pursued his scientific studies, surveyed and mapped the Roman scene. After three lonely, frustrating years, in January 1517 he accepted the invitation of the twenty-three-year-old Francis I (1494–1547; reigned 1515–47) to move to France. And he lived out his last three years near the king's summer place at Amboise on the Loire with his favorite disciple, Francesco Melzi, in a small country palace. His title was "Premier Peintre, architecte et méchanicien du Roi," but the king called on him only for conversation and advice. There Leonardo produced little besides designs for court festivals, along with his relentless scientific studies and his last apocalyptic drawings.

Of the many mysteries surrounding Leonardo da Vinci none is more remarkable than the disproportion between the quantity of his finished works and the grandeur of his reputation. Our awe of Leonardo is as much for what he was as for what he did, as much for his reach as for his grasp. His career was vagrant and unfocused—in fact, he never had a career. His efforts and his works were dispersed among Florence, Milan, Venice, and Rome, in a lifelong search for patrons. Unlike Dante, he had no passion for a woman. Unlike Giotto, Dante, or Brunelleschi, he seemed to have had no civic loyalty. Nor devotion to Church or Christ. He willingly accepted commissions from the Medici, the Sforzas, the Borgias, or French kings—from the popes or their enemies. He lacked the sensual worldliness of a Boccaccio or a Chaucer, the recklessness of a Rabelais, the piety of a Dante, or the religious passion of a Michelangelo.

His vast disorderly notebooks in his own hand mystify as much as they explain. They tell us almost nothing of his personal feelings about anyone. No word of love for a woman, nor for a man! On the death of his father he gives only the barest obituary: "On Wednesday, the 9th of July, 1504 my father, Ser Piero da Vinci, Notary at the Palazzo de Podesta, died; he was eighty years old; left ten sons and two daughters." No other artist bequeathed so copious a record of his thoughts and yet told us so little of himself. The thirty-five hundred closely written pages that have survived of his notebooks may be only a quarter of those left at his death. Whole notebooks have been lost or broken up, and single sheets now turn up around the world. Some of the nineteen existing notebooks were small enough to be carried about on Leonardo's belt for occasional jottings, some were large folios.

His earliest notebooks began only when he was thirty. "This will be a collection without order . . . hoping afterwards to arrange them . . . accord-

ing to the subjects of which they treat," he explains at the outset of a volume begun in 1508. "I believe that before I am at the end of this I shall have to repeat the same several times; and therefore, O reader, blame me not, because the subjects are many, and the memory cannot retain them and say 'this I will not write because I have already written it.' " At his death he left his papers to his lifelong companion Francesco Melzi, who compiled them in various ways. One would become his *Treatise on Painting*.

While most of his script is clear, and legible if viewed in a mirror, it is almost all in mirror writing, written "backwards." Since Leonardo was probably left-handed, this way of writing might have come quite naturally to him. It could hardly have kept the contents secret or deceived the censors, since his texts were copiously illustrated. Perhaps Leonardo wished only to make trouble for any who dared to read his private jottings. Or were these "written monologues" another symptom of his self-sufficiency? "The painter must be solitary," he wrote, "especially when he is intent on those speculations and considerations, which if they are kept continually before the eyes give the memory the opportunity of mastering them. For if you are alone you are completely yourself but if you are accompanied by a single companion you are only half yourself." Leonardo never abridged himself by publishing. His copious notes are repetitive and contradictory, but often eloquent and scintillating. Kenneth Clark compares Leonardo's notebooks to the famous Chinese examinations where the candidate was told to write down everything he knew.

Were the ideas in Leonardo's notes his own? Or were they only an anthology of his reading? He was not learned, and even called himself *uomo senza lettera*. He finally taught himself Latin in 1494 at the age of forty-two. He rarely gives sources, but scholars have found Latin passages that may have been sources for some of his most quoted ideas. Many of his "prophetic" drawings of inventions may only depict devices that he saw. But if, as the historian of science George Sarton suggests, Leonardo was "almost illiterate," his prodigious notebooks were an even more astonishing feat. The eminent French physicist Pierre Duhem (1861–1916) produced three volumes on Leonardo's notebooks and ten more on medieval physics that have shown Leonardo to be the grand reviser of medieval science.

Leonardo seems to have luxuriated in the experimental tentativeness of his observations. And also to have enjoyed projecting numerous never-to-be-written "treatises"—on painting, anatomy, mathematics, optics, and mechanics. Yet this "greatest of great amateurs" had something to add to all the sciences. He amazes us by his reach in all directions.

Grand engineering projects also remained unfulfilled. Leonardo had commended himself to Ludovico Sforza as a military engineer and inventor of bridges, with secret plans for "an infinite number of engines of attack and

defense." When he returned to Florence in 1503 and found his city at war with Pisa, he offered an ingenious scheme to deprive Pisa of access to the sea by diverting the river Arno. Then he planned an Arno canal to improve Florence's own access to the sea by circumventing the stretch of the river that was not navigable. Neither of these proved feasible, but the modern highway from Florence to the sea was eventually built along the course he had charted. Back in Milan in 1506, he developed a similar grand scheme for making the Adda River navigable, providing a waterway to Lake Como and the sea. In Rome ten years later he explored the draining of the Pontine Marshes. And in his last years with Francis I he proposed a plan to drain marshes for a palace for the king's mother. None of these projects was fulfilled in his time.

There is a monumental irony, too, in Leonardo's sculptural projects. When Leonardo first came to Milan, Ludovico Sforza had long been planning an equestrian monument to his father, Francesco. The self-confident Leonardo about 1483 boasted to Ludovico that his sculpture and painting "will stand comparison with that of anyone else, whoever he may be. Moreover, I would undertake the work of the bronze horse, which shall endue with immortal glory and eternal honour the auspicious memory of the Prince your father and of the illustrious house of Sforza." His notebooks for the next years showed scaffolding, lifting devices, and casting methods for the monumental horse, which was to be twenty-three feet high, twice the height of Verrocchio's equestrian statue of Colleoni, and consume two hundred thousand pounds of copper. "Tell me if ever," he asked himself in his notebook, "anything like this was built in Rome." But neither was anything like this to be built in Milan! Leonardo's full-scale clay model was displayed in the city square for the marriage of Sforza's niece to Emperor Maximilian. It was then moved to the court of the Castello. Vasari and other visitors reported that there was "never a more beautiful thing or more superb." But when French soldiers invaded Milan they used it for target practice. Meanwhile war had taken precedence over filial piety, and the bronze set aside for the horse was sold to Ludovico's ally the duke of Ferrara to be made into cannon. "About the horse I will say nothing," a resigned Leonardo wrote to Ludovico of his sixteen years' labor, "for I know the times."

Leonardo knew the times well enough to change his loyalties and his patron as occasion required. When Gian Giacomo Trivulzio (1440?–1518) of a rival Milanese family, passionate enemy of the Sforzas, conquered Milan in 1499, Leonardo eagerly accepted the commission for *his* tomb—another monumental equestrian statue. Leonardo's notebooks show plans for a life-size rider on a high pedestal containing the sarcophagus, along with brilliant new anatomical studies of the horse. He finally began work on the

tomb about 1511, with a novel scheme for casting the rider separately. But when, in June 1512, Milan was occupied by Spaniards, papal mercenaries, and Venetians, the city relapsed into chaos, and another Leonardesque monument went into limbo.

A catalog of Leonardo's architecture shows the same unhappy disproportion between plan and execution. His notebooks are replete with elegant architectural projects and town plans—for Sforza residences, for churches, and the cathedral in Milan, for a Medici residence in Florence, and for gardens and a villa for the young French king at Amboise. All the while Leonardo was being acclaimed for his fantastic ephemerae, the floats, buildings, and costumes for pageants, masquerades, and festivals, which survive only in Leonardo's notebooks or the diaries of witnesses.

Leonardo's reputation as one of the great artists of the West rests, of course, on his painting, which was never excelled. But the remains of his painting are tantalizingly few. His energetic sixty-seven years left only seventeen surviving paintings that can be reliably attributed to him, and several of these are unfinished. The cryptic smile of the *Mona Lisa,* the most famous Western painting, still entices us. Following Vasari's report, centuries called her *La Gioconda,* wife of the Florentine Francesco del Gioconda, and said she was painted about 1503. "After toiling over it for four years, he left it unfinished. . . . He made use, also, of this device: Mona Lisa being very beautiful, he always employed, while he was painting her portrait, persons to play or sing, and jesters, who might make her remain merry, in order to take away that melancholy which painters are often wont to give to the portraits they paint." Now we know that this was one of Leonardo's last works in Florence, after 1514, probably an idealized portrait of one of Giuliano de Medici's mistresses.

The Last Supper, painted for the refectory of the cloister of Dominican friars in Milan (1495–98), is commonly considered Leonardo's masterpiece. The contemporary writer Matteo Bandello (1480?–1562) recalled:

> Many a time I have seen Leonardo go early in the morning to work on the platform before the Last Supper; and there he would stay from sunrise till darkness, never laying down the brush, but continuing to paint without eating or drinking. Then three or four days would pass without his touching the work, yet each day he would spend several hours examining it and criticising the figures to himself. I have also seen him, when the fancy took him, leave the Corte Vecchia when he was at work on the stupendous horse of clay, and go straight to the Grazie. There, climbing on the platform, he would take a brush and give a few touches to one of the figures: and then suddenly he would leave and go elsewhere.
> (Translated by Kenneth Clark)

Leonardo could not have painted the work so sporadically if it had been fresco, which would have incorporated his labors into the body of the wall. Fresco had to be painted speedily and on schedule while the plaster was still moist. Instead, Leonardo painted *The Last Supper* with oil and varnish, the wall was damp, and the paint quickly deteriorated. By 1556 Vasari reported "nothing visible except a muddle of blots." In the following centuries the painting has been repeatedly "restored." And Leonardo's greatest work, despite expert modern efforts, survives only as a ghost of itself.

Leonardo secured his most important commission in Florence in 1503 through his friend Machiavelli (1469–1527), then a city official. This was to paint a monumental mural (twenty-three by fifty-six feet; twice as large as *The Last Supper*) for the Council Hall of the Palazzo Vecchio. For his subject he chose the Battle of Anghiari, where, in 1441, the Florentines had defeated the Milanese forces of the pope. Leonardo intended to depict the moment of victory when the enemy's standard was captured. In a Florence of so many artists, to be chosen for this work was a great honor. But Leonardo's pleasure was diluted a few months later when a commission for the other half of the wall went to his youthful archrival Michelangelo. Leonardo, who had long wanted to paint a battle, luxuriated in notebook visions of leaping horses and "the conquered and beaten pale, their brows raised and knit, and the skin about their brows furrowed with pain, the sides of the nose with wrinkles going in an arch from the nostrils to the eyes, and . . . the nostrils drawn up and the lips arched upwards discovering the upper teeth; and the teeth apart as with crying out and lamentations." His many preparatory sketches of men and horses captured the fury of battle, incorporated in a cartoon of the large design that has not survived.

The Battle of Anghiari, the commission for which he was probably best known in his own time, was never painted, for Leonardo delayed this work to take on still another assignment, an urgent invitation from the governor of Milan to return there for three months "to furnish us with a certain work [perhaps the London version of *The Virgin of the Rocks*] which we have had him begin." When the governor of Milan asked Leonardo to stay on, the Council of Florence complained that "Leonardo da Vinci . . . has not borne himself as he ought to have done towards this republic, in that he has received a good sum of money and has made little beginning of a great work which he is under obligation to execute, and has already comported himself as a laggard." Leonardo returned to Florence briefly in 1507, not to fulfill his commission but to bring a lawsuit against his brothers over his father's estate.

Although he made no effort to complete the Battle of Anghiari, Leonardo had prepared for it by putting binder on the wall. But it soon peeled off. Both Leonardo and Michelangelo drew their sketches on the palazzo wall,

and as long as these remained, Benvenuto Cellini observed, these were "the school of the world." Posterity can judge Leonardo's effort only from some of his own surviving sketches and from a sketch by Rubens of another artist's engraving of a fragment.

The *Mona Lisa, The Last Supper,* and other "unfinished" paintings make up in quality what his lifework as a painter lacked in quantity. Leonardo's early years in Florence produced his *Saint Jerome* and his large *Adoration of the Magi,* both left unfinished when at the age of thirty he went to Milan. There in Milan he produced his superb *Virgin of the Rocks* notable for its *sfumato,* the mysterious haze that became Leonardo's hallmark. Leonardo's scientific writings themselves were overcast by the *sfumato* that enchants his painting. For the science of art had made "the work of the painter . . . nobler than that of nature, its mistress."

This "unfinished" quality of Leonardo's work is essential to his character as an artist, the self-styled Disciple of Experience. While revelation and dogma might be sharp and clear, experience was always revising itself. Leonardo's most characteristic works and his lifelong favorite creations were notebooks and fragmentary drawings that expressed his genius more spontaneously than his finished paintings. It is not surprising that many of his playful sketches for grand monuments were never finally frozen into bronze, for he enjoyed the first encounter more than the laborious execution.

Drawing, though it did not have the prestige or command the price of a painting, was the ideal medium for experiment and for Leonardo's "fragmentary abundance." A grotesque nose or ear or chin might not have merited a painting, but was perfect for a drawing. These were not caricatures but exercises of his imagination, capturing the whole spectrum of visual experience. Through this freedom of drawing he finally expressed his apocalyptic visions of the forces of nature—"Visions of the End of the World" and the "Deluge." Few medieval drawings have survived to modern times, for the artist then would not casually consume a costly piece of paper to sketch momentary impressions. But the experimental Renaissance brought fondness and even prestige for drawings and rough sketches. The capacity for achievement, to which drawings were clues, came to be revered almost above the achievement itself.

Leonardo, who never sought eminence as a scientist, applied art to all the sciences. Unlike Galileo, he was not adept at abstracting principles from experience, but found his home in experience of the visible world. Leonardo created his own kind of scientific exposition, which he called *dimostrazione.* And so, incidentally he became the pioneer of modern scientific illustration. Whether depicting the vascular system or the vertebrae of man, or the wing structure of a bird, or a new lifting machine, Leonardo's drawings verified

the function, the stability and motion of every part. "Let no one read me who is not a mathematician," he wrote in the margin of an anatomical study. He valued mathematics for its visual "fruits," and for him "Mechanics is the paradise of the mathematical sciences."

"Occasionally," Vasari observed of Leonardo, "in a way that transcends nature, a single person is marvellously endowed by heaven with beauty, grace, and talent in such abundance that he leaves other men far behind." Leonardo's life would be a dramatic competition between science and art. In the Empire of the Eye the painter was the sovereign creator. "If the painter wishes to see beauties that would enrapture him," Leonardo said, "he is master of their production, and if he wishes to see monstrous things which might terrify or which would be buffoonish and laughable or truly pitiable, he is their lord and god."

45

"Divine Michelangelo"

A legacy from the Renaissance, the belief in genius, something rarer than skill or talent, would transform the arts. It has taken us from respect for the trained talent, manipulating the experience that is out there for all to know, to awe before the uniquely inspired self. From admiration to awe, from the imitation of nature to the re-creation of nature. From the artist filling a patron's orders, to the patron awaiting an artist's creations. "Talent," observed James Russell Lowell, "is that which is in a man's power; genius is that in whose power a man is."

In ancient Roman religion, the "genius" (Latin: the begetter) was the ruling spirit that perpetuated a household or a family. It came to mean the guardian spirit of a guild, a place, or an individual, which a person might worship on his birthday. After Augustus the "genius" of an emperor would be worshiped. The spirit of a woman or a goddess was known and worshipped as a "Juno."

Medieval Europe did not put a high value on originality. If it had been proved that Leonardo da Vinci had copied the items in his notebooks from other books it would only have increased respect for his learning, and would not have stirred charges of plagiarism. "Individualism"—"a novel expres-

sion to which a novel idea has given birth"—did not enter our English vocabulary until 1835, when Tocqueville used it to describe what he found in America. But "genius," suggesting originality, had deeper roots. Supremely embodied in Michelangelo, the unique unpredictable creator has cast a spell over the arts in modern times.

Suger, Dante, and Giotto were admired for the awesome immortality of their works. Yet the word "divine" was rarely applied to living artists or poets before the sixteenth century. Alberti in his work on painting (1436) already saw in the artist a "divine" power. Leonardo, too, declared the painter's work "nobler than that of nature" and his painter was "a second god." The Portuguese painter Francisco de Hollanda observed in Rome in 1538, that "in Italy, one does not care for the renown of great princes, it's a painter only that they call divine."

During the Middle Ages the artist had been a man of trained skills and disciplined life. The earliest painters' guilds in the late thirteenth century oversaw the lives and works of members, their religious activities, their contracts of apprenticeship, and their relation to patrons. In Florence after 1293 no one had civic rights who was not a member of his proper guild, and defiance of the guild was unusual. When Brunelleschi refused to pay his dues to the guild of building workers in 1434, he was imprisoned for eleven days, until the authorities secured his release to work at the cathedral. Guilds were losing their monopolies, but not until 1571 did a decree exempt members of the Florentine Academy from guild membership. The Protestant Reformation, wary of images in churches, deprived painters and sculptors of their best traditional patron. But about the same time merchant bankers like the Medici created a more varied demand, offering the artist a new chance to be original.

The roles of patron and of artist were being strangely reversed. When the marchioness Isabella d'Este of Mantua, collecting works by the best painters of her time, contracted with Perugino on January 19, 1503, for an allegorical picture to be delivered by the following June, she still specified every detail. "You are at liberty to omit figures but not to add anything of your own." But we see the modern spirit in her dealings with Leonardo da Vinci. In 1501 she wrote to the Carmelite vicar-general of Florence, "Your Reverence might find out if he would undertake to paint a picture for our studio. If he consents, we would leave the subject and the time to him; but if he declines, you might at least induce him to paint a little picture of the Madonna, as sweet and holy as his own nature." Giovanni Bellini in 1506 in Venice let her specify the size of the painting but insisted that all else be left to his imagination. In this same year Albrecht Dürer of Nuremberg (1471–1528), who happened to be in Venice, was impressed by this independence of Italian artists. "Here I am a gentleman," he wrote, "and at home a mere parasite."

Even when court painters were exempt from guild restrictions they could not accept outside work without permission. They painted everything to order and, like other craftsmen, were paid by the hour. But by the end of the fifteenth century the best Italian artists were well-off and were paid like professionals. Leonardo received a substantial annual salary in Milan and later from the king of France. Raphael and Titian could afford a notoriously luxurious way of life. Michelangelo himself received three thousand ducats for the Sistine ceiling, and had a large income from his work. When he refused payment for his work on St. Peter's he was already a wealthy man, which made his modest way of life all the more remarkable. Established artists like Giovanni Bellini and Titian could count on sinecures or salaried offices with few duties.

When the artist was no longer a mere craftsman trying to do better what others had already done, his life became interesting, worth writing and reading about. We know of no Western artist before Brunelleschi whose life was written by a contemporary. The new era, as we have seen, was emphatically announced in the copious and readable *Lives of the Most Eminent Painters, Sculptors, and Architects* (1550), by Giorgio Vasari (1511–1574). Commonly called the first Western historian of art, Vasari should more precisely be called the first historian of artists, for his work was a celebration of individual artist geniuses. At a lively dinner party in Rome in 1546 at Cardinal Farnese's, Vasari was challenged to write an account of "all illustrious artists from the time of Cimabue up to the present." Disciple and friend of Michelangelo (they wrote each other regularly when they were separated), and a competent artist, Vasari was at home with the leading artists of his day. No one saw more vividly the artist's new role.

Vasari grouped his artists into three periods, each distinguished by its artist geniuses. The first, led by Cimabue and Giotto, marked "a new beginning, opening the way for the better work which followed; and if only for this reason I have to speak in their favour and to allow them rather more distinction than the work of that time would deserve if judged by the strict rules of art." His second period, which included Uccello, Botticelli, and Mantegna, "was clearly a considerable improvement in invention and execution, with more design, better style, and a more careful finish. . . . Even so, how can one claim that in the second period there was one artist perfect in everything. . . . These achievements certainly belong to the third period, when I can say confidently that art has achieved everything possible in the imitation of nature and has progressed so far that it has more reason to fear slipping back than to expect ever to make fresh advances." This third period opened with Leonardo. "It is inherent in the very nature of these arts to progress step by step from modest beginnings and finally to reach the summit of perfection"—in Michelangelo.

From printed sources, manuscripts, interviews, and travel reports en-

riched by legend, anecdote, and rumor, Vasari produced two volumes in
Florence in 1550 containing 133 lives. The success of this work and his
growing intimacy with Michelangelo then led him to produce an enlarged
and illustrated second edition (1568) of three volumes treating 161 lives. Here
he provided the framework for art historians in later centuries. Vasari
inspired the classic caricature of the typical artist in the *Autobiography* of
Benvenuto Cellini (1500–1571). And he led another Michelangelo disciple,
Condivi, to write a corrective biography of their hero.

Climaxing his history of artists with a life of his teacher and idol Mi-
chelangelo that was several times as long as any of the others, Vasari
depicted the genius artist, the modern creator, the Sovereign Self. His
"Divine Michelangelo" ironically signaled a secular religion of art. Back in
the days of Giotto "all artists of energy and distinction were striving to give
the world proof of the talents with which fortune and their own happy
temperaments had endowed them."

> Meanwhile, the benign ruler of heaven graciously looked down to earth, saw the
> worthlessness of what was being done, . . . and resolved to save us from our errors.
> So he decided to send into the world an artist who would be skilled in each and
> every craft . . . so that everyone might admire and follow him as their perfect
> exemplar in life, work, and behaviour and in every endeavour, and he would be
> acclaimed as divine. . . . And . . . he chose to have Michelangelo born a Florentine,
> so that one of her own citizens might bring to absolute perfection the achieve-
> ments for which Florence was already justly renowned.
>
> (Translated by George Bull)

There was little in his family or his circumstances to explain this ascent to
divinity.

Michelangelo was born on March 6, 1475, to Lodovico Buonarroti, a
substantial citizen and mayor of the village of Caprese, near Arezzo, of a
family that boasted its descent from the counts of Canossa. "A fine nativity
truly," Condivi noted, "which showed how great the child would be and
of how noble a genius; for the planet Mercury with Venus in seconda being
received into the house of Jupiter with benign aspect, promised what after-
wards followed, that the birth should be of a noble and high genius, able
to succeed in every undertaking, but principally in those arts that delight
the senses, such as painting, sculpture, and architecture." The family soon
moved to Florence. Michelangelo's mother died when he was only six, and
the artist liked to note that his nurse was the daughter of a stone carver and
the wife of a stone carver. "If my brains are any good at all," he told Vasari,
"it's because I was born in the pure air of your Arezzo countryside, just as
with my mother's milk I sucked in the hammer and chisels I use for my
statues."

Lodovico Buonarroti placed his other four sons with the wool and silk guilds, but he could afford to send Michelangelo to a grammar school. There the boy stole time from his studies to pursue his obsession with drawing, which his father and older brothers tried to cure by occasional beatings. Finally abandoning hope of forcing the boy to give up drawing for some more elevated pursuit, Lodovico apprenticed him at the age of fourteen to the painter Domenico Ghirlandaio. The precocious Michelangelo made copies of works by masters that were indistinguishable from the originals, then aged them with smoke, and exchanged them for the originals that he coveted.

After a year he left the painter's workshop for a curious art school that Lorenzo the Magnificent had set up in the Medici gardens. Lorenzo, who had collected antique sculpture and employed a pupil of Donatello as teacher, now hoped by gathering young talents like Michelangelo to establish a new school of painters and sculptors. Even as a boy Michelangelo had sculpted masterly reliefs, his *Madonna of the Stairs* and the *Battle of the Centaurs.* Discovering Michelangelo's rare talent in "the prime art," sculpture, Lorenzo added the boy to his household. The philistine Lodovico Buonarroti still found it hard to see the difference between a stonemason and a sculptor and thought neither occupation suitable for a scion of the counts of Canossa. Another Medici apprentice, the envious Torrigiano, left his mark on the face of Michelangelo. In one of their many ill-tempered encounters for which Torrigiano was banished from Florence, Torrigiano's fist broke Michelangelo's nose. When Lorenzo de Medici died in 1492, the boy returned to live with his father, but, except for a brief interval, never ceased to be known as a Medici partisan in Florence's turbulent politics.

While living with his father from 1492 to 1494, Michelangelo often heard the eloquent Savonarola (1452–1498) preach in the cathedral of Florence. The passionate and persuasive Savonarola was the declared enemy of the arts that made Florence great, and he mistrusted the ancient classics. "The only good thing which we owe to Plato and Aristotle," Savonarola preached, "is that they brought forward many arguments which we can use against the heretics. Yet they and other philosophers are now in Hell. An old woman knows more about the Faith than Plato." Savonarola drove the Medici from Florence in 1494 and established a "democratic" dictatorship with himself at the head. There in the Piazza della Signoria in 1497 he ignited his famous Bonfire of the Vanities, feeding it with carnival costumes and masks, wigs and cosmetics, mirrors, playing cards and musical instruments, every kind of work of art, along with volumes of "corrupt" Latin and Italian poets, including Boccaccio. When the Medici fled Florence, so did Michelangelo, first to Bologna and then in 1496 to Rome "as the widest field for a man to show his genius in." There he took some commissions,

a Bacchus for a banker and for a cardinal the *Pietà*, which was his first important work on the Christian themes that would consume his life and would become one of St. Peter's featured attractions. Meanwhile, in Florence, Savonarola, having exhausted the power of his eloquence, was tortured, hanged, and burned. When Michelangelo returned in 1501 the Republic of Florence commissioned him (at twenty-six) to do the *David* that became a symbol of the city, and in 1504 to do a fresco in the Palazzo Vecchio opposite Leonardo's. This *Battle of Cascina,* like Leonardo's battle piece, was never finished and never survived.

When the ambitious and impetuous Julius II (1443–1513) came to the papacy (1503–13), he became the patron and catalyst of Renaissance art and a dominant force in Michelangelo's life. He brought Michelangelo back to Rome, commissioning him to design and build a tomb for him that would be the wonder of the world. Michelangelo remained in Rome until 1514, when the Medici pope Leo X sent him back to Florence, where Leo X and still another Medici pope Clement VII would set him at projects commemorating their family. In 1534 he left Florence for Rome, where projects for succeeding popes kept him occupied until his death in 1564.

The contrast between Leonardo and Michelangelo is an allegory of the arts in modern times. Leonardo left copious notes of his observations on nature and the world around him, but little about his feelings or his inner life. Michelangelo, in his letters, his poetry, in biographies by his friends and students Vasari and Condivi, in conversations with Francisco de Hollanda and others, left us vivid revelations and eloquent chronicles of himself. Leonardo, the self-styled "disciple of experience," was a hero of the effort to re-create the world from the shapes and forms and sensations out there. But Michelangelo, prophet of the sovereign self, found mysterious resources within. These two greatest figures of Italian Renaissance art dramatized a modern movement from craftsman to artist. If Leonardo could be called the Aristotle—practical-minded organizer and surveyor of experience—Michelangelo would be the Plato, seeker after the perfect idea.

The same Platonism and Neoplatonism that must have discomfited Leonardo in Florence appealed to Michelangelo. The ideas of Marsilio Ficino and Pico della Mirandola and others of the Platonic Academy whom he would have known in the household of Lorenzo de Medici he expressed in poems and letters to the handsome Tommaso Cavalieri, his earthly embodiment of "the divine idea." But Leonardo's was a religion of scientific skepticism, the faith of a discoverer. He seems to have been a disciple of the mathematical pioneer and heretic Nicholas of Cusa (1401–1464), who had proved the Donation of Constantine to be a forgery, invented a "total science" based on the knowledge of objects, tolerated religious diversity, and recognized the conjectural truth of all religions.

Michelangelo in his twenties had fallen under the spell of the fanatical Savonarola and never recovered. He was seduced into the most unlikely discipleship in the history of art. The *Pietà* of his first trip to Rome had signaled the leitmotif of his life. Michelangelo's piety, despite the secular and sometimes vulgar interests of the popes he served, deepened with the years. While he combined pagan and Christian themes, he still shared Savonarola's narrow Christian view of the ancients. Michelangelo's faith was reinforced in Rome after 1536 by the brilliant and charming widow Marchioness Vittoria Colonna. Sixty years old when he met her, he was enamored of her "divine spirit," and was "in return tenderly loved by her." A disciple of the Spanish theologian Juan de Valdés (1500?–1541), and a partisan of German Reformation ideas, she seems to have converted him to the theological dogma of justification by faith. Michelangelo adored her in his later Roman years, and she fired his religious passion, attested by his poems and letters and drawings for her.

Michelangelo's major works were not merely assignments fulfilled but had an aura of the preternatural, of his uncanny ability to overcome all competitors. His most familiar early masterpiece, his *David*, in what he called "the prime art" of sculpture, revealed his ability to do what others could not: if other artists required a piece of marble specially suited to their design, Michelangelo could make a masterpiece from marble already mangled by others. Back in 1463 the authorities of the cathedral of Florence had acquired a sixteen-foot-high chunk of white marble to be carved into a figure to top an external buttress of Brunelleschi's dome. Two well-known sculptors, one from Siena, another from Florence, had worked on the piece but had given up, and the block was put in storage. Forty years later the authorities still sought a sculptor. In 1501 they decided to take their chance on the twenty-six-year-old Michelangelo for the giant figure to be placed conspicuously at the door of the Palazzo della Signoria. Condivi tells the story.

> As they were not able to get anything out of this piece of marble likely to be any good, it seemed to Andrea del Monte a San Savino, that he might obtain the block, and he asked them to make him a present of it . . . but the Operai, before disposing of it, sent for Michel Angelo, and told him the wish and offer of Andrea, and, having heard his opinion that he could get something good out of it, in the end they offered it to him. Michel Angelo accepted it, and extracted the above-mentioned statue without adding any other piece at all, so exactly to size that the old surface of the outsides of the marble may be seen on the top of the head and in the base. . . . He received four hundred ducats for this work, and finished it in eighteen months.
>
> (Translated by Charles Holroyd)

In Florence, Michelangelo's work for those months became proverbial—how he measured and scrutinized the mangled piece to see what it would accommodate, how he made small wax models and drawings for parts, how he slept in his clothes to save time, and finally "released" his fabled Giant from material abandoned for a half century.

This surprising achievement in sculpture would be outdone by his masterpiece in painting. Here, too, was the genius besting all others and even somehow exceeding himself. After Pope Julius II summoned Michelangelo to Rome in 1505 to design and build for him a world-dazzling tomb to be completed in four years, Michelangelo himself went to the mountains of Carrara to select and quarry the marble needed for the forty more-than-life-size figures in the plan. Michelangelo stayed in the mountains for eight months "with two workmen and his horse, and without any other salary except his food." From the unpredictably undulating marble veins he sought out huge blocks without blemishes and had them laboriously loaded on ships. When Michelangelo himself arrived in Rome, to his astonishment the pope refused to see him. The pope had been persuaded by Bramante to rebuild the whole basilica of St. Peter's in place of his own grandiose tomb.

This episode Condivi appropriately called the First Act in the Tragedy of the Tomb. It baptized Michelangelo in the dirty politics of Vatican art. And its melodrama would ironically produce Michelangelo's masterpiece. Bramante (1444–1514) and his kinsman Raphael were jealous of Michelangelo, irritated by his exposure of Bramante's mistakes and by the pope's favoritism (including even a private drawbridge between the pope's rooms and Michelangelo's). They hatched a plan that would release the pope's resources from the tomb for their own project of rebuilding St. Peter's. They reminded the pope that building a tomb in one's lifetime was bad luck and might bring an early death. Their project for Michelangelo would remove him from the scene of competition for some years and impose on him a task for which he was not competent. Then the discredited Michelangelo would no longer be their rival in other projects. These diversionary tactics produced the most spectacular Pyrrhic victory in the history of the arts.

The project they persuaded Julius II to assign to Michelangelo was relatively obscure but sufficiently difficult. It was to fresco the ceiling of the private chapel that Julius's uncle Pope Sixtus IV a quarter century before had built (1473–81), and which came to public notice only when it was used for papal elections. The chapel had already been copiously decorated with frescoes by Perugino, Botticelli, Ghirlandaio and others. Michelangelo would be commissioned to decorate the tunnel-vaulted ceiling, a curved surface broken up by eight windows that produced unmanageable triangles and lunettes. "In this way," Vasari reports, "Bramante and Michelangelo's other rivals thought they would divert his energies from sculpture, in which

they realized he was supreme. This, they argued, would make things hopeless for him, since he had no experience of colouring in fresco he would certainly, they believed, do less creditable work as a painter. Without doubt, they thought, he would be compared unfavourably with Raphael, and even if the work were a success, being forced to do it would make him angry with the Pope; and thus one way or another they would succeed in their purpose of getting rid of him." Michelangelo, protesting that painting was not his art, still took on the project.

In every way it was a challenging task. Since Michelangelo had never used color, nor had he painted in fresco, he had to enlist friends to teach him the techniques. He had to discard the scaffolding that Bramante had erected, which would have left holes in the ceiling, for a scaffold of his own. Though he would engage some workmen as helpers, he determined to design and paint the whole ceiling himself. The impatient Julius tried repeatedly to see the work in progress and demanded to know when it would be completed. "When it satisfies me as an artist!" was the proverbial reply. "Finally," Vasari reports, "the Pope threatened that if Michelangelo did not finish the ceiling quickly, he would have him thrown down from the scaffolding. Then Michelangelo, who had good reason to fear the Pope's anger, lost no time in doing all that was wanted."

After four years of Michelangelo's furious solitary labor, the ceiling was unveiled in 1512. "I have finished the chapel which I was painting," he wrote his father. "The Pope is well satisfied." And so were the crowds that now thronged in. "He executed the frescoes in great discomfort," Vasari recalled, "having to work with his face looking upwards, which impaired his sight so badly that he could not read or look at drawings save with his head turned backwards, and this lasted for several months afterwards." His enemies had stage-managed the masterpiece that quickly established him as the artist genius of the age. In that awkward curved space fragmented by lunettes and triangles Michelangelo managed to depict the history of the Earth from the Creation to Noah, surrounded by ancestors and prophets of Jesus and finally revealing the liberation of the soul. Writhing nudes dramatized the agony of the body preparing for spiritual freedom in Michelangelo's version of the Neoplatonist doctrine that the body was only the vehicle of the soul. The work would have been remarkable enough on a wide unbroken canvas, but thrust into this space it was unmistakable witness to genius. "There is no other work to compare with this for excellence, nor could there be," exclaimed Vasari, "and it is scarcely possible even to imitate what Michelangelo accomplished. The ceiling has proved a veritable beacon to our art, of inestimable benefit to all painters, restoring light to a world that for centuries had been plunged into darkness." Succeeding centuries have not dissented.

Michelangelo was barely able to benefit from the pope's acclaim, for
Julius died four months after the ceiling was unveiled. The heirs renewed
the contract for an enlarged tomb for Julius in Rome. But Michelangelo
returned to Florence, where the Medici in turn commissioned him to make
a grandiose funerary monument of their own. Much of the rest of his life
he would be torn between the Medici monument and the promised tomb
of Julius II, which the heirs never ceased to demand. And he continued to
benefit from the rivalry of papal families when in 1534 the Farnese pope Paul
III commissioned Michelangelo to paint the wall behind the altar in the
Sistine Chapel. His *Last Judgment,* begun in 1536, was completed in 1541.
This Christian panorama depicted the Second Coming and mankind tested
by the revolving forces of the universe, in the aura of his favorite poet,
Dante. "To any discerning critic the Last Judgment demonstrates the sub-
lime force of art and Michelangelo's figures reveal thoughts and emotions
that only he has known how to express . . ." acclaimed Vasari. "All these
details bear witness to the sublime power of Michelangelo's art, in which
skill was combined with a natural inborn grace. Michelangelo's figures stir
the emotions even of people who know nothing about painting."

In 1546 the seventy-nine-year-old Pope Paul III confidently called on the
seventy-one-year-old Michelangelo to be chief architect and superintendent
of the rebuilding of St. Peter's. Michelangelo again objected "that architec-
ture was not his vocation." But "against his will" he took on the job at the
pope's command. Despite his protests of architectural incompetence Mi-
chelangelo had already designed several remarkable buildings in Florence.
For the Medici pope Clement VII he had built the New Sacristy, or Medici
Chapel, in the Church of San Lorenzo. And his bold Biblioteca Laurenziana
was the first great Western library to be designed (1524) specifically for its
secular purposes rather than by the canons of religious architecture. Its
famous vestibule, an enclosed space with a freestanding staircase in the
center, became the model for monumental staircases in the seventeenth and
eighteenth centuries. It led up, not to the familiar three naves of religious
buildings, but to a long low rectangular reading room. Simply designed for
the quiet concentration of readers, it became a prototype of countless library
reading rooms to follow.

But the St. Peter's task was on a scale without precedent since the
medieval cathedrals. The rebuilding of the basilica had been going on for
forty-one years plagued by vacillating plans, from Bramante's simple Greek
cross (1506) to Sangallo's complex Latin cross (1530). Braving the displea-
sure of those who had been working at the basilica in recent decades,
Michelangelo ordered a return to Bramante's simple design, which he said
was "clear, straightforward, luminous, and isolated from the Vatican Palace
all around." When the pope commanded all to take their orders only from

him, "Michelangelo, seeing the great trust and confidence that the Pope reposed in him, wanted to demonstrate his own good will by having it declared in the papal decree that he was devoting his time to the fabric for the love of God, and without other reward."

This was to be the grand project of his next seventeen years. He resisted all efforts to distract or seduce him from the job, or remove him from it. Since his completion of St. Peter's had become a religious mission, to fail in it would be "a great disgrace and sin." He stayed on but the work was not completed in his lifetime. The project was so vast, and so many architects had a hand, that it is not easy to separate the parts for which Michelangelo should be credited. But his sculptural approach to architecture and his belief in buildings as organisms with lives of their own would be embodied in the completed St. Peter's. The dome was inspired by Brunelleschi's cathedral dome in Florence, and the façade was not his design. There remained, however, Michelangelo's grand and simple concept for the building: a dome of the heavens over the four cardinal points of the earth.

A cult of Michelangelo began to appear about 1540, when the vigorous creator was only sixty-five. The popes sanctified his plans for St. Peter's and took measures to prevent the slightest change. Three sets of imaginary dialogues with him were published by 1552, and biographies appeared while he was still alive. He would never be more extravagantly appreciated than by his contemporaries. Vasari noted in 1568 that he had "in the three arts a perfect mastery that God has granted no other person, in the ancient or modern world, in all the years that the sun has been spinning round the world." The awe-inspiring quality of the artist and his work they called *terribilità*. "Michelangelo's genius," according to Vasari, "was recognized during his lifetime, not, as happens to so many, only after his death. As we have seen, Julius II, Leo X, Clement VII, Paul III, Julius III, Paul IV, and Pius IV, all these supreme pontiffs, wanted to have him near them at all times; as also, as we know, did Suleiman, Emperor of the Turks, Francis of Valois, King of France, the Emperor Charles V, the Signoria of Venice, and lastly . . . Duke Cosimo de' Medici, all of whom made him very honorable offers, simply to avail themselves of his great talents."

No longer painting to order by the hour as a minion of court or cathedral, the creator, the genius artist, had become an inspired source, sought after by pope and prince. The Sistine ceiling and *The Last Judgment* displayed the new independence of the artist. And for Michelangelo, in the limbo between patron and client, this cost personal agony. While Leonardo had spent much of his life in pursuit of patrons, Michelangelo was more often the pursued. The funerary project that Julius II proposed to Michelangelo in 1505 would dog him for the next forty years. He changed the design at

least six times with the changing nuances of his own religious sentiments, and Julius II himself vacillated. After Julius's death, the Rovere family continued their demands while the Medici popes pressed their competing projects. "I am solicited so much," he complained, "that I cannot take time to eat."

Michelangelo was well aware of the awesome quality of his person and his art. "When Buonarroti comes to see me," Pope Clement VII used to say, "I always take a seat and bid him be seated at once, feeling sure that he will do so without leave or license otherwise." Stories of his *terribilità* were legion. On his abrupt departure from Rome in 1506, when Julius II had changed his mind about the tomb, the pope sent five horsemen after him, Michelangelo recalled, with a threat of the pope's displeasure if he did not return at once. "I replied then to the Pope that as soon as he would discharge his obligations towards me I would return; otherwise he need not hope ever to see me again." This caused a diplomatic incident between the papacy and the city of Florence. Michelangelo was not pacified until the Signoria of Florence finally agreed to write the pope that should he do Michelangelo harm, "he will be doing it to this Signoria." About that time Julius II was going to Bologna, which was nearer to Florence than to Rome and when Michelangelo met him there the pope considered that he had deferred to the artist. The bishop "who had presented Michelangelo to the Pope began to make excuses for him, saying to his holiness that such men were ignorant creatures, worthless except for their art, and that he should freely pardon him. The Pope lost his temper at this and whacked the bishop with a mace he was holding, shouting at him: 'It's you that are ignorant, insulting him in a way we wouldn't dream of.' "

In his late years Michelangelo was notoriously tempestuous and difficult to deal with. "Painting and sculpture, labour and good faith," he wrote friends in 1542, "have been my ruin and I continually go from bad to worse. Better would it have been for me if I had set myself to making matches in my youth. I should not be in such distress of mind." And he observed at seventy-four, "You will say that I am old and mad, but I answer that there is no better way of keeping sane and free from anxiety than being mad." He seemed to enjoy his agonizing, as he explained in the lines of his oft-quoted late sonnet:

> Melancholy is my joy
> And discomfort is my rest.
>
> (La mia allegrez' e la maniconia
> g'l mio riposo son questi disagi)

The *terribilità* of Michelangelo, the terrifying power of the inspired artist, would leave its mark on the future of the arts. The genius of Michelangelo inspired others to make a fetish of genius.

46

The Painted Word: The Inward Path of Tao

WE have seen how narrowly Western art escaped the Iconoclasts' onslaught on images at the Second Council of Nicaea in 787, and so Christianity remained an inspiring resource for centuries of painters. The Chinese experience shows us another might-have-been that would have changed the focus of artists in the West. In China with the great improvement of paper-making in the second century A.D. and its widespread use thereafter, calligraphy (using the ancient writing brush and ink) was quickly transformed into an art and married to painting in a union that shaped Chinese painting for centuries. In Europe this marriage never took place, and the quill pen on paper took over from the stylus and reed pen that the ancient Mesopotamians had used on their soft clay tablets. Western painting went the way of the brush, while writing was the way of the pen.

In China the Way of the Brush remained the path for both painting and writing, with crucial consequences for poetry and the graphic arts. While Chinese painters generally had philosophic aspirations far grander than those of artists in the West, their works were less varied in subject matter, color, and materials. Their hopes and their triumphs offered nothing like the Western temptations to novelty, and their legacy is not easy for Western minds to understand.

Chinese painters would be neither craftsmen nor artists in the Western sense. For they would be neither skilled workers hired by the hour to accomplish a specific task nor inspired originals commissioned to produce a unique work. By the eighth and the ninth centuries the way of the brush, the way of calligraphy, had become the scholar's way, which made painting a pursuit of the educated class, a closer ally of the poet than of the draftsman. After about A.D. 1000, when there was a theoretical distinction between scholar-painters and professional painters, many of the greatest painters were professionals. Still the painter's work remained an exercise of

traditional wisdom, for scholar gentlemen following revered ancients in harmony with the forces of nature. The Chinese thus saw their painters as inspired practitioners of the art of living, which included two artistic skills higher than painting—calligraphy and poetry.

The Taoist current in Chinese thought set man the task of seeking unity with nature and the cosmos, to abdicate the self in harmony with "nonbeing." Pursuing the *way,* the painter had his task, his subject, and even his materials prescribed for him. Only the man educated in using the brush for writing would be qualified to use the brush for painting. It is not surprising, then, that in China sculpture (which involved physical labor and so was not for gentlemen) was not considered a fine art.

The history of Chinese painting did not produce precocious Giottos or maverick Picassos. Many of the great masters distinguished themselves first as government officials, as scholars or poets, and often were noted calligraphers. And as the arts of calligraphy and painting developed, these arts prescribed the discipline to assure a calm mind, a cultivated memory. All the scholar's activities were acts of reverence for nature, or as a metaphor for the nobility of man. The rules of ceremony, the Ancient Book of Rites declared, while they "have their origin in heaven, the movement of them reaches to earth. The distribution of them extends to all the business of life." All acts of community and the individual should be acts of reverence and sacrifice (in the sense of making an offering or obeisance).

While the Sung dynasty (960–1279) saw some of the best of Chinese realistic and representational painting, it also saw the rise of painters in an emphatically Taoist spirit. For them landscape, a literary subject, dominated at first because of the traditional association of the hermit scholar with wild scenery, as well as the symbolism of pine trees, bamboo, rocks, mountains, and running water. The painter was not expected to seek the most beautiful vantage point and remain there to reproduce what he saw in his painting. Instead, he was to paint what he recalled in memory. "The idea precedes the brush" was his motto. "To paint the bamboo," the Sung scholar, poet and painter Su Shih (Su Tung-p'o, 1036–1101) explained, "one must have it entirely within one. Grasp the brush, look intently [at the paper], then visualize what you are going to paint. Follow your vision quickly, lift your brush and pursue directly that which you see, as a falcon dives on the springing hare—the least slackening and it will escape you." The Chinese scholar, who from an early age memorized and learned to reproduce the forms of the written characters, had cultivated the "eidetic" faculty, the capacity to reproduce automatically, vividly, and in detail a remembered image.

But, to capture the eidetic memory, and connect the painter to the Tao of nature, the painting had to be spontaneous, and not deliberately done by

stages. The "photographic" memory, the eidetic image, as the psychologist G. W. Allport explains "in distinction to the visual memory-image revives the earlier optical impression when the eyes are closed . . . with hallucinatory clearness." Looking inward for a view of the subject to be painted, Chinese artists prepared themselves with a calm readiness of spirit. What the painter drew then would not be a particular bird or pine tree or bamboo, but a composite compounded in the memory. He might have prepared for this, seeking peace of mind and harmony with the rhythms and renewals of nature, by reflective walks in the woods or mountains. He was pursuing Chang Tzu's goal of "sageliness within and kingliness without" which meant "having achieved the goal of self-cultivation."

When spiritually prepared, the artist would take his plunge and put his brush to paper. His materials forced him to spontaneity, requiring that he paint quickly in one continuous process. The Western painter applying oil to wood or canvas lived in quite another world. We have seen how Leonardo da Vinci, working on his *Last Supper,* could return when he took the fancy to "take a brush and give a few touches to one of the figures," or how Michelangelo spent four years on the ceiling and five years on the *Last Judgment* of the Sistine Chapel. The proverbial patience of the Chinese found another expression—awaiting the moment of concentration.

"In painting any view," the eleventh-century landscapist Kuo Hsi said, "the artist must concentrate his powers to unify the work. Otherwise it will not bear the peculiar imprint of his soul. . . . If a painter forces himself to work when he feels lazy his productions will be weak and spiritless, without decision." This moment of decision was crucial, for the painter's brush-strokes of ink on absorbent paper could not be erased or retouched. The urgency that would speed Monet to capture the visual image of a moment before the light changed, pressed on the Chinese painter too, but for quite other reasons. He had to capture the interior image and could not work in laborious stages.

In spite of, or perhaps because of, this celebrated interior quality, Chinese painting displayed a remarkable continuity over the centuries, in the never-ending pursuit of the Tao. Even as the brush techniques of individual painters changed, their subjects were selected from a conventional list and painted to a formula. The timelessness of Chinese painting, though on a briefer scale, is as striking as that of Egyptian sculpture.

Classic texts had codified the rules of Chinese painting. The most influential of these was the *Six Canons,* by the late-fifth-century artist Hsieh Ho (Southern Ch'i dynasty, 479–501), significantly entitled *Notes on the Classification of Old Paintings.* The *Six Canons* remained a guide for painters and their critics for a millennium and a half. Embodying the ancient Tao of

painting, the canons were designed to perpetuate the Way over the centuries and yet allow some stylistic variance. By prescribing for spontaneity Hsieh Ho embodied the paradox of Chinese painting and defied definitive translation into the jargon of Western art criticism. One translation, by Susan Bush and Hsio-yen Shih, captures Hsieh Ho's spirit:

> What are these Six Elements? First, Spirit Resonance which means vitality; second, Bone Method which is [a way of] using the brush; third, Correspondence to the Object which means the depicting of forms; fourth, Suitability to Type which has to do with the laying on of colors; fifth, Division and Planning, that is, placing and arrangement; and sixth, Transmission by Copying, that is to say the copying of models. . . . But, while works of art may be skillful or clumsy, aesthetics knows no ancient and modern.

The first canon seems to have become the most important because it required the painter to reveal the *ch'i,* the Breath of Heaven (or of Nature), in the work of his brush.

In the Sung dynasty, the arts of painting and of calligraphy flourished together. But their works were not much appreciated in the West and European travelers seldom brought back their paintings. The Sung emperor Hui Tsung (reigned 1100–26), notorious for being a better artist than an emperor, founded the first Chinese academy of painting on the model of the Confucian college. There he himself taught students, set subjects for competition, and judged the works. He built his unexcelled collection of sixty-four hundred paintings by 231 masters, many of them contemporary. One of his own paintings, his celebrated *Pigeon on a Peach Branch,* survives to show us his elegant and meticulous observation of nature. The emperor ended his life as an exile in the Manchurian wilderness. And the Mongol conquest ended the days of glory of Sung art, but not of Chinese painting.

The catalog of Emperor Hui Tsung's collection showed a range of Taoist and Buddhist subjects, portraits, dragons and fishes, landscapes, animals, flowers and birds, ink bamboo, and vegetables and fruits. The tie of paintings to calligraphy appeared in the "ink bamboo." The mere outline painting of bamboo was not considered a separate category, but the brushstrokes that painted growing bamboo were thus dignified. For life was to be read in a properly painted "ink bamboo." Each significant part was to be made with a single brushstroke. Some painters of the Yuan dynasty (1279–1368) made a career of painting bamboo. They traveled through China and Annam to see the various species in natural conditions, and studied the old masters of bamboo painting to serve as guides. In the mid-fourteenth century, pictures of bamboo blown by the wind became popular as emblems of resistance to the gale of the Mongol Conquest, and provided the subject for some of the best painters.

But even when the subjects are similar to those of Western paintings, their significance is different. The belief seemed to survive in China that there was only a limited number of appropriate subject matters and that these could be depicted in a certain number of techniques—always toward the Tao in painting. A beautiful statement of the Chinese emphases was the book published in Nanking in 1679, curiously entitled *The Mustard Seed Garden Manual of Painting,* after the home of its publishers. A collaborative work of three brothers based on an album of paintings that had been in their family for generations, it summed up traditions and became the standard handbook for painters. Though intended as a guide for beginners, it had wide influence, went through numerous editions, and attracted attention in the West by its beautifully colored woodcuts.

Just as the *Six Canons* had expressed the aspirations of Chinese painters a thousand years earlier, *The Mustard Seed Garden Manual* now summed up the technical and brushwork elements of Chinese painting in the intervening centuries. Reading it, the Western student of art finds himself in a strange land. To the inexpert Western eye, the Chinese painter seems less an original creator than a performer—like an inspired Western musician playing the composition of great artists before seasoned listeners. Though opening with the exhortation that "the end of all method is to seem to have no method," the manual proceeds to enumerate and specify. After Hsieh Ho's six canons, it goes on to list "the six essentials and the six qualities," followed by "the three faults" (all connected with the handling of the brush), and "the twelve things to avoid." The uses of the brush are then described, along with the methods for preparing ink and the colors. The sixteen different brushstrokes range from "brushstrokes like entangled hemp fibres" through those "like big ax cuts" or "small ax cuts," to those like "skull bones" or "like horses' teeth." Similarly there is a repertory of dots—from "dotting like small eddies" to "dotting in the form of a plum blossom." Then follows a Book for each of the nine kinds of subjects, beginning with Trees (the first essential for the landscape painter), through Rocks (all of which have three "faces"), to People and Things, Orchid, Bamboo, Plum, Chrysanthemum, Grasses, Insects and Flowering Plants, Feathers-and-Fur and Flowering Plants. The beginner is cautioned against the "banal," for "in painting, it is better to be inexperienced (young in *ch'i*) than stupid. It is better to be audacious than commonplace." And also "be careful to avoid the deadening effects of merely copying the methods of the ancients."

Plainly marking out the path of the Tao, *The Mustard Seed Garden Manual* guides the painter to the symbolism of all his figures. "When trees . . . grow among rocks, are washed by springs, or are clinging to steep cliffs, the roots of old trees are exposed. They are like hermits, the Immortals of

legends, whose purity shows in their appearance, lean and gnarled with age, bones and tendons protruding. Such trees are marvelous." "In estimating people, their quality of spirit (*ch'i*) is as basic as the way they are formed; and so it is with rocks, which are the framework of the heavens and of earth and also have *ch'i*. That is the reason rocks are sometimes spoken of as 'roots of the clouds.' Rocks without *ch'i* are dead rocks, as bones without the same vivifying spirit are dry bare bones. How could a cultivated person paint a lifeless rock? . . . rocks must be alive." And so too of flowers. "The chrysanthemum is a flower of proud disposition; its color is beautiful, its fragrance lingers. To paint it, one must hold in his heart a conception of the flower whole and complete. Only in this way can that mysterious essence be transmitted in a painting." "All the plants in the world rival one another in their beauty and give pleasure to the hearts and eyes of men. They offer great variety. Generally speaking the wood-stemmed plants may be described as having a noble elegance, the grasses a soft grace. Grasses please the heart and eye mightily."

The composition, too, expressed the order of nature, with a tension between giving and taking, passive and aggressive, host and guest. In a group of trees, the "host" tree will be bent with spread branches, and the guest tree slim and straight. If a third tree is added, it must not be exactly parallel. Such a group of trees can itself be a host in relation to another "guest" group in another part of the painting. "Mark well the way the branches dispose themselves, the *yin* and *yang* of them; those in front and those in the back, those on the left and those on the right; mark well the tensions created by some branches pushing forward while others seem to withdraw." The host-guest principle of tree to tree can be equally well applied to the relation of rock to rock, mountain to mountain, or man to man.

The inward emphasis of Chinese painting is expressed also in its peculiar form of perspective. While the West developed central perspective, the vanishing point of Brunelleschi and Alberti, the Chinese did not. Instead, the Chinese captured space in their painting by an invisible linear perspective that diminished objects in the distance, and by aerial perspective that made more distant objects increasingly indistinct. The Chinese developed and classified three personal points of view, all related to ways of viewing landscape: the "level distance" perspective, where the spectator looks down from a high vantage point; the "deep distance" perspective, where the spectator's vision seems to penetrate into the landscape; and the "high distance" perspective, where the spectator looks up. This helps explain why the Western observer feels strange when looking at a Chinese painting. And also why Chinese paintings seem to need no frame. For the painter's point of view has already provided a kind of frame. The Chinese painter wishes

to avoid what would pretend to be a complete or finite statement, like that implied in a vanishing point. "All landscapes," the eleventh-century critic Shen Kua declared, "have to be viewed from the angle of totality . . . to see more than one layer of the mountain at one time. . . . see the totality of its unending ranges."

The Chinese painter's subject matter, too, is quite different from the Western painter's. Western painters have exploited the sufferings of Christ on the Cross, the travail of Mary, the tortures of the martyr saints, and the scenes of battle. But Chinese painters, for the most part, stayed with their tradition of refreshing images of nature in familiar categories. To the Chinese painter of the Sung dynasty, Western painting might have seemed like the garish decorations of Buddhist temples done by skilled craftsmen. Landscape painting, which in Europe seemed less significant than figure painting, in China was not a mere background for historic events, ritual drama, or national sentiment. The role of explicit religious, historical, or mythological themes in the West was played by the landscape itself (its trees, rocks, rivers, mountains, and birds) in China. Tradition made the familiar theme universal, and engaged both painter and public. The fact that great and famous masters have handled the same theme in their own way, the poet-historian Laurence Binyon (1869–1943) explains, "tests [the painter's] originality far more severely . . . than if he had set out on a road of his own in the deliberate quest of originality." The artist is like a skilled performer giving his own expression to a long-respected work of music.

The Chinese kind of Impressionism was based not as in the West on the science of sight but in the soul of the painter. When the Chinese ranked works of art by class denoting their quality, and used terms translated as "divine class" or "marvelous class," they did not mean by "divine" what is meant in the West, since the Chinese did not acknowledge any supreme divinity. For them "genius" did not mean "touched by God" (as in the "divine Michelangelo") but rather an innate quality of spirit revealing superior individual capacities (what a man was endowed with by heaven or Nature), fulfilled by personal cultivation. What they meant by "individual achievement" was different from what we think of as "originality." Yet the Abstract Expressionists in the West, in the works of Mark Tobey, Morris Graves, and Franz Kline, seem to have learned from the calligraphic expressionism of the Chinese.

While the tie to calligraphy excluded the unlettered from the scholar-painter's craft, it invited gentlemen amateurs. An artist's bohemia was inconceivable. And Chinese painting was a realm of rich paradox as the painter seeking to forget the self found his very own way of reconciling past and present in a "revolutionary archaism." "The greater the aesthetic and technical achievement," F. W. Mote observes, "the more the creative indi-

vidual was thought to be in command of the past, or under command of the past—for they were the same thing." Chinese artists tended to follow the style of one of the great masters of an earlier period, and sometimes copied them stroke by stroke. "Forgery" acquired a new ambiguity. The Chinese artists' proverbial talent for copying leads reputable art dealers nowadays to be wary of offering "authentic" old Chinese paintings. Seeking constant touch with the past and the works of great masters by hanging pictures on the wall in rotation according to the seasons or festivals, the Chinese created a continuing demand that supported workshops for mass production by professional painters. These artists following the Tao showed remarkable skill in making both new originals and copies of copies.

While Western painters had set out on the bold and sometimes reckless passage from artisan to artist, the Chinese found originality in their many ways of revering nature and their past. Their paths led neither toward Leonardo's Sovereign of the Visible World where man had the power to re-create nature nor toward Picasso's effort to transcend nature. Rather to acquiesce and share the awe of Confucius, who declared himself the inheritor rather than the progenitor. "I transmit rather than create, I believe in and love the ancients."

The inspiration of nature and past masters gave a special kind of continuity, originality, and inwardness to painters in the Tao tradition. They brought together past and present, nature and art, poetry and painting, in a way beautifully illustrated in the work of the late master Shih T'ao (1641–c.1717). Suddenly moved to make a series of drawings transposing twelve poems that Su Shih (Su Tung-p'o, 1036–1101), six centuries before, had written about the different seasons of the year, Shih T'ao recalled (as translated by Chang Chung-yuan):

This album had been on my desk for about a year and never once did I touch it. One day, when a snow storm was blowing outside, I thought of Tung-p'o's poems describing twelve scenes and became so inspired that I took up my brush and started painting each of the scenes in the poems. At the top of each picture I copied the original poem. When I chant them the spirit that gave them life emerges spontaneously from my paintings.

PART NINE

COMPOSING
FOR THE
COMMUNITY

All art constantly aspires towards the condition of music.

—WALTER PATER (1873)

Music is another planet.

—ALPHONSE DAUDET (C. 1890)

A Protestant Music

IT is not surprising that Johann Sebastian Bach (1685–1750), the first colossus of music in an age that idolized the artist genius, insisted that the composer was essentially a craftsman. For centuries in Europe other crafts had been handed down in families, and often—like the Carpenters, Shoemakers, Smiths, and Wagners—they took their family name from their craft. Vividly aware that he descended from seven generations of musicians, he composed his own "Genealogy of the Musical Bachs," and saw himself as heir of a craft tradition. The idea was abroad in that Enlightened Age that right reason industriously applied would produce a harvest of science. Why not of the arts too? "Genius," observed the French biologist Buffon, "is nothing but a great aptitude for patience." Bach put it his own way. "I have had to work hard; anyone who works just as hard will get just as far."

There was, he believed, a right way for composing any piece of music, even for what was called a "free fantasy." When Bach heard the beginning of a fugue, his son Carl Philipp Emanuel (1714–1788) reported, he would state "what contrapuntal devices it would be possible to apply, and which of them the composer by rights ought to apply." The composer's satisfaction came, not from bold original plunges, but from producing what was properly expected.

By his own teaching Bach demonstrated his belief that composing could be taught. He was instructing his pupils in a spiritual craft, not just an instrumental technique. And to emphasize this he would not allow his pupils to compose at the instrument. He himself had the rules so clearly in mind that the manuscripts of his works were remarkably clean and uncorrected. If his pupils followed the rules for polyphony, he promised them, their compositions would be like "persons who conversed together as if in select company." He had no patience with the quixotic "knights of the keyboard" who went off on their own. And he offered guidance to his sons and other novice composers with his *Little Organ Book,* his *Well-Tempered Clavier* and his *Art of the Fugue.*

Bach's elaborations of contrapuntal technique seemed to justify the fears of "wordless" music expressed by Saint Augustine, Pope Gregory the Great, and others. They had rightly suspected that when music became wordless it could easily become an icon. A form of creation all its own, music would be the messenger of musical charms in place of Heavenly Truths. Audiences would then be moved not with "the thing sung," but

with "the singing." The fear of images that had almost prevailed against visual art in the Church long survived against the arts of music.

The rise of the arts of music in the West would be a dual story—of the liberation from fear of instruments and also of the elaboration of vocal music. From antiquity to the Middle Ages, we have seen, "music" had a career of narrowing meaning—from the Pythagorean music of the spheres to the Gregorian music of the word. But pious efforts to keep the creators of music on this strait track inevitably failed. The Roman Catholic Church itself found ways to admit the music of instruments, and the Protestant churches followed the lead, while adding popular new forms of music of the word. In modern times as music became an expanding realm of creation it became more and more secularized. Churchly music would be only a narrow current of the widening torrents of composition and performance.

Johann Sebastian Bach was qualified by his talents and by his personal strengths and weaknesses not only to celebrate the possibilities of churchly music, but also to induct church music into the concert hall, for Bach, as Albert Schweitzer explained in his classic study of 1908, was the very model of the "objective" artists who "are wholly of their own time, and work only with the forms and the ideas that their time proffers them . . . and feel no inner compulsion to open out to new paths." Contrary are the "subjective" artists, like Schweitzer's contemporary Richard Wagner, who are "a law unto themselves, they place themselves in opposition to their epoch and originate new forms for the expression of their ideas." While Bach was the last great composer to create mostly church music, he has also been acclaimed as the first great figure of modern music—a living bridge between the music of the word and the music of instruments.

In his time, Bach was admired more as an organist and expert on organs than as a composer. And it was the organ that overcame the taboo and brought instrumental music into the Christian churches. The organ was an ancient instrument, known in Hellenistic Alexandria (third century B.C.) and across the Roman Empire. Alexandrian technicians had devised a clever machine called the hydraulus that used a piston pump and wooden sliders to make a sound in the pipes. This complicated system was displaced about the eighth century by pneumatic bellows. In the age of Charlemagne, organ pipes of copper or bronze joined in acclamation of the emperor. By the ninth century the organ was known in churches, and monks in German monasteries were building organs. The grand Winchester Cathedral organ built about 950 is said to have had some four hundred pipes and twenty-six bellows, and required two players and many men to operate the bellows. The organ played an increasing part in the Mass, the canonical hours, and other rituals. But some clerics complained that the wheeze of bellows and

the clank of machinery made the organ at Canterbury sound "more like thunder than sweet music."

By the thirteenth century the cumbersome old sliding levers were displaced by a modern keyboard with mechanical linkages to direct the access of air. And the organ came into wider use. In "The Nun's Priest's Tale" Chaucer noted that "His vois was merrier than the mery organ. On massedayes that in the churches gon." Scruples against instrumental music were overwhelmed by the grandeur, volume, and playful refinements of the unique organ timbre that "penetrated beyond the church doors." The organ, too, was peculiarly suited to the architecture of churches. For the effect depended on live acoustics and reverberation, preferably with a line-of-sight path to the listeners. Organ music sounded best with masonry walls and floors that reflected the sound, and in large spaces that were high, long, and narrow.

The seventeenth and early eighteenth centuries, the age of Bach, was the golden age of the organ, and some of the best organs were being built in northern and central Germany. These baroque organs, ideally suited also for the polyphonic music of the time, have never been excelled. Reputedly the greatest organ builder of all time, Gottfried Silbermann (1683–1753) did his work in Dresden, a city Bach repeatedly visited, and on whose organs he played. The decline in the organ builder's craft in the nineteenth century marked the decline of the organ in European music.

Born in 1685 into a musical family in Eisenach in Thuringia, next door to Silbermann's Saxony, Johann Sebastian Bach naturally made his debut with the organ. The first musical Bach was a baker who probably came from Hungary. Legend has him taking his guitar to the flour mill to play while his corn was being ground, untroubled by the racket of the machinery, or perhaps keeping time to it. In Eisenach the family name became synonymous with their art. The town musicians continued to be known as "The Bachs" (die Baache) long after the last Bach had served them. The family was firmly Lutheran, and significantly, the last of the great musical Bachs, Johann Christian (1738–1782; "the English Bach"), was also the first to become a Roman Catholic. He converted to be eligible to be organist in the cathedral of Milan.

Johann Sebastian's father was a musician serving the town and the ducal court of Eisenach. His mother died and then his father, leaving him an orphan at the age of ten. By 1695 he was sent to live with his eldest brother, Johann Christoph (1671–1721), a pupil of the famous organist and composer Johann Pachelbel (1653–1706), organist at the village of Ordruff, who gave him his first lessons on the keyboard. When Bach became impatient with the slow pace of instruction, he secretly secured the text of more advanced clavier composers, which he copied at night. This brother secured Bach a

place in the choir of St. Michael's Church at Lüneburg, where he was kept on, even after his voice broke, because of his aptitude with several instruments. He was only eighteen when he was asked to test the new organ at the Neukirche in Arnstadt, and was then appointed church organist.

But his passion for the organ soon got him into trouble. In October 1705 he secured a month's leave of absence to walk the two hundred miles to Lübeck and hear the organ playing of his idol, Dietrich Buxtehude (1637–1707), then considered the most eminent organist in North Germany. Bach was so engrossed by what he heard that he stayed for three months, returning to Arnstadt in January 1706. Overstaying his leave added to the grievances of his Arnstadt employers, who were already irked by his free harmonizing of hymns that made it impossible for the congregation to sing to his organ accompaniment. He quarreled with the singers and the players of other instruments who did not come up to his standards. His offensive words to one of the choristers had led to a street fracas in which Bach had drawn his sword. He was also accused of having "made music" in the church with a "stranger maiden." At the time women were not allowed to sing in church.

A clash with the Arnstadt church council, whom he offended, and the congregation, who did not like his liturgical innovations, led him to move on to Mühlhausen in 1707. There he married his cousin, whose father also was an organist. She seems to have been the "stranger maiden" in the church in Arnstadt. During his brief stay at Mühlhausen, he began applying his keyboard skills. Even before he was twenty-three he had created his Toccata and Fugue in D Minor, his Prelude and Fugue in D Major, and his Passacaglia in C Minor, some of his most famous organ works. And he composed a cantata (*Gott ist mein König,* God is my King), his first work to be published. Within two years, however, after complaining of his salary and being entangled in theological disputes, he resigned his post.

Bach's move to Weimar in 1708 was more productive, but hardly trouble-free. As organist and court musician to the imperious Duke Wilhelm Ernst, he had wider duties. He continued to compose toccatas, fugues, and fantasias for the organ, especially enjoying the thirty-two-inch pedal of the Weimar organ and he was finally promoted to concertmaster in 1714. Now it was his duty to compose a new cantata each month. For in those days the church musician, like the court musician, was expected not merely to perform the music of others but to present music of his own, and Bach began composing some of his most brilliant vocal music, a vast body of Lutheran cantatas, of which some two hundred survive. Into his sacred vocal music he incorporated recitatives and arias in a quasi-operatic style— things he had heard in the works of Vivaldi and others—and gave a lesser role to the chorus.

Despite repeated raises in salary at Weimar, Bach remained disgruntled.

When he received an invitation to be director of music to Prince Leopold of Cöthen, the duke of Weimar's brother-in-law, the outraged duke jailed him for a month, then ordered his dismissal in disgrace. Yet, at Weimar, before the age of thirty-two, he had already created a body of music that would have brought immortality to a lesser composer. These included his *Little Organ Book,* seventeen of his eighteen "Great" chorale preludes, and most of his organ preludes and fugues.

Cöthen, where he was not required to compose church music but where his responsibilities were mainly for chamber and orchestral performances, provided Bach the incentive to compose more secular music, including sonatas for violin and clavier, the Brandenburg Concertos (completed at Cöthen but dedicated to the margrave of Brandenburg), his *Little Clavier Book,* his *Well-Tempered Clavier* (two books each of twenty-four preludes and fugues), cantatas for festive occasions, and various dance suites and concertos.

The sudden death of his wife in 1720 had added to Bach's troubles at Cöthen. But he married again happily in 1721. And he became a model family man—eventually the father of twenty children, half of whom died before they became adult. When the duke of Cöthen married a woman with no interest in music (Bach called her an *amusa*—enemy of muses), it only confirmed Bach's determination to move on once more. He applied for the post of organist at St. Jacob's Church in Hamburg, but could not make the donation that might have assured his appointment. Still, this would have been less onerous than the common requirement that a new organist marry into the former organist's family.

In 1723, having passed a test of his Lutheran orthodoxy, he became cantor and musical director of St. Thomas's Church in Leipzig, a cosmopolitan cultural center, where he would remain till his death in 1750. Besides running a choir school for boys, he had heavy obligations as composer, director, and performer. His varied duties included accompanying the choir at funerals, and providing music for four other churches. His response to these demands created the works that established him as a preeminent religious composer. In the first four years he composed some 150 cantatas for Sundays and the major festivals. But he disturbed the Sunday peace by thrashing the boys for their incompetent performance of difficult solo parts and offended church authorities by ill-tempered disputes over the curriculum. Still, his offerings at Leipzig included some of his masterpieces—the *Passion According to Saint John* (1723; written in Cöthen) and the *Passion According to Saint Matthew* (1729), which startled the congregation by its elaborate operatic character.

Unhappy with his working conditions and the incompetent choir at his disposal, in 1730 he complained to the authorities, who responded with a threat to reduce his salary. Again he began looking for a post elsewhere.

A sympathetic new rector at the school temporarily relieved his uneasiness, and his appointment as director of the city's *collegium musicum* put him in touch with mature musicians and wider audiences. Now he gave less attention to his cantatas and devoted himself to the keyboard pieces for his *Clavier-Übung* (four volumes, 1731–42), which included the Italian Concerto, organ pieces, and the Goldberg Variations. New quarrels with the authorities of his school and the collegium had to be settled in the law courts. Meanwhile Bach found other outlets for his talents, visiting Dresden and other cities for organ recitals. He continued revising and enlarging his keyboard works—with a second collection for *The Well-Tempered Clavier* (1742) and improvements on his earlier chorale preludes.

In the hope that he would be named court composer Bach put theological scruples aside and created his most famous work. The *Mass in B Minor,* sometimes called "the greatest piece of Western music ever composed," he made in the first instance for Augustus III, elector of Saxony, who was a Catholic. The Lutheran service had shortened the Catholic Mass, including only its first two divisions, the Kyrie and the Gloria: it was these that Bach sent to Augustus in 1733. But for some reason Bach was impelled to expand these sections into a complete Catholic Mass. Since it takes three hours to perform, it is not suited for the regular liturgy and nowadays is performed as a "concert Mass." Bach created it from his earlier compositions—a Sanctus of 1724, a Kyrie and Gloria of 1733, and other items—and it was completed about 1747. The five years he spent putting it together were longer than the time Michelangelo devoted to the ceiling of the Sistine Chapel. Bach may never have intended it to be offered at a single performance. It was certainly never performed in its entirety in Bach's lifetime. Nearly a century later his *Mass in B Minor* had a complete performance, and it has remained a pinnacle of modern religious music.

Bach's son Carl Philipp Emanuel was musician at the court of Frederick the Great in Potsdam. In 1747 Frederick invited Bach to his royal apartments at the hour when Frederick usually listened to chamber music. Frederick himself, a witness reported, went to the "forte piano" that stood there, and played "in person and without any preparation, a theme to be executed by Capellmeister Bach in a fugue. This was done so happily by the . . . Capellmeister that not only his Majesty was pleased to show his satisfaction thereat, but also all those present were seized with astonishment. Mr. Bach has found the subject propounded to him so exceedingly beautiful that he intends to set it down on paper in a regular fugue and have it engraved on copper." This became Bach's *Musical Offering* (1747)—his personal gift to Frederick—in numerous pieces collected around Frederick's own theme. Bach's final work, left incomplete, was *The Art of the Fugue,* a comprehensive survey of the uses of counterpoint in his time.

. . .

While Bach reached out to secular forms, his remarkable work was both a fulfillment and a by-product of the limitations of churchly music. His inability to settle into a comfortable routine prevented his having a single conventional career for town or court or church. The Protestant reformers had been wary of the arts that flourished in the Roman Church.

Martin Luther (1483–1546) himself loved music, composed pieces that have survived, and sought to give music a larger role in congregational worship. But he was suspicious of the organ for its "papistical" past. John Calvin (1509–1564), more earnestly than Luther, hoping to root out traces of Catholic liturgy or music, forbade the use of instruments (including organs) even for recreation. English reformers in 1586 demanded the pulling down of churches "where the service of God is grievously abused by piping with organs, singing, ringing, and trowling of Psalms from one side of the church to another, with the squeaking of chanting choristers, disguised in white surplices." And Protestant enthusiasm in England led to the destruction of many of the best early organs. Organ builders made a living as carpenters, and the pipes of organs were pawned for pots of beer. Still, a few early organs did escape, including that of St. Paul's Cathedral. Cromwell, a music lover, was rumored to have removed the organ of Magdalen College, Oxford, to Hampton Court for his personal entertainment.

The place of the organ in Protestant worship enlisted the interest of Albert Schweitzer, the most fervent and learned of Bach's disciples, who worked to discover, preserve, and restore early organs. Schweitzer himself could have had a career as an organist, but chose to become a medical missionary. And when he went to Africa he took with him an organ zinc-lined for protection against the damp climate. He spent six years (1905–11) on his classic volumes on Bach, and edited Bach's organ music.

Luther had found good theological reasons to incorporate vocal music—music of the word—in the Reformed service. In 1546 he described the awesome wonders of contrapuntal polyphony:

When natural music is heightened and polished by art, there man first beholds and can with great wonder examine to a certain extent, (for it cannot be wholly seized or understood) the great and perfect wisdom of God in His marvellous work of music, in which this is most singular and astonishing, that one man sings a simple tune or tenor (as musicians call it), together with which three, four or five voices also sing, which as it were play and skip delightedly round this simple tune or tenor, and wonderfully grace and adorn the said tune with manifold devices and sounds, performing as it were a heavenly dance, so that those who at all understand it and are moved by it must be greatly amazed, and believe that there is nothing more extraordinary in the world than such a song adorned with many voices.

When the congregation sang they expressed the priesthood of all believers. The congregational hymns translated worship into the vernacular, from the Latin of Rome into the language of the marketplace. Luther had gone to school in Eisenach, and it was at nearby Wartburg that he had made his historic translation of the Bible into German (1521–22). Here too he was said to have written "Ein feste Burg is unser Gott," which Heine called the Marseillaise of the Reformation and on which Bach composed one of his grandest cantatas.

It is conceivable that the Iconoclasts might have won against music as they nearly had against images a millennium before. The Council of Trent (1545–63), doing the work of the Catholic Counter Reformation, might have inhibited church music by draconian measures, but finally went no further than to condemn everything "impure or lascivious" to preserve the House of God as the House of Prayer. According to a famous legend, the council was about to pass a rule against polyphony. But Giovanni Perluigi de Palestrina (1525?–1594), the leading composer in Rome at the time, composed a Mass for six voices to prove that polyphony was compatible with the reverent spirit and did not prevent an understanding of the sacred text. Palestrina's Mass was supposed to have defeated a rule against polyphony. But now instead it appears that the legendary Mass (finally published in 1567) was actually written on Pope Marcellus II's orders to Palestrina to create a decorous Mass in which the text could be understood for Holy Week.

The Council of Trent reflected the ongoing battle between the music of the word and the music of instruments. The main objection to polyphony had been its disregard for sacred words, and the council finally decreed that future church music must be more simply written so the words could be clearly understood. Palestrina's genius surely had much to do with preserving music in the Roman Church. Named after the small town near Rome where he was born, Palestrina spent his life in Rome as choirmaster and organist at various churches and finally at the Vatican. He supervised the revision of music in the liturgy following orders of the Council of Trent to purify the chants of their "barbarisms, obscurities, contrarieties, and superfluities" due to the "clumsiness or negligence or even wickedness of the composers, scribes, and printers."

Palestrina's prolific creations for the church included 102 Masses, 450 motets and liturgical compositions, and 56 spiritual madrigals. Still, he "blushed and grieved" that he had written some music for love poems. He brought into being a "Palestrinian style," a counterpoint of voice parts in continuous rhythm with a new melody for each phrase in the text. Probably the best-known composer of Western music before Bach, he was a landmark in the history of Western music as the first musician to become an identified

model for later composers. If he was not the Savior of Polyphony, he was the undisputed Prince of Roman Catholic Music.

While the Protestant Reformation was ambivalent about the organ and the music of instruments, it invigorated the music of the word. The "chorales," congregational hymns, became the main current of Protestant church music. As Luther explained in 1524, he never intended "that on account of the Gospel all the arts should be crushed out of existence, as some over-religious people pretend, but I would willingly see all the arts, especially music, in the service of Him who has given and created them." Under Italian influence, the motet, elaborated into the longer and more complex cantata, took on operatic qualities, combining the chorus, solo singers, and even instruments. To precede the sermons in words, these became Bach's "sermons in music." Some two hundred of Bach's creations in this form have survived. Most use a chorus, but some are for solo singers, with recitatives and arias.

In variety, too, Bach's brilliant music is unexcelled among modern composers. For instruments he made his own organ trios, in addition to some 170 chorale preludes for the organ, as well as music for the clavier (clavichord or harpsichord). His famous *Well-Tempered Clavier* consisted of two installments of twenty-four each, in each of the twelve major and minor keys. His numerous clavier suites adapted the French and Italian styles. His six delightful Brandenburg Concertos (1721) and the Goldberg Variations (1742) still charm audiences who do not attend church. All these were noted for their intricate contrapuntal technique in the styles of his time.

Bach's vocal music—music of the word—attained a grandeur that might have worried Luther, and has never been excelled in music for the Church. His secular cantatas, which he called dramma per musica, he sometimes adapted to sacred texts. His Passions—settings of the Gospel story in Oratorio form for Easter services—were dramatic triumphs. The *Passion* based on the Gospel according to Saint John (1724) included fourteen chorales, with added lyrics and some of Bach's own verses. The *Saint Matthew Passion* (1729) for double chorus, soloist, double orchestra, and two organs, is an overpowering Christian epic of twenty-four scenes recounting the last days of the Savior. It is narrated by the Evangelist, a tenor part in recitative. Choruses speak for the crowd with frightening realism. In addition, there are minor scenes with devotional chorales supposed to have been sung by the congregation. Although Bach never wrote an opera, there are few operatic feats not found in his Passions—and with a dramatic coherence seldom found in opera.

Bach the craftsman also did more than his bit to perpetuate his craft by didactic works. While his *Well-Tempered Clavier* exemplified the range of baroque keyboard compositions, it was intended to be an argument for the tempered scale of equal semitones as against the old "natural scale."

. . . .

"The more a man belongs to posterity, in other words to humanity in general," Schopenhauer wrote in his essay on "Fame" (1891), "the more of an alien is he to his contemporaries. . . . People are more likely to appreciate the man who serves the circumstances of his own brief hour, or the temper of the moment—belonging to it, and living and dying with it." By Schopenhauer's test Bach proves his appeal to humanity in general. For his preeminence among modern composers was attained only slowly. His works of "divine mathematics" demonstrated his mastery of the established contrapuntal technique of the preceding age. During the three decades while he was composing in great quantities, musical styles were changing. And by Bach's late years his early works in Weimar and Cöthen must have seemed old-fashioned. New composers were denouncing counterpoint and producing popular melodies, simplifying the complex structures that Bach had built. Even before his death his music was becoming unpopular. Moreover, he was composing his cantatas, his Passions, and his Mass in an age whose taste was becoming increasingly "enlightened" and secular. The music audiences for the next age would be in ducal and princely courts and then in public concert halls to paying audiences.

The rise of a "German" consciousness in the early nineteenth century would make it plausible for him to be idolized as a German genius (despite his Hungarian roots!). While he stretched Lutheran and Pietist dogma to the limit with his operatic style, the flamboyance of the Passions, and the *Mass in B Minor* for a Catholic prince, he still composed to the order of town council, church authorities, or petty prince, or to secure their favor. His *Art of the Fugue* had sold only thirty copies by 1756, and for some fifty years afterward no complete composition by Bach was separately published. The name of Bach was increasingly associated with his sons and pupils. Bach was admired with nostalgia. Mozart himself in Vienna in 1782 had taken part in Sunday noon concerts at the Baron van Swieten's house where they played Handel and Bach. He then wrote a prelude and fugue, and when he sent it to his sister (April 20, 1782) explained that he had come to compose it only after a prodding by his wife, Constanze. "Now, since she had heard me frequently improvise fugues, she asked me whether I had never written any down, and when I said 'No,' she gave me a proper scolding for not wanting to write the most intricate and beautiful kind of music, and she did not give up begging until I wrote her a fugue, and that is how it came about." When Mozart visited Leipzig in 1789, he heard Bach's double-chorus motet, "Sing unto the Lord a New Song," and was newly shocked into recognition. "What is this?" he exclaimed. "Now there is something one can learn from!"

Beethoven, too, became a Bach enthusiast. On first coming to Vienna, Beethoven's virtuoso performance of *The Well-Tempered Clavier* attracted

attention. He continually sought copies of Bach's works, and planned a
benefit concert for Bach's last surviving daughter. For him Bach was the
Father of Harmony, and "not *Bach* [brook], but *Meer* [sea] should be his
name." After Goethe had heard a friend play some of Bach's works on the
organ, he recalled, "it is as if the eternal harmony were conversing within
itself, as it may have done in the bosom of God just before the Creation of
the World."

Ironically the historic revival of Bach was a product of the same Enlight-
enment spirit that was making him seem the outmoded musician of another
age. The growing interest in the historical past expressed by Voltaire's *Age
of Louis XIV* (1751) and Winckelmann's *History of Ancient Art* (1764) also
awakened the widening community of music lovers. The rediscovery of
Bach's church music was the feat of the twenty-year-old Felix Mendelssohn
(1809–1847), a brilliant and precocious composer of Jewish descent. The
Saint Matthew Passion, first performed in 1729, was one of Bach's grandest,
most complex and difficult works. The young Mendelssohn enlisted ama-
teur and professional singers and players and the whole music-loving com-
munity of Berlin in a centennial performance. Though inexperienced at
conducting he managed the numerous rehearsals and the performance was
a spectacular success. The worshipers of Bach, Eduard Devrient, one of the
professional performers, noted, "must not forget that this new cult of Bach
dates from the 11th of March, 1829, and that it was Felix Mendelssohn who
gave new vitality to the greatest and most profound of composers." When
the performance produced some unpleasant jealousy in the Berlin musical
community, the young composer's father promptly sent him on his grand
tour. Then stirred by Mendelssohn's example the repeated performances of
the *Saint Matthew Passion* in other cities initiated the uncanny fame of Bach
in modern music. It also stimulated the massive program of the Bach-
Gesellschaft (sponsored by Robert Schumann and founded in 1850) to
publish Bach's complete works. Johannes Brahms (1833–1897) declared that
the two greatest events of his lifetime were the founding of the German
Empire and the completion of the Bach-Gesellschaft publications. In 1950,
two centuries after Bach's death, a new Bach Institute was founded in
Göttingen to provide a revised edition.

Bach fully merited his posthumous acclaim. Even while he embodied the
European religious spirit in music he sounded the way for the next centuries
from the church to the public concert hall. As Bach explained, the charac-
teristic techniques of his Baroque music served both God and the listening
audience.

The thorough bass [or continuo] is the most perfect foundation of music, being
played with both hands in such manner that the left hand plays the notes written

down while the right adds consonances and dissonances, in order to make a well-sounding harmony to the Glory of God and the permissible delectation of the spirit; and the aim and final reason, as of all music, so of the thorough bass should be none else but the Glory of God and the recreation of the mind. Where this is not observed, there will be no real music but only a devilish hubbub.

48

The Music of Instruments: From Court to Concert

THE arts of instrument-created music changed the relation of performer to audience. Western drama had been born in the separation of ancient Greek spectators from the participants, and the "orchestra," once a dancing place for community ritual, became a site where some danced while others looked on. So, too, modern music climaxing in the symphony would separate the audience from the music makers in a new way. Since Gregorian chants had been sung by the clergy only, Luther's emphasis on congregational music aimed to allow all to affirm their faith by the very act of singing. But the elaboration of musical instruments, increasingly specialized and requiring increasing skill, opened a widening gulf between performer and listener. Now the audience heard someone else's affirmation.

A product of this rise of instrumental music, a grand creation of Western music, was the symphony. The word "sonata" (from Latin *sonare,* to sound) as opposed to "cantata," a composition for voices (from Latin *cantare,* to sing), first comes into English about 1694, for a musical composition for instruments. The great creators of symphony had at hand a new musical form along with a newly elaborated array of instruments in an orchestra—in communities eager to support their work. All these elements came into being slowly after the Renaissance, the product of some people we know and of more who remain anonymous.

The "sonata" in the baroque period (1600–1750; the era of Monteverdi, Purcell, and J. S. Bach) came to denote a new type of instrumental work in the "abstract" style. This meant music without words, and referring to nothing outside itself. By the end of the seventeenth century the sonata had emerged and begun to be standardized in the works of the Italian violinist and composer Arcangelo Corelli (1653–1713). His two versions were classi-

fied not by their music form but by their social function. One was the *sonata da chiesa,* or church sonata (with a slow introduction, a loosely fugal allegro, a cantabile slow movement, and a melodic "binary" finale), the other was the *sonata da camera,* or chamber sonata mainly of dance tunes. A classical style was foreshadowed in the solo sonatas for keyboard instruments of Domenico Scarlatti (1685–1757) and Carl Phillip Emanuel Bach (1714–1788).

The term "symphony" and its variants were first used in the seventeenth century simply for the various forms of instrumental music. But it came to be used mainly for the Italian opera overture of three movements (fast, slow, fast). These overtures began to be played in concerts apart from their operas. Meanwhile the three-movement (or four-movement) symphony for orchestra became a form all its own for the classical symphony, quite separate from the overture, with a unique dignity. "Symphony" now came to mean a sonata for orchestra. It would have been impossible without the new wealth of musical instruments.

In Western Europe the practice began, about the fifteenth century, of building whole "families" of instruments. A typical family, like the shawms (double-reed woodwind instruments), would be made in instruments from the smallest to the largest size. The social role of music was revealed by the fact that instruments were differentiated mainly into *haut* (loud) and *bas* (soft). Loud instruments were for outdoor music and soft were for more intimate, usually indoor, occasions. The shawm came to be known as the *hautbois* (loud wood), which left its trace on the modern version of this same instrument, the oboe (a correct transcription of how the French word was pronounced in the eighteenth century).

A clue to the newly flourishing technology of musical instruments was the piano. "Pianoforte" (later abbreviated to "piano") first appears in English about 1767. An abbreviation of *piano e forte,* meaning "soft and strong," "pianoforte" named a new instrument that, unlike the harpsichord, could vary its tone. The harpsichord could only be plucked. But the sound of the piano was made by hammers operated from a keyboard and striking metal strings. The varying force of the hammer, controlled by dampers and pedals, made the gradations of tone. The first successful piano, about 1726, was the work of an Italian harpsichord maker, Bartolomeo Cristofori (1655–1731). Described at the time as a "harpsichord with soft and loud," it had all the essentials of modern piano action. Haydn's active life as a musician spanned the years from the piano's invention nearly to its modern form. He had decided tastes in pianos, preferring the Viennese to the English. Mozart, too, was interested in the mechanics of the piano, still developing in his lifetime, and he contributed to its improvement. He had a pedal constructed for his piano that he used when improvising and for the

basso continuo of his concerti. Beethoven believed the musical possibilities of the piano were still imperfectly understood and helped reveal them.

When cast iron replaced wooden frames to hold the strings, it increased their tension and the loudness of their music. The piano was designed in various shapes and sizes as the Industrial Revolution brought mass production. Within a century the piano in the living room became a symbol of middle-class gentility, and eligible young ladies needed their piano lessons. As the audiences of music lovers multiplied, the power and versatility of the piano enlisted the talents of the best composers.

But the piano was only one of a wide array of new instruments and of newly perfected ancient instruments that would make the modern symphony orchestra. The violin, originating in the medieval fiddle and developed during the Renaissance, was much improved by Antonio Stradivari (1644–1737), Giuseppe Guarneri (1698–1744), and others. The modern bow was invented by François Tourte (1747–1835), and the violin had its modern form by the early nineteenth century. Trumpets and horns were elaborated and made more versatile by added lengths of tubing; clarinets became respectable in the woodwind section by 1800. There was hardly an instrument of the modern orchestra, from the trombone to the harp, that did not acquire greater volume and subtlety in the late eighteenth and early nineteenth century.

As the elaborated sonata was matched by the elaborating instruments of all kinds, the modern large orchestra emerged—a collection of instruments equipped to play symphonies. Mid-eighteenth-century orchestras were commonly solo ensembles with one player in each part and little interdependence of the parts. The large orchestra for a public concert hall needed other music. Meanwhile chamber music, in the form developed by Haydn, Mozart, and Beethoven, attained an intimacy and expressive range it lacked when it was merely synonymous with instrumental music. "Chamber music" acquired an elite and even arcane tone by contrast with the newly flourishing public music.

The "orchestra," a grand new instrument of instruments, was itself a creation of these "classical" Western composers and a by-product of their symphonies. Slowly after the Renaissance, with the rise of "wordless" music, there developed the arts of "orchestration," of using instruments for their special music properties. Until then music, not generally composed for particular instruments, would be played by whatever instruments were available. An organist of St. Mark's in Venice, Giovanni Gabrieli (1557–1612), may have been the first Western composer to designate particular instruments for the parts. The rise of opera in Italy about 1600, and the coming of the opera orchestra reinforcing dramatic effects, led to more

specific scoring and greater reliance on strings to balance winds and percussion. And the *Orfeo* of Claudio Monteverdi (1567–1643), performed in Mantua in 1607 with an orchestra of some forty instruments, is said to be the first occasion when a composer specified which instruments were to be used at which moments.

Not until the eighteenth century did the word "orchestra" cease to have only its ancient Greek meaning for the space in front of the stage where the community had once danced and where dramatic choruses danced and sang. Now it meant a company of musicians performing concerted instrumental music. And now Byron condescended to "the pert shopkeeper, whose throbbing ear aches with orchestras which he pays to hear." "To orchestrate" would not enter our language until the late nineteenth century.

The modern symphony orchestra arose out of the Italian opera orchestra and English and French court orchestras, which at first had only strings, but gradually added woodwinds and other instruments. By the mid-eighteenth century the basic modern symphony orchestra had its four sections—woodwinds, brass, percussion, and strings. Surprisingly, these features of the modern symphony orchestra took shape not in a great capital but in the phoenix-city of Mannheim on the right bank of the Rhine in southwestern Germany. Founded in 1606 on a checkerboard pattern of rectangular blocks, Mannheim was destroyed in 1622, during the Thirty Years' War, rebuilt and then again destroyed by the French in 1689. But the irrepressible community at the convenient confluence of the Rhine and the Neckar rose again. It became a cultural center for the electors palatine in the mid-eighteenth century. The elector Karl Theodor (ruled 1743–59; in Mannheim, 1743–78) had a personal passion for music that attracted some of the best performers and composers, creating an orchestra that became a prototype for the modern symphony. This Mannheim School, which flourished until the abrupt removal of the court to Munich in 1778, adapted the dramatic Italian overture to the new form of the concert symphony, and devised novel instrumental effects. Musicians across Europe came to recognize the "Mannheim sign" (a melodic appoggiatura) and the "Mannheim rocket" (a controlled orchestral crescendo making a swiftly ascending melodic figure).

Here the classical symphony acquired the form that would be elaborated by Haydn, Mozart, and Beethoven. And Mannheim announced the age of public concerts, when symphony orchestras would become symbols and catalysts of civic pride. As these orchestras multiplied in the next century the public appetite for music became more historical and more cosmopolitan. Now concerts not only offered works commissioned for the occasion or sacred or traditional music. They reached back to revive earlier works. The Concerts of Ancient Music held in London (1776–1848) pointed the way

to this "historicism," dramatized by Felix Mendelssohn's 1829 centennial performance of parts of Bach's *Saint Matthew Passion.* Mannheim was destined to be destroyed again in World War II, but again showed its capacity to be reborn. Did the city's shallow past help explain its openness to new ways in music?

The founder of the improbable Mannheim School of symphonists was the vigorous Johann Stamitz (1717–1757), whose leadership made it famous across Europe. His orchestra, large for its day, included twenty violins, four each of violas, violoncellos, and double basses, two each of flutes, oboes, and bassoons, four horns, one trumpet, and two kettledrums. The musical traveler-historian Charles Burney (1726–1814) was so impressed that he called this orchestra "an army of generals." Stamitz achieved new melodramatic effects with the full range of these instruments for crescendo, diminuendo, sforzando, tremolo, and virtuoso violin performances, expanding from the whispery pianissimo to the explosive fortissimo. He added a contrasting second theme to the sonata's allegro movements, and increased movements from three to four by adding a fast finale after the minuet. While these four movements would become standard for the symphonies of Haydn and Mozart, Beethoven would replace the minuet with a scherzo.

The symphony orchestra, increasing in size and cost, needed patrons. It required new complex musical compositions, along with organization, leadership, and a responsive audience. In Beethoven's lifetime a new creative role was beginning to be revealed for the conductor. The arts of drama and architecture also required leadership, organization, and community participation. But the writer, painter, or sculptor could create for himself, needed no other performer and no stage but paper, canvas, or stone. Music shared with painting, sculpture, and architecture the peculiarity that it too could be a "background" or ambient art. The classification of instruments as "loud" (for outdoors) or "soft" (for indoors) revealed this role. Music transformed the atmosphere as other things were happening. While the book required a focused reader, music allowed variant degrees of inattention. This ambient nature of music, which made it useful for worship, ritual, festival, nuptials, and coronations also explained its long subordination to the needs of church and court. And this wonderfully protean character explains Walter Pater's observation that "all art constantly aspires towards the condition of music."

Just as the Gregorian chant enlisted music for the church, the symphony and its orchestra signaled the emergence of instrumental music as an art in its own right, becoming dependent not on prince or church but on a public of music lovers. In this story Haydn, Mozart, and Beethoven played crucial roles in their creation of the modern symphony. Their lives overlapped, they

knew and influenced each other, but their careers and their products were spectacularly distinctive. In their lives they dramatized the changing resources and opportunities for Western music.

Joseph Haydn (1732–1809), often called the father of the symphony, found his opportunity and his challenge in a small but rich principality in western Hungary. His career showed how much could be done within the narrows of princely patronage, where he spent his thirty maturing years.

> My prince was always satisfied with my works. Not only did I have the encouragement of constant approval, but as conductor of an orchestra I could make experiments, observe what produced an effect and what weakened it, and was thus in a position to improve, to alter, make additions or omissions, and be as bold as I pleased. I was cut off from the world; there was no one to confuse or torment me, and I was forced to become original.

The story of Haydn's life is how he secured and used this playground for his music. Then how he finally reached out to the wider world.

Born in 1732 into the family of a wheelwright in an eastern Austrian village near the Hungarian border, he fortunately impressed the choirmaster of the Cathedral of St. Stephen in Vienna, who toured the countryside to find choristers. The beauty of the eight-year-old Haydn's voice and his remarkable ability to trill his notes brought him the reward of a pocketful of cherries, which he never forgot, and an invitation to the choir school of St. Stephen. There he acquired a wide musical experience but no education in musical theory. When his voice changed, he was dropped from the school and at seventeen had to shift for himself in the big city. He took young pupils, and made music for dances and serenades while he taught himself musical theory in the works of C.P.E. Bach and others. Recommended by his aristocratic pupils, in 1758 he became music director in the chapel of a minor Bohemian nobleman, Count Morzin. When Morzin found he could not afford a sixteen-piece orchestra, it was lucky for young Haydn. His first symphony composed for Count Morzin had already charmed a grander patron, Prince Paul Anton Esterhazy.

Along with his title of prince of the Holy Roman Empire, Prince Paul Anton (1710–1762) inherited a family tradition of hospitality and patronage. His baroque castle at Eisenstadt, outside Vienna, offered two hundred rooms for the guests who provided the audience for his concerts, the visitors to his picture gallery, the readers for his library, and walking companions on the countryside of grottoes and artificial waterfalls. The prince himself played the violin and cello and admired the young Haydn, whom he engaged as assistant conductor of his large and active orchestra. The contract, dated May 1, 1761, obliged Haydn "to conduct himself in an exemplary

manner, abstaining from undue familiarity and from vulgarity in eating, drinking, and conversation," to preserve the harmony of the musicians, and "to instruct the female vocalists, in order that they may not forget in the country what they have been taught with much trouble and expense in Vienna." His musical duties required him to "appear daily in the antechamber before and after midday, and inquire whether His Highness is pleased to order a performance of the orchestra," to "compose such music as His Serene Highness may command . . . and not compose for any other person without the knowledge and permission of His Highness."

The prince's brother Nicholas "the Magnificent," who succeeded to the title and the family tradition of patronage in 1762, put competing princes in the shade. Returning from France, he decided to build his own Versailles. To prove his power over nature, he purposely chose an insect-infested swamp, which he had drained and cleared, as the site of his fantasy castle, which he called Esterhaza. Prince Nicholas's own illustrated book recalled its charms. Besides the usual country amenities of parks, grottoes, and waterfalls, there was a library of "seventy-five hundred books, all exquisite editions, to which novelties are being added daily," manuscripts, "old and new engravings by the best masters," a picture gallery "liberally supplied with first-class original paintings by famous Italian and Dutch masters," a marionette theater "built like a grotto," and a luxurious opera house that would hold four hundred people.

> Every day, at 6 PM, there is a performance of an Italian *opera seria* or *buffa* or of German comedy, always attended by the prince. Words cannot describe how both eye and ear are delighted here. When the music begins, its touching delicacy, the strength and force of the instruments penetrate the soul for the great composer, Herr Haydn himself, is conducting. But the audience is also overwhelmed by the admirable lighting and the deceptively perfect stage settings. At first we see the clouds on which the gods are seated sink slowly to earth. Then the gods rise upward and instantly vanish, and then again everything is transformed into a delightful garden, an enchanted wood, or, it may be, a glorious hall.

In 1776, when Esterhaza was completed and Haydn was named musical director, Prince Nicholas fully deserved his title as "the Magnificent."

Haydn helped make Esterhaza famous by attracting the best singers from Italy and musicians from all over for his celebrated orchestra (from sixteen to twenty-two players). "If I want to enjoy a good opera," said Empress Maria Theresa (1717–1780), "I go to Esterhaza." For one of her visits Haydn wrote a symphony (No. 48) and produced his opera, *Philemon and Baucis,* in the marionette theater. After a masked ball and sensational fireworks came a finale of a thousand colorfully costumed folk-dancing peasants.

Haydn's proudest present for the empress's table was three grouse that he had miraculously felled with one shot.

He was expected to plan similar celebrations at least once a year, and most of Haydn's operas were written for such occasions. The robust festivities sometimes included mock country fairs and performances by whole villages with their own bands and dancing troupes. Haydn's musicians, engaged for the season without their families, were exhausted by the frequent performances and endless rehearsals that stretched their stay deep into the autumn. "Papa" Haydn looked after them and tried to persuade the prince to send musicians on furlough back to their families. Hoping the prince would get the message, he even wrote a "Farewell" symphony in which the sounds of one instrument after another ceased as each player put out his candle.

Haydn spent some thirty years—most of his adult life—in this gilded prison, not lacking performers or appreciative audiences for his compositions. His family life was unhappy. During his early days teaching music in Vienna he had fallen in love with a pupil, the daughter of a hairdresser, but she would not have him, and entered a convent. He then allowed her family to persuade him to marry her unattractive and quarrelsome elder sister. They had no children, and she did not "care a straw whether her husband [was] an artist or a cobbler." Which encouraged Haydn to compose a canon for the familiar poem by Lessing:

> If in the whole wide world
> But one mean wife there is,
> How sad that each of us
> Should think this one is his!

He sought relief hunting and fishing in the countryside he loved. No wonder it is impossible to make an edition of Haydn's works that includes all his ephemera. As his fame grew, calls for new compositions multiplied, even exceeding his fantastic powers of creation. His good-natured desire to satisfy admirers tempted him to sell the same work to several different persons or (as with his Paris symphonies) to publishers in different countries.

Liberation from Esterhaza, the widening of Haydn's vistas and his audience to match his growing fame, did not come from his own initiative. If Prince Nicholas the Magnificent had lived on, Haydn might have spent the rest of his life in Esterhaza. In September 1790 Haydn's patron of twenty-eight years died, succeeded by his son Prince Anton, who had no interest in music and dismissed all the musicians except Haydn himself and a few others to carry on the chapel services. With a pension, now feeling free to leave

Esterhaza, Haydn moved so hastily to Vienna that he left many of his belongings behind. Flattering invitations from the king of Naples and others came in. At last Haydn, nearly sixty, was being tempted out into the world. Luckily the winning invitation was from John Peter Salomon (1745–1815) a German-born violinist and concert organizer who had settled in London. He brought an attractive commission—an opera for the king's theater, six symphonies and twenty new smaller compositions—for fees of twelve hundred pounds. While the London orchestras then led Europe in instrumental music, Haydn still showed courage when he chose London over Naples. In place of the cloistered security of the court of the king of Naples, Haydn risked the fickle public. He was at home in Italian but knew not a word of English. And then to brave the horrendous Channel crossing, which, even a century later, led Brahms to refuse an honorary degree from Cambridge! "Oh, Papa," Mozart warned, "you have had no education for the wider world, and you speak so few languages." "But my language," Haydn replied, "is understood all over the world."

Arriving on New Year's Day, 1791, he found "this mighty and vast town of London, its various beauties and marvels," a cause of "the most profound astonishment." His reach to the world would enlarge his music, for his London symphonies showed a mastery of instruments, a melody and wit, that excelled his earlier output. English audiences responded with frenzied enthusiasm. He was lionized by royalty and awarded an honorary degree in Oxford. These eighteen months produced a new Haydn. On his way back to Vienna he stopped at Bonn, where he met the twenty-two-year-old Beethoven, whom he advised to move to Vienna for his instruction. In his letter to the elector in Bonn urging him to support Beethoven's stay in Vienna, he testified, from the work he had already heard, "that Beethoven will eventually reach the position of one of Europe's greatest composers, and I will be proud to call myself his teacher."

After less than a year in Vienna Haydn was tempted back to London and to another triumph. There he produced the last of his brilliant twelve "London" symphonies. The king and queen tried to persuade him to make his home in England. When his London apotheosis as the God of Musical Science did not persuade him to stay, the British were offended. Meanwhile Prince Nicholas II, who had succeeded to the House of Esterhazy, brought Haydn home to Vienna for a dream revival of the prince's family's orchestra.

Somehow Haydn was not quite ready to take his chances with the public. But the English experience had stimulated him to compose some eight hundred pages of music, and widened his hopes for himself. He had been moved by the oratorios at the Handel commemoration in Westminster Abbey in 1791 and, back in Vienna, tried his hand again at that form. The

product was two oratorios, both derived from English texts. Composing *The Creation,* with a libretto based on Milton's *Paradise Lost* and the Book of Genesis, he said, put him in closer touch than ever with his Creator, and it was a public success when performed in 1798. By 1801 he had completed another oratorio on the text of James Thomson's long poem *The Seasons.* In these works Haydn grandiosely celebrated the rural delights that he had enjoyed in thirty years around Esterhaza. To lift his countrymen's morale during their siege by Napoleon, he composed on the English model of "God Save the King" an Austrian national anthem, "Gott erhalte Franz den Kaiser," the melody of which was later adopted by the Germans for "Deutschland über Alles." Haydn used the theme for his "Emperor Quartet," and played the anthem on his piano three times when he felt death approaching.

Haydn's last years were filled with accolades. At the Vienna concert on his seventy-sixth birthday, Beethoven acknowledged his teacher by kneeling before him and kissing his hand. When Napoleon occupied Vienna he stationed a guard of honor before Haydn's house, and when Haydn died in 1809 the French army of occupation joined in honoring him. The numerous legacy of false attributions also attested to his fame. His authentic legacy was enormous—108 symphonies, 68 string quartets, 60 piano sonatas, 25 operas (of which 15 survive), and 4 oratorios.

In his symphonies Haydn gave form to what would be called the classical style, to be reshaped and fulfilled by Mozart, Beethoven, and others. His triumph, the twelve "Salomon" symphonies that he wrote for London, showed a new range of orchestration, new uses for trumpets, timpani, clarinets, cellos, and woodwinds. Re-creating the sonata in its symphonic form, he was creating the orchestra into a new composite instrument.

The career of Haydn, the last fine fruit of the community of princely patronage, offered stark contrast to that of his successor in creating the classical style. Haydn did not attain fame and fortune until he was nearly forty. Mozart's talents were exploited and displayed across Europe when he was six. Haydn spent most of his life under comfortable patronage; Mozart never ceased searching for a patron. Yet they collaborated in shaping the symphony and its new orchestral resources into a classical style. Toward the end of his life, Haydn himself did test the new public world of concertgoers, but Mozart lived in that world. As admirers of each other they saw rising European communities of musical creators, amateurs, and concertgoers.

Leopold Mozart described his son, Wolfgang Amadeus, as the "miracle which God let be born in Salzburg." There was no better place than Salzburg, Austria, in which a musical prodigy could have been born in 1756. Nor

a more effective father for such a prodigy. Competent violinist and author of a famous treatise on violin playing, Leopold Mozart was expert enough to discern the genius of his son yet shrewd and self-effacing enough to spend himself cultivating his son's genius. His domineering nature would painfully inhibit Wolfgang's personality, but would nurture his talent and sense of mission. An active composer himself, Leopold ceased composing in deference to his precocious son. After Wolfgang's first public appearance at Salzburg University in 1762, his father began a ceaseless round of tours, showing off the boy and his talented but less precocious sister, Nannerl (five years his senior). A sensation at the imperial court in Vienna, they then visited towns in southern Germany, the Rhineland, Brussels, Paris, Munich, Holland, Berne, and Geneva. Three Italian tours touched the principal cities from Milan to Naples. Between the ages of six and fifteen Wolfgang was on tour more than half the time, impressing audiences by virtuoso performances on the keyboard instruments, on the organ, and the violin, playing on sight, and improvising variations, fugues, and fantasias. Most astonishing was Wolfgang's ability to write music, at an age when others had only begun to read it. At six he had composed minuets, before his ninth birthday his first symphony, at eleven his first oratorio, and at twelve his first opera. These contributed to the more than six hundred compositions eventually cataloged in 1862 and numbered by an Austrian scholar Ludwig von Köchel (1800–1877), who christened each with a "K" number.

While Wolfgang was a sight to be seen and a talent to be heard, the boy himself saw and heard a great deal that enriched his own work. His tours introduced him to the range of music composed and heard across Europe, when there were distinctive Italian and German styles. Bach had never visited Italy, nor had Haydn who spent most of his life in an Austrian village. Mozart would be able to combine the lightness of Italian vocal music and opera buffa and the seriousness of German instrumental music, sonata and symphony. No other composer so succeeded in marrying Italian homophony with German polyphony to make a European music.

It is not easy to separate the public astonishment at the child from admiration for his music. At Schönbrunn, where the imperial family played musical instruments, they delighted in the little boy who kissed the empress and jumped in her lap asking, "Do you really love me?" Goethe, then fourteen, remembered hearing music from the "little man, with powdered wig and sword." At Louis XV's Versailles only Madame de Pompadour was not impressed. "The Empress kisses me," Wolfgang announced. "Who is this that does not want to kiss me?" In England George III satisfied himself by setting the boy difficult tests on the keyboard, and Queen Charlotte's music master, J. C. Bach, engaged him in musical games. The London

concerts were a box-office success, and the Royal Society received for its Philosophical Transactions the "Account of a very remarkable young Musician" with documentary proof of Wolfgang's age, and anecdotes of how he would "sometimes run about the room with a stick between his legs by way of horse."

After the tours, commissions came in—music for the marriage of Archduke Ferdinand in Milan, and for the enthronement of Hieronymus Colloredo as archbishop of Salzburg. But this new archbishop was less tolerant of his concertmaster Leopold's absences to tour with his son. In Salzburg in a few months in 1772, the sixteen-year-old Mozart composed eight symphonies, four divertimentos, and some sacred works. He was appointed an honorary concertmaster, but the archbishop made unreasonable demands. In Salzburg from 1774 to 1781 Wolfgang ceaselessly composed while both Mozarts sought refuge anywhere else from the tyrannical archbishop. Wolfgang still was not allowed to tour alone and Leopold assigned Frau Mozart to accompany him to Mannheim and Paris. En route Wolfgang fell in love with Aloysia Weber, a sixteen-year-old soprano, but his father forbade marriage. Frau Mozart died in Paris, and Wolfgang returned gloomily to Salzburg. When Aloysia refused to marry Wolfgang, he pursued her younger sister, Constanze. "She is not ugly," he observed, "but at the same time far from beautiful. Her whole beauty consists in two small black eyes, and a handsome figure. She has no wit, but enough sound sense to be able to fulfil her duties as a wife and mother." The successful premiere of *Die Entführung aus dem Serail* on July 12, 1782, in Vienna encouraged Mozart to believe he could afford a wife and he outraged his father by marrying Constanze three weeks later.

Despite his growing fame and multiplying commissions, Mozart never became rich. He remained improvident and extravagant, lived hand-to-mouth, and never in relaxed comfort. In 1781, when Mozart quit the service of the archbishop who had made him eat with the servants, his resignation was confirmed "with a kick on my arse . . . by order of our worthy Prince Archbishop." That year, too, he met Haydn. During the next four years Mozart composed the six quartets that he dedicated to Haydn. We do not know how intimately they knew each other, but Mozart freely admitted his debt to his "most dear friend," from whom "I first learned how to compose a quartet." After meeting Haydn and receiving his accolades, Mozart was stimulated to produce some symphonic novelties all his own, such as the "Haffner Symphony," without a patron. During these years he also developed and perfected the classical concerto for piano and orchestra.

Mozart's estrangement from the archbishop of Salzburg left him living on the income from his performances or sale of his music. This was risky, and no major composer since Handel had ventured it. Now he wrote

memorable concertos (most of those from K. 413 to K. 595) for his own performances in Vienna. At long last, and after a strenuous pursuit, in 1787 Emperor Joseph II engaged Mozart as chamber composer. But while his predecessor Gluck had received twelve hundred gulden annually, Mozart received only eight hundred. In these last years, being otherwise occupied, Mozart composed few symphonies, but the three he produced in the summer of 1788—the symphonies in E Flat (K. 543), G Minor (K. 550) and C (the "Jupiter," K. 551)—were unexcelled in symphonic brilliance and in new uses of the orchestra.

In Vienna finally, from age thirty to thirty-six, Mozart produced some of his most durable music on the flightiest themes and showed his ability to respond to passing tastes. *Le Nozze di Figaro* (1786), *Don Giovanni* (1787), and *Così fan tutte* (1790) were based on comic librettos by Lorenzo da Ponte (1749–1838), a man of many talents. Da Ponte had taken the name of the bishop who converted him from Judaism to Catholicism. He was said to have consulted Casanova himself for an authentic Don Giovanni. He eventually came to America, became professor of Italian in Columbia College in New York City, and the leading exponent of Dante and Italian opera here. In 1791 Mozart adopted a plot supplied by an old Salzburg acquaintance for *Die Zauberflöte*.

In July 1791 a stranger came to Mozart and commissioned a requiem. The fee was large, and the only condition was that the transaction never be revealed. The ailing and hypochondriac Mozart wondered whether this request was an omen of his own funeral. The requiem remained unfinished at Mozart's death on December 5, 1791. Constanze gave the manuscript to be completed by Mozart's friend Franz Xaver Süssmayr, who delivered it to the stranger as a finished work by Mozart. The stranger, the perverse Count Franz von Walsegg-Stuppach, then had it performed as a work of his own, which made it a "double forgery." Eventually Constanze allowed it to be published under Mozart's name. And the ghostwritten *Requiem* was performed at the memorial service for Beethoven on April 3, 1827, a week after his death.

Mozart had for some time had the notion that he was being poisoned by his relentless rival Antonio Salieri. But this proved quite groundless, and Salieri himself took the trouble on his deathbed to make an official denial. Mozart seems to have died of several recurring ailments, aggravated by overwork and malnutrition. "I have finished before I could enjoy my talent," Mozart declared at thirty-six. According to Viennese custom, he was buried unceremoniously in a mass grave in a churchyard outside the city.

New Worlds for the Orchestra

TESTED and demonstrated in obscure Mannheim, the music of instruments would be re-created by Beethoven. When it became more than an ambient art, background for festivities and ceremonies of church and court, it was the focused delight of music-loving audiences who paid to listen. Haydn and Mozart had shaped a classical style for the orchestra to be heard by a specialized concert audience, attuned to a newly developing art and its new instruments. Beethoven (1770–1827) would discover a new range and create his own world of the orchestra and its symphonies. And, incidentally, with his own proper instrument, the piano, he created a new sonata world. As the art of music became something for itself, it became more professional, more complex, and less accessible to the public. But Beethoven, who inherited the forms of classical music from Haydn and Mozart, elaborated them in his own way for wider audiences.

More than an elaborator of musical forms, Beethoven opened the gates. Nothing could have been more ironic than Beethoven's role as prophet and exemplar of a new European community of music, for there had never been a composer more isolated from his audience—by the deafness that prevented his hearing (except in his mind's ear) what the audience would hear and by an irascible temperament that aroused enemies and tested friends.

Yet there never was a time when a translingual art was more needed in Europe, for the languages of the marketplace had marked the boundaries of the nations that emerged from the parts of the Roman Empire. In the long run, Dante, Boccaccio, Chaucer, Rabelais, Cervantes, Shakespeare, Milton, and Goethe would be messengers of the human comedy and create a legacy of Western literature. But in their time they were eloquent of national personalities, of the differences among peoples. The classical age of Western music—the age of Haydn, Mozart, and Beethoven—was a time of spreading literacy. No longer confined to church and monastery, to noble courts or universities or prosperous merchant households, readers were beginning to be everywhere, even among women and the laboring classes.

In the next decades the widely read books of Balzac and Dickens would remind Frenchmen and Englishmen of their special virtues and vices, and national literatures would create needs for the translingual arts.

The lifetime of Beethoven, the era of the American Revolution and the French Revolution, saw the rise of popular government. As literature became public, as authorship became a paying profession, as poets, novelists, historians, biographers, essayists, and artists reminded Europeans of their peculiar hopes and idiosyncrasies, people were alerted to their right to govern themselves. Another art was needed to affirm their community. Haydn and Mozart opened a European concert world where language was no barrier—Haydn in his London triumph, Mozart with his international travels as a prodigy. But the grand gesture of public music, which transcended the community of music lovers, was to be the work of Beethoven.

Beethoven's conspicuous and enduring triumphs were with the orchestra and the symphony, in the new world of instruments. Yet, as Wagner observed, Beethoven would embody the singing voice in the myriad-instrument orchestra. His homophonic instrumental style offered an unmistakable dominant melody accompanied and reinforced by subsidiary voices, a top melody with chords beneath. Beethoven used the entire orchestra of strings and woodwinds to state his theme. This style already appeared in his First Symphony (1800), and was demonstrated in the familiar opening theme of the Fifth Symphony (1807) and the adagio movement of the Ninth Symphony (1823). The unforgettable simple element in each of these complex structures reached all who were puzzled by the contrapuntal elegancies of other master composers.

He reached beyond the concert hall, too, when he wrote music on themes outside the world of music. During the Middle Ages and the Renaissance the music of instruments, in contrast to the music of words, did not aim to depict nonmusical subjects. Since the music of instruments was a merely ambient art, providing atmosphere for ritual or ceremony, it lacked the dignity of a fine art that produced a work beautiful in itself. "Program," or "illustrative," music developed in Europe about 1700, when instrumental music, borrowing the techniques of vocal music, was becoming a distinct respectable art. "Program" music could dignify the music of instruments. A program would guide the unprofessional audience, reassuring the listener that what he heard was not "mere" music but something significant in experience. The orchestra had powers—beyond words or even visual images—to express, to depict, and to narrate. So program music became vehicle and messenger to the whole community, not just to lovers of sonatas and concertos, not just to concertgoers, but to all who enjoyed nature, who loved, who felt joy or sorrow, lamented defeat, or rejoiced in victory. Program music was newly public.

In this, too, Beethoven was a prophet and pioneer. Not until 1881 did the

expression "program music" enter our English language for "music intended to convey the impression of a definite series of objects, scenes, or events; descriptive music." At the same time a "program" came to mean a printed list describing the music in a concert. Then "absolute music" came into use for the opposite of program music and meant "self-dependent instrumental music without literary or other extraneous suggestions." And some avant-garde music lovers (such as G. B. Shaw, who called it "abstract" music) gave this name to the oldest form of instrumental music. Beethoven would be pathmarker of the program music that dominated the West in the nineteenth century, the era of Romantic music. In place of *Musiker* (musician) Beethoven preferred to be known as *Tondichter* (tone poet). He sometimes protested against reading events into his symphonies, but he was not unwilling to help the public "understand" his music.

The prototype of program music was Beethoven's Sixth Symphony, in F Major (the "Pastoral," published in 1809 as *Sinfonie pastorale*). He described it in the advertisement for its first concert (December 22, 1808) as "A recollection of Country Life." For each of the five movements he provided an explanatory inscription:

(1) Awakening of Cheerful Feelings on Arrival in the Country
(2) Scene by the Brook
(3) Merrymaking of the Country Folk
(4) Storm
(5) Song of the Shepherds, Joy and Gratitude after the Storm

This "program" came verbatim from a work by a little-known German writer entitled *Musical Portrait of Nature*. Beethoven's familiar characterization of a violin part used in the first performance revealed his intention that his music should refer to something other than itself—"More expression of feeling than painting" (*Mehr Ausdruck der Empfindung als Malerei*). In this symphony his contemporaries heard a plain expression of Beethoven's own feelings for nature, which seem to have been accentuated by his increasing deafness. In summer it was said that he stripped down to his underpants for long morning and evening walks in the woods. "Nature was like food to him," the British pianist Charles Neate noted, "he seemed really to live in it."

In the music of his oratorio *Israel in Egypt* (1739), Handel had depicted the plagues, and the works of others had imitated birdsong, waterfalls, and battle sounds. Beethoven unified the stages of feeling into a coherent music drama. And program music would flourish with the Romantic movement in the nineteenth century, in the works of Weber (1786–1826), Berlioz (1803–1869), and Liszt (1811–1886). Later the music of Richard Strauss (1864–1949), in which the program threatened to drown out the music, helped account for the disrepute of "descriptive" music, and the turn to new forms of

absolute "anti-Romantic" music. Later still, totalitarian governments made program music a way of enslaving artists to politics.

Beethoven was the first of the great musicians to be a public man, an advocate through his music on the issues of his time. Bonn, where he was born and raised, was a center of sympathy for the French Revolution. As Napoleonic armies surged across Europe and twice occupied the Austrian capital of Vienna, Beethoven found it difficult to avoid public commitment. Unlike Haydn or Mozart, he was not satisfied to be a mere ornament for church or court. There was no precedent for the public role of his "Eroica," his Third Symphony. In 1804, he had originally entitled the work "Bonaparte" in honor of the Napoleon (then first consul) who still seemed the "liberator" of Europe. But when Beethoven heard that Napoleon had made himself emperor, he was enraged, and in a scene witnessed by his friend Ferdinand Ries exclaimed, "Is he then, too, nothing more than an ordinary human being? Now he too will trample on all the rights of man and indulge only his ambition. He will exalt himself above all others, become a tyrant!" Beethoven tore off the title page, threw it on the floor, and rewrote it with the title "Eroica." When the work was published it bore the subtitle "To celebrate the memory of a great man." But Beethoven's political judgments oscillated with his personal fortunes and opportunities. Lionized by Talleyrand and Metternich, by the reigning czar, by kings and queens—the cementers of the old order at the Congress of Vienna in 1814—he composed especially for them, embracing the role of their prized entertainer.

Beethoven's background hardly suggests the revolutionary role he would play in Western music. Born in Bonn in northwestern Germany to a family of musicians, Beethoven was well set for a conventional career. His grandfather was musical director for the archbishop-elector of Cologne. His alcoholic father, noting young Beethoven's precocious talent at the piano, tried to make him into a Mozart-style prodigy. Returning drunk from the taverns late at night, he would rouse the sleeping Ludwig for lessons. He failed in these efforts, for Beethoven would be a slow developer.

Still, at twelve he was named a court organist and at thirteen continuo player to the Bonn opera. Through his mentor, the composer Christian Gottlob Neefe, he was introduced to Bach's *Well-Tempered Clavier,* and in 1783 had his first composition published at Mannheim. Some would later describe Beethoven as "the last flower on the Mannheim tree." He began the habit he never lost of reading widely in the classics, including Shakespeare. At fifteen, he was sent to Vienna to study with Mozart, who is supposed to have said that this young man would "make a great name for himself." After only two months his mother's death brought him back to Bonn, where he began to make his way, helped by influential aristocratic

friends. Frau von Bruening, widow of the chancellor, engaged him as music teacher for her children. When Count Ferdinand von Waldstein, a Viennese patron of music, visited Bonn in 1788 he was impressed by young Beethoven and commissioned him to write a piece for ballet. Waldstein offered this over his own name, and then secured a number of other commissions for Beethoven. In July 1792, when Haydn passed through Bonn on his way back from London, he admired a cantata score of Beethoven's composition, and invited the young man to be his pupil in Vienna. The timing was providential. Waldstein and Beethoven's teacher persuaded the elector of Bonn to support Beethoven's study in Vienna. And in November, Beethoven left Bonn, never to return. The forces of Napoleon were approaching the city. All his life Beethoven would be caught in the maelstrom of revolution and counterrevolution, in the age of Robespierre and Metternich.

But Beethoven was not cut out to be a disciple. In 1794 his lessons with Haydn in Vienna did not go well. While Haydn charged very little for his lessons, Beethoven felt he was getting little. Beethoven began taking other lessons in secret, for his teacher was preoccupied and not demanding enough of him. Preparing for his second London visit, Haydn had actually invited Beethoven to join him. Then, on Haydn's departure alone for London, the lessons ended. The two temperaments were plainly incompatible. When Haydn asked Beethoven to put "Pupil of Josef Haydn," on his early publications Beethoven refused. He did dedicate to Haydn his first three piano sonatas, but ungraciously insisted that he had "never learned anything" from him.

In convivial Vienna, Beethoven quickly became a social success, which was not irrelevant to his musical career. On arrival he was grateful for a garret room in Prince Lichnowsky's house, but within a year he had elegant quarters. His musical talents were developing in these next seven years, which were relatively carefree, for he did not yet feel the threat of deafness. He took lessons on three instruments, studied counterpoint, and began filling his notebooks. Often compared with Leonardo's, these notebooks reveal efforts to elaborate a major work from simple elements continually worked over. In Vienna Beethoven enjoyed applause as a virtuoso pianist and improviser, and toured Germany and Hungary. A rival pianist complained, "Ah, he's no man—he's a devil. He will play me and all of us to death."

Unlike the private preserve of the Esterhazy family where Haydn had spent most of his life, Vienna offered a more public audience. The city was a refuge for the rich, vastly more cosmopolitan than any country estate, but not yet threatened by the spreading fever of revolution. Noble families of wealth originating in Italy, France, Russia, or Hungary had established households there. And, after dining and dancing, music became their main

urban entertainment. Rival families supported groups of musicians, quartets, and chamber orchestras. Playing a musical instrument and patronizing musicians was as acceptable an aristocratic pastime as hunting or attending masked balls. Prince Karl Lichnowsky, Beethoven's friend and neighbor on fashionable Alserstrasse, was a pianist of high competence. The emperor himself played the violin. But the motley audiences who paid admission to urban concerts would hardly have been among Count Esterhazy's invited guests. Beethoven's first public appearance in a benefit concert for Mozart's widow spread his fame across the whole community. Pleased by his piano concertos, the audiences came back. On April 2, 1800, at the first public concert all his own, he offered the First (C Major) Symphony, which was still in the Mozartian mold.

The widening audience for orchestral music and for Beethoven's work was revealed in the three earliest performances of the "Eroica." First heard in August 1804 in the palace of Prince Lobkowitz, in a room only fifty-four feet long and twenty-four feet wide, it was played again that December in the home of a wealthy banker. Then in April 1805 it was performed in the Theater an der Wien to a large paying audience. Located just outside the city walls, this spacious playhouse was said to be the largest on the Continent. It was the scene of the premieres of Mozart's *Magic Flute* and Beethoven's own *Fidelio*. Court officials noted that the occasion showed how music was appealing to not only the "higher and middle orders" but "even the lower orders."

About 1798, at the maturing of his powers as a composer, Beethoven, not yet thirty, began to be troubled by the ringing in his ears, the first hints of the affliction that would dominate his life. Perhaps originating in an attack of typhus or another dangerous illness about 1798, the deafness became increasingly troublesome. On October 6, 1802, from a village near Vienna, he wrote his premature farewell in a letter to his two brothers. This came to be known as the Heiligenstadt Testament, for it was written in the village where he had hoped to enjoy the sounds as well as the sights of the countryside, but where he realized that his deafness would be incurable. After asking forgiveness for seeming "unfriendly, peevish, or even misanthropic," he recounted his six years' affliction "with an incurable complaint which has been made worse by incompetent doctors." His deafness, he was now convinced, was permanent:

> Though endowed with a passionate and lively temperament and even fond of the distractions offered by society I was soon obliged to seclude myself and live in solitude. If at times I decided just to ignore my infirmity, alas! how cruelly was I then driven back by the intensified sad experience of my poor hearing. Yet I could not bring myself to say to people: "Speak up, shout, for I am deaf." Alas!

how could I possibly refer to the impairing of a sense which in me should be more perfectly developed than in other people, a sense which at one time I possessed in the greatest perfection, even to a degree of perfection such as assuredly few in my profession possess or ever possessed—Oh, I cannot do it; so forgive me, if you ever see me withdrawing from your company which I used to enjoy.

His postscript, four days later, had the plaintive ring of a suicide note: "yes that beloved hope—which I brought with me when I came here to be cured at least in a degree—I must wholly abandon, as the leaves of autumn fall and are withered so hope has been blighted . . . even the high courage—which often inspired me in the beautiful days of summer—has disappeared—O Providence—grant me at last but one day of pure *joy.* "

Some have explained the depth of Beethoven's agony by the possibility, now widely doubted, that his deafness was due to syphilis. His canonical biographer, Thayer, seems to have suppressed any such "incriminating" evidence. The first serious suggestion came from Sir George Grove in the first edition of his standard *Dictionary of Music and Musicians* (1878). Syphilis would also help explain Beethoven's strange combination of attitudes to women: his abhorrence of "immorality," which led him to force his brother Karl into a painful marriage for appearance's sake, his affairs with highborn women whom he could never marry, and (despite his professed belief that marriage was the solace he needed) his refusal to take a wife. Beethoven's frequent changes of doctors and his obsessive efforts to save his wayward nephew from sexual temptations are more understandable if he knew he had a venereal disease. Perhaps some peculiarities we assign to his deafness had other causes.

Yet, as Beethoven's deafness worsened, so his talents grew and his performance became more magnificent. Increasing deafness, which made it impossible for him to perform as a virtuoso pianist or a conductor, forced him back into himself. Perhaps this focused his talent to compose his great works. After about 1801, when his deafness had become serious, he had to find ways other than performing to support himself. Mozart seems to have resisted publication of his compositions, but Beethoven had no choice. For most of his productive life his earnings came from selling his original music, either for publication or for performance by others. Hard pressed, he was tempted to sell works still uncomposed or never to be composed, and to offer the same work as an original to several buyers. By 1817 he complained, "I am obliged to live entirely on the profits from my compositions." For posterity this has been lucky. Almost all of Beethoven's music appeared in print during his lifetime, and at his death few of his manuscripts were found to have been unpublished.

To nonmusicians, Beethoven's achievement despite his deafness seems

miraculous, but musicians assure us that a composer must be able to hear his music in the "mind's ear." Whatever the explanation or the difficulties, Beethoven the creator developed and his music deepened and broadened even as his deafness became complete.

Critics divide his work into three periods: "Imitation, externalization, and reflection." In his first period, from his move to Vienna until about 1802, he elaborated the classical tradition of Haydn and Mozart, and produced some of his most durable sonatas (including the "Pathétique"), the quartets of Opus 18, and his first two symphonies. His second period began to fulfill his distinctive talent—from the Third ("Eroica") through the Eighth symphonies, his own opera, *Fidelio,* and the "Leonore" overtures. In the full flood of his years of fame after 1815, he produced fewer works. All were the product of long labor and some had the greatest subtlety and grandeur—such as his last five piano sonatas, the *Missa Solemnis,* the Diabelli Variations, and the Ninth Symphony. At his death in 1827 he seems to have been planning a Tenth Symphony.

Nothing could have done more to give Beethoven a heroic stature than his deafness. As Beethoven himself explained, his infirmity forced him to isolate himself. We have bizarre documentary evidence of this isolation in his "conversation books." Surprisingly, Beethoven's deafness would provide us with the most intimate conversational record we have of anyone before the days of the tape recorder. Of no other artist's everyday "talk" do we have so copious, detailed, and random a report. To communicate with people he met—relatives, friends, publishers, visitors—as Beethoven became deaf he increasingly relied on the bound memorandum pads on which he invited a person to write questions or remarks. If a conversation book was not at hand he might use a slate, a loose sheet of paper, or rely on gestures.

At his death some four hundred of these books were inherited by his heir, Stephan von Bruening, who gave them to Anton Schindler, Beethoven's devoted servant, secretary, pupil, and companion for the last ten years of his life. Schindler used them for his copious adulatory biography, finally published in 1860. Having drawn on them for his own purposes, in 1846 Schindler sold them to the Royal Prussian Library in Berlin, recalling that Beethoven had wished them to be available to everybody. What he delivered to the library was not 400 conversation books but only 126. When the librarian asked for the missing 264, Schindler explained that he had destroyed some because they contained nothing significant, and others because they were politically embarrassing with "licentious assaults against persons in highest places." It is more likely that Schindler destroyed them to conceal damaging facts about his idol's private life or uncomplimentary remarks about himself. For obvious reasons, this strangely intimate record

covering mostly the last nine years of Beethoven's life is emphatically one-sided. Beethoven remained a vivacious talker and loved to have his say. In these conversation books we read mainly the words of his interlocutors or their answers to his questions. When he wrote in the books it was to put down a reminder, or when he feared being overheard or addressed another deaf person, or to record his frequent sense of outrage. But through them we can follow everyday conversations, the fees offered for composing, his concert arrangements, complaints of the price or quality of food or lodging, his reading tastes, the state of his opinions or his digestion, comments from his wayward nephew, menus from his housekeeper, and endless other trivia.

Visitors were appalled by Beethoven's personal disarray and slovenly household. He had hardly moved into one apartment before he vacated for another. His biographer, Thayer, could identify more than sixty residential addresses for him after 1800. When Carl Maria von Weber visited him in 1822 he noted music, money, and articles of clothing lying on the floor, wash piled on a dirty unmade bed, thick dust on the grand piano, and a chipped coffee set on the table. Rossini, whose *Barber of Seville* Beethoven much admired, was invited for a visit in 1822, as he reported to Wagner. "Oh! The visit was short. That is easily understood because one side of the conversation had to be carried on in writing. I expressed to him all my admiration for his genius, all my gratitude for having given me the opportunity to express it. He answered with a deep sigh and the single word: 'Oh! *un infelice.*'" The neglect of his person, John Russell noted about 1820, gave him "a somewhat wild appearance. His features are strong and prominent; his eye is full of rude energy; his hair, which neither comb nor scissors seem to have visited for years, overshadows his broad brow in a quantity and confusion to which only the snakes round a Gorgon's head offer a parallel."

At the height of his fame in Vienna after 1802, he managed to support himself without an official position. His bargains with music publishers were more favorable than those of Haydn or Mozart. Noble patrons supported him with honoraria and fees for dedications. Vienna had not treated him badly, but he was ingenious at finding causes for quarrel. After the benefit concert in 1808 where the Fifth and Sixth symphonies and his Fourth Piano Concerto were first played, he imagined a conspiracy led by Salieri, Mozart's archenemy. Outraged at the "intrigues and cabals and meannesses of all kinds," he threatened to leave Vienna. He would accept the invitation of Napoleon's brother, Jerome Bonaparte, installed as king of Westphalia, to be his music master. With this as a bargaining chip, he drew up a remarkable document, to be signed by three of his rich Vienna patrons— Archduke Rudolph, Prince Lobkowitz, and Prince Kinsky. It stated the conditions on which Beethoven would remain to enrich the musical life of Vienna and Austria, his "second fatherland." Since a composer had to be left free "for the invention of works of magnitude," Beethoven would be

given financial security now and for his old age. With an annual stipend from them of not less than four thousand florins "considering the present high cost of living," he would still be free to make tours "to add to his fame and to acquire additional income." They noted his desire to be named imperial musical director, and his salary would be adjusted if he received the appointment. He would conduct one charity concert every year or at least contribute a new composition for it. The three Viennese noble guarantors generously added that should Beethoven be prevented from musical work by sickness or old age, his stipend should still go on. On his side Beethoven agreed to continue to make Vienna or some other city in the Austrian monarchy his residence. This agreement, dated March 1, 1809, remained in force his whole life. But Beethoven had not put financial worries behind him.

Even these benefactions of his admirers became the seeds of dispute, for when Austria declared war in April 1809, the value of its currency sank to half. Then, in 1814, at the very time when Beethoven, lionized in Vienna by the visiting royalty of Europe, was prospering more than ever, he insisted that his stipend be adjusted upward for inflation. He won lawsuits against the heirs of Prince Kinsky and against Prince Lobkowitz, yet somehow preserved friendly relations with their families. But he would need more than their stipends. For he acquired new responsibilities at the death of his brother Karl. Hating his brother's widow, he fought a long legal battle for control over his weak and unhappy nephew. The young man attempted suicide, and was finally packed off to the army. When the city of Vienna gave Beethoven its freedom, he became tax-exempt, but his pension was reduced by the death of one of the benefactors, and his financial troubles still multiplied.

Beethoven never managed an affable continuing relationship with his intellectual or artistic equals. Goethe was eager to meet him, and Beethoven, who much admired his poetry, declared, "If there is any one who can make him understand music, I am the man!" Their much anticipated meeting was a disappointment, as Goethe wrote:

> I made the acquaintance of Beethoven in Teplitz. His talent amazed me; unfortunately he is an utterly untamed personality, who is not altogether in the wrong in holding the world to be detestable but surely does not make it any the more enjoyable either for himself or others by his attitude. He is easily excused, on the other hand, and much to be pitied, as his hearing is leaving him, which perhaps mars the musical part of his nature less than the social. He is of a laconic nature and will become doubly so because of this lack.

And Goethe was especially irritated by his arrogance.

Beethoven's erratic judgment of people led him to be fascinated by the

charming charlatan Johann Nepomuk Mälzel (1772–1838), who was famous for his "mechanical" Chess Player against which Napoleon played in Vienna in 1809, but which really had a man inside. He did invent the metronome, which made it possible to express musical tempo as a given number of beats to the minute. He also designed the ear trumpets used by Beethoven as hearing aids, and a "panharmonicon," which mechanically imitated instruments of the orchestra. It was for the panharmonicon that Beethoven composed his notorious "Wellington's Victory, or the Battle of Victoria" (the "Battle Symphony"), celebrating Wellington's victory over the French in 1813. Then Beethoven, again at Mälzel's urging, adapted it for orchestra. Ironically, its performance was a sensational success in Vienna in December 1813 along with the less celebrated first performance of the Seventh Symphony. Later performances of the two works continued to be applauded, and were profitable to Beethoven. Although the program had been advertised as a performance of "Mälzel's Mechanical Trumpeter with orchestral accompaniment," and "Wellington's Victory" had been conceived by Mälzel, Beethoven gave him none of the credit, nor any of the profits from its repeated success.

In his last Vienna years Beethoven never mellowed. He seemed driven to dubious business arrangements for some of his noblest works. The *Missa Solemnis* (Mass in D), which he wrote for the installation of his friend Archduke Rudolf as archbishop of Olmütz (completed in 1823, three years late), had been promised to six different publishers, and finally sold to still another.

In 1822 he had received a fee from the Philharmonic Symphony Society of London for composing the Ninth Symphony, which they hoped to be the first to hear. By the time the score for the Ninth Symphony was written out in February 1824 Beethoven felt peevishly at odds with the musical taste of Vienna. He thought music lovers had been seduced from serious German music by Rossini's trivial melodies and fluffy Italian opera. Fearing his symphony would not be well received in Vienna, he asked admirers in Berlin whether his new Mass in D and his Ninth Symphony might be given their performance there. When word of this leaked out in Vienna, thirty leading citizens and music patrons of Vienna addressed an open letter to him urging that he offer the premiere performance in Vienna. The grandiloquent memorial reminded him of his proper loyalties:

> . . . for though Beethoven's name and creations belong to all contemporaneous humanity and every country which opens a susceptible bosom to art, it is Austria which is best entitled to claim him as her own. . . . We know that a new flower glows in the garland of your glorious, still unequalled symphonies. . . . Do not longer disappoint the general expectations!. . . . Need we tell you with what regret

your retirement from public life has filled us? Need we assure you that at a time when all glances were hopefully turned towards you, all perceived with sorrow that *the one* man whom all of us are compelled to acknowledge as foremost among living men in his domain, looked on in silence as foreign art took possession of German soil, the seat of honor of a German muse, while German works gave pleasure only by echoing the favorite tunes of foreigners and, where the most excellent had lived and labored, a second childhood of taste threatens to follow the Golden Age of Art?

When this letter was published and gossips accused Beethoven of having instigated the letter, he was outraged. "Now that The Thing has taken this turn," he exploded in a conversation book, "I can no longer find joy in it." Still, flattered by the letter, Beethoven settled on Vienna for the premiere. The conversation books record his concern about every detail. The London Philharmonic Society, which had paid for what it thought would be a performance, would have to be satisfied by a manuscript.

At the first performance of the Ninth Symphony in Vienna on May 7, 1824, Beethoven, who had his back to the audience, did not notice the thundering applause until a friend tugged his sleeve and made him turn around to see it. The police had refused to allow Beethoven to charge what he thought an appropriate price of admission, and censors objected that anyway "church music" was not supposed to be played in a theater. Despite the tumultuous reception, Beethoven was dissatisfied and dismayed at the performance, and "collapsed" when he saw the accounts, which netted him only 420 florins. At the festive dinner afterward in an elegant restaurant, Beethoven accused Schindler of swindling him, and drove his guests away. Home in a rage, he went to bed with his clothes on. A second performance two weeks later was played to a half-full house, and at a loss.

Credited with many innovations, Beethoven became the prophet of the Romantic movement in Western music, and was so described by E.T.A. Hoffmann (1776–1822), the pioneer of German Romantic literature. "Beethoven's music," he wrote, "sets in motion the lever of fear, of awe, of horror, of suffering, and awakens just that infinite longing which is the essence of romanticism." With that longing, Beethoven, the hero-composer, created classical music for an audience far outside the concert hall. His concerns were as public as those of a statesman. The orchestra, the new instrument of instruments, had the power to transcend the world of words and so could liberate instrumental music from dependence on vocal style.

It was in "Beethoven's instrumental music" that Hoffmann heard the "infinite longing." Instrumental music itself was "the most romantic of the arts—one might say, the only purely romantic art—for its sole subject

is the infinite." The prolific German Romantic writer Ludwig Tieck (1773–1853) observed in 1820 that vocal music had been "only a qualified art," but instrumental music was "independent and free." "It prescribes its own laws, it improvises playfully and without set purpose, and yet attains and fulfills the highest; it simply follows its own dark impulse and in its dallying expresses what is deepest and most wonderful."

Beethoven would be adopted as the hero, the Holy Spirit of new worlds of instrumental music. Hector Berlioz (1803–1869), who saw Beethoven as his master, explained why, in the famous garden and cemetery scenes in his dramatic symphony *Romeo and Juliet* (1847), the lovers' dialogues are not sung but are given to the orchestra.

> . . . it is because the very sublimity of this love made its depiction so dangerous for the composer that he had to give his imagination a latitude that the positive sense of the sung words would not have allowed him, and he had to resort to instrumental language—a language more rich, more varied, less limited, and by its very unliteralness incomparably more powerful in such circumstances.

Wagner, too, would agree in 1850 that instrumental music offered "the sounds, syllables, words, and phrases of a language which could express the unheard, the unsaid, the unuttered." Again justifying the fears of early Christian philosophers, the very wordlessness of instrumental music made it a vehicle for the wildest extravagances of German antirational philosophers. For Arthur Schopenhauer (1788–1860), in his *World as Will and Idea* (1818), some of which he said had been dictated to him by the Holy Ghost, music became the main force against reason—"not an image of the appearance, or rather of the adequate objectification of the Will, but a direct image of the Will itself . . . the Thing-in-Itself of every phenomenon." Beethoven had created new forms of this transcendent experience. "If there had not been a Beethoven," Wagner insisted, "I could never have composed as I have."

Beethoven's great achievement was his invigoration of instrumental music and his discovery of new possibilities in the orchestra. But his "Choral Symphony" was a manifesto of new powers of musical creation still to come. While a choral symphony was not unprecedented, there was no such major work before his. He had originally planned an instrumental finale (on a theme he later used in a quartet), but instead seized the opportunity to unite the music of words and the music of instruments. So, too, he affirmed the new public role of music. The words he chose spoke to the great issues of his time, making explicit his concern for freedom and brotherhood. He chose the words of Schiller's "Ode to Joy" (*Freude*) published in 1785, which had originally been an "Ode to Freedom" (*Freiheit*) but was altered

for political reasons. This use of voices by the great master of instrumental music is still debated by critics, to some of whom the words of the "Ode to Joy" seem an anticlimax, a confinement of the "infinite longing" of which Beethoven's instrumental music was prophetic, and for which instruments set the composer free. Beethoven's return to the music of words and his bold marriage of words and instruments foreshadowed grand new forms marrying voice and orchestra to create new nations.

50

The Music of Risorgimento

THE story of the arts in the West had been a chronicle of separations. Vocal music had been a servant of the Church, with a message of faith and worship. Instrumental music developed structures of its own, of which the sonata and the symphony were the most fertile. The ancient Greek theater had united dance, music, and words into drama. But drama in Renaissance England, the art of Shakespeare, was an art of words. A modern art of opera would remarry music with drama and create something new from the union of voice and orchestra. Outside the Church, with its long-standing suspicion of the theater, opera would be a secular art. And it called for grand secular purposes which were slow in coming.

The first opera in the modern sense does not appear until about 1600, and the word enters English by mid-century as a shortened form of the Italian *opera in musica* ("work of music"). "In Italy," an English dictionary explained in 1656, "it signified a Tragedy, Tragi-Comedy, Comedy or Pastoral, which (being the studied work of a Poet) is not acted after the vulgar manner, but performed by Voyces in that way, which the Italians term *Recitative,* being likewise adorned with Scenes by Perspective, and extraordinary advantages by Musick."

Not only the word but the art of opera came from Italy, embroidering themes of classical mythology. The first opera of which the music has survived was performed in 1600 at the wedding of Henry IV of France and Marie de' Medici at the Pitti Palace in Florence. The opera, *Euridice,* from an Italian poem by Ottavio Rinuccini, set to music by Jacopo Peri and Giulio Caccini, recounted the classical myth of Orpheus and Eurydice.

Orpheus was allowed to rescue his beloved Eurydice from Hell on condition that he did not look back to her before he had taken her to the upper world. But Orpheus did look back and challenged poets to find ways to prevent the tragic result.

The theme attracted Claudio Monteverdi (1567–1643) for his first opera, *La Favola d'Orfeo* (The Fable of Orpheus, 1607), which is still performed. Monteverdi gave a new dramatic role to the instrumental music. If music was to "move the whole man," Monteverdi insisted it had to be joined with words. When *Orfeo* was performed in Mantua, it enlisted an orchestra of thirty-eight instruments and numerous choruses and recitatives (a vocal style carrying on the narrative) to make a lively drama. Later, as director of music at St. Mark's in Venice, Monteverdi spent thirty years producing books of madrigals and writing operas for Venice's growing musical audience. The first public opera house, the Teatro San Cassiano, opened in Venice in 1637. Along with the familiar less sophisticated entertainment, such as the *commedia dell'arte,* the opera flourished.

Within forty years Venice had ten opera houses. By the end of the century more than 350 operas had been produced in the new theaters in Venice, and an equal number by Venetian composers elsewhere. Four companies were performing in seasons that ran for thirty weeks of the year. Wealthy families had season boxes while inexpensive tickets brought in others. Foreign visitors came to Venice for the music. "This night," John Evelyn wrote in June 1645, ". . . we went to the Opera where comedies and other plays are represented in recitative music . . . with variety of scenes painted . . . and machines for flying in the aire . . . one of the most magnificent and expensive diversions the wit of man can invent."

The seventeenth and eighteenth centuries produced new opera styles. Alessandro Scarlatti (1660–1725) made Neopolitan opera famous with the *aria da capo* that gave a new dominance to music over the libretto. The brilliant librettos of Apostola Zeno (1668–1750), from Venice, exploited Greco-Roman themes. One of the most remarkable talents was "Pietro Metastasio" (Antonio D. B. Trapassi, 1698–1782), the son of a Roman grocer, who published his first drama at the age of fourteen. After becoming a court poet in Vienna in 1730, he produced librettos that composers found irresistible. Some of these were set to sixty different scores, and became more familiar than the music. Gluck, Handel, Haydn, and Mozart all used Metastasian librettos.

The German composer Christoph Willibald Gluck (1714–1787) aimed to liberate opera from the singers who demanded show-off arias. "I have striven to restrict music," Gluck wrote in 1769, "to its true office of serving poetry by means of expression and by following the situations of the story, without interrupting the action or stifling it with useless superfluity of

ornaments." In his own opera on the Orpheus theme he had shown the way toward simple convincing drama.

Still, the hybrid nature of opera exposed it to ridicule. But despite ridicule and the protests of impatient listeners the protean art flourished. Endless combinations of the music of words and the music of instruments, embellished with ballet and the decorative arts, carried the messages of myth, poetry, drama, and panorama. Opera became the profligate art as large casts and lavish settings made it the most expensive public entertainment. It was the only art that without embarrassment called itself "grand." Then in the nineteenth century "grand opera" came into English from France, where for works suitable for performance at the Paris Opéra it was distinguished from "opéra comique." It came to mean a serious epic or historical opera in four or five acts with chorus and ballet in which there was no spoken dialogue but all the musical numbers were connected by recitatives (sung dialogue). This kind of musical drama dominated the Paris Opéra in the first half of the nineteenth century. A rising and prospering middle class (Karl Marx's contemned "bourgeoisie") became patrons of this luxurious art. Seventy-six volumes of librettos by Eugène Scribe (1791–1861) and numerous compositions of Giacomo Meyerbeer (1791–1864) scored box-office successes again and again. Melodramatic plots and sudden emotional contrasts called for flamboyant music. Performances became longer and longer. Meyerbeer's *L'Africaine* lasted six hours. Plots became ever more complicated, choruses grew, and crowd scenes multiplied, with a new generation of scene designers. The heroic singer held center stage. Wagner contemptuously called this a style of "effects without causes."

In Western Europe it was an age of grandiose political hopes, volatile city mobs, and revolutions without number. In Scribe's first work for the Paris Opéra (*La Muette de Portici*, 1828), the heroine, a mute, becomes the victim of the populace she and her brother are trying to defend. When performed in Brussels on August 25, 1830, it sparked a climactic uprising in the movement to establish the Belgian state. It is no wonder that nervous princes kept their censors busy!

Mere political oratory seemed feeble against the power of the grand opera stage to inspire revolutionary ardor or patriotic awe. Now grand opera proclaimed the emerging modern nations. Two new nations, one of the North and the other of the South, each produced an opera composer laureate. Each consummated his own brilliant marriage of the arts—one Italian and Romantic, the other German and Teutonic. Born in the same year, each expressed his country's new reach for national identity. Giuseppe Verdi (1813–1901), immersed in the warm peasant tradition, remained rooted in Sant' Agata near his native Busseto in the duchy of Parma, where he finally

tried to live the life of a farmer and kept in touch with the rich peasant culture. Richard Wagner (1813–1883), born in Leipzig yet spending much of his life in exile from his native Germany, climaxed his lifework in a feat of artistic megalomania. One succeeded in drama of warm romance, the other in grandiose pageants of folkloric mystery.

The two men never met. While Verdi felt contempt for Wagner's grand theories and regretted their influence on Italian composers, he grudgingly had to admire Wagner's music. But Wagner had little more than contempt for Verdi's music, for "*I Vespri Siciliani* and other nights of carnage." Protean opera proved a perfect medium both for the burgeoning Italian national spirit and for Germanic megalomania. Distinctive musical traditions had long flourished in both Italy and Germany. Some historians have simplified the contrast as "the eternal antithesis between the playing North and the singing South." After the sixteenth century the opera houses of Venice and Naples heard a new florid vocal music. The eighteenth century brought from the orchestras of Mannheim and elsewhere a new wealth of instrumental music. Beethoven, as we have seen, had been reluctant to allow his Ninth Symphony to have its first performance in Vienna because he saw musical tastes there "corrupted" by the bel canto and opera buffa of the Italian Rossini (1792–1868). So opera helped new nations find themselves with ties to local history, lore, and tradition, while celebrating the national language.

Verdi was born, before there was an Italy, in Le Roncole, a village of the duchy of Parma. In this province of Napoleon's empire he had ample reason to feel deprived of nationality because a French clerk had arbitrarily christened him Joseph-Fortunin-François. Then during his youth a new invader made him an "Austrian." The only son of a village grocer and innkeeper, of peasant stock, Verdi never forgot his hard boyhood. His interest in music was first awakened by the sounds of the church organ. His father acquired an old spinet and had it repaired by a neighbor. Verdi, taught by the village organist, at the age of twelve played the organ well enough to succeed his teacher. His father sent him to neighboring Busseto to live with a cobbler while he went to school. Every Sunday he returned to Le Roncole to play the organ at Mass. Luckily in Busseto lived the merchant from whom Carlo Verdi bought his groceries and wine. This Antonio Barezzi, a music lover adept at wind instruments, was president of the Busseto Philharmonic Society. He took young Verdi into his house as apprentice in his business, and supported his musical education. Verdi, the industrious apprentice, played duets with his employer's daughter. Barezzi sent Verdi at the age of eighteen to Milan to enter the conservatory of music. Unfortunately the normal age for admission was nine to fourteen, and the authorities were not inclined to bend the rules for a "foreigner" from the duchy of Parma. And

he lacked the required grounding in musical theory. Still, he did impress a member of the committee who introduced him to Vincenzo Lavigna, a musician at the Teatro alla Scala, the opera house, who took on Verdi as his pupil. At the age of twenty, Verdi became an adept student of harmony, counterpoint, and the fugue. When the conductor of a performance of Haydn's *Creation* at the Milan Philharmonic Society failed to turn up, Verdi filled in. He did so well that he repeated at a command performance before the Austrian governor. He then received his first commissions, a cantata for the wedding of a noble family and an opera, which has not survived.

Instead of remaining for the promising opportunities in Milan, Verdi answered his patron's call to return to Busseto, to apply for the post vacated by the death of the organist of Busseto Cathedral who was also conductor of the Philharmonic Society. Local jealousies and opposition of the churchmen kept Verdi from the post, left a bitterness toward the citizenry of Busseto that he never forgot, and brought his increasing separation from the Church. Completing the "industrious apprentice" scenario, he married Margherita Barezzi in 1836, and after three years returned to Milan. There he saw his opera *Oberto* produced in 1839. "Not extraordinarily successful," Verdi reported, yet it was well enough received to lead his friend Bartolomeo Merelli, impresario of La Scala, to give him a contract to compose three operas at intervals of eight months for four thousand livres and half the sale of the copyright.

But before the twenty-six-year-old unknown composer could seize his opportunities, he was overwhelmed by tragedy. "A severe attack of angina" prevented him even from writing a letter to his patron for help. To pay their rent his wife had to pawn "the few valuable trinkets she had." Now "terrible misfortunes" crowded upon him. His infant daughter had died only the year before in Busseto. The death of his infant son was followed within a few months by the death of his young wife. He was living out the tragic extravagances of the crudest opera melodrama. To complete the irony, his patron at La Scala had changed plans and now demanded a comic opera. Merelli submitted to Verdi some librettos that had already been used unsuccessfully. Verdi chose the least unattractive and gave it his own title.

> In the midst of these terrible sorrows I had to write a comic opera! *Un giorno di regno* proved a failure; the music was, of course, partly to blame, but the interpretation had a considerable share in the fiasco. Harrowed by my domestic misfortunes and embittered by the failure of my opera, I despaired of finding any comfort in my art, and resolved to give up composition.

When Verdi went to ask release from his contract, Merelli scolded him "like a naughty child."

Merelli saw the genius in Verdi. "I cannot compel you to write; but my confidence in your talent is unshaken. Who knows but some day you may decide to take up your pen again! At all events if you let me know two months in advance, take my word for it your opera shall be performed." Verdi's black mood hung on, but Merelli persisted. The next year Verdi weakened enough to take home a libretto that Merelli insisted was just for him. Verdi was overcome by the story's biblical grandeur, and in the autumn of 1841 completed the score for *Nabucco* on the theme of the Jewish exile in Babylon. Merelli, living up to his promise, produced *Nabucco* in March 1842. Despite improvised scenery and costumes, it was a great success, brilliantly sung by Giuseppina Strepponi, who would play a leading role in Verdi's life. The audience applauded the first scene for ten minutes, which produced Verdi's dour philosophy: "My experience has taught me the truth of the proverb: *Fidarsi è bene, ma non fidarsi è meglio!* [Faith in your luck is good, but lack of faith is better]." *Nabucco* had more than fifty performances that season.

At twenty-eight Verdi was on his way. Merelli now offered him a contract to compose an opera for the following season, leaving a blank space for him to fill in the fee. Verdi's first step to fame was also the first of his operas on ancient subjects with modern themes. His operas about oppressed peoples wove dramas of rebellion, conspiracy, assassination, and martyrdom around the struggle for liberty. *Nabucco* became such a parable, and his next operas, too, dramatized an Age of Revolutions. *I Lombardi* (1843), *Ernani* (1844), *Giovanna d'Arco* (1845), *Attila* (1846) and *La Battaglia di Legnano* (1849) were all taken by the volatile Italian public to be allegories of their own time. Each of these occasioned a demonstration for the new Italy. The Risorgimento (1815–70), the Italian revolt against foreign domination and toward a unified nation, was in full flood. This was a movement of many diverse groups—Mazzini's "Young Italy" for democracy, the Neo-Guelfs aiming at a confederation led by the pope, and the Piedmontese favoring the House of Savoy. But Verdi's passionate music was nonpartisan, in operas celebrating the language, the history, and the romance that could make a nation.

Naturally Verdi became the victim of the foreign occupiers. He was plagued by Austrian censors in Milan and Venice, and by the papal censors in Rome and Naples. In those days merely to utter the word *libertà* onstage might put the singer in prison. When *Un Ballo in Maschera* was performed in Naples in 1859, the role of Gustavus III of Sweden had to be changed into an imaginary Earl of Warwick and the sense was garbled by transferring the scene to Puritan Boston in New England. On this occasion, when the crowds before Verdi's hotel shouted "Viva, Verdi," they were saluting both Verdi and the new Italy. Everybody knew that the letters of Verdi's name were also the initials of "Vittorio Emmanuele Re D'Italia."

What made Verdi's operas Italian was more than their political message. He never thought of himself as a political person. But he could not prevent the popular symbolism attached to his works, and came to enjoy his own heroic role and the power of his melodies to stir Italian patriotism. Romance, passion, and personal conflict provided the setting for the music that gave his operas their perennial appeal. Some of his librettos originated in Shakespeare, Dumas, or Hugo, others came from run-of-the-mill theater professionals, but his melodies made audiences forget melodramatic crudities of plot. In his fertile period he produced masterpieces year after year, but still could keep his creative powers in reserve over long years of disuse.

At the age of thirty-eight, within the two years after 1851 he composed three operas that alone would have established him in musical history. *Rigoletto* (1851), commissioned by the theater of La Fenice in Venice, the seventeenth of his twenty-eight operas, and the one that first brought him international fame, was almost not performed. The libretto by Francesco Piave based on Victor Hugo's play *Le roi s'amuse* (1832) was originally titled *La Maledizione* (The Curse). Censors objected that the title smacked of blasphemy and the plot, too, had subversive overtones. It not only showed the central figure, a king (originally the libertine King Francis I of France), in an unfavorable light and allowed him to be upbraided by his court jester for seducing his daughter, but even staged an attempted assassination. For less obvious reasons they objected to Gilda's body being brought onstage in a sack and to the fact that the leading figure was cast as a hunchback. The Austrian military governor of Venice, banning the performance, expressed to the directors of La Fenice his surprise that "the poet Piave and the celebrated Maestro Verdi should have chosen no better field for their talents than the revolting immorality and obscene triviality of the libretto entitled La Maledizione."

When Verdi was ordered to write another opera, he reluctantly agreed instead to make changes. The libertine king was transformed from the historical Francis I to an imaginary duke of Mantua (who now had no key to Gilda's bedroom). Verdi's focus had shifted from the sins of the prince to the paternal devotion of the hunchback court jester (whose name was changed from Triboletto to Rigoletto).

But Verdi would not alter his music. When a prima donna in Rome demanded a new aria to show off her talents, Verdi refused, although this would have suited operatic conventions. "My idea," he explained, "was that 'Rigoletto' should be one long series of duets without airs and without finales, because that is how I felt it." This emphasis on duets signaled Verdi's diversion from the melodramatic fireworks of grand opera librettos to the melodic expression of character and the musical reaction of people to one another. His original touches included the brilliant delineation of

minor characters and the storm music of the final act with a "wordless chorus" offstage suggesting the wind.

Il Trovatore, one of his most beloved and durable works, was composed in twenty-eight days, and completely scored by the end of 1852, even before it had been commissioned. The libretto, set in fifteenth-century Spain, recounted a civil war and rebellion against the king of Aragon. It was no wonder that, for a change, the censors gave him no trouble. The impossibly complicated plot of witch burning, poisonings, gypsies, and mistaken identities leaves modern audiences as puzzled as the Roman censors must have been. But the plot is dissolved by Verdi's music. Though sophisticated critics ridicule it as "the fool's gold of song," laugh at the "Anvil Chorus" and the farrago of "overscored folk songs," *Il Trovatore* has captured audiences everywhere. In this bizarre Italian marriage of the arts, a musical drama attained immortality without the aid of a plausible story. The audience at the first performance in the Teatro Apollo in Rome on January 19, 1853, cheered it to a success that rivaled *Rigoletto*'s.

But Verdi's next triumph would be quite different. *La Traviata,* at the opposite pole from the wild histrionics of *Il Trovatore,* was a real-life contemporary tragedy. Alfredo, a man of good family, falls in love with Violetta, a beautiful woman of ill-repute, and shocks his family by taking her to live with him in the country. Knowing that she is dying of consumption, she sacrifices herself and gives up Alfredo in response to the pleas of his father who is unhappy because the scandal is endangering the marriage prospects of Alfredo's sister. The tragedy is compounded when Violetta returns to her former protector, who challenges Alfredo to a duel. Later, Alfredo, learning of her sacrifice, returns to her as she is dying. The libretto by Piave was adapted from a play (1852) and a novel (1848) by Alexandre Dumas *fils* that was drawn from Dumas's own experience. First performed at La Fenice in Venice in March 1853, only six weeks after the Roman triumph of *Il Trovatore,* the new opera was hooted off the stage. " 'La Traviata,' last night," Verdi wrote a friend, "was a fiasco. Is the fault mine or the singers? . . . Time will show." Some blamed the disaster on the plump singer playing the consumptive Violetta, and on a hoarse Alfredo. A more likely explanation was Verdi's defiance of all operatic conventions. Grand opera was a drama of kings and emperors, generals and gypsies. But here was a tubercular heroine caught up in a scandal of the contemporary demimonde.

The story must have had a special poignancy for Verdi himself at that moment. Since the death of his young wife he had been living with Giuseppina Strepponi, a talented actress who had once had a "clear, sweet, and penetrating" voice. She had borne three sons to her earlier paramour, and the people of Busseto were loudly complaining of the scandal. Verdi had

to defend himself to his ailing father. Antonio Barezzi, Verdi's patron and father-in-law, was slow to accept Giuseppina. For years Verdi dared not take her along to openings of his new operas in Italy. And not until 1859 did Verdi agree to legalize their union.

The Venetian audience would not tolerate an opera heroine in contemporary costume, wearing a gown she might have worn into the theater, as she did on the first performance of *La Traviata*. At its revival the following year, Verdi ordered costumes from the age of Louis XIII, two centuries earlier. Somehow the audience did not mind the incongruity of a mid-nineteenth-century tragedy of manners in seventeenth-century costume, and *La Traviata* was soon acclaimed in London, Paris, New York, and St. Petersburg.

After *La Traviata*, Verdi ceased composing at his manic pace. He chose his projects deliberately either because the themes appealed to him or because he now could command large fees. Commissions came from abroad. For the Paris Opéra he composed *Les Vêpres siciliennes* (1853) in the Meyerbeer "grand opera" mold, followed by *Simon Boccanegra* for Venice (1857; 1881), *Un Ballo in Maschera* for Naples (1859), *La Forza del Destino* (1862) for St. Petersburg, and *Don Carlos* for the Paris Exhibition of 1867. Verdi was no longer impatient for glittering commissions, but his great and most improbable successes were yet to come.

Aida, widely agreed to be the most popular of operas, had a bizarre origin. Although Verdi never wrote his own librettos, his active role in shaping the libretto and the plot of *Aida* appears in his letters. In 1869 an invitation purporting to be from Ismail Pasha, khedive of Egypt, asked Verdi to compose the music for an opera to celebrate the opening of the Suez Canal. The request came from a French librettist, Camille du Locle, who offered a scenario by Auguste Mariette (1821–1881), the pioneer French archaeologist. Mariette had settled in Egypt, founded the Egyptian Museum, unearthed the temples of Dandarah and Edfu, excavated Karnak, and was the government's inspector of Egyptian monuments. He now provided the plot and would assure the historical authenticity of scenery, costumes, and institutions. Working with an Italian opera singer Antonio Ghislanzoni (1824–1893) who had lost his singing voice and turned to writing librettos, Verdi would put together the text for the drama that endlessly enchants opera audiences.

When the request came, Verdi, contented on his farm at Sant' Agata, was thought to have given up composing. Probably pleased that the khedive had chosen him over Wagner, he still twice refused. Verdi was finally persuaded less by the large fee and the rights in all countries outside Egypt than by the romantic site, and the chance (recalling his first success with *Nabucco*)

to reach out again beyond the conventional European subjects. *Aida* was not completed in time for the opening of the Suez Canal in 1869, nor even for the opening of the Cairo Opera House that same year, which had to be (and was) satisfied with *Rigoletto*.

Verdi paid close attention to the words of the libretto and made a great effort to avoid the cliché. Yet *Aida* would become the stereotype of grand opera. There were last-minute difficulties. The Prussian siege of Paris in 1871 prevented Mariette from taking his scenery and costume designs to Egypt, and Verdi's preferred conductor could not come. Appalled at the sensational publicity to celebrate an engineering triumph in the land of the pharaohs, Verdi determined not to go to Cairo. To the correspondent of a Milan newspaper who had been sent there, he complained:

> You in Cairo? . . . in these days art is no longer art, but a trade . . . something that must achieve, if not success, notoriety at any price! I feel disgusted and humiliated. In my early days it was always a pleasure to come before the public with my operas, almost friendless and without a lot of preliminary chatter or influence of any kind, and stand up to be shot at; and I was delighted if I succeeded in creating a favourable impression. But now what a fuss is made about an opera! Journalists, singers, directors, professors of music and the rest must all contribute their stone to the temple of publicity, to build a cornice out of wretched tittle-tattle that adds nothing to the worth of an opera, but may rather obscure its true merits. It is deplorable, absolutely deplorable! . . . All I want for *Aida* is good and, above all, *intelligent* singing, playing and stage production.
>
> (Translated by Dyneley Hussey)

Opening to a resounding success in Cairo on December 14, 1871, six weeks later *Aida* was performed at La Scala, and continued its triumphal career in Trieste and London. But Verdi generally refused invitations to attend openings, saying his presence would not improve the opera.

Even in the exotic setting of *Aida* we hear the theme of patriotism that had resounded throughout Verdi's earlier operas. The conflict between love of a person and love of country is dramatized in Radames and in Aida herself, while the audience is constantly reminded that Egypt is being menaced from without by the Ethiopians. Was *Aida,* appearing just after Rome had been captured and made the capital of a new Italy, and the Kingdom of Italy established under Victor Emmanuel, Verdi's final operatic celebration of his newly unified independent nation? At the death of Manzoni (1785–1873), author of the classic *I Promessi Sposi* (1825–27), the poet laureate of Italian nationalism and Verdi's idol, Verdi composed a requiem Mass, in which he incorporated passages he had composed for the death of Rossini. It was performed in 1874 on the first anniversary of Manzoni's death.

Verdi seemed able to hold his energies in reserve as he vegetated on his farm, Sant' Agata. After *Aida* he allowed sixteen years to pass before composing another opera. He turned to Shakespeare. His own talents had not declined. And in his two final operas, each the fruit of many years, he had the perceptive collaboration of the composer, librettist, and man of letters Arrigo Boito (1842–1918). Verdi's *Otello,* substantially Shakespeare's plot with the Venetian first act omitted, was performed at La Scala in 1887. He enjoyed its spectacular success, toured Europe with the company, and for a while was lifted out of his depression. Verdi would not be pleased to hear critics acclaim it for its Wagnerian dramatic continuity—with no breaks allowed, even for applause. But the poignancy of his characters is Shakespearean. As a tragic opera it may be unexcelled.

Few expected to hear another new opera by Verdi. But without the opera companions whom he enjoyed creating, Verdi felt lonely. Even as the audience was applauding *Otello* at La Scala, he lamented, "I loved my solitude in the company of Otello and Desdemona! Now the public, always eager for novelty, has robbed me of them, and I have only the memory of our secret conversations, our cherished intimacy." Encouraged by Boito, he created a new, and more affable, companion. By 1890 Verdi had begun composing music for *Falstaff,* a libretto that Boito had fashioned from Shakespeare's *Merry Wives of Windsor* and and the two parts of *Henry IV.* Verdi had composed no comic opera since *Un Giorno di Regno,* his fiasco fifty years before, in the midst of his overwhelming personal tragedy. For a while after *Otello* he seems to have considered doing something with Don Quixote. And he might have wondered if he was not living out that Quixote theme. Why, after a half century of triumph in tragic opera, should he go to such lengths to risk himself on what he had never proven himself able to do?

Characteristically and self-consciously, Verdi refused to quit while he was ahead, or rest with the laurels of world fame at the age of eighty. "It may be thought very rash of me," he wrote Boito in 1889, "to undertake such a task." But he went ahead playfully, while refusing to agree to terms or to reveal his progress on the work. He wrote a friend in January 1891, "all projects for the future seem to me folly, absolute folly! . . . I am engaged on writing *Falstaff* to pass the time, without any preconceived ideas or plans; I repeat, *to pass the time*! Nothing else." "In writing Falstaff," he noted six months later, "I have thought neither of theaters nor of singers. I have written it to please myself, and I believe that it ought to be performed at Sant' Agata and not at the Scala."

But it was performed at La Scala on February 9, 1893, with both Verdi and Giuseppina (who had sung fifty years before in his first opera) in the audience. Not only a grand personal success, but an opening to the future,

Falstaff proved that comic opera was alive and full of promise. Sober critics have exhausted their vocabularies in praise of *Falstaff,* its brilliant orchestration, its melody, its marriage of libretto and music, its wit and subtlety. Although *Falstaff* has never attained the popularity of Mozart's *Figaro,* Rossini's *Barber of Seville,* or Wagner's *Die Meistersinger,* it carries the mature wit and wisdom of Verdi's eighty years.

The last words of *Falstaff,* sung to a fugue accompaniment, declared, "*Tutto nel mondo è burla*" (All the world's a joke). So he proclaimed the gulf between himself and his still-envied adversary, Richard Wagner, a decade after Wagner's death. Human warmth, wit, and resignation were Verdi's way of expressing the national spirit. When the man who had conducted *Otello* reported its brilliant successes in England, Verdi wrote in 1889:

> You talk of the "triumph of Italian art"! You are mistaken! The young Italian composers are not good patriots. If the Germans springing from Bach have arrived at Wagner, that is well. But if we, the descendants of Palestrina, imitate Wagner, we commit a musical crime and produce works that are futile, not to say harmful.

51

A Germanic Union of the Arts

THERE could hardly have been more antithetic characters than Verdi and Wagner. Verdi flourished in the traditions of romantic opera, composing music for librettos that captured his fancy. He took his subjects where he found them—in Shakespeare, Hugo, Dumas, and from talented librettists like Piave, Boito, Ghislanzoni. These subjects varied from ancient Babylon, Egypt, or medieval Spain to mid-nineteenth-century Paris. Though he wrote letters, he was not a man of words. He refused to write his memoirs, and appealed to collaborators to provide the poetry for his music. Verdi was inarticulate except in his music, which seemed to satisfy his needs for expression. Rooted in the soil of his Italy, he spent his later years in retreat on his farm, Sant' Agata. His modifications of opera aimed to make it a more effective vehicle for his music.

Richard Wagner's aims were cosmic and metaphysical. He was plagued by twin talents, for words were as much his medium as music. He left twelve volumes of prose and poetry, a diary, and a seven-hundred-page autobiography, which he dictated in his last years to Cosima, "my friend and wife, who wished me to tell her the story of my life." Unlike Verdi's, Wagner's musical works had a conscious coherence and focus, which he tried also to express in writing. And he remains the only great composer meriting a place in the history of literature. His struggle to see the world whole haunted him, and eventually governed his musical genius. While his writings remain known only to scholars, his music reaches across languages into concert halls, living rooms, and airwaves everywhere. His versatility was his burden. And in Wagner raged the age-old Western conflict between the music of the word and the music of instruments, between ideas and feeling, thought and sound. This too explained his unique creations.

Still, even if he had never come to the idea of the *Gesamtkunstwerk* (unified work of art), he would be among the great composers. Before he made his grand synthesis of the arts he had paid his dues to the conventions of operatic tradition.

It was appropriate that Wagner's birth at Leipzig on May 22, 1813, was encompassed in mystery. His mother, Johanna Wagner, never gave her eight children a full account of her own origins. Her parents were bakers, but her mother may have been an illegitimate daughter of a prince of Weimar. It is not even certain whether Richard's father was Johanna Wagner's husband, Friedrich, the police official charged with keeping order during the turbulent days of Napoleon's occupation of the city. Or was Richard the son of Johanna's intimate friend and frequent visitor Ludwig Geyer, a painter-actor-singer who took the numerous family under his care on the death of Friedrich Wagner by typhus in November 1813? Richard himself harbored, and perhaps enjoyed, the suspicion that Geyer was his father, but near the end of his life (1878) he seems to have changed his mind. The question had an added piquancy, which attracted Nietzsche, for the Geyer paternity seemed to raise the possibility that Wagner was a Jew.

Apart from the Napoleonic turbulence of his surroundings, little was unusual about Richard Wagner's boyhood. Johanna married Geyer and moved the family to Dresden. Geyer died in 1821 but left his influence on the young Wagner through his friendship with Carl Maria von Weber. "Look, there's the greatest man alive!" Richard would exclaim to his little sister when Weber passed their house, "You can't have any idea how great he is!" While he was no prodigy, he early discovered a passion for the theater. Exploring backstage in Geyer's theater, he never forgot "something mysteriously ghostly about the beards, wigs, and costumes, which the addition of music only intensified." He early conceived an enthusiasm for Greek

history and mythology, and at thirteen translated the first three books of
the *Odyssey*. When the family moved back to Leipzig in 1827, his classical
interests were stirred by a literary uncle, and he developed an adolescent
passion for Shakespeare. At fourteen he had decided to be a poet.

It was a performance of Beethoven's *Fidelio* in Leipzig in 1829, by Wag-
ner's own account, that awakened his interest in music. And he developed
a crush on the famous prima donna who played the title role. He recalled
this as the most important single experience of his life. When he learned of
Beethoven's life and struggles, he was impressed by "the most sublime,
transcendental originality." Wagner had found the polestar by which he
would chart his new course for music. Teaching himself, he found music
his "daemonium." Plunging into Beethoven's Ninth Symphony at seven-
teen, he made a piano arrangement. His earliest surviving letter is his
unsuccessful effort to persuade a Mainz publisher to issue the work. A
decade later Wagner would write a short story with the title that might have
been given to his whole musical autobiography, *A Pilgrimage to Beethoven*
(1840). "I don't really know what career had been planned for me," a
German musician in the story recalls, "I only remember that one evening
I heard a Beethoven symphony for the first time, that I thereupon fell ill
with a fever, and when I recovered, I had become a musician."

At the University of Leipzig he studied music and enjoyed the romantic
student life. But his real master remained Beethoven, whose quartets and
symphonies he studied obsessively. Wagner's own symphony was per-
formed in Leipzig when he was twenty. In that year he composed an opera
for which, as would be his lifelong custom, he wrote his own libretto. But
Die Feen (The Fairies) was not produced till a half century later. His second
opera *Das Liebesverbot* (The Ban on Love, following Shakespeare's *Measure
for Measure*) failed after a single disastrous performance. The next six years
he spent conducting small-town opera companies around Germany. In 1836
he married the self-centered and erratic actress Minna Planer. Their turbu-
lent off-and-on life together would bring him unhappiness till her death in
1866. They went to Riga, where he conducted concerts and opera, but soon
had to flee to escape his creditors.

En route to London, Wagner experienced the storm that drove his ship
into a Norwegian fjord and stirred the crew to sing and tell the stories of
the flying Dutchman that became material for his opera. Then on to Paris,
the opera mecca of the age. The misery of his three years in Paris was
compounded of starvation and professional failure. But it was rich in prepa-
ration. There he completed *Rienzi* (after a novel by Bulwer-Lytton about
fourteenth-century Rome), which ends with the Capitol in flames consum-
ing the hero and others. And he came to know Berlioz. At this time, too,
he had the leisure to be stimulated by Friedrich Raumer's history of the

Hohenstaufens and by a classical-scholar friend from Königsberg, Samuel Lehrs, to explore medieval Germany. There he discovered the folk ballad of Tannhäuser and Venus, and the story of Lohengrin. He also composed *Der fliegende Holländer* (The Flying Dutchman), his first opera to enter the permanent repertory, and his first statement of the theme of redemption through love and sacrifice that would occupy him throughout his life.

When Dresden accepted *Rienzi* for performance in 1842, it was lucky for Wagner, freeing him at twenty-nine from the orbit of the Paris Opéra and returning him to Germany, where he belonged. He happened upon a copy of *German Mythology,* by Jacob Grimm (1795–1863), which, along with a bottle of mineral water, he would take on his solitary walks. For him, he recalled, Grimm was "a complete rebirth," an "intoxicating joy" at perceiving "a world in which, until then, I had been like a child in the womb, apprehending but blind."

Rienzi, still in the Parisian grand opera tradition, was Wagner's first triumph. After *Der fliegende Holländer* he was appointed a conductor of the Dresden Opera, where he developed the medieval mythological themes to which he had been awakened in Paris. *Tannhäuser* showed him already struggling toward his "unified" concept of opera, which would not depend on featured arias and "numbers," and used orchestral motifs for continuity. *Lohengrin,* usually considered the last of the great German Romantic operas, advanced from the theme of personal renunciation to the myth of the Holy Grail and to cosmic issues. But the Dresden Court Opera forbade its performance, with personal objections to Wagner for his project of a new autonomous national theater and for his political activities.

These next years were revolutionary not only for European politics but for Wagner and the future of music. The "specter" that Marx and Engels saw "haunting Europe" in their *Communist Manifesto* of 1848 was also haunting Wagner. He published three revolutionary articles and distributed incendiary handbills during the Dresden uprising of May 1849. Luckily he was not shot by the Saxon soldiers and escaped arrest, but fled for his life. He had been impressed by the flowing hair and energy of Mikhail Bakunin, a most unlikely companion—for Bakunin envisioned a revolution that would destroy all cultural institutions, while Wagner foresaw a society newly shaped by artists. Ironically, it was the long-dead Beethoven who brought them together. After secretly attending Beethoven's "Choral Symphony" conducted by Wagner on Palm Sunday, 1849, Bakunin exclaimed, "All, all will perish, not only music, the other arts too . . . only one thing will not perish but last forever: the Ninth Symphony."

Wagner's flight from Dresden and his detachment from the German opera and concert halls opened an interlude when he did not compose.

Arriving in Zurich in May 1849, he began a decade of Swiss exile. Removed from the familiar competitive musical scene, he was forced to seek expression in his other medium, and immediately began writing. These years of exile would produce some of his most interesting observations on life, art, and civilization. Wagner was as much intoxicated by his power with words as by the power of his music. Frantically he sought to unify the two worlds within him and make them collaborate. Wagner struggled, yearned, and wrote for a coherent world of the arts. The traditional opera would be no more than his point of departure. He now wrote a series of essays—*Art and Revolution* (1849), *The Art Work of the Future* (1850), *Opera and Drama* (1850–51)—a credo for his future composing. As a practicing composer of opera in the traditional mold he was painfully aware of the competition in the past between the two musics, the music of words and the music of instruments. He now used his talent with words to declare a truce and create a theory marrying them in a new art form. And he would then prove his theory by his own monumental creation in that mold. What Wagner would call the Art Work of the Future was foreshadowed in his own.

The ideal of a single unified work that would consummate all the arts was far from new. Ancient Greek drama had been such a synthesis of ritual, poetry, music, and dance. It was an obvious model for the *camerata,* the groups of musicians and literary figures who met in Florence in the late sixteenth century, discussing the music of the ancient Greeks. Members of the group collaborated on *Dafne,* performed in 1598, which survives only in fragments but which some give the title of the "first opera." Others in Germany, reacting against the Italian operas that had become mere showcases for singers' arias, sought a better balance of the arts. Weber, the idol of Wagner's youth, back in 1816 had envisioned "a self-sufficient work of art in which every feature and every contribution by the related arts are moulded together in a certain way and dissolve to form a new world."

The German language could provide a single word for this unifying concept, *Gesamtkunstwerk,* and Wagner described the ideal art work of the future (*Gesamtwerk der Zukunft*) (1849). His view is ambitious and universal. He wants to add to the "three purely human arts" (music, poetry, dance) "the ancillary aids of drama" (architecture, sculpture, painting). *Oper und Drama* (Opera and Drama) in 1851 elaborated his art ideal. "It is a very remarkable work," he recalled to Cosima, "and I was very excited when I wrote it, for it is without a predecessor in the history of art, and I was really aiming at a target no one could see." Fanatic in pursuit of his idea, he prescribed a "radical" water cure for himself and friends, and a "fire cure" for mankind, which started with setting fire to Paris to serve as a beacon. "How much better we shall be after this fire cure!"

The dogma he now expounded was carefully developed, analytical, histor-

ical, and full of examples. Through it all runs his effort to reconcile word and music, in a new all-encompassing art form. In Part One, "Opera and the Essence of Music," Wagner focused on the cardinal weakness of all opera before his time. "A means of expression (music) has been made the object; and . . . the object of expression (drama) has been made the means." Gluck's reform, "the revolt of the composer against the singer," aimed to rescue opera from singers trying to show off. Mozart was indifferent to the words of the libretto and "all he did was to pour the fiery stream of his music into the operatic forms, developing their musical possibilities to the utmost." But the drama was still only an excuse for the music. "Up to now this melody has been merely song-melody." Then Beethoven discovered and developed a new more expressive kind of instrumental melody. "In his grandest work," the Choral Symphony, finding the "absolute-musical," the "instrumental language," inadequate to his message he "at last felt the necessity of throwing himself into the arms of the poet" to clarify the meanings of his melody. Wagner went on with his customary extravagance, "The organism of music is capable of bearing living melody only when fructified by the poet's thought. Music is the female, destined to bring forth—the poet being the real generator; and music reached the very peak of madness when it aspired not only to bear but also to beget."

Moving on to "The Drama and the Essence of Dramatic Poetry," Wagner described the unified art work of the future. It will not be a mere mixture of the arts, not merely "reading a romance by Goethe in a picture gallery adorned with statues, during the performance of a Beethoven symphony," but a merging of all arts into a new form. Drama, till now drawn from romance and Greek drama, has been "an appeal to understanding, not to feeling." The future must "return from understanding to feeling." The poet-dramatist must rise above the drab "commonplaces, intrigues, etc., things which modern comedy and drama without music are far more successful in presenting" to "the holy spirit of poetry as it comes down to us in the sagas and legends of past ages." This required a new collaboration of word-language and tone-language. Poetry, which has mistakenly become only the medium for "understanding," must be recalled to be the medium of feeling. "The inner man's most primitive medium of utterance," "the first emotional language of mankind," was a language of melody consisting only of vowels. It acquired rhythm by adding gestures. By adding consonants this primitive tone-language became a full-fledged word-language. And when common consonants were grouped together in different words they helped produce a coherent mental picture by alliteration (*Stabreim*) and made poetry the vehicle of understanding. "Feeling sought refuge from an absolute speech of this intellectual kind and sought it in that absolute tone-language which constitutes our music of the present day."

The modern problem, according to Wagner, is how to bring together word-language and tone-language. But modern opera has made this effort only in a crude mechanical way. The poet writes his words and waits for the composer's music to "transform the nakedness of articulate speech into the fullness of the tone-language." The result is confusion. For a *Gesamtkunstwerk* the artist must from the outset create an organic work fusing words and music. Wagner himself would prove this possible by writing his own librettos.

Looking ahead to "Poetry and Music in the Drama of the Future," Wagner proposed a new kind of verse, better for "the purely emotional element," going back to "the sensuous substance of the roots of speech." Modern opera makes the mistake of treating the voice as only another musical instrument, but in the unified art work the voice part will become "the connecting link between articulate speech and tone speech." Then the words will "float like a ship on the sea of orchestral harmony." Modern instrumental music does "possess a capacity for speech," for all that cannot be expressed in words. "The unifying bond of expression therefore proceeds from the orchestra." "Translated" opera, he says, makes no sense and destroys its very essence. The German language is better than others for the art work of the future because it "still displays an immediate and recognizable connection with its own roots." The art work needs a new public, not like the present, which seeks only to be amused, but a public with a feeling for cosmic unity.

Opera and Drama, which Wagner called his "testament," was also his manifesto. He created a new concept of opera to which Verdi's talents were not equal, and which Verdi in fact found menacing. Verdi would consider it an insult to be accused of "Wagnerism." Wagner spent the next twenty years composing *Der Ring des Nibelungen* (The Ring of the Nibelung), which came close to fulfilling his grandiose hopes. The *Ring,* which Wagner himself described as "a stage festival play (*Bühnenfestspiel*) for three days and a preliminary evening," provided twelve hours of opera: *Das Rheingold* (the Prologue), *Die Walküre, Siegfried,* and *Götterdämmerung.* His earlier operas had been adapted from folklore, history, or legend, but the myth to which he now turned did much more.

Not mere entertainment, this Germanic mythology dramatized the eternal conflict between people and with their gods, giving opera the seriousness proper to a *Gesamtkunstwerk.* Some felt Wagner's operas merely embodied the interminable. Combining two Germanic myth cycles, the stories of Siegfried and of the fall of the gods, the *Ring* dramatized the great issues of power, love, humanity, and divinity. In *Das Rheingold* Wagner revealed his unifying concept, for the music is continuous with the drama, without

discrete melodies or set numbers. Leitmotivs now were not in vocal melody but in instrumental orchestral themes. After completing his prose sketches for *Das Rheingold* and *Die Walküre* in Zurich in late 1851, he declared, "With this conception of mine I *totally* abandon all connection with the theater and audiences of today. . . . I cannot think of a *performance* until *after the revolution,* only the revolution can give me the artists and the audiences. . . . Then I will summon what I need out of the ruins. I will find *then* what I must have."

Before Wagner could complete his own *Gesamtkunstwerk* and see it performed, a friend introduced him to the stirring *World as Will and Idea* (1819) of Arthur Schopenhauer (1788–1860). As he worked on the sketch for *Die Walküre,* Schopenhauer's work had an effect like that of Beethoven's Ninth Symphony. And he read the whole book four times over in 1854. For him it expressed the powers of intuition and the irrational that would be explored by Bergson, Freud, and others in the next century. Schopenhauer was saying something Wagner wanted to hear. Apart from philosophy, it seemed to justify Wagner's pessimism for never having had a fulfilled love in his life. About this time, too, he had conceived a hopeless love for Mathilde Wesendonck, the wife of the Swiss benefactor who had recently saved him from catastrophe by paying all his debts. Was he inspired to compose *Tristan* by his love for Mathilde? Or, as others suggest, was writing *Tristan* what inspired his love for Mathilde? The liaison made it uncomfortable for Wagner to stay on in Zurich. He went to Venice and then to Lucerne to complete *Tristan* in 1859. After seventy rehearsals in Vienna in 1862–63 it was given up as unperformable, but was finally performed in Munich in 1865.

That performance was directed by Hans von Bülow, a friend whom Wagner had encouraged to become a conductor in defiance of his family. Von Bülow had married Franz Liszt's daughter, Cosima. Wagner had met her years before, but now their relationship developed. They traveled together and she bore Wagner three children before her divorce in 1870. The self-sacrificing von Bülow observed, "If Wagner writes but one note more, then it will be due to Cosima alone." Wagner and Cosima were married in a Protestant church in Lucerne in 1870. This was another chapter in Wagner's happy relationship with Liszt (1811–1886), who had produced his *Lohengrin* and constantly cheered him on to compose the *Ring* and to build Bayreuth. Von Bülow's prediction was not far wrong, for Cosima was Wagner's companion and inspiration till his death.

Wagner had been unduly pessimistic in predicting that his *Ring* could not be properly performed until "after the revolution." *Das Rheingold* (1869) and *Die Walküre* (1870) were produced separately in Munich. But the first performance of *Siegfried* and of *Götterdämmerung* was reserved for the

festival of the whole *Ring* at Bayreuth in August 1876. More than a bouquet
of new operas, this was a *Gesamtkunstwerk*. When before had a composer
written the words for his own music, to be performed in an opera house of
his own conceiving? At Bayreuth Wagner came close to being the total
creative artist. For more than ten years Wagner had been thinking of the
proper architectural setting for his *Ring*. With aid from his sponsor, King
Ludwig II of Bavaria, he would build his own auditorium. In the shape of
an amphitheater with two prosceniums, one behind the other, the theater
would create "a complete dislocation of scale," enlarge the appearance of
everything on the stage and separate "the ideal world on the stage from the
real world on the far side of the . . . orchestra pit."

He searched the countryside to find the ideal site for his ideal theater.
"Oh, I feel as though I was trying to build a house on a catalpa flower. I
should have to fill the world with airy vapours first, to separate me and my
art from the human race." Nietzsche reported Wagner's emotions in May
1872 as the foundation stone was laid on a hill in Bayreuth in the pouring
rain. "Wagner drove back to town with some of us; he did not speak and
communed long with himself with an expression on his face that words
cannot describe. He began the sixtieth year of his life on that day: everything
that had gone before had been preparation for that moment. . . . What may
Alexander the Great have seen at that moment when he caused Asia and
Europe to be drunk from the same cup?"

This widely publicized architectural gesture brought attacks on Wagner
even from former students. A Munich doctor published *A Psychiatric Study*
(Berlin, 1870) proving that Wagner suffered manic delusions. But with
encouragement from Cosima and his father-in-law, Liszt, and financial aid
from King Ludwig, construction proceeded as Wagner kept in constant
touch with the work. Meanwhile Wagner toured Germany in search of the
ideal performers. Till the last moment Wagner oversaw every detail, and he
hastened to complete the music. The first performance of the *Ring,* August
13, 14, 16, and 17, 1876, was a resounding success. At the end of *Götterdäm-
merung,* King Ludwig led the applause of celebrities who had come from
all over Europe. Wagner said the applause itself justified his calling this a
"festival drama." In retrospect, within a month Wagner was depressed by
the inept performers, and he wrote, "There is no footing for me and my
work in this day and age."

Ideally the four parts of the *Ring* should have been performed consecu-
tively and without intermissions. Orchestral interludes would provide the
continuity from one scene to the next. Bayreuth had come close to providing
Wagner with the kind of audience a *Gesamtkunstwerk* required. Wagner
had done much to change the opera atmosphere from the vaudeville infor-
mality of the opera buffa to a quasi-religious solemnity. But the first Bay-

reuth festival incurred such a heavy deficit that twenty years passed before it was repeated there.

Even after conceiving the *Ring*, Wagner had composed more conventional works. An amnesty had allowed him to return to Germany in 1861. After *Tannhäuser* even when revised was a failure in Paris, and the Vienna production of his *Tristan* was put off because of its unfamiliar style, he turned to comedy-opera. The tuneful *Die Meistersinger*, which he had been working on for a decade, was performed in Munich in 1860 and would never cease to be popular. It has been laboriously interpreted, either as an allegory of two sides of his own character or of the conflict between tradition and creation which was reconciled in Hans Sachs. To escape his creditors, as he had fled Riga before, in 1864 again Wagner had to flee Vienna. Then by good luck the eighteen-year-old Ludwig II, a music lover, came to the throne of Bavaria. He had read the poem of the *Ring*, which had been published to raise money for the festival production. He invited Wagner to Munich to complete the *Ring*, and he remained the essential prop for Wagner and his Bayreuth theater. In 1874 he also provided the house at Bayreuth that Wagner called Wahnfried (peace from illusion) where he completed preparations for the *Ring*.

After the triumphant festival of the *Ring*, Wagner stayed on at Wahnfried. His last opera, *Parsifal*, the product of five years, pursued again the theme of redemption in the quest for the Holy Grail. Even before its first performance at Bayreuth in 1882, Wagner had written to Ludwig that this *Bühnenfestspiel* should never be performed anywhere except there. Opera, he insisted, was not mere entertainment but a religious ritual that required the proper setting. At Wagner's death in 1882 as the most famous composer in Europe, he was buried in a tomb he had prepared in the garden of Wahnfried.

Though Wagner was not satisfied to be known as a musician, he has survived as a musician. His utopian vision of the unity of the arts drew him on. With twin talents in word and in music he united the arts in himself and proved it could be done. In an age of many other unifying concepts— evolution and progress, socialism and nationalism—Wagner pursued his own quest for unity. He proved that a *Gesamtkunstwerk* was possible, but failed to establish the tradition of Total Art Work for which he had hoped.

Later he was to become a patron saint of Nazism, Hitler's favorite composer. The annual party rallies of the Nazi Party opened with a performance of *Die Meistersinger*. So Wagner tests our ability to separate our aesthetic from our moral judgment. He exalted music as the universal language and said a *Gesamtkunstwerk* would unify all humanity in the arts. But he was himself a narrow, envious man, consumed by chauvinism and bigotry. He

curiously insisted that German was the only proper language for opera. And his venom against Jews, which his defenders would justify as an expression of self-hate in reaction to his "isolation," may really have expressed a resentment of his personal debts to Jews. The young Jew Samuel Lehrs, a companion of Wagner's unhappy years in Paris, had introduced him to the legends of the Wartburg War, Tannhäuser, and Lohengrin. Giacomo Meyerbeer (1791–1864) had strongly influenced his early operas, had lent him money, and had given him enthusiastic critical support when he most needed it. But Wagner made Meyerbeer the target of his vicious anti-Semitism, which he shamelessly dared defend as "necessary for the complete birth of my mature being." Wagner's *Jewry in Music* was plainly in the Nazi tradition. His enthusiasm for *das Volk* and his contempt for *das Publikum* were ominous. And his Germanic themes resound with the belligerent spirit of "Deutschland über Alles."

"When Wagner was born in 1813," George Bernard Shaw explained in *The Perfect Wagnerite* (1898–1923), "music had newly become the most astonishing, the most fascinating, the most miraculous art in the world. Mozart's Don Giovanni had made all musical Europe conscious of the enchantments of the modern orchestra, and of the perfect adaptability of music to the subtlest needs of the dramatist. Beethoven had shown how those inarticulate mood-poems which surge through men who have, like himself, no exceptional command of words, can be written in music as symphonies. . . . After the symphonies of Beethoven it was certain that the poetry that lies too deep for words does not lie too deep for music." Wagner, "the literary musician par excellence," united in himself the arts of word and music. "A Beethoven symphony . . . expresses feeling, but not thought: it has moods but no ideas. Wagner added thought and produced the music drama."

52

The Ephemeral Art of the Dance

To bring dance into Wagner's universal art, his widow, Cosima, invited the dynamic Isadora Duncan (1878–1927) and gave her "free rein over the dance in Bayreuth." After her performance of the dance of the Three Graces of

the Bacchanal in Tannhäuser in 1904, Isadora appalled her patron by announcing that the idea of music drama was pure nonsense. "Man must speak, then dance," she explained to the stunned Cosima, "but the speaking is the brain, the thinking man. The singing is the emotion. The dancing is the Dionysian ecstasy which carries all away. It is impossible to mix in any way, one with the other. *Musik-Drama kann nie sein.*" Cosima was properly shocked, for the performances of the *Ring* in Bayreuth were the living legacy of Richard Wagner's passion to combine the arts.

Dance, sometimes called the original art, is also the universal art, for man always carries it with him. The earliest Egyptian tomb paintings show people dancing. And, as we have seen, Greek drama, on which Western drama is formed, begins with the community joining in the orchestra (dancing place). Western dance as an art shows us the movement from a dancing community to dancers on a stage. Yet despite its antiquity the dance, unlike architecture, sculpture, and literature, has left us a meager record. Not effectively documented and perpetuated, ancient dance—"the Dionysian ecstasy"—did not become part of our usable heritage. We must seek clues to its character in vase painting and other visual arts. And dance was the last of the art forms to acquire a separate identity.

It was the late-coming ballet that transformed the convivial delights of bodily movements—of folk dancing and social dancing—into a controlled dramatic art. "Ballet, as a form," observes dance historian Lincoln Kirstein, "is as important as the invention of perspective in painting or the symphony in music; that is, a major contribution of Western culture." The rise of ballet reveals an effort to create an art to outlive the transient grace of bodily movement. "Ballet" (from Italian *balletto,* diminutive of *balla,* dance) first enters English about 1667 to describe a theatrical representation. And its history reveals ingenious efforts to give rigor and definition to these movements. Ballet arose out of the lavish efforts of members of the Italian Renaissance court to entertain themselves. And the first authentic *ballet de cour* was organized by Catherine de' Medici (1519–1589) in 1581 to celebrate the marriage of her sister. When Catherine came to France as the wife of King Henry II, she brought her Italian musicians with her. It was said that she had planned a comic entertainment because she believed that performing a tragedy might bring bad luck. This was a significant occasion, too, as the first important festivity since the bloody Saint Bartholomew's Day Massacre (August 23–24, 1572) that she had ordered. For this spectacular icebreaker Catherine brought Italian and French talents in music, verse, dance, and drama all together in unprecedented splendor to tell the familiar Homeric story of Ulysses escaping from Circe. The costly production was described by its director as "a geometrical arrangement of many persons dancing together under a diverse harmony of instruments."

Catherine had also imported from Florence her respect for academies and an enthusiasm for court spectacles. Out of these interests grew a new literature of ballet as a self-conscious art of the dance. A pioneer was Jean-Antoine de Baïf (1532–1589), wealthy member of the celebrated Pléiade, who aimed to enrich French language and literature while reviving the Greek theater. Baïf invented a system of *vers mesures* "to unite music with dance, song and measure as in the ancient days of Greece." Insisting on "music" as the art of all the Muses, it made dance an equal of all the other arts, and seventeenth-century France produced a philosophy and a vocabulary for the ballet.

Louis XIV (1638–1715; reigned 1643–1715) himself gave the ballet a royal dignity. "The dance," Voltaire reported in his *Age of Louis XIV,* "which may still be reckoned one of the arts since it is subject to rules and gives grace to the body, was one of the favourite amusements of the court. Louis XIII had only once danced in a ballet, in 1625; and that ballet was of an undignified character which gave no promise of what the arts would become in France thirty years later. Louis XIV excelled in stately measures, which suited the majesty of his figure without injuring that of his position." Louis XIV acquired the sobriquet "le roi soleil" from his role wearing a headgear of sun's rays in *Le Ballet de la nuit* (1653), under the influence of the imported Italian violinist-composer Jean-Baptiste Lully (1632–1687). With a taste for the grand and the melodramatic, Lully collaborated with Molière in a series of *comédies-ballets* of which *Le Bourgeois Gentilhomme* (1670) was the most famous.

The French Academy (L'Académie Française), founded by Louis XIII in 1635 to be guardian of the French language, was the first of several academies designed to enrich the national culture. The manifesto of the Academy of Painting and Sculpture (1648), created by Colbert, minister to Louis XIV, declared that the purpose of art was to deal only with grand and important subjects, never with the common or the familiar (in which "nature" was included). The painter was to rely on the ancients, because "observation" was degrading. And painting was to be judged not by artists or the public but only by the "infallible king." An Academy of Science was Colbert's creation in 1660, followed by the Académie Royale de Danse in 1661 to reform abuses and raise standards in the art of dance. It employed thirteen dancing masters "to re-establish the art in its perfection." Then the Académie Royale de Musique (1669) added a school of dancing in 1672, from which the professional dancer developed. "Colbert, the Maecenas of all the arts," Voltaire reported, "founded an Academy of Architecture in 1671. A Vitruvius is not enough, one must have an Augustus to employ him." For Colbert, Louis XIV would play the role of Augustus.

Until 1670, when he was thirty-two, the king himself made a practice of

dancing in the ballet. Then, at a performance of Corneille's tragedy *Britannicus,* he was struck by the following lines:

> His chief desert in trifling feats to place,
> To drive the chariot foremost in the race,
> In low pursuits to win th' ignoble prize,
> Himself expos'd a show to vulgar eyes.
> (Translated by Martyn P. Pollack)

From that time he danced no more in public; the poet had reformed the monarch.

This era produced the *ballet d'action,* not a mere bouquet of dances, but a new form that told a story without words spoken or sung. This put new pressure on the dancer to be expressive. Yet Vitruviuses of the dance, offering treatises which purported only to summarize "the great masters," actually prescribed rigid rules. One of the most influential was *The Dancing Master* (*Maître à Danser*) (Paris, 1725), by the French composer Jean-Philippe Rameau (1683–1764). Following earlier textbooks, he prescribed that the feet must always be turned outward, and then he precisely described the five basic "positions" that bear the modern names.

This dogmatic "perfection" of prescribed forms invited a liberator. He came in the person of Jean-Georges Noverre (1727–1810), sometimes called "the Shakespeare of the dance." While he created some 150 ballets in Paris, Vienna, and Stuttgart, his influence was mainly as a reformer. He aimed to free the expressive body of the dancer from stereotyped positions, to liberate the face from heavy masks, and remove the cumbersome armor in battle dances and other costumes that concealed the body. In that age of "rococo" (from French *rocaille,* for elaborately carved rockwork), which concealed beautiful forms with extravagant decoration, Noverre's *Lettres sur la danse et sur les ballets* (1760; 1807) marked a new era. His theories of *ballet d'action* and expressive movement reached across Europe even to St. Petersburg and still speak to modern ballet.

Noverre's first successful creation in ballet, *Les Fêtes Chinoises* (1754) had caught the attention of the famous actor David Garrick (a member of Dr. Samuel Johnson's Literary Club), who produced it in London the next year. Then Garrick's copious library provided Noverre with the materials for his epoch-making *Letters.* He was said to have done for ballet what Gluck (1714–1787) did for the opera. He knew Gluck and collaborated with him, choreographing an opera about ancient Greek games. Just as Gluck gave up the set patterns of Neapolitan recitative and aria for a coherent opera drama, so Noverre abandoned the fragmentary divertissement and the tech-

nical performance of the several prescribed positions for a coherent *ballet d'action,* a connected story.

The growing popular interest was fed by controversy between the "high dance" (*danse haute*) and the low dance (*danse basse*) or close-to-earth (*danse terre à terre*). The Renaissance ballet of aristocrats and amateurs in a ballroom was seen on a horizontal plane. But with the movement onto the opera stage, the old "noble" dance along the floor acquired a new vertical dimension, tempting dancers to spring into the air. "Once there were dances," some complained, "now only jumps," which Addison at the turn of the century had forecast in *The Tatler:*

> I was this morning awakened by a sudden shake of the house, and as soon as I had got a little out of my consternation I felt another, which was followed by two or three repetitions of the same convulsion. . . . I looked in at the keyhole, and there I saw a well-made man look with great attention on a book, and on a sudden jump into the air so high that his head almost touched the ceiling. He came down safe on his right foot, and again flew up, alighting on his left; then looked again at his book, and holding out his right leg, put it into such a quivering motion, that I thought he would have shaked it off.

Public interest was also piqued by rivalry between two famous ballerinas, Marie-Anne Camargo (1710–1770), who scandalized spectators by shortening her skirts above the ankle to reveal her new footwork, and her rival Marie Salle, (1707–1756), who shocked them by displacing the heavy panniered skirts with simple drapes and allowing her hair to hang loose instead of being covered with a wig.

Noverre, whom Voltaire christened "a Prometheus," had come from the provinces, and so was not quite a Parisian. But he spoke up in a voice that would reach dancers across Europe: "Children of Terpsichore, renounce cabrioles, entrechats and over-complicated steps; abandon grimaces to study sentiments, artless graces and expression; study how to make your gestures noble, never forget that is the life-blood of dancing; put judgment and sense into your pas de deux; let will-power order their course and good taste preside over all situations; away with those lifeless masks, but feeble copies of nature. . . ." When, at the time of the French Revolution, Noverre found refuge (1782–89) in London, he also finally returned to the stale conventions of professional ballet, contradicting his lifelong message against stilted rules. He now decreed that the dancer's two feet must be no more than eighteen inches apart, that no stage could hold more than thirty-two dancers, and that no previously composed music could be used by a choreographer. But Noverre's earlier ideas could not be put back in the bottle. He had already liberated the dance and made possible the "Roman-

tic" ballet with its emphasis on lightness and grace. This was the ballet that dominated the stages of European capitals in the nineteenth century.

"Romantic" ballet was still another move toward the vertical. To keep the dancer in the air, Charles Didelot (1767–1837) in his *Zephyre and Flore* (1796) in London introduced the *pointes,* dancing on the tips of the toes. He was said to have originated flesh-colored tights for women. Aerial dancing was made easier by the English mechanics' flying machine, which lifted dancers around the stage and held them momentarily on their toes before they took flight. Summoned to Russia in 1801, Didelot was principal dancer and ballet master in the Imperial St. Petersburg School, which had been founded by Empress Anne in 1738, and where dance was languishing. Didelot added other signal innovations, making the pas de deux a conversation between two dancers. His choreography, and especially his reform of the training of dancers in the Imperial School, brought a new expressiveness to the dance in Russia, and created the grand spectacles of Russian ballet. Reinforced shoes made toe dancing easier and facilitated brilliant pirouettes.

Meanwhile in Paris, too, *La Sylphide* (1832) signaled the Romantic spirit, with dancers on their toes, and newly defined the difference between the male and female dancers. The poet Théophile Gautier (1811–1872) became the prophet of the movement. After the epoch-making production of *La Sylphide,* with the sensational Italian ballerina Marie Taglioni (1804–1884), he rejoiced that "the Opera was given over to gnomes, undines, salamanders, nixes, willis, peris—to all that strange and mysterious folk who lend themselves so marvellously to the fantasies of the ballet master." It was said that Taglioni gave a new spirituality to ballet by her astonishing ability to remain suspended in the air. Her lightness was the more phenomenal because her shoes were not blocked and her support came simply from the darning of the toe.

If ballet was at first a French creation, modern ballet was very much a Russian re-creation—the curious product of foreigners like Didelot who came to Russia, and of Russians abroad. A new classical ballet developed. In several senses it was an expatriate renaissance. A French dancer, Marius Petipa (1819–1910), went to the Maryinsky Theater in St. Petersburg in 1847 where, in the next sixty years, he choreographed and produced more than sixty ballets, which became there the foundation of modern classical ballet. He collaborated with Tchaikovsky on *The Nutcracker,* and *Sleeping Beauty.* He choreographed his own version of *Swan Lake.* Tchaikovsky's first ballet for the Imperial Theater (*Swan Lake,* 1877) had initially not been enthusiastically received. And when Tchaikovsky was asked to write the music for *Sleeping Beauty,* he accepted the commission only after he had

received a libretto from Petipa. Petipa's new classical ballet style combined the ballet of grand spectacles with close attention to the brilliant performance of the traditional positions.

The ephemeral character of the art of dance was dramatized in the remarkable man who refurbished the modern ballet. Sergei Diaghilev (1872–1929), though he had the greatest shaping influence on modern ballet, was not himself a dancer or choreographer, nor a creator of music or poetry or painting. He was simply a creator of occasions. But he was more than an impresario—a mere promoter or manager—for he created unique balletic spectacles that retained a Russian character while co-opting the great choreographers, dancers, composers, and painters of his day. Diaghilev was born to an old Russian family in Perm in the Urals. His father was a major general and his mother a noblewoman, who died in childbirth. When he arrived in St. Petersburg to attend law school at the university, he was decidedly a provincial Russian. While a student he fell in with painters and musicians, and developed a lively interest in all the arts. He enjoyed the operas at the Maryinsky Theater, and his first ambition was to be a composer, but when Rimsky-Korsakov heard him play one of his own compositions, he persuaded the young Diaghilev to look in some other direction. On his first trip abroad in 1893 he met the great figures of the day, including Zola, Gounod, and Verdi.

Diaghilev's broad enthusiasm for the arts led him to aspire to be a patron even though he lacked the wealth. And his homosexuality made many wary of collaborating with him. Still very early he found ways to focus interest on the artists he admired. He organized an exhibit of German and British watercolors in 1897, and other art exhibits soon thereafter. His International Exhibition of painting in 1899 included works by Degas, Monet, and Renoir. In the first issue in November 1898 of his magazine, *Mir Isskustva* (The World of Art), Diaghilev took for his motto a quotation from Michelangelo, "He who follows another will never overtake him." And then from Dostoyevsky, tying literature to the fine arts, "Ideas fly through the air, but they are conditioned by laws which we cannot understand. Ideas are infectious, and an idea which might be thought the prerogative of a highly cultured person can suddenly alight in the mind of a simple, carefree being and take possession of him." His regular visits to Bayreuth introduced him to Wagner's *Gesamtkunstwerk*—unified work of art—which he would try to realize in his own way.

After a brief stint on the staff of the Imperial Theater in St. Petersburg, Diaghilev organized exhibits of portraits and concerts and produced his first opera, *Boris Godunov,* to Moussorgsky's music at the Paris Opéra in 1908, with Fyodor Chaliapin singing the title role. In 1909 Les Ballets Russes de Serge Diaghilev opened its first season at the Théâtre Chatelet in Paris.

From the beginning the brilliant renaissance of modern ballet drew on Russian sources. His collaborator in this beginning was the young Michel Fokine (1880–1942), who choreographed *The Firebird* (1910), based on Russian folktales to the music of Igor Stravinsky, who would make his reputation composing for Diaghilev. The next season he produced another Stravinsky ballet, *Petrouchka* (1911), with scenery painted by Aleksandr Benois, which developed the Russian folk theme of puppets coming to life in scenes at the fair on the frozen Neva River. For this, Fokine created memorable choreography for the great dancer Vaslav Nijinsky (1888–1950), proving that in ballet "it should be the whole body that dances. Everything down to the last muscle must be expressive, be eloquent."

When Diaghilev produced *The Rite of Spring* (1913) with Stravinsky's music, he had already shocked the Paris audience by the realistic eroticism of his production in 1912 of *L'Après-midi d'un Faune,* also choreographed by Nijinsky. Now he aimed to re-create a primitive Russian folk ritual, with its adoration of the earth, selection of a sacrificial victim, and finally the sacrifice itself. At the first performance on May 29, 1913, the audience rebelled against the dissonance of hammered discords and rhythmic repetition in Stravinsky's music, accentuated by the frenetic twists and jerks of Nijinsky's dance. Screams and catcalls from the outraged audience drowned out the music. "Listen first!" Diaghilev shouted, "Whistle afterward!" Critics the next day called it *Le Massacre du Printemps.* The audience proved that something shockingly new had been created. "But we must wait a long time," Stravinsky prophesied, "before the public grows accustomed to our language. Of the value of what we have accomplished I am convinced, and this gives me strength for future work."

After the London season that year, Diaghilev's company, which Fokine had left, went on tour to South America. Plagued by obsessive fear of the ocean, Diaghilev did not accompany them. When Diaghilev heard that Nijinsky had married a dancer in the corps de ballet he dismissed him and ended their intimacy. To replace Nijinsky, he boldly chose the eighteen-year-old Léonide Massine (1895–1979). While drawing on the post–1917 nostalgia for the aristocratic splendor of czarist Russia, Diaghilev had a wonderful catalytic power to find the latent talent in young artists. His expatriate Russian renaissance of the ballet spread the gospel of ballet across the Atlantic. His famous exhortation to Cocteau, with whom he was collaborating on *Parade* in the very year of the Russian Revolution, expressed his evocative powers, "*Etonne-moi!*" The lavish spectacles of the Russia of the czars took on a new life.

With a succession of choreographers—Michel Fokine, Vaslav Nijinsky, Léonide Massine, and George Balanchine—Diaghilev re-created classical ballet. For composers he drew on Ravel, Richard Strauss, Prokofieff, De-

bussy, Milhaud, and for set design and costumes he enlisted Derain, Picasso, Roualt, and Chirico among others. Disciples like Anna Pavlova (1881–1931) formed their own companies and carried the Ephemeral Art to spectators around the world.

After Diaghilev's death in 1929, Lincoln Kirstein invited his most brilliant disciple, George Balanchine (1904–1983), to New York. There Balanchine founded the School of American Ballet (1934), and after 1948 was artistic director of the New York City Ballet. He created new freer dance movements, sometimes geometric, sometimes drawn from ice-dancing and gymnastics, and choreographed several hundred ballets to the music of a wide variety of composers. Emphasizing abstraction, he was innovative in bodily movements and in extracting movement from the music. Balanchine ballet was American in more than name. It was a far cry from the czar's Imperial Theater when he drew boldly on American subjects, choreographing *Who Cares?* to music by Gershwin and *Stars and Stripes* to Sousa. And he popularized ballet by incorporating it into musical comedy. His choreography for *On Your Toes, I Married an Angel, Babes in Arms,* and *Louisiana Purchase* helped make these into Broadway hits, and happily blurred the distinctions between the dance, drama, and music. He also helped make the art less ephemeral by staging dances for motion pictures, including *The Goldwyn Follies, On Your Toes,* and *I Was an Adventuress.*

While Balanchine was adeptly mixing dance with drama in his choreography for American musical comedy, American pioneers of modern dance were declaring independence from the ballet. Their prophet was Isadora Duncan (1878–1927). Born in San Francisco the fourth child of a reckless businessman who abandoned the family, she led a vagrant childhood as her mother tried to avoid unpaid landlords. Her strong mother supported the children by giving piano lessons, and instilled a love of drama and music by playing for them the works of the great composers and by reading poetry aloud. As a child Isadora began dancing by herself—for the family at home and out on the beach. At six, when seen teaching neighborhood children how to wave their arms gracefully, she explained to her mother that this was her own dancing school.

Reading widely, Isadora came under the influence of the writings and disciples of François Delsarte (1811–1871), the French inventor of a system of calisthenics to increase coordination and grace. Delsarte's nine laws of gestures were designed for freedom of expression and relaxation of all parts of the body. Ruth St. Denis (1877–1968), another American pioneer, was also influenced by Delsarte's ideas. In New York Isadora became "the pet of society," dancing at private occasions for wealthy ladies to recitations of the *Rubaiyat,* and to the music of Strauss and Mendelssohn. Voluble about

her philosophy of the dance, she boasted at nineteen that she had had ten years' experience teaching and innovating. Like Ruth St. Denis, she had already conceived a dislike for the stilted ballet when her mother shepherded the family to London in 1900. There she began as an actress-dancer, but soon focused on the dance. Reading Winckelmann's *Journey to Athens,* she studied the Greek vases and sculptures in museums for the figures of ancient dancers and developed her own ideal of Greek dance.

Pursuing this Greek ideal, Isadora shocked society audiences in London and Paris by her bare feet and legs, her clinging and revealing costume, and her free movements. "Toe walking deforms the feet," she declared, "corsets deform the body; nothing is left to be deformed but the brain. . . ." In Paris she supported herself by teaching dance to the children of the rich. Working for hours by herself in her studio she arrived at her own simple dance formula, which made "solar plexus" a familiar phrase among those who could not locate it. "For hours I would stand quite still, my two hands folded between my breasts, covering the solar plexus. . . . I was seeking and finally discovered the central spring of all movement, the crater of motor power, the unity from which all diversities of movement are born, the mirror of vision for the creation of the dance—it was from this discovery that was born the theory on which I founded my school." As apostle of the "free dance," she performed in European capitals, and visited Russia in 1905. Diaghilev, who had not yet made his mark, recalled that then "Isadora gave an irreparable jolt to the classic ballet of Imperial Russia." But the patron of the ballet, Prince Peter Lieven, saw in Isadora "the beginning of the new outlook . . . the first to bring out in her dancing the meaning of the music; she was the first to *dance* the music and not dance *to* the music."

Isadora returned for tours to America, where again she shocked audiences by her scanty costume, especially now when obviously she was pregnant. She already had borne her first child to the English stage designer Gordon Craig, and now carried the child of Paris Singer, the sewing-machine heir. But in France she was a celebrated success. The new Théâtre des Champs-Élysées immortalized her in a bas-relief on the theater's façade and in a mural within. Still, it was a time of tragedy. In 1913 her two children were drowned with their nurse when their automobile ran into the Seine. Three years passed before she could recover enough from her anguish to resume dancing. In 1921, she was invited by the Soviets to set up her own school of the dance. Exhilarated by this call "to meet my destiny," she was soon frustrated by the Soviets' delays in providing a place to meet her pupils and then their refusal to support the school. She still did her best to find some way to teach dance to Soviet children.

Then she multiplied her problems in 1922 by a passionate love affair with a half-mad young Russian poet, Sergei Yesenin. To take him to the United

States with her, he would have to be her husband, so she overcame her scruples against marriage and brought him along. A tempestuous tour followed in which hostility to her as a "Bolshevik agent" was complicated by Yesenin's riotous behavior as he ranted nude through hotel corridors smashing bottles and furniture. Since the Soviets still would not release the children of her school for her American tour, all her performances were solo—and a spectacular well-publicized failure. Her frustrated impresario Sol Hurok used all his efforts to keep her dancing instead of lecturing to hostile audiences, and to prevent the drunken Yesenin from beating his wife in hotels. Isadora repeatedly claimed that she was not a "Bolshevik" but only a "revolutionist," which was too fine a distinction for American audiences. In 1923, the couple went back to Europe. She performed in Paris; Yesenin returned to Russia and committed suicide.

Isadora made a last tour of Russia and Germany. But she was getting old for a dancer, drinking heavily, and gaining weight. She created two dances for Lenin's funeral in 1924. Increasingly suspect as a Bolshevik propagandist, she lost bookings in France and Germany. Needing money, she pretended to be starving to death, and when friends rushed to her rescue she persuaded them to replenish her wine cellar. She signed a contract to write her memoirs, but before the book was written she had used up the advance. Friends planned benefit concerts to repurchase her house, which had been sold to meet her extravagant debts. After farewell performances in Paris, she moved to Nice, depressed and still looking for her ideal lover.

Pursuing her luxurious tastes and pretending, although she was penniless, that she wanted to buy a flashy Bugatti sports car, she had it delivered to her for a test ride with the handsome driver. Wearing a long red scarf wrapped around her neck, she climbed into the car announcing *"Adieu, mes amis, je vais à la gloire"* (Farewell, my friends, I go to glory). As the car lurched forward her scarf caught in the spokes of a wheel and she was instantly strangled.

Isadora's legacy was not so much in her often-repeated theory of dance as in her insistence on the freedom to dance, and her unforgettable demonstration of what that meant. "Don't be merely graceful," she declared. "Unless your dancing springs from an inner emotion and expresses an idea, it will be meaningless." She insisted, too, that "the real American type can never be a ballet dancer." "I shall not teach the children to imitate my movements—I shall help them develop those movements natural to them." She preached the liberation of the dance less effectively in her words than in herself. The English choreographer Sir Frederick Ashton, who saw her in London when he was a schoolboy, never forgot. "She was a little heavy by that time in her career, but it didn't matter. . . . Anyone of any age could duplicate *what* she did but not *how* she did it. When she raised her arms,

it was an incredible experience. She could also stand still—and often did—but it was an alive stillness and it was dancing."

Meanwhile Ruth St. Denis (1878–1968), whose career paralleled Isadora's, was finding her own way to give new life to the dance. She too sought to give outward expression to the "inward impulse," with exotic themes from Mexico, China, Japan, and elsewhere.

Martha Graham (1894–1991), Isadora's successor, came closer to creating a modern dance as a distinctive form with a recognizable style, which aimed to free the dancer from a stilted vocabulary. And her dance would be distinctively American. She was born to the family of a physician of old New England stock in a small town in Pennsylvania. "My people were strict religionists," she recalled, "who felt dancing was a sin. They frowned on all worldly pleasures. . . . My upbringing led me to fear it myself. But luckily we moved to Santa Barbara, California. . . . No child can develop as a real Puritan in a semitropical climate. California swung me in the direction of paganism, though years were to pass before I was fully emancipated." After high school she persuaded her family to send her to the Denishawn School of Dance in Los Angeles. Within three years after entering she was given the leading feminine role in Ted Shawn's Aztec ballet, *Xochitl.* Then she was hired for the Greenwich Village Follies and danced successfully with them for the next two years. Her opportunity to develop her own style came when she was engaged to teach dance at the new Eastman School, which also marked her break from the romantic strain of the Denishawn company. Now she saw herself no longer as a mere entertainer but as a committed artist in the dance.

By 1927 she had begun to create her own dance vocabulary. She was building her dance on contemporary American subjects, as in *Revolt* and *Immigrant,* and *Poems of 1917,* which excited the ridicule of Fanny Brice in a sketch for the Ziegfeld Follies. It is not surprising that her spectators were astonished, for Martha Graham had created a modern dance, a shocking kind of anti-ballet. This novelty was recognized in 1927, when *The New York Times* appointed its first dance critic, John Martin, who would become the theorist and philosopher of the new movement. The modern dance needed such a sympathetic critic and interpreter, for it was as different from the spectacular beauties of Diaghilev's Ballets Russes as Picasso's *Demoiselles d'Avignon* had been from the sentimental idols of the Academy. And, much as Picasso defied the conventions of "beauty" and of perspective, Martha Graham would defy the conventions of ballet. The classical ballet had refurbished the forms and traditions of court ballet, and the Romantic ballet was the freer elaboration of those forms by Fokine and others.

Like the Romantic ballet, modern dance was a kind of liberation but was still more radical. Its possibilities had been suggested by Isadora Duncan's "Greek" dance, and Ruth St. Denis's themes of "Oriental" dance. But Martha Graham would go further, to become the celebrated symbol and dominant influence in creating a new art of dance. The grand movement, as John Martin explained, was from spectacular dance (or ballet) to expressional dance (or modern dance). This was a simplifying revolution, which had few if any counterparts in the other arts. The extravagant productions of Diaghilev, bringing dancers together with the most celebrated musicians, painters, and dramatists, cried out for an art of simplification, which became the modern dance. And which returned to the basic movements of the human body.

The pioneers of the anti-ballet—Isadora Duncan and Martha Graham— both had their theories of the physiological basis of the dance. Martha Graham, however, sought her source not in the solar plexus but in the rhythm of breathing, inhaling and exhaling, contraction and response, "percussive" motion. What they both accomplished, however, was not the embodiment of a theory but a personalizing of the dance to express every dancer's self. They both had set themselves an individualist American ideal.

If there had been no ballet—spectacular, grandiose, formalized—modern dance might not have seemed radical. Ballet had made a spectacle of defying gravity, and depended on the dancer's ability to employ elegantly the canonical "positions," but Martha Graham's modern dance hugged the earth in bare feet. While ballet was the very model of prettiness, Martha Graham's modern dance was stark and angular. While the ballet dancers on their toes pointed the elongated feet to provide a graceful line of the leg, Martha Graham kept her bare feet at right angles to the leg. And while the ballet's "turn-out" tested the dancer's ability to turn out the knees farther than in everyday life to show the legs in profile even when the dancer faced forward, the modern dancer kept feet in their normal parallel.

Modern dance claimed its special creation to be an art of movement. By contrast, what had formerly been crucial in ballet was the positions, the attitudes and poses, and their combinations. "Movement," John Martin explained, "is the most elementary physical experience of human life . . . found in the expression of all emotional experiences; and it is here that its value lies for the dancer. The body is the mirror of thought. When we are startled, the body moves in a quick, short, intense manner. . . ." Martha Graham's language of dance was a new vocabulary of movement. And it was her aggressive, unpretty but expressive movements that irritated the seasoned ballet audience.

Martha Graham's creation also was a distinctively American revolution in dance. While the ballet was for and about kings and princes, she would

dance the common experience. With her own company, the Dance Group, in 1929 she turned from the exotic themes of Denishawn to simpler more familiar subjects, heralded by her *Adolescence*. And she developed American themes. For *Frontier* in 1935, her set was designed by the sculptor Isamu Noguchi, who used a simple section of a fence post at the rear of the stage and ropes overhead forming a broad V to suggest the boundless plains as she danced the American conquest of space. In *Primitive Mysteries* (1931), she tried to give American Indian religious rituals a universal significance. And she climaxed her Americana with her most celebrated work, *Appalachian Spring*, to Aaron Copland's music. In the spirit of all frontiers, her high kick expressed the desire to reach out. And her *Letter to the World* (1940), which danced the two spirits—the conformist and the rebel—in Emily Dickinson, expressed a similar conflict within everyone.

Finally Martha Graham made her own marriage of the arts, dancing theatrical themes of universal significance. *Deaths and Entrances* (1943) revealed the experiences of the Brontë sisters. She choreographed numerous works from Greek sources—*Cave of the Heart* (1946) on Medea, *Errand into the Maze* (1947) on the Minotaur legend, *Night Journey* (1947) on Oedipus, *Clytemnestra* (1958), and many on biblical themes, such as *The Legend of Judith* (1962) and *Acrobats of God* (1960). So Martha Graham finally proved able to transform myths, legends, and tradition into dances revealing "the inner man." With astonishing energy and versatility, while leading the revolution that liberated dance from the ballet, she created more than 150 of her own dances. And at last she ceased to be imprisoned in the stark simplicity of her early work. She was willing to use sets by Noguchi and other sculptors, costumes designed by the best painters, and to draw on the music of a widening variety of composers—Samuel Barber, Carlos Chavez, Gian-Carlo Menotti, and William Schuman. The style of her dance company became richly eclectic, combining avant-garde gymnastics with the themes of primitive ritual and folk dance, with some Japanese mime, some theater of the absurd, and surrealism, and even with the familiar ballet positions. Having sought ways to express emotion "directly" in movement, Martha Graham found that modern dance in America, like the nation itself, had to draw on myths and hopes from everywhere.

53

The Music of Innovation

As the arts of music flourished—and even as American popular music sped across the world—some of the most innovative composers became estranged from the large audience. Igor Stravinsky (1882–1971), often called the apostle of modernism in music, had the freedom of the self-trained amateur, and never lost his eagerness to try the new. But the works that brought him fame before he was thirty would, to his irritation, create unfulfilled popular expectations for the rest of his life. In his autobiography, written when he was forty-eight, he was already expressing his alienation from those who listened.

> At the beginning of my career as a composer I was a good deal spoiled by the public. Even such things as were at first received with hostility were soon afterwards acclaimed. But I have a very distinct feeling that in the course of the last fifteen years my written work has estranged me from the great mass of my listeners. They expected something different from me. Liking the music of *L'Oiseau de feu, Petroushka, Le Sacre,* and *Les Noces,* and being accustomed to the language of those works, they are astonished to hear me speaking in another idiom. They cannot and will not follow me in the progress of my musical thought. What moves and delights me leaves them indifferent, and what still continues to interest them holds no further attraction for me. . . . I believe that there was seldom any real communion of spirit between us. If it happened—and it still happens—that we liked the same things, I very much doubt whether it was for the same reasons. Yet art postulates communion, and the artist has an imperative need to make others share the joy which he experiences himself.

His first works, which established him as a major innovative composer, were still firmly rooted in the Russian folk tradition. The career that would take him away from "the great mass of listeners" was a voyage less of exile than of transplantation into Switzerland, France, and then into the United States.

Born near St. Petersburg, the third of four boys, as a son of the leading bass singer of the Imperial Opera, he would hear his father practicing arias. His boyhood memories of colorful St. Petersburg and visits to the nearby country estate of his uncle, and to rural summer fairs, stayed with him, as did the explosive temper of his father and the coldness of his mother. The first musical performance he recalled attending was Tchaikovsky's *Sleeping Beauty* when he was only seven. At nine he was given piano lessons, but was by no means precocious. His father did secure him a pass to opera rehearsals at the nearby Maryinsky Theater, where, by the time he was sixteen, he was spending five or six nights a week. To discourage his interest in making a career in music, his parents sent him to study law at St. Petersburg University.

A desultory law student, he went on composing, still hoping to prove to his family his talent for a musical career. A fellow student was the son of Nikolai Rimsky-Korsakov (1844–1908), the Russian nationalist composer whose works Stravinsky much admired. One summer while staying with the Rimsky-Korsakov family, he asked advice on how to become a composer. Rimsky-Korsakov, not impressed at hearing Stravinsky play his own compositions, sympathetically advised him not to enter the conservatory where Rimsky-Korsakov was a professor but to pursue his studies of harmony and counterpoint and to seek private instruction. Rimsky-Korsakov himself was mostly self-educated. He had never taken an academic course in musical theory, but had received crucial advice and encouragement as a young man from Tchaikovsky. Now he would play a similar role for Stravinsky.

With the death of his father Stravinsky was liberated from the pursuit of the law. Now, he said, his mother's "delight in torturing me seemed slightly less intense." He joined the disciples who met weekly at Rimsky-Korsakov's house to hear their compositions. Rimsky-Korsakov, now Stravinsky's mentor, for three years gave him two composition lessons a week, including the principles of sonata form and orchestration. When Stravinsky married Catherine Nossenko in 1906 (despite the law banning marriage between first cousins), the witnesses were Rimsky-Korsakov's two sons. Meanwhile Stravinsky was showing sketches for his compositions to his master for criticism and approval.

The death of Rimsky-Korsakov in mid-career in 1908 was a blow for Stravinsky, but a new patron would set the stage for his career. In February 1909, when two of Stravinsky's works—the *Scherzo Fantastique* and *Fireworks*—were performed in St. Petersburg, the audience included Sergei Diaghilev. His art review, *Mir Isskustva*, had recently ceased, and, as we have seen, Diaghilev was moving his energies to Paris. There, offering concerts of Russian music, he had just produced the first Paris performance of *Boris Godunov*, and was planning a season of Russian ballet. When the

established composer whom he had commissioned to write a new score for the ballet on the Russian folktale of the firebird could not deliver, Diaghilev turned to the young man whose music had so impressed him. Stravinsky's *Firebird* music drew on the young composer's lessons in orchestration from Rimsky-Korsakov, revived folk melodies, and charmed by its distinctive rhythms and syncopations for the ballet. Stravinsky's deft and lively score, distinguishing between the human and the magical elements in the story, delighted audiences and critics and brought him instant celebrity. This, the twenty-eight-year-old Stravinsky's first composition for the stage, would remain his most popular work, though he still had six productive decades ahead.

Even before the production of *The Firebird* in 1910 Diaghilev saw in him "a man on the eve of celebrity." Stravinsky joined Diaghilev's group, whom he captivated by his enthusiasm for all the arts and his "absence of the slightest dogmatism." The dazzling Paris galaxy of his acquaintances included Claude Debussy, Maurice Ravel, and Giacomo Puccini, Marcel Proust and Paul Claudel, and Pablo Picasso.

His next work with Diaghilev, *Petrouchka,* was also based on a Russian folk theme. This time it was the story of a puppet at a Russian country fair, how it is brought to life, then dies, but finally reappears as a ghost. The first performance on June 13, 1911, with Nijinsky as Petrouchka, was again acclaimed, doubly reassuring Stravinsky, who had a newly active role in planning the ballet. "It gave me the absolute conviction of my ear just as I was about to begin *The Rite of Spring.* "

Stravinsky's triumph with his music for Diaghilev's *The Rite of Spring,* first performed at the Théâtre des Champs-Élysées in Paris on May 29, 1913, as we have seen, created a *scandale* in the musical community, but confirmed his role as the leading modernist composer. At the end of the tumultuous evening Diaghilev had commented, "Exactly what I wanted!" Stravinsky reported himself and Nijinsky to be "excited, angry, disgusted and happy." The shocking originality of his music for *The Rite* was Stravinsky's unmistakable victory over his parents' efforts to stifle his talents in an uncreative conventional life. And it was no accident that he chose the rite of *spring,* the season that Stravinsky himself remembered from his childhood on the Russian countryside as a time of sudden rebirth "that seemed to begin in an hour and was like the whole world cracking."

At the age of thirty-one, Stravinsky had achieved a reputation as the musical prodigy of the twentieth century and created works that would continue to please large audiences. His next sixty years produced an encyclopedia of sometimes contradictory musical experiments. During his long and restless life he would divide himself among three nationalities. When World War I

broke out he was a European celebrity in the world of music, and for the past four years had been living in a Swiss mountain chalet, returning to Russia only for the summers. Exempted from Russian military service for reasons of health, he preferred the peace of neutral Switzerland to a nation threatened by revolution and disrupted by war. But he did not feel exiled from what interested him most—music and the arts. He kept in touch with Diaghilev, and during visits to Rome he found an affinity of spirit with Picasso. He came to know André Gide and was asked to write incidental music for Gide's translation of Shakespeare's *Antony and Cleopatra.* "When I suggested that the production be in modern dress," according to Stravinsky, "he was shocked—and deaf to my arguments that we would be nearer Shakespeare in inventing something new." In 1920, restless and ready to leave Switzerland, he first thought of moving to Italy, but decided instead to settle in France, the country of his epochal successes. There he would remain for the next twenty years, becoming a French citizen in 1934.

A series of personal losses—the death of his daughter, his wife, and his mother—and the opening of World War II led him in 1939 to move to the United States—and to new experiments. His Charles Eliot Norton Lectures on poetry at Harvard became the *Poetics of Music,* where he collected his ideas on the phenomenon of music, the composition of music, and the performance of music. In 1940 he married Vera de Bosset, an artist of long acquaintance, and they went west—he said that he needed the California climate for his health. They formally reentered the United States from Mexico in the Russian quota and applied for naturalization papers, bought a house and settled in Hollywood for the next twenty-five years.

In 1938, even before coming to America, he had received a request from the Disney office for permission to use the music of *The Rite of Spring* in *Fantasia.* They explained that they did not really need his permission since *Le Sacre* had not been copyrighted in the United States, but still they offered five thousand dollars for the right to show it abroad. Stravinsky attended a showing with George Balanchine in Hollywood in 1939. "I remember someone offering me a score and, when I said I had my own, the someone saying, 'But it is all changed.' And it was indeed." After settling in Hollywood, he never could agree with the moviemakers despite many invitations, including one for Orson Welles's *Jane Eyre* and for Franz Werfel's *Song of Bernadette.* When he was offered one hundred thousand dollars "to pad a film with music," he refused, but was told that he would receive the same fee if he would let someone else compose in his name.

He was not averse to bizarre experiments in his own name. When George Balanchine was asked by Ringling Brothers of the Barnum and Bailey Circus to commission a ballet for young elephants in 1942, he passed on the request to Stravinsky. "If they are very young," Stravinsky agreed, "I'll do

it." And he produced his *Circus Polka* in two versions. Stravinsky's music for *The Firebird* had made Pavlova so uneasy in 1910 that she refused the title role. Now Stravinsky's rhythms made the young elephants uneasy. Elephants, their trainer explained, were dignified animals who preferred waltzes and soft, dreamy tunes, but they finally gave in, and, costumed in tutus, performed Stravinsky's *Polka* 425 times. The symphonic version was performed by the Boston Symphony in 1944.

In the war years Hollywood had much to offer a lover of experiment. Thomas Mann said he found Hollywood at that time "a more intellectually stimulating and cosmopolitan city than Paris or Munich had ever been." The Stravinskys, too, enjoyed a circle of the arts that included Nadia Boulanger, Aldous Huxley, Franz Werfel, and countless others. "The ferment of composers, writers, scientists, artists, actors, philosophers and phonies did exist," observed Vera Stravinsky, "and we often attended the lectures, exhibitions, concerts, performances, social gatherings of these people ourselves." In 1945, after the war had ended, Stravinsky became an American citizen.

Stravinsky's career as a refugee from disorder through three nationalities and the turbulence of two world wars affirmed his indelible and uninterrupted citizenship in the experimental world of music. Thus he remained always at home making something new of every form. Although his early success had been in the traditional materials of his Russian nationality, his later experiments ran the gamut of musical genres and traditions. After the shocking modernism and complexity of *The Rite of Spring,* he turned in new directions, in a "neoclassical" period all his own. *The Soldier's Tale* (*L'Histoire du Soldat*) in 1918 was a landmark departure from nineteenth-century performance styles—in its surprising mixture of instruments, in rejecting the familiar forms both of orchestra and opera. With three dancers, a narrator, and seven instrumentalists, it was designed for performance on a portable stage, and helped introduce the "group-virtuoso" or "combo"—clusters of performers who see themselves uniquely re-creating the composer's work, each performance being a new experiment. Composed in collaboration with the Swiss writer C. F. Ramuz, *The Soldier's Tale* was an entertainment "to be read, played, and danced." It was another new style for Stravinsky, using a small orchestra and borrowing the rhythms of jazz. A kind of simplified mini-Faust, it told of a soldier returning to his native village, being tempted by the Devil, falling in love with a princess, and finally losing his soul to the Devil. Stravinsky later explained that he had never heard a work of jazz performed, but took his knowledge from the sheet music. "I could imagine jazz sound, however, or so I like to think. Jazz meant, in any case, new sound in my music, and *l'Histoire* marks my

final break with the Russian orchestral school in which I had been fostered."

Stravinsky showed the boldness of his departure in his *Symphonies of Wind Instruments* in 1921 where by "symphony" he did not suggest the sonata form but simply meant that instruments were sounding together. "This music is not meant 'to please' an audience," he later explained, "or to rouse its passions. I had hoped, however, that it would appeal to those in whom a purely musical receptivity outweighed the desire to satisfy emotional cravings." But this had never happened "as the character of my music demanded the most delicate care to attain the ear of the public and to tame the audience to it." Collaborating with his friend Jean Cocteau (1889–1963), he made an opera-oratorio of *Oedipus Rex,* intended as a present in honor of Diaghilev's twentieth anniversary in the theater, first performed by the Russian Ballet in Paris in 1927.

He could also experiment in religious music, where he was hardly more at home than in jazz, but where he was no less imaginative. Living in France, in 1929 he was commissioned by Koussevitsky to write a symphonic work for the Boston Symphony Orchestra's fiftieth anniversary. His publisher wanted "something popular"—a work in the nineteenth-century symphony form without chorus. But Stravinsky had other ideas. He had long been thinking of a psalm symphony compounded of parts of the Thirty-eighth and Thirty-ninth psalms and the whole of the Hundred and fiftieth Psalm, to be sung in Latin. What emerged was his Symphony of Psalms in three parts—Prelude, Double Fugue, and Allegro symphonique—for a chorus of mixed voices and orchestra.

Music historians have ranked this high among his works. But Stravinsky was dismayed that the work was not properly appreciated at the time, and he explained in his *Autobiography:*

> Most people like music because it gives them certain emotions, such as joy, grief, sadness, an image of nature, a subject for daydreams, or—still better—oblivion from "everyday life." They want a drug—"dope." It matters little whether this way of thinking of music is expressed directly or is wrapped up in a veil of artificial circumlocutions. Music would not be worth much if it were reduced to such an end. When people have learned to love music for itself, when they listen with other ears, their enjoyment will be of a far higher and more potent order, and they will be able to judge it on a higher plane and realize its intrinsic value. . . .
>
> All these considerations were evoked by my *Symphonie des Psaumes* because, both by the public and the press, the attitude I have just described was specially manifested in regard to that work. Notwithstanding the interest aroused by the composition, I noticed a certain perplexity caused, not by the music as such, but

by the inability of listeners to understand the reason which had led me to compose a symphony in a spirit which found no echo in their mentality.

There was ample reason for puzzlement in the audience hearing a symphony of religious texts whose composer warned against seeking any religious meaning. Before this work he had been a communicant of the Orthodox Church for some four years. His Swiss friend and a favorite conductor of his works, Ernest Ansermet, observed that "as Stravinsky, in response to some form of inner compulsion, does not make of music an act of self-expression, his religious music can reveal only a kind of 'made-up' religiosity. The *Symphony of Psalms,* for instance, expresses the religiosity of others—of the imaginary choir of which the actual singing choir is an *analogon:* but it must be agreed that the expression of this religiosity is itself absolutely authentic."

The quarter century of Stravinsky's American reincarnation offered example after example of new experiments. In 1947 a Chicago exhibition of eight paintings by William Hogarth (1697–1764), *The Rake's Progress* (1732–33), seemed to provide a "succession of operatic scenes" for the opera around English themes and with "music originated in the English prosody" that he had long thought of composing. His Hollywood neighbor Aldous Huxley suggested W. H. Auden as the librettist, and Stravinsky brought Auden, who considered this assignment the "greatest honor" of his life, to Hollywood. There they laid out the plot, action, scene, and characters. In 1948 Auden delivered the brilliant libretto, written with his friend Chester Kallman, and Stravinsky spent three years composing the music. He aimed to create an opera in the "Italian-Mozartian" style. The story followed the themes of Hogarth's series from the inheritance of a fortune by Tom Rakewell through his exploits, his drunken orgy with whores, his arrest for debt, his rescue from prison by the lovely Sarah Young, whom he had seduced and who had borne him a child, his marriage to a rich old lady, gambling away his second fortune, then being imprisoned for debt, and ending life in a madhouse. The Hogarth themes are enriched and embellished by witty Auden touches—hints of Dr. Faustus and a new character who offers Faustian temptations to the hero. In Auden's fantastic epilogue the devil fails in his gamble for Tom Rakewell's soul, but succeeds in condemning him to Bedlam, where Tom believes he is Adonis awaiting his Venus, before his death and the end in a morality-play message.

To Stravinsky his two earlier short operas, *The Nightingale* (1914) and *Mavra* (1922), seemed strangely remote from what he had now done. "I believe 'music drama' and 'opera' to be two very, very different things," Stravinsky observed at the first American production of *The Rake's Prog-*

ress in 1953. "My life work is a devotion to the latter. *The Rake's Progress* is, emphatically, an opera—an opera of arias and recitatives, choruses and ensembles. . . . in the line of the classical tradition." Already, in his Norton lectures, he was gladly "provoking a quarrel with the notorious Synthesis of the Arts. I do not merely condemn it for its lack of tradition, its *nouveau riche* smugness. . . . the application of its theories has inflicted a terrible blow upon music itself . . . the halcyon days of Wagnerism are past and . . . the distance which separates us from them permits us to set matters straight again." Opera was badly in need of renewal. "In the past one went to the opera for the diversion offered by facile musical works. Later on one returned to it in order to yawn at dramas in which music, arbitrarily paralyzed by constraints foreign to its own laws, could not help tiring out the most attentive audience in spite of the great talent displayed by Wagner. So, from music shamelessly considered as a purely sensual delight, we passed without transition to the murky inanities of the Art-Religion."

When Auden delivered his libretto for *The Rake's Progress* in 1948, he introduced Stravinsky to Robert Craft, a young man of twenty-four, a fervent admirer, who would play a crucial role in Stravinsky's work during the next years. Craft came to Hollywood, lived in Stravinsky's house, became his close assistant, and helped on *The Rake's Progress.* "During the intermissions," Craft reported of the first performance at La Fenice in Venice, in September 1951, "one . . . heard the expected comments about Stravinsky's right to use the old operatic conventions and formulae—by people who had not yet learned the wisdom of Ezra Pound's remark 'Beauty is a brief gasp between one cliché and another'—but the majority of the audience would have conceded him anything or followed him anywhere."

And it was Craft in his mid-twenties who would lead the eminent Stravinsky nearing seventy in new directions. An enthusiast for "modern" music, Craft had directed performances of Schoenberg, Webern, Berg, and Bartók—and an all-Stravinsky program. Now Craft urged Stravinsky himself into a new world of serial music. Serialism, of which twelve-tone music is an example, was music constructed through permutations of elements (for example, pitch or duration) in a series. It had been tried by some medieval composers and others, but it developed in Europe after World War I. Its pioneer and most influential champion, the Austrian-born Arnold Schoenberg (1874–1951), had abandoned traditional concepts of consonance and dissonance. A work would not conform to the tonal family of keys declared in Bach's *Well-Tempered Clavier* and instead was constructed around a series of tones repeated and patterned in various ways. In Schoenberg's twelve-tone method a composition was created from a row or series of twelve different tones, played consecutively or inverted. The harmonies and melodies were all drawn from the original row. Schoenberg saw this as

a liberation from tonal restraints, using all twelve tones of the chromatic scale in a particular work. Others objected that it confined the composer. But with this technique Schoenberg produced his most important work, the opera *Moses and Aaron* (1930–32, never completed), which contrasted the visionary but inarticulate Moses (Schoenberg himself?) with his disciple the selfish and voluble Aaron. Schoenberg did not admire Stravinsky's neoclassical style, which he rather nastily mocked in a verse that he set to music in 1926 (translated from the German by Eric Walter White):

> Why, who's coming here?
> It's little Modernsky!
> He's had his hair cut in an old-fashioned queue,
> And it looks quite nice,
> Like real false hair—
> Like a wig—
> Just like (at least little Modernsky thinks so)
> Just like Father Bach!

Schoenberg and Stravinsky had met casually in Europe many years before. For eleven years the two lived near each other in Hollywood, but did not meet again. Both were sought out by pilgrims who would not tell one he was visiting the other. Schoenberg's disciple Pierre Boulez also had attacked Stravinsky's neoclassical style for "a sclerosis of all realms: harmonic and melodic, in which one arrives at a fake academicism." He accused Stravinsky of being "incapable by himself of reaching the coherence of a language other than the tonal one" and so of "intellectual laziness, pleasure taken as an end in itself!"

With the death of Schoenberg in 1951, all the founders of serialism were gone, and Stravinsky may have felt that the modern world of serialism was ready for a new prophet. Now Stravinsky heard and studied the music of the serialists, whom he came increasingly to admire as "the only ones with a discipline that I respect. Whatever else serial music may be, it is certainly pure music. Only, the serialists are prisoners of the figure twelve, while I feel greater freedom with the figure seven." And he gradually moved into the serial world, with the *Canticum Sacrum* (1955) and *Agon* (1953–57), and then he began writing in the purely serial style. He adapted this technique for his song *In Memoriam Dylan Thomas* (1954), his *Threni* (1958) for voices and orchestra on texts from Jeremiah, and for *Movements* (1959). He composed a memorial *Introit* for his friend T. S. Eliot in 1965, and (orchestral) variations dedicated to Aldous Huxley in 1965. Some music critics were troubled that Stravinsky had so suddenly joined the bandwagon of a fashionable modernism, while others admired his versatility in adapting serial-

ism to his own purposes. But the large audience responded without enthusiasm. In 1962, Stravinsky remarked, when a new recording of *The Firebird* would sell up to fifty thousand sets in the United States, recordings of his recent serial works would seldom exceed five thousand. His early popular works were at the top of serious music played and broadcast by American symphony orchestras, but his serial works were seldom heard. Even his old friend Ansermet could not admire Stravinsky's works as a serialist.

While Stravinsky's first and enduring fame was based on his use of Russian motifs, he had no sympathy for the Revolution of 1917, which had expropriated his family's property, deprived him of his "last resources" and left him "face to face with nothing, in a foreign land and right in the middle of the war." "Russia has ever been untrue to herself," he observed in his Harvard lectures in 1939, "she has always sapped the foundations of her own culture and profaned the values of the phases that have gone before." Shostakovich's Ninth Symphony had been attacked in Stalinist Russia in 1946 for showing "the unwholesome influence of Stravinsky—an artist without a fatherland and without confidence in advanced ideas."

Still, after Stalin's death, when Stravinsky was invited to return to the Soviet Union and conduct a concert of his own works on his eightieth birthday, he found it hard to refuse. Denying that "nostalgia" had attracted him, he said he accepted the invitation only because of the "need for me by the younger generation of Russian musicians. No artist's name has been more abused in the Soviet Union than mine, but one cannot achieve the future we must achieve with the Russians by nursing a grudge." There were performances of *Petrouchka* and *The Firebird* at the Kremlin Palace of Congresses, and the concert he conducted of his own works was enthusiastically applauded. At the reception by the Minister of Culture attended by Shostakovich and Khachaturian, he gave a warmly sentimental speech: "The smell of the Russian earth is different." And though he had changed his nationality twice, he insisted, "A man has only one birthplace, one fatherland, one country"—the place of birth. He regretted that he had not been there "to help the new Soviet Union create its new music."

But Stravinsky did not need a Russian Revolution for his incentive. "I was made a revolutionary in spite of myself," he observed in 1939. Or, more precisely, he had found revolutions in himself. And in the very years when American popular music, assisted by the phonograph, motion pictures, and radio was reaching out to the world, creating vast new audiences, Stravinsky's quest for the new took him farther and farther away from the large community of listeners. From a composer who created a riot in the Paris Opéra with his rhythms and dissonances, he became a "musician's musician." Moving from *The Rite of Spring* through his versions of the neoclas-

sical, finally as a serialist his appeal was to the community of musicians. And he became the greatest single influence on the music produced in his lifetime. The modernism of his spirit consisted in his insatiable appetite for the new and his talent for making any musical form—opera, oratorio, concerto, symphony, song—something of his own.

PART TEN

CONJURING WITH TIME AND SPACE

Where the light is brightest the shadows are deepest.

—WOLFGANG GOETHE (1771)

54

The Painted Moment

THE story that begins with the reach to eternity climaxes in our time with the effort to capture the elusive moment. The power of stone enticed the builders of Stonehenge, the Pyramids, and the Parthenon. But it was the power of light that produced the most modern art forms, for light, the nearly instantaneous messenger of sensation, is the speediest, the most transient. Light, after the heavens and the earth, God's first creation in Genesis (1:3), remains the Judeo-Christian symbol of the presence of God. John the Baptist announced Jesus as light (John 1: 4ff.), affirmed by Jesus himself. Candles are lit on the Jewish Sabbath and mark holy festivals. And in modern times light has played surprising new roles for those who would re-create the world.

"Modernity," said Baudelaire, "is the transitory, the fugitive, the contingent, one half of art of which the other half is the eternal and the immutable." For this modern half, light is the vehicle and the resource. It was the Impressionists who made an art of the instantaneous, and Claude Monet (1840–1926) who showed how it could be done. To shift the artist's focus from enduring shapes to the evanescent moments required courage. It demanded a willingness to brave the jeers of the fashionable salons, a readiness to work speedily anywhere, and an openness to the endless untamed possibilities of the visual world. Cézanne summed it up when he said, "Monet is only an eye, but my God what an eye!"

The son of a prosperous grocer, Monet was born in Paris in 1840 and as a child of five moved with his family to Le Havre on the north side of the Seine estuary on the Normandy coast. That city, it was said, was "born of the sea," and so too was Monet the Impressionist. In the weather of Normandy, as generations of Channel passengers have painfully learned, the proverbially unpredictable sun, clouds, rain, and fog transform the sky and its sea reflections from moment to moment. Young Monet, impatient to flee the "prison" of school, eagerly explored beaches and cliffs. Until 1883 he was frequently refreshing his vision with visits to the French coast, north or south. Then he found in the Seine, in the Thames, and in his ponds at Giverny other water mirrors for his ever-changing world. "I should like to be always near it or on it," he said of the sea, "and when I die, to be buried in a buoy."

The first signs of his talent were his caricatures of teachers and other local characters in his school copybooks. By the time he was fifteen he was selling these in the shop of the local picture framer. There a chance encounter

would shape Monet's life as an artist and the future of Western painting. Eugène Boudin (1824–1898), a painter and son of a pilot, had worked on an estuary steamer before opening the picture-framing shop patronized by some of the leading artists of the age. They urged him to try his hand at landscapes. With Millet's encouragement Boudin went to Paris, where he rebelled against the studio style of the Beaux-Arts by painting natural scenes in the open air. Back in Normandy he painted vivid seascapes.

The fifteen-year-old Monet later recalled that when he first saw Boudin's seascapes he disliked them so much—they were not at all in the "arbitrary color and fantastical arrangements of the painters then in vogue"—that he did not want to meet the man who painted them. But one day in the shop, about 1856, Monet ran into Boudin, who praised the young man's caricatures. "You are gifted; one can see that at a glance," he said, "But I hope you are not going to stop there . . . soon you will have had enough of caricaturing. Study, learn to see and to paint, draw, make landscapes. The sea, the sky, the animals, the people, and the trees are so beautiful, just as nature made them, with their character, their genuineness, in the light, in the air, just as they are." Painting outdoors was still unusual for artists when Boudin took it up. Constable and Corot had done outdoor sketches, but painting had been an art of the studio, where the artist could control the subject and the light. The introduction of metal-tubed pigments in the 1840s in place of the laborious studio process of mixing colors had made outdoor painting practical.

"The exhortations of Boudin," Monet recalled, "had no effect . . . and when he offered to take me with him to sketch in the fields, I always found a pretext to decline politely. Summer came—my time was my own—I could make no valid excuse; weary of resisting, I gave in at last, and Boudin, with untiring kindness, undertook my education. My eyes were finally opened and I really understood nature; I learned at the same time to love it." That summer Monet went on an outdoor excursion with Boudin to Rouelles, near Le Havre. "Suddenly, a veil was torn away. I had understood—I had realized what painting could be. By the single example of this painter devoted to his art with such independence, my destiny as a painter opened out to me." Boudin preached the need to preserve "one's first impression." "Everything that is painted directly on the spot," he insisted, "has always a strength, a power, a vividness of touch that one doesn't find again in the studio." Boudin was urging him to capture the moment of light.

The artist's move out of doors was not only a change of place. As Monet would show, it changed the "subject" of his painting and the pace of his work, leaving a predictable studio world of walls and windows and artificial light for scenes of evanescent light. Monet would create new ways of capturing that light and that evanescence.

At the age of eighteen, encouraged by Boudin, Monet applied to the Municipal Council of Le Havre for a grant to study art in Paris. The council turned him down on the grounds that "natural inclinations" for caricature might "keep the young artist away from the more serious but less rewarding studies which alone deserve municipal generosity." Still his father sent him to Paris for advice from established artists and a tour of the salons where artists' reputations were made. Originally sent for only a month or two, he was quickly seduced by the city and decided to remain indefinitely. He was fascinated by the artists' café world, by the debates between the romantic "nature painters" and the "realists" known for their still lifes and workers' scenes.

The headstrong young Monet refused to enroll in the École des Beaux-Arts, citadel of the establishment, though it would have pleased his father and assured a parental allowance. Instead he joined the offbeat Académie Suisse, where there were no examinations and no tuition. For a small fee artists could work from a living model. The "academy" had been started by a former model in a decrepit building where a dentist had once pulled teeth for one franc each. The free atmosphere and low cost had attracted some great talents. Courbet and Manet had worked there. Pissarro still stopped in occasionally to paint or to meet friends, and Monet found him a kindred spirit. Perhaps the most intellectual and self-conscious of the Impressionist circle, Pissarro (1830–1903), introduced Monet to the scientific rationale for their new approach to painting.

Monet's parents in Le Havre were alarmed at the rumors of his bohemian life in Paris, and in 1860, when young Monet was unlucky enough to have his number called for the obligatory seven years of military service, they thought they had him cornered. Monet's father offered to "buy" a substitute if Monet would commit himself to the career of a respectable artist. But they had misjudged their son.

The seven years of service that appalled so many were full of attraction to me. A friend, who was in a regiment of the Chasseurs d'Afrique and who adored military life, had communicated to me his enthusiasm and inspired me with his love for adventure. Nothing attracted me so much as the endless cavalcades under the burning sun, the *razzias* [raids], the crackling of gunpowder, the sabre thrusts, the nights in the desert under a tent, and I replied to my father's ultimatum with a superb gesture of indifference. . . . I succeeded, by personal insistence, in being drafted into an African regiment. In Algeria I spent two really charming years. I incessantly saw something new; in my moments of leisure I attempted to render what I saw. You cannot imagine to what an extent I increased my knowledge, and how much my vision gained thereby. I did not quite realize it at first. The impressions of light and color that I received there were not to classify themselves until later; they contained the germ of my future researches.

He had long admired Delacroix's paintings of Algeria, which had first awakened him to the wonders of the North African sun.

When he fell ill with anemia and was granted sick leave, his parents bought him out of the Chasseurs. And in the summer of 1862 he had another lucky encounter, this time with a half-mad Dutch painter, Johan Barthold Jongkind (1819–1891), who would inspire Monet's later work by his bold outdoor sketches and watercolors not so much of the ships and windmills but of the changing atmosphere. "He asked to see my sketches, invited me to come and work with him, explained to me the why and wherefore of his manner and thereby completed the teaching I had already received from Boudin. From that time he was my real master; it was to him that I owe the final education of my eye."

The very "sketchiness" of Monet's drawings that so much appealed to Jongkind was what troubled his artist aunt in Le Havre. "His sketches are always rough drafts, like those you have seen; but when he wants to complete something, to produce a picture, they turn into appalling daubs before which he preens himself and finds idiots to congratulate him." His father let him go back to Paris on the firm understanding "that this time you are going to work in dead earnest. I wish to see you in a studio under the discipline of a well-known master. If you resume your independence, I will stop your allowance without more ado." Through family connections he found a place in the studio of Charles Gleyre, who was both reputable and conventional enough to satisfy his father. "When one draws a figure," Gleyre advised, "one should always think of the antique. Nature . . . is all right as an element of study, but it offers no interest. Style, you see, is everything." Another student was the young Renoir (1841–1919), whom Gleyre lumped together with Monet as misguided spirits and so encouraged a lasting friendship. They also felt kinship with another Gleyre pupil, Frédéric Bazille (1841–1870), whose wealthy family had allowed him to have his fling at art and who more than once would be a lifesaver for Monet.

By the summer of 1864, Monet had left Gleyre's studio and begun his staccato life of painting-excursions to the forests near Paris and the seacoasts of Normandy and elsewhere. It was during these twenty years that Monet developed as the Arch-Impressionist. Outside the familiar line of development of Western painting, with new ways of depicting the solid outer world, Monet instead aimed to report whatever the alert artist self could make of the moments of light that came to it. As Monet's biographer William C. Seitz puts it, he was "shucking off the image of the world perceived by memory in favor of a world perceived momentarily by the senses."

Monet came to this freedom of re-creation by stages. His early success at the Salon of 1865 with a harbor seascape *(Pointe de la Hève, Sainte-Adresse)* and in the Salon of 1866 with his life-size portrait of Camille

Doncieux showed that he had the competence to satisfy the Academicians. Zola praised the portrait ("a window open on nature") for its "realism," and extolled Monet as "a man amid this crowd of eunuchs." But Manet was irritated when, through the similarity of their names, he was praised for a work by that "animal" Monet. Despite such minor premature triumphs more than twenty years would pass before Monet was widely recognized or could make a comfortable living. Meanwhile, he suffered all the pangs of the bohemian, which would provide Zola's painful details for his novels about the egoism and frustrations of the Impressionist artists. When Zola published *L'Oeuvre* (The Masterpiece) in 1886, it ended his thirty-year friendship with Cézanne, and deeply offended Pissarro and Renoir. Monet still confessed "fanatical admiration" for Zola's talent, but would never forgive him. "I have been struggling fairly long and I am afraid that in the moment of succeeding, our enemies may make use of your book to deal us a knockout blow."

Nor was Monet exaggerating the pain of those years. In the gloomy summer of 1866, when all his possessions were about to be seized by his creditors, Monet slashed two hundred of his canvases to save them from that fate, which explains why so few of his early works survive. In those years he was continually on the move, avoiding creditors and seeking a home he could afford. For lack of any other place, in 1867 he had to go back to his family in Le Havre. There he was temporarily rescued by his wealthy artist friend Bazille who bought Monet's *Women in the Garden* for twenty-five hundred francs to be paid out in fifty monthly installments of fifty francs each. This work had been refused at the Salon of 1867. When the Franco-Prussian War broke out in 1870, despite his financial difficulties Monet took Camille Doncieux, his mistress, whom he had just married, and their son born three years before, to London, and then to Holland—painting all the while. Returning to France in 1871, he found the enterprising dealer Paul Durand-Ruel willing to pay good prices for his paintings. He included Monet's works in his catalog, which unfortunately was never published because of the financial crash of 1873 and the following six-year depression.

What is remarkable is not that Monet's talents were not recognized sooner, but that, even without powerful patrons, his new vision was recog-* nized during his lifetime. Unlike many other pioneer artists of his generation, he would end his life prosperous and acclaimed. For twenty years, meanwhile, he migrated from one seacoast or river site to another, with occasional forest and urban interludes.

When the jury of artists for the annual Paris Salon of 1863 had rejected three fifths of the paintings submitted, there was such an outcry that the politically sensitive Napoleon III "wishing to leave the public as judge of the

legitimacy of these complaints has decided that the rejected works of art be exhibited in another part of the Palais de l'Industrie. This exhibition will be elective . . ." This historic Salon des Refusés included pictures by Monet's friends, Jongkind, Pissarro, and Cézanne. The center of interest and of controversy was Manet's *Le Déjeuner sur l'herbe,* a large canvas (six by nine feet) of two fully dressed male artists and two fully undressed female models decorously picnicking in the woods. A painting by Courbet had also been rejected for "moral reasons." When the emperor publicly labeled Manet's painting as "immodest," he attracted the crowds. The young Monet had none of his works in this salon. But it heralded a new spirit among Paris artists, of which Monet himself would be one of the brightest stars.

As Manet had adapted his shocking *Le Déjeuner sur l'herbe* from works of Giorgione and Raphael, now Monet, who had seen Manet's work at the Salon des Refusés, decided in 1863 to have his own try at the familiar theme. His work, he hoped, would be more true to nature. The surviving central fragment is now in the Louvre, and a smaller replica he made in 1866 can be seen in the Pushkin Museum in Moscow. Monet was already beginning to use his characteristic Impressionist technique of flat colors, bright patches, and broken brushwork.

During these years Monet was developing into the bold Impressionist. On a visit to Le Havre in 1872 he painted a view of the harbor, *Impression: Sunrise,* which in 1874 was one of his twelve works (five oils, seven pastels) in a historic private group exhibit. The 165 works also included Degas, Pissarro, Cézanne, Monet, Renoir, Sisley, and Morisot, among others. Monet's painting became the eponym for the school and for a decisive movement in Western arts (not only painting). Monet's painting of Le Havre harbor viewed from his window showed a small brilliant red disk of a sun reflected in broken brushwork on the waters, with shadowy masts and hulls enveloped in damp vapors of a nebulous atmosphere. "I was asked to give a title for the catalogue; I couldn't very well call it a view of Le Havre. So I said: 'Put *Impression.*' "

The month-long exhibition attracted a large paying audience. But more seem to have come to laugh than to admire. One pundit praised these painters for inventing a new technique: load a pistol with some tubes of paint, fire at the canvas, then finish it off with a signature. The critic Louis Leroy's sarcastic article in the *Charivari* (April 5, 1874) noted the "cottony" legs of Renoir's dancers. He made Monet's painting the hallmark of the show, which he called Exhibition of the Impressionists. He reported a puzzled conversation before Monet's painting:

"What does the canvas depict? Look at the catalogue."
" '*Impression, Sunrise.*' "

"*Impression*—I was certain of it. I was just telling myself that, since I was impressed, there had to be some impression in it . . . and what freedom, what ease of workmanship! Wallpaper in its embryonic state is more finished than that seascape."

The Impressionist label stuck, and was adopted by the painters themselves. But the laughter died away. "They are being attacked—and with good reason," some friends responded, "because they resemble each other a bit too much (they all derive from Manet) and because sometimes they happen to be shapeless, so predominant is their desire of exclusively sketching reality."

This was only the first of a series of brilliant group exhibits every year from 1876 to 1882. In 1877 Mary Cassatt was invited to join. Their last group exhibit was held in Paris in 1886, and a selection by Durand-Ruel was taken to New York. Monet was regularly represented, with fifty works in the New York show. Collectors became interested in his work, and Durand-Ruel had taken him up again.

Monet's family life was not untroubled. His romance with Camille Don- cieux, *The Woman in the Green Dress,* painted in 1866, began in Paris in 1865 and she bore him their first child in 1867, just before he returned penniless to Le Havre. Constantly short of money, in June 1875 he appealed to Manet to lend him twenty francs, for Camille's money was used up. Then during an 1876 visit seeking support from the wealthy collector Ernest Hoschedé at his chateau, Monet formed a liaison with Hoschedé's wife, Alice. The winter of 1877 was desperate for Monet back in Paris. Camille was ill and Monet had no money for food or rent. (Zola would later depict his straits in *L'Oeuvre*.) Again, he sought help from friends, and Manet again responded. Driven out of his Argenteuil house by debts, with Manet's financial assistance he rented a house farther from Paris at Vétheuil, also on the Seine but near open country. Before this move he offered Dr. Gachet a painting in exchange for a loan to pay for the imminent delivery of his second child. He asked Zola for money to cover the cost of moving his furniture to the house that Manet had helped him rent. Disaster piled on disaster. When the celebrated singer Jean-Baptiste Faure, who had collected Monets on speculation, now put them on auction they brought depressingly small prices. Hoschedé, financially ruined, was suddenly forced to sell his collection of Monets at sacrifice figures.

Mme. Hoschedé left her husband in that summer of 1878, about the time of her husband's disastrous sale of Monets. With her six children she moved in with the Monets at Vétheuil. There she also cared for the ill Camille and the two young Monet children. Monet still had no money for paint or canvas. "I am no longer a beginner," he wrote a friend on December 30,

1878, "and it is sad to be in such a situation at my age [thirty-eight], always obliged to beg, to solicit buyers. At this time of the year I feel doubly crushed by my misfortune and 1879 is going to start just as this year ends, quite desolately, especially for my loved ones to whom I cannot give the slightest present." Despite all, the indomitable Monet kept up his spirits by painting fields of poppies and views of the Seine. He had to pawn everything to pay for Camille's last illness. She died in September 1879, ending their thirteen troubled years together. At her death Monet wrote again to the friend asking him to retrieve from the pawnshop "the locket for which I am sending you the ticket. It is the only souvenir that my wife had been able to keep and I should like to tie it around her neck before she leaves forever." Though broken in spirit, he remained the almost involuntary servant of optical impressions. Seeing Camille on her deathbed, he could not prevent himself from capturing on canvas the blue, gray, and yellow tones of death on her face. Appalled, he compared himself to an animal that could not stop turning a millstone, for he was "prisoner of his visual experiences." The painting now hangs in the Louvre.

The life Monet shared with Alice Hoschedé for the next thirty years, despite its pains, had many sunny days. After the impoverished Ernest Hoschedé had withdrawn from his family to a bachelor life in Paris, Monet and Alice lived together with their combined eight children. In the 1880s, Alice by looking after the children made possible Monet's frequent painting excursions around France and abroad. They moved to Giverny in 1883 in rented quarters. Ernest died in 1891, and they married the next year. As Monet developed the now-famous Giverny properties, this became an artist's mecca and a model bourgeois household. In the 1890s Monet traveled much less. With Alice taking a strong hand, they both developed the astonishing gardens at Giverny. Alice died in 1911.

While "impressionist" painters flourished separately, Impressionism as a group movement disintegrated. By 1881 the original group of the first Impressionist Exhibit of 1874 had dispersed, and pristine Impressionism had no group exhibits after 1886. With the aid of enterprising dealers and increasingly adventurous collectors, including many Americans, Monet became a self-supporting painter. By the 1890s he was a recognized master. And Monet experimented ever more boldly with his optical self. He offered more than a new style in his way of re-creating the artist's visual world. Monet's early experience of the volatile atmosphere of Normandy, and of the dazzling sunshine of North Africa, as we have seen, had prepared him for the fireworks of light. He had the courage to give up the publicly agreed-on world of the known for the world seen only by the artist himself.

This was a revolutionary shift in focus, a change both in the resources

of the artist and the demands made on the artist. For while the descriptive artist had his tasks limited by the observed world out there, the Impressionist's assignments were infinite. And this way of re-creating the world came close to abolishing "subject matter." The Impressionist artist's "motifs" had no other purpose than to call attention to the painting and give the viewer his bearings in the artist's world of impressions. Gone was the need for mythological, historical, religious, patriotic, or epoch-making subject matter. The optical impressions of an artist-self at a given moment were quite enough. Monet tended toward landscape or seascape, not because of their special significance, nor from a romantic love of nature. His motifs were not so much Nature as the Out-of-Doors, a world of ambient atmosphere, of ever-changing light and infinite iridescence. No object had a fixed color and even shadows could contain the whole spectrum.

Impressionists were prophets of the new, prototypical re-creators. As the young poet-critic Jules Laforgue observed of them, "The only criterion was newness. . . . it proclaimed as geniuses, according to the etymology of the word, those and only those who have revealed something new." Every Impressionist painting was of a new "subject," which was the visual world of the artist at that evanescent moment. For novel subjects Monet found nothing more fertile than water—in the sea or the river, and in the snow, constantly changing and reflecting. And so he said "the fog makes London beautiful."

The outdoor painter worked under stringent time limits. While the studio painter could take four years for a Sistine ceiling and another five to paint the wall behind the altar, an impression by Monet had to be painted with near-photographic speed. Monet sometimes painted for only fifteen minutes at a time on a canvas. If the light was sufficiently similar on another day he might return. Atmosphere, sun, shadow and the time of day were all crucial. "One day at Varengeville," the French dealer and collector Ambroise Vollard reported, "I saw a little car arriving in a cloud of dust. Monet gets out of it, looks at the sun, and consults his watch: 'I'm half an hour late,' he says, 'I'll come back tomorrow.' "

This was an age of focused interest in optics, in the theory of light and color and the burgeoning art and science of photography. At no time since Newton had physicists made such advances or been so adventurous in their theories of light. In Germany Hermann Helmholtz (1821–1894) had invented the ophthalmoscope (1850) and a new theory of color vision, the Scotsman James Clerk Maxwell (1831–1879) was investigating color perception and the causes of color blindness, while Ogden N. Rood (1831–1902), an American professor of Columbia University, was developing a flicker photometer for comparing the brightness of light of different colors, and producing *Modern Chromatics* (1879). The kaleidoscope and the stereoscope had entered living rooms. Joseph Nicéphore Niepce (1765–1833), Louis Daguerre (1787–1851),

and William Henry Fox Talbot (1800–1877) had already pioneered the age of photography. It was impossible for men and women of culture not to know this magical new graphic art.

Of special interest to painters was the work of the French chemist Michel Eugène Chevreul (1796–1889) who, besides doing pioneer research in animal fats to improve the candle and soap industry, had been experimenting with color contrasts at the Gobelin tapestry works. Charged with preparing dyes at the Gobelin works, Chevreul discovered to his surprise that the major problems were less those of chemistry than of optics. If a color did not register its proper effect, it was apt to be due not to a deficiency of the pigment but to the influence of neighboring colors. His researches produced his "law of simultaneous contrast," published in 1839. While Chevreul built on Newtonian theory, he discovered his own "law" by observation. "Where the eye sees at the same time two contiguous colors," he noted, "they will appear as dissimilar as possible, both in their optical composition and in the height of their tone." Any color therefore would influence its neighbor in the direction of that color's complementary (those elements of white light absorbed by the given color). Thus red would tend to make adjacent surfaces appear greener, green would be enhanced by juxtaposed red, as red in turn would be enhanced by a neighboring green.

The intellectual Pissarro became an enthusiast for Chevreul and for the new science of color. "We could not pursue our studies of light with much assurance," he observed, "if we did not have as a guide the discoveries of Chevreul and other scientists." Neo-Impressionists, he urged, should aim "to seek a modern synthesis of methods based on science, that is, based on M. Chevreul's theory of color and on the experiments of Maxwell and the measurements of O. N. Rood. To substitute optical mixture for mixture of pigments. In other words, the breaking up of tones into their constituents. For optical mixture stirs up more intense luminosities than mixture of pigments does." Chevreul provided the basis of the "divisionist" technique of painting. He charted the way to the *pointillisme* of Seurat and Signac and for Pissarro himself. And Pissarro enlisted a group he called "scientific impressionists" for whom the optical sciences were to be steps toward the liberation of man.

Monet may have known the work of Chevreul. He could hardly have avoided hearing of it from his talkative friend Pissarro. Even while Monet professed to abhor theory, he found ways of applying the emerging theories of color, and he became the archprophet of an impressionism based on bold new juxtapositions of light and color. Just as Giotto had found his way to a kind of linear perspective ahead of the modern theories of Brunelleschi and Alberti, so Monet seems intuitively to have been led to the techniques that would be justified and explained by the new science of light and color.

·　·　·

The influence of photography, which had ceased to be arcane, was quite another matter, for it seemed to provide the equivalent of a momentary Impressionist's sketch, a scientific and foolproof grasp on instantaneity. Baudelaire had warned that photography and poetry were incompatible. But it is likely that some of the Impressionists made clandestine use of photography. It is hard not to suspect that the blurred image of photographed objects in motion had some effect on paintings like Monet's *Boulevard des Capucines* (1873). Perhaps the photographers' earnest quest to record the instantaneous encouraged painters like Monet to outdo them in color.

The Impressionist painter had accelerated the pace of his work to match the pace of modern life. Monet was in search of the *now,* and capturing a short-lived motif required a spontaneous style. Monet himself described the challenge of making a laborious art serve the aim of "instantaneity." Momentarily frustrated by the too-rapid changes of light as he painted his haystack series (October 1890), he wrote:

> I'm grinding away, sticking to a series of different effects, but the sun sets so early at this time that I can't go on. . . . I'm becoming so slow in working as to drive me to despair, but the more I go on, the more I see that I must work a lot to succeed in rendering what I am looking for: "Instantaneity," especially the envelope, the same light spread everywhere, and more than ever I am disgusted by easy things that come without effort.

This kind of painting required its own kind of patience, to wait for the precise moment and come again and again in search of that moment. Monet's friend Guy de Maupassant, who sometimes accompanied him in his search for that moment, compared Monet's life to that of a trapper.

If the bohemian artist had to survive the rigors of hunger and unheated studios, the Impressionist had to brave wind and rain and snow. A journalist in 1868 at Honfleur, opposite Le Havre, described Monet in his neighborhood. "We have only seen him once. It was in the winter during several days of snow, when communications were virtually at a standstill. It was cold enough to split stones. We noticed a foot-warmer, then an easel, then a man, swathed in three coats, his hands in gloves, his face half-frozen. It was M. Monet, studying a snow effect."

Of all painters' works those of Monet are the hardest to describe in words, precisely because they had no "subject" but the momentary visual impression on a unique self. Though suspicious of all prescribed "forms," Monet did create a spectacular new form of painting. In the "series" he found a way to incorporate time in the artist's canvases by capturing a succession of elusive moments. Monet's series were his way of making peace between

the laborious painter and the instant impression of the eye. In his early years Monet had sometimes painted more than one picture of the same scene, and so revealed the changing light and atmosphere. But now he planned extensive series of the same subject under variant light, season, and atmosphere. Here was a new use of time and atmosphere, a new epic form, in which the differences between paintings were part of the plot. Monet had done something of this sort in his paintings of London in 1870. The series concept flourished and grew as Monet in his fifties finally put poverty behind him. Now a prosperous celebrity, he could elaborate his ideas at will, as repetitively and outrageously as he wished, with no worry of having to appeal to the market. Back in 1874 he had begun a surprising series of smoke and fog at the Gare St. Lazare, and had done paintings of the same fields of poppies. In the 1890s he threw himself into his series with passion and in profusion.

Monet's first great series seemed to have a most unpromising subject. But for this haystack (*meule*) series the haystack was not really his subject. "For me," he explained, "a landscape does not exist as a landscape, since its appearance changes at every moment; but it lives according to its surroundings, by the air and light, which constantly change." In May 1891 he exhibited fifteen paintings of this haystack series, showing the same motif under varying conditions of atmosphere, sun and snow, sunrise and sunset. It was this series that had inspired Maupassant's characterization and Monet's own complaints of the painful elusiveness of "instantaneity." Another series, "Poplars on the Epte" (1891), followed, depicting the variations of vertical shapes just as the haystacks pursued the rounded bulk of a haystack against the flat landscape.

Then, as if to show that even man's works could nourish the most subtle impressions, Monet did a series of impressions of the façade of Rouen Cathedral seen from the window of a shop opposite. When twenty of the Rouen series were exhibited in the Durand-Ruel gallery in 1895, they sold for the high price of fifteen thousand francs each, a price Monet had insisted on. Monet's friend Georges Clemenceau acclaimed the series as a "*Révolution de Cathedrales*"—a new way of seeing man's material works, a hymn celebrating the cathedral as a mirror for the unfolding works of light in time. Here, he said, was a new kind of temporal event. Two more great series still remained on Monet's agenda. A series on the Thames, begun in 1900, had produced more than a hundred canvases by 1904. Then, after Monet had settled down in Giverny in 1900, he began his water-garden series, which he was still elaborating at the time of his death in 1926.

It is difficult to grasp the grandeur of any of these series when we see only individual canvases in different museums. The delight of each haystack painting comes also from our view of its Impressionist companions. Monet's fascination with the gardens at Giverny and his attention to their care were

another witness to his obsession with visual change. His small home territory—Giverny, its paths, arbors, trees, and flowers and its Japanese bridge—provided inexhaustible motifs for Monet in his last years. He delighted in the daily opening and closing of pond-lily blossoms and in the moving clouds mirrored in the shifting surface of the ponds. In 1977 the Académie des Beaux-Arts, which he had spurned a century before, took possession of Giverny and made it a national Monet shrine. Clemenceau, as a politician less attracted by evanescence than was Monet, proposed that despite failing eyesight and depression at the loss of his wife, Alice, Monet should paint an encircling mural for a new studio. These dazzling murals became a monument to Monet, dedicated two years after his death, in the Orangerie of the Tuilleries and would be christened by some the Sistine Chapel of Impressionism.

Still, no encircling mural could properly celebrate Monet the Impressionist. His achievement was not in the durable but in the elusive moment. He conquered time by capturing light, the speediest messenger of the senses. "I love you," Clemenceau wrote to Monet, "because you are you, and because you taught me to understand light."

55

The Power of Light: "The Pencil of Nature"

WITH photography, light did the artist's work for him as it captured the instant moment, preserving the ephemeral image. The speediest force in nature became the artist's ally in an age obsessed by speed. The art of photography would bear two birthmarks of the modern age, instantaneity and multiplicity. The speeding moment, diffused in countless copies, would democratize both the enjoying and the making of visual art. The best photographers would reach millions.

For creators of images this power to make exactly repeatable pictorial statements was as important as movable type and the printing press were for creators of literature. Woodblock prints, engraving, etching, and lithographing had offered epochal new opportunities to spread information, misinformation, and works of the imagination. But photography, which made every man his own artist, was democratic beyond the earliest dreams, as William Henry Fox Talbot explained in his *Pencil of Nature* (1844):

This is the first work ever published with photographic plates, that is to say, plates or pictures executed by Light alone, and not requiring for their formation any knowledge of drawing in the Operator.

They are obtained by merely holding a sheet of prepared paper for a few minutes (or sometimes only for a few seconds) before the object whose picture is wished for, using a lens or glass to throw the light upon the paper. . . .

It has been often said, and has passed into a proverb, that there is no Royal Road to Learning of any kind. However true this may be in other matters, the present work unquestionably demonstrates the existence of a *royal road to drawing,* presenting little or no difficulty. Ere long it will be in all probability frequented by members who, without ever having made a pencil sketch in their lives, will find themselves enabled to enter the field of competition with Artists of reputation, and perhaps not unfrequently to excel them in the truth and fidelity of their delineations, and even in their pictorial effect; since the photographic process when well executed gives effects of light and shade which have been compared to Rembrandt himself.

When people began to believe that the photograph was the image of truth, epistemology, the science of knowledge, once the province of philosophers, would become a branch of technology. The truth that photography transformed would be revised again and again by cinematography and television, and technologies still unimagined. And these in turn would revise the standards of art.

Photography has a long and sluggish history—full of false starts, long hesitations, and failure to see the obvious. The word "camera" itself is a relic of the camera obscura, or dark room, which Leonardo da Vinci described in his notebooks as a darkened chamber where the real image of an object is received through a small opening and focused onto a facing surface. After the Italian physicist Giambattista della Porta (1538?–1615) described it in his *Natural Magic* (1568), the device was used by artists, draftsmen, and magicians. In 1727, the German chemist Johann Heinrich Schulze, experimenting with stencils of opaque paper on a flask containing chalk and silver nitrate, proved that light could darken the silver compound and produce images. But decades passed before this chemical discovery was applied to making pictures. Meanwhile makeshifts were gratifying the prospering urban middle class with portraits of themselves and their heroes. The physionotrace made a silhouette on transparent glass, which was then engraved with the subject's features. The camera lucida projected an image on a plane surface to be traced by the artist.

Might it not be possible somehow, by focusing light on a sensitive chemical base, to create images and avoid the need for tracing? A motley cast joined the search. Thomas Wedgwood, son of the British potter who had been employing the camera obscura to sketch country houses for the deco-

ration of Wedgwood plates, collaborated with the eminent chemist Sir Humphry Davy (1778–1829). Their "sun prints" used the effect of light on silver nitrate to copy paintings on glass. But they could find no way to make the images permanent. The ingenious French inventor Niepce, who had actually made a rudimentary internal combustion engine, turned to heliography. As early as 1816 he succeeded in fixing a camera image by chemical means. But the sunlight that darkened the silver compound produced an image that inverted the shades of nature. Niepce formed a partnership with the painter Daguerre, who was known for his illusionist dioramas of Edinburgh by moonlight and of Swiss villages. Daguerre improved Niepce's technique into his "daguerreotypes," images on thin plates of silver. Besides being expensive, these had the disadvantage that they were unique and could not be reproduced. Since long exposures were required while the subject remained immobile, the first daguerreotypes were mainly of buildings. But with more powerful lenses and more sensitive plates, daguerreotypes became popular for portraits. Daguerre had kept his technique secret, and some thought his invention was a hoax. A few even believed that to "plagiarize nature by optics" might be sacrilege.

But the eminent French experimenter in optics, François Arago (1786–1853), thought otherwise and headed a special commission of the French Academy of Sciences in Paris. After working with Daguerre in secrecy for six months, they recommended that his techniques be purchased for the nation with a government annuity. Daguerre's secrets would then be revealed. After Arago's public demonstration on August 19, 1839, "a few days later, opticians' shops were crowded with amateurs panting for daguerreotype apparatus, and everywhere cameras were trained on buildings." In Europe popular interest soon abated when the difficulty of making good pictures was discovered and Daguerre himself returned to painting illusionist pictures.

Daguerre's techniques remained popular in America. The versatile Samuel F. B. Morse of telegraphic fame, who was both a competent painter and an imaginative inventor, visited Daguerre in Paris and became an enthusiastic daguerreotypist. In September 1839, his wife and daughter cooperated by sitting for their portraits facing the bright sunlight for twenty minutes. Itinerant daguerreotypists like the hero of Hawthorne's *House of the Seven Gables* (1851) and the prospering city daguerreotype studios have left us an unprecedented visual record of Americans in the mid-nineteenth century. While people paid admission to see dioramas of Niagara Falls, fashionable portrait-daguerreotypists flourished in luxurious studios. And some of Mathew Brady's memorable Civil War battlefield portraits were daguerreotypes.

Still, the daguerreotype could never have produced the revolution that

would be accomplished by the photograph in the twentieth century. The long exposures made it impossible to take figures in motion or make candid pictures. Street scenes could be captured but not with moving traffic or pedestrians. In bright sunlight, an 1840 manual explained, a colored subject might require an exposure up to ten minutes in summer, and seventeen minutes in winter, while a subject in diffused sunlight required thirty minutes in summer, a full hour's exposure in winter. Even after exposure times were shortened by improved lenses and more sensitive daguerreotype plates, a portrait in a studio required the subject to remain still for a full minute's exposure. And each daguerreotype remained impossible to duplicate, except by tracing.

Meanwhile others were on the way to creating a graphic revolution. This would be a democratic revolution, after which images of experience could be made instantly by everybody, and could be diffused to the millions. The camera required no taste or skill, nor even discretion. This would be an age, not of picture *making*, but of picture *taking*. The power of light and an adept little machine made the gift. Now everybody could afford a family portrait. Reinforcing experience, photography abridged time perspectives, making visions of the recent past and the present more vivid, more universal, and more emphatic than ever before.

Three diverse personalities contributed the creative talents of the scientist, the inventor-industrialist, and the artist.

Of these William Henry Fox Talbot (1800–1877) was the most versatile but the least celebrated in history. From a wealthy and cultured family, he came to photography through his lack of artistic talent. While he had a subtle scientific imagination, his epochal contribution to photography was a bold thrust of common sense. From Harrow he entered Trinity College, Cambridge, where he won distinction in both classics and mathematics. After the young aristocrat's usual grand tour of the Continent, he established himself on the legend-laden family estate, Lacock Abbey, in Wiltshire, where he pursued his broadening scientific interests. He loved the works of Goethe and Byron, and named two of his daughters after characters in Scott's novels. The ancient past tantalized him. He studied Hebrew and was inspired by Thomas Young and Jean François Champollion's deciphering of hieroglyphics on the Rosetta Stone in the 1820s and the deciphering of the Assyrian cuneiform in the 1840s. While recognized as a brilliant Assyriologist for his translations from the ancient languages, at the same time he achieved distinction in mathematics, was elected to the Royal Society, and received the Society's Royal Medal for his work on elliptic integrals. With an ambitious imagination he joined the eminent astronomer Sir John Herschel and other great contemporaries in search of a unified

dynamic view of all physical phenomena. And by pursuing the new wave-theory of light, problems of light-matter interaction, and the vibratory theory of molecular behavior in gases, he suggested a connection between spectral lines and chemical composition which opened the way to the spectroscope.

Independent of the work of Daguerre, Talbot came to photography quite casually and as an amateur. In December 1832, ten days after his election to the House of Commons under the new Reform Bill, he married Constance Mundy, of a solid country family, who brought him a dowry of six thousand pounds. She could not have suspected that her talented husband would give her the distinction of being the world's first woman photographer. It was on their six-month delayed honeymoon that Talbot experienced his photographic epiphany:

> One of the first days of the month of October 1833, I was amusing myself on the lovely shores of the Lake of Como, in Italy, taking sketches with Wollaston's Camera Lucida, or rather I should say, attempting to take them: but with the smallest possible amount of success. . . .
> I then thought of trying again a method which I had tried many years before. This method was, to take a Camera Obscura, and to throw the image of the objects on a piece of transparent tracing paper laid on a pane of glass in the focus of the instrument. On this paper the objects are distinctly seen and can be traced on it with a pencil with some degree of accuracy, though not without much time and trouble. . . .
> And this led me to reflect on the inimitable beauty of the picture of nature's painting which the glass lens of the Camera throws upon the paper in its focus—fairy pictures, creations of a moment, and destined as rapidly to fade away.
> It was during these thoughts that the idea occurred to me. . . . how charming it would be if it were possible to cause these natural images to imprint themselves durably, and remain fixed upon the paper!
> And why should it not be possible? I asked myself.

Talbot reflected that, though silver nitrate was known to be peculiarly sensitive to light, no one had used it to capture natural images. Would the action of light for creating images be rapid or slow? "If it were a slow one, my theory might prove but a philosophic dream." Returning to England he tried different compounds of silver. In the bright summer of 1835 he made an image with the camera obscura on properly moistened paper with only ten minutes of exposure. And he found a way, still quite imperfect, of fixing the image. But it was difficult to keep the instrument steady and the paper moist during this whole exposure.

The fact that light darkened the silver, and produced a faithful image would make photography possible. But in the photographic image, unlike

the daguerreotype, lights and shadows were reversed from those in nature. This curse of the photographic pioneers seemed an insuperable problem until the inspired Talbot saw a simple solution. Why not just take a picture of the photograph? Then the lights and shadows would be reversed back to their true state in nature. This was Talbot's epoch-making commonsense idea.

Incidentally Talbot had thus conceived the two-step process of modern photography. His original exposed "photograph" on paper was "fixed," then waxed to make the paper transparent and laid on a fresh piece of photographic paper. When exposed to sunlight, this would produce on the paper beneath it an image precisely like that in nature. Now any number of copies could be made. For the prints Talbot then invented his own "calotype" (from Greek *kalos,* beautiful) paper, which required a much shorter exposure for printing, and took a latent image, which he brought out by gallic acid. When Talbot's friend Sir John Herschel offered *negative* as the name for the original and *positive* for the copy, he created the modern photographic vocabulary. By analogy to "telegraph" (already in use for *writing* at a distance) in 1839 Herschel made the first recorded use of the word "photograph" (from the Greek for "writing by light").

Following the advice of his mother who had encouraged him to be impatient for knowledge but not for fame, Talbot had experimented with photography for a decade and had made a photograph from nature as early as 1835. But he had not bothered to announce his new process nor tried to claim priority by securing a patent. In January 1839 he was stunned by the report from Paris that a Frenchman, Louis Daguerre, had "invented" photography, and Talbot ruefully noted "the sensation created in all parts of the world by the first announcement of this splendid discovery."

The sensation stirred Talbot to reveal his own experiments and successes. On January 15, 1839, he showed his work to the Royal Institution, and six days later delivered a hastily prepared paper on his work to the Royal Society. But he was late in the popular sweepstakes. Arago had already secured for Daguerre the glory of the "inventor." Although Talbot had not patented his original "photogenic drawing process," on February 21, 1839, six months before Daguerre, he himself published its details. In February 1841 Talbot applied for a patent on his improved technique for making and replicating photographs on calotype paper. Talbot rationalized patents as a way to secure public compensation for impecunious inventors who had not his good luck of inheriting landed estates, and also to provide the technology essential to expanding British industry. But Talbot's own pettifogging enforcement of his patent rights finally overshadowed public gratitude for his inventive genius.

Talbot exhibited his achievement in his epoch-making *Pencil of Nature,*

which appeared in three hundred copies of six elegant paper-covered installments (1844–46). As the first book ever illustrated by photography, it merits a place comparable to Gutenberg's in the history of typographic man. Apologizing that the term "photography" was already too well known to need definition, he still offered his "Brief Historical Sketch of the Invention of the Art." Twenty-four tipped-in photographs with brief texts displayed buildings, landscapes, portraits, still lifes, and copies of statues and manuscripts—"wholly executed by the new art of Photogenic Drawing, without any aid whatever from the artist's pencil." Variations of tint in the photographs showed how irregularly Nature used her pencil. Each photographic print was "separately formed by the light of the sun, and in our climate the strength of the sun's rays is extremely variable even in serene weather." When clouds intervened, the sun's impression on the negatives was less dark.

"The experiment of photographically illustrated books is now before the world," *The Athenaeum* acclaimed. And photography could "hand down to future ages a picture of the sunshine of yesterday or a memorial of the haze of today." For his calotype process Talbot was awarded the Rumford Medal of the Royal Society. Despite his greedy enforcement of his patent rights he never achieved commercial success with his photography. Public criticism became so unpleasant that he returned to research in ancient history and languages.

How could this new science of photography be useful to artists? Delacroix, a charter member of the French Society of Photography, welcomed the daguerreotype for the painter "as a translator, initiating us into the secrets of nature." In his *Modern Painters* Ruskin saw the daguerreotype helping artists "accomplish the reconciliation of true and aerial perspective and chiaroscuro with the splendor and dignity of elaborate detail." Courageous photographers, untroubled by whether they were scientists or artists, went on expanding the public experience. Roger Fenton made a record of the Crimean War, and Mathew Brady documented the American Civil War. But technical limits of wet-plate photography and the need to get back and forth to the traveling darkroom limited them to portraits, pictures of shattered buildings and bodies strewn on the battlefield. Most battle action was beyond their means.

In Paris a celebrated caricaturist and balloonist, the flamboyant "Nadar" (Gaspard Félix Tournachon, 1820–1910), created his own photographic pantheon with portraits of Balzac, Baudelaire, Delacroix, Daumier, Wagner, Rossini, and others. "Photography," he declared, "is a marvellous discovery, a science that has attracted the greatest intellects, an art that excites the most astute minds—and one that can be practiced by any imbecile.

. . . But what cannot be taught is the feeling for light. . . . It is how light lies on the face that you as artists must capture." On the Isle of Wight, Julia Margaret Cameron (1815–1879), wife of a British civil servant who at forty-eight received a gift of photographic apparatus from her family, made unexcelled portraits of her famous visitors—Herschel, Tennyson, Carlyle, Darwin, Browning, Longfellow, and many others. She also used her camera for "out of focus" fantasies in the Pre-Raphaelite painterly style, illustrations for Tennyson's *Idylls of the King,* children posed as angels or as "Venus chiding Cupid and removing his wings." Women seizing the opportunity for liberation of their talents would be among the best and the boldest photographers. But like Julia Cameron, other photographers vacillated between being scientist and artist, between naturalism and sentimentality.

The new freedom of the photographer to take natural images—call it science or art as you wish—came from a simple radical improvement in technique. The hectic wet-plate process had tied the photographer to his darkroom, where he could prepare and quickly develop his pictures. The long exposures required a tripod to hold the camera steady and keep it focused on the subject. And the wet-plate camera, like the muzzle-loading musket, had to be reloaded after each shot. Then the photographer had to hasten to his darkroom to develop his picture within ten minutes, before the image disappeared. In a whole day a wet-plate photographer in the field might make no more than six plates. Dry-plate photography would liberate the photographer to wander out of doors much as the oil paint in tubes had freed painters to go out into nature. An English amateur experimented with dry plates, and by 1878 they were on the market. Within twenty years they had transformed photography. The photographer now could take pictures as fast as he could load the plateholders, and he could develop them at leisure in his darkroom back home. The speedier dry plates made it possible to dispense with the tripod and to photograph moving objects and people on the landscape. But it was the first hand-held cameras, called "detective" cameras from their ability to take pictures without a conspicuous tripod attached, that really opened the world to photography and photography to the world. Now, an advertisement for a hand-held camera explained, "a lady might without attracting any attention go upon Broadway and take a series of photographs."

Photography beckoned to amateurs. Instead of laboriously aiming for a perfect shot, amateurs could shoot at random, hoping for a good one in the lot. In wet-plate photography, each photographer had prepared his own plates at the site of the photograph. While the new dry-plate technique much simplified the taking of pictures, it left the preparation of the plates to professional companies.

Still, none of this might have created a nation of photographers without

the practical imagination and merchandising genius of George Eastman (1854–1932). Son of a teacher of penmanship who had established Rochester's first commercial college, he had only seven years of schooling before becoming bookkeeper in a bank. As an early amateur photographer he had made his own wet plates. When he learned of the new dry plates, he saw their commercial promise and invented and patented a coating machine. Quitting his job at the bank, he invested his savings of three thousand dollars in the business, and at twenty-six he was on his way to making photography the American national hobby. Since glass plates had to be loaded one at a time, Eastman imagined the advantages of a flexible negative that could be rolled like a window shade past the focal plane. He first tried paper, then used celluloid. In 1888 his first "Kodak," a box camera with a fixed focus, holding a roll with one hundred negatives, was on the market. It sold for twenty-five dollars, including the processing of the first roll, which the photographer sent back to Rochester, where the camera was refilled with film and returned. Soon the photographer received his neatly mounted contact prints.

Eastman also had a talent for words. His slogan "You Press the Button, We Do the Rest" enticed thousands of amateurs and entered American folklore. He had invented the word "Kodak," he explained, with K, "a strong incisive sort of letter, at both ends." It signaled his hope for a world market, since Kodak could be easily pronounced in any language that used the Roman alphabet. A new vocabulary proclaimed the new photographable world. "Snapshot," originally a hunter's term for a hurried shot fired without taking careful aim, was applied to photography by Herschel, and now described pictures taken by the Kodak, which at first had no finder and was simply pointed in the direction of the object. "Photography," Eastman boasted, "is thus brought within reach of every human being who desires to preserve a record of what he sees."

But was it art? "If you cannot see at a glance," with his genius for overstatement, George Bernard Shaw declared in 1901, "that the old game is up, that the camera has hopelessly beaten the pencil and paint-brush as an instrument of artistic representation, then you will never make a true critic: you are only like most critics, a picture fancier. . . . Some day the camera will do all the work of Velasquez and Peter de Hooghe, colour and all." Photographers and their critics never ceased to be haunted by this question. Everybody knew that an art had to be difficult. With its increasing ease and universality, how could photography be an art? Photographers, conceived in a chemist's laboratory, envied the mystique of the artist's studio.

The most influential answer to the photographers' troubling question was offered by Alfred Stieglitz (1864–1946). Photographers aspiring to be artists

had understandably imitated painting, to give the newest of the graphic arts the prestige of one of the oldest. Stieglitz took the opposite tack. He became the apostle of photography as a unique art, and of America as its testing place.

Although Stieglitz boasted of his Americanness, his education was mostly European. Born in Hoboken in 1864 to a retired prosperous German-Jewish woolen merchant of broad culture, he attended the New York public schools and the City College. For their education his father moved the family of six children to Europe in 1881. In Berlin Stieglitz entered the Polytechnic for mechanical engineering, enjoyed the friendship of painters, and frequented theater and opera. In 1883, five years before Eastman's first Kodak, Stieglitz saw a little black-box camera on a tripod in a Berlin shop window.

> I bought it and carried it to my room and began to fool around with it. It fascinated me, first as a passion, then as an obsession. The camera was waiting for me by predestination and I took to it as a musician takes to a piano or a painter to a canvas. I found I was master of the elements, that I could work miracles; that I could do things which had never been done before. I was the first amateur photographer in Germany, or, for that matter, anywhere. But I had much to learn.

Stieglitz shifted his course to photochemistry, bought another camera, took up the new dry-plate techniques, and began experiments of his own. At home he improvised a darkroom by swinging a door back to the wall and covering the space with a blanket. In one of his first efforts to test the limits of the new art, he took his camera down to the cellar to test the proposition that photographs required sunlight. And with an exposure of twenty-four hours to a primitive electric lamp he made a perfect negative.

There in Berlin, Stieglitz, not yet twenty, started his crusade to have photography recognized as an art comparable to painting. His own photographs, for which he set the highest standard, were his best argument. In 1890, when he returned to the United States, he had charted the course of life from which he never deviated. A "born revolutionist," he found photography an ideal laboratory.

> I . . . never drew—painted—had any art lessons—never desired to draw—never tried to—never dreamt that I might be or become an artist—knew nothing about any of these things when I started photographing. . . . I went to photography a really free soul—and loved it at first sight with a great passion. . . . There was no short cut—no fool-proof photographing—no "art world" in photography. I started with the real A.B.C.—at the rudiments—and evolved my own methods and own ideas virtually from the word go. . . .

In 1892–93 he made his early classic photographs of New York in winter, *The Car Horses at the Terminal,* and *Winter Fifth Avenue,* which remained

among his most celebrated work. He soon made history with the first successful photographs in rain, in snow, and at night. Among these his photograph of the new Flatiron Building in a heavy snowstorm celebrated the skyscraper like "the bow of a monster ocean steamer, a picture of the new America which was in the making."

At first he saw the hand-held camera as a menace to the art of photography. "It is amusing to watch the majority of hand-camera workers shooting off a ton of plates helter-skelter, taking their chances as to the ultimate result." But by 1897 he applauded its new possibilities. In principle he opposed the awarding of medals in photographic competitions, but he submitted his own works and by 1910 had won more than 150 for himself. He was classified as an exponent of "straight photography," which meant not retouching or tinting but "working in the open air, with rapid exposures, leaving his models to pose themselves, and relying for results on means strictly photographic."

Uncomfortable in other people's organizations, in 1902 he founded his own group, which he called the Photo-Secession, after the German Secessionist painters who had revolted against academic art when the paintings of the Norwegian artist Edvard Munch (1863–1944) were rejected by a Berlin exhibition (1892). Urged on by his friend Edward Steichen, in 1905 Stieglitz set up the Little Galleries of the Photo-Secession at 291 Fifth Avenue. Three rooms, the largest only fifteen by seventeen feet, provided Stieglitz with a showcase for whatever was new in the visual arts. He quickly became a prophet of modern art in America. In the five years before the celebrated Armory Show of 1913, Stieglitz showed Americans the works of Rodin, Cézanne, Matisse, Brancusi, Braque, and Picasso. He also showed African sculpture. He displayed living American painters—John Marin, Marsden Hartley, Max Weber, Arthur Dove, and Georgia O'Keeffe. Timid fellow photographers protested his enthusiasm for modern painting, but he defended "291" as "a laboratory, an experimental station."

He was especially pleased that Picasso, then painting his *Demoiselles d'Avignon,* liked his photograph *The Steerage,* which he had made on the inspiration of the moment on an eastward sea voyage in 1907. Composed spontaneously, this became Stieglitz's own favorite picture—"a picture of shapes and underlying that the feeling I had about life." As a child he had enjoyed reading about the American Revolution, but George Washington was too conventional for his taste. He preferred Nathanael Greene, "who would make the English come after him, and then he would retreat. So that the English, without knowing it, would lose ground . . . whereas Greene would win while retreating. There was a sense of humour in his strategy."

When the Armory Show opened he urged all to see this, "The First Great Clinic to Revitalize Art." At the same time in "291" he put on an exhibit

of his own photographs in an effort to show what painting was not. Years before, in Berlin his painter friends would humor him by saying "Of course, this is not art, but we would like to paint the way you photograph." And Stieglitz would firmly reply, "I don't know anything about art, but for some reason or other I have never wanted to photograph the way you paint." Stieglitz celebrated the uniqueness of both painting and photography with 175 exhibitions at "291" (1905–17), The Intimate Gallery, and An American Place (1929–46). And he documented his photographic faith in *Camera Notes* and the fifty numbers of *Camera Work* (1902–17).

The two arts of photography and painting met in 1924, when Stieglitz, at the age of sixty, married Georgia O'Keeffe, then thirty-seven. She became the subject for one of his two masterworks. "To demand *the* portrait," he explains, "that will be a complete portrait of any person is as futile as to demand that a motion picture be condensed into a single still." So his "composite portrait" of Georgia O'Keeffe, made over many years, included more than four hundred photographs, "heads and ears—toes—hands—torsos," revealing every sort of expression against varied backgrounds. "When I photograph," Stieglitz said, "I make love." But Stieglitz never limited his lovemaking to his camera. He had a stormy career as lover, not only of Georgia O'Keeffe.

Stieglitz was prodded to his other great series, some four hundred photographs of clouds, by two disturbing comments. As he explained in 1923, a friend had written that much of the power of Sticglitz's photographs came from his influence over his sitters. And his brother-in-law asked how a person as musical as Stieglitz could get along without a piano. Stieglitz answered both questions at the same time.

> I'd finally do something I had in mind for years. I'd make a series of cloud pictures. I told Miss O'Keeffe of my ideas. I wanted to photograph clouds to find out what I had learned in 40 years about photography. Through clouds to put down my philosophy of life—to show that my photographs were not due to subject matter—not to special trees, or faces, or interiors, to special privileges, clouds were there for everyone—no tax as yet on them—free.

He began with a sample, which he called "Music—A Sequence of Ten Cloud Photographs," reminiscent of Monet's series. And he was delighted when the composer Ernest Bloch (1880–1959), seeing them, exclaimed "Music!" and was inspired to write a symphony.

Stieglitz's photographs were, of course, supposed to speak for themselves. But wanting a theory, he developed a pretentious and not entirely intelligible doctrine of "equivalents." "The fact that all true things are equal to one another is the only democracy I recognize." "All experiences in life are one.

... My cloud photographs, my *Songs of the Sky,* are equivalents of my life experience."

Despite this vague homogenizing philosophy, Stieglitz enjoyed and luxuriated in the distinction between painting and photography. His photographs were some of the first to be exhibited in the great art museums of Boston, New York, and Washington. And Stieglitz saw a fertile antithesis. The camera could liberate painters from the traditional need to be literal and representational. Modern painting could, would, and should be *"anti-photography."* At the same time, photography should be itself. "My ideal," he wrote of the exhibition of his work in 1921, "is to achieve the ability to reproduce numberless prints from each negative, prints all significantly alive, yet indistinguishably alike, and to be able to circulate them at a price not higher than that of a popular magazine or a daily paper.... I was born in Hoboken. I am an American. Photography is my passion. The search for Truth my obsession."

The unique power of photography, Stieglitz insisted, was to register the world directly. He was interested, as Paul Strand observed, not in photographers but in photography, a way to depict the world free of Academy inhibitions. Man the creator now worked in a new limbo of machines. The photographer must respect the machine, which was his camera, and not try to make it into a brush or a pencil. "If only people would broaden their concept of the brotherhood of man, to include concern about the brotherhood of man and the machine, the world would be a great deal better."

56

The Rise of the Skyscraper

THE next creation of Western architecture was a new collaboration of man and the machine. For centuries Western architecture had been dominated by only two styles—the classical Greco-Roman legacy and the Gothic legacy of the Middle Ages. Modern times would add another, the joint product of architect and engineer, of the "poetry and prose" of the building arts, which allowed creators to conjure with upward space. It would come from the heart of America and would be more than a style—a design for a new kind of building. The Greco-Roman borrowed from temples, the

Gothic adapted from churches. The skyscraper was created for the tall office building. Excelling all others in height, it would add a new scale and dimension to man's architectural creations. Its gesture was not to the gods, nor to God, but simply to the sky. Before the rise of the skyscraper, the American cityscape was commonly dominated by a church spire. In Lower Broadway in New York City in 1880 the tallest building was the spire of Trinity Church.

Chicago was to be the birthplace, the Athens or St.-Denis, of the architecture that took businessmen into the sky, where they could look down on the steeples of their churches. And Chicago itself was a phenomenon, in the intensity, speed, and magnitude of its growth. In 1833 the city had barely acquired the 150 population required to incorporate, which fifteen years later reached 20,000, by 1870 counted more than 300,000. In 1890 its 1.1 million made it the nation's second city. A Chicago novelist declared it was "the only great city in the world to which all of the citizens have come for the avowed object of making money." "The lightning city" thrived on growth and expansion, on the movements of people and what they produced.

Focus and terminus of every then-known form of transportation, at the northern end of a canal connecting the Great Lakes with the Mississippi River, Chicago commanded the greatest inland waterway system in the world, which the steamboat made more fluent than ever. From Chicago, a rail network reached the Atlantic, Gulf, and Pacific coasts. The center for gathering, processing, and distributing the produce of a burgeoning continental-agricultural nation, for a century Chicago remained the livestock and meatpacking capital of the world. In Chicago, even before the Civil War the need for quickly built, easily demounted, and readily transported buildings had produced a bizarre architectural novelty. The widely ridiculed "balloon frame house" was displacing the traditional heavy mortise and tenon frame with lightweight planks of milled lumber quickly nailed together. Some objected that such flimsy houses would be blown away by the first wind. But in this community with few skilled carpenters and no restrictive guilds a new technology won the day. The balloon frame would house millions in American cities and suburbs to come.

Meanwhile, in the nation's largest city, New York, there was pressure to provide offices for the growing financial empires headquartered there. In the 1880s and 1890s the first tall buildings still fitted somehow into the city scene. Not until 1892 did a secular building, the 309-foot-tall Pulitzer Building, overshadow Trinity Church (284 feet). For centralized business administration, to bring businesses that dealt with one another close together, and to fit them into the congested downtown, New York builders began building tall. Elevators were necessary, but at first the public was put off by fears of

falling. The ingenious Elisha Graves Otis (1811–1861), who had been working in a bedstead factory, invented a safety device that prevented the elevator from falling if the lifting chain broke. He set up his factory in Yonkers, in 1861 patented and manufactured the steam elevator, and so made the tall building convenient. These "vertical railways" were first generally used in hotels. They were the uncelebrated essential engineering feature that made possible the modern skyline.

While adopting the new elevators New York architects still used traditional materials in the traditional way for their high buildings. What is sometimes called the first tall office building was erected (1868–70) at 120 Broadway. Though rising to a height of 130 feet, it contained only five working stories. Except for its height, there was nothing novel in its construction, which was of masonry with some brick and some wrought-iron beams in the interior. The fear of fire, which might cause the exposed metal frame to buckle and collapse, prevented the use of iron framing throughout. But new ways of fireproofing ironwork by cladding with fireproof tile as well as speedier and safer elevators encouraged more high buildings in the next five years. The Western Union Building rose to 230 feet, the Tribune Building to 260. Despite their unusual height, they still relied on masonry walls and partitions, with supporting wrought-iron beams.

Masonry, however, was ill-suited to tall buildings. The outside walls at the bottom would have to be made thicker to support the great weight of the masonry and the increasing weight of beams and floors for each added story. As a result the entrance floors to a tall masonry office building would require the lower walls of a medieval fortress. Before electric lighting, which was not practical till the 1880s, illumination was also a problem. The space allowed for windows in such structures would be more suited for shooting arrows out than for admitting sunlight, while the most valuable shop and office space near the ground would be consumed with thick masonry.

For the upreaching modern skyscraper some other kind of construction was required. New York was not to be the place. Two centuries old at the time of the Civil War, it was ancient by American standards, and had accumulated countless building regulations. Its architects, dominated by the Beaux-Arts academic tradition, imagined monuments to outshine their French or British counterparts. But Chicago was a young city bursting with new arrivals. There in 1880 the median age of architects active in designing large buildings was only thirty. More often than not they were engineers rather than architects. With few exceptions they were not infected by the Beaux-Arts tradition, and were prepared to create new structures for new needs. And the newest need was office space for expanding American enterprise in the congested city.

To these Chicago advantages an inscrutable providence added a trau-

matic incentive, one of the great urban catastrophes of modern times. In America, unlike the Old World, destructive catastrophes such as earthquakes, floods, and invasions had not generally been required to provide a clean slate for innovation. But the Chicago fire of October 8–10, 1871, destroyed within two days much of the physical product of the city's forty years. The city had been built with no thought of fire. Even the sidewalks were of resinous pine. The cause of the great Chicago fire remains unknown, but the legend of Mrs. O'Leary's cow knocking over a lantern persists. Between nine o'clock Sunday evening, October 8, and ten-thirty the following night, three and a half square miles of the central city were burned out. Although there was a confirmed loss of only three hundred lives, eighteen thousand buildings were incinerated and one hundred thousand people were left homeless. Local moralists, comparing it with the ancient destruction of Babylon, Troy, and Rome, called it a modern apocalypse. "Very sensible men," Frederick Law Olmsted reported from the scene, "have declared . . . that it was the burning of the world." In sober fact, the catastrophic fire offered American architects an opportunity like that seized by Nero in ancient Rome.

The phoenix would become the appropriate symbol of the city, for a new Chicago arose speedily from the ashes. "Oh it was an enlivening, inspiring sight," only five months later a visitor exclaimed, "to look out each morning, upon a brave wall of solid masonry, which one had not noticed before! . . . the constant stream of vehicles that went plunging through the streets, like fire engines bent on saving a city from destruction; and, indeed, their errand was of equal moment—the building up of the New, since the Old could no longer be saved!" The speed and magnitude of the catastrophe were said to be another confirmation of the city's uniqueness. Like the settlers starting over at Plymouth Rock, they found new reason to see Chicago as the archetypal American city. Within a month, five thousand cottages were being built, and real estate prices rose above prefire levels. The stage was set for a building boom—and architectural creation—without precedent.

Chicago, the New World's new city, had become perforce a scene for the first American urban renewal. And on what a scale! Frontier engineer-architects, at home in building iron bridges, were open to new ways. Steel-frame construction, the additional element needed for the skyscraper, was created in Chicago within a dozen years after the fire. This "cage construction" had obvious essential advantages over masonry. A steel-frame skeleton supporting a tall building would not have to be thick at the base, and so would free the valuable rentable space near the ground. A conventional eleven-story masonry building required thick bearing walls at the bottom

that would leave clear interior room widths of only sixteen feet. A steel frame would open up the interior of the building, regardless of its height, and at the same time would open the outer walls for large windows and natural light, which now could penetrate the interior.

The first building of true skyscraper design—or "cage construction"—the Home Insurance Company Building, was built in Chicago (1884–85) by William LeBaron Jenney (1832–1907). Major Jenney, father of the skyscraper, was a New Englander who, at seventeen, had sailed in one of his father's whalers around the Horn in 1849 to join the gold rush to California. After three years at the Lawrence Scientific School studying engineering and eighteen months in Paris studying art and architecture, he served as engineer building the trans-Panama railroad, then as engineer for General Sherman in the Civil War. After the war he settled in Chicago. The assignment that made history was his commission to design for the Home Insurance Company a fire-resistant building with the greatest number of well-lighted small offices. A piece of folklore circulated by the contractor for this building helps us understand the simple virtues of the "cage" construction. One evening, it seems, when Jenney came home depressed at his inability to solve his problem, his wife happened to be reading a heavy book. Casually putting it aside, she laid it on top of a nearby birdcage. With a Eureka flash, Jenney suddenly saw that if the flimsy wire frame of the birdcage would support a heavy book, a similar metal cage might support the weight of a tall building. By creating steel-skeleton construction he opened the era of the skyscraper.

The nine-story Home Insurance Company Building, finished in 1885, proved that a steel skeleton could support a high structure. Architects had feared that in case of fire the different rates of thermal expansion between iron and masonry might buckle the metal and crack the masonry. And Jenney had planned to use heavy granite piers to bear some of the weight of the frame, which was to be cast-iron columns. Before these cast-iron columns were delivered, the Carnegie-Phipps Steel Company perfected a way of rolling steel columns. Jenney substituted these for the iron above the sixth floor, and so, finally, steel entered buildings. This was fifteen years after steel had been used in an American bridge. The lightness of steel compared with wall-bearing masonry, together with the new processes of riveting, opened up the building to sunlight and allowed grand increases in height. The greater strength of steel columns made it possible to space the columns farther apart inside the building, leaving the interior space flexible for movable partitions. Steel-skeleton construction where the enclosing walls had no load-bearing function would eventually make possible increasingly dramatic use of glass. The steel frame not only created an enormous new demand for steel. It allowed the architect's imagination to soar upward as well as outward. Now the sky would be the limit.

This was not the first time that Americans had added a new material for the architect. The versatile James Bogardus (1800–1874), trained as a watchmaker, improved the striking parts of clocks, devised new machines for engraving, and a metal-cased pencil that was "forever pointed." In Italy in 1840, "contemplating rich architectural designs of antiquity," he had first conceived the idea of emulating them in modern times by the use of cast iron. His own five-story factory (1850) was said to be the first complete cast-iron building in the world. He patented his "Improvements in the Methods of Constructing Iron Houses" (1850), and made whole buildings, including the frames, floors, and supports, of cast iron. Such buildings could be erected speedily at all seasons "by the most ignorant workman," could easily be taken to pieces and removed, making possible thinner walls, "fluted columns and Corinthian capitals, the most elaborate carvings, and the richest designs" at little cost. All of which "would greatly tend to elevate the public taste for the beautiful, and to purify and gratify one of the finest qualities of the human mind." Bogardus's cast-iron buildings never became popular, but his concept was prophetic. His 175-foot-high tower (1855) for the McCullough Shot and Lead Company in New York, with its octagonal cast-iron frame of true skeletal construction and nonbearing curtain walls, may have been known to Jenney.

Once Jenney had shown that it could be done, many others followed. Chicago became a living museum of the new American architecture and a forum for its prophets. The most eloquent of these was Louis Henri Sullivan (1856–1924). Born in Boston, son of an immigrant Irish dancing master, he attended public schools. At the age of thirteen, impressed that anyone could make up a building out of his head, he decided to become an architect. At sixteen he entered the course in architecture at the Massachusetts Institute of Technology, where he learned to draw, and was offered the classical orders "in a sort of misch-masch of architecture theology." He left impatiently after a year. In New York he met the famous Richard Morris Hunt, who told him that to become an architect he must go to Paris. He found employment in an architectural office in Philadelphia. When he lost this job in the disastrous panic of 1873, he joined his dancing-master father in Chicago. At the age of seventeen, he arrived there on the day before Thanksgiving, a month after the Great Fire. He found a city in ashes, and architects measuring their commissions by the mile. He later exuberantly reported his impressions:

> Louis thought it all magnificent and wild: a crude extravaganza, an intoxicating rawness, a sense of big things to be done. . . . The elevated wooden sidewalks in the business district with steps at each street corner, seemed shabby and grotesque; but when Louis learned that this meant that the city had determined to raise itself three feet more out of the mud, his soul declared that this resolve meant

high courage; that the idea was big; that there must be big men here. The shabby walks now became a symbol of stout hearts. . . . The pavements were vile, because hastily laid; they erupted here and there and everywhere in ooze. Most of the buildings, too, were paltry. . . . But in spite of the panic, there was stir; an energy that made him tingle to be in the game.

Young Louis found a job with the warm and generous Major Jenney, who had begun practice only five years before. "The Major was a free-and-easy cultured gentleman but not an architect except by courtesy of terms. His true profession was that of engineer."

Following Hunt's advice, after six months the restless Sullivan set off for the École des Beaux-Arts in Paris. To prepare himself in six weeks for the rigorous entrance examination he studied eighteen hours a day (with an hour off for exercise at the gymnasium), he wore out three successive tutors in French, engaged a tutor in mathematics, and read widely in history. The three-week-long examination—written, drawn, and oral—he passed brilliantly. To recover from the strains of the examination he went to Italy. There the high point was the two days he spent in the Sistine Chapel in Rome, and so at eighteen he discovered Michelangelo, who would be his lifelong idol. "Here Louis communed in silence with a Super-Man. Here he felt and saw a great Free Spirit. Here he was filled with the awe that stills. . . . Here was power as he had seen it in the mountains, here was power as he had seen it in the prairies, in the open sky, in the great lakes stretching like a floor toward the horizon, here was the power of the forest primeval."

At the Beaux-Arts, as at MIT, the problems posed to students were purely academic, unrelated to the real world. The history of architecture taught there focused on abstractions called "styles." But Sullivan saw architecture "not merely as a fixation here and there in time and place, but as a continuous outpouring never to end, from the infinite fertility of man's imagination evoked by his changing needs." And here was a clue to his principle "so broad as to admit of no exception," which became his "holy grail" for architecture.

After about a year in Paris, Sullivan returned to Chicago in 1875 seeking work as an architect. Fascinated by the great bridge recently completed (1867–74) by James B. Eads (1820–1887) across the Mississippi at St. Louis, he spent his spare time reading up on engineering, and discovered engineer heroes. When he entered the firm of Dankmar Adler in 1879, which became Adler and Sullivan in 1881, the urgent architectural problem in the congested city was how to provide light for offices and how to build higher. The new sciences of Spencer, Huxley, and Tyndall reinforced Sullivan's revulsion against an architecture of historic styles.

The quest for an American architecture had found a prophetic voice a

half century before Sullivan. The New England sculptor Horatio Greenough (1805–1852) had scandalized patriots by his gigantic statue of a half-naked George Washington in the guise of a Roman warrior, but his plea for an "American Architecture" (1843) was acclaimed by Emerson and others. Greenough dared to mock Thomas Jefferson's use of a Roman temple as a model for an American State House. Even while the Washington Monument was being constructed he ridiculed the "palpable absurdity" of the original design, "the intermarriage of an Egyptian monument— whether astronomical, as I believe, or phallic, as contended by a Boston critic, matters not very much—with a Greek structure or one of Greek elements."

Louis Sullivan was to be the spokesman as well as the exemplar of an American architecture. The professional architects of his day, grateful legatees of Vitruvius and Suger, were sitting ducks for this Walt Whitman of the building arts:

> You are ill. Your eye wanders. This is no Roman temple built by a motley crowd of organ-grinders—spook-creatures of your fertile brain—it's a bank; just a plain, ordinary, every-day American bank, full of cold hard cash and other cold things. I know all about it, I read about it in the papers. I saw it built, I know the president. . . . The Roman temple can no more exist in fact on Monroe Street, Chicago, U.S.A., than can Roman civilization exist there. Such a structure must of necessity be a simulacrum, a ghost. . . . But Roman does not mean American, never did mean American, never can mean American. Roman was Roman; American is, and is to be, American. The architect should know this without our teaching, and I suspect that he does know it very well in his unmercenary moments.

Sullivan's brief article, "The Tall Office Building Artistically Considered," in *Lippincott's Magazine* (March 1896) became the manifesto of a modern and an American architecture. This was no Vitruvian Ten Orders for modern architects but an eloquent defense of what was already visible in the pioneer American skyscrapers. The word "skyscraper" had already entered the American language in a *Chicago Tribune* article (January 13, 1889) entitled "Chicago's Skyscrapers" to describe this new kind of tall building.

"The architects of this land and generation," Sullivan began, "are now brought face to face with something new under the sun—namely, that evolution and integration of social conditions, that special grouping of them, that results in a demand for the erection of tall office buildings." On the ground floor there must be "a main entrance that attracts the eye to its location," and spaces suitable for stores and banks, a story below ground

for the services of power, heating, and lighting, and an attic space on top for the machinery of the circulatory system. Rising above the ground floor should be "an indefinite number of stories of offices piled tier upon tier, one tier just like another tier, one office just like all the other offices—an office being similar to a cell in a honey-comb, merely a compartment, nothing more. . . . We, without more ado, make them look all alike because they are all alike." Tall buildings in New York and Chicago had been plastered with imported ornaments—classical architraves, Gothic windows and gargoyles—that bore no relation to the modern structure.

To his earthy empiricism Sullivan added "the imperative voice of emotion." "It demands of us, what is the chief characteristic of the tall office building? And at once we answer, it is lofty. This loftiness is to the artist-nature its thrilling aspect. It is the very open organ-tone in its appeal. . . . It must be tall, every inch of it tall." Sullivan, no master of understatement, generalized his inspiring prescription for the skyscraper into a universal law.

Whether it be the sweeping eagle in his flight or the open apple-blossom, the toiling work-horse, the blithe swan, the branching oak, the winding stream at its base, the drifting clouds, over all the coursing sun, form ever follows function, and this is the law. Where function does not change form does not change. The granite rocks, the ever-brooding hills, remain for ages; the lightning lives, comes into shape, and dies in a twinkling.

In his wordy Whitmanesque manifesto for functionalism Sullivan exhorted American architects to "cease struggling and prattling handcuffed and vainglorious in the asylum of a foreign school" and produce a democratic art "that will live because it will be of the people, for the people, and by the people." But the architect of the future would be tempted by "the art of covering one thing with another thing to imitate a third thing, which, if genuine, would not be desirable."

Early skyscrapers irked city-neighbors by blocking their sunlight and their view of the heavens. The Equitable Life Building completed in 1915 at 120 Broadway in New York City covered a full block and rose without setbacks to thirty-nine stories. Its 1.2 million feet of rentable space made it the world's largest office building, but its east–west mass deprived adjacent buildings of light, and cast long, broad shadows. The neighbors' protests sparked the first zoning ordinance in the United States, in 1916, which limited a skyscraper's total floor area to twelve times the size of its plot. The Equitable had provided inside floor space more than thirty times the size of the land it covered. The perils of the skyscraper to city life were being revealed.

The American half century after the first building of true skyscraper design, William LeBaron Jenney's Home Insurance Company Building in Chicago in 1885, was one of the most productive in the history of architecture. As distinct an architectural type as the Greek temple or the Gothic cathedral, the skyscraper showed the same uncanny capacity for variation, adaptation, camouflage, and embellishment. But while those earlier types stayed on the ground and only occasionally punctuated the skyline, the skyscraper reached relentlessly upward, and created a new heaven-bound delineation for the modern city. American cities came to be identified less by their street plans than by their recently created "skylines."

The skyscraper leitmotif was elaborated in three overlapping phases: the classic, the theatrical, and the international. The classic phase appeared in the first prototypes of skeleton-frame construction in the 1880s and 1890s built in Chicago, or mostly by Chicago architects. While they overshadowed other city buildings by going up over ten stories, in silhouette they still seemed a squarish piling of story on story. The revolutionary skeleton of the Home Insurance Company Building was so well hidden that not until the original was demolished to make way for a higher building in 1931 did three expert investigating committees establish its claim to be the first building of skeleton-frame skyscraper design. Sullivan's masterpieces in this classic skyscraper style were the Wainwright Building in St. Louis (with Adler, 1891), the Chicago Stock Exchange (with Adler, 1894), the Guaranty Building in Buffalo (with Adler, 1895), and the Carson Pirie Scott store (1901–4) in Chicago.

When the leading architecture critic of the day, Montgomery Schuyler (1843–1914), assessed "The Sky-Scraper Up to Date" in 1899, he attacked American architects for aiming at all costs at "originality" instead of "shining with new grace through old forms." He reminded Americans of the enduring wisdom of Aristotle, "the father of criticism, that a work of art must have a beginning, a middle, and an end." The best skyscrapers, he noted, had followed "the Aristotelian triple division . . . the more specific analogy of the column." Just as the ancient Greek column had a base, a smooth supporting body, and a decorated capital, so the skyscraper should visibly distinguish these elements—decorated treatment on the ground floor, an ornamented cornice at the top, and in the body of the building an unbroken repetition of the "tiers of similar cells" like the column itself. Despite his protestations, Sullivan's own most esteemed early "skyscrapers" like the Wainwright Building seemed to follow this Aristotelian model.

The liberation of the American skyscraper came not in Chicago but in New York in what the architecture critic Paul Goldberger has called the "theatrical" phase. The different layouts of cities encouraged giving a different

aspect to their tall buildings. The streets of recently settled Chicago had marked out symmetrical square blocks, providing sites for squat squarish buildings. But in New York the narrow crooked lanes and varied angular intersections inherited from two centuries of history gave a different challenge to its architects. "As the elephant . . . to the giraffe, so is the colossal business block of Chicago to the skyscraper of New York," the novelist William Archer observed. "There is a proportion and dignity in the mammoth of Chicago which is lacking in most of those which form the jagged skyline of Manhattan Island. . . . They are simply astounding manifestations of human energy and heaven-storming audacity." These dramatic architectural experiments had special appeal for Edward Steichen and Alfred Stieglitz and their new art of photography. On the curious triangular plot (only six feet wide at its apex) at the intersection of Broadway and Twenty-third Street in 1903 rose Chicago architect Daniel Burnham's Flatiron Building, which was the subject of one of Stieglitz's most dramatic photographs. Its surrounding downdrafts added human sensations to the architectural by flapping up the petticoats of long-skirted women as they passed by. Bizarre towers rose across the city—the Metropolitan Life tower (1909) had a replica of the campanile in St. Mark's Square in Venice, while the Woolworth Building (1913), the world's tallest at the time, adapted Gothic motifs (gargoyles and all) to ornament the top of its 792 feet and even to embellish entrances of its twenty-nine speedy elevators.

Skyscraper theatrics provided a new American kind of advertisement. Across the land in the Old World big buildings had always advertised the power of prince and Church. Now skyscrapers wrote their commercial message in the sky—advertising life insurance, sewing machines, or five-and-tens. F. W. Woolworth paid $13.5 million in cash for his building, an expensive advertisement but well worth it. On April 24, 1913, President Woodrow Wilson turned the opening switch from the White House, and the eminent Methodist clergyman S. Parkes Cadman proclaimed it "The Cathedral of Commerce," sending a brand-name message around the world. "Just as religion monopolized art and architecture during the Medieval epoch, so commerce has engrossed the United States since 1865. . . . Here, on the Island of Manhattan . . . stands a succession of buildings without precedent or peer. . . . Of these buildings, the Woolworth is Queen, acknowledged as premier by all lovers of the city . . . by those who aspire toward perfection, and by those who use visible things to obtain it."

By 1930 another theatric advertisement had overtaken the Woolworth Building. The seventy-seven-story Chrysler building, rising to 1,048 feet, was the world's tallest when completed in 1930. It also combined a romantic spire of jazzy stainless-steel arches with ornamental trim and gargoyles fashioned after the device on the hood of the 1929 Chrysler car, and earned

its architect William Van Alen the sobriquet of "the Ziegfeld of the profession." It was wonderful how rapidly the skyscraper sweepstakes were lost or won. The very next year the Empire State Building rose to 102 stores and 1,200 feet. With former Governor Alfred E. Smith as the front man, it proved a better advertisement for American architecture than for the American economy. When it opened in the midst of the Depression, it had so few tenants that it was called the Empty State Building. Still, it became rich in news and folklore. In 1933 it proved a convenient perch for King Kong, who made a spectacular climb to the top. But in 1945, when a small plane rammed into its seventy-sixth floor, killing the pilot and thirteen others, some said it proved that God never intended that there should be such tall buildings.

Chicago entered the theatric sweepstakes when the Chicago Tribune Company in 1922 announced a competition for the design of its skyscraper office in the heart of the city. Of the 160 architects from all over, the competition was won by Chicago architects John Mead Howells and Raymond Hood with their Gothic tower crowned by a circle of buttresses. In New York's Woolworth tradition it succeeded as an advertisement for "the world's greatest newspaper" but had little influence on the future of architecture. In sharp contrast, the second-prize design by the Finnish architect Eliel Saarinen for a clean stepped-back central tower with no cornices or belt courses separating the floors and with no imitation of classical or Gothic themes provided the model for future American skyscrapers. "It goes freely in advance," Louis Sullivan acclaimed, "and with the steel frame as a thesis, displays a high science of design such as the world up to this day had neither known nor surmised." Saarinen immigrated to the United States to become one of the most influential city planners of the generation.

The next phase of the American skyscraper, like other triumphs of American culture, would become international. No longer in the tones of a Walt Whitmanesque muscular America, the skyscraper celebrated the technology that was bringing the world together. The provincial, rural-minded Thomas A. Edison in 1926 prophesied doom. "If . . . New York keeps on permitting the building of skyscrapers, each one having as many people as we used to have in a small city, disaster must overtake us." And Thomas Hastings (1860–1929), an American Beaux-Arts disciple, foresaw "the city of dreadful height." But on seeing the city, the bold French-Swiss architect Le Corbusier declared, "The skyscrapers of New York are too small and there are too many of them." Others, too, like Raymond Hood, saw new opportunities. "Congestion is good," he insisted, "New York is the first place in the world where a man can work within a ten-minute walk of a quarter of a million people. . . . Think how this expands the field from which

we can choose our friends, our co-workers and contacts, how easy it is to develop a constant interchange of thought."

The flamboyant Frank Lloyd Wright (1869–1959), from rural Wisconsin, shared Edison's fear of the congested overbuilt city. His practice had been mainly in domestic architecture, but he had been entranced by the skyscraper since his early years as apprentice to Sullivan. He let his imagination soar, offered thin-slab designs long before Rockefeller Center, pioneered in glass for tall buildings with his plan for a Luxfer Prism Skyscraper (1895), which was never built, and topped the competition with his grand solution (1956) to congestion on the ground, a Chicago Mile-High Skyscraper (never built). His tall-building designs, some said, were nothing but small Wright houses blown up to skyscraper scale. His successes would eventually be buildings of a smaller scale hugging the ground.

The later triumphs of the American skyscraper, appropriately for a nation of nations, would be called the International Style and invited architects from all over the world. Its first great monument, cleansed of classical and Gothic frippery, was Rockefeller Center. Conceived in 1927 as a new home for the Metropolitan Opera Company, its planning was interrupted by the Depression of 1929, but was carried on by John D. Rockefeller, Jr., as the first great privately financed mixed-use urban project. The product (1932–40) of Raymond Hood and a team of architects, its seventy-story skyscraper, surrounded by lower buildings with an open plaza in the center, became a delightful focus of pedestrian life. The thin skyscraper slab, a dramatically simple form, did not require the setbacks customary in other tall buildings. The lower surrounding buildings and the open central plaza showed respect for community light and air and provided social amenities. For the first time it offered larger and smaller skyscrapers as a group.

The International Style was dramatized again in the slender thirty-nine-story slab of the United Nations Secretariat building (1952), which was created by a Rockefeller Center architect, Wallace K. Harrison, around a sketch by Le Corbusier. Its unbroken vertical line, a response to Sullivan's plea, was the vivid opposite to the theatrical Woolworth or Chrysler Building. Sheer walls of green glass faced east and west and narrower stretches of white marble rose on north and south. This International Style, so chaste in steel and glass that it could hardly be called a style, found its apostle in the colorful Mies van der Rohe (1886–1969), a refugee from the German Nazis. In Chicago he made the Illinois Institute of Technology a nursery of modernism. His masterpiece in 1958, the Seagram Building at 375 Park Avenue in New York City, was a thirty-eight-story tower of bronze and glass (with no setbacks and no classic or Gothic adornment at top or bottom) set in its own inviting plaza with two fountains in the foreground and a site for an elegant restaurant in the rear. This plain tower became a

prototype for Miesian architecture, a simple structure boasting its simplicity. Some critics objected that Mies was not as honest as he seemed, for his buildings really depended on hidden supports. One admirer called the Seagram Building "a beautiful lady in hidden corsets." But Miesian simplicity prevailed—in the Lever House (1952) in New York, the Inland Steel Building (1957) in Chicago by Skidmore, Owings, and Merrill, the CBS Building (1965) by the Finnish architect Eliel's son Eero Saarinen, in I. M. Pei's John Hancock Tower in Boston (1975), in Kevin Roche's United Nations Plaza Building (1976), and in the twin 110-story towers of the World Trade Center (1976) in lower Manhattan, the city's tallest buildings, which added height, without adding much interest, to the skyline.

Just as steel had made the skyscraper possible, now quite unpredictably the magic of glass incorporated sun and light and all surroundings into buildings in ways the Gothic acolytes could not have imagined, and added a new ambiguity to "structural honesty." The walls of windows made buildings like the Lever House look as if they were made of glass by the deceptive use of spandrel glass to cover the external steel structure between the floors. Glass, this newly versatile ancient material, brought together indoors and outdoors, with new problems of heating and cooling and extravagant demands for energy. Ironic for those who preached that "form follows function," glass varied the appearance of tall buildings without revealing their structure or function.

In architecture of all the arts it would be most difficult to abandon the secure and familiar forms in which people had lived and worshiped and been governed. But in 1890, when the Congress of the United States authorized a World's Columbian Exposition in Chicago to celebrate the four hundredth anniversary of the "discovery" of America, it might have been assumed that the exposition would display the wonders of this new American architecture in its birthplace. Left to themselves Chicagoans had been bold and original. The skyscraper had already made its dramatic appearance. But, facing the Old World art world, frontier Americans became insecure and apologetic. A commission of the city's best architects and landscape designers produced a "white city" of 686 acres to be recovered from the swamps of the city's south side, embellished with lagoons. Its buildings, though newly lit by electricity, were a grandiose array of classical and neo-Renaissance designs. With twenty-eight million visitors from May through October in 1893, it would be acclaimed as the most successful and influential of all world's fairs in the United States.

The Columbian Exposition set a new fashion in urban boosterism, for it "put Chicago on the map." It was also part of the City Beautiful Movement that resulted in the invitation to Daniel Burnham (1846–1912), who was in

charge of the construction in Chicago, to become a designer of the Mall in Washington, D.C., under the McMillan Plan, sponsored by Senator James McMillan of Michigan. This plan, which restored the almost forgotten L'Enfant plan of 1792, was adopted in 1901, and eventually made the capital a city of parks and vistas. So the skyscraper found its place as a separate facet of urban design alongside the "horizontal city" that preserved human scale and warmth in otherwise cold city environments.

Burnham also was the Chicago champion of the classical revival. "The influence of the Exposition," he prophesied, "will be to inspire a reversion toward the pure ideal of the ancients. We have been in an inventive period, and have had rather contempt for the classics." In this competition between the Wild West and the Cultured East, the East won hands down. The White City of columns, temple fronts, arches, and domes showed little that was Chicago American. But the only building admired abroad was Louis Sullivan's Transportation Building, not in the classical mold. Burnham's prediction was on the mark. The Exposition, displacing the fashionable Romanesque of H. H. Richardson, heralded a revival of classical forms.

Louis Sullivan, prophet of an American architecture, deplored this triumph of "good taste" and academic pallor. He stigmatized as dangerously contagious "the virus of the World's Fair." Thus Architecture died in the land of the free and the home of the brave.

> . . . the architectural generation immediately succeeding the classic and Renaissance merchants are seeking to secure a special immunity from the inroads of common sense, through a process of vaccination with the lymph of every known European style, period, and accident. . . . There is now a dazzling display of merchandise, all imported. . . . We have Tudor for colleges and residences; Roman for banks, and railway stations and libraries—or Greek if you like—some customers prefer the Ionic to the Doric. We have French, English, and Italian Gothic, classic and Renaissance for churches. In fact we are prepared to satisfy, in any manner of taste. Residences we offer in Italian or Louis Quinze. We make a small charge for alterations and adaptations.

Architects, Thorstein Veblen explained, were again playing their familiar role, for "the office of the leisure class in social evolution is to retard the movement and to conserve what is obsolescent."

While Americans remained charmed by the obsolescent, Sullivan paid the prophet's price. The spectacle of the World's Columbian Exposition left him embittered, in a slough from which he never recovered. His remaining years were an undocumented nightmare, too frustrating to be recorded in his autobiography. The economic depression of 1893 made architectural commissions scarce. His longtime partner, Dankmar Adler, left him briefly in 1895 for a lucrative post with an elevator company. Then his assistant of

many years left him. By 1909, desperate for lack of commissions, Sullivan had to sell his library and household effects, and then he migrated from one cheap hotel to another. In 1918 he had to give up his office in the Auditorium Tower, which had brought him fame, and move to a small office in the second floor. His marriage in 1899 had ended in separation and divorce. In 1918 he tried unsuccessfully to obtain work for the war. By 1920 he had no office, was living in one bedroom and depended on donations from friends. But he did collect his thoughts, published numerous articles, and in 1918 composed his *Kindergarten Chats,* a meandering Whitmanesque manifesto of American architecture, for which no publisher could be found at the time. Then he wrote his *Autobiography of an Idea* and collected a series of nineteen plates of his designs for ornaments, which a friend placed in his hands as he was dying in his lonely hotel room in 1924.

BOOK THREE

CREATING THE SELF

We have stopped believing in God, but not in our own immortality.

—ÉMILE ZOLA (1886)

Creativity: a type of learning process where the teacher and pupil are located in the same individual.

—ARTHUR KOESTLER (1964)

Man finally comes to himself as a rich raw material of creation. Not just the public notables whom Plutarch celebrated among the Greeks and Romans, but the idiosyncratic everyday person. Everyone is a subject, no act or feeling too intimate, too trivial, to be shaped into biography—or autobiography. Not only the soul, which has engaged saints and priests and prophets, but the self in all its vagrancy. The wilderness within is not only a jungle of hopes and frustrations, but a place of mystery and beauty, of epic memories, bitter struggles and exhilaration, where the whole history of the human race is reenacted. From this vantage point are vistas never seen or revealed before.

PART ELEVEN

THE
VANGUARD
WORD

The man is only half himself, the other half is his expression.

—RALPH WALDO EMERSON, "THE POET"
(1844)

Inventing the Essay

CENTURIES passed in Western literature before authors let themselves be themselves in what they wrote. Dominated by classical conventions, the literati found no forms in which to describe themselves freely and randomly. We should not be shocked, then, by Oscar Wilde's paradox "Being natural is only a pose." Saintly epiphanies and confessions like Saint Augustine's had recorded the search for salvation. A letter addressed to a particular person, usually not intended for publication, was governed by the candor and the good manners of the writer. But how could an author show himself naked, unboastful and unashamed?

For literary self-portrait a new form was created by a French provincial landowner of the Renaissance. Michel de Montaigne (1533–1592) christened his creation "Essays." From the French *essayer,* "to try," the name itself revealed that the task Montaigne had set himself seemed difficult and uncertain. He dared claim only that he had made some "tries" in this new exercise of self-revelation. Montaigne's preface to his 1580 *Essays* declared:

> This, reader, is an honest book. . . . I want to appear in my simple, natural, and everyday dress, without strain or artifice; for it is myself that I portray. My imperfections may be read to the life, and my natural form will be here in so far as respect for the public allows. Had my lot been cast among those people who are said still to live under the kindly liberty of nature's primal laws, I should, I assure you, most gladly have painted myself complete and in all my nakedness.
>
> So, reader, I am myself the substance of my book, and there is no reason why you should waste your leisure on so frivolous and unrewarding a subject.
>
> (Translated by J. M. Cohen)

Despite this uninviting invitation the book survived to become a model for our most popular, most influential, and most widely imitated form of non-fiction.

Yet in contrast to the "forms" of rhetoricians, the essay was not really a form at all. Rather it was a way of literary freewheeling, a license to be random and personal. Aldous Huxley, himself a brilliant practitioner, explained: "By the time he had written his way into the Third Book he had reached the limits of his newly discovered art. . . . Free association artistically controlled—this is the paradoxical secret of Montaigne's best essays. One damned thing after another—but in a sequence that in some almost miraculous way develops a central theme and relates it to the rest of human

experience." The "central theme" that held his *Essays* together, Montaigne repeatedly reminds his reader, was nothing but Montaigne himself.

Personal reflections had previously been cast in certain recognized molds, tamed and domesticated into familiar paths. Some, like the *Moralia* of Plutarch (c.46–120), were treatises on moral conduct—"How to Discern Between a Flatterer and a Friend," or "How to Restrain Anger." Others, like the *Meditations* of Marcus Aurelius (121–180), offered aphorisms and moral precepts. Montaigne knew these works. And his focus, not on morality but on the elusive, ever-changing, contradictory self, was courageously new. Not as a prescription for the Good Life, but for the sheer joy of exploration and self-discovery. Offering not the Good, but the Unique. Here was a landmark in man's movement from the complacency of divine certitude to the piquancy of experience and human variety.

How did Montaigne, who boasted only of his ordinariness, become the creator of a momentous new form of literary freedom and literary creation? Montaigne's ancestry and education were well designed to sharpen his sense of personal uniqueness. His father, Pierre Eyquem, sometime mayor and prosperous merchant of Bordeaux, bore the name "de Montaigne" because Pierre's grandfather had bought the Montaigne château and feudal territory that came with it. His mother descended from a Spanish Jewish family, the Lopez de Villeneuva, who lived in Aragon at the height of the Inquisition in the late fifteenth century. Three members of the family, including Michel's great-great-great-grandfather Micer Pablo (in 1491) were burned at the stake. They were prominent marranos, Spanish Jews who had gone through the motions of conversion to escape persecution, but who continued to practice Judaism secretly. The marrano memory could not have been lost on Michel. He frequently expressed his sense of the injustice done to the Jews, which confirmed his doubts of force as an effective agent of persuasion. "Some turned Christians," he wrote, "of their faith, or of that of their descendants, even today, a hundred years later, few Portuguese are sure, though custom and length of time are far stronger counselors than any other compulsion." The marranos remained suspect in both the Jewish and the Christian world.

Michel was born in the Château de Montaigne, thirty miles east of Bordeaux. The oldest of eight surviving children, he yet enjoyed close attention from "the best father there ever was." To widen the noble child's sympathies, he "had me held over the baptismal font by people of the lowest class, to bind and attach me to them." And Montaigne recalls in his *Essays* that, instead of bringing in a nurse, as many noble families did, his father sent Michel

> from the cradle to be brought up in a poor village of his, and kept me there as long as I was nursing, and even longer, training me to the humblest and common-

est way of life. . . . His notion aimed . . . to ally me with the people and that class
of men that needs our help; and he considered that I was duty bound to look
rather to the man who extends his arms to me than to the one who turns his back
on me. . . . His plan has succeeded not at all badly. I am prone to devote myself
to the little people, whether because there is more vainglory in it, or through
natural compassion, which has infinite power over me.

(Translated by Donald M. Frame)

Believing that the "tender brains" of children were shocked by being rudely
awakened from sleep, "he had me suddenly awakened by the sound of some
instrument' and I was never without a man to do this for me." As a painless
way of teaching the boy Latin, still the language of European learning, his
father hired a German tutor who spoke good Latin but no French, and
decreed that no one should speak anything but Latin in Michel's presence.

"Altogether we Latinized ourselves so much that it overflowed all the
way to our villages on every side, where there still remain several Latin
names for artisans and tools that have taken root by usage." He was six
before he knew French, his mother tongue and the language of the neigh-
borhood. He was taught Greek "artificially, but in a new way in the form
of amusement and exercise. We volleyed our conjugations back and forth,
like those who learn arithmetic and geometry by such games as checkers
and chess." In this domestic Athenaeum, it is remarkable that Michel grew
up to be even as normal as he was.

Sent off to school in Bordeaux, he completed the twelve-year course in
seven. His teachers feared he would show up their imperfect Latin, and he
declared himself lucky that at least they did not teach him the "hatred of
books" that they somehow instilled in other noblemen. His own philosophy
of education would be shaped by seeing the brutal discipline that made the
school "a jail of captive youth. They make them slack, by punishing them
for slackness before they show it. Go in at lesson time; you hear nothing
but cries, both from tortured boys and from masters drunk with rage."

After studying law at the university, Michel through family connections
became a magistrate. For the next dozen years (1554–70) he experienced the
world of affairs, the venality and injustices of the law. He saw one fellow
judge tear a scrap from the paper on which he had sentenced an adulterer,
to write a love note to the wife of a colleague on the same bench. Lawless
France, he complained, had "more laws than all the rest of the world
together."

One crucial experience, not the kind that could be prescribed generally for
the preparation of an author, marked Montaigne's path to become an
essayist. In 1559, soon after he had joined the Bordeaux Parlement, he met

a brilliant fellow magistrate two years his elder whose person would inspire and haunt him for the rest of his life. This was Étienne de la Boétie (1530–1563).

> Some inexplicable power of destiny . . . brought about our union. We were looking for each other before we met, by reason of the reports we had heard of each other, which made a greater impression on our emotions than mere reports reasonably should. I believe that this was brought about by some decree of Heaven. We embraced one another by name. And at our first meeting, which happened by chance at a great feast and gathering in the city, we found ourselves so familiar, so bound to one another, that from that time nothing was closer to either than each was to the other.
>
> (Translated by J. M. Cohen)

This friendship lasted till La Boétie's death from dysentery in 1563. Since 1554 La Boétie had been happily married to an older woman of an eminent local family, the widowed mother of two children. She had no children with La Boétie.

Again and again, Montaigne described his intense relationship with La Boétie. But he does not detail the erotic element. Unlike the Greeks, he writes, "our morality rightly abhors" a homosexual relationship. Still, in the chapter "On Friendship" and elsewhere in his *Essays* he discloses feelings not usual in accounts of friendship between men. Taking his relationship with La Boétie as his prototype of friendship, Montaigne contrasts marriage. "Not only is it a bargain to which only the entrance is free, continuance in it being constrained and compulsory, and depending upon other things than our will, but it is a bargain commonly made for other ends." Acquaintanceship can be enjoyed with many. "But that friendship which possesses the soul and rules over it with complete sovereignty cannot possibly be divided in two. . . ." For nearly five years, he tells us, communications with this alter ego satisfied his need to reveal himself.

The death of La Boétie, who was only thirty-three, hit him hard. On the wall of the entrance to the study he recorded his debt to "the tenderest, sweetest, and closest companion, than whom our age has seen no one better, more learned, more charming, or indeed more perfect, Michel de Montaigne, miserably bereft of so dear a support of his life . . . has dedicated this excellent apparatus for the mind." He recalled with satisfaction "not having forgotten to tell anything" to his friend. The sudden deprivation of this uninhibited friendship and its opportunities for self-revelation left a vacuum. "Hungry to make myself known," Montaigne sought a way to replace his conversations with his best friend. And later generations must be grateful for this premature death of La Boétie, for Montaigne himself

suggests that if La Boétie had lived, instead of the essays he might only have written letters.

> Letter writing . . . is a kind of work in which my friends think I have some ability. And I would have preferred to adopt this form in which to publish my sallies, if I had had someone to talk to. I needed what I once had, a certain relationship to lead me on, sustain me, and raise me up. . . . I would have been more attentive and confident, with a strong friend to address, than I am now, when I consider the tastes of a whole public. And if I am not mistaken, I would have been more successful.
>
> (Translated by Donald M. Frame)

But writing letters to imaginary correspondents, to "traffic with the wind, as some others have done," would not satisfy Montaigne. With his "humorous and familiar style . . . not proper for public business, but like the language I speak, too compact, irregular, abrupt, and singular" he had to create a form of his own. And so came the *Essays*, which marked a new path for authors in future centuries.

This synopsis of Montaigne's personal incentives to create the modern essay leaves out the broad currents of life in his time and the frustrations of public life that also played their part. From his grief at the death of La Boétie, Montaigne sought relief in marriage. "Needing some violent diversion to distract me from it, by art and study I made myself fall in love, in which my youth helped me. Love solaced me and withdrew me from the affliction caused by friendship." The object of this factitious love was the twenty-year-old daughter of an eminent Catholic family of Bordeaux. He boasted that the decision was not made by himself. "We do not marry for ourselves, whatever we say; we marry just as much for our posterity, for our family. . . . Therefore I like this fashion of arranging it rather by a third hand than by our own, and by the sense of others rather than by our own. How opposite is all this to the conventions of love!" In 1565, two years after he lost his friend, he married Françoise de la Chassaigne. By conventional standards it seemed a good marriage, although of the six children she bore him only one survived more than a few months after birth. Montaigne still insisted that friendship, not love, should be the bond of marriage.

Meanwhile, life in Montaigne's France did not encourage a firm religious faith. In religious wars tainted by political intrigue and dynastic feuds it was seldom clear whether the parties were fighting for their king or for their God, and they were inclined to confuse the two. Just as Montaigne's relation to La Boétie had bred habits of honest self-revelation, so the spectacle of the "wars of the three Henrys" bred a skeptical frame of mind. The word "Huguenot" now entered the French language for the Protestant sect that

was widening its appeal, especially to the nobility of southwestern France. The year when Montaigne began writing his essays, 1572, was the year of the Saint Bartholomew's Day Massacre. The devious Catherine de' Medici took advantage of the assemblage of nobles in Paris for the wedding of her daughter to Henry of Navarre (later Henry IV) to order the assassination of the Huguenot leader Coligny and many others. The butchery in Bordeaux, too, was terrifying, and nobody knows how many thousands were massacred across the provinces. For this bloody victory of the faith Pope Gregory XIII celebrated a thanksgiving Mass in Rome.

The volatile religious spirit was symbolized in Henry IV, a Protestant who vainly tried to pacify the country and save his life by his pretended conversion to Catholicism (1593). His conciliatory Edict of Nantes (1598) which offered Huguenots in some places political and religious freedom only sparked another cycle of civil wars, and led to his own assassination. Still, Montaigne's father, an enemy of forced convictions, had been tolerant in the family, allowing his children to follow their own faiths. Two of Michel's brothers were Protestant. Montaigne himself, though professing to be a Catholic, was a trusted adviser and chamberlain to Henry, the leading Protestant. The moderation of his faith made him suspect on both sides.

Even before the Saint Bartholomew's Day Massacre, Montaigne had decided to withdraw from public life. He had served thirteen years in the Bordeaux Parlement and had spent much of the last seven years reverently tracking down and editing the writings of La Boétie. He marked the occasion of his retirement, on his thirty-eighth birthday, with a Latin inscription near the entrance to his library-study:

> . . . Michel de Montaigne, long weary of the servitude of the court and of public employments, while still entire, returned to the bosom of the learned Muses, where in calm and freedom from all cares he will spend what little remains of his life. . . . and he has consecrated it to his freedom, tranquility, and leisure.

The pleasures of the library were, of course, not new to Montaigne. The past year, as a task of filial piety, he had worked at translating from Latin into French a little-known work of theology. The Spanish scholar Raymond Sebond's *Book of Creatures, or Natural Theology,* published some one hundred fifty years before, had caught his father's fancy as an antidote to Protestantism. His father had instructed Michel to translate it, and he dedicated the translation to his father on the very day of his father's death.

The enduring product of this act of piety was not what the elder Montaigne had hoped for. Michel's own "Apology for Raymond Sebond," became the longest and most philosophically explicit of his essays. While exploring the role and the limits of reason and pretending to defend Sebond,

Montaigne expounded his own skepticism. Ironically, his act of filial piety had provided him with a way to dispose of his father's faith. Montaigne's message here too is still in the spirit of the *Essays,* which he sums up in his famous motto "What do I know?" (*Que sais-je?*) Montaigne purports to prove that "Man is nothing without God," but the burden of his argument is that since Man has no knowledge, skepticism is the only wisdom.

He reveals man's delusion of superiority over other animals. Yet reason, knowledge, and imagination, which seem to distinguish man from the other animals, seldom add to his happiness. Our memory is as often a pain as a comfort. "For memory sets before us, not what we choose, but what it pleases. Indeed, there is nothing that imprints a thing so vividly on our memory as the desire to forget it." Montaigne divides philosophers into three classes: those who claim to have found the truth; those who deny that truth can be found; and those like Socrates who confess their ignorance and go on searching. Only the last are wise. All others make the mistake of believing that truth and error can be measured by man's capacities. Our senses are our only contact with the world, and they tell us nothing but what the senses can tell. How can we know what is really out there? Montaigne still professes that he supports the Catholic religion, which is beyond the reach of reason or the senses. Yet his father would not have been happy to see that he was supporting the Faith "as the rope supports the hanging man."

Montaigne was not as successful as he had hoped in his efforts to withdraw completely from public life. He continued to be enlisted in the battles and diplomacy of the religious wars. But he had begun writing essays soon after his retirement in 1571. By 1578 he had found, or invented, "Essays" as the title for his literary creation. Perhaps it came, somehow, from a literary competition in 1540 at the Floral Games in Toulouse, his mother's home-town. To break the tie among the leading competitors in the poetry contest, a last line would be supplied to which each contestant "tried" to supply the best opening lines. The idea of "trial" or "experiment" is essential to Montaigne's new literary creation. He is aiming not to construct a philosophy or prescribe a morality, but only "to spy on himself from close up. This is not my teaching, this is my study; and it is not a lesson for others, it is for me." "These are my humors and opinions; I offer them as what I believe, not what is to be believed."

The ninety-four essays of varying length published in his first two volumes in 1580 were delightfully miscellaneous, with all the charm of randomness. "I am myself the substance of my book," his Preface explained. "Whatever these absurdities may be, I have had no intention of concealing them, any more than I would a bald and graying portrait of

myself, in which the painter had drawn not a perfect face, but mine." Their very heterogeneity testified to frankness. "Of Idleness" is followed by "Of Liars" and "Of Prompt or Slow Speech." "Of the Uncertainty of Our Judgment" precedes "Of War Horses," and "Of Smells" before "Of Prayers." "Of the Greatness of Rome" comes just before "Not to Counterfeit Being Sick," and "Of Thumbs." There is no effort at chronology, at the development of arguments, ideas, or narrative, no attempt to deny the flux, or to insist that flux can know flux. "I do not portray being: I portray passing . . . from day to day, from minute to minute. . . . This is a record . . . of irresolute and, when it so befalls, contradictory ideas; whether I am different myself, or whether I take hold of my subjects in different circumstances and aspects." With his *Essays,* Montaigne had discovered and begun to explore himself, then he created a self in words. When these volumes were published in Bordeaux he observed with his usual self-deprecation that the farther away the readers were, the better they would like his work. At home "they think it droll to see me in print."

One of his most outlandish and most influential essays revealed that Montaigne could use his self-explorations to help others illuminate the world. "Of Cannibals" urges caution before we stigmatize any people as "barbarous," a term that the Greeks indiscriminately applied to all strange ways. "We see from this how chary we must be of subscribing to vulgar opinions; we should judge them by the test of reason, and not by common report." He describes the savagery of torturing heretics, prisoners, and criminals, which really seems to him a way of "eating a man alive." "I consider it more barbarous to eat a man alive than to eat him dead; to tear by rack and torture a body still full of feeling, to roast it by degrees, and then give it to be trampled and eaten by dogs and swine—a practice which we have not only read about but seen within recent memory, not between ancient enemies, but between neighbours and fellow-citizens, and what is worse, under the cloak of piety and religion—than to roast and eat a man after he is dead." But his reflections on cannibals would have a more cheerful afterlife when Shakespeare, who probably read this passage in Florio's translation, himself translated these charitable sentiments into *The Tempest.*

It was at the conclusion of this work of nine years that Montaigne wrote his familiar self-disparaging preface. His book was only "to amuse a neighbor, a relative, a friend." He sought his well-earned respite in Italy, where he visited the watering places seeking relief from the kidney stone that never ceased to plague him. At Rome, where "every man shares in the ecclesiastical idleness," he was courteously received by the same Pope Gregory XIII who had celebrated the grateful Mass for the Massacre of Saint Bartholomew's Day. His *Essays,* which had been reviewed by a papal censor who

could not read French, were, to his surprise, only mildly "corrected." Gone only a year, he received an urgent message to return to Bordeaux, where he had been elected mayor. A Catholic loyalist respected by the Protestants who now surrounded Bordeaux, he might be useful in trying to keep the peace. He reluctantly accepted the call, and after serving creditably he was allowed to return to his study in 1585. There he revised Books I and II of his essays and worked on Book III. The religious war heated up again, with the Holy Catholic League in the ascendant. Now Montaigne, suspect for not having joined the Catholic army, and with a Protestant brother and sister and friends among the heretics, was in constant peril. "I incurred the disadvantages that moderation brings in such maladies. I was belabored from every quarter: to the Ghibelline I was a Guelph, to the Guelph a Ghibelline. . . . It was mute suspicions that were current secretly."

An epidemic of the plague that drove him and his family for six months from his château decimated the neighborhood. Wherever they went, the terror followed them, "having to shift their abode as soon as one of the group began to feel pain in the end of his finger."

The first two volumes of the *Essays,* which had gone through four editions in Bordeaux, were finally being published in Paris, and were respectfully received by scholars. This encouraged him to go on. His third volume with thirteen essays appeared in 1588, with additions to the earlier volumes. Volume III offered more in the "essay" spirit. "This essay of myself" is more emphatic in his opinions and more self-conscious. "I would rather be an authority on myself than on Cicero." Again he is free with self-doubts and self-criticism. "Stupidity is a bad quality" he observes in "On the Art of Conversation," "but to be unable to bear it, to be vexed and fretted by it, as is the case with me, is another kind of disease that is hardly less troublesome." "I often risk some intellectual sallies of which I am suspicious, and certain verbal subtleties, which make me shake my head. But I let them go at a venture. I see that some are praised for such things; it is not for me alone to judge. I present myself standing and lying down, front and back, facing left and right, and in all my natural attitudes." "Our follies do not make me laugh, our wisdom does."

Montaigne never ceased to yearn for another living partner in his conversations about himself. His *Essays* still seemed only a substitute for spoken revelations to his departed friend. In 1588, in this third volume, a quarter century after the death of La Boétie, he is still plaintively reaching out:

> Amusing notion: many things that I would not want to tell anyone, I tell the public; and for my most secret knowledge and thoughts I send my most faithful friends to a bookseller's shop. . . .
> If by such good signs I knew of a man who was suited to me, truly I would

go very far to find him; for the sweetness of harmonious and agreeable company cannot be bought too dearly, in my opinion. Oh, a friend!

(Translated by Donald M. Frame)

Nor would he reach in vain.

The answer to his prayer was almost as surprising and puzzling as his relationship with La Boétie. Early in 1588, when he was in Paris on one of his diplomatic missions, he met the brilliant and learned Marie de Gournay (1566–1645), a young woman of twenty-two who had so admired his *Essays* that she had written asking to meet him. As her father had died ten years before, she now became his *fille d'alliance,* his informally adopted daughter. The term had no legal significance but described a soul mate to whom one had no blood tie. The adoration may have been more on her side than on his, but ailing and "friendless" he welcomed her literary intimacy. He lived at her house for some months while he dictated passages of the *Essays* to her, and he designated her his literary executor. After painful bouts with a kidney stone and other ailments, when Montaigne died in his château in 1592, his wife and family welcomed de Gournay and embraced her. She was responsible for the belated shorter 1635 edition of the *Essays,* incorporating some of her own omissions and some new passages she attributed to him.

Marie de Gournay took the occasion in her 1635 edition to tone down Montaigne's references to her. But her emendations revealed her desire to obscure a relationship that may have been more than filial. Montaigne had written that he loved her "more than a daughter" but she substituted "as a daughter." She omitted, among others, his statement that "she is the only person I still think about in the world." The rest of her life (she died in 1645) she spent editing, "improving," and defending Montaigne's works.

Montaigne's enduring legacy was not a philosophy, however appealing his tolerant skepticism has remained. His afterlife was a rare creation, a new form for literature, a new catalyst for literary conversation, self-exploration, and doubt. "A loose sally of the mind;" Dr. Johnson defined "essay" in his *Dictionary* (1755), "an irregular indigested piece; not a regular and orderly composition." No other Western author unwittingly created so vivid a witness as did Montaigne to the congenital rigidity of thought and the power of artistic archetypes. How astonishing that anyone should have had to "create" a literary form to dignify the loose sallies of the mind!

Few literary creators, Western adventurers of the word, have had so widespread or so interstitial an influence as Montaigne. The spirit of the essay has survived the obsolescence of Montaigne's faiths and the irrelevance of his doubts. He lived on in the courageous freedom of his example.

His essay quest to put in words the self in all its vagueness and contradiction has become ever more appealing.

"Essay," which for Montaigne was a term of self-deprecation, for confessions of the elusive self, in later centuries became a banner for assertions, declarations, and bold exploration. Like the novel and biography, it would become a vehicle and a catalyst of modernity. The essay would be at once a vehicle of self-discovery, an affirmation of the writing individual, and a way of sharing the individuality of others. Every essay implied the need for experiment, for incremental random thoughts.

It is no accident that the pioneer English essayist Francis Bacon (1561–1626) was also a pioneer in the experimental, incremental approach to science. Bacon's political ambitions and his temperament led him to make his essays "Counsells, Civil and Morall" (1597, 1612, 1625). This put him in the tradition of Plutarch's *Moralia,* lacking the whimsicality and randomness of Montaigne. The essay became more intimately tied to everyday concerns by the new vogue of periodical publications, facilitated by printing presses and a reading public. Richard Steele's *Tatler* (1709–11) appeared three times a week, and the *Spectator* (1711–12), with Joseph Addison, appeared daily. Journalism, the current press, was the essayist's natural ally. The journalist had to be an essayist, in every new issue hoping to make a better try, needing to shift subjects continually, to treat topics briefly, and to compete for the attention of impatient readers. The newspaper would be a bundle of essays, now not about the self but about the world.

The flood and variety of essays and essayists increased with the multiplication of magazines and newspapers. The essay provided a versatile and appealing form for the literary criticism and moral reflections of Dr. Johnson and Sainte-Beuve (1804–1869), for the political and philosophical speculations of John Locke and the Federalist papers, for the labored whimsies of Charles Lamb. Emerson (1803–1882) made the essay his own vehicle for an American substitute for a philosophy. And the essay was providentially suited to the existential philosophy of Camus, the random insights of Lafcadio Hearn, the tentative judgments of Thomas Mann, the opinions of G. K. Chesterton, the fantasies of George Orwell, the playfulness of E. B. White.

While the essay became a respectable form, its novelty was in its celebration of the self. Its reason for being was the belief that the thoughts, feelings, uncertainties, certitudes, and contradictions of a person merited statement and then attention by others. Experience of the doubting self became more intriguing than the fervency of belief. "When I play with my cat," Montaigne asked, "who knows if she does not amuse herself more with me than I with her."

58

The Art of Being Truthful: Confessions

EXPERIMENTAL and incomplete, the modern creations of the self were an ever-changing subject looking at an ever-changing object. The two classic autobiographies we explore here were never finished by their authors, and not published till years after their authors' death. Yet both live on to entertain us and show how hard it is to tell the truth. They remind us that every effort of the self to describe the self must be no more than what Montaigne called it—an "essay," a try.

The vast spectrum of modern accounts of the self is suggested in the pioneer creations of two spectacular characters, Jean-Jacques Rousseau (1712–1778) and Benjamin Franklin (1706–1790), who, though contemporaries, were opposite in almost every way. Each encouraged countless imitators; one offered his confessions, the other his success story. Both, like Montaigne, purported to tell the truth about themselves. Both tantalize us by what they leave untold.

For modern moralists Rousseau has become an anti-Christ, champion of the amoral "purely exploratory attitude towards life," "the man who has cast off prejudices without acquiring virtues." Whatever we think of Rousseau's morals, we can see in him a spokesman of the modern search for the unique and the new, a pathfinder in the exploration of the self.

In self-imposed exile in England in 1766, Rousseau wrote the opening sentences of his *Confessions:*

> I have resolved on an enterprise which has no precedent, and which once complete, will have no imitator. My purpose is to display to my kind a portrait in every way true to nature, and the man I shall portray will be myself.
>
> Simply myself. I know my own heart and understand my fellow man. But I am made unlike any one I have ever met. I will even venture to say that I am like no one in the whole world. I may be no better, but at least I am different.
>
> (Translated by J. M. Cohen)

Rousseau's *Confessions* was written in self-defense against an imaginary conspiracy. A by-product of this self-defense was a new concept of literature, in which the subject was the author.

How Rousseau transformed himself into such a subject and how he came to think that he needed so impassioned a self-defense is an intriguing though not a pleasant story. If he had never written his confessions he would still merit a place among the shapers of modern thought. But while his other works carried new messages on education and government in the familiar form of the essay or the novel, his *Confessions* created a new kind of literature. The "confessions" of Saint Augustine were chapters in hagiography, an intimate story of conversion to Christianity. But Rousseau's life was anything but saintly, and his life was in need of whatever modern alternative could be found for the confessional.

"My birth," Rousseau wrote, "was the first of my misfortunes." A few days after his birth in Geneva in 1712 his mother died. In the library of his father, a watchmaker with literary tastes in belligerently Calvinist Geneva, Jean-Jacques read widely and passionately. He reports how he immersed himself every night and "until we heard the morning larks," in classics, novels, histories, Plutarch's *Lives,* whatever was at hand. "Plutarch . . . was my especial favorite, and the pleasure I took in reading and re-reading him did something to cure me of my passion for novels." "I felt before I thought: which is the common lot of man, though more pronounced in my case than in another's. . . . In a short time I acquired by this dangerous method, not only an extreme facility in reading and expressing myself, but a singular insight for my age into the passions. I had no idea of the facts, but I was familiar with every feeling. I had grasped nothing; I had sensed everything."

His life changed abruptly at the age of ten when his irritable and quarrelsome father had to flee Geneva after a brawl. Jean-Jacques was sent to the countryside to live with the pastor Lambercier "to learn Latin and all that twaddle as well that goes by the name of education." There he acquired his first taste for rural delights. Incidentally he learned something about himself from the pastor's unmarried sister, Mlle. Lambercier, as he explained in his *Confessions:*

> Since Mlle Lambercier treated us with a mother's love, she had also a mother's authority, which she exercised sometimes by inflicting on us such childish chastisements as we had earned. . . . But when in the end I was beaten I found the experience less dreadful in fact than in anticipation; and the very strange thing was that this punishment increased my affection for the inflicter. It required all the strength of my devotion and all my natural gentleness to prevent my deliberately earning another beating; I had discovered in the shame and pain of the punishment an admixture of sensuality which had left me rather eager than

otherwise for a repetition by the same hand. No doubt, there being some degree of precocious sexuality in all this, the same punishment at the hands of her brother would not have seemed pleasant at all. . . .

Who could have supposed that this childish punishment, received at the age of eight at the hands of a woman of thirty would determine my tastes and desires, my passions, my very self for the rest of my life, and that in a sense diametrically opposed to the one in which they should normally have developed. At the moment when my senses were aroused my desires took a false turn and, confining themselves to this early experience, never set about seeking a different one.

(Translated by J. M. Cohen)

This episode was a fitting prologue to a life of masochism.

Passionately in need of love, Rousseau was torn between a desperate quest for independence and an equally desperate search for someone who would accept his dependence. It was not surprising that this internal conflict ended in madness. But in his *Confessions* he left us his plea for affection and respect, while producing one of the first vivid portraits of modern man's tussle with himself. After only two years in the country he returned to Geneva, where he served as apprentice to an engraver. Then in 1728 he began the vagabondage of a lifetime. He escaped the Calvinist capital with the aid of an underground run by the Savoy clergy seeking converts. They directed him to Annecy and to "a good and charitable lady, whom the King of his bounty, has empowered to save other souls from the error under which she once laboured herself."

So at the age of nineteen he began his first bondage to a patron, Mme. de Warens, then twenty-eight, who had left her husband to become a Catholic. She sent Rousseau to Turin, where he passed a brief unpleasant stint as a convert in a monastery. He then returned to this woman to whom he remained attached for ten years. "Her manner was tender and caressing, her gaze was very mild, her smile angelic, her mouth small like mine, her hair, which was ash blond and extraordinarily plentiful, she wore with an affected negligence that increased her attraction. She was small in stature, almost short, and rather stout, though not in an ungainly way but a lovelier head, a lovelier throat, lovelier hands, and lovelier arms it would have been impossible to find." She found him a job in the tax office in Chambéry, where he worked briefly before going to Lyons, where he made his living as a tutor. By 1742 Rousseau was in Paris trying to make his fortune with his new scheme of musical notation. He wrote an opera, a play, dabbled in chemistry, and gained the confidence of a wealthy banker, whose wife he tried to seduce. His employment as secretary to the French ambassador to Venice ended in a protocol quarrel over Rousseau's right to be invited to a state dinner. Then back to Paris, where he formed his association with the encyclopédistes and especially their leading spirit, Denis Diderot. He

eked out a living as secretary to the wealthy banker Dupin, and as research assistant to him and his wife.

Rousseau first came to public notice when he entered the essay competition of the Dijon Academy in 1750. The question was whether the progress of the arts and sciences had purified or corrupted morals. His paradoxical thesis, designed to shock the academy, was that the savage man was superior to the civilized. He argued that the sciences and the arts had been instruments of oppression, securing wealth for the wealthy and riveting poverty on others. "Virtue!" he concluded, "sublime science of simple minds. . . . Are not your principles graven on every heart? Need we do more to learn your laws, than examine ourselves and listen to the voice of conscience, when the passions are silent?" He had tactfully omitted from the printed version his more shocking original passages attacking kings and clergy. What remained was still shocking enough to make him an enfant terrible in the learned world.

The next year he elaborated his subversive notions. "Wealth inevitably leads to luxury and idleness;" he now insisted, "luxury permits the cultivation of the arts, and idleness that of the sciences." These evils have a still-deeper cause explained in his *Discourse on the Origin of Inequality among Men* (1755). "The greater part of our ills are of our own making, and . . . we might have avoided them nearly all by adhering to that simple, uniform, and solitary manner of life which nature prescribed. . . . I venture to declare that a state of reflection is a state contrary to nature, and that a thinking man is a depraved animal." The disposition to think, together with the discovery of iron and wheat, created private property, war, and the need for laws.

But somehow Rousseau more than many of his contemporaries suffered from the depravity of thought. He wrote the articles on music for the epoch-making *Encyclopédie,* and composed an opera, along with an essay on political economy. At the same time he undertook a "great reform" in his own life. He would support himself as a music copyist. During a brief visit to Geneva he reconverted to Calvinism and so recovered his Genevan citizenship. Then he found another patroness, Mme. d'Épinay, who offered him lodging for the next two years (1756–57) at l'Ermitage, her idyllic country house near Montmorency. When after a quarrel he moved out in a huff, he transferred to a nearby country house owned by his friend the maréchal de Luxembourg where he had five years' free lodging. There he wrote *Émile,* his seminal work on education, which never lost its influence and in the twentieth century became a basis for the progressive education movement. There, too, he wrote his famous *Social Contract* (1762), a plea for "civil religion" and popular sovereignty, which became the sacred text of the French Revolution of 1789 and the reason why the revolutionaries would move his remains with those of Voltaire to the Pantheon in Paris.

. . .

Rousseau, ever since 1753, had been under surveillance by the Paris police for his subversive views. When his latest works brought him condemnation by the Parlement of Paris in 1762, he sought refuge in Switzerland. Forbidden to remain in Geneva, he settled in a village in the heart of the Jura mountains, in the canton of Neuchâtel, then a territory of the tolerant Frederick the Great of Prussia. There he luxuriated in the beauties of the countryside, received the sacraments from the Protestant pastor and, to mollify the authorities, promised that he would never write anything more. Promptly violating his promise, he wrote his *Letters from the Mountain,* a bitter polemic against the Geneva authorities who had burned his works. His fame brought him an invitation from the Corsican patriot Pasquale di Paoli to write a constitution for his island, and a visit from James Boswell. In 1764 an anonymous pamphlet (actually written by Voltaire) appeared in town, and after the pastor denounced Rousseau in a strident sermon, the citizens began throwing stones at his home. It was this episode that Rousseau and his friends magnified into a monstrous life-threatening "lapidation." Again he fled, this time under the patronage of the generous David Hume, who had been awed by Rousseau's writings and who accompanied him to England in January 1766. Hume set him up in a comfortable house for a nominal rent at Wootton in Derbyshire.

But by June 23 Rousseau had succumbed again to his delusions of persecution. He wrote Hume a contemptuous letter accusing him of a dire conspiracy, swearing never to write him again or to have "further commerce with him." The gentle Hume was thunderstruck. Without thanks or apology Rousseau then unaccountably disappeared, and finally turned up in France in May 1767. The next years were a time of more flight and panic. Haunted by the imaginary conspiracy against him, and the delusion of omnipresent spies, he took an assumed name and sought refuge in a village outside Paris, then in another village near Lyons, then back to the heart of Paris in 1770, where he remained off and on until his death in 1778.

The vagabondage that kept Rousseau's erratic spirit from settling anyplace also prevented him from committing his affections to a person. He swore on many occasions that Mme. de Warens was his only true love, and he made the same oath to Mme. de Houdetot and uncounted others. His amorous attentions shifted with his place of residence and his needs for a sheltering patron. Mme. de Warens was preceded by Mme. Basile and Mme. de Vercelles, to mention two—and followed by a long list, among whom we know prominently Mme. d'Épinay and Mme. de Houdetot. After he was sent away by Mme. de Warens his definitive attachment was to Thérèse le Vasseur, whom he met in Paris in 1744. "What I needed to replace my stifled ambition was a strong affection to fill my heart. What I needed, in short, was a successor to Mamma [de Warens]." Luckily, he

found waiting on the table at his Paris hotel the very person he needed. "The first time I saw this girl appear at table I was struck by her modest behavior and even more, by her bright and gentle looks, of which I had never seen the like before." "She was shy and so was I. Yet the intimacy which our common shyness seemed to preclude was speedily formed. Our landlady noticed it and became furious. But her unkindness only improved my position with the girl. . . ." "She believed she saw in me an honorable man, and she was not mistaken. I believed that I saw in her a girl with feelings, a simple girl without coquetry; and I was not mistaken either. I declared in advance that I would never abandon her, nor ever marry her. Love, esteem, and simple sincerity were the agents of my triumph, and since her heart was tender and virtuous, I did not need to be bold to be fortunate."

Rousseau did not abandon this Thérèse, nor did she abandon him, despite his numerous amatory interludes with other women. "At first I decided to improve her mind; I was wasting my time. . . . I lived as pleasantly with my Thérèse as with the finest genius in the world." He supported her along with her aging mother as best he could. And he did finally "marry" her in 1768 in a bizarre ceremony of his own devising with the authority of no ecclesiastical body, at the Auberge de la Fontaine d'Or at Bourgoin, near Grenoble. To dignify the occasion he invited the mayor and two witnesses. There were no legal formalities, but some have called this "the most genuine act he had ever performed." He gave a speech that moved all present to tears. "I have never fulfilled any duty so gladly or so willingly," he declared in a sober interval. "I owed at least this to the woman for whom my respect has only increased during an attachment which has lasted now for twenty-five years, and who has resolved to share all the misfortunes in store for me, rather than be parted from me." Thereafter Thérèse was finally known as Mme. Jean-Jacques Rousseau.

Their union appears to have produced five children, all of whom were deposited at birth at the Foundlings' Hospital. "I cheerfully resolved on this course without the least scruple." This would be his most widely self-advertised sin, of which he boasted and which he never ceased to defend. "In handing my children over for the State to educate," he wrote in the *Confessions,* "for lack of means to bring them up myself, by destining them workers and peasants instead of adventurers and fortune-hunters, I thought I was acting as a citizen and a father, and looked upon myself as a member of Plato's Republic. . . . I have often blessed Heaven for having thus safeguarded them from their father's fate, and from that which would have overtaken them at the moment when I should have been compelled to abandon them. . . . I am sure that they would have been led to hate, and perhaps to betray, their parents. It is a hundred times better that they had never known them."

An aura of legend and mendacity surrounds these children, like almost

every other "fact" in Rousseau's life and confessions. The practice of abandoning unwanted children, Rousseau said, was "the custom of the country." In Rousseau's lifetime the number and proportion of abandoned children was increasing. Buffon noted that in 1772 they numbered about one third of all children born in Paris. The philosopher-encyclopédiste d'Alembert (1717?–1783) was abandoned by his mother, the eminent writer and saloniste Claudine de Tencin (1685–1749), on the steps of the church of Saint-Jean-le-Rond. When found, he was given the name Jean le Rond, which he kept throughout his life. Since no trace of Rousseau's children has been found outside Rousseau's letters and confessions, some biographers have doubted their existence. Others note that the very purpose of the foundling institution was to make it possible to dispose of infants without leaving any record. Perhaps, some suggest, Rousseau simply imagined these offspring to refute the rumors of his impotence.

Still, Rousseau, who refused to nurture his own children, held himself out as an expert on child-rearing. His *Émile, or Education* insisted that mothers breast-feed their children, and offered some little ways to help the individuality of each infant to blossom. Cultivation of the mind should be postponed while the emotions were fostered. He would guide John Dewey and other twentieth-century educationists who have shared Rousseau's hostility to the rigid discipline of classical education. And *Émile* offered a perverse apology for his own callousness.

Rousseau's confessions would be an apology for his whole life. "Sincerity," wrote La Rochefoucauld, "is a desire to compensate for one's defects and even reduce their importance by winning credit for admitting them." If admitting faults is a proper claim to respect, Rousseau should be among the most respected of modern men. It is perhaps appropriate that the prototype of modern "true" confessions was written by a madman.

A publisher had solicited Rousseau to write his autobiography, but he produced only a few fragments. Voltaire provided him with the incentive to write an autobiography in self-defense by portraying Rousseau as a monster, enemy of Geneva and of Christ, and so sparking the "lapidation" of Rousseau at his Swiss mountain retreat. Increasing paranoia focused Rousseau's writing, composed in lucid intervals. The first part of the *Confessions* was written at Wootten under Hume's auspices, in 1766 during his English refuge from Swiss and French persecutors. The second part was written after his flight to France in 1766–70, this time in refuge from the imaginary conspiracy led by Hume. As Rousseau explained:

> I had always been amused at Montaigne's false ingenuousness, and at his pretence of confessing his faults while taking good care only to admit to likeable ones; whereas I, who believe, and always have believed, that I am on the whole the best

of men, felt that there is no human heart, however pure, that does not conceal some odious vice. I knew that I was represented in the world under features so unlike my own and at times so distorted, that notwithstanding my faults, none of which I intended to pass over, I could not help gaining by showing myself as I was. Besides, this could not be done without also showing other people as they were, and consequently the work could only appear after my death and that of many others; which further emboldened me to write my *Confessions,* for which I should never have to blush before anyone.

(Translated by J. M. Cohen)

Saint Augustine's *Confessions,* the principal work of that title in the Western tradition, may have been in his mind, but Rousseau left it to his reader to make the comparison. While he never ceased to see himself as a martyr, he did not quite claim sainthood. But Saint Augustine's is no confession in the modern mode, for he "confesses" to the infinite wisdom of God. "For love of Thy love I do it." Rousseau "confesses" to the greatness and uniqueness of "myself."

Imagining himself the victim of malicious conspiracy by his contemporaries, Rousseau hoped by his *Confessions* at least to secure the esteem of posterity. But he was impatient. When he returned to Paris in 1770, he was a pitiful spectacle, afflicted with a painful bladder complaint, aged beyond his fifty-three years, haunted by hosts of nameless spies. Everywhere he went *they* seemed to follow him. His books were enriching only his publishers. In those days before the legal rights of authors, his own experience justified Voltaire's description of printers as "pirates." He eked out a living by returning to copying music at tenpence a page.

Still sought after in the fashionable salons, Rousseau was eager for an audience to whom he could "defend" himself, though against whom or what was never quite clear. Though determined not to publish his *Confessions,* he entertained salon wits and courtesans with readings from them. Having given up his affectation of colorful Armenian costume, he wore a peasant's drab gray as he intoned his sensational apologies for himself. His last reading was at the home of the comtesse d'Egmont, daughter of the maréchal de Richelieu. The poet Dorat (1734–1780) reported one of these sessions lasting from nine o'clock in the morning until three o'clock the following morning. To the last Book of the *Confessions* Rousseau appended his own account of his final words at the reading of his manuscript to Count and Countess d'Egmont, Prince Pignatelli, and other titled Parisians.

"I have told the truth. If anyone knows anything contrary to what I have here recorded, though he prove it a thousand times, his knowledge is a lie and an imposture; and if he refuses to investigate and inquire into it during my lifetime he is no lover of justice or of truth. . . ."

Thus I concluded my reading, and everyone was silent. Mme d'Egmont was the only person who seemed moved. She trembled visibly but quickly controlled herself, and remained quiet, as did the rest of the company. Such was the advantage I derived from my reading and my declaration.

(Translated by J. M. Cohen)

Mme. d'Épinay, one of his surviving liaisons, picked up the challenge and persuaded the lieutenant of police to order Rousseau to cease his readings. But the *Confessions* reached posterity in various forms with other works of self-revelation published (1781–88) after his death. And they were promptly translated.

Rousseau's *Confessions,* his most distinctive creation, marks a new era in literature, with a new form for the writer's candor. And this first full-blown modern revelation of the self was written by a madman. Is there any better evidence of Rousseau's madness than his belief that this work of boastful self-denigration could rescue his reputation? Modern "literature" would not simply use language for communicating but would become a self-regarding act. Authors would celebrate themselves by the mere act of self-revelation. Rousseau, a pathfinder for this modern literature, offers us a seductive if somewhat unpleasant adventure into the Rousseauan self. Although the *Confessions* is a new literary form, it is not quite as formless as the essay. While Montaigne's essays are topical, Rousseau's chapters are chronological, pursuing the miscellany of the author's experience with the charm of surprise and disorder, the suspense of a stream of consciousness. Our interest is increased by our doubt that he is telling the whole story.

Rousseau recounts in several places the episodes that made him think it necessary to write these confessions. When he was at Mme. de Vercellis's he accused an innocent servant girl of stealing a little pink and silver ribbon, which he himself had taken. That, "the sole offense that I have committed . . . secured me for the rest of my life against any act that might prove criminal in its results. I think also that my loathing of untruth derives to a large extent from my having told that one wicked lie." Another was his disgraceful abandonment on the streets of Lyons of a friend and fellow musician who had fallen in an epileptic fit.

Having made for himself in literature a secular equivalent for the confessional, he felt free to write with abandon passages that were sometimes omitted from popular editions or bowdlerized in translation. Incidentally he recorded the last words of his patroness, Mme. de Vercellis, which have been undeservedly forgotten:

I watched her die. She had lived like a woman of talents and intelligence, she died like a philosopher. . . . She only kept her bed for the last two days, and continued

to converse quietly with everyone to the last. Finally, when she could no longer talk and was already in her death agony, she broke wind loudly. "Good," she said, turning over, "a woman who can fart is not dead." Those were the last words she spoke.

<div style="text-align: right">(Translated by J. M. Cohen)</div>

Though pretending to full revelation, he still does not confess as vividly as became customary in the twentieth century.

His inhibitions appear in the episode that he says "plainly reveals my character" and will give the reader "complete knowledge of Jean-Jacques Rousseau." In Venice he visited the attractive young Giulietta. "I entered a courtesan's room as if it were the sanctuary of love and beauty; in her person I saw the divinity. . . . No sooner did I recognize from our first familiarities the value of her charms and caresses than, fearing to lose the fruit prematurely, I tried to make haste and pluck it. Suddenly, instead of the fire that devoured me, I felt a deathly cold flow through my veins; my legs trembled; I sat down on the point of fainting, and wept like a child." He gives us the shocking explanation. "Just as I was about to sink upon a breast which seemed about to suffer a man's lips and hand for the first time, I perceived that she had a malformed nipple. I beat my brow, looked harder and made certain that this nipple did not match the other." He was frozen in horror. "I saw as clear as daylight that instead of the most charming creature I could possibly imagine I held in my arms some kind of monster, rejected by Nature, men, and love." He told Giulietta his horror. First she took his comment as a joke, blushed, adjusted her clothes, and walked about the room fanning herself. "Finally she said to me in a cold and scornful voice: 'Gianetto, lascia le donne, e studia la matematica.' " ("Johnny, give up women, and study mathematics.") Jean-Jacques still asked her for another appointment, but when he arrived three days later she had left for Florence. He confessed and regretted what must have been her "scornful memory of me." Again and again he reports his similar dismay at being displaced by others from the bed of his successive patronesses.

As we witness Rousseau's painful effort to reveal his true self he reminds us how elusive is this person whom he imagines himself to be, transformed by the very process of being revealed. You cannot know the later self, he explains, without knowing the earlier self. And he prefaces the second half of the *Confessions:* "What a different picture I shall soon have to fill in! After favouring my wishes for thirty years, for the next thirty fate opposed them and from this continued opposition between my situation and my desires will be seen to arise great mistakes, incredible misfortunes, and every virtue that can do credit to adversity except strength of character." We join Rousseau's adventure in search of himself.

The Arts of Seeming Truthful: Autobiography

ONE of the most famous writings by Benjamin Franklin was the epitaph he wrote for himself in 1728, at the age of twenty-two: "The Body of B Franklin Printer, (Like the cover of an old Book Its contents torn out and stript of its Lettering & Gilding) Lies here, Food for Worms. But the Work shall not be lost; For it will (as he believ'd) appear once more, In a new and more elegant Edition Revised and corrected, by the Author." This epitaph proved appropriate to a life filled with personal events that survived in what Franklin printed about them. His momentous discoveries in electricity were printed as letters. His political tracts were commonly written as episodes of life. His *Poor Richard,* sometimes called the first famous character of fiction created by an American, is really an alter ego chronicled in the first person whose maxims are Franklin's personally tested prescription for his own success. In his *Autobiography* Franklin repeatedly characterized the missteps in his life as *Errata,* items to be corrected in a printed record.

Some have wondered that this man who invented so many other things did not invent a new form of literature. But they have underestimated Franklin. For his *Autobiography*—probably the most widely read work by an American, after the Declaration of Independence—did create a new and decisively modern form of literature, the success saga. It is a chronicle, a credo, and a scenario for self-made men. It is a tale hard to imagine taking place in any but an urban capitalist society with a rising middle class. Benvenuto Cellini two centuries earlier had written his boastful memoirs of an artist-picaro. But his account, unlike Franklin's, could not be a model for the lives of modern readers. And unlike Franklin's "Art of Virtue," Loyola's *Spiritual Exercises* is hardly a handbook for the urban citizen.

Franklin's life, a parable of New World possibilities, abounded in novelties. "The first Drudgery of Settling new Colonies, which confines the Attention of People to mere Necessaries, is now pretty well over," Franklin wrote in 1743 proposing an American Philosophical Society, "and there are

many in every Province that set them at Ease, and afford Leisure to cultivate the finer Arts, and improve the common stock of Knowledge." His own life would document his open-ended list of "new discoveries" and inventions. The bare facts of his career needed no embellishment to become the success saga of a self-made man. Born in Boston in 1706, he attended grammar school and a school for writing and arithmetic. At ten he helped in his father's business making tallow candles and boiling soap. From twelve to seventeen he served as apprentice in his brother's printing shop, till they quarreled and he ran away to Philadelphia in 1723. There the affable young Franklin found work as a printer and attracted the attention of the governor, Sir William Keith, who promised to set him up in a printing business with assurance of government contracts. When Franklin went to London to secure the equipment, Keith never delivered on his promise and a disappointed Franklin returned to Philadelphia.

By 1730, with thrift and the aid of influential citizens, he set up his own printing establishment and began publishing the *Pennsylvania Gazette*. "The Business of Printer being generally thought a poor one, I was not to expect Money with a Wife unless with such a one, as I should not otherwise think agreeable. In the mean time, that hard-to-be-governed Passion of Youth had hurried me frequently into Intrigues with low Women that fell in my Way, which were attended with some Expense & great Inconvenience, beside a continual Risk to my Health by a Distemper which of all Things I dreaded, tho' by great good Luck I escaped it." He prudently married Deborah Read, the daughter of the respectable family with whom he had been lodging.

Franklin prospered in business and became a leading citizen by promoting every imaginable kind of improvement. He proposed to make the streets safer by a police force, to make them more passable by paving and cleaning and lighting. He organized a volunteer fire department, promoted a city hospital and a circulating library, an academy for youth and a university for the promotion of learning. The Junto, the debating club he founded in 1727, flourished anew in the American Philosophical Society, which became the forum for botanists, physicians, natural historians, and philosophers from all the colonies. He made his own basic discoveries in electricity, speculated on earthquakes, and devised practical inventions like his lightning rod and his Franklin stove, which have not been much improved since.

His public services—first in trying to make the separation unnecessary, then in winning Independence, and finally in creating the new nation and shaping its government—led some to call him, even before Washington, the father of his country, later emended to grandfather of his country. His last public act was a petition to Congress for the abolition of slavery. He seems not a mere individual but, as his biographer Carl Van Doren says, a whole committee.

Although an American ambassador and a versatile high priest of the European Enlightenment he was somehow not a literary man. Unlike his younger friend Thomas Jefferson, he was notoriously uninterested in the beauties of nature or of literature, and not stirred by poetry, architecture, or the romance of history. "Many people are fond of accounts of old Buildings and Monuments, but for me I confess that if I could find in my travels a receipt for making Parmesan cheese, it would give me more satisfaction than a transcript from any inscription from any Stone whatever." He generally made his own writing, as he prescribed, "smooth, clear, and short," and he always persuaded his readers to a practical (and often benevolent) purpose. Franklin's "Advice to a Friend on Choosing a Mistress" was simply: "Prefer old Women to young ones!" His reasons concluded "8th and Lastly. They are *so grateful*! (1745)." His "Rules by which a Great Empire May be Reduced to a Small One" (1773) exposed the follies of George III. His writings, like his American Philosophical Society, aimed at "promoting useful Knowledge."

It is surprising that Franklin's famous literary creation, his *Autobiography,* the record of so well-organized and forethoughtful a life, would be so fragmentary, so incomplete, and so accidentally composed. It was not divided into chapters, nor even into a clear chronology. Yet the inchoate work survived and became popular through the centuries and across the world, a model for a whole genus of modern writing.

The incentive for Franklin came not in Philadelphia but when he was in England in August 1771 during his mission of reconciliation for the colonies. While enjoying the convivial family life of the pro-American bishop of St. Asaph, Jonathan Shipley, and his wife and five small daughters at their country house in Twyford near Winchester, Franklin entertained them with anecdotes of his early life in Boston and Philadelphia. The bishop's wife, learning it was the birthday of Franklin's grandson, Benjamin Franklin Bache, celebrated the occasion with a dinner where "among other nice things, we had a floating island," and all toasted the grandson and the grandfather. In such amiable circumstances, "expecting the enjoyment of a week's uninterrupted leisure," Franklin was stirred to begin his autobiography (he always called them his Memoirs) in the form of a letter to his son.

During these thirteen days in "the sweet retirement of Twyford where my only business was a little scribbling in the garden study," he wrote the whole first part, in a room that the Shipley family later called Franklin's Room. He probably read parts of the book to the family of assembled daughters nightly as he wrote them. He was at home and still fluent as a letter-writer, as he had been some twenty-five years before in describing to Peter Collinson his "Experiments and Observations on Electricity." This first part of the *Autobiography,* which finally was nearly half the whole manuscript of

his unfinished work, brought the story down to 1730, when he was only twenty-four. He recounted his youth in Boston and Philadelphia, his trip to England under the misleading auspices of Governor Keith of Pennsylvania, his return to Philadelphia, his marriage to Deborah and the launching of his own printing business, and the first of his Philadelphia projects, "the Mother of all the North American Subscription Libraries, now so numerous."

His autobiography must not have been Franklin's passion, for he allowed thirteen years to pass before he turned to the work again, and under less happy family circumstances. In 1776, after helping to draft and then signing the Declaration of Independence, he had been home only a year when he sailed again for France as American commissioner. The next years would be busy and fruitful in negotiating the crucial alliance with France and then finally settling the treaty of peace with Britain, which brought the war to an end on September 3, 1783. Franklin asked to be recalled, but Congress kept him on, seeking treaties of commerce with the European nations, till he returned to Philadelphia in 1785, after nine years' service abroad.

On arrival in Paris in 1776, Franklin had become an instant celebrity. Parisians fancied him to be a backwoods Voltaire and he did nothing to discourage them. They admired him as a Quaker, which he was not, but he preferred to let them think so. To keep his head warm on the November transatlantic crossing he had worn a fur cap, which the Parisians took for the badge of a frontiersman. Franklin cooperated by wearing it on special occasions, and in his French portraits he made it his trademark.

Franklin's legendary frontier charm enchanted the most elegant drawing rooms and most desirable bedrooms. The rumors of his liaisons were countless. One of the most appealing concerned his relationship with the beautiful Mme. Helvetius, widow of the famous philosopher, and herself known for her Tuesday philosophical salons. Her caresses and familiarities with Franklin shocked the proper Abigail Adams, in Paris with her husband John. When Mme. Helvetius was sixty and the French writer Fontenelle was nearly one hundred, he paid her the proverbial compliment of an aging wit, "Ah, Madame, if I were only eighty again!" Which the witty Franklin, himself now nearly eighty, managed to improve when she once accused him of putting off a visit to her that she had expected. "Madame," he said, "I am waiting till the nights are longer."

After two months in a room in a hotel on the Rue de l'Université, he retreated to Passy, on the road to Versailles, "a neat village on a high ground, half a mile from Paris, with a large garden to walk in." There, in the intervals of his diplomacy for the new nation, Franklin held a quite original philosophical court. Though constantly warned of the danger of spies, he boasted that he need have no fear of them because surely he would

"be concerned in no affairs that I should blush to have made public." But after his death it would be revealed that Edward Bancroft, his confidential aide, was a British spy, regularly reporting to London the American deliberations.

In 1784, after the signing of the Treaty of Paris, and while at Passy awaiting recall, Franklin received a letter from a Philadelphia friend, Abel James, who had seen the copy of the manuscript of the first part of the *Autobiography* that Franklin had left years before with his fellow Philadelphian Joseph Galloway. In England, Galloway had led the Loyalist cause, and helped General Howe plan his American maneuvers. But the manuscript that James described as "about twenty-three sheets in thy own handwriting, containing an account of the parentage and life of thyself, directed to thy son, ending in the year 1730" remained in the hands of Galloway's wife after Galloway died, leaving Abel James an executor of his estate. James urged Franklin to carry on. "What will the world say if kind, humane and benevolent Ben. Franklin, should leave his friends and the world deprived of so pleasing and profitable a work; a work which would be useful and entertaining not only to a few, but to millions." About the same time he received a letter from Benjamin Vaughan (1751–1835), the English firebrand and friend of revolutionary causes, who had dared publish a selection of Franklin's papers in London in 1779. In a lengthy letter praising Franklin and "a rising people" Vaughan begged him to "let the world into the traits of your genuine character, as civil broils may otherwise tend to disguise or traduce it."

Franklin incorporated both these letters in his manuscript as a kind of apologia or advertisement at the outset of the Paris continuation of his *Autobiography*. Since he had no copy of the earlier manuscript with him he could not remember precisely where he had stopped. He wrote only a few pages at Passy, but these included some of the most characteristic sections detailing his program for self-perfection. On the long sea voyage home in 1785, instead of pursuing his memoirs he preferred to write his reflections on science. Franklin did not return to the *Autobiography* until after the Constitutional Convention when he was back home in Philadelphia in August 1788. This third part, about half the whole manuscript, recounted his rise to prosperity and prominence in Philadelphia, his improvement projects, his efforts to engage the Quakers in defense of the colony, his electrical experiments, and his work raising supplies for General Braddock's ill-starred American expedition of 1754, carrying his story down to 1757. In November 1789 Franklin sent off manuscript copies of all three parts of his memoirs to friends in France and England asking whether they should be published at all, and whether he should bother "to finish them." "I shall rely upon your opinions, for I am now grown so old and feeble in

mind, as well as body, that I cannot place any confidence in my own judgment." Without waiting for these replies, ailing and near death, in the early months of 1790 he added a few pages in a manuscript that ends with crooked lines, suggesting they may have been written in bed. The work was not only unfinished but the manuscript appropriately ends in midsentence.

In more ways than one, Franklin's *Autobiography* was an appropriate literary creation to come from America and has often been called the first American addition to world literature. But of the works that have lived it is one of the most incoherent and incomplete. The work breaks off before even the rumblings of the coming American Revolution, and tells us nothing of Franklin's part in the Revolution, the framing of the Constitution, and the peacemaking, in all of which he played a leading role.

The first part of the *Autobiography,* which opened, "Dear Son," as a letter to William Franklin (1731–1813), was enlivened by "several little family Anecdotes of no Importance to others." But the second part, written at the prodding of James and Vaughan was "intended for the public. The Affairs of the Revolution occasion'd the Interruption." The Revolution, too, had explained the unhappy rupture with his son that made it impossible now for him to continue his memoirs as a family letter. William Franklin had accompanied his father to England in 1757 and had become an effective governor of New Jersey in 1763. But he remained a Loyalist and sided with Britain in the Stamp Act controversy. In 1776 he was arrested by the Jersey Provincial Assembly and the Continental Congress and spent two years in a Connecticut prison before moving to England in 1778. When Franklin was at Passy in 1784, William wrote offering to visit him for a reunion. But Franklin, with uncharacteristic coldness, refused the offer. "Deserted in my old Age by my only Son," he explained that he might have excused William remaining "Neuter" in the late war, but not for "taking up Arms against me, in a Cause wherein my good Fame, Fortune, and Life were all at Stake." Though never reconciled to his Loyalist son, en route home Franklin did stop at Southampton in 1785 for a last formal meeting. He recorded his bitter intransigence when he willed William a conspicuously small bequest. "The part he acted against me in the late war, which is of public notoriety, will account for my leaving him no more of an estate he endeavored to deprive me of."

During these years in France, Franklin sought to meet writers he admired, but more than once he suffered their distrust of the American cause. One day in 1781 Franklin found himself staying at the same French inn with Edward Gibbon, whom we have met as the famous historian of the *Decline and Fall of the Roman Empire.* He sent a friendly message to Gibbon expressing admiration for his work and asking for the pleasure of his

company. Gibbon, an unrepentant Tory, answered that, much as he admired Franklin as a man and philosopher, being a loyal subject of his king he could not have conversation with a rebel. Franklin, unfazed, is reputed to have replied to Gibbon that he still had great respect for Gibbon the historian. And, he added, he would be glad to provide all the materials in his own possession when Gibbon came to write his history of the Decline and Fall of the British Empire.

Franklin's miscellaneous *Autobiography* had an appropriately disorderly publishing history. None of the work was ever published in Franklin's lifetime or by him. Its first known publication was an unauthorized version in French in 1791, the year after Franklin's death, which was then translated back into English by an unidentified London journalist. And it was only through retranslations from the French that the work was known in English until 1818, when Franklin's grandson printed an authorized version from a manuscript that Franklin himself had revised in 1789. Franklin's original manuscript was finally found in France in 1868, the fourth part was now included, and the whole work at last appeared in Franklin's own words.

America offered a new stage for European man. And what Franklin euphemistically called the "Art of Virtue," his "arduous Project of arriving at moral Perfection," was really a prescription for success in this modern world. His thirteen virtues were all self-regarding: Temperance, Silence, Order, Resolution, Frugality, Industry, Sincerity, Justice, Moderation, Cleanliness, Tranquility, Chastity, and Humility. None of them pertained to God or Salvation. His was an eminently practical scheme, for which he gave detailed instructions. He prepared a ruled notebook, then devoted one week to each of his virtues, making a black mark in the appropriate box every time he committed a fault. "To avoid the Trouble of renewing now & then my little Book, which by scraping out the Marks on the Paper of old Faults to make room for new Ones in a new Course, became full of Holes: I transferr'd my Tables & Precepts to the Ivory leaves of a memorandum Book, on which the Lines were drawn with red Ink that made a durable stain, and on those Lines I marked my Faults with a black Lead Pencil, which Marks I could easily wipe out with a wet Sponge." The number thirteen, in which he saw no ill omen, made it possible for him to go through one whole course of perfection in thirteen weeks, and four courses in a year.

Franklin seemed always to be asking himself and his reader, "How am I doing?" In his inward battle between Appearance and Reality, Appearance always wins and remains a challenge to Reality. Self-improvement was his "Way to Wealth," his sure path to success. Humility, "Imitate Jesus and Socrates," was the afterthought thirteenth of his virtues. "I cannot boast of much success in acquiring the *Reality* of this Virtue; but I had a good deal

with regard to the *Appearance* of it. I made it a rule to forbear all direct Contradiction to the Sentiments of others, and all positive Assertions of my own. . . . and I adopted instead of them, I *conceive,* I *apprehend,* or I *imagine* a thing to be so, or so it appears at present." His *Autobiography* became a prototype for generations of popular success sagas—from Samuel Smiles to Horatio Alger, Edward Bok, Elbert Hubbard, Andrew Carnegie, and Dale Carnegie. Franklin pioneered with elementary rules for "Personal Relations" in an era before mass media had made possible a vocation of "Public Relations."

Foreshadowing the new age to come, Franklin emphasizes appearances—the image—not in confession but as a boast. His *Autobiography* explained his technique for success as a rising young printer in Philadelphia, and no twentieth-century public relations consultant could have done better.

> In order to secure my Credit and Character as a Tradesman, I took care not only to be in Reality Industrious & frugal, but to avoid all Appearances of the Contrary. I dressed plainly; I was seen at no Places of idle Diversion; I never went out a-fishing or Shooting; a Book, indeed, sometimes debauch'd me from my Work; but that was seldom, snug, & gave no Scandal: and to show that I was not above my Business, I sometimes brought home the Paper I purchased at the Stores, thro' the Streets on a Wheelbarrow. Thus being esteem'd an industrious thriving young Man, and paying duly for what I bought, the Merchants who imported Stationery solicited my Custom, others propos'd supplying me with Books, & I went on swimmingly.

Poets and romantics would not admire Franklin's cosmetics for the successful self. John Keats called Franklin "a philosophical Quaker full of mean and thrifty maxims."

"He that falls in love with himself," warned Franklin's Poor Richard, "will have no rivals." But the modern explorer of the self would have rivals everywhere. The temptation of the modern self-made man (which John Bright noted of Disraeli) was to worship his creator. And each such sounder of the self naturally distrusted others. "Benjamin's barbed wire fence," was D. H. Lawrence's name for Franklin's "list of virtues, which he trotted inside like a grey mare in a paddock." In Franklin, Lawrence in 1923 saw only "this dummy of a perfect citizen as a pattern to America. . . . Either we are materialistic instruments, like Benjamin or we move in the gesture of creation, from our deepest self, usually unconscious. We are only the actors, we are never wholly the authors of our own deeds or works. It is the author, the unknown inside us or outside us. The best we can do is to try to hold ourselves in unison with the deeps which are inside us." So Lawrence foresaw the rewards and frustrations of the self pursuing the self.

60

Intimate Biography

WE might suppose that it would be easier to write the life of an individual than of a city or a nation. But in the West the art of history long preceded the art of biography. The word "biography" does not enter the English language to describe "the history of the lives of individual men, as a branch of literature" until 1683, when John Dryden used it to describe the writings of Plutarch (A.D. c.46–c.120). But what Plutarch wrote was not biography in the modern sense. He called his work *Parallel Lives of the Noble Grecians and Romans.* The lives of these soldiers, statesmen, lawmakers, and orators were "parallel" because Theseus and Romulus, Alcibiades and Coriolanus, Alexander and Caesar, Demosthenes and Cicero, played similar roles in the public life of their time. Plutarch offered twenty-three pairs (with an essay comparing each of nineteen pairs) and four single lives, making fifty in all. Though peppered with telling anecdotes to amuse the reader, the dominant purpose of his *Lives* was ethical. He hoped by these examples to encourage virtue and discourage vice in public life. A Greek from Boeotia, he could not conceal his preference for the Spartan over the Roman virtues, but he aimed by the similarities of roles and qualities to encourage mutual respect of Greeks and Romans and provide models for imitation.

Plutarch's lively style and his shrewd selection of anecdotes made his work popular in following centuries. Sir Thomas North's elegant and idiomatic Renaissance translation (1579) from Jacques Amyot's French was the principal source for Shakespeare's Roman plays, *Julius Caesar, Antony and Cleopatra,* and *Coriolanus.* Whole passages of Shakespeare were mere revisions of North. But Plutarch's *Lives* had a rhetorical rigidity. They generally followed the prescription for an encomium—a celebration of a man, originally a Greek choral hymn sung in honor of the victor at the national games or at the end of the *komos,* a banquet in praise of the host. The plan called for the man's origins, nature, character, actions, virtues, achievements, and then for a comparison with others. Plutarch included no

women, who presumably could provide no useful public models. Vasari too wrote only *Lives of the Most Eminent Painters, Sculptors, and Architects*. These classical "lives" became prototypes for later writing about individuals. A rival for Plutarch was Suetonius (flourished A.D. 112–121), whose *Lives of the Caesars* overflowed with anecdotes of lust, violence, and idiosyncrasy. But sycophancy or malice prevented these from being biographies in the modern sense, the full-bodied story of a life from beginning to end. Instead they were homilies, biographical Sunday school lessons. With few exceptions, English "biography" remained in this sanctimonious mold. A popular English clerical writer of the mid-nineteenth century defined biography as "the chronicle of goodness—the history of the lovely, the beautiful—the assurance of the certainty of something better than we are." "How delicate, how decent is English biography," exclaimed Carlyle, "bless its mealy mouth!"

The transformation of "lives" from a branch of morals or of the history of the arts into a literary art was accomplished by a most unlikely author on a most unpromising subject. "Homer is not more decidedly the first of heroic poets, Shakespeare not more decidedly the first of dramatists, Demosthenes is not more decidedly the first of orators," Macaulay wrote in 1831, "than Boswell is the first of biographers. He has no second." Macaulay meant *first* both in time and in eminence. In the years since there has been only occasional ill-tempered dissent.

Boswell's subject, Samuel Johnson, would hardly have qualified for one of Plutarch's noble Greeks or Romans. He was not a public figure, a statesman, a soldier, a lawmaker, or an orator. Though honored by the king as a pioneer lexicographer, he struggled to support himself by writing dedications and prefaces to other people's books. In the public eye of London he was a crotchety man of letters and surely not a model of courage or character. In later years his *Dictionary* would be superseded, his edition of Shakespeare and his *Lives of the Poets* would seldom be read. He would live on in literary history as the man about whom the great biography had been written.

The author James Boswell was no more likely as the author. First of all, as a Scotsman he was one of the "race" for whom Dr. Johnson had outspoken contempt. A man of irregular habits and sexual excesses, frustrated in his chosen profession, he had little to commend him to a man who considered himself a moral arbiter and, above all, respected rank and "subordination." When Boswell undertook his life of Johnson his small literary reputation depended on an obscure work about Corsica. To this work Dr. Johnson reacted characteristically. "I wish there were some cure, like the lover's leap, for all heads of which some single idea has obtained an unreasonable and irregular possession. Mind your own affairs, and leave the Corsicans to theirs."

During the whole seventy-five years of Johnson's life, Boswell had a direct experience of his subject for parts of only twenty-one. "Nobody can write the life of a man," Johnson said, "but those who have eat and drunk and lived in social intercourse with him." After Boswell's marriage to his Scots cousin in 1769 he spent almost all the rest of his life in Scotland as a practicing lawyer. Apart from his tour of Scotland and the Hebrides with Johnson (August to November 1773) Boswell was in Johnson's presence altogether for parts of some three hundred days. This left him with only a fragmentary secondhand knowledge of two-thirds of Johnson's life and a patchy if minute knowledge of the third of Johnson's life when he knew him.

With only this limited firsthand contact with his subject, Boswell needed the steady industry of the scholar to collect his facts. For this, too, his passion for strong drink and weak women would seem to have left him ill qualified. In his book he would make up for his lack of personal knowledge by copiously reprinting Johnson's letters. But even to collect these, along with notes of Johnson's life and utterances, was a laborious, exacting, and miscellaneous task. "Were I to detail the books which I have consulted, and the inquiries which I have found it necessary to make by various channels, I should probably be thought ridiculously ostentatious," Boswell boasted in his advertisement to the first edition. "Let me only observe, as a specimen of my trouble, that I have sometimes been obliged to run half over London, in order to fix a date correctly."

If ever there was an unnecessary book when Boswell set about his work, it was surely another life of Dr. Samuel Johnson. Although Johnson was buried in Westminster Abbey, at his death in December 1784 he was no national hero. Still, within the next two years three lives of Dr. Johnson appeared. The first, by the scholarly William Shaw (1749–1831), a member of Johnson's literary circle, a noted Gaelic lexicographer, and unmasker of James Macpherson's *Ossian*, appeared in 1785. Then Johnson's intimate friend and comfort, Mrs. Hester Lynch Thrale (1741–1821), who on remarriage had become Mrs. Piozzi, published her warm and personal *Anecdotes of the Late Samuel Johnson* in 1786. These she followed in 1788 by publishing her letters to and from Johnson. Most notable was the *Life of Samuel Johnson,* by Sir John Hawkins, also a member of the Literary Club, who had known Johnson well enough to be asked to draft his will. Hawkins's *Life,* appearing in March 1787, had a second edition in June. Was the market for lives of this dyspeptic icon of English letters inexhaustible? It seemed so.

Boswell's friend, and a fellow member of the Literary Club, Edmond (or Edmund) Malone (1741–1812), the Irish scholar who pioneered in dating the plays and purifying the texts of Shakespeare, prodded Boswell to do a more ample life. Without the selfless Malone's confidence and persuasion the *Life* might never have been written.

At Johnson's death, Boswell had been asked to put together a book of Johnson's sayings for immediate publication. But he did not seize the auspicious moment. Instead he postponed publication until he could produce his more copious work. With painful deliberation, though depressed by the death of his wife, he publicly committed himself to excel the other lives. After Hawkins's *Life* appeared, Boswell inserted this advertisement in the *Gentleman's Magazine:*

> The Publick are respectfully informed that Mr. Boswell's LIFE of Dr. Johnson is in great Forwardness. The Reason its having been delayed is, that some other Publications on that Subject were promised, from which he expected to obtain much Information, in Addition to the large Store of Materials which he had already accumulated. These Works have now made their Appearance; and, though disappointed in that Expectation, he does not regret the Deliberation with which he has proceeded, as very few Circumstances relative to the History of Dr. Johnson's private Life, Writings, or Conversation, have been told with that authentic Precision which alone can render Biography valuable.

Malone's relentless persuasion now led Boswell to overcome his fits of indolence and melancholy to produce the voluminous finished work in May 1791. Even the patient and faithful Malone could not suppress his doubts of the public's readiness for so vast a book on a subject already so much written about. Near the end, in January 1790, when Boswell told Malone that the work had grown beyond two quarto volumes, Malone responded, "I might as well throw it into the Thames, for a folio would not now be read."

Still Boswell took his chances. He gambled that there would be buyers willing to pay two guineas for his two large quartos. Instead of selling the copyright, he produced the work at his own expense. With the help of a loan of two hundred pounds from a printer and another two hundred from a distributor, he printed 1,750 copies, which appeared on May 16, 1791. Boswell's hopes were promptly justified, for within two years the first edition had sold out, and Boswell had cleared the sum of six hundred pounds. A second edition, in July 1793, appeared in three quarto volumes. In his preface to the second edition, pursuing a report from Burke that the king had called his work "the most entertaining book he had ever read," Boswell had boldly styled himself "By Appointment to His Majesty, Biographer of Samuel Johnson, LL.D." But Malone saved Boswell from this embarrassing conceit by removing the page from print at the last minute. Unfortunately ill health prevented Boswell from doing any substantial revision, but Malone himself provided a revised standard text for the third edition in 1799 after Boswell's death.

. . .

The alchemy by which the persons of James Boswell and of Samuel Johnson combined into the classic English biography and a model for modern biography is hard to fathom. Somehow, it seems, Boswell needed Johnson, and was fulfilled by him. In 1790, when Johnson's *Life,* and Boswell's own life, were nearly finished, Boswell pronounced the writing of that life "the most important, perhaps *now* the only concern of any consequence that I ever shall have in this world."

James Boswell was fortunate to be born, in 1740, into the family of Alexander Boswell, eminent and prosperous laird of Auchinleck in southwestern Scotland. The estate had been founded by a royal grant from James IV of Scotland in 1504 to a Boswell ancestor who had been killed at the battle of Flodden Field (1513). In young Boswell's time the lands of the laird of Auchinleck reached out a full ten miles from the "sullen dignity" of the ruined ancestral castle and its neighboring elegant Palladian manor. Six hundred tenants deferred to him as overlord. Alexander Boswell attained distinction in his own right as an advocate in the Scottish courts and, elevated to the bench, became Lord Auchinleck. James's ambitious father foresaw for him a bright career at the bar.

The boy Boswell, not robust, suffered every sort of pressure. His passive mother had a taste for the mystical. But his father subjected him to the rigors of Calvinism, with the torturing ambiguities of predestination and the terrors of hellfire. From eight to thirteen he was educated at home by tutors. At twelve he seems to have suffered a psychological crisis. Entering the University of Edinburgh at thirteen, he completed the course in liberal arts. Somehow the metaphysics he studied reinforced his fears of hellfire and plunged him into a depression, which would recur all the rest of his life. He returned to the university in 1758 for the study of law. When his father heard rumors of his attending a "Romish chapel" and consorting with a Roman Catholic actress, he promptly separated James from the seductions of Edinburgh by enrolling him at the University of Glasgow. There Adam Smith was the professor of moral philosophy and rhetoric.

After two years in Glasgow, Boswell took off to London, where he became converted to the Roman Catholic Church. At the same time, under the misguidance of Samuel Derrick (1724–1769), a disreputable minor man of letters, Boswell developed a taste for sexual lowlife that he never lost and never fully satisfied. He also discovered his lifelong passion for London, both for its lowlife, from which he contracted gonorrhea, and for its literary high life. A commission in the foot guards would justify his staying in London. When he came of age his father agreed to let him join the guards and even to support him with an allowance provided he first passed his examinations for the Scottish bar. With this incentive, young Boswell

passed the examinations and went to London hoping that his family connec-
tions would procure him the needed commission. As part of the bargain
with his father he signed away most of his rights in the estate of Auchinleck
for a paltry annuity of one hundred pounds a year. When he went to London
his father increased his allowance to two hundred pounds.

His plunge back into London in 1762 with his father's acquiescence failed
to produce the commission, and set a lifelong pattern of professional frustra-
tion. He also set the pattern of his appealing conviviality, the "good humour
and perpetual cheerfulness," which would be interrupted by patches of deep
melancholy and self-doubt. At the age of twenty-two he learned of the birth
of the son he had recklessly fathered back in Scotland and made provision
for the infant's baptism. At the same time he pursued and won an actress
on the London stage.

Boswell's first meeting with his subject was wonderfully casual. What he
had heard from his friend Thomas Davies, who kept a bookseller's shop in
Russell Street, "of Johnson's remarkable sayings . . . increased my impa-
tience more and more to see the extraordinary man whose works I highly
valued, and whose conversation was reported to be so peculiarly excellent."

> At last, on Monday the 16th of May [1763], when I was sitting in Mr. Davies's
> back-parlour, after having drunk tea with him and Mrs. Davies, Johnson unex-
> pectedly came into the shop; and Mr. Davies having perceived him through the
> glass-door in the room in which we were sitting, advancing towards us,—he
> announced his awful approach to me, somewhat in the manner of an actor in the
> part of Horatio, when he addresses Hamlet on the appearance of his father's
> ghost, 'Look, my Lord, it comes.' I found that I had a very perfect idea of
> Johnson's figure, from the portrait of him painted by Sir Joshua Reynolds soon
> after he had published his *Dictionary*. . . . Mr. Davies mentioned my name, and
> respectfully introduced me to him. I was much agitated; and recollecting his
> prejudice against the Scotch, of which I had heard much, I said to Davies, 'Don't
> tell where I come from.'—'From Scotland,' cried Davies roguishly. 'Mr. Johnson,
> (said I) I do indeed come from Scotland, but I cannot help it.' . . . this speech
> was somewhat unlucky; for with that quickness of wit for which he was so
> remarkable, he seized the expression, 'come from Scotland,' which I used in the
> sense of being of that country, and, as if I had come away from it, or left it,
> retorted, 'That, Sir, I find, is what a very great many of your countrymen cannot
> help.'

From this inauspicious beginning Boswell developed the friendship that
produced his *Life*.

Boswell cherished a special feeling for that shop on Russell Street, "No.
8—the very place where I was fortunate enough to be introduced to the
illustrious subject of this work . . . I never pass by it without feeling
reverence and regret." Boswell "boldly" called on Johnson at his chambers

in Inner-Temple Lane on Tuesday of the next week. "He received me very courteously; but it must be confessed, that his apartment, and furniture, and morning dress, were sufficiently uncouth. His brown suit of cloaths looked very rusty; he had on a little old shrivelled unpowdered wig, which was too small for his head. . . . But all these slovenly particularities were forgotten the moment that he began to talk." Johnson favored him with a miscellaneous discourse—on the madness of a poet who prayed on his knees in the street, on the evidences of Christianity, and the superb conversational talents of David Garrick. Twice when he rose to leave, Johnson urged him to remain, and to come visit him more often. "Come to me as often as you can." Boswell followed up. And within a month after one of these casual meetings "he called to me with warmth. 'Give me your hand; I have taken a liking to you.' "

The intimacy and mutual affection grew. When Boswell could not find a place in the foot guards, he deferred to his father's determination to make him a Scottish lawyer, and to round out his training in the civil law he agreed to go to the University of Utrecht. After that he would complete his liberal education by a grand tour of cultural capitals of the Continent. On August 5, 1763, when Boswell left London for Harwich en route to Holland, Johnson had already conceived such affection for his young disciple that he spent four days traveling by carriage to see Boswell off on the Channel boat. The distance in age (Boswell was twenty-two and Johnson fifty-three) and in social position, between a landed Scots laird and an impoverished Grub Street writer, seems only to have whetted their appetite for each other.

Boswell reported their parting at the port of Harwich.

My revered friend walked down with me to the beach, where we embraced and parted with tenderness, and engaged to correspond by letters. I said, 'I hope, Sir, you will not forget me in my absence.' Johnson. 'Nay, Sir, it is more likely you should forget me, than that I should forget you.' As the vessel put out to sea, I kept my eyes upon him for a considerable time, while he remained rolling his majestick frame in his usual manner; and at last I perceived him walk back into town, and he disappeared.

At Utrecht Boswell diligently pursued his studies and enjoyed the sophisticated Dutch society. He began an affair with the vivacious daughter of one of the richest noblemen in the province, and he spent vacations touring the rest of Holland. At the end of a year he was impatient for his grand tour. People interested him far more than places or buildings. Despite his friendship with a favorite of Frederick the Great, George Keith, earl marischal of Scotland, he never managed a meeting with Frederick. But with this exception there is no other record of his failure to wangle an interview with anyone he wanted to meet.

When Boswell announced his intention to meet Rousseau on his way through Switzerland, he was told the French philosopher had become a recluse and was seeing no one. This only encouraged him to write a letter that was a masterpiece of sycophancy and cajolery. "Trust a unique foreigner," Boswell wrote. "You will never regret it. But, I beg of you, be alone." He secured the interview and developed a friendship based at first on their common interest in music, then on his flattering requests for advice. When Boswell confessed to recurrent fits of melancholia, Rousseau declared that there were points at which their two souls joined. Boswell rashly asked permission to write Rousseau's mistress, Thérèse le Vasseur, at the same time swearing that he had no intention of carrying her off. "I sometimes form romantic plans, never impossible plans." A year later, when Rousseau traveled to England with his friend David Hume, he entrusted Mlle. le Vasseur to Boswell, who escorted her, too, to England, with consequences veiled by the family's censorship of Boswell's papers.

Then by an unknown stratagem he bagged Voltaire for an hour's interview at his retreat on Lake Geneva, where he explored the sage's notions on religion. Asking Voltaire what happens to our ideas that we have forgotten but can later recall, he received the elegant response from Thomson's "Seasons"—"Aye, Where sleep the winds when it is calm?"

Then Boswell learned that John Wilkes (1727–1797), the notorious English champion of political liberty, happened to be in Turin. On January 10, 1765, Boswell wrote Wilkes his desire to discuss with him "the immateriality of the soul":

> John Wilkes the fiery Whig would despise this sentiment. John Wilkes the gay profligate would laugh at it. But John Wilkes the philosopher will feel it and will love it.
> You have no objection to sitting up a little late. Perhaps you may come to me tonight. I hope at any rate you will dine with me tomorrow.

Wilkes could not resist and they rendezvoused in Naples, from where they joined in the risky climb of Mount Vesuvius.

Before he returned home, Boswell would add still another, and even more unlikely, character to his bouquet of captive celebrities. His Scots love of independence made him admire the romantic Corsican patriot Pasquale di Paoli (1725–1807) for his efforts to free his home island from the rule of Genoa in 1755, and then from France, to whom the Genoese had ceded the island. Rousseau gladly gave him an introduction to Paoli. To dispel suspicions that he was a spy or an assassin, he announced on his arrival from Rome, "I am come from seeing the ruins of one brave and free people: I now see the rise of another." Paoli embraced him and treasured him as a

friend. When Paoli took refuge in England, Boswell helped secure him a handsome pension from the British government. Out of this trip, Boswell wrote *An Account of Corsica, The Journal of a Tour to that Island; and Memoirs of Pascal Paoli,* published in London in 1768, soon after his return. The book was widely translated and brought fame to Boswell at the age of twenty-eight.

In 1766 the Edinburgh life he returned to was a drab contrast to the world of Rousseau and Voltaire. Again he gratified his father by securing admission to the Faculty of Advocates, the Scots bar, preparing for a respectable legal career. For the next twenty years he would carry on a better-than-average law practice, which kept him in Edinburgh. Though his marriage to his cousin Margaret Montgomerie in 1769 disappointed his father by not adding substantially to the family estates, it provided him with a happy family life for a few years. Still the convivial Boswell interrupted the Edinburgh routine with occasional trips to London. After 1773, when he was elected to the Literary Club, he had a reason for regular visits. There Sir Joshua Reynolds presided and Samuel Johnson held court among figures like actor David Garrick, the philosopher-economist Adam Smith, the statesmen Edmund Burke and Charles James Fox, the naturalist Sir Joseph Banks, the Shakespearean scholar Edmond Malone, and the historian Edward Gibbon. The group dined together at a London tavern once a fortnight during meetings of Parliament. Boswell would come to town during the vacations of the Scots courts, but sometimes a whole year would pass without a London visit. In 1785, after his father, the laird of Auchinleck, had died and Boswell became his own man, he moved to London.

There at the age of forty-five he tried to establish himself as an English barrister while pursuing his ambition for a seat in the House of Commons. Frustrated in both these efforts, he had to satisfy himself with the writing that would make him immortal but would not make him happy. He seemed never to realize the proportions of his achievement, and finally considered himself a failure. His last years in London found him seeking the solace of drink. In June 1793 he was mugged and robbed while he was drunk. This mishap, with the effects of lifelong dissipation in bed and with the bottle, brought on his death in 1795.

Even at this distance, when literary styles have changed and the personalities in Boswell's pages are no longer celebrities, his book remains endlessly entertaining. Like a good journalist, Boswell had a talent for finding the "peg" that gave Johnson's miscellaneous conversational comments an enduring relevance. When Johnson was asked his opinion of a book sent him by the author but which he could not recall, Johnson commented on the practice of authors sending gift copies, "People seldom read a book which

is given to them; and few are given. The way to spread a work is to sell it at a low price. No man will send to buy a thing that costs even sixpence, without an intention to read it." Or on the perils of conversation:

> Goldsmith should not be forever attempting to shine in conversation: he has no temper for it, he is so much mortified when he fails. Sir, a game of jokes is composed partly of skill, partly of chance. A man may be beat at times by one who has not the tenth part of his wit. Now Goldsmith's putting himself against another, is like a man laying a hundred to one who cannot spare the hundred. It is not worth a man's while. . . . Goldsmith is in this state. When he contends, if he gets the better it is a very little addition to a man of his literary reputation: if he does not get the better, he is miserably vexed.

Reading the *Life,* we have no doubt that from the many celebrities of his acquaintance Boswell's peculiar talents could not have chosen a better subject. But why did he focus on Johnson when he might have chosen so many others? "The author, Boswell, is a strange being," Horace Walpole complained to the poet Thomas Gray in 1768, "and . . . has a rage for knowing anybody that was ever talked of." But unlike Rousseau, Voltaire, or Paoli, Johnson was neither a romantic nor a heroic figure. Boswell's interest and his project had grown slowly. In 1768 Boswell asked Johnson if he might publish his letters after his death, and there was no objection. "I have a constant plan to write the *Life* of Mr. Johnson," he noted in his *Journal,* "I have not told him of it yet; nor do I know if I should tell him." "I said that if it was not troublesome and presuming too much, I would request him to tell me all the little circumstances of his life; what schools he attended, when he came to Oxford, when he came to London, &c. &c. He did not disapprove of my curiosity as to these particulars; but said, 'They'll come out by degrees as we talk together.' " That autumn (1772) with Johnson on his long-planned tour of Scotland and the Hebrides, Boswell took notes "on separate leaves of paper" in Johnson's presence. "I shall lay up authentic materials for The Life of Samuel Johnson LL.D., and if I survive him, I shall be one who shall most faithfully do honour to his memory. I have now a vast treasure of his conversation at different times since the year 1762 [1763] when I first obtained his acquaintance; and by assiduous inquiry I can make up for not knowing him sooner."

Over the next years Boswell seized every opportunity to collect Johnsoniana. Mrs. Thrale objected to his violating hospitality by his "ill-bred" habit of writing down whatever Johnson said. Edmund Burke complained that Boswell inhibited the "convivial ease and negligence" of the meetings of The Literary Club. Some, like the eminent Scottish lawyer and pioneer anthropologist, Lord Monboddo (1714–1799), simply thought Johnson no

better than a provincial schoolmaster and not worth all Boswell's efforts.

Still, nothing could dissipate Boswell's fascination with his subject, nor discourage his efforts to collect every scrap of Johnsoniana. By 1780 he began to see a way of organizing the work. He ceased to be daunted by his earlier difficulty in recalling the "genuine vigor and vivacity" of Johnson's conversation. "Strongly impregnated with the Johnsonian aether, I could with much more facility and exactness, carry in my memory and commit to paper, the exuberant variety of his wisdom and wit." At the time of Johnson's death, Boswell had accumulated copious materials—including his own *Journal* and notes since 1763, miscellaneous documents, which he called "Papers Apart," and Johnson's own letters to him.

How could he give form to this ocean? How compete with the anecdotal charm of Mrs. Piozzi's recent book and the others? Following the advice of his sensible friend Edmond Malone "to make a Skeleton, with reference to the materials, in order of time," on July 9, 1786, he began writing. But it was slow going, and his own intentions were complicated by the competing books. Interrupted by fits of indolence and melancholia, he labored on. For months in 1788 he did not write a single page. But under Malone's prodding, he had completed a draft by March 1789. The customs of the trade were especially taxing in those days for printers, who would set up the early pages of a book even before the author had written the final pages. The result was costly and sloppy with the author's last-minute revisions. In February 1791, Boswell was still asking Malone, "Pray how shall I wind up?" The book was in the bookstores on May 16.

Boswell's *Life of Johnson* displayed a vivid encounter between the demands of truth and the exactions of art. Again and again Boswell claimed that his book would exhibit Johnson "more completely than any person, ancient or modern, has yet been preserved." "I am absolutely certain," he wrote to his lifelong friend William Temple in 1788, "that *my* mode of biography, which gives not only a *history* of Johnson's *visible* progress through the world, and of his publications, but a *view* of his mind, in his letters and conversations, is the most perfect that can be conceived, and will be *more* of a *Life* than any work that has yet appeared." Boswell confessed that he had not included "the whole of what was said by Johnson, or other eminent persons. . . . What I have preserved, however, has the value of the most perfect authenticity."

Johnson himself declared that "the biographical part of literature . . . is what I love most." But, he explained:

> Great abilities are not requisite for an Historian: for in historical composition, all the greatest powers of the human mind are quiescent. He has facts ready to

his hand; so there is no exercise of invention. Imagination is not required in any high degree; only about as much as is used in the lower kinds of poetry. Some penetration, accuracy, and colouring will fit a man for the task, if he can give the application which is necessary.

Boswell, on the contrary, was well aware that verisimilitude itself—subtlety "in the Flemish picture I have given of my friends"—demanded something more than precise completeness of the record. "I observe continually," he noted when he was twenty-nine and only projecting his *Life,* "how imperfectly on most occasions words preserve our ideas. . . . In description we omit insensibly many little touches that give life to objects. With how small a speck does a painter give life to an eye!" There is hardly a scene or a page to which Boswell has not added the "small speck"—Johnson's habit of talking to himself, of collecting dried orange peels, of counting his steps into or out of a room, of preferring the sausages of Bologna—all unworthy of a Plutarchian monument but essential to a Flemish portrait.

The obsessive Boswell was peculiarly well qualified to embellish his complete record with these "small specks." Only in this century have we discovered how obsessive Boswell was. His copious *Journals,* which have established him as a great diarist, have thrown a bright new light on his literary character. His *Life of Johnson* may not, after all, have been his primary personal concern, for he seems to have considered the embodying of his own life in his *Journal* to be his first daily duty. "I should live no more than I can record," he wrote, "as one should not have more corn growing than one can get in. There is a waste of good if it be not preserved." He could tolerate even the most unpleasant experience "if only I am to give an account of it." It seems that he intended this comprehensive *Journal* to remain private. The *Life of Johnson* would be another product of this same obsession with capturing experience by recording it. Which also helps explain the directness, the simplicity, and lack of contrivance in the biography.

In seeking to explain the enduring charm of Boswell's *Life of Johnson* some have looked for "the Boswell formula." But there is no formula. Instead we must seek the "art" in a work that seems conspicuously artless, that is not even divided into chapters, and simply follows the flow of Johnson's life day by day. What is ironic in the history of literary creations is that so many centuries should have elapsed before one man devoted himself to make a full report of another. Writers had spent their art on cities, states, and empires, on comedy and tragedy, on the ways of the gods and the absurdities of institutions, before someone tried to record a person in all his idiosyncrasy.

The enduring success of Boswell's work is precisely in its artless surren-

der to chronology. Perhaps Johnson's lack of any grand public role saved his biographer from the temptation to box his life into exemplary moral categories. By committing the flow of his narrative to chronology, Boswell allows us to share the randomness of daily experience. For example, within the three pages recording Johnson's life on April 7 through 10, 1775, we hear Johnson on the inauthenticity of the pretended works of Ossian, the ferocity of wolves and bears, the temptations of patriotism, the superiority of Mrs. Abington's jelly to Mrs. Thrale's, the virtues of General Oglethorpe, how happiness is produced by the dissolving of present into future, and why there is no justification for poetry unless it is "exquisite in its kind."

Simply by faithfulness to the full chronological record, Boswell recaptures the manifold qualities, contradictions, evasions, passions, and prejudices of the living person. "But in the chronological series of Johnson's life, which I trace as distinctly as I can, year by year, I produce, wherever it is in my power, his own minutes, letters or conversation, being convinced that this mode is more lively, and will make my readers better acquainted with him, than even most of those were who actually knew him, but could know him only partially. . . ."

Johnson was a heroic conversationalist, and conversation is a peculiarly random and serendipitous art. It was in this world of the spoken word that Johnson shone and came alive. "What I consider as the peculiar value of the following work," Boswell wrote in his foreword, "is, the quantity that it contains of Johnson's conversation." Boswell claimed for himself a talent "in leading the conversation. I do not mean leading, as in an orchestra, by playing the first fiddle; but leading, as one does in examining a witness— starting topics, and making him pursue them."

To ensure the authenticity of his records, Boswell had his own technique, which has not been easily fathomed. If he used "shorthand" it was not the special kind he discussed with Johnson on several occasions but the method of abbreviating words for our own use. At one especially lively conversation, Boswell exclaimed to Mrs. Thrale, "O, for short-hand to take this down!" "You'll carry it all in your head, (said she;) a long head is as good as short-hand." The recently recovered *Journals* and *Notes* reveal that, since Boswell, despite Mrs. Thrale's complaints, only seldom noted down the words when they were uttered, he made his own record as soon as possible thereafter. With his irregular habits of sex and drink, his primary concern—a kind of religion, even more urgent than his duties to his law clients or to his family—was regularly capturing his life in "my Journal." "Bring that up," he wrote to himself, "and all will then be well."

Boswell's scrupulous regard for authenticity has led a few critics to accuse him of having written a great book by accident. Some of his contemporaries, like the acerbic Fanny Burney, even preferred not "to be named

or remembered by that biographical, anecdotal memorandummer." The poet Thomas Gray had shrugged off Boswell's record of his tour in Corsica. "Any fool," Gray wrote, "may write a valuable book by chance." Envious critics said that Boswell's *Life of Johnson* was merely the accidental by-product of the encounter between a naive and obsessive "memorandum-mer" and a brilliant conversationalist. After Macaulay and Carlyle extravagantly praised the book as both the best biography ever written and the best product of the eighteenth century, others have joined in a rare literary consensus. By the mid-nineteenth century the verb "to Boswellize" had entered the language, describing the effort to make a total record of another person. It was a clue both to the uniqueness of Boswell's literary achievement and to the disparaging suspicion that once Boswell had shown it could be done anybody else could do it. What it really announced was a modern literary creation—the individual life becoming the raw material of art.

61

The Heroic Self

THE self that Boswell chronicled was notable for its wit and oddity, but had nothing of the heroic. The sovereign metaphor for modern man's heroic aspiration and frustration remained the medieval legend of the megaloma-niac Dr. Faustus. Goethe, who gave this spirit its enduring form, was himself an allegory of modern frustration, of limitless hopes and limited achievement. He was unsatisfied in love, experimental in all the arts, skepti-cal of all philosophies, yet hoped finally to grasp the world through science. In a Europe dividing into national languages, specializing Science into sciences, he stood for the universal man. Also in the modern mode he was the celebrity sage, known across Europe less for what he did than for what he was or was reputed to be.

At the age of twenty-five Johann Wolfgang von Goethe (1749–1832) be-came notorious in 1774 for his short novel, *The Sorrows of Young Werther.* In the form of letters it tells how the eager Werther falls hopelessly in love with Charlotte, already betrothed to Albert. In Albert's absence Werther can enjoy her company only for a few weeks. On Albert's return Werther withdraws, Albert and Charlotte are married, and Werther in despair ends

his own life with a pistol. "I am not the only unfortunate," wrote the young Werther. "All men are disappointed in their hopes and cheated out of their expectations."

This spirit that luxuriated in its own misery and was already beginning to stalk Europe found a voice in Goethe's little book. It became "Wertherism," the self-indulgent melancholy of youth. Concocted of the German ingredients of *Weltschmerz* (pain or dissatisfaction with the world) and *Ichschmerz* (pain or dissatisfaction with the self), it had wide appeal. Two years earlier Goethe had already promoted the closely related *Sturm and Drang* (Storm and Stress) movement, which had taken its title from a drama of the American Revolution by a German playwright who had been a childhood friend of Goethe. Inspired by the love of nature and by Rousseau's writings, the "Wertherites" rebelled against literary conventions. Their mentor Johann Gottfried Herder (1744–1803) drew them to Homer, to Gothic architecture and German folksongs. Shakespeare was their idol and they called for a German counterpart. Goethe had attracted attention by his try at Shakespearean grandeur in his play *Götz von Berlichingen mit der eisernen Hand* (Götz of the Iron Hand) (1773) about a sixteenth-century German Robin Hood.

Enthusiasm for heroic folk figures like Götz was one thing, suicide quite another. And Goethe's *Werther* seemed to prescribe suicide as a way of joining the international community of Weltschmerz. At the request of the theological faculty in Leipzig, where the book had been published, it was promptly banned by the City Council, and its translation even in Denmark was prohibited. Across Europe despondent young men, not quite suicidal, showed they were with-it by wearing Werther's blue frock coat, buff waistcoat, and yellow breeches. Tea sets showed scenes from the novel, ladies perfumed themselves with Eau de Werther, wore Werther jewelry, Werther gloves, and carried Werther fans. Poems, plays, and operas about Werther appeared in London and Vienna. The vogue survived long enough to evoke Thackeray's own mock "Sorrows of Werther," which ended:

> Charlotte, having seen his body
> Borne before her on a shutter,
> Like a well-conducted person
> Went on cutting bread and butter.

The tie of *Werther* to the cult of suicide was not entirely imaginary. In January 1778 Christine von Lassberg, deserted by her lover and with a copy of *Werther* in her pocket, drowned herself in the river Ilm behind Goethe's house in Weimar. Journalists and novelists somehow tied all current suicides to *Werther*.

The story of the novel was rooted in the facts of Goethe's personal

miseries. In the spring of 1772 when he visited Wetzlar, forty miles north of Frankfurt, he had been captivated by the bright and beautiful nineteen-year-old Charlotte (Lotte) Buff, then engaged to her fellow townsman Christian Kestner. Goethe took a liking to Kestner and in what Goethe later described as "a genuine German idyll" the three enjoyed that summer together. When Goethe declared his love to Lotte, she rebuffed him and he left Wetzlar precipitately. His farewell note to her ended, "I am alone now, and may shed my tears. I leave you both to your happiness, and will not be gone from your hearts."

That October 1772 Goethe heard an unfounded rumor that one of his Wetzlar friends had committed suicide. He wrote his friend Kestner, "I honor the deed. . . . I hope I shall never trouble my friends with news of such a kind." Before the end of the month another young friend, Karl Wilhelm Jerusalem, really committed suicide. As Goethe recalled, he was a gentle youth who "wore the clothes that were usual, in imitation of the English, in northern Germany: a blue frock-coat, a buff leather waistcoat and breeches." With a brooding disposition, he liked to draw deserted landscapes, and had a passion for another man's wife. Snubbed by Wetzlar society, he had actually written a defense of suicide. His beloved asked her husband to forbid him their house. At that point, Jerusalem borrowed Christian Kestner's pistol for a pretended trip. Just after midnight, seated in his room he shot himself. The account that Goethe received of the burial from Kestner ended, "No priest attended him"—the very words with which Goethe ended his *Werther*.

Goethe's own frustrations were dramatized when Kestner and Lotte married in April 1773 and he lost another object of his flirtation when the attractive Maximiliane von La Roche was married the next January.

Then Goethe turned to writing his *Sorrows of Young Werther,* completing it in four weeks. "I had written thus much almost unconsciously, like a somnambulist." He was astonished at the effect of the work on others "precisely the reverse of my own. . . . I felt, as if after a general confession, once more happy and free, and justified in beginning a new life." Some have called *Werther* the first "confession" that was successfully made into literature. Werther's suicide note to Lotte read:

> Albert is your husband—well, what of it? Husband! In the eyes of the world—and in the eyes of the world is it sinful for me to love you, to want to tear you from his embrace into my own? Sin? Very well, I am punishing myself; I have tasted the whole divine delight of that sin, and have taken balm and strength into my heart. From this moment you are mine! Mine, oh Lotte! I am going on ahead! Going unto my Father, your Father. I shall tell Him my sorrows and He will comfort me until that time when you come and I fly to meet you, hold you and remain with you in a perpetual embrace in the sight of the Eternal.

Goethe did change his way of life suddenly and surprisingly. At the height of his celebrity as the author of *Werther* in November 1775 he was invited to Weimar. When the reigning duke Karl Augustus unaccountably named the twenty-seven-year-old Goethe to his Privy Council, the duke explained to Goethe's father that Goethe would still be free to leave the duke's service at any time, but Weimar would remain Goethe's home till his death in 1832. "Goethe can have but one position—" the duke wrote, "that of my friend. All others are beneath him." The young Goethe speedily became an energetic administrator of the little dukedom, inspecting mines, overseeing irrigation projects, organizing the small army, setting up a fire brigade, developing and directing the court theater. Like Benjamin Franklin about the same time in Philadelphia, he made the little community his own.

One of Goethe's first and most delightful innovations was ice-skating. Before Goethe no Weimar gentleman had been seen on the ice. Some applauded Goethe's "daring grace," others found his performance on the ice "outrageous." Skating on the Schwansee became "the rage." These first "wild weeks" in Weimar made him the duke's boon companion. Here (to match his Wilhelm Meister) he found his apprenticeship in the arts of living.

The rapid rise of this upstart author of a book of scandalous reputation did not please all the burgers of Weimar. When the duke raised him to the highest post in his service, Goethe found it "strange and dreamlike that I in my thirtieth year enter the highest place which a German citizen can reach. *On ne va jamais plus loin que quand on ne sait ou l'on va,* said a great climber of this world." Goethe later confessed in conversations with his friend Johann Peter Eckermann that these first years at Weimar were "perplexed with love affairs." He was appealing to many of the attractive women who caught his eye, and he enjoyed flirting. Only one became a great love, but she too proved unattainable. This was the baroness Charlotte von Stein, wife of the duke's master of the horse, remarkable for her gaiety, intelligence, and broad literary culture. When he met her she was thirty-three, and already the mother of seven children. "She is really a genuine, interesting person, and I quite understand what has attached Goethe to her," Schiller wrote, "Beautiful she can never have been; but her countenance has a soft earnestness, and a quite peculiar openness. . . . They say the connection is perfectly pure and blameless." Over the next years Goethe sent her some fifteen hundred letters. She would remain his guide and inspiration, but that she never became his mistress seems to have been one of the bitter trials of his life—which he made a theme for some of his plays and lyrics.

After ten successful years in the microcosm of Weimar, he obtained the duke's permission for a journey to an unknown destination. With ostentatious secrecy and in quest of anonymity, he left Weimar on September 3,

1786. Italy, his destination, he reached as "Herr Moller," a German mer-
chant. There he hoped to escape his celebrity as the author of *Werther.* The
relics of ancient culture, the objects of his nostalgia from long immersion
in classical literature, would provide another allegory of his unfulfillment.
In his *Italian Journey,* eloquently translated by W. H. Auden and Elizabeth
Mayer, he recorded rapture at seeing the palatial architecture of Venice
mirrored in "the Canal Grande, winding snakelike through the town." He
suppressed his old Gothic enthusiasms, spent only three hours touring
Florence, but found refreshment in Rome and Greece. "All the dreams of
my youth I now see living before me," he exclaimed at his four months in
Rome, "everywhere I go I find an old familiar face; everything is just what
I thought it, and yet everything is new. It is the same with ideas. I have
gained no new idea, but the old ones have become so definite, living, and
connected one with another that they may pass as new." Going south, he
explored Pompeii, climbed the erupting Vesuvius, and concluded that "if
in Rome one must *study,* here in Naples one can only *live.*" The Greek
temples at Paestum were the climax, "key to the whole." At Palermo he
bought a copy of the *Odyssey* in Greek, which he enthusiastically translated
aloud for Kniep, his traveling companion. And he made a plan for a play
(never completed) that would sum up Homer's tale.

Returning to Rome for ten months, he tried his hand as painter and
sculptor, learned perspective, sketched from models, and, somewhat to his
astonishment, discovered that he lacked great talent as an artist. At the
same time he industriously pursued his writing, rewrote *Egmont,* revised
two early comic operas, wrote lyrics and some scenes for *Faust*—all to fulfill
a commitment to prepare for his publisher the last four volumes of his
collected works. In June 1788 he returned to Weimar, where his critics (even
including Schiller) had been grumbling at the large ducal stipend he still
received for doing nothing. In Italy he had been captivated by a young
Milanese, whom he pursued until he discovered that she, too, was already
engaged, and then abandoned her in dark regret. But he had not been able
to conceal the episode in his weekly letters to Charlotte von Stein, and when
he returned their relationship had changed.

Goethe's discovery that he was no painter confirmed his determination
to spend his next years in writing, to "produce a Greece from within." His
encounter with the ancients had sharpened his distinction between the
classical and the modern ways of thinking. "The ancients," he concluded,
"represented *existence,* we usually represent the *effect;* they portrayed the
terrible, we terribly; they the agreeable, we agreeably, and so forth. Hence
our exaggeration, mannerism, false graces, and all excesses. For when we
strive after effect, we never think we can be effective enough." And he even
apologized for the heroic self. "All eras in a state of decline are subjective;

on the other hand, all progressive eras have an objective tendency. Our present time is retrograde, for it is subjective." But in his time the depths of "subjectivity" had only begun to be revealed.

A by-product of the Italian journey was his sensual *Roman Elegies,* a product also of his new love affair with Christine Vulpius.

> Saget, Steine, mir an, o sprecht, ihr hohen Palaste!
>> Strassen, redet ein Wort! Genius, regst du dich nicht?
> Ja, es ist alles beseelt in deinen heiligen Mauern,
>> Ewige Roma; nur mir schweiget noch alles so still.
> O wer flüstert mir zu, an welchem Fenster erblick ich
>> Einst das holde Geschöpf, das mich versengend erquickt? . . .
>
> Tell me, you stones, oh speak, you lofty palaces!
> Streets, say a word! Spirit of the place, will you not stir?
> Yes, everything is alive within your holy walls, eternal Rome;
>> only for me it is all still so silent.
> Oh who shall whisper it to me, at what window one day shall I see
>> the sweet creature who will burn me and refresh me? . . .
> Oh Rome, though you are a whole world, yet without love
>> the world would not be the world, nor would Rome be Rome.
>
> (Translated by David Luke)

He had met her in a Weimar park when she politely approached him to find a post for her brother, a struggling writer. This bright, attractive girl of a lower social class, the daughter of a ne'er-do-well drunken father, appealed to Goethe and he scandalized the neighbors by taking her into his house. She had several children by him, and remained his domestic comfort for twenty-eight years. He did not marry her until 1806, when the French had occupied Weimar.

While celebrated in Germany as the poet and across Europe as the last universal man, Goethe claims a place among great creators of Western literature for one work, his *Faust.* He probably first conceived it when he was a twenty-one-year-old law student in Strassburg in 1770, he wrote and revised it off and on until his death in 1832, and the last part was published posthumously. A product of his whole writing career, it became his own kind of anthology of all forms of prose and verse, from doggerel to the subtlest meter, in varied forms of drama, dance, and lyric.

Goethe's *Faust* theme, like that of Joyce's *Ulysses,* had been tested long before his time. The original Dr. Faustus was an unsavory necromancer of German folklore, who traveled widely, who died about 1540, and left a legacy of alchemy, magic, and astrology. He made a pact with the Devil, for which he was expelled from several cities. Despised as a sodomite, a

gourmand, and a drunkard, he died from mysterious causes. Philipp Melanchthon (1497–1560), Luther's collaborator, reported that Faust was strangled by the Devil in a rural inn in Württemberg on the day his evil pact came due. The legend, spread by Lutherans in the Reformation, expressed both reaction against the Roman Church and awe at Renaissance magic and science. As a parable of the perils of forbidden knowledge the Faust legend seemed to prove the need to keep learning within respectable bounds. But precisely because Faust explored the frontiers of forbidden knowledge his notoriety grew alongside Protestant orthodoxy. A collection of Faust stories, the *Spies Faustbuch,* published in German in Frankfurt in 1587, was reprinted eighteen times in the next ten years, was widely translated and frequently revised. Goethe probably knew the book.

It told the simple story of an arrogant scholar seeking unlimited power and knowledge who puts aside the proper science of theology for the forbidden science of magic. To secure this power for a number of years he sells his soul to the Devil. Faust then delights the theater audience by raising the dead, flying over the earth, and winning the beautiful Helen of Troy for his mistress. Finally, when his time is up, he is taken off to Hell.

The English translation of the *Spies Faustbuch,* entitled *The historie of the damnable life and deserved death of Doctor John Faustus* was itself magically transformed by Christopher Marlowe into his immortal play *The Tragical History of Doctor Faustus* (1604). Marlowe's Faustus is no mere necromancer but a man of infinite ambition lusting to be "great Emperor of the world." The familiar plot is embellished with some of Marlowe's best poetry, including the classic salutation to Helen:

> Was this the face that launched a thousand ships,
> And burnt the topless towers of Ilium?
> Sweet Helen, make me immortal with a kiss.
> Her lips suck forth my soul; see, where it flies!

The dramatic climax is the anguish of Faust when his twenty-four years of power come to an end and he is dragged off to Hell. Marlowe stays in the tradition of the medieval morality play. But he adds the Reformation note that Faustus is damned not only for inordinate ambition but for his fatalism and his refusal to accept the Protestant doctrine of justification by faith. Marlowe's play was popular in the German puppet theater, where both Lessing and Goethe saw it as children. They both used the old scenario to challenge the Enlightenment faith in reason, to affirm instead the sovereign self, the power of Weltschmerz and the striving of the individual genius.

As Goethe developed the Faust legend he transformed the leading character. Doctor Faust, no longer a mere legendary necromancer, has become

a universal hero, a self in quest of fulfillment, as recounted in two parts. Part One, the most widely read, which was published in 1808, offers scenes long familiar on the stage; Part Two, twice as long and published only after Goethe's death in 1832, is complex, obscure, and symbolic. His hero turns out to be not only a man of lust (he is that too), but a restless striver, reaching for his full humanity, and finally justified by God Himself.

The play begins with a Prologue in Heaven, where God agrees to let Mephistopheles (the Devil) try to win his bet that he can capture the soul of Doctor Faust. While God is confident that Mephistopheles cannot succeed, the play shows the Devil's efforts and Faust's response. An opening soliloquy by Faust declares his disillusionment with all knowledge—"philosophy, jurisprudence and medicine, too, and, worst of all, theology." Mephistopheles then engages Faust in a pact to give himself up to be the Devil's servant if at any moment of delight, he says, "Stay, thou art so fair! (*Verweihle doch, du bist so schön.*)" Hoping to trap Faust into this moment of climactic satisfaction, Mephistopheles tempts him finally with the delectable Gretchen. Faust, though with misgiving, seduces her, she ends in a dungeon and a miserable death—a victory for Mephistopheles—while Faust himself is overcome with remorse.

The second part offers five wildly melodramatic and allegorical acts. These include a scene of Helen of Troy recalled from Hades to be pursued by Faust. Their son Euphorion, who stands for poetry and the union of classical and romantic traditions (and incidentally, too, Lord Byron!) disappears in flames. This works a kind of catharsis, and a born-again Faust goes seeking ways to serve his fellowman. When, with the help of Mephistopheles, he has reclaimed some land from the sea, he feels the ultimate satisfaction, exclaims "Stay, thou art so fair!" and falls dead. When Mephistopheles tries to seize Faust's soul for Hell, it is rescued and borne away by angels. With this happy ending, the drama becomes, in Dante's sense, a Comedy.

Like *Hamlet,* Goethe's *Faust* offers a wide panorama of scenes from the vulgar to the sublime, with passages of wondrous poetry that can be sensed even through the veil of translation. And it also preserves the iridescence of its modern theme. From it Oswald Spengler christened our Western culture "Faustian," and others too have found it an unexcelled metaphor for the infinitely aspiring always dissatisfied modern self.

Goethe himself was wary of simple explanations. When his friends in Rome accused him of incompetence in metaphysics, he replied. "I, being an artist, regard this as of little moment. Indeed, I prefer that the principle from which and through which I work should be hidden from me." In his conversations (May 6, 1827) with Eckermann he explained why he laughed

at "the people who . . . come and ask what idea I sought to embody in my *Faust.*"

> As if I myself knew that and could express it! "From heaven through the world to hell," one might say in a pinch; but that is no idea but the course of the action. . . . It was altogether not my manner as a poet to strive for the embodiment of something abstract. . . . My opinion is rather this: *The more incommensurable and incomprehensible for the understanding a poetic creation may be, the better.*

From the beginning God, too, explains that man will always be in the Devil's path:

> Solang er auf der Erde lebt,
> So lange sei dir's nicht verboten;
> Es irrt der Mensch, solang er strebt.
>
> As long as he may be alive,
> So long you shall not be prevented
> Man errs as long as he will strive.
> (Translated by Walter Kaufman)

Man is to be judged, then, not only by his acts, but by his hopes, always better than his deeds:

> Ein guter Mensch, in seinem dunklen Drange,
> Ist sich des rechten Weges wohl bewusst.
>
> The good man however dark his striving,
> Is ever mindful of the better way.
> (Translated by Thomas Mann)

Man's problem, and his hope, come from the divine in him, which Mephistopheles explains:

> Der kleine Gott der Welt bleibt stets von gleichem Schlag
> Und so wunderlich als wie am ersten Tag.
> Ein wenig besser würd er leben,
> Hätt'st du ihm nicht den Schein des Himmelslichts gegeben;
> Er nennt's Vernunft und braucht's allein,
> Nur tierischer als jedes Tier zu sein.
>
> The small god of the world will never change his ways
> And is as whimsical—as on the first of days,
> His life might be a bit more fun,
> Had you not given him that spark of heaven's sun;
> He calls it reason and employs it, resolute

To be more brutish than is any brute.
(Translated by Walter Kaufman)

In his opening soliloquy Faust asks himself:

Binn ich ein Gott? Mir wird so licht!
Ich schau in diesen reinen Zügen
Die wirkende Natur vor meiner Seele liegen.

Am I a god? Light grows this page—
In these pure lines my eye can see
Creative nature spread in front of me.
(Translated by Walter Kaufman)

And Faust's ambition has no bounds.

Zu neuen Sphären reiner Tätigkeit.
Dies hohe Leben, diese Götterwonne! . . .
Ja, kehre nur der holden Erdensonne
Entschlossen deinen Rücken zu!
Vermesse dich, die Pforten aufzureissen,
Vor denen jeder gern vorüberschleicht!
Hier ist es Zeit, durch Taten zu beweisen,
Dass Manneswürde nicht der Götterhohe weicht. . . .

Uncharted orbits call me, new dominions
Of sheer creation, active without end.
This higher life, joys that no mortal won! . . .
Upon the mild light of the earthly sun
Turn bold, your back! And with undaunted daring
Tear open the eternal portals
Past which all creatures slink in silent dread.
The time has come to prove by deeds that mortals
Have as much dignity as any god. . . .
(Translated by Walter Kaufman)

Faust finally discovers that he is to be judged not by his finding but by his seeking. The last words of Part II end not with a conclusion but with a beckoning: "Das Ewig Weibliche/Zieht uns hinan" (The Eternal Feminine draws us on). This, Goethe's greatest work, was a monument to the inconclusiveness of experience. And man's life, like *Faust,* was an unfinished poem. Since "Doubt grows with knowledge," Goethe urged his readers "to quietly revere the unfathomable."

If a measure of self-esteem is willingness to put oneself in words, surely few men have lived who can match Goethe. The standard critical edition of his

works in German comes to 133 volumes and includes every form of prose, poetry, fiction, and drama. These comprise letters, speeches, essays, travel journals, treatises, government reports, scientific papers, recorded conversations, diaries, and much more. They are heroic in purpose as well as in volume, for there is no art, no aspect of politics or science on which Goethe does not express himself. His European celebrity probably even exceeded that of Voltaire, whose collected works come only to some thirty volumes and who never produced a work of the stature of *Faust.* And Goethe somehow managed to be praised for all the virtues, including skepticism and humility. Carlyle, never given to understatement, acclaimed him "the Wisest of our Time." Goethe focused the adoration of the eminent Victorians, including Matthew Arnold and George Eliot, who accompanied George Henry Lewes (1817–1878) to Weimar for his classic *Life of Goethe* (1855). Even if it were in our tradition to match the German scholars' humorless idolizing of their great writers, W. H. Auden observed, "it would be much more difficult for us to idolize Shakespeare the man because we know nothing about him, whereas Goethe was essentially an autobiographical writer, whose life is the most documented of anyone who ever lived; compared with Goethe, even Dr. Johnson is a shadowy figure."

Goethe's own writings, beginning with *Werther,* spotlighted himself and drew pilgrims to Weimar. Largely because of him, Weimar became "the Athens of Germany." Thomas Mann captured Goethe's permeating influence on Weimar in *The Beloved Returns* (1940), when Charlotte Buff, having borne eleven children, and now a widow of sixty, comes back. No shrewd public relations consultant could have bettered what Goethe did casually for himself—by his attractive person, his many widely advertised love affairs, and his numerous books, which reached all Europe in translation. Goethe's audience with Napoleon at Erfurt in October 1808 became a legend. On greeting Goethe, Napoleon exclaimed with a fixed look, *"Vous êtes un homme!"*—a rapid compliment, which he repeated to his entourage and was then spread across Europe. Napoleon noted that Goethe was "very well preserved" for his age, said he had read *Werther* seven times, and had taken it to Egypt with him. And he asked if Goethe had ever written tragedies. Incidentally, the emperor criticized a passage in *Werther* as being "unnatural," because, according to Goethe, it suggested an undue power for fate.

Goethe himself, in a widely quoted aphorism, declared that all his works were only "fragments of a great confession" (*Bruchstücke einer grossen Konfession.*) The heroic self Goethe created was something quite new in Western literature. He said that the classic axiom "Know thyself" only expressed the efforts of a priesthood to distract men from the active life and commit them to a sterile preoccupation with the self. Yet Goethe probably

wrote more about himself than anyone before or since. Along with Gibbon he is one of the first writers to chronicle the history of his own life fully, as a history of himself, and not of his deeds or works. Goethe knew and admired the works of Montaigne, he read Rousseau and made a pilgrimage to his place of refuge on the Lake of Biel, and he translated Cellini's autobiography into German.

Goethe's self-preoccupation never ceased. At the age of sixty he wrote his autobiography under the puzzling title *Dichtung und Wahrheit* (Poetry and Truth). Its two volumes began with his birth, followed his early loves and enthusiasms, and concluded in 1775, when at twenty-six he was invited to Weimar. So he declared the public importance of everything about himself even when he had only begun to be a public person. "For the principal task of biography," Goethe declared in his Preface, "I believe, is to present a man in the conditions of his time, and to show to what extent those conditions, taken as a whole, thwart or favor him, how he forms from it all a view of the world and of man, and how, if he is an artist, a poet, or a writer, he then takes that view and projects it back into the world."

In his autobiography Goethe seems to have made an effort to be as truthful in detail as was possible for a man of sixty recalling himself in his twenties. Though a pioneer creation in the modern literature of self-development (*Bildungsgeschichte,*) it has few passages of self-analysis, and, unlike Rousseau, Goethe offers no brief in self-defense. All the vignettes—from his first encounter with Charlotte Buff to his discovery that his trials at oil painting "show more energy than skill," to the time when "the names of Franklin and Washington began to shine and sparkle in the firmament of politics and war," to his decision on how his hair should be cut—show remarkable detachment. But each of its four parts is dominated by the story of one of his young loves.

Goethe's profligacy with words and his alertness to record every item of his time suggest his hope to find in the world of facts a refuge from his inner uncertainty. He often complained that while his poetry had been acclaimed, people did not appreciate his more important works on science and the study of nature. When Weimar was overrun by invading troops he worried most about the safety of his scientific manuscripts. Again unwittingly, in his own obsession with "science" he played out the role of a modern Dr. Faust.

Goethe himself insisted that the refusal of scientists to accept his scientific observations and his cosmic theories was only the obstinate pedantry of the professionals. In sober retrospect his work has proved less a contribution to science than an adaptation of the Faust scenario to the Western Europe of his time. As a boy he listened silently at the table to his pious Lutheran parents' talk of theology, then retreated to his bedroom, where he had

created an altar to Nature from a music stand adorned with minerals and flowers, and topped by a flame he had lit by a burning glass from the rays of the newly risen sun. He opened his autobiography with his "propitious" horoscope "in the sign of the Virgin" and explained that the auspicious astrological moment might account for his survival though "through the unskilfulness of the midwife, I came into the world as dead."

As a young man he had been a follower and collaborator of Johann Kaspar Lavater (1741–1801), the Swiss founder of the pseudoscience of physiognomics, a Christian version of phrenology, and he had been susceptible to forms of nature-philosophy. His novel *Elective Affinities* (1809), describing how lovers were unwittingly drawn to one another by some external force, took its title from a term of eighteenth-century chemistry that was used to suggest the chemical origins of love. It was therefore condemned as immoral. When a sophisticated friend objected to the book, Goethe responded, "But I didn't write it for you, I wrote it for little girls!"

Awed by Goethe's literary fame, dazzled by his reputation as the universal man, in the decades after his death even noted scientists like Ernst Haeckel early praised him as the bold amateur precursor of Darwin. Goethe, who had always enjoyed nature and collected plants, was in charge of the state forestry and agriculture at Weimar. He knew the recently popularized Linnaean system of classification. But he had difficulty remembering the names, which he blamed on the basic error in Linnaeus's "frozen" view that all species had been created in the Beginning and could neither become extinct nor be added to. As the physiologist Sir Charles Sherrington has shown, "Creative genius in literature, in science his genius longed to create." Goethe's Nature, too, was always creating and all existing species were in constant flux. His was no crank hobbyist's notion but the corollary of his Faustian conviction that he had penetrated to the mind of Nature.

Just as Goethe's *Faust* expounded the destiny of all mankind in this world and the next, so too Goethe's science had no petty purpose. In fourteen volumes of scientific writing Goethe offered his skeleton key to nature and his theory of living forms. Goethe divided all the phenomena of nature into two classes. Most are not subject to analysis because in them fundamentals are hidden by irrelevancies. The phenomena that are accessible to human inquiry he called *Urphanomenen* or primal phenomena. While these could never be resolved or taken apart, they allowed insight into the processes of Nature. One example was magnetism, the attraction and repulsion that we comprehend immediately and instinctively. It reveals "in Nature both animate and inanimate, a something which manifests itself as contradiction." Similarly, in mineralogy and geology, Goethe found it self-evident that the *Urphanomenon* is granite, which is at the base of the earth's crust and is the core of mountains. "My spirit's wings," Goethe concluded, "can go no further."

Equipped with this vocabulary, Goethe surveyed all nature with an eye for unities, for primal phenomena and primal forms. His poetic interest in the colors of nature quickly led him to the study of light, and into the arena with Sir Isaac Newton's well-established optics. Back in 1666, in a crucial experiment in Trinity College, Cambridge, Newton had passed white light through a tiny hole in a shutter and then through a triangular glass prism, showed white light to be the product of the combination of colors, and proposed his corpuscular theory of light. By Goethe's time, Newton's theories were widely accepted. But not by Goethe. "That all colors mixed together make white," said Goethe, "is an absurdity."

And he saw the greatest significance in his own optical theories. "I do not attach importance to my work as a poet," he told Eckermann, "but I do claim to be alone in my time in apprehending the truth about color." He insisted with poetic obstinacy, that there obviously could not be many different colored "lights," but there must be only one light. "Refractivity" was no part of direct experience. By using a prism Newton had violated the necessary simplicity of experiment, and so had introduced "*hundertlei*" complications. Worse than that, Newton had employed mathematics, which had no place in our observations of nature, and showed disrespect for nature's own beautiful simplicities. "Light is an elemental entity, an inscrutable attribute of creation, an 'Einziges,' which has to be taken for granted." How outrageous to violate the open-air dignity of nature by squeezing a tiny ray of light through a hole and forcing it by a piece of crude glass into a darkened room—when the full abundance of light was available just outside the door! How brutal! How prosaic!

Goethe held fast to the ancient dogmas of Theophrastus and Aristotle, which he had translated in 1801, that somehow colors were a varying mixture of light and darkness. His work *Zur Farbenlehre* (1810) finally came to 450 pages, a vast structure of simile and the poetic imagination.

In botany and biology Goethe once again let his creative faculties run riot, in pursuit of "morphology." *Urphanemenon* here meant the "ideal" form, which was variously realized in all particular organisms. He proposed, for example, that all plants were elaborations of an "ideal" leaf, and that all parts of a given plant—petals, sepals, stamens—were also modifications of the ideal leaf. When he learned that in man the incisor part of the upper jaw (the intermaxillary, or premaxillary, bone) at first appears separate from the rest of the bone, just as in other animals, he saw a vestigial partition of the human facial bone, confirming the original form of all animals. Goethe could not contain himself. "I have found—not gold or silver—" he wrote Herder when he compared the human and animal skulls, "but something which gives me unspeakable delight." When Goethe proposed one of his new "findings" in science, Schiller simply responded, "That is not a fact; it is an idea."

But Goethe was not daunted, and went on to create his grandiose "law" of the "correlation of parts," a kind of rule of compensation for all living bodies. Thus the snake could have a long body only by giving up its limbs, and a frog had long legs only by shortening its body. And man's skull was simply several enlarged vertebrae.

Goethe provided charming and sometimes witty verses to accompany his biological observations. And some of his aesthetic preferences, such as his prejudice against violent forces in nature, happened to coincide with later discoveries of Lyell, Darwin, Huxley, and other nineteenth-century pioneers of science. But he was not on the path to a modern theory of evolution because he had no feeling for the vast extents of time, nor for the role of great geologic uplifting movements.

His heroic Faustian self went in search of Skeleton Keys to Nature, which he finally created from his fertile poetic imagination. "Goethe could not readily bear contradiction with respect to his Theory of Colours," Eckermann reported of their conversations. "His feeling for the Theory of Colours was like that of a mother who loves an excellent child all the more the less it is esteemed by others." Goethe's love of Nature was the love of one creator for another. "We are in her and she is in us. . . ." Whatever his doubts of the Creator God, he had no doubts of Creator Nature!

> Let anybody only try with human will and human power, to produce something that may be compared with the creations that bear the names Mozart, Raphael, Shakespeare. God did not retire to rest after the well-known six days of Creation, but is evidently as active as on the first. It would have been for Him a poor occupation to compose this heavy world out of simple elements and to keep it rolling in the sunbeams from year to year if he had not had the plan of founding a nursery for a world of spirits upon this material basis.

When, a century after Goethe's death, James Joyce in *Finnegans Wake* listed the three reigning spirits of European literature, he named Daunty, Gouty, and Shopkeeper. To readers of English, Dante and Shakespeare would be recognizable enough. But Goethe, a popular eponym for streets in Chicago and other immigrant-settled American cities, would remain still more a mystery, seldom read, another symbol of the unfulfillment of Faustian ambitions.

62

Songs of the Self

IN an age of revolutions, which had recently seen the American "Declaration of Independence" and the French "Declaration of the Rights of Man and the Citizen," Wordsworth's inconspicuous Preface to the second edition of *Lyrical Ballads* in 1801 announced a revolution in poetry. Declaring independence from the stilted conventions of "poetic" language, the private language of men of letters, he proclaimed the equality of all readers with poets. He announced the poet's mission "to choose incidents and situations from common life, and to relate or describe them . . . in a selection of language really used by men."

To the layman this might seem a harmless, and even an obvious, way of thinking about poetry. But at the time it had a radical sound. The poet, like other artists, had been told to "hold the mirror up to nature." The word "poet" itself came from the Greek word for "maker." Aristotle's *Poetics,* the authority, said that since all the arts aimed at imitation, they differed from one another only in their ways of imitating. The poet was a craftsman, the Latin poet Horace explained, shaping and fitting the parts toward an intended finished product.

By the eighteenth century, the neoclassic tradition in England had hallowed an artificial high-flown language and a canon of literary "forms" for the poet-craftsman. The neat couplets of Dryden and Pope offered "What oft was thought but ne'er so well expressed." Then impatient poets, reaching for a more emotional view of poetry, found a new spirit in poems of melancholy like Gray's "Elegy Written in a Country Churchyard," in popular ballads, and in Gothic romance. The Wordsworthian revolution in poetry, brilliantly described by critic M. H. Abrams, was from the "mirror" to the "lamp." And Rebecca West dryly expressed the rebels' feelings, "A copy of the universe is not what is required of art; one of the damned things is ample." A new "expressive" view of poetry was in the making. While older critics, focusing on form, had contrasted poetry to prose, now poetry

was contrasted to "science," the dispassionate recounting of facts. A new dignity was given to the outcries of primitive people and the songs of peasants, which the new poets tried to forge in the legendary "Ossian" (1760). In place of the Homeric epic of great deeds, the new poetic norm was the lyric, the first-person utterance of thoughts and feelings in verse. And it was no accident that the epochal collection of new poems was *Lyrical Ballads*.

The first edition of this 1798 sampler of new poetry was anonymous. It was introduced only by a brief apologetic "Advertisement" for the "experiments" aiming to see "how far the language of conversation in the middle and lower classes of society is adapted to the purposes of poetic pleasure." The reviewers were not enthusiastic, but the work sold out in two years. The second edition no longer apologized but instead argued that "*all* good poetry"—like the works in this volume—must be "the spontaneous overflow of powerful feelings," taking its origin from "emotion recollected in tranquillity." Everyman his own Poet! The poet must be judged only against himself. Or, as Oliver Goldsmith had declared, "I am myself the hero." The poet was simply "a man speaking to men."

While the Preface had appeared under the name of Wordsworth alone, Coleridge (1772–1834) said it was "half a child of my own brain." The *Lyrical Ballads* contained poems by both Wordsworth and Coleridge, and the later edition added new poems. The two poets were an odd couple, as different in temperament and cast of mind as could be found among literary men of the same generation. They were such intimate collaborators that we cannot know how, or how much, each contributed to the other. In this alchemy there was also an unlikely catalyst, Wordsworth's sister Dorothy, who was part of their literary life, but whose role is also a mystery.

William Wordsworth, born in 1770 in the Lake District of northern England, was one of five children in a prosaic family. His father was a business agent of a local landowner who was a member of Parliament. His mother, daughter of a linen draper, died when he was eight and his father died when he was thirteen, leaving him under the frigid guardianship of uncles. Luckily they boarded him and his three brothers with a sympathetic housewife in a cottage in the countryside who left them free to ramble.

> There was a Boy: ye knew him well, ye cliffs
> And islands of Winander! —many a time
> At evening, when the earliest stars began
> To move along the edges of the hills,
> Rising or setting, would he stand alone
> Beneath the trees or by the glimmering lake . . .

He recalled later in *The Prelude* how these walks had first awakened him to the charms of nature and the virtues of cottagers and shepherds. Luckily, the headmaster at his school encouraged his interest in poetry, and introduced him to the eighteenth-century poets. He was charmed by the precocious Thomas Chatterton (1752–1770), who had captivated the literary world by forging the works of "primitive" English poets, and then had committed suicide at the age of eighteen. Surprisingly, Wordsworth's father had made him memorize passages of Spenser, Shakespeare, and Milton.

When his guardian uncles sent him with a scholarship to St. John's College, Cambridge, they expected him in due course to take holy orders and become a Fellow of the College, like the uncle who had secured the scholarship for him. Feeling confined by academic life, he refused to read for honors, and ended with a pass degree. But enjoying nature on his walks around Cambridge gave him the sense of being born again. In 1790, before coming down from Cambridge, with a friend he took a brief walking tour of the Continent. France entranced him by its promises of the political millennium. Returning there in 1791, he plunged enthusiastically into the spirit of the Revolution.

> Bliss was it in that dawn to be alive
> But to be young was very heaven.

One of his best friends was a young man on the way to becoming a general in the Republican army. An impetuous love affair with Annette Vallon, the daughter of a French surgeon, produced a daughter, Caroline. He thought of marrying Annette, staying on and joining in revolutionary politics, which might have been difficult, since Annette was a Catholic of a royalist family. Anyway, the guardian uncles would have none of it and refused to support him abroad.

Only two months after his return home in February 1793, England joined the war against France, creating a "moral" crisis for Wordsworth. His affection for the English land, nourished from his youthful rambles, suddenly was to be tested. Which would be stronger, love of England or love of "freedom"? The pain of this divided self was soon compounded by news of the Terror in France—Robespierre's festival of slaughter, which killed the moderate Girondins who were Wordsworth's friends. Within only forty-nine days 1,376 people were guillotined, as he later recalls in *The Prelude:*

> Domestic carnage, now filled the whole year
> With feast-days, old men from the chimney-nook,
> The maiden from the bosom of her love,

> The mother from the cradle of her babe,
> The warrior from the field—all perished, all—
> Friends, enemies, of all parties, ages, ranks,
> Head after head, and never heads enough
> For those that bade them fall.

Wordsworth, now in his early twenties, suffered the disillusion of naive young revolutionaries in all ages.

Flooded by self-reproach for mistaking the French cause, for doubting his England, and for betraying and abandoning Annette Vallon, where to turn? Just then the unexpected legacy of nine hundred pounds from a friend allowed him to set up housekeeping in the countryside with his sister Dorothy, return to rural nature, and become a full-time poet. Dorothy, his companion and solace for the rest of of his life, had a great literary talent, as her posthumously published journals would show. But as a woman, she was sentenced to be "the angel in the house," while both Wordsworth and Coleridge would borrow from her journals.

In 1795, when Wordsworth met Samuel Taylor Coleridge, who was also living in the West Country, the effect on both was electric. Coleridge persuaded the Wordsworths to take a cottage nearer him. Even before they met, Coleridge had applauded Wordsworth's first poems about his walking tour in the Alps. Now "the giant Wordsworth," he said, was not merely a poet of promise, but "the best poet of the age, the only man to whom at all times and in all modes of excellence I feel myself inferior." In turn, Wordsworth's admiration of Coleridge was boundless. Oddly these poets of individualism, who believed poetry to be the voice of the unique self, soon used the same phrases, labored over the same passages, and Coleridge even tried to finish poems that Wordsworth had left incomplete.

Coleridge sketched the contrast of their natures when he described their division of labor for the *Lyrical Ballads:*

> It was agreed that my endeavours should be directed to persons and characters supernatural, or at least romantic; yet so as to transfer from our inward nature a human interest and a semblance of truth sufficient to procure for these shadows of imagination that willing suspension of disbelief for the moment, which constitutes poetic faith. Mr. Wordsworth, on the other hand, was to propose to himself as his object, to give the charm of novelty to things of every day, and to excite a feeling analogous to the supernatural, by awakening the mind's attention from the lethargy of custom, and directing it to the loveliness and the wonders of the world before us; an inexhaustible treasure. . . .

Coleridge was voluble and sociable, bookish and mystical, charmed by the exotic experience and metaphysical ideas. The withdrawn Wordsworth,

seeing himself as "the recluse," was charmed by everyday nature and the commonplace virtues. Coleridge sought solace in opium and the mists of German speculation, Wordsworth found his comfort in rural walks, spring flowers, and conversation with shepherds. While Wordsworth's life would be troubled by the love-child of his youth, he had a happy marriage to a childhood friend. But Coleridge made himself unhappy by his loveless marriage to a woman who had fitted into his youthful scheme for an ideal community on the shores of the Susquehanna.

The first edition of the *Lyrical Ballads* (1798) offered some of Wordsworth's most durable poems, including "Tintern Abbey," in which he declared:

> For I have learned
> To look on nature, not as in the hour
> Of thoughtless youth; but hearing oftentimes
> The still sad music of humanity,
> Not harsh nor grating, though of ample power
> To chasten and subdue.

Coleridge invoked the supernatural in his unforgettable "Rime of the Ancient Mariner."

> "God save thee, ancient Mariner!
> From fiends, that plague thee thus!—
> Why look'st thou so?"—"With my cross-bow
> I shot the Albatross!"

The volume sold well enough to help pay for their trip with Dorothy to Germany. While Coleridge used the opportunity to learn German for better access to philosophy, Wordsworth was isolated by his ignorance of German and began his enormous blank verse autobiography, *The Prelude.* Only the "ante-chapel to the body of a Gothic church," it was intended to be an introduction to "The Recluse," an even vaster work, never completed. Wordsworth's monumental epic, addressed to Coleridge and frequently referring to Dorothy, would record in verse "the origin and progress of his own powers, as far as he was acquainted with them."

The Prelude, widely recognized as Wordsworth's masterpiece, is praised as "the greatest and most original long poem" since Milton's *Paradise Lost.* Perhaps the longest English epic of the self, it remains one of the least read classics of English literature. But its influence on other poets has been incalculable. In chronicles of the self it holds a place somewhere between Rousseau's *Confessions* and Joyce's *Portrait of the Artist.* When it was

finally published after Wordsworth's death in 1850, his wife titled it "Growth of a Poet's Mind: An Autobiographical Poem." A rare feat of self-preoccupation, it was a monument to Wordsworth's sense of mission as poet-prophet, putting into verse the nuances of a long life's thoughts and feeling. But anticipating that readers might find conceit in his unusual subject, he dared to affirm his "real humility."

It is not surprising that John Keats, who never lived to see *The Prelude*, had already made Wordsworth his example of the "Egotistical Sublime." The critics who accused Edward Gibbon in his autobiography of confusing himself with the Roman Empire might have asked whether Wordsworth in his *Prelude* had not confused himself with the cosmos. Yet *The Prelude* provides the patient reader with an oddly compact narrative of the seedtime of modernism—the growing belief in the shaping power of childhood, the enthusiasms and disillusions of Revolution, the obsessions with crises of personal faith, and "Love of Nature leading to Love of Man." Wordsworth begins with the inner conflict of the divided self. "Fair seed time had my soul, and I grew up fostered alike by beauty and by fear." He seeks solace in withdrawal:

> When from our better selves we have too long
> Been parted by the hurrying world, and droop,
> Sick of its business, of its pleasures tired,
> How gracious, how benign is Solitude.

The healing of Wordsworth's divided self, if there was to be a healing, would come from lonely self-revelation, the remembrance of things past, of which Freud would be a latter-day prophet. Saint Augustine and others seeking solace in Confession had appealed to a higher Judge. But for Wordsworth self-revelation was all—"each man's Mind is to herself/Witness and judge."

Wordsworth, if anyone, should have realized how little "to herself" his mind could be. For he continued to depend on the solace of Dorothy, and on the stimulus of Coleridge. Returning from Germany in 1799, he and Dorothy settled at Grasmere in his native Lake Country where he would spend the rest of his life, and Coleridge took a house just thirteen miles away. Wordsworth's financial worries ceased when he finally came into his inheritance, and he reached a settlement with Annette Vallon. Then, in 1802 he married Mary Hutchinson, a childhood friend from the neighborhood, and an intimate of Dorothy. Though distraught at being displaced, Dorothy somehow accommodated herself and remained William's constant support. Mary's family was so displeased at her marrying a "vagabond" with no gainful occupation that the Wordsworths received not a single wedding present. The marriage was happy. Mary bore five children, and Dorothy played the affectionate aunt. But the next years brought tragedy and tribula-

tion. Wordsworth's brother John, to whom they were devoted, drowned in a shipwreck in 1805, and two of their children died in 1812.

Then, as the opposition of temperaments might have forecast, there developed a painful estrangement between the two poets. While Wordsworth had settled placidly in Grasmere, Coleridge, who was in Malta as secretary to the governor, suffered deteriorating health. He became increasingly dependent on opium in the form of laudanum, then prescribed as a drug. When Coleridge returned to England—fat, irritable, and horrified at reunion with his unloved wife—he vented his frustration on his intimate friends. Also he had just fallen hopelessly in love with Mary Wordsworth's sister, Sara Hutchinson, whom he knew he could never marry. He became passionate and demanding, while Sara tried unsuccessfully to cure him of his addiction to opium and alcohol. The Wordsworths were alarmed.

Convinced that he was not loved by those who had meant most to him, Coleridge broke off the friendship. He lamented into his notebooks in November 1812, that for fourteen years "and those 14 are the very life of my life," he had enjoyed "the most consummate friendship" with Wordsworth, and been "enthusiastically watchful" over Wordsworth's literary career "even at the price of alienating the affections of my benefactors." And how had he been repaid? "What many circumstances ought to have let me see long ago, the events of the last year, and emphatically of the last month, have now forced me to perceive—no one has ever LOVED me." Soon after, he stumbled into Charles Lamb's house mumbling, "Wordsworth, Wordsworth has given me up." Friends intervened to bring the two together, but the breach was never fully healed. Nor did the pair ever revive their historic collaboration, their alchemy of opposites.

Each hastened down his own way, Coleridge on the rocky path of opium and German mysticism, Wordsworth on the smooth ways of rural nature and friendly neighbors. As their paths separated, the poetry of both deteriorated. And as Wordsworth became more prosperous, and more conservative in politics and religion, his poetry became more voluminous but less interesting. In 1813, on Wordsworth's own request for a sinecure, he received a modest recognition of his national eminence in the form of the distributorship of stamps for Westmoreland. He was decorated with the customary honorary degrees. Finally, in 1843, on the death of Robert Southey, after assurance from the prime minister, Sir Robert Peel, that there would be no duties attached, he accepted the poet laureateship. And so he provided Browning with a plausible subject for "The Lost Leader":

> Just for a handful of silver he left us,
> Just for a riband to stick in his coat— . . .
> Shakespeare was of us, Milton was for us,

> Burns, Shelley, were with us—they watch from their graves!
> He alone breaks from the van and the freemen—
> He alone sinks to the rear and the slaves.

The critics were not far wrong. Wordsworth had written most of his best poetry before his estrangement from Coleridge—before he became a literary idol. And his memorable pieces were short poems. Even the longer of them, "Tintern Abbey" (1798) and the "Ode: Intimations of Immortality from Recollections of Early Childhood," were each only two hundred lines. This lovely ode, on a familiar Romantic theme, celebrated the clairvoyance of childhood.

> Our birth is but a sleep and a forgetting:
> The Soul that rises with us, our life's Star,
> Hath had elsewhere its setting,
> And cometh from afar:
> Not in entire forgetfulness,
> And not in utter nakedness,
> But trailing clouds of glory do we come
> From God who is our home:
> Heaven lies about us in our infancy!
> Shades of the prison-house begin to close
> Upon the growing Boy . . .

Perhaps there was a natural limit to the length of a "lyric" (originally a poem for singing to the lyre) which was the proper medium for the Romantic spirit. When the celebration of the self in poetry expanded beyond bounds, it defeated its object.

John Keats (1795–1821), master of the lyric, saw this weakness, the hypertrophy of the self, in Wordsworth. He met Wordsworth several times, dined with him, heard him pontificate about poetry, and after each meeting found him less sympathetic. "For the sake of a few fine imaginative or domestic passages," Keats asked in 1818, "are we to be bullied into a certain Philosophy engendered in the whims of an Egotist? . . . Poetry should be great and unobtrusive, a thing which enters into one's soul and does not startle it or amaze it with itself, but with its subject. Let us have the old Poets and Robin Hood."

Perhaps the decline of Wordsworth's poetry was a natural consequence of his specific talent. Having defined poetry as "emotion recollected in tranquillity," he made his best poems works of remembrance. He was a poet of what he called "the two consciousnesses," the moments of the present called up moments of the youthful past. As his later life became increasingly calm and sedentary there was ever less contrast between the agony of the

present and the delights of youth. Wordsworth's remembrance of things past, so focused on himself, became a drama with only one actor, which was not enough to sustain an epic. And he lamented:

> The world is too much with us; late and soon,
> Getting and spending, we lay waste our powers;
> Little we see in Nature that is ours.

Coleridge, Wordsworth's stimulus and catalyst, was quite another story. He had his own problems, but he did not feed on himself. His plague was his reaching out to the ungraspable exotic, demanding universal truths of theology and philosophy. In his youth in 1793, in a characteristic flight of fancy and in despair over an unrequited love, during his third year at the university, Coleridge had fled Cambridge. Happening on a recruiting office for the Light Dragoons, he was sworn in as "Silas Titus Comberbacke." But his cavalry career was not a success. He could not groom his horse, ride, or even keep his equipment in order, and was finally assigned to cleaning stables and serving as a hospital orderly. When his older brother James responded to his frantic appeals and bought his release, he returned to Cambridge and the world of letters.

Romantic in a most un-Wordsworthian sense, he was seduced by the otherworldly. "The Rime of the Ancient Mariner," his main contribution to the *Lyrical Ballads,* had originated in the dream of a friend who imagined a skeleton ship with figures in it.

> Day after day, day after day,
> We stuck, nor breath nor motion;
> As idle as a painted ship
> Upon a painted ocean.
>
> Water, water, everywhere,
> And all the boards did shrink;
> Water, water, everywhere,
> Nor any drop to drink.

Coleridge's idea for the poem had convinced Wordsworth "that the style of Coleridge and myself would not assimilate." Still Wordsworth claimed to have contributed the idea of shooting an albatross, which made the poem an allegory of man's sins against nature. "Kubla Khan; or a Vision in a Dream" (1798) was first published in 1816 with Coleridge's apology that it was only a "fragment . . . here published at the request of a poet of great and deserved celebrity," Lord Byron. Coleridge offered his own opinion that it was "rather a psychological curiosity, than . . . of any supposed *poetic* merit." Conceived in Coleridge's own opium dream, it began quite simply:

> In Xanadu did Kubla Khan
> A stately pleasure-dome decree;
> Where Alph, the sacred river, ran
> Through caverns measureless to man
> Down to a sunless sea.

And it concluded with a cryptic warning:

> And all should cry Beware! Beware!
> His flashing eyes, his floating hair!
> Weave a circle round him thrice,
> And close your eyes with holy dread,
> For he on honey-dew hath fed,
> And drunk the milk of Paradise.

"Christabel," which Coleridge intended to include in the second edition of the *Lyrical Ballads* but never completed, was again a poem in the tradition of Gothic romance, of abduction, bewitchings, and mysterious spells, with heavy sexual overtones. It is no wonder that Wordsworth, to Coleridge's disappointment, refused to include it in the volume.

In 1800 Coleridge, who still abased himself before "the giant Wordsworth," was dismayed and depressed. As he wrote a friend, "I abandon Poetry altogether—I leave the higher and deeper kinds to Wordsworth, the delightful, popular and simply dignified to Southey, and reserve for myself the honourable attempt to make others feel and understand their writings, as they deserve to be felt and understood." Wordsworth argued that since the second edition of the *Lyrical Ballads* was to appear under his own name, it would be "indelicate" to include so long and so admirable a poem from another pen. Also, Wordsworth found "Christabel" "discordant" with his own style of celebrating "incidents of common life." Coleridge justified the exclusion with doubtful humility. "He [Wordsworth] is a great, a true Poet—I am only a kind of Metaphysician." The German he had learned in his youth had opened for him the world of Kant, Lessing, Schlegel, and the German Romantic philosophers. When Coleridge finally published his own collected poems in 1817, he emphasized their cryptic message by entitling them *Sibylline Leaves.* So he publicly boasted his oracular style, aiming at "suspension of *dis*belief" in contrast to Wordsworth's everyday world.

Coleridge became increasingly bookish, literary, and philosophical, devoting himself to explaining the works of the great English authors, notably Shakespeare. *His* autobiography was no song of himself, but a *Biographia Literaria,* a life in literature. In his later years more and more of his work was what he called "theologico-metaphysical" writing, expounding his own theories of Church and State. "What is it that I employ my metaphysics

on?" he asked himself in his notebook. "To perplex our dearest notions and living moral instincts?" Unlike his anti-ego Wordsworth, who had settled into rural self-satisfaction, Coleridge had set himself on "The Road to Xanadu." The last eighteen years of his life he lodged under the care of "a respectable Surgeon and Naturalist at Highgate," the generous Dr. James Gillman, who tried to help him keep his opium habit under control. But Coleridge managed to have his laudanum smuggled in to him. Charles Lamb's "archangel slightly damaged" worked at his long-planned "magnum opus"—a new *Summa* of theology, morals, psychology, logic, and all the sciences and arts—that was never published. "Coleridge sat at the brow of Highgate Hill, in those years," wrote Carlyle, "looking down on London and its smoke-tumult, like a sage escaped from the inanity of life's battle."

A half century after Wordsworth's manifesto, there appeared on the other side of the Atlantic another poets' proclamation, emphatically American. In 1855 a tall thin volume was published with *Leaves of Grass* but no author on its title page. This author was no mystic opium addict nor any rural recluse, but a self-educated printer's devil turned vagrant journalist. "Walter Whitman" was listed as the person who had registered the copyright, and facing the title page was a portrait of the author, "broad-shouldered, rough-fleshed, Bacchus-browed, bearded like a satyr." The volume contained twelve poems without titles and a ten-page Preface. From the New World of individualism came a boast of the collective self. "The Americans of all nations at any time upon the earth have probably the fullest poetical nature." "The proof of a poet," the Preface concluded, "is that his country absorbs him as affectionately as he has absorbed it." His first lines announced his plain theme:

> I celebrate myself, and sing myself,
> And what I assume you shall assume,
> For every atom belonging to me as good belongs to you.
>
> I loafe and invite my soul,
> I lean and loafe at my ease observing a spear of summer grass.

The thirty-six-year-old Whitman was, for a poet, late in making his debut. But *Leaves of Grass* became a lifework as he continually expanded it, to 456 pages (third edition), into two volumes (sixth edition), and even till his "Deathbed Edition" of 1891–92.

A journeyman printer, he seems to have set some of the type for the first edition himself. He gave most of the nine hundred copies to friends and critics. But when, after a few weeks, there were no reviews, Whitman rounded out the task of self-creation by writing his own enthusiastic re-

views, and publishing them in magazines and the *Brooklyn Times*. The volume plainly showed the influence of the eminent Ralph Waldo Emerson. From Emerson he received a letter acclaiming "the wonderful gift of *Leaves of Grass* . . . the most extraordinary piece of wit and wisdom that America has yet contributed. . . . I greet you at the beginning of a great career, which yet must have had a long foreground somewhere, for such a start." Whitman showed a thoroughly American feeling for public relations when he published Emerson's letter (without his permission) to promote the second edition.

The volume startled by its indiscriminate subject matter. The long opening poem, which he would later title "Song of Myself," celebrated the miscellany of American life—butcher-boy, canal boy, paving-man, prostitute, the crew of a fishing-smack, all the motley of "the Nation of many nations." It included fragments of American history, the fall of the Alamo, and spoke with unfamiliar frankness.

> On women fit for conception I start bigger and nimbler babies,
> I do not press my fingers across my mouth,
> I keep as delicate around the bowels as around the head and heart,
> Copulation is no more rank to me than death is.

And he hailed the unpoetic vocations.

> Hurrah for positive science! Long live exact demonstration!
> Fetch stonecrop mixt with cedar and branches of lilac,
> This is the lexicographer, this the chemist, this made a grammar of the old cartouches,
> These mariners put the ship through dangerous unknown seas,
> This is the geologist, this works with the scalpel, and this is a mathematician.

Who was this who celebrated the collective self of America?

> Walt Whitman, a kosmos, of Manhattan the son,
> Turbulent, fleshy, sensual, eating, drinking and breeding,
> No sentimentalist, no stander above men and women or apart from them,
> No more modest than immodest.

The form was just as surprising. This New World self would no longer be channeled and confined by rhyme or meter, nor imprisoned in stanzas. "A poem must be unconventional, organic, like a tree growing out of its own proper soil." The freedom of "blank verse" with its iambic pentameters, though good enough for Marlowe, Shakespeare, and Milton, was not free enough for Whitman. Instead, he proclaimed the utter freedom of "free

verse." French poets in the 1880s would give this a name as if it were a form (*vers libre*). But Whitman had already demonstrated that freedom in *Leaves of Grass*. And that free "form" inspired twentieth-century poetry in the works of the Imagists, of T. S. Eliot, Ezra Pound, Carl Sandburg, and many others. Free verse aimed "to compose in sequence of the musical phrase, not in sequence of the metronome." Some found Whitman's free verse prosaic. Emerson, who had hoped Whitman would write the nation's songs, appeared disappointed that Whitman "seemed content to make the inventories."

By his late thirties Whitman was experienced at making the nation's inventories. His years as a wandering journalist had provided the "long foreground" that Emerson imagined—a varied American experience of village, city, and countryside, north and south. Born in Huntington, Long Island, in 1819, he was the second of nine children of whom both the eldest and the youngest were mentally defective. When Walt was only four, his father, Walter Whitman, a farmer turned carpenter, moved the family to Brooklyn, then a town of ten thousand. His whole schooling was five years in the Brooklyn public schools. After four years as an apprentice printer, at thirteen he became a printer's devil. Before 1848 he had held a half-dozen different jobs on newspapers in New York and Brooklyn. The longest was a two-year stint (1846–48) as editor of the *Brooklyn Daily Eagle*. He wrote a few poems, many stories, and a temperance novel, *Franklin Evans: the Inebriate, a Tale of the Times* (1842). Enjoying the color and variety of urban life, he rode omnibuses and ferries, bathed on the beaches, frequented the opera and the Bowery Theater where he saw Fanny Kemble, Junius Brutus Booth, and Edwin Forrest. He read the Bible, Shakespeare, Coleridge, Dickens, the Ossianic poems, and Sir Walter Scott. Though an active Democrat, he lost his job on the Democratic *Eagle* because of his vocal Free Soil sentiments.

Then, in a theater lobby, someone offered him a job writing for the New Orleans *Crescent*. He and his brother crossed Pennsylvania and Virginia and took a steamer down the Ohio and Mississippi. He was stirred by the sights and sounds of New Orleans. He later spread the legend that a New Orleans romance had produced six illegitimate children, but these seem to be the offspring of his imagination at the age of seventy. His poem "Once I passed through a Populous City," was formerly thought to refer to his procreative romance. "Day by day and night by night we were together all else has long been forgotten by me." But close examination of the original manuscript now reveals that the object of the romance was not a woman but a man.

After three months in New Orleans he and his brother took a roundabout return to Brooklyn via St. Louis, Chicago, the Great Lakes, Niagara Falls,

Albany, and the Hudson River. He was collecting the impressions and tag ends of experience that would be strung together in *Leaves of Grass.* Whitman's biographers suggest that, in New Orleans or just after, he somehow experienced an epiphany. Did some sudden revelation of reality and of himself prepare him over the next seven years to produce the twelve poems of his shocking book, and transform him from a vagrant journalist into the first American poet? When did he know that his talent set him apart?

> The spotted hawk swoops by and accuses me, he complains of my gab and my
> loitering.
> I too am not a bit tamed, I too am untranslatable,
> I sound my barbaric yawp over the roofs of the world.

Part of him insisted that since he was only an "average man" he was qualified to speak for the people, another part expressed the prophet-superman who spoke "a word of the modern, the word En Masse."

> Divine am I inside and out, and I make holy whatever I touch or am touch'd
> from,
> The scent of these arm-pits aroma finer than prayer,
> This head more than churches, bibles, and all the creeds.

A tormented homosexual in a heterosexual world, he was still determined to speak for the whole world. But only his mother and other men are his "darlings."

In the next years he published eight more expanded editions of *Leaves of Grass.* And while making a living writing for newspapers, he joined a mini-bohemia meeting at "Pfaff's Cellar" at Broadway and Bleecker Street. The *Leaves of Grass* (third edition) in 1860 contained two complementary groups of poems. One, "Children of Adam," a "cluster of Poems . . . to the passion of Woman-Love":

> From my own voice resonant, singing the phallus,
> Singing the song of procreation,
> Singing the need of superb children and therein superb grown people,
> Singing the muscular urge and the blending,
> Singing the bedfellow's song (O resistless yearning!
> O for you whoever you are your correlative body! O it, more than all else you
> delighting!)

While this cluster, Whitman said, celebrated the "amative" love of men and women, a complementary "cluster"—the Calamus poems—celebrated the "adhesive love" of men for men. Whitman, vaguely and unpersuasively,

argued that he intended only a political-democratic message. But even before these two clusters, his sexual allusions caused him trouble. The publisher who sold a thousand copies of the second edition refused to handle the book any longer. Emerson had failed to persuade Whitman not to publish his "Children of Adam" or to expurgate the poems. The third edition was far more explicit and sold well in the hands of a new publisher.

Meanwhile, the Civil War engaged Whitman's life and his talents. In 1862, learning that his brother had been wounded, he went south in search of him, then settled in Washington for the next eleven years. As long as the war lasted he spent himself as itinerant nurse and companion to the wounded Northern and Southern soldiers in Washington's huge military hospitals. He brought gifts of oranges, jelly, and candy, wrote letters for them, and dressed their wounds. It is not clear how much of his homosexual feelings entered into these friendly efforts. He now wrote some of his best-known poems, inspired by the death of Lincoln, "When Lilacs Last in the Dooryard Bloom'd," which some consider his masterpiece.

> Come lovely and soothing death,
> Undulate round the world, serenely arriving, arriving,
> In the day, in the night, to all, to each,
> Sooner or later, delicate death.

And, more familiar:

> O Captain! My Captain! our fearful trip is done,
> The ship has weathered every rack, the prize we sought is won,
> The port is near, the bells I hear, the people all exulting.

When the Secretary of the Interior read the *Leaves of Grass* with its two sexual clusters, he promptly fired Whitman from his clerical job. But his friends soon secured a post for him with the Attorney General.

The episode made Whitman a martyr to literary freedom and attracted outspoken champions. The attacks on his indecency only increased his readers. A decade later, when the Society for the Suppression of Vice in Boston threatened prosecution, the publisher withdrew the book, which was taken over by a publisher in more tolerant Philadelphia. A result, phenomenal for the time, was the sale of three thousand copies of the Philadelphia (sixth) edition (1882) in a single day. Still in Washington, in a retort to Carlyle's antidemocratic diatribe, *Shooting Niagara,* Whitman expressed his passions in the prose of *Democratic Vistas* (1870), criticizing current fashions and championing a future for American literature.

In 1873 Whitman suffered a paralytic stroke, which he said resulted from his infection with gangrene and fever when he was attending wounded Civil War soldiers. But these several illnesses were probably complicated by the strains of his sexual ambiguity. He moved in with his brother in Camden, New Jersey, where he remained an invalid and produced little of significance until his death in 1892. Before he left Washington he had written "Passage to India," included in the fifth edition of *Leaves of Grass* (1871). In this, his last great poem, he tried to tone down his chauvinism, even admitting that America needed the world. It celebrated three world-unifying events: the opening of the Suez Canal, the meeting of the Union Pacific and the Central Pacific railways in Utah, and the laying of the transatlantic cable. He insisted that America needed its past and "Passage to more than India!"

But Whitman never repaired his divided self. As prophet and pundit receiving the great and famous in Camden, he still carried on his loving correspondence with a young horse-car conductor he had met in Washington in 1866. The refined George Santayana, seeing in Whitman's poetry only bundles of unassimilated particulars, made him his prototype of "The Poetry of Barbarians"—revealing a "wealth of perception with intelligence and of imagination without taste." And this new freedom of the self, however tormented, that Whitman declared would mark the future path of poetry. Mostly unappreciated and widely condemned by the America he had idolized, Whitman remained the relentless creator. He lived a long and prosperous afterlife, even in the works of American poets who had abandoned his America and seceded from his idealized collective life. "It was you who broke the new wood," Ezra Pound said in his poem to Whitman. "Now is the time for carving. We have one sap and one root—Let there be commerce between us."

63

In a Dry Season

A century after the Romantic Revolution announced by Wordsworth, there came into English literature an anti-Romantic Revolution. Its Wordsworth was T. S. Eliot (1888–1965), and its manifesto another brief essay, "Tradition

and the Individual Talent" (1917). And he, too, had his Coleridge, his catalyst, anti-ego, and critic, in the person of Ezra Pound (1885–1972). They plainly and simply declared themselves enemies of the Egotistical Self. Denying the poem to be about the poet, Eliot declared that "The progress of an artist is a continual self-sacrifice, a continual extinction of personality. . . . The poet has, not a 'personality' to express, but a particular medium, which is only a medium and not a personality, in which impressions and experiences combine in peculiar and unexpected ways. Impressions and experiences which are important for the man may take no place in the poetry, and those which become important in the poetry may play quite a negligible part in the man, the personality. The emotion of art is impersonal."

A far cry from "emotion recollected in tranquillity"! Not enough to let powerful emotions overflow. Not enough that the poet "be himself." The poet, Eliot insisted, must be equipped too with "the historical sense . . . nearly indispensable to anyone who would continue to be a poet beyond his twenty-fifth year. . . . a perception not only of the pastness of the past but of its presence." Which means that the poet must be learned and know his great predecessors. "Someone said: 'The dead writers are remote from us because we *know* so much more than they did.' Precisely, and they are that which we know." The poet cannot reach the needed "impersonality" without a sense of history—"unless he lives in what is not merely the present, but the present moment of the past, unless he is conscious, not of what is dead, but of what is already living."

Eliot's wariness of the romantic self had led him, as it would lead Joyce, Picasso, and others, to a strange new way of comprehending the world in art. The familiar Western way of portraying the world, whether in poetry or in painting, would no longer do. Just as Picasso, escaping the prison of perspective and the traditional canons of "beauty," abandoned the familiar arrangements of images in space, so Eliot abandoned the conventional narrative order of poetic images in time. The Romantics had sought to capture the beauty of the world in their feelings. But Eliot would use all available images and experience, learning and fragments of learning, to make an object of the poet's emotion. Young readers welcomed his expression of the sterile world their elders had made for them.

> We are the hollow men
> We are the stuffed men
> Leaning together
> Headpiece filled with straw. Alas!
> Our dried voices, when
> We whisper together

Are quiet and meaningless
As wind on dry grass
Or rats' feet over broken glass
In our dry cellar. . . .

This is the way the world ends
This is the way the world ends
This is the way the world ends
Not with a bang but a whimper.

"The Waste Landers" would become a cult and *The Waste Land* a sovereign metaphor. The most effective polemic against television was to call it "a vast wasteland." Seldom has a poet so successfully imprisoned his age in a phrase. But Eliot, an expert at self-disparagement, still affirmed the sovereign self in the poet. He said *The Waste Land* was not so much "an important bit of social criticism" as "the relief of a personal and wholly insignificant grouse against life; it is just a piece of rhythmical grumbling."

Eliot was no more predictable as a spokesman for modern anti-Romanticism than Wordsworth had been as a prophet of Romanticism. He was born in 1888 in St. Louis to a scion of an old New England family with a long line of ministers known for their Unitarian conscience. His grandfather, leaving Boston in 1834 to carry the faith to the frontier, had been a founder of Washington University. The university might have been named after him if he had not objected. Thomas Stearns Eliot's father, Henry Ware Eliot, defied family tradition by becoming a businessman. After several unsuccessful ventures he finally went into brick manufacturing, which prospered in burgeoning St. Louis. Proud of his own business success, he admired it in others. Eliot's mother wrote poems and seems to have been a woman of some literary talent, but felt herself a failure because she had never managed to go to college, and had to earn her living as a schoolteacher. For young T. S. Eliot the family tradition prevailed, he was sent to Milton Academy and entered Harvard in 1906. He graduated in three years, but with no show of brilliance.

At Harvard his lifelong attitudes were shaped by the dogmatic and domineering Irving Babbitt (1865–1933), professor of French and comparative literature, the apostle of anti-Romanticism. In *Rousseau and Romanticism* and other books he made Rousseau the anti-Christ and Romanticism the modern heresy that aimed to replace the reason and restraint of the classics and religion by the mush and conceit of self-expression. "Those who call themselves modern have come to adopt a purely exploratory attitude towards life." They had abandoned discipline and made their ideal "the man who has cast off prejudices without acquiring virtues." He liked to quote Byron's "true Rousseauistic logic"—"Man being reasonable must

therefore get drunk. The best of life is but intoxication." To compose a poem like Coleridge's "Kubla Khan" "in an opium dream without any participation of his rational self is a triumph of romantic art."

Eliot stayed on at Harvard to work for an M.A. in philosophy. Then his father staked him to a year in Paris, where he followed Bergson's lectures and improved his French and his knowledge of the Symbolist poets Baudelaire and Mallarmé. Returning to Harvard as a graduate student in philosophy, he studied Sanskrit, and was temporarily tempted by Buddhism. He was attracted by F. H. Bradley's philosophy of the Absolute and chose him as the subject of his Ph.D. thesis. Bradley preached skepticism of the uses of conceptual intelligence in defining reality, and insisted that truth could be reached only through some systematic whole. In Bertrand Russell's seminar on logic, Eliot surprised the professor by his learning, and made an acquaintance that would complicate his later life. Russell characterized Eliot as "altogether impeccable in his tastes but has no vigor or life—or enthusiasm."

A Sheldon traveling fellowship from Harvard sent him to Merton College, Oxford, to pursue his studies of Bradley. In 1914 at the urging of his friend Conrad Aiken, but only after some hesitation, he went to see Ezra Pound and his wife, Dorothy, in London. This was the crucial encounter of his life. Eliot said that Pound reminded him of Irving Babbitt. Pound himself, born in Idaho and raised in Philadelphia, noted Eliot's "Americanness" and said he "has it perhaps worse than I have—poor devil." Their quests had converged, for both were seeking an authentic tradition abroad as an antidote to American philistinism and to the sentimental tradition in English poetry. Eliot all his life was known for his Anglophile obsession with correct dress. But a friend once remarked of him that while his clothes were English, his underclothes were American. Instantly, Pound responded to Eliot's talent and began to promote him. When Eliot showed him "The Love Song of J. Alfred Prufrock" and "Portrait of a Lady," Pound sent them to Harriet Monroe, the Chicago patron and editor of *Poetry* magazine. He declared them "the best poems I have yet seen or had from an American. . . . He has actually trained himself *and* modernized himself *on his own.*" Pound may not have known that Eliot did not admire the poems of Pound that he had seen.

Both Pound and Eliot had arrived in Europe with interrupted academic careers, but their paths had been quite different. Pound's father, Homer, had set up the government land office in Hailey, Idaho, a town with one hotel and forty-seven bars. There Homer's job was to certify the land titles of optimistic mining prospectors and deal with angry competing claimants. Ezra was born in 1885, and when he was four his family moved to Philadel-

phia where his father had obtained a job in the United States Mint. Homer became an elder in the local Presbyterian church, and sent Ezra to a nearby military school. He entered the University of Pennsylvania in 1901, when he was only sixteen, but the family was troubled by his erratic interests and associates (one was a young medical student, William Carlos Williams). After two years they encouraged him to transfer to Hamilton College, in upstate New York, where his studies and his morals might be more closely supervised. Then he returned to the University of Pennsylvania for graduate study. He never completed his Ph.D., but en route he acquired the classical and modern European languages, in addition to Provençal and Anglo-Saxon.

The president of Wabash College in Crawfordsville, Indiana, impressed by Pound's learning and his trips to Europe, appointed him to the faculty. The literary associations of Crawfordsville consisted of the fact that Lew Wallace, author of *Ben Hur,* had lived there. And the Presbyterian elders were not prepared for Pound's freewheeling tastes and shocking ways. He spiked his tea at college gatherings from his flask of rum, and actually smoked cigarettes. "For I am weird untamed," he wrote "that eat of no man's meat." He had been warned that he would have to marry if he was to stay in Crawfordsville. But when he struck up an acquaintance with an English actress who performed as a male impersonator in the local theater, he was suspected of being "bisexual and given to unnatural lusts." He felt "stranded in a most Godforsaken area of the middle west," the sixth level of Dante's hell.

Dismissed in disgrace, he had little chance for another American academic post, and sailed for Europe in 1908. In Venice he published a little volume of his poems at his own expense, then settled in London, where he joined the literary circle of William Butler Yeats. The group was dominated by a philosophical poet and critic, T. E. Hulme (1883–1917), who had much in common with Babbitt. Hulme became a philosopher of the Imagist school of poetry, hated Romantic optimism, and pleaded for a "hard dry" art and poetry. He opposed Bertrand Russell's pacifism, and himself was killed in the War. Pound worked at odd journalistic assignments. As London correspondent for *Poetry,* founded and edited by Harriet Monroe (1860–1936), he sponsored a catholic assortment of the best writers of the age—Robert Frost, D. H. Lawrence, James Joyce, and Ernest Hemingway.

Pound earned his title as "midwife of twentieth-century modernism," for he helped bring to public life the rebels against the Romantics, who by then were the literary establishment. Wordsworth and his generation had expressed Revolutionary individualism, the movements for Independence and the Rights of Man. "Bliss was it in that dawn to be alive, but to be young was very heaven!" Theirs was the joy of the ebullient self, to be expressed in the language of common men. A century later, in the age of Eliot, the

cycles of nineteenth-century revolution had run their course. The latest "revolution," on the eastern borders of Europe, had paradoxically sought salvation not in the individual self but in the mass. In four years of world war, as Ezra Pound observed in 1920:

> There died a myriad,
> And of the best, among them,
> For an old bitch gone in the teeth,
> For a botched civilization. . . .

How should the poet respond?

In that discomfited postwar world it was not so curious that someone as different as Pound should have been Eliot's promoter and mentor. Both were American expatriates seeking the poet's response to what they saw as a confused and dreary world. And Pound's personal response was passionate. He was a political person, which explained his success in promoting the publication of authors he admired. But in politics he was a crank and a utopian, a willing victim of panaceas. In London he had found employment with an iconoclastic socialist magazine, *The New Age*. It was bought by Major Douglas, a self-made economist with a prescription for all social evils. His "social credit" scheme was based on the notion that depressions could be avoided and social justice attained by the manipulation of the monetary system. This became an obsession for Pound, who, loving conspiratorial theories, made it (like almost any other notion that caught his fancy) a basis for his rabid anti-Semitism, which in turn provided the foundation of his theory of history. With the rise of Mussolini in Italy Pound became an enthusiastic Fascist and even came to the United States in 1939 to persuade the country not to go to war. Incidentally, Pound was an energetic and unscrupulous salesman for the vicious hoax "the Protocols of the Elders of Zion," even when he knew it was a forgery. "For God's sake, read the Protocols," he urged listeners in 1942.

In 1924 Pound left London for Paris, where he briefly joined Gertrude Stein's circle. Then on to Rapallo, on the coast near Genoa, where he would live for the next twenty years. When war came, having failed to persuade Americans to support Mussolini by his book *Jefferson and/or Mussolini* (1935) and his trip back to the United States, he became a tireless Fascist propagandist. In hundreds of radio broadcasts he exploded diatribes against Jews, America, and Democracy. Arrested by American forces in 1945, he was confined in the prison for military criminals in Pisa, where he wrote more of his *Cantos,* which had begun in Homeric vein:

> And then went down to the ship,
> Set keel to breakers, forth on the godly sea, and

We set up mast and sail on that swart ship,
Bore sheep aboard her, and our bodies also
Heavy with weeping, and winds from sternward
Bore us out onward with bellying canvas,
Circe's this craft, the trim-coifed goddess
Then sat we amidships, windjamming the tiller,
Thus with stretched sail, we went over sea till day's end.

Returned to the United States to be tried for treason, he was pronounced "insane and mentally unfit for trial." For the next twelve years (1946–58) he was confined in St. Elizabeths Hospital in Washington, D.C., for the criminally insane. There Pound held bizarre court, edited his poetry, wrote letters, received visitors, and became an icon for artistic freedom when, over loud objection, the Bollingen Prize was awarded him by the Library of Congress. In 1958 the charges against him were dropped, and he returned to Rapallo and Venice, where he died in 1972.

The disciple of the wild and belligerently political Pound was the withdrawn and respectable T. S. Eliot. While Pound was the public advocate of panaceas and of hate, Eliot was on a traditional search for personal salvation. Dante was his ideal poet. "The poetry of Dante," Eliot wrote, "is the one universal school of style for the writing of poetry in any language. And the less we know of a poet before we read him, the better. For the poem is a thing in itself, and should be enjoyed even before it is understood." Both Pound and Eliot were refugees from the self, but it was Pound oddly who would help Eliot find his refuge in poetry.

After leaving Merton College in 1915 Eliot discovered, somewhat to his surprise, that he would have to earn his own living. He had met and impulsively married the vivacious but mentally disturbed Vivien Haigh-Wood, of a wealthy and respectable English family, whom he had met at Oxford. Bertrand Russell, who was to have several affairs with her after her marriage, called her "light, a little vulgar, adventurous." Her mental illness, never clearly described, was unknown to Eliot before their marriage. The disorder became so serious after 1933 that she and Eliot lived separately. She entered a mental hospital in 1938, where she died in 1947. When Eliot married her in 1915, he saw more cheerful prospects. He went to America alone in a futile effort to explain his marriage to his family, who thought it only proved that he would never amount to anything. Back in England he taught briefly in a private grammar school. When Vivien would not go to America, he tried to earn a living in London. First he gave a series of university extension lectures on literature, which listeners found so dull that his appointment was not renewed. Then in 1917, with the help of Vivien's family, he secured a post in the Colonial and Foreign Department of Lloyd's

Bank. They were told he knew the European languages, but in fact he knew only French and Dante's Italian. The routine work in a formal environment suited his temperament and he stayed there for the next nine years.

The contrast between the temperaments of Pound and of Eliot was dramatized in Pound's repeated efforts to "liberate" Eliot from his bank-clerical routine. But Eliot repeatedly refused to be liberated. He appears to have found a welcome security in the routine formality of his work, and he began writing poetry again. Now he seemed at ease in the observer's role, which he might have lost if he were out on his own in the competitive world. In 1922 Pound led the movement to raise the Bel Esprit fund to provide a fellowship for Eliot to write his poetry without other employment. But the result of the movement and of Eliot's reticence was embarrassing. The *Liverpool Daily Post* reported that after eight hundred pounds had been raised to free Eliot of his bank employment, he had taken the money with thanks and then said he would stay with the bank anyway. Eliot considered a libel suit against the newspaper, but was satisfied when they published his statement that he had had no intention of leaving the bank and that the fund had been raised without his consent. The episode unnerved him with fears that it might jeopardize his position at the bank, but his fears proved unfounded and he remained until 1925. Then he left for a five-year contract with the London publishing house Faber & Faber.

The poetry that established Eliot was written and published before he gave up his observer's post at the bank. Significantly, his first modernist poem was published in the America whose culture he had fled. "The Love Song of J. Alfred Prufrock" was published, at Pound's urging, in *Poetry* magazine in Chicago in 1915.

> Let us go then, you and I,
> When the evening is spread out against the sky
> Like a patient etherised upon a table;
> Let us go, through certain half-deserted streets,
> The muttering retreats
> Of restless nights in one-night cheap hotels
> And sawdust restaurants with oyster shells. . . .

Then in 1917, only four months after he entered the bank, his first volume of poems, *Prufrock and Other Observations,* appeared under the imprint of Harriet Weaver's *Egoist,* which Pound had made a vehicle for Imagist poets. In this magazine she had just been publishing Joyce's *Portrait of the Artist* in serial form. Pound had confidentially offered to publish this, Eliot's first volume of poems, at his own expense if Harriet Weaver would let him

use her imprint. She agreed, and with the help of money from Dorothy Pound (not known to Eliot) five hundred copies were printed. Five years passed before these were all sold.

Some critics objected that Eliot's work was not really poetry because the author had no notion of "the beautiful." This was not surprising, for Eliot had spent the last five years behind a desk, in an urban routine not much different from Kafka's in Prague about the same time. From this narrow perspective, how could poetic beauty bring order into "the vast panorama of futility which is contemporary history"? The months in 1921 when he was writing his most famous poem were especially dreary. His mother, Charlotte, whom he had not seen for six years, was coming to London. She had not met Vivien, whom the family blamed for Eliot's decision not to return to the United States. And Vivien resented the affluent Charlotte's refusal to support them in a more comfortable life. Now Eliot was painfully reminded of his estrangement from a family that had made much of tradition when, in June, Charlotte arrived with his father, Henry Ware, and sister Marian. England was suffering a disastrous drought. No rain fell for six months. Eliot himself was writing in the *Dial* of the new type of influenza, which left a dryness and a bitter taste in the mouth. It was a season like that which had inspired Rabelais's dipsomania. Vivien was on the verge of a "breakdown." Incidentally American authorities were harassing him to pay his income tax. When the family left in late August, Eliot's doctor explained his feelings of anxiety and dread as a nervous disorder and told him to take a vacation. Lloyd's gave him a leave of absence for his "nervous breakdown."

While shaping *The Waste Land* in May 1921, Eliot was reading the later chapters of Joyce's *Ulysses*. He wrote Joyce of his high admiration but added that he wished he had not read it. Later he applauded Joyce's use of myth to bring order into a chaotic world, and acclaimed *Ulysses* as "the most important expression" of the age. Summing up this age was no easy matter. And when Virginia Woolf had lamented "We're not as good as Keats," Eliot retorted, "Yes we are. . . . We're trying something harder."

With the energetic aid of Pound (to whom *The Waste Land* was dedicated) and guided by the myths that his age had used to transmute religion into anthropology, Eliot set out to express in cryptic verse what Joyce had expressed in the cryptic prose of *Ulysses*. What meaning was there in the desiccation of his age? How to make an international anthem of emptiness? How to make 433 lines of poetry a classic expression of the modern self in quest of salvation?

Eliot's friend and admirer Conrad Aiken said that *The Waste Land* succeeded "by virtue of its incoherence, not of its plan; by virtue of its ambiguities, not of its explanations." Anyone coming to the poem fresh

today must be puzzled that it seemed to its first readers to have such a
focused message.

> 'My nerves are bad to-night. Yes, bad. Stay with me.
> 'Speak to me. Why do you never speak. Speak
> 'What are you thinking of? What thinking? What?
> 'I never know what you are thinking. Think.'
>
> I think we are in rats' alley
> Where the dead men lost their bones.

Its five sections proceed from "The Burial of the Dead," to "A Game of
Chess," "The Fire Sermon," "Death by Water," and "What the Thunder
Said." In what seems a contrived incoherence it begins with a lyrical passage
(parodying Chaucer), "April is the cruellest month." Occasional lyrical
lines recur, interlarded with fragments of conversation and of quotations,
allusions to obscure and well-known ancient classics, Sanskrit scriptures,
ornithological treatises, and Antarctic expeditions. Search for structure
seems futile in a poem that aimed to express incoherence, and which con-
cluded in a phrase from the Upanishad:

> These fragments I have shored against my ruins
> Why then Ile fit you. Hieronymo's mad againe.
> Datta. Dayadhvam. Damyata.
> Shantih shantih shantih

The Waste Land was published in October 1922 in the first issue of the
Criterion, which Eliot was editing. He had failed to secure publication in
the *Dial* when they refused to pay the £856 he demanded, but he allowed
publication in their November 1922 issue with the understanding that he
would receive their annual award of $2,000. An American edition in De-
cember of one thousand copies by Liveright quickly sold out, and the
Woolfs published it at their Hogarth Press the next year. Eliot added his
own notes to the published volumes at first only to avoid charges of plagia-
rism, then he enlarged the notes to seven pages to make the printed work
long enough to be a book.

"Not only the title, but the plan and a good deal of the incidental
symbolism," Eliot explained, were suggested by Jessie Weston's *From Rit-
ual to Romance,* about the legend of the Holy Grail, and also by "another
work of anthropology . . . which has influenced our generation profoundly,"
James G. Frazer's *Golden Bough.* These would supply the Homer for his
verse Ulysses. Eliot himself later ridiculed the notes as a "remarkable
exposition of bogus scholarship." But he did reveal how his work and his

style suited the modern quest, for as he quoted his mentor F. H. Bradley, "the whole world for each is peculiar and private to that soul." Eliot had already named his poetic device for expressing the private self in the images of the world out there. No more sentimental Songs of the Self! None of that Egotistical Sublime. "The only way of expressing emotion in the form of art," he insisted as he explained the success of Shakespeare's tragedies, "is by finding an 'objective correlative'; in other words, a set of objects, a chain of events which shall be the formula of that *particular* emotion; such that when the external facts, which must terminate in sensory experience, are given, the emotion is immediately evoked." His examples were the sensory impressions accompanying Lady Macbeth's sleepwalking or the words of Macbeth on hearing of his wife's death. Eliot's phrase had a vogue that surprised Eliot himself, for it expressed the modern revolt against Romantic sentimentalism.

In revising *The Waste Land* Pound had been his guide. The recent publication of Eliot's manuscript has revealed that Pound cut many passages, especially the parodies of earlier poets, and removed dramatic lines for the sake of poetic conciseness and cadence. The resulting poem, a paean to emptiness, was widely recognized as an expression of the "malaise of our time."

> What are the roots that clutch, what branches grow
> Out of this stony rubbish? Son of man,
> You cannot say, or guess, for you know only
> A heap of broken images, where the sun beats,
> And the dead tree gives no shelter, the cricket no relief,
> And the dry stone no sound of water.

Pound hailed it as justifying the " 'movement' of our modern experiment since 1900." But he was privately envious. "Complimenti, you bitch," he had written Eliot on first reading Eliot's draft, "I am wracked by the seven jealousies." Pound was stirred to resume his own effort at a modernist epic in his *Cantos.*

Still, in later life Eliot felt himself confined and encapsulated by the "rhythmical grumbling" of his *Waste Land.* Unlike Wordsworth, who luxuriated in the vagaries of the self, Eliot became a refugee and, like his idol Dante, a seeker for salvation. In 1927, when he was thirty-nine, he became a British subject and joined the Anglican Church. He abjured Babbitt's effort to find an alternative to religion. "Humanism," Eliot complained, was only "a product—a by-product—of Protestant theology in its last agonies." And Eliot gave up the Religion of Art for the Religion of

Religion, describing himself as "classical in literature, royalist in politics, and Anglo-Catholic in religion." He found solace in the English metaphysical poets Donne and Marvell, who, unlike Milton and other rationalists, had brought thought to the aid of feeling. "A thought to Donne was an experience; it modified his sensibility." The catastrophe from which English literature—poetry and drama—still suffered, according to Eliot, was "the dissociation of sensibility," producing "intellectual poets" like Tennyson and Browning.

While some of Eliot's phrases became bywords, his poetry remained cryptic to the very community whose Waste Land he depicted. He became a high priest but no therapist. Ironically, in his search outside the expressive self, Eliot found refuge in a style and allusions that were arcane and almost secret. Even Virginia Woolf, his friend, patron, and admirer, would find his poetry "obscure." He found his solace and his "objective correlatives" not only in classic figures like Dante and Shakespeare but in a host of lesser figures. Many of these were unknown to the reading public. An unsympathetic critic called *The Waste Land* "a true picture of the junkyard of the intellectual mind." When, after his conversion, Eliot became a more conventional Christian poet, as in *Ash Wednesday* (1930) and in *Four Quartets* (1935–43), his style became less compact and less distinctive.

He showed unsuspected versatility as he turned to poetic drama, expressing his reconciliation with himself and his reach out to the community. And he had some success. *Murder in the Cathedral* (1935) on the martyrdom of Archbishop Thomas à Becket used chorus and a sermon to carry its Christian message. It continued to be performed even by those who did not share his Anglo-Catholicism. *The Family Reunion* (1939) pursued similar Christian themes.

> We can usually avoid accidents,
> We are insured against fire,
> Against larceny and illness,
> Against defective plumbing,
> But not against the act of God. . . .
> And what is being done to us?
> And what are we, and what are we doing?
> To each and all of these questions
> There is no conceivable answer.
> We have suffered far more than a personal loss—
> We have lost our way in the dark.

And he made surprising adaptations of Greek drama in *The Cocktail Party* (1949), after Euripides. His children's verse, *Old Possum's Book of Practical Cats* (1939), was transmuted in 1981 into a popular Broadway musical.

Eliot finally found a new happiness in 1957, when he married Valerie Fletcher, his secretary for the previous eight years. She was now thirty and he was sixty-eight. Friends were shocked at this union by a man who had made a fetish of propriety. Some of his oldest friends were alienated, but, Valerie later explained, "He obviously needed to have a happy marriage. He couldn't die until he had had it."

The alchemy that had brought Pound and Eliot together, and given Pound the power to shape and guide Eliot's talents, somehow had sent them in opposite directions for salvation. Pound never gave up his frantic quest for panaceas and conspiracies, his bumper harvest of hates, nor his belief that private salvation, if there was any, must be in poetry. Eliot settled for the respectable institutions about him. While he shared many of Pound's prejudices, including anti-Semitism, he finally tried to put his poetry in the service of an ecumenical Anglican Christianity. In 1948, while Pound was incarcerated in Washington's St. Elizabeths Hospital for the criminally insane, the painfully sane Eliot was receiving the Nobel Prize for Literature from the king of Sweden and the prized Order of Merit from King George VI at Buckingham Palace.

PART TWELVE

THE WILDERNESS WITHIN

Consider them both, the sea and the land; and do you not find a strange analogy to something in yourself? For as this appalling ocean surrounds the verdant land, so in the soul of man there lies one insular Tahiti, full of peace and joy, but encompassed by all the horrors of the half known life. God keep thee! Push not off from that isle, thou canst never return!

—HERMAN MELVILLE, *MOBY DICK* (1851)

An American at Sea

IN an age of American city-building, when Chicago and Omaha were rising out of the prairies, when the California gold rush suddenly made San Francisco, when Americans moved westward to fill the continent and new states were being created in startling numbers, the great American epic of the self was cast in the tropical oceans halfway around the world. When the other eloquent voices of an American Renaissance—Emerson (1803–1882), Thoreau (1817–1862), and Whitman (1819–1892)—were singing the beauties of American "Nature" and the wonders of "Democratic Vistas," the heroic American literary myth would be a classic tale of revenge, negation, ambiguity, madness, and encounter with evil.

The great heroic metaphor the whale—a monster rich in ancient legend—had a short sensational real life in the American economy. The worldwide hunt began when a Nantucket whaler caught its first sperm whale in 1712, and by 1755 New Bedford, Massachusetts, was the world's greatest whaling port. It was appropriately American, too, that the prosperity of the new whaling adventure was so brief, that it would be the victim of technological change and of the changing styles of women's clothing. During its brief heyday until the 1850s whale oil was prized for soap-making and especially as a lamp's fuel, and whalebone was in demand for corset stays and umbrella ribs. But the discovery of petroleum and the kerosene distilled from it in the 1850s displaced whale oil in American lamps. Then in the 1860s the explosive harpoon head, followed later by the harpoon gun and the electric harpoon, and power-driven catcher boats made the whaleboats' strenuous tussle with thrashing diving whales only a memory.

How Herman Melville (1819–1891) seized this brief window of opportunity as the subject of the Great American Epic, which survives vigorously into the twentieth century, is one of the most surprising tales of the creating imagination. For Melville's life was a tale of frustration and disappointment, and such brief success as he enjoyed was irrelevant to his enduring work. Melville's family (before Herman's generation, Melvill), early Scottish and Dutch settlers of New York, linked him to great events in American history, but his own life was no American success story. One of his grandfathers took part as an "Indian" in the Boston Tea Party in 1772, and another had held Fort Stanwix against the British. His father, Allan Melvill, was a sophisticated importing merchant of dubious business judgment, dealing in fancy French dry goods. He frequently brought back art objects

and fine books and furniture for their comfortable house on lower Broadway. Herman's father found him, at the age of seven, compared with his bright elder brother, "very backward in speech & somewhat slow in comprehension, but . . . of a docile & amiable disposition." His mother, who had social ambitions, never quite satisfied him with her affection, and later in life he seems to have thought that she hated him.

After Allan Melvill went bankrupt in 1830 the family left New York for Albany to be near their Gansevoort relatives. Young Herman and his seven brothers and sisters were catapulted from ease into poverty and the indignity of the decayed aristocrat. When Melville's father died in a delirium in 1832—a troublesome personal legacy for his son—it was rumored that he had gone mad. Because he left heavy debts the numerous family now depended on the charity of Melville's uncle Peter Gansevoort. Years later when Herman Melville visited New York and stopped in at the Gansevoort Hotel en route to his Customs House office on Gansevoort Street, he would reflect on the transience of glory and the "evanescence of—many other things."

At the age of twelve Melville left school, clerked in an Albany bank for two years, then worked in his brother's store selling fur caps. At eighteen he had a three-month tour teaching in a country school outside Pittsfield while he lived with a local family. But he did not like teaching and returned to Albany. In 1837 his brother went bankrupt and the family moved to Lansingsburgh (now Troy). He took a brief course in engineering and surveying one spring at nearby Lansingsburgh Academy, to prepare for a construction job on the Erie Canal. But the panic of 1837 intervened and jobs were scarce. For a while Melville was burdened with the family he could not support. Frustrations piled up. How was he to escape into some fixed way of life? His brother Gansevoort in 1839 found him a summer tour as a cabin boy on the *St. Lawrence,* a merchant ship sailing from New York to Liverpool. Before he left home he had joined a Juvenile Total Abstinence Association and an Anti-Smoking Society, but he soon lost his inhibitions, acquired a taste for wine and tobacco (especially in cigars), which became a "beguiling" solace. His first taste of the sea also gave him a brief and unforgettable glimpse of the poverty and stench of a modern industrial city in Liverpool.

The next five vagrant years, including three at sea, gave him the material for his writing all the rest of his life. Going to sea seemed an obvious course for a young man with no trade or profession and no fortune. His cousin had gone out on a whaler a few years before. For Melville the sea was escape from family responsibilities. In January 1841 he joined the crew of the whaler *Acushnet,* and set off from Buzzard's Bay to the South Pacific. A special appeal of such a voyage, Melville later said, was "the overwhelming idea

of the great whale himself." Whales fired the popular imagination in the 1840s, stimulated by an article in the *Knickerbocker Magazine* (1839) on "an old bull whale of prodigious size and strength" who was "as white as wool." Called Mocha Dick, or the White Whale of the Pacific, it was known to shatter boats in its powerful jaws. When Mocha Dick was finally captured, it was said to have nineteen harpoons in him, with a record of having stoved three whaling ships and fourteen boats, and having killed thirty men.

Melville's record of these adventures and misadventures was almost exclusively in his novels. Unlike his contemporaries Emerson and Thoreau, he kept no journal, and for his novels he relied on "simple recollection." So it is impossible for us to compare his real experiences with those he imagined. During his eighteen months on the *Acushnet* the ship touched at Rio, spent forty days rounding Cape Horn, stopped on the coast of Peru and Ecuador, glimpsed the Galápagos, and sailed on to the Sandwich (Hawaiian) Islands, then a favorite recruiting and outfitting port for the whaling grounds southward around the Society and Marquesas islands, fabled for their volcanic mountains and fertile tropical valleys. At twenty-two Melville had his first intense experience of the rigors and terrors of whaling. Thirteen members of the crew of twenty-three either deserted the ship or left because of disease. One balmy morning in late June 1842, when Melville saw the peaks of the island of Nuka-Hiva behind a delightful bay, he could not resist the opportunity to jump ship and escape its filth and the brutality of his officers, who ruled with "the butt-end of a handspike." Joined by another crew member, he took off into the lush tropical interior.

This casual decision, the turning point of Melville's life, set him on the path to become a high priest of American letters, if only posthumously. It provided the exotic adventure that transformed a young life of frustration and vagrancy into a writer's career. Once on the uncharted island he and his young companion, Toby Greene, hoped to take refuge with the Happar tribe, that was known to be friendly. But, by a lucky misadventure, they took the wrong valley and arrived instead at the land of the feared Typee, a tribe of cannibals. To their relief they were greeted warmly, feasted, and coddled. While Melville's mysteriously infected swollen leg was treated by the medicine man, they were troubled that the Typees would not let them leave. To obtain medicine for Melville's leg, they did allow Toby to go back to the bay, but there he was shanghaied onto another whaler. Now alone, Melville was terrified to discover three human heads and the human remains of a feast. "Long pig"—human flesh—was reputed to be the Typees' great delicacy, and later anthropologists have confirmed their cannibalism.

Meanwhile Melville was enjoying a tropical idyll—as much as was possible in his uncertainty whether he was being fattened for a feast. He was generously fed on local delicacies washed down with coconut milk. He

found the physical beauty of the Typees irresistible, and gossip had it that he fathered a child by one of their charming girls. Between naps and leisurely smokes on tapa mats he passed his days swimming. But he secretly sought ways of escaping the ominous hospitality. A young man from a neighboring tribe who spoke a little English took word to an Australian whaler that was passing by. The captain sent a boat to his rescue, Melville limped hastily on board, and despite desperate efforts of the outraged Typees he joined the *Lucy Ann,* a whaler out of Sydney.

The *Lucy Ann* provided an unromantic adventure under an incompetent captain and a drunken mate, who found no whales, and within a month a mutiny put the whole crew in a jail in Tahiti. But this was only a manner of speaking, for they were left free to become "omoos" (beachcombers) around Papeete. There Melville in the company of the ship's surgeon observed the corrupting effects of European conquest and missionary conversion on Polynesian life. In early November 1842 he signed on with another whaler, the *Charles and Henry* out of Nantucket, and by late spring disembarked at Lahaina on the Hawaiian island of Maui. This was to be his last trip on a whaler. In Honolulu Melville signed a contract to become a clerk and bookkeeper in a store, but he had little enthusiasm for the Hawaiian life.

In August he gladly joined the crew of the frigate *United States* as an enlisted man, and had his first experience of the American navy, until it docked in Boston fourteen months later. The ship retraced Melville's original course from Nantucket—down the coast of Peru, which remained one of his most vivid and forbidding memories ("Corrupt as Lima" was his phrase). His routine duties included washing decks, polishing brass, regular drill, and caring for Gun No. 15. The only adventure was a spirit of rebellion against the senseless draconian discipline. He was outraged at the bloody floggings he was ordered to witness 163 times. But he did make warm friends among the crew, including the "matchless and unmatchable Jack Chase," to whom he would dedicate his last work, *Billy Budd.* After a stormy winter passage around Cape Horn, the *United States* touched at Rio and arrived in Boston Harbor on October 3, 1844. Three years at sea had brought an end to Melville's seafaring experience. So speedily had he equipped himself to be what D. H. Lawrence called "the greatest seer and poet of the sea."

It is easy enough to explain how and why Melville came to have these experiences. But no Melvillian mystery is more tantalizing than how and why he became a writer. Most others in our history of creators had somehow made writing their vocation and from an early age chosen this way of man's "making himself immortal." Boccaccio, Chaucer, Shakespeare, Milton, Balzac, and Dickens all found their calling in the word. But we find

no clues to such an ambition in the little we know of the young Melville. Critics, with some reason, accused Boswell of having written his great book by accident. We might with more reason say that Melville was an "accidental" author, an inspired amateur. Or, less charitably, that he came to writing as an act of desperation—for lack of anything better to do.

His early years gave him his fill of the sea and now he casually turned to the world of words. "Until I was twenty-five," he once wrote to Hawthorne, "I had no development at all. . . . From my twenty-fifth year I date my life." Returning in 1844 to live with his mother in Lansingburgh, he charmed friends and relatives by exotic tales of his life among "the cannibals." When he was pressed to put them in a book, his model, if he had a model, seems to have been the popular recent travel books, like Mungo Park's *Travel in the Interior of Africa* and "my friend Dana's unmatchable *Two Years Before the Mast.*"

When Melville completed his manuscript in the autumn of 1845, he gave it to his brother Gansevoort, who was departing to be secretary to the American legation in London, to submit to the publisher John Murray. After hesitating until he was reassured that the recounted experiences had really happened, Murray published it in two installments in his "Home and Colonial Library" early in 1846. The dispute over its authenticity, which kept interest alive, was calmed by a surprise statement from Toby Greene (then a house painter near Buffalo) confirming the "entire accuracy" of the story. At the urging of Washington Irving, G. P. Putnam bought the American rights and it was published under the coy title *Typee, a Peep at Polynesian Life During Four Months' Residence in a Valley of the Marquesas.* When Putnam's partner, John Wiley, was shocked by what he read, Melville agreed to expurgate thirty pages found "objectionable" for their sexual, political, or antimissionary message. Meanwhile Melville, in the fashion of the time, was planning to plant his own enthusiastic review.

Melville's first literary effort already illustrated his special form of documentary fiction that would flower in *Moby Dick.* His exotic personal experience set him reflecting on the paradoxes of good and evil, of civilization and barbarism. "After passing a few weeks in this valley of the Marquesas, I formed a higher estimate of human nature than I had ever before entertained. But alas! since then I have been one of the crew of a man-of-war, and the pent-up wickedness of five hundred men has nearly overturned all my previous theories." The sensational appeal of *Typee* depended less on its noble sentiments than on a simple adventure story and its vivid and convincing detail in a period hungry for "colonial" travel literature. Would the hero be eaten by cannibals? And all spiced with mildly salacious passages on the unclad Polynesian beauties and the hero's romance with Fayaway, who was "speechless with sorrow" when she saw him escape on the Australian whaler.

For Melville the popular success of *Typee* had the charm both of a win-at-the-first-try and of a *succès de scandal*. Though the book had what some called the "charm of indelicacy," Longfellow had not found it necessary to omit any passages when he read *Typee* to his family before the fire. Melville seized the moment and quickly wrote *Omoo*, a "Narrative of Adventures" in the Society Islands of Tahiti and Eimeo, which appeared in January 1847. Elaborating his experience as an *omoo* wandering from island to island, it lacked the life-and-death suspense of *Typee*, but offered "a *familiar* account of the present condition of the converted Polynesians, as affected by their promiscuous intercourse with foreigners, and the teachings of the missionaries, combined."

When his brother Gansevoort died, Melville was responsible for supporting his mother and four sisters. His instant celebrity at the age of twenty-eight had given him new confidence. Now he asked the eminent Judge Lemuel Shaw, chief justice of Massachusetts, to whom he had dedicated *Typee*, for the hand of his daughter, Elizabeth, and they were married in August 1847. While the marriage of Melville and Elizabeth was troubled, she remained a comfort and a stabilizing fixture in his unhappy life. And the marriage had practical benefits. Shaw advanced the funds for the newly married couple to buy their house in New York. And this provided Melville with a base for his new role as pundit and man of letters in the circle of the Duyckinck brothers who published the *Literary World*, the leading weekly literary review.

Melville had warned John Murray, his English publisher, that his next book would be quite different from *Typee* and *Omoo*. And the sales performance of *Mardi*, too, was a hapless reverse. This book was a flight of fancy, which recycled his Polynesian experience into a sentimental metaphysical romance of the hero, Taji, and the mysterious white beauty, Yillah, whom he rescues from a native priest taking her to be sacrificed. From the transcendental realm of Mardi, where she suddenly disappears, Taji's desperate search takes him across the world to Dominora (Great Britain) and Vivenza (the United States), in quest of perfect wisdom, pursued by "three fixed specters . . . over an endless sea." When *Mardi* was published in 1849, critics found it dull or ridiculous. Melville tried to shrug off these attacks as "matters of course . . . essential to the building of a permanent reputation."

Perhaps the birth of his first child in February 1849 sobered him with the need to write what people would read. During the next five months he doggedly turned out two books based on his youthful trip to Liverpool and his experience as an enlisted man in the United States navy. *Redburn: His First Voyage*, a short novel, followed closely Melville's own impressions to depict the miseries of the Liverpool slums. It fulfilled Melville's promise to his publisher to omit mysticism and metaphysics, was well received, and has

survived also as a boy's book in the genre of *Robinson Crusoe.* The more substantial *White Jacket or The World in a Man-of-War* (1850), Melville explained, aimed "by illustrative scenes" at an accurate account of "the established laws and usages of the Navy." The book remains a reliable, if shocking, source for the history of American seafaring life.

"If you begin the day with a laugh," he opens his chapter on a flogging, "you may nevertheless end it with a sob and a sigh." He reports how four crew members were being punished for nothing more than a seaboard scuffle among themselves.

> The fourth and last was Peter, the mizzen-top lad. . . . As he was being secured to the gratings, and the shudderings and creepings of his dazzlingly white back were revealed, he turned round his head imploringly; but his weeping entries and vows of contrition were of no avail. "I would not forgive God Almighty!" cried the Captain. The fourth boatswain's mate advanced, and at the first blow, the boy shouting "My God! Oh! my God!" writhed and leaped so as to displace the gratings, and scatter the nine tails of the scourge all over his person. At the next blow he howled, leaped, and raged in unendurable torture.
>
> "What are you stopping for, boatswain's mate?" cried the Captain. "Lay on!" and the dozen was applied.
>
> "I don't care what happens to me now!" wept Peter, going among the crew, with blood-shot eyes, as he put on his shirt. "I have been flogged once, and they may do it again if they will. Let them look for me now!"

No less excruciating is Melville's patient description of the unnecessary amputation of a sailor's leg by the vain chief surgeon Cuticle, for the instruction of the junior surgeons on board.

> "The saw!" said Cuticle.
> Instantly it was in his hand.
> Full of the operation, he was about to apply it, when, looking up, and turning to the assistant surgeons, he said, "would any of you young gentlemen like to apply the saw? A splendid subject!"
> Several volunteered; when, selecting one, Cuticle surrendered the instrument to him, saying, "Dont be hurried, now, be steady."
> While the rest of the assistants looked upon their comrade with glances of envy, he went rather timidly to work; and Cuticle, who was earnestly regarding him, suddenly snatched the saw from his hand. "Away, butcher! you disgrace the profession. Look at *me!*"
> For a few moments the thrilling, rasping sound was heard; and then the top-man seemed parted in twain at the hip, as the leg slowly slid into the arms of the pale, gaunt man in the shroud, who, at once made away with it, and tucked it out of sight under one of the guns.

Melville himself considered both *Redburn* and *White Jacket* uninspired and routine. But, now trying to make his living as an author, he went to

London in October 1849 to secure the best terms from some publisher. On publication in 1850 *White Jacket* was well received. And in February 1850 he returned to New York to enjoy the favorable reviews from both sides of the Atlantic.

In his seafaring youth Melville had spent the better part of three years on whaling ships, but whaling itself was the one experience he had not mined for his writing. Yet, he observed in his Preface to *Omoo,* nowhere do sailors more plainly show their "wilder aspects" than on these vessels in the Sperm Whale Fishery—"a business not only peculiarly fitted to attract the most reckless seamen of all nations, but in various ways is calculated to foster in them a spirit of the utmost license." His books had all been more or less autobiographical. And *Mardi,* the one least so, was a blot on his literary reputation. Having once found it necessary to assure his publisher that his book would be quite free from philosophy, at this stage in his career it would have been strange if he had purposely written a metaphysical book.

There are few more satisfactory explanations of how and why Melville, author of South Sea travel romances and accounts of life in the United States Navy, came to write the great American epic of man's struggle against the evil in the universe than D. H. Lawrence's:

> *Moby Dick, or the White Whale.*
> A hunt. The last great hunt.
> For what?
> For Moby Dick, the huge white sperm whale; who is old, hoary, monstrous, and swims alone; who is unspeakably terrible in his wrath, having so often been attacked; and snow white.
> Of course he is a symbol.
> Of what?
> I doubt if even Melville knew exactly. That's the best of it.

The story of whaling, his only untapped resource, was rich in weird and legendary possibilities. On his return from England Melville began writing, and by May 1, 1850, he told his friend Richard Henry Dana that he was halfway through. By the middle of the next year he was calling it *The Whale* (eventually the title of the English edition), and after seventeen months of writing off and on he had finished the book. This seems a short time for a long, intensely researched, and fact-packed work. But it was long enough to admit new influences that shaped *Moby Dick* and put it in a different class from his earlier books. These two influences were Hawthorne and Shakespeare.

In the summer of 1850 Melville with his wife and baby went to stay with

the widow of his uncle Thomas who was then running a summer hotel in their large house in Pittsfield, Massachusetts. Liking the place and its long family associations, he bought a neighboring house with money advanced by Judge Shaw. There he and his numerous family lived for the next thirteen years. They called it Arrow Head after the Indian relics they had found. And they enjoyed the rural social life of picnics, costume parties, and overnight excursions to mountain summits. The Berkshire Hills, at the time a favorite resort of Henry Ward Beecher, Holmes, Lowell, Longfellow, Audubon, and lesser celebrities, pretentiously boasted of being "a jungle of literary lions." Hawthorne had recently moved to Lenox. A romanticized contemporary account of a picnic outing on August 5, 1850, by a writer who knew both Hawthorne and Melville described the sparking of their sudden intimacy. "One day it chanced that when they were out on a picnic excursion, the two were compelled by a thundershower to take shelter in a narrow recess of the rocks of Monument Mountain. Two hours of enforced intercourse settled the matter. They learned so much of each other's character, and found that they held so much of thought, feeling and opinion in common that the most intimate friendship for the future was inevitable." Later Hawthorne, in his *Wonder Book* would recall his meetings with "Herman Melville, shaping out the gigantic conception of his 'White Whale,' while the gigantic shadow of Greylock looms upon him from his study window."

The shadow of Hawthorne himself would loom across Melville as he wrote his book. And a dark shadow it was. When they first met, Melville hardly knew Hawthorne's writings, but he now began to read them. About the time of the famous picnic, Melville wrote a long and extravagantly favorable review of Hawthorne's *Moses from an old Manse* for Duyckinck's *Literary World* (August 17, 24, 1850). He praised Hawthorne as *the* great American author whose works "should be sold by the hundred-thousand, and read by the million; and admired by every one who is capable of Admiration." And he explained. "Now it is that blackness in Hawthorne . . . that so fixes and fascinates me."

> For spite of all the Indian-summer sunlight on the hither side of Hawthorne's soul, the other side—like the dark half of the physical sphere—is shrouded in blackness, ten times black. But this darkness but gives more effect to the evermoving dawn, that forever advances through it, and circumnavigates his world. . . . this great power of blackness in him derives its force from its appeal to that Calvinistic sense of Innate Depravity and Original Sin, from whose visitations, in some shape or other, no deeply thinking mind is always and wholly free.

This blackness, too, showed Hawthorne's kinship with Shakespeare. Melville would "not say that Nathaniel of Salem is a greater than William of Avon, or as great. But the difference between the two is by no means

immeasurable. Not a great deal more, and Nathaniel were verily William." For the profundity of Shakespeare, too, came from this "mystical blackness" seen in "the dark Characters of Hamlet, Timon, Lear, and Iago."

The nation, inspired by Emerson and his disciples, was sailing a continent-sea of optimism. In April 1851 Melville gives us a clue to the grand antithesis he sensed in Hawthorne. "He says NO! in thunder; but the Devil himself cannot make him say *yes.* For all men who say *yes* lie; and all men who say *no,* —why, they are in the happy condition of judicious, unincumbered travellers in Europe; they cross the frontiers into Eternity with nothing but a carpet-bag,—that is to say, the Ego."

Never before had the troubled self found such a grand oceanic scene or more heroic men and beasts for its struggles. Now, since Hawthorne had shown that American writers could be Shakespearean, Melville would make his own try. Before and during the writing of *Moby Dick* he had been "hypnotized" by reading and rereading Shakespeare, especially *Lear* and *Hamlet* and *Timon of Athens.* Melville adored Shakespeare as "the profoundest of thinkers," master of "the great Art of Telling the Truth,—even though it be covertly, and by snatches." What he most revered was not "the great man of tragedy and comedy. . . . But it is those deep far-away things in him; those occasional flashings-forth of the intuitive Truth in him; those short, quick probings at the very axis of reality:—these are the things that make Shakespeare, Shakespeare. . . . Tormented into desperation, Lear the frantic King tears off the mask, and speaks the sane madness of vital truth."

The mark of Shakespeare on *Moby Dick* is plain, not only in borrowed phrases—the "tiger's heart" and countless others—but in stage directions for chapters ("Enter Ahab: then all—Ahab standing by the helm. Starbuck approaching him"), in the soliloquies (Ahab in the manner of Macbeth), and in subtler ways. The Epilogue announces, in Shakespearean style, "The drama's done." Some critics have found a structure like the five acts of an Elizabethan play, though others compare its design with the Books of the *Odyssey* or of *The Lusiads.* And the continual interlacing of the slow oceanic narrative with encyclopedic fragments leaves the reader free to find his own pattern.

Melville had industriously researched his subject. "I have swam through libraries," he recalled, but he also bought books, and finally, in addition to his own experience, he relied on a few of the best-known works in English on whales, whaling, and whaling voyages. He was confident enough of the dramatic appeal of his book to interrupt the story with minitreatises on taxonomic cetology, on the form and dimensions of the whale's head, tail, and skeleton, on its habits, history, legends, and fossils, along with the craft and technology of harpooners, blacksmiths, and carpenters, and facts on instruments of navigation, the quadrant, compass, the long and line.

He appears to have been aware, too, that the developing science of

psychology was providing a new vocabulary for describing the kind of madness he would depict in Ahab. The pioneer British psychiatrist James C. Prichard (1786–1848) in 1833 introduced into English "the term monomania, meaning madness affecting one train of thought . . . adopted in late times instead of melancholia." Chief Justice Shaw, Melville's father-in-law-to-be had handed down an opinion in 1844 defining monomania as cases where "the conduct may be in many respects regular, the mind acute" and at the same time there may be insane delusions. . . . The mind broods over *one idea* and cannot be reasoned out of it." Melville had used "monomania" in *Mardi,* and in *Moby Dick* he would describe Ahab's "final monomania." All of this had helped him set the stage for the manic quest and the climactic encounter with the White Whale.

The book was published in London in October 1851 and the next month in America. Dedicated to Hawthorne "in token of my admiration for his genius," it was neither a commercial nor a critical success. Because he still owed Harper's, his New York publisher, seven hundred dollars of unearned advances on his earlier books in April 1851, they had refused to give him a new advance on this one. He was pinched for money, but managed to borrow two thousand dollars from a friend. "Dollars damn me," he wrote Hawthorne in June, "and the malicious Devil is forever grinning in upon me, holding the door ajar. . . . What I feel most moved to write, that is banned,—it will not pay. Yet, altogether, write the *other* way I cannot. So the product is a final hash, and all my books are botches."

The book that so dissatisfied Melville and did not charm his contemporaries would have an uncanny appeal to generations in the next century. That appeal came not only from his resonant Shakespearean eloquence and the grandeur of the adventure, but also from the book's rough-hewn structure and its challenging ambiguity. Melville sensed this, as he concluded one of his longest—and surely his most "systematic"—chapters on cetology.

> But I now leave my Cetological System standing thus unfinished, even as the great Cathedral of Cologne was left, with the crane still standing upon the top of the uncompleted tower. For small erections may be finished by their first architects; grand ones, true ones, ever leave the copestone to posterity. God keep me from ever completing anything. This book is but a draught—nay, but the draught of a draught. Oh, Time, Strength, Cash, and Patience!

Melville's grand sea metaphor—like the exotic settings of *Hamlet, Macbeth,* and *Lear*—was wonderfully suited to allow each future reader to make his own copestone. Three quarters of a century would pass before the common reader discovered this opportunity. Had the whale not been a whale—so

legendary and biblical a beast for the reading public—it might not have been so easy to invent one's own versions of the book.

Or had Ahab been depicted with more human nuance, in the manner of the realistic novel, Ahab might have been a less apt vehicle for our varied hopes and fears. There was ambiguity, also, in the very name of "Ahab." In history Ahab, the seventh king of Israel (c.875–853 B.C.), married Jezebel and, without abandoning Yahweh himself, allowed her idolatrous religion of the Phoenician Baal to be practiced in Israel and encouraged her idolatrous cult. Then in the contest that Elijah arranged between the prophets of Baal and those of Yahweh (I Kings 18:19–46) Yahweh was established as "God in Israel." And Ahab, a dubious champion in the historic battle between God and the religion of idols, remained a symbol of all our inner uncertainties.

Moby Dick, it has often been observed, is not really a novel, for it lacks the development and conflict of characters. From the opening sentence the focus is on the troubled self:

> Call me Ishmael. Some years ago—never mind how long precisely—having little or no money in my purse, and nothing particular to interest me on shore, I thought I would sail about a little and see the watery part of the world. It is a way I have of driving off the spleen, and regulating the circulation. Whenever I find myself growing grim about the mouth; whenever it is a damp drizzly November in my soul, whenever I find myself involuntarily pausing before coffin warehouses, and bringing up the rear of every funeral I meet; and especially whenever my hypos get such an upper hand of me, that it requires a strong moral principle to prevent me from deliberately stepping into the street, and methodically knocking people's hats off—then I account it high time to get to sea as soon as I can. This is my substitute for pistol and ball. With a philosophical flourish Cato throws himself upon his sword; I quietly take to the ship.

There are no women in the story. Despite its abundance of facts, it is not realistic fiction but a poetic or mythic epic. Though Melville had written documentary polemics on the miseries of seamen and the tyranny of their officers, we do not see this in *Moby Dick,* which tells of not one flogging. Qualities that prevent it from being a modern realistic novel actually suit it to be a versatile epic vehicle for the modern self in quest of itself. The name of Ishmael, which he has taken, recalls the not entirely legitimate son of Abraham by an Egyptian concubine, who would be hailed by Muslims as an ancestor of Mohammed and be buried in the Kaaba in Mecca.

The story has a Homeric simplicity—the relentless monomaniac sea captain seeking revenge against a monster. Captain Ahab, who stalks the deck of the *Pequod* with an ivory leg in place of the one that the White Whale has taken from him, never deviates from his one purpose. We know

almost nothing of him except the one earlier consuming misadventure. The cetology and vivid specifics of whales and whaling in the first three quarters of the 135 short chapters of the long book are interrupted only by occasional encounters with passing vessels, to whom Ahab's one question is "Hast thou seen the White Whale?" Episodes of Ahab's impatience and rage show him shattering the quadrant that has refused to take him to his quarry, destroying his trusty but unproductive compass, and turning to dead reckoning with log and line. But he also rashly loses the rudimentary log and line needed for calculating speed and position. And there are omens: the cabin boy, Pip, who goes mad after an ordeal afloat alone, the mysterious Saint Elmo's light that transforms the three masts into incandescent candles. All leading to three climactic days of encounter and chase of the White Whale.

The few personalities described, apart from Ishmael's self-description, are caricatures: the three mates—prudent and cautious Starbuck, carefree Stubb, obtuse but professional Flask; and the exotic harpooners—Polynesian Queequeg, American Indian Tashtego, and African Daggoo. All play their roles as allegories.

But who really is Ahab? He emerges slowly at the beginning and only occasionally later. Before he appears we are warned of that man who "makes one in a whole nation's census—a mighty pageant creature, formed for noble tragedies. . . . For all men tragically great are made so through a certain morbidness. Be sure of this, O young ambition, all mortal greatness is but disease." To Captain Peleg, who knew him, "He's a grand, ungodly, godlike man." An earlier whaling encounter gave Ahab reason enough for his morbidness:

And then it was, that suddenly sweeping his sickle-shaped lower jaw beneath him, Moby Dick had reaped away Ahab's leg, as a mower a blade of grass in the field. No turbaned Turk, no hired Venetian or Malay, could have smote him with more seeming malice. Small reason was there to doubt, then, that ever since that almost fatal encounter, Ahab had cherished a wild vindictiveness against the whale, all the more felt for that in his frantic morbidness he at last came to identify with him, not only all his bodily woes, but all his intellectual and spiritual exasperations. The White Whale swam before him as the monomaniac incarnation of all those malicious agencies which some deep men feel eating in them, till they are left living on with a heart and half a lung. . . . He piled upon the whale's white hump the sum of all the general rage and hate felt by his whole race from Adam down and then, as if his chest had been a mortar, he burst his hot heart's shell upon it.

While Ahab's need for revenge may have been sound, the act of vengeance was far from godly. As the blacksmith forges the harpoon barbs, tempered in the blood of Tashtego, Queequeg, and Daggoo, the three harpooners,

Ahab deliriously howls, "*Ego non baptizo te in nomine patris, sed in nomine diaboli!*"

Ahab in one of the most familiar passages reminds us that we can each seek in Moby Dick what each of us wants to find.

> "Vengeance on a dumb brute!" cried Starbuck, "that simply smote thee from blindest instinct! Madness! to be enraged with a dumb thing, Captain Ahab, seems blasphemous."
>
> "Hark ye yet again,—the little lower layer. All visible objects, man, are but as pasteboard masks. But in each event—in the living act, the undoubted deed—there, some unknown but still reasoning thing puts forth the mouldings of its features from behind the unreasoning mask. If man will strike, strike through the mask! . . ."

So too each of us is served by the doubloon Ahab has posted as a reward for sighting the White Whale. "And this round gold is but the image of the rounder globe, which, like a magician's glass, to each and every man but mirrors back his own mysterious self."

The central mystery of Ahab's hunt for Moby Dick is the mystery of the self. "Consider them both, the sea and the land; and do you not find a strange analogy to something in yourself? For as this appalling ocean surrounds the verdant land, so in the soul of man there lies one insular Tahiti, full of peace and joy, but encompassed by all the horrors of the half known life. God keep thee! Push not off from that isle, thou canst never return!" Here is no buried treasure, but only grassy glades and "ever vernal landscapes in the soul."

The story ends in an ocean of ambiguities. After three days of encounter and chase, Moby Dick destroys the whaleboats, Ahab is fouled in the line and tied to Moby Dick, who staves and sinks the *Pequod*. Only Ishmael—the self—escapes, supported by the *Pequod*'s life buoy, which had been made from a coffin. By floating to the "vital centre" of the vortex, Ishmael avoids being sucked down with the sinking *Pequod*. "The unharming sharks, they glide by as if with padlocks on their mouths; the savage seahawks sailed with sheathed beaks." He is rescued on the second day by "the devious-cruising Rachel, that in her retracing search for her missing children, only found another orphan."

Melville never recovered from the effort of writing *Moby Dick*, which he said had been "broiled in hell-fire." From Hawthorne he received a letter of appreciation, to which he responded that "A sense of unspeakable security is on me this moment, on account of your having understood the book." His reference to "security" was ominous.

He continued to write, but what he wrote might not have survived had they not been written by the author of *Moby Dick*. And his next book, a token of uncertainty, was titled *Pierre; or, the Ambiguities* (1852). This is a semimystical, semiautobiographical tale of a wealthy young man who pretends to marry his illegitimate half-sister, writes an unpublishable book, kills his own cousin, and then commits suicide with his true love. To add to Melville's discouragement, a fire at Harper's consumed the stock of his books. No longer the celebrity who had lived among the cannibals, he was now a forgotten—or ridiculed—writer in search of a way to support his family.

In vain he sought a government post, preferably a consulship, with the aid of Judge Shaw and Hawthorne, who was a friend of President Franklin Pierce. Melville managed somehow by the generosity of friends and relatives to meet the pressing financial needs of his family. But he would never again have the satisfaction of earning his own living as a writer. Within five years he would give up his effort to write for the book-buying public. Meanwhile he wrote *Israel Potter* (1855), based on an anonymous book published thirty years before retailing the adventures of a New England boy who joins the Revolutionary army, is captured by the British, takes part in naval intrigues and battles, meets the Revolutionary celebrities, returns home, fails to secure a pension and dies in poverty. Melville turned to writing short stories, brought together in *The Piazza Tales* (1856), including the remarkable and still readable "Bartleby the Scrivener." Then, *The Confidence Man: His Masquerade* (1857), his last novel published in his lifetime, tells a puzzling unfinished satirical tale of a trickster who boards a Mississippi steamboat in the guise of a deaf mute, and in a series of roles, tests the goodwill and trustfulness of his fellow passengers.

Seeing him on the verge of a "breakdown," Melville's family sent him on a trip to Europe and the Near East, paid for by Judge Shaw, hoping to relieve his tensions. The limited psychiatric vocabulary of the period could not provide a name for his disability, nor any remedy. He stopped in Liverpool to see Hawthorne, who noted Melville's need "to take an airing through the world, after so many years of toilsome pen-labour, following upon so wild and adventurous a youth as his was. . . . Melville, as he always does, began to reason of Providence and futurity, and of everything else that lies beyond human ken."

He informed me that he had "pretty much made up his mind to be annihilated"; but still he does not seem to rest in that anticipation, and I think will never rest until he gets hold of some definite belief. It is strange how he persists . . . in wandering to and fro over these deserts, as dismal and monotonous as the sandhills amidst which we were sitting. He can neither believe, nor be comfortable

in his unbelief; and he is too honest and courageous not to try to do one or the other.

Melville said the spirit of adventure had gone out of him. But he showed uncertainty even about this by leaving his trunk behind at the Hawthornes' and taking only a carpetbag, recalling his old South Sea days when he carried nothing more than a shirt and duck trousers.

This was their last intimate meeting, and a reminder that still another hope, his wish for a lifelong solacing friendship with his ideal spiritual companion, would not be realized. This trip to the Holy Land via Italy and Egypt did not produce solace or any new certainties. When Melville returned home he was still "a pondering man." For three seasons he tried lecturing—on "Statues in Rome," "The South Seas," and "Traveling"—which brought neither money nor applause. Then an inheritance on Judge Shaw's death provided the funds to move the family back to New York. Finally, he turned to poetry, and published *Battle-Pieces* (1866), on Civil War themes, which made little impression. His irrational behavior to his family, on whom he vented his frustrations, led his wife, recalling Allan Melville's last days, to fear that Herman, too, had gone mad.

In 1866 he finally received a government post—not the remote romantic consulship in Hawaii but the prosaic job of deputy inspector of customs, around the corner from his house in New York City. His eldest son, Malcolm, committed suicide at the age of eighteen in 1867. In hours stolen from his routine Melville wrote a monumental epic poem of eighteen thousand lines (two volumes, published in 1876 with a bequest from his uncle). This was a tale of an American theology student, Clarel, who goes to Jerusalem in search of faith, there encounters the lengthy confessions and doubts of a Roman Catholic, an Anglican, and a Jew, and finally suffers the tragic death of his beloved. New legacies made it possible for Melville to retire from the Custom House in 1886. He wrote more poems and left unfinished a short cryptic novel, *Billy Budd, Sailor,* which ends in the unjust hanging of the sailor hero, for his rebellious murder of an evil petty officer. This has provided critics with the Christological symbolism for endless speculation on Melville's faith. It was not published till 1924.

When Melville died in 1891, there were no praising obituaries, for he had been forgotten. Only a few years before, an English writer seeking him in New York, was puzzled that "No one seemed to know anything of the one great imaginative writer fit to stand shoulder to shoulder with Whitman on that continent." But long before, Melville had taken the precaution of justifying his obscurity. Since "all Fame is patronage," he had written, "let me be infamous." He continued to find reasons to discount the reward that had eluded him. "The further our civilization advances upon its present

lines, so much the cheaper sort of thing does 'fame' become, especially of the literary sort." While Melville could disparage fame, he could not prevent it. The unaccountable resurrection of Melville began with the centennial of his birth in 1919, which brought articles and numerous editions of all his works. The first full-length biography, by Raymond A. Weaver, appeared in 1921. But the materials were meager, because Melville had burned his letters from Hawthorne, and his family had expurgated their papers for the period of his deepest depression.

Into *Moby Dick* twentieth-century American readers would pour their own frustrations and ambiguities, making it one of the most popular vehicles for the modern self. To acknowledge Hawthorne's praise of *Moby Dick,* Melville had written, "I feel that the Godhead is broken up like the bread at the Supper, and that we are the pieces." In Melville's ship of ambiguities each twentieth-century reader would seek that piece of the self.

But, as Melville in a rare moment of humor warned Hawthorne, readers must not expect too much help from him.

In reading some of Goethe's sayings, so worshipped by his votaries, I came across this, *"Live in the all."* That is to say, your separate identity is but a wretched one,—good; but get out of yourself, spread and expand yourself, and bring to yourself the tinglings of life that are felt in the flowers and the woods, that are felt in the planets Saturn and Venus, and the Fixed Stars. What nonsense! Here is a fellow with a raging toothache. "My dear boy," Goethe says to him, "you are sorely afflicted with that tooth; but you must *live in the all,* and then you will be happy!" As with all great genius, there is an immense deal of flummery in Goethe, and in proportion to my own contact with him, a monstrous deal of it in me.

65

Sagas of the Russian Soul

"I plunge into the depths," Fyodor Dostoyevsky (1821–1881) wrote at the age of twenty-five when his first work had brought high praise from the leading Russian literary critic. "And, while analysing every atom, I search out the whole; Gogol takes a direct path and hence is not so profound as I. Read and see for yourself. Brother, I have a most brilliant future before me!" His

reception into the world of letters had the explosive drama of a scene in one of his novels. The friends to whom he showed the manuscript had burst into his room at four o'clock one morning to shout his praise. They gave the manuscript of his short novel, *Poor Folk,* to Vissarion Belinsky (1811–1848), the patron of the radical intelligentsia and the literary arbiter of the day, who quickly summoned the astonished Dostoyevsky to christen him the new Gogol. "That is truth in art!" exclaimed Belinsky, "That is the artist's service to truth! The truth has been revealed and announced to you as an artist, it has been brought as a gift; value this gift and remain faithful to it, and you will be a great writer!"

Poor Folk (1846), not much read now, tells the frustrations of a lonely clerk who hopelessly schemes for respectability but whose life is warmed only by love for an orphan girl. It is called the first Russian social novel because its hero is poor and oppressed. Such subjects were a by-product of the age of revolutions that Wordsworth and Coleridge expressed in their *Lyrical Ballads.* By the 1840s the Romantic celebration of the self was giving way to realism, dramatizing the lives of the common people and the dispossessed. That revolutionary spirit was reaching eastward in 1848, when Marx and Engels's *Communist Manifesto* exhorted the workers of the world to unite.

European writers of the next century would move in two contrary directions. Like Balzac and Dickens, some would reach outward, becoming more public and more social in their subjects and their heroes, re-creating the world. Others, like Kafka, Proust, Joyce, and Virginia Woolf, would reach inward to create the intimate self, its memories, fantasies, hopes, fears, and myths. The literature of the outward reach was immediately popular; the literature of the inward reach was arcane, first touching only the literate, and only gradually attracting a wider public.

One of the surprises in this history is that Dostoyevsky, whose novels laid siege to the values of the West, should become an idol of Western literature. For Stefan Zweig he was, with Balzac and Dickens, one of "the supremely great novelists of the 19th century . . . an epic master . . . endowed with encyclopedic genius . . . a universal artist, who constructs a cosmos, peopling it with types of his own making, giving it laws of gravitation that apply to it alone, and a starry firmament adorned with planets and constellations." Perhaps an explanation of Dostoyevsky's grandeur for Western readers is that he, like no other novelist before him, embodied the two contrary directions. No other writer had more amply encompassed all the lowest and most unfortunate—criminals, cripples, the sick, and the insane. Nor had any other more relentlessly reached inward to the self. He also translated great moral issues into detective stories with lurid climaxes to engage the unphilosophic reader.

Biography had recently created citadels of uniqueness. When the biographer "plunged" he found a peculiarly troubled, frustrated, or ambitious person. What Dostoyevsky saw was a responsible soul, free to choose and take the consequences. Unlike his progressive Western contemporaries, he did not see men as rational beings pursuing social and material ends but as the work of a Creator. "And the Lord God formed man of the dust of the ground, and breathed into his nostrils the breath of life; and man became a living soul" (Genesis 2:7). To this soul Dostoyevsky gave a role in a world of good and evil, dazzled by a bewildering panorama of choices, of crimes and acts of mercy. And he cast his modern dramas of freedom in the ancient vocabulary of Western religion.

In his appreciation of Dostoyevsky as "one of the supreme novelists of the world" Somerset Maugham says he was "vain, envious, quarrelsome, suspicious, cringing, selfish, boastful, unreliable, inconsiderate, narrow and intolerant. In short, he had an odious character." By what alchemy did this odious character create novels revealing the grandeur, the struggles and tenderness of the Russian soul?

While Turgenev and Tolstoy were born into the educated landed classes, Fyodor Dostoyevsky was born to a poor and pious retired army surgeon working in a Moscow hospital. As a boy he played in the cheerless garden among patients in hospital garb, whom his father had forbidden him to address. These sick made indelible impressions on him. A girl of nine years, one of Fyodor's closest friends, was found raped in the hospital yard, and she died shortly afterward, providing an episode that would recur in his novels. But there were other memories, too, of evenings the family spent reading aloud from patriotic Russian literature and Pushkin, from Gothic novels, from Homer, Cervantes, and Scott. And he remembered "the profound effect on my spiritual development" of the rare occasion when his father took the family to see a performance of Schiller's play *The Robbers.*

Despite his claims to the contrary Dostoyevsky was no proletarian. His family held minor noble rank, which had been lost when an ancestor refused to convert to Catholicism, and then regained in 1828. This entitled Dr. Dostoyevsky to own property with serfs, and in 1831, when Fyodor was only ten, his father bought a tiny village outside of Moscow. "You must know," Dostoyevsky explained nostalgically in the voice of the saintly Alyosha near the end of *The Brothers Karamazov,* "that there is nothing higher and stronger and more wholesome and good for life in the future than some good memory, especially a memory of childhood, of home . . . some good sacred memory, preserved from childhood, is perhaps the best education."

After schooling in Moscow he was sent to a military engineering school in St. Petersburg. There he found respite from drill, from the hazing, and from studying the science of fortifications, by sitting up nights reading his

beloved Homer, Shakespeare, and Goethe. Besides Pushkin, Gogol, and the other Russian writers, he also took refuge in Gothic novels, in Rousseau, Byron, and Schiller, and popular novelists like Scott, Balzac, Victor Hugo, and Eugène Sue. He translated Balzac's *Eugénie Grandet,* and then announced his intention to write a novel of similar length himself. When Dostoyevsky completed the engineering course in 1843 he had decided to be a writer, and resigned his commission. The *Poor Folk* that had brought him sudden acclaim was his first product. But the novel that followed, *The Double* (1846), on the split-personality theme he would explore again and again, was not well received.

Meanwhile the Belinsky clique drew Dostoyevsky into a circle of reformers attracted by Western models, and they secretly conspired against czarist autocracy. It was an era, as the acute French traveler the Marquis de Custine observed, when "At Petersburg, to lie is still to perform the part of a good citizen; to speak the truth, even in apparently unimportant matters, is to conspire. You would lose the favor of the emperor, if you were to observe that he had a cold in his head." With youthful enthusiasm and without reckoning the consequences, in 1847 Dostoyevsky joined the liberal Petrashevsky Circle, named after the host at whose house they met every Friday evening to discuss literature and social problems. They debated Western social theorists like Proudhon and Fourier, seeking to apply their theories to Russia. Seven of the group, including Dostoyevsky, formed an activist inner circle who planned to secure a lithograph outfit for printing their projects of reform. In Russia at the time illegal printing was a form of treason.

Mikhail Petrashevsky, the mysterious strong leader of the group, was a wealthy landowner, an atheist and a communist, who charmed Dostoyevsky and later became the God-tormented hero (Stavrogin) of *The Possessed.* He viewed Christ as simply an unsuccessful demagogue, and others had their own brands of atheism. Although Dostoyevsky seems to have entered the circle casually, he took its work seriously. "Socialists sprang from the Petrashevskys," he later explained. "The Petrashevskys sowed many seeds. Among them was everything that existed in succeeding conspiracies . . . a secret press and a lithography, although of course they were not employed."

On the morning of April 23, 1849, Dostoyevsky was awakened by police and taken to the prison at the Peter-Paul fortress. Before the lengthy commission of inquiry Dostoyevsky claimed that his subversive remarks had been unintentional and pleaded loyalty to czar and Church. The commission then condemned fifteen of the Circle, including Dostoyevsky, to be shot. The often-told story of the December morning when the condemned were

taken to be executed on the platform in Semenov Square was another melodrama worthy of a Dostoyevsky novel. Nicholas I himself had designed the sadistic details—the height of the platform of execution, the script for the clerk who preached the words of Saint Paul, "The wages of sin is death," to each prisoner, and the final appearance of a priest to allow each condemned man to kiss the cross. A sword was broken over the heads of those of nobility, including Dostoyevsky. Then all were clothed in white burial shrouds and tied to posts where they would be shot.

As the order "Ready, aim!" was heard, drums rumbled, and the rifles were tilted upward as a courier hastened in flourishing a paper with the czar's reprieve. The sentences were commuted to hard labor in Siberia. One of the condemned fell to his knees crying "The Good Czar! Long live our Czar!" Each was given a convict's cap, a sheepskin coat, and felt boots for Siberia. Dostoyevsky kept his shroud for a souvenir. Back in his cell, after his initial stupor, he wrote to his brother. "Never has there seethed in me such an abundant and healthy kind of spiritual life as now. Whether it will sustain the body I do not know. . . . Now my life will change, I shall be born again in a new form. Brother! I swear to you that I shall not lose hope and shall keep pure my mind and heart. I shall be born again for the best. That is all my hope, all my comfort."

The next four years laboring in chains in Siberia alongside lowborn thieves and murderers gave him ample opportunity for the suffering that he came to think he deserved. The hard labor seemed better than sedentary Petersburg for his general health, but he was periodically plagued by epileptic seizures. Here too he was an outsider, in a new role. The czar had ordered that despite Dostoyevsky's descent from nobility, he was not to be treated differently, but the other prisoners would not have it so. As he later reported in "Grievances," in *The House of the Dead,* they resented him as a gentleman and did not admit him to their camaraderie. His wondrous powers of imagination and survival helped him see the lice, cockroaches, chains, and labor—and even ostracism by his fellow convicts—as only proper punishment for his sin of defying the czar and the will of Holy Russia.

After these four years in Siberian prisons Dostoyevsky seemed somehow less melancholic and more affirmative in his view of life. The New Testament, the only reading permitted him in prison, had helped him to be reborn once again in a faith that dominated his later writing. "I have composed within myself a confession of faith," he explained, "in which everything is clear and holy for me. This confession is very simple . . . to believe that there is nothing more beautiful, more profound, more sympathetic, more reasonable, more manly, and more perfect than Christ. . . . Furthermore, if anyone proved to me that Christ was outside the truth, and it really was a fact that the truth was outside of Christ, I would rather remain with Christ than with

the truth." He believed, as he had one of his characters observe, that "it is impossible for a convict to be without God." What made prison life bearable was his faith that man was destined to imitate the suffering Christ.

Dostoyevsky's novels, then, can be understood as a species of prison literature, to "justify the ways of God to men" (*Paradise Lost*, I, 1.26). Exercises in narrative "theodicy," they explained God's goodness and the need for the existence of evil. He defends God not by abstract theology but in human life. As his Russian philosophical disciple Nikolai Berdyayev (1874–1948) observed, "The existence of evil is a proof of God's existence. If the world consisted solely and exclusively of goodness and justice, God would not be necessary, for then the world itself would be God. God exists because evil exists. And this means that God exists because freedom exists." Which helps us understand why Dostoyevsky's novels focus on the story of a crime as he creates the theological detective story. His question is not who "committed" the crime, but who is guilty of it. And there are countless forms of guilt. The guilt of Dmitri Karamazov, who imagined and wished the patricide, of Smerdyakov, who performed the deed, and of the sinful old Karamazov himself.

Other novels in Western literature, as André Gide observed, had been concerned "solely with relations between man and man, passion and intellect, with family, social, and class relations, but never, with the relations between the individual and his self or his God, which are to Dostoyevsky all important." And every crime was a witness to freedom, the need of the soul to make a choice. "Consequently," as Berdyayev noted, "he exhorts man to take suffering upon himself as an inevitable consequence of freedom."

For Dostoyevsky, Western science and its materialism and mathematics were the denial of freedom. "What sort of free will is left when we come to tabulation and arithmetic," complains the hero of *Notes from the Underground* (1864), "when it will all be a case of twice two makes four? Twice two makes four without my will. As if free will meant that!" "I admit that twice two makes four is an excellent thing, but if we are to give everything its due, twice two makes five is sometimes a very charming thing too." That mathematical way of looking at the world makes man no more than an "organ-stop," or a "piano-key"! Fifteen years later, in *The Brothers Karamazov*, Father Zosima still warns us.

> The world has proclaimed the reign of freedom, especially of late, but what do we see in this freedom? Nothing but slavery and self-destruction! For the world says: "You have the same rights as the rich and powerful. Don't be afraid of satisfying them and even multiply your desires." That is the modern doctrine of the world. In that they see Freedom.
>
> (Translated by Constance Garnett)

These years in Siberia were Dostoyevsky's apprenticeship in the suffering that was his imitation of Christ. After the hard labor in prison, in 1854 he began serving an additional penal term as a common soldier in Semipalatinsk. There he performed his duties scrupulously, became a junior officer, and read books sent him by his brother. But where the suffering was less acute life seemed less interesting. Still he did manage to make an unfortunate marriage to a young widow who was ill with consumption and had a son. With the stigma of the ex-convict he needed official permission to do anything but breathe and serve in the army. Finally in 1859, six years of maneuvering by friends secured his release from the army and permission to return to St. Petersburg. There he refused to allow himself to be lionized as a liberal martyr. Instead he became a sycophant of Church and czar, partly from conviction, partly to secure official permission to pursue his vocation as a writer. His efforts included a patriotic poem on the birthday of the dowager empress, another on the death of Nicholas I, and public adoration of the new young czar Alexander II, to whom he pledged his life. He edited a magazine called *Vremya* (Time), which (despite his prison experience) proclaimed the uniqueness of Russia as a country without class distinctions that needed autocracy to express a monolithic people, destined to lead the world in "panhumanism."

Dostoyevsky briefly recaptured the early celebrity of *Poor Folk* with novelized memoirs of his prison years. *The House of the Dead* (1861–62) was published serially in his magazine as the writing of a man condemned for murdering his wife. He followed it with *The Insulted and the Injured,* also published serially, one of his first accounts of a woman suffering for her unconventional love. But he already envisioned a great epic. "The basic idea of the art of the nineteenth century," he wrote, "is the rehabilitation of the oppressed social pariah, and perhaps toward the end of the century this idea will be embodied in some great work as expressive of our age as the *Divine Comedy* was of the Middle Ages."

When *Vremya* was banned by the censor for an unpatriotic article, in 1862 Dostoyevsky borrowed enough money for his first trip abroad. There he rendezvoused with a woman contributor to his magazine, sought treatment for his epilepsy, and tried his fortune at the Wiesbaden gambling tables. On his return he started another magazine in which he published serially his *Notes from the Underground* (1864), a kind of prologue to his great novels. Originally entitled "A Confession," it recounts the humiliation and suffering of a forty-year-old "undergroundling" who aims not to be good or great or rich, nor to be rational, but only to affirm his independence as a human soul. It opens:

I am a sick man. . . . I am a spiteful man. I am an unattractive man. I believe my liver is diseased. However, I know nothing at all about my disease, and do

not know for certain what ails me. I don't consult a doctor for it, and never have, though I have a respect for medicine and doctors. Besides, I am extremely superstitious, sufficiently so to respect medicine anyway (I am well-educated enough not to be superstitious, but I am superstitious). No, I refuse to consult a doctor from spite. That you probably will not understand. Well, I understand it, though.

<div align="right">(Translated by Constance Garnett)</div>

In these *Notes* he includes symbolically his dominant ideas. London's Crystal Palace, the triumph of Western materialism (it burned down in 1936), suggests halcyon days that will never be. The undergroundling encounters a prostitute who tries to give him wholehearted love, which somehow he cannot accept. Instead he asserts himself and humiliates her by trying to pay for her affection.

Notes from the Underground in 1864 opened the creative years of Dostoyevsky's four great novels, along with new chapters of sufferings. From the gaming tables of Bad Hamburg where his gambling obsession kept him in futile pursuit of fortune, he was recalled to the deathbed of the wife to whom he had been unhappily married since his military service in Siberia. On the day after her death he reflected:

> April 16. [1864] Masha is lying before me on the table. Will I ever see Masha again?
>
> To love another as oneself according to Christ's commandment is impossible. Man is bound on earth by the law of personality. The Ego holds him back. Only Christ was able to do this, but Christ is a perpetual and eternal ideal towards which man strives and according to the law of nature must strive against. . . .
>
> And therefore on earth man strives towards an ideal that is opposed to his nature. When man sees that he has not lived up to the commandment to strive for the ideal, that he has not sacrificed his Ego to other people or to another person (Marsha and I), he suffers and calls this state sin. Man must suffer unceasingly, but this suffering is compensated for by the heavenly joy of striving to fulfill the commandment through sacrifice. This is the "earthly equilibrium"; without it, life would be meaningless.
>
> <div align="right">(Translated by Siri Hustvedt and David McDuff)</div>

That year too his beloved brother Mikhail died.

To ward off debtor's prison, he tried to sell his idea for a novel to be called *The Drunkard,* but publishers were not interested. Instead he sold the rights to a new three-volume edition of his work to an unscrupulous speculator, Fyodor Stellovsky. To this agreement was added the outrageous condition that if Dostoyevsky did not submit a new novel by November 1 of the following year, Stellovsky would acquire the rights to publish all his work for the next nine years free of charge. In late July 1865 Dostoyevsky left to

try his luck at the roulette tables. "But in the course of five days in Wiesbaden," he wrote to Turgenev, "I have lost everything. I am completely broke—I even gambled away my watch, and I owe money at the hotel." When a small loan from Turgenev was not enough to pay his way home, the city's Russian priest advanced him enough to escape debtor's prison in Wiesbaden and travel back to St. Petersburg in October 1865.

The plan for *The Drunkard* was developing into the story for *Crime and Punishment,* but that writing would take time. Meanwhile the deadline for his bondage to Stellovsky was approaching. To meet it he decided to write a shorter piece, originally titled "Roulettenburg," which became *The Gambler.* And to speed it along, fortunately he engaged a twenty-year-old stenographer recommended by a friend to take his dictation. This Anna Snitkina had wept over his *House of the Dead.* As a schoolgirl she had been so devoted to his books that she became known as Netochka, after one of his heroines. Although Dostoyevsky was irritable and difficult, she was submissive, and wonderfully efficient. With her help he managed to complete the whole novel in sixteen days. Meanwhile the unscrupulous Stellovsky had left town to prevent the manuscript from being delivered on time and so trap Dostoyevsky into bondage. Still Dostoyevsky managed to secure a receipt from a district police officer for its delivery on October 31.

Only a week later, when the devoted Anna came to take dictation for the conclusion of *Crime and Punishment,* he was uncharacteristically cheerful. He surprised and delighted her when he proposed marriage by recounting his dream of finding a tiny sparkling diamond. He told the plot of a new novel in which a poor sick artist falls in love with a much younger girl who happened to have the name of Anya. The celebration of their marriage brought on a double attack of epilepsy, which made her fear "that my beloved husband was in the process of going insane." But by accepting this novelized proposal Anna began fourteen years of a happy stenographic marriage. Her shorthand would record his life's work. Despite the twenty-five years' difference in their ages, they found a way, based on her patience with his epilepsy, her tolerance of his gambling obsession, her adoration and submission, to what she called "my life's sun."

Crime and Punishment, which drew on his prison experience to create the story of a struggling soul, was the result of endless labor and revision. Dostoyevsky had first cast it as a confession, then as a diary, before its final form, which appeared serially for a year beginning in January 1866. Fortunately, since the magazine never came out on time, he could come up with the next installment at the last minute. The hero, Raskolnikov, a nihilist governed by "reason," makes his own definition of good and evil and commits murder to serve a "better" end. Dostoyevsky summarized in his

notebooks the "Idea of the Novel": "There is no happiness in comfort; happiness is brought by suffering. Man is not born for happiness." Finally Raskolnikov too discovers that the soul is satisfied only by confession and accepting punishment. The public reception of the book was sensational, but somehow did not relieve Dostoyevsky's personal agonies. The seven thousand rubles from it soon disappeared into the pockets of unsatisfied creditors.

Fleeing abroad with the money secured by Anna's sale of her dowry of furniture, piano, and silver, they departed in April 1867. The next four years brought excruciating poverty, frequent removals to avoid debtor's prison, and humiliating pleas to friends and relatives for loans to keep them alive. Dostoyevsky's epileptic seizures came as regularly as his disastrous plunges at the gaming tables, which unaccountably ceased in 1870. Nowhere did Dostoyevsky find ease or peace of mind—not in Berlin or Dresden, or Baden-Baden, nor in Geneva, Vevey, Milan, or Florence, or other way stations back to St. Petersburg in July 1871. He could hardly have survived without the bottomless sympathy, warmth, and encouragement of his "little diamond."

Despite or perhaps because of all this, in transit he wrote doggedly. To keep up with life at home he devoured the Russian newspapers, selecting sensational items as subjects for his own writing. Trial by jury, newly introduced in Russia, made the details of criminal cases more public. Dostoyevsky's interest was captured by the story of a family in the provinces who treated their daughter Olga so cruelly that she tried to burn down their house, and finally was driven out of her mind. This became the nucleus of *The Idiot* (1868–69) and Olga was the model for the heroine Mignon. The story slowly developed around "my old favourite idea, but so difficult that for a long time I did not dare to cope with it."

The chief idea of the novel is to portray the positively good man. There is nothing in the world more difficult to do, and especially now. All writers, and not only ours, but even all Europeans who have tried to portray the *positively* good man have always failed. . . . There is only one positively good man in the world— Christ. . . . I recall that of the good figures in Christian literature, the most perfect is Don Quixote. But he is good only because at the same time he is ridiculous. Dickens' Pickwick (an infinitely weaker conception than Don Quixote, but nevertheless immense) is also ridiculous and succeeds by virtue of this fact. One feels compassion for the ridiculous man who does not know his own worth as a good man, and consequently sympathy is invoked in the reader. This awakening of compassion is the secret of humour. . . . In my novel there is nothing of this sort, positively nothing, and hence I am terribly afraid that I shall be entirely unsuccessful.

(Translated by Ernest J. Simmons)

His hero, Prince Myshkin, unlike Don Quixote, is not a crusader but a gentle Russian Orthodox believer, set against his sensual antagonist Rogozhin.

While writing this novel he was awaiting the birth of his first child, a girl who arrived to his exuberant delight in March 1868. And when the baby died three months later, Dostoyevsky was plunged into the deepest despond of his whole unhappy life. He kept his sanity by working at *The Idiot,* which he completed the next January. It was hardly a subject of good cheer, for the heroine is murdered, the anti-hero becomes a murderer and goes mad, and the hero relapses into idiocy. Even before *The Idiot* was delivered, Dostoyevsky was deep in debt to his publisher Katkov for another novel still unwritten. And *The Idiot* was not a publishing success.

More than ever Dostoyevsky now envied the prosperity of his popular contemporaries Turgenev, Goncharov, and Tolstoy. He continually begged friends and relatives for money, repeating his plea that "it is only once in a lifetime that money can possibly be so cruelly needed." Still he kept insisting that he was the most unmercenary of men. "I have never invented a theme for money's sake, to meet the obligation of writing up to a previously agreed time-limit. I always made an agreement . . . and sold myself into bondage beforehand . . . only when I already had my theme in mind prepared for writing, and when it was one that I felt it necessary to develop." At the outset of his career he had promised himself, "Even if driven to the extreme limit of privation, I shall stand firm and never compose to order. Constraint is pernicious and soul-destroying. I want each of my works to be good in itself."

While reading Russian newspapers in the Dresden library in late 1869 Dostoyevsky noted the story of a young man found drowned on the grounds of the Moscow Agricultural Academy with stones tied to his head and feet. The trial revealed that he was the victim of fellow members of a secret revolutionary society, which aimed at a popular uprising and the public execution of the czar. With slogans hardly distinguishable from those of the revolutionists of 1917 they sought the emancipation of mankind. Dostoyevsky seized this story as the framework for *The Possessed,* which would dramatize the evils of Western nihilism and materialism. He returned to St. Petersburg in July 1871 with Anna and his daughter, born in Dresden. The first published installments of *The Possessed* attracted great interest and established him as the darling of the reactionary government.

Dostoyevsky saw the book as "almost a historical study" of the consequences of the separation of Russian intellectuals from the Russian masses. In Shatov, he projected Russia's world mission against the West. "To be with the soil, to be with your own people, signifies to believe that precisely through this people all humanity will be saved, and finally the idea will be

born into the world and a heavenly kingdom with it." After finishing *The Possessed* in 1872, he developed the theme "of our national spiritual independence" in his *Diary of a Writer*. This miscellany of trials and crimes and popular fads became the source for his last and greatest novel.

The Brothers Karamazov was Dostoyevsky's creation from the accumulated thoughts and impressions of his life—from the Siberian prison, countless news stories, voluminous notebooks, and his grandiose plan for the "Life of a Great Sinner." Early in 1878 he received an advance from his publisher Katkov. Encouraged by Anna and with the companionship of a young philosopher who shared his faith in the Church, Dostoyevsky made a long-postponed arduous pilgrimage to the monastery Optina Pustyn. It was celebrated for the piety and wisdom of its elders, especially its charismatic Father Amvrosy. In only two days at Optina Pustyn he noted everything he saw and that Father Amvrosy told him, for chapters of the novel. The installments of *The Brothers Karamazov* began appearing in Katkov's magazine, *The Russian Messenger,* in January 1879. The enthusiasm of readers grew with each installment. He finished the last chapter in November 1880. Then Dostoyevsky began a series of public readings from his own works and from Pushkin, Gogol, and others. Without Dickens's histrionic flair, he still had his own solemn charm, always encouraged by the presence of Anna. Finally, when he was nearing sixty, he had paid off his creditors and was making money from the sale of his novels. Anna added to their income by selling books by mail.

The longest of Dostoyevsky's novels, *The Brothers Karamazov* was also the most explicit and elaborate in dealing with theology and the Russian soul. Of the varied characters and their separate doubts in search of God Dostoyevsky makes violent scenes. At the same time he explains why no theology is adequate to the needs of life. Alyosha, like the "entirely good man," Prince Myshkin in *The Idiot,* insists to his brother Ivan, "I think every one should love life above everything in the world." "Love life more than the meaning of it?" asks Ivan. "Certainly," replies Alyosha, "love it, regardless of logic as you say, it must be regardless of logic, and it's only then one will understand the meaning of it."

A passionate Eastern Orthodox Christian, Dostoyevsky still resists the temptations of dogma. "But the greatness of it," says Father Zosima, "lies just in the fact that it is a mystery—that the passing earthly show and the eternal verity are brought together in it. In the face of the earthly truth, the eternal truth is accomplished." When the Grand Inquisitor denies Christ for having left man freedom of choice between good and evil, the answer is not in reason but in the heart, and in suffering for the sins of others. In his notebook Dostoyevsky explained that this "whole novel" was an answer

to those who accused him of a naive and retrograde "faith in God." "I do not believe in God like a fool (a fanatic). And they wished to teach me, and laughed over my backwardness! But their stupid natures did not dream of such a powerful negation as I have lived through."

So Dostoyevsky transforms the bloodless abstractions of theology into human hopes and conflicts. The powerful "negations of God . . . in the Grand Inquisitor" showed that Dostoyevsky himself had faced the question. "Even in Europe there have never been atheistic expressions of such power. Consequently, I do not believe in Christ and His confession as a child, but my hosanna has come through a great *furnace of doubt.*"

Dostoyevsky did not long outlive the spectacular success of his *Brothers Karamazov.* When it first appeared in book form in January 1881 it sold fifteen hundred copies in a few days. But by the end of that month he suffered fatal hemorrhages of the lungs complicated by an attack of epilepsy. The attacks had occurred from childhood but became acute only after Dostoyevsky was snatched from execution to his years in Siberian hard labor. Thereafter they had occurred about once a month, sometimes twice a week. The onset of an attack, Dostoyevsky himself recounted, was a sense of rapture and resurrection, of being born again. But the terrible aftermath brought a "feeling of being a criminal," guilty of some horrible unknown crime. All this, says Thomas Mann, we can see in the "profound, criminal, saintly face of Dostoyevsky." So Mann was "filled with awe, with a profound, mystic silence-enjoining awe, in the presence of the religious greatness of the damned, in the presence of genius of disease and the disease of genius, of the type of the afflicted and the possessed, in whom saint and criminal are one."

In a vast public funeral Dostoyevsky was praised as the irreplaceable champion of Holy Russia. Turgenev, with a wit Dostoyevsky lacked, noted that the Russian bishops there were really celebrating the Russian Marquis de Sade. It was said that students had to be prevented from marching behind the coffin with fetters like those Dostoyevsky had worn for four years in Siberia to commemorate the death of the man who had once loved freedom and been punished for it.

The cult of Dostoyevsky, like that of Wagner, attests to the victory of art over ideas. Both had their own curious brands of chauvinism and expounded ideas unpopular in the free West, yet both attained there a cosmopolitan fame and influence. Thus Dostoyevsky proved the ineffectiveness of the "lackeys of thought" against the sagas of the soul. Although he aimed to reach everybody, he has remained, as his biographer Avrahm Yarmolinsky observes, largely "a writer's writer," finding his most enthusiastic response among fellow literati. His ever-widening audience can be ex-

plained, too, by what other writers were not saying. And by the vivid passion and suffering of his characters.

Western readers, delighted by the commemorative involutions of Proust and the filigreed everyday trivia of Joyce, would be challenged by the mysteries of Dostoyevsky's men and women in search of God. His characters discovered their uniqueness in their soul, in their own peculiar circumstances—lover, priest, parricide, reformer, revolutionary—and in the infinite variety of choices of good and evil.

Dostoyevsky's fanatic Slavomania reminded the West that there might be dimensions of life not seen in the clear stream of consciousness or in the murky depths of the unconscious. So he provided a foil for the Western self. As a chauvinist Russian he had declared war on the West, whose symbols were science, reason, and materialism. He opposed the perversion of Christianity into an authoritarian Catholic Church, the perversion of selflessness into the enforced sharing of socialism, and the multiplying of desires by industrial capitalism.

While Marxist scriptures exhorted workingmen of the world to "lose their chains," Dostoyevsky dramatized the virtue of unmerited suffering. When *The Brothers Karamazov* ends with Dmitri being found guilty of a crime he did not commit, he protests his innocence. But he adds, "I accept the torture of accusation, and my public shame. I want to suffer and by suffering I shall purify myself." Nurturing his punishment, Dmitri refuses escape to America. "I hate that America already! And though they may be wonderful at machinery, everyone of them, damn them, they are not of my soul. I love Russia, Alyosha, I love the Russian God, though I am a scoundrel myself. I shall choke there!" While Dostoyevsky never sold suffering to the West, he gave the experience of it in his novels an outlandish charm. So he lends an exotic cosmic dimension to our struggles within ourselves.

At his last public appearance, at the Pushkin Festival in Moscow on June 8, 1880, he offered the future mission of Russia. If Russia would be backward and behind the West in wealth, this only saved her from materialist distraction, preparing for her world mission to unify mankind under Christ. To which his enthusiasts in the audience exclaimed "Saint!" "Prophet!" While some comrades after the Russian Revolution of 1917 also hailed him as a prophet, when Lenin was asked what he thought of Dostoyevsky he is reported to have said, "I have no time for such trash!"

Journey to the Interior

WHEN Dante thanked Brunetto Latini for teaching him "how man becomes eternal" through the written word, he was speaking for the Western tradition. The writer aimed to create something with an independent life outside himself. But the writer who chronicled a world inside himself could well believe that world was bounded by his life. Franz Kafka (1883–1924) repeatedly said, "I consist of literature, and am unable to be anything else." When he died of tuberculosis at the age of forty-one in a sanatorium outside Vienna on June 3, 1924, he left notes to his friend Max Brod instructing him to destroy all his unpublished manuscripts and not to republish any of his works already printed. By then Kafka had published only fragments from his prodigious imagination.

If Brod had obeyed his friend's instructions, Kafka would hardly be known to the world of letters. But Kafka was in character when he left his instructions to the one person in the world who had his complete confidence and who therefore could be trusted (as he had assured Kafka in advance) not to carry out these instructions. So Kafka's writings survive in an aura of uncertainty whether he even intended them to reach us. Kafka's fame in Western letters is itself a tease, fruit of the loyal disobedience of his closest friend.

Kafka created a whole new world of rich ambivalence and tantalizing ambiguities. Even as a young man of twenty-one, before he had begun serious writing, he seemed clear enough on the kind of books that should be written.

I think we ought to read only the kind of books that wound and stab us. If the book we're reading doesn't wake us up with a blow on the head, what are we reading it for? So that it will make us happy, as you write? Good Lord, we would be happy precisely if we had no books, and the kind of books that make us happy are the kind we could write ourselves if we had to. But we need the books that

affect us like a disaster, that grieve us deeply, like the death of someone we loved more than ourselves, like being banished into forests far from everyone, like a suicide. A book must be the axe for the frozen sea inside us.

(Translated by Arthur S. Wensinger)

Within himself Kafka would create adventures as engrossing as Gargantua's Parisian frolics or Don Quixote's knightly sallies. In his short, sedentary, tuberculosis-ridden life, he lived centuries "in my own interior."

Born in Prague to a prosperous Jewish family in 1883, he went there to school and university. He made his living in Prague and took only brief summer trips to the countryside, to Paris, Switzerland, and Berlin, and a week's pilgrimage with Brod to Goethe's Weimar. His last eight years were spent in hospitals and sanatoriums.

Kafka's life was surrounded by inhibitions, of which his father, Hermann, became the unpleasant symbol. From the countryside, Hermann Kafka had come to Prague, married the daughter of a wealthy brewery owner, and prospered as a merchant in fancy goods. As he climbed the social ladder in the status-conscious Jewish community, he remained acutely conscious of status. Kafka recorded later in his undelivered "Letter to His Father" the sources of his fear. As a child one night he kept whimpering for water, and would not stop after repeated warnings. His father came into the bedroom, snatched him up, carried him out to the balcony in his nightgown, and locked the door. "I subsequently became a rather obedient child, but I suffered inner damage as a result. . . . I kept being haunted by fantasies of this giant of a man, my father, the ultimate judge, coming to get me in the middle of the night, and for almost no reason at all dragging me out of bed onto the balcony—in other words, that as far as he was concerned, I was an absolute Nothing." His acquiescent mother could not repair the damage, nor was she a bulwark against Hermann's uncomprehending hostility to Franz's literary life.

Kafka's obsession with the father-son relationship even led him once to give Hermann a copy of Benjamin Franklin's *Autobiography*. Kafka hoped Franklin's description of his pleasant relationship with his own father, in a memoir written for his son, would awaken Hermann to their problem. But Hermann sarcastically dismissed the gift as a feeble defense of Kafka's vegetarianism.

The very language that Franz spoke and in which he would write was an instrument of oppression. From Vienna, German-speaking emperors of the Austro-Hungarian Empire, seeing the Czech language as a vehicle of disloyalty, separation, and disorder, required the education of the literate classes in German. In Franz's youth the bitter language question was agitated with violence. Hermann Kafka himself was at home in the Czech

language, which helped his business in Czech-speaking Prague. But Franz
went to German-speaking schools, received his law degree from the Ger-
man university in Prague, and wrote in German. Still, he sympathized with
the Czech independence movement, and occasionally attended Czech mass
meetings and debates.

The grand constricting and nourishing fact of Franz's life was his Jewish-
ness. The repression of Jews, a leitmotif of all European history, had
touched Kafka's own family. Franz's grandfather, Jakob Kafka, born in a
one-room shack in a Czech village in 1814, was the second of nine children.
"A surly giant of a man," reputed to be able to lift a bag of potatoes with
his teeth, he made his living as a kosher butcher. Under the Austro-
Hungarian laws designed to curb the Jewish population, only the eldest son
in any Jewish family was allowed a marriage license. And since Jakob had
a stepbrother elder by a year, he could not marry or have legitimate chil-
dren. After the Revolution of 1848 the Hapsburg monarchs, desperate for
an antidote to the rising demands of contending nationalities, sought to
make allies of the Jewish peddlers and moneylenders. They granted full
citizenship to all the Jews in the empire, which included the right to settle
in cities, to enter previously closed trades and professions, and to marry at
will. The thirty-four-year-old Jakob could finally get married, which he
promptly did, to the daughter of his next-door neighbor.

Franz's father, Hermann, was of the first generation of "liberated" Jews.
Along with many others, Franz's family seized the opportunity to become
"non-Jewish Jews—Austrian citizens of the Mosaic faith." "At bottom,
your guiding faith in life," Franz wrote in his "Letter to His Father,"
"consisted of the belief that the opinions of a certain Jewish social class were
unassailably correct; since these opinions were also part and parcel of your
own personality, you actually believed in yourself. Even this still contained
enough Judaism, but not enough to pass on to the child; it dribbled away
in the process. Part of the problem was the impossibility of passing on the
memories of one's youth, the other was the fear you inspired." Franz's
"religion" remained uncertain and elusive, but his Jewish identity was never
in doubt. Yet his boredom in the synagogue, the rowdiness of the Passover
Seder, the charade of the bar mitzvah, led him to think that "getting rid
of the faith" might be "the most reverential of acts." Now that the Jews
were no longer living in their ghetto, his Jewishness separated him by an
invisible wall.

This Jewish sense of being different was all the more tantalizing because
it was not closely tied to dogma or ritual but consisted only of being thought
of by the world and oneself as indelibly different. Its residue, a sense of
"otherness," of living in a larger community but not being wholly part of
it and not quite understanding why not, would qualify Kafka to be the

prophet and the acknowledged spokesman of modern man's sense of "alienation." The story of Kafka's life is how these and other forces pushed him back into himself, and made him a pioneer into the wilderness that he would explore and re-create in words.

Kafka's qualifications to express twentieth-century man's bewilderment were reinforced by the bureaucratic routine of his own employment and his observation of the industrial technology that he could only partly comprehend and could not control. No dweller on any Left Bank, he earned his living in the mainstream of the new industrial bureaucracy. After receiving his law degree at the university, and serving the legal internship for the civil service, he secured through his uncle's influence a job in the Prague branch of an Italian insurance company. Oppressed by the meager pay for nine hours a day for six days a week, he dreamed "of someday sitting in chairs in faraway countries, looking out of the office windows at fields of sugar cane or Mohammedan cemeteries."

Within a year, in 1908, the father of a schoolmate helped him move to a position at the Workers Insurance Company for the kingdom of Bohemia. This company, half private, half public, had been set up in Prague following Bismarck's example, to give Czech workers their rights to accident insurance against injuries on the job. Luckily this was a "single shift" job from 8:00 A.M. to 2:00 P.M. six days a week, and would be Kafka's only paid position for the rest of his life. Workmen were not getting their rights, and "the company seemed little more than a dead body, whose sole sign of life was its growing deficit." The situation soon changed with a new director who was willing to resist the employers' violent protests. In the insurance company, according to his superiors, the twenty-five-year-old Kafka showed "superb administrative talent" by filing papers for injured workers, drafting policy statements on compulsory insurance, and writing brochures to inform workers of their rights.

To discover and prevent risks on the job, Kafka was assigned to inspect neighboring factories outside Prague in the rapidly growing industrial complex of northern Bohemia. There he viewed the costs of the new industry, in fingers lost and arms and legs crippled. He was both impressed and discouraged by the "modesty" of the men. "They come to us and beg. Instead of storming the company and smashing it to little pieces, they come to us and beg." The hopeless quest for justice glimpsed in *The Trial* and *The Castle* was rooted in this personal experience. "Wept over the account of the trial of twenty-three-year-old Marie Abraham, who, through want and hunger, strangled her almost nine-month-old child with a tie which she was using as a garter and which she unwound for the purpose. A thoroughly typical story."

At the insurance company he was supposed to classify trades by their

degrees of risk and to find ways to prevent accidents. Apparently he never thought of himself as a first-class bureaucrat, despite the high opinion his superiors held of him. Noting a certain naiveté, they admired his regularity, his devotion to duty, and his good nature. Kafka was on his way to a respectable career.

But in 1912, the turning point of his life, he became a born-again Man of Letters. "Who is to confirm for me the truth or probability of this," he wrote in his March diary, "that it is only because of my literary mission that I am uninterested in all other things and therefore heartless." This destiny, he explained to himself, was shaped by "my talent for portraying my dreamlike inner life . . . my life has dwindled dreadfully, nor will it cease to dwindle."

We do not know the precise cause of his self-discovery. One element may have been his summer pilgrimage with Brod to Weimar pursuing the spirit of Goethe and Schiller. Using the additional vacation he had because of "a pathological nervous condition manifesting itself in nearly continuous digestive disturbances and sleep problems," he went for a three weeks' "cure" to Justs Jungborn (Just's Fountain of Youth), an open-air resort in the Harz mountains that featured nudism, vegetarianism, and Eastern mysticism. With the motto "Light, Air, Mud, Water," the resort was known to specialize in "raw vegetables and uncooked ideas." In the "sun-and-air parks" guests walked about naked, but Kafka refused to conform and so was called "the man in the swim trunks." Outside they wore "reform" clothing and sandals designed by the proprietor, who lectured on "Nature and Christianity." The Jungborn vegetarian diet that Kafka followed in later years emphasized "various nut meats—which must be recognized as the central ingredient in human nourishment." There was a Bible in every room and Kafka seems then to have made his first effort to read both the New and the Old Testaments. Unfortunately nudism and vegetarianism were not strong enough medicine for what ailed his body.

At twenty-nine, Kafka had discovered himself as a writer, as he recorded in his diary for September, 1912:

This story, "The Judgement," I wrote at one sitting during the night of 22nd-23rd, from ten o'clock at night to six o'clock in the morning. I was hardly able to pull my legs out from under the desk, they had got so stiff from sitting. The fearful strain and joy, how the story developed before me, as if I were advancing over water. . . . How everything can be said, how, for everything, for the strangest fancies there awaits a great fire in which they perish and rise up again. . . . Only in this way can writing be done, only with such coherence, with such a complete opening out of the body and soul.

(Translated by Arthur S. Wensinger)

A parable of Kafka's life, "The Judgment" is a bizarre tale of a son who decides to marry, and is about to write the news to an old friend in Russia. He goes to his aged father to ask whether he should send the letter. The father, unaccountably offended, accuses the son of deceiving him. "You have no friend in St. Petersburg. You've always been a leg-puller and you haven't even shrunk from pulling my leg. How could you have a friend out there? I don't believe it." Upset by the son's "deception" the father collapses and the son puts him gently to bed. Then the father confesses that he himself has been writing to that friend, who "knows everything a hundred times better than you do yourself, in his left hand he crumples your letters unopened while in his right hand he holds up my letters to be read through." After another accusatory interchange, the father concludes, "An innocent child, yes, that you were, truly, but still more truly you have been a devilish human being!—and therefore take note: I sentence you to death by drowning!" At which the son rushes out of the house, leaps over the railing at the water's edge, and into the water to drown. "Dear parents," the son exclaims as he leaps, "I have always loved you all the same."

In the next months Kafka began to write *Amerika*. Then he wrote his best-known piece, "The Metamorphosis," which he called an "exceptionally repulsive story." Gregor Samsa, an ordinary traveling salesman living with his father, mother, and sister, awakens one morning to find himself transformed into a gigantic insect. At first, in his "regular human bedroom," he tries to ignore his transformation, but his family cannot. Since Gregor can no longer contribute to the family support, they must take in boarders. The family tries to keep him confined to his room, but they cannot, nor do they feed him properly. The horrified boarders move out. To the family's relief, Gregor the insect dies. Then his sister "bloomed into a pretty girl with a good figure . . . it would soon be time to find a good husband for her."

Kafka had begun his ceaseless exploring of the wilderness within, both stimulated and obstructed by abortive love affairs. In his "Letter to His Father" he blamed Hermann for not having prepared him for the good life—"marrying, founding a family, accepting all the children that come, supporting them in this insecure world and even guiding them a little." In August 1912, at Max Brod's house, he met Brod's distant relative Felice Bauer, who was twenty-four and had come from Berlin on her firm's business. He was much taken by her but the next morning was already worried that she had distracted him from his revision of *Amerika* with some "stupidity." They announced their engagement in June 1914, but broke it off stormily in a few months, while he explained to himself that it was "because he felt chained by invisible chains to an invisible literature."

And now he was relieved at "the feeling that my monotonous, empty,

mad bachelor's life has some justification. I can once more carry on a conversation with myself, and don't stare so into complete emptiness." His health was already weak enough to make him "physically unfit for military service," and he was not drafted into the Austro-Hungarian army in World War I. In March 1917 he was once again engaged to Felice. Then one morning that summer, to his horror, Kafka began spitting blood, disclosing the "illness which had been coaxed into revealing itself after [five years of] headaches and sleeplessness." The doctor gave him a Kafkaesque reassurance. "All city dwellers are tubercular anyway, an inflammation of the lung tips (one of those figures of speech, like saying piglet when you mean big fat sow) isn't all that terrible; a few tuberculin injections will take care of it." But he would never recover.

All the rest of his life he would be taking intermittent sick leave, trying one sanatorium after another, as described in Thomas Mann's *Magic Mountain*. Tuberculosis would force him to take his pension and retire from his insurance job in 1922, at the age of thirty-nine. This now provided still another reason to break off his engagement to Felice, and Kafka welcomed so "miraculous" a release from office routine. He gave an inward and conspiratorial explanation of his disease:

> What happened was that the brain could no longer endure the burden of worry and suffering heaped upon it. It said: "I give up; but should there be someone else interested in the maintenance of the whole, then, he must relieve me of some of my burden and things will still go on for a while." Then the lung spoke up, though it probably hadn't much to lose anyhow. These discussions between brain and lung which went on without my knowledge may have been terrible.
>
> (Translated by Arthur S. Wensinger)

Naturally he saw his father in this conspiracy. "If my father in earlier days was in the habit of uttering wild but empty threats, saying: I'll tear you apart like a fish—in fact, he did not so much as lay a finger on me—now the threat is being fulfilled independently of him. The world—F[elice] is its representative—and my ego are tearing my body apart in a conflict that there is no resolving."

The indisposition of his outer body came to seem a mere inconvenience. And his illness, like his Jewishness, forced him back into himself. There is no evidence that his tuberculosis decisively interrupted his writing or stunted his exuberant imagination. But would he have written what he did if he had been in robust health, expecting a long life? His tuberculosis relieved him of the need to choose between "living a life and earning a living."

. . .

Kafka again and again explained that the inner and the outer worlds ran their separate ways. As he began writing *The Castle,* in his diary for January 12, 1922, he speculated on the consequences:

First: breakdown, impossible to sleep, impossible to stay awake, impossible to endure life, or, more exactly, the course of life. The clocks are not in unison, the inner one runs crazily on at a devilish or demoniac or in any case inhuman pace, the outer one limps along at its usual speed. What else can happen but that the two worlds split apart, and they do split apart, or at least clash in a fearful manner. There are doubtless several reasons for the wild tempo of the inner process; the most obvious one is introspection, which will suffer no idea to sink tranquilly to rest but must pursue each one into consciousness, only itself to become an idea, in turn to be pursued by renewed introspection.

Secondly: this pursuit, originating in the midst of men, carries one in a direction away from them. The solitude that for the most part has been forced on me, in part voluntarily sought by me—but what was this if not compulsion too?—is now losing all its ambiguity and approaches its denouement. Where is it leading? The strongest likelihood is, that it may lead to madness; there is nothing more to say, the pursuit goes right through me and rends me asunder. Or I can—can I?—manage to keep my feet somewhat and be carried along in the wild pursuit. . . . I can replace it by the metaphor of an assault from above, aimed at me from above.

(Translated by Martin Greenberg and Hannah Arendt)

It is not surprising that Kafka's literary product, not of our earthly world, was as idiosyncratic, as inchoate and cryptic in form as in content. The inner world is not so easily ordered as Dante's levels of the Christian afterlife or Cervantes's conventions of knightly chivalry. None of Kafka's long novels was completed. He was prolific in short stories, aphorisms, and parables, all sallies into the inner unknown. His table of contents is an outrageous miscellany, which touches everything that does or does not exist and in no discernible order.

He teases us even by his very definition of a parable:

Many complain that the words of the wise are always merely parables and of no use in daily life, which is the only life we have. . . . All these parables really set out to say merely that the incomprehensible is incomprehensible, and we know that already. But the cares we have to struggle with every day: that is a different matter.

Concerning this a man once said: Why such reluctance? If you only followed the parables you yourselves would become parables and with that rid of all your daily cares.

Another said: I bet that is also a parable.

The first said: You have won.

The second said: But unfortunately only in parable.
The first said: No, in reality: in parable you have lost.

<div align="right">(Translated by Willa and Edwin Muir)</div>

In Kafka it is not allegory but symbolism that entices us. And as his soul
mate Max Brod insists, there is a world of difference. Allegory simply makes
one thing stand for something else. But in a symbol the thing and the
something else are somehow united, like Christianity in the cross. In an
allegory realism is superfluous, but not in a symbol, where the thing and
what it stands for come together. Every real detail enriches the life symbol-
ized. The brittleness of the insect's carapace, the yelp of the dog, the
emptiness of the burrow—all enrich the real world.

Into everything he touches, Kafka brings this symbolic concreteness and
mystery. We can sample it in one of his stories almost as well as in any other.
In "The Burrow" (1923), one of the two last stories that Kafka wrote, an
animal digs with head and hands to build an underground dwelling. To be
still safer against his enemies the animal goes down into the burrow and
builds a hole within the hole. Hidden in these unsubstantial labyrinthine
tunnels he seeks security. Having built the burrow, the animal comes above
ground and suddenly feels free:

> Yet I am not really free. True, I am no longer confined by narrow passages,
> but hunt through the open woods, and feel new powers awakening in my body
> for which there was no room, as it were, in the burrow, not even in the Castle
> Keep, though it had been ten times as big. The food too is better up here.
> . . . And so I can pass my time here quite without care and in complete enjoyment,
> or rather I could, and yet I cannot. My burrow takes up too much of my thoughts.
> I fled from the entrance fast enough, but soon I am back at it again. I seek out
> a good hiding place and keep watch on the entrance of my house—this time from
> outside—for whole days and nights. Call it foolish if you like; it gives me infinite
> pleasure and reassures me.

When others want to know about the burrow, the animal retorts, "I built
it for myself and not for visitors." Perhaps like Kafka's works? Was the
burrow Kafka's labyrinth inside the labyrinth of himself?

His three long novels—*Amerika, The Trial,* and *The Castle*—which we
owe to Max Brod's refusal to obey Kafka's last instructions, show the
wealth and the poverty of this inward world. Of course he had never been
to America, but his first novel (1912) was a picaresque tale of the adventures
of a poor sixteen-year-old boy packed off across the Atlantic to escape the
consequences of his seduction by a servant girl. He explained his intention
"to write a Dickens novel" with all Dickens's "wealth and naive sweeping
power." A combination of fairy tale and Disneyesque caricature, it recounts

Karl Rossmann's rescue by an immigrant German uncle who has become a senator, harassment by hobo thugs, taunting by the daughter of a suburban New York millionaire, tribulations as a resort-hotel elevator operator, and assorted misadventures across the continent. Despite all these American troubles, young Karl ends his journey in an epiphany of optimism at the Nature Theatre of Oklahoma. "Today only and never again! If you miss your chance now you miss it for ever! If you think of your future you are one of us! Everyone is welcome! If you want to be an artist, join our company! Our Theatre can find employment for everyone, a place for everyone!" At first Karl is exultant, and enjoys his try at blowing the trumpet. Then he is frustrated when he must name his occupation, for he thought he was being engaged as an actor. Of course the tyrant father reappears in episodes of unexplained guilt and undeserved punishment, but the father himself remains back in Europe. Kafka's first title for the book was "The Man who Disappeared." He was so delighted by this book that he used to amuse himself by reading passages aloud.

The two novels, *The Trial* and *The Castle,* that established his fame led W. H. Auden to describe Kafka as "the author who comes nearest to bearing the same kind of relation to our age as Dante, Shakespeare and Goethe bore to theirs." One near the beginning and the other near the end of his writing career, these were both excursions to the America within.

The Trial, written in 1914, when he was thirty-one, became for Sartre, Camus, and others in France a parable of life under the Nazis. With the rise of Stalin and his successors in the Soviet Union, and the Cultural Revolution in China, the book retained the aura of prophecy. But when Kafka wrote the book, these gargantuan modern horrors were all in the future.

"Someone must have been telling lies about Joseph K.," *The Trial* begins, "for without having done anything wrong he was arrested one fine morning. His landlady's cook, who always brought him his breakfast at eight o'clock, failed to appear on this occasion. That had never happened before." Not knowing what crime if any he has committed, he is pursued by investigators and repeatedly interrogated. He has difficulty finding the court, is subjected to tortured legalistic technicalities, and is repeatedly beaten by a court functionary who simply says "I'm employed to beat people, so I beat them." His respectable life as a middle-class bachelor is made to seem a kind of guilt. But since Joseph K. refuses to admit his guilt, he must die "like a dog."

An unpleasant companion piece on the same multivalent theme and also written during the first months of World War I is "In the Penal Colony." An officer of the Old Commandant has preserved a bizarre instrument of torture to extract confessions. The accused is put in this machine where a

set of needles incise into his skin the nature of his crime. There he can read his crime and confess in a final moment of truth. As the explorer arrives he sees a prisoner about to be put in the machine for his crime of disobedience, failing to salute a doorpost. When the explorer objects, the officer releases the prisoner. As an act of faith in the machine and a kind of act of "redemption," he puts himself on the machine. The machine destroys the officer, who still shows no sign of redemption, then destroys itself.

The leitmotif of many of Kafka's early stories—uncomprehended guilt and disproportionate punishment—is revealed in his undelivered "Letter to His Father" (1919), rich with Kafka's autobiographical insights. "My writing was all about you," he confesses to his father, "all I did there, after all, was to bemoan what I could not bemoan upon your breast. It was an intentionally long-drawn-out leave-taking from you." We owe an ironic debt, then, to the brutal father who drove Kafka to explore the wilderness within.

Kafka's works are so cryptic that it is hard to trace development in his thinking. When he began his last long work, *The Castle* (1922), the decade just past had been wonderfully fertile for him. No longer preoccupied with guilt, and even less realistic than *The Trial, The Castle* for once features a hero who is not merely a victim or culprit of some unknown crime. This hero just reaches up and suffers the consequences. Arriving in a village in the Valley below the Castle he must have authority from the Castle to spend the night or to proceed. "K." fraudulently claims that the Count has summoned him as a land surveyor. The inn initiates a fruitless effort to communicate with the Castle. Whenever K. seems to have succeeded in communicating, he remains baffled by the response.

> Just then in the hut on his left hand a tiny window was opened. . . . Then a man came to the window and asked, not unamiably, but still as if he were anxious to have no complications in front of his house: "Are you waiting for somebody?" "For a sledge, to pick me up," said K. "No sledges will pass here," said the man, "there's no traffic here." "But it's the road leading to the castle," objected K. "All the same, all the same," said the man with a certain finality, "there's no traffic here."

> (Translated by Willa and Edwin Muir)

Still K. cannot make himself at home in the inn or dispel suspicion in the village, which is his base.

Max Brod, to whom Kafka first read the beginning of *The Castle,* saw it as an account of the Faust or Don Quixote in each of us, "a book in which each of us recognizes his own experience. . . . Kafka's hero, whom he calls simply K., in autobiographical fashion, passes through life alone. He is the loneliness-component in us, which this novel works out in more-than-life-

size, terrifying clarity." The word "Jew" does not appear in *The Castle*.
"Yet, tangibly, Kafka in *The Castle*, straight from his Jewish soul, in a
simple story, has said more about the situation of Jewry as a whole today
than can be read in a hundred learned treatises." Kafka seems to be confess-
ing that inner resources are not enough. But the reach upward and outward
brings no response—or only one we cannot fathom. And from whom? Is
it perhaps, our own humiliating mistake to try to reach the Castle?

Where does Kafka the creator-artist fit? Kafka's last finished story, and
one which he himself destined for the printing press, was "Josephine the
Songstress—or the Mice-Nation" (1923). Among the mice people Josephine
is the greatest singer ever to emerge. But piqued by the refusal of her fellow
mice to release her from her everyday citizen's duties, she refuses to sing
anymore. Then finally she goes into hiding, hoping she will be sought out
and beseeched to resume her singing. "What Josephine really wants is not
what she puts into words . . . what she wants is public, unambiguous,
permanent recognition of her art, going far beyond any precedent so far
known. But while everything else is within her reach, this eludes her persis-
tently." And she fails in her arrogant demand that, in return for the gift of
her art to them, they guarantee her fame and immortality. "Was her actual
piping notably louder and more alive than the memory of it will be? Was
it even in her lifetime more than a simple memory?" In the long history of
the mice people Josephine is destined to be redeemed not by fame but in
quite the opposite way. She "will happily lose herself in the numberless
throng of the heroes of our people, and soon . . . will rise to the heights of
redemption and be forgotten like all her brothers." "She hides herself and
does not sing, but our people, quietly, without visible disappointment, a
self-confident mass in perfect equilibrium, so constituted, even though ap-
pearances are misleading, that they can only bestow gifts and not receive
them, even from Josephine, our people continue on their way."

In Josephine the mice songstress Max Brod, who knew Kafka better than
anyone else, found Kafka's parable of the Jewish literary world and perhaps
an explanation of why he wanted his works destroyed. Any artist is deceived
if he thinks he alone is chosen. If there is "redemption" for the artist or
writer it comes not from his work, but from realizing that, like Josephine,
every artist is only "a tiny episode in the eternal history of our people, and
our people will get over the loss."

Finally with self-effacing wit, Kafka expresses his doubts about the supe-
rior performance of any artist. Perhaps the artist is only an unusually adept
practical joker. Maybe he does the work no better than others but only more
consciously, as Kafka noted in the mice nation:

> To crack a nut is certainly not an art, therefore no one would dare to bring an
> audience together and crack nuts before them in order to entertain them. But if

someone should do this nevertheless, and if he successfully accomplishes his "art," then the thing does cease to be a mere nut-cracking. Or rather, it continues to be still a matter of cracking nuts but it becomes apparent that we have normally overlooked what an art it was, because we could do it so easily, and that this new nutcracker was the first person to show us what the real nature of the business was; and it might then even be more effective if he was a little less good at cracking nuts than the majority of us.

Ambiguity is the enduring charm of Kafka's wilderness within. Some would put Kafka in the tradition of Greek tragedy, others who see him as a surrealist wit complain that translators have left out his humor. The classic photograph of Kafka shows a man who never laughed. But those who knew him say he broke into uncontrollable laughter when he read his stories to friends. The absurd was Kafka's delight, and he makes it ours. "It's unjust," he warned, "to smile about the hero who lies mortally wounded on the stage and sings an aria. We lie on the ground and sing for years."

67

The Garden of Involuntary Memory

THE discovery of the self as a resource of art let the writer bring time within, making his inward life a microcosm of the mystery, a personal laboratory where the vast expanses can be recaptured. Space had seemed manageable, mastered in buildings, in pictures, in words. But time, the elusive dimension, challenged modern creators to flex their ingenuity. In the effort they would demonstrate unsuspected resources of the self. And now, instead of complaining, with Wyndham Lewis, of modern man's "morbid time consciousness," we can marvel at what man has made of his most ancient enemy.

Marcel Proust (1871–1922) chose for his work "that invisible substance called time." In the eight volumes of his fourteen-year lifework he created a new way of conquering time's transience and evanescence. He was providentially qualified by both his capacities and his infirmities to show what could be made of the encounter of the inward self with time.

Born in Auteuil, a Paris suburb, he inherited a secure social position from his father's distinction as physician, professor of hygiene, and eminent

government servant. Adrien Proust had come of an ancient Catholic family from Illiers, near Chartres. Proust's mother came of a wealthy Jewish family, and he kept memories of his Jewish forebears alive by an annual pilgrimage to lay a pebble on the ancestral grave in the cemetery. Jeanne Weil Proust's difficult pregnancy with Marcel during the Commune and the siege of Paris began a maternal bonding that shaped Proust's life and work. For a person who saw art as his liberation into eternity, he remained strangely obsessed by his roots, and by his ties to his mother and his maternal grandmother. He spent his childhood holidays at a Normandy seashore resort with his grandmother. His sense of a divided Franco-Jewish inheritance would be intensified, even before he began his great work, by the appalling Dreyfus Affair, which brought out the worst anti-Semitic passions in French society. Proust himself collected petitions to vindicate the unjustly accused Dreyfus and bring him back from Devil's Island.

His schooling was conventional enough. First to the elite Lycée Condorcet, from 1882 to 1889, where he made his lifelong friendships. There he remembered reading *The Arabian Nights,* modern French classics, and translations of Dickens, Hardy, Stevenson, and George Eliot. Already known for his personal charm and intellectual precocity, he dazzled classmates by his observations on the miraculous "effect of associated ideas." Surprisingly, too, he enjoyed his year of conscript military service at Orleans in 1889–90. He might have enjoyed it less if he had had to serve the five years generally required. But under the law he was privileged to serve only one year by having attained his baccalaureate and by his parents' ability to pay the fifteen hundred francs for his uniform and maintenance. He barely came under the wire before a rigid three-year conscription went into effect.

About this time, at the age of twenty, he gave revealing answers to a questionnaire:

> *Your most marked characteristic?* A craving to be loved, or, to be more precise, to be caressed and spoiled rather than to be admired
> *The quality you most like in a man?* Feminine charm
> *The quality you most like in a woman?* A man's virtue, and frankness in friendship
> *What do you most value in your friends?* Tenderness—provided they possess a physical charm which makes their tenderness worth having
> *What is your principal defect?* Lack of understanding, weakness of will . . .
> *What is your favorite occupation?* Loving . . .
> *Who is your favorite hero of fiction?* Hamlet . . .
> *What are your favorite names?* I have only one at a time
> *What is it that you most dislike?* My own worst qualities . . .
> *What event in military history do you most admire?* My own enlistment as a volunteer . . .

<div align="right">(Translated by Gerhard Hopkins)</div>

After his year of service he went on to the École des Sciences Politiques, where he secured his *license* in law (1893) and then in literature (1895). There he was exhilarated by the philosophical ideas of Henri Bergson (his cousin by marriage), who also was obsessed by time. And he frequented the salons embellished by titles of various vintages. He published his first stories, essays, and reviews in a short-lived little magazine, *Le Banquet,* subsidized by wealthy parents of his Condorcet classmates. To his fellow editors he seemed "far more anxious to find a way into certain drawing-rooms of the nobility than to devote himself to literature." His family's wealth made it unnecessary for him to have a regular occupation. He used his diploma in law to work briefly for a notary, served as volunteer librarian at the Bibliothèque Mazarine, and began an autobiographical novel, *Jean Santeuil.*

Suddenly in 1899 he dropped his autobiography because of his new passion for John Ruskin's "religion of Beauty." At first it seemed a charming irrelevance, and was short-lived, but it became a focus and provided a vocabulary for Proust's own quest to recapture Time. Proust and Ruskin (1819–1900) had come from similar backgrounds. Both were born into wealthy families who relieved them of the need for employment. Both had an overprotected childhood and doting parents. Ruskin's father, a prosperous wine merchant and connoisseur, collected paintings and beginning when Ruskin was only fourteen took him on grand tours of the Continent. When Ruskin became a prize student at Christ Church, Oxford, his father staked him to collecting paintings by J.M.W. Turner. There, bored by the curriculum and frustrated in love affairs, he developed those lifelong passions for nature and the Gothic that prepared him for his battle against the industrial ethos and his championship of medieval ideals of chivalry. In a celebrated Victorian scandal, Ruskin's wife secured annulment of their marriage on the grounds of Ruskin's impotence in order to marry the Pre-Raphaelite painter John Everett Millais. Haunted by fits of madness, the last twenty years of his life were a nightmare.

Ruskin's passion for architecture captivated Proust, for architecture, exhibiting the power of stone, was Ruskin's arena for his recapture of time. Proust recounted how, on the very day of Ruskin's death in 1900, he happened to be rereading the passage in *The Seven Lamps of Architecture* (1849) where Ruskin described in the cathedral of Rouen a curious little stone figure "vexed and puzzled in his malice; his hand is pressed hard against his cheek-bone, and the flesh of the cheek is *wrinkled* under the eye by the pressure." "I was seized by the desire to see the little man of whom Ruskin speaks, and I went to Rouen as if he had bequeathed to the care of his readers the insignificant creature whom he had, by speaking of him, restored to life." So Proust led his friends to Rouen on what seemed a futile quest among the countless figures adorning the vast cathedral. They

searched together until his sculptor companion with a practiced eye ex-claimed at a six-inch likeness: "There's one that looks just like him!" And this small rediscovery was the triumph of their day. "I was moved to find him still there, because I realized then that nothing dies that once has lived, neither the sculptor's thought, nor Ruskin's." Ruskin challenged the twenty-nine-year-old Proust to recapture his past in words, just as the medieval sculptors had captured theirs in stone.

When Proust and his mother went to Venice, on the train coming in his mother was reading to him Ruskin's *Stones of Venice* (three volumes, 1851–53). Naturally they stayed at the fashionable Hotel Danieli, where Ruskin had stayed before them. "I found," Proust recalled, "that my dream had become—incredibly but quite simply—my address!" As they sat eating granita at Florian's café on the Piazza San Marco, Proust's transforming imagination made him exclaim, "Pigeons are the lilacs of the animal king-dom!" Though Proust knew very little English, he enthusiastically "trans-lated" Ruskin by simply polishing a rough draft provided by others. Exhilarated by Ruskin's "religion of Beauty," his adoration of Nature and the Gothic, even through an alien language Proust felt an affinity that helped him discover the world in himself. Proust's half-dozen years as an acolyte of Ruskin left a permanent imprint. "The universe suddenly re-gained an infinite value in my eyes," he recalled even after his first enthusi-asm had passed, "and my admiration for Ruskin gave such importance to the things he had made me love that they seemed charged with something more precious than life itself." Had it not been for Ruskin, Proust declared, he would have lacked "any understanding of the Middle Ages, a sense of history, and the feeling of a sort of natural sympathy for all things that have grown dim with age, and an awareness of their continuing presence."

Proust's enthusiasm for the living past was also a by-product of his infirmi-ties, his loneliness, and his self-exile. A frail infant, at the age of nine he had a first attack of the asthma that threatened and confined him all the rest of his life. An overprotected child coddled and doted on by his mother and grandmother, after their death he doted on and coddled himself. After his years at the university, in his late twenties his health worsened, and he withdrew from the salon circuit. His father died in 1903, his mother in 1905, leaving him at thirty-four feeling bereft and lonely, for he had been living with them. After fifteen months he moved into a flat at 102 Boulevard Haussmann owned by the widow of his mother's uncle, for "I could not reconcile myself to the idea of moving straight away into a house that Mama had never known."

Now secure financially, he organized and fortified himself, with the little table beside his bed that he called his "pinnace" for the voyage to recapture

his past. Piled round were notebooks, papers, fountain pens, and the apparatus for the frequent medicinal fumigations that filled the room with a yellow mist and purifying odors. When his neighbor, a M. Sauphar, began construction, Proust complained, " 'Sauphar' is the name of the kind of loud trumpet that used to be sounded in the Synagogue to wake the dead for judgment. There is not much difference between these Sauphars of old and the Sauphars of today." To improve his insulation from the outer world he had all four walls of his bedroom lined with cork. There the occasional visitors saw him thickly enveloped in woolen pullovers.

It was in that bizarre self-exile that Proust, sometime after 1905, began to write his novel. We do not know exactly when or how he decided to write this book of his life. But in the new preface to his revised *Contre Sainte-Beuve* (1908–9), still oscillating between fiction and the essay, he hinted his direction. "Every day I attach less and less importance to the intellect. Every day I realize more that it is only by other means that a writer can regain something of our impressions, reach, that is, a particle of himself, the only material of art. What the intellect restores to us under the name of the past is not the past. . . ."

Proust's "past" was a world of the involuntary memory, the welling up from the self in a force beyond his understanding. About January 1, 1909, he experienced an epiphany. This sudden manifestation of meaning was his first revelation of the flowing depths of the self that his whole eight volumes would report from a re-created world inaccessible to the conscious intellect. The occasion of his famous epiphany was not a momentous event. In the most familiar passage of *Swann's Way:*

> . . . one day in winter, as I came home, my mother, seeing that I was cold, offered me some tea, a thing I did not ordinarily take. I declined at first, and then, for no particular reason, changed my mind. She sent out for one of those short, plump little cakes called "petites madeleines," which look as though they had been moulded in the fluted scallop of a pilgrim's shell. And soon, mechanically, weary after a dull day with the prospect of a depressing morrow, I raised to my lips a spoonful of the tea in which I had soaked a morsel of the cake. No sooner had the warm liquid, and the crumbs with it, touched my palate than a shudder ran through my whole body, and I stopped, intent upon the extraordinary changes that were taking place. An exquisite pleasure had invaded my senses, but individual, detached, with no suggestion of its origin. And at once the vicissitudes of life had become indifferent to me, its disasters innocuous, its brevity illusory— this new sensation having had the effect which love has of filling me with a precious essence; or rather this essence was not in me, it was myself. I had ceased now to feel mediocre, accidental, moral. Whence could it have come to me, this all-powerful joy? . . . What did it signify? . . . And just as the Japanese amuse themselves by filling a porcelain bowl with water and steeping in it little crumbs of paper which until then are without character or form, but, the moment they

become wet, stretch themselves and bend, take on colour and distinctive shape, become flowers or houses or people, permanent and recognisable, so in that moment all the flowers in our garden and in M. Swann's park, and the water lilies on the Vivonne and the good folk of the village and their little dwellings and the parish church and the whole of Combray and of its surroundings, taking their proper shapes and growing solid sprang into being, town and gardens alike, from my cup of tea.

(Translated by C.K.M. Scott-Moncrieff)

By now, it seems, Proust had determined to write a novel as long as *The Arabian Nights,* which would require a strength and courage he had not yet shown. "I had lived a life of idleness and dissipation, of sickness, invalidism, and eccentricity. I was embarking on my work when already near to death, and I knew nothing of my trade." He later declared that his early indisposition was good luck, for it prevented him from trying his great work prematurely.

Now reborn in the vision of involuntary memory, he set about reworking his outline. And so began the lonely writing years in his cork-lined bedroom, preserved in the Carnavalet Museum in Paris. For his work of memory Proust dared not rely on his memory. According to Samuel Beckett, Proust had a bad memory, which, Beckett explained, may have been fortunate, for "The man with a good memory does not remember anything because he does not forget anything." Proust seldom went out of his apartment, using letters and messengers to secure the scrupulous details for the passage he was writing at the moment. Every little thing—music, costume, flowers, trees—had to be just right. He wrote his friend Madame Straus for advice about fox furs, because he said he wanted to buy a fur as a present. The "lady" for whom he wanted these furs was the Albertine in his novel.

When he did go out, it was at odd hours in interludes of writing and for a specific purpose. At half-past eleven one evening he suddenly dropped in on his old friends the Caillavets. He explained that it had been many years since he had seen their young daughter. "Madame, what I ask of you now is that I should be permitted to see Mlle. Simone tonight?" He needed to confirm his impressions of her so he could describe Mlle. de Saint-Loup in the role in which he had cast Simone, as the daughter of the woman whom the narrator had once loved. Though she had long since gone to bed, they obliged by bringing her down from her bedroom. Somehow the impressions of "involuntary memory" had to be verified. Anyone who has seen the manuscript in the Bibliothèque Nationale in Paris can attest to his endless revisions to perfect his unconscious.

By September 1912 Proust had completed the first draft of *Swann's Way.* He sent samples to the *Nouvelle Revue Française,* where André Gide turned

it down. When the prosperous Fasquelle also refused to publish it, Proust was ready to give up the effort and print it at his own expense, for he hoped to reach beyond his literary coterie to "the kind of people who take a book with them on a railway journey." Still, he ventured one more try, with the successful Ollendorff firm, which promptly replied, "Dear friend: I may be thicker skinned than most, but I just can't understand why anyone should take thirty pages to describe how he tosses about in bed because he can't get to sleep. I clutched my head. . . ." Yet just this passage would become the classic "overture" that, in the authorized translation by C.K.M. Scott-Moncrieff (1889–1930) invited generations to their long voyage through Proust's memories:

> For a long time I used to go to bed early. Sometimes, when I had put out my candle, my eyes would close so quickly that I had not even time to say "I'm going to sleep," and half an hour later the thought that it was time to go to sleep would awaken me; I would try to put away the book which, I imagined, was still in my hands, and to blow out the light; I had been thinking all the time, while I was asleep, of what I had just been reading, but my thoughts had run into a channel of their own, until I myself seemed actually to have become the subject of my book: a church, a quartet, the rivalry between Francois I and Charles V. This impression would persist for some moments after I was awake; it did not disturb my mind, but it lay like scales upon my eyes and prevented them from registering the fact that the candle was no longer burning. Then it would begin to seem unintelligible, as the thoughts of a former existence must be to a reincarnate spirit; the subject of my book would separate itself from me, leaving me free to choose whether I would form part of it or no. . . .

Self-imprisoned in his bedroom, Proust was not well situated to negotiate with other possible publishers.

Proust finally arranged for publication at his own expense by an enterprising young publisher, Bernard Grasset. The publisher would take a percentage of the published price and the author would pay for publicity. These were hardly "negotiations," for Proust insisted on giving the publisher better terms than were offered, including a share of the translation rights. They planned a first printing of 1,200 copies, soon increased to 1,750. As Proust worked over the manuscript for publication the book expanded to some eight hundred pages. The publisher objected that it could not all be put in one volume and the public would not buy such a long book. Proust finally divided his work into three volumes, and began by publishing only a first volume. Later the plan would be further expanded, and the last three parts of *Remembrance of Things Past* would be published posthumously without the author's final revisions. As Proust sent *Swann's Way (Du côté de chez Swann)* to the press he had mutilated the galleys with insertions and corrections all around. "I've written a whole new book on the proofs," he

told his friend, and he was heavily charged for excess corrections. When the book was well received on publication on November 14, 1913 (English translation, 1922), now André Gide offered to take over the novel, but Proust remained loyal to Grasset.

The remainder of the manuscript for *Swann's Way* that Proust had already prepared might have been published soon, and the whole *Remembrance* might have remained inchoate had not the most melodramatic of Proust's frustrated love affairs intervened. The ill-starred object of his passion was Alfred Agostinelli, an affable young man of twenty-five who had been his chauffeur in Cabourg back in 1907. This anguished interlude would have the effect of interrupting and eventually expanding Proust's *Remembrance*. A native of Monaco, and of Italian extraction, Agostinelli had himself been one of those who had fallen in love with the automobile in its early days, and he sped Proust breathlessly across the Normandy landscape. "May the steering-wheel of my young mechanic," prayed Proust, "remain forever the symbol of his talent, rather than the prefiguration of his martyrdom."

In January 1913 Agostinelli, whom he had not seen for five years, walked into his apartment asking to be taken on again as his chauffeur. Proust already had a chauffeur, another holdover from the Cabourg days. In an unlucky moment he took on Agostinelli as his secretary, to type the second half of his novel. Proust found Agostinelli's devoted wife, Anna, unattractive, and she disliked him. But he put them both on a luxurious allowance, which they spent recklessly. He went on courting them by gifts and still-larger allowances. Anna became his rival as he nourished his consuming passion for Agostinelli, which proved less invigorating than paralyzing. With Agostinelli, in that summer of 1913, he drove to Cabourg, the Channel resort, bringing some printer's proofs to work on. There he seems to have declared his passion to Agostinelli, though he was still torn by love for a young girl in Paris whom he had thought he was going to marry. Unaccountably and impetuously Proust hastened back to Paris, where he completed revising the final proofs of *Swann's Way*.

In the custom of literary Paris, Proust spent some months maneuvering and wangling favorable notices in Paris publications, and pressed his acquaintances for quotable comments. The book was shrewdly dedicated to M. Gaston Calmette, influential editor of *Le Figaro*, whom Proust had courted for years, even to the extent of giving him a cigarette case from Tiffany's which Calmette had not even acknowledged. An unexpected sensational touch was added in February 1914, when Calmette was murdered in his office by the wife of a pro-German minister of finance whom Calmette had tried to blackmail.

Proust tortured himself with the feeling that his passion for Agostinelli

was not sufficiently reciprocated. He added to his misery with unfocused jealousies of male or female rivals, and his knowledge that Agostinelli was planning to leave his employ. Meanwhile Agostinelli, nurturing a new passion for the airplane, began taking flying lessons at Proust's expense. When Proust saw that the airplane would displace him in Agostinelli's affections, he felt frustrated and betrayed. And he told friends he was too unhappy to take pleasure even in the appearance of *Swann's Way.* In a rage he warned Agostinelli that if he was killed in an airplane accident his wife would "find in me neither a protector nor a friend, and will never get a halfpenny from me." In December 1913, Agostinelli, with the sums he had saved from Proust's munificence, fled to his native Riviera and enrolled in a flying school under the pseudonym of Marcel Swann. On May 30, 1914, on his second solo flight, carrying with him the seven thousand francs left from Proust's gifts, he plunged into the sea and so ended Proust's greatest love. On hearing the news Proust was devastated, and fell into one of his worst bouts of asthma. He responded with constant fumigations of his bedroom "which help me breathe, but would prevent anyone else," he explained to Gide to prevent a condolence visit. Proust, despite his threats, took Anna under his protection. And Agostinelli played posthumous roles as Albertine, whose career closely parallels that of the flamboyant chauffeur-aviator, the prisoner of love who "disappears." Proust, who saw symbols everywhere, took his death, like Calmette's, as an omen of the World War slaughter to come.

Proust's debility and self-exile limited the effects on his personal life of the guns of August. What Proust was writing during these World War years was an autobiographical chronicle of French high society in the whole half century before. It is the story of an author's growth in consciousness until at the end of it all the author is ready "to begin work." The final work, one third of which was published only posthumously, came to about three thousand pages. But Proust's original versions were at least ten thousand pages, and thirty thousand draft pages were destroyed at his orders. He was a prolific correspondent. Some three thousand of his letters have already appeared in print. He died in Paris in November 1922 of pneumonia while revising his book.

Of all novels, Proust's *Remembrance of Things Past* is least suited to summary. For it is the story of itself, of how the author came to write the book. In place of a plot there is the flow of unconscious memory, purposely undirected by the intellect. Nor is it well suited for anthologies. Many a sentence becomes a long paragraph, and every memory flows with a stream.

> And so it was that, for a long time afterwards, when I lay awake at night and revived old memories of Combray, I saw no more of it than this sort of luminous

panel, sharply defined against a vague and shadowy background, like the panels which a Bengal fire or some electric sign will illuminate and dissect from the front of a building the other parts of which remain plunged in darkness: broad enough at its base, the little parlour, the dining-room, the alluring shadows of the path along which could come M. Swann, the unconscious author of my sufferings, the hall through which I would journey to the first step of that staircase, so hard to climb, which constituted all by itself, the tapering "elevation" of an irregular pyramid; and, at the summit, my bedroom, with the little passage through whose glazed door Mamma would enter. . . .

(Translated by C.K.M. Scott-Moncrieff)

The book is divided into seven sections, on different themes. The narrator, Marcel, relives his own growth and the trivial travails of French aristocratic society. Proust had given up the idea of a linear narrative around the single character Swann. Instead he clustered the parts around themes, which he thought could be as inspiring and intelligible as a cathedral—infinite detail surrounding the grand direction of a nave. Never forgetting Ruskin, Proust described writing as his "architectural" labor, and often wrote of the architectural structure of his book. He had made a cathedral of his memories, as he confessed to a friend in 1919:

When you speak to me of cathedrals, I cannot but feel touched at the evidence of an intuition which has led you to guess what I have never mentioned to anybody, and here set down in writing for the first time—that I once planned to give to each part of my book a succession of titles, such as *Porch, Windows in the Apse,* etc., so as to defend myself in advance against the sort of stupid criticism which has been made to the effect that my books lack construction, whereas I hope to prove to you that their sole merit lies in the solidity of their tiniest parts. I gave up the idea of using these architectural titles because I found them too pretentious, but I am touched at finding that you have dug them up by a sort of intelligent divination. . . .

(Translated by Gerhard Hopkins)

His seven themes were childhood (*Swann's Way*); awakening loves for people and the arts (*Within a Budding Grove*); high society (*The Guermantes Way*); heterosexual and homosexual love (*Cities of the Plain*); ways of being possessed (*The Captive*); deprivation (*The Sweet Cheat Gone*); and the cycle of recapturing life through memory (*The Past Recaptured*).

The whole book is a story of what Proust described as his "favorite occupation," loving. And it tells of the narrator and others falling in and out of love: Swann's passion for the courtesan Odette; the narrator's own love affair with Gilberte, the daughter of Swann and Odette; his meeting with the attractive nobleman Saint-Loup, and Saint-Loup's uncle Baron de Charlus, Albertine, and others; a passing love affair with the duchesse de Guermantes, and Charlus's homosexual pursuits. Then the narrator's suspi-

cions of Albertine's lesbian love affairs and his keeping her captive until she flees and dies. Then other love affairs punctuated by scenes of Paris in wartime, with the possible disintegration of several of the characters by assorted passions and the passage of time, and how Saint-Loup, become homosexual, marries Gilberte, and later dies in battle. Finally, after the war, the narrator at a reception of the princesse de Guermantes in another madeleine-like epiphany discovers how the past has been made eternal. In *The Past Recaptured,* his final volume, he recalls how slow he was to recognize the effects of passing time:

> The first instant I did not understand why I could not immediately recognize the master of the house and the guests, who seemed to have "made themselves up," usually with powdered hair, in a way that completely changed their appearance. The Prince, as he received his guests, still retained the genial manner of a fairyland king which had struck me in him the first time, but this day, having apparently submitted to the same etiquette as he had established for his guests, he had rigged himself up with a white beard and what looked like leaden soles which made his feet drag heavily. He seemed to have taken it upon himself to represent one of the Seven Ages of Man. His mustachios were also white, as though a hoar-frost from the forest of Hop-o'-my-thumb. They made his mouth stiff and awkward and he should have removed them, once they had produced their effect.
>
> (Translated by Frederick A. Blossom)

Time finally is recaptured and the narrator is now ready to write this novel. All these episodes are overcast with ambiguities, which even open doubts about the sex of the heroine Albertine, who becomes a kind of embodied (or disembodied?) symbol of generalized love. At the same time the whole narrative is replete with rich detail of Paris's disintegrating high society, its family connections and disconnections, its nuances of climbings, of greetings and snubbings on the street and in the salon.

Like the first creators of the arts, Proust saw man in a battle against time, and his art as a weapon and a monument of man's victory in the battle. This was his religion of art—immortality achieved not in an unworldly otherworld but in the worldly otherworld of the arts. The Vanguard Word, the literary art, had a strange power of giving immortality not just to a single "soul," some one unique transtemporal distilled self in each individual, but to the whole succession of "selves" in whom Proust's memories flowed and through whom they came to the present.

> And I saw myself, as though in the first truthful mirror I had found, through the eyes of old folk who thought they had remained young (just as I believed I had

myself) and who, when I pointed to myself as an example of an old man, hoping they would contradict me, shewed no look of protest in their eyes, which saw me as they did not see themselves but as I saw them. . . . And now I understood what old age was—old age which, of all the realities, is perhaps the one concerning which we retain for the longest time a purely abstract conception, looking at the calendars, dating our letters, watching our friends get married and our friends' children, without understanding, whether through fear or indolence, what it all means, until the day we catch sight of a strange silhouette, such as M. d'Argencourt's, which opens our eyes to the fact that we are now living in a different world. . . .

(Translated by Frederick A. Blossom)

Although "the disintegration of the self is a continuous death" in time, the artist can capture and make these many selves immortal. Proust has made explicit the battle all artists had been fighting, and he has won the battle in the act of chronicling it, for he has enlisted Time as his ally, the principal character and force in his novel. He has brought Time inward, where it is one with his life, creating in the unconscious. "It is plain that the object of my quest, the truth, lies not in the cup but in myself. . . . Seek? More than that: create. It is face to face with something which does not so far exist, to which it alone can give reality and substance, which it alone can bring into the light of day."

Back in his *Bible of Amiens* (1904) he saw this uncanny power "that Claude Monet has fixed in his sublime canvases, where he has displayed the life of that *thing* which men have created but which Nature has resumed and made part of herself—a cathedral whose existence, like that of the earth in her double revolution, has unwound through the long tale of the centuries, yet every day is renewed and achieved afresh." As he explained of Renoir and Manet, this was what every great artist accomplished.

If they are to succeed, they have—the original painter and the original writer—to proceed much in the manner of oculists. The treatment administered through their paintings or their literature, is not always pleasant. When it is finished, they say to us "*Now* look!"—and suddenly the world, which, far from having been created once and for all, is created afresh each time that a new artist comes on the scene, is shown to us in perfect clarity—but looking very different from the one we knew before. . . . Such is the new and perishable universe freshly created. It will remain convincing until the next geological catastrophe precipitated by a new painter or a new writer of originality. . . .

(Translated by Gerhard Hopkins)

Proust's originality was his way of conquering Time, not in Rouen stone nor on Manet canvas but in the word. His way was also a kind of surrender to Time, re-creation not by a bold stroke of the conscious intellect, but by

allowing experience to flow again in unconscious memory. Thus, while Proust sees how in the outer world everything and everybody is disintegrated by Time, his narrator finally discovers that "they can all remain alive, young, and beautiful in the artist's recapturing memory, drawing from his inner consciousness those forms which he finds in a supernatural world which is his own exclusive experience." Over the narrator finally came "a feeling of profound fatigue at the realization that all this long stretch of time not only had been uninterruptedly lived, thought, secreted by me, that it was my life, my very self, but also that I must, every minute of my life, keep it closely by me, that it upheld me, that I was perched on its dizzying summit, that I could not move without carrying it about with me." The author would finally conquer time in autobiography by exploring the self—but in his own special way, for, as his biographer George Painter observes, he "invented nothing but altered everything."

Proust reveals how he has encompassed the enemy in the last sentence of the last volume of his novel. "If, at least, there were granted me time enough to complete my work, I would not fail to stamp it with the seal of that Time the understanding of which was this day so forcibly impressing itself upon me, and I would therein describe men—even should that give them the semblance of monstrous creatures—as occupying in Time a place far more considerable than the so restricted one allotted them in space, on the contrary, extending boundlessly since, giant-like, reaching far back into the years, they touch simultaneously epochs of their lives—with countless intervening days between—so widely separated from one another in Time." He finally conquers Time, then, by writing the novel we have just read.

Just as the Japanese in their buildings conquered Time by acquiescing in it with their structures of wood, so Proust was playing his version of literary judo, "the gentle way." He conquered Time by deferring to it, making it the raw material of his novel, making it his art to re-create life in time rather than in space. But somehow critics were bound, with Bergson, to see Time in the metaphors of space, and they said that Proust had seen experience distorted through a microscope. "My instrument," Proust retorted, "is not a microscope but a telescope directed upon Time."

The Filigreed Self

PROUST went far to make the remembered self a resource for re-creating the world. The refluent self became his "inner book of unknown symbols." But the self had other outreaching possibilities, which James Joyce (1882–1941) explored with surprising consequences. For Joyce, encompassed time was no mere private garden of involuntary memory but a microcosm of all human history. This he chronicled in no heroic figure on a grand stage but in "the dailiest day possible," not in a history-making capital but in a provincial metropolis on the periphery. He folded time in by making his work, like Proust's, the story of its own making and of the making of himself. But he would also prove that Homer had never died.

Joyce and Proust, to be coupled forever as pioneer explorers of the self, were near-contemporaries. Proust was only ten years older than Joyce, and they appealed to the same select audience. They did meet once, at a Paris supper party for Stravinsky and Diaghilev in May 1921. Proust, on a rare excursion from 102 Boulevard Haussmann, arrived late in a fur coat and was seated beside Joyce. The best account of this legendary meeting came from the American poet William Carlos Williams, who was there. "I've headaches every day," complained Joyce. "My eyes are terrible." To which Proust replied, "My poor stomach. What am I going to do? It's killing me. In fact, I must leave at once." As they left each expressed regret at not having read the work of the other. But Proust tried to enliven the conversation by asking Joyce if he liked truffles. To which Joyce replied, "Yes, I do."

Joyce's failing eyesight and the twenty-five eye operations that left him blind for periods had a self-confining effect like Proust's asthma. Proust's divided Franco-Jewish self had its counterpart in the self-exile of Joyce, whose life was a web of paradox. Never living in Ireland after his twenty-second year, Joyce remained passionately Irish. He explained to his publisher that his purpose in *The Dubliners* was "to write a chapter of the moral history of my country and I chose Dublin for the scene because that city

seemed to me the centre of paralysis." The city became his Mediterranean. From his birth he was entangled with the issue of Irish independence. His father, John, a passionate follower of the firebrand Charles Stewart Parnell (1846–1891), had made a living as one of Parnell's election agents, then enjoyed his reward as a well-paid collector of taxes for Dublin, where Joyce was born in 1882.

Joyce's first known writing was a poem at the age of nine attacking Parnell's opponents. And his family's fortunes fell with those of Parnell, in melodramatic decline when he was accused of terrorist murders in Phoenix Park (which Parnell's men had not committed) and when Parnell was named corespondent in the divorce suit of a fellow Home Rule politician. John Joyce's heavy drinking, neglect of his office, and habit of dipping into money from the taxpayers' till were enough reason for his dismissal from his remunerative post. The family naturally charged up their misfortunes to the enemies of Irish Home Rule. In 1891 John Joyce's family of ten children who survived infancy tumbled from prosperity to poverty. "For the second half of his long life," James's brother Stanislaus observed, "my father belonged to the class of the deserving poor, that is to say, to the class of people who richly deserve to be poor." The insecurity of the rest of James's young life left unforgettable memories of household furniture in and out of pawn, and moving about to stay one jump ahead of the bill collector.

Somehow James Joyce still had the benefit of the best Irish schools. At six he briefly attended an elite Jesuit boarding school until his family could no longer pay the fees. For two years after 1891 he stayed home under his mother's tutelage, then in 1893 both brothers were admitted tuition-free to a Jesuit grammar school in Dublin. Then on to another Jesuit institution, University College, Dublin, where Joyce pursued languages and made his first literary sallies. Admiring the Norwegian playwright Henrik Ibsen (1828–1906), at the age of eighteen he published (1900) a review of *When We Dead Awaken* (1899), where he contrasted "literature" that dealt with the temporary and the unique with "drama" that posed the laws of human nature. "The great human comedy in which each has share, gives limitless scope to the true artist, today as yesterday and as in years gone." *Lohengrin* "is not an Antwerp legend but a world drama. *Ghosts,* the action of which passes in a common parlour, is of universal import." To read Ibsen in the original, he studied Dano-Norwegian.

A message from Ibsen himself thanking him for his "benevolent" review made him ecstatic. In a letter congratulating Ibsen on his seventy-third birthday in 1901, Joyce confessed:

> But we always keep the dearest things to ourselves. I did not tell *them* what bound me closest to you. I did not say how what I could discern dimly of your

life was my pride to see, how your battles inspired me—not the obvious material battles but those that were fought and won behind your forehead—how your wilful resolution to wrest the secret from life gave me heart, and how in your absolute indifference to public canons of art, friends and shibboleths you walked in the light of your inward heroism.

The catalytic role that Ruskin, fixing the universal past in stone, played for Proust, Ibsen played for Joyce, helping him find the universal in the everyday. University College mates were more impressed by the twelve guineas that the *Fortnightly Review* (April 1, 1900) paid Joyce for his piece.

On receiving his B.A. degree with second class honors in Latin from University College, Dublin, he went to Paris, where he toyed with the idea of studying medicine. Lacking both the academic qualifications and the tuition fees, he quickly returned to literature, supported by small sums from his mother. Coming back to his dying mother in Dublin in 1904, he sold to a farmers' magazine (for one pound each) three of the stories that would later go into *The Dubliners*. On June 16, 1904 (destined to be known in literary history as Bloomsday) he fell in love with Nora Barnacle, whom he had met only four days before. Though Joyce refused to go through a marriage ceremony, they left together for the Continent in October. He would never again live in Ireland. First he tried teaching in the Berlitz School in Pola, near Venice, before he and Nora moved to Trieste, where their two children were born. They were joined by his brother Stanislaus. There Joyce taught English to businessmen. Then on to a brief distasteful stint in a bank in Rome. He visited Ireland briefly in 1909, to try to publish *The Dubliners,* and to start a chain of Irish movie theaters, and again for the last time in 1912.

When Italy declared war in 1915, Joyce moved from Trieste to Zurich. There he remained for the duration, piecing out a living by teaching English, selling short pieces, and enjoying patronage—from the Royal Literary Fund (seventy-five pounds), from Edith Rockefeller McCormick, and from the bountiful Harriet Weaver (eventually some twenty-three thousand pounds). In 1920 Ezra Pound induced him to move to Paris, where he remained until his death in 1941. He and Nora finally went to London in 1931 to be married to satisfy his daughter. Though he made a career of writing, he never really made a good living from it, only surviving on meager fees from short pieces supplemented by patrons.

Joyce, most modern of novelists, encompassed time in autobiography, creating new ways to make the self universal. Despite his migratory life of self-exile, his writing remained rooted in Ireland. His first published work was a volume of verse, *Chamber Music* (1907), which already revealed his witty mastery of the beauty in words. And his writing had an unfolding

logic, astonishing from so vagrant an imagination. His collection of stories, *The Dubliners* (1914), offered the background for *A Portrait of the Artist as a Young Man* (1916), which was his autobiography, and *Exiles* (1918), an Ibsenesque play of emigrants returning to Dublin, which dramatized Joyce's own marriage problems. His masterpiece, *Ulysses* (1922), was a personal epic, and finally came *Finnegans Wake* (1939), intended to be an epic of all humankind. Except for short experimental pieces and brief volumes of poetry, this was his whole lifework. He showed wonderful progress from the most objective and external ever inward and toward the self, finally penetrating to a new language of consciousness. Yet as his subject matter became more self-bound and his purpose and meaning ever broader, his style grew more arcane, his language more cryptic. His way of conquering time revealed the limits of the self, the need to reach out through community. But he was finally tempted to make language into a self-regarding ornament.

He brought together the two modern literary forms, the novel and biography, as none had done before. And incidentally, in the progress of his writing he provided a summary history of modern literature—from narrative in the human comedy of *The Dubliners*, to biography-autobiography-confession in *The Portrait of the Artist*, to ruthless exploration of the self in *Ulysses*. Unsatisfied by the unique self and its experience, he found refuge in the ancient community of myth. But his self-preoccupation did not leave him alone. Finally in *Finnegans Wake* he made his very language a toy, an embellishment and labyrinth, of the self. As his works became more self-absorbed they became harder to understand and less accessible until finally they reached the outer limits of intelligibility.

The Dubliners, a collection of stories about the daily life of his city, was mostly written in Trieste in 1905. And it shows what Joyce meant when he called Dublin the center of Ireland's paralysis. Without melodrama or suspense, they reveal the everyday frustrations and disappointments of a disgraced priest, of an unconsummated love, of a compromised girl, of the electioneers for Parnell and Home Rule. This was Joyce's album of the "moral history" of his country, of the faiths of ordinary people. The final haunting story, "The Dead," he added, after his brief unhappy interlude in Rome, to fill out his portrait of Dublin. "I have not reproduced its ingenuous insularity and its hospitality, the latter 'virtue' so far as I can see does not exist elsewhere in Europe." He made the simple story of a Dublin Christmas party a parable of the rivalry between the living and the dead. His efforts to have *The Dubliners* published were a foretaste of his lifelong publishing tribulations. Publishers objected to his use of the word "bloody," his disrespectful reference to King Edward VII, and his naming of actual streets and people. First refused by a London publisher, it was taken on by

Maunsel in Dublin, who printed a whole edition. But then Maunsel decided to play safe, broke their contract, and had all (except one copy) burned.

Joyce had gone to Dublin in 1912 to hasten publication, but when Maunsel destroyed his books he resolved never to return to Ireland. And he never did. He had a Dutch printer set up a broadside that he wrote especially for this occasion to be circulated in Dublin:

> . . . But I owe a duty to Ireland
> I hold her honour in my hand,
> This lovely land that always sent
> Her writers and artists to banishment
> And in a spirit of Irish fun
> Betrayed her own leaders, one by one. . . .
> O lovely land where the shamrock grows!
> (Allow me, ladies, to blow my nose) . . .

The Dubliners was published after all in 1914 by Grant Richards of London, who had reneged eight years before. The reviews were not unfavorable, but in the first year after publication, only 379 copies were sold (120 to Joyce himself). The publisher reassured Joyce that no books were selling well in wartime.

"Why did you leave your father's house?" Leopold Bloom would ask Stephen Dedalus in *Ulysses.* To which Stephen replied, "To seek misfortune." "The Dead," as his biographer Richard Ellmann notes, was Joyce's first song of the exile that proved to be his proper element. On leaving Ireland with Nora in 1904, he had promised a great book within ten years. The year 1914 was indeed his *annus mirabilis,* on which his lifework converged—when *The Dubliners* was published, *A Portrait of the Artist as a Young Man* was substantially finished, *Exiles* was written, and *Ulysses* was begun. All were products of his residence in Trieste.

With the outbreak of the war in 1914, instead of being interned by the Austrian government Joyce was allowed to go to Zurich, which became his headquarters for the next five years. *A Portrait of the Artist* which bore at its conclusion "Dublin 1904/Trieste, 1914" was Joyce's first plunge into himself, an autobiography in the character of Stephen Dedalus of the first twenty years of his life. He recounted his infancy, his childhood, Clongowes School and the university with unprecedented fluency and candor.

The line between Stephen Dedalus's consciousness and his external experience is dissolved. After this immersion Joyce could not withdraw. His friend Herbert Gorman, who knew him when he was writing *Ulysses,* saw *A Portrait of the Artist as a Young Man* as "the coffin-lid for the emaciated corpse of the old genre of the English novel. It was a signpost pointing along

that road which led to *Ulysses* and which still stretches wide and inviting albeit stony and difficult for other novelists who would be among the outriders of our intellectual progress."

Just as Boswell opened the gates of biography by recounting the trivial idiosyncrasies of an unheroic figure, so Joyce first dramatized the fantastic resources in the consciousness of a boy. So he made a narrative art of the flow of consciousness. Its grandeur came not from significant external events nor potent antagonists, but from the inner mystery. Proust, too, had found the well of involuntary memory rich and deep in childhood. Joyce finds drama and suspense in the inner struggles of young Stephen Dedalus's discomfitures on the playground, his bewilderment before arcane Jesuit propositions, his pain at unjust punishment for his broken eyeglasses, his malaise of disbelief and of insecure belief, haunted by the terrors of hell. And his unease at hearing the priest tell him that he might have been destined for the Church. Dedalus's conversations cover death, love, art, salvation—all the topics that figure in Joyce's later works. Foreshadowing *Ulysses,* the style varies and progresses, from the familiar opening, "Once upon a time and a very good time it was there was a moocow coming down along the road, and this moocow . . . met a nicens little boy named baby tuckoo. . . ." gradually toward the mature finale:

Welcome, O life! I go to encounter for the millionth time the reality of experience and to forge in the smithy of my soul the uncreated conscience of my race.
27 April. Old father, old artificer, stand me now and ever in good stead.
Dublin 1904
Trieste 1914

In Dedalus's encounters at school and the university we meet some of Joyce's most elegant, most eloquent, and often-quoted aphorisms.

Now, at the name of the fabulous artificer, he seemed to hear the noise of dim waves and to see a winged form flying above the waves and slowly climbing the air. . . . a symbol of the artist forging anew and in his workshop out of the sluggish matter of the earth a new soaring impalpable imperishable being?

Ireland is the old sow that eats her farrow.

To live, to err, to fall, to triumph, to recreate life out of life!

The artist, like the God of the creation, remains within or behind or beyond or above his handiwork, invisible, refined out of existence, indifferent, paring his fingernails.

And even in this straightforward narrative of a boy's education, word and idea interpenetrate. Words become ideas, the self's inward product of a

blurred vision of the outer world. Not in re-creating the outer world but in making words their own world Joyce the creator imitated God.

> Words. Was it their colours? . . . No, it was not their colours: it was the poise and balance of the period itself. Did he then love the rhythmic rise and fall of words better than their associations of legend and colour? Or was it that, being as weak of sight as he was shy of mind, he drew less pleasure from the reflection of the glowing sensible world through the prism of a language many-coloured and richly storied than from the contemplation of an inner world of individual emotions mirrored perfectly in a lucid supple periodic prose?

The continuity of thought in all Joyce's writing is not surprising, for it is all autobiography. He would expand the application of his ideas from childhood and adolescent tribulations to personal epic, and on to his epic of world history. Stephen Dedalus, whose young consciousness is chronicled in *A Portrait* becomes a hero of Joyce's next book. *A Portrait* ends on April 27, 1904, and *Ulysses* picks up the autobiography in a new mode on "Bloomsday," Tuesday, June 16, 1904. During the short omitted interval, Stephen has been in Paris, until his dying mother brings him back to Dublin. And as *Ulysses* opens, Stephen is living in the Martello tower at Sandycove with his friend the medical student Buck Mulligan.

> Buck Mulligan came from the stairhead, bearing a bowl of lather on which a mirror and a razor lay crossed. A yellow dressinggown, ungirdled, was sustained gently behind him by the mild morning air. He held the bowl aloft and intoned:
> —*Introibo ad altare Dei.*
> Halted, he peered down the dark winding stairs and called up coarsely:
> —Come up, Kinch. Come up, you fearful jesuit.
> Solemnly he came forward and mounted the round gunrest. He faced about and blessed gravely thrice the tower, the surrounding country and the awakening mountains. Then, catching sight of Stephen Dedalus, he bent towards him and made rapid crosses in the air, gurgling in his throat and shaking his head.

And *Ulysses* re-creates Joyce's personal story in a new world of myth and symbol.

But why Ulysses? Joyce's reading had opened to him the world of biblical and classical myth, of Irish legend and history. At school, when his English teacher asked him to write an essay on his "favorite hero," he had chosen Ulysses. So the vagrant Ulysses must have lingered on when Joyce sought a frame for his work about 1914. By then his own experience of exile had given the most famous ancient exile a special intimacy. Back in 1906 he had thought of a work to be called *Ulysses at Dublin* (in place of *Dubliners*) recounting the ordinary day of an ordinary Mr. Hunter. And then, halfway

through *A Portrait* he began to see how *Ulysses* might provide the frame of his next book. The only competition might have been Dante's frame for his *Divine Comedy,* which had engrossed Joyce and left its mark on all his work.

"I am now writing a book," Joyce explained to his friend Frank Budgen in 1918, "based on the wanderings of Ulysses. The Odyssey, that is to say, serves me as a ground plan. Only my time is recent time and all my hero's wanderings take no more than eighteen hours." When Budgen seemed puzzled, Joyce asked him if he knew "any complete all-round character presented by any writer." Budgen ventured Goethe's Faust or Shakespeare's Hamlet. To which Joyce retorted that not these but Ulysses was his "complete man in literature." It could not be Faust. "Far from being a complete man, he isn't a man at all. Is he an old man or a young man? Where are his home and family? We don't know. And he can't be complete because he's never alone."

> No-age Faust isn't a man. But you mentioned Hamlet. Hamlet is a human being, but he is a son only. Ulysses is son to Laertes, but he is father to Telemachus, husband to Penelope, lover of Calypso, companion in arms of the Greek warriors around Troy and King of Ithaca. He was subjected to many trials, but with wisdom and courage came through them all. Don't forget that he was a war dodger who tried to evade military service by simulating madness. He might never have taken up arms and gone to Troy, but the Greek recruiting sergeant was too clever for him and, while he was ploughing the sands, placed young Telemachus in front of his plough. But once at the war the conscientious objector became a Jusqu'auboutist [bitter-ender]. When the others wanted to abandon the siege he insisted on staying till Troy should fall.

The *Odyssey* became Joyce's way of measuring his hero against "the complete man."

Later, when Joyce said he had been working hard on the book all day, Budgen asked if Joyce had been "seeking the *mot juste.*" He already had the words, Joyce said, but was seeking "the perfect order of words in the sentence. I think I have it."

> I believe I told you that my book is a modern Odyssey. Every episode in it corresponds to an adventure of Ulysses. I am now writing the *Lestrygonians* episode, which corresponds to the adventure of Ulysses with the cannibals. My hero is going to lunch. But there is a Seduction motive in the Odyssey, the cannibal king's daughter. Seduction appears in my book as women's silk petticoats hanging in a shop window. The words through which I express the effect of it on my hungry hero are: "Perfume of embraces all him assailed. With hungered flesh obscurely, he mutely craved to adore." You can see for yourself in how many different ways they might be arranged.

Joyce went on to explain that his book was also "the epic of the human body." The thoughts of the characters cannot be recounted otherwise. "If they had no body they would have no mind. . . . But I want the reader to understand always through suggestion rather than direct statement."

In his Odyssey of the eighteen hours of Bloom's and Dedalus's day Joyce combined a scrupulous verisimilitude with extravagant symbolism. He pored over maps of Dublin and made sure that his book could be read in the same length of time in which the events occurred. In 1920, writing to the critic Carlo Linati, Joyce attached a Homeric title to each chapter, along with its own hour of the day, a dominant color, a technique, a science or art, an allegorical sense, an organ of the body, and symbols. After revising the scheme in 1921, he sent it to a few critics and to Stuart Gilbert to be included in his *James Joyce's Ulysses* (1930). But when Sylvia Beach published *Ulysses* in Paris in 1922, Joyce had suppressed the Homeric tags, leaving his reader the challenging Joycean opportunity to explore for himself.

Joyce did generally follow the Homeric story of the wanderings of the heroic warrior. Homer's first four books (the Telemachcia) tell of Odysseus' son Telemachus, unhappy at home in Ithaca, then visiting the mainland for news of his father. The eight following Homeric books recount Odysseus' wanderings and adventures in the twenty years after the fall of Troy that took him from Calypso's island to the encounter of the naked hero with Nausicaa, and the legendary encounters with Polyphemus and Circe. Finally, Homer's concluding twelve books (the Nostos, or Homecoming) tell how Odysseus returns home and recovers his kingdom.

Joyce adapts this Homeric scheme to his own purposes. His first three chapters (his Telemacheia) offer a prologue of the daily life of Stephen Dedalus. When the book opens at 8:00 A.M. on Tuesday, June 16, 1904, Stephen is at home in the Martello tower in Dublin with his roommate, the medical student Buck Mulligan, and their visiting Englishman Haines. We see Stephen teaching his class at the school and the headmaster Deasy (Nestor) asking him to help secure publication of his article on the foot-and-mouth disease. En route Stephen is tempted by girls on the beach at Sandymount (Proteus). Then in Book II the other Ulysses-hero, Leopold Bloom, appears, also at 8:00 A.M. on the same day, preparing breakfast for his wife, Molly.

—Milk for the pussens, he said.
—Mrkgnao! the cat cried.
They call them stupid. They understand what we say better than we understand them. She understands all she wants to. Vindictive too. Cruel. Her nature.

Curious mice never squeal. Seem to like it. Wonder what I look like to her. Height of a tower? No, she can jump me.

—Afraid of the chickens she is, he said mockingly. Afraid of the Chookchooks. I never saw such a stupid pussens as the pussens.

—Mrkgnao! the cat said loudly.

There follow twelve chapters of everyday episodes in the life of this Jewish salesman for newspaper advertisements. These include soliciting a customer, attending a funeral, discussing politics, eating lunch, visiting the library and pubs, enjoying the sight of attractive women, celebrating the safe delivery of a baby to his acquaintance, and finally going into Dublin's brothel quarter.

These episodes are not told in the order of Odysseus wanderings, but do include counterparts to Calypso, the Lotus Eaters, the Voyage to Hades, Aeolus King of the Winds, the Lestrygonians, Scylla and Charybdis, the Wandering Rocks, the Sirens, Cyclops, Nausicaa, the Oxen of the Sun, and Circe. Joyce's final three chapters, the Homecoming (Nostos), offer counterparts of Homer's Eumaeus, Ithaca, and Penelope, as they converge the day of Stephen and Leopold. Stephen accepts Leopold's invitation to a cup of cocoa at his 7 Eccles Street home. Stephen walks off into the night, and we are left with Bloom, whose Molly ends the book with the famous stream of her consciousness.

Joyce himself explained to Linati that *Ulysses,* besides being an encyclopedic cycle of the human body, was an epic of two races, the Jews and the Irish—both historic victims on the periphery of European history. Joyce seized his opportunity, using pagan and Judeo-Christian lore to rescue them both to the center of the human stage. The headmaster Deasy put the question:

—Ireland, they say, has the honour of being the only country which never persecuted the jews. . . . And do you know why?. . . .

—Why, sir? Stephen asked, beginning to smile.

—Because she never let them in. . . .

At first it seems odd that Joyce should have chosen one of the few Chosen People to stand for Everyman. But in this way he gives his readers another opportunity "to understand through suggestion rather than direct statement." By creating Leopold Bloom as his Ulysses he showed he was not confined by autobiography.

Ulysses is the story of itself. Ingenious theological interpreters see Bloom as God the Father and Dedalus as God the Son, who must be united by the

Holy Ghost in the miracle of artistic creation. And the accounts of Bloom's bodily processes affirm the universal humanity of the story. While the chapters recounting Dedalus's day have their correspondences in the Gospels (the Last Supper, Jesus' conflict with the scribes and Pharisees, the Temptation of Jesus in the Desert), Bloom's day has its Old Testament counterparts (from Genesis to Elijah).

Dublin, a modern city-state, was providentially suited for the Joycean Odyssey. "It was . . . a happy accident," Stuart Gilbert notes, ". . . that the creator of Ulysses passed his youth in such a town as Dublin, a modern city-state, of almost Hellenic pattern, neither so small as to be merely parochial in outlook, nor so large as to lack coherency, and foster that feeling of inhuman isolation which cools the civic zeal of Londoner or New-Yorker." Joyce's confidant in Zurich in 1918, Frank Budgen, luckily for us described the process of writing *Ulysses*. "Joyce wrote the 'Wandering Rocks' with a map of Dublin before him on which were traced in red ink the paths of the Earl of Dudley and Father Conmee. He calculated to a minute the time necessary for his characters to cover a given distance of the city. . . . Not Bloom, not Stephen is here the principal personage, but Dublin itself. . . . All towns are labyrinths. . . ." While working on his chapter, Joyce bought a game called Labyrinth, which he played every evening for a time with his daughter, Lucia. From this game he cataloged the six main errors of judgment into which one might fall in seeking a way out of a maze. Just as the *Odyssey* would become a geographical authority on the Mediterranean world, so *Ulysses* would be a social geography of Dublin, with no falsifying for effect, no "vain teratology" or study of monsters.

Joyce's most celebrated literary innovation—the "stream of consciousness," unspoken soliloquy, or silent monologue—was for him no flight of fancy but a device of realism, making art follow nature. Still, he disavowed credit for its invention. In 1920, as he was completing the last episodes of *Ulysses,* he explained to Stuart Gilbert that the *monologue intérieur* had been used as a continuous form of narration by a little-known French symbolist, Édouard Dujardin (1861–1949), in his novel *Les Laurier sont coupés* (1887) some thirty years before. "The reader finds himself, from the very first line, posted within the mind of the protagonist, and it is the continuous unfolding of his thoughts which, replacing normal objective narration, depicts to us his acts and experiences." Joyce's own way of revealing, exploring, and recounting the secret sources of the self by the interior monologue was already inviting imitation even before the whole of *Ulysses* was published in book form, for parts were being published in the little magazine *The Egoist*. Joyce set the example in the stream of Molly Bloom's consciousness, the last forty pages, which he explained to Budgen:

Penelope is the clou of the book. The first sentence contains 2500 words. There are eight sentences in the episode. It begins and ends with the female word *yes.* It turns like a huge earthball slowly surely and evenly round and round spinning. Its four cardinal points being the female breasts, arse, womb and cunt, expressed by the words because, bottom, woman, yes. Though probably more obscene than any preceding fertilisable untrustworthy engaging shrewd limited prudent indifferent *Weib.* "*Ich bin das Fleisch das stets bejaht.*"

And this is how her soliloquy ended:

. . . or shall I wear red yes and how he kissed me under the Moorish wall and I thought well as well him as another and then I asked him with my eyes to ask again yes and then he asked me would I yes to say yes my mountain flower and first I put my arms around him yes and drew him down to me so he could feel my breasts all perfume yes and his heart was going like mad and yes I said yes I will Yes.

Joyce himself had arranged a public lecture by a popular French novelist, Valéry Larbaud (1881–1957), who had been "godfather" to Sylvia Beach's bookshop. Having been instructed by Joyce, Larbaud explained the Homeric correspondences and other symbolisms in the hope of making the book intelligible and persuading readers that this might be an epic for their time. Joyce seems finally to have been torn between his axiomatic desire only to "suggest" and his fear that readers would not understand.

To make his book universal, Joyce drew heavily on anthologies, handbooks, compilations, and textbooks. Critics have marveled at the prodigious learning revealed, for example, in the "Oxen of the Sun" chapter, written in the different styles of the periods of English literature in chronological order. But their authenticity comes from the fact that they are mosaics of the authors parodied, drawn from their very words found in two textbooks, Saintsbury's *History of English Prose Rhythm* and Peacock's *English Prose from Mandeville to Ruskin.* Joyce, never forgetting the self, found ways to make this progress of styles symbolize the growth of the human fetus in the womb.

Ulysses, like Joyce's other works, was focused on the act of creation in the arts. Significantly he had finally titled the first part of his autobiography, revised from his earlier *Stephen Hero,* "A Portrait of the *Artist* as a Young Man." By naming his autobiographical hero Dedalus after the "fabulous artificer" of wax wings, he depicted "a hawklike man flying sunward above the sea, a prophecy of the end he had been born to serve and had been following through the mists of childhood and boyhood, a symbol of the artist forging anew in his workshop out of the sluggish matter of the earth a new soaring impalpable imperishable being?" Like Proust, Joyce made his

work the story of its own creation. By adding Bloom he chronicled the divided self in *Ulysses*, the commonplace alien part of the artist, the Jew always in exile.

In *Ulysses* Joyce re-created the mystery of art and the universe. "Here form is content, content is form," as Samuel Beckett would say of *Finnegans Wake.* "His writing is not about something, it is something itself." And a mystery, too—realist, naturalist, symbolist, parodist, comic, epic—of countless levels, embodied and enshrouded in the Word.

Still, the cryptic depth of *Ulysses* did not faze censors across the English reading world when the book was published by Sylvia Beach's Shakespeare and Company in Paris in 1922. The authorities struggled to protect the public from the frank interior monologues and from a few taboo words. Five hundred copies of the Egoist Press London edition were burned that year by the Post Office authorities in New York, and 499 of their third printing of 500 were seized by the English customs authorities in Folkstone. But the censor's efforts eventually enlivened the Federal Law Reports with a concise and favorable review of *Ulysses* by Judge John M. Woolsey. He found it "not an easy book to read . . . brilliant and dull, intelligible and obscure by turns," but not obscene.

> Joyce has attempted—it seems to me, with astonishing success—to show how the screen of consciousness with its ever-shifting kaleidoscopic impressions carries, as it were on a plastic palimpsest, not only what is in the focus of each man's observation of the actual things about him, but also in a penumbral zone residua of past impressions, some recent and some drawn up by association from the domain of the subconscious. He shows how each of these impressions affects the life and behavior of the character which he is describing.

Eleven years after *Ulysses* first appeared in English, in that same first week of December 1933, when Americans repealed their Prohibition of alcoholic beverages, Judge Woolsey determined that Americans should no longer be prohibited from reading Joyce's "true picture of the lower middle class in a European city" and sharing Joyce's effort "to devise a new literary method for the observation and description of mankind." Although certain scenes were strong medicine for "some sensitive, though normal, persons to take . . . my considered opinion, after long reflection, is that whilst in many places the effect of 'Ulysses' on the reader undoubtedly is somewhat emetic, nowhere does it tend to be an aphrodisiac." And since there was no law against importing emetic literature, he ordered *Ulysses* to be admitted to the United States.

Where to go after *Ulysses*? There seemed no place to go, either in realistic depiction of daily life or in symbols to give art and grandeur to the trivia

of the conscious self. "I will try to express myself," Stephen Dedalus had declared, "in some mode of life or art as freely as I can and as wholly as I can, using for my defence the only arms I allow myself to use—silence, exile, and cunning." Joyce's cunning in elaborating and embroidering Everyman's self was limitless and undaunted. He had taken on the vocation of a writer but had added little to his outward experience in a world of turmoil. He spent the years of World War I under the umbrella of Swiss neutrality in Zurich writing *Ulysses*. Now at the war's end he went to Paris at the invitation of his patron and mentor Ezra Pound. With his vision confined by near-blindness, he turned deeper inward. And not merely to the resources of involuntary memory. He re-created his language into a refuge, a sanctuary, and a whole New World of the self.

Ulysses, as Judge Woolsey had certified, was surely "not an easy book to read." To one uncomprehending American reader, Joyce explained, "Only a few writers and teachers understand it. The value of the book is its new style." On other occasions he was less patient with the obtuse audience. At the end of one evening in Paris soon after *Ulysses* had been published, his melancholy at the cool reception of his book had been deepened by strong drink. As the taxi delivered him home to his door he ran up the street shouting, "I made them take it!" But a full decade would pass before he could make Englishmen or Americans "take it." In 1932 he was still trying to persuade T. S. Eliot to publish the book in London for Faber & Faber. While willing to publish episodes in his *Criterion Miscellany*, Eliot would not take on the whole book and Joyce refused to allow publication of either an abridged or an expurgated edition. "My book has a beginning, a middle, and an end," he insisted. "Which would you like to cut off?"

Meanwhile he spent himself on what he only called his "Work in Progress," which would occupy him for sixteen years from March 11, 1923, when he wrote the first two pages—"the first I have written since the final *Yes* of *Ulysses*. Having found a pen, with some difficulty I copied them out in a large handwriting on a double sheet of foolscap so I could read them." Just as *Ulysses* was the sequel (in a new mode) to *A Portrait*, so *Finnegans Wake* would be a sequel (in another new mode) to *Ulysses*. As *Ulysses* had ended with Molly and Leopold eating the same seedcake (Eve and Adam eating the "seedfruit"), now *Finnegans Wake* would begin with the Fall of Man—symbolized in the fall of the hero of the music-hall ballad, the hod carrier Finnegan, from a ladder to his "death," then his resurrection by the smell of whiskey at his wake. The new novel would incorporate and exploit many leftover ideas from the twelve kilos of notes that he had collected for *Ulysses*.

Compared with *Finnegans Wake*, *Ulysses* would be simple clarity itself. Here the admiring reader of Joyce meets his match, and is reluctantly driven to a heavy reliance on interpreters. Even the puzzled serious student

comes to feel that he is trying to understand the ground plan of an elaborate filigreed castle in a treatise by its architect written in an only partly intelligible code. Is the plan itself all there is to the castle? We know much more about how the book was made than of what it was. Does *Finnegans Wake* describe anything, or is it itself the thing? The book reminds us of an existentialist parable. A man sees a "For Sale" sign outside a house and goes up to ask the price. To which the occupant replies, "Only the sign is for sale!" Does *Finnegans Wake* tell us about anything beyond itself?

It is one of those books, Anthony Burgess reminds us, "admired more often than read, when read rarely read through to the end, when read through to the end not often fully, or even partially understood." Burgess has dared help us with *A Shorter Finnegans Wake.* Other intrepid critics, Joseph Campbell and Henry Morton Robinson, "Provoked by the sheer magnitude of the work . . . felt that if Joyce had spent eighteen years in its composition we might profitably spend a few deciphering it." Why has so eloquent and lucid a writer as Joyce spent his energies teasing us with a book of colossal proportions, of 628 dense often-unparagraphed pages, with its puzzling plenitude of invented words, multiple puns, and onomatopoetic inventions? Is it inconceivable that this master of the comic may have launched the biggest literary hoax of history? But generations of readers still assume that it is they and not the author who is amiss.

Whatever else it is, the book is the *ne plus ultra* of the literature of the self. Perhaps at this dead end the book is something only the author (and he only partially) can understand.

What was it about? "It's hard to say," Joyce told a sculptor friend, August Suter, in 1923. "It is like a mountain that I tunnel into from every direction, but I don't know what I will find." He had already christened it "Finnegans Wake," omitting the apostrophe because it was about both the death of Finnegan and the revival of all Finnegans (Finn-again).

In another time sense, too, it was a sequel to *Ulysses.* As *Ulysses* was a day book, he had already decided that *Finnegan* would be a night book, with its own special language. "I'm at the end of English" (*Je suis au bout de l'anglais*), he confessed. "I have to put the language to sleep."

> In writing of the night, I really could not, I felt I could not, use words in their ordinary connections. Used that way they do not express how things are in the night, in the different stages—conscious, then semi-conscious, then unconscious. I found that it could not be done with words in their ordinary relations and connections. When morning comes of course everything will be clear again. . . . I'll give them back their English language. I'm not destroying it for good.

When someone objected to his puns, Joyce replied, "The Holy Roman Catholic Apostolic Church was built on a pun. It ought to be good enough

for me." ("Thou art *Peter,* and upon this *rock* I will build my church." Matthew 16:18). And as for triviality, "Some of the means I use are trivial—and some are quadrivial." *Finnegan* was to make his quadrivial dimension the world of dreams.

The theme of this night story was the whole history of the human race. "Art is the cry of despair," Arnold Schoenberg observed in 1910, "of those who experience in themselves the fate of all mankind." And a night story it should be, for Stephen Dedalus had explained in *Ulysses* that "History is a nightmare from which I am trying to awake." Though Joyce's history was veiled in myth and in his private language of sleep, *Finnegans Wake* was still a story designed to be everybody's—of the fall and resurrection of mankind. The comical fall of Finnegan with which the book begins is only a prologue to the entry of the hero, a stuttering Anglican Dublin tavern-keeper, HCE—Humphrey Chimpden Earwicker, or Here Comes Everybody, or Haveth Childers Everywhere. A candidate in a local election, HCE had once reputedly committed an exhibitionist act (Original Sin?) in Phoenix Park before two girls. This memory and rumor never cease to dog him, and he is also cursed by an incestuous passion for his daughter. After several bouts of gossip, of changing winds of public opinion, and trivial misadventures, HCE is arrested for disturbing the peace, which seems to express his own obsessive guilt.

Earwicker's wife, Anna Livia Plurabelle (ALP), is the woman of many forms—Eve, the mother at the Wake, the River Liffey which changes from the nymphlike brook in the Wicklow Hills to the drab filthy scrubwoman river that drains the city of Dublin in its circular course into the Ocean, then up into mists to fall in mountain rains to refresh the brook again. And we hear Anna Livia's complaints of those who soil her currents:

Yes, I know go on. Wash quit and don't be dabbling. Tuck up your sleeves and loosen your talktapes. And don't butt me—hike!—when you bend. Or whatever it was they threed to make out he thried to two in the Fiendish park. He's an awful old reppe. Look at the shirt of him! Look at the dirt of it! He has all my water black on me. And it steeping and stuping since this time last wik. How many goes is it I wonder I washed it?

The reader ceases to be puzzled, and simply wonders at Joyce's bardic music when he hears Joyce's recorded voice reading the liquid words of Anna Livia Plurabelle.

Their twin sons were curiously modeled on two feeble-minded brothers whom Joyce had known in Dublin. "Shem the Penman" (Jerry: the artist, man of thought, explorer of the forbidden) and "Shaun the Postman" (Kevin: the practical political man of action) reveal again the eternal con-

flict between the Bloom side and the Dedalus side of Everyman in all history. All this is in mythic tales of flesh-eating and stories like "The Ondt and the Gracehoper." Their conflict is finally resolved in the reunion of their father, HCE (from whom their two natures originated), with their all-embracing mother, ALP, in a diamond wedding anniversary.

But the story is not as easy to follow as the ordinariness of the intelligible characters would suggest. Joyce himself gives us a clue in the opening words of the book:

> riverrun, past Eve and Adam's, from swerve of shore to bend of bay, brings us by a commodious vicus of recirculation back to Howth Castle and Environs.

These first words are meant to complete the incomplete sentence that concludes the book:

> A way a lone a last a loved a long the

Like all Joyce's clarifying symbols, this has a cryptic iridescence. By opening with a small letter, he declares the cyclical, circular character of experience, and "vicus," the Latin form of the Italian name Vico, identifies the scheme of the whole book with the mythic philosophy of history of Giambattista Vico (1668–1744).

Vico's scheme of history described each community rising from the "bestial" and passing through three stages: the Age of Religion and the Gods, the Age of Heroes celebrated in poetry and ruled by custom, and the Age of the Peoples expressed in prose and ruled by laws. The last stage results in anarchy, and the return to relive the cycle (*corso*).

It is surprising that Joyce should have turned from poetry to philosophy, from Homer to Vico, for the frame of his final work. But in an age when the arts were turning inward, exploring and re-creating the self, it is not surprising that he chose Vico, sometimes called the first modern historian. While others had seen history as the chronicle of men and events or the unfolding of a divine providence, for Vico history was a saga of the human consciousness, of man's different ways of seeing himself. Against Descartes's view of history as the unfolding of reason, which was the same in all ages, and of man's encounter with nature, Vico focused instead on the self. Man, he said, was capable of understanding only what he could create. Since man had created culture, he could understand it, could observe the universal stages in his consciousness, reflected in the institutions of his making. Vico's *New Science* was a science of the stages and cycles of human consciousness. Joyce used Vico's scheme to fold the whole history of the race into *Finnegans Wake*. For Vico, like Joyce, gave primacy to language

and myth and justified Joyce's re-creating the language as the sanctuary of the self.

So, in his own way, Joyce accomplished what Gertrude Stein, also in Paris, hoped for—to be "alone with English," but with his own re-created English. Joyce's *Finnegans Wake* was a letter to himself that neither the writer nor the recipient fully understood—"that letter selfpenned to one's other, that neverperfect everplanned." It is not surprising, either, that it would entice and frustrate generations of interpreters.

Finnegans Wake was his "essay in permanence," still another Joycean way of conquering Time. "A huge time-capsule," Campbell and Robinson, his pioneer interpreters, explain. "The book is a kind of terminal moraine in which lie buried all the myths, programs, slogans, hopes, prayers, tools, educational theories, and theological bric-a-brac of the past millennium." Yet this miscellany of the past revealed a universal pattern of repetitive recurrence, Joyce's way of denying time.

Joyce's ultimate accomplishment in symbolism was to make his final book almost as unintelligible as the whole mysterious universe. *Finnegans Wake,* Joyce himself confessed, was addressed to "that ideal reader suffering from the ideal insomnia." Knowledgeable interpreters call it "one of the white elephants of literature"—"notoriously the most obscure book ever written by a major writer; at least, by one who was believed not to be out of his mind." Yet the riddle of *Finnegans Wake* reflected no obscurity or confusion in the author. It re-created the language with unfathomed possibilities. And when Murray Gell-Mann in 1964 needed a name for the newly discovered ultimate particle of matter and found that there were three of them in the proton and the neutron, he recalled from *Finnegans Wake* the exclamation, "Three quarks for Muster Mark!" So Joyce's ultimately unintelligible language provided the name for the ultimately intelligible particle of matter.

Asked why he had written the book as he had, Joyce mischievously answered, not in apology but as a boast, "To keep the critics busy for three hundred years." Perhaps Joyce shared Einstein's wonder that "the eternal mystery of the world is its comprehensibility." Joyce's final "extravagant excursion into forbidden territory" made the language of the self an invitation to rediscover and delight in the mystery.

"I Too Am Here!"

BESIDE the Mystery of Time, with its staccatos and its continuities, there is the Mystery of Woman. Virginia Woolf's novels of consciousness let us share her wonder at the feminine self. Sometimes she can take refuge from time in the instantaneity of her "moments of being," which fill her writer's diary. Or she can follow the self through time—for centuries in *Orlando,* years in *To the Lighthouse,* and hours in *Mrs. Dalloway.* But for her there is no refuge from being a woman. She writes a great deal about women writers and their inhibitions in the England of her day, their endless "confinements" in pregnancy, their deprivation of education to play "the Angel in the House." She knows there is a unique feminine perception, but its definition eludes her. A woman needs *A Room of One's Own* (1929) to make her free. "In fact, as a woman, I have no country. As a woman I want no country. As a woman my country is the whole world."

Virginia Woolf's feat was finding, like Joyce, so many different ways to reveal "the flickerings of that innermost flame which flashes its messages through the brain." Called a pioneer of the "stream of consciousness," she was properly a pioneer of *streams* of consciousness. Proust and Joyce created their great works around one master consciousness. But each of Virginia Woolf's novels is a new experiment with the self. Unlike Proust or Joyce, she produced no copious masterpiece but numerous cogent experiments. Unlike Dickens or Balzac, who created new vistas of experience, she was concerned not with narrative but with reflection. Nor did she seem impoverished by her lack of experience. Any country house could be her Dublin.

Women had not the raw materials in their own lives for chronicles of worldly conflict and adventure, of struggles for wealth and power. The few who enriched English literature in the eighteenth and nineteenth centuries, when women were becoming an increasing part of the reading public, had the talent to embroider their limited experience.

Jane Austen (1775–1817), whose stature has increased with the years, led an uneventful life on the English countryside in her father's parsonage and in the Hampshire cottage to which the family retired. As she grew up she suffered no Dickensian poverty, nor did she witness the troubled city scene. Her family life was a caricature of the respectable literate middle class, with the six boys and two girls being inducted into literature by their father. While she never married, she seems to have had suitors, and her novels explored the provincial quests for propertied husbands for marriageable daughters. She made a human comedy of provincial manners. In her forty-two years, with *Pride and Prejudice* (1813), *Emma* (1816), and other novels, she earned a secure place in English literature. The most dramatic event in Jane Austen's own life was accepting the offer of marriage by the heir of a neighboring Hampshire family, then changing her mind overnight to refuse him after all.

Women were not to expose themselves to public view as authors, and in her lifetime her name never appeared on the title page of her works. Only after her death was her authorship publicly noted. Other women authors, such as Charlotte and Anne Brontë, sought the cover of a male pseudonym to avoid the condescension reserved for female authors. And Mary Ann Evans adopted the male nom de plume of George Eliot. The young Brontë sisters took refuge in the fairy-tale kingdoms of Angria and Gondal. Mrs. Radcliffe's *Mysteries of Udolpho* and Mrs. Shelley's *Frankenstein* and other Gothic novels sought escape from feminine confinements in tales of fear and fantasy.

The conspicuous disproportion until recently between the numbers of male and female authors reflected the narrowness of women's lives. Women wrote about what they were allowed to know about—the manners they witnessed in country houses, the follies and ironies of the marriage market. Or they reacted into exotic imaginings of horror. Ironically, English women writers of the early nineteenth century who were still conventionally confined by female proprieties became pioneers of realism in the modern novel. They made their own way. Sir Walter Scott acclaimed the "nameless author" of Jane Austen's *Emma* as a prophet of modern realism, and praised her "exquisite touch which renders commonplace things and characters interesting." Charlotte Brontë's *Jane Eyre* (1847) was censured for dealing too freely with subjects not proper for young ladies even to read about. Then there was the scent of scandal because she was rumored to have had an affair with Thackeray, to whom the second edition of *Jane Eyre* was dedicated. Like the hero of the book, Thackeray also had an insane wife. George Eliot (1819–1880), sometimes called the first practitioner of psychological realism in the English novel, defied convention by living with G. H. Lewes, a married man. And Virginia Woolf praised *Middlemarch* (1871–72) as "one of the few English novels written for grown-up people."

Important women novelists in the English language suddenly increased in the twentieth century. The "women's movement" was bearing fruit. Also the inward resources of the self had finally become the novelists' raw material. For these explorations, women needed no male passport. Women writers then pioneered in novels of the self, which liberated literary women from the private audience of their diaries and letters.

"I too am here!" Jane Welsh Carlyle (1801–1866) wrote plaintively to her friend John Sterling on June 15, 1835. The problems of literary women were eloquently revealed in her life. She had married the domineering Thomas Carlyle—"a warm true heart to love me, a towering intellect to command me, and a spirit of fire to be the guiding star—light of my life." Jane Welsh's uncommon literary talent was revealed in her letters, which survived. A letter directed expressly to her, she explained:

> . . . was sure to give me a livelier pleasure, than any number of sheets in which I had but a secondary interest. For in spite of the honestest efforts to annihilate my I-ity, but merge it in what the world doubtless considers my better half; I still find myself a self-subsisting and alas! self-seeking *me*. Little Felix, in the Wander-jahre [of Goethe], when, in the midst of an animated scene between Wilhelm and Theresa, he pulls Theresa's gown, and calls out, "Mama Theresa I too am here!" only speaks out, with the charming truthfulness of a child, what I am perpetually feeling, tho' too sophisticated to pull people's skirts, or exclaim in so many words; Mr. Sterling "I too am here."

While she dared not compete with the "towering intellect" of her husband in the public literary form, the letter was perfect for her, as it had served frustrated literary women for centuries. Whenever she and Carlyle were separated she sent him a daily letter, "which must be written dead or alive," and she expected the same from him. When he once apologized for the length of a letter, she replied, "Don't mind length, at least only write longly about yourself. The cocks that awake you; everything of that sort is very interesting. I hasten over the cleverest descriptions of extraneous people and things, to find something 'all about yourself, all to myself.' "

After Jane Welsh Carlyle nearly a century passed before Virginia Woolf (1882–1941) made the novel her versatile medium for exploring the self. The even tenor of her life, as lacking in worldly adventures as that of Jane Austen or Franz Kafka, forced her to wreak her literary talent on herself as her raw material. She wrote of the world within her, which she imagined also to be within others.

She was born in London in 1882 into a numerous family dominated by her father, Sir Leslie Stephen. A leading intellectual and editor of the monumental *Dictionary of National Biography,* to which he contributed

some four hundred articles, he gave her "the free run of a large and quite unexpurgated library." Her father's first wife was Thackeray's daughter, her godfather was the poet James Russell Lowell, then American minister to England, and she was tutored in Greek by Walter Pater's sister. The eminent Victorians, one way or another, swam into her sedentary bookish ken. She longed for the life of the university that her brothers had enjoyed at Cambridge, but which her sex had denied her. She and her sister, Vanessa, were allowed to spend only the mornings studying Greek or drawing, but afternoons and evenings had to be given to proper womanly activities—looking after the house, presiding at tea, or being agreeable to other people's guests. To brother Thoby at Cambridge she wrote:

> I dont get anybody to argue with me now, & feel the want. I have to delve from books, painfully all alone, what you get every evening sitting over your fire smoking your pipe with [Lytton] Strachey, etc. No wonder my knowledge is but scant. Theres nothing like talk as an educator I'm sure. Still I try my best with Shakespeare. I read Sidney Lee's life. . . .

She never lost her sense of being ill-educated, which she blamed on the feminine stereotype.

Her evenings out remained a painful memory. For example, when she accompanied her half brother George Duckworth and Lady Carnarvon to dinner and theater, she made the terrible mistake, as they talked of art, of asking Lady Carnarvon if she had read Plato. If she had, Lady Carnarvon said, she surely would remember it. Virginia's question had spoiled the evening and appalled George, for Plato could lead to subjects unsuitable for a young lady to think about, much less discuss in public. He reminded her that "they're not used to young women saying *anything.*"

But George showed less respect for the proprieties in his brazen sexual advances to his two half sisters, which they found impossible to repulse. He tried to smother their pain and disgust with ostentatious courtesies, presents, and invitations to parties and excursions, but Virginia and Vanessa freely expressed their venomous detestation of him to the puzzlement of friends. Virginia's first distasteful experience of sex and of child abuse, from her sixth year, affected her profoundly. "I still shiver with shame," she wrote in the last year of her life, "at the memory of my half brother." She was also abused by her other half brother, Gerald Duckworth. There is no evidence that Virginia was sexually abused by her father, but he did nothing to protect her. Victorian modest reticence and her mother's insensitivity prevented her seeking protection. Her recurrent "madness" may have been a reaction to these traumatic childhood experiences.

She had a number of passionate and sometimes troubling love affairs with

women, not only with Vita Sackville-West, whom she admired. Being hotly
pursued in 1930 by the aging Ethel Smyth (who sometimes wrote her twice
a day) she found less pleasant, for Ethel blew her red nose in her table
napkin, and her table manners were repulsive. "It is at once hideous and
horrid and melancholy-sad. It is like being caught by a giant crab." In her
letters Virginia casually refers to her own frigidity and wonders why people
"make a fuss about marriage & copulation?" She never had children, pre-
sumably on her doctor's advice, but there may have been other reasons.
"Never pretend," she wrote in 1923, "that the things you haven't got are
not worth having. . . . Never pretend that children, for instance, can be
replaced by other things." Still, her unsavory childhood experiences with
George may also have nourished her willingness to rebel against the male-
dominated literary world.

To be the writer she wanted to be, she recalled in 1931, she had to conquer
a "phantom" hovering over her:

> And the phantom was a woman, and when I came to know her better I called
> her after the heroine of a famous poem [by Coventry Patmore (1823–1896)]. The
> Angel in the House . . . It was she who bothered me and wasted my time and
> so tormented me that at last I killed her. You who come of a younger and happier
> generation may not have heard of her. . . . She was intensely sympathetic. She
> was immensely charming. She was utterly unselfish. She excelled in the difficult
> arts of family life. She sacrificed herself daily. If there was chicken, she took the
> leg; if there was a draught she sat in it— in short she was so constituted that she
> never had a mind or a wish of her own, but preferred to sympathise always with
> the minds and wishes of others. Above all—I need not say it—she was pure. Her
> purity was supposed to be her chief beauty—her blushes, her great grace. . . . And
> when I came to write I encountered her with the very first words. The shadow
> of her wings fell on my page; I heard the rustling of her skirts in the room.

Having killed the Angel in the House, what was the woman writer to do?
She need only be herself! "Ah, but what is 'herself'? I mean, what is a
woman? I assure you, I do not know. . . . I do not believe that anybody can
know until she has expressed herself in all the arts and professions open to
human skill."

Despite the world's inhibitions Virginia Woolf found in herself the re-
source for her creations. Her birth, her father's "unexpurgated" library, her
female loves, and the circle of leading male intellectuals all helped. But she
missed the stimulus of her own generation that she might have had at the
university, even as she observed the galaxy of Victorian men of letters whom
her father attracted. Seeing Thomas Hardy, John Ruskin, John Morley, and
Edmund Gosse over the teacups must have cured any awe of the literary
establishment and encouraged her to make new literary connections of her

own. On her father's death in 1904, with her sister and brothers she moved to 46 Gordon Square in the Bloomsbury district of London. There they attracted a galaxy of their own generation, including Lytton Strachey, Clive Bell, Roger Fry, John Maynard Keynes, and E. M. Forster.

On Thursday evenings, guests gathered at about ten o'clock and stayed till two or three making conversation over whiskey, buns, and cocoa. The Bloomsbury Group—an anti-university of artists, critics, and writers from the universities—were notorious rebels against Victorian inhibitions in art, literature, and sex. By 1941, in wartime London the prim *Times* accused them of producing "arts unintelligible outside a Bloomsbury drawing-room, and completely at variance with those stoic virtues which the whole nation is now called upon to practise." The Cambridge philosopher G. E. Moore (1873–1958) had taught them that "by far the most valuable things . . . are . . . the pleasures of human intercourse and the enjoyment of beautiful objects . . . the rational ultimate end of social progress."

Virginia Woolf became the presiding genius of the group. Among them everything was discussable and seems to have been discussed, including whom Virginia should marry. Dismissing other possibilities, she married Leonard Woolf, whom she described as "a penniless Jew." At Cambridge he, too, had been a follower of G. E. Moore and a member of the elite Apostles. Woolf had entered the colonial civil service and served in Ceylon for eight years before marrying Virginia in 1912. They had no children, but otherwise this proved an idyllic match, with their shared passion for literature and ideas. Leonard gave up writing novels, but was a prolific editor and author of works of politics, philosophy, and memoirs. Unfailingly attentive to Virginia, he seemed eager to nurture a literary talent superior to his own. Vita Sackville-West noted Virginia's dislike of "the possessiveness and love of domination in men. In fact she dislikes the quality of masculinity."

Leonard and Virginia moved out of the Bloomsbury salon and began new collaborations. She had not yet completed her first novel at the time of their marriage. In 1917 at their house in Richmond they founded the Hogarth Press, which consumed much of their energies in following years. Their first publication was *Two Stories,* one by Leonard, one by Virginia. They aimed to publish only experimental work, which included stories by Katherine Mansfield, T. S. Eliot's *Poems* (1919), poems by Robinson Jeffers and E. A. Robinson, translations of Russian novelists, and Virginia's own works. They did the typesetting and press work themselves with the occasional help of a friend. At the insistence of Harriet Weaver, the American patron of poets, and through the good offices of T. S. Eliot, the manuscript of Joyce's *Ulysses* was submitted to them for publication. They were tempted, but found it beyond their capacities. They would have had to employ professional printers, and the ones they consulted objected that printing such a

work would surely lead to their prosecution. Virginia was especially troubled because she and Joyce were pioneering on the same paths of exploring the self. But, as her nephew and perceptive biographer explains, "it was as though the pen, her very own pen, had been seized from her hands so that someone might scrawl the word fuck on the seat of a privy." Joyce's "smoking-room coarseness" must have revived the hovering phantom of The Angel in the House.

While there were limits to Virginia's defiance of convention, her Bloomsbury Group enjoyed tweaking the establishment with pranks in the undergraduate tradition. Most notorious was their Dreadnaught Hoax on February 10, 1910, planned by Virginia's brother Adrian, to outwit the British Navy and its formidable security with a tour of the most secret vessel of the fleet. A forged telegram from the "Foreign Office" to the commander of the Home Fleet announced a visit of the "emperor of Abyssinia." The Bloomsbury company, wearing blackface and costumes of imaginary Abyssinian nobility, arrived at Weymouth, were grandly welcomed and given a steam-launch tour of the fleet. Virginia herself, as aide to the emperor, wore actors' black greasepaint, false mustache and whiskers, but found it hard not to burst out laughing when she ceremoniously shook hands with the admiral of the fleet, who happened to be her cousin. For the "Swahili" they were expected to speak, "Emperor" Adrian concocted phrases from pig Latin and half-remembered lines of Virgil. The London press had a field day, and the House of Commons discussed the matter on the floor. When the pranksters apologized to the first lord of the admiralty, he treated them as schoolboys and told them not to do it again. The press had been especially attracted to the bewhiskered young lady, "very good looking, with classical features," reputed to be in the party, and Virginia gave them her story. Naval regulations were tightened, especially on telegrams, making it hard to repeat the joke and Virginia recalled, "I am glad to think that I too have been of help to my country."

Despite her lively sense of humor Virginia's life was one long bout with "madness," a vague, emotion-laden label then attached to all sorts of mental illnesses, especially those of women. In Virginia's own circle, cases of madness were familiar. Thackeray's wife, the mother of Leslie Stephen's first wife, had been a victim. Her half-sister Stella had been pursued by a "mad" cousin. The wife of Virginia's close friend, the painter and critic Roger Fry, was said to be going mad, and had just been committed to an asylum when Virginia joined the tour of Byzantine art in Constantinople that Fry had organized in 1911. Some may have thought Fry himself should be committed for championing the works of Cézanne and others in the first Postimpressionist Exhibition in November 1910.

Virginia Woolf's first signs of mental illness, at the age of thirteen, came just after her mother died in May 1895. She had a "breakdown" that summer, when she heard "horrible voices" and became terrified of people. All her life she was haunted by fears of recurrence of her madness and of the painful treatment that she suffered. For example, in June 1910, soon after the Dreadnaught Hoax, she fell ill with the "acute nervous tension" that later afflicted her whenever she neared the end of writing a novel. For the "complete rest" that her doctor recommended, she was incarcerated in Miss Thomas's private nursing home at Burley Park, Twickenham, known as "a polite madhouse for female lunatics." There two months of penal "rest cure" kept her in bed in a darkened room, eating only "wholesome" foods, while Miss Thomas limited her letters, her reading, and her visitors. Of course she was kept from all London society. After a bad bout in 1913 Leonard feared she would throw herself from the train on their return from the country, and she did attempt suicide with a mortal dose of Veronal, from which she was barely saved by a stomach pump.

Friends wondered that with Virginia's constant threats of suicide, Leonard too did not go mad during her two years of "intermittent lunacy." In 1915 one morning at breakfast she suddenly became excited and incoherent, talking to her deceased mother, with spells of violence and screaming, ending in an attack on Leonard himself. She was taken to a nursing home, then to their new home at Hogarth House where they expected to install their printing press. Under the care of four psychiatric nurses, she gradually became lucid and rational, and by the end of 1915 was as much back to normal as she would ever be.

But she never fully recovered, and her "madness" would bring on her death. In late March 1941 Leonard had taken the despondent Virginia to Brighton to consult a doctor in whom she had confidence. Having recently finished *Between the Acts,* she wrote to her publisher saying she did not want the book to be published. On a bright cold morning she wrote two letters, one to Leonard, the other to her sister, Vanessa. She explained that she was once again hearing voices and was sure she would never recover. She would not go on spoiling Leonard's life for him. "I feel certain," she wrote Leonard, "I am going mad again. You have given me the greatest possible happiness. . . . I don't think two people could have been happier till this horrible disease came. I can't fight any longer." She took her walking stick and walked across the meadow to the River Ouse. Once before she had made an unsuccessful effort to drown herself, and this time she had taken the precaution of forcing a large stone into the pocket of her coat. As she walked into the water to her death, her regret, she had already explained to her friend Vita, was that this is "the one experience I shall never describe."

. . .

Virginia Woolf's whole experience had driven her inward. To write about the affairs of the world, the struggles for power and place, or the grand passions, she had little to go on. Her world, a friendly critic put it, was the little world of people like herself, "a small class, a dying class . . . with inherited privileges, private incomes, sheltered lives, protected sensibilities, sensitive tastes." Instead of pretending to know people whom she had never known, she accepted her limits, and explored the mystery within. She had the advantage over other pilots on the stream of consciousness of a clear critical style that helped her describe where she was going. And where her predecessors had failed to go.

She had no patience with those who only looked outward, chronicling mere externals. Her literary manifesto, "Mr. Bennett and Mrs. Brown," replied to Arnold Bennett's strictures on her for being "obsessed by details of originality and cleverness." He had insisted that "the foundation of good fiction is character-creating and nothing else." The Edwardian novelists whom she now targeted—Arnold Bennett, H. G. Wells, and John Galsworthy—"laid an enormous stress upon the fabric of things. They have given us a house in the hope that we may be able to deduce the human beings who live there." Such novelists had abandoned their mission.

> Look within and life, it seems, is very far from being "like this." Examine for a moment an ordinary mind on an ordinary day. The mind receives a myriad impressions—trivial, fantastic, evanescent, or engraved with the sharpness of steel. From all sides they come, an incessant shower of innumerable atoms . . . so that if a writer . . . could write what he chose, not what he must . . . there would be no plot, no comedy, no tragedy, no love interest or catastrophe in the accepted style, and perhaps not a single button sewn on as the Bond Street Tailors would have it. Life is not a series of gig lamps symmetrically arranged; but a luminous halo, a semi-transparent envelope surrounding us from the beginning of consciousness to the end. Is it not the task of the novelist to convey this varying, this unknown and uncircumscribed spirit, whatever aberration or complexity it may display, with as little mixture of the alien and external as possible?

James Joyce and T. S. Eliot were on a new track, but they had "no code of manners." "Their sincerity is desperate, and their courage tremendous; it is only that they do not know which to use, a fork or their fingers. Thus if you read Mr. Joyce and Mr. Eliot you will be struck by the indecency of the one, and the obscurity of the other."

After two early novels in conventional style, she began her own experiments with *Jacob's Room* (1922), about a young man killed in the World War. T. S. Eliot applauded, "you have freed yourself from any compromise between the traditional novel and your original gift." Others objected that

the book had no plot. In *Mrs. Dalloway* (1925), her first accomplished novel in the style she would bring to life, nothing momentous "happened." Its opening pages, like Molly Bloom's reflections at the end of *Ulysses,* would become a classic of "stream of consciousness." For a single day we share the consciousness of the fashionable wife of a member of Parliament as she is planning and hosting a party.

> Mrs. Dalloway said she would buy the flowers herself.
> For Lucy had her work cut out for her. The doors would be taken off their hinges; Rumpelmayer's men were coming. And then, thought Clarissa Dalloway, what a morning—fresh as if issued to children on a beach.
> What a lark! What a plunge! For so it had always seemed to her when, with a little squeak of the hinges, which she could hear now, she had burst open the French windows and plunged at Bourton into the open air. How fresh, how calm, stiller than this of course, the air was in the early morning; like the flap of a wave; the kiss of a wave. . . .

We follow her thoughts and feelings through all that June day's trivia, from her shopping for flowers to greeting the guests at the party, which ends the book.

Mrs. Dalloway's reminiscent experience recalls her encounters with a former suitor who for the last five years has been in India, flavored with gratification and regret at her chosen life. The specter of death interrupts her party with news of the suicide of a young man, a victim of wartime shell shock, who had seen "the insane truth" and hurled himself from a window. We are not led down a narrative path but only share staccato "moments of being." Constantly reminded of the mystery of time, even on a single day, we are reminded too of the elusiveness of "our self, who fish-like inhabits deep seas and plies among obscurities threading her way between the boles of giant weeds, over sun-flickered spaces and on and on into gloom, cold, deep inscrutable; suddenly she shoots to the surface and sports on the wind-wrinkled waves; that is, has a positive need to brush, scrape, kindle herself, gossiping."

To the Lighthouse (1927), reflections of quiet family holidays on an island in the Hebrides, is often considered her best work. We follow the interrelations of the consciousness of the central figure, the charming, managing Mrs. Ramsay, wife of an egocentric professor of philosophy, their eight children, and miscellaneous guests, who include a woman painter and a mawkish young academic. The first section, "The Window," fills more than half the book with "moments of being" on one summer day. The second, "Time Passes," admits the outer world by noting the death of Mrs. Ramsay and a son killed in the war, revealed in the sad abandonment of the once-cheerful holiday house.

So with the lamps all put out, the moon sunk, and a thin rain drumming on the roof a downpouring of immense darkness began. Nothing, it seemed, could survive the flood, the profusion of darkness which, creeping in at keyholes and crevices, stole round window blinds, came into bedrooms, swallowed up here a jug and basin, there a bowl of red and yellow dahlias, there the sharp edges and firm bulk of a chest of drawers. Not only was furniture confounded; there was scarcely anything left of body or mind by which one could say, "This is he" or "This is she." Sometimes a hand was raised as if to clutch something or ward off something, or somebody groaned, or somebody laughed aloud as if sharing a joke with nothingness.

The last section, "The Lighthouse," reports the painter Lily Briscoe's final success in a painting, "making of the moment something permanent." "In the midst of chaos there was shape; this eternal passing and flowing (she looked at the clouds going and the leaves shaking) was struck into stability. Life stands still here." Fulfilling Mrs. Ramsay's promise, after petty squabbles and despite Mr. Ramsay's misgivings, the remnants of the family finally reach the Lighthouse.

Having admitted time to interrupt the inward life of the Ramsay family, Virginia Woolf then plays with time as the interrupter of consciousness in *Orlando* (1928). In October 1927 she was suddenly taken by the idea, which first interested her as a dinner-table joke, of tracing the literary ancestors of her lover Vita Sackville-West. The product was "a biography beginning in the year 1500 and continuing to the present day called Orlando: Vita; only with a change about from one sex to another. I think, for a treat, I shall let myself dash this in for a week." And she explained to Vita how the idea had captured her—"my body was flooded with rapture and my brain with ideas. . . . But listen; suppose Orlando turns out to be Vita." She could think of nothing else, and wrote rapidly.

Just as *To the Lighthouse* had been fashioned of her own youth, *Orlando*, from items already noted in Virginia's diary, turned out to be an adventure in consciousness through time. A beautiful aristocratic youth from the Elizabethan court lives on until October 11, 1928, through various incarnations. As King Charles's emissary to the Court of the Sultan in Constantinople, suddenly and unaccountably—

The sound of the trumpets died away and Orlando stood stark naked. No human being, since the world began, has ever looked more ravishing. His form combined in one the strength of a man and a woman's grace. . . . Orlando had become a woman—there's no denying it. But in every other respect, Orlando remained precisely as he had been. The change of sex, though it altered their future, did nothing whatever to alter their identity. . . . Orlando herself showed no surprise at it. Many people . . . have been at great pains to prove (1) that Orlando had always been a woman. (2) that Orlando is at this moment a man. Let biologists

and psychologists determine. It is enough for us to state the simple fact; Orlando was a man till the age of thirty; when he became a woman and has remained so ever since.

But let other pens treat of sex and sexuality; we quit such odious subjects as soon as we can.

On finishing the book she had her usual spell of doubts, and thought that it too was not worth publishing.

To the Lighthouse had made her a writer whom the literati had to know, and now *Orlando,* a simple fantasy, could reach others. While the earlier book had sold less than four thousand copies in its first year, *Orlando* sold more than eight thousand in its first six months. Leonard called *Orlando* the turning point in her career, for Virginia Woolf could now support herself as a novelist.

Though tempted to write another *Orlando,* she did not take the easy path. She continued to experiment, sometimes cryptically, with streams of consciousness. *The Waves* (1931), which some call her masterpiece, is a contrived interweaving of selves—six not very extraordinary people from childhood through middle age, telling their own thoughts about themselves and others. Self-revelations are divided by passages of lyrical prose on how the rising and declining sun transforms the landscape and the waves. Again there is a haunting interruption at word of the death of a young friend in India.

She deferred to the *Orlando* audience again with *Flush* (1933), which purported to enter the animal consciousness in a biography of Elizabeth Barrett Browning's spaniel. Virginia Woolf was not a dog lover, but she liked to imagine herself as an animal—a goat, a monkey, a bird, and now a dog, and then wonder what this would have done to her self.

Her impatience with any one way of viewing the self prevented her writing a monumental book. Never so confident of the mainstream of consciousness as was Proust or Joyce, she sought the many possible streams.

. . . a novelist's chief desire is to be as unconscious as possible . . . imagine me writing a novel in a state of trance . . . a girl sitting with a pen in her hand, which for minutes and indeed for hours, she never dips into the inkpot. The image that comes to mind when I think of this girl is the image of a fisherman lying sunk in dreams on the verge of a deep lake with a rod held out over the water. She was letting her imagination sweep unchecked round every rock and cranny of the world that lies submerged in the depths of our unconscious being. Now came the experience . . . that I believe to be far commoner with women writers than with men. The line raced through the girl's fingers. Her imagination had rushed away. It had sought the pools, the depths, the dark places where the largest fish slumber. And then there was a smash. There was an explosion. There was foam and

confusion. The imagination had dashed itself against something hard. The girl was roused from her dream. . . . Men, her reason told her, would be shocked. The consciousness of what men will say of a woman who speaks the truth about her passions had roused her from her artist's state of unconsciousness.

70

Vistas from a Restless Self

FOR centuries Western vision had been confined by two ways of looking. The first was the Window—the perspective view from a single point, which the artist invited the viewer to share. The second was the ancient ideal of Beauty—the quality that "pleasurably exalts the mind or senses," and included the pretty, which pleased by grace or delicacy. A modern revolution would free our vision from these conventions.

While many artists played roles in this revolution, the heroic figure was Pablo Picasso (1881–1973), who was peculiarly qualified for such a work of liberation. Like Joyce, he was self-exiled. The son of a teacher of painting in Málaga, he never ceased to be Spanish. "The character, the vision of Picasso is like himself, it is Spanish," his close friend Gertrude Stein (1874–1946) insisted in her very own prose, "and he does not see reality as all the world sees it, so that he alone amongst the painters did not have the problem of expressing the truths that all the world can see but the truths that he alone can see and that is not the world the world recognizes as the world." After 1904 Picasso made France his home and divided his life between Paris and the South.

He created his own reasons for believing that he was exempt from the rules that governed artists. The legend that he was a child prodigy in the arts was of his own (and his adoring secretary-biographer Jaime Sabartès') making. None of the few surviving works of his childhood confirms the legend, and their scarcity even suggests that others may have been destroyed. Perhaps the fact that he was not a child prodigy encouraged him early in habits of hard work. Part of the legend was the story that at fourteen, when he applied to the Barcelona Academy of Fine Arts (La Llotja) he finished on the first day the examination drawings on which other candidates spent a month. But it appears that one day was not unusual for

finishing the required work, and the examiners had allowed only two days. Picasso later boasted that he was so precocious that he could not have taken part in an exhibition of children's drawings. "When I was their age," he romanticized, "I could draw like Raphael, but it took me a lifetime to learn to draw like them." Perhaps such fantasies were ways of saying that he saw painting not as an acquired skill but as an aspect of himself. "In my opinion to search means nothing in painting, to find is the thing." And, when at seventy-four he was being filmed at work, he admitted that he found his creative powers *"un mystère totale."*

His father, with a passion for painting pigeons, "would cut off the claws of a dead pigeon and pin them to a board in the position he wanted; then I would have to copy them very carefully until the result satisfied him." Characteristically, he liked to say that one day in 1894 his father was thoroughly satisfied with Pablo's work, "so he handed me his paint and his brush and he never painted again." But this was only another episode in his rich self-serving imagination.

Picasso painted more than enough for them both in unending variety, a rich miscellany. The range of his styles is staccato, full of interruptions, switchbacks, and even repetitions. "I don't develop," Picasso protested, "I am." His works reveal a volatile and restless self in fantastic discontinuity. His career might have shown more coherence and the succession of his styles might have been more intelligible if he had committed himself to please a particular patron, or to affirm a faith, or to sell his product or promote a program, or glorify a nation or city. But none of these was his way.

"The painter," he observed, "goes through states of fullness and evaluation. That is the whole secret of art. I go for a walk to the forest of Fontainebleau. I get 'green' indigestion. I must get rid of this sensation into a picture. Green rules it. A painter paints to unload himself of feelings and visions." He was a man, as Gertrude Stein observed, "who always has need of emptying himself, of completely emptying himself." His copious work is a product of this prodigious, unpredictable capacity for continual refilling and emptying.

By the time he reached twenty-five, in 1906, he had produced what could have been a solid lifework of more than two hundred paintings and hundreds of drawings. These included brilliant portraits (like that of Gertrude Stein) and his Blue Period, which would remain the favorite of a public put off by his later experiments. "To know all, without having learned it," said Molière, "was one of the characteristics of great artists." By now Picasso had definitively settled in Paris, enjoying the convivial artists' life in a hive of studios (affectionately christened the Bateau Lavoir [Floating Laundry]) on the slopes of Montmartre. He had already shown a peculiar indifference

to the public, and he regretted being parted from a work by the need to exhibit or sell it. Perhaps he had been soured by the reception of his early exhibitions. In one of his earliest self-portraits, after Velasquez, he had written three times on his brow "I the King" (*Yo el rey*), and he would never divide this sovereignty over himself, or await approval of what he was doing. He liked to choose those who shared his work, and it was said that he gave away more than he sold. Not till later would he enjoy tilting with dealers, playing them against one another to raise their offers. By 1901 he luckily had come to the attention of Ambroise Vollard, the dealer who had sponsored Cézanne and was a familiar of Degas, Renoir, Redon, Gauguin, and Rodin. And Vollard respected Picasso's pride by not showing his work to strangers.

In late 1906 and early 1907 Picasso made a sudden turn from the nostalgic blues and pinks and sentimental charms of acrobats and harlequins to the shocking and puzzling visions of cubism. With this movement he first lent his prodigious powers to denying the Western tradition and prepared to leave his impact on the century. But still this was only an episode in his kaleidoscopic career. For Picasso, who disliked joining groups or collaborating, even being a cubist was out of character. Though unstinting in praise of painters or poets he admired, he repeatedly said that all he could learn was how to be himself.

The great twentieth-century revolution against linear perspective, cubism was a product of many influences—trends in science and mathematics, African sculpture, the personal experiments of Cézanne, Henri Rousseau, Seurat and others, the enthusiasms of poet-critics like Appollinaire and dealers like Daniel-Henry Kahnweiler. Though emphatically not a "joiner," when Picasso caught the new vision he went headlong. And his collaboration with Georges Braque (1882–1963) in creating cubism became so intimate that sometimes each could not distinguish his own work from that of the other. The fruitful but unlikely partnership came to an abrupt end when Braque went off to war in 1914.

"Cubism," like names for other schools of modern painting, began in derision. In 1908, when Braque's paintings were being hung for exhibition, a critic exclaimed, "Still more cubes! Enough of cubism!" (*Encore des cubes! Assez de cubisme!*). What really distinguished the cubists was not the use of "cubes" but the rejection of the traditional Western single-point-of-view perspective. Instead they offered ways of showing simultaneously in two dimensions varied planes of the same subject. For the familiar linear perspective they substituted a many-viewpoint perspective. For the illusion of space they substituted a subjective geometry. For the tradition of God's mathematics in diffusing his truth that the artist could only imitate, the

cubist substituted varied forms and complexes of planes that the artist created from what was seen. From capturing space it was a movement toward capturing time—not a single-point, but a single-moment perspective. How many aspects could be visible in a moment?

Before 1912, in "analytical cubism," Picasso luxuriated in complexes of planes, in works like his *Woman with a Book* (1909) or *Girl with a Mandolin* (1910). Then "synthetic cubism" showed flat, abstract colored shapes, familiar in his *Still Life with Guitar* (1913) and his *Card Player* (1913–14), and moved into collages and constructions of metal, wire, paper, and wood. Now liberated from the need to deceive by capturing the illusion of three-dimensional space, the artist turned inward. Whatever shapes and planes were suggested to him by the object out there, he now shared with a viewer of his painting. Linear perspective had offered a prescription for everybody, but Cubism was a unique prescription for each artist and each subject.

Why Picasso at this moment came to Cubism would remain as much a mystery as all his other experiments. But we have some clues to the *how*. In 1905 a group of young painters—Vlaminck, Derain, and others, led by Matisse—exhibited in the Autumn Salon in Paris using bright pure colors in whimsical outlines and flat patterns, suggested by nature but not following nature. Entranced by color and form, they did not worry over congruence with what everybody saw out there. Because of their disregard for natural forms and their taste for bold colors, they were derisively christened the Fauves (French for "wild beasts," or "savages"). Encouraged and inspired by African and other exotic sculpture, they too declared independence from nature, and from the Western perspective tradition. Picasso met Matisse (1869–1954) in late 1906, and would remain a close admirer and competitor until Matisse's death. In 1906 the Fauves offered another exhibition, again led by Matisse. While Picasso did not join the Fauves he seemed stirred to newly independent experiments of his own. In 1906 Matisse had begun a large canvas of nudes in a landscape that he called *Le Bonheur de Vivre,* exhibited in 1907. Some critics would call this the first "major masterpiece" of painting in the twentieth century. And in the same year there was a great memorial exhibit of fifty-six of the paintings of Cézanne (1839–1906).

The competitive Picasso seems to have taken these as a challenge. By now he had produced a torrent of paintings that might have been the work of a half-dozen quite different artists. The sculptural archaic solidity of his *Two Nudes* (1906), unlike the paintings of his Blue and Pink periods, had begun to show his defiance of the traditions of pictorial prettiness. Vollard had bought most of his Pink pictures and for the first time relieved him of the pressures of poverty. As recently as 1902 he had confined his energies to drawing because he did not have the money to buy canvas. Now he could more comfortably experiment in new directions without having to stint.

Picasso's next large work, *Les Demoiselles d'Avignon* (now in the Mu-

seum of Modern Art in New York), would mark an epoch in Western painting. In an art that had long served Western culture as an alternative to literacy, carrying a plainer message than words, this painting produced in the untutored viewer a response of shock, dismay, and puzzlement. It revealed a revolution from the art of the common experience seen through a window to the art of the artist's unique self. Hardly reminiscent of other great paintings, it was not pretty. Originally called *The Brothel of Avignon,* after the street of brothels in Barcelona near the shops where Picasso bought his paper and watercolors, it shocked his friends by the resemblance of one of these figures to a grandmother of his friend Max Jacob, who came from Avignon, while another resembled his current mistress, Fernande Olivier. A less puzzling title would have been inappropriate.

In Picasso's months of reflection and experiment and in a score of his composition sketches and dozens of figure studies, critics have found clues to the influences of El Greco and Cézanne, of ancient Egypt, of African Negro masks from the French Congo, among others. *Les Demoiselles d'Avignon* was painted mostly in the spring of 1907. Picasso continued painting "postscripts" to these figures long after the painting was finished and exhibited.

What had emerged after these months of experiment was a canvas in oil about eight feet square of five static female figures, four standing and one seated. Unlike his recent archaic heavy nudes, here were no natural curves but straight lines and flat planes. The work was startling rather than pleasing. There were archaic features—profile noses on frontal faces and frontal eyes on profile faces. The two figures on the right, one squat and awkward, differed from the others in their sharper angles and planes. With touches of blue background the work as a whole was predominantly in light brown, pinks, terra cottas, and orange.

The response even from friends was almost unanimously hostile. Artist friends were offended by what seemed an unpleasant practical joke, but simply laughed. Some saw an effort to ridicule their modern movement. The outraged Matisse swore he would find some way to get back at Picasso. "It is as though we were supposed to exchange our usual diet for one of tow and paraffin," exploded Braque. "What a loss to French Art!" an influential Russian collector agreed. His friend and patron Leo Stein called it "Godalmighty rubbish!" When one critic said it showed that Picasso should devote himself to caricature, Picasso agreed that all good portraits were somehow caricatures. One sympathetic voice was the young Kahnweiler, who had just given up a promising financial career for the volatile Paris art market. He greeted *Les Demoiselles* with enthusiasm:

> This is the beginning of Cubism, the first upsurge, a desperate titanic clash with all of the problems at once. These problems were the basic tasks of painting: to

represent three dimensions and color on a flat surface, and to comprehend them in the unity of that surface. . . . Not the simulation of form by chiaroscuro, but the depiction of the three dimensional through drawing on a flat surface. No pleasant "composition" but uncompromising, organically articulated structure. . . . His innermost being creates the beauty; the external appearance of the work of art, however, is the product of the time in which it is created.

Kahnweiler became Picasso's dealer. Perhaps the *Demoiselles* explained Henri Rousseau's cryptic compliment in November 1908, "Picasso, you and I are the greatest painters of our time, you in the Egyptian style, I in the Modern!"

This painting, Picasso's most influential single work, shocked less by its "Egyptian" mannerism than by its refusal to be bound into a tradition, even into any clear course of personal "development." "In the old days," Picasso said, "pictures went forward toward completion by stages. Every day brought something new. A picture used to be a sum of additions. In my case a picture is a sum of destructions." The poet Apollinaire (1880–1918) had already admired Picasso, as the artist whom "everything enchants," with an "undeniable talent . . . to serve an imagination in which the delightful and the horrible, the low and the delicate, are proportionately mingled." Now the *Demoiselles* helped Apollinaire define the two kinds of artists— those whose works were somehow "prolongations of nature, and their works do not pass through the intellect" and those like Picasso who "must draw everything from within themselves . . . (and) live in solitude." The *Demoiselles* revealed Picasso's struggle within himself and his fantastic metamorphosis into an artist of the inner self.

His friends worried over the loneliness that Picasso had created for himself. Derain feared that "one day we shall find Pablo has hanged himself behind his great canvas." But Picasso had created a realm where the self reigned comfortably supreme. The larger outside world was not his concern. Memory played a new, more intimate role in the painter's work—not the academic or public memory that recalled noble or historic or literary or mythical or religious events. Now any object in the studio or café acquired dignity by digestion in the painter's self. So he exploited the objects in his studio—pipes, bowls, bottles, guitars, fruit, pieces of newspaper, along with an occasional human figure. This "fourth dimension," Apollinaire explained, was vaguely related to new scientific ideas springing "from the three known dimensions . . . the immensity of space eternalizing itself in all directions at any given moment. It is space itself, the dimension of the infinite; the fourth dimension endows objects with plasticity." All power to the painter's self! "When we invented Cubism," Picasso recalled in 1935, "we had no intention of inventing Cubism. We wanted simply to express

what was in us." The shrewd Gertrude Stein saw sources of Picasso's cubism in the landscape and architecture of his Spain, where architecture always cuts the lines of landscape, "and that is the basis of Cubism."

What emerged was nothing anyone had seen before. It was not out there to see, but *in here*. Apollinaire, the first known to use "cubism" to name the movement in print, and one of their most intimate critics in 1912, described this "art of painting original arrangements composed of elements borrowed from conceived reality rather than from the reality of the vision. Everyone has a sense of this interior reality." And he explained, "Cubism differs from the old schools of painting in that it aims, not at an art of imitation, but at an art of conception, which tends to rise to the height of creation. In representing conceptualized reality or creative reality, the painter can give the effect of three dimensions."

For Western art, cubism was a way station in new directions, but for Picasso it was only a temporary stopping point in unpredictable directions. While Picasso was a prophet of cubism and its occasional practitioner, he still disliked identification with "movements." Once later he did allow others to identify him with an artist group. This time he was not creator of the new style but was adopted as one of its unconscious creators. After World War I, some European artists yearned for the security of tradition. "Back to Raphael, Poussin, Ingres!" Picasso seemed to respond, not by ceasing to paint cubist pictures but by a prodigious neoclassical output, which still satisfies conventional Western tastes. The early 1920s produced some of his most impressive and durable work of both kinds.

The next movement that dominated adventurous Western artists and Picasso's friends would be called "surrealism," a name invented in 1917 by Apollinaire especially for the works of Marc Chagall. The French poet André Breton (1896–1966) defined the movement in 1924 as "Pure psychic automatism . . . Thought's dictation, in the absence of all control exercised by the reason and outside all aesthetic or moral preoccupations." "I believe in the future transmutation of those two seemingly contradictory states, dream and reality, into a sort of absolute reality, of surreality." Surrealists resolved "to render powerless that hatred of the marvelous. . . . The marvelous is always beautiful, anything that is marvelous is beautiful; indeed, nothing but the marvelous is beautiful." The "marvelous" works of Hans Arp, Max Ernst, Salvador Dalí, and Joan Miró, along with surrealist poetry and films, had wide appeal. Picasso had inspired Max Ernst (1891–1976) as a young man of twenty to turn to painting. Other surrealists, too, adopted Picasso as their godfather.

Picasso never joined the group, but he did allow them to reproduce his work in their *Revolution Surréaliste*. He admired their poetry more than

their painting, but he suppressed his distaste for group exhibition when he permitted his paintings to be shown in the first surrealist exhibition in 1925. Picasso found ways to prove his independence. He braved their censure of ballet as the art of "the international aristocracy" when he designed for the ballet, and he encouraged Ernst and Miró to do the same. When Breton, the philosopher of surrealism, declared that "beauty must be convulsive or cease to be," they found their ideal in Picasso's *Three Dancers* (1925) and his inexhaustible capacity to invent new convulsions. Unwilling to be confined in anybody else's "dream-world," Picasso remained interested but aloof.

The next fifty years of Picasso's life, until his death in 1973 at the age of ninety-two, were prodigiously productive. They were an encyclopedia of arts in the twentieth century. "Each new picture by Picasso," observed his first dealer, Ambroise Vollard, "is met by the public with indignation, and then their amazement changes into admiration." But Picasso repeatedly insisted that there were no "stages" in his own development, only the fireworks of an ebullient self, a Picasso. From time to time he returned to his harlequins and his neoclassical style. And besides painting on canvas and murals, he also did copious works of collage, sculpture (in metal, wood—and bicycle handles!), etchings and lithographs (on all subjects from the Minotaur to Buffon's *Natural History*), ceramics (some two thousand pieces in 1947–48), stage and costume design for ballet (*Parade, Mercure*), and poetry.

While Picasso was convivial, he was anything but political. Ironically, the most famous work of his middle years became a political totem for millions who were not admirers of his art. In January 1937 Picasso, as an outspoken partisan of the Republican cause in the Spanish Civil War, agreed to paint a mural for the pavilion of their Republican government at the Paris World's Fair of 1937. The project was out of character, for he disliked commissions or anything that seemed to channel his imagination. He first thought of the theme "Painter and Studio," which might have celebrated the creator-artist. Then on April 29, 1937, Picasso in Paris heard of the destruction of the Basque town of Guernica by German bombing planes flying for General Franco. Two days later, on May 1, with a new focus, he began work on the mural. Making sketches, within ten days he set up in his Paris studio a canvas eleven and a half feet high and nearly twenty-six feet long, which he fitted into the room by sloping it backward. The top could be painted only by a long brush from a ladder.

The photographic record of his work (by Dora Maar, his mistress at the moment) Picasso found interesting, to show "not the successive stages of a painting but its successive changes . . . to the embodiment of the artist's dream." Less than two months from the day he began, *Guernica* was ready

to be mounted in the Spanish Pavilion. The puzzled critics reacted according to their politics. Though meant to be a comment on the news, it still arrests viewers a half century later. After Paris, *Guernica* went to New York, to the Museum of Modern Art. Picasso insisted that it not go to Spain until the end of Fascism there. Finally in 1981 it went to the Prado in Madrid, where it was both a national symbol and a Spanish reminder, in the Quixotic tradition, of the power of people to destroy themselves.

In black, white, and gray, *Guernica* is a gross caricature of horror and terror. Flat figures of almost no modeling and only the faintest hint of perspective are spread out in a spectacle that could not meet any conventional standard of Beauty. Parts of four horrified women, one holding the drooping corpse of a baby, the carnage of one soldier on the ground still holding a broken sword, and pieces of other bodies, the head of a tooth-gnashing horse and of a satanic bull, lambent flames, a figure holding a lamp out a window, and a light bulb in the sun—all in unforgettable disarray. Some noticed the irony that what purported to be a plea for the common man could speak only "within a limited range to those whose ears are attuned by previous experience to the language it uses—an intellectual, sophisticated idiom, removed by historical events from the understanding of the common man." Picasso, though "honestly and poignantly," spoke "a language unintelligible to popular ears." He seemed not to care, perhaps thinking what he said was obvious. In 1940, when Paris was occupied by the Germans, he would hand out photographs of his *Guernica* to German officers. "Did you do this?" one of them asked. "No," he replied, "you did."

Picasso's art might have been easier to understand if he had committed himself to some religious or political faith or to an institution or to a nation (Spain or France?). But he remained a restless vagrant spirit. During World War II and the German occupation of Paris he had admired the courage of French Communists in the Resistance and he was horrified by the barbarism of the Germans. His friends and admirers were puzzled and troubled by the fact that the Germans, though keeping him confined and forbidding him to exhibit, had not treated him with their customary brutality. Perhaps, because of his Spanish nationality, they hoped to enlist him or at least to commit him as a collaborator. In 1944, soon after the liberation of Paris, Picasso made news when he joined the Communist Party. Parisians chose sides in a clash of demonstrations on the Place de l'Opéra, one crowd shouting "*A nous Picassou!*" the other "*A bas Picasso!*" Admirers of his art were troubled, for the Soviets had been as brutal as the Nazis in suppressing modern movements in art and the freedom of the artist for which Picasso was a symbol. The Nazis labeled his work *Kulturbolschevismus,* the Soviets called it bourgeois-decadent. Would the Party be converted, or would Picasso be enslaved?

But Picasso was no ideologue, and not to be tamed. His joining the Party was a sentimental personal act, not a political statement. He had not been able to compensate for his artistic independence and loneliness by love for one woman or by a family of his own. Perhaps, as he said, the Party would give him a "family."

> I was so anxious to find a homeland again, I have always been an exile, now I am no longer; until Spain can at last welcome me back, the French Communist Party has opened its arms to me, I have found there all those whom I esteem most, the greatest scientists, the greatest poets and all those faces, so beautiful, of the Parisians in arms which I saw during those days in August, I am once more among my brothers.

His art did not change toward the orthodox nor show the slightest taint of "social realism." Even after he joined the Party, the Soviets still did not approve his work. "From past experience," he observed, "I would have been suspicious if I had found they did appreciate my work."

For the Party he did a few public relations chores, joining their "Peace" Congress in Wroclaw, Poland, in Paris, and in Sheffield. He designed the "Dove" lithograph, a bizarre resurrection of his father's favorite pigeons, which became familiar worldwide. When Stalin died in 1953, the Party urgently asked him for a memorial portrait. He had never seen Stalin, whom he remembered only as a man in a uniform with big buttons down the front, a military cap, and a large mustache. What he produced turned out to be an imaginary portrait of the father of Françoise Gilot, his latest companion. The Party condemned him for it. Refusing to confute the Communist politicians he simply said he was "not technically proficient in such matters." But in 1956, when the Soviets suppressed the rising in Hungary, Picasso joined with nine others in a public letter of protest, which the Party condemned as "illicit." Still they did not dare lose their world-famous partisan.

In the search for lifelong themes and continuities Picasso's biographers have seized on his relations with women. They played prominent, if sporadic, roles in his life. He was outspoken about their roles and his attitude toward them. "For me," he told Françoise Gilot, "there are only two kinds of women—goddesses and doormats." After their years together, she began "to have the feeling that if I looked into a closet, I would find a half-dozen ex-wives hanging by their necks." But he gave her fair warning. When he kept reminiscing about his earlier mistresses, she discovered his "Bluebeard complex that made him want to cut off the heads of all the women he had collected in his little private museum." "You won't last as long as I will,"

he said. She lasted only from 1943 to 1952. "Every time I change wives," he explained, "I should burn the last one. That way I'd be rid of them. They wouldn't be around now to complicate my existence. Maybe that would bring back my youth, too. You kill the woman and you wipe out the past she represents."

The full catalog will probably never be made. We do know of Fernande Olivier (c.1904–11) of the green eyes and auburn hair, who charmed him when he was only twenty-three, who would never marry him but refused to explain it was because she was already married. Then the mistress of a painter friend, Marcelle Humbert (1911–17), who had persuaded him to try doing a ballet for Diaghilev, and whose sudden death depressed him. And the ballet dancer Olga Koklova (married 1918; divorced 1935) whose high-flying tastes led him into his "duchess period." She gave way to the blond Marie-Thérèse Walter (who bore him his daughter Maia in 1935), but was displaced by the ravishing Yugoslav Dora Maar (1936–43), with whom he was living at the time of *Guernica,* until he met the talented and articulate Françoise Gilot (1943–53). She yielded intermittently to the wife of a painter friend, "Helene Parmelin," until he met Jacqueline Roque, of the heavenly profile, whom he married in 1958. The incomplete chronicle gives intimate meaning to his aphorism that "in art there is no past or future." Can these amorous experiments provide clues to Picasso's "development"? His shifting passions seem only symptoms of Picasso's restless, ruthless repetitive efforts to re-create himself.

And what a self! The "present" for Picasso stretched to superhuman dimensions. Between the ages of eighty-five and ninety he produced more than four hundred drawings and engravings, among his best, still trying new mythological subjects but occasionally reviving his beloved harlequins. In his late years he gave new evidence of muscular restlessness, trying his hand at versions of Old Masters—Velasquez, El Greco, and Poussin. On his ninetieth birthday in October 1971 Paris celebrated the artist of the century by showing eight Picassos in the Louvre in the place of Leonardo's *Mona Lisa.* Assuming he was immortal, the world was surprised to learn of his death on April 8, 1973.

"When I die," he had told Françoise Gilot, "it will be a shipwreck, and as when a huge ship sinks, many people all around will be sucked down with it." He himself had been a victim as well as a beneficiary of his peculiarly modern celebrity. He was unlike other great and famous Western artists of preceding centuries, for while his face and his foibles and his loves were widely known, many for whom his name was a household word could not recognize even one of his works. The Sistine Chapel was Michelangelo's monument, but it was appropriate in an age of the exploring self that Picasso should have become his own monument. He was notorious as the

painter genius, the millionaire Communist who could trade a painting for a country estate, the octogenarian who could still attract young women, the artist of worldwide fame whose work only a select few could enjoy or understand. Although he aimed to conquer mortality with his art, it was his mortal person that engaged the popular imagination. In his late years, in what might have been a complaint or a boast, he observed, "People don't buy my pictures, they buy my signature." "He had no need of style," André Malraux explained of his last bitter years, "because his rage would become a prime factor in the style of our time."

His death brought horrors even Picasso's imagination could not have conceived. When his grandson Pablito asked his father, Paulo, to let him be present at his grandfather's funeral, Paulo, drunk at the time, refused. Then Pablito drank a container of potassium chloride bleach, which, despite the doctors' efforts, ate away his digestive organs. Three months later he died of starvation. Marie-Thérèse, who also had not been allowed to join the family at the burial at Vauvenargues, a few years later hanged herself in the garage of her house at Juan-les-Pins.

The last news made by Picasso was the notorious family quarrel over his estate, exacerbated by Picasso's earlier efforts and those of Jacqueline Roque to exclude the illegitimate children. But a recent change in French law had preserved their rights. The estate was finally shared by his children—Claude, Paloma, Maia, Paulo, and their heirs—and of course the lawyers. The many Picasso works in the estate produced a large tax problem, settled only by giving to the state enough of his works to cover the death duties. These works became the nucleus of the Picasso Museum in Paris, a permanently dazzling panorama of Picasso's achievements. The $260 million estimate of his estate for tax purposes (September 1977) was a gross underestimate. The assessors photographed some 50,000 works—including 1,885 paintings, 1,228 sculptures, 2,880 ceramics, 18,095 engravings, 6,112 lithographs, 3,181 linocuts, 7,089 drawings, and an additional 4,659 drawings and sketches in 149 notebooks, 11 tapestries and 8 rugs. And the assessor's inventory provided only a clue to the proportions of this prodigy.

Epilogue: Mysteries of a Public Art

WHILE writers went inward, creating and probing the self, there developed in the twentieth century a surprising new public art focused on the outward visible shape of the world in motion. It, too, had the power to re-create the world, to conjure with time and space. And soon it was to have the power to bring the world into everyone's living room. The film artist, newly freed from the bondage of nature, was in thrall to a vast audience. A painter or sculptor could create at will in the studio or out of doors, the writer in his study, the composer at his piano. Even the architect could do great work for a private patron or a Medici pope. And a stage for theater could be improvised anywhere. But this art of film was on a grand scale that dwarfed the imperial extravagance of opera and served patrons across the world.

Emerging and flourishing in America, land of conquest of space and time, film art was newly democratic and popular in the very age when literature was newly arcane. Within the first century, the art of film showed a novelty appropriate to the democratic New World, a reach and a versatility unlike any art before. No earlier art was so widely and so complexly collaborative, so dependent on the marriage of art and technology, or on the pleasure of the community.

Other arts—architecture since ancient Egypt and drama since classic Greece—have been communal, focusing the energies, hopes, and beliefs of many. But the art of film would be vastly public, and have the public as its patron. Its future was full of mystery and of promise suggested in the early twentieth century, when it suddenly became the most popular American art. The "movies" (which entered our written language about 1912) re-created all the world's dimensions with bold abandon. Giving a new immortality to life in all times and places, its medium was the very antithesis of stone, the static material in which man from the beginning of history had tried to make his work immortal. Light, the unlikely medium of man's newly created immortality, was the most elusive, most transient, most ephemeral of all phenomena. Recently revealed as "the pencil of nature" with the power to create durable images, light—when properly managed, captured, and focused in a camera and then in the human eye—had the power to make moving images that could be mistaken for the real world. The movies, it was said, had the power of "making us walk more confidently on the precarious ground of imagination."

The novelties and mysteries of the new art were numerous—in its process

of creation, in its audience, in its powers to re-create the world, and to probe, create, and reveal the self.

The "motion" picture phenomenon was a discovery of a versatile and ingenious English doctor, Peter Mark Roget (1779–1869), best remembered for his still-useful *Thesaurus* (1852). One day as he looked out through the Venetian blinds in his study, he noticed that the cart moving through the street seemed to be proceeding by jerks. He suspected that it was a series of stationary impressions joined together that gave the eye the impression of a cart in motion. In 1824 he offered the Royal Society his paper on "Persistence of Vision with Regard to Moving Objects." So casually he had noted what would make possible the motion pictures. Sir John Herschel had observed it too when spinning a coin on a table he found it "possible to see both sides of the coin at once." Inventors applied this phenomenon to toys. With pretentious names—Thaumatrope, Fantoscope, etc.—these gadgets viewed a series of still drawings of an object in motion placed on a disk and seen through a slit in another disk on the same axis. Thus the animated "moving picture" preceded photography.

With photography it became possible to make "moving pictures" of the natural world. But this first required images of objects in motion, which was not possible in the early days of photography. Then the most famous of these was made in 1877 by Eadweard Muybridge of a galloping horse to help Leland Stanford, governor of California, to win his bet that at some moment all four hooves of a galloping horse are off the earth. When the cumbersome glass plate was replaced by the celluloid film improved by George Eastman with perforations fitted on sprocket wheels, it was possible to make ten pictures a second from a single camera. In 1888 an Englishman, William Kennedy Laurie Dickson, working in Thomas Edison's laboratory made a Kinetograph and shot the first film on celluloid—*Fred Ott's Sneeze,* of a worker in Edison's factory. The first feasible projector, the Vitascope, was the work of Thomas Armat, but when bought out by Edison it was adver-tised as "Thomas A. Edison's latest marvel." By 1912 Edison boasted, "I am spending more than my income getting up a set of 6,000 films to teach the 19 million school children in the schools of the United States to do away entirely with books."

In Europe, inventors were improving the apparatus for an audience dazzled by the mere spectacle of pictures in motion. The Lumière brothers impressed Parisians with their film of workers leaving a factory and a train arriving in a station. Among their spectators in 1895 was a professional magician, George Meliès (1861–1938), who saw the film's magical promise. In the next fifteen years he made more than four hundred films, which exploited the camera with stop motion, slow motion, fade-out, and double exposure to show people being cut in two, turning into animals, or disap-

pearing. From trick shots he went on to simple narrative, filming *Cleopatra, Christ Walking on the Waters* (1899), *Red Riding Hood* (1901), and his renowned *A Trip to the Moon* (1902). But he kept the camera fixed like the eye of a spectator seated in the audience, and did not move it for long shots or close-ups. The unlucky Meliès was put out of business by pirates who sold copies of his works, and he ended his life selling newspapers in the Paris Métro.

By the opening of the twentieth century, the basic technology of the silent films had developed, but the art was yet to be created. Americans had their first glimpse of film art in the work of Edwin S. Porter (1870–1941), the uncelebrated pioneer of the movie narrative of suspense. After his discharge from the navy Porter worked as handyman and mechanic in Edison's skylight studio on East Twenty-first Street in New York City. And he had the inspired idea—which now seems quite obvious—of using the camera not just to take photographs of actors on a stage but to put together moving picture "shots" of actions at different times and places to make a connected story. In what is called the first American documentary, *The Life of an American Fireman* (1903), he showed the dramatic possibilities of replacing the theatrical "scene" of actors on a stage by the "shot" created by the motion picture camera. In this six-minute film he brought together twenty separate shots (including stock footage from the Edison archive and staged scenes of a dramatic rescue from a burning building) by dissolves or cuts, to make a suspenseful story.

Porter himself made film history with the twelve minutes of *The Great Train Robbery* later that year. Using fourteen separate shots (not scenes), quickly shifting from one to another, without titles or dissolves, he left the spectator to connect this story of desperadoes who rob a mail train, shoot a passenger, and finally die in a shoot-out with the posse sent to pursue them. Conjuring with time, Porter showed his shots not necessarily in chronological order, and pioneered in "parallel editing," which invited the viewer to understand the jumps back and forth in time. He demonstrated that the camera, unlike the theater, did not have to carry out each scene to its end. His success temporarily set the single reel (eight to ten minutes) as the standard length for American films. At the same time he liberated the movies from the studio by providing a model for the American Western, with action, pursuit, and outdoor glamour. The biggest box-office success in its day, it drew audiences for ten years.

While making *Rescued from an Eagle's Nest* (1907), a hair-raising thriller of a baby snatched from a cradle by an eagle and then rescued by a brave mountaineer, Porter enlisted David Wark Griffith (1875–1948) to play the hero. A young man of limited experience and meager education, Griffith

had been born on a farm in rural Kentucky. His earliest memories were of "my father Colonel Jacob Wark Griffith of the Confederacy," returning from the war, a wounded and beaten man, and of his father's flamboyant gestures with his officer's saber. Griffith's whole life would be overcast by nostalgia for his idealized Old South. He happened into the theater as an actor in the Louisville theater, and pieced together a living as a book salesman for Brittanica, picking hops in California, with occasional roles in a traveling stock company. In his first film role at Biograph he had wrestled convincingly with a stuffed eagle manipulated by wires, and so came into the art that he would transform in the next decade. Obsessed by a past that never was, he became the shaper of an art that would reshape the American imagination.

From acting, Griffith moved into directing and at the Biograph Company in the next five years he directed more than four hundred films, most on one reel. In these gestation years of motion picture technique Griffith would liberate the movies from the theater.

> I found that the picture-makers were following as best they could the theory of the stage. A story was to be told in pictures, and it was told in regular stage progression; it was bad stage technique to repeat; it would be bad stage technique to have an actor show only his face; there are infinite numbers of things we do in pictures that would be absurdities on the stage, and I decided that to do with the camera only what was done on the stage was equally absurd.

Griffith proceeded to show what could be done with the new dramatic art. When he left Biograph in 1913, his advertisement in *The New York Dramatic Mirror* described how his "innovations" had been "revolutionizing Motion Picture Drama and founding the modern technique of the art"—by "the large or close-up figures, distant views . . . , the 'switchback,' sustained suspense, the 'fade-out,' and restraint in expression, raising motion picture acting to the higher plain which has won for it recognition as a genuine art." What he had done, in a word, was to lift the spectator out of his seat and put him among the actors, or at any other vantage point to serve the story. There was no longer a standard distance between the audience and the actor.

While Porter had gambled on the spectator's ability to piece the movie "shots" together into a connected narrative, Griffith created a whole syntax. The movie viewer would soon be at home in a new language, adept at putting together a disconnected succession of close-ups, medium shots, panoramas, fade-ins, fade-outs, switchbacks, switchforwards, masked shots, iris-in shots, and the moving perspectives of tracking shots. The art of film, Griffith observed, "although a growth of only a few years, is boundless in

its scope, and endless in its possibilities. The whole world is its stage, and time without end its limitations."

But his employers at Biograph were shocked when they saw his version of Tennyson's *Enoch Arden* (*After Many Years*, 1908), with its parallel shots of Annie Lee at the seaside and of Enoch shipwrecked on a desert island, each thinking of the other. "How can you tell a story jumping about like that? The people won't know what it's about." "Well," Griffith replied, "doesn't Dickens write that way?" "Yes, but that's Dickens; that's novel writing; that's different." "Oh, not so much," Griffith retorted, "these are picture stories; not so different." That very night he went home, reread one of Dickens's novels, and came back next day to tell his employers they could either use his idea or dismiss him. Griffith had been led by the Vanguard Word to lift the spectator from his seat in the theater and put the camera into the consciousness of characters—and viewers.

The power of the new art was proved in *The Birth of a Nation*, in which film historians see Griffith's creation of the grammar and syntax of the modern film. Its three hours on the screen pioneered the long feature film. And it was a box-office bonanza. Budgeted at $40,000 (four times the usual cost for a feature at the time), it finally came to $110,000, which included Griffith's savings and investment by his friends. Within five years after its release in 1915 it would earn $15 million, thirty years later had grossed some $48 million, and it went on earning. Its popular success, despite a banal and vicious message, was an ominous sign of the hypnotic power of the technology of the new art to overwhelm its content. Taken from a play by a bigoted North Carolina minister, the movie told a nostalgic tale idealizing the Old South and the institution of slavery, extolling the heroism of the Ku Klux Klan in saving white Southerners from bestial Negroes and their white political accomplices, and exhorting against racial "pollution."

Griffith had prophesied that "in less than ten years . . . the children in the public schools will be taught practically everything by moving pictures. Certainly they will never be obliged to read history again." *The Birth of a Nation* proved that there was substance in his grim prophecy. In the 1920s the film helped spark a revival of the Ku Klux Klan, which reached a membership of five million by the 1940s, and it continued to be used for recruiting and indoctrination into the 1960s. Thorstein Veblen hailed the movie as a triumph of "concise misinformation." Organized protests by enlightened citizens who labeled it "a deliberate attempt to humiliate ten million American citizens and portray them as nothing but beasts" and the refusal of eight states to license the film for exhibition did not prevent its spectacular box-office success.

Griffith himself tried to make the censorship of his film a patriotic issue, and cast himself as a martyr for "free speech" rather than for bad history.

He launched into another blockbuster film, *Intolerance* (1916), which outdid its predecessor in scale and use of his new film syntax to tell the story (in four scenes) of intolerance through the ages: Babylon falling from the "intolerance" of a priest, Christ forced to the Cross by intolerant Pharisees, the massacre of Huguenots by intolerant Catholics on Saint Bartholomew's Day, and modern intolerance forcing poor women into prostitution and sending innocent men to the gallows. A single scene, of Belshazzar's feast, cost $250,000, more than twice the whole budget of *The Birth of a Nation*. But the audience, put off by the abstract thread and shrieking polemics, did not share Griffith's enthusiasm. The film was withdrawn from circulation after only twenty-two weeks and reedited into two separate films. At his death in 1948 Griffith was only a decayed celebrity, still paying off his debts on *Intolerance*.

Meanwhile, Griffith's work had gathered influence abroad. On Lenin's instructions it was widely shown in the Soviet Union. While Sergei Eisenstein (1898–1948) called himself a disciple of Griffith, his life and career could hardly have been more different. Born in Riga, Latvia, into a prosperous Christianized family of Jewish descent, Eisenstein had been a student of engineering in Petrograd when the Revolution approached in February 1917. He enlisted in the Red Army and in 1920 joined the Proletkult Theater producing plays in the new proletarian spirit. Eisenstein read widely, and had a talent for abstraction, which he cultivated in arcane Marxist disputes between Stanislavsky's acting "method," Meyerhold's theory of "biomechanics," and the vagaries of the futurist Mayakovsky, the "tireless one-man communist manifesto." Eisenstein, saying it was like trying to perfect "a wooden plough" to imagine a theater independent of the Marxist "revolutionary framework," elaborated his own mechanistic theory of film. The film, too, was admirably suited for his Marxist "collective hero," since it was possible to accumulate many more people on the screen than on the stage, and he embraced the opportunity to produce mass epics.

Eisenstein found his inspiration in Griffith and made a conscious technique of what Griffith, with his intuitive practical sense for visual drama, had been practicing. For Eisenstein *Intolerance* seemed "a brilliant model of his method of montage." This was a name for the distinctive feature of the new art, which the intellectual Eisenstein explained and demonstrated in his writing and his films. "Montage" (which did not come into the English language until 1929) from the French word for "assembly" meant bringing together film images not in chronological order but for their psychological and emotional stimulus. And it described the new role of the film editor. Eisenstein, with materialist bias, emphasized its origin in "engineering and electrical apparatus." And he saw Griffith as the pioneer. "This was the montage whose foundation had been laid by American film-culture, but

whose full, completed, conscious use and world recognition was established by our [Soviet] films."

In montage Eisenstein saw both the creation of the film art and a newly creative role for the spectator. He found a similarity to the Japanese ideogram that combined the character for "dog" with that for "mouth" to mean not "dog's mouth" but "bark." Similarly he noted that child + mouth = scream, bird + mouth = sing, water + eye = weep, etc. Thus, by juxtaposing concrete images in montage the moviemaker could lead the viewer to create his own abstractions. Eisenstein found montage similar to "the method of parallel action," which Griffith had seen in Dickens. He too was amazed at "Dickens's nearness to the characteristics of cinema in method, style, and especially in viewpoint and exposition."

In his masterpiece *Battleship Potemkin* (1925), commissioned by the Communist Party to celebrate the twentieth anniversary of the 1905 Revolution, Eisenstein gave classic form to his theory of montage. Minutely dissected and extravagantly praised, as late as 1958 it was acclaimed by an international poll of film critics as the best film ever made. A story of mutiny in the czarist navy against tyranny and filth, it produced the famous "Odessa steps sequence," showing the massacre by imperial troops of innocent Russian civilians who had come to pay their respects to an assassinated leader of the mutiny. This became the classic textbook sequence of montage—a baby carriage rolling slowly down the steps over massacred bodies, past a pair of crushed eyeglasses, and blood-soaked arms and legs. Going far beyond Griffith in multiplying shots for montage, this film, which ran to only 86 minutes, contained 1,346 shots, while *The Birth of a Nation,* which ran 195 minutes, had only 1,375 shots. While it was predictably attacked by the Party as another example of bourgeois "formalism," the film's appeal was not confined to Russia. Its emotional antiestablishment message led it to be banned in some European countries and it had to be shown underground. "After seeing *Potemkin*" the famous theater director Max Reinhardt confessed that "the stage will have to give way to the cinema."

The new public art of film, in curious ways, would reunite the community that millennia before had seen ritual transformed into drama on the slopes of the Athenian Acropolis. As the film art grew, it multiplied puzzling elements in the mystery of creation. It became more and more uncertain who was creating what, from what, and for whom. In Shakespeare's London, drama required a theater, of which only six would be flourishing. The live drama needed a stage, but the new art was conveyed in a machine that could project its message anywhere. The extent of this mystery was daz-

zling. By 1948 *The Birth of a Nation* had been seen by 150 million people all over the world.

Cinema art became collaborative on a scale and in a manner never before imagined. Griffith observed that in *The Birth of a Nation* "from first to last we used from 30,000 to 35,000 people." Producing a film resembled commanding and supplying an army more than any earlier kind of art. The set for *Intolerance* included a full-scale model of ancient Babylon rising three hundred feet aboveground on a scene that stretched across ten acres. With sixty principal players and eighteen thousand extras, it sometimes had a payroll of twenty thousand dollars a day. The commanders, besides Griffith, included eight assistant directors. The rough cut of the film ran for eight hours. There was a creating role, too, for the cinematographer and all who helped provide lighting, color, sound, and music. Reaching popular audiences never imagined for the opera, films provided vast audiences for composers and countless spectators for the dance, creating new forms of musical drama. When sound came to film in the late 1920s the movies could vie with opera as a union of the arts, ironically satisfying Wagner's hope for a *Gesamtkunstwerk*.

To all its other charms, the movies, by the 1950s, added the intriguing question of who really was the "maker" of the hypnotic products of the new art. The brilliant French moviemaker and critic François Truffaut (1932–1984) insisted that the director was a new kind of "author" (*auteur*) in this modern audiovisual language. So, he said, the director (or *auteur*) really was the person who created the film, and so should be given the major credit. This plausible suggestion itself sparked a lively controversy over the "auteur" theory, which debated who if anyone should be considered the prime creator of the complex collaborative product.

Over the actors, too, there came a new ambiguity and a new aura. Griffith had boasted "raising motion-picture acting to the higher plane which has won for it recognition as a genuine art." Now that all spectators could see the actor's face close up, it removed the temptations to mug, and encouraged a subtler, "more restrained" style of acting. But there was a colossal irony in what the new art did to these "more restrained" actors in the new art. Biograph had at first banned the names of actors from credits in their films, and insisted on their anonymity. But film gave a vivid unique personality to every actor as a person who could not be denied and became a magnet for its audience. By 1919 "movie star" had entered our written language for this new human phenomenon of awesome dimensions. The celebrity of movie actors overshadowed even that of eminent statesmen, baseball heroes, and notorious criminals. Gargantuan film creations became only vehicles for a Douglas Fairbanks, Greta Garbo, Humphrey Bogart, or Marilyn Monroe, whose off-screen lives became news.

While movies gave actors a newly vivid role, they obscured the "author," who often disappeared from the scene. Even while movie rights to books sold for astronomical sums, films "based on" them often had scant resemblance to the original. Some of the best authors, despairing at the scenes, the characters, and the ideas mangled out of their works, refused to participate in their "story conferences," and became refugees from Hollywood.

An increasingly technological and industrial art, the movies gave technicians, lighting experts, and cinematographers crucial roles in making every film, just as the collaboration and enthusiasm of bankers, movie moguls, and executives were essential. By the 1920s there developed in Hollywood a "studio system," with companies like Warner Bros., M-G-M, and Universal organized to focus vast investment and countless collaborators. How did the popular products emerge from this technological-industrial-artistic maelstrom? Some suggested that there was a Genius of the System, which, like the Muses of ancient Greece, somehow converged and balanced all the elusive elements. But by the 1950s the colossi of the studio system were themselves in decline, and "independent" producers were producing some of the most successful films. While this diffused the powers of movie creation, it did not dissolve the mystery.

The heart of the mysteries of this new art was the audience. While Dickens could await public response to one number of his novel before shaping the next, the moviemakers could not so easily test their costly product as it was being created. From the beginning there was a hint of mystery in the movie audience. Since stage drama required light, the early Elizabethan theaters were in the open air, and performances were limited by the climate and the season. The movie house required darkness, where spectators could hardly see one another. Still, the public had become the patron and had to be pleased.

And who was the public? Moviemakers had the box-office test of whether they were pleasing their audience. But every step in the rise and diffusion of film drama deepened the mystery of the audience, who became less and less dependent on a theater. Now anyplace could be a theater. In every living room, television viewers could choose the film to be played and replayed at their pleasure. The creators of the newest art were in bondage to a spectral master.

SOME REFERENCE NOTES

These notes will help the reader share my delight in the lives and works of the creators treated in this book. At the same time they will suggest my debts to other scholars. I have selected accessible works likely to be found in a good public library or the library of a college or university, omitting the more specialized works and the articles in learned journals. For each book the date of the most recent publication is noted, and I have tried to note works still in print and in paperback editions. Many of the books listed here contain helpful bibliographies. Where subjects in this volume overlap or touch on those in my companion book, *The Discoverers*, the reader can consult its Reference Notes. In treating literary works from languages other than English I have tried, where the quoted passage is lengthy and of literary interest, either in the text or in these Reference Notes to credit the translator, who is too seldom adequately rewarded and recognized. Of course there is no substitute for seeing the great works of art and architecture and hearing the great works of music. I would hope this book would encourage readers to see and hear for themselves.

GENERAL

There is a vast literature on "creativity" that tends to tell us more about the authors than about their subjects. It seeks simple explanations for the most elusive, complex, and mysterious of all human processes, and homogenizes the people and the works that interest us precisely because of their uniqueness. Among the general works on artists that I have found most interesting are William James, *Principles of Psychology* (2 vols., 1890), with brilliant observations on genius and imagination; Arthur Koestler, *The Act of Creation* (1964), with intriguing descriptions of "bisociative" thinking and the creative leaps; Milton C. Nahm, *The Artist as Creator* (1956), offering the creativity of the artist as a new ingredient of freedom introduced by the West; Rudolf and Margot Wittkower, *Born under Saturn* (1963), on

sources of creativity in the personal miseries of artists. And on the artists' products and their meanings: André Malraux, *The Voices of Silence: Man and His Art* (1953), a bold view of how modernity—the museum and photography—has created a "museum without walls" and the consequences; Joseph Alsop, *The Rare Art Traditions* (1982), an original history of art collecting and its linked phenomena.

As a devotee of reference books, I find no substitute for the *Encyclopaedia Britannica*. For individual creators there is nothing of the scope and quality of the *Dictionary of Scientific Biography* (C. C. Gillispie, ed., 16 vols., 1970–80). General reference works that illuminate the subjects of this book include notably: *The Encyclopedia of Religion* (Mircea Eliade, ed., 16 vols., 1987); *Encyclopaedia of Religion*

and Ethics (James Hastings, ed., 12 vols., n.d.); *Dictionary of the History of Ideas* (Philip P. Wiener, ed., 4 vols., 1973). For American and British readers the inexhaustible treasure house of *The Oxford English Dictionary* (James A. H. Murray and others, eds., 13 vols., 1930; R. W. Burchfield, ed., 4 supplements, 1972–86) makes our language an avenue to the history of all our arts. For epochal works on print, see *Printing and the Mind of Man: The Impact of Print on Five Centuries of Western Civilization* (John Carter and Percy H. Muir, eds., 1967).

For the visual arts a delightful starting point, elementary in the best sense of the word, is E. H. Gombrich's concise *The Story of Art* (3d ed., 1950). And for reference: *Encyclopedia of World Art*, McGraw-Hill (15 vols. 1959–1968; 2 vols. supp. 1983–1987), copiously illustrated, but with a heavy bias toward Italian scholarship. The most satisfactory textbook is H. W. Janson, *History of Art* (4th ed., rev. by Anthony F. Janson, 1991), bulky but brilliantly illustrated, with convenient aids and time charts. More compact is the Thames and Hudson *Encyclopaedia of the Arts* (Herbert Read, ed., 1966). On particular periods I have enjoyed *The Oxford Classical Dictionary* (2d ed., 1970; N.G.L. Hammond and H. H. Scullard, eds.); *The Oxford History of the Classical World* (John Boardman et al., eds., 1986); the admirable *Dictionary of the Middle Ages* (Joseph R. Strayer, ed., 13 vols., 1982–86); the compendious and sensible *Penguin Companion to the Arts in the Twentieth Century* (Kenneth McLeish, ed., 1985). All these offer bibliographies.

An array of imaginative scholars in this century have opened paths from arts to all the rest of our history: the stimulating and original works of Sigfried Giedion, *Mechanization takes Command* (1948), *Space, Time and Architecture* (1949), *The Eternal Present: The Beginnings of Art* (1962); E. H. Gombrich, *Art and Illusion* (1972); Erwin Panofsky's subtle *Meaning in the Visual Arts* (1955; 1982), *Renaissance and Renascences in Western Art* (1970); Heinrich Wölfflin, *Principles of Art History* (1932). Basic texts are conveniently collected in *Great Books of the Western World*

(54 vols., 1952; rev. ed., 1990), a publication of Encyclopaedia Britannica.

THE RIDDLE OF CREATION: A PROLOGUE

A good introduction to the difficulty mankind has experienced in coming to the idea of novelty is any one of the lucid works of Mircea Eliade, beginning with his brief *Cosmos and History: The Myth of Eternal Return* (1959), then *Myth and Reality* (1968), or *Patterns in Comparative Religion* (1972), explored in more detail in his *History of Religious Ideas* (3 vols., 1978–85). For concise essays on the contrasts of Western and Eastern cosmologies, we are fortunate in having Hajime Nakamura's *Ways of Thinking of Eastern Peoples* (1964) and his *Comparative History of Ideas* (2d ed., 1986). Cyclical thinking has also charmed the West—from Plato to Vico, Hegel, and Toynbee—and seemed to provide a refuge from the complexity of history. Helpful introductions are Grace E. Cairns, *Philosophies of History* (1962), and G. W. Trompf, *The Idea of Historical Recurrence in Western Thought* (1979).

The vast literature of Eastern religions and alternatives to religion can overwhelm the Western reader. An accessible path is the Introduction to Oriental Civilizations series (William Theodore de Bary, ed., Columbia University Press, 1958–64), with its *Sources of Indian Traditions* (1958) and companion volumes on the Chinese and the Japanese traditions. And for a collection of lively scholarly essays: *Mythologies of the Ancient World* (Samuel Noah Kramer, ed., 1961). There is no better reference guide than the Asia Society's readable and scholarly *Encyclopedia of Asian History* (Ainslie T. Embree, ed., 4 vols., 1987) with bibliographies.

Part I: Worlds without Beginning

Chapter 1. The Dazzled Vision of the Hindus. We are lucky to have A. L. Basham's readable *The Wonder That was India* (1954; 1971) and illuminating brief works: Diana L. Eck, *Darsan, Seeing the*

Divine Image in India (1981) and *Banaras, City of Light* (1982); S. Radhakrishnan, *The Hindu View of Life* (1957). For a visual sample of the awesome multiplicity of roles of Hindu gods, see Stella Kramrisch, *Manifestations of Shiva* (1981), the catalog of a brilliant exhibit at the Philadelphia Museum of Art. Where the translator is not indicated in the text, the source is: de Bary (ed.), *Sources of Indian Tradition*.

Chapter 2. The Indifference of Confucius. For a straight path to Confucius, see Arthur Waley's translation of *The Analects of Confucius* (1938) and his *Three Ways of Thought in Ancient China* (1956). On Confucius and Confucianism, Herrlee G. Creel offers models of scholarly liveliness in *Confucius and the Chinese Way* (1960) and *What Is Taoism?*, (1970), besides his classic *The Birth of China* (1964). Especially helpful: C. P. Fitzgerald, *China: A Short Cultural History* (4th ed., 1976); L. Carrington Goodrich, *A Short History of the Chinese People* (4th ed., 1958); Herbert G. Giles, *A History of Chinese Literature* (n.d.), and Frederick W. Mote, *Intellectual Foundations of China* (2d ed., 1989). More specialized are Derk Bodde, *Essays on Chinese Civilization* (1981); Benjamin I. Schwarz, *The World of Thought in Ancient China* (1985); Chang Chung-yuan, *Creativity and Taoism: A Study of Chinese Philosophy, Art and Poetry* (1975); On Chinese views of nature, see Joseph Needham's brilliant and succinct *Within the Four Seas, the Dialogue of East and West* (1979). No one should miss Kenneth Clark's *Landscape into Art* (1949; 1976). Where the translator is not indicated in the text, the source is: de Bary (ed.), *Sources of Chinese Tradition* (2 vols., 1960), or Shigeru Nakayama and Nathan Sivin (eds.), *Chinese Science* (1973).

Chapter 3. The Silence of the Buddha. A convenient access to the Scriptures is Edward Conze, *Buddhist Scriptures* (Penguin Books, 1973), illuminated by his *Buddhism* (1953) and *Buddhist Meditation* (1956), supplemented by *Sacred Books of the Buddhists* (T. W. Rhys Davids, ed., 4 vols., 1910–21). Where the translator is not indicated in the text, the source is: de Bary (ed.), *Sources of Indian Tradition* (1958).

Chapter 4. The Homeric Scriptures of the Greeks. While Homer provides a delightful touchstone of ancient Greek thought, the literature about Homer is a microcosm of Western literary culture. For a spirited introduction M. I. Finley has given us *The Ancient Greeks* (1963), *The World of Odysseus* (2d ed., 1977), and *The Greek Historians* (1959). A lively path into Greek thinking about origins is W.K.C. Guthrie, *In the Beginning* (1965), broadened by his *The Greeks and Their Gods* (1955), and documented by his *History of Greek Philosophy* (2 vols., 1962–65). For the work of Milman Parry, see a detailed account by a brilliant disciple who pursued the implications and applications of Parry's techniques: Albert B. Lord, *The Singer of Tales* (1960); and Adam Parry, ed., *The Making of Homeric Verse* (1971).

To place Homer in context, see G. S. Kirk, *Myth: Its Meaning and Functions in Ancient and Other Cultures* (1973), *Homer and the Oral Tradition* (1976), *Homer and the Epic* (1979); C. M. Bowra's eloquent *The Greek Experience* (1957), *Homer* (1972); G. Lowes Dickinson, *The Greek View of Life* (1958); W. H. Auden, ed., *The Portable Greek Reader* (1955). For reference, see A.J.B. Wace and F. H. Stubbings, eds., *A Companion to Homer* (1962). We glimpse the iridescence of Homer in the English translations from Chapman (1611; 1614–15) to Hobbes, Dryden, and Pope and those in our century: the verse of Robert Fitzgerald (1961), Richmond Lattimore (1965–67), and Robert Fagles (1990), and the prose translations of E. V. Rieu (the first Penguin Classic, 1946) and I. A. Richards (1950). Matthew Arnold's lectures *On Translating Homer* (1861) defines "the grand style" and shows us the apotheosis of "the Poet." For Hesiod's *Works and Days* and his *Theogony,* see the translation by Apostolos N. Athanassakis (1983), to compare with that by Richmond Lattimore (1959).

Part II: A Creator-God

The history of theology, written mostly for theologians and believers, does not offer us easy paths of entry. But we are fortunate in having *The Encyclopedia of Religion* (Mircea Eliade, ed., 16 vols., 1987), which offers us succinct and readable scholarly essays. And see William Foxwell Albright,

"From the Stone Age to Christianity," in *Monotheism and Historical Process* (1957). Jaroslav Pelikan's magisterial survey of the history of Christian theology has the authentic flavor of personal conviction: *The Christian Tradition* (5 vols., 1971–89). Or more succinctly *The Melody of Theology* (1988), and *Jesus Through the Centuries* (1985). His *Mystery of Continuity* (1986) introduces us to the amplitude of Saint Augustine's thought and influence. A convenient reference work is *Harper's Bible Dictionary* (8th ed., 1973).

Chapter 5. The Intimate God of Moses. I am much indebted to Martin Buber's *Moses* (1946) and his *I and Thou,* (1937), which makes the Mosaic experience a basis for his version of Judaism. Sigmund Freud, too, found his own meanings in *Moses and Monotheism* (1939), recently explained as an aspect of his own personal quest, in Yosef Hayim Yerushalmi, *Freud's Moses* (1991). For Moses' place in the history of theology, see William F. Albright, *From the Stone Age to Christianity* (2d. ed., 1957), and George Foot Moore, *Judaism in the First Centuries of the Christian Era* (2 vols., 1946). Of extraordinary interest is Josiah Royce's article "Monotheism" in Hastings, *Encyclopaedia of Religion and Ethics,* Vol. 8, pp. 817ff., which reminds us of the many varieties of belief traveling under that name.

Chapter 6. The Birth of Theology. The literary background of the intriguing Philo is brightened by Edward A. Parsons, *The Alexandrian Library: The Glory of the Hellenic World* (1952), and F. E. Peters, *The Harvest of Hellenism . . . the Near East from Alexander the Great to the Triumph of Christianity* (1970). The main avenue to him is Erwin R. Goodenough, *Introduction to Philo Judaeus* (2d ed., 1963), followed by Harry A. Wolfson's comprehensive *Philo, Foundations of Philosophy in Judaism, Christianity, and Islam* (2 vols., 1947).

Chapter 7. The Innovative God of Saint Augustine. Saint Augustine of Hippo remains one of the most versatile and challenging thinkers in Western history. The best introduction to his thought is Jaroslav Pelikan, *The Mystery of Continuity: Time and History, Memory and Eternity in . . .*

Saint Augustine (1986) and *The Excellent Empire: The Fall of Rome and the Triumph of the Church* (1987). For biography, see Peter Brown's readable *Augustine of Hippo* (1967) and Homes F. Dudden, *The Life and Times of St. Ambrose* (2 vols., 1935). For the wider background, see: Charles N. Cochrane's brilliant *Christianity and Classical Culture* (1944); Ludwig Edelstein, *The Idea of Progress in Classical Antiquity* (1967); Robert Nisbet, *History of the Idea of Progress* (1980). Saint Augustine's *Confessions* are in popular English translations by E. B. Pusey (1930) and F. J. Sheed (1943). *The City of God* is in the Everyman Library (2 vols., 1945–47) and in the Modern Library, trans. Marcus Dods, with an introduction by Thomas Merton. Both with a selection of theological writings are in *Great Books of the Western World,* Vol. 18 (1952).

Chapter 8. The Uncreated Koran. The strangeness of the idea of the uncreated Koran to those raised in the Judeo-Christian tradition is a clue to the effort required of the English reader to grasp the meanings of Islam. The best introduction in English to the problem of interpreting the Koran is *Bell's Introduction to the Qur'an* (revised by W. Montgomery Watt, 1970). For the history of interpretation and the wider context, see the articles "Kalam" and "Qur'an" in *The Encyclopedia of Religion;* Gustave von Grunebaum, *Medieval Islam* (2d ed., 1971); F. E. Peters, *Allah's Commonwealth: a History of Islam in the Near East, 600–1100* (1973); Albert Hourani, *A History of the Arab Peoples* (1991), especially the brilliant essay in Chapter 4, "The Articulations of Islam," and *The Encyclopaedia of Islam* (1960–). The special role of language and the word in Islam is revealed in the distinctive study of Kalam surveyed in Harry A. Wolfson, *The Philosophy of the Kalam* (1976). This has given Islam a linguistic cultural role quite different from that in Christianity. While the sacred Scriptures in Western Christendom have had a leading role in spreading and defining vernaculars (German, French, English), Islam itself has been a powerful agent for the spread of Arabic. Strictly speaking, "translation" of the Koran is not possible and not permissible—which explains why M. M. Pickthall

can give us only *The Meaning of the Glorious Koran* ("An Explanatory Translation," 1930; Mentor Paperback, 1959). The version generally accepted by Muslims in the English-language world, *The Holy Qur'an, Text, Translation and Commentary*, by A. Yusuf Ali (3d ed., 1946), offers the Arabic and the English in parallel columns.

BOOK ONE:
CREATOR MAN

Part III: The Power of Stone

In this century, the history of architecture has invited bold and imaginative interpreters, who carry us out from the buildings we see. The most far-ranging and cosmopolitan of these is the Swiss Sigfried Giedion, who has made contemporary art and technology his point of departure. Start with his *Space, Time and Architecture, the growth of a new tradition,* (1949), then *Mechanization Takes Command* (1948). Especially relevant for this Part of the book are *The Eternal Present: The Beginnings of Art* (1962) and *The Beginnings of Architecture* (1981). Architecture is the starting point also for Lewis Mumford's reflections on American and other civilizations, from his *Sticks and Stones* (1924) to *The City in History* (1961) and *Roots of Contemporary Architecture* (1972). A concise survey is Nikolaus Pevsner, *An Outline of European Architecture* (new ed., 1948). *The Architecture Book* (1976), by Norval White, is an illustrated glossary of architectural terms. A brilliant array of scholars offer well-illustrated studies of periods in the volumes of *The Pelican History of Art,* listed under topics below. For essays on the relation between architecture and the sophisticated currents of thought, see Rudolf Wittkower, *Architectural Principles in the Age of Humanism* (1973); Geoffrey Scott, *The Architecture of Humanism* (1974); Heinrich Wölfflin, *Principles of Art History* (1932).

Chapter 9. The Mystery of Megaliths. Few simple monuments have tantalized historians of science and art more than Stonehenge. A delightful short path into

the doubts and debates is Glyn Daniel's *Megaliths in History* (1972). These can be further explored in R.J.C. Atkinson's conjectural reconstruction in *Stonehenge* (1960); in Gerald Hawkins, *Stonehenge Decoded* (1966) and *Beyond Stonehenge* (1973). An excellent introduction to the possible technology of constructing Stonehenge is by R.H.G. Thomson in Charles Singer and others, eds., *A History of Technology* (5 vols., 1967), at Vol. I, pp. 490ff. For modern modes of dating, including dendrochronology and radiocarbon dating: Colin Renfrew, *Before Civilization: The Radiocarbon Revolution and Prehistoric Europe* (1973). For the wider vistas, see Glyn Daniel, *The Idea of Prehistory* (1971); and the stimulating essays of Grahame Clark, especially *Prehistoric England* (1974). Prehistory, because of the fragmentary nature of the evidence, has been a happy hunting ground for dogmatic historians. One of the most stimulating and influential of these is the Australian V. Gordon Childe (1892–1957), whose *Dawn of European Civilization* (1925, 6th ed., 1967) and *What Happened in History* (1946), a Penguin book, open scores of new questions.

Chapter 10. Castles of Eternity. Starting our study of the arts of architecture with deep antiquity reminds us of how dependent the arts are on technology, explored in the illuminating chapter by Seton Lloyd, "Building in Brick and Stone," in Singer, *A History of Technology,* Vol. I. The best layman's introduction to the Pyramids is the Penguin paperback, I.E.S. Edwards, *The Pyramids of Egypt* (1972). For the background of the culture and politics there is still no better avenue than James H. Breasted's *History of Egypt* (1905, 1967), followed by John A. Wilson, *The Culture of Ancient Egypt* (1951). An appealing path into ancient Egypt that gives us our bearings among its ancient neighbors is Henri Frankfort et al., *The Intellectual Adventure of Ancient Man* (1946; reprinted as Penguin paperback (*Before Philosophy,* 1949). No one is a more enticing or eloquent guide than Frankfort, for example in his *Kingship and the Gods* (1948), *The Birth of Civilization in the Near East* (1956), and *Ancient Egyptian Religion* (1948). For some of the intimacies of that

time, see Alan H. Gardiner, *Egypt of the Pharaohs* (1961), *The Attitude of the Ancient Egyptians to Death and the Dead* (1935); Gardiner and Kurt Sethe, eds., *Egyptian Letters to the Dead* (1928); Jon Manchip White, *Everyday Life in Ancient Egypt* (1973).

The most tantalizing sphinx of antiquity has been the Great Pyramid itself. The dimensions of the puzzle are suggested by Peter Tomkins, *Secrets of the Great Pyramid* (1978), and Kurt Mendelssohn, *The Riddle of the Pyramids* (1974). To help us understand the problems, we should begin with O. Neugebauer's concise and readable *The Exact Sciences in Antiquity* (2d ed., 1969), supplemented by Somers Clarke and R. Engelbach, *Ancient Egyptian Masonry, the Building Craft* (1930). The Battle of the Standards, which long resounded in the most respectable scientific circles in Britain, became an effort to assert the divine mission of Britain to establish the British "inch" as the proper unit of earthly measure. Its icon was supposedly (and cryptically) embodied in the Great Pyramid. The speculations of an English mathematician traveler John Greaves (1607–1652) entangled the pious Sir Isaac Newton in this controversy. The measurements of Napoleon's archaeologists in 1798 provided new data for the debate, English literati were enticed to apply the English inch to Noah's Ark, the Temple of Solomon, and the height of Goliath, and enlisted the eminent John Herschel to support the British inch as "very far more accurate than the boasted metrical system of our French neighbour." These conclusions were published in a bizarre volume by John Taylor, *The Great Pyramid* (1864). The acrimony, the extravagance, and the passion of this debate appear in the climactic volume by Piazzi Smyth, who with his wife visited and measured the Great Pyramid in 1864 and produced *The Great Pyramid: Its Secrets and Mysteries Revealed* (4th and much enlarged edition, reprinted in 1974).

The history of Egyptology is itself fraught with mysteries and strange turns. Follow some of them in Glyn Daniel's *Origin and Growth of Archaeology* (1971). The Battle of the Standards enticed to Egypt the founder of a modern science of Egyptology who revolutionized the techniques of archaeology. William Matthew Flinders Petrie (1853–1942) at the age of twenty-four published his epoch-making *Inductive Metrology, or the Recovery of Ancient Measures from the Monuments* (1877), and surveyed the Great Pyramid, followed by his survey of Stonehenge (1880). His survey produced "the ugly little fact which killed the beautiful theory," and only a few fanatics refused to admit the irrelevance of the Great Pyramid to the divinity of the British Inch. All students of history will be stimulated by Petrie's *Seventy Years in Archaeology* (1932) and *The Revolutions of Civilisation* (1972) and should be sobered by his observation that "civilisation is an intermittent phenomenon."

Chapter 11. Temples of Community. For the vast literature on classical culture, convenient reference guides on the background of Greek and Roman architecture are *The Oxford Classical Dictionary* (2d ed., 1970) and John Boardman et al., eds., *The Oxford History of the Classical World* (1986) with authoritative up-to-date essays and bibliographies. A focused introduction is D. C. Robertson, *Greek and Roman Architecture* (2d ed., 1983).

On ancient Greek thought: see the references above for Part I, especially W.K.C. Guthrie's readable *History of Greek Philosophy* (2 vols., 1965) and *The Greeks and their Gods* (1955); M. I. Finley's lively *The Ancient Greeks* (1963). A concise, well-illustrated handbook is the volume in the Pelican History of Arts: A. W. Lawrence, *Greek Architecture* (4th ed., revised by R. A. Tomlinson, 1983). On the building professions and their tasks: the chapter in Spiro Kostof, ed., *The Architect* (1986); Rhys Carpenter, *The Architects of the Parthenon* (1970); R. E. Wycherley, *How the Greeks Built Cities* (2d ed., 1967). And on the technology: Singer, *A History of Technology*, Vol. 2. For enticing questions on the relations of ancient Greek architecture to the land and the gods: Rhys Carpenter, *Discontinuity in Greek Civilization* (1966), and especially Vincent Scully's eloquent and elegant *The Earth, the Temple, and the Gods: Greek Sacred Architecture* (rev. ed., 1979), with copious photographs of the temples and their environs, and his sugges-

tive *Architecture: The Natural and the Manmade* (1991).

Chapter 12. Orders for Survival. An admirable introduction to Vitruvius, his life and work, with bibliography is found in *The Dictionary of Scientific Biography*, Vol. 15, Supp. I. The standard biography in English is Alexander McKay, *Vitruvius, Architect and Engineer: Buildings and Building Techniques in Augustan Rome* (1978). The *De Architectura* is available in a Dover paperback: Vitruvius Pollio, *The Ten Books on Architecture* (trans. Morris Hickey Morgan, 1960). For the architect's role in his time, see the chapter in Spiro Kostof, ed., *The Architect* (1986). For the American afterlife, see Talbot Hamlin, *Greek Revival Architecture in America* (1944).

Chapter 13. Artificial Stone: A Roman Revolution; Chapter 14. Dome of the World. For Rome, a brief introductory essay is Mortimer Wheeler, *Roman Art and Architecture* (1981). William L. Mac-Donald leads us into all Roman culture in his brilliant *Architecture of the Roman Empire*, Vol. 1, *An Introductory Study* (rev. ed., 1982), Vol. 2, *An Urban Appraisal* (1986). And we should keep beside us Gibbon's *Decline and Fall of the Roman Empire*. On the technology, Singer, *A History of Technology*, Vol. 2, pp. 404ff., gives us the elements, well illustrated. In more detail in the Penguin book Axel Boethius and J. B. Ward-Perkins, *Etruscan and Roman Architecture* (1970), and Axel Boethius, *The Golden House of Nero* (1960). On the baths, see Jerome Carcopino, *Daily Life in Ancient Rome* (Henry T. Rowell, ed., 1947); and the still-useful Samuel Dill, *Roman Society in the Last Century of the Western Empire* (1899). Eleanor Clark's evocative description of Tivoli in *Rome and a Villa* (1952) provides a seductive point of departure, along with Marguerite Yourcenar's *Memoirs of Hadrian* (1954) for all visitors to Rome. Then William L. MacDonald, *The Pantheon: Design, Meaning, and Progeny* (1976), a Penguin book; Stewart Perowne, *Hadrian* (1976). Procopius's *On the Buildings* is found in the translation (1953–61) of his complete works by H. R. Dewing, and *The Secret History* (trans. G. A. Williamson, 1966) is handily available in a Penguin book.

Chapter 15. The Great Church. The Great Church is surveyed in a detailed study by Emerson Rowland Swift, *Hagia Sophia* (1940). For biography, besides Procopius we have Robert Browning, *Justinian and Theodora* (1971). Again, a chapter in Kostof, *The Architect* (1986), helps us understand the roles of patron, architect, and craftsmen. For the wider background, in addition to the ever-illuminating Gibbon, we have the welcome introduction by Steven Runciman, *Byzantine Style and Civilization* (1987) in Penguin Books, and on the city as a focus of civilization, Glanville Downey, *Constantinople in the Age of Justinian* (1960).

Other great stone monuments of antiquity had their own kind of afterlife. Edward Gibbon would find the inspiration for his great history as he "sat musing amidst the ruins of the Capitol." Others too found inspiration in the fragments, shadows, and moss-filled cracks of ancient ruins. The chaste, sharp-edged column was "classical" but the broken column would be romantic, inspiring not only melancholy but even wild imaginings. The high priest of these imaginings, who made his own creations of them was Giovanni Battista Piranesi (1720–1778), trained as an architect, who fulfilled himself making an art of the ruins of ancient architects. There is no better invitation than Marguerite Yourcenar, *The Dark Brain of Piranesi and Other Essays* (1985), and the elegant lecture of Peter Murray, *Piranesi and the Grandeur of Ancient Rome* (1971). The substantial biography, A. Hyatt Mayor, *Giovanni Battista Piranesi* (1952), can be supplemented by the critical study of his prisons and views of Rome by Arthur M. Hind (1967) and the catalog of his etchings by Andrew Robison, *Piranesi, Early Architectural Fantasies* (1986).

Chapter 16. A Road Not Taken: The Japanese Triumph of Wood. How and why Japan did not provide the raw material for Piranesi's kind of romantic musing is the story of the unique role Japanese architects assigned to wood. Useful reference works in English: the *Kodansha Encyclopedia of Japan* (9 vols., 1983) with perceptive brief articles; Arthur Drexler, *The Architecture of Japan* (1955). Documents are translated

in *Sources of Japanese Tradition,* in the Introduction to Oriental Civilizations series (de Bary, ed.). *Ise Prototype of Japanese Architecture* (1965), by Kenzo Tange and Noboru Kawazoe, provides historical and technical background, copiously illustrated. For the wider background: Bruno Taut, *Houses and People of Japan* (1937); Richard M. Dorson, *Folk Legends of Japan* (1962). For intimate eyewitness glimpses of the relation between architecture and everyday life we are fortunate to have handy Dover and Tuttle paperback reprints of Edward S. Morse, *Japanese Homes and Their Surroundings* (1885, 1961, 1984). The works of an eminent living architect, Yoshinobu Ashihara, remind us of the continuing distinctiveness of Japanese ways: *The Hidden Order: Toyko Through the Twentieth Century* (1989; 1992) Kodansha paperback; *Exterior Design in Architecture* (rev. ed., 1981); *The Aesthetic Townscape* (1983). The piquant essay of a brilliant novelist on all the Japanese arts should not be missed: Junichiro Tanizaki, *In Praise of Shadows* (1984). And for perspective: Marius B. Jansen, ed., *Changing Japanese Attitudes Toward Modernization* (1985).

Part IV: The Magic of Images

Chapter 17. The Awe of Images. The caves of Altamira, Lascaux, and les Trois Frères are scenes of one of the great mystery stories in our history of creators. The works of those nameless artists can be seen in a sumptuous volume of text and drawings by Abbé Henri Breuil himself: *Four Hundred Centuries of Cave Art* (1952), from the French Center for Prehistoric Studies in Montignac. And see the biography of him by A. H. Broderick, *Father of Prehistory* (1963). For a charming illustrated account re-created from interviews with the boy discoverers themselves: Hans Baumann, *The Caves of the Great Hunters* (1954). For a wider view the basic book is the readable first volume in the UNESCO-sponsored "History of Mankind": Jacquetta Hawkes and Leonard Woolley, *Prehistory and the Beginnings of Civilization* (1963) or Jacquetta Hawkes, ed., *The World of the Past* (1963). On the progress of the study of prehistory: Geoffrey Bibby,

The Testimony of the Spade (1956); Glyn Daniel, *The Origins and Growth of Archaeology* (1971). For a scholarly portrait of the cave painters in their landscape: Grahame Clark, *The Stone Age Hunters* (1967), *Aspects of Prehistory* (1974).

Chapter 18. Human Hieroglyphs. The unique charm and grandeur of ancient Egyptian sculpture can be glimpsed in the few objects in our great museums, notably in the Metropolitan Museum of Art in New York City. The history is well illustrated in the compendious Kurt Lange and Max Hirmer, *Egypt: Architecture-Sculpture-Painting in three thousand years* (1968). For more detail: William Stevenson Smith, *A History of Egyptian Sculpture and Painting in the Old Kingdom* (1978); Cyril Aldred, *Old Kingdom Art in Ancient Egypt* (1949), *Middle Kingdom Art . . .* (1950), *New Kingdom Art . . .* (1951). For background, see references for Chapter 10 above, especially Henri Frankfort, *Ancient Egyptian Religion* (1948), *Kingship and the Gods* (1948). For the shocking story of the fate of the great monuments: Brian M. Fagan, *The Rape of the Nile: Tomb Robbers, Tourists, and Archaeologists in Egypt* (1975).

Chapter 19. The Athletic Ideal. In addition to the references at Chapters 4 and 12 above, see Alfred Zimmern, *The Greek Commonwealth* (5th ed., 1931). Then begin with the illuminating details and illustrations in Gisela M. A. Richter, *The Sculpture and Sculptors of the Greeks* (4th ed., 1970), *Kouroi: Archaic Greek Youths* (1960). Other illustrated views: Rhys Carpenter, *Greek Sculpture, A Critical Review* (1960); George M. Hanfmann, *Classical Sculpture* (1967); A. W. Lawrence, *Greek and Roman Sculpture* (1972). For sources and documents: J. J. Pollitt, *The Art of Greece 1400–31 B.C.* (1965). For the athletic background: E. Norman Gardiner, *Athletics of the Ancient World* (1930), *Olympia: Its History and Remains* (1973); H. A. Harris, *Greek Athletes and Athletics* (1966). Some lively perspectives: J. J. Pollitt, *The Ancient View of Greek Art* (1974); Kenneth Clark, *The Nude* (1959). *The Odes of Pindar* reach us in an elegant translation by C. M. Bowra, a Penguin book (1985).

Chapter 20. For Family, Empire—and History. In addition to the references for

Chapters 14 and 15 above, relevant illustrated articles are found in *The Encyclopedia of World Art*. For background topics: John Boardman et al., eds., *The Oxford History of the Classical World* and *The Oxford Classical Dictionary*. Readable focused studies include: George M. Hanfmann, *Roman Art: A Modern Survey of the Art of Imperial Rome* (1965); A. W. Lawrence, *Greek and Roman Sculpture* (1972); J. J. Pollitt, *The Art of Rome c.753 B.C.–A.D. 337: Sources and Documents* (1966).

Chapter 21. The Healing Image. This critical moment for the history of Western art is not sufficiently noted in histories of Western culture. The reference notes for Chapters 6, 7, and 15 above provide background, supplemented by some excellent articles on figures and topics in the Iconoclastic controversy in Mircea Eliade, ed., *The Encyclopedia of Religion* (16 vols., 1987), in Joseph Strayer, ed., *The Dictionary of the Middle Ages* (1982–89), and the relevant chapters in Gibbon's *Decline and Fall*. The best introduction to the theological issues is Jaroslav Pelikan, *Imago Dei: The Byzantine Apologia for Icons* (1990), with his *Christian Tradition*, Vol. 2. For details, documents, and interpretive essays, see the *Dumbarton Oaks Papers:* Gerhart B. Ladner (1953), Ernst Kitzinger (1954), A. A. Vasiliev (1956). For the social context: Gerhart B. Ladner, *The Idea of Reform . . . in the Age of the Fathers* (1967); Romilly Jenkins, *Byzantium: The Imperial Centuries* (1966); and the vivid Steven Runciman, *Byzantine Style and Civilization* (1987).

Chapter 22. "Satan's Handiwork." For background essays, see *The Encyclopedia of Religion* and, for particular artists, *The Encyclopedia of World Art*. And for the broader Muslim context: Gustave von Grunebaum, *Medieval Islam* (2d ed., 1971); Thomas W. Arnold and Alfred Guillaume, eds., *The Legacy of Islam* (1931). On the arts: Thomas W. Arnold, *Painting in Islam . . . the place of pictorial art in Muslim culture* (1965); Annemarie Schimmel, *Calligraphy and Islamic Culture* (1984); Oleg Grabar, *The Formation of Islamic Art* (1973); Bernard Lewis, *The Muslim Discovery of Europe* (1982), Chapter X, "Cultural Life."

Part V: The Immortal Word

Chapter 23. Dionysus the Twice-Born; Chapter 24. The Birth of the Spectator: From Ritual to Drama; Chapter 25. The Mirror of Comedy. For the background in ancient Greek culture, see references for Chapters 4, 11, and 19, and Mircea Eliade, *History of Religious Ideas*, Vol. 2 (1982); W.K.C. Guthrie, *The Greeks and Their Gods* (1955); Lewis R. Farnell, *The Cults of the Greek States* (1909); E. R. Dodds, *The Greeks and the Irrational* (1951). On Dionysus and his festivals: Jane Ellen Harrison, *Themis* (1962); illuminating works by Arthur Pickard-Cambridge, *The Theatre of Dionysus in Athens* (1946), *The Dramatic Festivals of Athens* (1953), *Dithyramb Tragedy and Comedy* (2d ed., 1962), and A. E. Haigh, ed., *The Attic Theatre* (3d ed., 1969).

Ancient Greek literature has elicited eloquent critics as well as emulators, like the friends and enemies satirized in Jonathan Swift's *Battle of the Books* (1704). An appealing account of the ancient Greeks' view of culture is Werner Jaeger, *Paideia: The Ideals of Greek Culture* (3 vols., 1973–86). Modern critics have made Greek drama a standard for their judgments of Shakespeare, Goethe, and Shaw. Readable surveys of the place of ancient Greek drama in literary history: Margarete Bieber, *The History of Greek and Roman Theater* (1939); Jane Ellen Harrison, *Ancient Art and Ritual* (1923); Allardyce Nicoll, *The Development of the Theatre* (5th ed., 1966). An excellent introduction is H.D.F. Kitto, *Greek Tragedy* (1955); then C. M. Bowra, *Sophoclean Tragedy* (1944); Gilbert Murray, *Euripides and His Age* (1913); *Aristophanes* (1933; 1964); Victor Ehrenberg, *The People of Aristophanes* (3d ed., 1962), which puts the characters in their time.

Of the many translations of Greek drama, among the most accessible are David Grene and Richmond Lattimore, eds., *The Complete Greek Tragedies* (4 vols., 1959), and Whitney J. Oates and Eugene O'Neill, Jr., eds. *The Complete Greek Drama* (2 vols., 1938).

Chapter 26. The Arts of Prose and Persuasion. For the Arts of Memory, see my *The Discoverers*, Chapter 60. In addition

to the general works above, for ancient Greek education, see: H. I. Marrou, *A History of Education in Antiquity* (1956); William M. Small, ed. and trans., *Quintillian on Education* (1966). For prose, rhetoric, and oratory: J. B. Bury, *The Ancient Greek Historians* (1958); J. F. Dobson, *The Greek Orators* (1919); George Kennedy, *The Art of Persuasion in Greece* (1963); Ivan M. Linfooth, *Solon the Athenian* (1919). And for the relation of rhetoric to philosophy, Bertrand Russell's stimulating and opinionated *History of Western Philosophy* (1945). Texts of Herodotus, Thucydides, Plato, and Aristotle are available in *The Great Books of the Western World*. These and other Greek classics are in numerous translations and paperback editions, including the Penguin Classics. Of Plutarch's many translations, that by T. North (1599) was a sourcebook for Shakespeare, but the fluent translation by John Dryden has been most popular through the centuries. Convenient access to the major Greek historians in some of the best translations is Francis R. B. Godolphin, ed., *The Greek Historians* (2 vols., 1942).

BOOK TWO:
RE-CREATING
THE WORLD

Part VI: Otherworldly Elements

For the legacy of the Middle Ages there is no more delightful introduction than Morris Bishop, *The Middle Ages* (1970), and J. Huizinga, *The Waning of the Middle Ages* (1970), to liberate us from the stereotypes that Henry Adams's *Mont-Saint-Michel and Chartres* (1913, 1986) and his *Education* (1918, 1974) did much to create. Another antidote is Lynn White, Jr., *Dynamo and Virgin Reconsidered* (1971). We must not forget that Gibbon's *Decline and Fall* does not end till 1453 and has much to tell us about this era. For particular topics, *The Encyclopedia of Religion* and *The Dictionary of the Middle Ages*. And for background: Henri Pirenne's elegant and cogent *Mohammed and Charlemagne* (1939), *Medieval Cities* (1952); H. O. Taylor's suggestive *The Medieval Mind* (2

vols., 4th ed., 1930); E. K. Rand, *Founders of the Middle Ages* (1928, 1982); William Anderson, *Dante the Maker* (1980); Christopher Dawson, *The Making of Europe* (1956), and the deft collection of documents in *The Portable Medieval Reader* (1967).

Chapter 27. The Consoling Past. For Boethius's life, see Margaret Gibson, ed., *Boethius, His Life, Thought and Influence* (1981); and for his afterlife, Howard Rollin Patch, *The Tradition of Boethius* (1935). *The Consolation of Philosophy* (V. E. Watts, trans., 1969) is conveniently available in a Penguin paperback; and see *Boethius, Fundamentals of Music* (Calvin M. Bower, trans., 1969), and *The Theological Tractates* (H. F. Stewart and E. K. Rand, trans., 1918).

Chapter 28. The Music of the Word. For background and special topics, in addition to the general works above, the cogent *New Harvard Dictionary of Music* (Don Michael Randel, ed., 1986) and the *New Oxford Companion to Music* (2 vols., Denis Arnold, ed., rev. 1990) help us before taking the plunge into the copious *New Grove Dictionary of Music and Musicians* (20 vols., Stanley Sadie, ed., 1980). Two excellent durable works for putting the music in context: Hugo Leichentritt, *Music, History, and Ideas* (1939); Paul Henry Lang, *Music in Western Civilization* (1941); and the textbook Donald Jay Grout, *A History of Western Music* (rev. 1973). For the period, lively texts: Willi Apel, *Gregorian Chant* (2d ed., 1966), *Medieval Music* (1986); Richard H. Hoppin, *Medieval Music* (1978); Andrew Hughes, *Medieval Music: The Sixth Liberal Art* (1980). For comprehensive lives: F. Homes Dudden, *Life and Times of St. Ambrose* (2 vols., 1935), *Gregory the Great: His Place in History and Thought* (2 vols., 1967). For Saint Augustine's *De Musica,* there is a synopsis (by W. F. Jackson Knight, 1979) and a collection of essays, *Augustine on Music* (Richard H. LaCrois, ed., 1988).

Chapter 29. An Architecture of Light. For a lively introduction to the age, begin with Amy Kelly, *Eleanor of Aquitaine and the Four Kings* (1959), then Georges Duby, *The Age of the Cathedrals: Art and Society 980–1420* (1981). On Suger and St.-Denis we are fortunate in having Otto von Sim-

son's brilliant and cogent *The Gothic Cathedral: Origins of Gothic Architecture and the Medieval Concept of Order* (1988). For a scintillating exploration of the connections with medieval thought: Erwin Panofsky, *Gothic Architecture and Scholasticism,* and for the documents that have luckily survived, Erwin Panofsky, ed., *Abbot Suger on the Abbey Church at St.-Denis and Its Art Treasures* (2d. ed., 1979). Detailed studies: Sumner McK. Crosby, *The Royal Abbey of Saint-Denis, from Its Beginnings to the Death of Suger, 475–1151* (Pamela Z. Blum, ed., 1987), *The Apostle Bas-Relief at Saint-Denis* (1972), and *The Royal Abbey of Saint-Denis in the Time of Abbot Suger (1122–1151),* a catalog of the Metropolitan Museum of Art (1981). For the rich afterlife: Paul Frankl, *The Gothic: Literary Sources and Interpretations through Eight Centuries* (1960) and a classic study by Émile Mâle, *Religious Art from the Twelfth to the Eighteenth Century* (1949); Kenneth Clark, *The Gothic Revival* (new ed., 1962), a Penguin paperback. And the views of recent scholars, Paula Lieber Gerson, ed., *Abbot Suger and Saint-Denis, a Symposium* (1986).

Chapter 30. Adventures in Death. Coming to Dante anew, as some English readers will, it is hard not to be daunted by his "divine" reputation and the copious literature. T. S. Eliot, an adorer of Dante, can lead us with his essay in *Selected Essays* (1932). A good factual introduction and guide into the literature is Robert Hollander's article in the *Dictionary of the Middle Ages.* William Anderson, *Dante the Maker* (1980) helps us into Dante's world by treating his work straightforwardly as the visions of a believer, as does Jaroslav Pelikan, *Eternal Feminines: Three Theological Allegories in Dante's Paradiso* (1990), which can be compared with Erich Auerbach, *Dante: Poet of the Secular World* (1961), and E. K. Rand, *Founders of the Middle Ages* (1982). Ricardo J. Quinones, *Dante* (1985) provides a concise guide to the relation between Dante's life and his writings. Paget Toynbee, *Dante Alighieri* (6th ed., 1924) remains useful, with his study of the afterlife, *Dante in English Literature* (2 vols., 1909). For the institutions and literature of courtly love, see C. S. Lewis's delightful *The Allegory of Love* (1936, 1985). For English readers, the definitive scholarly edition with commentary is by Charles S. Singleton, *The Divine Comedy* (6 vols., 1970–75). The most appealing and accessible recent translations with commentary are by Dorothy Sayers in Penguin Classics (1949) and by John Ciardi in Mentor paperback (1954–1970).

Part VII. The Human Comedy: A Composite Work

For background to these chapters on heroes of the Vanguard Word, we must see how the written word was diffused and circulated, both before and after printing and the coming of movable type to the West. See my *The Discoverers,* Chapters 60–68. We must not forget that *"Littera Script Manet"* was written by Horace long before words were circulated in print. On what the printed book did and how: Lucien Febvre and Henri-Jean Martin, *The Coming of the Book* (1976), Sandra Hindman and James Douglas Farquhar, *Pen to Press* (1977); H. J. Chaytor, *From Script to Print . . . Medieval Vernacular Literature* (1976). And for a broader view of the role of print in Western culture: *A Short History of the Printed Word* (1970); John Carter and Percy H. Muir, eds., *Printing and the Mind of Man* (1967), a guide to an exhibit of "The Impact of Print on Five Centuries of Western Civilization," an invaluable compendium of facts on the first entry into print of works that have made a difference. An admirable anthology with concise biographies of authors is *The Norton Anthology of World Masterpieces* (4th ed., 2 vols., 1979). And there are comparable Norton anthologies of English and American literature. For guidance into the vocabulary of literary criticism and jargon, see M. H. Abrams, *A Glossary of Literary Terms* (5th ed., 1988).

Chapter 31. Escaping the Plague. For the context in Boccaccio's time, see Barbara Tuchman's engrossing *A Distant Mirror: The Calamitous Fourteenth Century* (1978); William H. McNeill, *Plagues and People* (1976). And for a scholarly and readable biography: Thomas G. Bergin, *Boccaccio* (1981). Until recently the most widely circulating English translation of *The Decameron* was the stilted version of

John Payne (1928), with an introduction by Sir Walter Raleigh. G. E. McWilliam's translation for the Penguin Classics is more colloquial. My favorite is the vigorous version by Mark Musa and Peter Bondanella (Mentor paperback, 1982), with an introduction by Thomas Bergin.

Chapter 32. Joys of Pilgrimage. For pilgrimage as a path to discovery, see my *The Discoverers,* Chapter 15, and the Reference Notes there to Part V. *The Dictionary of the Middle Ages* provides readable essays on people, places, and institutions. Lively and learned essays on the background: J. J. Jusserand, *English Wayfaring Life in the Middle Ages* (4th ed., 1950); G. G. Coulton, *Chaucer and His England* (8th ed., 1963); Boris Ford, ed., *The Age of Chaucer* (1961). Enticing introductions to the man and his works: G. L. Kittredge, *Chaucer and His Poetry* (1925); J. L. Lowes, *Geoffrey Chaucer and the Development of His Genius* (1934), *Geoffrey Chaucer of England* (1951). A comprehensive biography: Donald R. Howard, *Chaucer* (1987). For Chaucer's text the most accessible is F. N. Robinson, *The Works of Geoffrey Chaucer* (2d ed., 1957) with unobtrusive glossaries; and for an appealing "modernized" version of selections, Theodore Morrison, *The Portable Chaucer* (1949). Few other English authors have been so extensively and enthusiastically written about. An up-to-date selective bibliography is found in the latest edition of *Encyclopaedia Britannica.*

Chapter 33. "In the Land of Booze and Bibbers." Readers should not be discouraged from tasting the outrageous Rabelais by the bulk of *Gargantua and Pantagruel,* by his awesome classic status, or the wilderness of scholarship that surrounds him. Despite his verbosity and his ability to make ten words do the work of one, Rabelais's chapters can stand alone to open his wonderful world of the absurd. We can begin, for example, with Chapter 13 of *Gargantua* in J. M. Cohen's robust unadulterated translation (a Penguin Classics paperback), which gives even fecal matter some comic charm without barnyard vulgarity. For biography: Donald M. Frame, *Rabelais* (1977); M. A. Screech, *The Rabelaisian Marriage . . . Rabelais's religion, ethics and comic philosophy* (1958); Mikhail Bakhtin, *Rabelais and His World* (1968), a suggestive but labored Marxist view. Every reader will have to decide for himself whether Rabelais deserved to be the eponym for "Rabelaisian," which the dictionary defines as "broadly and coarsely humorous." Rabelais was introduced to English readers by the lively free translations of Sir Thomas Urquhart (Books I and II, 1653; Book III, 1693–94) and Pierre Motteux (Books IV and V, 1693–94), reprinted in the Everyman Classics. Samuel Putnam's Introduction is helpful, with a selection of translations from all the books in *The Portable Rabelais* (1946).

Chapter 34. Adventures in Madness. For the English-language reader there is no better introduction to Cervantes than Carlos Fuentes's eloquent foreword and introduction to Tobias Smollett's translation ("a novelist's translation") of 1755, with Smollett's own brief life of Cervantes recently reprinted in an attractive paperback by Farrar, Straus and Giroux. For other insights into his life: William J. Entwhistle, *Cervantes* (1940); the detailed James Fitzmaurice-Kelley, *Miguel de Cervantes Saavedra: a Memoir* (1913); Rudolph Schevill, *Cervantes* (1919, 1966). And for some stimulating suggestions: Salvador de Madariaga, *Don Quixote: An Introductory Essay in Psychology* (1961); Josef F. Mora, *Unamuno: A Philosophy of Tragedy* (1962); José Ortega y Gasset, *The Dehumanization of Art* (1968). The first notable English translation (done freely in 1712) by the same Pierre Motteux who translated Rabelais was often republished with revisions. The translation (1949) by Samuel Putnam with notes in the Modern Library became the Anglo-American standard, and he has provided an attractive *Portable Cervantes* (1951), with selections from *Don Quixote* and *Exemplary Novels,* along with Cervantes's *Farewell to Life.* J. M. Cohen has given us his translation in the Penguin Classics (1950) that matches his Rabelais in colloquial fluency.

Chapter 35. The Spectator Reborn. Of the countless editions of Shakespeare, I have found most helpful *The Riverside Shakespeare* (2 vols., 1974), with a conveniently glossed text, lively introductions by Harry Levin and others, chronologies, and facts about Shakespeare and the Elizabe-

than scene. And see G. B. Harrison, *Introducing Shakespeare* (3d ed., 1968), a Penguin book. In the vast Shakespearean literature it is easy to get lost and wander away from what Shakespeare wrote. For biography I have enjoyed Marchette Chute, *Shakespeare of London* (1949) and S. Schoenbaum, *Shakespeare's Lives* (1970; 1991). For the theater: Bernard Beckerman, *Shakespeare at the Globe, 1599–1609* (1962); H. S. Bennett, *Shakespeare's Audience: Annual Shakespeare Lecture of the British Academy* (1944); Gerald E. Bentley, *The Profession of Dramatist in Shakespeare's Time, 1590–1642* (1971); and the copious E. K. Chambers, *The Elizabethan Stage* (4 vols., 1923). On the background: Boris Ford, ed., *The Age of Shakespeare* (1964); John Dover Wilson, ed., *Life in Shakespeare's England: A Book of Elizabethan Prose* (1949); Kenneth Muir, ed., *A New Companion to Shakespeare Studies* (1968); David Riggs, *Ben Jonson* (1989). Samples of the vast critical literature: A. C. Bradley, *Shakespearean Tragedy* (1904); Theodore Spencer, *Shakespeare and the Nature of Man* (2d ed., 1966); C. L. Barber, *Shakespeare's Festive Comedy* (1959); Edwin Wilson, ed., *Shaw on Shakespeare* (1961).

A history of Shakespearean criticism would be a history of English literature since his time. For me the most rewarding Shakespearean criticism is by Samuel Taylor Coleridge, who once called this his most important contribution to literature, to be sampled in his *Shakespearean Criticism* (T. M. Raysor, ed., 2 vols., 1930) or *Coleridge on Shakespeare* (R. A. Foakes, ed., 1971). To sense the captiousness and intensity of Shakespeare scholarship, look at the *New Variorum Shakespeare* (H. H. Furness et al., eds., 1871–), frequently reissued and supplemented, and E. K. Chambers, *William Shakespeare: A Study of Facts and Problems* (2 vols., 1930). The "Shakespearean Literature" is a microcosm of the possibilities, follies, and frustrations of literary critics. Long before deconstruction, they industriously explored the possibilities that Shakespeare was someone else (perhaps Francis Bacon or the Earl of Oxford), or did not exist. Glimpse some of these theories in S. Schoenbaum, *Shakespeare's Lives*. For recapturing half-remembered lines, see the comprehensive *Harvard Concordance to Shakespeare*, Marvin Spevack, ed. (1973). For the afterlife of Shakespeare in twentieth-century technologies: Peter S. Donaldson, *Shakespearean Screen: An International Filmography and Videography* (1990).

Chapter 36. The Freedom to Choose. A convenient introduction is Douglas Bush, ed., *The Portable Milton* (1949), with all the major poems and a selection of prose, including *Of Education, Areopagitica,* and some autobiographical passages. An elegant brief introduction to the relation of the life to the works is David Daiches, *Milton* (1957). We are fortunate in having the now-standard biography, William Riley Parker, *Milton* (2 vols. 1968), copious, subtle, and delightfully readable. This displaces David Masson's *Life of Milton* (7 vols., 1859–94), which like some other "classics" of literary history is now remembered for having been forgotten. For a surrogate autobiography, see J. S. Diekhoff, *Milton on Himself* (2d ed., 1965). For a guide into the Milton literature, see James Holly Hanford and James G. Taaffe, *A Milton Handbook* (5th ed., 1970). Like Shakespeare, Milton provides a point of reference for a full history of English literature since his time: John T. Shawcross, ed., *Milton: The Critical Heritage* (1970); Joseph A. Wittreich, Jr., *The Romantics on Milton* (1970). For background, see: E. M. Tillyard, *Milton* (rev. ed., 1966); Douglas Bush, *English Literature in the Earlier Seventeenth Century* (2d ed., 1962). A convenient edition of the prose: Malcolm W. Wallace, *Milton's Prose* (1925) in the World's Classics. A comprehensive one-volume annotated scholarly edition: *Complete Poems and Major Prose*, M. Y. Hughes, ed. (1957). The many editions and the vast critical literature attest to Milton's power to stir the most diverse readers— from C. S. Lewis, *A Preface to Paradise Lost* (1942) to Isaac Asimov's popular annotated *Paradise Lost* (1974). Dr. Johnson disliked Milton's "foreign idiom." William Blake found him "a true Poet, and of the Devil's party without knowing it." Interest has focused on the role of Satan as hero, and *Paradise Lost* has had an uncanny appeal to illustrators, including William

Blake (1806), J.M.W. Turner (1835), and Gustave Doré (1866).

Chapter 37. Sagas of Ancient Empire. The reader will share my passion for Gibbon's *History* by beginning with the eloquent and seductive Chapter 1, then turning to the provocative Chapters 15 and 16 on the rise of Christianity. Though available in many scholarly reprints, Gibbon is best read in the edition by J. B. Bury (7 vols., 2d ed., 1926), with illustrations, maps, helpful appendixes and notes on how later scholars have revised or added to Gibbon's story. I recommend reading a volume or two of Gibbon unabridged rather than a one-volume selection, like that of D. M. Low (1960). The best introduction to Gibbon's life is his own *Memoirs of My Life and Writing,* which was edited and published by his friend and executor, Lord Sheffield, as the *Autobiography of Edward Gibbon.* This, itself a classic of its kind and a pioneer in the paths marked off by Montaigne (see below, Chapter 56), is handily available with an introduction by J. B. Bury in the World's Classics. The best short life until now is the readable Roy Porter, *Gibbon: Making History* (1988). For details of the life and writings we have the scrupulous and exhaustive works of Patricia B. Craddock, *Young Edward Gibbon: Gentleman of Letters* (1988), *Edward Gibbon, Luminous Historian, 1772–1794* (1989), *Edward Gibbon: A Reference Guide* (1987).

Chapter 38. New-World Epics. The Library of America gives attractive access. Prescott's *Conquest of Mexico* and his *Conquest of Peru* are conveniently available unabridged in a single Modern Library Giant. Both works begin with an engrossing detailed exposition of the geography, institutions, religion, mythology, and science, and are surprisingly respectful of the peculiar institutions of these non-European peoples. While passages inevitably betray prejudices of Prescott and his age, they also show an impressive sympathy for the variety of human cultures and a sense of the interconnection of all of a society's ways. William Charvat and Michael Kraus, eds., have provided *Representative Selections* (1943), with introductions. A cogent and appreciative introduction to Prescott's life is the essay by Roger B.

Merriman in the *Dictionary of American Biography* (1935). G. Harvey Gardiner, *William Hickling Prescott* (1969) provides a comprehensive critical biography.

The Oregon Trail has often been reprinted in editions for young readers. Parkman's other writings are less conveniently available today, but can be found in numerous subscription and library editions of the last century. An attractive sampler is the *Parkman Reader* (1955), selected and edited by Samuel Eliot Morison, with his usual grace. And, for Parkman's life, begin with the essay by James Truslow Adams in *The Dictionary of American Biography,* then to the admirable biography by Mason Wade, *Francis Parkman: Heroic Historian* (1942), illuminated by *Letters of Francis Parkman* (2 vols., 1960), edited by Wilbur R. Jacobs. To put Prescott and Parkman in literary context: G. P. Gooch, *History and Historians in the Nineteenth Century* (new ed., 1959); Michael Kraus, *The Writing of American History* (1963); David Levin, *History as Romantic Art: Bancroft, Prescott, Motley, and Parkman* (1959); Robert E. Spiller et al., *Literary History of the United States,* Vol. 1 (1948); Van Wyck Brooks, *The Flowering of New England* (1936).

Chapter 39. A Mosaic of Novels. For a wide perspective on the place of the novel in the history of printed literature, see: Warren Chappell, *A Short History of the Printed Word* (1970); S. H. Steinberg, *Five Hundred Years of Printing* (3d ed., 1974), a Penguin book; Daniel P. Resnick, ed., *Literacy in Historical Perspective* (1983); Richard D. Altick, *The English Common Reader* (1957), a social history of the mass reading public. And for great novelists' perspectives: Henry James, *French Poets and Novelists* (1878); *Essays on the Art of Fiction* (Leon Edel, ed., 1956), Vintage paperback; E. M. Forster, *Aspects of the Novel* (1927), often reprinted. For sharply focused views: W. Somerset Maugham, *Ten Novels and their Authors* (1954); Stefan Zweig, *Three Masters: Balzac, Dickens, Dostoeffsky* (1930), *Balzac* (1947); V. S. Pritchett's vividly illustrated brief biography, *Balzac* (1973). André Maurois has found Balzac an ideal subject for his risky art of making biography read like a novel:

Prometheus: The Life of Balzac (1965). The critical literature on Balzac is as copious as his works. Especially helpful are: Samuel Rogers, *Balzac and the Novel* (1969); H. J. Hunt, *Balzac's Comédie Humaine* (1959); Harry Levin, *The Gates of Horn . . . Five French Realists* (1963). Balzac's writings, often translated, are in numerous reprint series, notably the Modern Library and Penguin Classics.

Chapter 40. In Love with the Public. Dickens's beloved public has not forgotten him, and has organized the Dickens Fellowship, with headquarters in Dickens House in London, and branches across the world, three times a year publishing the *Dickensian.* For the dimensions of public enthusiasm, see G. K. Chesterton, *Charles Dickens, Last of the Great Men* (1942). We are fortunate that John Forster, Dickens's close friend and publishing collaborator, wrote a detailed three-volume *Life* (1872–74), new ed. by A. J. Hoppe in Everyman Library (1969), providing a source for many later biographies. The standard recent life is Edgar Johnson's admirable *Charles Dickens: His Tragedy and Triumph* (2 vols., 1952), abridged and revised (1986) for Penguin Books. For other views: the copious Norman and Jeanne Mackenzie, *Dickens* (1979); the massive Peter Ackroyd, *Dickens* (1990). For Dickens in perspective: Humphry House, *The Dickens World* (2d ed., 1962); Angus Wilson, *The World of Charles Dickens* (1970); Stefan Zweig, *Three Masters* (1930). Dickens's writings are available in editions to suit any pocketbook—from the deluxe Nonesuch Dickens, to paperbacks at airports.

Part VIII. From Craftsman to Artist

The movement from craftsman to artist, from doing the familiar task better to doing something new is a legacy of the Renaissance, dramatized most vividly in Italy. The histories of the arts of the Renaissance are seldom tainted by the envy that can mar the history of literature written by authors manqué. The word "renaissance" ("*rebirth*") is an understatement of the novelty that marked the creators we meet in Chapters 41–45. This spirit is savored in its pioneer spokesman Jacob Burckhardt, *The Civilization of the Renais-*

sance in Italy (in German, 1860; available in many English translations and reprints). The idea of the Renaissance was popularized in the English-reading world by J. A. Symonds, *History of the Renaissance in Italy* (1875–86) and Walter Pater, *Studies in the History of the Renaissance* (1873), and by John Ruskin's championship of the Gothic against the Renaissance in his *Seven Lamps of Architecture* (1849) and *The Stones of Venice* (1851–53). As a stimulus to seeing and thinking, few can excel Erwin Panofsky: *Renaissance and Renascences in Western Art* (1970), *Meaning in the Visual Arts* (1982), *The Life and Art of Albrecht Dürer* (1971). For wider perspectives: E. H. Gombrich, *The Story of Art* (3d ed., 1950), *Meditations on a Hobby Horse* (1963), illustrated essays on the theory of art, and *Art and Illusion* (1972). And viewed by a historian of science: George Sarton, *The Renaissance* (1929). For a delightful plunge into the world and conceit of Italian Renaissance artists, read Benvenuto Cellini's *Memoirs* in a newly unexpurgated translation in the World Classics (1961). An admirable selection of the writings by and about artists in this period is Elizabeth Gilmore Holt, ed., *A Documentary History of Art,* Vol. I (1980), in paperback. Giorgio Vasari's *Lives of the Artists* (translated and selected by George Bull; 2 vols., 1987) is in Penguin Books.

Chapter 41. Archetypes Brought to Life. In addition to the general works above, an excellent introduction to the life and works: Mario Bucci, *Giotto* (1968), with eighty color plates; Roberto Salvini, *All the Paintings of Giotto* (2 vols., 1963).

Chapter 42. Roman Afterlives. Two good points of departure: Peter Murray, *The Architecture of the Italian Renaissance* (rev. ed., 1986); Jacob Burckhardt, *The Architecture of the Italian Renaissance* (revised and edited by Peter Murray, 1985). Alberti's *Ten Books of Architecture* (the 1755 Leoni Edition) is in a Dover reprint (1986). Manetti's *Life of Brunelleschi* has been edited with an introduction by Howard Saalman (1970). For the architect's profession: Spiro Kostof, ed., *The Architect* (1986). And for another afterlife of Roman architecture, see James S. Ackerman's brilliant essay *Palladio* (1966), in the Penguin series The Architect and Society,

and Andrea Palladio, *The Four Books of Architecture* (1965), a Dover reprint.

Chapter 43. The Mysteries of Light: From a Walk to a Window. The basic works on the history of perspective in this period are John White, *The Birth and Rebirth of Pictorial Space* (3d ed., 1987), and Samuel F. Edgerton, Jr., *The Renaissance Rediscovery of Linear Perspective* (1975). For insight into the contrasting ways of nonperspective art, see Heinrich Schäfer, *Principles of Egyptian Art* (1974).

Chapter 44. Sovereign of the Visible World. The life of Leonardo challenges both the historian of science and the historian of the arts. See my *The Discoverers,* Chapters 45 and 46. To bring the two cultures together, begin with Kenneth Clark, *Leonardo da Vinci . . . His Development as an Artist* (2d ed., 1952); Martin Kemp, *Leonardo da Vinci: The Marvellous Works of Nature and Man* (1981), *The Science of Art: Optical Themes in Western Art from Brunelleschi to Seurat* (1990); Morris Philipson, ed., *Leonardo da Vinci: Aspects of the Renaissance Genius* (1966). For biographies, see: Ludwig H. Heydenreich, *Leonardo da Vinci* (2 vols., 1954); V. P. Zubov, *Leonardo da Vinci* (originally published in Russian, 1961, 1968); Serge Bramly, *Leonardo: Discovering the Life of Leonardo da Vinci* (1991). Leonardo's own writings are best available in *The Literary Works of Leonardo da Vinci* (2 vols., 3d ed., 1970), edited from the original manuscripts by Jean Richter. See also *The Notebooks of Leonardo da Vinci* (Edward MacCurdy, trans., 1941); *Leonardo on Painting* (1989, Martin Kemp, ed.), an anthology of his writings with documents on his career. For the interesting suggestion that Leonardo may have been right-handed, and some of the evidence, see Henry Petroski, *The Pencil* (1990), Ch. 1.

Chapter 45. "Divine Michelangelo." A stimulating introduction to the idea of the genius artist is Rudolph Wittkower's essay "Genius: Individualism in Art and Artist," in *Dictionary of the History of Ideas* (Philip P. Wiener, ed., 4 vols., 1973) at Vol. 2, pp. 297–312, amplified by his *Born Under Saturn: The Character and Conduct of Artists . . . from Antiquity to the French Revolution* (1963). For Vasari, see reference notes to Chapter 41 above, and especially Vasari, *Lives of the Artists* (2 vols., 1987), Vol. 2, Penguin Books. An excellent introduction to all aspects of Michelangelo is the article by Charles de Tolnay in *Encyclopedia of World Art,* Vol. 9, pp. 861–914. And for a full-length biography, the lively and subtle Charles H. Morgan, *The Life of Michelangelo* (1960). For documents, see: Charles Holroyd, *Michael Angelo Buonarroti with . . . the Life by . . . Condivi and Three Dialogues of . . . d'Ollanda* (2d ed., 1911); *Documentary History of Art* (Elizabeth G. Holt, ed., 4 vols., 1981), Vol. 1. A magisterial work is James S. Ackerman, *The Architecture of Michelangelo* (2 vols., 1961); and, with J. Newman, *The Architecture of Michelangelo, with a Catalogue of Michelangelo's Works* (Penguin Books, 1971); to be consulted with Jacob Burckhardt, *The Architecture of the Italian Renaissance* (revised and edited by Peter Murray, 1985), and Robert J. Clements, *Michelangelo's Theory of Art* (1961). For wider background, see: Burckhardt, *Civilization of the Renaissance* (1944); George Brandes, *Michelangelo, His Life, His Times, His Era* (1963); J. H. Plumb, *Renaissance Profiles* (1961); and the suggestive if dogmatic Arnold Hauser, *The Social History of Art* (2 vols., 1951), *Mannerism: The Crisis of the Renaissance and the Origin of Modern Art* (1986). It is not surprising that Michelangelo has inspired romanticized and novelized biographies, for example Romain Rolland, *Michelangelo* (2 parts; French, 1905–6; English, 1962).

Chapter 46. The Painted Word: The Inward Path of Tao. For anyone schooled in the West, discovering Chinese painting in its masterpieces (for example those in the National Palace Museum in Taipei, Taiwan) is wonderfully refreshing. A lively orienting introduction is F. W. Mote, *Intellectual Foundations of China* (2d ed., 1989). For the backgrounds of Chinese culture, see above reference notes for Chapter 2, especially: Herrlee G. Creel, *Confucius and the Chinese Way* (1960), *What Is Taoism?* (1970); C. P. Fitzgerald, *China: A Short Cultural History* (4th ed., 1976), *The Chinese View of Their Place in the World* (1960); *The Legacy of China* (Raymond Dawson, ed., 1964). The general works I have found most helpful: William Willetts,

Foundations of Chinese Art: From Neolithic Pottery to Modern Architecture (1965); Mario Prodan, *An Introduction to Chinese Art* (1958); Christian F. Murck, ed., *Artists and Traditions: Uses of the Past in Chinese Culture* (1976). On the history of the stylus and other early writing instruments, see the excellent illustrated Chapter 29, by S. H. Hooke, "Recording and Writing," in Charles Singer et al., eds., *A History of Technology* (1967), Vol. I. We are fortunate in having several vivid works to answer the Westerner's puzzlement and explain the relation of Chinese painting to calligraphy: Laurence Binyon, *Painting in the Far East . . . Pictorial Art in . . . China and Japan* (1959), a Dover paperback; Chih-Mai Ch'en, *Chinese Calligraphers and their Art* (1966); Annie Chen, *The What and How of Chinese Painting* (1978); especially helpful—Mai-Mai Sze, *The Way of Chinese Painting: Its Ideas and Techniques,* with selections from the seventeenth-century *Mustard Seed Garden Manual of Painting,* available at the National Palace Museum, Taipei.

For some of the painters and texts mentioned in this chapter see: Susan Bush and Hsio-yen Shih, eds., *Early Chinese Texts on Painting* (1985) and Chang Chung-yuan, *Creativity and Taoism: A Study of Chinese Philosophy, Art and Poetry* (1975). And for an illuminating example of the application of the traditions of Chinese painting by a talented Chinese artist in the twentieth century, see Shen C.Y. Fu, *Challenging the Past: The Paintings of Chang Dai-chien (1899-1983)* (1991), a catalog of an exhibit in the Arthur M. Sackler Gallery of the Smithsonian Institution, Washington, D.C.

Part IX. Composing for the Community

In addition to the general reference works listed under Chapter 28 above, of the countless works on Western music I have found especially helpful: Douglas Moore, *A Guide to Musical Styles* (rev. 1962); Donald F. Tovey, *The Forms of Music* (1956); Joan Peyser, ed., *The Orchestra: Origins and Transformations* (1986); Curt Sachs, *The History of Musical Instruments* (1940); Donald Jay Grout and Hermine Weigel

Grout, *A History of Western Music* (rev., 1973), *A Short History of Opera* (3d ed., 1988). Of the many popular essays and biographies by musicologists for nonmusicians these are attractive: Aaron Copland, *Music and Imagination* (1957); Harold C. Schonberg, *The Lives of the Great Composers* (1989); Wallace Brockway and Herbert Weinstock, *Men of Music,* (rev. ed., 1950), *The World of Opera* (1962); Edward J. Dent, *Opera* (1978), illustrated; Gerald Abraham, *One Hundred Years of Music* (4th ed., 1974). Handy for dates and reference: Arthur Jacobs, *The New Penguin Dictionary of Music* (4th ed., 1979); Karl Nef, *An Outline of the History of Music* (1964). For an eighteenth-century view, see: Charles Burney, *A General History of Music: from the earliest ages to the present period* (1789) (2 vols., Frank Mercer, ed., reprint, 1935). Urban life in the ages of the great composers is vividly re-created by Ilsa Barea, *Vienna* (1966). And to bring the great figures together: Charles Rosen, *The Classical Style: Haydn, Mozart, Beethoven* (1976).

Chapter 47. A Protestant Music. The best introduction to Bach's life is Karl Geiringer, *Johann Sebastian Bach: The Culmination of an Era* (1966). The foundation for later biographies remains the copious *Johann Sebastian Bach: his work and influence on the music of Germany, 1685–1750,* by Philipp Spitta (3 vols., 1873-80), now available in Dover reprints (1951); revised in Charles Sanford Terry, *Bach* (1928). An admirable and convenient collection of the documents is Hans T. David and Arthur Mendel, eds., *The Bach Reader* (1945). We should let Bach introduce us to the remarkable Albert Schweitzer (1875–1966), whose engrossing and personal *J. S. Bach* (Ernest Newman, trans., 2 vols., 1966, Dover reprints) reveals another Bach. A passionate Bach devotee, Schweitzer also made an enduring edition of Bach's organ music. It is astonishing that this medical missionary to the African jungle (winner of the Nobel Peace Prize 1952), versatile and adventurous pursuer of "Reverence for Life," found his hero in the craftsman-musician of German princelings. For the technical context: C. F. Abdy Williams, *The Story of the Organ* (1972).

Chapter 48. The Music of Instruments: From Court to Concert. Excellent short lives of Haydn and Mozart by Denis Arnold appear in the *New Oxford Companion to Music* (2 vols., rev. 1990). Scholarly and readable full-length biographies: Karl and Irene Geiringer, *Haydn: A Creative Life in Music* (2d ed., 1968) and H. C. Robbins Landon, *Haydn* (1972); a shorter life, Rosemary Hughes, *Haydn* (5th ed., 1970). For Haydn's own record, see H. C. Robbins Landon, *The Collected Correspondence and London Notebooks of Joseph Haydn* (1959), *Haydn: Chronicle and Works* (1976–80). The Mozart literature is vast for his brief life. Stanley Sadie helps us into the literature with his readable *New Grove Mozart* (1983). H. C. Robbins Landon and D. Mitchell, eds., *The Mozart Companion* (2d ed., 1965), essays by specialists. The debate over the cause of Mozart's early death has never ceased. For a recent popular account arguing that he was poisoned and hurried to an unmarked grave to avoid autopsy: Francis Carr, *Mozart & Constanze* (1985).

Chapter 49. New Worlds for the Orchestra. Excellent starting points for Beethoven are the readable and cogent George R. Marek, *Beethoven: Biography of a Genius* (1969), or Stanley Sadie, *Beethoven* (1967) in Faber's Great Composer Series. The monumental life is by Alexander Wheelock Thayer, revised and edited by Elliot Forbes, *Thayer's Life of Beethoven* (2 vols., 1967). But none of these has the intimacy and authenticity of *Beethoven as I Knew Him* (D. W. Macardle, ed., 1966), by Anton Felix Schindler (1795–1864), the German conductor and Beethoven's close friend. The great man is illuminated from many sides in C. G. Sonneck, ed., *Beethoven: Impressions by His Contemporaries* (1967), a Dover paperback. For the wider background and the auguries of Romanticism, see Jacques Barzun's engrossing *Berlioz and the Romantic Century* (2 vols., 3d ed., 1969).

Chapter 50. The Music of Risorgimento. Since Verdi was not a literary person, he left few writings about himself except his letters and we depend heavily on anecdotal materials. A perceptive introduction is Frank Walker, *The Man Verdi* (1962), supplemented by the full-length biography,

Dyneley Hussey, *Verdi* (rev. 1973), illustrated with music examples. See also John F. Toye, *Giuseppe Verdi* (1931); D. Kimbell, *Verdi in the Age of Italian Romanticism* (1981), a documented panorama.

Chapter 51. A Germanic Union of the Arts. Wagner's own voluminous writings and his encompassing interests have produced a vast literature. A useful introductory essay is by John Warrack in *The New Oxford Companion to Music.* The standard up-to-date biography is Curt von Westernhagen, *Wagner* (2 vols., 1978). For copious detail: Ernest Newman, *The Life of Richard Wagner* (4 vols., 1933–47), *The Wagner Operas* (1949). Wagner's own writings: *My Life* (A. Gray, trans.; Mary Whittall, ed., 1983), *Opera and Drama* (Edwin Evans, trans., 2 vols.), *Three Wagner Essays* (Robert L. Jacobs, trans., 1979). An intimate view: M. Gregor-Dellin and D. Mack, eds., *Cosima Wagner's Diaries* (1978–80). And brilliantly suggestive essays for the context: Jacques Barzun, *Darwin, Marx, Wagner: Critique of a Heritage* (2d ed., 1981); George Bernard Shaw, *The Perfect Wagnerite, a Commentary on the Ring* (1923, 1967), a Dover paperback; Peter Viereck, *Metapolitics,* the roots of the Nazi mind, from the Romantics to Hitler (rev. 1961).

Chapter 52. The Ephemeral Art of the Dance. A stirring introduction by one of the leading American patrons of dance: Lincoln Kirstein, *Dance: A Short History of Classic Theatrical Dancing* (anniversary ed., intro. by Nancy Reynolds, 1987). A wider view: John Lawson, *A History of Ballet and Its Makers* (1964); on individual dancers and styles, Kenneth McLeish, *Penguin Companion to the Arts in the Twentieth Century* (1955), and the handy *Dance Encyclopedia* (Anatole Chujoy, ed., 1949). A lively introduction to Russian ballet in its setting: Suzanne Massie, *Land of the Firebird: The Beauty of Old Russia* (1980). For biography, begin with Richard Buckle, *Diaghilev* (1979), and find details in S. L. Grigoriev, *The Diaghilev Ballet, 1909–1929* (1953). For the tantalizing Isadora Duncan, begin with Walter Terry, *Isadora Duncan: Her Life, her Art, her Legacy* (1984). Then Allan Ross Macdougall, *Isadora: A Revolutionary in Art and Love* (1960) on her sensational impact,

and the more sober V. Seroff, *The Real Isadora* (1971). And enjoy Isadora Duncan's own version in *My Life* (1927). For Martha Graham: *Blood Memory: An Autobiography* (1991); Don McDonagh, *Martha Graham* (1973); *Martha: The Life and Work of Martha Graham* (1991), the passionate and breathless chronicle by Agnes de Mille, her friend for sixty years. To define modern dance and put it in context: the eloquent John Martin, *Introduction to the Dance* (1965), *The Modern Dance* (1965), *American Dancing: the background and personalities of the modern dance* (1968), illustrated.

Chapter 53. The Music of Innovation
The best introduction to Stravinsky is Eric Walter White's comprehensive and readable *Stravinsky: The Composer and his Works* (2d ed., 1979). The composer himself was articulate, voluble, affable, and sometimes venomous. See, for example: his *Autobiography* (1936; 1975); *Poetics of Music* (1947), his Norton Lectures at Harvard; and *Themes and Conclusions* (1972), a collection of his program notes, reviews, and interveiws. His friend and aide Robert Craft elicits a wide range of opinions in *Conversations with Igor Stravinsky* (1959). Lillian Libman, a warm admirer, provides intimate details of Stravinsky (1959–1971) as composer, performer, and stirring conversationalist, in *And Music at the Close: Stravinsky's Last Years* (1972). Few other modern composers have provided such a lively arena of personal aesthetic, and professional controversy. For the context see: Eric Walter White, *Stravinsky: A Critical Survey* (1979); the richly suggestive *Style and Idea: Selected Writings of Arnold Schoenberg* (ed. Leonard Stein, 1975), including his influential "Composition with Twelve Tones" (1941), explaining how "the method of composing with twelve tones grew out of necessity." And for Schoenberg's relation to Stravinsky, see Dika Newlin *Schoenberg Remembered: Diaries and Recollections (1938–76)* (1980).

Part X. Conjuring with Time and Space

For the relation of Western discovery and definition of time and space to thinking about the world, see Boorstin, *The Discov-*erers, Books I and II. See also my *Republic of Technology* (1978), *The Image* (1961, 1987), and *The Americans: The Democratic Experience* (1973). On the role of the arts and technology in these perceptions, two of the most rewarding writers are the Swiss historian Sigfried Giedion, *The Eternal Present: The Beginnings of Art* (1962), *The Beginnings of Architecture* (1981), *Mechanization Takes Command* (1948), *Space, Time, and Architecture* (1949); and the American polymath Lewis Mumford, *Sticks and Stones* (1924) on American life interpreted through architecture, *The Culture of Cities* (1938), *The City in History* (1961), *The Myth of the Machine* (1970). For particular topics, consult the scholarly and readable *A History of Technology* (Charles Singer et al., eds., Vols. 4 and 5, 1958; Trevor Williams, ed., Vols. 6 and 7, 1978), and for persons, see the incomparable *Dictionary of Scientific Biography*.

Chapter 54. The Painted Moment. We are fortunate in having the comprehensive and perceptive *History of Impressionism* (4th ed., 1987) by John Rewald to give us our bearings. Martin Kemp's magisterial *The Science of Art, Optical Themes in Western Art from Brunelleschi to Seurat* (1990) relates the artists to the sciences. See also: Phoebe Pool, *Impressionism* (1967); Herschel B. Chipp, *Theories of Modern Art* (1968), selections from artists and critics; Aaron Scharf, *Art and Photography* (1974), with intriguing detail, illustrated; Richard Shiff, *Cézanne and the End of Impressionism* (1984); *Impressionism 1874–1886; The New Painting,* catalog of an exhibition at the National Gallery of Art in 1986; Alan Bowness, *Great Art and Artists of the World, Impressionists and Post-Impressionists* (n.d.). For an illuminating history of the materials and technology of the artist: W. G. Constable, *The Painter's Workshop* (1954). And some stimulating speculation: Remi Clignet, *The Structure of Artistic Revolutions* (1985), testing hypotheses of historians of science in relation to the arts. To glimpse the surprising range of dominant theories: Vasco Ronchi, *The Nature of Light: An Historical Survey* (1970). Excellent illustrated biographies from various points of view: John House, *Monet: Nature into Art (1986);* Robert Gordon and Andrew Forge, *Monet* (1983)

with ample quotations from Monet; William C. Seitz, *Claude Monet* (1960); Stephen Shore, *The Gardens at Giverny: A View of Monet's World* (1983), vividly illustrated.

Chapter 55. The Power of Light: "The Pencil of Nature." This new popular art has invited a vast literature, with a history that is readily illustrated. The best up-to-date introduction is John Szarkowski, *Photography until Now* (1989). See also Beaumont Newhall, *The History of Photography* (rev. ed., 1982); Sarah Greenough et al., *On the Art of Fixing a Shadow: 150 Years of Photography* (1989), catalog of an exhibit at the National Gallery of Art. Renata W. Shaw, comp., *A Century of Photographs, 1846–1946* (1980), from the collections of the Library of Congress. And for a scintillating essay on the history of illustration: William M. Ivins, Jr., *Prints and Visual Communication* (1953). And again: Martin Kemp, *The Science of Art: Optical Themes in Western Art* (1990); Aaron Scharf, *Art and Photography* (1974). For a comprehensive illustrated biography: Gail Buckland, *Fox Talbot and the Invention of Photography* (1980). We gain insight into the early debates over the relation of photography to "art," from Peter Henry Emerson, *Naturalistic Photography for Students of the Art: The Death of Naturalistic Photography* (reprinted in Literature of Photography series, Arno Press, 1973). For an entertaining digression on an instrument of writer and artist: Henry Petroski, *The Pencil: A History of Design and Circumstance* (1990). Much of the literature on Alfred Stieglitz is by his uncritical acolytes: Waldo Frank et al., eds., *America and Alfred Stieglitz: Collective Portrait* (1934); *Alfred Stieglitz: Photographer* (1965); Dorothy Norman, *Alfred Stieglitz: Introduction to an American Seer* (1960). These can be corrected by the uncompromising dual biography: Benita Eisler, *O'Keeffe and Stieglitz: An American Romance* (1991), and by Georgia O'Keeffe's autobiography (1976). André Malraux boldly and brilliantly describes the consequences of photographic reproduction for our experience of all the arts, finally creating a "museum without walls," in *Voices of Silence* (1953), Part I. And for a stimulating essay on the effect of photography on our experience of the world, see Susan Sontag, *On Photography* (1977), in Anchor paperback. See also my *The Image* (1961; 1987).

Chapter 56. The Rise of the Skyscraper. The best introduction is Paul Goldberger's well-illustrated *The Skyscraper* (1981). For the wider context, David P. Billington, *The Tower and the Bridge: The New Art of Structural Engineering* (1983). For the American context, see Earle Shultz and Walter Simmons, *Offices in the Sky* (1959), and the readable works of Carl W. Condit, *American Building Art: The Nineteenth Century* (1960), . . . *The Twentieth Century* (1961), *American Building* (2d ed., 1982), a concise treatment of materials and techniques since Colonial times. Some distinctively American developments in architecture appear in my *The Americans: The National Experience* (1966), Chapters 18 and 19, and *The Americans: The Democratic Experience* (1973), Chapters 39 and 40. Writings by architects and their critics: Don Gifford, ed., *The Literature of Architecture . . . in Nineteenth-Century America* (1966); Horatio Greenough, *Form and Function* (Harold A. Small, ed., 1957); *Montgomery Schuyler, American Architecture and Other Writings* (1948), William H. Jordy and Ralph Coe, eds. Well-illustrated surveys: Carl W. Condit, *The Chicago School of Architecture . . . 1875–1925* (1952); *Chicago Architecture 1872–1922, Birth of a Metropolis* (John Zukowsky, ed., 1987). On Sullivan, the basic Hugh Morrison, *Louis Sullivan: Prophet of Modern Architecture* (1935), and Sherman Paul, *Louis Sullivan: An Architect in American Thought* (1962). However crisp were the members of the Chicago School in their architecture, they were wordy, repetitive, and emotive in their writing, for example Louis H. Sullivan, *The Autobiography of an Idea* (1924), *Kindergarten Chats* (1947). Sullivan's "Tall Office Building" is reprinted in *An American Primer* (Daniel J. Boorstin, ed., Mentor paperback, 1968), at pp. 58off. Brendan Gill has given us an engrossing life of Frank Lloyd Wright in *Many Masks* (1987). And see Frank Lloyd Wright's *Autobiography* (1987). For the mythic and legendary meanings of the Chicago Fire: Ross Miller, *American Apocalypse* (1990).

BOOK THREE:
CREATING THE SELF

Part XI. *The Vanguard Word*

To grasp the novelty of the modern biography as a literary form we need only glance at the writers of "lives" before Boswell. Sample, at least, Plutarch's *Lives of the Noble Grecians and Romans* (often referred to as the *Parallel Lives*) in *Great Books of the Western World,* vol. 14, or in any of many handy reprints—for example, in Penguin Books. The best-known examples of "lives" in earlier English literature are those by Izaak Walton (1593–1683), who wrote pious life stories to sanctify John Donne (1640), Richard Hooker (1665), George Herbert (1670), and other Anglican worthies, and the writings of Thomas Fuller (1608–1661), whose lives of local notables were appropriately titled (after his death) *The History of the Worthies of England* (1662). Such bloodless adulatory chronicles are a far cry from the creators of our Chapters 57–60. See John A. Garraty, *The Nature of Biography* (1957) and André Maurois, *Aspects of Biography* (1929), by a master of popular lives. On the history of the genre in England we have a delightful essay by Harold Nicolson, *The Development of English Biography* (1928). And see Donald A. Stauffer, *English Biography before 1700* (1930), *The Art of Biography in Eighteenth-Century England* (1944); Leon Edel, *Literary Biography* (1957). For autobiography: Roy Pascal, *Design and Truth in Autobiography* (1960); James Olney, *Metaphors of Self: the Meaning of Autobiography* (1981); John N. Morris, *Versions of the Self* (1966), English autobiography from Bunyan to Mill; Thomas Mallon, *A Book of One's Own* (1984), an introduction to the history of diaries and diarists. For a lively survey of works after Boswell: Richard Altick, *Lives and Letters: A History of Literary Biography in England and America* (1965). Phyllis Rose, *Parallel Lives: Five Victorian Marriages* (1983), offers an engaging combination of the techniques of Plutarch and Boswell in her account of eminent authors and their spouses. And, for a suggestive contrast, Robert E. Hegel and Richard C. Hessney, eds., *Expressions of Self in Chinese Literature* (1985). An entertaining anthology: Edgar Johnson, *A Treasury of Biography* (1941). As usual, André Malraux makes something tantalizingly new with his *Anti-Memoirs* (1968).

Chapter 57. Inventing the Essay. A brief introduction to Montaigne is "Montaigne, or the Art of Being Truthful," the essay by Herbert Luthy, in *The Proper Study* (Quentin Anderson and Joseph A. Mazzo, eds., 1962). We can enjoy the lively and scholarly biography, *Montaigne* (1984), by Donald M. Frame. The *Essays* are in *Great Books of the Western World* (1952), Vol. 25 (Charles Cotton, trans.) and in many reprints, of which my favorite is the lively J. M. Cohen translation in Penguin Classics (1958). Essays are commonly distinguished into the "formal," which fill current magazines on all topics; and the "informal" or "familiar," which are now the mainstay of *The New Yorker,* chronicled in W. F. Bryan and R. S. Crane, eds., *The English Familiar Essay* (1916).

Chapter 58. The Art of Being Truthful: Confessions. A history of meanings of the word "confessions" from theology to psychology would be a microcosm of Western thinking about the self. A clue to the transformations is the contrast between the private searchings of Saint Augustine and the sensational "revelations" in an American *True Confessions* magazine. Rousseau alone has inspired literatures both of psychoanalytic dissection and of philosophic debate on his political theories, for example in Irving Babbitt, *Rousseau and Romanticism* (1919). For a copious biography, see Jean Guehenno, *Jean-Jacques Rousseau* (2 vols., 1966, John and Doreen Weightman, trans.); and a shorter C. E. Vulliamy, *Rousseau* (1972). And do not miss the searching and readable Maurice Cranston, *Jean Jacques . . . The Early Life and Works . . . 1712–1754* (1982), in paperback, and *The Noble Savage: Jean Jacques . . . 1754–1762* (1991). For Rousseau's works: *The Confessions* is in Everyman's Library (2 vols., 1941) and in the vivid translation by J. M. Cohen (Penguin Classics, 1953), *Émile* (Barbara Foxley, trans.) in Everyman's Library; *The Social Contract* (in many reprints), *A Discourse on the Origin of Inequality,* and *Discourse*

on *Political Economy* are in *Great Books of the Western World,* Vol. 38.

Chapter 59. The Arts of Seeming Truthful: Autobiography. The best biography is the scholarly and readable Esmond Wright, *Franklin of Philadelphia* (1986), with bibliography. A perceptive short introduction is Carl L. Becker's article in the *Dictionary of American Biography* (1931); and for reference, the massive Carl Van Doren, *Benjamin Franklin* (1938). Franklin's *Autobiography* and his other writings are widely available, for example, in Penguin Books (1987). The definitive scholarly edition of Franklin's *Papers* is edited by Leonard W. Labaree (15 vols., 1959–71). For a "classic" depreciation of Franklin, see D. H. Lawrence, *Studies in Classic American Literature* (1953). And for the American context of Franklin's thought, see my *Lost World of Thomas Jefferson* (1948; 1981). Some tantalizing questions are raised by Roy Pascal, *Design and Truth in Autobiography* (1960).

Chapter 60. Intimate Biography. Boswell's private papers, which had been believed to have been destroyed, were recovered at Malahide Castle, near Dublin, in the 1920s and 1930s, and sold to an American collector by Boswell's great-great-grandson. The papers, acquired by Yale University, have been published in eighteen volumes (Geoffrey Scott and F. A. Pottle, eds., 1928–37). These, Boswell's journals, even if only sampled, give us the best access to the man. The first biography of Boswell to draw on these papers was F. A. Pottle, *James Boswell, The Earlier Years, 1760–1769* (1966). An attractive short life is by D. B. Wyndham Lewis, *James Boswell* (1980). See also Chauncey B. Tinker, *Young Boswell* (1922). Boswell's *Life of Johnson* is unabridged in *Great Books of the Western World,* Vol. 44, and is available in many other reprints, for example, in the World's Classics (R. W. Chapman, ed.), and in a useful abridgment, with a helpful introduction, by Christopher Hibbert in Penguin Classics (1987). We should read both T. B. Macaulay's and Thomas Carlyle's vigorous essays on biography and on Boswell's *Life of Johnson* in those writers' collected essays. For twentieth-century interpretations, see James L. Clifford, ed., *Boswell's Life of*

Johnson (1970), and Marlies K. Danziger and Frank Brady, eds., *James Boswell, The Great Biographer, 1740–1795* (1988).

Chapter 61. The Heroic Self. The Goethe literature is as vast and as international as that on Shakespeare, amplified by the fact that Goethe's own writings, which came to 133 volumes in the Weimar Edition (1887–1919), have since been many times reedited. Goethe societies around the world add to the literature. The most interesting life is still *The Life and Works of Goethe* (2 vols., 1855; new ed., 1965) by George Henry Lewes, the "husband" of George Eliot, who helped his researches in Weimar and Berlin. See also Georg Brandes, *Wolfgang Goethe* (2 vols., 1924) and the suggestive essay by Erich Heller, "Goethe and the Avoidance of Tragedy," in *The Proper Study* (1962). Goethe biographies in this century are a panorama of the world of letters, with notable lives in English by Benedetto Croce (1970), Ludwig Lewisohn (1949), Albert Schweitzer (1949), Karl Vietor (1970), and Thomas Mann (in *Three Essays,* 1932), among others. *The Sorrows of Young Werther* (1989), *Elective Affinities* (1987), and selected *Verse* (1987) are in Penguin Books. Goethe's *Autobiography,* a translation of his *Dichtung und Wahrheit* by John Oxenford (2 vols., 1974), is available in an attractive University of Chicago Press paperback with an illuminating introduction by Karl Weintraub. Goethe's *Faust,* many times translated, is in *Great Books of the Western World* (George Madison Priest, trans.), Vol. 47, in Everyman's Library (Albert G. Latham, trans.), and Modern Library (Bayard Taylor, trans.). My favorite is the Anchor paperback (1963, new translation by Walter Kaufman, with the German text on the facing pages). Few episodes are more revealing of Goethe than the journals (1962) of his *Italian Journey* (1786–88) with the perceptive comments of W. H. Auden. For Goethe the scientist: Charles Sherrington, *Goethe on Nature and on Science* (2d ed., 1949); the excellent article by George A. Wells in *Dictionary of Scientific Biography* (1972), Vol. 5. Thomas Mann has cast into a novel his view of Goethe as genius creator, with his view of how contemporaries saw Goethe: *The Beloved Returns:*

Lotte in Weimar (1940; 1990 with introduction by Hayden White).

Chapter 62. Songs of the Self. Convenient access to the prose and poetry of Wordsworth and Coleridge with helpful notes is in *The Norton Anthology of English Literature*, Vol. 2 (M. H. Abrams, ed. 4th ed., 1979), in addition to numerous reprint editions of their separate works. The standard edition of Wordsworth's poetical works is in 5 vols. (1940–49), E. de Selincourt and R. Darbishire, eds.; an edition of *The Prelude* by de Selincourt (rev. ed., 1970) offers the versions of 1805 and 1850 for comparison. Do not overlook *Journals of Dorothy Wordsworth* (William Knight, ed., 1930). For perceptive biography: the comprehensive Mary Moorman, *William Wordsworth* (2 vols., 1957–65), and the shorter Hunter Davies, *William Wordsworth* (1980). To put Wordsworth in context: Jonathan Wordsworth et al., *William Wordsworth and the Age of English Romanticism* (1987), *The Prelude, 1799, 1805, 1850* (1979) relating the poem to the poet's life and times. For Coleridge's writings: the attractive and well-chosen *Selected Prose and Poetry of Coleridge* (Stephen Potter, ed., 1933); *The Poetical Works of Coleridge* (James Dykes Campbell, ed., 1924). For a scholarly and readable short life: Walter Jackson Bate, *Coleridge* (1973), or Basil Willey, *Coleridge* (1972); and for detail E. K. Chambers, *Samuel Taylor Coleridge* (1938, 1973). John Livingston Lowes, *The Road to Xanadu* (1927), offers an intriguing study of the making of Coleridge's "Kubla Khan." For the wider background of Romanticism in philosophy and psychology: the brilliant M. H. Abrams, *The Mirror and the Lamp* (1953; Oxford University Press paperback, 1971), *Natural Supernaturalism: Tradition and Revolution in Romantic Literature* (1971); S. Prickett, *Coleridge and Wordsworth: The Poetry of Growth* (1970). To seek how literary dogmatists have blamed romanticism as the source of modern evils—relativism in morals and "enthusiasm" in politics—Irving Babbitt, *Rousseau and Romanticism* (1935), *The New Laökoon* (1934), an essay on the confusion of the arts. Suggestive clues on how the rise of romantic individualism has stimulated pride and property in authorship: Thomas

Mallon, *Stolen Words . . . the Origins of Plagiarism* (1989); *The Forger's Art: Forgery and the Philosophy of Art* (Denis Dutton, ed., 1983).

A good introduction to the life of Whitman is the article by Mark Van Doren in the *Dictionary of American Biography* (1936), and the well-written Justin Kaplan, *Walt Whitman* (1980). *Walt Whitman: Complete Prose & Selected Prose and Letters*, Emory Holloway, ed., is in an attractive Nonesuch Press edition (1938, 1964). Whitman's poetry and "Democratic Vistas" are in many anthologies and paperback reprints; The *Complete Writings of Whitman* (10 vols., 1902; 1965). A good selection, with helpful notes: *The Norton Anthology of American Literature*, Vol. 1 (4th ed., 1979), pp. 1850–2032. For background, the reflective Edmund Wilson, *Patriotic Gore* (1962), and the chatty Van Wyck Brooks, *The Times of Melville and Whitman* (1947), *New England: Indian Summer 1865–1915* (1940). Whitman has been the butt of passionate criticism from different sides: George Santayana attacked him as the poet of "barbarism," *Interpretations of Poetry and Religion* (1951); D. H. Lawrence contemned his "empty Allness. An addled egg," (*Studies in Classic American Literature*, 1953).

Chapter 63. In a Dry Season. Begin with the perceptive Peter Ackroyd, *T. S. Eliot: A Life* (1984). To test the range of Eliot's thought, enjoy his elegant acerbic prose: *Selected Essays (1917–1932)* (1932); *After Strange Gods: A Primer of Modern Heresy* (1934); *Essays Ancient and Modern* (1936); *Selected Prose* (1953), a Penguin book. Find his poetry in *Collected Poems, 1909–1935* (1936), *Old Possum's Book of Practical Cats* (1939), *The Waste Land and Other Poems* (1940). His plays: *Murder in the Cathedral* (1935; film script, 1951), *The Family Reunion* (1939), *The Cocktail Party* (1950). We gain some perspective on his ideas from his Harvard thesis, *Knowledge and Experience in the Philosophy of F. H. Bradley* (1964). Varied perspectives: Elizabeth Drew, *T. S. Eliot, The Design of his Poetry* (1949); F. O. Matthiessen, *The Achievement of T. S. Eliot* (3d ed., 1958, with a chapter by C. L. Barber); Helen Gardner, *The Art of T. S. Eliot* (1949). Especially illuminating: Valerie Eliot, ed., *The Waste*

Land: A Facsimile and Transcript of the Original Draft Including the Annotations of Ezra Pound (1971). Ezra Pound continues to challenge biographers who try to appreciate his literary achievement without denying his wild and vicious social views. Readable recent efforts: Peter Ackroyd, *Ezra Pound and his World* (1980), with illustrations; John Tytell, *Ezra Pound: the Solitary Volcano* (1987); Humphrey Carpenter, *A Serious Character: The Life of Ezra Pound* (1988). *The Literary Essays of Ezra Pound* (1954) are collected and introduced by T. S. Eliot. For Pound's poetry: *Selected Poems* (1928, 1933), edited with an introduction by T. S. Eliot; *Selected Poems of Ezra Pound* (new ed., 1957), a New Directions paperback; *The Cantos of Ezra Pound* (1948).

Part XII: The Wilderness Within

Along with the discovery of hidden dimensions of experience by pioneers like Charles Darwin, James G. Frazer, Sigmund Freud, Carl G. Jung, among others, came the inwardness of modern man. (See my *The Discoverers,* Chapter 76.) It is significant that some of the most influential American thinkers of the early twentieth century—for example, William James and John Dewey—pursued these paths of inward discovery. These writers, too, focused on the concrete experiences of the individual person, and did not seek refuge in metaphysics. But it is easier to describe the symptoms than to explain the causes of this trauma (and feast) of inwardness that we find among the creators of Part XII. Again we are better able to see the what and the how than the why. Much of the literature about literature is an effort to explain and describe this new focus of the Vanguard Word and cast it into a definition of "the modern." One of the more influential and prophetic of these interpretations of modern literature was Edmund Wilson's *Axel's Castle* (1931; with introduction by Hugh Kenner, 1991). For another American perspective: Steven Watson, *Strange Bedfellows: The First American Avant-Garde* (1991).

Defining "modernity" has intrigued and challenged literary critics: Ricardo J. Quinones, *Mapping Literary Modernism*

(1985); Frederick R. Karl, *Modern and Modernism, The Sovereignty of the Artist 1885–1925* (1985), which relates writers to painters. Some have sought a definition in the character of particular writers: Julian Symons, *Makers of the New: The Revolution in Literature 1920–1939* (1987); Malcolm Bradbury, *The Modern World: Ten Great Writers* (1988). Or in selected writings: the admirable *The Modern Tradition: Backgrounds of Modern Literature* (1965), edited by Richard Ellmann and Charles Feidelson, Jr.; *Modernism: A Guide to European Literature 1890–1930* (Malcolm Bradbury and James McFarlane, eds., 1976), a richly varied critical anthology, a Penguin book. For brief essays on particular arts and artists, see Kenneth McLeish, *Penguin Companion to the Arts in the Twentieth Century* (1985), and for writers, *Columbia Dictionary of Modern European Literature* (Jean-Albert Bede and William B. Edgerton, eds., 2d ed., 1980). And for the context of modern criticism: M. H. Abrams, *Doing Things with Texts: Essays in Criticism and Critical Theory* (1989).

Chapter 64. An American at Sea. Begin with Newton Arvin, *Herman Melville* (1950, 1976). There is a special interest in Raymond M. Weaver, *Herman Melville: Mariner and Mystic* (1921, 1968) as the first full-length biography. For factual detail, see Leon Howard, *Herman Melville: A Biography* (1951, 1967), and for a personal interpretation, *Herman Melville* (rev. ed., 1963) by the versatile Lewis Mumford. An ample collection of documents, letters, and photographs: Jay Leyda, *The Melville Log: A Documentary Life of Herman Melville* (2 vols., 1951, 1969). For the development of Melville's ideas: Ellery Sedgwick, *Herman Melville: The Tragedy of Mind* (1944, 1972), and a subtle study of his relationship with his eminent contemporaries, F. O. Matthiessen, *American Renaissance* (1941, 1979). Melville's writings have often been reprinted, individually and in sets. A special delight is the Modern Library edition of *Moby-Dick,* elegantly designed, with Rockwell Kent illustrations. Again, D. H. Lawrence has something to tell us about Melville that others never thought of or did not dare to say: *Studies in Classic American Literature* (1951, Anchor paperback), Chapters 10 and 11. An excellent se-

lection of Melville's letters, short stories, and verse is in *The Norton Anthology of American Literature,* Vol. 1 (4th ed., 1979), pp. 2032–48. The standard scholarly edition of Melville's writings is in the North-western-Newberry Edition (1968–), edited by Harrison Hayford, Hershel Parker, and G. Thomas Tansolle. For the social scene: Van Wyck Brooks, *The Times of Melville and Whitman* (1947).

Chapter 65. Sagas of the Russian Soul.
The recent disintegration of the Soviet Union encourages us to reflect again on the ways of creators in an oppressive society. The great Russian writers whose works in translation have become classics of Western literature—Tolstoy, Turgenev, Chekhov, and the others—were products of a society ruled by czarist autocracy. The literature about Dostoyevsky rivals that on Shakespeare or Goethe, and his well-chronicled life gives us vivid insights into a writer of fertile imagination reacting in that society—with rebellion, acquiescence, sycophancy, and escape into religious orthodoxy. Selecting among the numerous lives, begin with Avrahm Yarmolinsky, *Dostoyevsky: His Life and Art* (2d ed., 1957); *Dostoevsky: Works and Days* (1971); and Ernest J. Simmons, *Feodor Dostoevsky* (1969); Anna G. Dostoevsky, *Dostoevsky: Reminiscences* (1975). See also Geir Kjetsaa, *Fyodor Dostoyevsky* (1989; translation from the Norwegian). For interpretive essays: Nikolai Berdyayev, *Dostoevsky* (1957); André Gide, *Dostoevsky* (1949 with an introduction by Arnold Bennett); Thomas Mann, *Essays of Three Decades* (1947); W. Somerset Maugham, *Ten Novels and Their Authors* (1954); Ernest Simmons, *Dostoevski: The Making of a Novelist* (1940); Stefan Zweig, *Three Masters: Balzac, Dickens, Dostoeffsky* (1930). The standard edition in English is *The Novels of Fyodor Dostoevsky* (12 vols., 1912–59) translated by Constance Garnett, whose translations have been the most widely used in reprints of individual novels, for example in the Modern Library and Bantam paperbacks. Thomas Mann has provided a cautionary introduction, "Dostoevsky—in Moderation," to *The Short Novels of Dostoevsky* (1945) where he concludes, " 'Be careful! You will write a book about him.' I was careful." A widely acclaimed new

translation of *The Brothers Karamazov* (helpfully annotated), by Richard Pevear and Larissa Volkhonsky, is available in paperback in Vintage Classics (1991). New discoveries and new editions of Dostoyevsky's notebooks for the separate novels, edited by Edward Wasiolek and others, continue to appear. For the wider perspective: James H. Billington, *The Icon and the Axe* (1966); Richard Pipes, *Russia under the Old Regime* (1974); the journal of a Russian Tocqueville, Marquis de Custine, *Empire of the Czar* (1989); D. S. Mirsky, *A History of Russian Literature . . . to 1900* (1958); Henry Gifford, *The Novel in Russia* (1964); Marc Slonim, *An Outline of Russian Literature* (1959); *The Portable Twentieth-Century Russian Reader* (Clarence Brown, ed., 1985), a Penguin paperback.

Chapter 66. Journey to the Interior. For the life of Kafka, begin with Ernst Pawel, *The Nightmare of Reason: A Life of Franz Kafka* (1985), and Anthony Thorlby, *Kafka: A Study* (1972). Max Brod's *Franz Kafka* (2d ed., 1960) offers the view of a friend. See also Klaus Wagenbach, *Franz Kafka: Pictures of a Life* (1984); *Kafka's Letters to Felice* (E. Heller and J. Born, eds., 1972), *Letters to Ottla and the Family* (H. Binder and K. Wagenbach, eds., 1982). *Kafka's Diaries* (1910–1923), edited by Max Brod, are in Penguin Books (1972); Kafka's novels and stories are separately available in several editions. The best collections are *The Basic Kafka* (Erich Heller, ed., Pocket Books, 1979); *The Complete Stories and Parables* (Nahum N. Glatzer, ed., Quality Paperback, 1981). There has as yet been no complete edition in English of all Kafka's writings, but see *The Penguin Complete Novels of Franz Kafka* (1983). Of special interest: Franz Kafka, *Amerika* (1946; Preface by Klaus Mann, Afterword by Max Brod). The critical literature grows, for example: J. P. Stern, ed., *The World of Franz Kafka* (1980); Frederick R. Karl, *Franz Kafka, Representative Man* (1991), with copious detail relating the writer to his age.

Chapter 67. The Garden of Involuntary Memory. After Proust's own writing only a bold author would venture comparison by writing his biography. George D.

Painter has done it well in his *Marcel Proust: A Biography* (2 vols., 1978, 1989). And for shorter lives: Ronald Hayman, *Proust* (1990); André Maurois, *The Quest for Proust* (1950), *The World of Marcel Proust* (1974). See also *Selected Letters of Marcel Proust, 1880–1903* (Philip Kobb, ed., 1983); Harold Pinter, *The Proust Screenplay* (1978). The standard translation of *À la Recherche du temps perdu* (1913–27) is the elegant work of C. K. Scott-Moncrieff, *Remembrance of Things Past* (1922–31), revised in 1981. For the relation of Proust's neuroses to his art, see George Pickering, *Creative Malady* (1974).

Chapter 68. The Filigreed Self. Since much of Joyce's writing is autobiographical, the biographer must compete with his subject. The task is superbly performed by Richard Ellmann, *James Joyce* (1959; rev. ed., 1982). And do not miss the engrossing and revealing love story: Brenda Maddox, *Nora: A Biography of Nora Joyce* (1988). Shorter studies on aspects of the life: Ezra Loomis Pound, *Pound/Joyce* (1968), letters of Ezra Pound to James Joyce with Pound's essays on Joyce; Stanislaus Joyce, *My Brother's Keeper: James Joyce's Early Years* (1958; notes by Richard Ellmann, preface by T. S. Eliot); Herbert S. Gorman, *James Joyce: His First Forty Years* (1974); Frank Budgen, *James Joyce and the Making of Ulysses* (1960), a vivid account by someone who was there, with the author's portrait of Joyce; Richard Ellmann, *Four Dubliners: Wilde, Yeats, Joyce, and Beckett* (1986). The best introduction to the writings: Harry Levin, *James Joyce, a Critical Introduction* (rev. ed., 1980), and *The Portable James Joyce,* including collected poems, Penguin Books (1976), *Dubliners* and *Portrait of the Artist as a Young Man,* and *Ulysses* (with the decision by Judge John M. Woolsey) are in Modern Library. A "corrected text" of *Ulysses* (1986) is in Vintage paperback. *Finnegans Wake* is a Penguin book. For light on Joyce's way of writing: *Finnegans Wake,* facsimile of the Buffalo Notebooks (Danis Rose, ed., 1978). For aid in reading Joyce: Matthew Hogart, *James Joyce, A Student's Guide* (1978); Stuart Gilbert, *James Joyce's Ulysses* (1932); Joseph Campbell and Henry Morton Robinson, *A Skeleton Key to Finnegans Wake* (1961); Anthony Burgess, ed., *A*

Shorter Finnegans Wake (1968). A sample of the criticism: Thomas E. Connolly, ed., *Joyce's Portrait: Criticisms and Critiques* (1962); C. George Sandulescu and Clive Hart, *Assessing the 1984 Ulysses* (1986), a publication of the Princess Grace Irish Library in Monaco.

Chapter 69. "I Too Am Here!" A richly detailed biography is by her nephew, Quentin Bell, *Virginia Woolf* (2 vols., 1972). For a shorter life: P. Rose, *Woman of Letters: A Life of Virginia Woolf* (1978). See also Louise De Salvo, *Virginia Woolf: the Impact of Sexual Abuse on Her Life and Work* (1989); Leonard Woolf, *Downhill All the Way: An Autobiography of the Years 1919 to 1939* (1975), and his edited version of Virginia Woolf's own account of herself, *A Writer's Diary* (1973); extracts from her diary, *Virginia Woolf: Moments of Being* (1976), unpublished autobiographical writings, edited by Jeanne Schulkind. For an excellent selection, *The Virginia Woolf Reader* (1984), edited by Mitchell A. Leaska; *Virginia Woolf: Selections from her Essays* (1966). Virginia Woolf's individual works are conveniently available in Harcourt Brace Harvest paperbacks or in Penguin Books. For background, see the brilliant Ellen Moers, *Literary Women: The Great Writers* (1977), an Anchor paperback; Karen Peterson and J. J. Wilson (1976), *Women Artists;* Alan and Mary Simpson, eds., *I Too Am Here . . . Letters of Jane Welsh Carlyle* (1976), a vivid portrait of another talented woman writer struggling to be herself.

Chapter 70. Vistas from a Restless Self. Begin with the incomparable John Richardson (with Marilyn McCully), *A Life of Picasso* (1991), Vol. 1, 1881–1906, copiously illustrated. Briefer lives: Alfred H. Barr, ed., *Picasso: Fifty Years of His Art* (1946, 1980); Roland Penrose, *Picasso: His Life and Work* (3d ed., 1981); Pierre Daix, *Picasso* (1965). Picasso's life has been a storm center of works by adorers, critics, competing artists, and former mistresses: Ingo F. Walther, *Pablo Picasso: 1881–1973, Genius of the Century* (1986); William Boeck and Jaime Sabartès, *Picasso* (1955), illustrated; Françoise Gilot and Carlton Lake, *Life with Picasso* (1989); Fernande Olivier, *Picasso and his Friends* (1933, 1964); the muckraking Arianna Stas-

sinopoulos Huffington, *Picasso: Creator and Destroyer* (1988); M. McCully, ed., *A Picasso Anthology: Documents, Criticism, Reminiscences* (1981). For some arresting insights: *Gertrude Stein on Picasso* (Edward Burns, ed., 1984), or Gertrude Stein, *Picasso* (1933, 1938, 1984), a Dover paperback; André Malraux, *Picasso's Mask* (1976). For background: Gertrude Stein, *The Autobiography of Alice B. Toklas* (1980), *Selected Writings of Gertrude Stein* (1946), edited by Carl Van Vechten; Herschel B. Chipp, *Theories of Modern Art* (1968); Daniel H. Kahnweiler, *The Rise of Cubism* (1949); Guillaume Apollinaire, *The Cubist Painters* (1913; 1970).

Epilogue: Mysteries of a Public Art. An anecdotal history of the early days of movies: Terry Ramsaye, *A Million and One Nights: A History of the Motion Picture* (1926; 1964), can be updated and corrected by David Cook, *A History of Narrative Film* (2d ed., 1990). A discriminating account of the beginnings: Arthur Knight, *The Liveliest Art: A Panoramic History of the Movies* (1957), a New American Library paperback. For the technology: Robert Conot, *A Streak of Luck* (1979), a biography of Thomas Edison. A brilliant account of how movies affect the audience: Jon Boorstin, *The Hollywood Eye: What Makes Movies Work* (1990), amply illustrated. A readable full-length biography of Griffith: Richard Schickel, *D. W. Griffith: An American Life* (1983). For sidelights on the man: L. Arvidson (Mrs. D. W. Griffith), *When the Movies were Young* (1925); Harry M. Geduld, ed., *Focus on D. W.*

Griffith (1971), with revealing biographical documents; Lillian Gish, *Mr. Griffith, the Movies, and Me* (1969); F. Silva, *Focus on "The Birth of a Nation"* (1971). Eisenstein's life is recorded in the filmmaker's fragmentary autobiography, *Immoral Memories* (1983), to be filled out by Marie Seton, *Sergei M. Eisenstein* (1960), a Grove paperback, and in Harcourt Brace Harvest paperback. See also Leon Moussinac, *Sergei Eisenstein* (1970), with documents. Eisenstein's writings are stirring even when dogmatic: *Film Sense* (1942) and *Film Form* (1949), edited by Jay Leyda; *Notes of a Film Director* (1958); *Film Essays* (1968). For adventures in film theory: Ernest Lindgren, *The Art of the Film: An Introduction to Film Appreciation* (1948); V. I. Pudovkin, *Film Technique and Film Acting* (1954), with an introduction by Lewis Jacobs; George Bluestone, *Novels into Film* (1957); Rudolf Arnheim, *Film as Art* (1969); Bela Balazs, *Theory of the Film Character and Growth of a New Art* (1970), Ralph Stephenson and Guy Phelps, *The Cinema as Art* (rev. ed., 1989). For the development of film art in relation to stage, studio, and audience: A. Nicholas Vardac, *Stage to Screen: Theatrical Origins of Early Film: David Garrick to D. W. Griffith* (1987); Lewis Jacobs, *The Emergence of Film Art* (2d ed., 1979); Gilbert Seldes, *The Public Arts* (1956); Russell Lynes, *The Lively Audience, A Social History of the Visual and Performing Arts in America, 1890–1950* (1985); Thomas Schatz, *The Genius of the System: Hollywood Filmmaking in the Studio Era* (1988).

ACKNOWLEDGMENTS

Since this book is a kind of autobiography, it has profited from my opportunities to read at leisure and to visit the art galleries and architectural monuments of Europe and the Mediterranean. I owe these opportunities in the first instance to the generous advantages many years ago of a Rhodes Scholarship and to the Oxford calendar of long vacations. And more recently I owe them to my experiences of teaching and lecturing in universities in the United States and in Europe, Japan, and India. The monuments and works of art here described, almost without exception, I have visited and seen more than once. During the last fifty years I have had the special advantage of the inspiration and companionship of my wife (and editor) Ruth F. Boorstin, who has shared these sights and visits. And my reflections on literature, first stirred by my college tutor, F. O. Matthiessen, during these years have had the benefit of her guidance, stimulus, and encouragement. As this book is intended to be not a mere exposition but an invitation, I hope it may entice readers to the source, the works of the creators, a journey always enriched by the right companion.

This book would have been impossible without the incomparable collections of the Library of Congress in Washington, D.C.

It is a pleasure to thank friends and fellow scholars who have given me suggestions or read parts of the manuscript. They have saved me from errors of fact, but often have not shared my interpretations or my emphases. They include: Dr. James S. Ackerman, Professor of Fine Arts Emeritus, Harvard University; Mr. Yoshinobu Ashihara, architect, Tokyo, Japan; Dr. Jacques Barzun, University Professor Emeritus, Columbia University; Dr. Kenneth Brecher, Professor of Astronomy and Physics, Boston University; Dr. Alan Fern, Director, National Portrait Gallery, Smithsonian Institution, Washington, D.C.; Dr. Gerald Holton, Mallinkrodt Professor of Physics and Professor of History of Science, Harvard University; Mr. Eugene Istomin, concert pianist, Washington, D.C.; Mrs. Marta Istomin, former Artistic Director, Kennedy Center, Washington, D.C.; Mr. David Jackson, architect, Sydney, Australia, Dr. Joseph Kerman, Professor of Music, Uni-

versity of California, Berkeley; Dr. Bernard Knox, Director Emeritus, Center for Hellenic Studies, Washington, D.C.; Dr. Angeliki Laiou, Professor of Byzantine History, Harvard University; Director, Dumbarton Oaks Research Library and Collections, Washington, D.C.; Dr. R.W.B. Lewis, Professor Emeritus of American Studies and English, Yale University; Dr. Kenneth Lynn, Arthur O. Lovejoy Professor of History Emeritus, The Johns Hopkins University; Dr. William H. McNeill, Robert A. Millikan Distinguished Service Professor of History Emeritus, University of Chicago; Dr. Henry A. Millon, Dean, Center for Advanced Study in the Visual Arts, National Gallery, Washington, D.C.; Dr. F. W. Mote, Professor Emeritus of East Asian Studies, Princeton University; Dr. Jaroslav Pelikan, Sterling Professor of History, Yale University; Dr. Phillips Talbot, President Emeritus, The Asia Society, New York, N.Y.; Dr. Paul Walker, Chicago, Illinois; Mr. George M. White, The Architect of the Capitol, Washington, D.C.; Dr. Esmond Wright, former Director of the Institute of United States Studies and Professor Emeritus of American History, University of London; and my sons, Paul Boorstin, Jonathan Boorstin, and David Boorstin.

My friend Genevieve Gremillion has helped at every stage in the preparation of the manuscript. Once again, her devotion to the project, her patience, and her good cheer have lightened the task of preparing and revising these many pages. Mrs. Mae Barnes has given prompt and valuable assistance in the final stages. Mrs. Sono Rosenberg has given the copy editing of this book the benefit of her exceptional knowledge and expertise.

Robert D. Loomis, vice president and executive editor of Random House, once again has shown me how a publishing editor at his best can guide and encourage an author. Most important has been his feeling for what this book should (and should not) try to be. By his close editing of what I have included and his rigorous insistence on what I should omit, he has helped me give focus and direction to the book.

Ruth F. Boorstin, my wife, has been as always my principal and most penetrating editor. Her poetic feeling for words and her impatience with vagueness and the cliché have made the book briefer, clearer, and more readable than it otherwise would have been. To dedicate this book to her is, once again, a conspicuous understatement, which is only one of the literary virtues she has tried to teach me.

INDEX

ABOUT THE AUTHOR

Historian, public servant, and author, DANIEL J. BOORSTIN, the Librarian of Congress Emeritus, directed the Library from 1975 to 1987. He had previously been director of the National Museum of History and Technology, and senior historian of the Smithsonian Institution in Washington, D.C. Before that he was the Preston and Sterling Morton Distinguished Service Professor of History at the University of Chicago, where he taught for twenty-five years.

Born in Atlanta, Georgia, and raised in Tulsa, Oklahoma, Boorstin graduated with highest honors from Harvard College and received his doctorate from Yale University. As a Rhodes Scholar at Balliol College, Oxford, England, he won a coveted double first in two degrees in law and was admitted as a barrister-at-law of the Inner Temple, London. He is also a member of the Massachusetts bar. He has been visiting professor at the University of Rome, the University of Geneva, the University of Kyoto in Japan, and the University of Puerto Rico. In Paris he was the first incumbent of a chair in American history at the Sorbonne, and at Cambridge University, England, he was Pitt Professor of American History and Institutions and Fellow of Trinity College. Boorstin has lectured widely in the United States and all over the world. He has received numerous honorary degrees and has been decorated by the governments of France, Belgium, Portugal, and Japan. He is married to the former Ruth Frankel, the editor of all his works, and they have three sons and four grandchildren.

The Discoverers, Boorstin's history of man's search to know the world and himself, was published in 1983. A Book-of-the-Month Club Main Selection, *The Discoverers* was on the *New York Times* best-seller list for half a year and won the Watson Davis Prize of the History of Science Society. This and his other books have been translated into more than twenty languages.

Boorstin's many books include *The Americans: The Colonial Experience* (1958), which won the Bancroft Prize; *The Americans: The National Experience* (1965), which won the Parkman Prize; and *The Americans: The Democratic Experience* (1973), which won the Pulitzer Prize for History and the Dexter Prize and was a Book-of-the-Month Club Main Selection. Among his other books are *The Mysterious Science of the Law* (1941), *The Lost World of Thomas Jefferson* (1948), *The Genius of American Politics* (1953), *The Image* (1962), and *The Republic of Technology* (1978). For young people he has written the *Landmark History of the American People.* His textbook for high schools, *A History of the United States* (1980), written with Brooks M. Kelley, has been widely adopted. He is the editor of *An American Primer* (1966) and the thirty-volume series *The Chicago History of American Civilization,* among other works.

HIDDEN HISTORY
Exploring Our Secret Past

A collection of 24 incisive essays that examine rhythms, patterns, and institutions of everyday American life—from intimate portraits of legendary figures to expansive discussions of historical phenomena.

"Highly representative of his awesome scope ... eminently readable and provocative." —*Washington Post Book World*

History/0-679-72223-8/$12.00 (Can. $16.00)

THE IMAGE
A Guide to Pseudo-Events in America
With an Afterword by George F. Will

In this analysis of America's inundation by illusion, Boorstin introduces the concept of "pseudo-events"—events such as press conferences and presidential debates, which are staged solely in order to be reported—and redefines *celebrity* as "a person who is known for his well-knownness." The result is an essential resource for anyone who wants to distinguish the manifold deceptions of our culture from its few enduring truths.

"A very informative and entertaining and chastising book." —*Harper's*

History/0-679-74180-1/$12.00 (Can. $15.00)